Index to
Nineteenth Century
American Art
Periodicals

INDEX
TO
NINETEENTH
CENTURY
AMERICAN ART
PERIODICALS

Vol II: AUTHOR/SUBJECT INDEX

Mary Morris Schmidt

SOUND VIEW PRESS
AN AFFILIATE OF
INSTITUTE FOR ART RESEARCH & DOCUMENTATION
A NON-PROFIT ARTS EDUCATIONAL ORGANIZATION

1999

© 1999 by Sound View Press

Published in the United States of America by
Sound View Press
P. O. Box 833
Madison, CT 06443
Telephone: 203-245-2246 • Fax: 203-245-5116
email: info@falkart.com
Internet: www.falkart.com

ISBN 0-932087-56-6

Vol II
AUTHOR/SUBJECT INDEX

A

A., *11148, 23268, 24272*
A., B., *18171*
A., C. A., *14201*
A., C. R., *21470*
A., F. (monogram F. A.) See: **Anger, F.**
A., N., *11136, 13599*
A., S., *13614*
A., T. C., *9523*
Aachen (Germany). Suermondt Museum
 art gallery founded by collector Suermondt, 1883, *14922*
Abadie, Paul, 1812-1884
 Sacré Coeur, Paris, *15703*
Abbatt, Agnes Dean, 1847-1917
 exhibitions
 American Art Galleries, 1885, *1921*
 American Watercolor Society, 1881, *296*
 American Watercolor Society, 1882, *24390*
 American Watercolor Society, 1885, *1933, 25239*
 Denver Artists' Club, 1898, *12706*
 Denver Artists' Club, 1899, *12327, 12886*
 National Academy of Design, 1885, *1970*
 influences, *22520*
 models, flowers, *22519*
 Neighbor's hayfield, *22731*
 painted panel for table, 1880, *892*
 portraits, photograph, *22502*
 summer studio, 1893, *22491*
 watercolor of chrysanthemums, *813*
 whereabouts, 1883, returns from Marblehead, *24817*
 woman in art, *22525*
 work, 1883, *24883*
Abbéma, Louise, 1858-1927
 illustrations
 pen sketch, *3287*
 portrait of Mlle. Sarah Bernhardt, *694*
ABBEY, Edwin Austin, 1852-1911, *13369*
Abbey, Edwin Austin, 1852-1911, *848*
 award from French government, 1889, *25678*
 book plates, for Brander Matthews, *16349*
 collection, sale, 1895, *16865*
 commission for murals for Pennsylvania State House, *13549*
 commission for Westminster coronation scene, 1901, *13208*
 compared to Reinhart, *15429*
 compared with John Gilbert, 1897, *6426*
 decorations for Boston Public Library, *4283, 5640, 6106,
 13332, 22131, 26211*
 frieze, *13128*
 murals, *11549, 11561, 13351*
 murals of the Holy Grail, *12909*
 preparation, *3483*
 design for invitation card, *10151*
 designer of book-plates, *16326*
 designs for decoration of Philadelphia Common Council cham-
 ber, *11833*
 drawing technique, *7155*
 drawings for *She Stoops to Connquer* shown in New York,
 1887, *534*
 drawings for *She Stoops to Conquer* shown at Grolier Club,
 1886, *529*
 elected member of Athenaeum Club, 1901, *13199*
 elected member, Royal Institute of Painters in Water-Colors,
 1883, *24713*
 elected to National Academy of Design, 1902, *13436*
 exhibitions
 American Art Association, 1895, *21531*
 American Art Galleries, 1882, *1297*
 American Watercolor Society, 1878, *8979*
 American Watercolor Society, 1882, *1300, 9612*
 American Watercolor Society, 1883, *1510*

 American Watercolor Society, 1885, *1933*
 American Watercolor Society, 1886, *2150*
 American Watercolor Society, 1890, *3178, 25777*
 American Watercolor Society, 1897, *Quiet conscience, 6190*
 American Watercolor Society, 1906, *14118*
 Architectural League of New York, 1894, *4787*
 Architectural League of New York, 1894, stained glass, *4711*
 Berlin Akademie der Künste, 1903, *13605*
 Berlin Akademie der Künste, 1903, gold medal, *13629*
 Carnegie Galleries, 1901, *13322*
 Carnegie Institute, 1907, *14328*
 Chicago Art Institute, 1895, *5342*
 Internationale Kunstausstellung, Munich, 1883, *1637*
 London, 1884, *Stony ground, 10983*
 New York, 1890, drawings, *25805*
 New York, 1890, pen drawings, *3208*
 New York, 1894, Shakespeare drawings, *5120*
 New York, 1895, *5302*
 New York, 1895, drawings, *16865*
 New York, 1896, *16984*
 New York, 1896, pastels, *5735*
 New York, 1897, *Pavane, 17293*
 New York, 1898, scene from *Hamlet, 6557*
 Paris Exposition Universelle, 1889, *25675*
 Pennsylvania Academy of the Fine Arts, 1902, *13363*
 Pennsylvania Academy of the Fine Arts, 1905, *13851*
 Royal Academy, 1885, *2019*
 Royal Academy, 1890, *May Day morning, 25897*
 Royal Academy, 1894, *16556*
 Royal Academy, 1896, *23008*
 Royal Academy, 1896, *Richard, Duke of Gloucester and the
 Lady Anne, 5825*
 Royal Academy, 1897, scene from *Hamlet, 6311*
 Royal Academy, 1898, *12711, 12734*
 Royal Academy, 1898, scene from *King Lear, 6644*
 Royal Academy, 1899, *Mistress mine where are you roaming,
 6983*
 Royal Academy, 1902, *13431*
 Royal Academy, 1903, *8243, 13605*
 Royal Academy, 1906, *14116*
 Royal Institute of Painters in Water Colours, 1883, *24684*
 Royal Institute of Painters in Water Colours, 1884, *1813,
 10012*
 Royal Institute of Painters in Water Colours, 1885, *10183*
 Salmagundi Club, 1882, *1265*
 Salmagundi Club, 1887, *2364*
 Salon, 1896, illustrations of Shakespeare, *23618*
 Society of American Artists, 1897, *10538*
 Holy Grail pictures, *13265*
 illustrates Goldsmith's *Deserted Village*, 1891, *3506*
 illustrations
 bookplate, *4791*
 character sketch, *22610*
 Holy Grail (poster), *22344*
 No offense, 10764
 portrait of F. Hopkinson Smith, *1484*
 With dainty steps (etching), *22549*
 illustrations for *Harper's, 22476*
 illustrations for *Harper's Magazine*, 1892-3, *22482*
 illustrations for *Harper's Magazine*, 1893, *22490*
 illustrations for Herrick's poems, *9938*
 illustrations in periodicals, 1894, *4897*
 illustrations of Shakespeare plays for *Harper's Magazine*,
 25833
 illustrator of Boughton's *Sketching Rambles in Holland, 10115*
 illustrator of *She Stoops to Conquer, 10744, 10754*
 King Lear, at Royal Academy, 1898, *24090*
 May day morning, 3281, 3355
 member, Tile Club, *1851, 11267*
 Moran's lyrics to Abbey, *3623*
 mural painting, 1893, *4387*
 notes
 1885, *11255*
 1888, *25547*
 1902, *8059*

on London as center for American art students, 1902, *7804*
painting for Royal Exchange, London, *13316*
painting of coronation not finished, 1904, *13572*
painting of coronation of Edward VII, *8281*
paintings reviewed, 1882, *1495*
pastels, *7290*
portraits, bronze portrait by E. O. Ford, *7803*
position in American art, *70*
promotion to full honors at Royal Academy, *12782*
Richard, Duke of Gloucester and Lady Anne, acquired by Art
 Union of London, 1896, *17102*
Trial of Queen Catherine of Aragon, shown in Chicago exhibi-
 tion, 1906, *14222*
work difficult to reproduce, *5862*
abbeys
 England
 Battle Abbey, *21132*
 Cistern abbey of Dore, *16890*
 Ireland, *20961*
Abbot, John S. C. See: **Abbott, John Stevens Cabot**
Abbott, Agnes Dean See: **Abbatt, Agnes Dean**
Abbott, C. Yarnall, 1870-1938
 exhibitions
 Chicago Photographic Salon, 1900, *13035*
 Philadelphia Photographic Salon, 1900, *13120*
 illustrations
 Alphabet (photograph), *12973*
 Coryphée (photograph), *13342*
 Dying fire (photograph), *13238*, *13738*
ABBOTT, Charles Conrad, 1849-1919, *22618*, *22749*
Abbott, Charles Conrad, 1849-1919
 book in preparation, 1880, *147*
Abbott, Emma, 1840-1891
 portraits, marble bust by G. C. Keusch, *22738*
ABBOTT, Holker W., 1858-1930, *10890*
Abbott, Holker W., 1858-1930
 exhibitions, Boston Art Students' Association, 1884, *10898*
Abbott, John Stevens Cabot, 1805-1877
 Empire of Russia, review, *20153*
Abbott, Katherine G. See: **Cox, Katherine G. Abbott**
ABBOTT, Merrill E., *13323*
ABBOTT, Nelson R., *13203*
ABBOTT, Rosa G., *23122*
Abbott, Samuel Nelson, 1874-1953
 illustrations
 Idea, *23779*
 note from "Le Gendre de M. Poirier", *23680*
 Old Italian, *11443*
 poster for *The Quartier Latin*, *23727*
 Thousand-dollar touches, *24014*
Abdul Karim See: **Jossot, Henri Gustave**
Abdulaziz, Sultan of the Turks, 1830-1876
 Turkish sultan, *22801*
A'BECKET, John Joseph, 1849-1911, *12535*
A'Becket, Maria J. C., d.1904
 exhibitions
 Boston, 1885, *1983*
 Boston Art Club, 1880, *807*
 Philadelphia, 1884, *25056*
 Washington, 1884, *25109*
 Woman's Art Club of New York, 1891, *15550*
 Moonlight on the sea and *Coming storm* at Berkeley Lyceum,
 1890, *15128*
 whereabouts
 1883, leaves summer studio in Strasburg, Va. for Boston,
 24959
 1883, Strasburg, Va, *24607*, *24755*
 1894, leaves St. Augustine for North, *26997*
 1896, summer in Newport, *23056*
 work, 1883, *24871*
A'Beckett, Arthur, *pseud*. See: **Hopkins, Robert Thurston**
Abendschein, Albert, b.1860
 exhibitions, Salmagundi Club, 1884, drawings, *25211*
Abercrombie, George A., fl.1902
 exhibitions, Kansas City Art Club, 1902, *13337*

Aberdeen, George Hamilton-Gordon, *4th earl of*, 1784-1860,
 21261
Aberdeen (Scotland)
 Art Exhibition, 1890, *26201*
 exhibitions, 1881, John Phillip, *22059*
Aberdeen (Scotland). Aberdeen Art Gallery
 funded by bequest of Alexander MacDonald, *10127*
Abiff, Hiram See: **Hiram Abiff**
Ablett, Thomas Robert, 1849-1945
 views on art education in England, *1416*
ABNEY, William de Wiveleslie, *Sir*, 1844-1920, *21838*
Abney, William de Wiveleslie, *Sir*, 1844-1920
 experiments in color photography, *7666*
Abot, Eugène Michel Joseph, 1836-1894
 obituary, *16535*
Abraham, Tancrède, 1836-1895
 illustrations, *Fountain of the English near Montmuron*, *7075*
Abram, Paul, fl.1882-1912
 illustrations, *Douarnenez digne*, *13613*
ABRAM, W. A., *10290*
Abrantés, Andoche Junot, *duc d'* See: **Junot, Andoche, *duc***
 d'Abrantés
Abry, Léon Eugène Auguste, 1857-1905
 exhibitions, Internationale Kunstausstellung, Munich, 1883,
 14916
acacia
 Robinia pseudo acacia in Jardin des Plantes, Paris, *21351*
Academia de bellas artes de San Fernando See: **Madrid**
 (Spain). Academia de bellas artes de San Fernando
ACADEMICIAN, *11077*
Académie de Belgique See: **Brussels (Belgium). Académie**
 des sciences, des lettres et des beaux-arts de Belgique
Académie de France à Rome See: **Rome. Académie de**
 France à Rome
Académie des beaux arts, Paris See: **Paris (France).**
 Académie des beaux arts
Académie des inscriptions, Paris See: **Paris (France).**
 Académie des inscriptions et belles lettres
Académie française See: **Paris (France). Académie française**
Académie Julian See: **Paris (France). Académie Julian**
Académie Montparnasse See: **Paris (France). Académie**
 Montparnasse
Académie Whistler See: **Paris (France). Académie Whistler**
Academy for the Promotion of the Fine Arts See: **Bristol**
 (England). Academy for the Promotion of the Fine Arts
Academy of Art, Des Moines See: **Des Moines (Iowa).**
 Academy of Art
Academy of Design, Chicago See: **Chicago (Illinois). Chicago**
 Academy of Design
Academy of Fine Arts, Chicago See: **Chicago (Illinois).**
 Chicago Academy of Fine Arts
Academy of Fine Arts, Cincinnati See: **Cincinnati (Ohio).**
 Academy of Fine Arts
Academy of Music, Baltimore See: **Baltimore (Maryland).**
 Academy of Music
Academy of Music, New York See: **New York. Academy of**
 Music
Academy of Natural Sciences of Philadelphia See:
 Philadelphia (Pennsylvania). Academy of Natural Sciences of
 Philadelphia
Academy of Science of St. Louis See: **Saint Louis (Missouri).**
 Academy of Science of St. Louis
Academy of Sciences, New York See: **New York. New York**
 Academy of Sciences
Accademia di San Luca See: **Rome. Accademia di San Luca**
Achenbach, Andreas, 1815-1910
 Coast scene, in American Art Union Gallery, 1849, *14573*
 compared to Lessing, *20385*
 exhibitions
 New York, 1849, *14508*
 Pennsylvania Academy of the Fine Arts, 1857, *19658*
 landscape in Munger collection at Chicago Art Institute, *12785*
 pictures in Schwabe collection, *10238*
 Port of Ostend, in Schaus collection, *15840*
 Sicilian landscape in Philadelphia Art-Union, 1849, *21404*

24886, 24899, 24908, 24918, 24927, 24936, 24950
1884, 24961, 24973, 24985
1889, 25672, 25681, 25689, 25691
1890, 25707, 25717, 25719, 25729, 25739, 25756, 25767,
 25776, 25786, 25802, 25809, 25817, 25836, 25852, 25860,
 25870, 25881, 25894, 25903, 25914, 25923
1891, 26360, 26369
1892, 26874, 26882
1893, 26890, 26903, 26912, 26913, 26926, 26927, 26942,
 26943, 26948, 26956, 26965, 26973, 26979, 26980, 26988
1894, 26995, 27003, 27011, 27021, 27023

Ady, Julia Cartwright, d.1924
 Jean François Millet, publication noted, 13508
 Raphael, a Study of his Life and Work, review, 11714

AEOLIA, 10654, 10713

Aesop
 Fables
 illustrated by Caldecott, 9835
 illustrated by Griset, 8656

Aesthetic Movement
 color in interior decoration, 3244
 influence on interior decoration, 3216
 W. R. Bradshaw on aestheticism, 1898, 6796

aestheticism
 satirized by R. Buchanan, 11042

aesthetics, 23414, 23424, 23439
 absolute standard of art, 19238
 abstract and naturalism in art, 19982
 address by C. E. Norton, response by W. Crane, 21476
 aesthetical study of art, 20254, 20266
 aestheticism of the Bible, 10936
 America and beauty, 18909
 American houses, 9108, 9158
 ancient and modern spirit, 18858
 appreciation of pictures, 9794
 appreciation of the beautiful, 20543
 architect as artist, 20517
 architecture, 20516
 paper read by L. Eidlitz, 1861, 20361
 art and beauty, 18550
 art and morals, 20456
 art and nature as tools of reform, 18244
 art and the common man, 23333
 art and true religion, 19191
 art as a window to the soul, 17930
 art as idea, 24934
 art as mediator between nature and man, 19602
 art for art's sake, 22930
 art for its own sake, 11320
 art talk, 22368
 art through love, 23264
 artist and amateur, 124, 138
 artistic liscense, 18757
 artist's standard, 18806
 beauty, 13929, 18050, 18231, 18362, 19589, 24534
 and deformity, 18049, 19264
 and expression in art, 18859
 and expression in classical art, 18258
 and its enemies, 18684
 and metaphysics, 19533
 and truth in nature, 19554
 and utility, 20548
 as concept of the imagination, 24409
 definition, 20823
 discourse by John Stuart Blackie, 19810
 dissemination of the beautiful in *Cosmopolitan Art Journal*,
 17895, 17896
 expression of honest intention in art, 7685
 in art, 19285
 nature and use, 19425
 related to sublime, 19410
 the beautiful and the practical in America, 19098
 the beautiful in art, 19373
 theories of the beautiful, 20569
 transition from the beautiful to the un-beautiful, 18849

transition from un-beautiful to beautiful, 18797
boredom and fin de siècle, 8343
causes of failure in modern art, 14511
clever vs. serious art, 24445, 25084
comparison of national styles, 651
creative sympathy in the arts, 18889
decline of art since Raphael, 23333
decoration of public schools, 9137
decorative and pictorial elements in art, 9702
decorative art, 20486
definition of art, 12880
divine sanctification of role of beautiful, 18016
divinity of beauty, 19340, 19368, 19393
dress, 9314, 9382, 9402
duty in art, 18586
education of the eye, 11234
Emerson on beauty, 17971
ethics of taste, 8533
excerpts from Hegel, 20137
fat women, 18321
fidelity to nature, 21607, 22020, 23286
fin de siècle, 8314
finish in art, 20055
function and formation of museums, 9352
future of art, 27
George Inness on art, 9242
great art, 23260
grotesque in art, 21945
Hegel's concept of beauty, 20036
Hegel's philosophy, 20070
higher ideals, 24396
higher ideals forsaken for clever effects, 24432
higher standards in art, 18444
idea as proper end of art, 25039
ideal and real in art, 14121, 18395
idealism and the imagination, 21466
idealism in art, 8721
imitation and truth in art, 13190, 18972
imitation in art, 9377, 19047
Impressionism, 22215
incentives and aims of art, 18587
individuality in art, 18642
influence of artists' way of life on art, 18462
Japanese, 8972, 9030, 9041
Knight Errant, 21462, 21501
lecture by Parke Godwin, 23383
mechanization and art, 13217
men of genius, 19216
Mendelssohn on creativity and meaning, 19050
mission of art, 12866, 18022
moral beauty of landscape, 9649
moral influence of art, 1175
music, 21475
nationality in art, 17947
naturalism and ornament, 20542
nature and divinity of beauty, 19319
nature of art, 18783
nemesis of art, 9784
old and new system of art culture, 9444
old vs. new art, 11117
originality in art, 9792
painting, 13557
painting and sculpture, 18055, 18491
passion in art, 21845
perception of beauty, 20101
philosophical and religious significance of art, 22337
photography and art, 23368
pictures, 10555
pictures as loop-holes of escape to the soul, 17916
poetic imagination, address by C. E. Norton, 21464
poetry, 640
poetry and painting, 23280, 23318
popular amusement in London, 20772
portraiture and the ideal, 19033
power of beauty, 17980

printing, beauty in typography, *21479*
progress in art, *22609, 23276*
propriety in art, *19077*
purpose of art, *13340, 21569, 23271, 23295*
quality in technique, *13573*
realism and rationality, *12925*
realism as truth and honesty in art, *23362*
relation of admiration to art, *1494*
relation of art to art industries, *8811, 21617, 21640*
role of art, *18409*
role of art in society, *18514*
Ruskin for pure color, *18996*
Ruskin on systems and laws of art, *19241*
Ruskin on taste, *19225*
Ruskin on wholeness and finish, *19274*
science and art, *23357, 23364, 23367*
scientific and artistic perception of nature, *18921*
separation of beauty from meaning, *12929*
seriousness in art, *23078*
sisterhood of the arts, *23636*
spiritual in Greek art, *18048*
spiritual versus material life, *18013*
spiritual versus materialistic beauty, *18356*
theories inspired by Cole's *The progress of empire, 24957*
Thomas Moran's theory of art, *13569*
thoughts on art by Mrs. Jameson, *14523*
truth
 and beauty, *18961, 23284*
 in architecture, *20545*
 in art, *19256*
 in landscape, *19400*
 the true in fine art, *11937, 11951, 11970, 11988*
 true and popular art systems, *23317*
 true artists, *24313*
 versus artistic innovation, *24406*
unity of art, *22467*
Affeld, Helen W., fl.1896-1903
 exhibitions, Chicago, 1896, *11813*
Africa
 ambush of sailors, *21323*
 anecdote, *16667*
Africa, North
 description, *24422*
Agache, Alfred Pierre, 1843-1915
 exhibitions
 Chicago World's Fair, 1893, *Annunciation, 4605*
 Chicago World's Fair, 1893, *Vanity, 4805*
 Salon, 1888, *2694*
 Salon, 1889, *2966*
Agassiz, Alexander, 1835-1910
 notes, 1897, *23812*
Agassiz, Louis, 1807-1873
 portraits, bust by Preston Powers in Cincinnati Exposition, 1879, *756*
age
 youth and old age, *17903*
Agnew, Thomas and Sons See: **London (England). Agnew, Thomas and Sons**
Agnew, William Thomas Fischer, *Sir*, 1847-1903
 knighted, 1895, *5429*
Agostino di Duccio, 1418-1481?
 Madonna, acquired by Louvre, 1903, *13643*
agricultural exhibitions
 sites, art, and grounds, *25356*
agriculture
 United States, irrigation, 1897, *23220*
Aguado, Alejandro Maria, *marqués de* Marismas See: **Marismas del Guadalquivir, Alejandro Maria Aguado, *marqués de***
Agundo, Madrazo y See: **Madrazo, José de**
Ahlborn, Lea Fredrika Lundgren, 1826-1897
 Columbus medal, 1893, *16321*
 designs Columbian medal, 1894, *26999*
 engraver of medal after design by C. Osborne, *25235*
 medal for American Numismatic Society, 1891, *26295*

Washington medal, 1884, *1767*
Ahrens, Carl Henry, 1863-1936, *13737*
 illustrations, *House in the clearing, 13865*
Ahrens, Ellen Wetherald, 1859-1953
 exhibitions
 Carnegie Galleries, 1901, *13322*
 Carnegie Institute, 1907, *14328*
 Chicago Art Institute, 1899, watercolors, *12902*
 Pennsylvania Academy of the Fine Arts, 1901, *13163*
 illustrations, *Sewing - a portrait, 13536*
 Philadelphia studio, 1901, *22131*
Aid, George Charles, 1872-1938
 exhibitions
 American Art Association of Paris, 1906-7, *14252*
 Society of Western Artists, 1906, etchings, *14038*
 illustrations
 Miniature, 13875
 student sketch, *11782*
Aiken, Frank A., 1859-1933
 exhibitions, Prize Fund Exhibition, 1887, *2456*
Aikman, George W., 1831-1905
 exhibitions, Royal Scottish Academy, 1887, *10430*
Aimée, *Mlle* See: **Rapin, Aimée**
Ainsley, Oliver, fl.1899-1909
 exhibitions, Chicago Art Institute, 1899, watercolors, *12902*
Ainslie, Frank D.
 collection, sale, 1897, *17276*
Ainslie, George H., fl.1897-1906
 collection, sale, 1897, *17276*
Ainsworth, Harrison, 1805-1882
 Flitch of Bacon, 16792
AITCHISON, George, 1825-1910, *9619, 9724, 9800, 9816, 9896, 10049, 10064, 10195*
Aitchison, George, 1825-1910
 designs for needlework, *10245*
 illustrations, border to curtains, *10286*
 lecture on color in architecture, 1882, *1283*
 lecture on "Healthy decoration in the home", *1971*
 fviews at Social Science Congress, 1882, *1432*
Aitken, James F., fl.1870's
 gallery manager, Chicago, *11599*
 Opera House Art Gallery, Chicago, *10591*
Aitken, Robert Ingersoll, 1878-1949
 bust of McKinley unveiled, 1902, *22142*
 Claus Spreckels music stand, *22099*
 decorates Spreckels pavilion, Golden Gate Park, 1900, *22104*
 decorations for Hearst Mining Building, University of California, *22190*
 illustrations
 book plate design, *22115*
 Charles J. Dickman, 22196
 McKinley monument, San Francisco, *22141*
 Navy monument, San Francisco, *22182*
 notes, 1904, *22203*
 portraits of C. R. Peters and C. J. Dickman, *22176*
 San Francisco house decorations, *22139*
 Victory for monument, Union Square, *22134*
Aivazovskii, Ivan Konstantinovich, 1817-1900
 anecdote, *25960*
 Christopher Columbus series in progress, 1892, *4100*
 exhibitions
 American Art Galleries, 1892, *26869*
 Paris, 1890, *3227, 25890*
 Paris Exposition, 1878, *9096*
 notes, 1895, *16639*
 Russian marine painter, *25623*
Aivazovsky, Ivan See: **Aivazovskii, Ivan Konstantinovich**
Aiwasoffski, Iwan Konstantinowitsch See: **Aivazovskii, Ivan Konstantinovich**
Aix La Chapelle (Germany). Suermondt-Museum See: **Aachen (Germany). Suermondt Museum**
Akademie der bildenden Künste See: **Vienna (Austria). Akademie der bildenden Künste**
Akerberg, Knut, fl.1901-1906
 exhibitions, Minnesota State Art Society, 1905, *13905*

1883, summer on western plains, *24728*
1883, trip to Yellowstone, *24820*
1894, England, *5073*
1895, returns from Paris, *11571*
1898, *12255*
Alexander, Lawrence Dade, 1843-1923
library, sale, 1895, *16720, 16743*
Alexandra, *princess* See: **Alexandra, *queen, consort of Edward VII***
Alexandra, *queen, consort of Edward VII*, 1844-1925
criticized for having photos of family painted on china service, 1892, *3920*
ALEXANDRE, Arsène, 1859-1937, *17427*
Alexandre, Arsène, 1859-1937
collection, sale, 1903, *13600*
comment on Inness exhibition, 1898, *17412*
comments on Van Dyck, 1899, *17688*
Alexandre, Eva, d.1870?
illustrations, peacock and butterfly decoration, *2846*
Alexandria (Egypt)
excavation plans and findings, *454*
libraries destroyed, excavations cancelled, 1896, *16905*
Alfano, Vincenzo, b.1854, *13920*
illustrations
sculpture for Louisiana Purchase Exposition, 1904, *13685*
Time in Pennsylvania State Capitol, *14131*
Alfieri, Vittorio, 1749-1803
tomb by Canova in Santa Croce, *18219*
Alfonso I, *king of Aragon and Navarre*, ca.1073-1134
spiritual message, *20699*
Alford, Marianne Margaret Compton Cust, *Vicountess*, 1817-1888
Needlework as Art, *10314*
Alfred, *king of England*, 849-901
monuments, statue by Count Gleichen, *8920*
New York exhibitions relating to Alfred, 1901, *7740*
Alfred (New York). Alfred University
summer classes in ceramic arts, 1901, *7586*
Alfred the Great See: **Alfred, *king of England***
Alger, Russell Alexander, 1836-1907
collection, *15518, 15797*
plans for Detroit Art Loan Exhibition, 1883, *24721*
purchase of Munkácsky's *Death of Mozart*, 1887, *2477*
Algeria
antiquities
megalithic village excavated, 1895, *16789*
private houses excavated, 1895, *16767*
Roman town of Auzia, *14890*
views, paintings of F. A. Bridgman, *24007*
Algonquin Club, Boston See: **Boston (Massachusetts). Algonquin Club**
Alhambra See: **Granada (Spain). Alhambra**
Aligny, Claude Félix Théodore d', 1798-1871
illustrations, landscape sketch, *3314*
Jesus and the woman of Samaria, *22858*
Alinari Fratelli, Florence
illustrations, *Ostia antica - avanzi del teatro* (photograph), *13063*
photographs Italian art, 1896, *16980*
photographs published of St. Mark's mosaics and Layard collection, 1896, *16948*
Alisal, José Casado del See: **Casado del Alisal, José.**
Alison, Archibald, 1757-1839
theories of beauty, *19340*
Alizard, Joseph Paul, 1867-1948
exhibitions, Société des Artistes Français, 1907, *14312*
Allais, Paul, b.1827
Prayer (after Dubufe), *21398*
available from International Art-Union, *21421*
Allan Fraser, Patrick See: **Fraser, Patrick Allan**
Allan, J., fl.1895
illustrations, *Witches' flight*, *22856*
Allan, John, b.1875
illustrations, illustration to Keats' *Lamia*, *23655*

Allan, Robert, 1774-1841
portraits, portrait by Henry Raeburn, *21737*
Allan, Robert Weir, 1851-1942
English artists praised, *14928*
exhibitions
Carnegie Galleries, 1900, honorable mention, *13130*
Carnegie Galleries, 1901, *13322*
Royal Academy, 1907, *14312*
member of international jury for Carnegie Art Galleries exhibition, 1901, *7740*
Allan, William, 1782-1850
obituary, *14620*
Allan, William R., fl.1891-1895
portraits, photograph, *22539*
Allegheny (Pennsylvania)
Carnegie funds sought for art museum, 1902, *13366*
monuments
General James Anderson by D. C. French, *22108*
statue of George Washington, *26245*
Allegri, Antonio See: **Correggio**
Allemand, Conrad L' See: **L'Allemand, Conrad**
Allen, A. E.
collection, Civil War photographs, *16162*
Allen, Amanda P. Austin See: **Austin, Amanda Petronella**
Allen Brothers, Interior Decorators and Furnishers, Boston
illustrations, design for draperies, *517*
mural decorations, *493*
ALLEN, Charles Bruce, *8601*
Allen, Charles Dexter, 1865-1926
American Book-Plates
Blackwell's review criticized, *5361*
omissions, *5250, 5293*
prepares, 1893, *16329*
publication notice, 1894, *16621*
review, *5209, 5292*
on misuse of coats of arms in bookplates, 1894, *4826*
organizes book-plate exhibition, Grolier Club, 1894, *22294*
Allen, Charles Grant Blairfindie See: **Allen, Grant**
ALLEN, Elizabeth Ann Chase Akers, 1832-1911, *10607, 10665*
Allen, Ethan, 1737-1789
monuments
statue by L. G. Mead, *20195*
statue by Larkin Mead, *19899*
portraits, bust by Kinney, *14696*
relics, sword, *16562, 16571*
Allen, Ethan, 1832-1911
notes, 1896, *23038*
Allen, Frances S., 1854-1941
photographs, *22561*
ALLEN, Fred Hovey, 1845-1926, *22555*
Allen, Fred Hovey, 1845-1926
Great Cathedrals of the World, *15387*
lecture on artist life in Germany, Unity Art Club, 1892, *26547*
lectures on German art, 1893, *26952*
Allen, Frederick Baylies, b.1840
leads protest against display of nudes in Boston Art Club exhibition, 1891, *3601*
ALLEN, Grant, 1848-1899, *9799, 9849, 21950, 21990, 22019, 22028*
Allen, H. J. & W. B., interior decorators See: **Allen Brothers, Interior Decorators and Furnishers, Boston**
Allen, Hall and Co., Boston
illustrations, residence of James E. Martin, drawing room, *20614*
Allen, Heron See: **Heron Allen, Edward**
ALLEN, Ira W., *18220*
Allen, J. A., fl.1895
illustrations, *Picturesque dress*, *22752*
Allen, James Baylis, 1803-1876
illustrations, *Freiburg, Switzerland* (after W. H. Bartlett), *13100*
obituary, *8641*
Allen, Mary E., 1858-1941
photographs, *22561*
Allen, R. Lee, *Mrs.* See: **Austin, Amanda Petronella**
Allen, Robert Weir See: **Allan, Robert Weir**

antelopes
 leucoryx antelope, *20924*
Anthony, Andrew Varick Stout, 1835-1906
 exhibitions, Boston Museum of Fine Arts, 1881, *1254*
 illustrations
 Rain in summer (after J. G. Brown), *9302*
 William Louis Sonntag, *18226*
 wood engravings, *137, 155*
Anthony, Edward
 offers reward for photography, 1851, *14753*
Anthony, Henry Mark, 1817-1886
 exhibitions, Society of British Artists, 1850, landscapes, *14632*
Anthony, Jessie May See: **Mixer, Jessie Anthony**
Anthony, Ripley O., fl.1887-1900
 illustrations
 landscape drawing, *599*
 Mt. Monadnock, *602*
Anthony, Susan Brownell, 1820-1906
 notes, 1895, *22837*
anthropology
 human skeletons discovered, 1894, *16553*
 notes, 1895, *16710*
Antikythera
 antiquities, shipwreck, *13366*
Antiq, Charles, d.1895
 collection, sale, 1895, *16758*
Antiquarian Society, Chicago See: **Chicago (Illinois). Art Institute of Chicago. Antiquarian Society**
antiques
 fraudulent curios, *17556*
antisemitism
 France, Zola-Dreyfus-Esterhazy case, *24155*
 United States, treatment of Lt. U. P. Levy, *25481*
Antocolsky, Mark See: **Antokolskii, Mark Matveevich**
Antokolskii, Mark Matveevich, 1842-1902
 Christ before the people, *2024*
 obituary, *13473, 13504*
 Russian sculptor, *13759*
Anton, P. G.
 violin collection, *15999*
Antonello da Messina, ca.1430-1479
 portrait painting acquired by National Gallery, London, 1883, *14899*
 works in Hamilton collection, *1421*
Antonin Carles, J., fl.1886
 exhibitions, Chicago World's Fair, 1893, *4463*
Antwerp (Belgium)
 exhibitions, 1902, *13361*
 triennial exhibition planned, 1861, *20367*
Antwerp (Belgium). Congrès artistique de 1877
 subjects under discussion, *8942*
Antwerp (Belgium). Congrès international de la paix, 1894
 peace bell, *22793*
Antwerp (Belgium). Musée Plantin-Moretus
 notes, 1896, *5766*
 opened to the public, 1877, *8916*
Antwerp (Belgium). Musée royal des beaux arts
 acquisitions, 1906, *14143*
 building, opens, 1890, *26006*
Antwerp (Belgium). Oudheidkundige musea
 exhibitions, 1902, *13361*
Ape See: **Pellegrini, Carlo**
Apol, Lodewyk Franciscus Hendrik, 1850-1936
 illustrations
 Boschweg bij winter, *13693*
 Landscape, *23190*
 Snows of Christmas-tide, *14004*
Apol, Louis See: **Apol, Lodewyk Franciscus Hendrik**
Apolloni, Adolfo, 1845-1923
 bust of Chauncey Depew, *26150*
 bust of Depew, *26493*
 exhibitions, New York, 1894, *4758*
apparitions
 atmospherical phenomena in England and Germany, *20869*
Apperson, Phoebe See: **Hearst, Phoebe Apperson**

Appian, Adolphe, 1818-1898
 illustrations, *Avant la pluie* (etching), *14064*
Appian Way, *20519*
Appleton family
 pedigrees, *20470*
Appleton, Thomas G., fl.1886-1905
 portrait of Lady Austen (after Romney), mezzotint published, 1891, *26366*
APPLETON, Thomas Gold, 1812-1884, *321*
Appleton, Thomas Gold, 1812-1884
 collection, *876*
appliqué, *2670*
 appliqué or cut-work., *2199*
 church works, *2420*
 description and technique, *3301*
 history and national characteristics of appliqué, *7656*
 notes
 1888, *2790*
 1890, *3272*
 technique, *2218, 3352, 3916, 4961*
 altar frontal, *4090*
Apurva Krishna, Bahadur, fl.1841-1855
 poet visited by C. E. Norton, *19094*
aquatint, *10814*
 technique, *17495*
aqueducts
 Rome, *20615*
arabesques
 designs, *9368*
Arabian art See: **art, Arabian**
Arabs
 social life and customs, the emir, *18997*
ARACHNE, *1743*
Arachne (Greek mythology)
 and Minerva, *1095*
Arago, Alfred, 1816-1892
 obituary, *26529*
Arago, Dominique François Jean, 1786-1853, *21322*
Aram, Eugene, 1704-1759
 murder of Daniel Clark, *20969*
Aranda, José Jiménez See: **Jiménez y Aranda, José**
Aranyi, Joseph, fl.1900-1903
 instructor, art metal, Pratt Institute, 1900, *7421*
Arapa, Josi, fl.1902
 exhibitions, Kansas City Art Club, 1902, *13337*
Arbo, Pieter Nicolai Niels, 1831-1892
 paintings of Norway, *22986*
Arborelius, Olof Per Ulrik, 1842-1915
 exhibitions, Louisiana Purchase Exposition, 1904, *13831*
Arc Vallette, Louise, fl.1894-1923
 illustrations, *Night on the Loire*, *13444*
archaeological expeditions
 1896, Sinai Peninsula, *17053*
Archaeological Institute of America
 annual reports, 1879-1880
 1880-81, *375*
 review, *175*
 Crete excavation, *306*
 early history, *133*
 expedition to Assos, *209, 254, 407*
 formation, *46*
 funds excavations in Athens, 1893, *16261*
 meeting, 1892, *26557*
 New York Society proposes excavations at Delphi, 1890, *26148*
 School of Classical Studies at Athens to have building, 1886, *516*
 sponsors Greek play in New York, 1887, *504*
archaeology, *63*
 America, notes, 1895, *16652*
 American support, 1898, *6527*
 book reviews, *175*
 catalogue of Imperial Museum of Constantinople, *1517*
 German archaeologists store Greek finds in leaky warehouse, 1899, *6841*
 notes

1879, *19, 34*
1880, *47, 64, 83, 103, 118, 134, 150, 165, 179, 192, 219, 240*
1881, *254, 264, 314, 335, 360, 383, 430, 454*
1895, *16821*
United States
human skeletons found in Arizona, 1896, *17075*
New York, relics at Rhinelander homestead, 1895, *16875*
Archambault, Anna Margaretta, 1856-1956
exhibitions, Philadelphia Plastic Club, 1902, *13537*
Arché Club, Chicago See: **Chicago (Illinois). Arché Club**
Archer, A. M., fl.1894
illustrations, *Big tree, 22572*
Archer, James, 1824-1904
exhibitions, Royal Academy, 1877, *8859*
pictures shown in Boston, 1885, *25259*
portrait of Thomas De Quincy, *25665*
ARCHER, James Henry Lawrence, *8496*
Archer, Lawrence See: **Archer, James Henry Lawrence**
ARCHER, William, 1856-1924, *10413, 10425*
Archer, William, 1856-1924
Fridtiof Nansen, review of translation, *23178*
arches, triumphal
New York City, proposed, 1889, *25603*
*ARCHITECT, 1892, 1907, 1926, 1939, 2010, 2060, 2644, 2669,
2683, 2711, 2734, 2773, 2849, 2870, 2896, 2947, 6082, 6129*
architects
bill introduced in New York State to license architects, 1906,
14109
buildings should be signed, *22307*
professional status of American architects, *19778, 19793,
19812, 19845, 19870, 19909, 19923, 19940*
role in decoration of their buildings?, *7014*
scholarship offered by the *American Architect, 26116*
training, *26463*
Architectural Club, Chicago See: **Chicago (Illinois). Chicago
Architectural Club**
architectural drawings
exhibitions
American Art Galleries, 1886, *2131*
Architectural League of New York, 1887, *2380*
Architectural League of New York, 1897, *6237*
National Academy of Design, 1865, *23334*
New York, 1893, women's work, *4379*
Royal Academy, 1878, *21644*
Royal Academy, 1884, *10026*
ownership, *20044*
portfolio of Indian buildings in Rajputana, *25799*
technique, *3544*
for photoengraving, *3640*
architectural inscriptions
Florence, *9183*
Architectural League of America
annual meeting, 1901, *13221*
exhibitions, 1899, *6905*
founded, 1899, *12967, 13005, 13049, 22071*
Architectural League of New York See: **New York.
Architectural League of New York**
architectural metal work
railings and finials, *9806*
architectural practice
building committees, *19940*
facetiae, *19897, 19909, 19923, 20148*
architectural woodwork
technique, *2790*
architecture
See also: **art and architecture; building; cast iron architec-
ture; color in architecture; landscape architecture; music in
architecture.**
A. Brick on modern religious architecture, 1903, *8279*
aesthetics, *18614, 20351, 20516, 20517, 20545*
paper read by L. Eidlitz, 1861, *20361*
American Architect travelling scholarship is doubled, 1891,
3524
art or profession?, *26463*
character, *9816*

character and expression, *9760*
Christian architecture, Eidlitz's paper to American Institute of
Architects meeting, 1858, *19780*
churches, *20108*
Chapel and Church Architecture by George Bowler
reviewed, *19886*
Christian church edifice origins, *19868*
Henry Ward Beecher's comments on church architecture,
20032
meeting houses or churches, paper read by R. A. Cram,
22325
planning, *19940*
poor design, *10584*
competitions, Peabody Institute, *19678*
conservation and restoration, church restorations in Italy,
1870's, *8845*
criticism by the public, *12173*
definition by J. Coleman Hart, *19992*
definition of European architecture, *22455*
details, gargoyles, *22255*
ethics of architectural design, *9787*
European Architecture, periodical, *12659*
exhibitions, London, 1857, *19642*
history, *9800, 11996*
unbiased history needed, *10743*
knowledge of architecture important to the people, *11963*
literature in U.S. in 1880's, *591*
modern painting and sculpture too ugly to be of use, *10497*
picturesque, *649*
placement of architectural styles in the city, 1901, *7670*
poets' insensibility to architecture, *9726*
proportion and decoration of doors and windows, *20571*
public monuments to great men, *19915*
purpose of building reflected in design, *17539*
red brick as ornament, *21904*
role of ornament in relationship to structure, *18337*
Royal Institute of British Architects on *Terra-cotta and its
treatment*, 1894, *5019*
Ruskin on architectural design, *19622*
settlement houses, *13028*
signatures on buildings, *13643*
simplicity vs. ornamentation, *25168*
study and teaching, *13262*
study course, *11998*
superiority in fine arts, *20339*
terminology, Parthenon, *20608*
use of sculpture, *21981*
architecture, American
19th century, reform of architecture, *23299*
American style of domestic architecture, *12172*
California architecture and the influence of adobe, *12380*
call for originality and freedom from European influence,
14264
Chicago World's Fair, 1893, buildings, *4337, 4355, 4431, 4524,
4563, 4564*
churches
competition designs for St. John the Divine, New York, 1891,
3600
design, *19378*
interiors, *19837*
colonial, *13036*
development of an indigenous style, *12870*
development of national style a goal of Architectural League of
America, *12979*
exhibitions, National Academy of Design, 1865, designs, *23334*
formation of Architectural League of America, *13005*
frame houses, *26553*
future of architecture in America, *23285*
glass for architectural decoration, *13025*
Greenough on the state of American architecture, 1843, *19095*
history, *23275, 23281*
home planning, *19338*
influence of discoveries at Pompeii and Herculaneum, 1890,
3348
influenced by international expositions, *13428*

lack of picturesque, *14642*
national expression, *12702*
national style, *19870*
need for development, *487*
praised by Germans, 1899, *7072*
public buildings, *19871*
role of press in promoting bad architecture, *20164*
skyscrapers an American architectural form, 1901, *7670*
state of architecture, 1856, *19401*
style, *13049*
trends in American architecture, *3514*
typical American house, *4264*
use of carved wood, *10792*
western states, *49*
wood carver's home, *1540*
architecture and socialism
development of a national style, *12868*
architecture and society
architectural beauty and the public welfare, *12888*
architecture, Assyro-Babylonian, *186*
study course, *12087*
architecture, Chinese
Chinese buildings at Chicago World's Fair, 1893, *4563*
architecture, Cistercian
lecture by Ruskin, *9742*
architecture, domestic
aesthetics of house design, *26207*
alteration of city houses for loggia on second story, *2236*
alterations of houses, *2315*
artist's country home, 1893, *4416*
building a Queen Anne summer house, *3644*
England, *21725*
 18th century, *21823*
 19th century, *21865*
 artists' houses, *9599*
 British villa, *18799, 18809, 18821, 18830*
 color, *21856*
 farm houses, *21851*
 home of architect Burges, *10297, 10348*
 lowland villas, *18777*
 principles of composition of English villa, *18789*
 Ruskin's home, *9552, 9563*
 suburban architecture, *6759*
 trends in London, 1890, *3216*
France, *2275*
Greece, *20592*
home decoration, low budget, *4206*
honesty in design and decoration, *12443*
house designed by F. R. Comstock, 1901, *7578*
house is reflection of character of owner, *19890*
ideal houses, *1794*
inexpensive country house designed by Hapgood, 1895, *5248*
Ireland, W. Raleigh's house and Duke of Devonshire's Lismore Castle, *7511*
Italy
 mountain villas at Lago di Como, *18722, 18759*
 villas, *18768*
 villas at Lago di Como, *18734, 18748*
Japan, *Japanese Houses and Their Surroundings* by E. S. Morse, *10352*
lecture by F. L. Wright, 1898, *12175*
Palestine, *9289, 9321*
remarks by C. Vaux, *19666*
Rome, Pompeian house described and illustrated, 1890, *3348*
Syria, *9289*
United States
 alteration of city houses, *2163*
 American frame house, *26553*
 American style, *12172*
 article on American houses in French periodical, *1505*
 C. Barnard's Connecticut cottage, 1890, *3168*
 Connecticut, domestic architecture in countryside, *1520*
 history, *9108*
 Jersey City, N.J, *3911*
 log cabins, *1840*

mansions built in New York City, 1899, *6925*
Massachusetts, *10744*
Minnesota, lake cottage designed by Carlton Strong, 1887, *549*
Mrs. Eugene Davis residence, LaFollette, Tennessee, 1895, *5511*
New York City, *25486, 25493*
New York houses, 1883, *1496*
New York State, Albany, *9053*
New York townhouse remodelled, 1892, *3856*
Newport tea house, *547*
Newport villas, *8724*
Ohio houses, *9215*
oldest house in United States in St. Augustine, Fla, *16953*
Pennsylvania houses, *8878*
Philadelphia homes, *17711*
Philadelphia, illustrations, *17727*
Pittsburgh mansion built ca. 1841, *11232*
Searles house, San Francisco, criticized, 1893, *16304*
Southern California, *12377*
summer houses, *1358*
typical American house, *4264*
urban dwellings, *19622*
vestibule, hall and staircase, *1777*
architecture, Egyptian
study course, *12012, 12034, 12062*
architecture, English
alteration of buildings spoils design, *21922*
artists' studios, *9474*
British Museum of Natural History, 1881, *22012, 22040*
Chicago World's Fair, 1893, English Government building, *4564*
churches
 building-stone, *19327*
 church building, *19828*
 old churches in Northern suburbs, *9991*
conservation and restoration, *19542*
criticism of urban architecture, 1879, *21745*
factories, interior views, *20735*
Gothic and classical, a Pre-Raphaelite critique, *23269*
Gothic revival, *23272*
Gothic style, 1855, *19328*
Gothic style revived, *1432*
lady architects, *20367*
notes
 1882, *1416*
 1890, *3216*
Queen Anne style, *10438, 17770*
Queen Anne style revival, *17735*
railway stations, King's-Cross, *20830*
restoration of ancient buildings question, *1432*
secular buildings, *21618, 21680*
Victorian, *10439*
architecture, French
Brittany, *21763*
Chateau d'Anet, *1175*
Chicago World's Fair, 1893
 casts of architecture exhibited, *4568*
 French Government building, *4564*
churches, *19202*
historic styles, *2813*
Renaissance, *20520, 20605*
architecture, German
German Rococo court in Liberal Arts Building, Chicago World's Fair, 1893, *4563*
architecture, Gothic, *17576*
adaptability, *20607*
Cologne cathedral, *21956*
contrasted to Greek style, *20538*
discussion at meeting of American Institute of Architects, 1858, *19871*
excerpt from Whewell, *23354*
Hotel de Ville, Ghent, *21239*
architecture, Greek, *12395*
adaptability, *20604*

subjects, *13535*
photography versus wood engraving, *5130*
photography vs. painting in portraiture, *24335*
relationship of photography and art to reality, *9763*
relative merits of painting and photography, *13182*
reproduction of paintings, 1896, *17123*
reproductions by photography on canvas, *13533*
sketching versus photography, *10698*
will colored photography interfere with painting?, 1902, *7818*
art and religion, *19206, 19220*
Alfred Brick on modern religious architecture, 1903, *8279*
Bellows on moral perspective, *19585*
Catholic protests over paintings for Pennsylvania State House, *14097*
exhibitions, New York, 1895, religious art, *5359*
God in art and nature, *18220*
highest ideal in religious art, *24759*
iconography of the nimbus, *4822*
Iroquois mounds, *18532*
meetings houses or churches, paper read by R. A. Cram, *22325*
modern religious painting, *7646*
notes, 1893, *4656*
philosophical and religious significance of art, *22337*
philosophical relation, *19461*
reform of church decoration, London, 1901, *13213*
regeneration of society through art, *13389*
religious painting falls to low level, 1901, *7505*
religious subjects in art for Protestants, *19935*
Tissot's religious art, *13484*
art and society, *23479*
amalgamation of the arts with life itself, *12925*
art attracts tourists, *13034*
art education in public schools, *12954*
art in America, *13575*
art in the home, *19539*
art viewed by Philistines and Bohemians, *17442*
artists donate to Emergency Fund to Give Relief by Work, 1894, *16535*
commercialism detrimental to art, *12868*
conditions for art development, *13531*
democratic art should be inexpensive, *13613*
fountains bring art into public places, *12927*
importance of art, *11583*
money in family structure, *19510*
municipal art museums, *13571*
role of artist in society, 1899, *17661*
United States
art as schoolroom decoration, *12884*
art in colonial New York, *13521*
growing demand for art, *13004*
Metropolitan Museum expels improperly-dressed patron, 1897, *17241, 17264*
survey of public taste in art taken, 1899, *17512*
University Settlement Society brings art exhibition to lower East Side, New York, 1893, *4555*
use of art to improve society, *12913*
use-value of artistic sensibility, *13010*
art and state
amounts spent on art by Denmark, England and United States, *556*
France, *26032*
bureau established to facilitate museum exchanges with U.S., *9391*
notes, 1881, *430*
government patronage, *23459*
Great Britain, government support for museums, 1880's, *9450*
Italy, Pacca edict, 1894, *16544*
need for state-level support of art, *24921*
open competitions for government buildings, *22294*
relationship between art and government, *18434*
United States
American government should establish Salon to encourage quality, *24965*
appeal for government support for art, *8310*
Art Critic's political program to gain federal support for the

arts, *8311*
artists recommend Art Commission to Congress, *20033*
bearings of art upon elections, *19977*
bills before Congress, 1890, *26080*
coins and postage stamps, *976*
Congressional aid for Revolutionary War monuments, 1880, *261*
creation of national advisory board on civic art, *14175*
federal art bill introduced in Congress, 1906, *14131*
government and art, *545*
government art commissions, *19913*
government needs to support American art, *24999*
government patronage of art, 1860, *24320*
governmental ruling regarding status of art associations, *25909*
on creation of national art department, 1894, *16505*
pictures painted for U.S. government, *623*
plan for organization of government support for art, *8312*
tax on bequests to art institutions and public charities, *12877*
art, Arabian
collectors and collecting, advice on collecting antiquities, 1891, *3513*
Art Association of Indianapolis See: **Indianapolis (Indiana). Art Association of Indianapolis**
Art Association of Ireland
inaugurated, 1881, *407*
Art Association of Orange, N.J. See: **Orange (New Jersey). Art Association**
art, Assyrian
aesthetics, *20546*
art, Assyro-Babylonian, *186*
depiction of hunting, *21324*
excavations of A. H. Layard at Nimrud, *20799*
art, Austrian
exhibitions
Louisiana Purchase Exposition, 1904, *13802*
Paris Exposition Universelle, 1900, *7373*
art, Belgian
exhibitions, Pennsylvania Academy of the Fine Arts, 1882, *1333, 1354*
French influence, *1354*
notes, 1860, *20282*
Art, Berthe, 1857-1934
exhibitions
Boston Art Club, 1892, *26604*
National Academy of Design, 1890, *3455*
Woman's Art Club of New York, 1891, *15550, 26292*
Woman's Art Club of New York, 1892, *26542*
art, Brazilian
notes, 1851, *14794*
art, Byzantine
Benedictine Abbey, Monte Cassino, *411*
exhibitions, World's Columbian Exposition, 1893, Byzantine Madonnas, *16409*
Mount Athos, *21044*
Lambros' studies, *430*
relief of Christ discovered, 1894, *16466*
art, Canadian
national conservatory proposed, 1902, *13403*
works selected for World's Fair, 1904, *13739*
art, Celtic, *9557*
ancient Irish treasures to be displayed at World's Columbian Exposition, 1893, *16019*
art centers
shifting art centers of the world, 1899, *17632*
art, Chilean
Pan-American Exposition, 1901, *13281*
art, Chinese
context of civilization, *19922*
art, classical
influence on American artists in Rome, *17962*
use in teaching, *21516*
Art Club of New York See: **New York. Art Club of New York**
Art Club of Philadelphia See: **Philadelphia (Pennsylvania). Art Club of Philadelphia**

Parisian notes, *12515*
Art nouveau (gallery) See: **Paris (France). Art nouveau S. Bing (gallery)**
art, Oriental
 aesthetics, *21482*
 Brayton Ives collection, *3494, 3559, 3575*
 exhibitions
 Pedestal Fund Loan Exhibition, 1883-4, *1705*
 Union League Club of New York, 1889, *3055, 3099*
 Union League Club of New York, 1890, *3127*
 sales and prices, 1887, *2439*
art patronage, *23289*
 American art patronage in Rome, 1851, *14765*
 anecdote, *7776*
 anecdotes, *18418*
 as censorship, *13699*
 Denmark, Carl Jacobsen's foundation of Ny Carlsberg Glyptothek, Copenhagen, *8348*
 England
 British patronage, *19148*
 expansion, *14526*
 government patronage, *19431*
 patronage by British government, *17093*
 Queen Victoria, *21833*
 Europe, 1851, *14763*
 for the young artist, *19133*
 foreign artists' hostility towards American patrons, 1899, *17465*
 France, Paris, city pays artists more than state, 1893, *16412*
 millionaires should endow public art galleries, *17763*
 papal court in the Renaissance, *161*
 public encouragement of living artists, *20629*
 reasons to buy pictures, *24701*
 role of patrons in creating process, *6674*
 United States, *10579, 17924*
 advance made, 1880's, *24857*
 American Art Union, *14558*
 American patronage of portraitists, 1897, *17233*
 artists' receptions, *18542*
 commissions for American subjects, *24376*
 compared with France, *11157*
 criticism of federal and private patronage, *24921*
 government patronage of art, 1882, *24387*
 lack of patronage, *11155*
 lack of patronage in America, *18434*
 lack of sculpture patronage, 1891, *15722*
 principles of Cosmopolitan Art Association, *18070*
 public apathy in Baltimore, *24944*
 support for American art and artists encouraged, 1883, *24781*
art, Persian
 casts taken of Persian inscriptions and sculpture, 1895, *16841*
 place of calligraphy, *26464*
 sales and prices, 1899, *6903*
 variety of forms, *778*
art, Philippine
 sign lettering, wood carving, and photography, 1902, *7833*
art, Polish
 temperament, *13597*
art, Polynesian
 sale in London, 1878, *21648*
art, pre-Columbian
 Peruvian ceramics and metal work at the Louvre, Paris, *21035*
art, prehistoric
 engraved reindeer-horn found in caves of Montgandier, *25341*
 painted caves discovered in Dordogne, France, 1896, *17143*
art, primitive
 comparison of American Indian art and western European art, *18532*
 exhibitions, Pedestal Fund Loan Exhibition, 1883-4, *1705*
art, Renaissance
 Adoration of the Magi theme, *8787*
 Boston Museum of Fine Arts, *3232*
 knowledge and perspective, *19194*
 Limbus in Italian Renaissance art, *10208*
 Müntz' *Les Précurseurs de la Renaissance*, *10104*
 relationship between art and architecture, *69, 89*

 Renaissance systems, *19241*
 depictions of children, *9614*
 study course, *11999*
art, Rococo
 definition, *9209*
art, Roman
 Dictionnaire des antiquités grecques et romaines, review, *25340*
art, Russian, *9411, 13759*
 contemporary, *13943*
 exhibitions, Chicago World's Fair, 1893, *4528*
 nineteenth century, *25623*
art sales and prices
 1767-1843, Willem van de Velde sales, *21015*
 1850, prices for fictitious engravings, *18505*
 1880, *134, 179, 192, 871*
 prints, *879*
 1881, *1218*
 etchings and engravings, *1156*
 1882, *1366, 1382*
 sale of fake Tintoretto, *1298*
 1883, *14884, 14901*
 1884, *1801*
 1885, *1998*
 1888, *2782*
 1890, *3207, 3254, 15228*
 1891, *3598*
 auction sales affect art market, *3490*
 1893, *4387, 4514*
 1894, *16556, 16573, 16577, 16586*
 Christies prices, *16674*
 1895, *5257, 5369, 16800*
 1896, *5611, 17027*
 low prices, *5967*
 1898, *6674, 17429*
 1899, *7074, 17558, 17577, 17641, 17643, 17658, 17673, 17702*
 authenticity of art sales doubted when buyers remain anonymous, *6987*
 inconsistent prices, *7005*
 Wallis & Son gallery, *17470*
 1901, *7611, 13329*
 early 19th c. colored engravings, *13313*
 1902, *7944*
 1904, *13763*
 anecdote, *5693*
 anecdote on art speculation, *18543*
 auctioneers as experts, *17562*
 auctions declining, 1885, *11168*
 Belgium, Antwerp, 1902, *13452*
 bidding practices criticized, *2428*
 catalogues
 humor, 1900, *7291*
 prices versus selling prices, *25052*
 England
 1650, *11071*
 1850, *14669*
 1854, *18862*
 1855, *18908*
 1859, *20028*
 1861, *20341*
 1878, *21647, 21649, 21653*
 1878, Novar collection, *21650*
 1880, *21891*
 1880, engravings and etchings, *1091*
 1882, manuscript Bible sold, *1360*
 1882, old porcelain, *1305*
 1882, pottery, *1337*
 1883, *9867*
 1883, *Virgin of the lectern* attributed to Michelangelo, *1507*
 1884, *10033*
 1885, *2035*
 1887, *10488*
 1893, *16301*
 1895, Craven and Hoffman collections, *16781*
 1896, *5862*

notes, 1890, *3450*

Ashburnham, Bertram Ashburnham, *4th earl of*, 1797-1878
collection, sale, 1850, *14669*
library
collection of manuscipts sold to Chicago millionaire, 1883, *24713*
negotiations for MSS. for British Museum, 1882, *14896*
sale, 1897, *17353*
to be sold, 1896, *17078*

Ashe, Edmund M., 1867-1941
illustrations
illustration for *Mrs. Wilkinson's Ghost*, *23085*
illustrations for *Life*, *22501*
illustrations for *The Thankfulness of Madame Maurice*, *23121*
In the woods, *22486*
Will you take my hand?, *22482*
magazine illustration, 1894, *22517*
summer studio, 1893, *22491*

Ashley, Anita C., fl.1894-1909
exhibitions, Woman's Art Club of New York, 1894, *4802*, *22540*

Ashmead, Condé
collection, sale, 1903, *13562*

Ashmolean Museum See: **Oxford (England). Oxford University. Ashmolean Museum**

Asia Minor
antiquities
Halicarnassus and Cnidus, *18282*
Tello excavations, 1894, *16623*
Tello excavations, 1895, *16664*
terra-cottas, *25567*

Askevold, Anders Monsen, 1834-1900
paintings of Norway scenes, *22715*

Asper, Hans, 1499-1571
decoration and ornament in his painting, *10358*
detail of carcanet from painting, *17741*

asphalt
presence in room where paintings are kept is damaging, *26969*

Aspinwall, William, 1743-1823
bequests to Brookline, Mass, *26835*

Aspinwall, William Henry, 1807-1875
collection, *18281*
Murillo's *Conception*, *19785*
paintings lost in shipwreck, 1850, *14657*
sale, 1886, *2190*
reception for artists, 1859, *19978*

Associated Artists, New York See: **New York. Associated Artists**

Associated Artists of Chicago See: **Chicago (Illinois). Associated Artists of Chicago**

Association for the Advancement of Truth in Art See: **New York. Society for the Advancement of Truth in Art**

Association of American Authors
founded, 1892, *26656*

Assos
antiquities, *209, 254*
excavations, *278, 407*
excavations, 1883, *14866*

Assur, C. F.
letter on professional modesty, 1858, *19819*

Assyria
hunting, *21324*
life as revealed through art and artifacts, *21329*

Astor, Caroline Schermerhorn, 1830-1908
collection, lace collection given to Metropolitan Museum, *2638*

Astor, John Jacob, 1864-1912
account books, *16803*
anecdote, 1894, *16448*
collection, *1286*

Astor, John Jacob, 1822-1890
obituary, *26303*

Astor Library, New York See: **New York. Astor Library**
Astor, William Backhouse, 1792-1875
collection, *1368*

Astor, William, *Mrs.* See: **Astor, Caroline Schermerhorn**
Astor, William Waldorf, 1848-1919
collection, *15616*
description, 1887, *17787*
commissions bronze doors for Trinity church as memorial to his father, *16041*
commissions to artists, *26051*
home, tile decorations in Buckinghamshire residence "Clevedon", *5878*
offers bronze gates to Trinity Church, New York, 1890, *25929*

astronomy
discovery of Uranus by William Herschel, *21327*

Athenaeum Association See: **New York. Athenaeum Association**

Athenaeum, Baltimore See: **Baltimore (Maryland). Athenaeum**

Athenaeum, Boston See: **Boston (Massachusetts). Boston Athenaeum**

Athenaeum, Chicago See: **Chicago (Illinois). Chicago Athenaeum**

Athenaeum, Manchester See: **Manchester (England). Manchester Athenaeum**

Athenaeum, Providence See: **Providence (Rhode Island). Athenaeum**

ATHENIAN, *10616*

Athens (Greece)
antiquities
ancient town excavated, 1896, *17016*
Athenian skulls excavated and measured, 1891, *26425*
excavation of Pallas, 1892, *26466*
excavations, 1891, *26392*
excavations, 1897, *17262*
excavations at Dipylon, 1892, *26591*
excavations by Dr. Schliemann, 1890, *26126*
excavations by M. Lambakis, 1890, *25751*
description, 1890, *25757*
description and views, photographs by Prof. Stillman, *15031*
Greek School for Art-weaving, *26126*

Athens (Greece). Acropolis
antiquities
Athena Parthenos found, *343*
excavations, 1858, *18282*
archaic statues found, 1885, *25362*
festival of Panathenaea, *19863*
restorations, *13605*

Athens (Greece). American School of Classical Studies at Athens
awards medal to Heinrich Brunn, 1893, *16387*
building
design, 1887, *566*
funds raised by Archaeological Institute of America, 1886, *516*
excavations
Argos, 1893, *16261*
discovers Fountain of Pirene, Corinth, 1898, *6674*
gymnasium in Eretria, 1895, *5521*

Athens (Greece). British School at Athens
excavations at Megalopolis, 1892, *26825*

Athens (Greece). Erechtheum
plans for restoration, *13504*

Athens (Greece). Parnassos See: **Athens (Greece). Philologikos Syllogos Parnassos**

Athens (Greece). Parthenon, *20608*
Athena Parthenos, *343*
fragile condition, 1897, *6247*
history of its destruction, *19951*
Jouy's model at Metropolitan Museum of Art, 1890, *3427*
research by L. Laborde and Paccard, *14511*
sculptures, *19863, 19883*
brought to light, 1883, *14910*
Greek government requests return from foreign governments, 1901, *7646*
to be strengthened with iron girders, 1894, *16610*

Athens (Greece). Philologikos Syllogos Parnassos
annual exhibitions, 1904, *13712*

ATHERTON, Gertrude Franklin Horn, 1857-1948, *12360*
Athletic Club of the City of New York See: **New York. Athletic Club of the City of New York**
Athos (monasteries)
 Byzantine art, *430*
 libraries, *288*
 mountain of monks, *10486*
 murals and monks, *21044*
Atkins, Arthur, 1873-1899
 exhibitions, San Francisco, 1899, *22075*
Atkinson, Arthur G., fl.1878-1898
 exhibitions, Royal Academy Schools, 1878, *21677*
Atkinson, Edward, 1827-1905
 letter on the Exhibition of 1892, *25656*
ATKINSON, Joseph Beavington, 1822-1886, *9298, 9361, 9403, 9421, 9499, 9534, 9541, 9630, 9650, 9668, 9704, 9770, 9847, 9923, 10088, 10124, 10156, 10181, 10316, 10331, 22035*
Atkinson, Joseph Beavington, 1822-1886
 obituary, *10388*
 Schools of Modern Art in Germany, review, *21895*
Atkinson, L., fl.1892
 exhibitions, Palette Club of Chicago, 1892, *11307*
Atkinson, Thomas Lewis, 1817-ca.1890
 Lion at home (after Bonheur), published, 1884, *10022*
Atkinson, Thomas Witlam, 1799-1861
 watercolors of the Orient, *19561*
ATKINSON, William Parsons, 1820-1889, *23514*
Atlan Ceramic Art Club See: **Chicago (Illinois). Atlan Ceramic Art Club**
Atlanta (Georgia)
 exhibitions, 1881, art to be featured at upcoming International Cotton Exposition, *448*
 monuments, statue of Henry W. Grady unveiled, 1891, *26402*
Atlanta (Georgia). Art Loan Exhibition See: **Atlanta (Georgia). Young Men's Library Association**
Atlanta (Georgia). Cotton States and International Exposition, 1895
 art, *11648*
 art awards, *5686*
 buildings, *11540*
 description of grounds and buildings, *11700*
 government building, *11514*
 New York room decorated by Joseph P. McHugh and Co., *5603*
 plans for Woman's Building, *27026*
 Woman's Building, *11698*
 carving examples, *5596*
 china painting, *5648*
 Fine Arts department, *11571*
 historical portraits, *16803*
 industrial and art exhibitions, *5568*
 influence on outdoor art, *13428*
 souvenir medal, *22787*
 women's clubs invited to attend, *11477*
Atlanta (Georgia). International Cotton Exposition, 1881
 works of art, *448*
Atlanta (Georgia). Young Men's Library Association
 Art Loan Exhibition
 1883, *24705*
 1883, catalogue, *24853*
Atlantic City (New Jersey)
 architecture, hall of James Reilly residence illustrated, *5803*
Atlantis
 historical references, *20643*
 myth of its ancient races, *20642*
Attucks, Crispus, ca.1723-1770
 document proves that name was actually Michael Johnson, *26226*
 monuments, Boston, *582*
Attwood, Francis Gilbert, 1856-1900
 elected officer, Boston Art Club, 1858, *19785*
 exhibitions, Boston Paint and Clay Club, 1887, *543*
 illustrations, *Southern school boy*, *22473*
 illustrations for *Scribner's Magazine*, *22482*
 portraits, photograph, *22502*

Atwood, Charles B., 1848-1895
 architect of Fine Arts building, Chicgo World's Fair, 1892, *26821*
 Art Building, Chicago World's Fair, 1893, *22218*
Atwood, Clara See: **Fitts, Clara Atwood**
Atwood, Gilbert See: **Attwood, Francis Gilbert**
Aubé, Jean Paul, 1837-1916
 faience sculpture, *2102*
Aubert, Jean Ernest, 1824-1906
 At the fountain, *10051*
 Broken thread, *9045*
 exhibitions
 Salon, 1859, *20077*
 Salon, 1882, *1352*
 Fountain of love, *8973*
 illustrations
 Birds of Passage, *1585*
 Breeze and *Winter*, *1348*
 Cupid's call (sketch), *2916*
 obituary, *14177*
 painting shown at Kohn's gallery, New York, 1884, *25213*
 Reverie, *9083*
 sales and prices, 1879, *Love's entanglements* in Spencer collection, *678*
Aubery, Jean, 1810-1893
 notes
 1860, *24322*
 1871, *10677*
 photograph painting, *20209*
 portrait paintings, 1871, *10651, 10710*
Aubiniere, C. A. de l' See: **L'Aubinière, C. A. de**
Aublet, Albert, 1851-1938
 exhibitions, Royal Academy, 1886, *Comtesse de Martel*, *2225*
 illustrations
 Bathing house at Tréport, *2018*
 Old sea dogs at Tréport, *4397*
 Portrait of Mlle G, *1585*
Aubrey, Frank
 Devil Tree of El Dorado, review, *23251*
Auburndale (Massachusetts). Lasell Seminary for Young Women
 art collection, *630*
Auchmuty, Richard Tylden, 1831-1893
 Episcopal church in the Berkshires, *10744*
 proposes technical schools for Metropolitan Museum, 1880, *9390*
auctioneers
 New York, *16260*
Auden Aert, Robert van See: **Audenaerde, Robert van**
Audenaerde, Robert van, 1663-1743
 group portrait found in Ghent museum, 1905, *13955, 14010*
Audsley, Berthold
 illustrations, *Grapevine border*, *5804*
AUDSLEY, George Ashdown, *4624, 4676, 4788, 4822, 4823, 4855, 5061, 5156*
Audsley, George Ashdown, 1838-1925
 illustrations
 cabinet in Gothic style, *4893*
 centerpiece design, *5159*
 embroidery design, *5108*
 Keramic Art of Japan, review, *416*
 Ornamental Arts of Japan, review, *10388*
 Polychromatic Decoration as Applied to Buildings in the Medieval Style, review, *9752*
 sues City of New York for not using design for City Hall, 1894, *5073*
AUDSLEY, William James, b.1833, *4624, 4676*
Audsley, William James, b.1833
 illustrations
 cabinet in Gothic style, *4893*
 china painting design, *5327*
 cup and saucer design, *4824*
 heraldic cup and saucer, *4896*
 maize motif for embroidery, *5642*
 Persian style tray, *4896*

Polychromatic Decoration as Applied to Buildings in the Medieval Style, review, *9752*
sues City of New York for not using design for City Hall, 1894, *5073*

Audubon, John James, 1785-1851
biography, *21139*
Birds of North America, review and description of research and publication, *21139*
engraving plates, *17105*
exhibitions, Southern Exposition, Louisville, 1884, *11051*
monuments
Audubon Monument Committee, *26272*
fund for New York monument, 1890, *26192*
grave monument in New York cemetery unveiled, 1893, *26932*
monument fund of American Ornithologists Union, 1892, *26853*
monument unveiled in Trinity Cemetery, New York, 1893, *26938*
proposal by New York Academy of Sciences, 1891, *26402*
obituary, *14731*, *23379*
sales and prices
1870, 350 original copper plates of *Birds of America*, New York, *10601*
1892, *Birds of America* sold in London, *15889*

Audubon, Victor Gifford, 1809-1860
obituary, *20263*

AUERBACH, Berthold, 1812-1882, *18524*

AUERSPERG, Anton Alexander, *Graf* von, 1806-1876, *19187*, *19633*

Augsburg (Germany)
German wall paintings uncovered in St. Jacob's church, *14910*

Augur, Hezekiah, 1791-1858
obituary, *19801*

Augustus Charles Eugène Napoléon, *prince of Portugal, duke of* Leuchtenberg, 1810-1835
amateur artist, *21154*

AULICH, Edward, fl.1901, *7561*

Aulich, Emmo, fl.1894-1903
studio, Cincinnati, 1895, *11570*

AULICH, Franz Bertram, fl.1894-1903, *6442*, *6478*, *6509*, *6536*, *6573*, *6602*, *6629*, *6772*, *6799*, *6830*

Aulich, Franz Bertram, fl.1894-1903
American china painter, *5844*
china decorator, *12016*
exhibitions
Chicago, 1894, *5070*, *11375*
Chicago, 1895, china, *11652*
Chicago, 1896, *11881*
Chicago Art Institute, 1899, ceramics, *7188*
Chicago Ceramic Association, 1895, *11706*
illustrations
Iris, *6510*
Pansies, *6573*, *6574*
Poppies, *7978*
Roses, *8002*
Study of blackberries, *7974*
Study of wild roses, *6442*
whereabouts
1894, returns to Chicago from abroad, *11405*
1895, trip to California, *11615*

Ault, Charles Henry, fl.1894-1910
exhibitions
Central Art Association, 1897, *11955*
Chicago Art Institute, 1895, *11673*
Cincinnati Art Museum, 1898, *12754*
Cleveland Art Association, 1895, *11470*
Society of Western Artists, 1898, *Nocturne* and *Moonrise*, *12802*
illustrations
In New Orleans harbor, *22567*
On the Gulf of Mexico, *22567*
member, Cleveland Water Color Society, *22591*
member, Society of Western Artists, 1898, *12083*
notes, 1898, *17403*

Placid stream, *22731*
review of Carnegie Exhibition, 1899, excerpt from the *Plaindealer*, *12826*

Aumale, Henri Eugène Philippe Louis d'Orléans, *duc d'*, 1822-1897
collection
Chantilly, *17376*
Chantilly collection catalogued, 1896, *16939*
Chantilly game book, *16515*
Chantilly given to France, 1886, *17838*
given to Institute of France, 1887, *2366*
illuminated manuscripts, *16182*

Aumonier, James, 1832-1911
exhibitions
Royal Academy, 1880, *21831*
Royal Academy, 1881, *21997*
illustrations, *Toilers of the field*, *21610*

Aumonier, Louisa, fl.1864-1901
illustrations, wall paper, *10438*

Aumonier, William, fl.1889-1930
lecture on wood carving before London Society of Architects, 1900, *7413*

Aune, fl.1899
exhibitions, Photographers' Association of America Convention, 1899, *12937*

Auque, Enrique Serra y See: **Serra y Auque, Enrique**

Aurora (Illinois)
exhibitions, 1895, *11517*

Aurora (New York). Wells College
Russell Memorial window designed by E. C. Lamb, 1902, *7944*

Aus, Carol, 1868-1934
exhibitions
Chicago, 1897, miniatures, *11977*
Chicago, 1899, *12337*
reception, New York, 1898, *12153*

Austen, Edward J., 1850-1930
illustrations for *The Cosmopolitan*, 1893, *22482*

Austen, Jane, 1775-1817
letters, sales and prices, 1895, *16734*

Austin, Alfred, 1835-1913
Conversion of Winckelmann, excerpt, *17266*
notes, 1896, *22931*

Austin, Amanda Petronella, 1856-1917
Santa Barbara artist, *2701*

AUSTIN, George Lowell, 1849-1893, *8640*, *8733*, *10705*

AUSTIN, Hariet, *23888*, *23927*

AUSTIN, Henry Willard, 1858-1912, *17746*, *17755*, *17759*, *17762*, *17768*, *17771*, *17776*, *17789*

Austin, Henry Willard, 1858-1912
poems, *17814*
poet, *17763*

Austin, John, 1790-1859
Austin on Jurisprudence, review, *20372*

Austin, Margarete, fl.1901
exhibitions, New York, 1901, *13202*

Australia
early travels, *20855*
gold discoveries, *20913*, *20951*
McIvor Diggings, *21088*
national gallery started by Sir Smith, *27006*
prospecting for gold, *21059*

Australian silver See: **silverwork, Australian**

Austria
criminal law, asylums, *20770*

Austrian art See: **art, Austrian**
Austrian decorative arts See: **decorative arts, Austrian**
Austrian furniture See: **furniture, Austrian**
Austrian industrial design See: **industrial design, Austrian**
Austrian pottery See: **porcelain and pottery, Austrian**

authors, American
American writers in Rome, 1850's, *18194*
need for recognition of new talent, *18244*

Authors Club, New York See: **New York. Authors Club**
authorship, *17949*

AUTOCRAT, The, *12088*

autographs, *10670*
 analysis of handwriting, *19385*
 autographs offered, 1895, *16705*
 collectors and collecting, *15214, 15395, 15421, 16257, 16313*
 1893, *16128*
 Aldrich collection, *16267*
 anecdotes, *16249, 16263, 16553*
 autographs of 1876 government officials, *17342*
 British Museum collection, *16734*
 British Museum collection of autographs of English sover-
 eigns, *16710*
 collection presented to Historical Society of Pennsylvania,
 1896, *17053*
 Columbus letter, 1890, *15197*
 craze for autographs declines, 1896, *16915*
 Dreer collection, *15192*
 Dreer collection donated to Pennsylvania Historical Society,
 15713
 Freeman collection, *16675*
 French president Faure collection, *16935*
 Gayarée collection, *16473*
 Gratz and Roberts collections, *16387*
 Gratz collection, *16136*
 handbook published, 1895, *16778*
 hotel registers, *16650*
 J. S. H. Fogg collection, *16480*
 Kirk collection donated to Johns Hopkins University, 1891,
 15568
 Lachmund collection of musical autographs, *16419*
 Leffingwell collection, *15414*
 literature, *15460*
 most valuable American collections, *16019*
 Nelson collection presented to Princeton University, 1897,
 17210
 P. T. Barnum collection, *16515*
 Rathbone collection, *16208*
 Seaboard National Bank collection, *16735*
 U.S. State Department collection, *16527*
 Diderot and Hugo, *25849*
 extra-illustrated book for preservation of autographs described
 by C. Guild, 1894, *16639*
 forgeries, *16335*
 letters of literary and musical celebrities, *16911*
 notes, 1890, *26167*
 Revolutionary autographs found, 1895, *16701*
 sales and prices
 1890, *15120, 15259, 15444*
 1890, Bovet collection, *15208*
 1890, Leffingwell collection, *15296*
 1890, Lossing collection, *15112*
 1890, manuscripts and letters by Thackeray and Rossetti,
 26135
 1891, *15620, 15656, 15676, 15693, 15705, 15723, 15783*
 1891, Leffingwell collection, *15367, 15479*
 1891, Paris, *15465*
 1891, Wilkie Collins autographs, *15692*
 1893, *16135, 16250, 16253*
 1893, Berlin, musical autographs, *16428*
 1894, *16523, 16531, 16535, 16544, 16586, 16600, 16628*
 1894, Cromwell letter, *16553*
 1894, Ouida collection, *16567*
 1895, *16746, 16764, 16789*
 1895, Jane Austen letters, *16734*
 1895, Recamier correspondence, *16781*
 1896, *16915, 16953, 17018, 17021, 17034, 17056, 17065,
 17068, 17083, 17218*
 1896, New York, *17010*
 1897, *17219, 17236, 17273, 17312, 17350*
 1897, Paris, *17205*
 1897, Parkes collection, *17245*
 vandalism, 1895, *16894*
autumn
 glories, *10216*
Auvergne Press
 establishment, 1897, *12596*

Auvers sur Oise (France)
 artist inhabitants, *16845*
Avebury, John Lubbock, *1st baron* See: **Lubbock, John, *Sir***
Avergno, Virginia See: **Gautreau, Virginie Avegno**
Averill, Anna Boynton, b.1843
 poetry on nature, *9171*
Avery, Benjamin Parke, 1829-1875
 collection, *16789*
 acquired by Mark Hopkins Institute of Art, 1898, *6545*
 given by wife to Regents of University of California, 1898,
 12806
Avery, Benjamin Parke, *Mrs.* See: **Avery, Mary Fuller**
Avery, Henry Ogden, 1852-1890
 Avery Library founded as memorial, *15265*
 memory honored by New York chapter of American Institute of
 Architects, 1890, *25978*
 obituary, *3254, 25952*
Avery Library See: **New York. Columbia University. Avery
 Memorial Architectural Library**
Avery, Mary Ann Ogden, d.1911
 gift of Matsys painting to Metropolitan Museum, 1884, *11027*
Avery, Mary Fuller, 1827-1913
 husband's collection donated to University of California, San
 Francisco, 1898, *12806*
Avery, Samuel Putnam, 1822-1904
 acquires Bouguereau painting, 1881, *22038*
 acquires painting by George Boughton, *9295*
 art importations to U.S., 1879, *734*
 award, 1897, *17368*
 *Catalogue of Etchings and Lithographs presented by Samuel P.
 Avery to the Cooper-Union Museum for the Arts of
 Decoration*, review, *6662*
 collection, *7315*
 1891, *3497*
 caricatures of Whistler, *13145*
 contemporary French medals and plaques acquired by
 Metropolitan Museum of Art, 1893, *4428*
 contributions to loan exhibition, 1893, *16227*
 decorative arts in New York loan exhibition, 1895, *5374*
 etchings, *15193*
 etchings by Flameng shown at Grolier Club, 1891, *26446*
 exhibited at National Academy of Design, 1894, *4760*
 French etchings and engravings after Meissoner, *14193*
 gems given to Museum of National History, 1892, *15866*
 Gleyre's *Prodigal son*, *26500*
 Oriental art exhibited at Union League Club of New York,
 1890, *3127*
 Persian and Indian art, *25779*
 prints given to New York Public Library, 1900, *22083*
 Rodin's sketch for statue of Bastien Lepage, *25748*
 sale, 1902, *13400*
 terracottas, *25742*
 works by Haden, *16618*
 defends authenticity of paintings sold to Seney, *25264*
 donates Flameng picture to Grolier Club, 1890, *15351*
 establishes Avery Memorial Architectural Library, 1890, *15265*
 fund to city of New York for superannuated artists, *14089*
 gift to Columbia College, 1891, *26258*
 illustrations
 Arthur F. Tait, *18121*
 William Hart, *18185*
 letter defending Metropolitan Museum's acquisitions of
 American art, 1896, *17042*
 library
 books given to Museum of Natural History, 1892, *15910*
 books on art and architecture given to Columbia University,
 1892, *26676*
 obituary, *13859*
 pictures at his gallery
 1875, *8573*
 1879, European pictures, *9263*
 1880, *846*
 1881, French pictures shown, *1217*
 presents collection of medals to Metropolitan Museum, 1893,
 26961

purchases at Paris Salon, 1880, *937*
receives gold medal for service in the arts, 1897, *6342*
sale of paintings at Chickering Hall, 1878, *9014*
sells Halsted collection, 1887, *10754*
speech on history of Metropolitan Museum of Art, 1894, *16632*
withdraws from Art Committee of Union League Club, 1883, *24381*

Avery, Samuel Putnam, art dealer See: **New York. Avery Art Gallery**

Avery, Samuel Putnam, *Mrs.* See: **Avery, Mary Ann Ogden**

Avison, Charles, 1709-1770
notes, 1890, *25751*

Avisseau, Charles Jean, 1796-1861
ornamental tobacco box, *21308*

Avisseau, Edouard, 1831-1911
ornamental tobacco box, *21308*

Avon River
description and views, *10130*
description of district between Nuneaton and Stratford-on-Avon, *10117*

Avon-By-The-Sea (New Jersey)
Seaside Assembly art school, 1892, *26752*

Avranches, Hugh of See: **Hugh of Avranches**

Avril, Edouard Henri, 1849-1928
illustrates Le Roux's *Fleurs à Paris*, *15241*
illustrates Loti's *Au Maroc*, *15709*
illustrates Shakespeare's *Antony and Cleopatra*, *15317, 15679*
illustrations, frontispiece to *L'art et l'idée* (after C. Schwabe), *26690*
illustrations for Uzanne's *Miroir du Monde*, *15055*
illustrator for Uzanne's *Sunshade, Glove and Muff*, *9876*

Avril, Paul See: **Avril, Edouard Henri**

awards and prizes
Art Journal design competition, *9272*
art juries, *11134*
 justice of juries, *11077*
art prizes vs. commissions stimulus to good art, *11105*
Belgium, Fine Art prize essays, 1855, *18556*
England
 1858, Royal Society of Arts awards medal for new wood embosser, *18178*
 1881, tapestry painting, *1245*
 1882, art school competition, *1416*
 1882, tapestry painting, *1303*
France
 1855, École des beaux arts, *19171*
 1855, Paris Exposition, *19234, 19276*
 1878, Paris Exposition, English winners, *21651, 21654*
 1880, competition for civic monument in Courbevoie, *9311*
 1881, Société des artistes, *21897*
 1897, Wanamaker prizes for American artists established, *23957*
 1900, Rosa Bonheur prize to Granshi Taylor, *13095*
 1902, Paris architecture awards, *13366*
 1903, Prix L'Heureaux, *13724*
 Henri Lehmann prize for classical art studies, *633*
Germany, 1901, Munich International Art Exhibitions, *13293*
prizes limited to male recipients considered unfair, 1891, *3524*
Scotland, 1855, Mr. Gourlay's prizes for Edinburgh renovations, *19090*
United States
 1859, Forrest medal, *18279*
 1860, Lily Martin Spencer, *18510*
 1879, San Francisco Art Association, *9279*
 1880, *216*
 1880, Christmas card competition, *1019*
 1880, competition for Christmas card design, *9327, 9357*
 1880, Prang Christmas card competition, *909*
 1881, *381*
 1881, decorative art competitions, *1147*
 1881, Mary Smith Prize for lady artists, *1128*
 1881, needlework competition, *1159*
 1881, wallpaper designs, *1233*
 1883, awards witheld in *Harper's* drawing competition, *24772*

1883, *Harper's Magazine* drawing competition, *24491*
1883, Goelet schooner yacht prize, *1543*
1883, Thomas B. Clarke Composition prize and Julius Hallgarten prizes established at National Academy of Design, *24866*
1884, Hallgarten and Harper art scholarship, *11005*
1885, Hallgarten scholarship, *25224*
1885, problem of selection, *11145*
1885, Suydam and Hallgarten awards at National Academy, *11179*
1891, National Academy of Design, *15626*
1893, Chicago World's Fair, W. Forsyth and T. C. Steele, *22230*
1893-94, *Art Critic*'s competition for Valhalla sketch, *8316*
1895, Chicago, *11708*
1895, illustrations, *21534, 21547*
1895, illustrations by prize students of the Art Students' League, *12474*
1895, *Modern Art* competition for intials and title-pages, *22329*
1895, National Academy of Design, *21554*
1896, Elkins prizes, *11738*
1896, *Modern Art* competitions, *22375, 22398*
1896, printing specimens, *12505*
1896, prizes for book and poster design, *12506*
1897, cover designs, *12585*
1898, competition for border, mantel and photograph by *Forms and Fantasies*, *20493, 20501, 20509*
1898, Revell prize, *12248*
1899, plan for University of California, *22065*
1901, *13213*
1901-02, Inter-State and West Indian Exposition, *13436*
1902, Pennsylvania Academy of the Fine Arts, *13379*
1902, Society of American Artists, *13403*
1902, Society of American Artists' Shaw fund, *13351*
1905, Lazarus scholarship for study of mural painting, *13869*
1905, Minnesota State Art Society, *13816*
origin of money prizes in America, *17441*
value of art prizes in general exhibitions, *11104*

Axentowicz, Teodor, 1859-1938
illustrations, *In deep sorrow*, *13597, 13759*

Ayer, Edward Everett, 1841-1927
collection
 Burbank Indian pictures, *6312*
 Burbank painting in collection, *12843*
 collector of Indian lore, *12774*
 painting from collection illustrated, *12860*
library of Americana, acquired by Newberry Library, 1896, *16926*
purchases for Field Columbian Museum, 1894, *16562*

Ayer, Harriet Hubbard, 1849-1903
portraits, portrait by Eastman Johnson, *14936*

Ayling, Arthur P., fl.1899-1900
pyrography, *7008*

Aylward, William James, 1875-1956
exhibitions, Chicago Society of Artists, 1895, *11483*

AYMAR, Allyn, *3759, 3798, 3839, 3875, 3903*

AYTON, Charles William, fl.1898-1924, *24149, 24199*

Ayton, Charles William, fl.1898-1924
exhibitions, Pennsylvania Academy of the Fine Arts, 1905, *13853*

Aytoun, William Edmondstoune, 1813-1865
Bothwell: a Poem, review, *19549*

Azeglio, Vittorio Emanuele Tapparelli, *marchese d'*, 1816-1890
obituary, *25962*

B

Baade, Knud Andreassen, 1808-1879
 obituary, *64*

Babb, George Fletcher, 1836-1915
 office building, Newburgh, N.Y, *25149*

Babbage, Frederick, fl.1880-1900
 illustrations, example of wood engraving, *21782*

Babcock, Charles, 1829-1913
 remarks on comtemporary architecture to American Institute of Architects meeting, 1858, *19871*
 toast at American Institute of Architects dinner, 1858, *19813*

Babcock, William P., 1826-1899
 collection, acquired by Boston Museum of Fine Arts, 1899, *17686*
 exhibitions, Boston, 1858, *19942*
 paintings at Everett's, Boston, 1858, *19875*
 paintings, Paris, 1858, *19912*

Babylon (ancient city)
 excavations, 1894, *16595*
 social life and customs, life during time of Nebuchadnezzar, *26390*

Babylon (Egypt) See: **Cairo (Old Cairo)**

Bac, Ferdinand Sigismund Bach, *known as*, 1859-1952
 illustrations, *Sweeping her out*, *22505*

Baccani, Attilio, d.1906
 obituary, *14177*

Bach, A., fl.1883
 illustrations, *Omega*, *22490*

Bach, Ferdinand See: **Bac, Ferdinand Sigismund Bach, *known as***

Bach, Johann Sebastian, 1685-1750
 manuscripts, sa, 1894, *16448*
 portraits, *16811*
 remains sought in 1750, *16789*

Bache, Alexander Dallas, 1806-1867
 collection, 1855, *18667*

Bachelder, John Badger, 1825-1894
 Battle of Gettysburg, *10594*

Bachelin, Auguste, 1830-1890
 collection, weapons and costumes donated to museum of art and history at Neuchâtel, *15444*
 obituary, *26018*

Bacher, Otto Henry, 1856-1909
 etchings, *222, 10808, 11335*
 etching of Japanese objects, *25556*
 etchings of Venice compared to Whistler, *15167*
 Milan cathedral, *25444*
 Venetian etchings, *457*
 exhibitions
 Detroit Art Loan Exhibition, 1883, *24826*
 National Academy of Design, 1886, *2112*
 National Academy of Design, 1888, *25516*
 National Academy of Design, 1893, *4388*
 New York Etching Club, 1888, *10843*
 New York Etching Club, 1891, *3533*
 Society of American Artists, 1894, *4834, 22540*
 Society of Painters in Pastel, 1890, *3256*
 illustrations
 etching of majolica inkstand, *25932*
 front elevation of house, *25486*
 Giuseppe Ceracchi (after Trumbull), *25658*
 library in small city-house, *25493*
 sketch of Hill and Turner's proposed Herald Square hotel, *23213*
 vestibule of small city-house, *25493*
 Interior of St. Marks, Venice (etching, after his own painting), *10814*
 notes, 1898, *17447*
 Parting, *25813*
 teacher, Cleveland Academy of Art, 1883, *24553*
 whereabouts
 1883, Cleveland, *24502*
 1883, New York, *24424*

Bachman, John, fl.1850-1877
 lithographs of American cities, *14821*

Backer, Harriet, 1845-1932
 exhibitions, Chicago World's Fair, 1893, *4496*

Backhuysen, Ludolf, 1630-1708
 paintings in English Royal collection, *10505*

Backus, George J., Mrs. See: **Backus, Katherine Fallis**

Backus, Katherine Fallis, fl.1903-1910
 exhibitions, Minnesota State Art Society, 1905, *13905*
 illustrations, decorative modeling, *13184*

BACKUS, William, *20044*

Bacon, Charles Roswell, 1868-1913
 exhibitions, Worcester Art Museum, 1904, *13803*
 summer studio, Connecticut, 1893, *22491*

BACON, Edgar Mayhew, *12485, 22503, 22529*

Bacon, Edgar Mayhew, 1855-1935
 quote, on Peter J. Mundy, *22492*

Bacon, Francis, 1561-1626
 monuments, statue by Woolner, *19542*

Bain Smith, Henry, 1857?-1893
 obituary, *26941, 26978*
Bainsmith, Henry See: **Bain Smith, Henry**
Baird, Henry Martyn, 1832-1906
 awarded Tiffany loving cup, 1901, *7549*
Bairnsfather, Arthur L., b.1883
 illustrations, drawing, *8288*
Baisch, Hermann, 1846-1894
 exhibitions, Internationale Kunstausstellung, Munich, 1883,
 9879
Bakalowicz, Ladislaus, b.1833
 exhibitions, Salon, 1877, *8872*
Baker, Daniel, Mrs. See: **Baker, Elizabeth Gowdy**
Baker, Elizabeth Gowdy, 1860-1927
 American citizen, *22968*
Baker, Ellen Kendall, 1839-1913
 exhibitions
 American Art Galleries, 1885, *1921*
 Prize Fund Exhibition, 1885, *1985, 11230, 25278*
 Prize Fund Exhibition, 1886, *25304*
 Salon, 1883, *1602*
 Knitter, selected for Chicago Exposition, 1883, *24725*
 sales and prices, 1886, *529*
Baker, Florence, fl.1899
 illustrations, *Zulu model*, *12964*
Baker, George Augustus, jr., 1821-1880
 exhibitions
 National Academy of Design, 1849, *21429*
 National Academy of Design, 1850, *14615*
 National Academy of Design, 1855, *18705, 18754*
 National Academy of Design, 1856, *19400*
 National Academy of Design, 1857, *19668*
 National Academy of Design, 1858, *19857*
 National Academy of Design, 1859, *20030*
 National Academy of Design, 1861, *20354*
 New York, 1859, *19978*
 New York artists' reception, 1858, *19784, 19800, 19817*
 Union League Club of New York, 1880, *235*
 obituary, *117, 9326*
 Othello narrating the story of his life, *14736*
 paintings in American Art Union Gallery, 1848, *14445*
 paintings in American Art Union Gallery, 1849, *14484*
 Portrait of a lady, at Century Club festival, 1858, *19783*
 tribute by National Academy, 1880, *9343*
 work, 1857, *19626*
Baker, George Fisher, 1840-1931
 collection
 Chinese decorative art exhibited at National Academy of
 Design loan exhibition, 1893, *4523*
 Chinese jade vase imported, 1890, *26411*
 exhibited at National Academy of Design, 1894, *4760*
 collector, *3561*
Baker, J. Elder, Mrs., fl.1884-1905
 exhibitions, American Art Association, 1884, study of still life,
 25209
Baker, John Carleton, b.1867
 man as favorite subject, *22704*
 newspaper illustration, *22504*
 portraits, photograph, *22580*
BAKER, John F., *24386, 24488, 24536, 24559, 24787*
Baker, John Remigius, 1818-1892
 collection, sale of Washington relics, 1891, *15520*
 library, sale, 1891, *26242*
Baker, Julia E., fl.1877-1885
 lady artist of New York, 1880, *915*
BAKER, Martha Susan, *12627, 12643, 12819*
Baker, Martha Susan, 1871-1911
 conducts summer school in Illinois, 1898, *12181*
 exhibitions
 Carnegie Galleries, 1904, honorable mention, *13792*
 Chicago, 1897, *12646*
 Chicago, 1898, *12251, 12269*
 Chicago, 1899, *12876*
 Chicago, 1899, miniatures, *12333, 12434*
 Chicago Art Institute, 1903, *13561*

 Chicago Art Students' League, 1895, *11469*
 Chicago Artists' Exhibition, 1899, *12310*
 illustrations
 Art student, *13370*
 Bit of the World's Fair, *22590*
 decoration of *Good Night* by W. C. E. Seeboeck, *12611*
 Girl, *13536*
 Tuning up, *22560*
 miniatures, *12814*
 sales and prices, 1905, *13866*
 teacher of illustration, *22525*
Baker, William Bliss, 1859-1886
 exhibitions
 American Art Association, 1884, sketches, *25209*
 American Art Galleries, 1885, *1916*
 American Watercolor Society, 1884, *25023*
 American Watercolor Society, 1885, *1933*
 National Academy of Design, 1883, *9936*
 National Academy of Design, 1884, *25125*
 National Academy of Design, 1884, Hallgarten prize for
 Woodland brook, *10982*
 New York, 1893, *Silence*, from Clarke collection, *16171*
 Prize Fund Exhibition, 1885, *1985, 25278*
 Society of American Artists, 1884, *1802*
 Society of American Artists, 1884, *Silence*, *11003*
 Union League Club of New York, 1884, *25090*
 Hallgarten prize, 1884, *1786*
 Monarch's fall, in Seccomb colllection, *15647*
 notes, 1885, *11273*
 obituary, *10754, 10773, 25378*
 pictures in Clarke collection, *24943*
 recovers from diphtheria, 1882, *24367*
 sales and prices
 1884, *Woodland brook - decline of an autumn day*, *25085*
 1887, *557, 10782, 25418, 25430*
 work, 1884, *25032*
 work in Ellsworth collection, *3919*
Baker, William H., 1825-1875
 notes, 1870, *10569*
 obituary, *8479*
 studio, 1871, *10618*
Baker, William Henry, b.1869
 book designer and photographer, *11737*
Baker, William Jay, fl.1847-1855
 illustrations, *Skeleton in armour* (after H. Billings), *14855*
Baker, William Spohn, 1824-1897
 book in preparation, 1879, *31*
 Engraved Portraits of Washington, review, *114*
Bakewell, John, jr., fl.1896-1899
 illustrations, decorative initial, *24252*
Bakker Korff, Alexander Hugo, 1824-1882
 Her character, *22021*
 illustrations, *Betsy Prig and Sairey Gamp*, *2393*
Balano, Cosme, Mrs. See: **Balano, Paula Himmelsbach**
Balano, Paula Himmelsbach, b.1878
 exhibitions
 American Watercolor Society, 1903, *13592*
 Philadelphia Plastic Club, 1902, *13537*
Balat, Alphonse, 1818-1895
 obituary, *16879*
Balatka, Hans, 1826-1899, *10614*
Balboa, Vasco Nuñez de, 1475-1519
 discovery of Pacific Ocean, *20939*
Balcarres, Lord See: **Crawford, David Alexander Edward
 Lindsay, 27th earl of**
Balcom, George Lewis, 1819-1900
 library, *16304*
BALCOMB, J. T., *10360, 10372*
bald eagle, *18881*
Balding, H. C., fl.1869-1876
 illustrations
 Blind-man's-buff (after F. Barzaghi), *9229*
 General "Stonewall" Jackson(after J. H. Foley), *8773*
 Her Majesty the Queen (after the statue by M. Noble), *8977*
 John Bunyan (after J. E. Boehm), *8731*

Marie Antoinette on her way to the place of execution (after R. Gower), *9045*
Moment of peril (after T. Brock), *9727*
monument to the late David Reid (after C. B. Birch), *9258*
monument to the Prince Imperial (after J. E. Boehm), *9510*
Oliver Cromwell (after M. Noble), *8639*
Queen's memorial to Princess Charlotte and Leopold, King of the Belgians (after F. J. Williamson), *9819*
Sisters of Bethany (after J. W. Wood), *8380*
Spring and autumn (after F. J. Williamson), *8439*
Summer flowers (after J. Milo Griffith), *10029*
BALDRY, Alfred Lys, *3899, 4074, 4101, 4103, 4105, 5433*
Baldwin, Albert H., fl.1864-1892
 whereabouts, 1883, returns from Europe, *24883*
Baldwin, Clara Townsend
 designer, *17465*
Baldwin, Edward J.
 collection, minerals, *16211*
Baldwin, Ellen Frances
 author of poem formerly attributed to Longfellow, *18609*
Baldwin, Esther M., fl.1893-1910
 exhibitions, National Academy of Design, 1893, *4236*
BALDWIN, Henry, *7022*
BALDWIN, Oliver Hingston, *13442*
Bale, Edwin, 1838-1923
 exhibitions, American Watercolor Society, 1880, *74, 9292*
Balfour, Marie Clothilde
 Maris Stella, excerpt and review, *12582*
Ball, Caroline Peddle, 1869-1938
 clock at Paris Exposition Universelle, 1900, *13074*
 exhibitions, Minnesota State Art Society, 1905, *13905*
BALL, Katherine M., *22225*
Ball, Katherine M., b.1859
 lectures, 1898, *12224*
Ball, L. Clarence, 1858-1915
 Day's declining, *22816*
 exhibitions, Chicago Society of Artists, 1895, *11483*
 illustrations
 Nooning time, *22590*
 Old willow, *22610*
 Wet hay meadows, *22610*
Ball, Mary See: **Washington, Mary Ball**
Ball, Thomas, 1819-1911
 anecdote, *11429*
 autobiography, *25733, 26152*
 bas-reliefs for Franklin statue, *19767*
 Boston monuments, *18*
 criticized by Wendell Phillips, *794*
 bronze bas reliefs, *19819*
 bust of Barnum, *24806*
 to be cast in Munich, 1887, *583*
 bust of Choate, *20114*
 bust of President Lord, *19801*
 Emancipation, *9191*
 monument, Boston, *46*
 unveiled in Boston, *9279*
 Eve, exhibited at Union League Club of New York, 1880, *46*
 Governor Andrew, *10655*
 Minute man, *18509*
 My Threescore Years and Ten, review, *11410*
 notes
 1859, *20080*
 1883, *24722*
 1897, *6457*
 portrait busts, *19899*
 sculpture in Florence, 1879, *21727*
 sculpture in Florence, 1881, *21895*
 Ship-wrecked boy, *19733*
 statue of Daniel Webster, *8480, 8778*
 statue of Josiah Quincy, Boston, *33*
 statue of Washington, *20330*
 offered to Methuen, Mass., by E. F. Searles, 1891, *26402*
 statuette of Henry Clay, *19913*
 and model for equestrian portrait of Washington, *18243*
 Washington, *19955, 20033*

and other works, *20146*
 fund for equestrian statue begun, 1859, *18380*
Washington monument, Philadelphia, proposed, 1880, *149*
whereabouts
 1860, new studio in Boston, *20259*
 1883, Boston, *24657*
 1883, sails for Florence, *24804*
work, 1856, *19581*
work, 1857, *19626*
Ball, Wilfrid Williams, 1853-1917
 exhibitions, London, 1892, *26678*
ballads, English
 history and illustration, *8971, 8990, 9090, 9160, 9195, 9214*
Ballarini, Ernesto, b.1845
 illustrations, *Tentation* (after A. Cencetti), *21639*
Ballin, Hugo, 1879-1956
 exhibitions
 American Watercolor Society, 1907, *14333*
 Carnegie Institute, 1907, *14328*
 National Academy of Design, 1905, Clarke prize, *14062*
 National Academy of Design, 1907, *14311*
Balling, H. See: **Balling, Ole Peter Hansen**
Balling, Ole Peter Hansen, 1823-1906
 Sixty-four, U.S. government declines buying, 1892, *26536*
Ballingall, William, fl.1840-1880
 illustrations
 Eldmuir, or Solitude (after J. Thompson), *9252*
 Hope beyond (after J. Thompson), *9252, 21913*
 Solitude (after J. Thompson), *21913*
balloon ascensions
 balloon photgraphy in France, *25341*
 drawing of hot air balloon, *7999*
 early ascents of Etienne Montgolfier, *21112*
 history, *21058, 21090*
balloons
 descriptions, *21090*
BALLU, Roger, *22353*
Balmoral Castle, *21021*
 Queen Victoria's residence, *10441*
Baltimore and Ohio Railroad Company
 artists' excursion
 1858, *18208, 19876, 19955*
 1860, *18473*
 exhibition at Chicago World's Fair, 1893, *16273*
Baltimore (Maryland)
 architecture, *19658*
 Garrett house designed by McKim, Mead and White, *538*
 Music Hall plans, 1892, *26758*
 Walters collection building planned, 1905, *13810*
 Walters collection building planned to house Massarenti collection, 1905, *14089*
 art
 1857, *19658*
 1858, *19819*
 1859, *20033, 20064*
 1861, *20355*
 1871, *10709*
 1887, private picture-galleries, *17787*
 1899, *6902*
 need for art patronage, *24944*
 artists, success, 1891, *26382*
 court house
 Blashfield frieze, *8059*
 Blashfield mural, *13781*
 mural decoration commissions, 1901, *13228*
 murals commission to John La Farge, 1906, *14071*
 stained glass dome near completion, 1899, *7098*
 Druid Park bronze lamp, *22765*
 exhibitions
 1880, *834*
 1884, paintings of Baltimore artists at Baltimore Club House, *25120*
 monuments
 Barye works in Vernon Square donated by W. T. Walters, *22264*

Battle monument, *19288*
 Fremiet's statue of Howard placed, 1904, *13752*
 monument to Leonard Calvert, *26322*
 monument to Thomas Holiday Hicks to be erected, 1891, *26341*
 Peale aids Mills with design of Washington monument, 1856, *19288*
 museum and art club proposed, 1892, *15847*
 sale of American and European paintings, 1880, *9310*
Baltimore (Maryland). Academy of Music
 exhibitions, 1876, *8646*
Baltimore (Maryland). Allston Association of Baltimore City
 building and exhibitions, *20104*
 exhibitions, 1860, *20209*
 soirée, 1859, *20146*
 soirée, 1860, *20179*
Baltimore (Maryland). Art Commission of the City of Baltimore
 members, 1903, *13676*
Baltimore (Maryland). Artists Association See: **Baltimore (Maryland). Baltimore Artists Association**
Baltimore (Maryland). Athenaeum
 reopens, 1880, *214*
Baltimore (Maryland). Baltimore Artists Association
 description, 1856, *19442*
Baltimore (Maryland). Baltimore Water Color Club
 annual exhibitions
 1904, cancelled, *13729*
 1905, *13913*
Baltimore (Maryland). Cathedral
 works of art, *18881*
Baltimore (Maryland). Charcoal Club
 exhibitions
 1886, *529*
 1892, *15910*
 notes, 1893, *16317*
Baltimore (Maryland). Crescent Club
 building, decoration, *529*
Baltimore (Maryland). Decorative Art Society
 meeting, 1880, first, *9310*
 notes, 1880, *211, 808*
 Prize competition, 1880, *1005*
Baltimore (Maryland). Department of Education
 art courses for City College, *8403*
Baltimore (Maryland). Gallery of Art See: **Baltimore (Maryland). Peabody Institute. Gallery of Art**
Baltimore (Maryland). Jenkins, Henry W., & Son
 furniture collection, *16240*
Baltimore (Maryland). Johns Hopkins Hospital
 acquisitions, 1895, portraits of physicians, *16685*
Baltimore (Maryland). Johns Hopkins University
 acquisitions
 1891, Kirk autograph collection given to historical museum, *15568*
 1891, Sharf collection, *26322*
 1892, numismatics, *15808*
 1894, Smith herbarium and botanical library, *16491*
 1895, Dillmann Oriental library, *16841*
 Johns Hopkins University Studies, series praised, 1891, *15783*
Baltimore (Maryland). Maryland Academy of Science and Literature
 acquisitions, 1896, Indian relics, *17202*
Baltimore (Maryland). Maryland Historical Society
 acquisitions, 1899, Rosa painting, *17591*
 collection
 art, *15847*
 catalogue published, 1893, *16323*
 Sully portrait of Charles Calvert, *24773*
 gallery, *14696*
Baltimore (Maryland). Maryland Institute for the Promotion of the Mechanic Arts, *211*
 exhibitions, 1891, designs for pottery, *26322*
Baltimore (Maryland). Maryland Institute for the Promotion of the Mechanic Arts. Schools of Art and Design
 classes, 1883, *24716*

 commencement, 1895, *22765*
 instruction, *21554*
 notes, 1879, *735, 757*
 reorganization, 1880, *834*
 students, 1884, *25007*
Baltimore (Maryland). Municipal Art Society, *12851*
 beautifies public school rooms, 1899, *17554*
 formation, *12921*
 meetings, 1899, papers and discussions, *12993*
 notes
 1899, *12977*
 1900, *13059*
 requests foreign artists for mural paintings for Court House, *14175*
Baltimore (Maryland). Myers & Hedian, art dealers
 sales, February, 1880, *858*
Baltimore (Maryland). Peabody Institute
 acquisitions
 1879, *9263*
 1893, *16347*
 building, competition for plans, 1857, *19678*
 establishment of Rinehart School of Sculpture, 1895, *22738*
 exhibitions
 1879, American art, *9124*
 1904, architectural drawings and designs, *13793*
 founding, 1857, *19609*
 lecture by Prof. W. E. Griffis on ceramic art in Japan, 1880, *834*
 notes, 1880, *9310, 9326*
 plaster casts, *46*
 Rinehart bequest awards given to H. A. MacNeil and C. E. Proctor, 1896, *5648*
Baltimore (Maryland). Peabody Institute. Gallery of Art
 gallery opens, 1881, *352*
 notes, 1883, *24704*
Baltimore (Maryland). Peabody Institute. Library
 acquisitions, 1892, *15934*
Baltimore (Maryland). Social Art Club
 exhibitions, 1881, *355*
Baltimore (Maryland). Wednesday Club of Baltimore
 Art Loan Exhibition, 1884, *25085*
 building, new building, 1880, *834*
Balzac, Honoré de, 1799-1850, *20443*
 censorship in America, 1890, *3359*
 Contes Drolatiques, illustrated by Doré, *14964*
 in Tours, *9640*
 monuments
 controversy over statues by Rodin and Falguière, 1899, *7074*
 selection of sculptor Chapu, *25562*
 statue by Falguière, *6841*
 statue by Rodin, *12265*
 statues by Edouard Fournier and Henri Chapu, *25698*
 portraits, Meissonier on painting portrait, 1897, *6150*
 relics
 cast of hand, *16675*
 housed in French museum, *17151*
Balze, Jean Paul Etienne, 1815-1885
 copy of *School of Athens* for University of Virginia, 1856, *19512*
Banajee, Dhunbai See: **Dhunbai Banajee, Fardoujee**
Bancroft, George, 1800-1891
 History of the American Revolution, review, *18190*
 library, *15505, 15862*
 purchased by Lenox Library, 1893, *26923*
 sold to Lenox Library, New York, 1893, *16212*
 to be bought for Library of Congress, 1892, *26721*
 to be bought for Library of Congress, 1893, *16171*
 Miscellaneous Essays, excerpt on the beautiful, *19549*
 relics, sales, 1893, *16250*
Bancroft, Hubert Howe, 1832-1918
 Book of the Fair, *26968*
 review, *11593*
 library, *15847, 16636*
 for sale, 1892, *26713*
 for sale, 1896, *16953*
 to be sold, 1896, *16939*

Bancroft, Milton Herbert, 1867-ca.1945
 illustrations
 Chester Cathedral, 22508
 Cloisters of Chester Cathedral, 22531
 sketch of antique room of Pennsylvania Academy of Fine
 Arts, 3432
Bancroft, Samuel, Jr., d.1915
 collection, Pre-Raphaelite paintings exhibited, 1893, 4286
Bandel, Joseph Ernst von, 1800-1876
 Hermann monument completed, 1875, 8423
 obituary, 8763
Bandelier, Adolph Francis Alphonse, 1840-1914
 research among the Pueblos, 375
Bandinelli, Baccio, 1493-1560
 Hercules and Cacus, 21868, 21882
 studio, 13638
Bandle, Bessie, fl.1903
 illustrations, *Funeral procession - from life*, 13624
Bangs, firms, auctioneers See: **New York. Bangs & co.**
BANGS, John Kendrick, 22632
Bangs, John Kendrick, 1862-1922
 Bicyclers, review, 12541
BANGS, William McKendree, 22511
bank notes
 designs, 1895, 11661
 engraving
 history and technique of banknote production in United
 States, 21140
 processes and machines, 21124
 United States, history, 18644
Bankart, George Percy, 1866-1929
 illustrations, ceiling design, 7184
Banks, Joseph, *bart.*, 1743-1820
 biography, 20827
Bannister, Edward Mitchell, 1833-1901
 exhibitions, Providence Art Club, 1883, 24553
 illustrations
 Lowland and upland, 620
 Stone quarries, 24818
 landscapes, 737
Bannister, Eleanor Cunningham, 1858-1939
 exhibitions
 National Academy of Design, 1886, 25370
 National Academy of Design, 1887, 10831
Bannister, John, 1760-1836
 meets Wilkie, 19225
Banvard, John, 1815-1891
 panorama of Mississippi River, 4100
 on exhibition, London, 1849, 14511
BANVILLE, Théodore de,, 23657, 23676
Bapst, Germain, 1853-1921
 Études sur l'Orfèvrerie Française au Dix-Huitième Siècle,
 review, 10492
Barau, Emile, 1851-1931
 exhibitions
 Salon, 1886, landscape, 2206
 Salon, 1887, 2449
 illustrations, *Village des Roches*, 1365
Barbant, Charles, d.1922
 illustrations
 His first catch (after G. Haquette), 4841
 In the forest (after Montbard), 5185
 Solitude (after G. Montbard), 5543
 Watering place (after L. Flahaut), 5169
Barbarin, Francis S., 1833-1900
 Corcoran curator denies Benziger commission, 1897, 6457
Barbedienne, Ferdinand, 1810-1892
 collection, 4037
 sale, 1892, 4012, 15921
 sale, Paris, 1892, 26714
 copies of Barye bronzes, 1889, 3102
 illustrations
 enamel works, 1406
 plaque in cloisonné enamel, 2123

obituary, 15869, 26580
use of *pantograph* to reproduce sculptures, 9428
Barbee, William Randolph, 1818-1868
 commission for Madison monument, 1860, 20166
 Coquette, 19682
 First smoke, 24883
 Fisher girl, 18437
 sale, 1860, 18417
 praised by W. Sonntag, 17907
 sculptor, 18436
 sculpture, 1860, 20151
 whereabouts, 1860, St. Louis, 20209
Barber, Alice See: **Stephens, Alice Barber**
Barber, Charles Burton, 1845-1894
 engaged to paint for Queen, 21655
 Order of the bath, engraved by R. Josey, 9920
 Wake up!, in Layton Art Gallery, Milwaukee, 12813
Barber, Donn, 1871-1925
 model for Maine monument, third prize, 13213
BARBER, Edwin AtLee, 11545, 11566, 11587, 11611, 11631,
 11653, 11675, 11716, 11729, 11761, 11788, 11828, 11962, 12301,
 12324, 12400
Barber, Edwin AtLee, 1851-1916
 Anglo American Pottery, review, 12374
 lectures, Central Art Association, 1895-96, 11606
 Pottery and Porcelain of the United States, review, 4818, 11331
Barber, John Warner, 1798-1885
 wood engravings, 87
Barber, William R. See: **Barbee, William Randolph**
Barberi, Michelangelo, fl.1843-1854
 mosaics in St. Petersburg, 14780
Barberini Colonna di Sciarra, Maffeo, 1850-1925
 collection
 disposes of paintings to Italian government, 1897, 17218
 illegally sold, 1894, 16466
 lawsuits, 1892, 26780
 right to sell pictures contested by Florence, 1892, 26548
 sales prosecuted by Italian government, 15869
 violates Pacca edict, 1894, 16535
barbers
 Turkey, 21221
Barbieri, Giovanni Francesco See: **Guercino**
Barbizon (France)
 American art students visit, 1883, 10906
 description, 22312
Barbizon school, 9697
 criticism of use of term by Americans, 1891, 15638
 forgeries of Barbizon landscapes, 1894, 4702
 influence on Arthur Parton, 22993
 John W. Mollett books on Barbizon painters, 1890, 3386
 misnomer, 17487
 monument competition, 1904, 13974
 obituary of patron Père Jacquette, 1899, 17641
 paintings at Chicago World's Fair, 1893, 4766
 paintings in Learmont collection, 1894, 5003
 sales and prices, 1890's, 20628
 Wickenden collection sale, 1893, 4355
 works in Angus and Drummond collections, 4974
 works in Seney collection, 1891, 3502
 works in the Lyall collection, 15990
Barbour, W. C., fl.1901
 illustrations, design for *The Integral*, 13236
 student work for *The Integral*, 13219
Barbudo Sanchez, Salvador, 1858-1917
 First communion, on view, New York, 1892, 16006
Barcelona (Spain)
 views, 9460
Barclay, Edgar, 1824-ca.1913
 exhibitions, Grosvenor Gallery, 1878, 21594
Barclay, Ethel Wright See: **Wright, Ethel**
Barclay, George C.
 collection, 16403
 sale, 1892, 26526
Barclay, James Edward, 1846-1903
 portrait of Paderewski, reproduced in photogravure, 1893,

13549
statue of Lafayette, commission criticized, 1900, *13012*
statue of Pan for Dakota apartment building, New York, *22958*
work, 1902, *8059*
BARNARD, Percy L., *13305*
BARNARD, William Francis, *23985, 23990, 24008, 24031, 24169*
Barnay, Ludwig, 1842-1924
 actor, *14904*
BARNES, A. M., *23248*
Barnes, Anna See: **Crane, Anna Barnes**
Barnes Bruce, Mrs. See: **Bruce, Barnes, Mrs.**
Barnes, Burt, 1879-1947
 exhibitions, Chicago Art Students' League, 1895, *11469*
Barnes, Culmer, fl.1893-1894
 drawings and illustrations, *22498*
 illustrations
 "*Please give me a push*", *22546*
 Real and ideal, *22576*
 models, favorite model, *22519*
 portraits, photograph, *22518*
Barnes, Demas, 1827-1888
 art patron, *10725*
 commissions sculpture from T. R. Gould, *10648*
Barnes, Gertrude Jameson Jenkins, b.1865
 exhibitions, Minnesota State Art Society, 1905, *13905*
Barnes, Henry A., Mrs. See: **Barnes, Gertrude Jameson Jenkins**
Barnes, J. F., fl.1887
 illustrations, decorative initial, *536*
Barnes, Lucy E. See: **Baxter, Lucy E. Barnes**
Barnet, James, 1827-1904
 designer of Sydney post office, *10103*
Barnett, Henry Walter, 1862-1934
 illustrations, *Princess* (photograph), *12973*
Barnett, Tom P., 1870-1929
 illustrations, *Evening*, *13958*
Barnhorn, Clement John, 1857-1935
 exhibitions, Cincinnati Art Museum, 1898, *12754*
 memorial tablet for Sixth United States Infantry, *12808*
 student, Cincinnati Art Academy, 1891, *26314*
Barnsley, James MacDonald, 1861-1929
 exhibitions
 Prize Fund Exhibition, 1886, *25304*
 Prize Fund Exhibition, 1889, *2960*
 Salon, 1883, *24666*
 illustrations, landscape (drawing), *2432*
 member of Sketch-Box Club, Paris, 1883, *24640*
Barnum, Phineas Taylor, 1810-1891
 autograph collection, *16515*
 collection, sale, 1895, *16845*
Barocci, Federico, 1526-1612
 exhibitions, American Fine Arts Society, 1893, *Holy family*, *4315*
Barr, Charles Hagan, d.1947
 exhibitions, Minneapolis Arts and Crafts Society, 1901, *13184*
 illustrations, candlestick, *12906*
Barrau, Théodore Henri, 1794-1865
 Du Fôle de la Famille dans l'Éducation, *19775*
Barraud, Allan F., fl.1873-1908
 illustrations
 English birds, *21990, 22019, 22028*
 Richmond Park, *9799*
Barre, Jean Auguste, 1811-1896
 obituary, *11765, 16965, 16996*
Barret, George, ca.1728-1784
 exhibitions, New York, 1895, *16726*
Barrett, Elizabeth See: **Browning, Elizabeth Barrett**
Barrett, Laura A., d.1928
 exhibitions, Woman's Art Club of New York, 1892, *26542*
Barrett, Lawrence, 1838-1891
 anecdote, *24237*
 debut at London Lyceum, Spring, 1884, *1752*
 New York performances, 1885, *1917*
Barrias, Louis Ernest, 1841-1905
 Defence of Paris, engraved by E. Stodart, *9932*

exhibitions
 Chicago Art Institute, 1896, *5701*
 Chicago World's Fair, 1893, *4463*
 Salon, 1881, *22029*
First burial, cast in Chicago Art Institute, *12669*
First funeral, copy commissioned by Fairmount Park Association, 1886, *2343*
French sculptor, *5934*
illustrations, *First funeral*, *4398*
obituary, *13878*
statue of Bernard Palissy, *1405*
statue of Lavoisier erected in Paris, *13177*
Barrick, Jessie Parker, fl.1895
 exhibitions, Cleveland Art Association, 1895, *11470*
Barrie, Alexander
 collection, *15647*
Barrie, James Matthew, bart., 1860-1937
 Little Minister, "Maude Adams edition" illustrated by C. Allen Gilbert, *12808*
 notes, 1896, *22912*
Barringer, Mary C., fl.1899
 illustrations, *Figure*, *22086*
Barrington, George, b.1755
 essay, 1893, *16380*
Barritt, Frances Fuller See: **Victor, Frances Fuller**
Barritt, Leon, 1852-1938
 cartoonist, *22504*
 illustrations, *Protection*, *22560*
 portraits, photograph, *22603*
Barron, Edward, Mrs. See: **Barron, Eva**
BARRON, Elwyn Alfred, *24029*
Barron, Eva
 gives building to Stanford University for use by art department, 1898, *12794*
BARROW, Isaac, *23088*
Barrow, John, 1764-1848
 Voyage to Cochin, China, in the Years 1792 and 1793, excerpts, *21043*
Barrow, John Dodgson, 1824-1906
 collection, donated to village of Skaneateles, New York, *13059*
 landscapes given to Syracuse Public Library, 1905, *13974*
Barrow, John Wylie, b.1828
 library, sale, 1891, *15614*
Barrows, A. H., fl.1883-1910
 umbrella stands ordered by Mrs. Mark Hopkins, 1883, *24424*
BARROWS, B. B., *11669*
Barry, August, fl.1878-1889
 portrait of Daniel Webster (after J. A. Ames), *25146*
Barry, Charles, 1795-1860
 request for funds for completion of Houses of Parliament, London, 1849, *14549*
Barry, Charles A., 1830-1892
 crayon drawings, *20146*
 crayon head, *19955*
 in Boston, 1858, *19785*
 crayon head of Ames, *19913*
 exhibitions
 Boston Athenaeum, 1858, *19899*
 National Academy of Design, 1860, *20208*
 head of Rhode Island School of Design, 1879, *775*
 Motherless, *19875*
 notes, 1870, *23601*
 obituary, *15897, 26642*
 portrait head, *19819*
 Rector's ward (drawing), *20186*
Barry, Edward Middleton, 1830-1880
 obituary, *103*
Barry, James, 1741-1806, *17634*
 excerpt from lectures, *20823*
 paintings in Society of Arts cleaned, 1880, *21889*
Barry, John, 1745-1803
 monuments, bill for monument in Washington, D.C., *13503*
Barry, John Daniel, 1866-1942
 Daughter of Thespis, review, *8279*
BARRY, Theodore Augustus, 1825-1881, *10714*

Barse, George Randolph, jr., 1861-1938
designer of Kansas City invitation to President Cleveland, *592*
elected academician of National Academy of Design, 1900, *13046*
exhibitions
Boston Paint and Clay Club, 1885, *25259*
National Academy of Design, 1886, *2188*
National Academy of Design, 1889, *2936*
National Academy of Design, 1901, *Question, 7524*
National Academy of Design, 1902, *13359*
Pennsylvania Academy of the Fine Arts, 1885, *11280*
Society of American Artists, 1897, *Surprise, 6250*
Society of American Artists, 1898, Shaw prize, *12701*
Society of American Artists, 1898, Shaw purchase prize, *12710*
illustrations
End of the day, 7527
Question, 13202
murals for the Congressional Library, *11934*
whereabouts
1883, Paris, *24589*
1884, return from Paris to Boston, *25106*
1896, summer in town, *23056*
Barstow, S. M., fl.1858-1889
exhibitions, National Academy of Design, 1858, *19857*
Bartels, Hans von, 1856-1913
illustrations, *Breaker, 13982*
Bartels, Lillian M., fl.1891-1899
exhibitions, Palette Club of Chicago, 1892, *11307*
illustrations, *Preparing for a sneeze, 11704*
Barter, Richard, ca.1824-1896
Lesson interrupted, shown at Irish Industrial Exhibition, 1853, *20937*
Barth, Ferdinand, 1842-1892
God of wine, 9091
Barthold, Manuel, b.1874
illustrations, *Two friends, 13792*
Bartholdi, Frédéric Auguste, 1834-1904, *1698*
attends Fourth of July celebration at American Art Association of Paris, 1897, *23843*
bronze sculpture representing Washington and Lafayette in New York, 1893, *16316*
commission from city of Strasbourg, 1891, *26397, 26434, 26486*
exhibitions, Salon, 1895, medal of honor, *22765*
gigantic sculpture of lion, 1883, *24829*
illustrations
Lafayette, 4355
Washington and Lafayette group, *4355*
Liberty enlightening the world, 9062
monument commemorating seiges of Paris, model, 1902, *8089*
monuments, France and United States to erect statue in Colmar, 1906, *14176*
portraits, engraving by Henri Meyer, *1692*
silver statue of Columbus for Chicago World's Fair, 1893, *26968*
statuary group of Washington and Lafayette for city of Paris commissioned, 1890, *3127*
statue of Columbus for Chicago World's Fair, 1893, *26952*
statue of Lafayette, *8735*
Statue of Liberty, *450, 474*
criticism, *501*
criticized by D. C. Eaton, *1218*
criticized by *The Studio*, 1884, *25163*
dedication ceremony, *529*
in preparation, 1883, *1603*
pedestal, *9718, 25280*
pedestal criticized by *The Studio*, 1885, *25265*
pedestal fund loan exhibitions, *10951*
pedestal praised, *501*
planned for New York harbor, 1882, *1412*
unveiled, 1886, *502*
statues for Gambetta monument at Ville d'Avray, *26392*
Vercingetorix, transport to Clermont-Ferrand, *13366*
Washington and Lafayette monument, Paris, *22384*

Bartholomé, Albert, 1848-1928
elected to Dresden Academy, 1901, *13269*
illustrations, *Study, 13515*
Bartholomew, Edward Sheffield, 1822-1858, *18186*
bust of Fillmore, *19836*
color blindness noted by B. Akers, *18542*
Eve repentant, 19995
exhibitions
Pennsylvania Academy of the Fine Arts, 1858, *19858*
Pennsylvania Academy of the Fine Arts, 1859, *20049*
memorial fund, *18208*
obituary, *19879*
statue of Washington, *19814*
statues on view, New Haven, 1858, *19875*
subject of a poem by L. Sigourney, *18397*
work, 1857, *19667*
works in studio, Rome, 1858, *19955*
Bartlett, Agnes A. See: **Brown, Agnes Augusta Bartlett**
Bartlett, Francis, d.1913
collection, antiquities given to Boston Museum of Fine Arts, *13604*
Bartlett, Frederic Clay, 1873-1953
exhibitions
Chicago Art Institute, 1900, *13137*
Chicago Art Institute, 1903, *13673*
Society of Western Artists, 1906, *14038*
whereabouts, 1893, summer at Lake Ontario, *22491*
Bartlett, Frederick Eugene, 1852-1911
sketch of Niantic Bay, 1892, *26839*
BARTLETT, Gertrude, *23967, 24080*
Bartlett, Jane E., fl.1870-1890
exhibitions, Boston Museum of Fine Arts, 1880, *1026*
Bartlett, John, 1820-1905
Collection of Familiar Quotations, review, *19391*
BARTLETT, John Allen, *20647, 20704*
Bartlett, Josiah, 1729-1795
monuments, statue commissioned from Gebhardt for Amesbury, 1887, *592*
Bartlett, Paul Wayland, 1865-1925
Bear tamer, acquired by Metropolitan Museum, 1891, *26356*
colossal horses, 1883, *14880*
commissions, 1901, *13253*
elected to art committee of American Art Association, Paris, 1903, *13701*
exhibitions
Boston, 1880, *1005*
Champs de Mars Salon, 1894, *16544*
Chicago World's Fair, 1893, *4565*
National Sculpture Society, 1898, *Columbus, 12721*
Paris Exposition Universelle, 1889, *3010*
Paris Exposition Universelle, 1889, *Bohemian, 25675*
Pennsylvania Academy of the Fine Arts, 1899, *Columbus* and *Michael Angelo, 12836*
Pennsylvania Academy of the Fine Arts, 1905, *13853*
Salon, 1887, *2449*
Society of American Artists, 1897, *10538*
Turin Esposizione, 1902, grand prize, *13618*
illustrations
Michael Angelo, 13806
sculpture for Pan-American Exposition, 1901, *13263*
John Brown, in American Art Galleries, 1884, *1899*
statue of General Joseph Warren, *13819*
statue of General Sherman, *23008*
sketch model, 1896, *22958*
statue of Lafayette, *14096*
commissioned, *13012*
commissioned for Paris, 1899, *22070*
erected in Paris, 1903, *8281*
in Paris, *7294*
preparation, *13065*
statue of Michelangelo, *17396*
at Paris Exposition, 1900, *13074*
cast by Henry Bonnard Bronze Company, *12844*
for Library of Congress, *12782, 12808*
whereabouts, 1896, trip to New york, *22980*

working with female model for Millet's *Angelus*, 1890, *3425*
BARTLETT, Truman Howe, *167, 181, 205, 385, 409*

Bartlett, Truman Howe, 1835-1923
 book in preparation, 1880, *177*
 exhibitions, St. Botolph Club, 1880, *159*
 school of modeling and terra-cotta design, 1880, *917*
 school of sculpture, Boston, 1880, *191*
 statue of Dr. Wells, Hartford, falls from pedestal, 1886, *25333*
 teacher of Cyrus E. Dallin, *12949*
 tiles of relief heads for Buffalo, *504*
 whereabouts, 1880, *960*
Bartlett, William Alvin, 1831-1917
 library, sale, 1895, *16820*
Bartlett, William Henry, b.1858
 artist-author, *17816*
 exhibitions
 Royal Society of British Artists, 1880, *21835*
 Salon, 1880, *21870*
 illustrations, *Freiburg, Switzerland*, *13100*
Bartoccini, Bartolommeo, b.1816
 engravings of Stations of the Cross after Overbeck, *14697*
Bartol, Cyrus Augustus, 1813-1900
 book in preparation, 1880, *80*
 Pictures of Europe, excerpt on Raphael, *19423*
Bartol, Elizabeth Howard, 1842-1927
 exhibitions
 American Art Association, 1883, *24398*
 Society of American Artists, 1880, *9324*
 portrait of her father shown in Boston, 1892, *26869*
Bartolini, Lorenzo, 1777-1850
 Carita, *13611*
 obituary, *14607*
Bartolommeo, Fra, 1475-1517
 Holy Family, in Cook collection, *10143*
Bartolozzi, Francesco, 1727-1815
 engraver, *6702*
 exhibitions
 New York, 1891, engravings, *15759*
 New York, 1893, *16277*
 illustrations
 engravings after Hans Holbein, *7344*
 Lady Smyth and her children (after J. Reynolds), *9603*
 Triumph of Bacchus, *2958*
 notes, 1891, *3793*
Bartolozzi, Gaetano Stefano, 1757-1821
 prints, *1240*
 sales and prices, 1897, *6143*
BARTON, Charles C., *22900, 22991*
Barton, Emery K., Supplies See: **Cincinnati (Ohio). Barton, E. H., Artists' Supplies**
Barton, Mary A., fl.1891-1892
 exhibitions, Palette Club of Chicago, 1892, *11307*
Bartram family
 library, given to Historical Society of Pennsylvania, 1892, *16073*
BARUS, Byron M., *11605*
Barye, Antoine Louis, 1796-1875
 anecdote, *954*
 autograph manuscript found, 1887, *25499*
 Barye: Life and Works of Antoine-Louis Barye by De Kay, *3171, 25715*
 biographical note, *16512*
 bronzes, *17742*
 bronzes in Corcoran Gallery, *6*
 counterfeits and prices, 1890, *3425*
 fakes sold in N.Y., 1889, *14950*
 forgeries, *15340*
 reproductions appear on market, 1888, *2800*
 exhibitions
 American Art Association, 1889, *25668*
 American Art Galleries, 1889, *3102, 14935, 14946, 14972*
 American Art Galleries, 1889, Barye Memorial Exhibition works criticized, *3127*
 American Art Galleries, 1889, Barye Memorial Fund

 Exhibition, *3180*
 American Art Galleries, 1889, Barye Memorial Fund Exhibition, *3128*
 American Art Galleries, 1889, Barye Memorial Fund Exhibition, animal paintings, *3154*
 American Art Galleries, 1889, Memorial Fund Exhibition, *3207*
 Chicago Art Institute, 1896, *5701*
 New York, 1889, *2908, 2934*
 New York, 1890, *25731*
 New York, 1893, *16098*
 Paris, 1876, *8603*
 Paris, 1889, *2839, 3055*
 Union League Club of New York, 1890, watercolors, *3227*
 illustrations
 bronzes in America, *1785*
 Lion and lioness, *2907*
 Lion and the serpent, gift to Metropolitan Museum, 1890, *3127*
 medals, *14962*
 monuments
 Bayre Monument Association catalogue, *25911*
 monument proposed, 1888, *2624*
 notes, 1896, *16911*
 obituary, *8516*
 poem by S. B. Stebbins, *22261*
 portraits, portrait by Bonnat, *22259*
 promotion by Cyrus Lawrence, *25748*
 sales and prices
 1884, *1786*
 1886, bronzes in Paris, *2205*
 1888, *2723*
 1892, *15886*
 tiger acquired by C. J. Lawrence, 1888, *2676*
 works donated to Baltimore by W. T. Walters, *22264*
 works in W. T. Walters collection, *1877*
Barzaghi, Francesco, 1839-1892
 Blind-man's-buff, *9229*
 monument to Napoleon III in Milan, 1881, *21895*
Basaiti, Marco, ca.1470-ca.1530
 use of landscape painting, *21849*
Basch, Arpád, b.1873
 notes, 1898, *17432*
Baschet, Ludovic, b.1834
 Salon de 1888, review, *2851*
baseball
 student team at National Academy, 1883, *24586*
Baseleer, Richard, 1867-1951
 exhibitions, Antwerp, 1902, *13361*
Bashkirtseff, Marie, 1860-1884
 anecdote, *3695*
 book by Arthur Tierney, 1897, *23943*
 exhibitions, Union des Femmes Peintres et Sculpteurs, 1885, *1981*
 in Paris, *24282*
 Journal, review, *3130*
 letters, *26053*
 monuments, monument in Passy, *26052*
 mother will not part with collection, *26044*
 paintings in her mother's possession, 1890, *3335*
 publications, 1890, *26136*
 quote, on Paris Salon, *5263*
 student at Academie Julian, *5186*
Basilewsky, Alexander
 collection, *17572*
 bought by Russian government, 1885, *10115*
baskets
 American Indian baskets, *17126*
 Colonial catchall, *547*
 Japanese basket work in E.C. Moore collection, *26057*
 National Indian Association basket collection, *17276*
Baskett, James Newton, b.1849
 Story of the Birds, review, *23251*
Basra
 antiquities, Chaldean relics found, *454*

Carnegie Galleries, 1899, *Mother and daughter* receives gold medal, *7153*
Carnegie Galleries, 1900, *13130*
Carnegie Galleries, 1901, *13322*
Carnegie Galleries, 1903, *13675*
Carnegie Galleries, 1905, *Portrait*, *14016*
International Society of Sculptors, Painters, Gravers, 1907, *14248*
Louisiana Purchase Exposition, 1904, *13785*
National Academy of Design, 1892, *26583*
National Academy of Design, 1893, *4388*
National Academy of Design, 1894, *4873*, *5174*
National Academy of Design, 1896, *22996*
National Academy of Design, 1899, *17566*
Pennsylvania Academy of the Fine Arts, 1885, *11280*
Pennsylvania Academy of the Fine Arts, 1890, *3181*, *25768*
Pennsylvania Academy of the Fine Arts, 1892, Mary Smith prize, *26535*
Pennsylvania Academy of the Fine Arts, 1896, *5656*
Pennsylvania Academy of the Fine Arts, 1897, portraits, *6179*
Pennsylvania Academy of the Fine Arts, 1899, *17503*
Pennsylvania Academy of the Fine Arts, 1900, Temple Gold Medal, *13007*
Pennsylvania Academy of the Fine Arts, 1901, *13163*
Pennsylvania Academy of the Fine Arts, 1902, *13363*
Pennsylvania Academy of the Fine Arts, 1903, *13548*
Pennsylvania Academy of the Fine Arts, 1904, *13716*
Pennsylvania Academy of the Fine Arts, 1905, *13851*
Pittsburgh, 1899, first prize, *12976*
Prize Fund Exhibition, 1885, *11230*, *25278*
Prize Fund Exhibition, 1886, *25304*
St. Louis Exposition, 1897, *12015*
Salon, 1896, *23618*
Salon, 1902, *13414*
Society of American Artists, 1895, *21531*
Society of American Artists, 1900, *13038*
Society of Painters in Pastel, 1890, *25904*
Worcester Art Museum, 1902, *13483*
exhibitions of work, *6530*
illustrations
Portrait, *13551*, *13792*
portrait, *14282*
Portrait of Mrs. John F. Lewis, *14244*
notes, 1896, *23030*
portrait paintings, *8335*
praised in London, 1898, *12201*
sales and prices, 1896, *New England women*, *22388*
BEAVER, Alfred, *9777*, *9808*, *9823*, *9867*, *9885*, *9912*, *9927*, *9946*, *9964*, *9977*, *9995*, *10011*, *10025*, *10032*, *10033*, *10055*, *10068*, *10081*, *10099*, *10135*, *10145*, *10170*, *10488*, *10500*, *21978*, *22037*, *22057*
Beavis, Richard, 1824-1896, *8807*
paintings in studio, 1878, *21575*
Becchi, Luigi See: Bechi, Luigi
Becci, Luigi See: Bechi, Luigi
Bechard, Emile, fl.1870-1880's
reproductions by photography on canvas, *13533*
Becher, Arthur E., 1877-1941
illustrations, *When the summer field is mown* (photograph), *13285*, *14107*
Becherel
collection, sale, 1883, *1694*
Bécherel (France)
description of Little Sisters of the Poor, *10416*
Bechi, Luigi, 1830-1919
paintings in Florence, 1878, *21627*
Beck, Carol H., 1859-1908
exhibitions
Pennsylvania Academy of the Fine Arts, 1899, Smith prize, *12314*, *12859*
Pennsylvania Academy of the Fine Arts, 1906, *14244*
Beck, J. Augustus, b.1831
exhibitions, American Watercolor Society, 1880, *827*
BECK, Karl, *19139*

Beck, Martin A., fl.1892-1913
exhibitions, American Watercolor Society, 1892, *3893*
Beck, Otto Walter, 1864-1954
critiques at Ohio state photographic salon, *12937*
influence on Clarence Hudson White, *12791*
Beck, R. K., fl.1882-1884
whereabouts, 1883, Pottsville, Pa, *24728*
Becker, Carl J., fl.1882-1905
silver-point drawings, *22720*
Becker, Carl Ludwig Friedrich, 1820-1900
art importations to U.S., 1879, *734*
exhibitions, Seventh Regiment Fair, N.Y., 1879, *766*
obituary, *13244*, *22118*
re-elected president, Berlin Academy of Fine Arts, 1893, *16343*
Becker, Florence, fl.1899-1901
exhibitions, Denver Artists' Club, 1899, *12886*
Becker, Georges, 1845-1909
exhibitions
Salon, 1877, *8858*
Salon, 1880, *9355*
Martyr's widow, *26327*
Becker, Jakob, 1810-1872
Reaper's return home, *19298*
Becker, Joseph, 1841-1910
newspaper illustrations, *16557*
Becker, P. A., fl.1883
student of Walter Satterlee, 1883, *24513*
Beckert, Paul, b.1856
portrait of Bismark, *25772*
Becket, Maria A' See: A'Becket, Maria J. C.
Beckett, Arthur, *pseud.* See: Hopkins, Robert Thurston
Beckett, Edmund See: Grimthorpe, Edmund Beckett, *1st baron*
Beckford, William, 1760-1844
notes, 1894, *16616*
Beckingham, Arthur, fl.1881-1920
picture in Bullock collection, *15121*
Beckington, Alice, 1868-1942
exhibitions, American Society of Miniature Painters, 1900, *13022*
Beckmann, Ludwig, 1822-1902
obituary, *13504*
Beckwith, Arthur, 1860-1930
whereabouts, 1883, Newport, R.I, *24728*
BECKWITH, James Carroll, 1852-1917, *2114*, *3433*, *5535*, *6106*, *21516*, *24507*
Beckwith, James Carroll, 1852-1917, *1314*, *12410*
article on art in New York, excerpt, *11612*
charcoal drawing illustrated in *Art Amateur*, 1883, *24569*
copies after old masters made for Metropolitan Museum's Loan Exhibition, 1883, *24538*
copies of Velasquez, 1899, *6955*
decorations for Liberal Arts Building, Chicago World's Fair, 1893, *4185*, *4378*, *4469*
decorative figures and sketches of women, *22606*
elected treasurer, Society of American Artists, 1893, *16252*
exhibitions
American Art Galleries, 1884, *24988*
American Watercolor Society, 1880, *827*, *9292*
American Watercolor Society, 1881, *1065*
American Watercolor Society, 1882, *1300*
American Watercolor Society, 1883, *Peasant against hay*, *1510*
Art Students' League, 1881, *256*
Charleston Interstate and West Indian Exposition, 1901-1902, gold medal, *13436*
Fellowcraft Club, 1890, *26181*
Fellowcraft Club, 1891, *3464*
Internationale Kunstausstellung, Munich, 1883, *1587*
Lotos Club, 1880, *804*
Louisiana Purchase Exposition, 1904, *13787*
National Academy of Design, 1879, *657*
National Academy of Design, 1880, *111*, *889*
National Academy of Design, 1881, *342*, *1129*
National Academy of Design, 1886, *2352*

statue by Ward for Brooklyn's Prospect Park, *633*
statue cast, 1890, *25798*
Mountain Farm to the Sea-side Farm, excerpt, *19060*
Plymouth Church design competition, *20126*
quote, *18351*
 on Anne Hathaway, *18359*
 on church architecture, *20032*
 on The Beautiful, *20034*
reminiscences by Horatio C. King, *22882*
Star Papers, excerpts and review, *18942*
Beecher, Henry Ward, Mrs. See: **Beecher, Eunice White Bullard**
Beecher, Herbert Foote, Mrs. See: **Beecher, Harriet Foster**
BEECHER, John Preston, *15703, 15720, 15741, 15755, 15766, 15774, 15785, 15792, 15806, 15822, 15834, 15843, 15854, 15864, 15874, 15890, 15904, 15906, 15943, 15981, 16001, 16036, 16092, 16137, 16149, 16221, 16239, 16669, 16787, 16805, 20465*
Beecher, John Preston
appointed U.S. consul at Cognac, France, 1893, *16260*
Beecher, Lyman, 1775-1863
ministry, *20966*
Beecher, Roxanna See: **Preuszner, Roxanna Beecher**
Beechey, William,, 1753-1839
illustrations, portrait, *6095*
portrait of Countess Delawarr, *8102*
Beek, Alice D. Engley, b.1876
exhibitions, American Woman's Art Association of Paris, 1897-8, *23992*
Beelepsch Valendas, H. E. von, fl.1902?
illustrations, corner of a dining room, *13502*
beer
brasseries in Paris, *23875*
Beer, Friedrich, 1846-1912
discovers process of making marble fluid, 1890, *25806*
Beerbohm, Max, 1872-1956
satirist, *24151*
Beernaert, Euphrosine, 1831-1901
exhibitions, Ghent Salon, 1883, *14870*
Beers, Jan van, 1852-1927
anecdotes, *15709*
exhibitions
 London, 1887, *10419*
 Paris, 1893, *16153*
 Salon, 1883, *24643*
exploits collector C. Yerkes, 1892, *3895*
illustrations
 Coquette, *22921, 23234*
 Study, *23039*
Jacob Van Maerlandt prophesying the deliverance of Flanders, *7803*
last picture of Bastien Lepage, *10139*
lawsuit against critic, *1312*
notes, 1891, *3751*
omitted from Grolier Club poster exhibition, 1890, *3427*
paintings forged by artist, *2746*
shady art dealer, *3490*
Beest, Albert van, 1820-1860
Marine, in Boston, 1858, *19785*
notes, 1860, *18417*
obituary, *18510*
Beethoven, Ludwig van, 1770-1827
Beethoven Festival in Bonn, 1890, *25978*
H. A. Rudall's *Beethoven*, 1890, *3386*
monuments
 Crawford's statue arrives in New York, 1855, *18839*
 memorial by H. Baerer for Central Park, *25137*
 sculpture by Crawford, *19033*
 statue by Crawford cast in Munich, 1855, *18801*
portraits
 bust by Baerer cast, 1894, *26999*
 chromo of portrait by Ferd. Schimon, *23585*
relics, given to Beethoven museum at Bonn, 1891, *26304*
Bega, Cornelis Pietersz, 1620-1664
Philosopher, *17206*

Begas, Karl Joseph, 1794-1854
monument for tomb of Frederick III, *25772*
monument to Emperor William, *26280*
obituary, *18583*
Syren of the Rhine, *20887*
Begas, Oskar, 1823-1888
Greek girl, posed by Marguerite Cortillo, *22522*
Begas, Reinhold, 1831-1911
Bismarck memorial, *13652*
illustrations, bust of Adolph Menzel, *4460*
beggars in art, *22822*
Beggs, John T., d.1897
exhibitions, Chicago Society of Artists, 1895, *11483*
portraits, photograph, *22559*
BEGGS, T., *20907*
Behenna, Katherine Arthur, fl.1896-1913
miniature painter, *7569*
whereabouts, 1896, London and Paris, *23056*
Behrens, Eduard L.
collection, *15942*
Behrens, Peter, 1868-1940
illustrations, vestibule at Turin Exposition, *13545*
Beirut (Lebanon)
history and description, *21094*
Bek Gran, Hermann, 1869-1909
illustrations, design, *7602*
Belasco, David, 1853-1931
notes, 1896, *22912*
Belassa, A., fl.1901
illustrations, sketches, *13249*
Belcher, Hilda, 1881-1963
exhibitions
 American Watercolor Society, 1907, *14333*
Belcher Mosaic Glass Co., New York
catalogue, 1886, *492*
catalogue of windows, 1886, *486*
BELDEN, Edgar Stanton, b.1870, *12443*
Belden, Elizabeth, fl.1905
illustrations, *Winter*, *13962*
Belfield, Henry Holmes, 1837-1912
paper on manual training, 1888, *623*
Belgian art See: **art, Belgian**
Belgian artists See: **artists, Belgian**
Belgian china painting See: **china painting, Belgian**
Belgian Gallery, London See: **London (England). Belgian Gallery**
Belgian painting See: **painting, Belgian**
Belgian sculpture See: **sculpture, Belgian**
Belgium
description
 art student's account of trip, 1891, *3577, 3605*
 English architects tour, 1892, *26523*
description and views, *10308*
Belin Dollet, Georges C., d.1903
exhibitions, New York Etching Club, 1885, *1934*
BELL, Charles,, *20315*
Bell, Charles Henry, 1823-1893
library, sale, 1895, *16865*
Bell, Charles James, 1858-1929
elected president, National Society of Fine Arts, 1905, *13899*
portraits, photograph, *23193*
Bell, E. Hamilton, fl.1893
stained glass window designs for Cincinnati City Hall, *4404*
Bell, Edith, fl.1896-1909
exhibitions, New York, 1896, *5700*
Bell, Edward August, 1862-1953
elected associate, National Academy of Design, 1901, *13228*
exhibitions
 National Academy of Design, 1887, *10831*
 National Academy of Design, 1893, *4316, 4388*
 National Academy of Design, 1897, *10540*
 New York Athletic Club, 1898, *Dreamers*, *6643*
 Prize Fund Exhibition, 1886, *25304*
 Prize Fund Exhibition, 1888, *2700*
 Society of American Artists, 1884, portrait study, *11003*

Bendelari, Sophie See: **DePeralta, Sophie Bendelari**
Bendemann, Eduard Julius Friedrich, 1811-1889
 illustrations, *Hebrew captives*, *20751*
 obituary, *25737*
Benedetto da Maiano, 1442-1497
 terracotta reliefs acquired by South Kensington Museum, 1889, *25628*
Benedetto da Rovezzano, 1474-1552
 architectural sculpture, *9425*
Benedict, Enella, b.1858
 exhibitions
 Chicago Arché Salon, 1896, second prize, *11750*
 Chicago Art Institute, 1895, *11547*
 Chicago Society of Artists, 1895, *11483*
Benedito Vives, Manuel, b.1875
 exhibitions, Société des Artistes Français, 1907, *14312*
BENEDIX, Roderich, *19221, 19240*
Bénévent, *prince* de See: **Talleyrand Périgord, Charles Maurice de,** *prince* de Bénévent
Benevento (Italy). Arco di Traiano
 copy for Princeton University, *12841*
Benguiat, Ephraim
 collection
 Jewish ceremonial objects given to U.S. National Museum, 1901, *22128*
 museum of oriental art at St. Louis Exposition, 1904, *22203*
Benham, Charles C., fl.1897-1901
 stoneware decoration, *11962*
Benjamin, Charles Henry, 1856-1937
 illustrations, *Bright morning*, *22567*
 member, Cleveland Water Color Society, *22591*
 Rudder Grange, *22741*
BENJAMIN, Charles Love, *6055, 12574*
BENJAMIN, Frederick, *12928*
Benjamin, Isaac, 1860-1928
 exhibitions, Photographers Association of America convention, 1899, *12937*
 illustrations, *Portrait of Mr. J. H. Sharp* (photograph), *13011*
 portrait photographs, *12818*
BENJAMIN, Park, *22954*
Benjamin, Park, 1849-1922
 portraits, bust by J. S. Hartley, *23008*
BENJAMIN, Samuel Greene Wheeler, *38, 70, 94, 111, 126, 142, 247, 296, 316, 338, 342, 367, 9097, 9261, 9270, 9292, 10812*
Benjamin, Samuel Greene Wheeler, 1837-1914
 Art in America: a Critical and Historical Sketch, review, *97*
 book in preparation, 1879, *31*
 entertained by Salmagundi Club, 1883, *1549*
 excerpt on old Persian book covers, *2516*
 Group of Etchers, published, 1883, *24372*
 lectures
 1880, *46*
 at Essex Institute, 1880, *257*
 notes, 1885, *11273*
 Persia and the Persians
 illustrated edition, 1886, *509*
 review, *2360*
 report on Persian rugs and carpets, *1907*
 Sea Spray, publication announced, 1887, *592*
Benjamin, Sarah Mathews, 1743-1858
 role in Revolution, *18137*
Benjamin, William Evarts, 1859-1940
 books offered, 1891, *15783*
Benjamin-Constant See: **Constant, Benjamin**
Benk, Johannes, 1844-1914
 Clytie, replica in New York, 1890, *15020*
Benlliure y Gil, José, 1855-1919
 illustrations
 Island of love, *13609*
 Juan de Rivera, *13609*
 notes
 1891, *15759*
 1898, *6586*
 painting in Mannheimer collection, 1896, *16989*

Benlliure y Gil, Mariano, 1862-1946
 illustrations, *Juan de Rivera*, *14026*
BENN, R. Davis, fl.1899-1920, *7109, 7127, 7163, 7184*
Benner, Emmanuel, 1836-1896
 illustrations, *Repose*, *1143*
 nudes, *22620*
Benner, Jean, 1836-1909
 illustrations, *At the well* (drawing), *2400*
 nudes, *22620*
Bennett, Agnes Maria, d.1808
 manuscript found, 1895, *16767*
BENNETT, Cecilia, fl.1898-1903, *6885, 6912, 6917, 6967, 6969, 6998, 7107, 7272*
Bennett, Cecilia, fl.1898-1903
 exhibitions, New York, 1899, china painting at studio, *6866*
Bennett, Edward Herbert, 1874-1954
 exhibitions, American Art Association of Paris, 1898, drawings, *24010*
 illustrations
 monogram, *23629*
 monogram for *The Anglo-American Annual*, *23649, 23667, 23690, 23712, 23731, 23754, 23775, 23797, 23816, 23837, 23858, 23879*
Bennett, Edwin Scott, fl.1895-1900
 artist photographer, *6740*
 illustrations
 Mill pond, *7975*
 Old road, *7977*
 Portrait (after J. Carroll Beckwith), *7013*
 Scene on the Brandywine (photograph), *6991*
 women (photographs), *22642*
Bennett, James Gordon, 1795-1872
 newspaper illustration, *22504*
 notes, 1896, *22943*
 relation to *New York Herald*, *12476*
BENNETT, John, fl.1870's, *687*
Bennett, John, fl.1870's
 development of ceramic resources in United States, *836*
 opens pottery studio in New York, 1877, *8950*
 pioneer in American pottery, *12324*
BENNETT, John Edward, b.1863, *6453*
Bennington (Vermont)
 monuments, Bennington Battle Monument by J. F. Weir, 1883, *24741*
Benois, Alexandre, 1870-1960
 exhibitions, Moscow, 1905, *13943*
Benouville, Jean Achille, 1815-1891
 exhibitions, National Academy of Design, 1858, *19857*
Benouville, Léon, 1821-1859
 St. Francis of Assisi, *19164*
Bensell, Edmund Birckhead, b.1842
 illustrations, *Dragon and the bee-man*, *22531*
 notes, 1871, *10619*
Bensell, George Frederick, 1837-1879
 obituary, *18*
Bensley, Martha S., fl.1895-1913
 exhibitions
 Chicago Art Students' League, 1895, *11469*
 Chicago Artists' Exhibition, 1899, *12310*
 Chicago Society of Artists, 1895, *11483*
BENSON, Eugene, 1839-1908, *10579, 10612*
Benson, Eugene, 1839-1908
 exhibitions
 Artists' Fund Society, 1863, *23289*
 Grosvenor Gallery, 1885, *2035*
 National Academy of Design, 1859, *20030*
 National Academy of Design, 1865, *23331*
 Hasheesh-smokers, *9014*
 paintings in Appleton collection, *876*
 studio in Rome, 1885, *2006*
 whereabouts, 1883, Rome, *24588*
BENSON, Frances M., *22474, 22478, 22563*
Benson, Frank Weston, 1862-1951, *11805, 13061*
 awarded T. B. Clarke prize, 1891, *3604*
 elected to Carnegie Institute jury of awards, 1897, *12020*

Ellsworth prize, 1891, *26433*
exhibitions
 Boston, 1898, *12805*
 Boston Art Club, 1890, *25730*
 Boston Art Club, 1894, *8340*
 Carnegie Galleries, 1899, *Sisters* receives silver medal, *7153*
 Carnegie Galleries, 1900, *13130*
 Carnegie Galleries, 1901, *13322*
 Carnegie Galleries, 1903, *13675*
 Carnegie Galleries, 1907, *14328*
 Central Art Association, 1895, *11537, 11564*
 Chicago Art Institute, 1895, *11570, 11673*
 Chicago Art Institute, 1896, *11894*
 Chicago Art Institute, 1896, *Spring* and *Autumn, 6010*
 Chicago Art Institute, 1899, *12423*
 Chicago Art Institute, 1902, *13536*
 Cincinnati Art Museum, 1900, *13067*
 Copley Society, 1902, *13442*
 Copley Society, 1905, *13924*
 Corcoran Art Gallery, 1907, silver metal, *14282*
 Fort Wayne, 1896, *Mother and children, 11827*
 Minneapolis Society of Fine Arts, 1895, *11512, 11513*
 National Academy of Design, 1891, Clarke prize, *15626*
 National Academy of Design, 1891, *Twilight, 3603*
 National Academy of Design, 1892, *26583*
 National Academy of Design, 1898, *12710*
 National Academy of Design, 1905, Proctor prize, *14062*
 New York, 1898, *Twilight, 6619*
 New York, 1903, *Sunlight, 8222*
 New York, 1905, *13886*
 New York Athletic Club, 1898, *Summer, 6643*
 Pennsylvania Academy of the Fine Arts, 1903, *13548*
 Pennsylvania Academy of the Fine Arts, 1903, Lippincott
 prize, *13563*
 Pittsburgh, 1899, second prize, *12976*
 Society of American Artists, 1888, *2678, 25505*
 Society of American Artists, 1889, *2986*
 Society of American Artists, 1890, *Portrait of a young girl,
 25915*
 Society of American Artists, 1896, Shaw fund prize for
 Summer, 22996
 Society of American Artists, 1896, *Summer* wins Shaw prize,
 5780
 Ten American Painters, 1899, *6954*
 Ten American Painters, 1906, *14095*
 Venice, 1901, *13257*
 Worcester Art Museum, 1902, *13483*
follower of Tarbell, *10521*
Girl with a red shawl, shown at Chicago World's Fair, 1893,
 26914
illustrations
 Along shore, 10868
 Early morning, 13985
 Hilltop, 13716
 Portrait of a child, 14244
 Portrait of two boys, 13792
 Sisters, 13785
 vignettes for poem, *10849*
murals for Library of Congress commissioned, 1896, *11794*
notes, 1905, *21531*
panels for Congressional Library, *23008*
prize, Art Institute of Chicago, 1891, *15768*
studio, Boston, 1895, *11561*
teaching, Boston School of Drawing and Painting, 1892, *4055*
Benson, John, fl.1853
 illustrations, ground plan of Irish Industrial Exhibition, *20897*
BENSON, John R., *23003, 23004*
BENSON, Nesbitt, fl.1896-1919, *23634*
Benson, Nesbitt, fl.1896-1919
 whereabouts, 1897, leaves Paris for Mississippi, *23750*
BENSON, William Arthur Smith, 1854-1924, *26050*
Bent, James Theodore, 1852-1897
 archaeological explorations, 1896, *17228*
 obituary, *17373*
BENTINCK, J. H., *23851, 24125*

Bentley, Charles E., fl.1881-1882
 illustrations, embroidery designs, *1262, 1293*
Bentley, John Theodore, fl.1884-1919
 Head of Christ
 destroyed by fire, 1890, *26200*
 destroyed in fire, 1891, *3490*
 lawsuit over painting destroyed by fire, 1891, *26396*
Bentley, M. Louise
 Practical Hints on the Art of Wood Carving, excerpt, *3384*
Bentley, Wilson Alwyn, 1865-1931
 illustrations, snow crystals photographed from nature, *7238*
BENTON, Dwight, b.1834, *851, 10677, 10710*
Benton, Dwight, b.1834
 Midsummer, 10597
 obituary, *13604*
 Stormy morning in the Sabine country, Italy, at Cincinnati
 Exposition, 1879, *756*
 whereabouts
 1883, Rome, *24588*
 1884, Rome, *25045*
Benton, George Bernard, b.1872
 illustrations
 Lady of Shalott (mural), *14087*
 Lancelot (mural), *14087*
 two decorative panels, *13504*
Benton Harbor (Michigan). Art League
 meeting, 1896, *11780*
 notes
 1896, *11913*
 1898, *12248*
 sketch class, 1899, *12339*
BENTON, J. H., *11322*
BENTON, Jeannette Allston, *11786, 11809, 11826, 11868, 11892,
 11908, 11920, 11933, 11945*
Benton, Thomas Hart, 1782-1858
 monuments
 St. Louis, *20166*
 statue by Hosmer commissioned, 1860, *20259*
Benziger, August, 1867-1955
 commissioned to paint portraits for Corcoran, denied by cura-
 tor, 1897, *6457*
 commissioned to paint portraits for Corcoran, 1897, *6425*
 portraits of McKinley and Hobart, *6527*
Benzoni, Giovanni Maria, 1809-1873
 Flight from Pompeii, acquired by San Francisco Art
 Association, 1899, *22072*
 Veiled statue, in Pittsfield, Mass, *12367*
Berain, Jean, 1640-1711
 furniture designs, *686*
Beraldi, Henri, 1849-1931
 Bibliothèque d'un Bibliophile, review, *2317*
 collection, *15759, 15800*
 catalogue of print collection, *15928*
 Estampe Française prints, *15275*
 Graveurs du XIX Siècle
 list of Meissonier prints, *16030*
 praised, 1893, *16227*
 publication, 1886, *10341*
 publication announcement of vol. 10, *15429*
 library, catalogue to book collection, *15899*
Bérard, Evremond de, fl.1852-1880
 paintings in S. M. Vose collection, 1896, *17068*
Béraud, Jean, 1849-1936
 Ascension, shows Christ rising in a balloon, *26722*
 Church interior, 3752
 Descent from the cross, 23020
 exhibitions
 Brooklyn Art Association, 1884, *1740*
 Cercle Artistique, 1880, *9325*
 Cercle Central des Lettres et des Arts, 1880, *9389*
 Chicago World's Fair, 1893, *Descent from the cross, 4605*
 New York, 1891, *3458*
 New York, 1894, *16451*
 Paris, 1884, *1791*
 Salon, 1884, *1789*

1895, prints, *16803*
1898, *17394*
reproductions issued
 1895, Rembrandt, *16882*
 1896, Hermitage collection, *17124*
 1896, Prado collection, *17146*
Secession portfolio, *22280*
review, *22315*
Berlin (Germany). Schulte, Eduard, firm
notes, 1892, *15966*
Berlin (Germany). Secession See: **Berliner Secession**

Berlin (Germany). Tiergarten
sculptural decoration, 1903, *8238*
Berlin Photographic Company, New York
catalogue published, 1892, *15882*
exhibitions, 1899, *17571*
opens New York office, 1892, *15844*
photogravures of London National Gallery collection, 1899, *17639*
Berliner Secession
annual exhibitions
 1901, *13257*
 1903, *13588*
building, begun 1903, *13652*
exhibitions, 1903, *8238*
notes, 1899, *17641*
Secession portfolio, *22280*
winter exhibitions, 1902, *13372*
BERLIOZ, Hector, *23787, 23807, 23850*
Berlioz, Hector, 1803-1869
Damnation of Faust, *862*
life in Paris in 1830's, *23988*
monuments, unveiling of monument by Lenoir, 1890, *26114*
notes, 1880, *839*
Bern, Karl Stauffer See: **Stauffer Bern, Karl**
Bern (Switzerland)
history and description, *20792*
Bern (Switzerland). Cathedral See: **Bern (Switzerland). Munster**
Bern (Switzerland). Eidgenössische Zentralbibliothek
established, 1895, *16753*
Bern (Switzerland). Munster
choir stalls, *25647*
Bern (Switzerland). Swiss National Library See: **Bern (Switzerland). Eidgenössische Zentralbibliothek**
Bernadotte, Désirée Clary See: **Désirée**, *queen, consort of Charles XIV John, king of Sweden and Norway*
Bernal, Ralph, d.1854
collection, sale, 1855, *18852*
BERNARD, *19057*
Bernard, A.
illustrations
 designs for Christmas embroideries, *1230*
 embroidery design, *1162*
Bernard, Eustache, 1836-1904
obituary, *13910*
Bernard, George, 1807?-1890
obituary, *26103*
Bernardus Pictor See: **Bernhard Maler**
Berne Bellecour, Etienne Prosper, 1838-1910, *751*
art importations to U.S., 1879, *734*
biographical note, *16510*
exhibitions
 Cercle Central des Lettres et des Arts, 1880, *9389*
 Cercle de l'Union Artistique, 1880, *9309*
 Cercle des Mirlitons, 1878, *8992*
 Chicago, 1902, *13399*
 Paris, 1887, palettes of artists, *2490*
 Paris Exposition, 1878, *21662*
 Paris Exposition Nationale, 1883, *1657*
 Salon, 1877, *8872*
 Salon, 1879, *9176*
 Salon, 1882, *1352*
illustrations, *Embarcation*, *1348*

paintings in Astor collection, *1368*
sales and prices, 1883, *1651*
Short rest, *7719*
studio in Paris, *8400*
Berneker, Louis Frederick, 1876-1937
exhibitions, Society of Western Artists, 1903, *13698*
illustrations, *1840, 13542*
Bernhard Maler, fl.1460-1483
woodcut borders, *10391*
Bernhardt, Carl Lewis, fl.1905
bookplate designs, *13946*
BERNHARDT, Sarah, 1844-1923, *23789*
Bernhardt, Sarah, 1844-1923
anecdotes, *697*
appearance as Virgin Mary cancelled, 1890, *25867*
as artist, *694*
as Lady Macbeth, *25158*
exhibitions
 1880, *1023*
 New York, 1880, *235*
 Salon, 1880, *21870*
 Salon, 1881, *22029*
feet, Sarony's admiration, *4609*
glorification in Paris, 1896, *17191*
illustrations
 sculptures, *1036*
 Young girl and Death, *999*
Legion of Honor cross proposed, 1894, *16639*
notes
 1881, *1043*
 1901, *7507*
Ophelia, *4534*
pen-and-ink drawings, *974*
performance in *Adrienne Lecouvreur*, *1023*
portraits
 Gérôme bust, *17309*
 portrait by Bastien-Lepage, *23020*
 portrait plaque by C. Piton, *991*
posters for performances at Théatre de la Renaissance by Alphonse Mucha, *12867*
Primavera, in Louisville's Southern Exposition, 1883, *24760*
sculpting on stage, *1001*
sculpture commission, Monaco, 1878, *21651*
Bernier, Camille, 1823-1903
illustrations, *Lake*, *1365*
Berninghaus, Oscar Edmund, 1874-1952
exhibitions, Society of Western Artists, 1906, *14038*
illustrations, *Santa Fe*, *13958*
Bernini, Giovanni Lorenzo, 1598-1680
tri-centenary celebration, December 1898, *12840*
Bernstamm, Léopold Bernard, 1859-1914
monument representing Franco-Russian sympathies commissioned, 1892, *3924*
Bernstrom, Victor, 1845-1907
obituary, *14320*
Berrian, William, 1787-1862
library, sale, 1895, *16834, 16866*
Berrier, F. E. See: **Berier, F. E.**
Berry, Patrick Vincent, 1843-1913
Foothills of the Blue Mountains, in Walker collection, Minneapolis, *12924*
Bert, J., 19th century
illustrations, *On the seacoast*, *3651*
Bertall, 1820-1883
on Impressionism, excerpt from *L'Artiste*, *12*
Bertault, Paul Seguin See: **Seguin Bertault, Paul**
Bertaux, Hélène Hébert, 1825-1909
offers herself for election to Académie des Beaux-Arts, 1892, *4094*
Bertaux, Léon, Mme See: **Bertaux, Hélène Hébert**
Berteaux, Hippolyte Dominique, 1843-1928
exhibitions, Salon, 1881, *22017*
Berthaud, M., fl.1860's-1890's
illustrations, portrait photograph of Henri Regnault, *21925*

French view of a French studio in the present day (after H. Valentin), *20852*
grand staircase of Burgos Cathedral (after D. Roberts), *20822*
Return of the herds (after K. Girardet), *20837*
sacristy of the cathedral of Notre Dame, Paris, *20800*
Best, Jean See: **Best, Adolphe Jean**
BEST, Saint-George, *23051, 23716, 23734, 23762, 23777, 23802, 23861, 23881, 23913, 23939, 23964, 23983, 24152, 24243*
BETA, *1737, 1852, 1884*
Bethany Presbyterian Church See: **Philadelphia (Pennsylvania). Bethany Presbyterian Church**
Bethnal Green Museum See: **London (England). Bethnal Green Museum**

Béthune, Gaston, 1857-1897
illustrations, *At the matinée*, *5582*
Betsellère, Emile, 1847-1880
obituary, *134*
Bettannier, Albert, fl.1881-1891
illustrations, *In Lorraine*, *1997*
BETTS, Beverley Robinson, *20404, 20425*
Betts, Edwin Daniel, jr., 1879-1915
illustrations, paintings, *13618*
Betts, Edwin Daniel, sr., 1847-1915
portrait of Miss Alliger, 1884, *24959*
Betts, Grace May, b.1885
exhibitions, Chicago Art Institute, 1903, *13673*
Betts, Harold Harrington, 1881-1915
exhibitions, Chicago Art Institute, 1903, *13673*
Betts, Louis, 1873-1961
exhibitions
Chicago Art Institute, 1900, *13137*
Chicago Art Institute, 1903, *13673*
prize, Philadelphia Academy of Fine Arts, 1903, *13618*
BEULAH, *22799*
Beurdeley, Alfred, 1847-1919
collection
sale, 1895, *16738, 16781*
sale, 1905, *13888*
Beurdeley, *pere*
collection, sale, 1883, *14894*
Beurnonville, Etienne Martin, *baron* de, 1779-1876
collection, *14886*
sale, 1883, *14901*
Beuron (Benedictine abbey)
art, *10150*
Beury, Gaston, b.1859
portraits, photograph, *22580*
Beveridge, David
library, *15518*
Beveridge, Kuhne, b.1877
article by G. Atherton, 1893, *26969*
bust of Cleveland, *26800*
life in New York, 1897, *10519*
notes, 1901, *13281*
statue of sprinter for Chicago World's Fair, 1892, *26779*
subject of article in *Lippincott's Magazine* by Gertrude Atherton, 1893, *26934*
whereabouts, 1892, New York, *26839*
Bevier, Alida, fl.1883-1886
exhibitions
American Art Galleries, 1885, *1921*
National Academy of Design, 1886, *2352*
Bewer, Clemens, 1820-1884
Death of Louis IX of France, A. D. 1270, *21317*
Bewick, John, 1760-1795
children's book illustrations, *9730*
wood engravings, *9525*
Bewick, Thomas, 1753-1828
Birds, Ruskin's notes, *10344, 10371*
Dobson's *Thomas Bewick and his Pupils*, *11114*
drawings to be given to British Museum, 1881, *21890*
exhibitions, Fine Art Society, 1881, *21890*
illustrations
illustrations from *Young Lady's Book*, *87*

wood engraving by John Hall, *106*
illustrator, *12191*
sales and prices, 1893, *16151*
wood engraving, *9525, 21666, 21712, 21742*
woodcuts, *14643*
Beyle, Pierre Marie, 1838-1902
exhibitions
Cercle Artistique, 1880, *9325*
Prize Fund Exhibition, 1886, *25304*
illustrations
Algerian woman, *2137*
Breton peasant, *4026*
figure picture, *2147*
plaque or panel design, *1308*
residence in America, *13603*
Beyschlag, Robert, 1838-1903
illustrations, *At church*, *1637*
Psyche, *8527*
Bianchini, Vincenzo, fl.1517-1563
subject of fiction, *19351, 19375, 19398*
Biard, François Auguste, 1798?-1882
Slave ship on the African coast, controversy, *19005*
whereabouts, 1860, returns to France after travel in North and South America, *24325*
Bible
aestheticism, *10936*
"Beza" Bible, *17628*
Biblia Pauperum, collectors and collecting, *15944*
bibliography, collection in Lenox Gallery, *9102, 9121*
collection exhibited at World's Columbian Exposition, Chicago, 1893, *16195*
collectors and collecting, *15131, 16271*
Copinger collection of Latin Bibles, *16439*
Douay Bible, *7263*
Eliot's Indian Bible, *16000*
extra-illustrated Bible of Augustin Daly, *16201*
first Welsh Bible, *16556*
illustrated Holy Bible to be published, 1898, *12741*
Kneeland Bible, *16746*
Lyons Heptateuch manuscript, *16935*
Mazarin Bible, *7761*
misprints, *17011*
New Testament manuscript know as *N*, *17065*
Old Testament, revision, 1885, *11180*
Polychrome Bible, *17176*
sales and prices
1894, Caxton Memorial Bible, *16491*
1895, Aitken Bible, *16734*
Saur's *German Bible*, *16710*
Stonewall Jackson's, *15748*
world's smallest bible, *17012*
Bibliographical Society, London See: **London (England). Bibliographical Society**
Bibliothèque national, Paris See: **Paris (France). Bibliothèque national**
Bibliothèque royale de Belgique See: **Brussels (Belgium). Bibliothèque royale de Belgique**
Bichard, Adolphe Alphonse Géry, b.1841
illustrations
Alexandre Dumas the Elder (after Chapu), *1623*
pen portrait of G. F. Watts, *3209*
Bickford, Nelson Norris, 1846-1943
exhibitions, American Art Galleries, 1882, *1297*
studies of animals, 1883, *24742*
Bickles, George Alexander, fl.1887
admitted to Art Students' League of New York, in spite of skin color, 1887, *566*
Bickmore, Albert Smith, 1839-1914
lectures at Museum of Natural History, 1892, *15910*
Bicknell, Albion Harris, 1837-1915
Battle of Lexington
shown in Boston, 1887, *611*
to be shown in Milwaukee, 1884, *25032*
commission to paint Senator Morrill, 1883, *24959*
drawings in printers' ink on copperplate, *475*

etchings, *1131, 2580*
 book of etchings published 1887, *614*
 to be reproduced in *L'Art*, 1887, *518*
exhibitions
 Boston Art Club, 1880, *878*
 Malden, 1896, studio show, *23030*
 New York, 1890, *25822*
illustrations, *Scene on the Merrimac River*, *481*
Bicknell, Evelyn Montague, 1857-1936
exhibitions
 Philadelphia Water Color Club, 1901, *13215*
 Worcester Art Museum, 1902, *13483*
illustrations
 Deserted, *22610*
 Trial trip of the volunteer, *4824*
marine painter, *22536*
marine paintings, 1892, *26839*
models, favorite model, *22519*
portraits, photograph, *22539*
sales and prices, 1889, *14961*
whereabouts
 1893, summer on coast of Maine, *22491*
 1896, summer sketching in Maine and Massachusetts, *23056*
Bicknell, Frank Alfred, 1866-1943
 Daybreak, *15170*
exhibitions
 National Academy of Design, 1896, *Temple - Yokohama*, *22996*
 New York, 1905, *13843*
 Salmagundi Club, 1889, *25692*
notes, 1896, *22988, 23008*
Bicknell, William Henry Warren, b.1860
 book plate (etched by Garratt), *16480*
exhibitions
 Boston Art Students' Association, 1884, *10898*
 Salon, 1895, medal, *22765*
illustrations, sketch, *10882*
student work, Boston, 1882, *10862*
bicycle racing
 France, three-day race in Paris, 1898, *24155*
bicycles and tricycles
 as an aid to art, *12486*
 design for bicycle attachment for artists' supplies
 competition, 1896, *5695, 5829*
 wins prize, 1897, *6210*
 how to draw a bicycle, *5770*
 in art, *5698*
 notes, 1895, *16647*
Bida, Alexander, 1823-1895
 exhibitions, Paris, 1883, *1660*
 obituary, *16650*
 sales and prices, 1895, studio to be sold, *16726*
Biedenweg & Flanagan Co., Chicago See: **Flanagan & Biedenweg Co., Decorator in Stained-Glass, Chicago**
Biel, Antonie, 1830-1880
 obituary, *134*
Bienaimé, Angelo, fl.1829-1850
 illustrations
 Innocence, *17934*
 statue of the wood-nymph, *17923*
 Wood nymph, reception in Vermont, *18002*
Biennoury, Victor François Eloi, 1823-1893
 exhibitions, Salon, 1849, *Lady Macbeth and the physicians*, *14544*
Bienville, Horace See: **Bieuville, Horace**
BIER, Robert, *7415*
Bier, Robert, d.1896
 American china painter, *6030*
 studio work, 1896, *6081*
BIERSTADT, Albert, *23577*
Bierstadt, Albert, 1830-1902
 anecdote, *6092*
 California sunshine, and *Early settlers* in Walker collection, Minneapolis, *12924*
 chairman of Grant Monument Association, 1892, *26639*

collection, sale, Boston, 1892, *26665*
criticism, *489*
donates painting to Cleveland Museum, 1893, *16379*
elected to National Academy of Design, 1858, *19859*
Emerald pool, *10652, 10659*
exhibitions
 American Art Union, 1883, *10913*
 American Exhibition, London, 1887, *25464*
 Louisville's Southern Exposition, 1883, *24760*
 Mutual Art Association, 1865, *23327*
 National Academy of Design, 1858, *19835*
 National Academy of Design, 1859, *20030, 20048*
 National Academy of Design, 1860, *20208*
 National Academy of Design, 1861, *20354*
 National Academy of Design, 1875, prepares, *8424*
 National Academy of Design, 1877, *8830*
 National Academy of Design, 1880, *126*
 National Academy of Design, 1881, *1129*
 National Academy of Design, 1888, *2695*
 National Academy of Design, 1892, *Farallon Island*, *4143*
 New Bedford, 1858, *19819, 19891*
 New York, 1898, *6527*
 Royal Academy, 1878, *9023*
 Union League Club of New York, 1889, *25565*
forgeries of paintings, *10943*
Halt in the Yosemite valley, *8550*
home, country house built by J. W. Mould, *8596*
Hudson River School, *11472*
Landing of Columbus
 description, 1892, *26842*
 to be painted for Chicago's Columbian Exposition, 1891, *15661*
landscapes in railway waiting rooms, *1801*
Last of the buffaloes, *15755*
letter from the Rocky Mountains, 1859, *20093*
notes
 1860, *18473, 20237*
 1870, *23601*
 1883, *24674*
obituary, *13379*
painting in Layton Art Gallery, Milwaukee, *12813*
painting in W. Richmond collection, *15585*
paintings for the Columbian Exposition of 1893, *26507*
paintings in Adams collection, *1315*
paintings in Stewart collection, *753, 2393, 10768*
paintings in White House, Congressional bill to purchase, 1893, *4560*
picture in Clarke collection, *24943*
pictures offered to United States government, 1892, *26649*
quote, on his art and business activity, *5257*
Rocky Mountain goat, shown at Century Club preview, 1884, *25064*
Rocky Mountain landscape, *20179*
Rocky Mountain sheep, *10981*
Rocky mountains, *23308*
role in Congress' tariff bill, 1883, *14896*
sales and prices
 1891, *Last of the buffalo*, *26424*
 1895, sheriff's auction, *11616*
 1898, *6614*
Sunset in California
 inspires poem by Rexford, *23583*
 reproduced by Prang in chromo, *23529, 23560, 23568, 23604*
Wetterhorn, *19667*
whereabouts
 1858, trip to Rocky Mountains, *19955*
 1859, return from Rocky Mountains, *20114*
 1859, sketching tour in Rockies, *20033*
 1884, visits to Yellowstone National Park, *25058*
 1892, Bahamas to research picture *Columbus' first landing*, *26547*
Bierstadt Brothers, New Bedford
 publishes photographic views of White Mountains, 1860, *20320*
Bierstadt, Edward Hale, d.1896
 library, sale, 1897, *17323, 17341*

Bird, May See: Mott Smith, May Bird
bird song, *651*
birds
 Abbot expeditions for Smithsonian ornithological collection, 1897, *17218*
 Africa, African water fowl, *20773*
 Australia, skeleton of unknown bird found by Stirling, 1897, *17360*
 England, *21990, 22019, 22028*
 Goss collection, *15612*
 Japan, game-birds, *22709*
 Lilford collection, *17105*
 moa skeleton discovered, 1895, *16823*
 New Zealand, Moa and Moho, *21036*
 painting birds on china, *5841*
 paintings by H. S. Marks, *21948*
 poetry, *19130*
 relics of extinct Madagascar birds, *16702*
 sales and prices, 1895, great auk skins, *16814*
 saving birds from milliners, *6217*
 Scott collection acquired by Harvard, 1895, *16800*
 Seebohm collection, *16968*
 Smith collection, *17053*
 technique for painting birds on china, *6443*
 Upham collection, *17027*
 viewed through field glasses, *10122*
Birge, M. H. & Sons Co., Buffalo
 Illustrations in Color of the Interior Decoration of a City House, review, *2756*
Birmingham (Alabama)
 Art League, 1894, *4968*
Birmingham (England)
 art congress, 1890, *26052, 26117, 26130, 26135*
 exhibitions, 1890, *26064*
 new art gallery opens, 1881, *21898*
 town council purchase of watercolors, 1890, *26117*
 Town Hall
 decoration, *26628*
 paintings of history of Birmingham produced by School of Art, 1892, *26801*
Birmingham (England). Birmingham Guild of Handicraft
 Quest, *22441*
Birmingham (England). Camm Brothers See: Camm Brothers, firm
Birmingham (England). Museum and Art Gallery
 acquisitions
 1891, *26441*
 1892, Rossetti water-color, *26476*
 catalogue of collection, 1892, *26641*
 collection
 Italian sculpture, *10230*
 pictures, *26412*
 exhibitions
 1891, Pre-Raphaelite loan collection, *26422*
 1892, English animal painters, *26771*
Birmingham (England). Royal Birmingham Society of Artists
 exhibitions
 1884, autumn exhibition, *10073*
 1884, spring, *9999*
 1885, autumn, *10223*
 1885, spring exhibition, *10161*
 1886, *10363*
 1886, spring exhibition, *10302*
 1887, *10502*
 1887, spring exhibition, *10452*
Birney, William Verplanck, 1858-1909
 Deserted, *22503*
 elected associate of National Academy of Design, 1900, *13046*
 exhibitions
 Internationale Kunstausstellung, Munich, 1883, *24693*
 National Academy of Design, 1884, *25187*
 National Academy of Design, 1896, *11909*
 National Academy of Design, 1898, *Comrades, 6815*
 New York, 1899, *17607*
 Prize Fund Exhibition, 1886, *25304*

 Prize Fund Exhibition, 1887, *562*
 illustrations, *China decorators, 22531*
 painter from Ohio, *16332*
 portraits, photograph, *22539*
 Searching for the will, *22741*
 story-teller on canvas, *22530*
 studio reception, New York, 1892, *26547*
 summer home and studio, *22571*
Biron, *marquis de* See: Gontaut Biron, Guillaume Marie Etienne de, *marquis de* Saint-Blancard
Birren, Joseph P., 1865-1933
 comments on own work, *22546*
 exhibitions, Chicago Society of Artists, 1895, *11483*
 illustrations
 figure drawing, *3706*
 Juice of the pump, *22590*
 Up-to-date girl, *12643*
 Young husband, *11599*
 magazine illustration, 1894, *22517*
 Potter's daughter, in permanent exhibition of Chicago's Palette and Chisel Club, 1905, *14036*
 summer home and studio, *22571*
birthdays
 children's party decorations, 1897, *23204*
Bisbing, Henry Singlewood, 1849-1933
 artist in Paris, 1898, *12266*
 elected to French Legion of Honor, *13379*
 exhibitions
 Carnegie Galleries, 1900, *13130*
 Chicago Art Institute, 1895, *11673*
 Chicago Art Institute, 1896, *11894*
 Chicago Inter-State Industrial Exposition, 1889, *3056*
 Paris, 1902, *13372*
 Pennsylvania Academy of the Fine Arts, 1880, *142*
 Prize Fund Exhibition, 1885, *Morning in Holland, 25278*
 St. Louis Exposition, 1894, *5036*
 Salon, 1886, picture of cows and oxen, *2206*
 Salon, 1889, *2938, 2985*
 Salon, 1896, *11825*
 Vienna, 1902, *13421*
 illustrations
 Cattle, 13101
 In the suburbs (drawing), *2432*
 picture of Dutch farm-servant at Reichard's, New York, 1884, *25195*
Bischoff, Franz A., 1864-1929
 American china painter, *5844*
 exhibitions
 Chicago, 1894, *5070, 11375*
 Chicago, 1896, gold medal, *11882*
 Chicago, 1898, china, *12195*
 New York, 1898, china painting, *6638*
 method of china painting, *5352*
 quote, on china painting technique, 1895, *5315*
 teacher of china painting at Miller's Art School, 1895, *5213*
 technique for china painting, 1901, *7705*
Bischoff, Friedrich, 1819-1873
 First snow, 19887
 Lost ball, 19853
Biscoe, W. H.
 collection, sale, 1896, *17160*
Bishop, Heber Reginald, 1840-1902
 collection
 catalogue of jades in preparation, 1891, *15560*
 objects of oriental art contributed to loan exhibition at National Academy of Design, 1893, *16304*
 Oriental bronzes exhibited at National Academy of Design, 1893, *4650*
 pre-historic jades, *8003*
 sale, 1906, *14073*
Bishop, Thomas, fl.1860-1881
 exhibitions, Pennsylvania Academy of the Fine Arts, 1880, *142*
BISHOP, W. H., *73, 74, 120, 136*
Biskra (Algeria)
 description, *24487*

Bismarck, Otto, *Fürst* von, 1815-1898
 illustrations by A. von Menzel, *9650*
 monuments, Emperor William's support, *25877*
 portraits, portrait by Lenbach, *15420*
Bispham, David, 1857-1921
 notes, 1897, *23225*
Bispham, Henry Collins, 1841-1882
 compared to Carleton Wiggins, *15478*
 obituary, *1486, 24421*
Bisschop, Christoffel, 1828-1904
 exhibitions, New York, 1894, *16505*
Bissell, Edgar Julien, b.1856
 exhibitions, Boston Museum of Fine Arts, 1880, *225*
 St. Louis artist, 1887, *540*
 whereabouts, 1884, Paris, *25046*
Bissell, George Edwin, 1839-1920
 exhibitions, Prize Fund Exhibition, 1887, *2456*
 illustrations
 Hospitality, 13263
 sculpture for Louisiana Purchase Exposition, 1904, *13685*
 monument to Scottish-American soldiers for Edinburgh, 1893, *26984*
 Navy on Dewey arch, *7096*
 notes
 1893, *16418*
 1896, *23008*
 statue of Chancellor Kent commissioned, 1894, *27004*
 statue of Colonel Abraham de Peyster, *16556*
 statue of John Watts, *26713*
 cast for Trinity churchyard, 1892, *15950*
 set up at Trinity Church, 1892, *16038*
 statue of President Arthur, *7074*
 cast by Henry Bonnard Bronze Company, 1899, *12844*
Bissen, Herman Vilhelm, 1798-1868
 finishes Thorvaldsen's sculptures, *14591*
Bisson, Alexandre, 1848-1912
 plays produced in America, *10544*
Bisson, Edouard, b.1856
 illustrations
 Butterfly time, 23033
 Cigale, 23148
 Prisoner, 23185
BITTER, Karl, 1867-1915, *13682*
Bitter, Karl, 1867-1915
 Boy stealing geese, prize medal at Art Club of Philadelphia, 1903, *13688*
 Combat on Dewey arch, *7096*
 commissioned to decorate Pennsylvania Railroad depot, Philadelphia, 1895, *22765*
 decoration of Chicago World's Fair Administration Building, 1892, *4171*
 decorative work commissioned for Metropolitan Museum, *13177*
 doors for Trinity Church, New York, *4603, 5064*
 elected to Society of American Artists, 1901, *13240*
 exhibitions
 Architectural League of New York, 1894, *4711*
 Architectural League of New York, 1896, *5699*
 Architectural League of New York, 1897, *10535*
 Architectural League of New York, 1897, *Atlantes* and studio, *23213*
 Architectural League of New York, 1897, residence design, *6237*
 National Sculpture Society, 1895, relief for Philadelphia railroad station, *5373*
 National Sculpture Society, 1898, *12733*
 Pennsylvania Academy of the Fine Arts, 1899, *17526*
 fountain, *17639*
 illustrations
 Portrait of Mrs. C.R.C. and child, 14080
 sculpture for Pan-American Exposition, 1901, *13263*
 statue of Dr. William Pepper, *13556, 13985*
 Thanatos, 13549, 13785
 monument to General Franz Sigel, commission award, 1904, *13793*

replaces Ruckstull as chief of sculpture department, Louisiana Purchase Exposition, 1904, *13543*
 sculptural decorations of Chicago World's Fair buildings, 1893, *4433*
 sculpture, *13728*
 sculpture for Louisiana Purchase Exposition, 1904, *13685*
 sculptures at Chicago World's Fair, 1892, *26821*
 sculptures at Paris Exposition, 1900, *13074*
 statue of William Pepper, *12974*
 statues for Columbian Exposition, assisted by Emil H. Wuertz, *12792*
Bittinger, Charles, 1879-1970
 exhibitions, Salon, 1906, *14116*
Bixbee, William Johnson, 1850-1921
 exhibitions, Boston Art Club, 1907, *14252*
BIXBY, Allan C., *13410, 13668*
Bizzarri, Luciano, 1830-1905
 statuette of Queen Margaret of Italy, *21957*
BJERREGAARD, Carl Henrik Andreas, *22647, 23103*
Blaas, Eugen von, 1843-1931
 Miser, 22034
 Peasant girl, on view, New York, 1892, *16006*
Blaas, Karl von, 1815-1894
 obituary, *16553*
BLACK, Alexander, *12484, 22489, 22512, 22537, 22553, 22619, 22654, 22717, 22751*
Black, Alexander, 1859-1940
 lecture on photography, 1892, *26871*
 lecture on photography in its relation to art, 1893, *26907*
Black, Alexander G.
 collection, Oriental porcelain sale, 1894, *4832*
Black and White Club, New York See: **New York. Black and White Club**
Black, Andrew, 1850-1916
 illustrations
 Broomielaw, 9478
 Broomielaw, Glasgow, 21973
Black artists See: **artists, Negro**
Black, J. D., Mrs. See: **Potter, Margaret Horton**
BLACK, Ladbroke Lionel Day, 1877-1940, *23909, 23951, 23986, 24079*
Black, Olive Parker, 1868-1948
 illustrations, *Near Egremont, 13202*
 landscape drawing, *22684*
Black, Starr & Frost, inc.
 Bryant vase, *8436*
Black, William, 1841-1898
 Macleod of Dare, illustration of book, *21654*
 notes, 1896, *22931*
Blackall, Clarence Howard, 1857-1941
 illustrations, Belem doorway of a church, *3544*
BLACKBURN, E. Vernon, *10160*
BLACKBURN, Henry, 1830-1897, *21610, 21660, 25073*
Blackburn, Henry, 1830-1897
 arranges exhibitions of English artists in U.S., 1884, *25061*
 discussion of process of reproduction for illustration, 1895, *5489*
 editor, *English Art in 1884, 25221*
 lectures
 at Devizes School of Art, 1889, *17892*
 at National Academy of Design, 1884, *10947*
 in Boston on modern art, 1884, *1751*
 on art, 1883, *24475*
 on English watercolors, Boston, 1885, *2089*
 obituary, *17304*
 proposes English watercolor exhibition, Boston, 1885, *2035*
 sponsors exhibition of English water-colors, 1886, *2265*
 sponsors shows of English water-color artists in U.S., 1886, *2303*
 whereabouts, 1884, New York, *24998*
Blackburn, Joseph, ca.1700-ca.1763
 exhibitions, Union League Club of New York, 1895, *5261*
Blackburn, Josephine Eckler, b.1873
 illustrations, *Alameda marsh, 22125*
BLACKIE, John Stuart, 1809-1895, *19907*

Blackie, John Stuart, 1809-1895
 library
 bequeathed to Edinburgh University,1895, *16733*
 sale, 1896, *16935*
 On Beauty, review and excerpt, *19810*
 quote
 on modernization, *19823*
 on piety in art, *19842*
 on profuseness, *19971*
Blacklock, Thomas Bromley, 1863-1903
 obituary, *13701*
Blackman, Carrie Horton, b.1856
 illustrations
 Portrait of Horton Blackman, *11582*
 study from life, *13958*
Blackman, Walter, 1847-1928
 exhibitions
 American Art Galleries, 1881, *9588*
 American Art Galleries, 1882, *1268*
 American Art Galleries, 1883, *24663*
 American Art Galleries, 1884, *24988*
 Boston Mechanic Association, 1881, *1236*
 Prize Fund Exhibition, 1886, *25304*
 Salon, 1880, *9325*
 Salon, 1883, *24521*
 Ideal head, in Seccomb collection, *15647*
 member of Sketch-Box Club, Paris, 1883, *24640*
Blackmar, Ellen See: **Maxwell, Ellen Blackmar**
BLACKMORE, Arthur Edward, 1854-1921, *6910, 6932, 6961, 7018, 7049*
Blackmore, Arthur Edward, 1854-1921
 illustrations
 ornaments, *6773*
 Pelham Bay, *22569*
 Salmagundi mug, *13879*
 piano designer, *6767*
Blackmore, Richard Doddridge, 1825-1900
 bibliography, *16911*
 Lorna Doone, review, *9716*
blacksmiths
 history, *18241*
Blackstone, Harriet, 1864-1939, *6649*
Blackstone, Sarah E., fl.1898-1900
 illustrations
 Flower girl, *7318*
 Returning from market, *6642*
BLACKWELL, Henry, *4863, 5292*
Blackwell, Henry, 1851-1928
 bookbinder, *4899*
 collection
 American bookplates, *4791*
 bookplates described and illustrated, *5163*
 bookplates exhibited at Brentano's, 1895, *5331*
 illustrations of bookplates, *4826*
 library, *16705*
 review of C. D. Allen's *American Book-Plates*, *5361*
Blaeser, Gustav See: **Bläser, Gustav**
BLAIKIE, J. Arthur, *9802, 10019, 10094, 10165, 10330*
Blaine, E. M., fl.1901
 illustrations, *In sunny May* (photograph), *13285, 13894*
Blair, G. H., fl.1886-1887
 illustrations
 decorative initial, *582*
 headpiece, *525*
 headpiece and tailpiece, *526, 527*
 tailpiece, *496*
Blair, *Mrs.*, fl.1883
 illustrations, *Bouquet of flowers*, *20707*
Blaisdell, Mary H. Starr See: **Starr, Mary H.**
BLAISDELL, Mercy, *22622*
Blake, Abby See: **Blodgett, Abby Blake**
Blake, Anna Bowman See: **Dodd, Anna Bowman Blake**
Blake, Anne Dehon, fl.1897-1919
 exhibitions, Boston Art Students' Association, 1884, *10898*
BLAKE, Euphemia Vale, 1817-1904, *19963, 20056, 20190, 20217,*

20232, 20243, 20255, 20267, 20325, 20337, 20349, 20360, 20373, 20382
Blake, Jennie Cole
 medium, *20724*
Blake, Katharine Jex, 1860-1951
 translation of Pliny's *Historia Naturalis*, review, *6149*
Blake, William, 1757-1827, *17649*
 anecdote, *17027*
 as artist-writer, *10806*
 bibliography, 1891, *15549*
 Ellis and Yates' *Poetic books of William Blake*, publication, 1891, *15642*
 exhibitions
 Boston Museum of Fine Arts, 1880, *149, 917*
 Boston Museum of Fine Arts, 1891, *3574, 15517, 26266*
 Century Club, 1893, *26894*
 New York, 1892, *3957, 26535*
 New York, 1892, drawings and sketches, *26572*
 illustrations, *Queen of evil*, *20600*
 mapping of the human body, *4025*
 monuments, memorial tablet erected at Lambeth, 1899, *7125*
 relationship with wife, *22045*
 sales and prices
 1890, drawings, Boston, *15198*
 1892, *15808, 15897*
 1903, *8306, 13600*
 sayings, *9556, 9587, 9627, 9703*
BLAKE, William Phipps, *176, 273*
Blakelock, Ralph Albert, 1847-1919
 career, *15430*
 Circle dance, *25018*
 committed to insane asylum, 1898, *17423*
 exhibitions
 American Watercolor Society, 1880, *827*
 Chicago World's Fair, 1893, *4764*
 Kohn Gallery, 1890, *15428*
 National Academy of Design, 1880, *889, 9324*
 National Academy of Design, 1886, *2188*
 New York, 1893, *16277*
 New York, 1904, *13808*
 New York, 190l, *13158*
 Prize Fund Exhibition, 1885, *25278*
 Prize Fund Exhibition, 1886, *25304*
 Prize Fund Exhibition, 1889, *2960*
 Society of American Artists, 1880, *844*
 Society of American Artists, 1884, *1802, 11003*
 Union League Club of New York, 1890, *26155*
 Union League Club of New York, 1891, *26224*
 illustrations
 Indian girl, Uintah tribe, *14282*
 Landscape, *13482, 13726*
 Moonlight, *11873*
 On the river bank, *13531*
 Indian girl, in Clarke collection, *24943*
 landscape in American Art Galleries, 1884, *1899*
 mania, 1891, *15591*
 pictures in Evans collection, *15079*
 relief fund initiated by Lotos Club, 1903, *13594*
 work, *13356*
 works in Robert Graves collection, *2388*
 works recommended to collectors, 1889, *14941*
BLAKELY, Edward T., *21909*
Blakeslee Galleries See: **New York. Blakeslee Galleries**
Blakeslee, Theron J., d.1914
 See also: **New York, Blakeslee Galleries**
 career, *14978*
 collection
 pictures shown at American Art Galleries, 1899, *17563*
 sale, 1893, *22492*
 sale, 1899, *17547, 17597*
 sale, 1900, *7230, 7263, 13038*
 sale, 1902, *7915, 13418*
 sale, 1904, *13782, 13901*
 new galleries in New York, 1891, *15748*
BLANC, Charles, *11103, 11116*

Blanc, Charles, 1813-1882
 Artistes de mon Temps, description of English artists, *9929*
 obituary, *1298*
 quote, on abuse of color, 1895, *5184*
Blanc, Joseph Paul, 1846-1904
 obituary, *13938*
Blanchard, Auguste Jean Baptiste Marie, 1792-1849
 Christus Remunerator (after A. Scheffer), *14658*
 Dedication to Bacchus (after Alma-Tadema), published, 1893, *16171*
 In the time of Constantine (after Alma-Tadema), *14896*
Blanchard, Auguste Thomas Marie, III, 1819-1898
 Parting kiss (after Alma-Tadema), *10139*
 published, 1884, *10022*
Blanchard, Delia A.
 collection, sale, 1904, *13796*
Blanchard, Edouard Théophile, 1844-1879
 obituary, *47*
 sales and prices, 1880, *9341*
Blanchard, George B., *Mrs.* See: **Blanchard, Delia A.**
Blanchard, Joshua, fl.1729-1742
 architect of Old South Church, *16935*
Blanchard, Pharamond, 1805-1873
 illustrations, *Rocks of Castle Follit*, *21076*
Blanche, Jacques Emile, 1861-1942
 exhibitions
 Carnegie Galleries, 1903, *13675*
 Chicago World's Fair, 1893, *The host*, *4605*
 London, 1906, with Charles Conder, *14142*
 Salon, 1892, *Guest*, *26673*
 Salon, 1892, *L'Hote*, *4013*
BLÄNCKE, Athanase, *20362*
Blaney, Dwight, 1865-1944
 exhibitions
 Boston, 1892, *26851*
 Kansas City Art Club, 1902, *13337*
 illustrations
 decorative initial, *584*
 headpiece, decorative initial, tailpiece, *540*
 High and dry, *622*
Blaney, Henry Robertson, b.1855
 etchings of Boston, *26923*
 etchings of Watling's Island, 1893, *26907*
 notes, 1892, *15811*
Blanke, Esther See: **Blanke, Marie Elsa**
Blanke, Marie Elsa, 1882-1961
 exhibitions
 Chicago Art Institute, 1902, *13370*
 Chicago Art Students' League, 1895, *11469*
 illustrations
 Interior at Delavan, *12719*
 Mrs. Fidler's house, *11705*
blankets
 native American blanket-making, *22669*
Blankinship, James Alexander, 1859-1893
 obituary, *26978*
Blanquart Evrard, Louis Désiré, 1807-1872
 preparation of photographic paper, *14697*
 use of glass plates in photography, *14591*
Blaschka, Leopold, 1822-1895
 glass flowers in Harvard Botanical Museum, *16387*
Bläser, Gustav, 1813-1874
 monument to King Frederick William III, *18971*
Blashfield, Albert Dodd, b.1860
 illustrations, study of a head, *22576*
 magazine illustrations, 1893, *22490*
 models, favorite model, *22519*
 portraits, photograph, *22502*
 summer home and studio, *22571*
Blashfield, Edwin Howland, 1848-1936
 advice on arrangement of rooms, *2773*
 advice to Gotham Art Students, *1938*
 currency design, *11661*
 decorative work, *1907*
 design for Christmas card competition, 1884, *25206*

drawings and illustrations, *22498*
Emperor Commodus as Hercules leaving the Amphitheater, at American Art Gallery, 1880, *825*
exhibitions
 American Art Galleries, 1882, *9718*
 American Watercolor Society, 1888, *2641*
 Architectural League of New York, 1888, *25564*
 Architectural League of New York, 1897, *10535*
 Architectural League of New York, 1897, chalk studies for Library of Congress dome, *23213*
 Architecural League of New York, 1897, Library of Congress decorations, *6237*
 Boston Mechanic Association, 1881, *Deliverance*, *1236*
 Boston Museum of Fine Arts, 1885, *1983*
 Brooklyn Art Association, 1879, *679*, *9167*
 Chicago Inter-State Industrial Exposition, 1889, *3056*
 Cincinnati Art Museum, 1900, *13067*
 National Academy of Design, 1882, *1330*, *9646*
 National Academy of Design, 1883, *1552*
 National Academy of Design, 1886, *2352*, *10754*, *25370*
 National Academy of Design, 1891, *26313*
 National Academy of Design, 1892, *26583*
 New York, 1879, *9099*
 New York, 1884, pastels, *1769*
 New York, 1894, *4906*
 Paris Exposition, 1889, *Inspiration*, *25724*
 Pennsylvania Academy of the Fine Arts, 1882, *1450*
 Philadelphia Society of Artists, 1880, *246*, *1025*
 Philadelphia Society of Artists, 1883, *1490*
 Prize Fund Exhibition, 1887, *562*, *2456*
 Royal Academy, 1886, *2245*
 Salon, 1878, prepares, *8978*
 Salon, 1879, prepares, *9122*
 Salon, 1880, *913*, *9325*
 Society of American Artists, 1882, *1327*
 Society of American Artists, 1883, *1551*
 Society of American Artists, 1887, *2452*
 Society of American Artists, 1892, *Angel at the gates of paradise*, *26660*
 Society of Painters in Pastel, 1884, *25089*
 Union League Club of New York, 1887, *10833*
illustrations
 design for the seal of the Architectural League of New York, *2849*
 Duo, *1504*
 mosaic frieze, *20577*
 Tiger-lily, *10781*
illustrations for *Harper's Magazine*, 1893, *22490*
illustrations for *Scribner's Magazine*, *22482*
lecture to Municipal Art Society, Baltimore, 1899, *12993*
member, Society of Mural Painters, *22787*
murals
 ballroom ceiling for Waldorf Astoria Hotel, New York, *6474*
 ceiling paintings for New York house, 1884, *25032*
 collaborative design for New York Appellate Court, 1898, *6613*
 commission for Baltimore courthouse murals, 1901, *13228*, *13208*
 commissioned for Waldorf Hotel, 1897, *10550*
 commissioned to decorate Congressional Library, 1895, *22765*
 completes mural for A. Lewisohn residence, 1902, *8081*
 decorations for Liberal Arts Building, Chicago World's Fair, 1893, *4185*, *4378*
 decorations for Library of Congress, 1896, *6106*
 decorations for Twombly mansion, 1883, *24817*
 for Baltimore courthouse, *13781*
 for Hamilton McKay Twombly house, 1883, *24820*
 for Iowa state capitol, *13953*
 frieze for Baltimore Court House, 1902, *8059*
 mural for Appellate Division of Supreme Court building, New York, *12997*
 mural for Baltimore courthouse completed, 1903, *13549*
 panel paintings for Twombly house, *9941*
Music, in Clarke collection, *24943*

notes
 1883, *24568*
 1885, *11273*
 1901, *13177*
on government protection of art, *12048*
paintings in Clarke collection, *1719, 11207*
remarks on decoration, 1885, *25236*
Roman girl about to be married, offering her dolls to her patron saint, in Montross collection, *25418*
studio reception, 1884, *25079*
teaches in New York City, 1885, *11219*
Tiger-lily, 10782
whereabouts
 1883, Little Compton, R.I, *24728*
 1883, New England for summer, *24607*
 1884, to Europe, *25120*
 1896, Pittsburg, *23056*
work, 1882, *24390*
work, 1883, *24513*
Blashfield, John Marriott
 History and Manufacture of Ancient and Modern Terra Cotta, review, *18926*
Blaskovits, Matilda Lotz See: **Lotz, Matilda**
Blass, d.1892
 obituary, *15959*
Blauvelt, Charles Felix, 1824-1900, *18497*
 Counterfeit bill, 18283
 elected to National Academy of Design, 1858, *19859*
 exhibitions
 National Academy of Design, 1858, *19857*
 National Academy of Design, 1859, *20030, 20048*
 New York, 1859, *19978*
 New York artists' reception, 1858, *19817*
 figure painting, *19955*
 notes, 1860, *18473*
 whereabouts, 1858, Tenth St. studio, *18209*
Blavot, Marie Elisabeth See: **Cavé, Marie Elisabeth Blavot**
Blayn, Fernand, d.1892
 obituary, *26865*
Bleibtreu, Georg, 1828-1892
 obituary, *26819*
 studio, 1857, *19679*
Bleiman, Max
 importing pictures, 1890, *15377*
 New York gallery opened, 1891, *15745*
 whereabouts, 1890, touring America offering pictures for sale, *15294*
BLEISTEIN, George, *12447*
Blenheim palace, England
 architecture, *26193*
 collection
 dispersal, 1885, *10115*
 fire destroys paintings, 1861, *20352*
 Raphael and Van Dyck bought by British government, 1885, *10151*
 sale of Limoges enamels, 1883, *1589, 1628*
 description of estate and art collection, *19015*
Blenner, Carl John See: **Blenner, Carle Joan**
Blenner, Carle Joan, 1864-1952
 Contentment, 22503
 exhibitions
 Louisiana Purchase Exposition, 1904, *13787*
 National Academy of Design, 1899, third Hallgarten prize, *12896*
 New York, 1897, *23240*
 illustrations
 Elise, 22546
 Gretchen, 22588
 Harvest time, 3862
 landscape, *23096*
 Roses, 22789
 painter and illustrator, *22512*
 portraits, photograph, *22559*
 summer studio, 1893, *22491*

Blieck, Paul, 1867-1901
 obituary, *13327*
Bligh, John Stuart, *earl of Darnley* See: **Darnley, John Stuart Bligh, *6th earl of***
Blin, François, 1827-1866
 exhibitions, Salon, 1859, *20077*
Blind, Rudolf, 1846-1889
 World's desire, occasions lawsuit in London, 1892, *26628*
Blinks, Thomas, 1860-1912
 pictures published by Klackner, 1893, *16330*
BLISS, Howard, *12410*
BLISS, Merriam, *12477*
block books
 Along Ipswich River by Arthur W. Dow, *22406*
 earliest printed books by H. van den Bogaert, *407*
Block, Joseph, b.1863
 exhibitions, Chicago World's Fair, 1893, *4651*
Blodgett, Abby Blake, d.1904
 collection
 described, 1888, *17800*
 French pictures, *25469*
Blodgett, William Tilden, 1823-1875
 collection, sale, 1876, *8675*
Blodgett, William Tilden, *Mrs.* See: **Blodgett, Abby Blake**
Bloecker, Charles F., fl.1895
 exhibitions, Chicago Society of Artists, 1895, *11483*
Blois, Chateau de, *20520*
 photographs by D. H. Ranck Co., *22224*
Blois, F. B. de See: **Deblois, François B.**
BLOMFIELD, Reginald Theodore, 1856-1942, *17728*
Blomfield, Reginald Theodore, 1856-1942
 elected associate to Royal Academy of Arts, 1905, *13885*
Blommers, Bernardus Johannes, 1845-1914
 exhibitions, Chicago World's Fair, 1893, *4526*
 illustrations
 Brabant interior, 13632, 14183
 Interior, North Brabant, 13836, 14183
 Simple life, 13709, 13721
 work, *13640*
Blondel, François, 1618-1686
 Porte St. Denis, Paris, 20914
Blondel, Jacob D., 1817-1877
 exhibitions
 New York, 1859, *19978*
 New York artists' reception, 1858, *19784, 19800, 19817*
 studio, 1870, *10595*
Blondell, Jacob See: **Blondel, Jacob D.**
Bloodgood, Morris Seymour, 1845-1920
 Adirondack sketches, 1883, *24829*
 exhibitions
 American Art Association, 1885, *2085*
 Chicago Architectural Club, 1899, *12887*
 whereabouts, 1892, returns from abroad, *26839*
Bloodgood, Robert Fanshame, 1848-1930
 classes in water-color and drawing, New York, 1894, *27014*
 exhibitions
 New York Etching Club, 1893, *22483*
 Salmagundi Club, 1889, *25692*
 sales and prices, 1889, *14961*
 summer studio, 1893, *22491*
 watercolors, 1883, *24502, 24841*
 whereabouts, 1883, Quogue, L.I, *24728*
Bloodgood, Seymour See: **Bloodgood, Morris Seymour**
Bloomer, Hiram Reynolds, 1845-1911
 exhibitions
 Grosvenor Gallery, 1880, *9356*
 Paris Exposition, 1878, *9072*
 San Francisco, 1897, *6453*
 illustrations, *River view, 2749*
Bloomfield, Elizabeth L., fl.1900-1904
 exhibitions, Pennsylvania Academy of the Fine Arts, 1901, *13163*
Bloomfield Moore, Clara Sophia Jessup, 1824-1899
 gifts of pictures by Snyders and R. B. Browning to Pennsylvania Academy, 1882, *14865*

Festival, *11956*
murals for Peoria Public Library, *11947*
statues for Indianapolis Public Library, *26752*
Bockett, F. W.
Some Literary Landmarks for Pilgrims on Wheels, review, *13333*
Böcklin, Arnold, 1827-1901
Andromeda, reproduced in *Pan*, *22408*
anecdote, *16861*
Mermaidens, *26371, 27024*
notes
1891, *15759*
1898, *17393*
quote, *10548*
Saint Paul, *25791*
sales and prices, 1902, *13437*
Secession, *22315*
son Carlo accused of forging his paintings, 1903, *13672*
Böcklin, Carlo, 1870-1934
accused of forgery of father's paintings, 1903, *13672*
Bocourt, Etienne Gabriel, b.1821
illustrations, *Great chimpanzee recently discovered on the coast of Africa*, *20810*
Bocquet, Nicolas See: **Boquet, Nicolas**
Bodarevskii, Nikolai Kornilovich, b.1850
illustrations, *Portrait of Frau Morosoff*, *13759*
Boddington, Henry John, 1811-1865
exhibitions
National Academy of Design, 1853, *18762*
Society of British Artists, 1858, *19898*
Bode, Wilhelm von, 1845-1929
book on Rembrandt, 1896, *5891*
Complete Work of Rembrandt
published, 1894, *16519*
review, *6529, 7316, 7590*
review of volume 3, *7073*
review of volume 6, *7914*
volume 1, *17317*
Geschichte der Deutschen Plastik, review, *25891*
Bodenhausen, Cuno von, b.1852
illustrations, *Heroine of romance*, *1637*
Listening to the fairies, living picture created by actress Effie Shannon, *22563*
Madonnas, *12461*
Nydia, posed by Caroline Miskel, *22522*
Bodfish, William Parker, fl.1887-1893
exhibitions, Salmagundi Club, 1887, *534*
illustrations, *Prussian hostility*, *22490*
models, favorite model, *22519*
portraits, photograph, *22518*
quote, on own work, *22503*
Bodichon, Barbara Leigh Smith, 1827-1891
visit to Boston expected, 1858, *19859*
watercolor drawings brought to United States, *19875*
whereabouts, 1859, travel in Algeria, *20033*
Bodine, Clarence, fl.1901-1919
illustrations, water-color from still life, *13249*
Bodleian Library See: **Oxford (England). Oxford University. Bodleian Library**
Bodley, George Frederick, 1827-1907
portraits, photograph, *22660*
Bodom, Erik, 1829-1879
paintings of Norway scenes, *22715*
Bodtker, Sara, fl.1892
design for official seal of Board of Lady Managers, Chicago World's Fair, 1892, *26615*
Bodwell, Charlotte Elizabeth See: **Morgan, Charlotte Elizabeth Bodwell**
Bodwell, Elizabeth See: **Morgan, Charlotte Elizabeth Bodwell**
body, human
beauty, *11075*
divine human form, *24146*
proportions, *5499*
Boecklin, Arnold See: **Böcklin, Arnold**

Boehm, Henry Richard, 1870-1914
illustrations, *Midwinter sport*, *13405*
Boehm, Joseph Edgar, 1834-1890, *21846*
bronze equestrian statue of the Prince Consort, *25890*
Carlyle and Lord Stratford de Redcliffe as sitters, *26753*
commission for the statue of Lord Reay, *26176*
designer of Jubilee coinage, 1887, *10480*
equestrian statue of Prince of Wales, *21653*
illustrations, statue of Thomas Carlyle, *26060*
interviewed in his London studio, 1885, *11231*
John Bunyan, *8731*
model for Wellington, 1887, *10399*
monument to Princess Alice of Hesse, *9676*
monument to the Prince Imperial, *9510*
notes
1890, *26201*
1891, *26236*
obituary, *26194, 26213*
reminiscences, 1891, *26288*
sculpture, 1886, *10357*
sculpture in studio, 1878, *21576*
statue of Carlyle replicated for Edinburgh monument, 1897, *17241*
statue of Darwin, *26441*
statue of Dean Stanley, *26246*
statue of Earl Sidney, completed by Gilbert, *26392*
statue of Earl Sydney, *26035*
statue of Emperor Frederick, *26185*
statue of Lord Iddesleigh for Palace of Westminster, *25806*
statue of Lord Napier, *26310, 26376*
statue of the Bishop of Durham, *26166*
successor to be Prince Victor Hohenlohe, 1891, *26259*
terra cotta bust of J. M. Whistler, *729*
Thomas Carlyle, *9022*
Victorian sculptor, *10436*
Bogart, A. L., fl.1893
illustrations, plate design, *3947*
Bogart, Andrew B., fl.1889-1890
illustrations
bedroom set designs, *3162*
Poppy design, *3276*
Snowdrop vase design, *3191*
Bogart, Belmont DeForest, Mrs. See: **Humphrey, Maud**
Bogart, Maud Humphrey See: **Humphrey, Maud**
Bogart, Robert M., fl.1850-1857
See also: **Bross & Bogart, firm**
Boger, W. A., fl.1902
illustrations, *Putting on the green* (photograph), *13342*
Bogert, George Hirst, 1864-1944, *5968*
criticized, 1899, *17607*
director of Lotos Club exhibition, 1903, *13703*
elected president, Brooklyn Art Club, 1902, *13421*
exhibitions
Brooklyn, 1890, *15080*
Brooklyn Art Club, 1891, *26258*
Brooklyn Art Club, 1892, *26501*
Carnegie Galleries, 1900, *13130*
Carnegie Galleries, 1907, *14328*
Chicago, 1899, *12893*
National Academy of Design, 1887, *10831*
National Academy of Design, 1899, first Hallgarten prize, *12896*
National Academy of Design, 1900, *12997*
National Academy of Design, 1903, *13547*
New York, 1893, *16391*
New York, 1894, *4794, 4874, 26998*
New York, 1899, *17551*
Prize Fund Exhibition, 1888, *2700*
Salmagundi Club, 1899, *17571*
Society of American Artists, 1880, *10846*
Society of American Artists, 1889, *2986*
Society of American Artists, 1890, *October night*, *25916*
Society of American Artists, 1898, Webb prize, *12701, 12710*
Society of Landscape Painters, 1900, *7322*
Union League Club of New York, 1893, *4287*

illustrations
 Beach at Etaples, France, 11873
 From St. Ives to Lelant, 11669
 Waiting for the tide, 5978
letter on Gainsborough attribution of *Blue boy*, 1899, 17459
marries Margarat Austin Merryman, 1892, 26677
notes
 1898, 17447
 1899, 17538
October night, Chester, Connecticut, at Society of American
 Artists, 1890, 15205
painting in Walker collection, Minneapolis, 12924
picture in Evans collection, 11775
sales and prices, 1899, landscapes, 17571
whereabouts
 1895, Holy Land, 22765
 1896, return to New York, 16950
Bogert, J. Augustus, fl.1850-1881
illustrations, *Caught by the snow* (after T. Moran), 155
Boggs, Frank Myers, 1855-1926, *1817*
Dieppe, in Seney collection, 24977
exhibitions
 American Art Association, 1885, 2085
 Boston Mechanic Association, 1881, *Fishing boats at
 Dieppe*, 1236
 Brooklyn, 1890, 15039
 Internationale Kunstausstellung, Munich, 1883, 24693
 National Academy of Design, 1879, 679
 National Academy of Design, 1882, *1330*
 National Academy of Design, 1884, 25125
 National Academy of Design, 1888, 2695
 New England Manufacturers' and Mechanics' Institute, 1883,
 24768
 New York, 1893, 16391
 New York, 1894, watercolors, 4705
 New York Athletic Club, 1888, 2638
 Prize Fund Exhibition, 1885, *1985*
 Prize Fund Exhibition, 1885, *Rough day - entrance to the
 harbor at Honfleur*, 25278
 Prize Fund Exhibition, 1886, 2226, 25304
 Salon, 1883, *1603*
 Salon, 1883, *Port d'Isigny* bought by French government,
 24631, 24667
 Salon, 1884, *1767, 1789, 1806*
 Salon, 1884, preparation, *1738*
 Salon, 1885, *1967*
 Salon, 1886, *2193*
 Salon, 1887, *571, 2432*
 Society of American Artists, 1890, *Brooklyn bridge*, 15205
expatriate American artist, 11197
Fishing boats going out with the tide, selected for Chicago
 Exposition, 1883, 24725
illustrations
 Bièvre near Paris, 5407
 fragment of marine, 2210
 Low tide, 3677
 pen drawing of shipping, 7347
 Place St. Germain des Pres, 1601, 24801
 Trafalgar Square, 1819
Marine, in Clarke collection, 24943
notes, 1884, 25109
Off Honfleur, wins prize, 1885, 11294
painter from Ohio, 16332
portraits, sketch by P. Gervais, *1828*
St. Germain de Près, bought by John A. Lowell, 1883, 24740
sales and prices, 1885, Seney collection sale, *1963*
studio in Normandy, 2529
View of Dordrecht, in Seney collection sale, 1891, 15473
whereabouts, 1884, return from Paris, 25096
work, 1887, 2409
Bogle, William Lockhart, d.1900
illustrations, *Visitor*, 3899
Bohemian Art Club, Chicago See: **Chicago (Illinois).
 Bohemian Art Club**
Bohemian Sketch Club, Buffalo See: **Buffalo (New York).**

Bohemian Sketch Club
Bohemianism, *8345*
Böhm, Joseph Edgar See: **Boehm, Joseph Edgar**
Bohm, Max, 1868-1923
exhibitions
 Pennsylvania Academy of the Fine Arts, 1899, *12836*
 Royal Academy, 1907, *14312*
illustrations, *Motherland*, 13363
notes, 1899, 17600
Bohn, John Henry Martin, 1757-1843
English bookbinder, 9508
Boijmans Museum See: **Rotterdam (Netherlands). Museum
 Boijmans**
Bois, Henri Pène du See: **Pène du Bois, Henri**
Boisboudran, Horace Lecoq de See: **Lecoq de Boisboudran,
 Horace**
Boise (Idaho)
capitol, equestrian of George Washington moved, 1905, *14028*
Boisseau, Alfred W., 1823-1901
exhibitions, National Academy of Design, 1849, *21429*
Boissieu, Claude Victor de, 1784-1869
sales and prices, 1880, etchings, 896
Boissieu, Jean Jacques de, 1736-1810, *21057*
etchings, 879
Boit, Edward Darley, 1840-1916
exhibitions
 Boston, 1881, *1046*
 Boston, 1888, 2662
 Boston Society of Water Color Painters, 1887, 549
 Salon, 1885, *2000*
Impressionist water colors of Boston, 2602
Boito, Arrigo, 1842-1918
Mefistofele, 1013, 1031
production, 1881, *1052*
Bokelmann, Christian Ludwig, 1844-1894
Broken bank, in Layton Art Gallery, Milwaukee, *12813*
exhibitions, New York, 1879, *9110*
paintings in Whitney collection, 2108
Boker, George Henry, 1823-1890
Plays and Poems, review, 19583
Boker, John G.
collection
 paintings by Dusseldorf artists, *14632*
 possible removal to Europe, 1857, *18008*
 praised, 1857, *18039*
 purchase by Cosmopolitan Art Association, 1857, *18086*
 sale to Cosmopolitan Art Association, 1857, *18033*
commissions, 1850, *14657*
Boklund, Johan Kristofer, 1817-1880
obituary, 288
Boks, Marinus, 1849-1885
exhibitions, Paris Exposition, 1878, *9109*
Bol, Ferdinand, 1616-1680
exhibitions
 Chicago Art Institute, 1898, *6545*
 New York, 1893, *4234*
Portrait of an old lady, in Walker collection, Minneapolis,
 12924
relation to Rembrandt, *15701, 16171, 16208*
Bolckow, Henry William Ferdinand, 1806-1878
collection, 8699
Boldini, Giovanni, 1842-1931
Connoisseur, 9022
exhibitions
 Carnegie Galleries, 1903, *13675*
 International Society of Sculptors, Painters, Gravers, 1907,
 14248
 New York, 1878, *8962*
 New York, 1898, *6495*
 Salon, 1891, *3649*
 Salon, 1892, *4013*
 Seventh Regiment Fair, N.Y., 1879, *766*
 Union League Club of New York, 1884, *25090*
 Union League Club of New York, 1892, *26612*
illustrations

BONNEY, Thomas George, 1833-1923, *21937, 22026, 22036*
BONOMI, Joseph, 1796-1878, *19521*
Bononcini, Giovanni, 1670-1747
 rivalry with G. F. Handel, *648*
bonsai
 forged bonsai trees, *7260*
Bonsall, Elizabeth Fearne, 1861-1956
 exhibitions
 American Art Galleries, 1885, *1921*
 Pennsylvania Academy of the Fine Arts, 1889, *2885*
 Philadelphia Plastic Club, 1902, *13537*
 Pittsburgh, 1899, *12976*
 illustrations, *Catnip*, *13345*
Bonsall, Mary Waterman, b.1868
 exhibitions, Philadelphia Plastic Club, 1902, *13537*
 illustrations, pen drawing, *2418*

Bonvallet
 illustrations
 vase with enamel mountings, *13973*
 vases with mountings, *13558, 13563*
BONVIN, François, 1817-1887, *2355*
Bonvin, François, 1817-1887
 Etcher, *22279*
 French painter, *23045*
 illustrations, still life in charcoal, *3839*
 letter to Philippe Burty, excerpt, *16639*
 obituary, *2627*
 Scene in a convent, at Durand Ruel Galleries, New York, 1891,
 15590
Bonvoisin, Maurice See: **Mars**
book collecting, *3497, 10797, 15566*
 advice
 1887, *2377*
 1890, *3303, 15374*
 anecdotes, *15928, 15955, 16093, 16678, 16723, 16814, 16964,*
 17286, 20401
 collecting Caxtons, *16391*
 E. F. Bonaventure, *16412*
 Bibles, *15131, 16271*
 collection exhibited at World's Columbian Exposition,
 Chicago, 1893, *16195*
 bibliopholists qualifications, *25732*
 book collectors, 1899, *17638*
 books collected for their editors, illustrators and publishers,
 16964
 Brayton Ives case, *6927*
 changing fashions in collecting, 1899, *17606*
 chess books, *15251, 15278*
 club books, *15783*
 Comte de Lignerolles collection, *16494*
 condition of rare books, *2422*
 cook books, *15147*
 Crawford Library on astronomy, *15676*
 dramatic libraries, *20435*
 Elzeviers, *2284*
 Fables of Phaedrus, text provenance, *16387*
 Fonds Vattemare library of American history, *16797*
 George Salomon miniature library, *16567*
 George Washington's library, *20478*
 Golden Gospels, *16505*
 great men as bibliophiles, *20474*
 inscriptions in books, *16544*
 list of the largest book collections, 1894, *16603*
 local press imprints rare, *16781*
 manuscript copies of the New Testament, *16502*
 monomaniacs and thieves, *15921*
 notes, *2614*
 1886, *2255, 2338*
 1887, *2522, 2534*
 1892, *15953, 16014, 16042, 16064*
 1893, *16083, 16116, 16291, 16304, 16404*
 1894, *16502*
 1895, *16811*
 1896, *17193*

 oldest book, *16608*
 Pope collection, *15687*
 printers' marks, *16608*
 sales and prices
 1887, *2791*
 1892, *16085*
 1894, list of highest-priced books, *16569*
 thumb books, *16561*
 tips to collectors, 1898, *17436*
 United States
 Brooklyn and Cleveland collectors, 1894, *16544*
 leading private libraries of Brooklyn, 1893, *16264*
 New York, 1898, *6760*
 private American libraries and book auctions, 1894, *16608*
 Washington, D.C., 1891, *15735*
 use of agents, *15555*
book covers, *12975*
 Butler Paper Co., Chicago, competition, 1897, *12629, 12646*
 California School of Design competition
 1900, *22116*
 1902, *22158*
 cloth book cover designs, *4963*
 designing, *5519, 6244*
 designs by Thomas Clough, 1880, *9322*
 exhibitions
 Aldine Club, 1892, *3978*
 Architectural League of New York, 1894, *4787*
 marbling, *22456*
 old Persian book covers, *2516*
 technique
 making metal cover, *7490*
 making portfolios and reading covers, 1892, *4089*
 women designers, *15468*
book design, *12527*
 exhibitions
 Boston Society of Arts and Crafts, 1907, *14267*
 Grolier Club, 1896, Chiswick Press books, *17154*
 International modern book exhibit at L'art nouveau, Paris,
 1896, *22388*
 Stone & Kimball, publishers, *22334, 22373*
 United States, reviews of books, 1896, *22388*
 William Morris, *22390*
book industries and trade
 G. W. Smalley on what constitutes an edition, 1894, *16515*
 Germany, Leipzig, *21306*
Book of the Dead (funerary texts)
 facsimile in British Museum, 1890, *26088*
book ornamentation, *2401*
book plates, *8730, 11891, 15392, 22360*
 armorial book plates, *5516, 5517, 5600, 5644, 5684*
 children's, *12311*
 collectors and collecting, *3497, 4965, 5421, 16227, 16254,*
 16291, 16935
 Hewins collection sale, 1896, *5645*
 list of American collectors, 1894, *16589*
 trading bookplates, *16678*
 W. J. LeMoyne collection, *16523*
 competitions
 Modern Art, 1896, *22398*
 Society of Mayflower Descendants, 1897, *6487*
 conservation and restoration, *7465*
 removing, cleaning, repairing, *4863*
 deciphering coats of arms, *5476*
 designed by Bicknell and etched by Garratt, *16480*
 designs, *16243*
 for women, *5027*
 excerpts from W. J. Hardy's *Book Plates*, *5768*
 exhibitions
 Chicago, 1898, *12113*
 Grolier Club, 1894, *16567, 22294*
 Grolier Club, 1895, *5326*
 Grolier Club, 1898, *6620*
 history, *12640*
 identification, *5390*
 illustrations, *5451, 7762*

model for John Hancock statue by C. E. Dallin, *12949*
Boston (Massachusetts). South Boston School of Art
notes, 1892, *4172*
Boston (Massachusetts). South End Free Art Exhibition, 1899,
12877
Boston (Massachusetts). St. Botolph Club
annual meeting, 1881, *284*
exhibitions
1880, *159, 1005*
1880, opening, *894*
1881, *1108*
1881, plans, *1089*
1887, *2580*
1888, *2699*
1888, Sargent portraits, *2662*
1889, *2859*
1891, *3491*
1891, Gaugengigl, *3534*
1891, paintings of interiors of Italian church by Misses
Williams, *26303*
1891, watercolors, *3601*
1892, *26506*
1892, Monet, *15869, 26604*
1892, water colors, *26869*
1896, ship pictures, *16915*
1899, Breck, *12903*
1899, LaFarge, *12837*
1899, Monet, *12855*
1900, Benson, *13061*
1903, *13688*
1905, portraits of members, *13842*
formation, 1880, *807, 855*
history, *1852*
Boston (Massachusetts). State House
D. C. French's *Fighting Joe, 8175*
decoration, murals, *7776, 13351*
destruction protested by Society of Architects, 1896, *23008*
proposed destruction of dome, 1887, *2365*
witchcraft documents, *16662*
Boston (Massachusetts). Tavern Club
exhibitions, 1886, caricature, *504*
Boston (Massachusetts). Tilton & Co. See: **Tilton, S. W., &
Co., Boston**
Boston (Massachusetts). Trinity church
decoration by J. LaFarge, *681, 8886*
E. W. Gosse's remarks, *25240*
fragment of a window painted by Burne Jones, *2096*
interior, 1883, *1682*
plans for completion, 1890, *26157*
St. Gauden's *Phillips Brooks, 13604*
Boston (Massachusetts). Twentieth Century Association
exhibitions, 1906, *14109*
Boston (Massachusetts). Unity Art Club
annual dinner, 1893, *26952*
annual exhibitions, 1892, *26841*
exhibitions, 1892, china painting, *26606*
lectures, lecture by Rev. Fred. H. Allen, 1892, *26547*
notes
1891, *3524*
1893, *26916*
season, 1895, *27027*
summer location at South Duxbury, 1892, *26703*
Boston (Massachusetts). Vose Gallery See: **Boston
(Massachusetts). Robert C. Vose Gallery**
Boston (Massachusetts). Walter Rowlands Galleries
exhibitions, 1905, *13868*
Boston (Massachusetts). Watch and Ward Society See:
**Boston (Massachusetts). New England Watch and Ward
Society**
Boston (Massachusetts). Water Color Club See: **Boston
(Massachusetts). Boston Water Color Club**
Boston (Massachusetts). Water Color Society See: **Boston
(Massachusetts). Boston Society of Water Color Painters**
Boston (Massachusetts). Williams & Everett
exhibitions

1881, *1236*
1887, paintings by Bush and Picknell, *528*
1890, Madeleine Lemaire's watercolors, *25888*
1891, *3773*
1891, Gué's *What is truth?, 26226*
1895, special summer show of American painters, *22765*
1899, sales, *12892*
1905, *13868*
notes
1861, *20330*
1886, *493*
1893, *4283*
praised by Durand-Ruel, 1887, *531*
sales and prices, 1901, *13335*
Boston (Massachusetts). Woman's Educational Association
opens sculpture school for women, 1878, *8964*
Boston (Massachusetts). Zepho Club
notes, 1884, *1852*
Boston Terra Cotta Company
relief heads for Buffalo building, *504*
BOSTONIAN, 10646, 10674
Bostonian Society See: **Boston (Massachusetts). Bostonian
Society**
BOSTWICK, Kate M., *23142*
Bosworth, Sala, 1805-1890
obituary, *26213*
botany
C. C. Parry herbarium and library, *16531*
collectors and collecting
Duchess of Cleveland collection of botanical specimens,
16394
hints for taking specimens, *16553*
dry rot decay, *16505*
F. Darwin believes plants have sense of gravitation, 1903, *8281*
glossary of botanical terms, *6115*
how to dry and press seaweed, 1902, *8023*
Physic Garden of Chelsea, London, *8004*
rata trees, *16502*
study of botany recommended to flower painters, *3262, 7955*
terms for painters, *6234, 6257*
BOTELER, Alexander Robinson, 1815-1892, *24549*
Both, Andries Dirksz, ca.1608-1650, *21245*
Both, Jan Dirkz, 1618?-1652, *21245*
Guitar player, 7230
painting in Walker collection, Minneapolis, *12924*
Both, William C., b.1880
illustrations
drawing from life, *12146*
Scene in Doberon, 14227
Botham, Mary See: **Howitt, Mary Botham**
Bothe, Ida, fl.1881-1890
American woman painter, *11230*
Botticelli, Sandro, 1447?-1510, *9477*
Adoration of the Magi, re-attributed to Fra Lippi, *9740*
Assumption of the Virgin, acquired by National Gallery,
London, 1884, *10095*
attribution of unfinished picture in Uffizi, *430*
illustrations for Dante's *Divine Comedy, 14864*
published, 1887, *25412*
Madonna and Child, 17668
location unknown, 1899, *7074*
notes
1899, *12398, 17688*
1901, *13145*
painting discovered in Piacenza art gallery, 1902, *13504*
painting discovered in Pitti Palace, 1895, *16721*
painting stolen from Chigi collection, 1900, *7481*
paintings in London National Gallery, *4360*
poem by Ralph Adams Cram, *21477*
sales and prices
1892, *3895*
1899, *Trinity with crucifixion, 7043*
Spring (engraved by Geyger), *16556*
work in the Poldi-Pezzoli Museum, *9916*
works in Louvre, *5969*

works in National Gallery, London, 1894, *4913*
Böttiger, Johan Frederik See: **Böttiger, John**
Böttiger, John, 1853-1936
 inventor of hard porcelain, *859, 881*
Bouchardon, Jacques Philippe, 1711-1753
 statue returned to Louvre, 1893, *16371*
Bouché, H. L., fl.1883
 designs for artistic jewelry, *1580*
 illustrations, designs for jewelry, *1597, 1610, 1625*
Boucher, A.
 illustrations, portrait photograph of Louise Jopling, *21839*
Boucher, Alfred, 1850-1934
 French sculptor, *5934*
 exhibitions
 Salon, 1886, *At the Goal, 2206*
 Terre, shown at Tiffany's, 1893, *16316*
Boucher, Alfred Jean, d.1937
 illustrations, *Morning in the vallée- verte, 1355*
Boucher Desnoyers, Auguste Gaspard Louis See: **Desnoyers, Auguste Gaspard Louis**
Boucher, François, 1703-1770
 decorative design, *2591*
 decorative paintings, *16945*
 Duveens' discovery of Boucher-designed Gobelins tapestry, 1890, *3152*
 exhibitions, Chicago World's Fair, 1893, *4463*
 fan decoration, *1320*
 illustrations
 allegorical decorative designs, *1857, 1875*
 Autumn and *Winter, 3409*
 Boucher style decorations, *5999*
 ceiling decoration, *1811*
 ceiling decorations, *1897*
 china painting designs, *4400*
 Composition, 7083
 Courteous shepherd, 3187
 Cupids, 5353
 decorative figure design, *2264*
 decorative figures, *1829, 1845*
 decorative panels, *2359*
 designs for painted hand or fire screens, *3138*
 designs for tapestry painting, *4402*
 drawings, *4574*
 Elements (Air), 3030
 Elements (Earth), 3008
 Elements (Fire), 3054
 Elements (Water), 3072
 Fortune teller, 1992
 Fountain of love, 2866
 groups, *4006*
 Nymph and Cupid , 1576
 set of designs for painted hand or fire screens, *3164*
 sketch for a grand salon decoration, *2533*
 sketch of cupids and dolphins, *2941, 2943*
 Summer, 5799
 tapestry painting design, *3509*
 marriage fan of Marie Leczinska, *1451*
 over-door designs, *2550*
 style used in china painting, *3083*
 tapestry design, *795*
Boucher, Jean, 1870-1939
 exhibitions, Salon, 1901, *13270*
Boucheron
 illustrations, necklace set with pearls and brilliants, *1479*
BOUCHOT, Henri François Xavier Marie, *17887*
Bouchot, Henri François Xavier Marie, 1849-1906, *14224*
 Book: its Printers, Illustrators, and Binders, publication announcement, 1890, *14997*
 catalogue of crayon portraits in Bibliothèque Nationale, *10041*
 Ex-libris et les Marques de Possession du Livre, publication announcement, 1891, *15463*
 Livre, review, *10388*
 publications, *15759*
Boucicault, Dion, 1820?-1890
 Jilt, performances, 1886, *2191*

Boudier, Edouard Louis, d.1903
 illustrations, *Brévière in the forest of Compiègne, 1997*
Boudin, Eugène Louis, 1824-1898
 exhibitions
 American Art Galleries, 1886, *2208*
 Durand Ruel, 1899, *6841*
 New York, 1894, *4840*
 New York, 1897, *6370*
 New York, 1898, *12273*
 New York, 1905, *13889*
 illustrations
 Corvette russe, 11622
 Port of Trouville, 14333
 Villefranche, 11873
 obituary, *6758, 17446, 20633*
Boudry, Alois, b.1851
 exhibitions, Antwerp, 1902, *13361*
Bough, Samuel, 1822-1878
 Canal at sunset, 16734
 exhibitions
 Edinburgh, 1884, drawings, *10059*
 Glasgow Institute, 1879, *21714*
 Glasgow Institute, 1880, *21912*
 Royal Scottish Academy, 1879, *21714*
Boughton, Alice M., 1866-1943
 illustrations, *Mother and daughter, 13532*
Boughton, George Henry, 1833-1905, *1384, 9427*
 American nationality, *4702*
 Armistice, offered by Avery Gallery, 1890, *15422*
 biographical information, *16461*
 Canterbury pilgrims, 15039
 acquired by Layton Gallery, 1896, *17042*
 and *Departure of the Mayflower* in Layton Art Gallery, Milwaukee, *12813*
 bought for Layton Art Gallery, 1896, *23030*
 charcoal drawings, *5979*
 Dangerous consultation, 9295
 early work, *540*
 Edict of William the Testy, 8969, 26465
 elected Royal Academician, 1896, *11794, 23008*
 elected to National Academy of Design, 1858, *19859*
 English-American artist, *22524*
 exhibitions
 Albany, 1858, *19818*
 Avery Art Gallery, 1890, *15070*
 Grosvenor Gallery, 1878, *21594*
 Grosvenor Gallery, 1879, *9178*
 Grosvenor Gallery, 1880, *9356, 21885*
 Grosvenor Gallery, 1885, *2035*
 London, 1883, *24615*
 London, 1886, *2245*
 London, 1897, *Portrait of Esmé, 6278*
 Milwaukee Industrial Exposition, 1898, *Tea rose, 12800*
 National Academy of Design, 1858, *19835*
 National Academy of Design, 1859, *20030*
 New York, 1859, *19978*
 New York, 1878, *9084*
 New York, 1888, *2806*
 New York, 1891, *26411*
 New York, 1895, illustrations, *16678*
 New York, 1896, *17016*
 New York artists' reception, 1860, *20195*
 Paris Exposition, 1878, *9072*
 Royal Academy, 1878, *9023, 21613*
 Royal Academy, 1879, *9177, 21698, 21708*
 Royal Academy, 1880, *913, 9354, 21841, 21863*
 Royal Academy, 1881, *21997*
 Royal Academy, 1882, *1366*
 Royal Academy, 1883, *9827, 24649*
 Royal Academy, 1884, *1813, 10007*
 Royal Academy, 1885, *2019*
 Royal Academy, 1887, *2480*
 Royal Academy, 1897, *6311*
 Royal Academy, 1898, *Road to Camelot, 6644*
 Royal Academy, 1899, *Skating days of old Brabant, 6983*

Twilight, 1355
Virgin, Infant Jesus, and St. John the Baptist, 8080
Wasps, 12659
Italian women at the fountain, 8398
leads attack against juries of Paris Exposition, 1889, 3099
Maiden defending herself against Love, 937
marriage to Elizabeth Gardner, 1896, 11855
marries, 1880, 954
Mother and child, compared to Seymour Guy's *See-saw, Margery Daw*, 11051
Normandy peasant girls at prayer, in Walker collection, Minneapolis, 12924
notes
 1870, 23601
 1895, 16792
Nymphs and faun, 1312
 in Wolfe collection, 1880, 893
painting shown in New York, 1886, 25346
paintings in Hilton collection, 793
paintings in Stewart collection, 659, 753, 2393, 10768
paintings in the Salons of 1873-75 criticized by J. Claretie, 11697
paintings in Walker collection, Minneapolis, 12912
paintings of Christ, 22858
Pearl, 5050
promotion to grand officer of Legion of Honor, 13588
quote on Salon prizes, 1888, 2619
Return from the harvest, in Stewart collection, 25406
Return of spring
 Boussod sues for damage, 1895, 16738
 damaged by fanatic in Minneapolis, 26303
 destroyed in Omaha, 1891, 26266
 destroyed in United States tour, 1891, 26258
 mutilated in Omaha, 1890, 15447, 15475
 vandalized, 1891, 3571, 3598
Reverie, in Brandus gallery, 1898, 17405
sales and prices
 1883, 1486
 1891, 26270
son becomes lawyer, 26518
tapestry painting, 20529
Twilight
 on view at Knoedler's, 1882, 9693
 shown in New York, 1884, 25090
Watch and ward, 8814
Water carrier, at International Art Gallery, 1890, 15246
whereabouts, 1891, Paris to St. Petersburg, 26315
work in studio, 1876, 8637
works in Robert Graves collection, 2388
Bouguereau, William Adolphe, Mrs. See: **Bouguereau, Elizabeth Jane Gardner**
Bouilhet, André
on American designing at Chicago World's Fair, 1894, 4875
Boulanger, Gustave Clarence Rodolphe, 1824-1888
and Académie Julian, 6372
criticism of contemporary art movements, 1885, 2074
exhibitions
 Cercle des Mirlitons, 1878, 8992
 Paris Exposition, 1878, 9034, 21662
 Salon, 1877, 8858
 Salon, 1880, 21870
 Salon, 1883, 14898
Gynécée, 8713
illustrations
 drapery studies, 5500
 drapery study, 5124
 drawing, 7349
 figure drawing, 3507
 Mother of the Gracchi, 2018
 study, 3631
nudes offend Bostonians, 1889, 25578
paintings in Stewart collection, 753, 2393
paintings in Walker collection, Minneapolis, 12912
Boulanger, Henri See: **Gray, Henri**

Boulanger, Victor
collection, sale, 1880, 918
Boulard, Auguste, *fils*, 1852-1927
exhibitions, Paris, 1896, 23625
illustrations, *Piquet* (after J. L. E. Meissonier), 3527
Vive l'empereur (after F. Flameng), 7230
BOULEVARDIER, 17085
Boulle, André Charles, 1642-1732, 20448
family of furniture makers, 15748
furniture, 1643, 3268, 15748
illustrations, wedding casket, 866
wedding casket, 870
BOURCART, Sara, 11324
Bourdais, Jules Désiré, b.1835
Palais du Trocadéro, 21570
Bourdillon, Francis William, 1852-1921
Nephele, excerpt and review, 12582
Bourdon, Sebastien, 1616-1671, 21279
Bouré, Antoine Félix See: **Bouré, Félix**
Bouré, Félix, 1831-1883
Lizard, 21988
Bourgain, Gustave, ca.1879-1921
illustrations
 drawing, 7101
 figure drawing, 3656
 Lobster fishing, 2018
Bourgeois, Gaspard, d.1904?
collection, sale, 1905, 13956
Bourgeois, Stephan, d.1899
collection, sale, 1905, 13956
Bourgoin, Marie Désiré, 1839-1912
exhibitions, American Watercolor Society, 1878, 8979
Bourgoing, Suzanne Reichenberg, baronesse de See: **Reichenberg, Suzanne**
Bourland, Rudolph R., fl.1898
illustrations, photographs of Illinois, 12738
Bourlard, Antoine, 1826-1899
Prisoner, 9033
Bourne, Herbert, ca.1820-ca.1885
illustrations
 Cherry ear-rings (after F. Morgan), 10278
 Contrary winds (after T. Webster), 8503
 Isabella (after J. E. Millais), 9645
 Knuckle-bone player (after F. Leighton), 9962
 New curate (after D. W. Wynfield), 9307
 Syren (after C. L. Muller), 8694
BOURNE, M., 9583, 10164, 10177
Bournemouth (England)
description and views, 23135
Bouruet Aubertot See: **Richard, Maurice, *Mme***
BOUSFIELD, William Robert, 9578
Boussod, d.1894
obituary, 16466
photogravure process, 10214
Boussod, Valadon and Co. See: **New York. Boussod, Valadon and Co.**
Boussod, Valadon et Cie, Paris See: **Paris (France). Boussod, Valadon et Cie**
Bouteillier, Sophie de See: **Browne, Henriette**
BOUTELL, Charles, 8798, 8865
Boutelle, DeWitt Clinton, 1820-1884
commissions, 1849, 14537
exhibitions
 National Academy of Design, 1851, *Trout stream, shower passing off*, 14735
 National Academy of Design, 1859, 20030
paintings in American Art Union Gallery, 1848, 14445
Study - Basking Ridge, in the collection of the American Art Union, 1849, 14589
whereabouts, 1850, Binghampton, N.Y, 14657
Boutet de Monvel, Louis Maurice, 1850-1913, 12260, 12830
as painter of children, 13148
childrens' pictures, 1899, 17538
exhibitions
 American Art Galleries, 1899, 12877

Boston, 1899, *12874*
Chicago Art Institute, 1899, announcement, *12769*
London, 1891, watercolors, *3497*
St. Louis Exposition, 1894, *5036*
Salon, 1880, second class medal, *9371*
Société d'Aquarellistes Français, 1886, *2175*
French painter, *23045*
illustrates Fabre's *Xavière*, *15422*
illustrations
Aventures de Trompette, *22078*
combs, with enamel, *13973*
drawing, *7101*
Pic-nic, *2913*
illustrator of children's books, *12323*, *13633*
line technique for photo-engraving, *5377*
reception, Chicago, 1899, *12291*
reception in Chicago Fine Arts Building, 1899, *12862*
whereabouts, 1899, returns to Chicago, *12861*
Boutet, Henri, 1851-1919
Almanac Henri Boutet, *16480*
Bouton, J. W., booksellers
See also: **New York. Bouton, J. W., booksellers**
Bouton, James W.
catalogs Havemeyer book collection, 1889, *14933*
collection
Cruikshank sketches acquired, 1881, *1239*
portrait by Lawrence, *14953*
drama library for sale, 1889, *14957*
publisher of Sterne's *Sentimental Journey*, 1884, *25197*

Boutwood, Charles Edward, fl.1881-1933
Chicago member of Society of Western Artists, *12122*
design for breakfast window, Grand Pacific Hotel, *20503*
exhibitions
Chicago Society of Artists, 1896, prize for *Rain and tide*, *11813*
Cincinnati Art Museum, 1898, *12754*
Cincinnati Art Museum, 1900, *13067*
Society of Western Artists, 1898, *In wonderland*, *12802*
illustrations
In wonderland, *12676*
Jolly skipper, *11414*
Portrait of a girl, *11802*
In wonderland, wins prize in Chicago, 1898, *12110*
notes, 1896, *11883*
teacher at Delavan, Wisconsin, outdoor summer art school, 1898, *12719*
Bouvenne, Aglaüs, 1829-1903
obituary, *13724*
Six fauves (after Delacroix), *16556*
Bouveret, Dagnan See: **Dagnan Bouveret, Pascal Adolphe Jean**
Bouvier, Augustus Jules, 1825-1881
exhibitions, Royal Institute of Painters in Water Colours, 1858, *19898*
obituary, *314*
Bouyer, Raymond, b.1862
Paysage dans l'Art, review, *5430*
bow and arrow
Indian bows and quivers, *22735*
Bowdish, Edward Romaine, b.1856
illustrations, *Old mill*, *22546*
summer canal-boat and tent studio, *22571*
Bowditch, Nathaniel, 1773-1838
monuments, monument in Mount Auburn cemetery, *19928*
Bowdoin, Birdaline, fl.1895
illustrations, farmhouse interiors, *22593*
Bowdoin College See: **Brunswick (Maine). Bowdoin College**
Bowdoin College Museum See: **Brunswick (Maine). Bowdoin College. Museum of Fine Arts**
BOWDOIN, Harriette, *22593*
Bowdoin, James, 1752-1811
collection, *10583*
willed to Bowdoin College, *164*

Bowdoin, William Goodrich, 1860-1947
James McNeill Whistler, the Man and his Work, review, *13489*
Bowen, Abel, 1790-1850
wood engravings, *87*
Bowen, Clarence Winthrop, 1852-1935
lecture at Grolier Club on portraits of Franklin, 1893, *26886*
Bowen, Owen J., d.1900
See also: **Heinigke and Bowen, firm**
Bowers, Edward, 1822-1870
whereabouts, 1858, Philadelphia, *19891*
Bowers, George Newell, 1849-1909
exhibitions, Prize Fund Exhibition, 1886, *25304*
BOWERS, M. B., *12146*
BOWES, Adrian W., *12325*
Bowes (England)
Dotheboys Hall, described by Dickens in *Nicholas Nickleby*, *10451*
Bowes, James Lord, 1834-1899
collection, Japanese art, *15004*, *25679*
disagreement with Edward S. Morse, 1890, *26210*
Enamels, review, *10090*
Japanese Pottery
publication announcement, 1891, *15745*
review, *26218*
Keramic Art of Japan, review, *416*
Bowes Museum, Barnard Castle (England)
description, 1892, *26704*
Bowler, Archer, fl.1882
sketches of Goslar, Germany, *9668*
Bowler, George
Chapel and Church Architecture, with Designs for Parsonages, review and excerpts, *19886*
BOWLES, Joseph Moore, *12622*, *13633*, *13877*, *22218*, *22222*, *22230*, *22242*, *22248*, *22256*, *22263*, *22274*, *22287*, *22300*, *22316*, *22329*, *22380*, *22392*, *22407*, *22425*, *22426*, *22431*, *22438*, *22444*
Bowles, Joseph Moore, 1865-1934
announces *Ecclesiastes* by B. Rogers, *22297*
Bowman, J. C., fl.1882-1887
exhibitions, American Watercolor Society, 1882, *1300*
Bowne, Walter
collection, sale, 1890, *15033*, *15105*, *25813*
Bowring, John, 1792-1872, *18427*
Boxall, William, 1800-1879
obituary, *64*
boxing
England, mania, *20223*
Boy, Ferdinand, ca.1810-1881
obituary, *454*
Boyce, George Price, 1826-1897
collection, Rossetti water color, *10043*
home, house and studio designed by Philip Webb, *9474*
Boyce, Joanna Mary See: **Wells, Joanna Mary Boyce**
Boyd, Clarence, 1855-1883
For lack of gold, in Louisville's Southern Exposition, 1883, *24760*
obituary, *24726*
shot and wounded, 1883, *24704*
BOYD, Jeanie L., *5234*, *5707*
Boyd, Jeanie L., fl.1894-1912
notes, 1894, *16494*
to take art class to Holland, 1894, *4867*
whereabouts
1895, to take class to Holland, *5329*
1896, summer in Holland, *23056*
BOYD, Nannie Seawell, *11749*
Boydell, John, 1719-1804
engravings shown by R. E. Pine, Philadelphia, *18568*
father of engraving in England, *1112*
Boyden, Frederick Dwight, b.1860
landscape, *17639*
Boye, Bertha M., fl.1902-1919
book cover for Josselyn's *My Favorite Book-Shelf*, 1902, *22158*
illustrations
life class study, *22145*

study in composition, *22202*
Boyer, Ralph Ludwig, 1879-1952
 exhibitions, Philadelphia T-Square Club, 1902, *13334*
BOYESEN, Hjalmar Hjörth, *22601, 22651, 22715, 22986*
Boyesen, Hjalmar Hjörth, 1848-1895
 Alpine Roses, New York performances, 1884, *1733*
 quote, on northern European painting, *13423*
Boylan, Grace Duffie, 1861?-1935
 Kiss of Glory, review, *13527*
Boyle, Ferdinand Thomas Lee, 1820-1906
 exhibitions, National Academy of Design, 1849, *21429*
 family group in St. Louis, 1858, *19942*
 Judith and Holofernes, *10618*
 obituary, *14240, 14256*
 portrait of Bishop Hughes, *21405*
 work, 1870, *10569*
Boyle, Gertrude See: **Kanno, Gertrude Boyle**
Boyle, John J., 1852-1917
 Alarm, *24782*
 exhibitions
 American Art Galleries, 1887, *2607*
 Chicago World's Fair, 1893, *4565*
 National Sculpture Society, 1898, *Bacon, 12721*
 Salon, 1885, *2035*
 Salon, 1886, *Indian mother, 2206*
 Salon, 1887, *571, 2449*
 illustrations
 Benjamin Franklin, *13785*
 Protection, *7877*
 Savage age, *13263*
 sculptures, *13556*
 Indian group for Philadelphia, *529*
 Indian sculptural group in Chicago, *4911*
 notes
 1883, *24870*
 1886, *2323*
 1899, *17526*
 Porter on Dewey arch, *7096*
 professor, Pennsylvania School of Industrial Art, 1891, *3483*
 sculptural decorations of World's Fair buildings, *4433*
 sculpture for Louisiana Purchase Exposition, 1904, *13685*
 sculpture for Philadelphia's Fairmount Park commissioned, 1883, *24829*
 statue of Benjamin Franklin, *7074*
 cast by Henry Bonnard Bronze Company, *12844*
 commissioned by J. C. Strawbridge, *22388*
 for Philadelphia, *12849*
 statue of Horace Greely, *4956*
 Stone age, *10814*
Boynton, George Rufus, d.1945
 crayon heads, 1883, *24541*
 exhibitions, New York, 1883, *24817*
Boynton, Ray Scepter, 1883-1951
 illustrations, illustration, *14193*
boys
 New York street boys in pictures of J. G. Brown, *22526*
Bozérian, Jean Claude, 1762-1840
 illustrations, bookbinding, *20453*
Boznanska, Olga, 1865-1945
 exhibitions
 Carnegie Institute, 1907, third prize, *14328*
Bozza, Bartolomeo, d.1594
 subject of fiction, *19351, 19375, 19398, 19415*
Brace, Helen See: **Emerson, Helen Brace**
Bracken, Clio Hinton Huneker, 1870-1925
 equestrian statue of General Fremont commissioned, 1895, *11549*
 exhibitions, Atlanta Exposition, 1895, *11698*
 Omar Khayyam punch bowl, *7639*
Bracken, Julia M. See: **Wendt, Julia M. Bracken**
Bracken, William Barrie, *Mrs.* See: **Bracken, Clio Hinton Huneker**
Brackenbury, Georgine A., fl.1891-1907
 illustrations, *College athlete*, *5929*

Brackett, Edward Augustus, 1818-1908
 exhibitions, Boston Athenaeum, 1858, *19899*
 Hosea Ballou, *19596*
 notes, 1859, *20080*
 statue of Ballou, *20033*
 work, 1857, *19682*
 Wreck, *14524*
Brackett, Sidney Lawrence, 1852-1910
 paintings of St. Bernard dogs belonging to E. B. Sears, *25928*
Brackett, Walter M., 1823-1919
 fish paintings, *12903*
 fish picture, 1861, *20330*
 notes, 1871, *10616*
 painting of salmon, *813*
 Portrait, in Boston, 1858, *19785*
Bracony, Leopold, fl.1892-1921
 reception, Studio Building, Chicago, 1895, *11493*
 studio in Chicago, 1894, *27025*
 studio reception, Chicago, 1895, *11548*
Bracquemond, Felix, 1833-1914
 etchings, *26352*
 exhibitions
 London, 1891, etchings, *26293*
 New York Public Library, 1904, *13793*
 illustrations
 Effect of rain and sunshine, *2749*
 plate decoration, *3637*
 Partie perdue (after Meissonier), *15638*
 Rixe (after Meissonier), *2108*
Bracquemond, Félix Henri, *Mme* See: **Bracquemond, Marie**
Bracquemond, Marie, 1841-1916
 illustrations
 Month of May, *2433*
 plaque, *3966*
BRADBURY, Edward, *21711, 21740, 21760, 21776, 21804, 21813, 21920, 22056*
Bradbury, Mary R. See: **Howard, Mary R. Bradbury**
Braddon, Mary Elizabeth See: **Maxwell, Mary Elizabeth Braddon**
Brade, Daniel
 Picturesque Sketches in Italy, review, *10375*
BRADFIELD, C. P., Mrs., *12382*
BRADFORD, *10617, 10676, 10704*
Bradford Durfee Textile School See: **Fall River (Massachusetts). Bradford Durfee Textile School**
Bradford, M. A., fl.1886-1893
 exhibitions, Boston, 1886, *493*
Bradford, William, 1823-1892
 artists in San Francisco, *811*
 autumn work, 1879, *738*
 biography in brief, *11246*
 exhibitions
 American Art Union, 1883, *10913*
 Boston, 1881, Arctic pictures, *1236*
 Century Club, 1892, *26851*
 Cleveland, 1883, *24850*
 Providence, 1875, scenery of Labrador coast, *8403*
 Marine, in Boston, 1858, *19785*
 marine painting shown at Century Club preview, 1884, *25064*
 notes
 1871, *10676*
 1883, *24657*
 obituary, *26630*
 sales and prices
 1892, *26851, 26862*
 1892 or 1893, *11302*
 sketch of the wreck of the Vernon, *19995*
 whereabouts, 1860, New York, *20179*
Bradford, William, 1663-1752
 books shown at Grolier Club, 1893, *26930*
Bradish, Alvah, 1806-1901
 exhibitions, Chicago Academy of Design, 1871, *10712*
 portrait painting in Detroit, 1855, *18692*
 portrait paintings on art market, 1897, *17233*

Bradish, William K., d.1901
obituary, *13270*
Bradlaugh, Charles, 1833-1891
library, sale, 1891, *15745*
Bradley, Basil, 1842-1904
illustrations, *Spring*, *6262*
Bradley, Elizabeth P., 1841-1919
notes, 1901, *22134*
Bradley, Emily Tennyson See: **Smith, Emily Tennyson Bradley**
Bradley, George P., fl.1894-1898
exhibitions, Society of Western Artists, 1898, *July morning*, *After a rain* and *Harvest noon*, *12802*
illustrations
 landscape, *23137*
 marine sketches, *23159*
 Orchard in June, *22567*
member, Cleveland Water Color Society, *22591*
Bradley, Horace, fl.1883-1895
director, Fine Arts department, Atlanta Exposition, 1895, *11571*
illustrations, *At work*, *22486*
organizes art school in Atlanta, 1883, *24728*
portrait of Sen. B. H. Hill, wins prize, 1883, *24777*
Bradley, James A.
purchases statue of Goddess of Liberty, 1883, *24707*
Bradley, John Henry, b.1832
paintings in Florence, 1878, *21627*
Bradley, John William, 1830-1916
Dictionary of Miniaturists, Illuminators, Calligraphers and Copyists, 1887-1889, publication announcement, *15358*
Life and Works of Giorgio Giulio Clovio, Miniaturist, *15563*
Bradley, Milton, 1836-1911
Elementary Color, publication, 1896, *6083*
Bradley, Susan Hinckley, 1851-1929
exhibitions, Pennsylvania Academy of the Fine Arts, 1900, *13007*
BRADLEY, Will H., *12518, 12545, 12566, 12584, 12594, 12604*
Bradley, Will H., 1868-1962, *22398*
Beardsley imitator, *5614*
exhibitions
 Chicago, 1895, posters, *11501*
 Chicago Society of Artists, 1895, *11483*
 New York, 1902, *13334*
illustrations
 advertisements, *12488, 12497, 12528, 12542*
 Babies garden, design for nursery wallpaper, *12541*
 book plate for Owen Brewer, Esq., *22360*
 cover for *Bradley, His Book*, *12487, 12530, 12544*
 cover for Holden modern art book, *12488*
 cover stamp for *Singing Mouse Stories*, *12520*
 designs for American Type Founders Co, *12488*
 Down the road they came, *12518*
 I don't read ginger-pop literature, *12536*
 illustrations for *Secret History of the Rescue of the Duchess de Dragonflies*, *12575*
 illustrations for *Vengeance of the Female*, *12533*
 Night blooming cereus, *12493*
 "O my love is like a red, red rose", *12538*
 Silver brook, design for hall paper, *12541*
Kiss, a poster, *12504*
notes, 1895, *16713*
posters, *12499, 12529, 12867*
BRADNER, Harriet, *23064*
Bradshaw, S., fl.1869-1886
illustrations
 Gurth the swineherd (after C. E. Johnson), *10345*
 Jacques Coeur house, Bourges (after T. Allom), *13116, 14138*
BRADSHAW, William Richard, b.1851, *6777, 6796, 6895*
Bradstreet, John S., fl.1901
exhibitions, Minneapolis Arts and Crafts Society, 1901, *13184*
Bradwell, James Bolesworth, 1828-1907
portraits, portrait bust by C. Heber, *11391*
BRADY, C. E., *3242, 4730, 4783, 4815, 4816, 4858, 4859, 4891, 4921, 4922, 4959, 4987, 4989, 5014, 5015, 5054, 5056, 5101,*

5139, 5144, 5146, 5181, 5192, 5195, 5240, 5243, 5278, 5280, 5313, 5314, 5354, 5382, 5384, 5414, 5442, 5443, 5468, 5502, 5504, 5548, 5585, 5630, 5631, 5632, 5677, 5713, 5715, 5749, 5750, 5793, 5796, 5841, 5843, 5875, 5876, 5916, 5953, 5989, 6028, 6077, 6124, 6165, 6169, 6202, 6203, 6204, 6232, 6233, 6235, 6270, 6291, 6324, 6359, 6384, 6443, 6479, 6574, 6577, 6604, 6628, 6664, 6715
Brady, C. E. fl.1894-1898
illustrations
 cup and saucer, *5452*
 cup and saucer decoration, *5515*
 cups and saucers, *5474*
 cups and saucers designs, *5419*
BRADY, James Topham, *18434*
Brady, James Topham, 1815-1869
contributor to *The Lantern*, *16568*
lecture on American art for Ranney fund, *19956*
Brady, Mathew B., 1823-1896
illustrations
 Anna Cora Ritchie, *18227*
 Henry Ward Beecher, *20867*
obituary, *16948*
studio processes, 1850, *14668*
Braekeleer, Ferdinand de, 1792-1883
exhibitions
 Paris Exposition, 1855, *18841*
 Troy, New York, 1858, *19818*
obituary, *14895*
Bragdon, Claude Fayette, 1866-1946
Chap-book drawings, *22373*
exhibitions, Architectural League of New York, 1889, silver medal, *15019*
illustrations
 book plate design, *5684*
 book-plate, *12496*
 cover for *Minor Italian Palaces*, *22431*
Bragdon, Emma W., fl.1887
illustrations
 Cor. in Miss Bailey's room, Cowles Art School, Boston, *517*
 scenes and student work of Cowles Art School, *572*
Bragdon, R. H., fl.1882-1884
illustrations
 embroidery designs, *1343*
 screen panel design, *1323*
Brahms, Johannes, 1833-1897
notes, 1897, *23793*
will, *17373*
Braid, François, fl.1854
exhibitions, London, 1854, *21281*
brain
brain collection at Paris Faculty of Medicine, *16667*
casts of animal brains exhibited at Smithsonian Institution, 1896, *16935*
Brainard, Elizabeth Homes Washburn, d.1905
obituary, *13878*
portrait of Archbishop Williams, *12823*
Braith, Anton, 1836-1905
exhibitions, Seventh Regiment Fair, N.Y., 1879, *766*
Kid's playground, reproduced by Prang in chromo, *23529, 23560, 23568*
notes, 1870, *23601*
Bramhall, George W., d.1925
collection, etchings destroyed in fire, 1890, *15221*
Bramhall, Mae St. John
notes, 1895, *16639*
Bramley, Frank, 1857-1915
exhibitions, Royal Academy, 1898, *12734*
illustrations, *After the storm*, *13322*
Bramtot, Alfred Henri, 1852-1894
exhibitions, Salon, 1883, *14888*
illustrations, *Summer holiday*, *4571*
Brandard, Edward Paxman, 1819-1898
illustrations
 Iceberg lake (after R. T. Pritchett), *9095*

Iona (after J. MacWhirter), *10424*
Tynemouth (after Alfred Hunt), *10013*
Brandard, Robert, 1805-1862
etchings, *8545*
Brandegee, Robert Bolling, 1849-1922
exhibitions
Society of American Artists, 1887, *2452, 10789*
Society of American Artists, 1900, *13038*
Society of Independents, 1894, *22540*
Brander, J. C., fl.1899
illustrations, *Crucifixion, 12964*
Brandes, Georg Morris Cohen, 1842-1927
quote, on old age, *13260*
Brandner, Richard, b.1850
sales and prices, 1884, *Columbus in prison, 25033*
Brandt, Carl Ludwig, 1831-1905
director, Telfair Academy, Savannah, *10993*
exhibitions
National Academy of Design, 1883, *1552*
National Academy of Design, 1884, *1879*
illustrations, *Portrait of a lady, 1546*
Portrait of a lady, illustration for *Art Amateur*, 1883, *24569*
whereabouts, 1883, Hastings on the Hudson, *24728*
Brandt, Edward, fl.1898
illustrations, drawing from life, *12146*
Brandt, Josef von, 1841-1928
Tartarenschlacht, 9099
Brandt, Max August Scipio von, 1835-1920
collection, sale, 1893, *16157*
Brandus, Edward, fl.1896-1911
collection
sale, 1896, *5778, 17030*
sale, 1904, *13741*
sale, 1905, *13888*
sale, 1906, *14112*
to be sold, 1896, *16984*
gallery, New York
1899, *6845*
described, 1898, *17405*
imports paintings from Europe, 1902, *8081*
paintings by Millet and Diaz, 1903, *8102*
shows Barbizon School, 1900, *7260*
shows Rose Bonheur, 1900, *7481*
shows Roybet paintings, 1899, *7125*
gallery, Paris
facade described and illustrated, 1901, *7505*
plans to open, 1899, *7153*
Brangwyn, Frank, 1867-1956, *12054*
design for window by Tiffany, *12980*
exhibitions
Chicago Art Institute, 1898, *6545, 12668*
Pittsburgh, 1899, *12976*
Brannan, Sophie Marston, 1878-1962
notes, 1901, *22134*
Bransford, John Francis, 1846-1911
Archaeological Researches in Nicaragua, review, *370*
Branson, Kuhne Beveridge See: **Beveridge, Kuhne**
Branson, William B., *Mrs.* See: **Beveridge, Kuhne**
Branwhite, Charles, 1817-1880
exhibitions, Royal Society of Painters in Water Colours, 1858, *19898*
obituary, *103*
Brascasset, Jacques Raymond, 1804-1867
biography, *20219*
brass
composition, *8230*
polish for brass, *7907*
brass rubbings
collectors and collecting, Day collection, *16178*
brasses
Philadelphia Centennial Exhibition, 1876, *8749*
treatment for brass, *8256*
brasses, English
ecclesiastical brasses by J. H. Singer of Frome, *8541*

Brassey, Annie Allnutt, *baroness*, 1839-1887
In the Trades, the Tropics, and the Roaring Forties, review, *10140*
Sunshine and Storm in the East, or Cruises to Cyprus and Constantinople, review, *9303*
Brassington, William Salt, 1859?-1939
History of the Art of Bookbinding, review, *16639*
brasswork
brass sconce design, *3355*
Flemish tombs and other brasses, *10485*
use in home decoration, *584*
Brattleboro (Vermont)
exhibitions, 1895, art loan exhibition, *22738*
Braucher, W., fl.1902
illustrations, *Child of the slums* (photograph), *13342*
Braun & cie.
Central Art Association's plans to use autotypes, 1894, *11428*
Chefs d'Oeuvre, praise, *22431*
facsimiles of Raphael's drawings, *22392*
publications, praised, 1898, *17410*
reproduction of pictures in color, *17761*
reproductions of paintings, *24981*
Braun, Adolphe, 1811-1877
Authotype process, *10719*
illustrations, photograph of B. Luini's *La Columbine, 21470*
Braun, Clement, & cie See: **Braun & cie.**
Braun, Frederic
collection, sale, 1890, *15186*
Braun, Hermann de
drawings, *10723*
Braun, Ludwig, 1836-1916
Entry of the Grand-duke of Mecklenburg into Orleans, 9099
Braunhold, Louis E., b.1854
illustrator, *13233*
Brauwer, Adrian See: **Brouwer, Adriaen**
Bray (England)
architecture, Ockwells manor and Jesus hospital near Bray, *9725*
Brazilian art See: art, Brazilian
Brazington, William Cary, 1865-1914
elected to board of governors of American Art Association, Paris, 1903, *13701*
Brearly, William Henry, 1846-1909
collection, *15518*
Detroit collector, *3497*
Breasted, James Henry, 1865-1935
lectures on Egyptian art, 1898, *12130*
Breck, George W., 1863-1920
exhibitions, Pratt Institute, 1902, *8051*
illustrations
figure drawing, *3706*
Modelling class in the Art Students' League, 3705
pen sketches (figures), *22486*
Sketcher, 22513
wins American Academy in Rome prize, 1897, *23174*
wins Lazarus Scholarship, 1897, *6136*
Breck, John Leslie, 1860-1899
exhibitions
National Arts Club, 1900, memorial exhibition, *13021*
New York, 1900, *7265*
St. Botolph Club, 1891, *3491*
St. Botolph Club, 1899, *12903*
obituary, *12879*
pupil of Monet, *26108*
reception, Boston, 1893, *26932*
Breckenridge, Hugh Henry, 1870-1937
exhibitions
Carnegie Institute, 1907, *14328*
Cincinnati Art Museum, 1898, *12754*
National Academy of Design, 1903, *13702*
Pennsylvania Academy of the Fine Arts, 1904, *13716*
Society of Washington Artists, 1903, second Corcoran prize, *13578*
illustrations
Autumn, 13851

paintings in Whitney collection, *2108*
paintings in Wolfe collection, *832*
paintings shown at Knoedler's, 1886, *2303*
poetry published, *15718*
portraits, portrait by E. De Liphart illustrated, *3358*
retirement, 1892, *26558*
Romantic painting in France, *22994*
St. John's eve, *3561*
sales and prices
 1886, paintings, *2245*
 1893, pictures in Knoedler collection, *26928*
works in Seney collection, 1891, *3502*
Breton, Virginie See: **Demont Breton, Virginie Elodie**
Brett, John, 1830-1902
exhibitions
 Royal Academy, 1878, *21602, 21613*
 Royal Academy, 1880, *9354, 21850*
 Royal Academy, 1881, *22022*
 Royal Academy, 1883, *24675*
 Royal Academy, 1884, *10039*
 Royal Academy, 1885, *2019*
 Royal Academy, 1889, *2984*
home, house in Putney, London, designed by Martin and
 Chamberlain, *9599*
Brett, Peter, 1834?-1890
obituary, *26111*
Breuer, Henry Joseph, 1860-1932
illustrations, *Mission Canyon, Santa Barbara*, *22167*
notes
 1901, *22134*
 1902, *22161*
work, 1900, *22099*
Breuer, Theodore Albert, b.1870
appointed librarian, American Art Association of Paris, 1898,
 24114
Breughel, Jan See: **Bruegel, Jan**
Breughel, Pieter See: **Bruegel, Pieter**

Breul, Hugo, 1854-1910
director of Round Lake (N.Y.) Summer School of Art, 1895,
 5392
exhibitions, Prize Fund Exhibition, 1886, *25304*
notes, 1899, *17488*
painting portrait of ex-Governor Howard for Providence, 1887,
 583
Breull, Hugo See: **Breul, Hugo**
Brevoort, James Carson, 1818-1887
library, sale, 1890, *3221, 15236*
Brevoort, James Renwick, 1832-1918
Blustery day in November, *24569*
exhibitions
 National Academy of Design, 1858, *19835*
 National Academy of Design, 1859, *20030*
 National Academy of Design, 1881, *342*
 National Academy of Design, 1896, *22996*
landscape, 1883, *24586*
landscape shown at Century Club preview, 1884, *25064*
pen-sketches, *11026*
studies from nature, *19801*
whereabouts, 1883, Yonkers, N.Y, *24728*
Windmills in Holland, *24397*
work, 1883, *24380, 24829*
Brewer, Alice Ham, b.1872
elected to American Society of Miniature Painters, 1902, *13455*
Brewer, Charles H., fl.1897-1898
exhibitions, Chicago Art Students' League, 1898, *12819*
illustrations, student work, *12633*
Brewer, David Josiah, 1837-1910
notes, 1896, *22964*
Brewer, F. Layton, *Mrs.* See: **Brewer, Alice Ham**
BREWER, Henry William, 1836-1903, *9530*
BREWER, J. Harte, *25906*
Brewer, Nicholas Richard, 1857-1949
whereabouts, 1896, studio in St. Paul, *23008*
BREWSTER, Ada Augusta, *22564*

Brewster, Ada Augusta, fl.1893-1901
summer studio, 1893, *22491*
Brewster, Amanda See: **Sewell, Amanda Brewster**
Brewster, Anna Mary Richards See: **Richards, Anna Mary**
Brewster, Benjamin Harris, 1816-1888
library and collection given to Library Co. of Philadelphia,
 1892, *15913*
Brewster, George Thomas, 1862-1943
David, in American Art Galleries, 1884, *1899*
Decatur on Dewey arch, *7096*
exhibitions
 Architectural League of New York, 1890, *15019*
 National Academy of Design, 1886, *25370*
 Society of American Artists, 1887, *2452*
Fountain of Nature at Pan-American Exposition, 1901, *13263*
frieze of fame on Art Palace, St. Louis World's Fair, 1904,
 13775
illustrations, *David before the combat*, *10740*
lectern for chapel of Memorial Presbyterian Church, New York,
 14974
Soldiers' and Sailors' Monument in Indianapolis commission,
 1890, *25929*
statue for Soldiers' Monument, Indianapolis, *22280*
statue of Indiana for Indianapolis monument, 1892, *26752*
teaches class in modelling, Art Students' League, 1886, *516*
teaches life modeling at Art Students' League, 1886, *10754*
Brewster, William Tenney, *Mrs.* See: **Richards, Anna Mary**
Brewtnall, Edward Frederick, 1846-1902
illustrations
 decorative panel, *22001*
 Swanage Bay, *6791*
 Where are you going my pretty maid?, *4377*
Brian, Jean Louis, 1805-1864
statue of Poussin for Andelys, *14780*
Brice, Calvin Stewart, 1845-1898
collection, loan to Lotos Club exhibition, 1884, *1751*
Bricher, Alfred Thompson, 1837-1908, *8547*
Apple-blossoms, *9412*
Autumn and *Spring* reproduced by Prang, 1869, *23551*
exhibitions
 American Art Galleries, 1884, *24988*
 American Art Union, 1883, *In my neighbor's garden*, *10913*
 American Watercolor Society, 1876, *8624*
 American Watercolor Society, 1877, *8805*
 American Watercolor Society, 1880, *827, 9292*
 American Watercolor Society, 1881, *296*
 American Watercolor Society, 1884, *25038*
 Chicago Inter-State Industrial Exposition, 1880, *199*
 National Academy of Design, 1877, *8830*
 National Academy of Design, 1880, *126*
 Prize Fund Exhibition, 1885, *25278*
 Prize Fund Exhibition, 1886, *25304*
 Trans-Mississippi and International Exposition at Omaha,
 Nebraska, 1898, *12775*
illustrations
 In my neighbor's garden, *24509*
 Near Cape Elizabeth, *552*
landscapes reproduced by Prang in chromo, *23560, 23568,*
 23604
landscapes reproduced by Prang in chromo, 1868, *23501,*
 23529
Low tide at Cohasset, anecdote of its purchaser, 1893, *4425*
New Hampshire landscapes,1871, *10617*
notes
 1870, *23601*
 1883, *24657*
 1885, *11273*
painting of Newport garden scene, *813*
portraits, photograph, *22559*
sales and prices, 1891, *Morning at Nahant*, *15646*
seascapes, *22704*
sketches and studies, *9362, 9429*
summer home and studio, *22571*
summer travels, 1879, *703*
views on women's dress, *1257, 1277*

studies, *6198*
study of girl's head, *23611*
Turkish slipper dealer, *8101*
Victor Hugo after death, *2025*
Interesting game, Cairo, *1253*
Interior of a harem, new picture, 1875, *8591*
Ladies of the seraglio taking an airing, shown in New York, 1886, *25346*
Lesson in Arabic, shown in New York, 1884, *25090*
letter on Prize Fund exhibition, 1884, *25171*
Negro fete at Blidah, Algiers, *26382*
notes, 1899, *17465*
painting, 1894, *27014*
pen drawings, *2039*
picture in Waggaman collection, *15382*
pictures in Clarke collection, *24943*
pictures in Evans collection, *15079*
pictures in Seney collection, *24977*
pictures selected for Chicago Exposition, 1883, *24725*
Pirate of love, in New York, 1890, *15173*
prizes, Legion of Honor award, 1889, *3099*
reception, 1881, *9480*
Roumanian lady, gift to Pennsylvania Academy, 1882, *14865*
sales and prices
 1885, Seney collection sale, *1963*
 1891, *A. B. C.* in Seney collection, *15473*
 1899, *12330*, *12879*
studio in Paris and recent paintings, 1877, *8932*
teaching, atelier in Paris for female pupils, 1883, *24413*
whereabouts
 1880, *960*
 1883, summer in Switzerland, *24702*
 1886, Algeria, Tunis, Paris, *2367*
Bridgman, George Brandt, 1864-1943
exhibitions
 Fellowcraft Club, 1890, *26181*
 Salon, 1889, *2985*
Bridgwater, Henry Scott, fl.1888-1934
illustrations, *Georgiana* (after John Downman), *13998*
Bridwell, Harry Loud, 1861-1930
decorative work, *12495*
illustrations, drawing for memorial tablet for Sixth United States Infantry, *12808*
Brien, Jules Félix, fl.1902
illustrations, *Monk's hill, on the Sarthe*, *13444*
Brierly, Oswald Walters, 1817-1894
H.M.S. "Galatea" on a cruise, *8393*
knighted, 1886, *10270*
marine painter, *10422*
brigands and robbers
subject matter of paintings, *14664*
Brigden, W. P., fl.1893-1899
illustrations
 bedroom, *4960*, *5199*, *5589*, *5636*
 dining room, *6415*, *6826*
 drawings of Fenn house, *6040*
 F. Hopkinson Smith's studio, *4854*
 hall of James Reilly residence, *5803*
 interior views of seaside cottage, *6571*
 interiors, *4677*, *4734*, *4820*, *5248*, *5851*, *6599*, *6660*, *6689*, *6796*, *6894*, *6919*, *6942*, *7114*, *7169*
 Japanese reception room, *6477*
 library, *5151*
 Moorish smoking den and corner for a library, *6439*
 Oriental reception room, *6513*
 punch bowl and cup design, *4684*
 set of table glass, *5419*
Briggs, Anne Frances, fl.1901-1910
notes
 1901, *22134*
 1903, *22190*
teaches, 1904, *22203*
Briggs, Charles Frederick, 1804-1877, *18306*
congress, 1899, *12419*

Briggs, T. J.
collection
 Van Marcke forgery, *2504*, *2522*
 Van Marcke painting possibly a forgery, *2448*, *2477*
Briggs, Warren C., 1867-1903
exhibitions, Brooklyn Art Club, 1892, *26501*
BRIGGS, William M., *17706*, *17709*, *17720*, *17737*
Brigham, William Tufts, 1841-1926
exhibitions, Boston Society of Amateur Photographers, 1884, *10899*
Brightly, Henry A., b.ca.1791
illustrations, Chicago statuary (after T. Williams), *10613*
Brighton (England)
exhibitions, 1884, loan exhibition, *10087*
Brigstocke, Thomas, 1809-1881
obituary, *360*
Bril, Paul See: **Brill, Paul**
Brill, Paul, 1554-1626
works, *20980*
Brimmer, Martin, 1829-1896
collection, Millet paintings, *17787*
obituary, *16939*
BRINCKMANN, Justus, 1843-1915, *17873*
Brindley, Charles A., fl.1880-1898
design of border, *9336*
floral designs, *9368*
BRINGHURST, Robert Porter, *12802*
Bringhurst, Robert Porter, 1855-1925
exhibitions
 Chicago World's Fair, 1893, *4565*
 St. Louis, 1895, *11582*
 St. Louis, 1898, *12824*
 St. Louis Exposition, 1894, *5036*
 St. Louis Exposition, 1894, sculpture, *11402*
 Society of Western Artists, 1898, *Sappho*, *12802*
 Society of Western Artists, 1900, *12986*
Fame, for Trans-Mississippi Exposition, 1898, *12145*
illustrations
 Geography and history, *13686*
 Kiss of eternity, *13958*
Kiss of eternity, burns in Portland Fair, 1905, *13996*
Lipelt memorial, unveiled in St. Louis, 1891, *3483*
St. Louis sculptor, 1887, *540*
sculpture classes, St. Louis Museum art school, 1897, *12061*
sculpture for Louisiana Purchase Exposition, 1904, *13685*
statue of Grant for St. Louis, *631*
BRINGIER, Julien, *23633*, *23679*
Brinkley, Captain F. See: **Brinkley, Frank**
Brinkley, Frank, 1841-1912
collection
 sale, 1885, Japanese ceramic ware, *2132*
 sale, 1897, Chinese ceramics, *6425*
 sale of Japanese porcelain, 1894, *4938*
Brinkmann, Carlotta
illustrations, *Tapestry*, *13516*
Brinkmann, Ida
illustrations, *Tapestry*, *13516*
Brinkmann, J. See: **Brinckmann, Justus**
Brinley, George, 1817-1875
library, sale, 1893, *16204*, *16231*
Brinton, Caroline Peart, 1870-1963
illustrations, *Sea breeze*, *13549*
Brinton, Christian, Mrs. See: **Brinton, Caroline Peart**
Brion, Gustave, 1824-1877
exhibitions, National Academy of Design, 1859, *20128*
illustrations
 Funeral in Venice, *13882*
 illustrations for Hugo's *Jean Valjean*, *22634*, *22656*, *22807*
 illustrations for Hugo's *Les Misérables*, *22677*, *22697*, *22719*, *22746*, *22780*, *22835*
 When the sun rose (from Victor Hugo's *Ninety-Three*), *628*
obituary, *8950*, *8994*
Briot, François, b.1550?
pewter, *20769*

Bromwell, Elizabeth Henrietta, 1859-1949
 exhibitions
 Denver Artists' Club, 1898, *12180*, *12251*, *12822*
 Denver Artists' Club, 1899, *12886*
Bromwell, Henrietta See: **Bromwell, Elizabeth Henrietta**
BRONN, Cecile, *22913*, *22942*, *22967*, *22990*, *23018*, *23040*
Bronnikov, Fedor Andrevich, 1827-1902
 exhibitions, Paris Exposition, 1878, *9096*
Bronson, Samuel L.
 collection
 sale, 1907, *14336*
Bronte, Charlotte, 1816-1855, *18031*
 society and museum established, 1894, *16459*
Brontos, George, fl.1891-1893
 copies of antique sculptures commissioned for Stanford
 University, 1891, *26396*
 statuettes shown in New York, 1893, *26951*
Bronx
 Bronx Park snuff-mill, *7294*
 monuments, monument to be erected to men who died in war
 with Spain, 1901, *7666*
Bronx Botanical Garden, New York See: **New York. New**
York Botanical Garden
Bronx Zoo See: **New York. New York Zoological Society**
bronze
 recipe for bronzing images, *7987*
 superior to marble for public sculptures, *18484*
 treatment, *8256*
bronze casting, *8746*
 American sculpture, *19524*
 Barnard's *Pan* cast, *12779*
 Crawford horse cast in Munich, 1855, *19267*
 history and methods, *20960*, *21585*
 horse for Brown's statue cast, 1856, *19363*
 Kemeys' buffalo head cast by Favy foundry, *599*
 mechanical reduction of antique and Renaissance sculpture,
 25151
 ornamental casting, *20521*
 technique, *1611*, *13686*, *14026*
 cire perdue casting, *5962*
 cire perdue method, *3122*
 "cire perdue" method, *5963*
 description of casting at Novelty Works, 1855, *19278*
 Robinson's new process described, 1855, *18596*
 United States, *14026*
bronzes
 conservation and restoration, incrustations and patinas, *10224*
 Green Vaults, Dresden, *461*
 Philadelphia Centennial Exhibition, 1876, *8749*
 technique, *17742*
bronzes, American
 bronze sculpture, 1898, *17433*
 exhibitions, Tiffany and Co., 1902, *7894*
 statuettes to be distributed by American Art Union, 1849,
 14480, *14542*
bronzes, French
 exhibitions
 Chicago World's Fair, 1893, *4690*
 London, 1887, *10452*
 gilt bronze works, *1520*
 method of manufacture, *743*
bronzes, Japanese
 Chapman collection, *16984*
 method of manufacture, *761*, *9222*
bronzes, Oriental
 H. R. Bishop collection, 1893, *4650*
bronzes, Renaissance
 acquisitions by baroness Adolphe de Rothschild, 1878, *21647*
 copies, *7043*
bronzes, Roman
 statue of emperor Gallus purchased by Metropolitan Museum,
 1905, *13951*
Brooke, Charles, 1804-1879
 invention of self-recording meteorological instruments, *20840*

Brooke, Frances Moore, 1724-1789
 notes, 1896, *16948*
Brooke, Richard Norris, 1847-1920
 notes, 1899, *17516*
 Pastoral visit, 327, *22587*
 pictures in Waggaman collection, *15382*
 Washington artist, *24387*
Brookes, Samuel Marsdon, 1816-1892
 exhibitions
 Chicago Opera House Gallery, 1871, *10653*
 San Francisco, 1870, *10600*
 Peacock, acquired by Mark Hopkins Institute, 1898, *6545*
Brookes, Warwick, 1808-1882
 Warwick Brookes' Pencil Pictures of Child Life, 628
Brooklyn Academy of Design See: **New York. Brooklyn**
Academy of Design
Brooklyn Academy of Music See: **New York. Brooklyn**
Academy of Music
Brooklyn Art Association See: **New York. Brooklyn Art**
Association
Brooklyn Art Club See: **New York. Brooklyn Art Club**
Brooklyn Art Guild See: **New York. Brooklyn Art Guild**
Brooklyn Art School See: **New York. Brooklyn Art School**
Brooklyn Athenaeum See: **New York. Brooklyn Athenaeum**
and Reading Room
Brooklyn Etching Club See: **New York. Brooklyn Etching**
Club
Brooklyn Institute of Arts and Sciences See: **New York.**
Brooklyn Institute of Arts and Sciences
Brooklyn Museum See: **New York. Brooklyn Institute of**
Arts and Sciences
Brooklyn (New York)
 Angelo Club formed, 1890, *25782*
 architecture, Regiment Armory, Empire style of Company H
 room, *5320*
 art, classes, 1891, *3619*
 art collections, *15013*, *15702*
 artists' studios in Bank Building, *26116*
 book and butterfly collectors, *16544*
 City Hall, portraits of mayors, *26475*
 description, *19262*
 exhibitions
 1884, public response, *25116*
 1899, *17516*
 historical records, *17000*
 mayors, portraits, *25109*
 monuments
 memorial arch dedication, 1892, *26790*
 memorial arch for Prospect Park, 1892, *26776*
 memorial statues planned, 1888, *621*
 Soldiers' and Sailors' memorial arch, 1892, *26599*
 Soldiers' and Sailors' monument, *26150*
 statue of Stranaham, *26266*
 statue of Stranahan unveiled, 1891, *26348*
 parks, Superintendent Jones fired, 1892, *26547*
 private libraries, 1893, *16264*
 Prospect Park, destruction of trees, 1887, *25444*
Brooklyn (New York). Adelphi Academy See: **New York.**
Adelphi Academy
Brooklyn (New York). Adelphi Art Association See: **New**
York. Adelphi Art Association
Brooklyn (New York). Adelphi College See: **New York.**
Adelphi College
Brooklyn (New York). Adelphi Sketch Club See: **New York.**
Adelphi Sketch Club
Brooklyn (New York). Black and White Club See: **New York.**
Black and White Club
Brooklyn (New York). Crescent Athletic Club See: **New**
York. Crescent Athletic Club of Brooklyn
Brooklyn (New York). Greenwood Cemetery See: **New York.**
Greenwood Cemetery
Brooklyn (New York). Hamilton Club See: **New York.**
Hamilton Club, Brooklyn
Brooklyn (New York). Hanover Club See: **New York.**
Hanover Club, Brooklyn

Conversation on skates, 22490
Nursery blossoms, 22486
portrait study of Horace Bradley, *3705*
Vassar graduate, 22501
Brouillet, André, 1857-1914
exhibitions, Salon, 1887, *2432, 10463*
Brouwer, Adriaen, d.1638, *21099*
Fumeur, copy on exhibit New York, 1880, *804*
vagabond artist, *20139*
Browere, John Henri Isaac, 1792-1834
life mask of Gilbert Stuart, *375, 1147*
Brown, Abram English, 1849-1909
Beside Old Hearth-stones, review, *12023*
Brown, Agnes Augusta Bartlett, 1847-1932
exhibitions
 American Art Association, 1883, *24398*
 Boston, 1885, *1964*
Brown, Alice, 1857-1948
Mercy Warren, review, *23178*
Road to Castaly, excerpt and review, *12541*
Brown, Alice See: Chittenden, Alice Brown
Brown, Anna Wood, fl.1892-1920
exhibitions
 National Academy of Design, 1892, *4182*
 Woman's Art Club of New York, 1892, *26531*
 Woman's Art Club of New York, 1895, *5260*
 Woman's Art Club of New York, 1896, *Southerners, 5697*
Brown, Arthur Page, 1859-1895?
architect of Princeton Art Museum and other campus buildings,
 633
exhibitions, Architectural League of New York, 1893, *4304*
Brown, Augustus L.
collection, sale, 1887, *566*
Brown, Benjamin Chambers, 1865-1942
exhibitions, Society of Western Artists, 1900, *12986*
Mount Lowe at sunset, accepted at St. Louis Exposition, 1904,
 22201
Brown, Bolton Coit
article on ideal art school, 1892, *26538*
Brown, Brownlee See: Brown, J. G. Brownlee
Brown, Bush See: Bush Brown, Henry Kirke
Brown, Charles Francis See: Browne, Charles Francis
Brown, Charlotte Harding, 1873-1951
exhibitions, Pennsylvania Academy of the Fine Arts, 1901,
 13163
Brown, Edith Blake, fl.1893
designer of Massachusetts stained glass window for Chicago
 World's Fair, 1893, *26931*
Brown, Edward, fl.1883
in charge of sales at Academy, 1883, *24841*
manager of exhibitions at National Academy and at Brooklyn
 Academy, 1883, *24656*
Brown, Edward Hurst
on attractive rooms, *6174*
Brown, Ethel Isadore, 1871-1950
exhibitions, Society of American Artists, 1897, *10538*
illustrations
 After the ball, 22525
 Primer of design, 12604
magazine illustration, 1894, *22517*
Brown, Ford Madox, 1821-1893
artistic supervisor of Henry Irving's *King Lear,* 1892, *26722*
association with Pre-Raphaelite Brotherhood, *17525*
chest of drawers, *3440*
Emigrants, 19150
estate to be sold, 1894, *16556*
exhibitions
 Birmingham, 1891, *26422*
 Century Club, 1893, *26894*
 Chicago World's Fair, 1893, *4604*
 Liverpool Academy, 1856, prize, *19542*
 London, 1897, *17266*
 London Arts and Crafts Society, 1890, *26123*
 National Academy of Design, 1857, *19732*
illustrations, *Leaving England, 26892*

Last of England
 bought for Birmingham Museum, 1891, *26315*
 purchased by Birmingham Museum, 1891, *26310*
Manchester Town Hall decoration
 fresco, *26568*
 frescoes, *9502*
 murals, *26678*
 paintings, *26135*
obituary, *4599, 16329*
Pre-Raphaelite, *12827*
Pre-Raphaelite follower, *19723*
Stage of cruelty, 26126
Victorian artist, *10434*
BROWN, Frances, *20845*
Brown, Frank Chouteau, b.1876
Letters and Lettering, review, *13595*
Brown, Frederick, 1851-1941
apppointed Slade Professor of Fine Arts, 1893, *26888*
exhibitions, New English Art Club, 1892, *26678, 26868*
Brown, G. W.
article in *The Nineteenth Century* on modern French art,
 excerpt, *9391*
Brown, George Loring, 1814-1889, *8926*
Castle of Ischia, 10708
copies after Claude, *23339*
Crown of New England, reproduced by Prang in chromo,
 23551, 23568, 23604
etchings, *433, 10668*
 first American etching, *493*
exhibitions
 Boston, 1882, *1315*
 Boston Art Club, 1878, *9014*
 Boston Museum of Fine Arts, 1893, prints, *16280*
 New York, 1860, *20151*
influence of Claude on work, *17962*
New York at sunrise, 20272
notes
 1860, *18473*
 1870, *23601*
 1871, *10616, 10674, 10675*
painters in Boston, 1879, *794*
painting for the Prince of Wales, *10728*
Scene near Genzano, 10681
Swiss and Italian landscapes, *19850*
whereabouts
 1850, living near Albano, Italy, *14606*
 1857, *19752*
 1860, moves studio, *20237*
wood engravings, *106*
work, 1857, *19667*
BROWN, Gerard Baldwin, *9548, 9793, 9834, 9866, 9879*
Brown, Gerard Baldwin, 1849-1932
Fine Arts, review, *11410*
on Impressionism, 1892, *4078*
Brown, Gertrude See: Dale, Gertrude Brown
Brown, Glenn Madison, b.1876
calls for city planning advisory board for Washington D.C.,
 1907, *14271*
BROWN, Grace S., *22892, 22915, 22950, 23050, 23067, 23159*
BROWN, H. M., *22831*
Brown, Harrison B., 1831-1915
whereabouts, 1858, painting in White Mountains, *19913*
Brown, Helen Cheney, fl.1891-1915
exhibitions
 Palette Club of Chicago, 1892, *11307*
 Palette Club of Chicago, 1895, *11467*
Brown, Henry Box See: Brown, Harrison B.
Brown, Henry E., fl.1883-1886
pamphlet on perspective, 1883, *1667*
Perspective: The Brown Acme System, review, *24727*
BROWN, Henry Kirke, *18235, 18860*
Brown, Henry Kirke, 1814-1886
appointment to Art Commission, Washington, D.C., 1859,
 18319, 20051
art offered to Newburgh by nephew, 1888, *25528*

Detroit Art Loan Exhibition, 1883, *24826*
East Side Art League, 1892, *26701*
Internationale Kunstausstellung, Munich, 1883, *1835*
Louisville's Southern Exposition, 1883, *24760*
Milwaukee Industrial Exposition, 1898, *Be mine*, *12800*
National Academy of Design, 1875, *8424*, *8441*
National Academy of Design, 1880, *111*, *889*
National Academy of Design, 1881, *342*, *1129*
National Academy of Design, 1882, *1330*
National Academy of Design, 1884, *1772*, *1790*, *1879*
National Academy of Design, 1885, *1970*, *25271*
National Academy of Design, 1886, *10754*
National Academy of Design, 1887, *2431*, *25437*
National Academy of Design, 1890, *3228*
National Academy of Design, 1894, *4706*
National Academy of Design, 1897, *To decide the question*, *6248*
New York, 1892, and sale, *3894*
New York, 1893, *16316*
Paris Exposition, 1878, *9072*
Prize Fund Exhibition, 1885, *1985*, *25278*
Prize Fund Exhibition, 1886, *25304*
Royal Academy, 1880, *913*
Seventh Regiment Fair, N.Y., 1879, *766*
Trans-Mississippi and International Exposition at Omaha, Nebraska, 1898, *12775*
Union League Club of New York, 1890, *26155*
Union League Club of New York, 1891, *26224*
Far away, engraving published by Klackner, 1883, *24897*
First cigar, *23300*
Happy moments, in Kneeland collection, *15647*
Help me over, *24502*
illustrations
 Castles in Spain, *10788*
 Cozy corner in the barn, *13547*
 Heels over head, *11971*
 I aint no mugwump, *12787*
 Independence, *4752*
 Just before the extra is out, *22576*
 Maid of the hills, *13202*
 Making a soaker, *13746*
 Merry tune but a sad heart, *5577*
 My great-grandmother and I, *24509*
 Pegged out, *2641*
 Puzzled, *5108*
 Still courting, *13827*
 To decide the question, *12015*
 Young fisherman, *22560*
interview, 1894, *5089*
Little Bo-Peep, chromo inspires poem by L. L. A. Very, *23584*
Longshoreman's noon, *11896*
Lost child, *1234*
Noon at the docks, *813*
notes
 1870, *23601*
 1883, *24817*
 1887, *611*
paintings in Evans collection, *11185*
picture shown in Brooklyn, 1893, *26916*
pictures, 1883, *24541*
pictures at Chicago World's Fair, 1893, *26901*
pictures in Clarke collection, *24943*
pictures in Evans collection, *15079*
pictures of New York street boys, *22526*
Playing mother, reproduced by Prang in chromo, *23568*, *23604*
Poor corner, reproduced in *Review of Reviews*, 1892, *26497*
Queen of the woods and *Little Bo-Peep*, chromos by Prang, *23599*
quote, on art centers for American art students, 1902, *7804*
resigns as president of American Watercolor Society, 1904, *13739*
sales and prices
 1885, Seney collection sale, *1963*
 1891, *26270*
 1891, *In ambush*, *15646*

1892, *15811*, *26495*
satire, *14042*
sketches and studies, *9346*, *9429*
small boy subject, 1883, *24513*
Spat, in Seney collection, *24977*
Three romps, inspires poem by E. Marble, *23596*
Three tom-boys and *The maiden's prayer*, reproduced by Prang in chromo, 1870, *23576*
whereabouts
 1879, summer travels, *703*
 1883, New York State, *24728*
 1890, return to New York from the country, *26143*
 1893, summer, *22491*
Winter sports, in Hart-Sherwood collection, *792*
work, 1883, *24657*, *24856*
work, 1892, *26839*
Brown, John Lewis, 1829-1890
anecdote, *3985*
exhibitions
 American Art Galleries, 1886, *2189*, *25290*
 New York, 1896, *5615*
 Société d'Aquarellistes Français, 1884, *1756*
 Société des Pastellistes Français, 1887, *566*
illustrations
 Huntress, *7460*
 pictures in French Watercolor exhibition, 1884, *1758*
 sketches adapted for fan decoration, *1955*
 wash drawing, *2229*
obituary, *26153*
painting exhibited without permission, *26666*
paintings in Stewart collection, *10768*, *25406*
use of varnish, 1892, *3909*
BROWN, John, M.D., *20307*, *20312*, *20333*
Brown, John, M.D.
quote, on art, *20325*
Brown, Katharine R. See: **Browne, Kate R.**
Brown, Lucy Madox See: **Rossetti, Lucy Madox Brown**
Brown, Matilda See: **Browne, Matilda**
Brown, Maynard, fl.1878-1902
exhibitions, Royal Academy, 1883, *14892*
BROWN, Olive, *24982*
BROWN, Ralph, *9904*
Brown, Robert E., fl.1899-1904
exhibitions
 Chicago, 1899, miniatures, *12333*
 Chicago Art Institute, 1902, *13370*
portrait miniatures, *12104*
Brown, Sarah, d.1896
obituary, *16987*
Brown, Thomas, fl.1871-1887
illustrations
 Christ in the house of his parents (after J. E. Millais), *9764*
 Emperor Maximilian and Albert Dürer (after G. Köller), *10445*
 Feast of cherries (after B. Foster), *8602*
 Harvest of the sea(after G. Clausen), *9276*
 Huguenot (after J. D. Linton), *9162*
 Returning from communion (after P. R. Morris), *10082*
 Shrine in the forest (after W. Q. Orchardson), *8631*
 Taking home the bride (after J. D. Watson), *9560*
 Venetian fruit seller (after L. Fildes), *9465*
 Weal and woe (after C. Gregory), *9607*
 Weary (after E. Radford), *8802*
Brown, Thomas Allston, 1836-1918
books on American theater, *16331*
Brown, Thomas Austen, 1857-1924
exhibitions, Royal Scottish Academy, 1887, *10430*
Brown University Library See: **Providence (Rhode Island). Brown University. Library**
Brown, Walter Francis, 1853-1929
exhibitions
 Prize Fund Exhibition, 1886, *25304*
 Salon, 1880, *913*
 Salon, 1884, preparation, *1738*
Venice, morning of the carnival, etched by Stephen Parrish for

BRUSH, Edward Hale, *13287, 13920*
Brush, George de Forest, 1855-1941
class in pottery, *13108*
elected academician, National Academy of Design, 1901, *13228*
exhibitions
American Art Galleries, 1884, *24988*
Carnegie Galleries, 1902, *13520*
Carnegie Galleries, 1907, *14328*
Chicago Inter-State Industrial Exposition, 1889, *3056*
Lotos Club, 1899, *17467*
Louisiana Purchase Exposition, 1904, *13787*
National Academy of Design, 1886, *10754, 25370*
National Academy of Design, 1888, *2680, 25516*
National Academy of Design, 1890, *3228*
National Academy of Design, 1907, *14266*
New York, 1886, *10754*
New York, 1892, *26622*
New York, 1900, *Holy Family, 7265*
Pennsylvania Academy of the Fine Arts, 1898, *Mother and child, 6532*
Pennsylvania Academy of the Fine Arts, 1900, *13007*
Pennsylvania Academy of the Fine Arts, 1902, *13363*
Pittsburgh, 1899, *12976*
Prize Fund Exhibition, 1885, *Laying away a brave, 25278*
Prize Fund Exhibition, 1889, *2960*
Salmagundi Club, 1884, *I want to ask you a favor, 25211*
Society of American Artists, 1880, *94, 844, 9324*
Society of American Artists, 1884, *Picture writer, 11003*
Society of American Artists, 1887, *2452, 10789, 25451*
Society of American Artists, 1889, *2986*
Society of American Artists, 1892, *3986*
Society of American Artists, 1906, *14095*
Union League Club of New York, 1890, *25779*
Union League Club of New York, 1892, *3925, 26552*
Hallgarten prize, 1888, *25507*
illustrations
Mother and child, 13087
River god, 17742
Silence broken, 10828
instructor, Cooper Union's Woman's Art School, 1892, *26808*
member of art jury, Tennessee Centennial, 1896, *11843*
Mother and child, 4872
in Boston Museum of Fine Arts, *13073*
purchased by M. Sears, 1893, *22483*
Mourning her brave, in Clarke collection, *11207, 24943*
notes, 1883, *24502*
paintings of his increasing family, *13016*
picture in Evans collection, *15079*
Picture writer's story, 25047
quote, *10550*
recommended by McKim, Meade & White to decorate Boston Public Library, *22738*
response to survey on world's greatest masterpieces, 1898, *12732*
sales and prices
1894, *Mother and child* bought by Sears, *26999*
1899, painting in Clarke collection, *12871*
studio reception, 1884, *25079*
whereabouts, 1890, winter in Algiers, *26134*
Brush, Henry T., d.1879
obituary, *18*
Brush, J. A., fl.1899
exhibitions, Photographers' Association of America Convention, 1899, *12937*
Brussels (Belgium)
antiquities, discovery of Christian relics, 1890, *26064*
conference to promote and regulate exchange of reproductions of works of art, 1885, *10246*
exhibitions
1859, German art, *20092*
1860, work of living artists, *24359*
1892, snow sculpture, *26496*
1902, Sillon group, *13537*
fete artistique ball, 1850, *14607*
Mont des Arts project, 1903, *13545*

monuments
column in honor of Congress and the constitution, *20143*
monument in honor of National Congress of 1830, *14697*
Waterloo monument unveiled, 1890, *26052*
palace of Duke of Arenberg destroyed by fire, 1892, *26518*
Palace of Justice completed, 1883, *9919*
Brussels (Belgium). Académie des sciences, des lettres et des beaux-arts de Belgique
prize essays, 1855, *18556*
prizes for applied art, 1903, *13701*
Brussels (Belgium). Bibliothèque royale de Belgique
discovery of niellos in an album, 1857, *10274*
Brussels (Belgium). Cercle artistique et littéraire
exhibitions, 1905, old Brussels art, *13898*
Brussels (Belgium). Exposition générale des beaux arts
1851, *14795, 14809*
1854, *21369*
1878, *21653*
1887, committee decisions on awards and exclusions, *10515*
1903, site selection, *13516*
Brussels (Belgium). Exposition nationale, 1880
Belgian china painting, *21954*
Belgian manufactures, *21939*
Brussels (Belgium). Musée Ancien
exhibitions, 1890, portraits by masters of present century, *25806*
Brussels (Belgium). Musée Wiertz
collection, *224*
description, *17463, 21788*
Brussels (Belgium). Musées royaux des beaux-arts de Belgique
catalogue of collection published, 1906, *14239*
collection, *10139*
Brussels (Belgium). Palais royale
Hall of Golden Fleece planned by Duke of Brabant, *19872*
Brussels (Belgium). Salon triennal des beaux arts See: **Brussels (Belgium). Exposition générale des beaux arts**
Brussels (Belgium). Société de l'oeuvre
activities, *12841*
Bryan Gallery of Christian Art See: **New York. Bryan Gallery of Christian Art**
Bryan, Michael, 1757-1821
Dictionary of Painters and Engravers
review of new edition, *13677*
review of third volume, *13742*
Bryan, William Edward, b.1876
illustrations
Painted from life, 13637
painting, *8289*
Bryan, William Jennings, 1860-1925
anecdote, regarding father, *23111*
Democratic presidential nominee, 1896, *23091*
portraits, commissions Ralph Clarkson to paint portrait, 1898, *12662*
Bryant, Everett Lloyd, 1864-1945
exhibitions, Philadelphia Sketch Club, 1906, *14237*
Bryant, John, fl.1890's
collection
minerals, *16227*
Bryant, Marie Hungerford See: **Mackay, Marie Hungerford**
BRYANT, William Cullen, *18405, 18570, 18596, 18834, 19659, 20251, 22453*
Bryant, William Cullen, 1794-1878
address, Century Association, 1859, *19973*
eulogy for Thomas Cole, 1848, excerpt, *14446, 14460*
excerpts, on art in Switzerland, *19714*
Forest Hymm, review, *20305*
home, summer residence at Cedarmere, N.Y, *8700*
landscape images in his poetry, *18553*
letter from Rome, 1858, *19872*
letters, *19802*
monuments, bust for Central Park proposed by Century Club committee, 1893, *26966*
Picturesque America, wood engravings, *137*
Poems, illustrated edition, 1857, *19645*

poems for *New York Ledger*, *18321*
poetry on nature, *9089, 9117, 9130, 9171*
portraits
 bust for Central Park, 1893, *26969*
 engraving by A. Jones and S. A. Schoff (after A. B. Durand), *19942*
 statuette, *748*
 Sella, *8725*
 testimonial vase, *8436*
 whereabouts, 1857, departs for Europe, *19658*
BRYCE, F. G. S., *3684, 3776, 3882, 3911, 3942, 4057, 4087, 4123, 4207, 4302, 4334, 4416*
Bryce, F. G. S., fl.1891-1893
 illustrations
 interior decoration illustration, *4370*
 screen and armchair, *3684*
Brymner, William, 1855-1925
 exhibitions, Pan-American Exhibition, Buffalo, 1901, *13276*
Bryn Mawr (Pennsylvania). Bryn Mawr College
 exhibitions, 1891, works of D. G. Rossetti and E. Burne-Jones, *26314*
Brysakis, Theodoros Petros, 1814-1878
 notes
 1893, *16421*
 1894, *16532, 16556*
 1895, *16707*
Bryson, J. Ross, fl.1894-1895
 notes, 1895, *11521*
 portrait of J. G. Leonard, *27016*
 whereabouts, 1895, trip to Europe, *11615*
Buberl, Casper, 1834-1899
 bas-reliefs for Troy monument, *26391*
 dies while at work on Dewey arch, 1899, *7098*
 model for statue for Confederate Monument of Richmond, *26999*
 Soldiers' and Sailors' Monument in Buffalo, *24722*
 terra-cotta frieze on monument to soldiers, Hartford, Conn., 1885, *1983*
Buccleuch, Walter Francis Montagu-Douglas-Scott, *5th duke*, 1806-1884
 collection, sale, 1887, *540*
Buchanan, Charles W., 1854-1921
 illustrations, Memorial art gallery and club house, *12385*
Buchanan, James, *pres. U.S.*, 1791-1868
 appoints members to the Art Commission, 1859, *18319*
 monuments, monument in Mercerberg, Pennsylvania, 1903, *8279*

Buchanan, Robert Williams, 1841-1901
 Effie Hetherington, review, *12521*
 Lady Clare, New York performances, 1884, *1752*
 Martyrdom of Madeline, excerpt, *11042*
Buchdrucker, Anna Marie See: **Valentien, Anna Marie Bookprinter**
Büchel, Eduard, 1835-1903
 illustrations, *Othello* (after H. Hofmann), *9148*
 portrait study (after F. A. Kaulbach), *458*
BUCHER, Bruno, *56*
Buchot, Henri See: **Bouchot**
BUCK, Dudley, 1823-1909, *10557*
BUCK, John Henry, *20400*
Buck, John Henry, 1849-1914
 See also: **Huss & Buck, architects**
 Old Plate, Ecclesiatical, Decorative and Domestic, publication announcement, *15408*
Buck, Lawrence, 1865-1929
 exhibitions, Chicago Architectural Club, 1899, *12887*
 illustrations, *Chateau*, *11543*
Buck, Lillie West Brown See: **Leslie, Amy**
Buckborn, Edward
 illustrations, carved panel, *12918*
BUCKHAM, John Wright, *23086*
Buckingham, Sue A. See: **Moulton, Sue Buckingham**
Buckingham, William Alfred, 1804-1875
 monuments, statue by O. L. Warner, *9658*

Buckle, Henry Thomas, 1821-1862
 History of Civilization in England, review, *19726*
Buckley, Jeannette, fl.1894-1919
 Chicago landscape painter, *11416*
Bucklin, William Savery, 1851-1928
 illustrations
 Beeches, *568*
 Fruitful economy, *22590*
Buckman, Edwin, 1841-1930
 exhibitions, Dudley Gallery, 1880, *21780*
Buckner, Richard, fl.1820-1877
 illustrations, *Mlle. Rosa Bonheur*, *18195*
Budapest (Hungary)
 description of Pesth, 1855, *18588*
Budapest (Hungary). Szépmüvészeti Mùzeum
 acquisitions
 1896, by director Pulski, *16953*
 1896, scandal over Pulsky's acquisitions, *16968*
 thefts, 1897, *17346*
Budd, Charles Jay, 1859-1926
 illustrations
 Dusty Doolittle in Maine, *22501*
 In the ante-room, *22482*
 Unloading Hudson River boats, *22546*
 models, favorite model, *22519*
 portraits, photograph, *22518*
 whereabouts, 1893, summer, *22491*
Budd, Katherine Cotheal, fl.1899-1925
 exhibitions, Chicago Architectural Club, 1899, *12887*
 illustrations, *Sand dunes at Southampton, N.Y.*, *5038*
Buddha and Buddhism
 birthplace of Buddha, *17218*
 Buddha relics found, 1895, *16740*
 Kalmuck religious customs, *21286*
 pillar excavated traces origin of Buddhism, 1896, *17053*
Buddhist art and symbolism
 Buddhist statue in Kamakura, Japan, *17527*
 footprints of Buddha Shakkya-Mouni, *21296*
Budworth, William Sylvester, 1861-1938
 studio fire, 1893, *22521*
Buehr, Karl Albert, d.1952
 Chicago landscape painter, *11416*
 exhibitions
 Chicago Art Institute, 1896, *11894*
 Chicago Art Institute, 1902, *13370, 13536*
 Chicago Art Institute, 1903, *13561*
 Chicago Art Students' League, 1897, *12643*
 Cosmopolitan Club, Chicago, 1897, *12064*
 Society of Western Artists, 1903, *13698*
 Society of Western Artists, 1906, *14038*
 illustrations
 Loom, *13542, 13805*
 Reverie, *13785*
 study in oil, *12658, 12681*
Buehr, Karl Albert, *Mrs.* See: **Buehr, Mary Guion Hess**
Buehr, Mary Guion Hess, d.1962
 exhibitions, Chicago Art Students' League, 1897, *12643*
Buell, Alice, fl.1885
 exhibitions, American Art Galleries, 1885, *1921*
Buell, Charlotte See: **Coman, Charlotte Buell**
BUELL, James Ford, *13345, 13536, 13673*
Buell, Sarah Josepha See: **Hale, Sarah Josepha Buell**
Buena Yerba See: **Yerba Buena**
Buetler, Joseph See: **Bütler, Joseph Nikolaus**
Buff, Sebastian, 1829-1880
 obituary, *150*
Buffalo Bill's Wild West Show
 Paris, 1891, *26386*
Buffalo (New York)
 artists
 1851, *22452*
 commercially unviable for artists, *13658*
 propose exhibition offering art at low prices, 1891, *26402*
 collectors and collecting, *15825, 16710*
 exhibitions

Bunn, Fanny, fl.1896-1921
 illustrations, book plate, *22398*
Bunn, George, fl.1887
 exhibitions, Prize Fund Exhibition, 1887, *562*
Bunner, Andrew Fisher, 1841-1897
 Dutch windmills and Venetian scenes, *22743*
 exhibitions
 American Watercolor Society, 1880, *9292*
 National Academy of Design, 1880, *126*
 Pennsylvania Academy of the Fine Arts, 1880, *142*
 Philadelphia Society of Artists, 1882, *1270*
 Salmagundi Club, 1880, *73*, *247*
 Salmagundi Club, 1882, *1265*
 illustrations
 Palazzo Widmann Venezia, *1300*
 Salmagundi Club invitation sketch, *1041*
 Summertime in New England, *1330*
 notes, 1871, *10678*
 obituary, *17383*
 sales and prices
 1885, Seney collection sale, *1963*
 1891, *Evening in Dordrecht*, *15646*
 whereabouts, 1884, Venice, *25032*
Bunner, Henry Cuyler, 1855-1896
 author for book-collectors, *15437*
 Poems of H. C. Bunner, excerpt and review, *12595*
 Woman of Honor, novel of society life, 1883, *24805*
Bunner, Rudolph F., 1860-1931
 exhibitions
 American Watercolor Society, 1885, *25239*
 American Watercolor Society, 1887, *25409*
 American Watercolor Society, 1890, *25777*
 In doors, *22503*
 whereabouts, 1893, summer, *22491*
Bunney, John Wharlton, 1828-1882
 exhibitions, Fine Art Society, 1883, *9734*
 Venice views, *9786*
Bunny, Rupert Charles Wolston, 1864-1947
 exhibitions
 American Art Association of Paris, 1898, *24043*
 American Art Association of Paris, 1899, *12890*
Bunsen, Christian Karl Josias, *Freiherr* von, 1791-1860
 God in History, prophesies, *20057*
Bunting, Annie E., fl.1892
 studio reception, 1892, *26841*, *26851*
Bunyan, John, 1628-1688
 biography, *20831*
 Pilgrim's Progress
 panorama, *14711*
 panorama, 1850, *14657*
 portraits, *16996*, *17027*
 relics, silver tankard once belonging to Bunyan in Illinois collection, *16022*
 Some Gospel Truths opened according to the Scriptures, acquired by British Musuem, *15352*
Buonacorsi, Pietro See: **Perino del Vaga**
Buonarroti, Michelangelo See: **Michelangelo Buonarroti**
BURBANK, Elbridge Ayer, 1858-1949, *13114*
Burbank, Elbridge Ayer, 1858-1949
 biographical sketch, *11417*
 exhibitions
 Chicago, 1897, *12613*
 Chicago, 1898, *12202*
 Chicago Art Institute, 1895, *11673*
 Chicago Art Institute, 1896, *11894*
 Chicago Art Institute, 1897, *12042*
 Chicago Art Institute, 1897, Indian portraits, *6468*
 Chicago Society of Artists, 1892, *11308*
 Chicago Society of Artists, 1895, *11483*
 Cosmopolitan Club, Chicago, 1895, *11465*
 Cosmopolitan Club, Chicago, 1896, *11776*
 National Academy of Design, 1896, *11909*
 Society of Western Artists, 1898, *12802*
 Society of Western Artists, 1900, *12986*
 German town scenes, *22626*

His favorite wine, *22731*
 illustrations
 Anticipation, *11694*
 Antiquarian, *23152*
 Chief Bear Claw Crow, *7473*
 Chief Geronimo. Apache, *12825*
 Chief Joseph. Nez Perces, *12807*
 Gate of an old German city-wall, *22645*
 Gi-aum-e Hon-o-me-tah. Kiowa, *12795*
 He-See-O, a Zuni belle, *13829*
 Hong-ee. Moqui, *12933*
 Ko-pe-ley. Moqui, *12905*
 Little May, *11694*
 Negro playing a banjo, *11421*
 Old German houses, *22610*
 Quen-chow-a. Moqui, *12923*
 Siem-o-nad-o. Mojave, *12878*
 Si-We-Ka. Pueblo, *12860*
 Si-you-wee-teh-ze-sah. Zuni, *12889*
 Skyward, *22590*
 Wick-Ah-Te-Wah. Moqui, *12843*
 Zi-you-wah. Moqui, *12917*
 Indian paintings, *12826*
 in Ayer collection, *6312*
 shown in Chicago, 1899, *12423*
 Indian portraits, *6503*, *6527*, *11977*, *12774*
 letter from Fort Sill, 1897, *11957*
 letter on Moqui Indians, 1898, *6551*
 paintings of the Negro, *11637*
 pastels, *11934*
 study of the Indian, *12002*
 whereabouts
 1895, Vicksburg, *11570*
 1897, travels to Fort Sill to paint Indians, *11947*
 1898, returns to Chicago from far West, *12769*
Burbank, James, d.1873
 Angel delivering Daniel from the lion's den, *1005*, *8735*
BURBANK, William Henry, b.1853, *2812*, *2832*, *2848*, *2868*, *2894*, *2944*, *2971*, *2997*, *3024*, *3042*, *3064*, *3085*, *3110*, *3139*, *3165*, *3189*, *3214*
BURBURY, Selina, *21341*, *21367*
Burchett, Richard, 1815-1875
 obituary, *8497*
Bürck, Paul, b.1878
 illustrations, head studies, *13659*
Burckhardt, Jakob Christoph, 1818-1897
 Cicerone, review, *58*
 Civilisation of the Period of the Renaissance in Italy, review, *21651*

Burd, Edward Shippen, ca.1778-1848
 monuments, monument by Steinhauser to Burd's children, *23405*
Burden, Evelyn, fl.1902
 illustrations, design for rug, *13445*
Burdett Coutts, Angela Georgina Burdett-Coutts, *baroness*, 1814-1906
 provides housing for poor in London, *20341*
BURDETTE, Clara Bradley Baker, b.1855, *12378*
Burdette, Hattie Elizabeth, 1872-1955
 prize, Washington Water-Color Club, 1904, *13729*
BURDICK, Horace Robbins, 1844-1942, *22362*
Burdick, Horace Robbins, 1844-1942
 exhibitions
 National Academy of Design, 1886, *508*
 Prize Fund Exhibition, 1886, *25304*
 illustrations, decorative initial, *508*
Bureau of American Ethnology See: **United States. Bureau of American Ethnology**
Burgeon, Adelbert Joseph
 China Painting
 relates china painting to human condition, *4490*
 review and excerpts, *4475*
Burger, Johannes, 1829-1912
 illustrations, *Violante* (after Palma il Vecchio), *68*

Burger, Lina Schröder, b.1856
 illustrations
 Hops for copying on china, *7535*
 Music, *7813*
Burgers, Hendricus Jacobus, 1834-1899
 Duo, 9675
 picture in Bullock collection, *15121*
Burges, William, 1827-1881
 exponent of Gothic principles in design, *10438*
 home
 and collection, *10348*
 designed by architect himself, *10297*
 house on Melbury Road, *943*
 obituary, *383, 21895*
 Victorian architect, *10439*
Burgess, Edward, fl.1880-1888
 illustrations, design for dining-room in Elmhurst, Reading,
 England, *2836*
Burgess, Ethel K., fl.1898-1907
 exhibitions, London, 1898, *24114*
 illustrations, *Token, 24213*
Burgess, Gelett, 1866-1951
 In Janson Type (poem), *22373*
Burgess, Harry George, fl.1884-1915
 exhibitions, American Art Association, 1884, *25209*
Burgess, Ida Josephine, d.1934
 decoration of Orrington Lunt library, 1894, *27014*
 exhibitions, Society of Western Artists, 1906, *14038*
 illustrations, *Fearless, 11302, 11420*
 interior decoration studio, Chicago, 1897, *11982*
 murals for library, 1895, *11590*
 murals for library, Northwestern University, *11486*
 murals for Northwestern University, Chicago, 1894, *5075*
 paintings, 1901, *13302*
Burgess, John Bagnold, 1830-1897, *9415*
 Childhood in Eastern life, 21636
 exhibitions
 Royal Academy, 1878, *21602*
 Royal Academy, 1879, *21723*
 Student in disgrace, 9629
Burgess, Ruth Payne Jewett, 1865-1934
 illustrations, Newcomb embroidery, *13909*
Burgos (Spain). Catedral, *20822*
Burgschmiet, Jakob Daniel, 1796-1858
 obituary, *19872*
Burke, Edmund, 1729-1797
 Essay on the Sublime and Beautiful, critique, *19340*
 on the sublime, *19410*
Burke, Miss, fl.1884
 whereabouts, 1884, study in Paris, *10893*
Bürkel, Heinrich, 1802-1869
 At one hour's distance from Rome, 19853
Bürkner, Hugo, b.1818
 illustrations, *Toilette* (after A. Ludwig), *8991*
Burlamacchi, L., *marquesa*
 Luca della Robbia, review, *13172*
BURLEIGH, LeMoyne, *10618, 10648*
Burleigh, Sydney Richmond, 1853-1931
 exhibitions
 American Watercolor Society, 1884, *25023*
 American Watercolor Society, 1885, *1933, 25239*
 American Watercolor Society, 1888, *2641*
 Kansas City Art Club, 1902, *13337*
 illustrations
 Princess, 22588
 Thank you kindly, sir, she said, 24904
 Winter evening, 22610
 summer home and studio, *22571*
BURLEIGH, William Henry, *18428*
Burling, Gilbert, 1843-1875
 obituary, *8406*
Burlingame, Charles Albert, 1860-1930
 portraits, photograph, *22580*
 Up for repairs, 22503
Burlington Fine Arts Club, London See: **London (England).**

Burlington Fine Arts Club
Burlington Gallery, London See: **London (England).**
 Burlington Gallery
Burlington House, London See: **London (England). Royal
 Academy of Arts**
Burlington (Vermont)
 Elbert Hubbard lecture on Rembrandt, 1899, *17666*
 monuments, statue of Gen. Stannard unveiled, 1891, *26375*
Burnand, Eugène, 1850-1921
 illustrates Daudet's *Contes Choisis, 15357*
 illustrations, *Alpine ball, 2018*
Burne Jones, Edward, 1833-1898, *6699, 12213, 12428*
 Adoration of the Magi, 26135
 baronetcy conferred, 1894, *4832, 16482*
 Bell's *Sir Edward Burne-Jones*, review, *4307, 21488*
 Charity, 592
 Cophetua and the beggar maid, 17688
 decorator, *2093*
 design for window, *25669*
 designer, *10438*
 drawings, *9496*
 in Luxembourg Museum, *22320*
 Earth rise, from the moon, 26376
 Edward Burne-Jones, a Record and Review, published, 1892,
 16014
 elected Associate Royal Academician, 1885, *10185*
 elected to San Luca Academy of Arts, Rome, 1894, *26997*
 exhibitions
 Birmingham, 1891, *26422*
 Boston, 1884, photographs of works, *1883*
 Chicago World's Fair, 1893, *4653*
 Grosvenor Gallery, 1878, *21594, 21604*
 Grosvenor Gallery, 1879, *9178, 21708*
 Grosvenor Gallery, 1880, *9356, 21863, 21961*
 Grosvenor Gallery, 1883, *9828*
 Grosvenor Gallery, 1884, *10012*
 Grosvenor Gallery, 1887, *25442, 25455*
 London, 1883, *24615*
 London, 1886, *2225*
 London, 1890, *26059*
 London, 1895, *22359*
 London, 1896, *17016, 17165*
 London Arts and Crafts Society, 1890, *26123*
 New York, 1899, *17538*
 New York and Philadelphia, 1893, *4286*
 Paris Exposition, 1878, *9024*
 Salon, 1893, *Perseus* and *Depths of the sea* confused, *4490*
 Salon, 1895, *5375*
 Société Nationale des Beaux Arts, 1892, *4042*
 Syracuse Museum of Fine Arts, 1901, *13209*
 Golden stair, 4082, 4393
 illustrations
 Cupid and Psyche, 3770
 designs for outline embroidery, *10286*
 figure drawing, *3507*
 first page of Chaucer (Kelmscott edition), *12511*
 fragment of a painted window in Trinity Church, Boston,
 2096
 Furies (study for the masque of Cupid), *12184*
 Musica (design for needlework), *21803*
 Ruth, 3790
 stained glass windows for L. L. Lorillard mansion (draw-
 ings), *4081*
 studies of heads, *4079, 13764*
 study of a head in oils, *3830*
 Vestal virgin, 11938
 illustrations for Chaucer painted by R. Catterson Smith, *6872*
 King Arthur designs for Henry Irving, *22320*
 Legend of the Briar Rose, 26003, 26201
 four paintings, *25890*
 photogravures published, 1892, *15998*
 Love among the ruins, damaged, 1893, *16371*
 Marriage of Psyche, 16984
 at Boussod, Valadon & Co., 1896, *23008*
 noted pictures, *12212*

Cincinnati Art Museum, 1898, *12754*
Cincinnati Art Museum, 1900, *13067*
National Academy of Design, 1907, *14311*
Worcester Art Museum, 1904, *13803*
illustrations
decorative initial, *22419, 22421, 22426, 22427*
figure drawing, *3726*
Sancta Agnes, *23675*
sketches, *3725*
title-page for *Modern Art*, *22418*
notes, 1897, *6139*
Paris Prize, 1891, *26433*
wins Chanler prize, 1891, *3813*
Burroughs, Bryson, Mrs. See: **Burroughs, Edith Woodman**
Burroughs, Edith Woodman, 1871-1916
exhibitions
Architectural League of New York, 1897, *10535*
National Academy of Design, 1907, *14311*
Burroughs, John, 1837-1921
Whitman, a Study, review, *23178*
Burrows, Julius Caesar, 1837-1915
notes, 1896, *22896*
Burt, Charles Kennedy, 1823-1892
Anne Page, slender, and shallow (after C. R. Leslie), *14601*
Ball play of the Dahcota Indians (after Eastman), *14711*
exhibitions
Grolier Club, 1896, engravings, *17154*
Grolier Club, 1896, proof impressions, *5927*
Game of chess (after Woodville), *14759*
illustrations
Attainer of Strafford (after E. Leutze), *14573*
Disputed game (after T. Hinckley), *14624*
First love (after J. T. Peele), *14654*
Henry Inman (after C. L. Elliott), *14652*
landscape (after A. B. Durand), *14814*
On the wing (after Ranney), *14680*
Knight of Sayn (after E. Leutze), *14646*
prints in Library of Congress, 1898, *12806*
Putnam narrating the capture of the she-wolf (after T. F.
Hoppin), *14736*
Queen Mary signing the death warrant of Lady Jane Grey
(after D. Huntington), *14339, 14344, 14351, 14359, 14367,
14387*
Burt, E. C., fl.1883
collection, water colors by Blum and Crane acquired, 1883,
24817
Burt, Edith Noonan See: **Noonan, Edith**
Burt, Helen, fl.1871-1883
summer studio, Minetto, N.Y, *24777*

Burt, James, fl.1835-1849
Willow brook, in the collection of the American Art Union,
1849, *14589*
Burt, James M.
collection, sale, 1857, *19752*
Burt, Stanley Gano, Mrs. See: **Noonan, Edith**
Burtin, François Xavier de, 1743-1818
Traité des Connaissances Necessaires à l'Amateur de Tableaux,
excerpt on Dietrich, *21206*
BURTON, Charles Pierce, *12815*
Burton, Elizabeth L., fl.1901-1905
mural for John Sartain Public School, Philadelphia, 1905,
13936
Burton, Frederick William, 1817-1900
obituary, *22096*
Burton, H. Darwin
Paul Nugent, Materialist, review, *3386*
Burton, John
collection, bequeathed to York, 1884, *10069*
BURTON, Mary E., *11861*
Burton, Mungo, 1799-1882
obituary, *9766*
Burton, Richard, 1861-1940
Dumb in June, excerpt and review, *12541*

Burton, Richard Francis, 1821-1890
Arabian Nights
editions, *16639*
illustrated by Stanley Wood, *15241*
Kasidah, or Lay of the Higher Law by Haji Abdu El Yezdi,
excerpts, *12582*
obituary, *26187*
Burton, William Shakespeare, b.1830
illustrations, *Word's gratitude*, *13484*
Burty, Philippe, 1830-1890
collection
sale, 1891, *15513, 26357*
sale of etchings and lithographs expected, 1889, *3035*
criticism of etching, *10795*
notes on *Exposition des Peintres-Graveurs*, 1890, *3227*
obituary, *15279, 25980*
*Vingt-Cinq Dessins de Eugène Fromentin, Reproduits à l'Eau-
Forte par E. L. Montefiore*, publication, *8981*
Bury, Catherine Maria Dawson See: **Charleville, Catherine
Maria Dawson Bury, lady**
Busch Reisinger Museum of Germanic Culture See:
**Cambridge (Massachusetts). Harvard University. Busch-
Reisinger Museum of Germanic Culture**
Buscher, Sebastian, b.1849?
St. Martin and the beggar, for St. Martin's church, Chicago,
22787
Bush Brown, Henry Kirke, 1857-1935
address to Architectural League of America, 1899, excerpt,
13005
exhibitions, National Academy of Design, 1882, *1330*
Hull on Dewey arch, *7096*
illustrations
Buffalo hunt, *4603*
Horace Mann, *13684*
notes, 1896, *23038*
offers uncle's art to city of Newburgh, 1888, *25528*
sculpture for Louisiana Purchase Exposition, 1904, *13685*
sketch model for statue of General Sherman, 1896, *22958*
statuary group for a fountain, *23174*
summer home and studio, *22571*
whereabouts, 1896, Newburg-on-the-Hudson, *23008*
Bush Brown, Henry Kirke, Mrs. See: **Bush Brown, Margaret
Lesley**
Bush Brown, Margaret Lesley, 1857-1944
exhibitions
Architectural League of New York, 1897, *23213*
National Academy of Design, 1891, *26313*
Bush, Charles Green, 1842-1909
exhibitions, American Watercolor Society, 1882, *1300*
illustrations, *Gardner's favorite*, *1537*
BUSH, E. T., *14077*
BUSH, Luella, fl.1894-1899, *3505, 6891, 6928*
Bush, Norton, 1834-1894
exhibitions, Boston, 1887, *528*
Bushby & Macurdy, photographers
photographs, *493*
Bushmen art See: **art, San (African people)**
Bushnell, Cordelia See: **Plimpton, Cordelia Bushnell**
Bushnell, Stephen Wootton, 1844-1908
Oriental Ceramic Art, review, *22431*
Busi, Luigi, 1838-1884
Visit to the young mother, *21802*
Busk, E. M., fl.1873-1889
illustrations, *Psyche*, *21602*
Busley, Jessie, 1869-1950
performance in *Two Little Vagrants*, 1897, *23170*
Bussière, Gaston, 1862-1929
illustrations, *Ophelia*, *7352*
busts
how to pack a bust, *549*
portrait busts, *5125*
technique, *10217*
Buti, Enrico See: **Butti, Enrico**
Butin, Ulysse Louis Auguste, 1838-1883, *1718*
illustrations

Byers, Alexander McBurney, 1827-1900
 collection, *15388*
 paintings in Carnegie Institute annual exhibition, 1902, *13520*
Bynner, Edwin Lassetter, 1842-1893
 Begum's Daughter, review, *3353*
Byrne, J. F., fl.1903
 illustrations
 painting, *8289*
 Painting from life, *13637*
BYRNS, Arthur G., *13319, 14149, 14187*
Byrns, Arthur G., fl.1901-1906
 poster design, *13319*
BYRON, George Gordon Noël Byron, *6th baron*, 1788-1824, *19417*
Byron, George Gordon Noël Byron, *6th baron*, 1788-1824
 anecdote, *17219*
 Childe Harold, excerpt on Coblentz, *21256*
 Earl of Lovelace to edit edition, 1896, *17102*
 gondolier, Venice, *11040*
 insensibility to architecture, *9726*
 letters, *16273*
 life by Trelawny, *18128*
 monuments, models for memorial, *8776*
 portraits, portrait by Raeburn, *6092*
 relics
 bracelet with lock of hair sold, 1896, *17053*
 collectors and collecting, *16257*
 sale, 1899, *7005*
 Sardanapalus and Myrrha, *18359*
 views on nature and art, *18312*
Byron, Joseph, 1846-1923
 illustrations, scenes from a play (photographs), *22833*
Byzantine decoration See: **decoration and ornament, Byzantine**

C

C., *1775, 10725, 17841, 19074, 19386, 19578, 19606, 20021, 20088*
C., A. P., *18277, 18299, 18331, 18404, 18445, 18537*
C., C., *14297, 23353, 25328, 25361, 26328, 26604, 26786*
C., E. H., *13395*
C., E. I., *13876*
C., E. K., *808*
C. et B. (mongram), fl.1850's
 illustrations, *Karavellas and other Turkish vessels, 21010*
C., F., *19256*
C., F. N., *14248*
C., F. R., *9115, 13585*
C., H., *13190*
C., I. C., *18898*
C., J., *13774*
C., J. E., *21517*
C., J. (monogram J.C.)
 illustrations, London buildings, *21809*
C., J. S., *12840*
C., M., *24078*
C., M. E., *8625, 23864*
C., N. P., *20079, 20121*
C., P. A., *18118*
C., R., *13546, 13602, 13761, 13906, 13943, 13965, 13999, 14083, 14189, 14265, 14313, 14331*
C., R. N. Y., *14151*
C., S. L., *14135*
C., S. M., *18620*
C., S. N., *14000*
C., T., *14041*
C., T. S., *639, 644, 24468*
C., V., *17539*

C., W., *18592, 18667, 20260*
C., W. I., *2091*
C., W. L., *10318, 10383*
C., W. W., *8646*
Cabanel, Alexandre, 1823-1889, *9203*
 art in Paris, 1876, *8623*
 Birth of Venus, poem inspired by, *23199*
 classical painting, *22969*
 Disgrace of Vashti, *9405*
 exhibitions
 National Academy of Design, 1898, *17443*
 Paris Exposition, 1878, *9034, 21662*
 Paris Exposition Internationale, 1883, *14919*
 Paris Exposition Nationale, 1883, *1680, 2987*
 Salon, 1880, *173, 9355*
 Salon, 1883, *1568, 9838*
 Salon, 1885, *2000*
 Salon, 1887, *2449, 10463*
 Seventh Regiment Fair, N.Y., 1879, *766*
 illustrations
 Birth of Venus, *5830*
 Patrician of Venice, *1348*
 monuments, monument in Montpensier unveiled, 1892, *26872*
 notes, 1884, *1801*
 obituary, *2889, 17866*
 painting in collection of H. C. Gibson, 1891, *3500*
 painting in Seney collection, authenticity questioned, *25264*
 paintings in his atelier, 1875, *8382*
 paintings in progress, 1880, *9432*
 paintings in Wolfe collection, *832*
 Paris studio, 1879, *9217*
 Portia
 at International Art Gallery, 1890, *15246*
 engraved by Jacquet, *15162*
 Portia, Nerissa and Bassanio, in Schaus collection, *15840*
 portrait of Miss Ogden, *1671*
 president of jury of Paris Salon, 1881, *1143*
 Shulamite, in Wolfe collection, *25436*
 wall paintings in Pantheon, Paris, *17887*
 works, 1879, *9165*
Cabasson, A. H. See: **Cabasson, Guillaume Alphonse Harang**
Cabasson, Guillaume Alphonse Harang, 1814-1884
 illustrations
 Father explaining the bible to his children (after Greuze), *20930*
 five illustrations from paintings by David, *21150*
 Melancholy (after Dürer), *20981*
 Painting (after S. Bourdon), *21279*
 Paul preaching at Ephesus (after E. Le Sueur), *20984*
 Wreck of the Medusa (after Géricault), *20982*
Cabat, Nicolas Louis, 1812-1893
 obituary, *16218*
CABELL, Isa Carrington, b.1860, *10759*
Cabianca, Vincenzo, 1827-1902
 exhibitions
 Dudley Gallery, 1880, *21828*
 Rome, 1876, *8675*
 Royal Academy, 1880, *21885*
 Royal Academy, 1881, *22022*
Cable, Frances A. See: **Cox, Frances A. Cable**
CABLE, George Washington, 1844-1925, *12562*
cables, submarine
 invention by Morse, *19899*
Cabot, Edward Clarke, 1818-1901
 exhibitions, Boston, 1887, *2602*
Cabot, George E., 1861-1946
 exhibitions, Boston Society of Amateur Photographers, 1884, *10899*
Cabot, James Eliot, 1821-1903
 gifts to Boston Athenaeum, 1858, *19930*
Cabot, John, 1450-1498
 memorial, *17368*
Cabot, Lilla See: **Perry, Lilla Cabot**
Cachoud, François Charles, 1866-1943
 illustrations, *Twilight at Bouvans, 13444*

bust of Horace Greeley presented to Press Club of New York, 1891, *26356*
bust of Robert Burns, *15422, 23008, 26184*
bust of Scott completed, 1896, *22980*
medallion and bust, 1883, *24541*
portrait bust on view in New York, 1891, *15783*
portraits, photograph, *22539*
statue of Robert Burns, *26165, 26322*
 for Albany, *2559*
Calverly, Charles See: **Calverley, Charles**
Calvert, Albert Frederick, 1872-1946
Moorish Remains in Spain, review, *14084*
Calvert, Frederick Crace, 1819-1873
paper on laws of color, 1851, *22463*
Calvert, Leonard, 1606-1647
monuments
 Baltimore, *26322*
 St. Mary's City monument dedicated, 1891, *26356*
Cambiaso, Luca, 1527-1585
Dancing children, *9580*
notes, 1895, *16869*
Cambon, Charles Antoine, 1802-1875
obituary, *8572*
Cambridge (England). Cambridge Antiquarian Society
exhibitions, 1891, *26250*
Cambridge (England). Cambridge University
collection
 old college plate, *9804*
 portraits, *9957*
Cambridge (England). Cambridge University. Fitzwilliam Museum, *8573*
acquisitions
 1892, *26591*
 1893, Bulwer collection, *26939*
Charles Waldstein elected director, 1883, *9919*
Walter Kidman Foster bequest, *26403*
Cambridge, George William Frederick Charles, *duke* of, 1819-1904
collection
 sale, 1905, *13899*
 swords, *16878*
Cambridge (Massachusetts)
architecture, Holmes house, *10901*
description, 1855, *18824*
monuments, statue of Charles Sumner modeled by Anne Whitney offered, 1903, *13537*
Cambridge (Massachusetts). Cambridge Art Circle
meeting, 1892, *26607*
Cambridge (Massachusetts). Fogg Art Museum See: **Cambridge (Massachusetts). Harvard University. William Hayes Fogg Art Museum**
Cambridge (Massachusetts). Harvard Art Club
exhibitions, 1879, *9110*
Cambridge (Massachusetts). Harvard University
acquisitions
 1884, Chester Harding portrait of Samuel Rogers, *25047*
 1887, gifts of old plate, *20400*
 1890, miniature on silver of George Washington, *25806*
 1894, World's Fair maps, *16473*
 1902, gift of plaster casts presented by Kaiser of Germany, *13503*
art, 1900, *13041*
art history courses at Harvard College, 1875, *8444*
buildings
 class of 1874 memorial window by E. E. Simmons, *13003*
 window for Memorial Hall designed by E. Simmons, *26693*
College commencement photograph, 1887, *592*
Department of Fine Arts
 art classes, 1883, *24716*
 condemns Holman Hunt painting, 1881, *1089*
expeditions, H. A. Ward's expeditions, 1897, *17287*
Gray collection of prints, *10608*
Harvard students' campus vandalism after defeating Yale in base-ball, 1890, *25934*
Latin play to be produced, 1893, *26923*

lectures, Garland lectures on art, 1893, *16419*
music library, *17101*
musical instructor appointed at Harvard College, *18950*
President Eliot portrait by Hardie, *25950*
professional bias in instruction, *13510*
relics found, 1896, *17137*
statues
 John Harvard defaced, 1884, *25196*
 John Harvard statue by D. C. French, *12983*
Cambridge (Massachusetts). Harvard University. Botanical Museum
Ware collection of Blaschka glass models of flowers, *16387*
Cambridge (Massachusetts). Harvard University. Busch-Reisinger Museum of Germanic Culture
acquisitions, 1906, sandstone pulpit from German king, *14223*
opened, 1903, *13563*
solicits gifts from Germany, 1905, *13976*
Cambridge (Massachusetts). Harvard University. Library
building
 enlarged, 1895, *16806*
 need for space, 1890, *26108*
collection
 books on fish and fishing, *17222*
 Louisville cross stolen, 1895, *16878*
Cambridge (Massachusetts). Harvard University. Museum of Comparative Zoölogy
acquisitions
 1893, Scott bird collection, *16428*
 1895, Scott bird collection, *16800*
Cambridge (Massachusetts). Harvard University. Peabody Museum of Archaeology and Ethnology
acquisitions, 1895, Dana library, *16728*
collection, gems, *17115*
description, 1879, *18*
exhibitions
 1896, A. C. Hamlin tourmaline collection, *16905*
 1897, Hemenway archaeological collections, *17233*
notes, 1881, *468*

Cambridge (Massachusetts). Harvard University. Semitic Museum
opened, 1891, *26348*
Cambridge (Massachusetts). Harvard University. William Hayes Fogg Art Museum
acquisitions
 1896, photos, *17024*
 1898, Gray collection of engravings transferred from Boston Museum of Fine Arts, *12780*
 1900, Forbes gift of Italian paintings, *13145*
 1905, casts of Julius Caesar busts, *13837*
building, nears completion, 1895, *16828*
collection, statue of Meleager most notable large sculpture in United States, *13739*
exhibitions, 1904, casts of Julius Caesar portraits, *13810*
Cambridge (Massachusetts). Massachusetts Institute of Technology See: **Boston (Massachusetts). Massachusetts Institute of Technology**
Cambridge (Massachusetts). Old Cambridge Photographic Club
exhibitions, 1902, *13379*
Cambridge (Massachusetts). Semitic Museum See: **Cambridge (Massachusetts). Harvard University. Semitic Museum**
Cambronne, Pierre Jacques Etienne, *baron* de, 1770-1842
role at Battle of Waterloo, *16805*
cameo glass
history and technique, *17707*
cameos, *8549*
collectors and collecting, *16145*
Camera Club, New York See: **New York. Camera Club**
camera obscura, *21487*
sketching aid, *5252*
cameras
detective cameras, *2868*
lens, diaphragm and swingback, *2894*

perfect shutter, *2549*

Cameron, Anna Field, 1849-1931
silver candelabra present to Omaha Public Library Association, *11616*

Cameron, David Young, 1865-1945
exhibitions
New York, 1895, *5262*
New York, 1902, *7873*
Glasgow School painter, *22394*
illustrations, *Palace of Joannis Darius* (etching), *13703*
work at Keppel & Co., 1895, *11686*

CAMERON, Edgar Spier, *11919, 12964, 13230, 13274, 13447*

Cameron, Edgar Spier, 1862-1944
exhibitions
Chicago, 1897, *11957*
Chicago, 1898, St. Joe vistas, *12251*
Chicago Art Institute, 1902, *13370*
Chicago Art Institute, 1903, *13561*
Chicago Artists' Exhibition, 1899, *12310*
Cosmopolitan Club, Chicago, 1897, *12064*
illustrations
Court at Cermaise (drawing), *12031*
Night on the ocean, *13367*
studies, *13230*
lectures on composition at Chicago Art Academy, 1897-8, *12631*
member of international jury of awards, Paris Exposition universelle, 1900, *13059*
Niagara in winter, travelling to American cities, 1893, *26945*
paintings, *13246*
pastels, *11934*
quote, urging development of collections of American art, *12861*
sales and prices, 1898, Chicago, *12701*
teacher at School of Illustration, Chicago, *12964*

Cameron, Edgar Spier, *Mrs.* See: **Cameron, Marie Gélon**

Cameron, James, 1816-1882
Boneyard, Prisoner of Chilon, at Philadelphia Art-Union, 1849, *21404*

Cameron, Katherine, 1874-1965
struggle for European training, *697*

Cameron, Marie Gélon, fl.1896-1940
exhibitions
Chicago Art Institute, 1902, *13370, 13536*
Chicago Artists' Exhibition, 1899, *12310*
Society of Western Artists, 1896, *11919*
illustrations
Hallowe'en, *13561*
Spinning girl, *12063*

Camesina, Albert, 1806-1881
obituary, *454*

Camm Brothers, firm
stained glass windows, *9082*

Campana di Cavelli, Giovanni Pietro, *marchese*, 1808-1880
collection
Rome, *20078*
sale, 1880, *1023*
obituary, *240*

Campana, Domenic Mathews, b.1871
exhibitions, Chicago Ceramic Association, 1902, *13357, 13511*
illustrations, *Vestals*, *13912*

CAMPBELL, Ada Honorah, *22840*

Campbell, Bartley Theodore, 1843-1888
Separation, New York performance, 1884, *1733*

Campbell, Blendon Reed, 1872-1969
notes
1902, *22161*
1903, *22176*

Campbell, Charles William, 1855-1887
obituary, *25455*

CAMPBELL COPELAND, Thomas, *22836*

Campbell, Edward Morton, 1858-1911
exhibitions, Society of Western Artists, 1900, *12986*
illustrations, *Sunlight in the woods*, *11582*
still-life department, St. Louis Museum art school, 1897, *12061*

Campbell, Frank, *Mrs.*
medium, *20668, 20726*

Campbell, Georgine, 1861-1931
American woman painter, *11230*

Campbell, Gertrude Elizabeth Blood, *lady*, d.1911
portraits, portraits by Duveneck and Whistler, *2364*
quote, review of Sargent, 1900, *13071*

Campbell, James, 1828-1903
exhibitions, Society of British Artists, 1856, *19420*

Campbell, John H., 1821-1896
collection, theater souvenirs, *17098*

Campbell, Julia See: **Keightley, Julia Campbell Verplanck**

Campbell, Patrick, *Mrs.*, 1865-1940
as Lady Macbeth, *24206*

CAMPBELL, Pearl Howard, *12936*

Campbell, R. J.
illustrations, *Turning a new leaf*, *13405*

Campbell, Rose, fl.1902-1935
exhibitions, Oakland, 1903, *22176*

Campbell, V. Floyd, d.1906
obituary, *14125*

Campera, Alexis See: **Compera, Alexis**

Camphausen, Wilhelm, 1818-1885
Düsseldorf school, *14602*
Escape of Charles after the battle of Worchester, in Dusseldorf Gallery, 1850, *14657*
exhibitions, New York, 1849, *14508*

camping
description, 1897, *23198*
landscape painter's camping trip to an isolated lake, *11053*

Campion, Howard, *Mrs.* See: **Campion, Sarai M.**

Campion, Sarai M., fl.1878-1885
exhibitions
London, 1883, *1572*
Prize Fund Exhibition, 1885, *Winter - Brittany*, *25278*

Camuccini, Vincenzo, 1773-1844
paintings in collection of Cardinal Fesch, *14653*

Canada
description, 1855, *19088*
publication of *Picturesque Canada*, 1881, *1038*

Canadian art See: **art, Canadian**
Canadian artists See: **artists, Canadian**
Canadian interior decoration See: **interior decoration, Canadian**
Canadian medals See: **medals, Canadian**

CANALE, *18300*

canals
England, *23048*

Canby, William Marriott, 1831-1904
herbarium, bought for New York City College of Pharmacy, 1893, *16147*

Cancalon, L. Victor
Histoire de l'agriculture depuis les temps les plus reculés jusqu'à la mort de Charlemagne, review, *19746*

candelabra
descriptions and illustrations of Louis XVI candelabras, *4266*
English testimonial candelabrum, *8487*
silver candelabrum given to Cluny Macpherson, *9961*

candlesticks
Dr. Dresser candlesticks, *493*

Canedy, Grace, fl.1899-1904
awards in drawing and painting at N.Y. School of Art, 1899, *12844*

Canella, Giuseppe, 1837-1913
Bibliophile, engraved by S. A. Edwards, 1893, *16211*

canes
collectors and collecting, malacca canes, *15748*

Canfield, Mary See: **Gifford, Mary Canfield**
Cangiaci, Luca See: **Cambiaso, Luca**

Cannedy, Miss, fl.1896-1898
conducts summer school, Chicago Athenaeum, 1898, *12181*
instructor at Benton Harbor Art League, 1896, *11913*

Cannes (France)
description, *9913*

described by former pupil, 1892, *26741*
director of French School at Rome, 1904, *13817*
elected president, Société nationale des beaux arts, 1898, *6841*,
 12255
election as president of Champs de Mars causes secession,
 1899, *17688*
exhibitions
 Cercle Artistique, 1876, *8637*
 Cercle Artistique, 1879, *9135*
 Cercle Artistique, 1880, *9325*
 Cercle des Mirlitons, 1878, *8992*
 Chicago World's Fair, 1893, *4567*
 Chicago World's Fair, 1893, portraits, *22258*
 National Academy of Design, 1894, *5174*
 National Academy of Design, 1895, *Portrait of Duchess of
 Marlborough*, *5567*
 New York, 1893, *Odalisque*, *26921*
 New York, 1899, *6925*, *17538*
 New York, 1899, poor reviews, *12879*
 Paris, 1875, *8382*
 Paris, 1884, *1756*, *1791*
 Paris Exposition, 1878, *9034*
 Pittsburgh, 1899, *12976*
 Rome International Exhibition of Fine Arts, 1905, *13966*
 Royal Academy, 1886, *Miss Robbins*, *2225*
 Royal Academy, 1887, *2480*
 Royal Academy, 1898, *6644*, *12734*
 Salon, 1877, *8858*
 Salon, 1878, *9036*
 Salon, 1879, *9176*
 Salon, 1880, *9355*
 Salon, 1881, *22017*
 Salon, 1882, *9675*
 Salon, 1883, *9838*, *14888*
 Salon, 1887, *17774*
 Salon, 1889, *2966*
 Salon, 1891, *3649*
 Salon, 1892, *4013*
 Salon, 1902, *13414*
figure painting technique, *5310*
French painter, *23045*
friendship with John S. Sargent, *877*
Hamerton's article, 1894, *27008*
honored at Madrid dinner, 1899, *17655*
illustrations
 First exercize (engraved by Baude), *4598*
 Modjeska, *182*
notes
 1884, *25097*
 1893, *16342*
 1894, *16589*
 1895, *5217*
paintings in Hart-Sherwood collection, *792*
picture of Circassian girl, *1428*
Portrait of Mdlle X, *10244*
Portrait of Mme. Carolus Duran, damaged by fire, 1894, *5115*
portrait of Mrs. G. Gould, *22787*
portrait painting technique, *5234*
portraits, photograph of artist painting for students of Chase Art
 School, *12739*
portraits of American women, *4938*
president of the Société des Artistes Français, 1898, *12826*
quote, on quality of American exhibition at Paris Exposition
 universelle, 1900, *13046*
replaces Gérôme at Academie des Beaux Arts, 1904, *13735*
response to Chanler proposal, 1891, *26348*
students, American students, *24683*
studio
 artist at work, *2752*
 Paris atelier described, 1894, *21508*
teaching, *24683*
 description, 1895, *21518*
 method, *2416*
whereabouts
 1894, America to paint portraits, *5170*

1896-7, to work in America, *6054*
1898, coming to U.S, *12691*
1899, New York, *12292*
1899, sails for Paris from New York, *17571*
Caron de Beaumarchais See: **Beaumarchais, Pierre Augustin
 Caron de**
Caroni, Emanuele, b.1826
 African, *21605*
Carpaccio, Vittore, 1455?-1525?
 depiction of children, *9614*
Carpeaux, Jean Baptiste, 1827-1875
 Danse, to be moved indoors, *13629*
 Four quarters of the world supporting the Earth, *5934*
 notes, 1894, *16553*
 obituary, *8553*
 sales and prices, 1894, statue of Prince Imperial, *27007*
 sculptural decorations of World's Fair buildings, *4433*
 statue of young Prince Imperial of France for sale, 1894, *16586*
Carpenter, Dudley Saltonstall, b.1870
 competitor for Lazarus scholarship, 1897, *23174*
Carpenter, Edward, 1844-1929
 *Angels' Wings: a Series of Essays on Art and its Relation to
 Life*, review, *12925*
Carpenter, Ellen Maria, 1836-ca.1909
 exhibitions, Boston, 1890, *25917*
Carpenter, Francis Bicknell, 1830-1900
 Deathbed of Lincoln, absence of Andrew Johnson in picture
 explained, *2800*
 exhibitions
 National Academy of Design, 1857, *19668*
 National Academy of Design, 1858, *19857*
 New York artists' reception, 1858, *19817*
 International arbitration
 presented to Queen Victoria, 1892, *26485*, *26590*
 presented to Queen Victoria in name of women of U.S.,
 1892, *26607*
 obituary, *13059*
 portrait of Lincoln, *17527*
 *President Lincoln reading the Emancipation Proclamation to
 the Cabinet*, *23323*
CARPENTER, George B., *10630*
Carpenter, Grace See: **Hudson, Grace Carpenter**
Carpenter, Mary Virginia See: **Keenan, Mary Virginia
 Carpenter**
CARPENTER, Newton H., *11792*
Carpenter, Newton H., 1853-1918
 arranges sketching party excursion, 1894, *26999*
 seaside excursions, 1895, *11548*
Carpenter, Richard Cromwell, 1812-1855
 Victorian architect, *10439*
Carpenter, William Henry, 1853-1936
 suggests Dutch book collection for Columbia University, 1899,
 17527
Carpentier, Evariste, 1845-1912
 exhibitions, Pennsylvania Academy of the Fine Arts, 1882,
 1354
Carqueville, William, 1871-1946
 exhibitions, New York, 1902, *13334*
 teacher at School of Illustration, Chicago, *12964*
Carr, Adelia, fl.1887
 notes, 1887, *611*
CARR, J., *13746*
CARR, Lyell, *22570*
Carr, Lyell, 1857-1912
 depiction of life in the South, *22551*
 exhibitions
 National Academy of Design, 1886, *2352*
 National Academy of Design, 1892, *11302*
 National Academy of Design, 1896, *22996*
 Pennsylvania Academy of the Fine Arts, 1882, *1450*
 Prize Fund Exhibition, 1885, *25278*
 Society of American Artists, 1894, *22540*
 Feeding the calf, in Montross collection, *25418*
 illustrations
 By the cabin window, *22546*

Friendship, 22576
Taking a snack, 22576
This is the dog, 22590
Three-mule cotton team, 22610
notes, 1883, *24492*
painting, 1883, *24551*
Rendez-vous: Saturday, 24423
summer teaching, Milford, Ct, *24703*
summer work, 1882, *24367*
whereabouts
 1883, France, *24728*
 1883, Paris, *24871*
 1883, sails for France for a year, *24762*
 1883, to go to Europe, *24568*
Young Jersey, 24829
in Louisville's Southern Exposition, 1883, *24760*
Carr, Robert, *earl of Somerset* See: **Somerset, Robert Carr, earl of**
Carracci, Annibale, 1560-1609
Farnese palace decorative figures, *2027*
illustrations, *Hope, 20818*
Madonnas, *23136*
Carrara (Italy)
description of marble mines, *24722*
quarries, *10666*
Carré, Albert, 1852-1938
candidate to head Opéra-Comique, Paris, 1898, *24021*
Carré, E. A., fl.1897
library, sale, 1897, *17295*
Carreño, Teresa, 1853-1917
pianist, *23154*
Carrère & Hastings, architects
designs for Cathedral of St. John the Divine, *25697*
exhibitions, Architectural League, 1889, design for Protestant Cathedral, *25693*
monument to Pres. McKinley, Buffalo, *13676*
win competition for Academy of Design and New York Public Library, 1897, *12071*
Carrère, John Merven, 1858-1911
See also: **Carrère & Hastings, architects**
declines office of Supervising Architect of the Treasury, 1895, *21521*
letter on American architecture in T Square Club, Philadelphia, exhibition catalogue, 1899, *12870*
carriages and carts
exhibitions, Chicago World's Fair, 1893, *4511*
Lord Mayor's State coach, 1757, *26185*
Russian carriages, *20803*
Spanish diligence, *21234*
Turkey, araba, *21050*
Carrier Belleuse, Pierre, 1851-1933
exhibitions, Milwaukee Industrial Exposition, 1898, *12800*
illustrations, Sèvres porcelain, *13653*
Carriera, Rosalba, 1675-1757
anecdote, *14789*
pastellist, *4836, 10334*
Carrière, Eugène, 1849-1906
Dead Christ, acquired by Museé national du Luxembourg, *13643*
exhibitions
 Salon, 1889, *2966*
 Salon, 1891, *3649*
 Salon, 1895, *5375*
obituary, *14111*
Carriès, Jean Joseph Marie, 1855-1894
essay by Stanley, 1894, *16546*
exhibitions, Salon, 1892, *4013*
French ceramicist, *16789*
notes, 1892, *15910*
Carrillo, Job, fl.1881-1885
notes, 1883, *24791*
Carrington, James Yates, 1851-1892
obituary, *26668*
Carroll, Lewis, 1832-1898
Alice's Adventures in Wonderland, with illustrations by P.

Newell, review, *13347*
Carroll, Thomas B.
collection, sale, 1883, *1549*
Carrouges (France)
Castle, 15th century chasuble and mitres, *20920*
CARSON, Andrew Carlisle, *23081*
Carson, Pirie, Scott & Co., Chicago
furnishings, 1894, *11338*
Carspecken, George Louis, 1884-1905
exhibitions, Worcester Art Museum, 1902, *13483*
Carstairs, Charles S., 1865-1928
name cleared from association with Pittsburgh forgeries, 1894, *16577*
CARTAULT, A., *25873*
Carter, Charles Milton, 1853-1929
exhibitions, Denver Artists' Club, 1898, *12706*
illustrations, headpiece and initial, *105*
whereabouts, 1894, returns to Denver after travel in East, *27014*
Carter, Charles William, 1832-1918
exhibitions, Royal Academy, 1887, *10473*
photographs, *22541*
Carter, Dennis Malone, 1820-1881
altarpiece, New York, 1871, *10731*
exhibitions, New York, 1859, *19978*
obituary, *428, 9528*
sales and prices, 1858, Romney collection sale, *19957*
Carter, Frank A. See: **Carter, Freeland A.**
Carter, Freeland A., fl.1894
Escaping from Fort Fisher, 22501
illustrations
 Easy types, 22560
 sketches, *22564*
 ten-minute sketch, *22576*
 Tired, 22560
 Weary, 22560
models, favorite model, *22519*
Carter, Henry See: **Leslie, Frank**
Carter, James Coolidge, 1827-1905
portraits, portrait by J. S. Sargent, *13021*
Carter, John G., fl.1880-1884
exhibitions
 Boston, 1880, *258*
 Boston, 1881, *1046*
 Boston, 1883, *24896*
Hunt's assistant on Albany capitol frescoes, *917*
portrait of Col. Moore, 1884, *25106*
CARTER, Judge, *24313*
CARTER, Kate, *12483, 22588*
Carter, Lizzie Hedley, fl.1870's-1880's
illustrations
 Col. Issac E. Eaton and attendant spirits, 20712
 Col. Matt. Clary and attendant spirits, 20701
 Portrait of Carrie Miller and unknown spirits, 20679
 Portrait of Dr. L. H. Nason of Chicago, the medium of the Ancient Band and attendant spirit, 20671
spirit photographer, *20664, 20665, 20670*
Carter, P. J., fl.1894
illustrations, sketch, *11423*
CARTER, Susan Nichols, *8719, 8749, 8805, 8855, 8893, 8993, 9002, 9035, 9084, 9123, 9132, 9136, 9150, 9201, 9244, 9251, 9284, 9324*
Carter, Susan Nichols, fl.1876-1893
American woman painter, *11230*
Drawing and Painting in Black and White, review, *11640*
lady artist of New York, 1880, *915*
teacher, Free Art School for Women of Cooper Union, *24716*
Carter, Walter Steuben, 1833-1904
collection
 etchings and engravings exhibited at Union League Club, Brooklyn, 1891, *3524*
 prints, *26879*
Carthage
antiquities, excavations, 1899, *17702*
Cartier, Jacques, 1491-1557
voyage to America, 1535, *20903*

Cartland, G. P., fl.1880's-1890's
 illustrations, Queen's dogs, *10449*
Cartwright, Julia See: **Ady, Julia Cartwright**
CARUS, Paul, *22337*
Carus, Paul, 1852-1919
 essay on philosophical and religious significance of art, *22346*
 illustrated books on Buddhism, *12689*
Carvaille, Léon, 1825-1898
 collection, sale, 1890, *15279*
Carvalho See: **Carvaille, Léon**
Carver, Benjamin F.
 collection, sale, 1880, *46*
carving (decorative arts)
 Chinese carved fruit stones, *15982*
 sailors carve tusks, etc, *15988*
 shells, *10512*
 tea-root, *15841*
 technique, carving coconut shells, *6636*
CARY, Alice, *18223*, *18358*, *18457*, *18500*, *18525*
Cary, Alice, 1820-1871, *18122*
Cary, Constance See: **Harrison, Constance Cary**
Cary, Florence See: **Koehler, Florence Cary**
Cary, Francis Stephen, 1808-1880
 obituary, *83*
Cary, George, d.1945
 design of New York State building for Pan American
 Exposition, 1900, *7313*
CARY, Phoebe, *18459*, *18501*
Cary, Robert
 agent for Sharples' portraits of Washington, *10763*
Cary, William De La Montagne, 1840-1922
 exhibitions, American Exhibition, London, 1887, *25464*
 studio reception, 1884, *25079*
Casa Buonarroti See: **Florence (Italy). Casa Buonarroti**
Casado del Alisal, José., 1830-1886
 exhibitions, Madrid Salon, 1884, *10902*
Casanova, Francesco Giuseppe, 1727-1802
 notes, 1895, *16715*
Casanova, Giovanni Battista, 1730?-1795
 notes, 1895, *16715*
Casanova, Giovanni Jacopo, 1725-1798
 notes, 1895, *16715*

Casanova y Estorach, Antonio, 1847-1896
 biographical note, *16510*
 exhibitions, Salon, 1882, *1352*
 illustrations
 Girlhood of Mme Pompadour, *1594*
 Theologian, *1812*
 painting in Mannheimer collection, 1896, *16989*
 paintings in Prado, *9136*
 Stop your crying, in Munger collection at Chicago Art Institute,
 12785
Case, John Watrous, 1864-1937
 director of new department of architecture at Detroit Art
 School, 1899, *12859*
Case, Lyman W., 1828?-1892
 obituary, *15897*
Casella, Bertha Gabriella, 1858-1946
 Casella sisters revive art of wax miniatures, *3618*
Casella, Julia, fl.1891
 Casella sisters revive art of wax miniatures, *3618*
Casella, Louise Cornelia, 1860-1950
 Casella sisters revive art of wax miniatures, *3618*
Casenelli, Victor See: **Casnelli, Victor**
Casilear, John William, 1811-1893, *8581*
 exhibitions
 American Art Union, 1883, *10913*
 National Academy of Design, 1851, *14748*
 National Academy of Design, 1855, *18705*, *18727*
 National Academy of Design, 1856, *19379*
 National Academy of Design, 1859, *20030*, *20048*
 National Academy of Design, 1860, *20208*
 National Academy of Design, 1861, *20354*
 National Academy of Design, 1883, *24480*

 National Academy of Design, 1885, *25271*
 New Bedford, 1858, *19891*
 New York, 1859, *19978*
 Pennsylvania Academy of the Fine Arts, 1857, *19658*
 illustrations
 Peconic, Long Island, *13250*
 Roger's slide, Lake George (drawing), *11068*
 Sibyl (after D. Huntington), *316*
 Lake Dunmore, *20237*
 lake scene, 1861, *20330*
 mountain studies, 1855, *19201*
 notes, 1887, *603*
 obituary, *22505*
 paintings, 1855, *18670*
 sales and prices
 1857, *19752*
 1858, Romney collection sale, *19957*
 Sibyl (after Huntington), *14339*, *14344*, *14351*
 studies from nature, 1859, *20129*
 studio in Tenth Street building, *19913*
 summer plans, 1883, *24630*
 Swiss landscapes, *19995*
 Swiss scene, *19955*
 whereabouts
 1856, returns from country travels, *19545*
 1857, *19682*
 1857, Paris, *19781*
 1857, Switzerland, *19795*
 1859, summer travel, *20080*
 White Mountain scenes, *20302*
 work, 1892, *26839*
Casnelli, Victor, 1867-1961
 illustrations, landscape, *11870*
Cass, George Nelson, ca.1831-1882
 exhibitions, Boston, 1871, *10646*
 fish pictures reproduced by Prang in chromo, 1871, *23606*
 notes, 1871, *10616*
Cass, Lewis, 1782-1866
 monuments
 D. C. French receives commission, 1886, *25323*
 statue by D. C. French, *12983*
Cassaaday, Cornelia See: **Davis, Cornelia Cassaday**
Cassagne, Armand Théophile, 1823-1907
 advice on flower painting, 1890, *3156*
 charcoal drawing technique, *4243*
 drawings, *5498*
 illustrations
 drawing, *3999*, *7699*
 drawings of trees, *3290*, *4478*
 Edge of beech wood, *4054*
 In the forest, *7627*
 landcape studies, *4241*
 Monarch of the forest, *4298*
 Oak sketched at the edge of the forest of Fontainebleau, *4449*
 Path through the woods, *5491*
 pencil drawing of a chestnut tree, *4983*
 sketch of beech tree, *4918*
 Stork, *5465*
 studies, *8201*
 studies of horses, *3850*
 Studies of old beech trees, *4953*
 studies of trees, *4716*
 tree illustrations, *3341*
 tree studies, *4364*
 tree studies in pencil, *7700*
 trees, *3317*
 Tuning the violin, *7672*
 View in the Forest of Fontainebleau, *4718*
 View of Forest of Fontainebleau, *6377*
 View of the Village of Vezillon, France, *4322*
 Traité d'aquarelle, *8536*
Cassatt, Alexander Johnston, 1839-1938
 collection, exhibited at Chicago World's Fair, 1893, *4839*

1895, great men's chairs, *16796*
1902, Chippendale mahogany chairs, *7877*
Sheraton, Hepplewhite, and Chippendale, *3588*
sixteenth century chair, *7436*
technique, carved chair, *7815*
technique for chip-carving, *7035*
technique for making wood chair, *8260*
chairs, English, *9524, 9549, 9568*
chairs, French
history, *3000*
Chalfant, Jefferson Davis, 1856-1931
After the hunt, *25822*
exhibitions
National Academy of Design, 1887, *10786, 25437*
National Academy of Design, 1896, *22996*
portraits, photograph, *22580*
Chalfin, Paul, b.1874
awarded Lazarus scholarship, 1906, *14089*
chalices
designs, *9272*
Chalk and Chisel Club, Minneapolis　See: **Minneapolis (Minnesota). Chalk and Chisel Club**
Challamel, Augustin, 1818-1894
History of Fashion, excerpts, *1499*
Challener, Frederick Sproston, 1869-1959
exhibitions, Ontario Society of Artists, 1891, *26364*
Challenor Coan, Frances Catherine, b.1872
exhibitions, Chicago Art Institute, 1899, *12902*
Chalmers, George Paul, 1833-1878
biography with etchings to be published, 1881, *21892*
exhibitions
Glasgow Institute, 1880, *21912*
Royal Scottish Academy, 1878, *21714*
Chalmers, James, 1782-1853
inventor of adhesive postage stamp, *15063*
Chalon, Alfred Edward, 1780-1860
exhibitions
British Institution, 1855, *18908*
London, 1855, *18800*
Chalon, John James, 1778-1854
exhibitions
British Institution, 1855, *18908*
London, 1855, *18800*
Chalon, Rosalie Gill, *comtesse de*　See: **Gill, Rosalie Lorraine,** *comtesse* de Chalon
Chaloner, John Armstrong, 1862-1935
Paris Prize
attempt to establish in Cincinnati, 1892, *26649*
awarded to Bryson Burroughs, 1891, *26433*
competition, 1891, *26382*
established, 1891, *26355*
recipients, 1891, *26402*
plan to raise money for the foreign training of American artists, 1891, *26253*
prize for art students, 1891, *3772*
proposal for American artists in France, 1891, *26348*
raises money for art student scholarship, 1891, *26266*
to establish art scholarship, 1891, *3556*
Chaloner, Walter L., fl.1893-1904
exhibitions
Boston Art Club, 1893, *26951*
Springfield, 1894, *27026*
whereabouts, 1895, cruising in houseboat, *22738*
Châlons sur Marne (France). Notre Dame de l'Épine, *20864*
Cham　See: **Noé, Amédée de**
Chamber of Commerce of the State of New York　See: **New York. Chamber of Commerce of the State of New York**
CHAMBERLAIN, Arthur B., *6131*
Chamberlain, John Henry, 1831-1883
lecture on admiration as root of art, 1882, *1494*
obituary, *9919*
Chamberlain, John, *Mrs.*, fl.1880
lady artist of New York, 1880, *915*
Chamberlain, Joseph, 1836-1914
notes, 1896, *22943*

Chamberlain, Mellen, 1821-1900
autograph collection, presented to Boston Public Library, 1895, *16726*
Chambers, Earl, fl.1903
illustrations, drawing, *8288*
Chambers, George Wilbur, b.1857
Downs, in American Art Galleries, 1884, *1899*
exhibitions
American Art Association, 1886, *508*
Internationale Kunstausstellung, Munich, 1883, *24693*
Pennsylvania Academy of the Fine Arts, 1883, *1677*
Pennsylvania Academy of the Fine Arts, 1891, *In the Tennessee mountains*, *3535*
Prize Fund Exhibition, 1885, *25278*
Prize Fund Exhibition, 1886, *25304*
Prize Fund Exhibition, 1888, *2700*
Salon, 1883, *24521*
Salon, 1884, *1767, 1789*
illustrations, *In the Tennessee mountains*, *12005*
member of art jury, Tennessee Centennial, 1896, *11843*
St. Louis artist, 1887, *540*
Chambers, Oswald, fl.1895
illustrations, title page, *22329*
Chambers, William, 1800-1883
funds restoration of Cathedral of St. Giles, Edinburgh, 1881, *9391*
Champaign (Illinois). University of Illinois　See: **Urbana (Illinois). University of Illinois**
Champeaux, Alfred de, 1833-1903
book on tapestry, *795*
Champfleury　See: **Fleury, Jules**
CHAMPIER, Victor, *9662, 9675, 9746, 9776*
Champier, Victor, b.1851
Année artistique, review, *30, 189*
Champigneulle, Charles, 1853-1905
glass paintings, *1839*
Champin, Jean Jacques, 1796-1860
illustrations
Doria Palace at Genoa, *21002*
Fontenay Vendee, department of La Vendee, *20756*
CHAMPLIN, Edwin Ross, *17778, 17786, 17797*
Champlin, Hallie　See: **Fenton, Hallie Champlin**
CHAMPLIN, John Denison, *22641, 22671*
Champmartin, Charles Emile, 1797-1883
obituary, *1634*
Champney, B. F.
illustrations, *Early engraver at work*, *22598*

Champney, Benjamin, 1817-1907
exhibitions
Boston Athenaeum, 1859, *20104*
National Academy of Design, 1858, *19835*
New Bedford, 1858, *19891*
illness, 1858, *19785, 19913*
Klondike of the bees, *12823*
landscapes reproduced in chromo by Prang, 1870, *23595, 23606*
notes
1870, *23601*
1871, *10674*
Panorama of the Rhine, *14619*
studio
Boston, 1858, *19955*
North Conway, 1894, *27006*
view of Mount Washington, *18771*
whereabouts
1850, in White Hills of New Hampshire, *14696*
1857, Boston, *19767*
1858, returns to Conway, *19859*
1859, summer travel, *20080*
works, 1856, *19389*
CHAMPNEY, Elizabeth Williams, *20476, 22525, 22547, 22616*
CHAMPNEY, James Wells, *24596*
Champney, James Wells, 1843-1903
addresses Ladies Art Association, 1883, *24525*

decorations for Manhattan Hotel, *6085*
 commissioned to paint portraits, 1896, *5805*
 murals, *6135*
exhibitions
 American Art Galleries, 1879, *767*
 American Art Galleries, 1884, *24988*
 American Watercolor Society, 1880, *9292*
 American Watercolor Society, 1881, *1065*
 American Watercolor Society, 1882, *1300*
 American Watercolor Society, 1883, *Mountain picnic*, *1510*
 American Watercolor Society, 1884, *25012*
 Boston Athenaeum, 1861, *20355*
 Central Art Association, 1897, *11955*
 Century Club, 1893, pastel copies, *4314*
 Grolier Club, 1894, *16451, 22540*
 Grolier Club, 1894, pastel portraits, *4755*
 National Academy of Design, 1880, *111*
 National Academy of Design, 1881, *342*
 National Academy of Design, 1882, *9646*
 National Academy of Design, 1884, *Ophelia*, *10982*
 National Academy of Design, 1891, *26313*
 National Academy of Design, 1896, *6094*
 National Academy of Design, 1897, *10540*
 New York, 1890, *3229*
 New York, 1892, *26506, 26516*
 New York, 1892, copies of 18th century pastel portraits, *26860*
 New York, 1895, pastel copies, *5173*
 New York, 1896, pastel copies, *16905*
 New York, 1896, pastel copies of eighteenth-century paintings, *5613*
 New York, 1897, pastel portraits, *10541*
 New York Etching Club, 1885, *1934*
 New York Society of Amateur Photographers, 1888, *2848*
 Philadelphia Society of Artists, 1882, *1270*
 Prize Fund Exhibition, 1885, *1985*
 Prize Fund Exhibition, 1885, *Sweet girl graduates*, *25278*
 Prize Fund Exhibition, 1886, *25304*
 St. Botolph Club, 1880, *159*
 Salmagundi Club, 1880, *247*
 Salmagundi Club, 1882, *1265*
 Trans-Mississippi and International Exposition, Omaha, 1898, *12775*
ideas on copying, *8335*
illustrations
 At the ferry, *24904*
 Blessed damsel, *1504*
 Boarding school greenroom, *1330*
 child study, *22576*
 Eunice and John Stoddard's great dogge, *598*
 Hours of idleness, *10957*
 Jolly Royalist, *24434*
 Measuring the great elm, *1736*
 Pretty flower, *22610*
 seaside sketches, *11068*
 Sylvia, *566*
interview with artist, 1895, *5491*
invitation to fill chair of art-anatomy at National Academy of Design, *813*
lectures on pastels in Philadelphia, 1893, *4382*
Mount Washington, *19626*
notes
 1871, *10616*
 1883, *24829*
 1894, *22546*
obituary, *8222, 13604*
Ophelia, shown at Century Club preview, 1884, *25064*
pastel portraits, 1887, *10763*
pastels and sketches, *22557*
portraits, photograph, *22559*
sales and prices
 1904, paintings from estate, *13713*
 1904, estate at American Art Galleries, *13704*
scene of New Hampshire lake shown in Boston, 1861, *20330*
sketches, 1883, *24855*

sketches and studies, *9380*
studio, *22721*
teacher at National Academy school, *24716*
teaches art anatomy at National Academy of Design, 1883, *24678*
watercolors, 1884, *24995*
whereabouts
 1883, *24607, 24762*
 1883, Deerfield, Mass, *24689, 24728*
 1892, *26839*
 1896, summer in Europe, *23056*
work, 1882, *24380*
work, 1883, *24883*

Champney, Maria See: **Humphreys, Maria Champney**
CHAMPNEYS, Basil, *10439*
Champneys, Basil, 1842-1935
 house and studio for Henry Holiday, *9474*
Champollion, Jean François, 1790-1832
 translator of Rosetta stone, *20047*
CHAMPSAUR, Félicien, *12764*
chandeliers, American
 gas chandelier design by J. F. Travis, *8600*
 gas chandelier executed by Mitchell, Vance & Co, *8493*
Chandlee, Will H., 1865-1954
 Old granary, *22587*
Chandler, B. L., fl.1871
 See also:
 Bond & Chandler
Chandler, Clyde Giltner, fl.1907-1917
 exhibitions, Chicago Art Institute, 1907, *14263*
Chandler, Izora, d.1906
 miniatures, *13095*
Chandler, William Eaton, 1835-1917
 notes, 1896, *23015*
Changarnier, Nicolas Anne Théodule, 1793-1877
 February Revolution, 1848, *21238*
Chanler, John Armstrong See: **Chaloner, John Armstrong**
Channel Islands
 antiquities, Holder's excavations, 1897, *17214*
Channing, Walter, 1786-1876
 Physician's Vacation, or a Summer in Europe, review, *19619*
 quote, *19593*
Channing, William Ellery, 1780-1842
 monuments
 bequest for statue for Boston by John Foster, 1899, *12920*
 monument in Mount Auburn cemetery, *19928*
Chantilly (France). Chateau
 Duc d'Aumale's gift to France, *17838*
 house, library and art collection given to Institute of France, 1887, *2366*

Chantrey, Francis Legatt, 1781-1842
 anecdotes, *14693*
 bequest to National Gallery, *26568*
 bequest to Royal Academy, *9727*
 bust of Walter Scott, *19332*
 Chantrey Bequest Fund collection at Tate Gallery, *6493*
 Croston's *Chantrey's Peak Scenery*, review, *10270*
 drawing for Nelson monument, *16589*
 George Washington, *18692*
 on fountains and sculpture, *14779*
 tomb of Lady Frederica Murray Stanhope, *21794*
 trust for public collection of British art, *13810*
chantries
 England, chantry of Cardinal Beaufort, Winchester Cathedral, *21008*
chap books
 Laird o'Coul's Ghost, reprinted, 1893, *16244*
Chapin, A., *Miss*, fl.1886
 illustrations, drawing from the cast, *11319*
Chapin, Alfred Clark, 1848-1936
 portraits, portrait for Brooklyn City Hall proposed, 1891, *26475*
Chapin, Charles H., fl.1870-1883
 painting of West Indian scenery, *804*

Chapin, Edward S.
collection, sale, 1893, *16122*
CHAPIN, Ellis E., *13671, 14017*
CHAPIN, John R., *22598*
Chapin, John R., 1823-1904
illustrations
Despatches to the front, 22598
One of Marion's men: The Ballad of Gavin James, *18485*
vignettes for *Maggie Bell*, *17950*
portraits, photograph, *22603*
Chapin, Willis Ormel, 1860-1917
collection
engravings given to Buffalo Fine Arts Academy, 1891, *15832, 26303*
given to Buffalo Fine Arts Academy, 1891, *15586*
Masters and Masterpieces of Engraving, *16416*
to be published, 1893, *16316*
Chaplain, Jules Clément, 1839-1909
Conservatory prize medal in Avery collection, *4428*
exhibitions, New York, 1893, medals and plaques, *16217*
illustrations, *P. Baudry*, *5934*
medal commemorating Czar's arrival in Paris, 1896, *17113*
Chaplin, Alice Mary, fl.1877-1906
exhibitions, Grosvenor Gallery, 1880, *21885*
sculpture, 1886, *10357*
Chaplin, Charles, 1825-1891, *5432*
biographical note, *16512*
decoration of Salon de l'Imperatrice at the Tuileries, *20317*
etchings and lithographs, *15589*
exhibitions
Paris, 1887, palettes of artists, *2490*
Salon, 1859, *18315*
figure painting technique, *5310*
illustrations
Innocence, *22878*
Love's messengers, *22911*
Night, *1840*
Ninon, *1868*
Pâtres de Cévennes, offered for sale as a Millet, 1891, *15524*
sales and prices
1887, *2784*
1891, *15693*
Springtime, on exhibit, New York, 1883, *1586*
Chaplin, Christine, b.1842
flower paintings reproduced by Prang in chromo, 1871, *23606*
CHAPMAN, Carlton Theodore, *2849*
Chapman, Carlton Theodore, 1860-1925
exhibitions
American Watercolor Society, 1884, *25038*
American Watercolor Society, 1902, *13424*
American Watercolor Society, 1906, *14118*
Buffalo Society of Artists, 1897, *12085*
Chicago Art Institute, 1899, *12902*
Chicago Water-color Club, 1896, *5826*
Corcoran Art Gallery, 1907, *14282*
Essex Art Association, 1884, *25102*
New York, 1897, series depicting War of 1812, *23213*
New York Etching Club, 1891, *Street in Chartres*, *3533*
Prize Fund Exhibition, 1886, *25304*
Society of American Artists, 1887, *562*
Society of Painters in Pastel, 1890, *3256*
illustrations
Adventurer, A.D. 1740, 22663
After the battle, 13746
At Mount St. Michel, 22576
Battery, New York, 13830
Chase of "The President", 13359
design for country house, 2849
Fortress-town, 22560
Gothic bands for a wood-carving design, 2849
Ocean's mystery, 12481
Port, St. Malo, 13202
Sea flight, 22513
Street in Chartres (etching), 22549
Street in St. Malo (etching), 22549

Twilight, coast of Holland, 552
Winter along East river, 13215
illustrations for *The Century*, 1893, *22501*
marine paintings, *22499*
portraits, photograph, *22502*
whereabouts, 1899, *17571*
Chapman, Cyrus Durand, 1856-1918
illustrations, *Summer flirtation*, *22501*
Chapman, Frederic A. See: **Chapman, Frederick Augustus**
Chapman, Frederick A., 1870-1933
collection, *17233*
Chapman, Frederick A., New York (firm) See: **New York. Chapman, Frederick A. (firm)**
Chapman, Frederick Augustus, 1818-1891
notes, 1870, *10569*
Chapman, George, d.1880
obituary, *134*
Chapman, Henry Thomas, Jr.
collection, *15647, 15702, 15811, 15859, 16793, 16984*
acquires Gérôme's *Pifferari*, 1883, *14865*
Barbizon school, *15013*
Dupré landscape, *15077*
Etty's *Morning glory* acquired, 1891, *15660*
exhibited at Union League Club, 1893, *16374*
Lambinet landscape, *14973*
Michel paintings, *14949*
Murillo's *Apotheosis of the Virgin*, *17068*
open Sundays, 1897, *10524*
sale, New York, 1888, *2655*
shown at Brooklyn Art Association, 1892, *15934*
Troyon landscape, *15101*
credibility questioned and chairmanship of Brooklyn Union League criticized, 1891, *3454*
dealers' improprieties, 1891, *3490*
host, Rembrandt Club of Brooklyn, 1889, *14948*
quote, on collecting, *15882*
CHAPMAN, James H., *22476, 22574, 22769*
CHAPMAN, John Gadsby, *19946*
Chapman, John Gadsby, 1808-1889
American Drawing Book
excerpt, *18310*
review, *11553, 18652, 19659, 19736, 19898*
biography, *20159*
collection, *15842*
exhibitions
Albany, 1858, *19818*
Boston Museum of Fine Arts, 1893, prints, *16280*
Century Club, 1859, *19973*
National Academy of Design, 1858, *19857*
National Academy of Design, 1860, *20224*
illustrations, illustrations for *Harper's Illustrated Bible*, *87*
Italian girl, in E. U. Coles collection, *17693*
newspaper illustrations, *16557*
obituary, *15002*
painting for Rotunda of Capitol, *18667*
paintings, 1851, *14731*
paintings in Rome, 1858, *19887*
paintings of Italian subjects, *19850*
peasant paintings in Rome, *17962*
Seasons, painted in Rome, 1858, *19814*
Washington's retreat to Fort Necessity, in the American Art Union Gallery, 1848, *14341, 14345, 14352, 14360, 14368, 14376, 14384, 14392, 14400, 14407, 14413, 14419, 14427, 14443, 14445, 14452, 14458*
whereabouts
1849, Paris, *14537*
1859, return from Europe, *20093*
1859, Rome, *20045*
1879, summer travels, *703*
work, 1857, *19626, 19667*
work, 1859, *20129*
work in Florence, 1850, *14606*
works in Rome, 1855, *19106*
Chapman, Mary Berri See: **Hansbrough, Mary Berri Chapman**

Chapman, Minerva Josephine, 1858-1947
exhibitions, Salon, 1899, *12915*
illustrations, study head, *11443*
Chapman, S. Hudson, fl.1890's
illustrations, *Net-makers* (photograph), *13285*
Chapman, W. E., fl.1895-1921
exhibitions, Society of American Artists, 1895, *5338*
Chapon, Léon Louis, b.1836
illustrations, *Electra at the tomb of Iphigenia* (after F. Leighton), *2455*
Chappel, Alonzo, 1828-1887
notes, 1870, *10569*
original illustrations to Duyckinck's book, *16198*
Chapu, Henri Michel Antoine, 1833-1891
bronze medallion memorial to Th. Rousseau and J. F. Millet, *1786*
commission for Balzac statue, *25562*
exhibitions
Chicago Art Institute, 1896, *5701*
Salon, 1877, *8884*
illustrations
Joan of Arc, *12669*
monument to Henri Regnault, *21925*
monument to Henri Regnault, *8887*
obituary, *26325, 26336*
statue of Balzac, *25698*
statue of Flaubert unveiled, 1890, *26185*
statue of Princess of Wales, *25713, 25823, 25890, 25942*
Charcoal Club, Baltimore See: **Baltimore (Maryland). Charcoal Club**
charcoal drawing
history and technique, *17519*
materials, *8103*
fixative, *6565*
notes, 1892, *4065*
review of K. Robert's book, *205*
technique, *1556, 1557, 1989, 2076, 2610, 3211, 3340, 3580, 3681, 4193, 4243, 4774, 5534, 5559, 5840, 6563, 6713, 7380, 7484, 7573, 7653, 7950, 7972*
fixatives, *3371*
fixing charcoal drawings, *7465*
how to fix, *3355*
landscape, *3864, 6318*
of F. Hopkinson Smith, *2684*
problems in fixing drawings, *5408*
truthful renderings, *1703*
Charcot, Jean Martin, 1825-1893
theories on visual disturbance and color perception, *8322*
Chardin, Jean Baptiste Siméon, 1699-1779
exhibitions, Paris, 1899, planned, *17702*
French painter, *10125*
pastel technique, *5047*
still life acquired by Boston Museum, 1880, *210*
Woman at her washtub, in Robinson collection, *25357*
Charency, Hyacinthe, comte de, 1832-1916
Archéologie Americaine, review, *204*
chariots
spring-driven chariot, *21285*
charitable societies
Kyrle Society, London, decoration for the poor, *21810*
Charity Organization Society of the City of New York See: **New York. Charity Organization Society of the City of New York**
Charlemont, Eduard, 1848-1906
biographical note, *16570*
Charlemont, Hugo, 1850-1939
represented in Munger collection at Chicago Art Institute, *12785*
Charles Edward, the Young Pretender, 1720-1788
plot to overthrow George II, *21192*
Charles I, king of Great Britain, 1600-1649
collection, *9596, 9615, 14522, 17024, 18605*
pictures, *10437*
papers acquired by British Museum, 1895, *16841*
relics, prayer book, *17312*

Charles II, king of Great Britian, 1630-1685
anecdote, *17635*
correspondence, *17266*
letter, *16502*
portraits, Charles II portrait as solace to invalid, *20056*
Charles, James, 1851-1906
exhibitions
Chicago World's Fair, 1893, *4763*
Royal Academy, 1880, *21850*
Royal Academy, 1881, *21997*
Charleston (South Carolina)
monuments
monument to William Campbell proposed, 1904, *13781*
statue of John C. Calhoun by Haenisch, *540*
statue of John C. Calhoun dedicated, 1887, *566*
Charleston (South Carolina). Art School See: **Charleston (South Carolina). Carolina Art Association. Art School**
Charleston (South Carolina). Carolina Art Association, *18449*
anniversary address, 1859, *20034*
annual meeting, 1859, *19995*
exhibitions
1858, *19818, 19891*
1883, *24666*
1898, *6669*
formation, *18479*
history, *259*
notes, 1860, *20209*
reopening, 1880, *235*
Charleston (South Carolina). Carolina Art Association. Art School
art bazaar, 1883, *24587*
Charleston (South Carolina). Charleston Library Society
imperilled by lack of support, 1894, *16491*
notes, 1892, *15859*
Charleston (South Carolina). South Carolina Inter-State and West Indian Exposition, 1901-1902
art department directed by J. Townsend, *13312*
awards and prizes, *13436*
fine arts, *13334*
influence on outdoor art, *13428*
list of artists exhibiting, *13346*
notes, 1901, *7589*
Charlet, Emile, b.1851
illustrations, *Feeding time*, *13652*
Charlet, Nicolas Toussaint, 1792-1845
monuments, monument to be erected, 1895, *16840*
Charleville, Catherine Maria Dawson Bury, lady, 1762-1851
obituary, *23397*
Charlot de Courcy, Alexandre Frédéric de, b.1832
illustrations, enamelled panels, *1808*
Charlotte Augusta, princess of Wales, consort of Prince Leopold of Saxe-Coburg-Saalfeld, 1796-1817
amateur artist, *21154*
Charlton, George Edmund, fl.1880's
illustrations
decorated armor, *21928*
interior of Millais house (after W. Hatherell), *21994*
Italian wood carving, *21942*
charms
luck associated with art objects, *9257*
Charnay, Armand, 1844-1916
paintings, *1169*
Charnay, Claude Joseph Désiré, 1828-1915
expedition to Mexico, *102, 209, 351*
Charpentier, Alexandre, 1856-1909
illustrations
bronze bas reliefs, *13525*
bronze bas-reliefs, *13992*
Charpentier, Félix Maurice, 1858-1924
commemorative monument to Zola, *13712*
exhibitions
Salon, 1890, *26052*
Salon, 1893, Medal of Honor for *Wrestlers*, *22249*
Charpentier, Gaston, fl.1883
exhibitions, Salon, 1883, *14888*

copies of Velasquez, 1899, *6955*
Coquette, in Clarke collection, *24943*
Court jester, *9039*
decoration of St. Michael, *14144*
discussion on sketching sites, 1891, *3702*
dispute with Central Park Superintendent, 1890, *25964*
drawings in printers' ink on copperplate, *475*
elected Academician, National Academy, 1890, *3254*
elected president, Society of American Artists, 1893, *16252*
elected to Carnegie Institute jury of awards, 1897, *12020*
elected to Ten American Painters, 1905, *13899*
etchings, *267*
exhibitions
　American Art Association, 1884, *Port of Antwerp*, *25201*
　American Art Galleries, 1879, *767*
　American Art Galleries, 1887, *2607, 10832*
　American Society of Artists, 1881, *1130*
　American Watercolor Society, 1880, *9292*
　American Watercolor Society, 1881, *1065*
　American Watercolor Society, 1883, *1510*
　American Watercolor Society, 1884, *1736, 25038*
　American Watercolor Society, 1886, *2150*
　American Watercolor Society, 1889, *2883, 25576*
　American Watercolor Society, 1894, *22540*
　Art Association of Indianapolis, 1890, *3286*
　Art Club of Philadelphia, 1890, *3428*
　Art Students' League of New York, 1882, copies after
　　Velázquez, *9601*
　Berlin Akademie der Künste, 1903, *13605*
　Boston, 1905, *13868*
　Boston Art Club, 1881, *297, 1089*
　Boston Art Club, 1886, *518, 25375*
　Boston Art Club, 1887, *2346*
　Brooklyn Art School, 1892, *26860*
　Buffalo Fine Arts Academy, 1890, *25749*
　Carnegie Galleries, 1902, *13520*
　Carnegie Galleries, 1903, *13675*
　Carnegie Galleries, 1907, *14328*
　Charleston Inter-State and West Indian Exposition, 1902-
　　1902, gold medal, *13436*
　Chicago Art Institute, 1897, *12052*
　Chicago Inter-State Industrial Exposition, 1889, *3056*
　Chicago World's Fair, 1893, *4494*
　Cincinnati Art Museum, 1900, *13067*
　Essex Art Association, 1884, *25102*
　Internationale Kunstausstellung, Munich, 1883, *1637, 1835,*
　　14916
　Kansas City Art Club, 1902, *13337*
　London, 1901, *13332*
　Minnesota State Art Society, 1905, *13905*
　National Academy of Design, 1878, *9002*
　National Academy of Design, 1879, *679, 9151*
　National Academy of Design, 1880, *889*
　National Academy of Design, 1884, *25125*
　National Academy of Design, 1888, *2680, 2843, 25503*
　National Academy of Design, 1889, *2936*
　National Academy of Design, 1891, *26313*
　National Academy of Design, 1892, *3953, 26583*
　National Academy of Design, 1894, *5174*
　National Academy of Design, 1895, *5567*
　National Academy of Design, 1897, *10540*
　National Academy of Design, 1898, *12710*
　National Academy of Design, 1899, portrait of Miss C., *6846*
　National Academy of Design, 1903, *13547*
　National Academy of Design, 1907, *14311*
　New York, 1884, drawings in pastel, *1769*
　New York, 1887, *546, 2406, 2600, 10773*
　New York, 1888, *10846*
　New York, 1890, *3229*
　New York, 1891, *26286*
　New York, 1894, *4906*
　New York, 1897, landscape, *6370*
　Paris Exposition, 1889, portrait of Mrs C, *25695*
　Pennsylvania Academy of the Fine Arts, 1897, *6179*
　Pennsylvania Academy of the Fine Arts, 1898, *Ring toss*,

　　6532
　Pennsylvania Academy of the Fine Arts, 1899, *17503*
　Pennsylvania Academy of the Fine Arts, 1899, *Devotion*,
　　12836
　Pennsylvania Academy of the Fine Arts, 1900, *13007*
　Pennsylvania Academy of the Fine Arts, 1901, *13163*
　Pennsylvania Academy of the Fine Arts, 1902, *13363*
　Pennsylvania Academy of the Fine Arts, 1903, *13548*
　Pennsylvania Academy of the Fine Arts, 1904, *13716*
　Pennsylvania Academy of the Fine Arts, 1905, *13851*
　Philadelphia Society of Artists, 1882, *1270*
　Pittsburgh, 1899, *12976*
　Prize Fund Exhibition, 1885, *1985*
　Prize Fund Exhibition, 1885, *Gray day at Zandvoort*, *25278*
　St. Louis Exposition, 1894, *5036*
　St. Louis Exposition, 1894, *Reading fairy tales*, *11402*
　St. Louis Exposition, 1897, *Mother and child*, *12015*
　St. Louis Museum, 1883, *24553*
　Salon, 1883, *1568*
　Seventh Regiment Fair, N.Y., 1879, *766*
　Society of American Artists, 1878, *8993*
　Society of American Artists, 1879, *9150*
　Society of American Artists, 1880, *94, 844, 9324*
　Society of American Artists, 1881, *367*
　Society of American Artists, 1882, *1349, 1495*
　Society of American Artists, 1883, *1551*
　Society of American Artists, 1884, *1802*
　Society of American Artists, 1884, portrait, *11003*
　Society of American Artists, 1886, *2227, 25309*
　Society of American Artists, 1887, *2452*
　Society of American Artists, 1888, *2678, 2695, 25505*
　Society of American Artists, 1889, *2986*
　Society of American Artists, 1890, *3255*
　Society of American Artists, 1891, *15643, 26329*
　Society of American Artists, 1892, *26634*
　Society of American Artists, 1894, *4834, 22540*
　Society of American Artists, 1895, *5338, 21531*
　Society of American Artists, 1898, *12710*
　Society of American Artists, 1900, *13038*
　Society of Painters in Pastel, 1884, *9998, 25089*
　Society of Painters in Pastel, 1888, *2696*
　Society of Painters in Pastel, 1889, *2961*
　Society of Painters in Pastel, 1890, *3256, 25904*
　Society of Washington Artists, 1905, *13886*
　Union League Club of New York, 1884, *25193*
　Union League Club of New York, 1887, *10833*
　Union League Club of New York, 1890, *26155*
　Union League Club of New York, 1891, *26217*
　West Museum, 1891, *26382*
Fishmarket in Venice, *153*
forgeries discovered, 1907, *14319*
Garden attached to one of the orphan asylums, shown at Art
　Students' League, 1883, *24880*
gives Pittsburgh Art Students' League three paintings, 1899,
　17591
illustrations
　Autumn still life, *14282*
　Chase atelier, *12482*
　drawing, *1702*
　Here she comes, *1731*
　Japanese print, *13322*
　Like mother like daughter (from *Harper's Young People*),
　　22476
　Meditation, *10765*
　painting, *12661*
　Portrait, *13696*
　Ready for the ride, *168*
　Road through the field, *22610*
　Sisters, *14083*
　studies of heads, *13116*
　Widow, *12479*
illustrations in *Book of the Tile Club*, 1886, *509*
illustrator for *The Century*, *22473*
interview on future of women artists, 1890, *3389*
Lady with a rose, Temple gold medal, 1901, *13208*

William J. Baer to teach, 1893, *4455*
Chauvel, Théophile Narcisse, 1831-1910
 moonlit seascape (after Troyon), *1069*
Chavet, Victor Joseph, 1822-1906
 Promenade dans la Galerie des Glaces, 19109
Checa y Sanz, Ulpiano, 1860-1916
 illustrations, *Studies* (lithograph), *12952*
checkers
 history of game, *17078*
Cheever, Elizabeth S., fl.1892-1901
 exhibitions, Woman's Art Club of New York, 1892, *26531,*
 26542
Cheever, Lucile, fl.1905
 illustrations, design for dining-room, *13975*
Chelminski, Jan, 1851-1925, *1919*
 exhibitions
 Milwaukee Industrial Exposition, 1898, *12800*
 New York, 1892, *16061, 26869*
 Prize Fund Exhibition, 1885, *25278*
 horse painting shown in New York, 1887, *546*
 illustrations
 horse, *3067*
 In Central Park, New York, 1914
 Yorktown, 13759, 14213
 military paintings shown at Knoedler's, 1886, *2303*
 notes, 1892, *15840*
 pictures in New York, 1891, *15755*
 Polish painter, New York, 1884, *13597*
 whereabouts, 1892, New York, *16022*
 works in A. T. Stewart collection, *2408*
Chelmonski, Józef, 1849-1914
 art importations to U.S., 1879, *734*
 exhibitions
 American Watercolor Society, 1885, *1933*
 London, 1877, winter scene at Goupil, *8901*
 New York, 1878, *8994*
 Paris Exposition Internationale, 1883, *14919*
 Prize Fund Exhibition, 1885, *1985*
 First flight, at Knoedlers, 1886, *2151*
 illustrations, *In the church, 13759*
 Polish painter, *13597*
Chelsea (England). Chelsea Physic Garden
 history, *8004*
Chelsea (England). Royal Naval Exhibition, 1891
 silver ships, portraits, ets, *26365*
Chelsea (Massachusetts). Low, J. and J. G., firm See: **Low,**
J. and J. G., Chelsea, Mass.
chemistry
 practical uses, *20858*
Chenavard, Paul Marc Joseph, 1807-1895
 commissioned to decorate Pantheon, *14766*
 notes, 1895, *16767*
Chenay, Paul, 1818-1906
 Rixe (after Meissonier), *1801*
CHENEY, Ednah Dow Littlehale, *97*
Cheney, Ednah Dow Littlehale, 1824-1904
 book in preparation, 1879, *17*
 Gleanings in the Fields of Art
 excerpt, *21897*
 review, *393, 11352*
 lecture, 1879, *33*
 Memoir of Seth W. Cheney, Artist, review, *439*
Cheney, Harriet Elizabeth, 1838-1913
 crayon heads, *19930*
 portraits of children, 1860, *20227*
Cheney, John, 1801-1885
 engravings after Allston, *14615*
 proposed, 1849, *14525*
 exhibitions
 Boston, 1892, *15869*
 Boston Museum of Fine Arts, 1892, *26711*
 Boston Museum of Fine Arts, 1892, proposed, *26603*
 Boston Museum of Fine Arts, 1893, *16122*
 Koehler's *Catalogue of the Engraved and Lithographed Work of*
 John Cheney and Seth Wells Cheney, 15592

prints in Library of Congress, 1898, *12806*
Cheney, John Vance, 1848-1922
 lecture at the Evanston Woman's Club, 1895, *11686*
Cheney, Mary Moulton, b.1871
 exhibitions
 Minneapolis Arts and Crafts Society, 1901, *13184*
 Minnesota State Art Society, 1905, *13905*
Cheney, Seth Wells, 1810-1856, *17960*
 book in preparation, 1879, *17*
 engravings after Allston, *14615*
 proposed, 1849, *14525*
 eulogized by D. Huntington, 1857, *19611*
 exhibitions
 Boston, 1892, *15869*
 Boston Museum of Fine Arts, 1892, *26711*
 Boston Museum of Fine Arts, 1892, proposed, *26603*
 Boston Museum of Fine Arts, 1893, *16122*
 New York artists' reception, 1858, *19817*
 Koehler's *Catalogue of the Engraver and Lithographed Work of*
 John Cheney and Seth Wells Cheney, 1891, *15592*
 Memoir of Seth W. Cheney, Artist, review, *439*
 obituary, *19517*
CHENEY, T. Apoleon, *18532*
Chennevière, Cécile, fl.1889
 fan painting, *17884*
CHENNEVIÈRES, Henry, *comte* de, b.1859, *17719*
Chennevières Pointel, Philippe, *marquis de,* 1820-1899
 obituary, *12340*
CHERBULIEZ, Victor, 22913, 22942, 22967, 22990, 23018,
23040
Chereau, François, 1680-1729
 illustrations, rochet of Melchior, cardinal de Polignac (after H.
 Rigaud), *17752*
Chéret, Gustave Joseph, 1838-1894
 illustrations, Sèvres porcelain, *13653*
 vase designs in *L'Art et l'Idée*, 1892, *16038*
Chéret, Jules, 1836-1932
 awards and honors, 1890, *25912*
 exhibitions
 Chicago, 1895, *5301*
 Chicago, 1895, posters, *11501*
 Chicago World's Fair, 1893, bronzes, *4690*
 Grolier Club, 1890, *15398*
 Grolier Club, 1892, posters, *26556*
 New York, 1890, posters, *26171*
 Paris, 1890, posters, *3335, 25854*
 fin-de-siècle movement in Paris, *8313*
 illustrations
 posters, *12673*
 studies, *13558*
 lithography revival, *12952*
 posters, *12483, 12867, 15089, 15834, 22216, 24134*
 1894, *4950*
Chérié, Alfred, d.1896
 obituary, *5864*
Chéron, Paul Amédée, 1819-1881
 obituary, *407*
CHERRY, Emma Richardson, *14234*
Cherry, Emma Richardson, 1859-1954
 exhibitions
 Denver Artists' Club, 1898, *12706*
 Kansas City, 1897, *Spring song, 6487*
 Kansas City Art Club, 1902, *13337*
 illustrations, *Shell banks - Galveston Bay, 12726*
 summer school of art, University of Denver, 1894, *27014*
Cheshire, W. & J. R., engravers
 illustrations
 A Picardy pastoral (after D. Murray), *10337*
 birds (after Ch. Whymper), *10122*
 Margaret's garden (after H. H. Hatton), *10268*
 Nuremberg (evening) (after Hawes Craven), *10257*
 photographs by Berens, *10163*
 portion of the interior of the Indian Palace (after W. C.
 Symons), *10376*
 Reed stacks, Barton Broad, 10304

Chicago (Illinois). Carson, Pirie, Scott & Co. See: **Carson, Pirie, Scott & Co., Chicago**
Chicago (Illinois). Caxton Club
 exhibitions
 1895, *11500*
 1897, nineteenth century bookbindings, *12646*
 1898, bookplates, *12113*
 history, *12656*
 notes, 1895, *5329*
 publishes booklet on bookbindings, 1895, *16713*
 sponsor of Whistler exhibition at Chicago Art Institute and Roullier Gallery, 1900, *13006*
Chicago (Illinois). Central Art Association See: **Central Art Association of America**
Chicago (Illinois). Ceramic Association See: **Chicago (Illinois). Chicago Ceramic Association**
Chicago (Illinois). Chicago Academy of Design, *10630*
 classes
 1879, *735, 757*
 1883, *24716*
 exhibitions
 1871, *10652, 10712*
 1874, *8403*
 1875, *8425*
 1877, *8818*
 facilities and faculty, *8860*
 founding, *12749*
 notes
 1870, *10559*
 1871, *10587, 10627*
 1880, *9279*
 1883, *24553*
 schools to be re-established, 1882, *9670*
 tuition, 1871, *10684*
Chicago (Illinois). Chicago Academy of Fine Arts
 exhibitions
 1880, student work, *46*
 1881, *423*
 founding, *33*
 notes
 1881, *280, 353*
 1905, *13994*
 schools to be moved, 1882, *9670*
Chicago (Illinois). Chicago Architectural Club
 annual banquet, 1890, *26175*
 annual exhibitions
 1895, *11543*
 1896, *11764*
 1897, *6251*
 1898, *12149, 12697*
 1899, *12325, 12859, 12887*
 1901, *13209, 13221*
 1904, *13729, 13752*
 1905, *13886*
 1906, awards, *14142*
 1907, *14319*
 building, shares house with Society of Artists, 1894, *26999*
 classes, 1897, *12068*
 competition, Chicago park improvement project, *13027*
 exhibitions
 1896, *5783, 11789*
 1898, *6637*
 members' illustrations of picturesque architecture, 1895, *22688*
 merges with Chicago Society of Artists to form Art Club, 1894, *5110*
 national exhibit proposed, 1906, *14088*
 opens rooms to visitors to Exposition, 1893, *11308*
Chicago (Illinois). Chicago Architectural Sketch Club See: **Chicago (Illinois). Chicago Architectural Club**
Chicago (Illinois). Chicago Art Association
 address by Wallace Heckman, 1899, *12913*
 annual exhibition of Chicago artists
 1898, *12110, 12677*
 1898, satirized by Palette and Chisel Club, *12112*
 1899, *12310, 12876*

 exhibitions, 1899, *17623*
 membership and aims, *12866*
 notes
 1898, *12794*
 1899, *12842*
 1900, *13034*
 organization of various clubs to promote local art, 1897, *12065*
 organized, 1898, *6545*
 organized to purchase art at Chicago Artists exhibition, 1898, *12095*
 plans, 1894, *11404*
 work to suppress billboards, *13043*
Chicago (Illinois). Chicago Art Club
 acquires Art Institute building, 1892, *3887*
 exhibitions, 1883, *24586*
 formed, 1894, *5110*
 summer sketching in Maine, 1890, *25876*
Chicago (Illinois). Chicago Art Commission
 bill establishing Commission passed, 1899, *12340*
 created, 1899, *17626*
Chicago (Illinois). Chicago Art League
 annual exhibitions, 1884, *25085*
 classes, 1883, *24716*
 education, 1882, *9670*
 exhibitions, 1883, *24493*
 founded, 1880, *284*
 notes, 1884, *25096*
Chicago (Illinois). Chicago Arts and Crafts Society
 exhibitions
 1898, *6637, 12150, 12709*
 1898, with Chicago Architectural Club, *12697*
 notes, 1897, *12044*
 organized to promote creative workmanship, *12638*
 work by Bulger, Hazenplug, Taylor and Wynne, *12801*
Chicago (Illinois). Chicago Athenaeum
 fire destroys exhibition of Society of Artists, 1892, *26639*
 wood carving department, 1892, *11304*
Chicago (Illinois). Chicago Ceramic Association
 annual exhibitions
 1896, *11923*
 1899, *12435*
 1902, *13511*
 annual reception, 1894, *11431*
 collection, examples of ceramics, *11589*
 elections, 1902, *13436*
 exhibitions
 1894, *4795*
 1894, semi-annual exhibition, *5213*
 1899, *7188, 12423*
 1899, National League of Mineral Painters, *7030*
 1902, *13357*
 joins Central Art Association, 1894, *11327*
 lectures, 1897, *12068*
 meeting, 1892, *3887*
 notes
 1892, *4175*
 1893, *4552*
 1895, *11499*
 officers
 1892, *4066*
 1897, *12045*
 plans for winter, 1895-96, *11659*
 reception and china sale, 1895, *11706*
 sale of china, 1892, *11308*
 sponsors exhibition of National League of Mineral Painters, 1899, *12877*
Chicago (Illinois). Chicago Etching Club
 notes
 1870, *10567*
 1871, *10661*
Chicago (Illinois). Chicago Evening School of Design
 opens rooms in Marshall Field's, 1894, *11405*
Chicago (Illinois). Chicago Guild of Industrial Arts
 planned by Industrial Art League, 1901, *13332*

discussed, 1890, *26089*
Jackson Park selected as site, 1890, *26071*
landfill, 1890, *26143*
landscaping of Olmsted, *22294*
New York loses to Chicago, 1891, *15709*
Olmstead reports on Jackson Park, 1890, *26034*
recommended for New York City, 1889, *25655*
selection, 1890, *26157*
souvenir coin with portrait of Columbus, *26800*
souvenir coins, *26907*
U.S. *Constellation* brings art from Europe, *26907*
W. A. Smith presented with Tiffany vase for heading
 Transportation exhibits, 1894, *4968*
women's department supported by French government, *15723*
Chicago (Illinois). Young Fortnightly Club of Chicago
exhibitions, 1895, prizes, *11707*
sponsors exhibition, 1895, *11590*
Chicago River
industry and transportation, *12869*
CHICAGOAN, *10680*
chickens
painting fowl, *6742*
technique for painting, *3388*
technique for painting poultry, *3680*
text and illustrations by E. W. Lewis, *22818*
Chickering Hall See: **New York. Chickering Hall**
Chicopee (Massachusetts). Ames Manufacturing Co. See:
 Ames Manufacturing Co., Chicopee, Mass.
Chien-Caillou See: **Bresdin, Rodolphe**
Chierici, Gaetano, 1838-1920
Desperate venture, *21964*
exhibitions
 Florence, 1879, *21727*
 Royal Academy, 1879, *21730*
 Royal Academy, 1880, *9370*
 Royal Academy, 1881, *21999*
Chigi collection
Botticelli stolen, 1900, *7481*
Chigot, Eugène Henri Alexandre, 1860-1923
Mort de Matho, *1815*
Chilberg, N. Guy, fl.1897
illustrations, charcoal head, *12647*
Child, Edwin Burrage, 1868-1937
exhibitions, National Academy of Design, 1892, *4182*
illustrations
 His portrait, *22486*
 illustration for *Mrs. Wilkinson's Ghost*, *23085*
 Pensive, *22513*
Child, Jane Bridgham Curtis, b.1868
illustrations, drawings, *23078*
Study of a Spaniard, *22587*
CHILD, Lydia Maria Francis, *23511*
Child, Robert Coleman, b.1872
Adagio, *22587*
Child, Robert Coleman, Mrs. See: **Child, Jane Bridgham
Curtis**
CHILD, Theodore, *1657, 1680, 1718, 1721, 1724, 1738, 1741,
1754, 1760, 1773, 1805, 1817, 1854, 1864, 1870, 1890, 1903,
1951, 1967, 1971, 2000, 2025, 2135, 2174, 2193, 2206, 2238,
2258, 2366, 2410, 2429, 2432, 2449, 2453, 2476, 2479, 2482,
2528, 2624, 2627, 2660, 2684, 2694, 2938, 2966, 2985, 2987,
3010, 3032, 3033, 3170, 3199, 3394, 3624, 3649, 3672, 3991,
4013, 4360, 4913, 4941, 4978, 5005, 5043, 5088, 5969, 22211*
Child, Theodore, 1855-1892
Art and Criticism
 excerpt on Leyland's Peacock dining room, *3779*
 published, 1891, *26435*
 review, *3785*
comments on art museums, 1886, *2151*
criticism of Millet, 1887, *574*
Delicate Dining
 excerpts on dining rooms, *3783*
 review, *3785*
excerpt, *22929*
last hours, *4282*

obituary, *4179, 16022, 26846*
on Millet's poverty, *25696*
on William Dannat, 1897, *6187*
quote, *22367, 22368, 22955, 22977, 23028, 23054*
travel writer, *23106*
Young People and Old Pictures, *26073*
CHILDE, Cromwell, *12481, 22500, 22530, 22557*
children
anecdotes, *18077*
birthday party decorations and accident remedies, 1897, *23204*
childhood, *22870, 22899*
child's reaction to Correggio's *Reading Madonna*, *23512*
essays on childhood, 1895, *22841*
growth, interest in art, *12884*
institutional care, Randall's Island home for handicapped chil-
 dren, *22884*
management, *22808*
children in art, *9614*
18th century English depictions, *9715*
Academie des Beaux Arts to offer prize for best painting or
 sculpture of a baby, 1890, *3389*
boys and girls in paintings of G. A. Reid, *22651*
drawing children, *7701*
drawing technique, *6405*
exhibition proposed, 1895, *16767*
figure posing, *12914*
history, *9608*
illustrations, studies by various artists, *7353*
illustrations by M. Humphrey, *22511*
lack of eminent painter of children in America, *13148*
Lobrichon's sketches, *2585*
McCullough's sketches, *22734*
modern German art, *9847*
Northern European depictions, *9644*
painting and sculpture, *21993*
painting children, 1894, *4722*
Reynolds's portraits of children, *6552*
role of sentiment in portraits of children, *7751*
technique for painting, *3755, 4615, 4668, 4884*
technique for painting ideal subjects, *4768*
work of A. E. Albright, *13568*
children's art
competition for coloring Dora Wheeler's *Painting Book*, 1883,
 24774
drawing for children, *6633*
drawings in the early years, *11887*
exhibitions
 Boston, 1899, school drawings, *12417*
 Chicago Art Institute, 1896, drawings, *6012*
 University of Illinois, 1899, public school pupils' art, *17538*
instruction in public schools, *11932, 11941*
lessons in drawing, *6483, 6518, 6543, 6579, 6607, 6691*
watercolors for children recommended, 1887, *531*
children's rooms
decorating, *530, 4001*
tiles decorated with alphabet for nursery fireplaces, *7957*
Childs and Jocelyn, woodengravers
Othello narrating the story of his life (after G. A. Baker), *14736*
Childs, Benjamin F., 1814-1863
See also: **Childs and Jocelyn, wood engravers**
illustrations, *Jack, the giant killer* (after A. W. Rutherford),
 14474
obituary, *26268*
tinted wood engraving after F. O. C. Darley, *14510*
wood engravings, *106*
Childs, George William, 1829-1894
collection
 autographs, *16136*
 gives portraits of Generals to West Point Military Academy,
 1889, *25656*
 ivory carvings and curios given to Drexel Institute, *15811*
 manuscripts given to Drexel Institute, 1892, *15790*
 to be lent to Chicago Worlds Fair, 1893, *26333*
Chile
social life and customs

fruit plate with medallions, *6997*
game plate, *6481, 7959*
game plates, *3243*
gilding, *4447, 8295*
glazing painted china, *7305*
gold, *7059*
gold and enamel, *6603*
gold and silver, *3294, 3320*
gold paint from gold leaf, *6293*
gold, silver, and bronze, *5629*
gold work, *3374*
golden rod, *5442*
gooseberries, *6665*
gray paint, *4783, 7763*
grays, *4815*
grays for shading flowers, *6326*
Grecian tea set, *6965*
Hawthorn tea set, *7391*
heads, *6328*
high glaze, *6885*
Hill's manual, *3638*
hints, *4252*
hints for beginners, *7682*
honey bowl, *6295*
honeysuckle, *7472*
hops decoration, *7535*
hydrofluoric acid for removing stains, *3082*
hydrofluoric use for removing stains, *3807*
Indian heads, *7473*
inexpensive flower holders, *6202*
ink, *5990*
insect motifs, *6718*
ivory ground, *7138*
Japanese decorative fish, *5953*
Japanese-style marine design plates, *7602*
jardinière design, *3968*
jewelled china, *3661*
jewelled china and gilding pierced plates, *5444*
jewelling and enamels, *7765*
jewelling china, *3106*
jewels and enamels, *5240*
July flowers, *6324*
L. Hopkins's *Sea-weed* fish plates, *3296*
lace, *7767*
lamp globes, *7961*
lamp vase, *6862*
landscape, *3213, 4332, 6384, 6664*
landscape backgrounds for figures and firing, *4782*
landscape in mineral colors, *6861*
landscape in monochrome, *6744*
landscape miniatures, *6077, 6124*
landscapes, *4155*
laying grounds, *3438*
laying tints, *5546*
lessons from Japanese art, *1559*
lilacs, *6292*
limited palette, *7272*
liquid gold, *3192*
liquid lustre colors, *3704*
list of defects seen after firing, *4251*
loving cup, *7935*
lustre ware, *7387*
lustres, *6685, 6890, 6915, 7105, 7137, 7869, 8074*
M. C. Dexter's teaching method, 1898, *6511*
Macomber's *Water-lily* ice cream set, *3295*
maple leaves design for a pitcher, *7470*
Marie Bracquemond plaque, *3966*
material and color notes for winter work, *5013*
materials, *3163, 5059, 6630*
materials needed, *5501*
medallions, *7731*
mediums and their uses, *7764*
mineral colors, *2772, 6884, 7659*
mineral painting, *6774, 7166*
mineral paints, *6916*

mineral tints, *6937*
miniature portraiture, *6120*
moist watercolors, *3510, 3547, 3585*
monochrome, *5384, 7079*
monochrome and raised paste techniques, *8191*
monochrome painting, *3935*
monograms, *6746*
motives for fish and game serving dishes, *7936*
narcissus and jonquils, *7960*
nasturtium as decoration, *7468*
nasturtiums, *6629*
Old Delft style, *5383*
olive tray, *3240*
orchids, *6913*
Oriental chocolate set, *6935*
Oriental color schemes, *6859*
Oriental decoration, *6968*
Oriental designs, *6914*
Oriental fuschia design, *7063*
painting faces, *4616*
painting for firing, *7240*
painting on lincrusta, *1892*
painting over underglaze, *6203*
painting with burnish gold, *2942*
palette, *8048*
palette for painting peaches, *6747*
palette for Persian designs, *7842*
palettes, *7835*
pansies, *6573, 7561*
pansy bonbonnieres, *7931*
paste, enamels, metals, *6917*
pastoral figured scenes, *7083*
pâte-sur-pâte decoration, *1454*
pen gold, *6998*
pen work, *5193*
Persian designs, *7236*
Persian plates, *7730*
Persian style ware, *4476*
photograph flowers for subject matter, *5351*
pigments, *11305*
plate and bowl design, *7867*
plate borders, *5278*
plate decoration, *3972*
plate design, *7031*
poppies, *6799*
poppy and laburnum designs, *3212*
porcelain painting, *8274*
portraiture, *5547*
powder colors, *6832*
preparation of gold paint, *5955*
preparing gold and silver for porcelain decoration, *1497*
punch bowl design, *3136*
punch bowl with grape decoration, *7009*
purples, crystal, and glass, *3765*
Puvis de Chavannes designs, *3740*
raised paste, *5140, 5503, 7029*
raised paste work, *4923*
raising and gilding with watercolor, *5414*
recipe for oil, *8296*
removing paint from fired china, *6268*
ribbon plate, *3769*
rose and lily designs, *3936*
rosebud plaque, *6075*
roses, *3739, 3998, 5631, 5677, 5715, 6830*
Royal Worcester colors, *3081*
Royal Worcester decoration, *3013, 3036, 3373*
Royal Worcester ware, *3404*
Sea-weed fish plates, *3267*
selecting flowers for decoration, *6297*
Sèvres designs, *5279*
shell tints, *7058*
simplicity in table china, *7028*
snow scenes for ice-cream set, *5917*
solid tints, *3321*
solutions to new plate shape, 1901, *7581*

stencils, erasers, and India ink, *3848*
stock decoration for pitcher, *6749*
study should begin with basics of drawing and design, *8050*
subject matter found on vacation, *4987*
subjects and materials, *2685*
suggestions for painting flower pots, *4120*
suitability of designs, *6574*
Swallows in flight plate by H. Maguire, *3969*
sweet pea design plates, *7839*
table service decoration, *3905*
table service subjects, *3242*
tiger lily border for jardiniere, *7841*
tile decoration, *5674*
tiles, *7558*
tinting, *4053, 7332, 8049*
tinting and removing color, *5105*
tinting cup and saucer, *6200*
tinting grounds, *5794*
tracing and transferring designs, *7000*
tray with rococo decoration, *6886*
treatment of designs, *2469*
tree blossoms for large decorations, *5793*
tube and powder colors, *4299*
turpentines affect lustres, *7081*
under and overglaze, *6327*
under and overglaze blue tile decoration, *5675*
underglaze, *5141, 6966*
underglaze decoration, *4399*
underglaze painting, *5102, 7467, 11324*
underglazing, *1359*
unpainted china, *4350*
use of color, *1319*
use of enamels in decoration, *5282*
use of gold, *3586, 3741*
use of gold and care of brushes, *4084*
use of gold and other metals, *2810*
use of gouache or matt colors, *2789*
use of grays, *4730*
use of portable kiln, *4957*
use of red, *3190*
use of reds, *3161*
use of yellow, *3265*
various effects achieved with gold, *4119*
vase, *7444*
vase decorated with wistaria, *7536*
vase decoration, *7001*
vase with jonquils, *7060*
vase with poppies and ferns, *7495*
velvety ground of Royal Worcetser ware, *3238*
vines, *5412*
violets, *7604*
water-color flowers, *5443*
watercolor tints, *3637*
watercolors, *1776, 5382*
white enamel, *3683*
whortleberries design plate, *8098*
wild flowers, *7078*
wild rose bonbonnieres, *7932*
working methods when painting china for pleasure, *7416*
yellow flowers, *5989*
tête-à-tête set by M. L. Macomber, *3108*
undecorated china novelties, 1893, *4623*
vitrifiable water-colors, *1681*
white china designs available in shops, 1896, *5688, 5775*
china painting, American, *129, 13912*
American china painters, 1896, *5844, 5879, 5920, 5956, 6030*
Chicago Ceramic Association reception and sale, 1895, *11706*
china decorators active 1897, *12016*
exhibitions
Chicago, 1895, *11652*
Chicago World's Fair, 1893, *4512, 4620, 4689*
history, 1770-1895, *11729*
Illinois ceramics at Columbian Exposition, 1893, *11305*
Kansas, *11325*
origins, *11638*

pioneers in American pottery, *12301*
china painting, Belgian
Brussels exhibition, 1880, *21954*
china painting, English
exhibitions
1880, *21862*
London, 1878, English women artists, *21623, 21651, 21654, 21738*
London, 1880, prizes, *920*
London, 1890, paintings on china, *26006*
Chinese architecture See: **architecture, Chinese**
Chinese art See: **art, Chinese**
Chinese embroidery See: **embroidery, Chinese**
Chinese enamels See: **enamel, Chinese**
Chinese jade See: **jade art objects, Chinese**
Chinese jewelry See: **jewelry, Chinese**
Chinese national characteristics See: **national characteristics, Chinese**
Chinese painting See: **painting, Chinese**
Chinese porcelain See: **porcelain and pottery, Chinese**
Chinese scrolls See: **scrolls, Chinese**
Chinese sculpture See: **sculpture, Chinese**
Chinese silver See: **silverwork, Chinese**
Chinese tapestry See: **tapestry, Chinese**
Chinese vases See: **vases, Chinese**
Chinese wall decoration See: **mural painting and decoration, Chinese**
Ch'ing Hsüan-tsung, *emperor of China*, 1782-1850, *20824*
Chintreuil, Antoine, 1814-1873
notes, 1893, *16329*
sales and prices, 1889, *14976*
Chiostri, M., fl.1895
exhibitions, Chicago Art Students' League, 1895, *11469*
Chipiez, Charles, 1835-1901
supervises creation of Parthenon model, 1890, *3427*
Chippendale, Thomas, 1718?-1779
cabinetmaker of 18th century, *17738*
chairs, *3588*
furniture, *3268*
sales and prices, 1902, mahogany chairs, *7877*
Chippendale, Walter, fl.1886
exhibitions, Prize Fund Exhibition, 1886, *25304*
Chisholm, Archibald, *Mrs*. See: **Chisholm, Caroline Jones**
Chisholm, Caroline Jones, 1808-1877
biography, *21041*
Chislett, Mabel Clare, fl.1898-1908
illustrations, bust done in modeling class, 1898, *12736*
Chiswick Press, London
books exhibited at Grolier Club, 1896, *17154, 17165*
Chittenden, Alice Brown, 1859-1944
notes
1899, *22077*
1901, *22134*
1902, *22142*
1903, *22176*
1904, *22203*
Chlebowski, Stanislaus von, 1835-1884
exhibitions, Salon, 1877, *8872*
Choate, Joseph Hodges, 1832-1917
portraits
portrait by Sargent, *13021*
portrait by Sargent commissioned by Harvard Club of New York, *12909*
Choate, Rufus, 1799-1859
portraits, bust by Ball, *20114*
Choate, Sarah See: **Sears, Sarah Choate**
Choate, William M., *Mrs.*, fl.1894
on hand versus machine-made embroidery, 1894, *4852*
Chock, Pincus
collection, *10544*
exhibited at American Art Galleries, 1898, *6590*
Chocquet, Victor, *Mme*, d.1899?
collection, *17641*
sale, 1899, *17658*

Chodowiecki, Daniel Nikolaus, 1726-1801
 engravings, *22615*
 illustrator, *12191*
 journey from Berlin to Danzig, 1773, *10264*
choir stalls
 Berne's cathedral, *25647*
choirs (music)
 chorus choirs for use in church, *862*
 comments on changing members, *839*
 how to build a choir, *1137*
 volunteer choirs, *744*
Cholmley, Henry W.
 collection, sale, 1902, *13380*
Chominski, Theodore V., fl.1883-1894
 illustrations, *Winter's day*, *22482*
 magazine illustration, 1894, *22517*
Chopin, Frédéric, 1810-1849
 monuments, movement to raise funds for monument, 1897, *23750*
Chopin, Henri See: **Schopin, Henri Frederic**
Choppin, Paul François, b.1856
 illustrations, *Joan of Arc*, *11820*
Christchurch (England)
 description and views, *22026, 22036*
Christen, Raphael, 1811-1880
 obituary, *83*
Christian art and symbolism, *20117*
 animals, *1050*
 criteria, *19963*
 exhibitions, 1893, exhibition of Christian art proposed by
 Archbishop of Westminster, *4344*
 history, *4656, 20231*
 iconography of the nimbus, *4788, 4822, 4855, 5061, 5156*
 Jameson's *Sacred and Legendary Art.*, *19653*
 modern, *27006*
 monuments in Germany, *19887*
 philosophical relations of religion and art, *19461*
 religous art in Spitzer collection, *4374*
 symbolism of objects, *1010*
Christian iconography
 iconography of the nimbus, *4788, 4822, 4855, 5061, 5156*
Christiana (Norway). Nasjonalgalleriet
 collection, paintings of outdoor life, *22715*
Christianity
 and the fine arts, *20099*
 and the formative arts, *20108, 20117*
 Christianity without Judaism by Baden Powell, *19827*
 international exhibition of Christian art proposed in London,
 1893, *26918*
 United States, *17979*
Christiansen, Hans, 1866-1945
 illustrations
 art glass work, *13515, 13545, 13897*
 poster, *20525*
CHRISTIE, Dougall, *20919*
Christie, James Elder, 1847-1914
 exhibitions
 Royal Academy, 1881, *21999*
 St. Louis Exposition, 1895, *11622*
Christie, Manson and Woods, London See: **London
(England). Christie, Manson and Woods, Ltd.**
Christie, Stan, fl.1903
 illustrations, *Still-life*, *13618*
Christmas
 Christian and pagan representations and social aspects, *7153*
 Christmas customs around the world, *22854*
 disappearance of Christmas plays in New York, 1900, *7482*
 French traditions, *23139*
 gifts
 painted china, *5142*
 suggestions, 1890, *3149*
 suggestions, 1891, *3828*
 suggestions, 1892, *3863*
 suggestions, 1902, *8085*
 lack of religious images in Christmas season periodicals, 1893,

 4656
 list of Christmas mottoes, 1890, *3414*
 New York City holiday season, 1896, *16905*
Christmas cards
 competitions
 1880, *1019, 9327, 9357, 21926*
 1880, Prang's competition, *909*
 1881, *260, 310, 426, 1086, 1104, 1268, 9480, 9572, 21896*
 1882, *9718*
 1883, *1464*
 1884, Prang's design competition, *25206*
 design for illuminated card by C. M. Jenckes, 1888, *2811*
 etchings used, *1234*
 Lowell design, 1882, *1437*
 photography for Christmas cards, *2832*
 Prang and Raphael Tuck cards, 1887, *2594*
 Prang's cards, 1886, *518*
 Prang's cards, 1888, *633*
Christmas decorations, *1453*
 churches, *1030*
 decorating colonial hall for Christmas, *7169*
 decorations for church and home, *1892*
 floral decoration of churches, *4676, 5154*
 floral decoration of the home, *4207, 5153*
 holly, *3860*
 home decoration, *6474*
 interior decoration, *7790*
 suggestions, 1891, *3828*
 technique for making decorations, 1890, *3418*
Christofle
 illustrations, enamel works, *1406*
Christophe, Ernest, 1827-1892
 obituary, *26498*
Christy, Howard Chandler, 1873-1952
 illustrations
 Autumnal days, *22560*
 Landmark, *22528*
 scenes from Art Village, Shinnecock Hills, *22572*
 Shinnecock gardens, *22528*
 study sketch, *22576*
 trees, *22610*
 illustrations in Christmas magazines, 1899, *7182*
chromolithography, *10814*
 and education, *23514*
 Art Amateur's support, 1893, *4425*
 Art Amateur's use, *2695*
 cleaning, *23578*
 commended by Henry W. Longfellow, 1868, *23506*
 controversy between Louis Prang and Clarence Cook, 1868,
 23513
 criticized, 1893, *2504*
 criticized in *The Nation*, 1870, *23600*
 definition, *23582*
 development, *23500*
 educates eye through dissemination of popular art, *23516*
 extracts from the Philadelphia press, *23501*
 history, Louis Prang, founder of L. Prang and co., 1861, *23549*
 illuminated litho-chromatic volume on Rosetta stone, 1859,
 20047
 illuminated publications of L. Prang and co, *23526*
 lecture by school principal on its importance, 1868, *23515*
 letters to *Prang's Chromo*, 1868, *23508*
 pictures purchased for Army camp, 1868, *23534*
 Prang defends chromolithography, 1868, *23536*
 Prang lecture on color lithography, 1897, *17227*
 Prang's chromos, 1866, *23496*
 Prang's chromos, 1868, *23498*
 Prang's chromos praised by eminent persons, 1869, *23556*
 preservation and care, *23520*
 process, *23495*
 public art education through popularization of art, *23502*
 reproduction of paintings, *23580*
 reproductive quality, *23517*
 rival in Hoeschotype process, *1416, 1436*
 suggested to women as a career, 1893, *4406*

technique, *23497, 23575*
used by Prang and co., Boston, *9706*
work of P. S. Duval, *14510*
chrysanthemums
royal flower of Japan, *22820*
Chubb, Percival, b.1860
lecture on art, Brooklyn Art Association, 1891, *26440*
Chulalongkorn, *king of Siam*, 1853-1910
visit to Bibliothèque Nationale, 1897, *23943*
Chumar, Mary See: **Trask, Mary Chumar**
CHURCH, Arthur Herbert, *21579*
Church, Arthur Herbert, 1834-1915
advice on permanency of oil colors, *2492*
Chemistry of Paints and Paintings, *25824*
lectures on color, Royal Institution, 1891, *26310*
Manual of Color, review, *2990*
report on effects of light on color, *2992*
Church, Benjamin, 1639-1718
History of King Philip's War, excerpts, *19659*
Church Congress, 1878
exhibitions, ecclesiastical art, Croydon, *8980*
church decoration and ornament, *10644*
beauty in houses of worship, paper read by R. A. Cram, *22325*
Christmas decoration, *1030*
cressets and lamps, *26262*
exhibitions
1891, Ecclesiastical art at Rhyl, *26409*
Boston Society of Arts and Crafts, 1907, *14267*
floral decoration, *5357*
for Christmas, *4676, 5154*
for Easter, *5321*
history, *4624*
needlework, *2850, 2874*
notes, 1887, *2440*
pulpit hanging design, *2757*
church dedication
On the Dedication of American Churches, review, *21472*
CHURCH, Ella Rodman MacIlvaine, *1939, 2060, 9071, 9202*
Church, Ella Rodman MacIlvaine, b.1831
book in preparation, 1880, *115*
CHURCH, Frederic Edwin, *23563*
Church, Frederic Edwin, 1826-1900, *8966*
Aegean Sea, *9014*
artists' reception, New York, 1858, *19784*
Beacon off Mount Desert Island, in American Art Union
Gallery, 1851, *14836*
biography, *20159*
collection, purchases at Shaw collection sale, 1880, *911*
El Khasne, shown in Chicago, 1877, *8425*
etchings, *24391*
Evening after a storm, in collection of American Art Union,
1849, *14589*
exhibitions
Albany, 1858, *19818*
Boston Athenaeum, 1855, *18879*
Brooklyn Art Association, 1874, *8364*
Chicago, 1859, *18316*
Lenox Library, 1893, *4361*
London, 1859, *18343*
Metropolitan Museum of Art, 1900, *13071, 13107*
National Academy of Design, 1849, *21419, 21429*
National Academy of Design, 1849, *New Haven Scenery*,
14497
National Academy of Design, 1849, *Plague of darkness*,
14497
National Academy of Design, 1850, *14615*
National Academy of Design, 1851, *14731, 14735*
National Academy of Design, 1855, *18705, 18715*
National Academy of Design, 1856, *19379*
National Academy of Design, 1859, *20030, 20048*
New Bedford, 1858, *19891*
New York Athletic Club, 1888, *2638*
Heart of the Andes, *18317, 20033, 20050, 20093, 20132*
influence on standards of taste, *18318*
home, residence on banks of Hudson designed by artist, *8700*

Hudson River school, *11495*
iceberg scene, 1861, *20330*
Icebergs, at Goupil & Co., 1861, *20365*
illustrations, *West Rock, New Haven*, *14801*
landscapes, 1849, *14510*
letter on chromolithography, 1868, *23508, 23542*
Morning in the tropics, *20302*
contributed to the Artists' Fund Society, *11281*
New Haven scenery, *14487*
Niagara Falls, *17998, 19645, 19697*
excerpt from *London Times*, *18082*
exhibited in London, 1858, *19853*
in Stewart collection, *10768, 25406*
presented to Edinburgh National Gallery, 1887, *25464*
reception in London, *18028*
shown in New York, 1858, *18243*
North, picture of icebergs, *20376*
notes
1849, *21381*
1856, *19315*
1887, *611*
1900, *7291*
painting of Andean scenery, *18596*
painting of South American scene, 1883, *24502*
paintings in Osborn collection, 1894, *16505*
paintings in Stewart collection, *753, 2393*
panorama illustrating Bunyan's *Pilgrim's Progress*, 1850, *14657*
pictures in progress, 1855, *18762*
Rainy day in the tropics, in Roberts collection, *979*
River of the water of life, in American Art Union Gallery, 1848,
14376, 14384, 14392, 14400, 14407, 14413, 14419, 14435,
14443, 14445, 14452, 14458, 14459
sales and prices, 1858, Romney collection sale, *19957*
sketch of Niagara, *19596*
South American composition, *19801*
South American view, 1855, *18670*
subject of anonymous epigram, *18543*
Sunset among the hills, completed, 1850, *14606*
Twilight, *18473*
Twilight in the wilderness, *20237*
Valley of Santa Isabel, *8454*
View in South America, at Century Club festival, 1858, *19783*
View near New Haven, purchased by C. W. Field, 1849, *21405*
whereabouts
1849, in Vermont, *14537*
1857, *19682*
1859, summer travel, *20080*
1860, Ohio, *24334*
1883, Hudson country home, *24657*
1883, Hudson, N.Y, *24728*
1884, in Mexico, *25109*
work, 1861, *18542*
works, 1857, *19767*
works in Robert Graves collection, *2388*
Church, Frederick Stuart, 1842-1923
anecdotes, *22384*
design for library window for Tiffany's, 1883, *24742*
Dusty Cupid, *11026*
etchings, *267, 10808, 11335, 11357*
for *Art Portfolio*, 1889, *14979*
published, 1892, *15998*
exhibitions
American Watercolor Society, 1880, *827, 9292*
American Watercolor Society, 1881, *296*
American Watercolor Society, 1882, *1300, 9612*
American Watercolor Society, 1883, *24425*
American Watercolor Society, 1884, *1736, 25002, 25012*
American Watercolor Society, 1884, *Pandora, 10932*
American Watercolor Society, 1885, *1933*
American Watercolor Society, 1886, *2150*
American Watercolor Society, 1887, *534, 2384*
American Watercolor Society, 1896, *Yellow water lilies, 5696*
Architectural League of New York, 1888, *2873*
Art Students' League, 1887, *529*
Boston Art Club, 1880, *72*

Boston Art Club, 1884, *24992*
Chicago Inter-State Industrial Exposition, 1880, *199*
Chicago Inter-State Industrial Exposition, 1889, *3056*
London, 1883, American Water-Color Exhibition, *24684,*
24713
Metropolitan Museum of Art, 1881, *1165*
Milwaukee Industrial Exposition, 1898, *Jealousy, 12800*
National Academy of Design, 1881, *1061*
National Academy of Design, 1884, *1790, 1879*
National Academy of Design, 1884, *Retaliation, 10982*
National Academy of Design, 1886, *10754*
National Academy of Design, 1887, *10786*
National Academy of Design, 1888, *10846*
National Academy of Design, 1902, *13359*
National Academy of Design, 1903, *13702*
National Academy of Design, 1907, *14311*
New York, 1891, *15350*
New York, 1893, *22521*
New York Etching Club, 1882, *1296*
New York Etching Club, 1884, *25013*
New York Etching Club, 1885, *1934*
New York Etching Club, 1888, *10843*
Prize Fund Exhibition, 1886, *25304*
Prize Fund Exhibition, 1887, *562*
Salmagundi Club, 1882, *1265*
Society of American Artists, 1886, *25309*
Society of American Artists, 1890, *Fog, 15205*
Union League Club of New York, 1890, *25861*
illustrations
Chafing dish, 12015
charcoal sketch, *17753*
comic cartoon, *10634*
Dreamers, 10736
Mermaid, 17857
St. Cecilia, 6011, 11873
Sorceress, 13101
Tigers (watercolor), *12711*
Undine, 13547
illustrations for *Harper's Magazine*, 1893, *22490*
illustrations for magazines, 1893, *22482*
King's flamingoes (drawing), *11050*
member, Salmagundi Club, *11166*
notes
1870, *10567*
1871, *10686, 10731*
1883, *24871*
opinions of art in Europe, *14231*
painting, 1883, *24541, 24817*
paintings in Evans collection, *11185*
Pandora, subject of poem by G. Houghton, *17769*
pictures in Evans collection, *11775, 15079*
pictures of surf and fog, *26961*
pyrography, *6237*
sales and prices
1889, *14961*
1891, *Snow flakes, 15646*
studio, *22700*
Twilight cloud, shown at Macbeth Galleries, 1893, *16316*
Una and the lion, 11896
watercolor from *Uncle Remus*, 1883, *24502*
White tigress, to be published, 1895, *16726*
work, 1883, *24728*
church furniture, *10644*
cressets and lamps, *26219*
embroidery for Chalice veil and pall, *2631*
England, *10148*
English stalls, canopies and rood-screens of 15th century, *9868*
church music
description of the *Credo, 18131*
notes, 1879, *669*
Church, Nellie See: **Beale, Nellie Church**
Church of England. Church Congress See: **Church**
Congress, 1878
Church of the Divine Paternity, New York See: **New York.**
Church of the Divine Paternity

church pennants
church banners, *1095, 2926*
Easter decoration for banner, *2874*
church vestments
15th century chasuble and mitre at Carrouges, France, *20920*
decoration, *2375*
embroidery decoration, *2337, 2358*
Flemish embroideries, *10501*
history, *8355, 8377, 8392*
stole decoration, *2440*
CHURCHILL, Alfred Vance, *22272*
Churchill, Alfred Vance, 1864-1949
on teaching drawing in public schools, 1900, *7314*
Churchill, George Charles Spencer See: **Marlborough,**
George Charles Spencer Churchill, *8th duke of*
Churchill, *Miss*, fl.1902
exhibitions, Paris, 1902, *13372*
Churchill, William Worcester, 1858-1926
exhibitions
Boston Museum of Fine Arts, 1880, *1026*
Cincinnati Art Museum, 1900, *13067*
St. Botolph Club, 1892, *26506*
Ciani, Victor A., 1858-1908
exhibitions, Pennsylvania Academy of the Fine Arts, 1899,
17526
Cicero, Marcus Tullius
villas, *19792*
CICERONE, *659, 680, 719, 753, 793, 832, 876, 893, 938, 960,*
979, 1003, 1045, 1066, 1171, 1203, 1286, 1368
Cigoli, Lodovico Cardi da, 1559-1613
Circumcision, anachronisms, *17635*
Cilicia
description, Mount Amanus, *20917*
Cima da Conegliano See: **Cima, Giovanni Battista**
Cima, Giovanni Battista, ca.1460-ca.1517
notes, 1893, *26982*
Cimabue, Giovanni, 13th cent., *11987*
painting found, 1897, *17241*
works in Louvre, *5969*
works in National Gallery, London, 1894, *4913*
Cimiotti, Gustave, b.1875
illustrations, *Family outdoors, 14311*
Cincinnati (Ohio)
architecture, Pike's Opera House, *24321*
art
1855, *18623*
1860, *24310*
1870, *10597*
1871, *10651, 10710*
collectors, 1898, *17447*
photography in ascendency over painting, 1860, *24335*
Probasco and other collections, *12274*
Saturday Afternoon Club's weekly meetings, 1896, *22980*
artists, *195, 221*
conspire against ignorance and prejudice, *24311*
Cincinnati room at Chicago World's Fair, 1893, *4509*
City Hall, E. H. Bell's stained glass window designs, *4404*
collectors and collecting, 1894, *16589*
exhibitions
1887, Cincinnati artists, *574*
1896, portraits, *22958*
1901, Cincinnati artists, *13270*
monuments
statue of Gen. McPherson unveiled, 1881, *356*
statue of Harrison, *26703*
statue of Reuben R. Springer by L. Powers, *9658*
statue of Reuben R. Springer to be commissioned, 1880,
9310
statue of Wm. Henry Harrison, *26730*
Venetian water cistern given by L. Anderson, 1894, *27016*
pottery
center for ceramics, 1894, *4818*
ceramics, *14058*
controversy over "Limoges" ware, 1880, *997*
school of instruction opens in Rookwood Pottery, 1881, *400*

Clark, Alfred Corning, 1844-1896
 collection, Millet's *Trois glaneuses*, *15056*
 commissions bronze casting of George Gray Barnard's statue of
 Pan for Central Park in New York City, *12779*
CLARK, Alice B., *23225*
Clark, Alson Skinner, 1876-1949
 exhibitions
 Pennsylvania Academy of the Fine Arts, 1906, *14244*
 Salon, 1906, *14116*
 Society of Western Artists, 1906, *14038*
Clark, Alvan, 1804-1887
 notes, 1885, *11273*
Clark, Benwell See: Clark, Joseph Benwell
Clark, Daniel, d.1745
 murder of Clark by Eugene Aram, *20969*
Clark, David, 1880-1921
 illustrations, *Blossom time*, *7237*
 notes, 1900, *7313*
CLARK, Dr., *Mrs.*, *20700*
Clark, Edward
 See also: Berg and Clark, architects
Clark, Egbert Norman, b.1872
 illustrations, illustration for *Dr. Jekyll and Mr. Hyde* and *Song
 of the Shirt*, *12964*
Clark, Eliot Candee, 1883-1980
 exhibitions, National Academy of Design, 1907, *14311*
Clark, Emilia M. Goldsworthy, 1869-1955
 art teacher in Indianapolis, *12918*
Clark, Ernest Ellis, b.1869
 Handbook of Plant Form, review, *13931*
Clark, George Frederick Scotson See: Scotson Clark,
 George Frederick
Clark, George Merritt, d.1904
 exhibitions, American Watercolor Society, 1884, *25038*
 notes, 1883, *24586*
 sketches of inns, *22704*
 summer home and studio, *22571*
 summer reception, studio, Tarrytown, 1883, *24677*
 whereabouts, 1883, studio in Tarrytown, *24728*
Clark, Harriet Candace See: Clark, Rose
Clark, Helen M., fl.1894-1900
 china decorator, *12016*
 exhibitions
 Chicago, 1894, *11375*
 Chicago Ceramic Association, 1895, *11706*
Clark, I. Emmons
 illustrations, figure sketch, *22598*
Clark, James H., d.1893
 obituary, *16371*
CLARK, John, *11364*
CLARK, John Spencer, *22391*
Clark, John Spencer, 1835-1920
 article on public school art instruction, *22388, 22393*
 on teaching art in public schools, *11743*
 response to survey on world's greatest masterpieces, 1898,
 12732
Clark, Joseph Benwell, b.1857
 Dinner hour (etching), *10017*
Clark, Lewis Gaylord, 1808-1877
 editor, *The Knickerbocker*, *21433*
Clark, Marshall, *Mrs.* See: Clark, Virginia Keep
Clark, Mary Cowles
 Life and Adventures of Santa Claus, review of illustrations,
 13527
Clark, Mary Jenks Coulter See: Coulter, Mary Jenks
Clark, Rosalind See: Pratt, Rosalind Clark
Clark, Rose, 1852-1942
 exhibitions
 Chicago Photographic Salon, 1900, *13035*
 Philadelphia Photographic Salon, 1900, *13120*
 Turin Esposizione, 1902, gold medal, *13618*
 Woman's Art Club of New York, 1892, *26542*
 portrait photographs (with Elizabeth Flint Wade), *13052*
Clark, Virginia Keep, b.1878
 illustrations, book design, *7238*

Clark, W. F. See: Clerk, William F.
Clark, Walter, 1848-1917
 exhibitions
 Boston Art Club, 1902, *13353*
 Carnegie Galleries, 1900, *13130*
 Chicago, 1899, *12893*
 Denver Artists' Club, 1898, *12706*
 National Academy of Design, 1883, *24480*
 National Academy of Design, 1902, Inness gold medal,
 13359
 New York, 1899, *17551*
 Society of American Artists, 1898, *12710*
 Worcester Art Museum, 1902, *13483*
 Worcester Art Museum, 1904, *13803*
 Gleaners, at American Art Galleries, 1889, *14972*
 illustrations, *Mill at Brinton's bridge*, *13202*
 summer studio, Brookhaven, L.I., 1893, *22491*
 whereabouts
 1883, *24804*
 1883, East Hampton, L.I, *24728*
 1883, Milford, *24755*
Clark, Walter Appleton, 1876-1906, *7232*
 illustrations in Christmas magazines, 1899, *7182*
 notes, 1899, *12348*
 obituary, *14256*
Clark, William Andrews, 1839-1925
 collection, *17584, 17607*
 purchases Preyer collection, 1901, *13384*
CLARKE, Alice V., *13301*
CLARKE, Caspar Purdon, *14214, 14284*
Clarke, Caspar Purdon, 1846-1911
 appointed Keeper of Art Collections, South Kensington
 Museum, 1891, *26434*
 designs for Indian pavilion at Paris Exposition, 1878, *21578*
 director of Metropolitan Museum of Art, 1905, *13844*
 plans annual exhibition of American art, 1906, *14142*
 returns as active director of Metropolitan Museum of Art, 1906,
 14039
Clarke, Charles S.
 collection, *10731*
Clarke, Daisy E., fl.1894-1895
 illustrations
 Corner of my studio, *22610*
 No objection to color, *22537*
Clarke, E. Rees See: Rees Clarke, E., *Mrs.*
Clarke, Edward Francis C., fl.1881-1887
 illustrations, view of Lumley Castle, *21901*
CLARKE, Ellis T., *13101, 13205*
CLARKE, H. Gillette, *2514*
Clarke, Helen See: Clark, Helen M.
CLARKE, Herbert Edwin, *21471*
Clarke, Ida F., fl.1885-1889
 exhibitions, Architectural League of New York, 1888, *2873*
 wall paper design, *9993*
 work for Associated Artists, *1907*
Clarke, Isaac Edwards, 1830-1907
 *Art and Industry: Education in the Industrial and Fine Arts in
 the United States*, review, *2255*
 Democracy of Art, review, *2343*
 Tribute to Bayard Taylor, *749*
Clarke, John S.
 lecture on practical education, 1880, *9372*
Clarke, Joseph, ca.1820-1888
 designs for Bakers' Hall, *9888*
Clarke, Joseph Ignatius Constantine, 1846-1925
 Heartsease, performed, 1897, *23197*
Clarke, Mary Cowden, 1809-1908
 letter to Century Club, 1860, *20286*
 Shakespeare's Works, review, *20321*
Clarke, McDonald, 1798-1842
 mad poet, *22997*
 prints, *16387*
Clarke, Peyton Neale, b.1855
 member of art jury, Tennessee Centennial, 1896, *11843*
Clarke, Rebecca Sophia See: May, Sophie

Clarke, Robert, & co., publishers, Cincinnati
 Americana catalogue, 1893, *16230*
Clarke, Sara Ann, b.1808
 landscapes, 1858, *19819*
 studio in Boston, 1858, *19785*
 View near Sorrento, *19875*
CLARKE, Somers, *25995, 25996, 26087*
Clarke, Somers, 1841-1926
 article on *Stone and wood carving*, excerpt, *5201*
Clarke, Susan Cornelia See: **Warren, Susan Cornelia Clarke**
Clarke, Thomas Benedict, 1848-1931, *15599, 15696*
 anecdote, *17607*
 annual prize to best American figure composition, *25279*
 art dealer, New York City, *15790*
 Art House, *15748*
 Clarke prize, 1891, *26231*
 Clarke prize for Academy exhibition, 1884, *25099*
 collection, *1719, 11207, 11254*
 American landscapes exhibited at Union League Club of
 New York, 1890, *3152*
 American paintings exhibited at American Art Union gallery,
 1884, *10917*
 American paintings shown at Pennsylvania Academy, 1891,
 26411
 American pictures inspire Boston collectors, *25032*
 Bacchic dance vase, *3157*
 Chinese porcelains to be sold, 1901, *7550*
 description, 1886, *2265*
 description of house with collection in New York, 1891,
 15748
 discovers Harnett, *16316*
 exhibited at Pennsylvania Academy of the Fine Arts, 1891,
 3752, 15727
 exhibition, 1883, *24943*
 exhibition, 1883-4, *24955*
 exhibition, 1884, raises money for fund, *24995*
 exhibition of American works inspires appreciation of
 American art, *485*
 exhibition plans, 1883, *24723, 24829*
 frequently loaned collection for exhibition, *17584*
 Greek room, *15929*
 Homer paintings, *17191*
 motivation for collecting, *24940*
 moves, 1999, *7005*
 opens to public, 1883, *24931*
 Oriental art exhibited at Union League Club, New York,
 1889, *3099*
 paintings at National Academy of Design, 1892, *15988*
 paintings exhibited at National Academy of Design, 1892,
 4143
 Persian and Indian art, *25779*
 pictures selected for World's Columbian Exposition exhibit-
 ed, New York, 1893, *16171*
 praise, *15772*
 purchase of *Crucifixion* at Gabalda sale, 1890, *25848*
 purchase of *Iron workers' noon-day rest* by Thomas P.
 Anshutz, *12934*
 sale, 1898, *6551*
 sale, 1899, *6872, 6902, 12315, 12844, 12871, 17505, 17512,
 17527, 17531, 17535*
 sale, 1899, American paintings to be auctioned, *12845*
 sale, 1899, role of patriotism, *17523*
 sale of Chinese antiques, 1901, *13210*
 sale of Inness pictures to set standard for his market prices,
 1899, *20635*
 shown at Pennsylvania Acad. of the Fine Arts, 1891, *15753*
 Tanagra figurines, *15659*
 terracotta market place, *25886*
 terracottas, *25742*
 viewed by Rembrandt Club of Brooklyn, 1890, *15469*
 Yung Ching vase, *2697*
 collector, *3561*
 criticized in *L'art dan les deux mondes*, 1891, *15559*
 dealer of Oriental and ancient Greek art, 1891, *3571*
 elected chairman of Union League Club, 1897, *17241*

 funds prize for figure composition at National Academy, 1883,
 24866
 guarantees annual prize for figure painting in National
 Academy annual exhibitions, 1883, *10929*
 manager, summer exhibition, Fifth Avenue Galleries, 1894,
 27005
 moves, 1899, *7005*
 notes, 1892, *15882*
 opens commercial gallery, 1891, *15709*
 patron of American artists, *556*
 plans exhibition of American art, 1883, *24792*
 plans figure composition prize, 1883, *24695*
 plans to establish fund for annual prizes at National Academy,
 1883, *24723*
 prize, definition of "figure composition", *25124*
 quote, praises *The Studio*, *24729*
 resigns from art committee of Union League Club, 1892, *15800*
 sponsors summer exhibition of American painting, New York,
 1893, *16260, 16277*
 whereabouts
 1883, returns from western trip, *24829*
 1883, western states, *24804*
Clarke, Thomas Shields, 1860-1920, *13072*
 exhibitions
 Architectural League of New York, 1895, cartoon for stained
 glass, *5318*
 Architectural League of New York, 1900, *Alma Mater* for
 Princeton University, *7231*
 Chicago World's Fair, 1893, *4565*
 National Academy of Design, 1891, *3832*
 National Academy of Design, 1895, *5171*
 Pennsylvania Academy of the Fine Arts, 1905, *13853*
 Salon, 1893, *4426*
 illustrations
 bell in low relief, *14026*
 Caryatid "Autumn", *13556*
 kind of artist, *5033*
 McDonough on Dewey arch, *7096*
 notes, 1883, *24400*
 studio, in Paris, 1894, *27004*
 whereabouts
 1883, Europe, *24513*
 1883, goes abroad, *24631*
 1883, sails for Europe, *24855*
 1883, summer on western plains, *24728*
 1896, Millbrook, N.Y, *23056*
Clarke, Walter R., fl.1902-1907
 furniture, use of pyrography, *13433*
 illustrations, chest, *14267*
CLARKE, Walter S., *12280*
CLARKSON, Ralph Elmer, *12079, 12679, 12951*
Clarkson, Ralph Elmer, 1861-1942, *12654*
 Chicago portrait painter, *12081*
 commissioned to paint portrait of W. J. Bryan, 1898, *12662*
 elected president, Chicago Society of Artists, 1905, *13914*
 exhibitions
 Chicago, 1897, *12631*
 Chicago Art Institute, 1900, *13137*
 Chicago Art Institute, 1901, *13191*
 Chicago Art Institute, 1903, *13561*
 National Academy of Design, 1890, *26162*
 National Academy of Design, 1890, *Arrivée des nouvelles*,
 3455
 Society of Western Artists, 1900, *12986*
 Society of Western Artists, 1903, *13698*
 Society of Western Artists, 1906, *14038*
 illustrations
 Despair, *13936*
 portrait of Charles C. Curtiss, *14263*
 sketch in oil, *10879*
 member of jury for Chicago Society of Amateur Photographers,
 13035
 notes, 1897, *11924*
 vice-president, Chicago Municipal Art League, 1901, *13199*
Clary, Désirée See: **Désirée, *queen, consort of Charles XIV***

notes, 1850, *14646*
CLEVY, Frances E., *23214*
Clifford, Ada See: **Murphy, Ada Clifford**
Clifford, Chandler Robbins, 1858-1935
 Period Decoration, review, *13307*
Clifford, Edward, 1844-1907
 portrait painter in Boston, 1885, *1949*
Clifford, Maurice, fl.1890-1898
 exhibitions, London, 1898, *24114*
Clifford, R. A., fl.1871
 exhibitions, Chicago Academy of Design, 1871, *10652*
CLIFT, Ida Young, *7569*
climate
 influence on Greek art, *8933*
Clinedinst, Benjamin West, 1859-1931
 David Harum drawings, *13161*
 exhibitions
 American Watercolor Society, 1900, Evans prize, *13021*
 National Academy of Design, 1891, *3603*
 Prize Fund Exhibition, 1885, *25278*
 Prize Fund Exhibition, 1886, *2226*
 illustrations
 Household cares, *22752*
 portrait, *22482*
 Water-colorist, *3626*
 Watercolorist, *7264*
 teacher at Drexel Institute, 1900, *13046*
Clint, Alfred, 1807-1883
 obituary, *14879*
Clint, George, 1770-1854
 notes, 1893, *16304*
Clinton, Charles W., 1838-1910
 competition designs for Grant monument critiqued, 1890, *3360*
Clinton, DeWitt, 1769-1828
 monuments
 bronze colossal statue commissioned from H. K. Brown, 1851, *14779*
 funds raised by 1850, *14634*
 statue for Greenwood cemetery by H. K. Brown, *14606*
Clinton Smith, Murray See: **Smith, Murray Clinton**
clock and watch making, *10592*
clocks
 antique clocks, *15759*
 clock and candelabra in Royal Berlin porcelain, *17886*
 collectors and collecting
 Baron Rothschild's Louis XVI clock, *17231*
 Louis XVI's clock acquired by Rothschild, 1890, *15276*
 history, *17823*, *17854*, *17872*
 Kenyon and Burleigh collections, *15917*
 Master Humphrey's clock, *16357*
 tower of Palais de Justice, Paris, *20898*
Clodion, Claude Michel, 1738-1814
 authenticity of group disputed, 1884, *1760*
 illustrations, panel designs, attributed, *1558*
 notes, 1889, *2963*
 sculpture in Alfred de Rothschild collection, *10179*
CLOPATH, Henriette, *13182*
Closs, Adolf, 1840-1894
 illustrations, *Britomart and her nurse* (after G. F. Watts), *21678*
Closson, William Baxter Palmer, 1848-1926
 engraves old masters for *Harper's Magazine*, 1884, *25032*
 engraving process, *25831*
 exhibitions
 Boston Museum of Fine Arts, 1881, *1254*
 Boston Paint and Clay Club, 1884, *25083*
 New England Manufacturers' and Mechanics' Institute, 1883, *24768*
 New York, 1890, *25847*
 New York, 1890, wood engraving proofs and prints, *3229*
 New York, 1890, wood engravings, *15141*
 frontispiece for *Scribner's Magazine*, 1893, *22490*
 illustrations
 Daniel Huntington (after N. Sarony), *316*
 Goose girl (after W. Shirlaw), *409*
 Jean Louis Hamon, *436*

M. Muncácsy (after Klösz), *318*
 Magdalen (after Rimmer), *181*
 Mount Adams, Cincinnati (after E. K. Foote), *221*
 Palestine views, *9684*
 Portrait of Dr. William Rimmer, *167*
 Portrait of Elihu Vedder, *120*
 Young squire (after T. Couture), *460*
 illustrations in *Scribner's*, 1895, *5345*
 notes, 1899, *17527*
 pastels, *12903*
clouds
 description by Cropsey, *18938*
 remarks by R. Peale, *19747*
 storm clouds, described by Ruskin, *9972*
clouds in art
 meanings of cloud types in depicting nature, *18543*
 technique for painting, *7625*
 tinting, *7908*
Clouet, Jean, ca.1486-1540
 Elizabeth of Austria, *2062*
 painting stolen, 1890, *25978*
 Portrait of a young woman, found, 1890, *26016*
CLOUGH, Arthur Hugh, *18930*
Clough, George Albert, 1843-1910
 plans for courthouse in Boston, 1886, *515*
Clough, Jessie L., fl.1899-1915
 illustrations, *Portrait*, *12964*
Clough, Thomas, fl. 1880
 designs for book covers, *9322*
Clovelly (England)
 description and views, *21770*
CLOVER, Lewis Peter, *20346*
Clover, Philip, 1842-1905
 obituary, *13878*
Clovio, Giulio, 1498-1578
 Bradley's *Life and Works of Giorgio Giulio Clovio*, *15563*
 will found, *407*
Club Bindery See: **New York. Club Bindery**
club houses
 Harlem Club house, designed by Lamb & Rich, and Algonquin Club in Boston, designed by McKim, Meade and White, *25545*
Club of Odd Volumes, Boston See: **Boston (Massachusetts). Club of Odd Volumes**
clubs
 London, *10129*, *10142*, *10176*, *10200*, *10219*, *10227*
CLUIT, F. E., *14184*
Clulow, fl.1861
 quote, *20068*, *20371*, *20373*
 on poets, *19965*
Cluny Museum, Paris See: **Paris (France). Musée des Thermes et de l'Hôtel de Cluny**
Cluseret, Gustave Paul, 1823-1900
 exhibitions, Paris, 1895, *16705*
Clusmann, William, 1859-1927
 exhibitions, Chicago Art Institute, 1895, *11673*
 illustrations, *Harbor, Chicago River*, *11810*
 teaches oil or water-color in Chicago studio, 1894, *27025*
Clute, Beulah Mitchell, b.1873
 Art Students' League prize, Chicago, 1897, *12645*
 exhibitions
 Chicago Art Students' League, 1897, *12643*
 Chicago Art Students' League, 1898, *12819*
 illustrations
 Mother Goose melody, *12720*
 student work, *12633*
Clute, Fayette J., 1865-1921
 ABC of Photography, review, *13552*
Clute, Walter Marshall, 1870-1915
 exhibitions
 Chicago Art Institute, 1899, *12838*
 Chicago Art Institute, 1902, *13370*, *13536*
 Society of Western Artists, 1903, *13698*
 Society of Western Artists, 1906, *14038*
 illustrations

Favorite model, 12474
pencil sketch, *12699*
Portrait of Fred Richardson, *12686*
Clute, Walter Marshall, Mrs. See: **Clute, Beulah Mitchell**
coal mines and mining
Wales, *21237*
Coale, Samuel A., Jr.
art dealer and art patron, *4798*
collection, *4872, 15797, 15842, 16432*
description, *153*
Oriental musical instruments, *15699*
purchases, 1880, *9326*
sale, 1881, *329, 9467*
sale, 1894, *16519, 16553, 22320, 26999*
to be sold, 1894, *16494*
editor of art paper, 1889, *14957*
exhibition building in Saratoga opens, 1883, *24704*
letter warning collectors against dishonest art dealers, 1892, *4012*
notes, 1890, *15170*
proposes to build art gallery at Saratoga, 1883, *24569*
Coan, Frances Catherine Challenor See: **Challenor Coan, Frances Catherine**
COAN, Titus Munson, b.1836, *10806*
Coan, Titus Munson, b.1836
article on Courbet in *Century* angers Boston, 1884, *25046*
Coast, Oscar R., 1851-1931
portraits, photograph, *22539, 22559*
studio in New York, 1883, *24904*
Coate, Harry W., fl.1907-1915
exhibitions
Carnegie Institute, 1907, *14328*
Coates, Foster, d.1914
editor of *Advertiser*, *22988*
Cobb, Cyrus, 1834-1905
America, *22988*
illustrations, *America*, *23012*
Cobb, Darius, 1834-1919
Bridal procession of John Alden and Priscilla, *24981*
Christ before Pilate, *9086*
exhibitions
Boston, 1878, *8964*
Detroit Art Loan Exhibition, 1883, *24826*
portrait commission from Algonquin Club, 1895, *22738*
Cobb, Howell, 1815-1868
letter with stamp found, 1895, *16878*
COBBE, Frances Power, *21953*
Cobbett, Edward John, b.1815
exhibitions, Society of British Artists, 1858, *19898*
Cobden, A. B.
Practical Hints on China Painting, excerpt, *5070*
COBDEN SANDERSON, Thomas James, *26115*
Cobden Sanderson, Thomas James, 1840-1922
bookbindings, *12989, 17176, 25669*
criticised by G. Smalley, 1895, *16667*
English bookbinder, *17029*
Coblenz See: **Koblenz (Germany)**
Coburn, Alvin Langdon, 1882-1966
illustrations
Ely Cathedral (photograph), *13532, 13570, 14107*
Portsmouth pier (photograph), *13738*
Coburn, Frederick Simpson, b.1871
depiction of the face, *22759*
COBURN, Frederick William, *13651, 13700, 13725, 14133, 21526*
Coburn, Jean Pond Miner See: **Miner, Jean Pond**
Cochin, Charles Nicholas, 1715-1790
portrait of Benjamin Franklin, *19931*
sales and prices, 1894, drawings, *27007*
Cochrane, Nellie Welsh, fl.1901
illustrations, decorative head for copying, *7559*
notes, 1901, *7586*

Cockburn, Henry Thomas, 1779-1854
Memorials of His Time, excerpt, *19854*
Cockerell, Douglas, 1870-1945
Bookbinding and the Care of Books, review, *13415*
Cocking, John James, fl.1883-1888
illustrations, views of Holloway College, *10102*
Codman, Ogden, jr., 1868-1951
Decoration of Houses, review, *12115*
Codman, William Christmas, 1839-1923
statue of Roman sentinel for the Belgravia, New York, 1892, *26686*
CODY, Elphege G., *10150*
Coe, Benjamin Hutchins, 1799-1883
collection, *19899*
Coe, Ethel Louise, d.1938
illustrations, study in oil from life, *13249*
Coessin de la Fosse, Charles Alexandre, b.1829
Lion-hunting in Arabia: the rescue, *9010*
Coeylas, Henri, fl.1879-1900
illustrations, *Dolorida* (engraved by Fleuret), *4762*
coffee
use as beverage, *17858*
Coffin, E. L., fl.1875-1887
exhibitions, National Academy of Design, 1886, *2352*
Coffin, Elizabeth Rebecca, 1850?-1930
exhibitions
National Academy of Design, 1887, *10831*
National Academy of Design, 1892, *Hanging the nets* awarded Dodge prize, *3988*
Hanging the nets, wins Dodge prize, 1892, *26617*
Coffin, George A., fl.1894-1896
biographical sketch, *11446*
Coffin, George Y., 1850-1896
drawings acquired by Library of Congress, 1905, *13869*
Coffin, Haskell, 1878-1941
exhibitions, Charleston Art Association, 1898, portrait of Ethel Dawson, *6669*
COFFIN, William Anderson, *24966, 25570*
Coffin, William Anderson, 1855-1925, *2526*
address to National Academy, 1888, on Paris Exposition of 1889, *25551*
After breakfast, in Clarke collection, *24943*
article on American illustration, 1892, *26549*
article on illustration, 1892, *26538*
author of articles on technique for *The Studio*, 1884, *24964*
candidate for World's Fair art director, 1890, *3425*
collects American paintings in Europe for Pan American Exposition, 1901, *13199, 13240*
criticized, 1899, *17607*
director, Department of Fine Arts, Pan-American Exposition, Buffalo, 1901, *13150, 22110*
exhibitions
American Art Association, 1886, *2344*
American Art Galleries, 1884, *24988*
American Art Galleries, 1887, *10832*
American Watercolor Society, 1883, *Towers of Camelot*, *1510*
American Watercolor Society, 1884, *25012*
American Watercolor Society, 1885, *1933*
Architectural League of New York, 1898, *6571*
Berlin Akademie der Künste, 1903, *13605*
Brooklyn, 1890, *15039*
Brooklyn Art Association, 1884, watercolors, *25092*
Brooklyn Art Association, 1892, *26582*
Chicago, 1899, *12893*
Cincinnati Art Museum, 1898, *12754*
National Academy of Design, 1883, *1678*
National Academy of Design, 1886, second Hallgarten prize, *25293*
National Academy of Design, 1887, *10831*
National Academy of Design, 1892, *26594*
National Academy of Design, 1896, *22996*
New York, 1892-3, *22483*
New York, 1893, *4317, 16122*
New York, 1894, *4759*

1889, Richard H. Lawrence and J. V. Palmer collections, *14962*
1890, *15211, 15298, 15454*
1890, catalogue of Coulton-Davis collection criticized, *15073*
1890, Coulton sale, *15041*
1890, Parmelee collection, *15216, 15235, 15256*
1890, Van der Duyn collection, *15044*
1891, *15498, 15629, 15656, 15778, 15783, 15790*
1891, coins offered, *15467*
1891, Köhler, Lippert and Von Schennis collections, Frankfort, *15663*
1892, *15937, 15996, 16027*
1893, *16161, 16193, 16294*
1893, Borden and Roso collections, *16412*
1893, collections auctioned in New York and Philadelphia, *16278*
1893, gold and silver, *16382*
1893, Whitman collection sale, *16307*
1894, *16519, 16544, 16567, 16589*
1894, Carfrae collection, *4934*
1895, *16710, 16767, 16778, 16789*
1895, Greek and Roman coins, *16684*
1895, Hart collection, *16713*
1895, Ulin and Schiefflin collections, *16722*
1896, *16911, 16948, 17016, 17027, 17090*
1897, *17205, 17207, 17241, 17383*
1897, Frossard sale, *17276*
Spink lawsuit to recover value of broken coin, 1896, *17065*
"Sprinkle dollars", *16894*
standards for design, *10792*
terminology, Kimball's circular of numismatic terms, *10814*
United States, *18659, 18662*
 1894 dime, *16808*
 American silver coinage, 1891, *3722*
 American silver dollar compared with ancient medal from Syracuse, *25373*
 coinage, 1892, *26475*
 Columbian half-dollar minted, 1892, *16041*
 Columbian half-dollars, 1892, *26739*
 Columbian souvenir coins, 1892, *26779*
 Columbian souvenir half dollar, 1892, *26861*
 Columbian souvenir quarter, 1893, *26969*
 competition for new coins, 1891, *26356*
 competition to design new coinage, 1891, *26348*
 Confederate half dollar, *16646*
 design for souvenir half dollars, 1892, *26730*
 designs invited for American coins, 1891, *26309*
 double eagle, 1850, *14619*
 new designs exhibited, 1895, *5373*
 New Orleans and Confederate mints, *16828*
 souvenir coins for Columbian Fair, *26907*
 souvenir half dollars for Chicago World's Fair, 1893, *26878*
 souvenir quarters for Chicago World's Fair, 1893, *26937*
 state coins of New Jersey, *16329*
 World's Fair souvenir half dollars, *16342*
Colarossi Life School See: **Paris (France). Atelier Colarossi**
COLBERT, E., *13748*
Colburn, Jeremiah, 1815-1892
 obituary, *15800*

Colburn, Joseph Elliott, 1853-1927
 exhibitions, Chicago Society of Artists, 1895, *11483*
Colby, Charles D., b.1865
 painting of nude covered by drapery at Winnebago Count Fair, 1892, *26777*
Colby College See: **Waterville (Maine). Colby College**
Colby, Eugene C., 1846-1930
 elected president Rochester Art Club, *13213*
 illustrations, *Landscape*, *590*
Colby, George Ernest, b.1859
 biographical sketch, *11417*
 whereabouts, 1894, Chicago, *11374*
Colby, Madison, 1842?-1871?
 bust of Bret Harte, *10679*
 notes, 1871, *10623, 10686*

Cole, Adelaide See: **Chase, Adelaide Cole**
COLE, Alan Summerly, *9641, 9791, 21731*
COLE, Annette, *11318, 11999*
Cole, Annette, fl.1894-1897
 class in art history, Chicago, 1894, *11345*
 class studying Italian Renaissance, 1895, *11711*
Cole, Blanche Dougan, b.1869
 exhibitions
 Colorado Art Club, 1898, *12822*
 Denver Artists' Club, 1898, Indian studies, *12251*
 Denver Artists' Club, 1899, *12327, 12886*
 marries William Cole, 1894, *27014*
 pastel portraits, 1894, *27014*
Cole, George, 1810-1883
 exhibitions
 Royal Society of British Artists, 1879, *21706*
 Society of British Artists, 1858, *19898*
 obituary, *9892, 14912*
 Sunset-Sussex, *8802*
Cole, George *(medium)*
 medium, *20727*
 readings of photograph of "Mary" compared with engraving of statue of "Highland Mary", *20672*
Cole, George Townsend, 1874-1937
 whereabouts, 1901, visiting Los Angeles, *22127*
Cole, George Vicat, 1833-1893, *21616*
 exhibitions
 Royal Academy, 1880, *21874*
 Royal Academy, 1884, *10007*
 Royal Academy, 1886, *2245*
 Society of British Artists, 1858, *19898*
 health, 1891, *26315*
 Oxford seen from the meadows, shown in Boston, 1885, *25259*
 pictures in Layton Art Gallery, Milwaukee, *12813*
 Showery weather, *8585*
Cole, Hamilton, d.1889?
 collection, description, 1890, *3221*
 library
 sale, 1889, *14956*
 sale, 1890, *3248, 15041, 15132, 15171*
COLE, Helen, *12915, 13048*
COLE, Henrietta Lindsay, *21914*
Cole, Jennie See: **Blake, Jennie Cole**
Cole, Jessie Duncan Savage, 1858-1940
 exhibitions, St. Botolph Club, 1889, *2859*
Cole, Joseph Foxcroft, 1837-1892
 advisor to Boston collectors, *20628*
 album of lithographs published by Prang, 1870-71, *23598*
 anecdote, *15604*
 champion of Impressionism, 1891, *3601*
 circle of artists around him, *1848*
 etchings, *67*
 exhibitions
 American Art Association, 1883, *24398*
 American Art Galleries, 1883, *1485*
 Boston, 1890, *25822*
 Boston Museum of Fine Arts, 1880, *225*
 Boston Museum of Fine Arts, 1893, *16122*
 Boston Museum of Fine Arts, 1893, memorial exhibition, *22483*
 Boston Museum of Fine Arts, 1893, memorial exhibition planned, *4283*
 Boston Paint and Clay Club, 1884, *25083*
 Boston Paint and Clay Club, 1885, *1949, 25259*
 National Academy of Design, 1880, *126*
 Philadelphia Society of Artists, 1882, *1270*
 St. Botolph Club, 1880, *159*
 illustrations, *Norman farm*, *1750*
 Normandy pastoral, in Boston Museum of Fine Arts, *13073*
 notes
 1870, *23601*
 1871, *10616*
 1891, *3813*
 1899, *17536*
 obituary, *26642, 26649*

Columbia (South Carolina)
capitol, design by H. K. Brown, *20166*
Columbia University See: **New York. Columbia University**
Columbian Ceramic Society See: **Chicago (Illinois).**
 Columbian Ceramic Society
Columbus, Christopher, 1446-1506
biography, *20848*
birthplace, *26396*
Centennial, 1892
 anniversary celebrations, *26830*
 anniversary volume published in Germany, *15944*
 building decorations for celebration in New York, *4159*
 caravels reproduced in Barcelona, *26752*
 celebration in Huelva planned, *26578*
 celebration in New York, *4142*
 celebrations in Huelva, London and Madrid, *26817*
 commemorative medal, *15930*
 commemorative postage stamps, *15877, 16069*
 commemorative postage stamps, 1893, *16087*
 commemorative postage stamps ridiculed, 1893, *16140*
 exhibition in Genoa, *26704*
 medal by L. Ahlgren, 1893, *16321*
 medal designed by Lea Ahlborn, *26999*
 plans for centenary celebration, 1890, *26117*
 Spanish commemorative medal, *16297*
 voyage commemorated, 1892, *26713*
claim to discovering America disputed, 1894, *16473*
documents, collections and collecting, *15811*
letters
 bought by Lenox Library, 1892, *16022*
 discovery in Spain, 1890, *15197*
 in Ives collection sale, 1891, *15552*
 presented to Redwood, R.I., Library, 1892, *26740*
 to King Ferdinand's treasurer, *26043*
memorial celebration in Boston, 1890, *26116*
memorial celebration in Madrid, 1891, *26227*
monuments
 bronze statue for World's Fair, 1893, *26931*
 Buyens' statue not wanted by Boston Art Commission, 1892, *26786*
 Buyens statue to be replicated for Boston, 1892, *26779*
 colossal design by Palacio, *26163*
 Domincan government gives site for monument, 1892, *26517*
 Italian monument, 1892, *26713*
 Italian monument coming to New York, 1892, *26730*
 Italian monument for New York to be unveiled, 1892, *26577*
 Italian monument in New York needs funds, 1892, *26853*
 Italian statue arrives in New York, 1892, *26762*
 Italian statue for New York, *26686*
 memorial in Washington proposed, 1890, *25782*
 monument for New York made in Italy, 1892, *26656*
 monument porposed by Italian communities for New York, 1891, *26454*
 New York City, *26696*
 New York Columbus monument by Gaetano Russo, *4172*
 New York monument to be designed by Gaetano Russo, 1890, *26002*
 N.Y. Genealogical Society offers statue to New York, 1892, *26656*
 Russo's statue on its way to New York, 1892, *26721*
 silver statue by Bartholdi for World's Fair, 1893, *26952*
 statue by Buyens for San Domingo, *26752*
 statue by Sunol commissioned by New York Genealogical and Biographical Society, 1892, *26843*
 statue from Italy to arrive, 1892, *26740*
 statue in Buenos Aires, *26044*
 statue proposed for Central Park, 1891, *26475*
 statues in New York, *26666*
 statues in New York, 1892, *26762*
portraits, *15897, 15972, 16227, 16475, 25534*
 Aivazovsky at work on Columbus series, 1892, *4100*
 anonymous portrait painted from life shown in Boston, 1892, *16026*
 collection of American Antiquarian Society of Worcester, *16243*

collectors and collecting, *15769*
commemorative coin, 1893, *16084*
copy found in Lancaster, Kentucky, 1904, *13781*
etching by Dawson, *15847*
etching by Lefort published, 1892, *26563*
forgeries, *15996*
Gunther's Columbus, *15951*
history of pictures, *26824*
Lotto portrait to be copied by Olin Warner for souvenir coin, 1892, *26800*
medal, *16010*
medal by Pogliaghi, *16111*
painting by Lotto bought for America, 1891, *26402*
plate by Henri Lefort, 1892, *15821*
portrait attributed to Antonio Moro to be shown at Chicago World's Fair, 1893, *26382*
portrait by Lotto, *26035*
portrait for souvenir coins, 1892, *26740*
portraits with beard or ruff are forged, *4179*
recently discovered portrait to be exhibited at World's Columbian Exposition, *16197*
so-called Lotto portrait, *16006*
presented with ivory casket from Ferdinand and Isabella, 1503, *25838*
relics, *16840*
 excavated on San Carlos Bay, 1897, *17262*
 sought for Chicago World's Fair, 1892, *26761*
scenes from life on doors, Capitol, Washington, *20045*
subscription to benefit a descendant of Columbus, 1893, *4521*
Columbus (Ohio)
academy of arts funded by bequest, 1892, *26617*
art, new art club established, 1897, *12095*
monuments
 McKinley arch commissioned, 1903, *13618*
 statue of Schiller too large for transport, *26322*
Columbus (Ohio). Ceramic Club See: **Columbus (Ohio).**
 Columbus Ceramic Club
Columbus (Ohio). Columbus Art Association
exhibitions
 1905, arts and crafts, *13886*
 1905, Boston artists, *14009*
 1906, *14108*
Columbus (Ohio). Columbus Art School
annual exhibitions, 1890, *25959*
awards, 1897, *6306*
notes, *9372*
 1883, *24587*
 1899, *7090*
scholarships established, 1905, *14011*
Columbus (Ohio). Columbus Ceramic Club
reception, 1894, *11432*
Columbus (Ohio). Columbus Decorative Art Society
notes, 1882, *9680*
Columbus (Ohio). Columbus Gallery of Fine Arts
building, site requested by trustees, 1904, *13752*
Huntington elected president, 1903, *13618*
Columbus (Ohio). Gallery of Fine Arts See: **Columbus (Ohio). Columbus Gallery of Fine Arts**
Columbus (Ohio). Paint and Clay Club
notes
 1898, *12824*
 1899, *12859*
Columbus (Ohio). Pen and Pencil Club
exhibitions
 1899, book-plates, *12330*
 1901, *13209*
columns
France, column of July, *21047*
India, Hindu columns, *20530*
Colville, W. J., ca.1859-1917
medium, *Ode to spirit art*, *20646*
COLVIN, Sidney, *9575*
Colvin, Sidney
letter about Holbein's *Ambassadors*, *26095*

Colvin, Verplanck, 1847-1920
 letter on Adirondack Preserve, *10814*
Colyer, Vincent, 1825-1888
 exhibitions
 National Academy of Design, 1849, *21429*
 National Academy of Design, 1858, *19857*
 New York artists' reception, 1858, *19817*
 studio in Rowayton, Conn., 1883, *24480*
 whereabouts, 1883, Rowayton, Ct, *24728*
Coman, Charlotte Buell, 1833-1924
 art school in New York, 1884, *25132*
 exhibitions
 Anerican Art Union, 1883, *View near Dordrecht, Holland*, *10913*
 Brooklyn Art Association, 1884, watercolor, *25092*
 Carnegie Institute, 1907, *14328*
 National Academy of Design, 1892, *26594*
 National Academy of Design, 1907, *14311*
 Prize Fund Exhibition, 1886, *25304*
 Woman's Art Club of New York, 1903, *13703*
 lady artist of New York, 1880, *915*
 portraits, photograph, *22559*
 studio, pen drawing of by M. Landers, *2399*
 studio reception, 1884, *25079*
 woman artist of New York, *22474*
 woman in art, *22525*
Comb, Voltaire See: **Combe, Voltaire**
Combaz, Ghisbert, b.1869
 illustrations
 poster design, *13872*
 posters, *13488*
 tablet of bronze, *13862*
Combe, George, 1788-1858
 on physiological make-up of artists, *19439*
 Phrenology Applied to Painting and Sculpture, excerpts, *19505*
 Phrenology in its Connection with the Fine Arts, review, *18979*
 quote, *19602*
Combe, Voltaire, fl.1864-1901
 illustrations, musicians, *22613*
 portraits, photograph, *22603*
 Town character, *22968*
Comédie française See: **Paris (France). Comédie française**
Comerre, Léon François, 1850-1916
 exhibitions
 Salon, 1883, *1568, 14898*
 Salon, 1884, *1789*
 Société des Artistes Français, 1907, *14312*
 illustrations, *Young lord, 4639*
 modern French painter, *10260*
Comerre Paton, Jacqueline, b.1859
 feminine beauty in her paintings, *22654*
comets
 anecdotes, *18009*
COMFORT, George F., *13461, 13571*
Comines, Philippe de, *sieur* d'Argenton, 1445?-1509
 Mémoirs, editions, *16567*
Comins, Eben Farrington, b.1875
 resigns as director Saint Paul School of Fine Arts, 1901, *13208*
Comins, Elizabeth Barker, fl.1870-1893
 illustrations
 cup and saucer designs, *4156*
 decoration for cups and saucers, *4485*
 Melody, 4275
 illustrations for *Louisa May Alcott the Childen's Friend, 628*
Comins, Lizbeth See: **Comins, Elizabeth Barker**
COMINS, Lucy, *5051, 5098, 5153, 5286, 5321, 5357, 5386, 5418, 5450, 5470, 5501, 5545, 5584, 5629, 5794, 5795*
Comins, Lucy, fl.1891-1896
 illustrations
 coffee cup and saucer, *5452*
 Cupid plate, *3808*
 decoration for a coffee cup and saucer, *5455*
 milkweed decoration, *3719*
 Ribbon plate, instructions for copying, *3914*
 Ribbon plates, *3592*

Ribbon plates, *3642*
 Wild rose design, *4330*
Comly, A. B., fl.1894
 illustrations, scene from summer art school, *22572*
commercial art
 advertising in *The Quartier Latin*, *24181*
 Chicago, 1899, *12414*
 exhibitions, Central Art Association, 1899, *12373, 12406*
 newspapers, indecent use of nude figures, *565*
 Pears' soap use of paintings, *17747*
 Quartier Latin advertisements praised in *The Draper's Record*, 1898, *24180*
 use of human form, *12307*
Commerre, Léon See: **Comerre, Léon François**
Commission permanente des beaux-arts, France See: **France. Commission permanente des beaux-arts**
Common Council of Philadelphia See: **Philadelphia (Pennsylvania). Common Council**
Commynes, Philippe de See: **Comines, Philippe de**, *sieur* d'Argenton
Comolli, Giovanni Battista, 1775-1830
 bust of Napoleon, *16573*
Compera, Alexis, 1856-1906
 exhibitions, Denver Artists' Club, 1905, *13907*
Comperet, Alexis See: **Compera, Alexis**
composition (art), *2136, 2155, 9488, 9500, 18863*
 F. W. Moody on even distribution in design, 1895, *5466*
 high horizon line, *24839*
 importance, *7824*
 landscape, *2249, 4608*
 notes
 1893, *26957*
 1898, *6566*
 painting, *25080*
 children, *4884*
 technique
 composing paintings, *5488*
 sketching from nature, *3018*
 use of lines in depicting nature, *3160*
Compte Calix, François Claudius, 1813-1880
 exhibitions, National Academy of Design, 1858, *19857*
 obituary, *179, 9405, 21891*
 Scene at Fontainebleau, costume of Louis XI, acquired by Corcoran Gallery, 1875, *8462*
Comstock, Anthony, 1844-1915
 attacks licentious art, *2600*
 censors Fielding's *Tom Jones*, *16556*
 head of Society for the Supression of Vice, *25479*
 influence on censorship of art, *25578*
 raid on Art Students' League, *14203*
 rebuked in court, *2638*
 trial of dealer for selling obscene pictures, 1883, *24930*
Comstock, Caroline L., fl.1895
 illustrations, *Taken unawares*, *22625*
Comstock, Frederick R., 1866-1942
 moderate cost house described and illustrated, 1901, *7578*
Comte, Pierre Charles, 1823-1895
 obituary, *16901, 16964*
CONANT, Alban Jasper, *10936, 11030*
Conant, Alban Jasper, 1821-1915
 exhibitions
 Boston Art Club, 1894, *8340*
 National Academy of Design, 1887, *10831*
 St. Louis, 1871, *10654, 10713*
 group portrait of Garrison family, 1883, *24502, 24525*
 lecture, Rembrandt Club, 1889, *14948*
 notes, 1871, *10621*
 portrait of General Robert Anderson shown in New York, 1892, *26606*
 portrait paintings, 1870, *10570, 10599*
CONANT, C. B., *18637*
Conant, Cornelia W., fl. 1863-1900
 American woman painter, *11230*
 exhibitions, National Academy of Design, 1884, *Knitting lesson*, *10982*

Conant, Lucy Scarborough, 1867-1921
exhibitions, Art Students' Club, Worcester, Mass., 1895, *22738*
Conarroe, George Washington, 1801-1882
Contemplation, at Philadelphia Art-Union, 1849, *21404*
Concarneau (France)
American artists at artists' colony, 1883, *24736*
artists' colony, *22916*
description, 1883, *24932*
Concord (Massachusetts)
monuments, Minuteman statue by D. C. French, *12983*
Conder, Charles, 1868-1909
exhibitions, London, 1906, with Jacques E. Blanche, *14142*
CONDER, F. R., *8474, 8485, 9061*
Conder, Josiah, 1852-1920
lecture on Japanese flower arrangement, 1889, *25632*
Condie, Ella See: **Lamb, Ella Condie**
CONDIT, Ida Marcia, *12866, 12914*
Condit, Ida Marcia, fl.1895-1899
opens studio in Chicago, 1895, *11451*
Cone, Ada L.
Perspective: A Series of Elementary Lectures, review, *3094*
Confederate Museum, Richmond See: **Richmond (Virginia).**
Confederate Museum
conformity, *8344*
Confucius, 551-479 B.C.
biography, *20650*
spiritual nature, *20651*
Congdon, Charles Taber, 1821-1891
article on over illustration, *11113*
Congdon, Henry Martin, 1834-1922
architect, Brooklyn Academy of Design, *10648*
Congrès archéologique de France
1881, *430*
Congrès artistique de 1877 See: **Antwerp (Belgium). Congrès artistique de 1877**
Congrès international de l'art public, 1899 See: **Paris (France). Congrès international de l'art public, 1899**
congresses and conventions
England, Social Science Congress, 1882, *1432*
Coninck, Pierre de, 1828-1910
Strawberry girl, *8467*
Coninxloo, Jan van, b.ca.1489
Christ disputing with the Doctors, decorative motifs, *10367*
Conkey, Samuel, 1830-1904
exhibitions, Chicago, 1870, *10632*
notes, 1871, *10620, 10686*
Conley, Sarah Ward, 1861-1944
illustrations, *Elia*, *22588*
Conley, William Brewster, 1830-1911
exhibitions, Detroit, 1894, *27026*
Connah, Douglas John, 1871-1941
exhibitions, National Academy of Design, 1892, *26858*
Connard, Philip, 1875-1958
illustrations
Adrift, *24209*
headpiece, *24188*
tailpiece, *24225*
Tragic poesy, *24167*
Weird musician, *24224*
Connecticut
freak residents, *16667*
Connecticut Historical Society See: **Hartford (Connecticut). Connecticut Historical Society**
Connecticut Museum of Industrial Art See: **New Haven (Connecticut). Connecticut Museum of Industrial Art**
CONNELL, P. C., *13858*

Connely, Pierce Francis, b.ca.1840
colossal allegorical group of figures, *10640*
studio, Florence, 1871, *10639*
CONNOISSEUR, *11756*
Connoisseur Club, London See: **London (England). Kanooser Club**
Connolley, J., fl.1903
illustrations, *One of the disputants*, *13554*

Connor, Charles, 1852-1905
obituary, *13878*
Connor, Washington Everett, 1849-1935
collection, painting by Monchablon, *15035*
Conolly, Ellen, fl.1873-1885
exhibitions, Royal Academy, 1879, *9189*
Conover, Augustus W., d.1901?
obituary, *7714*
Conrad, Reine Adelaide, b.1871
illustrations, *Beggar at the church of St. Sulpice, Paris*, *12678*
Conrads, Carl H., b.1839
statue of Alexander Hamilton, New York, *237*
statue of Gen. Stark commissioned for Concord, N.H., 1890, *25782*
statue of General Thayer, unveiled at West Point, 1883, *14904*
Consani, Vincenzo, 1815-1887
sculpture in Florence, 1878, *21627*
Conscience, Hendrik, 1812-1883
obituary, *14912*
Conseil des musées nationaux See: **France. Conseil des musées nationaux**
conservation and restoration
canvas relining, *17421*
cleaning and restoring oils, watercolors and engravings, *11905*
cleaning and restoring prints, *4222*
cleaning, glazing, and caring for paintings, *8019*
how to repair paintings, 1893, *4309*
manuscripts, U.S. State Department collection, *16527*
notes
1880, *219, 240, 264*
1881, *335, 360, 407, 430*
1901, *7661*
paintings, removal of old varnish, *17536*
prints, how to keep chromo-lithographs, *23520*
restorer of paintings J. Vollmering, New York, *24783*
restorer's advertisement, 1894, *16589*
sculpture, methods used in European museums, *1818, 1838*
Societé des Artistes Français's study of painting methods, *3571*
techniques for cleaning paintings, 1903, *8109*
Constable, Henry, fl.1876
stained glass windows, Philadelphia Centennial Exhibition, 1876, *8769*
Constable, James Mensell, d.1900?
obituary, *7315*
Constable, John, 1776-1837
against imitation of old masters, *19056*
anecdote, *5482, 15869, 17276*
Dedham Vale, in Marquand collection, 1903, *8124*
English Landscape, excerpt, *5380*
excerpt from book by M. Brock-Arnold, *9491*
excerpts from James Orrock article, *5820*
exhibitions
American Fine Arts Society, 1893, *4315*
Boston Art Club, 1880, *878*
Burlington House, 1893, two questionable attributions, *4357*
Carnegie Galleries, 1902, *13520*
Chicago World's Fair, 1893, *4467*
Lenox Library, 1893, *4361*
Metropolitan Museum of Art, 1897, *6280*
New York, 1894, *Cornfield* first conception, *16589*
New York, 1895, *5400*
New York, 1896, *Vale of Stour*, *17191*
New York, 1898, *Weymouth Bay*, *6590*
forgeries
1894, *16466, 16515*
1895, *5458*
1897, *17335*
Hadleigh Castle
in Vanderbilt collection, *4428*
on view in New York, 1893, *16227*
Hampstead Heath, *16616, 17429*
illustrations
etching, *8109*
landscapes, *18463*
landscapes in American collections, *25585*

Cooper, Colin Campbell, *Mrs.* See: Cooper, Emma
Lampert
COOPER, E. H. Moyle, *23810, 23823, 23840, 23868, 23901,
23930, 23952, 23984, 24060, 24067, 24082, 24179, 24210*
COOPER, E. T., *20664*
Cooper, Edith, fl.1877-1898
 illustrations, *Feeding birds* (after Priou), *17809*
Cooper, Emma Lampert, 1855-1920, *12143*
 By the old mill, 22879
 exhibitions
 American Art Galleries, 1882, *1297*
 American Watercolor Society, 1903, *13592*
 Chicago Art Institute, 1907, *14333*
 Minneapolis Society of Fine Arts, 1895, *11513*
 Pennsylvania Academy of the Fine Arts, 1889, *2885*
 Pennsylvania Academy of the Fine Arts, 1901, *13163*
 Woman's Art Club of New York, 1896, *22958*
 Woman's Art Club of New York, 1903, *13703*
 quote, on painting landscape, *22525*
 whereabouts, 1887, Paris, *603*
Cooper, H. J., fl.1880-1881
 Art of Furnishing, on hall and staircase, *898*
 on furnishing, *1030*
Cooper, H. J., firm, London
 doctor's consulting room, *1303*
 furniture designs, *2100*
 house in London, *2628*
COOPER, James, *20640, 20641, 20657*
Cooper, James
 medium, *20726*
 translations of spirit writings, *20661, 20668, 20671*
Cooper, James Davis, 1823-1904
 illustrations
 Adoration of the Magi (after Botticelli), *9740*
 Apostles at the tomb (after Botticelli), *10095*
 balcony from Venice by Sansovino, *10230*
 Calling of Abraham (after Poussin), *10095*
 Capri (after M. G. Brennan), *10238*
 Child's funeral at Chioggia (after A. N. Roussoff), *9786*
 Christ mocked (after D. Morelli), *10226*
 Colonial and Indian exhibition: the vestibule (after F. G.
 Kitton), *10376*
 Drawing class room, 10155
 drawings of London after W. Hatherell, *10129*
 Fornarina (after Sebastiano del Piombo), *10143*
 frescoes by Masolino, *10181*
 Gateway to the Old London street, 10002
 Guards' Club at Maidenhead (after W. Hatherell), *10142*
 illustrations after Alma-Tadema, *8353*
 In Martha's garden (after W. H. Margetson), *10268*
 In the bleak wind, unsheltered (after G. Doré), *8530*
 Jersey trio (after Edwin Douglas), *10168*
 Junior United Service Club (after W. Hatherell), *10176*
 Last Supper (after Masaccio), *9740*
 Madonna della Casa Diotalevï (after Raphael), *10098*
 Marriage of Teniers (after Teniers), *10179*
 Mauro, sent to save Placido, walks on the water (after
 Sodoma), *9973*
 *Model of the Castle of Fenis, Val d'Aosta, at the Turin exhibi-
 tion, 10002*
 Mozart playing the clavier, with his father and sister, 10153
 Mr. Edwin Cooper (after portrait by Mr. Douglas, sen.),
 10168
 Naval and Military Club, Piccadilly (after W. Hatherell),
 10200
 New Museum and Art Gallery, Birmingham (after photograph
 by Thrupp), *10230*
 open-air performances at Coombe House (after W.
 Hatherell), *10204*
 perspective piece by Vredman de Vries, *10254*
 Phillip IV of Spain (after Velasquez), *9723*
 picture at Hampton Court by Guellim Strettes, *10240*
 picture at Hampton Court by Holbein, *10240*
 picture at Hampton Court by Lucas de Heere, *10240*
 picture at Hampton Court by Renée van Leemput, *10240*

picture at Hampton Court by Van Bassen, *10254*
 snowy landscapes (after Wilson's photographs), *10094*
 Theatre of the New Club, 10142
 Trout stream (after photograph by Berens), *10163*
 views of International Health Exhibition, *9983*
 views of London clubs (after W. Hatherell), *10219*
 views of the Riviera, *10062, 10077*
 Villefranche, 9963
 Watching and waiting (after J. E. Millais), *8530*
Cooper, James Fenimore, 1789-1851
 monuments
 memorial proposed, 1859, *18349*
 monument in Cooperstown, *26043*
 portraits, engraving by Marshall, *20302*
 Prairie
 excerpts, *14727*
 illustration by Darley, *14801*
 writings illustrated by Darley, *18380*
COOPER, Lena M., *12971*
Cooper, Peter, 1791-1883
 biography by Thomas Hughs, *17053*
 building for Mechanics Institute, *18092*
 monuments
 memorial statue designed by St. Gaudens, for Cooper Union,
 23008
 statue by Saint Gaudens, *2676*
 statue proposed, 1856, *19518*
Cooper, Samuel, 1609-1672
 documents, *10135*
 English miniaturist, *16606, 17679*
 miniatures, *17700*
Cooper, Susan Fenimore, 1813-1894
 Rhyme and Reason of Country Life
 excerpt, *18553*
 review, *18559*
Cooper, Thomas Sidney, 1803-1902
 autobiography, *25899, 26260, 26281*
 birthday, 1901, *13309*
 collection, bequest of gallery to Canterbury, 1902, *13436*
 notes
 1895, *16862*
 1901, *7692, 22131*
 obituary, *7850*
 On the Stour, acquired by Mark Hopkins Institute, 1898, *6545*
 popularity in England, *5073*
 royal decoration, 1901, *13270*
 sales and prices, 1901, *13241*
Cooper Union for the Advancement of Science and Art See:
New York. Cooper Union for the Advancement of Science
and Art
Cooper, William, 1852?-1892
 obituary, *26724*
Cooper, William Brown, 1811-1900
 letter on Tennessee's tax on artists, 1887, *574*
Coover, F. M., fl.1899
 illustrations, *Caricature, 12964*
Coover, Nell B., fl.1892-1940
 illustrations, *Little Breton, 4047*
Cope, Arthur Stockdale, 1857-1940
 illustrations
 Convocation (after H. S. Marks), *21581*
 General's head-quarters (after J. F. Pettie), *21581*
 Loot (after J. E. Hodgson), *21602*
Cope, Charles West, 1811-1890
 exhibitions
 Royal Academy, 1850, *Lear, 14655*
 Royal Academy, 1850, sketches for frescoes, *14644*
 Royal Academy, 1878, *9023*
 obituary, *26046*
 Young mother, 8871
Cope, Edward Drinker, 1840-1897
 collection, fossils, *15787*
 sale, 1896, *17016*
 obituary, *17339*

Cope, Edward Meredith, 1818-1873
Taste for the Picturesque among the Greeks, review, *19647*
Copeland, Alderman, fl.1827-1867
illustrations
Returning from the vintage, *20976*
Sabrina, *20976*
Copeland, Alfred Bryant, 1840-1909
copies of old masters, *46*
exhibitions, Salon, 1880, *913*
paintings in Appleton collection, *876*
Copeland and Day, publishers
book design, *22388*
Copeland, Charles, 1858-1945
exhibitions, Boston Society of Water Color Painters, 1887, *549*
watercolors, *1935*
COPELAND, Herbert, *21487*
Copeland, Meta Vaux, fl.1903-1904
exhibitions, Philadelphia, 1903-1904, *13676*
Copeland, Thomas Campbell See: **Campbell Copeland, Thomas**
Copenhagen (Denmark)
art, city acquires Jacobsen collection, 1899, *17505*
description, 1854, *21164*
exhibitions, 1895, woman's work, *11600*
Copenhagen (Denmark). Ny Carlsberg Glyptothek
establishment by Carl Jacobsen, *8348*
Copestick, Alfred, d.1859
illustrations
Thoughts while making the grave of a new-born child, *18329*
Wind against tide (after C. Stanfield), *18081*
obituary, *18382*
Copinger, Walter Arthur, 1847-1910
Latin Bible collection, presented to General Theological Seminary of New York, 1894, *16439*
Copley, John Singleton, 1737-1815, *21688*
American nationality, *4702*
biography, *20159*
in brief, *11246*
Death of Chatham, *5933*
exhibitions
Copley Society, 1902, *13442*
Philadelphia Centennial Exhibition, 1876, *8719*
Fitch family
acquired by Boston Museum, 1899, *17488*
loaned to Boston Museum of Fine Arts, 1899, *12837*
illustrations, *Portrait of Mrs. Winslow*, *13696, 13849*
Impeachment of five members of the House of Commons by King Charles, *20080*
life and work, *15971*
Long Parliament, *18349*
notes, 1901, *7641*
paintings in Boston Athenaeum, 1850, *14676*
paintings in Boston Museum of Fine Arts, *720, 2053, 17617*
portrait of judge discovered in Boston, 1893, *16326*
portrait of Major Andre bought by Gunther, 1891, *15705*
portrait of Mr. and Mrs. Izard, *13618*
portrait of Paul Revere, *26632*
portrait of Watson acquired by New York Historical Society, *19875*
portraits, portrait by Lord Lyndhurst, *6528*
portraits of Daniel Rea and his wife, *26319*
sales and prices
1859, *King Charles I demanding of the House of Commons the five impeached members*, *18316*
1903, portrait of Mr. and Mrs. Izard, *13604*
style, *21121*
subject of excerpt from Warren's *Men and Times of the Revolution*, *19610*
works acquired by Old State House Museum, 1888, *2801*
Copley Society of Boston See: **Boston (Massachusetts). Copley Society of Boston**
Copp, Ellen Rankin, b.1853
bust of Dr. Abraham Reeves Jackson for Chicago College of Physicians and Surgeons, *26932*
exhibitions

Chicago Art Institute, 1895, *11680*
Chicago Art Institute, 1896, *11894*
statue for Chicago World's Fair, 1892, *26778*
copper
technique for creating rainbow colors, *7947*
Coppet, Frederick de See: **DeCoppet, Frederick**
Coppier, André Charles, b.1867
Napoleon and his staff (after Meissonier), published, 1892, *16061*
copying
copying machine invented, 1894, *16448*
works of art
anecdote, *16935*
artist's consent necessary in England, 1861, *20341*
at Metropolitan Museum of Art, 1883, *24538*
at the Corcoran Gallery, 1879, *701*
examples, *22037*
forbidden by Metropolitan Museum, *1251*
forgeries due to misuse of artists' copies, 1894, *4702*
French copyists, *2542*
French government selects two best copies of paintings for purchase, 1902, *8015*
from engravings and photographs, *737*
illegal copying of prints, *16110*
moral right of artist to make and sell copies of own work, *591*
role in art education, *5880*
survey of museums' policies, 1906, *14217*
techniques for copying, *3355*
use of pastels, *16905*
copyright
American publisher fails to protect Walter Crane's *Noah's Ark Alphabet*, *25514*
art, *63, 117, 19381, 19458, 19484, 26386*
bill in English House of Commons, 1886, *10293*
bill submitted to Royal Academy, 1899, *12879*
book on artistic copyright by Reginald Winslow, *25713*
copyrights for English artists, 1899, *17608*
designs, *18604*
England, *19913*
France, *11139*
French barrister tries to pass laws protecting artists, *14010*
French legislation, *10938*
New South Wales, *10059*
proposed Senate bill, 1890, *25968*
recommended by Maitre Jose Thery, 1905, *13974*
reproduction of paintings can be restricted, *27016*
reproduction of pictures, 1895, *16723*
United States, *19995*
violations, *16309*
bill before Congress, 1860, *20199*
British copyrights not recognized in Canada, 1903, *8281*
International congress to be held to draft copyright bill, 1900, *7341*
New York World sued for copyright infringement, 1894, *4753*
photography, *9875*
R. U. Johnson and the International Copyright Act, 1891, *26454*
Coquand, Paul, fl.1873-1885
illustrations, *Corner of Brittany*, *1355*
Coquelin, Constant, 1841-1909
collection, sale, 1893, *26970*
Coquelin, Ernest Alexandre Honoré, 1848-1909
collection
sale, 1893, *4514, 16260, 26975*
shown in London, 1892, *26714*
Coquelin, Jean, 1865-1944
debut at Comédie française, 1890, *26166*
Coques, Gonzales, 1614-1684
Dutch interior shown in New York, 1887, *540*
Five senses, acquired by National Gallery, London, 1882, *9889*
corals
Ward's coral collecting expedition for Harvard, 1897, *17287*
Corbet, Matthew Ridley, 1850-1902
obituary, *13504*
Val d'Arno, acquired by Royal Academy, 1901, *7611*

Corbin, Austin, 1827-1896
 collection, *15616*
Corbould, Edward Henry, 1815-1905, *19853*
Corcoran Gallery of Art See: **Washington (D.C.) Corcoran Gallery of Art**
Corcoran School of Art See: **Washington (D.C.) Corcoran School of Art**
Corcoran, William Wilson, 1798-1888
 collection, *15797*
 1855, *18667*
 building for art, 1860, *20166*
 gallery nears completion, 1861, *20343*
 gallery open to public, 1855, *18619*
 gives portrait of Sir Moses Montefiore to Corcoran Art Gallery, 1887, *25412*
 notes, 1883, *24716*
Corcos, Vittorio Matteo, 1859-1933
 Portrait, *10283*
Cordew, Victoria
 illumination of books, *12961*
Cordier, Charles Henri Joseph, 1827-1905
 exhibitions, Paris, 1860, *20257*
Cordoba, Mathilde de See: **DeCordoba, Mathilde J.**
Cordonnier, Alphonse Amédée, 1848-1930
 Shepherds discovering the head of Orpheus, *21998*
Cordova (Spain)
 palace of Az-zahra, *20514*
 views, *9489*
Core, E. B., fl.1899
 exhibitions, Photographers' Association of America Convention, 1899, *12937*
Corelli, Augusto, b.1853
 exhibitions, New York, 1894, *4758*
Corelli, Marie, 1864-1924
 Thelma, excerpt, *13423*
CORINNE, *18051*
Corinth (Greece)
 antiquities
 excavations, 1896, *16977*
 Fountain of Pirene discovered, 1898, *6674*
Cork (Ireland)
 description and views, *21027*
Corliss, George, d.1898
 catalogue of Chicago Art Institute, *13311*
Cormon, Fernand, 1845-1924, *12121*
 exhibitions
 Salon, 1887, *17774*
 Salon, 1887, medal of honor, *2476*
 Salon, 1898, decorations for a museum, *6646*
 school in Paris, 1883, *24413*
 warns English artists against adopting French style, 1891, *3506*
Corneille, Michel, 1602-1664
 illustrations, *St. Cecilia* (engraving), *3019*
Cornelius, Peter von, 1783-1867, *14816*
 cartoons for Campo Santo, near Charlottenburg, 1850, *14658*
 cartoons for the Campo-Santo, Berlin, *14795*
 exhibitions, Paris Exposition, 1855, *18999*
 founder of Dusseldorf school, *18027*
 frescoes for the Campo-Santo of the King of Prussia, *14635*
 Last judgement, *19419*
 paintings, *20092*
 whereabouts
 1859, Rome, *19993*
 1860, leaves Rome to return to Dusseldorf, *20317*
Cornell College, Mount Vernon, Iowa See: **Mount Vernon (Iowa). Cornell College**
Cornell University See: **Ithaca (New York). Cornell University**

Corner, James M.
 Examples of Domestic Colonial Architecture in New England, issued, 1892, *15912*
Cornicelius, Georg, 1825-1898
 exhibitions, Hanover, 1899, *24302*

Cornoyer, Paul, 1864-1923
 exhibitions
 Central Art Association, 1897, *11955*
 New York, 1906, *14070*
 Society of Western Artists, 1898, *Venice*, *12802*
 illustrations
 Rainy day - Madison Square, New York, *14282*
 Side canal, *11582*
 member of art jury, Tennessee Centennial, 1896, *11843*
Cornu, Sébastien, 1804-1870
 murals in church of St. Mery, Paris, *14635*
Cornwall
 description and views, *21571*, *21614*
 moors and glens, *9864*
Cornwall, Barry, *pseud*. See: **Procter, Bryan Waller**
Corot, Jean Baptiste Camille, 1796-1875, *1186*, *15558*
 anecdote, *16592*, *16894*, *17481*
 art importations to U.S., 1879, *734*
 Barbizon School, *17487*
 biographical note, *16445*
 Bouleau, in Lyall collection, *15990*
 Dance of nymphs, *2286*
 in Fuller collection, *15828*
 Dante and Virgil, donated to Boston museum, 1875, *8517*
 description of a day painting out-of-doors, *25260*
 early struggles, *12475*
 essay by J. J. Rousseau, *8471*
 etchings, facsimiles, *15126*
 Evening, at Knoedler's, 1880, *846*
 exhibitions
 American Art Galleries, 1890, Barye Monument Fund Exhibition, *3154*
 Buffalo, 1896, *11806*
 Carnegie Galleries, 1902, *13520*
 Chicago Art Institute, 1898, *12668*
 Chicago World's Fair, 1893, *4766*
 Glasgow Institute, 1880, *21848*
 New York, 1878, *8981*
 New York, 1887, *10833*
 New York, 1889, *25683*
 New York, 1890, *25731*
 New York, 1890, facsimile prints after etchings, *3207*
 New York, 1892, *15863*, *26622*
 New York, 1894, *16519*
 New York Etching Club, 1884, *25013*
 Paris, 1875, *8510*
 Paris, 1887, palettes of artists, *2490*
 Paris, 1895, 100th anniversary, *22765*
 Paris Exposition, 1878, *21662*
 Pedestal Fund Loan Exhibition, 1883-4, *1705*, *24914*
 Providence, 1891, *15573*, *26319*
 Providence Art Institute, 1891, *26429*
 Salon, 1859, *20077*
 Union League Club of New York, 1887, *2406*
 forgeries, *10943*, *15322*, *25877*
 art dealer specializes in fake Corots, 1891, *3571*
 counterfeit works on Paris art market, 1883, *1616*
 Dumas-Trouillebert-Corot affair, *10961*
 pictures sold as Corots actually by Trouillebert, *14930*
 Trouillebert's paintings pass as Corot's, 1893, *4387*
 illustrations
 At break of day, *86*
 Canal at St. Quentin, *11873*
 Charette, *13807*, *14214*
 Edge of the woods, *13250*
 Lake Nemi, *5941*
 Landscape, *3500*, *14212*
 Myrtle wreath, *3567*
 Wood-gatherers, *23078*
 Just before sunrise, in Munger collection at Chicago Art Institute, *12785*
 Landscape, colors, *4533*
 landscape painter, *24946*
 landscape shown in New York, 1886, *25346*
 landscapes, *2268*, *4497*

letters in autograph sales, *25528*
lithographs, landscape, *6311*
Martyrdom of St. Sebastian, in Walters collection, *22226*
monuments
 centenary monument commission to Rodin, 1895, *11571*
 monument planned, 1895, *16721, 16751*
notes
 1856, *19421*
 1888, *2725*
 1898, *17408*
obituary, *8426*
Orpheus, as a poem, *24934*
painting acquired by San Fran. collector C. Crocker, 1891, *3490*
painting by Trouillebert sold as Corot to Dumas fils, *25267,
 25033, 25272*
painting in Crocker collection, San Francisco, *22787*
painting in Layton Art Gallery, Milwaukee, *12813*
painting shown in New York, 1887, *25399*
painting technique, *24683*
paintings acquired by London National Gallery, 1896, *17107*
paintings at Reichard and Co., 1889, *14946*
paintings in American collections, *2655, 15486, 25585*
paintings in Boston collections, *17787*
paintings in Henry Field Memorial Collection at Art Institute of
 Chicago, *12694*
paintings in Laurent-Richard's collection, *9012*
paintings in Robinson collection, *25357*
paintings in Secrétan collection, Paris, *10823*
paintings in Seney collection, *2458*
paintings in Shaw collection, *1205*
paintings in Walters collection, Baltimore, *1931*
paintings shown at Louisiana Purchase Exposition, 1904, *13790*
paintings suggested for exhibition of French masterpieces at
 American Art Galleries, 1889, *3073*
personality, *25150*
pictures discovered in church in Nantes, 1905, *13937*
pictures in W. H. Vanderbilt collection, *25469*
pictures in Wickenden collection, *22483*
portraits, sketch by Daumier, *3257*
praise, *15783*
pupils, *22787*
quote
 on guiding principles in art, *20618*
 on painting from nature, 1891, *3463*
 on sketching figures, *3460*
 praise of Dupré, *22240*
Robaut's catalogue, 1895, *5336*
Romantic painting in France, *22994*
sales and prices
 1875, *8573*
 1879, landscape in Spencer collection, *678*
 1887, *2477*
 1889, *Incendie de Sodôme* sold to Durand-Ruel, *3031*
 1890, *3208, 15250, 26135*
 1891, *15800*
 1893, *16243*
 1893, pictures in Knoedler collection, *26928*
 1899, *17600*
 1899, paintings in Richmond collection, *17500*
 1903, *13600*
Solitude
 in Brandus gallery, 1898, *17405*
 in collection of Madame De Cassin, *2528*
St Sebastien, purchased by Walters, 1884, *1694*
style, *15927*
View of Rome in 1834 and *Dance of the nymphs* in Walker col-
 lection, Minneapolis, *12924*
work in G. A. Drummond collection, *4974*
works in Seney collection, 1891, *3502*
Corr, Fanny See: **Geefs, Fanny Corr**
Correa, Rafael M., fl.1889-1930
 illustrations, *Landscape, effect of snow*, *13444*
Correggio, 1489?-1534, *434, 459, 14749, 18643*
 copies by P. Toschi, *9709*
 first picture, *19967*

frescoes
 discovered in Mantua, 1895, *11591, 16726*
 engraved by Paolo Toschi, *1069*
 for study of Gabriel d'Este discovered in Mantua, 1895,
 22765
illustrations
 Holy Night, *12717, 13570, 22849*
 Princess of Ferrari (attributed), *7200*
lost painting discovered, 1890, *25735*
Madonnas, *23136*
Magdalena
 reproduce by Prang in chromo, *23604*
 reproduced in chromolithography, *23499*
notes
 1870, *23601*
 1897, *6092*
painting in Clapham collection, 1896, *17074*
paintings in Borghese Palace collection, *19925*
pictures in Dresden, *21485*
play based on his life, *19115, 19132, 19147, 19160, 19177,
 19195, 19209, 19224, 19242, 19253*
Reading Madonna
 child's reaction, *23512*
 reproduced by Prang in chromo, 1868, *23529*
Reading Magdalen
 Morelli claims it not genuine, 1892, *3924*
 reproduced by Prang in chromo, *23560, 23568*
work in National Gallery, London, 1894, *4941*
Correja, Henry, fl.1881-1883
 exhibitions
 Pennsylvania Academy of the Fine Arts, 1882, *1450*
 Salon, 1883, *24521*
corridors
 decoration, *558*
 city hall and a country hall, *6942*
 hallway of country house, *6750*
 narrow hallway, 1892, *3910*
 treatment of the hall, 1893, *4370*
 designing halls, *3111, 3512*
 lighting dark hallways, *3911*
Corrodi, Hermann, 1844-1905
 obituary, *13878*
 paintings in studio, 1881, *21892*
Corsham Court, Wiltshire, England
 collection, sale, 1899, *17629*
Corsi Palace, Florence See: **Florence (Italy). Palazzo Corsi**
Corsini gallery See: **Rome. Galleria nazionale d'arte antica**
Corsini palace, Rome See: **Rome. Palazzo Corsini**
Corson, Alice Vincent See: **Patton, Alice Vincent Corson**
Corson, Helen See: **Hovenden, Helen Corson**
Corson, Katherine Langdon, 1869-1925
 landscape painter, *22525*
 portraits, photograph, *22539*
Corson, Walter Heilner, *Mrs.* See: **Corson, Katherine
Langdon**
Cortez, Hernando, 1485-1547, *21253*
CORTISSOZ, Royal, *22515*
Cortona, Pietro da See: **Pietro da Cortona**
Corvus Frugilegus See: **rook (bird)**
Corwin, Charles Abel, 1857-1938
 biographical sketch, *11417*
 exhibitions
 Chicago, 1899, *12876*
 Chicago Art Institute, 1900, Cohn prize, *13137*
 Chicago Art Institute, 1901, *13191*
 Chicago Art Institute, 1902, *13370, 13536*
 Chicago Art Institute, 1903, *13561*
 Chicago Artists' Exhibition, 1899, *12310*
 Chicago Society of Artists, 1892, *11308*
 Chicago Society of Artists, 1894, *11456*
 illustrations, *Ten Pound island*, *13251*
 pastels, *11934*
 sales and prices, 1898, Chicago, *12701*
 summer school at Lake Forest, 1895, *11637*
 whereabouts, 1894, returns to Chicago from New York, *27025*

Cory, Fanny Young, 1877-1972
 elected member of Society of Illustrators, 1903, *13604*
CORY, Florence Elizabeth, *1292, 4083*
Cos Cob (Connecticut) See: **Greenwich (Connecticut)**
Cos (Greece) See: **Kos (Greece)**
Cosens, Frederick William, 1819-1889
 collection, sale, 1890, *15444*
 library, sale, 1890, *15363, 26177*
Cosimo, Piero di See: **Piero di Cosimo**
Cosmopolitan Art Association
 acquisitions, 1857, Boker collection, *18033, 18086*
 annual distribution
 1856, *17917, 17923*
 1856, catalogue of works of art, *17937*
 1856, commissions, *17899, 17901, 17924, 17926, 17931,
 17932, 17934, 17938*
 1856, medallions from Carl Müller, *17900*
 1856, purchase of Genoa crucifix, *17908*
 1857, *17936, 17971, 18094*
 1857, commissions paintings by L. M. Spencer, *18038*
 1857, commissions paintings by L. M. Spencer and J. B.
 Thompson, *18010*
 1857, purchases Powers' *Greek slave*, *18084*
 1858, *18166, 18245*
 1859, *18286*
 1860, *18514*
 annual engraving
 1856, *17904, 17927*
 1856, *Saturday night* by Lemon (after Faed), *17923*
 1857, *18036, 18041, 18089*
 1857-1859, *18389*
 1858, *18253*
 1859, *18287, 18320, 18352, 18353, 18371, 18376*
 1859, criticism, *18285*
 1860, *18451, 18472, 18512*
 annual premiums, 1859, Herring's *Village blacksmith*, *18322*
 artists' prize fund
 1860, *18446, 18475, 18502, 18511*
 1861, suspension, *18545*
 benefits for soliciting subscriptions, *18044, 18388*
 benefits of membership, 1859, *18320*
 benefits of subscribing, *18090, 19682*
 definition of the word "cosmopolitan" and its significance in
 the Association's purpose, *17947*
 description and history of magazines distributed, *17935*
 Dusseldorf Gallery
 permanent headquarters, *18281*
 purchased, 1857, *18022, 18040*
 financial statistics, 1858, *18254*
 gallery design, 1856, *17923*
 governors' responses to receiving honorary memberships,
 17941
 history and purpose, *17896*
 honorary secretaries
 1856, *17939*
 1859, *18390*
 notes
 1856, *17902, 17929, 17942*
 1857, *17964, 17968, 17972, 18000, 18009, 18010, 18041*
 1858, *18252*
 1859, *18289, 18321, 18322, 18352, 18385*
 1860, *18480, 18514, 18516, 18517*
 1861, *18543*
 pictures awarded to subscribers
 1858, *18047, 18058, 18062, 18081, 18096, 18106, 18115,
 18127, 18139, 18151, 18168*
 1859, *18229*
 1860, *18482*
 plan and object, *18521*
 policies
 1857, *18165*
 1858, *18253*
 1859, *18387*
 1860, *18515*
 annual engravings, *18078*

 patronage, *18070*
 Power's *Greek slave*, repurchased, 1857, *18034*
 praise by E. D. Palmer, *17940*
 praise by eminent contemporaries, *18248, 18521*
 praise by press, *17908, 17911, 17932, 17943, 17944, 17975,
 17976, 18011, 18043, 18350, 18391*
 praise by R. Willis, *17916*
 praise by subscribers, *17939, 17965*
 praise by women, *17966*
 prizes for women who solicit subscriptions, *17938, 17940,
 17943, 17974, 18042, 18250*
 proposes monument to Poe, 1857, *17953*
 prospectus criticized by *Crayon*, 1855, *19213*
 public response, *18085, 18251*
 publishes Awards of Premiums in *Daily Herald*, 1859, *18285*
 purchases works of art for readers, *18547*
 purpose, *17946*
 reception of Bienaimé's *Wood nymph* in Vermont, *18002*
 role in developing taste in art, *17924*
 role in disseminating the beautiful, *18016*
 scholarship to study abroad, 1860, *18414*
 second annual catalogue criticized, *19249*
 statue for annual distribution, *17923*
 subscribers, *18288*
 subscription benefits, 1859, *18285*
 subscription terms, *17967, 18015*
 terms of membership, 1860, *18472*
 thanks to secretaries, women, the press and subscribers for a
 successful year, *17969*
 transactions
 1856, *17917*
 1857, *18094*
 1858, *18166, 18245*
 1859, *18286*
Cosmopolitan Art Club, Chicago See: **Chicago (Illinois).
 Cosmopolitan Art Club**
cosmoramas
 Stattler's cosmoramas, 1851, *14731*
Cossman, Hermann Maurice, 1821-1890
 Repose, *4151*
Cosson, Charles Alexander, *baron* de, d.1929
 armor collection, sale, 1890, *15400*
Costa, Antonio Maria Fabres y See: **Fabres y Costa, Antonio
 Maria**
Costa, Giovanni, 1826?-1903
 exhibitions
 Florence, 1879, *21727*
 Grosvenor Gallery, 1878, *21604*
Costa, Lorenzo, 1460?-1535
 works in the Poldi-Pezzoli Museum, *9924*
Costa, Nino See: **Costa, Giovanni**
Costa, Pietro, 1849-1901
 monument to Victor Emmanuel, *17702*
Costa, R. C. See: **Costa, Giovanni**
Costa Rica
 description and views, illustrations by C. Whitmore, *22733*
Costagini, Filippo, 1837-1904
 decoration of Capitol, Washington D. C, *25109*
 frescoes in U.S. Capitol, *149, 263*
 obituary, *13752*
Costello, Charles, b.1872?
 advertising designer, *12414*
Coster, Laurens Janszoon, ca.1370-1439
 invention of printing, *10797*
COSTER, Silvie de Grasse, *6161*
Costoli, Aristodemo, 1803-1871
 sculpture in Florence, *18872*
costume
 See also: **fashion; gloves; hats; shoes; stoles**
 absurdities in women's fashion from Middle Ages to
 Renaissance, *6300*
 advice on costume classes for artists, *2485*
 aesthetics of dress, *9314, 9382, 18599, 18697*
 art of dress, *1250, 8900, 8913, 8931, 8960, 18673, 18837*
 appropriate attire for older women, *18140*

illustrations, *Dogs and hare*, *4496*
influence on Belgian art, *1354*
landscape in Lyall collection, *15990*
Man playing on the 'cello, shown at Union League Club, 1889, *25565*
obituary, *8964*
paintings in Sayles collection, *9693*
pictures in American collections, *25585*
realism, *22403*
realism in France, *23020*
Source du Lison, on view in New York, 1892, *15863*
Stone breakers, praised, 1893, *16243*
technique, described by A. Schanne in his memoirs, *2406*
winter scene, *16603*
works in Robert Graves collection, *2388*

Courboin, Eugène, 1851-1915
illustrations
 decorative designs, *1292*
 Race, *7319*

Courcy, Alexandre de Charlot de See: **Charlot de Courcy, Alexandre Frédéric de**

Courdouan, Vincent, 1810-1893
obituary, *16491*

Cournault, Charles
Ligier Richier, review, *10503*

Coursy, Raoul Bigeon, *baron* de, fl.1882-1884
notes, 1883, *24492*
painting of interior, 1883, *24525*

Court, Suzanne de, fl.1600
Limoges enamel ewer, *1894*

Courtat, Louis, d.1909
Hagar and Ishmael, in Louisville's Southern Exposition, 1883, *24760*

Courtauld, Edith See: **Arendrup, Edith Courtauld**

Courteix, Fernand
illustrations, lace collar, *13526*, *14151*

Courtens, Franz, 1854-1943
exhibitions, New York, 1892, *26493*, *26506*
sales and prices, 1892, *15840*

COURTIS, H. E., *25581*

Courtois, Gustave Claude Etienne, b.1852
charcoal drawings, *5979*
exhibitions, Salon, 1891, *Portrait of Mme. Gautreau*, *3649*
illustrations, *Motherhood*, *6072*
portrait of Madame Gauthereau, compared with that of J. S. Sargent, *4708*
Virgin and Child, *25470*

Courtry, Charles Jean Louis, 1846-1897
illustrations
 Death of Marat (after David), *25971*
 Ferryman's daughter (after Adan), *9930*
 Homeless (after A. H. Marsh), *9947*
 Supper time (after Lhermitte), *10332*
 Washing day (after Laugée), *9994*

Couse, Eanger Irving, 1866-1936
Cowherd, purchased by Exposition Company at Omaha, 1898, *12824*
exhibitions
 American Watercolor Society, 1902, *13424*
 Chicago Art Institute, 1899, *12902*
 Cincinnati Art Museum, 1900, *13067*
 Kansas City Art Club, 1902, *13337*
 National Academy of Design, 1891, *26307*
 National Academy of Design, 1900, second Hallgarten prize, *12997*
 National Academy of Design, 1901, *13202*
 National Academy of Design, 1902, first Hallgarten prize, *13359*
 National Academy of Design, 1903, *13547*
 Salon, 1889, *2985*
 Society of American Artists, 1898, *End of the game*, *6618*
 Trans-Mississippi and International Exposition at Omaha, Nebraska, 1898, *12775*
 West Museum, 1891, *26382*
 Worcester Art Museum, 1902, *13483*

illustrations
 Bear cubs, *14282*
 Mirror signal, *14311*
 Returning to camp, *13114*

Cousen, Charles, ca.1819-1889
illustrations
 Dog and the shadow (after E. Landseer), *8914*
 End of the journey (after P. R. Morris), *9496*
 Home again (after E. A. Waterlow), *9803*
 Lochaber no more (after J. W. Nicol), *10072*
 On the hill-side (after W. H. Hunt), *8914*
 On the Llugy, north Wales (after B. W. Leader), *9057*
 Oxen at the tank: Geneva (after E. Landseer), *8699*
 Returning to the fold (after H. W. B. Davis), *9930*
 Shepherd (after R. Bonheur), *8844*
 Showery weather (after Vicat Cole), *8585*
 Simpletons (after S. L. Fildes), *8768*
 Their only harvest (after C. Hunter), *9749*
 Timon and Flavius (after H. Wallis), *8667*
 Tintern abbey - moonlight on the Wye (after B. W. Leader), *8354*
 Ulysses ploughing the sea shore (after H. Hardy), *8727*
 Woolwich docks (after H. T. Dawson), *9148*

Cousen, John, 1804-1880
obituary, *288*, *9455*

Cousin, Charles Marie Gabriel, 1822-1890
library, sale, 1891, *15599*

Cousin, Victor, 1792-1867
on intuition and mysticism, *19368*
Philosophy of the Beautiful, excerpts, *19319*

Cousins, Samuel, 1801-1887
elected to Royal Academy, 1855, *18716*
essay, 1899, *17554*
exhibitions, New York, 1887, *2477*
gift to Royal Academy for artists of merit, 1883, *14922*
obituary, *25455*
Order of release (after Millais), on exhibition, 1856, *19443*
Portrait of Coleridge (engraving after Allston), *18633*
portraits, portrait by Edwin Long engraved by Cousins himself, 1884, *10022*

Coutry, Charles See: **Courtry, Charles Jean Louis**

Coutts, Burdett See: **Burdett Coutts, Angela Georgina Burdett-Coutts, *baroness***

COUTURE, Thomas, *10850*

Couture, Thomas, 1815-1879, *460*
as artist-writer, *10806*
Baptism of the young prince Napoleon, unfinished, *20317*
biography, *20219*
classical painting, *22969*
commission to decorate Louvre withdrawn, 1859, *19971*
Day dreams, in Probasco collection, *25438*
Departure of the volunteers of 1792, *14789*
excerpt, *22929*
exhibitions
 London, 1858, *19851*
 Paris, 1880, *9389*, *9420*
 Paris Exposition, 1855, *19069*
 Paris Exposition Universelle, 1889, *2987*
 Union League Club of Philadelphia, 1899, *Pierrot*, *17618*
illustrations, *Triomphe d'une femme equivoque*, *86*
influence on Troyon and Diaz, *25357*
Liberty in chains, *15594*
Magdalen, in Chapman collection, 1895, *16793*
Méthode et entretiens d'atelier, excerpts, *21916*
obituary, *9152*
painting in collection of H. C. Gibson, 1891, *3500*
paintings and school, 1858, *19887*
paintings in Appleton collection, *876*
paintings in Laurent-Richard's collection, *9012*
paintings in Probasco collection, *2429*
paintings in Richmond, Va., *9167*
paintings in Wolfe collection, *832*
Pierrot and Harlequin reading the Moniteur, *960*
quote, *22977*, *23005*, *23054*
 on Salon exhibitions, *11146*

praise of Fortuny, *22259*
Roman orgy, 9291
Romans of the decadence, 19164, 19259
student's reminiscences, *9190*
studio
 atelier and teaching, Paris, 1857, *19594*
 atelier in Paris, 1850, *14652*
 Paris, 1855, *18770*
technique, *2178, 14574*
works in Robinson collection, *25357*
Cova, Raphael de la, fl.1883
statue of Bolivar
 commissioned for Central Park, 1883, *14896*
 criticized by *Studio*, 1884, *25137*
Covenanters
history in Scotland, *21133*
Cowan, E. S., fl.1897
illustrations, charcoal head, *12617*
Cowan, *Miss*, fl.1905
illustrations, composite arangement for the cultivation of the
 sense of decorative spacing, *13979*
cowboys in art
placques by Mrs. Kellerman, *503*
Cowdery, Eva D., fl.1893-1913
exhibitions, National Academy of Design, 1893, *4388*
Cowee, George L., fl.1884-1888
wood-engraving proofs, 1888, *2775*
Cowell, William Wilson, b.1856
exhibitions, Chicago Society of Artists, 1895, *11483*
marine painter, *11977*
whereabouts, 1897, painting aboard yacht on Lake Superior,
 12616
Cowles Art School See: **Boston (Massachusetts). Cowles Art
School**
Cowles, Frank Mellen, b.1846
founder of Cowles Art School, Boston, *490*
COWLEY, Abraham, *19514, 20432*
Cowper, Francis Thomas de Grey, *7th earl*, 1834-1905
collection, pictures on loan to Royal Academy, *9457*
Cowper, William, 1731-1800
monuments
 monument by W. C. Marshall, *14511*
 monument proposed, 1850, *14658*
residence at Olney, *26006*
Cox, Albert Scott, 1863-1920
illustrations
 decorative initial, *559*
 Spring pool, 559
 study head, *13865*
 Thistle down, 559
magazine illustration, 1894, *22517*
Cox, Alfred, fl.1899
illustrations
 Judge W. F. Tuley (photograph), *12298*
 Master Archie Tabor (photograph), *12298*
Cox, Charles Brinton, 1864-1905
exhibitions, Pennsylvania Academy of the Fine Arts, 1899,
 17526
Cox, Charles Hudson, 1829-1901
obituary, *13270*
Cox, David, 1783-1859, *16378*
anecdote, *9919*
drawings, *9437*
exhibitions
 Birmingham, 1890, *26135, 26176*
 Royal Society of Painters in Water Colours, 1850, *14632*
incidents in life, *21588*
monuments, statue in Birmingham planned, 1892, *26714*
portraits, testimonial portrait planned, 1855, *18908*
sales and prices
 1892, *15917*
 1892, *Vale of Clwyd, 26722*
signboard for Wales pub, *21888, 21891, 21892, 21894*
watercolors, *18824, 20045*

Cox, David, 1809-1885
exhibitions, Royal Society of Painters in Water Colours, 1861,
 20385
Cox, Frances A. Cable, fl.1880-1884
painting animals in New Orleans, 1883, *24728*
Cox, Frank E., b.1850?
Hampton Court in the olden time, 21795
Cox, George Collins, 1851-1902
photographer, *13738*
Cox, Henry T.
collection
 Barye bronzes, *15013*
 sale, 1902, *7823, 13354*
library, *16544*
Cox, Jacob, 1810-1892
studio, Indianapolis, 1871, *10711*
Cox, James Brevoort, fl.1894
pyrographic panel, *6878*
Cox, Katherine G. Abbott, b.1867
exhibitions
 Chicago, 1899, *12876*
 Chicago Artists' Exhibition, 1899, *12310*
COX, Kenyon, *12615, 13485, 21514, 21525, 21535, 21548,
21558, 25107*
Cox, Kenyon, 1856-1919
at Art Students' League, *12474*
biography in brief, *11246*
collaborative design for New York Appellate Court, 1898, *6613*
Conception of the Christ, commission, 1906, *14098*
criticism for painting nudes, 1891, *26285*
decorations for Liberal Arts Building, Chicago World's Fair,
 1893, *4185, 4378, 4469*
designs University Club seal, 1899, *17554*
drawings for the *Blessed Damozel* shown in New York, 1887,
 534
Echo, shown at Union League Club, New York, 1892, *26552*
elected associate, National Academy of Design, 1901, *13265*
elected vice-president, Society of American Artists, 1901,
 13240
elected vice-president, Society of American Artists, 1902,
 13421
elected vice-president, Society of American Artists, 1905,
 13914
exhibitions
 Architectural League of New York, 1888, *2873, 25564*
 Architectural League of New York, 1895, *5318*
 Architectural League of New York, 1896, Library of
 Congress decorations, *5699*
 Architectural League of New York, 1897, Library of
 Congress decorations, *6237*
 Architectural League of New York, 1897, studies for *Science*,
 23213
 Architectural League of New York, 1898, *6571*
 Boston Museum of Fine Arts, 1885, *1983*
 Brooklyn Art Association, 1892, *26582*
 Carnegie Galleries, 1900, *13130*
 Cincinnati Art Museum, 1900, *13067*
 National Academy of Design, 1883, refused entrance, *24834*
 National Academy of Design, 1887, *552*
 National Academy of Design, 1888, *2843*
 National Academy of Design, 1889, *2936, 3101*
 National Academy of Design, 1889, portrait of Emil Carlsen,
 25685
 National Academy of Design, 1890, *3228, 26162*
 National Academy of Design, 1891, *Vision of moonrise, 3603*
 National Academy of Design, 1892, *26583*
 National Academy of Design, 1897, *10540*
 National Academy of Design, 1897, *Bird song, 6248*
 New York, 1888, *10846*
 Paris Exposition, 1890, *Painting and poesie, 25724*
 Paris Exposition Universelle, 1889, portrait, *25675*
 Pennsylvania Academy of the Fine Arts, 1882, *1450*
 Pennsylvania Academy of the Fine Arts, 1883, *1677*
 Pennsylvania Academy of the Fine Arts, 1890, *Flying shad-
 ows, 25768*

drapery material in department stores, 1898, *6806*
drop curtain of Cleveland Opera House, 1883, *24850*
Evangeline portieres, *584*
French curtains, *780*
Glaister's book on needlework, 1880, *922*
inexpensive artistic draperies, 1890, *3349*
materials, *1777*
new designs for portières, 1886, *503*
painting draperies, *6538*
portière design, *2711*
Union League Club, 1881, *1159*
use and abuse of window curtains, *1626*
window draperies, *6826*
Curtin, Andrew Gregg, 1815-1894
monuments, memorial design by George G. Barnard accepted, 1903, *13594*
Curtis, Alice Marian, 1847-1911
exhibitions, Boston, 1898, *12805*
sketches in Chase collection, *1315*
CURTIS, Atherton, *4812*
Curtis, Atherton
Some Masters of Lithography, contribution to understanding of lithography, *12952*
Van Dyck exhibition catalogue introduction, excerpt, *23240*
CURTIS, Blanche Densmore, *12446*
Curtis, Calvin, 1822-1893
obituary, *26978*
Curtis, Charles Berwick, 1795-1876
book in preparation, 1879, *17*
collection, anecdote, *17512*
Curtis, Charles Boyd, 1827-1905
collection, Murillo shown at Metropolitan Museum, 1881, *376*
Descriptive and Historical Catalogue of the Works of Velazquez and Murillo, *9884*
Velazquez and Murillo, review, *24567*
Curtis, Constance, d.1959
exhibitions, Woman's Art Club of New York, 1903, *13703*
Curtis, Edward Sheriff, 1868-1952
exhibitions, National Arts Club, 1906, photographs of American Indians, *14088*
Curtis, Elizabeth, b.1873
exhibitions, Woman's Art Club of New York, 1903, *13703*
illustrations, *Quiet pool*, *22528*
Curtis, George, 1826-1881
obituary, *382*
CURTIS, George William, *11287*
Curtis, George William, 1824-1892
lecture on contemporary European art, New York, 1851, *14731*
Prue and I
illustrations by Albert Stearner, *12995*
illustrations by Albert Sterner, 1897, *23240*
Curtis, James Waltham, fl.1889-1897
paintings commissioned by Stanford University Gallery, 1897, *6421*
Curtis, Jane B. See: **Child, Jane Bridgham Curtis**
Curtis, Marion Browning, fl.1892-1895
studio exhibition, 1892, *26833*
Curtis, Mary See: **Richardson, Mary Curtis**
Curtis, Ralph Wormeley, 1854-1922
exhibitions
Pennsylvania Academy of the Fine Arts, 1883, *1677*
Salon, 1885, *2000*
Society of American Artists, 1884, *Souvenir of Paris*, *11003*
Lilacs from Fontainebleau, selected for Chicago Exposition, 1883, *24725*
Curtis, William Fuller, b.1873
prize, Washington Water-Color Club, 1904, *13729*
Curtius, Ernst, 1814-1896
library
acquired by Yale, 1897, *17239*
to be sold, 1896, *17093*
Zwei Giebelgruppen aus Tanagra, review, *15*
Cusachs y Cusachs, Jose, 1851-1908
military scene, *1220*

Cusacks, Philip, fl.1884
illustrations, *Two-minute sketch*, *1722*
Cushing, Howard Gardiner, 1869-1916
exhibitions
Carnegie Galleries, 1904, third class medal, *13792*
Pennsylvania Academy of the Fine Arts, 1905, *13851*
Salon, 1906, *14116*
illustrations, *Black fan*, *14082*
Cushing, Otho, 1871-1942
drawings, *13544*
Cushing, Robert, 1841-1896
bust of Cardinal McCloskey, 1883, *24513*
exhibitions, National Academy of Design, 1887, *10786*
monument to Father Drumgoole, *15897*, *16535*
obituary, *23008*
CUSHING, W. J., *20690*
Cushman, Alice, b.1854
exhibitions, Denver Artists' Club, 1899, *12886*
Cushman, Charlotte Saunders, 1816-1876
monuments, model of statue by Jonathan S. Hartley, *15562*
quote, on Powers' *Greek slave*, *18087*
Cust, Anna Maria Elizabeth
Ivory Workers of the Middle Ages, review, *13468*
Cust, Lionel Henry, 1859-1929
appointed director, National Portrait Gallery, London, 1895, *22765*
Cust, Robert Henry Hobart, b.1861
Pavement Masters of Siena, review, *13416*
Custer, Edward L., 1837-1881
exhibitions, Boston Art Club, 1880, *878*
obituary, *286*
Custer, George Armstrong, 1839-1876
monuments, proposed, 1880, *46*
Custis, George Washington Parke, 1781-1857
letters on authenticity of Sharples' portraits of Washington, *10763*
Recollections, excerpts, *19258*
Custis, Martha Dandridge See: **Washington, Martha Dandridge Custis**
cut glass, *14216*
technique, *10146*
cut glass, American, *498*
manufacture, *14007*
punch service made by T. G. Hawkes & Co., Corning, N.Y., 1893, *26969*
Cutting, Robert L.
collection, *1203*
exhibited at Ortgies Gallery, 1892, *26562*
sale, 1892, *3952*, *15847*, *15866*, *26556*, *26577*
to be sold, 1892, *3895*, *3924*
CUTTS, Edward Lewes, 1824-1901, *8355*, *8377*, *8392*, *8622*, *8649*, *8714*, *8758*, *8767*, *8787*
Cuvier Club of Cincinnati See: **Cincinnati (Ohio). Cuvier Club of Cincinnati**
Cuyer, Edouard, fl.1876-1889
lecture on anatomy, *11646*
Cuyp, Aelbert, 1620-1691, *21077*
painting offered to Boston Museum, 1881, *1108*
portrait of his father in Hutchinson collection, *22222*
Cuyp, Benjamin Gerritsz, 1612-1652
exhibitions, New York, 1897, *6427*
Cuypers, Petrus Josephus Hubertus, 1827-1927
architect of Rijksmuseum planned gallery for Rembrandt's *Night watch*, *13499*
Cyclopes
texts from J. Overbeck, *8*
cycloramas
Ancient Egypt on exhibition, London, 1892, *26763*
Battle of Bunker Hill, Boston, 1887, *2543*
Chicago fire nears completion, 1892, *3887*
Paris by night, shown in Boston, 1893, *26983*
Cyprus
antiquities
book by D. G. Hogarth, *25762*
controversy between Richter and Di Cesnola, 1893, *16245*

National Academy of Design, 1902, Thomas B. Clarke prize, *13359*
National Academy of Design, 1905, *14062*
Pennsylvania Academy of the Fine Arts, 1906, *14244*
Philadelphia Art Club, 1892, *26859*
Prize Fund Exhibition, 1887, *562*
Union League Club of New York, 1893, *26905*
Worcester Art Museum, 1902, *13483*
Holy Family, *7524*
illustrations, *Fools joke*, *24628*
Madonna and child, *6551*
painter of sentiment, *22611*
portraits, photograph, *22518*
sketch shown in New York, 1887, *25399*
summer home and studio, *22571*
whereabouts
 1883, Fayetteville, N.C, *24666*
 1883, Fayetteville, S.C, *24791*
 1895, South Carolina mountains, *22765*
 1896, summer in North Carolina mountains, *23056*
Dake, Carel Lodewijk, 1857-1918
Apres l'averse (after Mauve), *15656*
etchings published, 1892, *15998*
portrait of Beethoven, *25977*
Dake, Jabez Philander, 1827-1894
art patron of Nashville, *24694*
Dakin, C. E., fl.1887
illustrations, arms of American families, *17740*
Dalbono, Edoardo, 1841-1915
Neapolitan water carrier from Mergellina, *21907*
Dale, Gertrude Brown, 1851-1927
Lead, kindly light (after Emslie), published, 1892, *15998*
Sweetest beggar (after Frith), *26412*
DALE, Peace, *22928*
Dale, Robert, Mrs. See: **Dale, Gertrude Brown**
DALGLEISH, Scott, *23801, 23937*
Dallas, Jacob A., 1825-1857
illustrations
 headpiece, *17895, 17923, 17937, 17978, 18016*
 illustration for Cosmopolitan Art Association, *18521*
 illustration for Moore's *Night before Christmas*, *18361*
 illustration for Young's *Night Thoughts*, *18402*
 scene for *Life's Morning and Evening*, *18458*
marriage to M. Kyle, 1856, *17920*
notes
 1859, *18384*
 1894, *16548*
obituary, *19717*
panorama illustrating Bunyan's *Pilgrim's Progress*, 1850, *14657, 14753*
Dallas (Texas). Dallas Art Association
annual exhibitions, 1905, *13866*
Dallin, Colonna Murray
Sketches of Great Painters, review, *13489*
DALLIN, Cyrus Edwin, *13556*
Dallin, Cyrus Edwin, 1861-1944
exhibitions
 American Art Association of Paris, 1899, *12890*
 Boston, 1899, *12903*
 Boston Art Club, 1902, *13353*
 Louisiana Purchase Exposition, 1904, *13806*
 Paris Exposition, 1900, *13065*
 Prize Fund Exhibition, 1888, *2700*
illustrations
 Don Quixote, *13263, 13785*
 Pere Marquette, *13683*
 sculpture for Louisiana Purchase Exposition, *13688*
instructor, Drexel Institute, Philadelphia, 1895, *11638*
Medicine man, *13281*
notes, 1890, *3363, 26108*
sculptor, *12949*
sculpture for Louisiana Purchase Exposition, 1904, *13685*
Signal of peace, given to Chicago by Lambert Tree, 1894, *27006*
Sir Isaac Walton for east facade of Congressional Library,

22388
statue of Paul Revere, *1883*
 equestrian statue commissioned, 1884, *25196*
 prize, 1883, *24569*
statue of Sioux brave for St. Louis Exposition, *13637*
statuette of trotter Sunol, *26991*
Dall'Oca Bianca, Angelo, 1858-1942
exhibitions, Esposizione Internazionale di Belle Arti, Rome, 1883, *14884*
DALLOW, Wilfrid, *21977*
Dalmatia
Dalmatia, the Quarnero, and Istria by T. G. Jackson, review, *10503*
Dalmatie, Nicolas Jean de Dieu Soult, *duc de* See: **Soult, Nicolas Jean de Dieu, *duc de* Dalmatie**
Dalou, Aimé Jules, 1838-1902
Delacroix monument unveiled, 1890, *3394*
exhibitions, Salon, 1885, *2000*
illustrations, Sèvres porcelain, *13653*
Mirabeau - 23rd June, *1789, 25986*
nominated Chevalier of the Legion of Honour, 1883, *9875*
obituary, *13455*
sculpture in gallery at Sèvres factory, 1905, *13951*
statue of Boussingault, *26568*
statue of Delacroix, *26117*
Triomphe de la République, to be erected, 1896, *16964*
Dalrymple, Louis, 1865-1925
illustrations, *Hitting him back*, *22490*
DALTON, W. B., *12395*
Daly, Augustin, 1838-1899, *20473*
collection, *15882, 17686*
 sale, 1900, *13038*
library, *7263, 17639*
 extra-illustrated Bible, *16201*
 sale, 1900, *7291*
Life of Peg Woffington, illustrated by E. Grivaz, *26480*
Magistrate, review, *23222*
theater revivals, 1897, *23170*
Wonder: a Woman Keeps a Secret, revived, 1897, *23250*
Daly, Matt A., 1860-1937
illustrations, Rookwood vase, *13037*
Dalziel brothers
Dalziel's Bible Gallery, *1048*
engravings for Millais' *Parables of our Lord and Saviour Jesus Christ*, 1864, *23304*
illustrations
 Dunbrody Abbey, near Waterford, *20961*
 His Highness Mangol Sing, Rajah of Ulwar (after V. Prinsep), *21696*
 Lorenzo de Medici receiving the exiled Greek philosophers (after J. Gilbert), *20950*
 Malay, Japanese, Chinese, Persian, Arab, *21105*
 woodcuts, *1041*
Dalziel, George, 1815-1902
exhibitions, Boston Museum of Fine Arts, 1881, *1254*
illustrations
 caricatures (after J. Tenniel), *9581*
 view of the great central hall, *20937*
Damberger, Joseph, 1867-1951
illustrations, head, *22071*
Dameron, Emile Charles, 1848-1908
exhibitions, Salon, 1881, *22029*
Dammouse, Albert Louis, 1848-1926
illustrations
 plaque for copying, *6328*
 plate decoration, *2590*
 pottery decorated with enamel, *13766*
 recent designs in pottery, *13766*
Damolin, Oreste, fl.1889-1904
exhibitions, Louisiana Purchase Exposition, 1904, *13805*
Dampt, Jean Auguste, 1853-1946
art objects, *13050*
exhibitions
 Salon, 1894, *16556*
 Salon, 1896, carved bed, *23618*

Chicago World's Fair, 1893, *4602, 22256*
Liege Exposition, 1905, *13965*
London, 1884, *1720*
National Academy of Design, 1903, *13702*
New York, 1887, *2364*
New York, 1893, *16316*
Pennsylvania Academy of the Fine Arts, 1900, *13007*
Philadelphia Art Club, 1892, *26859*
Salon, 1883, *1568, 24631*
Salon, 1883, medal, *24667*
Salon, 1884, *1806, 10028*
Salon, 1884, preparation, *1738*
Salon, 1885, *1967, 2000*
Salon, 1886, *2193, 2206*
Salon, 1887, *571, 2449*
Salon, 1889, *2938*
Salon, 1891, *3649*
Salon, 1892, *Femmes Espagnoles, 4013*
Salon, 1894, *4939*
Salon, 1895, *5375*
Society of American Artists, 1893, *4235*
Society of British Artists, 1885, *10183*
Vienna, 1902, *13421*
expatriate American artist, *11197*
inherits fortune, 1887, *538*
meeting wih Whistler, 1892, *26697*
notes, 1899, *7043*
paintings in Art Institute of Chicago, 1894, *5138*
picture bought for Luxembourg Gallery, 1893, *26991*
prizes, Legion of Honor award, 1889, *3099*
Quartet, shown in New York, 1884, *1899*
Quartette, 25177
 shown at Metropolitan Museum loan exhibition, 1886, *25359*
Quatuor, presented by artist's parents to Metropolitan Museum, *14953*
sales and prices
 1891, *In the studio* in Seney collection sale, *15473*
 1893, *Portrait of Miss E. H* bought by French government, *16313*
studio in Paris, 1895, *11598*
studio interior shown at Reichard's, New York, 1884, *25195*
whereabouts
 1887, leaves U.S, *20426*
 1888, winter in Italy, *2624*
work appraised by T. Child, 1897, *6187*
Dannecker, Johann Heinrich von, 1758-1841
 Ariadne, 6487
 modern sculptor, *21747*
D'Annunzio, Gabriele See: **Annunzio, Gabriele d'**
Danse, Auguste, 1829-1929
 illustrations
 Churchwardens (after F. Meerts), *9543*
 Home after service (after F. W. W. Topham), *9623*
 Naughty pussy (after E. Farasyn), *9338*
 Prisoner (after A. Bourland), *9033*
Dantan, Edouard, 1848-1897
 exhibitions
 Salon, 1880, *187*
 Salon, 1887, *10463, 17774*
 French painter, *23045*
 illustrations, *Turner's workshop, 1812*
Dantan, Jean Pierre, 1800-1869
 statuettes of Jung Bahadoor, *14697*
Dante Alighieri, 1265-1321
 Beatrice exhibition in Florence, 1890, *25947, 25948*
 Canzone, 19773
 compared to Milton, *20217, 20232, 20243, 20255, 20267*
 Divine Comedy
 and Beatrice, *19135*
 copy of manuscript, *26372*
 illuminated manuscript found in Bombay, *26177*
 illustrated by Scaramuzza, *8901*
 illustrations by Botticelli, *25445*
 manuscript illustrated by Botticelli acquired by Prussian government, 1883, *14864*

sales and prices, 1903, *8199*
insensibility to architecture, *9726*
Love Jubilee, Florence, 1890, *25799*
Madonna Pia, 20778
New Life, translation by D. G. Rossetti published, 1896, *12582*
tomb in Santa Croce, *18219*
Danton, Ferdinand, fl.1892-1894
 portrait of Mr. O'Gorman, 1894, *26997*
 World's Fair painting showing apotheosis of Christopher Columbus, *26711*
Dantzig, Meyer Michael, 1876-1939
 exhibitions, Pennsylvania Academy of the Fine Arts, 1901, *13163*
Danube valley
 classical antiquities, Trajanic inscription, *20863*
Dapprich, Helen, b.1879
 illustrations, study in composition, *14169*
DARBY, E. C., *3213, 3243, 5586, 6774, 6800, 6833, 6858, 6884, 6916, 6937, 6938, 6970, 7000, 7029, 7059, 7079, 7106, 7136, 7166, 7306*
Darby, E. C., fl.1890-1899
 American china painter, *6030*
Darby, Henry F., 1829-1897
 exhibitions
 National Academy of Design, 1855, *18754*
 National Academy of Design, 1857, *19668*
 National Academy of Design, 1859, *20030*
 National Academy of Design, 1882, *1330*
DARCEL, Alfred, *200, 226*
Darcel, Alfred, 1818-1893
 obituary, *26978*
D'ARCY, M. Le Vengeur, *23274*
Dardoize, Louis Emile, 1826-1901
 illustrations, *Green night, 913*
 obituary, *13332*
Dare, Shirley, *pseud*. See: **Power, Susan C. Dunning**
Daremberg, Charles Victor, 1817-1872
 Dictionnaire des antiquités grecques et romaines, review, *25340*
Dargan, William, 1799-1867
 benefactor of Irish Industrial Exhibition, 1853, *20937*
 financing Dublin Exhibition, 1853, *21270*
 Irish exhibition of 1853, *20780*
Darley, Felix Octavius Carr, 1822-1888
 and Washington Irving, *16678*
 biography, *20159*
 book illustration, *12996*
 etchings
 outline etchings for American Art Union, 1850, *14603, 14657*
 outline etchings for American Art Union, 1851, *14725*
 praised by H. Mücke, 1850, *14632*
 exhibitions
 American Watercolor Society, 1880, *827*
 Artists' Fund Society, 1883, *1512*
 National Academy of Design, 1855, *18705, 18742*
 National Academy of Design, 1858, *19857*
 National Academy of Design, 1859, *20030, 20048*
 New York artists' reception, 1858, *19800*
 Pennsylvania Academy of the Fine Arts, 1858, *19858*
 Salmagundi Club, 1887, *2364*
 Troy, New York, 1858, *19818*
 home, house at Claymont, *8878*
 illustrations
 Brown moll, 14278
 Chilion, 14261
 illustration for Willis' *Saturday Afternoon, 18357*
 illustrations for *Knickerbocker's History of New york, 106*
 illustrations from *The Riverside Magazine, 123*
 Inauguration of the Crystal Palace, 16th July, 1853, 20976
 Lean and slippered pantaloon, 22598
 Murder, 14315
 illustrations for Cooper's novels, *18082, 20106*
 published by Wm. A. Townsend & Co., 1859, *18380*
 illustrations for edition of Poe's poems, 1858, *18212*

illustrations for *Fudge Doings*, 1855, *18572*
illustrations for *Kaloolah*, printed in tints, *14510*
illustrations for Longfellow's *Courtship of Miles Standish*, *19958*
illustrations for *Poetical Works of E. A. Poe*, *19943*
illustrations for *Reveries of a Bachelor*, *14834*
illustrations for *Rip Van Winkle* published, London, 1850, *14634*
illustrator for newspapers, *16536*
Leather Stocking at the grave of Chingach-Cook, outline etching for American Art Union, 1851, *14759*
Leather-Stocking, Paul Hover and Ellen, concealing themselves from the Indians, *14727*
Margaret, *18249*
 etched illustration, *14711*
 illustrated book, 1856, *19568*
 outline illustrations, *19558*
 publication, 1856, *19518*
member, Salmagundi Club, *11166*
notes, 1849, *21381*
outline etchings of *Rip van Winkle*
 American Art Union, 1848, *14367, 14387, 14395, 14403, 14438, 14445, 14459*
 English opinions, *14606*
outlines for American Art Union, 1848, *14477, 14494, 14505, 14518, 14530, 14570*
outlines for *Legend of Sleepy Howell*, English opinion, *14619*
panorama of Bunyan's *Pilgrim's Progress*, 1850, *14657*
portrait of Washington Irving, *16545, 20165*
portraits, photograph, *22603*
praise as wood-engraver, *14779*
reception in his honor, Philadelphia Sketch Club, 1875, *8425*
rejected by Salmagundi Club for 1893 black and white exhibition, *16227*
sales and prices, 1889, *2911*
scene of the Revolution engraved by Hanshelwood, 1860, *24325*
scenes from American history to be published, 1850, *14711*
Treachery of Mahtoree (etching), *14801*
Van Siclen collection of Darley books and plates, *16694*
Warning, outline engraving for American Art Union, 1851, *14827*
woodcuts, *10723*

Darling, Wilder M., 1855-1933
exhibitions, Prize Fund Exhibition, 1886, *25304*

Darmstadt (Germany)
exhibitions, 1901, artist colony, *13253*

Darnley, John Stuart Bligh, *6th earl of*, 1827-1896
obituary, *17302*

D'Aronco, Raimondo, 1857-1932
illustrations, view of main entrance of Turin Exposition, 1902, *13502*

Darragh, fl.1866-1888
portraits of Generals Grant, Sherman and Sheridan given to West Point, 1889, *25656*

Darrah, Ann Sophia Towne, 1819-1881
exhibitions
 Boston, 1881, *1131*
 Pennsylvania Academy of the Fine Arts, 1858, *19858*

Darrah, Frank J., fl.1899-1924
exhibitions, Worcester Art Museum, 1902, *13483*
Worcester artist, *12416*

Darrah, Robert Kendall, *Mrs.* See: **Darrah, Ann Sophia Towne**

Dartein, Marie Ferdinand de, 1838-1912
Oaks, *2286*

Dartmoor (England)
description, *10165*

Dartmouth College See: **Hanover (New Hampshire). Dartmouth College**

Dartmouth (England)
description and views, *21674*

D'Artois, Blanche
poem, *18351*
poems, *18513*

Darwin, Charles Robert, 1809-1882
Origin of the Species, review, *20214*
Darwin, Francis, 1848-1925
believes plants have sense of gravitation, 1903, *8281*
Daryl, Philippe, *pseud.* See: **Grousset, Paschal**
D'Ascenzo, Myrtle Dell Goodwin, 1864-1954
exhibitions, Philadelphia Plastic Club, 1902, *13537*
D'Ascenzo, Nicola, b.1871
classes at Pennsylvania Museum and School of Industrial Art criticized, 1893, *4355*
defended in letter to *Art Amateur* by L. W. Miller, 1893, *4381*
teaches house painting at Pennsylvania School of Industrial Art, 1893, *4314*
D'Ascenzo, Nicola, *Mrs.* See: **D'Ascenzo, Myrtle Dell Goodwin**
Dassel, Herminia Borchard, d.1857
exhibitions
 New York, 1858, *19957*
 New York, 1859, *19974*
obituary, *18158, 19767*
Old mill, in Boston, 1858, *19785*
whereabouts, 1849, arrives in U.S., *21407*
Dasson, Henry, 1825-1896
reproduction of Louis Quinze bureau, *1228*
Daubigny, Charles François, 1817-1878
art importations to U.S., 1879, *734*
Autumn at Anvers, in Hart-Sherwood collection, *792*
Barbizon School, *17487*
biographical note, *16445*
exhibitions
 American Art Galleries, 1889, Barye Memorial Fund Exhibition, *3180*
 Carnegie Galleries, 1902, *13520*
 Chicago Art Institute, 1898, *12668*
 Chicago World's Fair, 1893, *4839*
 New York, 1889, *25683*
 New York, 1890, *25731*
 New York, 1892, *3990*
 New York, 1895, *5222, 16882*
 New York, 1897, *17241*
 New York, 1898, *Cliff at Villerville*, *6590*
 Paris, 1861, *20367*
 Salon, 1859, *20060, 20077*
 Union League Club of New York, 1884, *25090*
 Union League Club of New York, 1895, *5564*
 Union League Club of Philadelphia, 1899, *Morning on the Oise*, *17618*
forgeries of paintings, *10943*
illustrations
 Bathers (after J. Vernet), *20796*
 detail of landscape, *153*
 Forest scene in Morvan, *21250*
 In the wake of the steamboat, *2807*
 Morning on the Oise, *13982*
 On the Marne, *13982*
 paintings after P. Brill, *20980*
 Tempest (after J. Vernet), *20796*
landscapes, *2286*
 in American collections, *25585*
May, in Stewart collection, *10768*
Moulin de gobelles, *16589*
notes, 1899, *17632*
obituary, *9003*
painting shown in New York, 1887, *25399*
paintings at Kohn Gallery, 1890, *15390*
paintings in Secrétan collection, Paris, *10823*
paintings in Shaw collection, *1205*
paintings suggested for exhibition of French masterpieces at American Art Galleries, 1889, *3073*
pen drawing, perspective, *2231*
picture of the Thames shown in London, 1887, *10502*
pictures in Fuller collection, *15828*
pictures in Wickenden collection, *22483*
pupil of Corot, *22787*
quote, *22368*

Return of the flock, 26458
Romantic painting in France, *22994*
Rue de Valmondois, in Brandus gallery, 1898, *17405*
sales and prices
 1896, *17000*
 1899, painting sells for $17,000 at Vever sale, Paris, *20628*
son Karl sues forgers of father's work, 1884, *1732*
Sunset, etched by L. Gautier, *25380*
works in Robert Graves collection, *2388*
Dauchez, André, 1870-1948
 exhibitions
 Carnegie Galleries, 1899, *Boats, 7153*
 Carnegie Galleries, 1900, gold medal, *13130*
 Carnegie Galleries, 1901, *13322*
 Pittsburgh, 1899, third prize, *12976*
 illustrations
 Herd, 14223
 Navire à quai, 13605
 Vessels at anchor, 13792
Daudet, Alphonse, 1840-1897, *20460*
 Arlesienne, American adaptation, 1897, *23250*
 Contes Choisis, illustrated by Burnand, *15357*
 health, 1890, *26165*
 notes
 1895, *16745*
 1896, *22943*
 pipe collection, *16936*
 portraits, pen portrait of Daudet by E. de Liphart illustrated, *3209*
 Recollections of a Literary Man, excerpt, *17105*
DAUDET, Ernest, *22991*
Daudet, Léon, 1867-1942
 memoirs, *24068*
Daughters of the American Revolution
 circular from Mrs. Benjamin Harrison, 1891, *26391*
 collects and loans Revolutionary relics, *16208*
 Fort Green chapter fund monument for Fort Green Park, 1903, *13618*
 New York chapter to present statue of Washington to France, 1892, *26871*
 organized to preserve historical sites and erect monuments, 1890, *26106*
D'AULTE, Frank, *20451*
Daumier, Honoré Victorin, 1808-1879
 as painter, *25159*
 exhibitions
 New York's Grolier Club, 1892, *26829*
 Union League Club of New York, 1890, *25861*
 illustrations, sketch, *13838*
 lithography used in satires, *12952*
 painting in Robinson collection, *25357*
 pen drawings, *1591*
 Picture-sale at the Hotel Drouot, Paris, 25973
 portrait sketch of Corot, *3257*
 special issue of *Studio*, 1904, *13797*
Daupias, conde
 collection
 sale, 1892, *15894, 15915, 26667*
 to be sold, 1892, *3945*
Dausch, Constantin, 1841-1908
 illustrations, designs for wood-carving of seasons, *1609*
Davenant, William, 1606-1668
 bust of Shakespeare, *16770*
Davenport, Cyril, 1848-1941
 Cameos, review, *13178*
Davenport, Fanny Lily Gypsy, 1850-1898
 notes, 1896, *22896*
Davenport, Homer Calvin, 1867-1912
 illustrations
 sketches, *22564*
 What say?, 22560
 newspaper illustration, *22504*
Davenport (Iowa)
 art gallery planned, 1990, *13046*

Davenport (Iowa). Davenport Academy of Sciences
 Putnam bequest, 1905, *14071*
Davenport (Iowa). Davenport Art Society
 notes, 1895, *11588*
Davenport, Mr., fl.1886
 carving on pianos, *518*
DAVEY, Mary Kent, *23619, 23652, 23681, 23693, 23718, 23744, 23767, 23791, 23822, 23889, 23912, 23923, 24202, 24291, 24297*
Davey, Mary Kent
 poem *The Dream* translated into French, 1896, *23646*
 whereabouts, 1898, leaves Paris for America, *24047*
Davey, Minnie Maddern See: **Fiske, Minnie Maddern Davey**
DAVID D'ANGERS, Pierre Jean, *14615*
David d'Angers, Pierre Jean, 1788-1856
 bust of Humboldt acquired by Louvre, 1860, *20317*
 bust of Washington, cast to be given to U. S, *13618*
 Gutenberg statue, study, acquired by Grolier Club, 1894, *16448*
 illustrations, bust of François Arago, *21322*
 statue of Thomas Jefferson
 given by Levy to U.S., 1889, *25587*
 in Capitol, 1887, *25481*
David, Gérard, ca.1460-1523
 illustrations, *Virgin and Infant, 13504, 13985*
David, Jacques Louis, 1748-1825, *21150*
 classical painting, *22969*
 Coronation of Napoleon, replica, *4872*
 Coronation of the Emperor, replica exhibited in New York, 1894, *16535*
 Death of Marat, 25971
 acquired by Versailles Museum, *13701*
 reproductions, *15254*
 descendants lose lawsuit to Mr. Durand-Ruel, 1892, *3924*
 exhibitions
 Ecole des beaux-arts, 1883, *14894*
 Paris Exposition Universelle, 1889, *2987*
 Union League Club of New York, 1891, *Playing the harp, 3454*
 illustrations, sketch of Marie Antoinette on way to her execution, *4904*
 Marat dans sa baignoire, authenticity questioned, 1890, *3310*
 monuments, commemorative tablet at Ecole des Beaux Arts, 1884, *25121*
 Napoleon in his coronation robes, in Walker collection, Minneapolis, *12924*
 paintings given to Brussels Museum by son, 1887, *557*
 Passage of the Alps, anecdotes, *21531*
 picture of the assassination of Lepelletier Saint-Fargeau, rescued from hiding place, 1885, *10198*
 portrait of Marie Antoinette discovered, 1904, *13795*
 portrait of Marshal Ney in Robinson collection, *25357*
 reburial proposed, 1895, *16911, 16828*
 Tintoretto painting his dead daughter, 8901
Davidson, Alexander, 1838-1887
 member, Glasgow Art Club, *10346*
Davidson, Clara D., 1874-1962
 illustrations, study of a French peasant, *13215*
Davidson, Julian O., 1853-1893
 Battle between the Constitution and the Guerriere, 22503
 Battle between the United States and the Macedonian
 on view, New York, 1892, *16006*
 Klackner publishes reproduction, 1893, *22207*
 printed in photogravure, 1892, *16028*
 biography in brief, *11246*
 exhibitions
 National Academy of Design, 1884, *1790*
 National Academy of Design, 1884, *Battle of Lake Champlain, 10982*
 National Academy of Design, 1887, *2606*
 Prize Fund Exhibition, 1885, *1985, 25278*
 illustrations
 Battle of Lake Champlain, 1772
 Fleet of Columbus, 22473
 lighthouses, *9270*
 naval battle scene on view, New York, 1893, *16240*

painting of sea battle shown in New York, 1892, *26822*
paintings of sea fights, 1882, *24400*
portraits, photograph, *22502*
sales and prices, 1892, *Battle between the United States and the Macedonian* bought for Plaza Hotel, *16022*
 Who won?, shown at Knoedler's, 1893, *26960*
yachting scene for Plaza hotel commissioned, 1892, *26871*
DAVIDSON, Thomas, *9, 15, 60, 197, 223, 301, 345, 388, 411*
Davidson, Thomas, 1840-1900
 description of Roman excavations, *134*
 lectures
 1879, *18*
 1880, *178*
 at Lowell Institute, 1880, *257*
Davies, Arthur Bowen, 1862-1928, *17444*
 early career, *8335*
 exhibitions
 American Watercolor Society, 1894, *4800, 22540*
 Chicago, 1896, *11813*
 New York, 1894, *4801, 4942*
 New York, 1894, competition designs for New York Criminal Court, *4907*
 New York, 1896, *16984*
 New York, 1897, *6102, 6281, 17335*
 New York, 1901, *7589*
 New York, 1905, *13889*
 New York Water Color Club, 1893, *4284*
 Pennsylvania Academy of the Fine Arts, 1899, *At the source*, *12836*
 St. Louis Exposition, 1894, *11402*
 Society of Independents, 1894, *22540*
 Worcester Art Museum, 1902, *13483*
 foremost painter of America, 1905, *13936*
 Hartmann's criticism, *10547*
 lithographs, *16329*
DAVIES, George Christopher, *9672, 10304*
DAVIES, Gerald Stanley, *10155*
Davillier, Jean Charles, *baron*, 1823-1883
 bequests, *10127*
 collection, in Louvre, 1885, *10139*
 obituary, *14879*
Davioud, Gabriel Jean Antoine, 1823-1881
 obituary, *360, 21895*
 Palais du Trocadéro, *21570*
Davis & Sanford, photographers
 illustrations, portrait of Charles T. Cook, *7548*
Davis, Ada, fl.1902
 illustrations, *Wrestlers, a quick study in composition*, *22145*
Davis, Alexander Jackson, 1803-1892
 exhibitions, National Academy of Design, 1865, *23334*
 library, offered to Cooper Union, 1880, *102*
DAVIS, Charles Harold, *10906*
Davis, Charles Harold, 1856-1933
 Abandoned on the New England coast, purchased by Exposition Company at Omaha, 1898, *12824*
 Close of day, in Chicago Art Institute, *12763*
 exhibitions
 Boston, 1883, *10893*
 Boston, 1884, *25072*
 Boston, 1885, *1983*
 Boston, 1899, *12874, 17554*
 Boston, 1903, *13587*
 Boston Art Students' Association, 1884, *10898*
 Carnegie Galleries, 1900, *13130*
 Carnegie Galleries, 1903, *13675*
 Carnegie Galleries, 1907, *14328*
 Chicago, 1890, winner of Potter prize for *Brook*, *26116*
 Chicago, 1899, *12893*
 Chicago Art Institute, 1900, *13137*
 Chicago Inter-State Industrial Exposition, 1889, *3056*
 Louisiana Purchase Exposition, 1904, *13785*
 Minneapolis Society of Fine Arts, 1904, *13789*
 National Academy of Design, 1886, *2188, 25370*
 National Academy of Design, 1887, *10786, 25437*
 National Academy of Design, 1902, *13359*

New York, 1887, *10773, 10782*
New York, 1890, *3208, 15306, 25822*
New York, 1891, *15643, 26341*
New York, 1893, *16277*
New York, 1899, *17551*
Pennsylvania Academy of the Fine Arts, 1883, *1677*
Pennsylvania Academy of the Fine Arts, 1900, *13007*
Pennsylvania Academy of the Fine Arts, 1901, *13163*
Pennsylvania Academy of the Fine Arts, 1902, *13363*
Prize Fund Exhibition, 1885, *25278*
Prize Fund Exhibition, 1886, *2226, 25304*
Prize Fund Exhibition, 1886, medal, *25305*
Prize Fund Exhibition, 1887, *562, 2456, 2457*
Salon, 1883, *24521*
Salon, 1885, *2000*
Salon, 1886, *2193*
Salon, 1887, *2449*
Salon, 1887, honorable mention, *2476*
Salon, 1888, *2694*
Salon, 1889, *2985*
Salon, 1890, *25986*
Society of American Artists, 1887, *10789*
Society of American Artists, 1890, landscapes, *3364*
Trans-Mississippi and International Exposition, Omaha, 1898, *12775*
Union League Club of New York, 1887, *10833*
 illustrations
 Flying clouds, *13182, 14003, 14200*
 New England homestead - winter, *12355*
 Twilight, *13300*
 life in France with Edward H. Barnard and Charles H. Hayden, *12883*
 Moonlight, shown in New York, 1889, *25674*
 Moonrise at twilight, purchased by Carnegie Institute, 1904, *13781*
 picture in Waggaman collection, *15382*
 pictures selected for Chicago Exposition, 1883, *24725*
 sales and prices, 1899, painting in Clarke collection, *12871*
 whereabouts, 1887, summer travel, *2543*
Davis, Charles Henry, 1845-1921
 exhibitions
 Avery Art Gallery, 1890, *15123*
 New York, 1887, *557*
 Summer afternoon, Lippincott prize, 1901, *13208*
Davis, Charles Percy, fl.1897-1931
 antique classes, St. Louis Museum art school, 1897, *12061*
 exhibitions, Society of Western Artists, 1900, *12986*
Davis, Cornelia Cassaday, 1870-1920
 exhibitions, Society of Western Artists, 1898, *Navajo scout*, *12802*
 Indian studies, *12808*
 pictures of Indian life shown in Chicago, 1897, *12094*
Davis, Cushman Kellogg, 1838-1900
 notes, 1896, *22964*
Davis, Edward C., *Mrs.* See: **Davis, Cornelia Cassaday**
Davis, Elizabeth Gilbert See: **Martin, Elizabeth Gilbert Davis**
Davis, Erwin
 collection
 auction rigged, *16157*
 Bastien-Lepage's *Joan of Arc* denied to French exhibition, 1889, *25621*
 Degas' *Behind the scenes - the ballet dancers*, *25411*
 Manet's *The Boy with a sword*, *25523*
 sale, 1889, *2881, 2909, 2934*
DAVIS, George Royal, *26107*
Davis, George Solomon, b.1845
 collection, relics of Napoleon I, *16038*
Davis, Georgina A., b.ca.1850
 illustrations, *Novel race on the Shrewsbury*, *22482*
 Man in armor, *22503*
 models, favorite model, *22519*
 portraits, photograph, *22580*
 subject of woman, *22704*
Davis, Hannah See: **Monachesi, Hannah Davis**

Peter Brugh Livingstone, 13958
portrait of P. Van Brugh Livingstone (mezzotint after Raeburn), *22738*
DAY, Barclay, *9794*
Day, Benjamin Henry, 1838-1916
newspaper illustrations, *16557*
DAY, Edward H., *689, 708*
Day, Francis, 1863-1942
Engagement ring, published, 1892, *15998*
exhibitions
American Watercolor Society, 1904, *13746*
National Academy of Design, 1884, *25187*
New York Water Color Club, 1891, *3833*
Society of American Artists, 1889, *2986*
Society of Painters in Pastel, 1890, *3256*
illustrations
Hearts are trumps, 2834
Puritan pumpkin pie, 22473
whereabouts, 1893, Nutley, N.J, *22491*
Day, Frank Miles, 1861-1918
architectural work for J. Boyle's statue of Benjamin Franklin, *22388*
collection, brass rubbings shown at Pennsylvania Academy of Fine Arts, 1893, *16178*
design for Germantown battle monument, *13819*
DAY, Frederick Holland, *21472, 21488*
Day, Frederick Holland, 1864-1933
exhibitions
Boston, 1899, *12892*
Philadelphia Photographic Salon, 1899, *12973*
Philadelphia Photographic Salon, 1900, *13120*
Philadelphia Photographic Salon, 1902, *13342*
illustrations, *Crucifixion* (photograph), *14110*
photographer, *13738*
Day, Joseph Rice, d.1908
illustrations, *Tuning up, 22531*
DAY, Lewis Foreman, *1626, 9565, 9611, 9702, 10110, 10132, 10154, 10167, 10438, 10448, 10497, 21775, 21806, 21830, 21852, 21858, 21935, 21962, 22001, 22039*
Day, Lewis Foreman, 1845-1910
Anatomy of Pattern, excerpt, *3712*
discussion of process of reproduction for illustration, 1895, *5489*
Everyday Art
excerpts, *1580, 1611*
review, *1496*
exhibitions, London Arts and Crafts Exhibition Society, 1890, *3196*
illustrations
decorative designs, *1230, 21775, 21806, 21830, 21852, 22039*
decorative initials, *22001, 22018*
designs for handles, *1055*
designs for home decoration, *21935*
dragons in art, *21858*
scheme for arrangement and decoration of a room, *21962*
vase, *21623*
lecture on using plants in ornamental design, 1888, *2736*
Day, Oriana, 1838-1886
Massachusetts scenes, 1871, *10675*
Day, Samuel Phillips, fl.1844-1888
Juvenile Crime: its Cause, Character, and Cure, review and excerpts, *19906*
DAYE, Wella, *24249*
Dayot, Armand Pierre Marie, ca.1851-1934
note from book on eighteenth-century French painting, 1903, *8281*
Dayton (Ohio). Ladies' Decorative Art Society
description, 1882, *9624*
Dayton (Ohio). Pottery Club See: **Dayton (Ohio). Ladies' Decorative Art Society**
De Grimm, Constantin See: **Grimm, Constantin de**
De La Gandara, Antonio See: **Gandara, Antonio de la**
De La Houve, Paul See: **LaHouve, Paul de**
Deakin, Albert, Galleries See: **Chicago (Illinois). Deakin**

Galleries
Deakin, Earl, fl.1900-1915
illustrations
pictures of sunset in the Adirondacks (photographs), *12990*
Sunset in the Adirondacks (photograph), *13274, 13894*
Deakin, Edwin, 1838-1923
exhibitions
San Francisco, 1900, *22114*
San Francisco, 1902, California missions paintings, *22142*
San Francisco, 1903, *22190*
illustrations, *San Juan Bautista, 14131*
paintings of California missions, *13801, 22086*
DEAKIN, Henry, *11848*
Deakin, Henry, d.1908
collection
catalogue, with introduction by Sir Edward Arnold, *15800*
gems exhibited, 1901, *13353*
illustrations of Japanese vases, *12126*
Japanese stencils, *12834, 13154, 13168*
Japanese stencils illustrated, *13119, 13136, 13189*
Oriental art, *11875*
Phoenician glass, *11931*
sale, 1892, *26495, 26507*
sale, 1892 or 1893, *11302*
sale, 1896, *11732*
sale, 1904, *13741*
shows Japanese collection, Burbank collection, 1898, *12202*
sales of Japanese objects, 1898, *12094*
shows Japanese objects and crafts, 1895, *11490*
shows largest Satsuma vase in the world, 1897, *11975*
Deakin, Peter, fl.1855-1879
exhibitions, Society of British Artists, 1858, *19898*
Dean, Darracotte See: **Dene, Darracotte**
Dean, David J.
library, sale, 1897, *17303*
DEAN, George Robinson, *12170, 12193, 12245, 13005, 13025*
Dean, George Robinson, 1864-1919
illustrations
Arch of Druses at Rome, 22688
door and architectural detail, *13005*
simple design in glass, *13897*
stained glass windows, *13132*
two stained glass windows, *13025*
window design, *14267*
lecture to Chicago Architectural Club on style, 1897, *11957*
Dean, James
arms collection, *17099*
Dean, Nicholas, d.1855
obituary, *19313*
Dean, Walter Lofthouse, 1854-1912
exhibitions
Boston, 1885, *1964*
Boston, 1888, *2662*
Boston Art Club, 1880, *878*
Corcoran Art Gallery, 1907, *14282*
Worcester, 1902, *13483*
illustrations
Dutch fishermen at sea, 613
Dutch fishing vessel, 22610
Vigilant passing Valkyrie, 22588
ocean as favorite subject, *22704*
DEANE, Eldon L., *5510*
Dearth, Henry Golden, 1864-1918
exhibitions
National Academy of Design, 1902, *13359*
New York, 1896, *16968*
Society of American Artists, 1893, Webb prize, *4389, 16215*
illustrations, *Day's work done, 14078*
sales and prices, 1889, *14961*
whereabouts, 1895, East Hampton, *22765*

Deas, Charles, 1818-1867
patronage by American Art Union, *14558*
pictures of Indian life, *19309*

Deats, Hiram Edmund, b.1870
 collection
 postage stamps sale, 1892, *15891*
 sale, 1892, *15859*
 stamps, *16237*
Debaines, A. Brunet See: **Brunet Debaines, Alfred Louis**
Debat Ponsan, Edouard Bernard, 1847-1913
 equestrian portrait of General Boulanger, *4344*
 illustrations, *Grape harvest*, *10456*
Debereiner, George, 1860-ca.1939
 exhibitions
 Cincinnati Art Club, 1900, *13037*
 Kansas City Art Club, 1902, *13337*
Deblois, Charles Alphonse, b.1822
 illustrations
 Marguerite (after J. Bertrand), *8615*
 Ophelia (after J. Bertrand), *8650*
Deblois, François B., 1829-1913
 exhibitions
 Boston Art Club, 1879, *9124*
 Boston Art Club, 1880, *72*
 National Academy of Design, 1880, *889*
 whereabouts, 1890, summer in New Hampshire, *25959*
DeBraun, Hermann See: **Braun, Hermann de**
DeBrosses, Charles See: **Brosses, Charles de**
decadence in art
 critics, *24060*
 description, 1898, *24034*
DeCamp, Joseph Rodefer, 1858-1923
 elected associate, National Academy of Design, 1902, *13436*
 exhibitions
 Boston Art Club, 1894, *8340*
 Carnegie Galleries, 1903, *13675*
 Cincinnati Art Museum, 1898, *12754*
 Cincinnati Art Museum, 1900, *13067*
 Copley Society, 1905, *13924*
 New York, 1898, *Magdalen*, *6619*
 New York, 1900, *13038*
 New York, 1905, *13886*
 Pennsylvania Academy of the Fine Arts, 1899, Temple gold
 medal, *12314*, *12859*
 Pennsylvania Academy of the Fine Arts, 1900, *13007*
 Prize Fund Exhibition, 1885, *1985*
 Prize Fund Exhibition, 1885, *St. John the Baptist*, *25278*
 St. Botolph Club, 1899, *12903*
 Society of American Artists, 1894, *4834*
 Ten American Painters, 1898, *12710*
 Ten American Painters, 1899, *6954*
 Worcester Art Museum, 1902, *13483*
 follower of Tarbell, *10521*
 illustrations
 Dr. Horace Howard Furness, *14244*
 Head of a young woman, *12787*
 In the studio, *14016*
 Little hotel, *13716*
 Magdalene, *12723*
 Sea wall, September, *13875*
 Woman drying her hair, *13040*
 lithographs, publication announced, 1897, *22445*
 paintings in Henry Field Memorial Collection at Art Institute of
 Chicago, *12694*
 sales and prices, 1901, *Arrangement in pink black and gold*,
 13210
 teacher at Art Student's League, 1899, *12920*
 whereabouts, 1890, summer in Annisquam, *25992*
 Woman drying her hair, acquired by Cincinnati Museum, 1899,
 7125
Decamps, Alexandre Gabriel, 1803-1860
 Barbizon School, *17487*
 biographical note, *16512*
 Clément's book, *2317*
 Eastern slave market, in Hart-Sherwood collection, *792*
 exhibitions
 American Art Galleries, 1889, Barye Monument Fund
 Exhibition, *3128*

 Paris, 1861, *20367*
 Paris Exposition, 1855, *19069*
 Paris Exposition, 1855, landscapes, *19259*
 Union League Club of New York, 1892, *26612*
 landscapes in American collections, *25585*
 Night watch at Smyrna, in Wolfe Collection, *832*
 obituary, *20282*
 paintings in Appleton collection, *876*
 paintings in Goldschmidt collection, *2723*
 paintings in Secrétan collection, Paris, *10823*
 paintings suggested for exhibition of French masterpieces at
 American Art Galleries, 1889, *3073*
 realism in France, *23020*
 Romantic painting in France, *22994*
 sales and prices
 1890, *3208*
 1893, *4314*
 Suicide, in Walters collection, *1003*
 Turkish patrol, *3497*
 Washing clothes, authenticity questioned of painting in Seney
 collection, *25264*
 water colors shown in New York, 1887, *538*
Deck, Désiré
 collection, *4100*
Deck, Joseph Théodore See: **Deck, Théodore**
Deck, Théodore, 1823-1891
 ceramicist, *4728*
 Deck plaque, *779*
 decorative ceramic plaques, *21816*
 illustrations
 plaque for copying, *6328*
 porcelain and pottery objects, *1646*
 obituary, *15693*, *26358*
 plaque decoration, *1909*
 volume on faïence, excerpt, *2465*
Decker and Edmonson, photographers, Cleveland
 exhibitions, Photographers' Association of America Convention,
 1899, *12937*
Decker, C. H., *Mrs.*
 reading of spirit Lucille Western's writing, *20713*
Decker, Joseph, 1853-1924
 exhibitions
 American Art Galleries, 1887, *10832*
 Brooklyn Art Association, 1884, *1696*
 National Academy of Design, 1884, *1772*, *1879*
 National Academy of Design, 1885, *25271*
 National Academy of Design, 1886, *508*, *2112*
 National Academy of Design, 1887, *10786*
 Society of American Artists, 1887, *10789*, *25451*
 illustrations, *Amateur cook*, *20441*
 painter of still lifes, landscapes and cattle, *15709*
Decker, Mary See: **Wellcome, Mary Decker**
Decker, Robert Melvin, 1847-1921
 exhibitions, Brooklyn Art Club, 1892, *26501*
 portraits, photograph, *22580*
DÉCOMBES, Emilie, d.1906, *22427*
Decombes, Emilie, d.1906
 studio exhibition, Boston, 1892, *26851*
Decompos
 illustrations, vase of silver repoussé, *13503*
DeConte, Fortune See: **Conte, Fortune de**
DeCoppet, Frederick, d.1914
 collection
 American stamps to be sold, 1893, *16129*
 sale, 1893, *16218*
decoration and ornament
 16th century Italian and Spanish decorative work, *2044*
 advice for converting natural plant forms into ornament, *6228*
 Americans deficient in decorative woodworking, *6106*
 animal forms, *8784*, *8810*, *8843*, *8880*, *8907*, *8929*
 arms and armor, *21928*
 color, *22460*
 copying, *20585*
 decorative designing, *8855*
 definition of decoration, *20530*

1893, Spitzer collection sale, *16255, 16272*
1895, Viscount Hill collection, *16841*
1896, Stiebel collection, *17016*
1897, Hirsch collection, *17337*
societies, opportunities for women artists to work in decorative
 arts, *12962*
taste, *12283*
decorative arts, American, *10812*
 aesthetics, *20486*
 art in American life in Knickerbocker days, *13103*
 art of Southern aristocracy, *13183*
 commercially viable versus fine arts, *13135*
 Decorative Art Rooms, New York, 1879, *664*
 development, *70*
 Egyptian designs, *9197*
 exhibitions
 London, 1889, *2951, 25637*
 Paris Exposition, 1878, *21635*
 progress, *9917, 9941, 9993, 10071*
 public taste, *1144*
 Society of Decorative Art products, *8958*
 value of art products, *19152*
decorative arts, Austrian, *9533*
decorative arts, English
 Art Journal competition designs, *9272*
 compared to French decorative arts, *21622*
 exhibitions, Paris Exposition, 1878, *21620*
 influence of great painters, *10289*
 motifs from van Orley's work, *10276*
 Royal Academy students' work, 1899, *7109*
 Victorian applied design, *10438*
decorative arts, Flemish
 beaker, *1388*
decorative arts, French, *8948*
 Empire Style, *1157*
 exhibitions
 Paris Exposition, 1855, *19178*
 Paris Exposition, 1878, *21639*
 Limoges enamels, *21710*
 objects in the Jones collection, *1540*
decorative arts, Icelandic
 collectors and collecting, Magnussen collection, *17276*
decorative arts, Indic
 exhibitions, Paris Exposition, 1878, *9056, 9069*
decorative arts, Italian
 16th century cabinet in the Basilewski collection, *2044*
 "Cellini ewer", *21710*
decorative arts, Japanese
 characteristics, *1388*
 designs on pottery and metalwork, *1212*
 Dresser's book, *Japan. Its Architecture, Art, and Art
 Manufacture*, *1496*
 exhibitions, Union League Club of New York, 1889, *2934*
 hanging panels, *722*
 importation to United States, *2123*
 interior decoration and costume design, *1208*
 misuse in England, *1030*
 objects etched by Otto Bacher, *25556*
 subtleness and truth, *705*
 technique, *17873*
decorative arts, medieval
 faience and furniture in the Cluny Museum, *1226*
Decorative Arts Museum, Paris See: **Paris (France). Musée
des arts décoratifs**
decorative arts, Oriental
 collectors and collecting
 Kelekian collection, *16591*
 Midland Counties Museum, Nottingham, *21640*
 Skidmore collection given to National Museum, Washington,
 D.C., 1903, *8245*
 sale at Bing & Co., 1887, *2570*
decorative arts, Persian
 ornamental motives, *761*
decorative arts, Rococo, *9209*

decorative arts, Russian
 Tiffany & Co. collection, *17322*
Decorative Designers, New York
 cover design for *Under the Cactus Flag*, *12975*
Decorative Needlework Society See: **London (England).
 Decorative Needlework Society**
DECORATOR, *11268*
Decorchemont, François, 1880-1971
 illustrations, bookbinding, *13950*
DeCordoba, Mathilde J., 1871-1942
 exhibitions, New York Water Color Club, 1895, *Alsatian shep-
 herdess*, *5566*
DeCoursy, R. B. See: **Coursy, Raoul Bigeon, *baron* de**
decoys (hunting)
 decoying structures for wild fowl enhance East Anglian land-
 scape, *9672*
DeCrano, Felix F., d.1908
 work, 1883, *24608*
Decritz, John, ca.1555-1642
 documentation, *10170, 10356*
Dedham pottery See: **porcelain and pottery, American**
Deen, Eleanor C., fl.1892
 teacher of china painting at Chautauqua summer school, 1892,
 26752
Deen, Harriet Ogden, b.1883
 exhibitions, American Watercolor Society, 1902, *13424*
Deerfield (Massachusetts)
 exhibitions, 1905, annual Arts and Crafts Exhibition, *13952*
**Deerfield (Massachusetts). Pocumtuck Valley Memorial
Association**
 collection, Indian and colonial relics, *16337*
DeFabris, Giuseppe See: **Fabris, Giuseppe**
Defaux, Alexandre, 1826-1900
 Château of Landon, in Schaus collection, *15840*
 French village in springtime, on view in New York, 1891,
 15752
 picture at International Art Gallery, 1890, *15246*
Defoe, Daniel, 1661?-1731
 relics, chair in Historical Society of Delaware, *16385*
DeForest, George Beach
 collection, posters exhibited at Grolier Club, 1890, *15370*
 library, *15018*
 Henriot drawings, *15575*
 Uzanne's *Miroir du Monde*, illustrated by E. H. Avril, *15055*
DeForest, Julia B., d.1910
 Short History of Art, review, *463*
DeForest, Lockwood, 1850-1932
 designs for fireplace linings, *25162*
 elected National Academician, 1898, *12273*
 exhibitions
 American Art Association, 1884, *25201*
 National Academy of Design, 1880, *126*
 National Academy of Design, 1891, *26307*
 National Academy of Design, 1902, *13359*
 New York, 1892, *15847*
 New York, 1892, Egyptian sketches, *26556*
 Prize Fund Exhibition, 1885, *25278*
 Prize Fund Exhibition, 1886, *25304*
 illustrations
 Autumn sunset, Pelham bay, *13202*
 June twilight, *13702*
 shows carvings from India, 1883, *24916*
 whereabouts, 1896, studio, Long Island, *23056*
deformities
 power of, *18018*
Defregger, Franz von, 1835-1921
 altar-piece for church at Bozen, 1895, *22765*
 biographical information, *16461*
 exhibitions
 Brooklyn Art Association, 1884, *1740*
 Chicago World's Fair, 1893, *4709*
 Metropolitan Museum of Art, 1884, *1803*
 illustrations, *Peasant of Tyrol*, *3334*
 Madonna and child, *22858*
 Munich painter, *10124*

968

14780
students, student dies in atelier hazing, 1891, *3528*
studio, atelier in Paris, 1850, *14652*
subject of poem by J. Winsor, *19572*
Taking of the Bastille, at the Louvre, *9262*
Victors of the Bastille, *9231*
Virgin at the foot of the cross, *22858*
Delâtre, Auguste, 1822-1907
advice on etching and dry-point, *3017*
as printer, *10795*
printer and artist, *15739*
Delâtre, Eugène, b.1864
illustrations, *Sunset*, *13298*
Delaunay, Elie, 1828-1891
French painter, *23045*
illustrations
 drapery study, *4814, 5124*
 sketch, *6347*
 study for decorative figure, *13230*
obituary, *26388*
Delavan (Wisconsin)
outdoor summer art classes, 1898, *12719*
Delavigne, Marie Odelle, 1873-1963
illustrations, Newcomb embroidery, *13909*
Delaware Historical Society See: **Wilmington (Delaware).**
 Historical Society of Delaware
DeLay, Harold S., fl.1894-1910
illustrations, sketch, *11423*
Delduc, Edouard, b.1864
illustrations, *Public writer at Seville* (after Aranda), *10203*
Delessard, Auguste Joseph, b.1827
exhibitions
 National Academy of Design, 1858, *19857*
 National Academy of Design, 1859, *20030*
Delff, Willem Jacobsz., 1580-1638
illustrations, lace collar of Gaspard, count de Coligny (after
 Miereveld), *17752*
Delft (Netherlands)
description, *10037*
Delhi
poet laureate, *19094*
DeLipman, M. See: **Lipman, M. de**
DeLisser, Richard Lionel, fl.1874-1896
illustrations
 Patient, *22501*
 Searching the records, *22490*
Della Rovere, Giuliano See: **Julius II**, *pope*
DELLENBAUGH, Frederick Samuel, *24627, 24932, 24945*
Dellenbaugh, Frederick Samuel, 1854-1935
exhibitions
 American Art Association, 1884, *25191*
 American Art Galleries, 1887, *10832*
 National Academy of Design, 1887, *10831*
 Pennsylvania Academy of the Fine Arts, 1883, *1677*
 Prize Fund Exhibition, 1885, *Navajo hunter*, *25278*
 Prize Fund Exhibition, 1886, *25304*
Mechanic, *22770*
member of Paris Sketch Box Club, 1883, *24457*
painting of fishing boats, in American Art Galleries, 1884, *1899*
portraits, photograph, *22580*
quote on art of American Indians, *13829*
whereabouts
 1882, summer in France, *24365*
 1883, Concarneau, *24703*
 1883, Paris, *24413*
 1883, summer at Concarneau, *24819*
 1884, Concarneau, *24983*
 1884, planning trip through Colorado and New Mexico,
 25132
Delmé Radcliffe, Emilius Charles See: **Radclyffe, Emilius
 Charles Delme**
Delmonico, L. Christ, gallery See: **New York. Delmonico, L.
 Christ, gallery**
Delmonico, Lorenzo Crist, 1860?-1932
collector, *6812*

DelMue, Francis See: **DelMue, Maurice August**
DelMue, Maurice August, 1878-1955
exhibitions, St. Louis Exposition, 1904, *22203*
Delobbe, François Alfred, 1835-1920
illustrations, *Breton fishermaidens*, *3697*
Reverie, *9323*
DeLome, Enrique Dupuy See: **Dupuy de Lome, Enrique**
DeLongpré, Paul See: **Longpré, Paul de**
Delort, Charles Edouard, 1841-1895
Bringing in a prisoner, shown at Reichard's, New York, 1884,
 25195
exhibitions
 Cercle de l'Union Artistique, 1880, *9309*
 Cercle des Mirlitons, 1878, *8992*
 New York, 1878, *8962*
 Salon, 1882, *1352*
 Société d'Aquarellistes Français, 1885, *1952*
illustrations
 drawing, *5881, 6624*
 drawing of man and woman, *2892*
 On the balcony, *2913*
obituary, *16705*
Poacher, *937*
Delos (Island)
antiquities
 discoveries, 1906, *14209*
 Greek dwelling found, 1883, *14918*
Delphi
antiquities
 bronze charioteer excavated, 1896, *17112*
 bronze statue of bearded man found, 1896, *17053*
 excavations, 1895, *16811*
 excavations proposed by New York Society of American
 Institute of Archaeology, 1890, *26148*
proposed grant for excavations, 1890, *26126*
temple of Apollo, *20596*
Delpy, Hippolyte Camille, 1842-1910
illustrations, *Entrance to Dordrecht*, *3629*
DeLuce, Percival, 1847-1914, *22612*
exhibitions
 American Watercolor Society, 1880, *827, 9292*
 American Watercolor Society, 1881, *1065*
 American Watercolor Society, 1882, *24390*
 American Watercolor Society, 1884, *25012*
 Essex Art Association, 1884, *25102*
 Trans-Mississippi and International Exposition, Omaha,
 1898, *12775*
illustrations
 Isabel, *23067*
 Sparkling rose i' th' bud, *23076*
 Tea-party, *23067*
 watercolor, *11214*
King's health, *22495*
notes, 1883, *24492*
Offer, completed, 1883, *24609*
painting of figure, 1883, *24513*
portrait of child, 1883, *24551*
portraits, photograph, *22559*
studio reception, 1884, *25079*
Venice, completed, 1883, *24959*
whereabouts, 1896, Arkville, N.Y, *23056*
Demachy, Robert, 1859-1936
exhibitions, Philadelphia Photographic Salon, 1900, *13120*
quote, on gum-bichromate printing, *12951*
Demaille, Louis Cosme, 1837-1906
obituary, *14256*
Demannez, Joseph Arnold, 1826-1902
illustrations, *Astrologer* (after S. Lucas), *9204*
DeMare, George, 1863-1907
exhibitions
 Chicago Art Institute, 1902, *13370*
 Chicago Art Institute, 1903, *13673*
illustrations, *Portrait of Mrs. Cox*, *13191*
DeMarini, E. M., fl.1893
notes, 1893, *26960*

Demesmay, Camille, 1815-1890
 obituary, *25921*
DeMeza, Wilson, 1857-1893
 American illustrator, *22487*
 exhibitions
 Prize Fund Exhibition, 1886, *25304*
 Salon, 1885, *2000*
 illustrator for *Harper's* and *The Cosmopolitan*, *22473*
 magazine illustrations, 1893, *22482*
 notes, 1893, *16412*
Demidov, Anatolii Nikolaevich, *principe* di San Donato, 1813-
1870
 collection, *870*
 Dutch paintings offered to Boston Museum, 1881, *307*
 portière and dalmatic, *4853*
 sale, 1880, *103*, *1001*
 sale, 1880, American purchases, *899*
 sale, 1880, Florence, *9327*
 sale, 1880, Paris, *838*, *846*, *857*
 watch collection sale, 1896, *17016*
Demidov, Paul See: **Demidov, Pavel Pavlovich**, *principe* di
San Donato
Demidov, Pavel Pavlovich, *principe* di San Donato, 1839-1885
 collection, paintings sold to Chicago Art Institute, 1890, *15293*
 home, building project in San Donato palace, *10139*
Deming, Edith, fl.1892-1906
 illustrations, decorative design, *14171*
DEMING, Edwin Willard, 1860-1942, *22675*
Deming, Edwin Willard, 1860-1942
 exhibitions, Fellowcraft Club, 1890, *26181*
 first prize, Municipal Art Society mural competition, 1906,
 14161
 illustrations, *When bleak winds blow*, *22546*
 Indian games, *22816*
 magazine illustration, 1894, *22517*
Demmin, Auguste Frédéric, 1823?-1898
 Guide de l'amateur de faïences et porcelaines, *706*
Democratic Club of the City of New York See: **New York.**
 Democratic Club of the City of New York
Democratic Party (U.S.)
 looses elections of 1895, *22872*
Demont, Adrien Louis, 1851-1928
 exhibitions, Chicago World's Fair, 1893, *Lilies*, *4605*
Demont, Adrien Louis, *Mme* See: **Demont Breton, Virginie**
 Elodie
Demont Breton, Virginie Elodie, 1859-1935
 Fisherwoman returning from bathing her children, *9623*
 Her man is on the sea, in Walker collection, Minneapolis,
 12912
 illustrations
 Madonna and Child, *7151*
 studies, *7349*
 Madonna and Child, *7153*
 modern French painter, *10250*
DeMonvel, Louis Maurice Boutet See: **Boutet de Monvel,**
 Louis Maurice
DeMorgan, William, 1839-1917
 English designer, *10438*
 exhibitions, London Arts and Crafts Exhibition Society, 1890,
 3196
Demoussy, Augustin Luc, 1809-1880
 obituary, *83*
Demoustier, Philibert, 1714-1784
 designs acquired by Louvre, 1883, *14889*
DEMPSEY, Charles, *21825*, *22050*
Denby, Edwin Hooper, b.1873
 exhibitions, American Art Association of Paris, 1898, drawings,
 24010
Denby, William, 1819-1875
 Cromwell, damaged in transit, 1889, *25799*
 obituary, *8535*
DENE, Darracotte, *23976*
Dengler, Frank, 1853-1879
 biography, *221*
 exhibitions, Boston, 1877, *8917*

studio in Cincinnati, *195*
Denham, John, 1615-1669
 Cooper's Hill, excerpts, *18359*
DENIO, Elizabeth, 1844-1922, *13611*
Denise, Ira Condit, b.1840
 landscapes, 1870, *10597*
 Miami sketches, 1871, *10651*
 notes, 1871, *10677*
Denison, Albert, *baron* Londesborough See: **Londesborough,**
 Albert Denison, *1st baron*
Denison, Edmund Beckett See: **Grimthorpe, Edmund**
 Beckett, *1st baron*
DeNittis, Giuseppe, 1846-1884, *1864*
 biographical note, *16512*
 exhibitions
 Cercle des Beaux Arts, 1881, *21897*
 Cercle des Mirlitons, 1877, *8828*
 French Gallery, 1879, *21767*
 London, 1879, *9198*, *21741*
 Paris, 1880, *9341*
 Paris Exposition, 1878, *9096*
 Paris Exposition Internationale, 1883, *14919*
 Paris Exposition Nationale, 1883, *1680*
 illustrations
 female head, *3471*
 Morning flowers, *3698*
 Nuns at prayer, *7023*
 Old woman, *7023*
 In the Green Park, eccentric composition, *2249*
 paintings in Hart-Sherwood collection, *792*
 paintings in Stewart collection, *753*, *10768*, *10823*
 paintings of London, *9025*
 Place des Pyramides, fraudulent copies, *10943*
 works in A. T. Stewart collection, *2408*
Denman, Herbert, 1855-1903
 exhibitions
 American Art Association, 1886, *508*, *2344*
 American Art Galleries, 1887, *10832*
 National Academy of Design, 1887, *10831*
 National Academy of Design, 1889, *3101*
 National Academy of Design, 1890, *3228*
 National Academy of Design, 1895, *5340*
 New York, 1886, *10754*
 Pennsylvania Academy of the Fine Arts, 1888, *2659*, *17804*
 Prize Fund Exhibition, 1887, *2456*
 Prize Fund Exhibition, 1888, *2700*
 St. Louis Exposition, 1894, *Voice of Spring*, *11402*
 Salon, 1886, *2193*
 Society of American Artists, 1888, *25505*
 Society of Painters in Pastel, 1888, *2696*
 Union League Club of New York, 1887, *10833*
 illustrations
 At a way station, *4254*
 Mandolinata, *10755*
 notes, 1887, *546*
 whereabouts
 1883, summer in America, *24702*
 1895, East Hampton, *22765*
Denmark
 antiquities, silver finds near Hobro, 1891, *26387*
Denner, Balthazar, 1685-1749
 Head of an old man, in Ehrich collection, *25541*
D'Ennery, Gisette Desgranges See: **Ennery, Gisette**
 Desgranges d'
Denneulin, Jules, 1835-1904
 illustrations, *Portrait of the cabin-boy*, *4723*
Dennis, James Hogarth, 1839-1914
 illustrations, *Amsterdam*, *593*
DENNISTOUN, James, *19013*
Denny, Gideon Jacques, 1830-1886
 marine views, 1870, *10600*
Denslow, William Wallace, 1856-1915
 exhibitions
 Chicago, 1895, posters, *11501*
 Chicago Society of Artists, 1895, *11483*

1891, American artists, *26382*
1891, Stearns collection on loan, *15457*
1893, Stearns collection of Japanese art, *16374*
1899, *12824*
1899, collection of paintings, *12340*
funds being raised to create Museum, 1886, *25337*
history, *15680, 22282*
 and collection, 1899, *17624*
loan collection, 1899, *12292*
medal to be struck for Frederick Stearns and James E. Scripps, 1891, *26433*
notes
 1890, *25782, 26063*
 1891, *3483*
 1892, *15934*
 1893, *26901*
 1899, *12859*
plans, 1884, *11046*
relation to school and director A. H. Griffith, 1891, *3556*
Sunday talks by director A. M. Griffiths begun, 1893, *22264*
Detroit (Michigan). Detroit School of Art
ban on women chewing gum, 1890, *25822*
department of architecture to be directed by John Watrous Case, 1899, *12859*
description, 1895, *21544*
list of teachers, 1897, *6306*
notes
 1891, *3556*
 1899, *17624*
 1900, *13124*
student work, *22625*
Viotti appointed to teach, 1899, *12292*
Detroit (Michigan). Detroit Sketching Club
notes, 1883, *24678*
Detroit (Michigan). Detroit Society of Women Painters
formation, 1903, *13578*
Detroit (Michigan). Detroit Water Color Society
solicits amateur works for Detroit Art Loan Exhibition, 1883, *24721*
Detroit (Michigan). George B. Angell Gallery
notes, 1896, *17027*
Detroit (Michigan). Institute of Arts See: **Detroit (Michigan). Detroit Museum of Art**
Detroit (Michigan). Keramic Club See: **Detroit (Michigan). Detroit Keramic Club**
Detroit (Michigan). Sketching Club See: **Detroit (Michigan). Detroit Sketching Club**
Detroit (Michigan). Society of Associated Artists See: **Detroit (Michigan). Detroit Artists' Association**
Detroit (Michigan). Society of Women Painters See: **Detroit (Michigan). Detroit Society of Women Painters**
Detroit (Michigan). Water Color Society See: **Detroit (Michigan). Detroit Water Color Society**
Detti, Cesare Augusto, 1847-1914
Fortune teller, in Munger collection at Chicago Art Institute, *12785*
Deutsche Jahrhundertausstellung, 1906 See: **Berlin (Germany). Deutsche Jahrhundertausstellung, 1906**
Deutscher Künstlerbund
exhibitions, 1907, *14270*
plan to obtain recognition at St. Louis Exposition, 1904, *13701*
Deutsches Archäologisches Institut, Rome See: **Rome. Archäologisches Institut des Deutschen Reichs**
Deveaux, James, 1812-1844
obituary, *643*
Devens, Mary, fl.1898-1905
exhibitions, Philadelphia Photographic Salon, 1900, *13120*
DeVere, Schele, 1820-1898
Stray Leaves from the Book of Nature, review, *19397*
Deverell, Walter Howell, 1827-1854
illustrations, portrait of D. G. Rossetti, *5460*
pre-Raphaelite follower, *19723*
DEVEREUX, Clara, *1160*
Devereux, George Thomas, b.ca.1810
illustrations, *Hero and Leander* (after Sartain), *21409*

wood engravings, *106*
Déveria, Achille Jacques Jean Marie, 1800-1957
illustrations, *Flower-girl of Picardy*, *2296*
Devil
bibliography, *15926*
Deville, Maurice, fl.1889-1892
illustrations, *Henri-Eugène-Philippe-Louis d'Orléans, due d'Aumale*, *17838*
Devlin, Thomas C.
Municipal Reform in the United States, review, *23178*
Devoe, F. W., & Co.
colors recommended by artists, 1883, *24728*
DeVoe, Thomas Farrington, 1811-1892
library, sale, 1896, *17000*
DeVries, Guy Horvath, d.1870
obituary, *10594*
Dewar, DeCourcy Lethwaite, ca.1882-1959
illustrations, *Vanity*, *13361*
Dewey, Charles Melville, 1849-1937
exhibitions
 American Art Association, 1884, studies, *25209*
 American Art Galleries, 1882, water color, *9624*
 American Art Galleries, 1884, *24988*
 American Watercolor Society, 1881, *1065*
 American Watercolor Society, 1884, *1736, 25023*
 American Watercolor Society, 1885, *1933*
 American Watercolor Society, 1890, *25777*
 National Academy of Design, 1880, *889*
 National Academy of Design, 1883, *24480*
 National Academy of Design, 1891, *26313*
 New York, 1890, *3229*
 New York, 1897, *10541*
 Philadelphia Society of Artists, 1880, *1025*
 Prize Fund Exhibition, 1885, *1985, 25278*
 Prize Fund Exhibition, 1886, *25304*
Fields in October, in Montross collection, *25418*
illustrations
 Along the shore, September, *24434*
 Edge of the wood, *12787*
 House in the trees, *13716*
 Meadow view, *24509*
 Old fields, *24913*
 watercolor, *11214*
 When snow the pasture sheets, *1731*
landscapes, 1883, *24513, 24541, 24586*
notes, 1887, *611*
picture in Crowell collection, *15184*
pictures in Evans collection, *15079*
sales and prices, 1899, *12879*
study of salt marsh, 1883, *24501*
Summer morning, *1253*
whereabouts
 1882, *24367*
 1883, Port Jefferson, L.I, *24762*
 1883, summer at Lowville, N.Y, *24728*
 1896, summer in Europe, *23056*
Winter effect, *24389*
works in Robert Graves collection, *2388*
Dewey, Charles Melville, Mrs. See: **Dewey, Julia Henshaw**
Dewey, George, 1837-1917
celebration in New York, 1899, with public decorations, *12968*
Dewey look-alike poses for photographs, 1899, *17686*
monuments
 Dewey arch, *7230*
 Dewey arch for Madison Square, New York, *7098*
 Dewey arch funding to make arch permanent, 1900, *7262*
 Dewey arch in New York, *7294*
 Dewey arch locations suggested, 1900, *7180*
 move of arch to Pan American grounds suggested, 1900, *7313*
 movement for permanent erection of arch in New York, 1899, *7125*
 New York funds to make arch permanent, 1900, *7201*
 triumphal arch in Madison Square, New York, *7095*
portraits, gift of portraits to be painted by Chartran criticized,

1900, *13046*
reception in New York, 1899, *7072*
DEWEY, George W., 23374, 23455, 23466, 23470, 23471, 23477, 23487
Dewey, J. W., fl.1880
exhibitions, National Academy of Design, 1880, *889*
Dewey, John, 1859-1952
letter on art education, 1897, *11967*
Dewey, Julia Henshaw, d.1928, *4828*
exhibitions
National Academy of Design, 1892, *4182*
Woman's Art Club of New York, 1892, *26531, 26542*
Woman's Art Club of New York, 1896, *22958*
illustrations, *Roses*, *4792*
Dewey, Orville, 1794-1882
lecture on artists as educators, 1856, *19333*
quote, on Powers' *Greek slave*, *18087*
Dewey, Stoddard, b.1853, *15748*
publication of series of manuals on the decorative arts, *15748*
Dewey, Walter M., fl.1894-1897
benefit sale, Chicago, 1896, *11737*
Chicago landscape painter, *11416*
DeWilde, Samuel, 1748-1832
portraits of actors, *14957*
Dewing, Maria Richards Oakey, 1845-1928
American woman painter, *11230*
Beauty in Dress, *1245, 1407*
review, *441*
exhibitions
Boston Museum of Fine Arts, 1880, *225*
Ladies' Art Association of New York, 1880, *9445*
National Academy of Design, 1876, *8660*
National Academy of Design, 1882, *1330*
Pennsylvania Academy of the Fine Arts, 1882, *1450*
Society of American Artists, 1878, *8993*
Society of American Artists, 1882, *1349*
Society of American Artists, 1897, *10538*
illustrations in *Harper's Magazine*, 1880, *932*
lady artist of New York, 1880, *915*
Dewing, Thomas Wilmer, 1851-1938
Days, *3273*
decorative work, *1907*
design for Christmas card competition, 1884, *25206*
Detroit monument, *13112*
exhibitions
American Watercolor Society, 1885, *1933*
Architectural League of New York, 1888, *25564*
Architectural League of New York, 1891, *26459*
Art Students' League, 1880, *9445*
Art Students' League, 1881, *256*
Boston, 1880, *831*
Boston Art Club, 1881, *1089*
Boston Museum of Fine Arts, 1880, *225*
Chicago World's Fair, 1893, *4764*
National Academy of Design, 1880, *126, 889*
National Academy of Design, 1887, *552, 2431, 10786*
National Academy of Design, 1887, Clarke prize, *25437*
National Academy of Design, 1888, *25503*
National Academy of Design, 1889, *2936*
National Academy of Design, 1891, *Summer*, *3603*
National Academy of Design, 1892, *26583*
New York, 1888, *10846*
New York, 1900, *13021*
New York, 1905, *13886*
Pennsylvania Academy of the Fine Arts, 1904, *13716*
St. Botolph Club, 1880, *159*
Society of American Artists, 1881, *367*
Society of American Artists, 1883, *1551, 9824*
Society of American Artists, 1887, *562, 2452, 10789, 25451*
Society of American Artists, 1888, *Allegorical figure*, *2678*
Society of American Artists, 1890, *25895*
Society of American Artists, 1906, *14095*
Ten American Painters, 1898, *12710*
Ten American Painters, 1899, *6954*
Union League Club of New York, 1890, *3177*

illustrations
drawings after J. L. Hamon, *436*
Portrait of a girl, *14083*
painter of women, *10550*
paintings in Clarke collection, *11207*
portrait of woman in ball costume, *2655*
quote, *10545*
sales and prices, 1883, *Prelude*, *24513*
secedes from Society of American Artists, 1898, *6527*
studio, *22700*
Paris, 1895, *11598*
teaching, Art Students' League, 1883, *24678, 24716*
whereabouts, 1894, moves to England, *5073*
women in his work, *8332*
Dewing, Thomas Wilmer, Mrs. See: **Dewing, Maria Richards Oakey**
Dewitz, William O., fl.1898-1906
picture in permanent exhibition of Chicago's Palette and Chisel Club, 1905, *14036*
DeWolf, Julia See: **Addison, Julia de Wolf**
Dexter, Franklin, 1793-1857
casts given to New England School of Design by son, 1858, *19801*
Dexter, Henry, 1806-1876
Binney monument in Mount Auburn cemetery, *19928*
General Warren, *19596*
inauguration, *19626*
Dexter, Josephine Moore
collection, purchases Tiffany Chapel from World's Columbian Exposition, 1894, *22294*
Dexter, M. C., fl.1897
teaching method for china painting, *6511*
Dexter, Wirt, Mrs. See: **Dexter, Josephine Moore**
Dey, Anna Lee See: **Stacey, Anna Lee Dey**
Dey, Henry Ellinwood, Mrs. See: **Dey, Sophie V. Schuyler**
Dey, Sophie V. Schuyler, b.1872
exhibitions, St. Louis, 1895, *11582*
DeYoung, Meichel Harry, 1849-1925
acquires art for proposed San Francisco museum, 1894, *16616*
collection, minerals, *16164*
DeYoung Memorial Museum, San Francisco See: **San Francisco. De Young Memorial Museum**
Deyrolle, Théophile Louis, d.1923
illustrations, *Fisherman's wife*, *4915, 5834*
Dhaubal Banajee, Miss See: **Dhunbai Banajee, Fardoujee**
Dhunbai Banajee, Fardoujee, b.1876?
exhibitions, Salon, 1894, *27007*
diamonds
De Beers Mining Co. exhibit at Chicago World's Fair, 1893, *26937*
Hope Diamond, *17636*
"Imperial diamond" stolen from Hyderabad, India, 1897, *17371*
koh-i-noor's return demanded by Maharajah, 1889, *17892*
largest black diamond, *16835*
Salisbury diamond, *16828*
South Africa exhibit at Chicago World's Fair, 1893, *26968*
test for detection, *724*
world's largest, *16218*
diamonds, industrial, *20963*
Diaper, Frederick, 1810-1905
residence, New York, *20150*
diaries (blank books)
creating engagement tablet in watercolor, *7057*
Díaz de la Peña, Narcisse Virgile, 1808?-1876
Autumn, *3990*
Barbizon School, *17487*
biographical note, *16445*
exhibitions
American Art Galleries, 1889, Barye Memorial Fund Exhibition, *3180*
Chicago World's Fair, 1893, *4766*
New York, 1878, *8981*
New York, 1890, *25731*
New York, 1897, *6143, 17218, 23190*
New York, 1903, *Bohemians*, *8102*

Paris, 1883, *Descent of the gypsies, 25842*
Union League Club of New York, 1888, *2638*
Union League Club of Philadelphia, 1899, *In the Forest of Fontainebleau, 17618*
Fontainebleau forest paintings, *9697*
forgeries, *6247*
 1900, *7294*
illustrations
 Bohemiens, 13807
 Feé aux Jouyoux, 3500
 Summer flowers, 4409
 Water mill, 14222
Interieur de fôret, at Durand-Ruel, New York, 1891, *15620*
Isle des amours, in Roos collection, *15203*
landscapes in Seney collection shown in Brooklyn, 1884, *24970*
Mare aux Grenouilles, purchased by Hermann Schaus, *9233*
obituary, *8778*
paintings confused with those of Millet, *3867*
paintings in Appleton collection, *876*
paintings in collection of Madame De Cassin, *2528*
paintings in Laurent-Richard's collection, *9012*
paintings in Probasco collection, *10782*
paintings in Robinson collection, *25357*
paintings in Secrétan collection, Paris, *10823*
paintings in Seney collection, *2458*
paintings suggested for exhibition of French masterpieces at
 American Art Galleries, 1889, *3073*
Romantic painting in France, *22994*
sales and prices
 1879, *Blindman's buff* and *Plains of Barbizon* in Spencer col-
 lection, *678*
 1880, paintings purchased by W. Schaus, *9371*
 1891, *15538*
 1891, *Parc au boeuf* purchased by American Art Association,
 15587
Storm
 in Walters collection, *22240*
 shown in New York, 1885, *25266*
technique, *14574*
DIBBLE, Mabel C., fl.1893-1899, *4175, 12873*
Dibble, Mabel C., fl.1893-1899
 exhibitions
 Atlan Club, 1895, *11458*
 Chicago, 1894, *11375*
 Chicago, 1895, china, *11652*
 Chicago, 1896, *11881*
 illustrations, decorated ceramics, *12873*
DiCesnola, Alessandro Palma, b.1837
 collection, sale, 1890, *15329*
DiCesnola, Luigi Palma, 1832-1904
 archeological finds disputed by Edward Robinson, 1894, *4872*
 charges against, *277, 305, 326, 350, 374, 934, 950, 972, 996,*
 1037, 1102, 1125, 1127, 1145, 1311, 1326, 1350, 1363, 1428,
 1446, 1464, 1486, 1530, 1569, 1674, 1689, 1694, 1709, 1714,
 1732, 1745, 2113, 9391, 9407, 9445, 9467, 9635, 10115,
 16227, 16245, 16262, 16300, 16311, 16316, 25286, 25295,
 26944
 arraigned, 1880, *930*
 controversy over Cypriote antiquities, 1885, *25233*
 cost of trial, *1767*
 exonerated by Museum, 1881, *1084*
 Feuardent brings suit, *405*
 French opinions, *25253*
 investigation, *1060*
 litigation, 1884, *25036*
 Museum's investigating committee, 1882, *1281*
 response to Feuardent's charges, *178*
 Richter discredits Metropolitan Museum of Art's Temple of
 Curium, 1893, *4425*
 sued by Feuardent for defamation of character, *1167*
 collection
 Cypriote antiquities in Metropolitan Museum of Art, *347,*
 874, 9397
 excavations in Cyprus, *8591*
 Handbook of Cypriote art in Metropolitan Museum of Art,

 345
 in Metropolitan Museum of Art, *14039*
 Temple of Curium objects discredited by M. O. Richter,
 1893, *4425*
 correspondence on Curium in *The Cyprus Herald*, 1886, *25311*
 Cyprus antiquities, *25173*
 director, Metropolitan Museum of Art
 1895, *16705*
 controversy, 1885, *25243*
 disagreeable manners at Metropolitan Museum, *25391*
 government transactions, 1881, *1105*
 honorary degree, 1880, *102*
 lecture, 1879, *18*
 notes, 1883, *24381, 24453*
 praised, 1887, *545*
 quote, praises *The Studio, 24729*
 reasons for Metropolitan Museum of Art's refusal of Marié col-
 lection, 1903, *8173*
 re-elected secretary of Board of Trustees of Metropolitan
 Museum of Art, 1895, *5298*
 suit against Richter, 1884, *1801*
 Treasure of Curium, correspondence, *25228*
 views on method of restoration of Cypriote antiquities, *1818*
Dicey, Frank, d.1888
 exhibitions, Royal Academy, 1880, *9370*
Dick, Alexander L., ca.1805-ca.1855
 illustrations, *Manuscript* (after C.R. Leslie), *10723*
Dickens, Charles, 1812-1870
 anecdote, *16694, 16968*
 as artist, *12473*
 catalogue of Dickensiana issued, 1896, *17053*
 Collector article, 1894, *16613, 16625*
 fascination with prisons, *16634, 16642, 16660, 16795, 16807,*
 16822, 16836
 illustrators, *977*
 manuscripts and letters, *16227*
 manuscripts and relics in South Kensington Museum, *16053*
 Nicholas Nickleby, description of Dotheboys Hall, *10451*
 obituary, *10590*
 Pickwick Papers, popularity and prices, 1896, *16928*
 Pickwick with the Two Wellers, Eichbaum illustrations, *15353*
 portraits, portrait by Scheffer, *17350*
 relics, *16647*
 sale, 1895, *16675*
 sales and prices, 1893, *16428*
 subject of New York store window design, 1896, *5615*
 title changes, *17074*
 Village Coquettes, 16582
 wardrobe, *8238*
Dickens, Kate See: **Perugini, Kate Dickens**
DICKERSON, James Spencer, 1853-1933, *12168, 12792*
DICKINSON, Anna Elizabeth, 1842-1932, *23563*
Dickinson, Anna Elizabeth, 1842-1932
 letter praising chromolithographs of Prang, 1868, *23542*
 notes, 1896, *23038*
Dickinson, Clarence, 1873-1969
 organist and composer, *12037*
DICKINSON, Ellen E., *686, 740, 791, 12677*
Dickinson, Emily, 1830-1886
 Poems
 excerpt and review of third edition, *12595*
 review, *12582*
Dickinson, John Reed, b.1844
 notes, 1899, *22077*
Dickinson, Lowes Cato, 1819-1908
 portrait paintings engraved, *25772*
DICKINSON, Sidney, 1851-1919, *526*
Dickinson, Sidney, 1851-1919
 lectures on art, 1886-7, *492*
 whereabouts, 1884, to study art in Europe, *25046*
Dickman, Charles John, 1863-1943
 illustrations, *Old Monterey, 22195*
 notes
 1901, *22134*
 1902, *22161*

portraits, portrait by R. I. Aitken, *22176*
Twilight, purchased for Mark Hopkins Institute,1899, *22072*
Dicksee, Francis Bernard, 1853-1928
Cynthia, posed by Estelle Clayton, *22522*
drawings for *Romeo and Juliet*, *10151*
election to the Royal Academy, 1891, *26376*
exhibitions
Dudley Gallery, 1881, *22025*
Royal Academy, 1879, *21698*
Royal Academy, 1881, *21997*
Royal Academy, 1882, *1366*
Royal Academy, 1883, *1603*
Royal Academy, 1887, *10473*
Royal Academy, 1891, *3648*
illustrations
House builders, *21831*
Ideal beauty, *21874*
painting of woman in forest, *21782*
illustrations for Longfellow's *Evangeline*, *9657*
Memories, etched by Herbert Dicksee, *16079*
notes, 1896, *23038*
Offering, at Royal Academy, 1898, *24090*
portraits, photograph, *22579*
Dicksee, Frank See: **Dicksee, Francis Bernard**
Dicksee, Herbert Thomas, 1862-1942
exhibitions, Chicago, 1902, *13399*
illustrations, *Head of a lion*, *7346*
Memories (after F. Dicksee), *16079*
Dicksee, Margaret Isabel, 1858-1903
illustrations, *Young Handel*, *8109*
Dicksee, Thomas Francis, 1819-1895
exhibitions
London, 1880, *9275*
Royal Academy, 1878, *21602*
Lady Madeline, *21575*
obituary, *16905*
Dickson, Mary Estelle, fl.1896-1902
exhibitions, Tennessee Centennial Exposition, 1897, honorable
mention, *11971*
Diday, François, 1802-1877
exhibitions, Geneva, 1854, *21373*
Diddaert, Henri, fl.1845
information wanted, 1896, *16942*
DIDEROT, Denis, *25217*
Didier, Charles Peale, 1870?-1900
portrait of first Lord Amherst completed, 1895, *22876*
Didier, Ida Joy, fl.1883-1893
portrait of Gambetta and *The smoker* shown in Minneapolis,
1884, *24982*
portrait of Gambetta at Minneapolis Art Loan Exhibitionn,
1883, *24948*
portrait paintings, *611*
whereabouts, 1887, summer trip, *583*
works in Minneapolis Industrial Exposition, 1887, *592*
Didier, Jules, 1831-1914
illustrations, *Conversion of St. Paul*, *13444*
Didier Pouget, William, 1864-1959
exhibitions, Salon, 1898, *Creuse*, *6646*
illustrations, *Morning*, *5899*
Didioni, Francesco, 1859-1895
exhibitions, Paris Exposition, 1878, *9096*
Didot, Ambroise Firmin, 1790-1876
collection
sale, 1877, *8846*
sale, 1878, *21649*
library, sale of portion of library, 1883, *14911*
Didron, Edouard Amédée, 1836-1902
French glass stainer, *10101*
Diefenbach, Karl Wilhelm, 1851-1913
whereabouts, 1892, flees Munich for Chicago, *26880*
DIEHL, Conrad Rossi, *10722*
Diehl, Conrad Rossi, fl.1870-1892
Disinheritance of St. Francis, *10598*
exhibitions, Chicago Academy of Design, 1871, *10712*
sketches called chalks, *26713*

Dielman, Frederick, 1847-1935, *935*, *22740*
copies after Vandyck and Palma Vecchio made for Metropolitan
Museum's Loan Exhibition, 1883, *24538*
design for Christmas card competition, 1884, *25206*
elected president of National Academy of Design, 1899, *7005*
exhibitions
American Watercolor Society, 1884, *25012*
American Watercolor Society, 1891, *26264*
Architectural League of New York, 1897, cartoons for
Library of Congress mosaics, *23213*
Artists' Fund Society, 1883, *1512*
National Academy of Design, 1879, *679*
National Academy of Design, 1880, *111*, *889*
National Academy of Design, 1885, *1970*, *25271*
National Academy of Design, 1894, *4873*
National Academy of Design, 1896, *Marion*, *22996*
National Academy of Design, 1897, *10540*
New York Etching Club, 1884, *25013*
Prize Fund Exhibition, 1886, *2226*, *25304*
Society of American Artists, 1880, *844*
Society of American Artists, 1881, *367*
Southern Exposition, Louisville, 1884, *New York Arab*,
11051
illustrations
Eleanor, *3532*
Old time favorites, *1504*
Scene in Rothenburg, *980*
Water-lilies, *2816*
illustrations for *Harper's* criticized, 1883, *24453*
Law mosaic for Library of Congress, lawsuit for copyright lim-
its, 1900, *7341*
lawsuit against Boston firm, 1900, *13128*
lectures, address on art tariffs in U.S., 1903, *13546*
on perspective at National Academy of Design, 1883, *24678*
member, Tile Club, *1851*
painted panel for table, 1880, *892*
panels for Congressional Library, *23008*
Prayer (leaf from sketchbook), *10957*
quote, on art centers for American art students, 1902, *7804*
teaching
Art Students' League, 1880, *785*
Art Students' League, 1883, *24716*
whereabouts
1883, Easthampton, *24755*
1883, home from East Hampton, *24817*
1883, Montclair and Boston, *24657*
1883, Montclair, N.J, *24728*
1896, summer plans, *23056*
Dieman, Charles, *Mrs.* See: **Sorenson, Clara Barth Leonard**
Dieman, Clara Leonard See: **Sorenson, Clara Barth
Leonard**
Dien, Louis Félix Achille, b.1832
illustrations
In the woods, *3947*
In the woods (drawing), *3934*
Under green boughs, *3992*
Dienay
illustrations, portrait of Russian, *3077*
DIERCKS, Gustav, *13609*
DIERHOLD, G. H., *6971*, *7002*
Dieterle, Marie van Marcke de Lummen, 1856-1935
cattle paintings in Chicago, 1898, *12273*
illustrations, *Morning in the fields of Monthières*, *1997*
Dietrich, Carl, fl.1884-1886
illustrations
Baiser envoyé (after Greuze), *10169*
Colin Hunter, A.R.A, *10136*
Gloire de Dijon (after P. H. Calderon), *10238*
Holy Family (after Fra Bartolommeo), *10143*
In the courtyard of the Indian Palace (after J. R. Brown),
10376
Lady Hamilton (after Romney), *10169*
Ludwig Richter (after Leon Pohle), *10156*
Madonna of Sant'Antonio (after Raphael), *10133*
Madonnas (after Raphael), *10113*

Diranian, Serkis, fl.1892-1900
portrait paintings, *7822*
directories
United States, history of city directories, *15859*
Disch, Carl Damian, d.1880
collection, sale, 1881, *21896*
Disraeli, Benjamin, 1804-1881
portraits, drawing by D. Maclise, *22736*
trustee of British Museum, *932*
Disraeli, Isaac, 1766-1848
anecdote, *3648*
Ditmars, Isaac E.,, 1850-1934
See also: **Schickel and Ditmars, architects**
Dittenberger, Gustav, 1794-1879
obituary, *47*
Ditzler, Hugh Witter, 1871-1949
exhibitions
Chicago Society of Artists, 1896, war paintings, *11813*
National Academy of Design, 1896, *11909*
Dix, Charles Temple, 1838-1873
exhibitions
Chicago Academy of Design, 1871, *10712*
Metropolitan Museum of Art, 1881, *1165*
National Academy of Design, 1858, *19835*
National Academy of Design, 1859, *20048*
sales and prices, 1858, Romney collection sale, *19957*
Dix, Emma S., fl.1887-1888
illustrations
charcoal sketch (after F. S. Church), *17753*
Fencing-lesson (after Robaudi), *17822*
Roman girl at the window (after Wiertz), *17795*
Rose of Provence (after Ph. H. Calderon), *17783*
Through an opera-glass (after Pinel de Grandchamp), *17824*
Dix, John, 1800?-1865?
contributor to *The Lantern*, *16568*
Dix, Morgan, 1827-1908
Plea for the Use of the Fine Arts in the Decoration of Churches, review, *19702*
quote, *19663*
Dixon, Charles, 1872-1934
exhibitions
New York Water Color Club, 1891, *3833*
New York Water Color Club, 1893, *4284*
Dixon Hartland, Frederick D., 1832-1909
collection, *Susannah* by G. B. Lombardi, *8475*
Dixon (Illinois). Rock River Assembly
classes and lectures, 1894, *11346*
Dixon, M. R. See: **Dixon, Maria R.**
Dixon, Maria R., d.1896?
exhibitions
Brooklyn Art Club, 1892, *26501*
National Academy of Design, 1891, *26307*
Woman's Art Club of New York, 1890, *25803*
figure painter, *22525*
illustrations
Meditation, *22560*
Private rehearsal, *22576*
Secret, *552*
Waiting, *24509*
Into each life some rain must fall, *22503*
lady artist of New York, 1880, *915*
Last mouthful, at Berkeley Lyceum, 1890, *15128*
models, favorite model, *22519*
portraits, photograph, *22502*
Weary eyes and hands are free, *22731*
whereabouts, 1893, summer sketching plans, *22491*
Dixon, Maynard, 1875-1946
frontier studies, *22185*
illustrations, *Carca de la Estufa, Islete*, *22125*
notes
1902, *22161*
1903, *22176*
Dixon, Paul, fl.1860-1872
illustrations, *Mountain gorge, Kaatskill Mountains*, *18487*
newspaper illustrations, *16557*

Dixon, William Hepworth, 1821-1879
Personal History of Lord Bacon, review, *18541, 20344*
Dixwell, Fanny Bowditch See: **Holmes, Fanny Bowditch Dixwell**
Djemila (Algeria)
antiquities, statue found, 1878, *9037*
Dmitriev Orenburgskii, Nikolai Dmitrievich, 1838-1898
exhibitions, Paris, 1880, *9262*
illustrations, *Found drowned*, *13759*
Dmochowski, Henryk See: **Saunders, Henry Dmochowski**
Doat, Taxile Maximin, 1851-ca.1945
illustrations, *Leap frog* (ceramic decoration), *1454*
DOBSON, Austin, *10188*
Dobson, Austin, 1840-1921
Horace Walpole, a Memoir
illustrated by Percy and Leon Moran, *15405*
published by the Grolier Club, *15442*
Life of William Hogarth, revised and expanded, 1891, *26297*
memoir of Hogarth revised, 1890, *26186*
Thomas Bewick and his Pupils, review, *11114*
William Hogarth
publication of new edition, 1892, *26592*
review, *15797*
Dobson, William, 1611-1646
exhibitions, Lotos Club, 1899, portrait of the Duke of Hamilton, *17588*
portrait of Sir Richard Fanshawe, *16845*
Dobson, William Charles Thomas, 1817-1898, *21625*
At the masquerade, *21611*
Child Jesus in the temple, *22858*
Dobuzhinskii, Mstislav Valerianovich, 1875-1957
exhibitions, Moscow, 1905, *13943*
DODD, Anna Bowman Blake, *9697, 9712, 9936, 10187, 10750*
Dodd, Anna Bowman Blake, 1855-1929
On the Broads, review, *23178*
Dodd, Mead & Co., New York
exhibitions, 1894, J. Trumbull sketches, *4909*
history of establishment, *16595*
Dodd, William J., fl.1902-1905
illustrations, pottery, *13883*
Teco pottery, *13360*
Dodd, William, Mrs., fl.1875-1880
exhibitions, Cincinnati, 1880, ceramics, *814*
Dodge, Anna Sheddon, fl.1894-1900
American china painter, *5956*
book decorations, *12293*
exhibitions, Chicago, 1894, *11375*
whereabouts, 1898, Chicago, *12223*
Dodge, Elsie See: **Stuart Dodge, Elsie**
DODGE, Mary Abigail, *10610*
Dodge, Norman W.
Dodge prize, 1891, *26231*
prize established to be awarded at National Academy annual exhibition, 1887, *540*
prize for woman artist at National Academy, *13173*
Dodge, William De Leftwich, 1867-1935
ceiling for Library of Congress, commissioned 1896, *11738*
collection, sale 1897, *17262*
colossal canvases critiqued, 1891, *3490*
criticized for painting nudes, 1891, *26285*
decoration of Puck Building dome at World's Fair, 1892, *4171*
decorations for Liberal Arts Building, Chicago World's Fair, 1893, *4378*
exhibitions
American Art Galleries, 1890, *15426, 26196*
American Art Galleries, 1891, *3457*
Architectural League of New York, 1897, *10535*
Chicago Art Institute, 1895, *5569*
Chicago Art Institute, 1898, *War*, *12251*
Fellowcraft Club, 1890, *26181*
Pennsylvania Academy of the Fine Arts, 1891, *3535*
Prize Fund Exhibition, 1887, *562, 2456*
Salon, 1889, *2938, 2985*
Salon, 1896, *11825*

Doyle, Arthur Conan, 1859-1930
 invents electric sculpturing machine, 1903, *13637*
 portraits, photograph, *23200*
Doyle, Henry Edward, 1827-1892
 death endangers Dublin National Gallery, *26591*
 obituary, *26539*
Doyle, Richard, 1824-1883
 exhibitions
 Grosvenor Gallery, 1878, *21604*
 Grosvenor Gallery, 1880, *21885*
 illustrator, DuMaurier's comments, 1894, *5082*
 Journal Kept by Richard Doyle in the Years 1840, review, *10270*
 obituary, *9951*
Dozzi, Louis Tonetti See: **Tonetti, François Michel Louis**
Drachmann, Holger Henrik Herholdt, 1846-1908
 quote, on future of American art, *13046*
Draddy, John G., 1833-1904
 obituary, *13846*
Drake, Alexander Wilson, 1843-1916
 collection, sale, 1907, *14306*
 on collecting, 1898, *6621*
Drake, Frances Ann Denny, 1797-1875
 notes, 1897, *23250*
Drake, Francis, *Sir*, 1540-1596
 biography, *21068*
 relics, sword, *16589*
Drake, Friedrich, 1805-1882
 invents process to protect marble against weather, *19594*
Drake, George B., fl.1893-1896
 illustrations, *Wet night*, *22546*
 models, favorite model, *22519*
 Stolen tête-à-tête, *22879*
 studio
 summer home and studio, *22571*
 summer studio, Maine, 1893, *22491*
 whereabouts, 1896, summer at Thousand Islands, *23056*
Drake, William Henry, 1856-1926
 Cincinnati artist of the Munich school, *195*
 exhibitions
 American Watercolor Society, 1885, *25239*
 National Academy of Design, 1898, *17402*
 New York, 1895, *Jungle Book* illustrations, *16894*
 New York, 1896, drawings for Kipling's *Jungle Book*, *5615*
 Philadelphia, 1883, water colors, *24607*
 Salmagundi Club, 1903, Inness prize, *13578*
 illustrations
 antique room in the Art Institute, Chicago, *3630*
 Dutch fishing boat, *3532*
 Lioness, *22645*
 Old salt, *6252*
 One of a mighty race, *22576*
 Prowler, *13746*
 sketch, headpiece, initial, *221*
 When day is done, *13218*
 Misty weather, *22503*
 portraits, photograph, *22539*
Drake, William Richard, 1817-1890
 obituary, *3497, 26203*
drama
 anonymous
 Autumn Leaves, *8333*
 Beauty Collapsed, excerpts, *18071*
 Banville, T. de, *Kiss*, *23657, 23676*
 Bradley, W., *Beauty and the Beast* (synopsis), *12545*
 Earle, M., *Freedom of Pere Mossey*, *22708*
 Essays on the Drama by W. B. Donne, review and excerpts, *19950*
 notes, 1897, *23170, 23197, 23222, 23250*
 Oehlenschläger, A., *Correggio*, *19115, 19132, 19147, 19160, 19177, 19195, 19209, 19224, 19242, 19253*
 School for Scandal, 1891, *3623*
dramatic criticism, *20554*
Dramatic Fine Art Gallery, London See: **London (England). Dramatic Fine Art Gallery**

Draper, Francis, fl.1902-1910
 exhibitions
 Boston Art Club, 1902, *13353*
 Boston Art Club, 1907, *14252*
Draper, Herbert James, 1864-1920
 illustrations, central figure in decorative design for a public building, *17775*
 prize for decorative design for public building, 1886, *10417*
Draper, John. fl.1802-1845
 See also: **Murray, Draper, Fairman, & Co.**
Draper, John William, 1811-1882
 Human Physiology, Statical and Dynamical, review, *19575*
Drapers' Hall See: **London (England). Drapers' Hall**
drapery
 artistic use, *2094*
 color in portraiture, *1534, 1554*
 drawing drapery on human figure, *5124, 5176*
 in painting and sculpture, *17547*
 Millet's treatment of peasant fabric in his paintings, *7979*
 technique, painting, *4482*
Draughtmen's and Artists' Association See: **Boston (Massachusetts). Draughtmen's and Artists' Association**
drawing, *9437*
 African Bushmen draw by connecting dots, *24729*
 artists' sketches on margins of letters, *12740*
 artists study anatomy while drawing, *3260*
 awards for pencil drawings by Dixon Graphite Co., Jersey City, 1883, *24728*
 black and white work, *24596*
 collectors and collecting
 Hovingham Park, *9580*
 Sir Charles Robinson collection, *16890*
 suggestion to collect, 1890, *3441*
 competitions, Harper Bros.' Christmas drawing competition, 1884, *25047*
 crayon and pen drawing, *4222*
 danger of exposure to light, *25648*
 drawing for magazines, *3468*
 elementary drawing, *18786*
 excerpts from Fowler's *Hints on Practical Drawing and Painting*, *4196*
 excerpts from Parkhurst's *Sketching from Nature*, *3319*
 exhibitions, Pratt Institute, 1899, *17574*
 freehand and mechanical drawing for designs, *11419*
 Hamerton on writing as a form of drawing, 1896, *5625*
 how to reproduce a drawing, *4347*
 importance to American artists, *25000*
 industrial, *11510*
 lesson for children, *6416, 6448, 6483, 6518, 6607, 6633, 6691*
 line-drawing for book illustration, *12996*
 materials for pen drawing, *3332*
 mounting drawings, *4102*
 notes
 1894, *5090*
 1895, *5252, 5363*
 1903, *8269*
 pen and ink art, *11306*
 pen and ink drawing, *5123*
 pen drawing a regular branch of study in art schools, 1890, *3254*
 pen drawings, *1591, 2039*
 "philograph" mechanical tool, *4968*
 red chalk drawing, *1638*
 requirements of black and white, *22596*
 review of Pennell's *Pen Drawing and Pen Draughtsmen*, *5328*
 sales and prices, 1893, Brück collection, *16412*
 sketching from nature, *14794*
 study and teaching, *19335, 20346*
 department of drawing in New York's Free Academy, 1849, *14543*
 emphasis on line in Art School of Art Institute of Chicago, *12939*
 importance of study, *2247*
 instruction in Chicago public schools, 1896, *11869*
 instruction in public schools, *11953*

Los Angeles public schools, 1899, *12382*
posing children for models, *12914*
teaching children to draw, *6073*
teaching drawing in schools, *12035*
teaching grade school children, 1898, *12108*
teaching in public schools, *19946*
teaching students to see correctly, *5908*
teaching the child to draw in perspective, *5624*
training from simple objects, *22016*
technique, *2194, 2684, 4023, 4078, 5497, 5498, 5519, 5709, 5905, 7004, 7239, 7673, 10369, 13152, 18834, 25126*
advice on drawing children, *7701*
American academic theory, *21514, 21525, 21535, 21548, 21558*
art of sketching from nature, *14773*
chalk drawing, *1577*
charcoal drawing, *2665*
circles and elipses, *5664*
color effects in pen sketching, *6430*
color translated into value, *5839*
copying drawings using silver nitrate, *8230*
crayon, *6793*
crayon drawing, *1576*
depicting action, *7102*
depicting distance, *7186*
depicting motion, *5041*
draped figure, *5124*
drawing for illustration, *5227, 6848*
drawing for photoengraving, *3103, 3209*
drawing for photoengraving, architectural drawing, *3544*
drawing from casts, *7532, 7552*
drawing live models, *5910*
drawing over photographs as learning device, *5986*
drawing the eye, *5909*
drawings in printers' ink on copperplate, *475*
E. J. Meeker on pen drawing, *4292*
education of the eye, 1893, *4260*
excerpts from Pennell's *Pen Drawing and Pen Draughtsmen*, *5127*
fixative, *3403*
fixitive for drawings, *7987*
flowers, *11447*
for china painters, *11867*
for engraving, *6879*
for illustration, *3761, 4534, 5835*
for photoengraving, *5407, 5463, 5536, 5607, 6021, 6135, 6255, 6402*
for photoengraving landscape, *6285*
for reproduction, *5079, 5175, 5268, 6365*
foreshortening, *6947, 6974*
formal instruction in pen drawing, 1890, *3277*
free-hand drawing, *3890, 4151, 4195*
from casts, *3542*
from casts and live models, *5621*
from live models, *5872*
from the live model, *4886*
gray "wash" of lead, *4045*
hints for sketching, *5406*
how to enlarge a drawing, *4049*
how to fix a drawing with milk, *4173*
how to preserve dead fish and insects as models, *8256*
igrid for enlarging and transferring drawings, *8151*
India ink, *2309*
landscape, *3799*
lead pencil, *2057, 6436*
lesson, *6918*
lesson for children, *6543*
lessons for children in foreshortening, *6579*
light and shade, *5744*
light and shading, *7024*
lighting for drawing from casts, *6504*
mannerism in pen drawing, *6651*
materials and technique for sketching, *4848*
materials for wash drawing, *8098*
measuring size and direction, *4295*

memory tricks to aid drawing from nature, *4048*
objects from difficult angles, *5786*
outdoor sketching, *5984*
parallel lines to create shadows and depth, *2913*
pen and ink, *4153, 4770, 4810, 6348, 6624, 7021, 7304, 7880*
pen and ink drawing for photoengraving, *7319*
pen and ink landscape, *6376, 7101*
pen drawing, *3744, 7131*
pen drawing for illustration, *6818*
pen drawing for photo-engraving, *3401, 5439*
pen drawing for photoengraving, *3129, 3182, 3259, 3287, 3314, 3436, 3504, 6499*
pen drawing for photoengraving, figures, *3336*
pen drawing for photoengraving, newspaper portraits, *3578*
pen drawings for reproduction by photo-engraving, *2892, 2939, 2968, 3012, 3035, 3077*
pen sketching, *6469*
pen studies of heads, *5126*
pen work for reproduction, *5177*
pens, *5080*
perspective, *4065, 5575*
perspective and horizons, *5538*
pine trees, *6535*
quill pen, *6791*
rapid sketching, *4945*
red chalk, *3339*
reflections in pen and ink, *6316*
repose and shading, *7019*
sketching, *5437, 6286, 7385*
sketching from nature, *3980, 5269, 5379, 6018, 6502, 6567, 6694, 7598, 14760, 14788*
sketching out of doors and values for still life, *4657*
sketching rapidity, *6022*
studying from nature, *18818*
subjects in nature, *7746*
subjects suggested, *4573*
textures, *5947*
two-point perspective, *5626*
use of lights, *7297*
Vierge's drawing technique, *5344*
wash drawing for half-tone reproduction, *26958*
wash drawing for reproduction, *26989*
wash drawings, *6498*
wash drawings for reproduction, *5950*
washes and types of paper, *4918*
with lead pencil, *3898*
working drawings for painting, *3736*
working from photographs, *6113*
technique for photoengraving, *5478, 6378, 6765, 6930, 7271, 7459*
animals and landscape, *7075*
avoiding solid black areas of ink, *7379*
opacity, *6907*
pen drawing, *6735, 7403*
technique for reproduction, *7431*
amount of detail, *7485*
pen and gouache for half-tones, *7155*
pen and ink, *3679*
use of dark paper for drawing, *2914*
wash drawings, *4592, 6486*
drawing, American
exhibitions
American Art Association, 1884, *25209*
New York, 1893, *22521*
Harper competition, 1883, *24723*
work by A. E. Sterner, *12995*
drawing, English
English skecth club drawings for sale at Bouton's, New York, 1861, *20365*
drawing, French
album of sketches by military artists for Marchand, 1899, *17655*
exhibitions, Ecole des beaux-arts, Paris, 1884, *1773*
sketches for *Paris-Murcie*, 1880, *806*

Dublin (Ireland). Exhibition of Art and Industry, 1853, *20897*, *20937*
 organization and financing, *21270*
 William Dargan, *20780*
Dublin (Ireland). National Gallery of Ireland
 acquisitions
 1883, *14909*
 1892, *26486*
 death of Director Doyle, 1892, *26591*
Dublin (Ireland). National Museum of Ireland
 building, new building opened, 1890, *26052*
Dublin (Ireland). Royal Hibernian Academy
 annual exhibitions, 1887, *10464*
 elections, 1892, *26714*
 exhibitions
 1884, *9999*
 1903, old masters, *13558*
 1903, portraits, *13613*
 1905, *13935*
 1905, Irish writers group to purchase pictures, *13870*, *13900*
Dublin (Ireland). Science and Art Museum See: **Dublin (Ireland). National Museum of Ireland**
DuBois, Charles Edward, 1847-1885
 exhibitions, Salon, 1877, *8884*
DuBois, H. H., 1837-1890
 exhibitions, Woman's Art Club of New York, 1891, *15550*
DuBois, Henri Pène See: **Pène du Bois, Henri**
Dubois, Louis, 1830-1880
 obituary, *134*
Dubois, Paul, 1829-1905
 Charity, *21586*
 exhibitions
 Chicago Art Institute, 1896, *5701*
 Salon, 1885, *2000*
 French sculptor, *23114*
 illustrations, *Charity*, *11647*, *12669*
 Joan of Arc, best sculpture in Salon of 1889, *11585*
 obituary, *14028*
Dubois, Paul, 1858-1938
 work in Ny Carlsberg Glyptothek, *8348*
Dubois Pillet, Albert, 1846-1890
 obituary, *26066*
DuBois, Samuel F., 1805-1889
 exhibitions, Pennsylvania Academy of the Fine Arts, 1855, *18793*
Dubouchet, Gustave Joseph, b.1867
 exhibitions, National Academy of Design, 1892, *4182*
Dubourjal, Savinien Edmé, 1795-1865
 notes, 1849, *21381*
DuBoys, Ambroise Bosschaert, 1543-1619
 illustrations, *Maximilen de Béthune, duc de Sully*, *17752*
Dubray, Vital, 1813-1892
 obituary, *26803*
 statue of the Empress Josephine, *18681*
Dubret, Henri, fl.1900-1904
 illustrations, design in gold and silver work, *13791*
Dubufe, Edouard, 1820-1883
 exhibitions
 Cercle Artistique, 1876, *8637*
 Société d'Aquarellistes Français, 1884, *1756*
 illustrations
 Philippe Rousseau, painter of animals and still-life, *2654*
 sketches adapted for fan decoration, *1955*
 obituary, *1634*, *9892*, *14912*, *24726*
 paintings in Stewart collection, *753*, *2393*
 portrait of king Louis-Philippe, *14697*
 Prayer, mezzotint copy available from International Art-Union, *21398*, *21421*
Dubuffe, Paul, d.1899
 Adam and Eve, shown in New York, 1860, *20284*
Dubuque (Iowa). Dubuque Ladies' Literary Association
 art class, 1896, *11833*
Duc, Joseph Louis, 1802-1879
 designer of column of July, *21047*
Duccio, Agostino di See: **Agostino di Duccio**

Duccio di Buoninsegna, ca.1255-1319
 altarpiece for Siena cathedral, *21986*
Duclos, Alberta, fl.1902
 illustrations, decorative design for wall, *13445*
Ducornet, Louis Joseph César, 1806-1856
 armless painter, *18020*
Ducos du Hauron, Louis, 1837-1920
 experiments in color photography, *7666*
Dudensing, Richard, d.1899
 exhibitions, New York Etching Club, 1888, *2641*
Dudevant, *Madame* See: **Sand, George**
Dudley, Alfred, fl.1881-1887
 exhibitions, Prize Fund Exhibition, 1887, *2456*
DUDLEY, C. Howard, *13424*
Dudley, Frank Virgil, 1868-1957
 exhibitions
 Palette and Chisel Club, Chicago, 1906, *14227*
 Society of Western Artists, 1906, *14038*
 illustrations, *Last load*, *14264*
DUDLEY, Henry, 1813-1894, *20122*
Dudley, Robert, fl.1865-1891
 Atlantic cable painting given by C. W. Field to Metropolitan Museum, 1893, *22249*
 English designer, *10438*
 pictures of laying of Atlantic cable given to Metropolitan Museum of Art, 1893, *22483*
Dudley, Thomas Haines, 1819-1893
 obituary, *16227*
Dudley, William Ward, *1st earl of*, 1817-1885
 collection
 picture gallery, London, 1855, *18974*
 sale, 1886, *2245*
 sale, 1892, *4094*, *15934*, *15957*
 sale, 1900, *7341*
 sale, London, 1892, *26714*
 to be sold, 1892, *3945*
dueling
 France, debate over custom, 1897, *23893*
DUEMMLER, Ferdinand, *25295*
Duero River (Spain and Portugal)
 description and views, *10261*
Duez, Ernest Ange, 1843-1896
 Children's dinner, *25321*
 exhibitions
 Cercle Central des Lettres et des Arts, 1880, *9389*
 Cercle de l'Union Artistique, 1880, *9309*
 Salon, 1879, *9188*
 Salon, 1887, *17774*
 Société d'Aquarellistes Français, 1883, *14871*
 Société d'Aquarellistes Français, 1884, *1756*
 Société d'Aquarellistes Français, 1886, *2175*
 fan decoration, *4109*
 fan painting, *17884*
 illustrations
 drawing, *7075*
 Evening (study), *4026*
 pen drawing, *7403*
 pen portrait sketch, *3209*
 Sleeping child, *3757*
 Sleepy student, *6405*
 obituary, *17031*
 painted fan, *1451*
 sales and prices, 1896, studio sale, *17085*
Dufaure, Jules Armand Stanislas, 1798-1882
 institutes Permanent Commission of the Fine Arts, 1848, *18631*
Duffer, Louis Stanislas Faivre See: **Faivre Duffer, Louis Stanislas**
DUFFIELD, H. T., *26113*
DUFFY, B., *9795*, *9853*
Dufner, Edward, 1871-1957
 exhibitions, Chicago Art Institute, 1902, *13536*
DuFresnoy, Charles Alphonse, 1611-1665
 friendship with painter Mignard, *24331*
Dugan, Blanche See: **Cole, Blanche Dougan**
Dugan, Peter Paul See: **Duggan, Peter Paul**

New York artists' reception, 1858, *19784, 19800, 19817*
First harvest in the wilderness, 19315
Fishkill studies, *20302*
Fountain, in the American Art Union Gallery, 1848, *14376, 14384, 14400, 14407*
Hudson River School, *11472*
illustrations
 Kaaterskill Clove, 14746
 landscape etched by Burt, *14814*
 Study from nature, 155
interviewed by Charles Lanman, 1883, *24720*
landscapes, *19955, 19995*
 1855, *18771*
 composition, *19801*
 in collection of American Art Union, 1849, *14575, 14589*
 in Sturges collection, *19331*
lead secession of National Academy of Design, *7044*
letter on Ruskin drawing, 1855, *18783*
notes
 1849, *21381*
 1857, *19752*
 1860, *20237*
obituary, *2303, 25353*
paintings, 1850, *14606*
paintings in American Art Union Gallery, 1848, *14445, 14459*
paintings in Springfield, Illinois, 1858, *19836*
picture in Layton Art Gallery, Milwaukee, *12813*
Primeval forest, at Century Club festival, 1858, *19783*
prints, *2428*
sales and prices
 1858, Romney collection sale, *19957*
 1887, *566*
 1891, *26270*
 1891, *Traveller's home, 3531*
studies from nature, 1859, *18380, 20104*
studies of White Mountains, 1855, *19201*
style, *21121*
Summer afternoon, 18670
whereabouts
 1849, Cornwall, *14537*
 1855, visits North Conway, N.H., *19088*
 1856, returns from West Campton, *19545*
 1857, *19682*
 1858, summer quarters, *19891*
 1859, summer travel, *20080*
 1883, South Orange, N.J, *24380*
Durand, Cyrus, 1787-1868
bank note engraving, *18644*
biography, *21124*
contributions to bank-note printing, *21140*
Durand, Elias Leon, fl.1878-1913
exhibitions
 National Academy of Design, 1883, *24480*
 Prize Fund Exhibition, 1888, *2700*
illustrations
 Glancer, 24434
 Too late, 22501
pen and ink drawing, *24423*
portraits, photograph, *22518*
whereabouts, 1883, sketching in Massachusetts, *24607*
DURAND GRÉVILLE, Emile, 1838-1914, *17787, 17800, 25469, 25675, 25695, 25724, 25854*
Durand Gréville, Emile, 1838-1914
catalogue of French paintings in American collections, 1887, *2559*
discovers green paint discoloration, 1898, *17386*
DURAND, John, 1822-1898, *432, 456*
Durand, John, 1822-1898
biography of Asher B. Durand published, 1894, *16519*
interviewed by Charles Lanman about father, Asher B. Durand, 1883, *24720*
Durand Ruel, Charles, 1864?-1892
obituary, *4142, 15988, 26811, 26819*
Durand Ruel Galleries, New York See: **New York. Durand Ruel Galleries**

Durand Ruel Gallery, Paris See: **Paris (France). Galerie Durand Ruel**
Durand Ruel, Georges
Paris apartment decorated with work by Impressionists, *7372*
Durand Ruel, Paul, 1828-1922
apostle of Impressionism in New York, 1887, *566*
champions Impressionism, *5217*
claims to deserve profits from American Art Association's sale of Probasco collection, 1890, *3127*
collection
 book by George Lecomte, *26708*
 engraved and published, 1892, *15902*
 exhibition, 1887, *10814, 10833*
 sale, 1887, *10467*
 shown in New York, 1887, *574*
 works by Monet, Pissarro, Sisley and Renoir, *13535*
courage to exhibit unknown talent, 1894, *5170*
describes American art market demands, 1896, *17061*
letter about Puvis de Chavannes, 1897, *6398*
letter on Dutch pictures in America, 1892, *15828*
notes, 1887, *25426*
patron of Impressionists, *25290*
purchases from Secrétan sale, 1889, *25628*
purchases Oriental porcelain, 1894, *4832*
quote, on Corot, Millet and Rousseau, *2725*
sales of Impressionist pictures, 1887, *538*
sponsor of Impressionist exhibition, New York, 1886, *2343*
wins lawsuit against descendants of David, 1892, *3924*
Durango (Colorado). Durango Archaeological and Historical Society
foundation, 1893, *16273*
Duranty, Edmond, 1833-1880
obituary, *134*
Duranty, Louis Emile Edmond See: **Duranty, Edmond**
Durazzo, Giacomo, *marchese,* 1718-1795
collection, nielli plates of the Renaissance, *25463*
Durazzo, Jacopo, *marchese* See: **Durazzo, Giacomo,** *march-ese*
D'Urban, W. H. M., fl.1887
illustrations, views of Santa Barbara, *10382*
Dùrcal, Pedro de Borbon, *duque* de, 1862-1892
collection, *25620*
 description, 1889, *25594*
 exhibited, New York, 1889, *2910*
 pictures described, *25604*
 sale, 1889, *2858, 2934*
 sale, 1890, *3177, 25793, 25806*
obituary, *15800, 26478*
Durden, James, 1878-1964
illustrations, *Reverie, 24247*
Dürer, Albrecht, 1471-1528, *9678, 18787, 21053*
Adam and Eve, 15970
and Emperor Maximilian, *10445*
anecdote about father, *21162*
Artist's Married Life, excerpt, *14548*
catalogue of works in Boston Museum of Fine Arts, *14964*
Crucifixion, in Claghorn collection, *1877*
depictions of children, *9644*
drawings, pen drawings, *1591*
early life and poverty, *23352*
Ecce Homo, authenticated with x-rays, 1898, *6492*
engravings, *17509*
exhibitions
 Boston Museum of Fine Arts, 1888, *631, 2841, 25552*
 Grolier Club, 1890, prints, *25758*
 New York, 1892, prints, *16081*
 New York, 1897, *17241*
 New York, 1897, prints, *6189, 23213*
 Society of American Artists, 1892, engravings, *4183*
frescoes sought in Wittenberg Castle, 1896, *16935*
illustrations
 drawing of hands, *12184*
 Melancolie, 13274
Knight, Death and the Devil, 22332
medal, *25398*

Study head (photograph), *13282*
Tragedy (photograph), *13738*
When my dream comes true (photograph), *13738*
photographs, *12951*
dyes and dyeing
history and technique, *25752*
William Morris recommends textile dyes, *5099*
Dyfverman, Carl Johan, 1844-1892
copy of Linnaeus monument for Chicago, 1891, *26356*
DYKEMA, Peter William, 1873-1951, *12717, 12732, 12750*
Dys, Jules Auguste Habert See: **Habert Dys, Jules Auguste**
Dziekonska, Casimira, *countess*, 1851-1934
reception, Studio Building, Chicago, 1895, *11493*
whereabouts, 1895, Chicago, *11476*

E

E., *9242, 19332, 19850, 23276*
E., D. M., *20849*
E., L., *18098*
E., L. B., *4663*
E. S., Master See: **Master E. S.**
E., W. H., *10641*
Eagle Eye, Erastus See: **Goddard, Ralph Bartlett**
Eakins, Susan Hannah MacDowell, 1851-1938
American woman painter, *11230*
exhibitions
Pennsylvania Academy of the Fine Arts, 1881, *1128*
Pennsylvania Academy of the Fine Arts, 1882, *1450*
Eakins, Thomas, 1844-1916, *10531*
Chess-players, exhibited at Metropolitan Museum of Art, 1881, *9516*
director, Pennsylvania Academy of Fine Arts, 1883, *24716*
director, Pennsylvania Academy of the Fine Arts, 1884, *11035*
elected to National Academy of Design, 1902, *13436*
exhibitions
American Art Galleries, 1880, *825*
American Art Galleries, 1882, *9646*
American Watercolor Society, 1878, *8979*
Boston Art Club, 1881, *1089*
Carnegie Galleries, 1900, *13130*
Carnegie Galleries, 1901, *13322*
Carnegie Galleries, 1903, *13675*
Carnegie Galleries, 1907, second prize, *14328*
Chicago World's Fair, 1893, anatomy pictures, *4459*
Internationale Kunstausstellung, Munich, 1883, *1637, 1835*
National Academy of Design, 1878, *9002*
National Academy of Design, 1879, *679, 9151*
National Academy of Design, 1881, *1061*
National Academy of Design, 1888, *2680, 10846, 25503*
National Academy of Design, 1891, *3603, 26307*
National Academy of Design, 1895, *5340*
National Academy of Design, 1896, *22996*
National Academy of Design, 1905, Proctor prize, *13827*
Paris Exposition, 1889, *Portrait of George H. Barker* and *Dancing lesson*, *25695*
Pennsylvania Academy of the Fine Arts, 1877, *8847*
Pennsylvania Academy of the Fine Arts, 1881, *391, 1128*
Pennsylvania Academy of the Fine Arts, 1882, *1450*
Pennsylvania Academy of the Fine Arts, 1884, *1884*
Pennsylvania Academy of the Fine Arts, 1899, *Salutat*, *17503*
Pennsylvania Academy of the Fine Arts, 1900, *13007*
Pennsylvania Academy of the Fine Arts, 1901, *13163*
Pennsylvania Academy of the Fine Arts, 1906, *14244*
Philadelphia Society of Artists, 1880, *1025*
Philadelphia Society of Artists, 1882, *1270*
Pittsburgh, 1899, *12976*

Society of American Artists, 1879, *9150*
Society of American Artists, 1880, *94, 844, 9324*
Society of American Artists, 1881, *367, 1130*
Society of American Artists, 1882, *1349, 1495*
Society of American Artists, 1887, *2452, 10789*
Society of American Artists, 1892, *22483*
Society of American Artists, 1897, *10538*
Worcester Art Museum, 1902, *13483*
illustrations
'Cello player, *13785*
Dr. William Smith Forbes, *14082*
Portrait of Archbishop Elder of Cincinnati, *13716*
Portrait of Charles L. Fussell, *13851*
Roll of the dean, *13359*
Lincoln, for Soldiers' and Sailors' Arch, Brooklyn, *5660*
Mending the nets, *1253*
notes, 1886, *2271*
Professionals at rehearsal, in Clarke collection, *11207, 24943*
student at Pennsylvania Academy of the Fine Arts, *22508*
study from living model, *2178*
supervisor, Pennsylvania Academy of Fine Arts, 1890, *3432*
teaching
Art Students' League, 1885, *11219*
Brooklyn Art Guild, 1883, *24716*
introduces nude into mixed class, 1895, *16713*
lectures on artistic anatomy at Art Students' League, 1886, *2115*
Pennsylvania Academy, 1884, *1699*
teacher of Thomas P. Anshutz, *12934*
Eakins, Thomas, *Mrs.* See: **Eakins, Susan Hannah MacDowell**
Eames, Charles, 1812-1867
speech to Washington Art Association, 1859, *20033*
Eames, William Scofield, 1857-1915
illustrations, sketches (after C. F. Wimar), *290*
ear
drawing technique, *12930*
Earhart, John Franklin, b.1853
exhibitions
Cincinnati Art Club, 1903, purchase prize, *13594*
Kansas City Art Club, 1902, *13337*
Earl, Maud, 1848-1943
illustrations, *I hear a voice*, *12796*
painter of dogs, *12183*
portrait of D'Orsay, *26704*
EARLE, Alice Morse, 1853-1911, *22600*
Earle, Alice Morse, 1853-1911
collection, china, *16260*
Earle and Fisher, architects
Worcester Art Museum, *11954*
Earle, Charles, 1830?-1893
obituary, *26941*
Earle, Elinor, fl.1894-1904
exhibitions, Pennsylvania Academy of the Fine Arts, 1902, Mary Smith prize, *13379*
illustrations, female nude, *21547*
EARLE, Francis, *9958*
Earle, Lawrence Carmichael, 1845-1921
Chicago studio, 1882, *9670*
decorations for Liberal Arts Building at World's Fair, 1893, *4493*
exhibitions
American Watercolor Society, 1889, *2883*
American Watercolor Society, 1892, *Old flute*, *3893*
Chicago Academy of Design, 1871, *10652*
Chicago Inter-State Industrial Exposition, 1880, *199*
Chicago Opera House Gallery, 1871, *10653*
illustrations, *Man's helpmates*, *13359*
murals for Chicago National Bank Building, *13495*
notes, 1871, *10678*
On Guard, *10567*
Running through fear and running for fun, *10681*
wall paintings for Manufactures and Liberal Arts Building, Chicago World's Fair, 1893, *26950*
EARLE, Mary Tracy, b.1864, *22562, 22578, 22613, 22670, 22681,*

22708, 22727, 22762, 22822, 23043, 23069, 23105, 23121, 23134, 23153

Earle, Stephen Carpenter, 1839-1913
See also: Earle and Fisher, Architects
Earle, Thomas, 1810-1876
obituary, *8707*
Earle, Virginia, 1875-1937
portraits, photograph, *23197*
Earlom, Richard, 1743-1822
engravings, *10320*
earth
orbit, *18150*
earthworks (archeology)
Iroquois mounds, *18532*
easels
how to construct an easel for use with unstretched canvas, 1893, *4257*
instructions on building folding easel, *3864*
East, Alfred, 1849-1913
exhibitions
London, 1890, pictures of Japan, *25830*
Royal Academy, 1907, *14312*
Hayle from Lelant, 26801
illustrations, *Road to the village, 14016*
quote, on art and photography, 1893, *4660*
East Hampton (New York)
artists, 1883, *24855*
artists' colony, *22571, 24751*
summer art community, 1883, *24689*
notes, 1883, *24842*
East India House, London See: **London (England). East India House**
Eastbourne (England)
description, *10177*
description and views, *10164*
Easter
Easter egg decorations, *4829, 5765*
Easter week in Jerusalem, Rome, and Moscow, 1897, *23216*
floral decoration of churches, *5321*
Eastern Art Teachers' Association
notes, 1899, *7008*
Eastern Drawing Teachers' Association
elections, 1905, *13914*
EASTLAKE, Charles Locke, 1793-1865, *646, 14536, 14708*
Eastlake, Charles Locke, 1793-1865
appointed director of National Gallery, 1855, *18800*
Beatrice, 18960
collection, sale, 1894, *16577*
cultivator of art in the household, *882*
elected president of Royal Academy, 1850, *14712*
exhibitions, Paris Exposition, 1855, *19119*
National Gallery, review and excerpt, 1899, *17678*
notes, 1894, *16556*
purchase of Old Masters for the National Gallery, 1858, *19795*
purchases for National Gallery, 1885, *19261*
relationship with Pre-Raphaelite Brotherhood, *18670*
scholarship critized, *537*
Eastlake, Charles Locke, 1836-1906
cultivator of art in the household, *882*
Hints on Household Taste, influence on English design, *10438*
ideas and furniture, *898*
Eastlake, Charles Locke, *Mrs.* See: **Eastlake, Elizabeth Rigby,** *lady*
Eastlake, Elizabeth Rigby, *lady,* 1809-1893
Five Great Painters, review, *10000*
recollections to be published, 1895, *16803*
Eastman Kodak Co.
exhibitions, 1898, Eastman Photographic Exhibition, *6545*
Eastman, Seth, 1808-1875
Ball play of the Dahcota Indians, etched by Burt, *14711*
Easton, Louis B., 1864-1921
illustrations, chair, *13537*
Eaton, C. Harry See: **Eaton, Charles Harry**
Eaton, Charles Frederick, b.1842
illustrations, cover for marriage certificate, *22154*

Eaton, Charles Harry, 1850-1901
exhibitions
American Watercolor Society, 1884, *25023*
American Watercolor Society, 1898, *Brook, 6556*
American Watercolor Society, 1902, *13424*
American Watercolor Society, 1904, *13746*
Brooklyn Art Association, 1884, watercolors, *25092*
Carnegie Galleries, 1900, *13130*
Detroit, 1886, *516*
Essex Art Association, 1884, *25102*
Philadelphia Water Color Club, 1901, *13215*
Prize Fund Exhibition, 1885, *25278*
Prize Fund Exhibition, 1886, *2226, 25304*
Society of American Artists, 1889, *2986*
illustrations
Along the pond, 10815
drawing, *1702*
Morning in the meadows, 10934
Riverside, 24904
Summer skies and meadows, 6190
landscapes, 1884, *25032*
Lily pond, purchased by Detroit Museum, 1887, *529*
Marsh meadow, 22503
notes, 1893, *22483*
obituary, *13270*
paintings in Frederick Gibbs collection, *13250*
picture in Evans collection, *15079*
sketches, 1883, *24878*
whereabouts, 1883, visits Adirondacks, *24728*
Eaton, Charles Warren, 1857-1937
elected associate, National Academy of Design, 1901, *13228*
exhibitions
American Watercolor Society, 1887, *25409*
American Watercolor Society, 1904, *13746*
American Watercolor Society, 1907, *14333*
Boston Art Club, 1888, *2620*
Carnegie Galleries, 1900, *13130*
Chicago Art Institute, 1899, *12902*
Chicago Art Institute, 1900, *13137*
Chicago Art Institute, 1902, *13536*
Cincinnati Art Museum, 1898, *12754*
Cincinnati Art Museum, 1900, *13067*
National Academy of Design, 1898, *12710*
National Academy of Design, 1902, *13359*
National Academy of Design, 1903, *13547, 13702*
National Academy of Design, 1907, *14311*
New York, 1893, *4359, 16171*
Prize Fund Exhibition, 1885, *Twilight, after rain, 25278*
Prize Fund Exhibition, 1886, *25304*
Salon, 1906, medal, *14161*
Worcester Art Museum, 1902, *13483*
illustrations
Forest of pines, 14002, 14282
Night cometh on, 552
Sketch on the Jersey shore, 24904
outdoor sketch class, Connecticut, 1892, *26762*
picture in Chicago Art Institute, 1895, *11703*
sales and prices, 1889, *14961*
studio in Leonia, N.J., 1893, *22491*
Eaton, Daniel Cady, 1837-1912
excerpt on *Statue of Liberty, 450, 474, 1218*
Eaton, Eleanor R., fl.1897-1898
illustrations
Girl in the garden, 12059
Picking cherries, 12719
EATON, Hugh McDougal, 1865-1924, *22575*
Eaton, Hugh McDougal, 1865-1924
illustrations
Only a girl's heart, 22473
Zylphy poled the Schooner, 22501
magazine illustrations, 1893, *22490*
models, favorite model, *22519*
portraits, photograph, *22518*
whereabouts, 1893, summer in Maine, *22491*
EATON, Isaac E., 1724-1772, *20665*

Eaton, Isaac E., 1724-1772
portraits, portrait with attendant spirits, *20712*
Eaton, Joseph Oriel, 1829-1875
notes, 1871, *10731*
obituary, *8406*
painting portraits, 1860, *24335*
photographs and portraits, Cincinnati, 1860, *20209*
portrait of Capt. Lovell H. Rousseau, *24359*
Types of womanhood, *10731*
work, 1860, *24322*
Eaton, Wyatt, 1849-1896, *9118*
anecdote, *954*
exhibitions
Boston Art Club, 1880, 72, *807*
Brooklyn Art Association, 1892, *26582*
National Academy of Design, 1877, *8830*
National Academy of Design, 1879, *679*
National Academy of Design, 1884, *1879*
National Academy of Design, 1887, *25437*
National Academy of Design, 1888, *25503*
National Academy of Design, 1892, *4143*
New York, 1888, *10846*
New York, 1891, *15350*
Paris Exposition, 1878, *9072*
Paris Exposition, 1889, *Portrait of Miss G. R.*, *25695*
Salmagundi Club, 1887, *2364*
Society of American Artists, 1878, *8993*
Society of American Artists, 1880, *844*
Society of American Artists, 1881, *1130*
Society of American Artists, 1882, *1327*
Society of American Artists, 1883, *1551*
Society of American Artists, 1884, *1802*
Society of American Artists, 1887, *2452, 10789*
Society of American Artists, 1888, *2678, 25505*
Forest-evening, exhibited at Metropolitan Museum of Art, 1881, *9516*
illustrations
Portrait, *10825*
Portrait of William Cullen Bryant, *168*
illustrator for *The Century*, *22473*
picture in Evans collection, *15079*
Portrait of a child, *25605*
portrait of Mme Modjeska, *24805*
portrait of William Cullen Bryant, *17670*
portraiture, *25582*
sales and prices, 1900, picture in Evans collection, *13008*
sketches and studies, *9429*
study of a young French peasant, *25634*
whereabouts
1883, summer in Europe, *24656*
1896, ill and destitute in Rome, *23008*
Ebbinghausen, Lavinia, fl.1881-1885
exhibitions, American Art Galleries, 1885, *1921*
Ebell Society See: **Oakland (California). Ebell Society**
EBERHARD, *18362*
Eberle, Abastenia St. Leger, 1878-1942
exhibitions, National Academy of Design, 1907, *14311*
Eberle, Adolf, 1843-1914
Dog cart, *9847*
exhibitions, Internationale Kunstausstellung, Munich, 1879, *21764*
Retarded dinner, *10483*
Eberlein, Gustav Heinrich, 1847-1926
Goethe monument, *8238*
Kultur Ideal, *13652*
monument to Wilhelm I and Bismarck, *11765*
Ebers, George Moritz, 1837-1898
Egypt, Descriptive, Historical, and Picturesque, review, *21938*
obituary, *20526*
Echteler, Josef, 1853-1908
busts in American Art Galleries, 1884, *1899*
exhibitions, National Academy of Design, 1886, *25370*
Echtler, Adolf, 1843-1914
picture in Bullock collection, *15121*

Eckermann, Johann Peter, 1792-1854
obituary, *18650*
Eckford, Henry, *pseud*. See: **DeKay, Charles**
Eckhardt, A. F.
invents "eidographie," 1881, *1245*
Eckler, Josephine C. See: **Blackburn, Josephine Eckler**
Ecole des beaux arts, Paris See: **Paris (France). Ecole nationale supérieure des beaux arts**
Ecole français de Rome See: **Rome. Ecole français de Rome**
Écouen (France)
artists' colony, *8743*
Edda Saemundar
origins, *21353*
Edda Snorra Sturlusonar, *21353*
EDDY, Arthur Jerome, 1859-1920, *12666, 14247*
Eddy, Arthur Jerome, 1859-1920
Delight the Soul of Art, review, *13581*
lecturer, Art Institute of Chicago, 1898, *12701*
portraits, portrait by Whistler, *5178*
Recollections and Impressions of James A. McNeill Whistler, review, *13742*
Eddy, Clarence, 1851-1937
organist, *12036*
Eddy, Henry Brevoort, 1861-1935, *12539*
illustrations, drawing of woman with cape, *12503*
Eddy, Sarah James, b.1851
exhibitions, Providence Art Club, 1883, *24553*
Eddy, William
medium, *20677*
Edelfelt, Albert, 1854-1905
exhibitions
Salon, 1892, *4013*
Salon, 1895, *5375*
obituary, *13996, 14047*
picture shown in New York, 1892, *16006*
EDELHEIM, Carl, *22390*
Edelheim, Carl
library, sale, 1900, *7291*
Eden Musée, New York See: **New York. Eden Musée**
Edgar, Isabel R., fl.1890
president of Art Association of Indianapolis, 1890, *3286*
EDGAR, M. C., *23827, 23904*
Edinburgh (Scotland)
architecture, *26537*
Art Congress, 1889, program, *25648*
description, *21204*
Newhaven fishwives, 1883, *24754*
exhibitions, 1884, International Forestry Exhibition, *10058*
monuments
monument to Scottish-American soldiers of Civil War, by George Bissel, unveiled, 1893, *26984*
monument to Scottish-American soldiers proposed, 1892, *26800*
Scott Monument, *26771*
Edinburgh (Scotland). Art Union
history, *18056*
Edinburgh (Scotland). International Exhibition, 1890
art exhibition, *25983*
Edinburgh (Scotland). International Exhibition of Industry, Science and Art, 1886
Fine Art Section, *10340*
loan exhibition of French and Dutch pictures, *25519*
Edinburgh (Scotland). Museum of Science and Art
acquisitions, 1889, cast of tabernacle from Belgium, *25648*
collection, *26425*
notes, 1890, *26006*
Edinburgh (Scotland). National Gallery of Scotland
acquisitions
1878, *21652*
1890, *26052*
1891, *26387*
1891, paintings by Van Mander and Poelenburgh, *26425*
building, planned, 1905, *13875*
collection, *25975*
grants for acquisitions, 1890, *26193*

brick pyramid excavated, 1894, *16562*
Cleopatra's tomb, 1890, *25814*
Coptic church discovered, 1883, *14910*
destruction of ancient monuments, *26101*
discoveries, 1898, *6613*
excavation of Cleopatra's tomb, 1890, *25772*
excavations, 1891, *26296*
excavations, 1894, *16502, 16620*
excavations, 1896, *16949*
excavations, 1897, *17311*
excavations by Flinders Petrie, 1890, *26149, 26185*
excavations by Norman Lockyer, 1891, *26315*
excavations sponsored by English Archaeological Society,
 1883, *14900*
Fifth Dynasty site excavated, 1898, *6527*
forgeries, 1860, *24361*
government donates collection to United States, 1893, *16371*
graves excavated, 1895, *16710*
irrigation scheme threatens monuments, 1894, *16553*
mummies and papyri discovered, 1881, *21899*
mummies found, 1895, *16734*
mutilation of monuments, 1890, *25820*
objects from Tel-el-Amarna on exhibit in London, 1892,
 26791
Petrie's excavations in Fayum, *25662*
preservation, *26135*
royal tomb discovered at Negada, 1897, *17328*
vicissitudes of art treasures, *21574, 21693*
description and views, *9103, 9114, 9126, 9142, 9156, 9169,*
 9182, 9193, 9208, 9224, 9236, 9254, 9394, 22803
 and history, *21938*
 by C. W. Allers, 1895, *22832, 22850*
 fellahin, *20736*
 Nile River landscape, *21255*
 wild animals peculiar to valley of the Nile, *20860*
education, *9426*
ethnographic report on ancient Egyptians, 1890, *25799*
lectures by Miss Edwards in New York, Boston, Philadelphia,
 1890, *25712*
travel precautions against buying forgeries, 1897, *17280*
Egypt Exploration Society
American officers, *26577*
appeal for funds, 1892, *26623*
finds sent to Boston Museum, 1887, *25492*
fundraising, 1892, *26465*
gift to Detroit Museum of Art of collection of Egyptian antiqui-
 ties found in past year at Dendereh, 1899, *12859*
meeting, 1890, *25751*
special fund, 1891, *26333*
Egyptian architecture See: **architecture, Egyptian**
Egyptian art See: **art, Egyptian**
Egyptian decoration See: **decoration and ornament,**
 Egyptian
Egyptian jewelry See: **jewelry, Egyptian**
Egyptian portraits See: **portraits, Egyptian**
Egyptian reliefs See: **relief (sculpture), Egyptian**
Egyptian sculpture See: **sculpture, Egyptian**
Egyptians
ancient Egyptian race discovered, 1895, *16752*
appearance of ancient Egyptians, *21362*
Ehat, Frederick Miller, *Mrs.* See: **Ferrea, Elizabeth M.**
Ehlers, Louis A.
collection, sale, 1890, *15082, 25734*
Ehninger, John Whetten, 1827-1889
biography, *20159*
elected to National Academy of Design, 1858, *19859*
etchings, *14696*
 photographic etchings, *20093*
exhibitions
 National Academy of Design, 1858, *19857*
 National Academy of Design, 1860, *20224*
 National Academy of Design, 1861, *20354*
 New Bedford, 1858, *19891*
 New York, 1859, *19978*
 New York artists' reception, 1858, *19800*

New York Etching Club, 1882, *1296*
 Pennsylvania Academy of the Fine Arts, 1858, *19858*
Foray, 19626
guest on Baltimore and Ohio Railroad excursion, 1858, *19876*
illustrations
 David's grief for his child, 18329
 History, 22598
illustrations for Longfellow's *Courtship of Miles Standish,*
 19958, 19995
Knickerbocker, in American Art Union Gallery, 1851, *14834*
newspaper illustrations, *16557*
Old Diedrich Knickerbocker telling stories to children, 14772
painting of Gen. Putnam, *25426*
watercolor sketch, *14487*
whereabouts
 1851, Paris, *14765*
 1859, summer travel, *20080*
 1860, moves studio, *20227*
works, 1857, *19767*
Ehrhart, S., fl.1893-1898
illustrations
 House economies, 22490
 Woman's recklessness, 22501
Ehrich Galleries See: **New York. Ehrich Galleries**
Ehrich, Louis Rinaldo, 1849-1911
collection, *15769*
 Dutch and Flemish masters shown in New York, 1894, *27026*
 Dutch and Flemish pictures, *25524, 25532, 25541, 25557*
 on exhibit at Yale Art Gallery, 1887, *586*
 sale, 1894, *5170*
 sale, 1895, *5217, 16667, 16673*
 to be sold, 1894, *16577*
letter on Metropolitan Museum, 1891, *26338*
Ehrmann, François Emile, 1833-1910
History of art, compared to Delaroche's Hemicycle, *20532*
illustrations
 decorated initial, *1010*
 studies of hands, *2920*
 Union of commerce and industry, 3685
Eichbaum, George Calder, 1837-1919
exhibitions
 National Academy of Design, 1875, *8441*
 St. Louis, 1871, *10654*
 Pickwick with the two Wellers, 15353
 portrait paintings, 1870, *10570, 10599*
 studio reception, 1884, *25079*
Eichelberger, Robert A., d.1900
exhibitions
 National Academy of Design, 1887, *2606*
 National Academy of Design, 1889, *2936*
 New York Etching Club, 1889, *2887*
 Society of American Artists, 1890, *Surf and for, 15205*
illustrations, sketch, *3470*
EICHENDORFF, Joseph Karl Benedikt, *Freiherr* von, *17849*
Eickemeyer, Rudolf, 1862-1932
exhibitions, Glasgow Exposition, 1901, *13238*
illustrations, photographs from *Down South, 13153*
illustrations for *Down South, 13122*
photographer, *13738*
Eidlitz, Julia T., fl.1890-1903
capital study at Berkeley Lyceum, 1890, *15128*
EIDLITZ, Leopold, *20351, 20361*
Eidlitz, Leopold, 1823-1908
appointed architect, Academy of Music in Brooklyn, 1859,
 20065
architect, Brooklyn Academy of Music building, 1861, *20331*
architect, Christ Church, St. Louis, *20076*
lectures
 paper on cast iron and architecture at American Institute of
 Architects, 1858, *19953*
 paper on Christian architecture read at American Institute of
 Architects meeting, 1858, *19780*
 paper on style read at American Institute of Architects meet-
 ing, 1858, *19831*
 remarks on Gothic architecture to American Institute of

National Academy of Design, 1856, *19400*
National Academy of Design, 1857, *19668*
National Academy of Design, 1858, *19857*
National Academy of Design, 1859, *20030, 20048*
National Academy of Design, 1860, *18452, 20224, 24352*
illustrations, *Henry Inman, 14652*
indignation at National Academy exhibition, *18542*
notes
 1849, *21381*
 1851, *14794*
portrait of Bacon, *19767*
portrait of Horatio Seymour, *19626*
portrait of Mount, *21405, 21458*
portrait paintings, 1856, *19363*
sales and prices, 1858, Romney collection sale, *19957*
ELLIOTT, Charles Wyllys, *8521, 8544, 8579, 8598, 8636, 8669,*
8697, 8813, 8826, 8836, 8856, 8870, 8882, 8894
Elliott, Elizabeth Shippen Green See: **Green, Elizabeth**
Shippen
Elliott, Emily Louise Orr, b.1867
illustrations, *Patience, 22537*
Elliott, Franc R., Mrs., fl.1896-1903
paper on expression presented to Northern Illinois Teachers'
 Association meeting, 1896, *11907*
Elliott, Huger, Mrs. See: **Green, Elizabeth Shippen**
Elliott, John, 1858-1925
painting for Boston library, *13095*
ELLIOTT, Julia E., *13530*
Ellis, Harvey, 1852-1904
exhibitions
 Chicago Art Institute, 1899, *12902*
 Cincinnati Art Museum, 1900, *13067*
 New York Water Color Club, 1900, *13141*
illustrations, interior decorations, *13221*
Ellis, John Stoneacre
collection, arms and armor presented to Metropolitan Museum,
 1896, *17197*
ELLIS, Leigh, *23911*
Ellis, Leigh, fl.1897-1898
illustrations
 decorative panel, *23824*
 Grief, 24200
Ellis, Salathiel, fl.1842-1864
work, 1857, *19626*
ELLIS, Sarah Stickney, *20101*
Ellis, Sarah Stickney, 1812-1872
quote on taste, *19571*
ELLIS, Tristram James, *9966, 9980, 9996, 10005, 10016, 10050,*
10261
Ellis, Tristram James, 1844-1922
exhibitions
 Belgian Gallery, 1879, *21741*
 London, 1886, *10302*
illustrations, view of Sark, *21608*
Sketching from Nature
 excerpts, *1624*
 review, *24629*
Ellis, Wynne, 1790-1875
bequest to National Gallery, 1876, *8691*
Ellsworth, Elmer Ephraim, 1837-1861
monuments, plans for monument in Chicago, 1892, *26835*
Ellsworth, James William, 1849-1925
Chicago collector, *3571*
collection, *3919, 3926, 15797, 15811, 16237*
 buys Vollon still-life from Schaus collection, 1892, *15847*
 exhibited at Art Institute of Chicago, 1890, *15102, 15284*
 exhibition for charity in Chicago, 1897, *6104*
 Japanese art loaned to Chicago Columbian Exposition, 1892,
 15907
 moves from Chicago to New York, 1898, *6586*
 moves to New York, 1898, *12133*
 open to public, 1896, *11764*
 Oriental art exhibited at Union League Club, New York,
 1889, *3099*
 terracottas, *25742*

Ellwood, George Montague, 1875-1955
exhibitions, National Arts Competition, 1899, awarded silver
 medal, *7127*
ELMER, Laura, *18303, 18401, 18539*
Elmira (New York). Elmira College
art gallery formed, 1884, *11032*
Elmira (New York). Inter-State Fair, 1893
decorated china exhibition, *4576*
exhibitions, china painting, *4455*
Elmore, Alfred, 1815-1881
Courtship of Miles Standish, 21575
exhibitions
 Paris Exposition, 1878, *9024*
 Royal Academy, 1800, *20257*
 Royal Academy, 1850, *14644*
 Royal Academy, 1877, *8874*
 Royal Academy, 1880, *9370*
illustrations, *Pompeii, A.D.79, 21613*
obituary, *314, 9467, 21892*
Elmquist, Hugo, 1862-1930
bronze casting machine invented, *13652*
Else, Joseph, 1874-1955
exhibitions, National Arts Competition, 1899, *7127*
Elsevier family See: **Elzevier family of printers**
Elsley, Arthur John, b.1861
illustrations, *Childhood days, 14213*
Elten, Elizabeth Kruseman van See: **Duprez, Elizabeth F.**
Kruseman van Elten
Elten, Hendrick Dirk Kruseman van See: **Van Elten,**
Hendrick Dirk Kruseman
Elwell, D. Jerome, 1857-1912
exhibitions
 Boston, 1882, *1315*
 Boston, 1884, *25106*
 Boston, 1884, Holland pictures, *25046*
 Boston, 1887, *540*
 Boston Art Club, 1891, *3491*
 Boston Paint and Clay Club, 1887, *543*
landscapes, *2324*
studio reception, Boston, 1884, *25072*
Elwell, Francis Edwin, 1858-1922
appointed instructor at National Academy, 1886, *10754*
Death of strength, 13379
Egypt awakening, 17396
equestrian statue of General Hancock commissioned, 1892,
 26871
exhibitions
 American Art Association, 1885, *2085*
 American Art Galleries, 1887, *2607*
 Architectural League of New York, 1891, *26459*
 Art Club of Philadelphia, 1891, medal, *15797*
 Cincinnati Art Club, 1900, *13037*
 National Academy of Design, 1887, *552, 10786*
 Pennsylvania Academy of the Fine Arts, 1901, *13163*
 Salon, 1885, *2035*
 Society of American Artists, 1886, *2227, 25309*
 Society of American Artists, 1887, *2452*
 Society of American Artists, 1888, *2678*
lecture on history of camera, 1894, *26998*
lecture on sculpture at Rembrandt Club, 1891, *26314*
Little Nell
 award of gold medal from Philadelphia Art Club, 1891,
 26440
 wins medal from Art Club of Philadelphia, 1892, *26465*
loses curatorship of sculpture, Metropolitan Museum, 1905,
 13996
medallion relief of Edwin Booth, *16419*
notes, 1887, *25426*
Pompeian water boy, 11279
proposal for an American Salon, 1891, *26232*
sculpture for Louisiana Purchase Exposition, 1904, *13685*
statue of Gen. Hancock, commissioned, 1892, *22483, 26879*
statue of Little Nell, *26528*
statues of Dickens and Alcott, *26493*
works in bronze, 1898, *17433*

Ewing, Juliana Horatia Gatty, 1841-1885
Leaves from Juliana Horatia Ewing's Canada Home, review, *12582*

excavations
Algeria, Djimillah, *9037*
Asia Minor, Halicarnassus and Cnidus, *18282*
Crete
 1894, *16558*
 Gnossos, *383*
Egypt
 notes, 1881, *476*
 Thebes and Alexandria, *454*
Greece
 Antikythera shipwreck, *13366*
 Athens, findings from the Acropolis, *18282*
 Mycenae and Priene, *192*
 Olympia, *52, 88, 109, 125, 8691*
 Pergamum, *64*
 Sipylos, *240*
 Tanagra, *476*
Hungary, *240*
Italy
 Florence, *8967*
 Rome, *39, 134, 141, 8589, 8605, 8734, 9049, 9295*
 Rome, columns found, 1855, *19077*
 Venetia, *476*
Mesopotamia
 Balawat Gates, *186*
 Basra, *454*
Mexico, Lorillard expedition, *351*
notes
 1880, *219, 240*
 1881, *254, 264, 335, 360, 383, 430*
 1894, *16506*
 1896, *17180*
Tunisia, Utica, *454*
Turkey, Assos, *407*
United States
 New Mexico, 1880, *306*
 Yalaha, Florida, *90*

Exeter (New Hampshire). Public Library
acquisitions, 1896, French bust of R. W. Emerson, *11794*

exhibition buildings
France, Paris Exposition, 1878, *21570, 21578*
United States
 Chicago Arts Building, 1893, *15709*
 gallery space of Art Club of Philadelphia, 1890, *3428*
 Philadelphia Centennial Fine Arts Gallery, 1876, *8397*

Exhibition of the Industry of all Nations, 1853-1854 See: **New York. Exhibition of the Industry of all Nations, 1853-1854**

exhibitions
1883, *14911*
artists should not have right to remove work from exhibition, *537*
catalogues, *1667*
 American inferior to French, *11221*
 part of art literature, *528*
club exhibitions criticized, 1899, *17692*
criticism of lending, *15759*
damage created by viewing public, *20365*
dealers pose as patrons in loan exhibitions to make sales, 1895, *5369*
demands on collectors to lend, *4798*
effect of painting on others hanging nearby, *1839*
England, old London picture exhibitions, *10394, 10406*
Europe
 1894, *27000*
 1894-95, *22330*
 1895, *22343, 22356, 22371, 22382*
 1896, *22395, 22410, 22422*
glazing of pictures should be prohibited, *11107*
hanging of pictures, *3743, 3940*
 by color relationshps, *21247*

policies, *24863*
historical value, *12993*
history, *12458*
importance to art students, *10864*
improvements in receiving systems, hanging and cataloguing suggested, 1892, *3897*
notes, 1881, *314, 360*
profit sharing for artists recommended, 1883, *24811*
public art exhibitions found tedious, *14332*
subscription art galleries, *9935*
United States
 1879, *18, 33*
 1880, *46, 63, 71, 82, 93, 102, 117, 133, 149, 164, 178, 191*
 1881, *245, 295, 378, 402, 470*
 1883, *14867, 14893, 24469, 24481, 24514, 24527, 24542, 24554, 24570, 24590, 24610, 24621, 24632, 24644, 24658, 24668, 24679, 24708, 24730, 24743, 24756, 24764, 24778, 24794, 24808, 24822, 24830, 24844, 24858, 24873, 24885, 24898, 24907, 24917, 24926, 24935, 24949*
 1883, exhibition season, *24748*
 1883, Western exhibitions, *24753*
 1884, *10954, 10998, 11022, 11064, 11090, 11120, 24960, 24972, 24984*
 1884-5, *25175, 25183, 25198, 25207, 25229, 25237, 25245, 25257, 25262, 25269*
 1884-85, *25164*
 1885, *25281*
 1886, *25302, 25306, 25314, 25326*
 1887, *518, 531, 540, 549, 559, 25392, 25404, 25414, 25432*
 1888, *623*
 1894, *27026*
 1894-95, *22330*
 1895, *22343, 22356, 22371, 22382*
 1896, *22395, 22410, 22422*
 1896, art exhibited in department stores, *17191*
 1899, foreign artists discriminated against by American exhibition juries, *17669*
 American government should establish Salon to encourage art, *24965*
 American salon recommended by *The Studio*, 1884, *25202*
 American Salon triennial planned, 1891, *26266*
 history, *18775*
 international art loan exhibition proposed, 1884, *25087*
 New York, 1887, *614*
 proposal for American Salon, 1891, *26232*
 satire on juries, *14042*
 Society of Exhibitors planned for inland cities, 1883, *24485*
 traveling exhibitions, *26381*

Ex-Libris Society, London See: **London (England). Ex-Libris Society**
EXPERTE CREDO, *16695*
Exposición nacional de bellas artes, Madrid See: **Madrid (Spain). Exposición nacional de bellas artes**
Exposition des produits de l'industrie française, Paris, 1849 See: **Paris (France). Exposition des produits de l'industrie française, 1849**
Exposition internationale du centenaire de la lithographie, 1895 See: **Paris (France). Exposition internationale du centenaire de la lithographie, 1895**
Exposition universelle, Paris, 1855 See: **Paris (France). Exposition universelle, 1855**
Exposition universelle, Paris, 1878 See: **Paris (France). Exposition universelle, 1878**
Exposition universelle, Paris, 1889 See: **Paris (France). Exposition universelle, 1889**
Exposition universelle, Paris, 1900 See: **Paris (France). Exposition universelle, 1900**
expression
absence of facial expression in Japanese art, *5985*
art mediums express feeling, *11366*
in art, *11508*
study of human expression, *5572, 5620*
Expressionism (art)
definition, *14175*

visit to United States, *18555*
Fell, J. R., *Mrs.*
 collection, description, 1887, *17787*
Fellowcraft Club, New York See: **New York. Fellowcraft Club**
FELLOWES, Francis Wayland, *25065, 25205*
Fellowes, Francis Wayland, 1833-1900
 exhibitions, New Haven, 1883, *24677*
 Indolence, rejected by National Academy of Design, 1889, *25722*
Fellows, Lawrence, fl.1906-1913
 exhibitions, Philadelphia Sketch Club, 1906, *14237*
FELLOWS, William K., *12695*
Fellowship of the Pennsylvania Academy of the Fine Arts See: **Philadelphia (Pennsylvania). Fellowship of the Pennsylvania Academy of the Fine Arts**
Felsing, Jacob, 1802-1883
 election to Académie des Beaux-Arts, 1855, *18569*
 obituary, *14902*
Felter, John D., b.1825
 illustrations
 illustrations for J. Dyer's *Fleece, 18314*
 Spring flowers, 18269
 Summer beauty, 18269
 vignettes for *Marian, 18262*
Felu, Charles François, 1830-1900
 armless artist, *7230*
 armless painter who paints with feet, *1412*
fences
 relics of barbarism, *582*
Fenetti, F. M. See: **Fenety, F. M.**
Fenetty, F. M. See: **Fenety, F. M.**
Fenety, F. M., fl.1884-1899
 exhibitions, National Academy of Design, 1886, *508*
 flower painter, Boston, 1899, *12855*
FENN, Alice Maud, *10305, 10319*
Fenn, Harry, 1845-1911
 book in preparation, *100*
 designs for wood engravings, *137*
 exhibitions
 American Watercolor Society, 1884, *25023*
 American Watercolor Society, 1885, *1933*
 Boston Art Club, 1887, drawing, *568*
 Brooklyn Art Association, 1884, watercolor, *25092*
 London, 1883, American Water-Color Exhibition, *24713*
 home, Montclair, N.J., house, 1896, *6040*
 illustrations
 Coenties Slip, New York, 22610
 drawings of the Niagara, *10319*
 Green mosque, 565
 In the derrick room, 22576
 New York dwellings, 22501
 October, 24904
 Outskirts of Lyndhurst, 22576
 Pennsylvania bee colony, 1731
 scenes along the Hudson River, *10305*
 Surrey garden, 13746
 Trout for breakfast, 22560
 Where blameless pleasures dimple quiet's cheek, 23060
 illustrations for *Picturesque Europe, 8770, 9280*
 Palestine views, *9684*
 illustrations in periodicals, 1894, *4897*
 illustrator for *The Century, 22473*
 newspaper illustrations, *16557*
 picture for Kansas City exposition, 1887, *603*
 portraits, photograph, *22539*
 travels and sketches, *22534*
Fenn, William J., fl.1889-1913
 illustrations, view of room in Fifth Avenue house, *2999*
FENN, William Wallace, *9649, 21629, 21661, 21684, 21689, 21703, 21713, 21732, 21758, 21770, 21783, 21811, 21842, 21860, 21941, 21966, 22020, 22024, 22048*
FENOLLOSA, Ernest Francisco, *21482*
Fenollosa, Ernest Francisco, 1853-1908
 catalogue for Hokusai exhibition, Boston, 1893, *16193*

collection, Japanese paintings in the Museum of Fine Arts, Boston, *25828*
influence on Arthur W. Dow, *12929*
introduction to catalog of Dow's prints series *Along Ipswich River., 22406*
lectures
 Goethe Society, 1892, *26607*
 lecture on art education at Brooklyn Institute, 1894, *27027*
 lectures on Japanese art in San Francisco, *22133*
 on Japanese art, 1896, *22958*
 on Japanese art at Boston Art Students' Association, 1892, *26533*
 on theory and history of art, 1892, *26481*
Masters of Ukioye exhibition, 1896, *22398*
speaks at Yale commencement exercises, 1895, *22738*
Fenton, Hallie Champlin, 1880-1935
 exhibitions, Chicago Art Students' League, 1897, *12643*
Fenton, Lavinia, 1709-1760
 portraits, portrait as Polly Peachem by Hogarth, *10121*
Fenton, Roger, 1819-1869
 Crimean photographs exhibited, 1855, *19150*
FENWICK, R., *10101*
Ferdinand II, *king of Portugal* See: **Fernando II,** *king of Portugal*
Ferdinandus, Alexandre, d.1888
 illustrations for books, 1888, *628*
Feret et Roux See: **Roux et Feret, Paris**
Ferguson, E. Lee, fl.1898
 illustrations, *Winter* (photograph), *12247*
Ferguson, Henry A., 1842-1911
 exhibitions
 New York, 1893, *4317, 22483*
 Prize Fund Exhibition, 1885, *25278*
 notes
 1870, *23601*
 1887, *611*
 sales and prices, 1893, auction in New York, *26895*
 Six views in Central Park, reproduced by Prang in chromo, *23568, 23604*
 view of horse market at Cairo, 1883, *24513*
 whereabouts
 1882-3, Mexico, *24380*
 1883, Franconia, N.H, *24703*
 work, 1883, *24829*
FERGUSON, James, *24020, 24176*
Ferguson, Nancy Maybin, 1872-1967
 mural for John Sartain Public School, Philadelphia, 1905, *13936*
Fergusson, James, 1808-1886
 Fergusson's Handbook of Architecture, review, *19496*
Fern, Fanny See: **Parton, Sara Payson Willis**
Fernald, George Porter, d.1920
 exhibitions, Architectural League of New York, 1890-1, *26206*
Fernando II, *king of Portugal*, 1816-1885
 collection
 sale announced, 1891, *15483*
 to be sold by widow, 1891, *26334*
Ferniani, firm, Faenza See: **Faenza (Italy). Ferniani, firm, majolica makers**
ferns
 collecting, *901*
 collection of sea ferns and mosses, *15790*
 fern cases for gathering ferns to dry, *567*
Ferrari, Ettore, 1849-1930
 exhibitions
 Esposizione Internazionale di Belle Arti, Rome, 1883, *14884*
 Paris Exposition, 1878, *9096*
Ferrari, Giuseppe, b.1846
 exhibitions
 American Watercolor Society, 1884, *25012*
 National Academy of Design, 1887, *552*
Ferrari, Joseph See: **Ferrari, Giuseppe**
Ferraris, Arthur von, b.1856
 exhibitions
 New York, 1894, *4758*

Fischer, M.
illustrations, study head, *17847*
Fischer, Theodor, 1862-1938
monument to Bismarck, plans accepted, 1899, *17686*
Fischer, Victor G.
letter on so-called Lotto portrait of Columbus, *16006*
Fischhof, Eugène
collection
sale, 1900, *7230, 7263, 13038*
sale, 1905, *13847*
sale, 1906, *14091*
notes, 1899, *17516*
purchases at H. G. Marquand sale, 1903, *8154*
Fish, Eugenia See: **Glaman, Eugenia Fish**
Fish, Franklin W.
contributor to *The Lantern*, *16568*
fish trade
London, market at Billingsgate, *20789*
Fish, William H., 1812-1880
obituary, *164*
Fisher, Alanson, 1807-1884
exhibitions, National Academy of Design, 1858, *19857*
Fisher, Alvan, 1792-1863
biography, *20159*
Fisher, Charles, 1816-1891
portraits, portrait by C. de Grimm, *20473*
Fisher, Clellan W.
See also: Earle and Fisher, architects
Fisher, Flavius J., 1832-1905
obituary, *13910*
Fisher, Harrison, 1875-1954
exhibitions, Baltimore, 1905, *13935*
illustrator of *My Lady Peggy Goes to Town*, 2019, *13371*
Fisher, Hugo Melville, 1876-1946
illustrations, *Old-time pot-hunter*, *22590*
Fisher, Mark See: **Fisher, William Mark**
FISHER, Mary Wager, *9149*
Fisher, Melton See: **Fisher, Samuel Melton**
Fisher, Richard
collection, sale, 1892, *26687*
Fisher, Robert C., fl.1893
designer of Audubon monument for New York, *26932*
Fisher, Samuel Melton, 1860-1939
exhibitions, Royal Academy, 1907, *14312*
Fisher, William Mark, 1841-1923
American nationality, *4702*
elected member of English Institute of Painters in Water-
Colours, 1881, *453*
exhibitions
Carnegie Galleries, 1900, *13130*
Grosvenor Gallery, 1880, *9356*
Grosvenor Gallery, 1885, *2035*
Grosvenor Gallery, 1886, *May morning*, *2245*
Internationale Kunstausstellung, Munich, 1883, *24693*
London, 1882, *1285*
Royal Academy, 1880, *9354, 21863*
Royal Academy, 1885, *2019*
Royal Academy, 1889, *2984*
Royal Academy, 1892, *4012*
notes
1871, *10674*
1892, *4073*
1894, *4710*
studio in Normandy, *2529*
When the kye come hame (with J. D. Watson), *9717*
whereabouts
1880, *960*
1884, London, *25046*
1894, England, *5073*
fishers
social life and customs, *10387*
fishes in art
painting salt-water and shell fish, *2629*
fishing in art
scenes in Quebec by Winslow Homer, *12723*

scenes of fishing, Hastings, England, *9849*
fishing, primitive
Chinese and Indian fishermen, *21304*
Fishkill (New York)
architecture, Dr. Howell White's house, 1893, *4625*
Fisk Free Library, New Orleans See: **New Orleans**
(Louisiana). Fisk Free Library
Fisk, William Henry, 1827-1884
Old noblesse in the concierge, *9175*
Fiske, Charles Albert, 1836-1915
summer home and studio, *22571*
FISKE, Horace Spencer, *12765, 12767, 12820, 12831, 12872,*
12904, 12950, 12984, 12985
Fiske, Minnie Maddern Davey, 1865-1932
acting style, *23222*
notes
1896, *22904*
1897, *23197*
performances
New York, 1895-6, *22888*
New York, 1896, *22995*
portraits, poster by Blanche Ostertag, *12799*
FISKE, Stephen Ryder, *1672, 1695, 1715, 1733, 1752, 1770,*
1831, 1847, 1860, 1878, 1900, 1917, 1948, 1965, 1982, 2036,
2051, 2071, 2086, 2109, 2133, 2172, 2191, 2246, 7428, 7456,
7482, 7507, 7525, 7551, 7570
Fiske, Stephen Ryder
quote, criticism of Munkacsy's *Christ before Pilate*, *2428*
Fitch, George L., fl.1883
portrait painting, 1883, *24821*
Fitch, John Lee, 1836-1895
exhibitions, National Academy of Design, 1875, prepares, *8424*
obituary, *16710*
paintings of trees, *17670*
whereabouts, 1883, Carmel, N.Y, *24728*
Fitch, Lucy See: **Perkins, Lucy Fitch**
Fitch, N. M., *Mrs.*, fl.1893
paper read before Congress on Ceramic Art, 1893, *4622*
Fitchburg (Massachusetts). Wallace Library
acquisitions, 1893, relic chair from the ship Somerset, *16409*
Fithian, Frank Livingston, 1865-1935
illustrations
Cooper's point, *22508*
Restin' a spell, *22531*
Rural philosopher, *22638*
Specter sportsman, *22590*
member of Pennsylvania Academy of the Fine Arts, *22508*
Fitler, Claude Raguet Hirst See: **Hirst, Claude Raguet**
FITLER, William Crothers, *24751*
Fitler, William Crothers, 1857-1915
Early spring, *22503*
exhibitions
Prize Fund Exhibition, 1885, *1985, 25278*
Prize Fund Exhibition, 1886, *25304*
illustrations
Landscape, 1722, *24653*
Meadowland, *22569*
illustrative work, 1882, *24367*
Old bridge, *22731*
portraits, photograph, *22539*
whereabouts
1883, Conshohocken, Pa, *24762*
1883, Springfield, N.J, *24728*
work, 1883, *24513*
Fitler, William Crothers, *Mrs.* See: **Hirst, Claude Raguet**
Fitts, Clara Atwood, b.1874
book plates for children, *12311*
Fitts, F. W., *Mrs.* See: **Fitts, Clara Atwood**
Fitz, Benjamin Rutherford See: **Fitz, Rutherford Benjamin**
Fitz, H. G., fl.1897
article on free-hand drawing in education, excerpt, *12035*
Fitz James, James Louis Francis Stuart, *duke of* **Berwick**
See: **Berwick, James Louis Francis Stuart Fitz James**, *15e*
duque de Alba

Home after service (after V. Demont Breton), *9623*
illustrations
　　A bientôt (after V. C. Prinsep), *9639*
　　Hamlet (after R. Gower), *9554*
　　Herodias (after B. Constant), *9662*
　　portrait of Louis Pasteur (after Edelfeldt), published, 1892, *15998*
　　Richelieu at the siege of Rochelle, *9710*
　　Widower (after Fildes), published, 1884, *10022*
Flameng, Marie Auguste　See: **Flameng, Auguste**
Flammarion, Camille, 1842-1925
　Uranie, review, *3353*
Flanagan & Biedenweg Co., Decorator in Stained-Glass, Chicago
　prizes for stained glass, 1900, *12452*
Flanagan, John F., 1865-1952
　clock for Library of Congress
　　designs, 1896, *17165*
　　installed, 1903, *13549*
　eagle and corner decorations for United States Pavilion at Exposition universelle, 1900, *12999*
　exhibitions, Pennsylvania Academy of the Fine Arts, 1899, *17526*
Flandrin, Hippolyte Jean, 1809-1964
　illustrations
　　drapery study, *4814*
　　study, *3631*
Flaubert, Gustave, 1821-1880
　Salammbô, illustrated by Louis Titz, *15062*
Flaxman, John, 1755-1826, *22014*, *22042*
　designs for Goldsmith's *The Hermit*, *25396*
　designs for Wedgwood, *1373*
　illustrations
　　Birth of Aphrodite, *2715*
　　classic designs for vase decorations, *1873*
　　classic figure designs, *1378*
　　Oceanus and the Nereids, *2715*
　　washstand double tile design, *2652*
　portraits, painting by Guy Head given to National Portrait Gallery, 1892, *26486*
　Waterloo medal, *14693*
　works, *23303*
Fleming, Alice Macdonald Kipling, b.1868
　Pinchbeck Goddess, review, *23251*
Fleming, Henry Stuart, b.1863
　elected to board, Society of Illustrators, 1903, *13604*
Fleming, J. M., Mrs.　See: **Fleming, Alice Macdonald Kipling**
Fleming, T.
　illustrations
　　Barye bronzes, *6*
　　Rimmer's sculpture, *167*
　　sketches for sculpture (after F. Dengler), *221*
Fleming, Thomas, 1853-1931
　newspaper illustration, *22504*
Flemish art　See: **art, Flemish**
Flemish decorative arts　See: **decorative arts, Flemish**
Flemish embroidery　See: **embroidery, Flemish**
Flemish ironwork　See: **ionwork, Flemish**
Flemish painting　See: **painting, Flemish**
Flemish tapestry　See: **tapestry, Flemish**
Flender, J. W., fl.1890's
　study of clouds shown in Pittsburgh, 1894, *27005*
Fletcher, Alice Cunningham, 1838-1924
　lecture, 1880, *178*
FLETCHER, Constance, *9954*, *10003*
FLETCHER, Lisa A., *22792*
Fletcher, Susan Webster Willis, b.1848
　medium, liberated from prison, *20681*, *20682*
Fleuret, Léon Louis, fl.1882-1908
　illustrations
　　Dolorida (after H. Coeylas), *4762*
　　Roses (after M. Schryver), *4646*
　　Servant (after C. Netscher), *6216*
　　Swedish peasant children (after H. Salmson), *4871*
FLEURY, Albert François, b.1848, *13088*

Fleury, Albert François, b.1848, *13603*
　exhibitions
　　Chicago Art Institute, 1900, *13123*
　　Chicago Art Institute, 1901, *13191*
　illustrations, *Gate of commerce*, *13129*
　views of Pan-American Exposition, 1901, *13288*
Fleury, Fanny Laurent, b.1848
　exhibitions, Union des Femmes Peintres et Sculpteurs, 1907, *14270*
Fleury, Joseph Nicolas Robert　See: **Robert Fleury, Joseph Nicolas**
Fleury, Jules, 1821-1889
　Artistes Célèbres: La Tour, review, *10472*
　collection
　　sale, 1890, *15231*
　　sale, 1891, *3561*
　　sale of autograph collection, 1891, *15620*
　forms museum of counterfeit Sèvres, *16466*
　novel epitomized by W. H. Bishop in *Atlantic Monthly*, *706*
　obituary, *15004*
　reminiscence by Anatole France, 1890, *25874*
Fleury, Tony Robert　See: **Robert Fleury, Tony**
Flint, Elizabeth　See: **Wade, Elizabeth Flint**
FLOEGEL, Joseph F., jr., *5190*, *5237*
floods
　anecdote, *21177*
floors
　floor coverings and finishes, *547*
　parquetry flooring, *3173*
　stained and polished wood floors, *1071*
　stained, painted and polished, *5063*
　staining versus painting, *6441*
　treating floors for rugs and carpets, *7488*
Florance, L. G., fl.1883
　portrait paintings, 1883, *24855*
Florence, Henry Smyth, Mrs.　See: **Florence, Mary Sargant**
Florence (Italy)
　American artists, 1850, *14606*, *14657*
　antiquities
　　excavations at Fiesole and Chiusi, *8967*
　　Roman remains found, 1895, *22787*
　architecture, inscriptions on building facades, *9183*
　art
　　1854, *18663*
　　1859, *19971*, *20113*
　　art objects for sale, 1876, *8705*
　　art treasures, *21918*, *21949*
　　copying pictures in galleries, *14620*
　　description, 1854, *18646*
　　sale of works from aristocratic homes, 1876, *8685*
　artists' life, benefits for American art students, *8999*
　bridges, Ponte Vecchio removal protested, 1898, *17432*
　description, *12193*
　　and civic problems, 1878, *9054*
　destruction of monuments, gardens, and parks, 1890, *26131*
　exhibitions
　　1861, Italian art, *20341*
　　1890, Beatrice exhibition, *25947*, *25948*
　　1906, annual international art exhibition, *14206*
　fourth centenary celebration of Michelangelo's birth, *8427*
　Misericordia traditions, *19380*
　monuments, monuments to Garibaldi and Victor Emanuel, *25832*
　municipal improvements, 1901, *13316*
　museums
　　Pitti and Uffizi Galleries, *9098*
　　proposal to bring together all of Michelangelo's works, 1907, *14302*
　　reorganization proposed, 1876, *8655*
　Yriarte's *Florence*, review, *9610*
Florence (Italy). Badia, *9425*
Florence (Italy). Biblioteca nazionale centrale
　building, new building, 1892, *26801*
Florence (Italy). Campanile
　Ruskin on Giotto's Tower, *9595*

Florence (Italy). Casa Buonarroti
history, *20143*
Florence (Italy). Duomo See: **Florence (Italy). Santa Maria del Fiore**
Florence (Italy). Galleria degli Arazzi
opens, 1885, *10201*
Florence (Italy). Galleria degli Uffizi
acquisitions, 1906, Madonna by Jacopo Bellini, *14144*
description, 1854, *18630*
exhibitions, 1881, recent rediscoveries, *21890*
new regulations for study, 1880, *913*
notes, 1881, *264*
statues added to portico, *18783*
Florence (Italy). Museo nazionale del Bargello, *8573*
Florence (Italy). Museum of Tapestry and Needlework See: **Florence (Italy). Galleria degli Arazzi**
Florence (Italy). Or San Michele
history and Donatello's statues, *17665*
Florence (Italy). Palazzo Corsi
sgraffiti decoration, *1275*
Florence (Italy). Piazza della Signoria
sculpture, *21859, 21868, 21882*
Florence (Italy). Sant' Onofrio monoastery
Last Supper attributed to Raphael, *21372*
Florence (Italy). Santa Croce
exhibitions, 1881, tapestry, *21891*
tombs and monuments, *18219*
Florence (Italy). Santa Maria del Fiore
strike by masons in 1423, *25310*
Florence (Italy). Santa Maria Novella
Louvre attempts to acquire gallery, 1897, *6396*
Florence (Italy). Società Donatello
exhibitions, 1880, *21888*
notes, 1881, *288*
Florence, Katherine, 1874-1952
portraits, photograph, *23197*
poses for living picture after F. Andreotti's *Wooing*, *22563*
Florence, Mary Sargant, 1857-1954, *3960*
exhibitions
American Watercolor Society, 1892, *3893*
Architectural League of New York, 1891, *26459*
National Academy of Design, 1891, *26307*
National Academy of Design, 1891, Dodge prize, *15626*
Woman's Art Club of New York, 1892, *26531, 26542*
illustrations, *Cupids and roses, 3970*
New-born death, receives Dodge prize, 1891, *3598*
on logistics of students boarding in Paris, 1892, *3997*
Florentine embroidery See: **embroidery, Florentine**
Florida
history, role of Osceola in Florida War, *23248*
nude paintings censored, 1894, *4904*
FLORIO, 20381
Florio, Caryl, *pseud*. See: **Robjohn, William James**
Flory, M. A.
Book About Fans, excerpt, *5672*
flower arrangement
advice, 1902, *8104*
art of arranging flowers, *9071*
bouquets, *924*
Christmas decorations for church, *5154*
Christmas decorations for the home, *5153*
color in gardening, *19056*
decorating home with flowers and plants, *5418*
decorating the home with dried plants and flowers, *5098*
floral arrangements for the table, 1894, *4740*
floral Christmas decorations for home and table, 1892, *4207*
floral decoration in the home and church, *5357*
floral decoration of churches for Christmas, *4676*
floral decoration of churches for Easter, *5321*
floral decorations for home weddings, *5386*
for flower painting, *6380*
for the home, *5450*
harmony with interior decoration, *5051*
hints, 1886, *2199*
history of floral decoration of churches, 1893, *4624*

notes
1893, *4592*
1899, *7010*
principles, *19352*
Queen Victoria's floral table decorations, *5506*
wild flowers, *17743*
wiring flowers, *901*
flower arrangement, Japanese, *2609, 13412*
lecture by Mr. Condor, *25632*
flower painting and illustration
advice from A. Cassagne, 1890, *3156*
advice on drawing indoor plants, *6079*
arranging flowers for painting, *3886*
botanical terms and descriptions for painters, *6234, 6257*
china painting decoration, *1909*
criticism of a flower painting, 1891, *3481*
formal analysis of irises, *8082*
golden rod in decoration, *3840*
illustrations, *8024*
lilies in art, *12120*
notes
1897, *6315*
1899, *7010*
old-fashioned Dutch flower painting, *2027*
recommendation that artists pay atttention to foliage, *7465*
reinventing floral decorations, *6123*
study of botany indispensable, *3262*
suggestion to turn to medieval styles and that of Redouté, *7374*
technique, *2827, 3049, 3546, 3607, 3632, 3687, 4198, 4612, 4955, 4980, 5971, 6013, 6160, 6182, 6244, 6320, 6352, 6736, 7017, 7310, 7432, 7688, 7773, 11324, 11341*
American Beauty rose, *7461*
arranging and painting lilacs and snowballs, *4919*
arranging flowers for painting, *4369, 6380*
background for yellow flowers, *4444*
backgrounds, *5627, 6226*
bleeding hearts and guelder roses, *3633*
bride roses, *6994*
carnations, *6823*
china painting, *6324, 7306*
chrysanthemums, *6408*
clover, *6359*
colors for crysanthemums, *6069*
copying Dangon's study of daffodils, *3159*
copying L. A. Fry's *Fresia, 3239*
copying Stumm's *Pansies, 5132*
crysanthemums, *6117*
cyclamen, *6851*
daisies, *6254*
daisies and daffodils, *6256*
designing with flowers, *6628*
drawing, *6350*
drawing decorative seed vessels in pen, *5228*
drawing exotic flowers, *5275*
drawing ferns, *5346*
drawing for industrial purposes, *11447*
drawing pansies, *5306*
drawing roses in pen and ink, *5129*
drawing wild flowers, *5081*
drawing wild flowers in pen and ink, *5179*
fleur de lis in watercolor, *5580*
flowers in still lifes, *4148*
formal analysis of flowers, *5970*
geraniums, wild roses, jonquils, *7675*
grasses and field flowers, *4951*
holly and mistletoe, *4131*
holly, Christmas roses, tulips, pansies, *4659*
iris and Egyptian design, *6932*
irises, *7337*
ivy, *5913*
Jacque roses, *7364*
kitchen garden subjects, *5876*
La France roses in watercolor, *7654*
lighting, *3511*
lilies of the valley and arum lilies, *4780*

mistletoe and holly, *4640*
Mme. Le Prince's suggestions for water-color painting, *4017*
monochrome painting in water-colors, *5083*
mountain laurel, *6353*
oils, *2230, 2394*
oils, watercolor, and china painting, *8212*
orchids, *3250*
painting, *3185, 3583, 4080, 4293*
painting and palettes, *4247*
painting azaleas, *8192*
painting azaleas and large flowers, *3104*
painting backgrounds, *3277*
painting chrysanthemums, *5131, 5276*
painting crysanthemums, *7835*
painting daffodils, *6911*
painting from nature, *4445*
painting golden rod, *5049*
painting golden-rod, asters, marsh-mallows, *3037*
painting hawthorne, blackberry, dogwood, *6015*
painting holly, *4614*
painting in oils, *2095, 2117, 2139, 2158, 2176, 2194, 2213,*
 2251, 2269, 2287, 2311, 2329, 2392, 4806, 4847, 4877
painting large white flowers, *3210*
painting nasturtiums, *3388*
painting on holland, *2568*
painting orchids, *3203*
painting pansies, *6964*
painting roses, *3315, 7892, 7893*
painting study of fuchsias, *3158*
painting sweet peas and crocuses in water-colors, *5277*
painting violets, *6933*
painting violets in water-colors, *5180*
painting wild flowers, *2770, 2788, 2891, 2918, 2969, 2993,*
 3019, 3061, 7854, 7878, 7919, 7949, 7973
painting wistaria, *4570*
palette for goldenrod, *5914*
palette for painting on china, *1581*
palette for watercolors, *3235*
palettes for roses, *5381*
palettes given, *7750*
pansies, *2893, 4807, 6229*
pansies, convolvuli, lilacs, wistaria, orchids, *3234*
pen and ink drawing, *5048*
ppainting roses, *3289*
Redouté's method, *3655*
Redouté's painting, *7785*
roses, *7563*
roses, chrysanthemums, lilies, *6595*
shrubby bittersweet plant, *7720*
sketching chiccory, *2996*
spring and summer flowers, *5837*
studies of fruits and flowers, *2509*
study of botany recommended, *7955*
subjects suggested for painting wild flowers, *4916*
summer flower suggestions for subject matter, *5409*
trumpet vine and poppies, *4530*
Van Huysum's technique, *3636*
wall flowers, *6360*
watercolors, *1514, 1536, 1555, 1574, 2587, 2750, 2771,*
 3658, 3708, 4036, 5308, 5741, 5944, 6379, 6883, 7575
water-colors and oils, *2844, 2863*
wild clematis, ferns, woodbine, and golden rod, *7409*
wild flowers, *2809, 7696*
wild flowers of autumn, *7726*
wild roses, *7661*
wistaria, *5866*
wistaria in pen and ink, *7020*
yellow flowers for china painting, *5989*
wild flowers as subjects for artists, 1895, *5441*

flowerpots
 flower pot holders made from household objects, 1903, *8253*
flowers, *22749*
 American Beauty rose and other flowers, *3171*
 analysis of fleur-de-lis, *6114*
 analysis of hawthorne, blackberry, dogwood, *6015*

analysis of pansy, nasturtium, sweet pea, *6068*
argument against goldenrod as American national flower, 1890,
 3393
autumn blossoms for decoration of house and garden parties,
 1895, *5470*
books of dried flowers, *5336*
choosing flowers for china decoration, *6291*
collecting, *708*
columbine chosen American national flower, 1896, *6059*
conventionalizing natural forms into designs, *6196*
description of garden, *19051*
dogwood, anemone, swamp apple and violet, *4411*
excerpts from W. Howitt and Digby, *20090*
exhibitions, New York Horicultural Society, 1855, *19105*
flower anatomy, *5741*
flowers and plants for afternoon teas, *5286*
flowers of July and August, *708*
golden rod, *3840*
history of Mrs. Alpheus Hardy chrysanthemum, *3118*
in ornament, *20524*
Indian corn suggested for American national flower, 1892, *3886*
June rich month for flowers, *689*
photographing flowers, *8066*
preserving by drying and pressing, *689, 2920*
preserving rose petals with salt and allspice, *8026*
selecting flowers for china decoration, *6297*
terminology, glossary of terms, *8110*
wild flowers of the Rocky Mountains, *23081*
yellow flowers, *22631*

Floyd, Charles, d.1804
 memorial celebration, Sioux City, 1895, *16792*
Flüggen, Gisbert, 1811-1859
 Rural conversation, *19853*
Focardi, Giovanni, 1842-1903
 You dirty boy, *21654*
 photographs sold by Archibald Ramsden, 1889, *3031*
Foerster, A. M., fl.1898-1901
 illustrations, *Arrest*, *12699*
Foerster, Emil, 1822-1906
 notes, 1856, *17910*
Fogarty, Thomas, 1873-1938
 drawings and illustrations, *22498*
 illustrations, pen sketch (standing man), *22486*
Fogelberg, Bengt Erland, 1786-1854
 notes, 1855, *18691*
 obituary, *18670*
Fogg Art Museum See: **Cambridge (Massachusetts).**
 Harvard University. William Hayes Fogg Art Museum
Fogg, John Samuel Hill, 1826-1893
 autograph collection, *16480*
Fogg, Margaret Galloway, fl.1894-1910
 illustrations, *On the Lighthouse Beach, Annisquam*, *11446*
Fogg, William H.
 widow's bequest to Harvard and other places, *26235*
Fol, Walther, 1832-1890
 collection, sale, 1891, *15470*
Foley, Harold Heartt, fl.1895-1899
 exhibitions, American Art Association of Paris, 1897, *24010*
 illustrations
 decorative initial, *23671, 24281*
 Dream, *23619*
 Girl from Campagna, *23922*
 headpiece, *24075*
 illustration for poem *Lay of St. Wulstan*, *23697*
 old tile roof of the American Art Association and roofs of the
 Ecole coloniale, *23634*
 Religieuse, *23828*
 Through a Latin Quarter window, *23768*
 view from the committee room window of the American Art
 Association of Paris, *23634*
Foley, John Henry, 1818-1874
 Albert, *8814*
 equestrian statues completed by T. Brock, *8950*
 Lord Gough, *9332*
 monument to O'Connell, Dublin, *9680*

statue of *General "Stonewall" Jackson*, *8773*
statue of Lieut-Gen Sir James Outram, *8362*
Foley, Margaret, 1827-1877
cameo portraits, *19955*
illustrations, fountain for Centennial exhibition, 1876, *8663*
whereabouts, 1858, summer quarters, *19891*
Folingsby, George Frederick, 1828-1891
illustrations
Eve (after H. Powers), *21101*
Fisher boy (after H. Powers), *21101*
Greek slave (after H. Powers), *21101*
Hiram Powers, *21101*
folk art, English, *9536*
folk songs, American
earlier version of *Yankee Doodle*, *18351*
folklore
fairy-lore tradition in American literature, *18260*
luck associated with art objects, *9257*
Folline, Miriam Florence See: **Leslie, Miriam Florence Folline**
Folsom, Frances See: **Preston, Frances Folsom Cleveland**
Folts, George P.
collection
exhibited at National Academy of Design, 1899, *17686*, *17695*
Folwell, Samuel, ca.1765-1813
portrait of Washington, *18063*
Fonce, Camille, b.1867
etchings, *15167*
Fond du Lac (Wisconsin)
mural paintings for interior of cathedral, *22787*
Fonda, Harry Stuart, 1863-1943
notes, 1900, *22099*
whereabouts, 1896, leaves Paris, *23626*
Fontaine, Andrew, 1676-1753
collection, *10052*
Fontaine, Pierre François Leonard, 1762-1853
decorative arts designs, *1157*
Fontainebleau
artist life, 1895, *5231*
forest, description, 1858, *19833*
forest's attraction for painters, *9697*
Fontana, Giovanni, 1821-1893
sculpture in studio, 1881, *21894*
sculptures for Sydney, 1884, *9925*
Fontenay, Eugène, d.1887?
illustrations, bracelet of gold, *1479*
Foote, Charles Benjamin
library
sale, 1894, *16608*
sale, 1895, *16687*, *16696*
sale of American first editions, 1894, *16619*
Foote, Edward K., fl.1880-1891
exhibitions, Cincinnati, 1891, watercolors, *26235*
Mount Adams, Cincinnati, *221*
whereabouts, 1890, return to Cincinnati, *26184*
Foote, Edward K., Mrs., fl.1891
exhibitions, Cincinnati, 1891, watercolors, *26235*
Foote, Mary Anna Hallock, 1847-1938
illustrations
Lady of the lake, *1459*
Noon in the corridor, Mexican hotel, *22480*
illustrations for Longfellow's *Skeleton in Armour*, *8777*
illustrator for *The Century*, *22473*
Foote, William Howe, 1874-1965
exhibitions
American Art Association of Paris, 1899, *12890*
National Academy of Design, 1902, third Hallgarten prize, *13359*
illustrations
Pond, Central Park, *13803*
Young woman in black and white, *14262*
Foppa, Vincenzo, 1427?-1516?
work in the Poldi-Pezzoli Museum, *9916*

Forain, Jean Louis, 1852-1931
caricatures that are anti-Zola and anti-Semitic, *24155*
caricatures vilifying Zola, *24068*
exhibitions, Société des Pastellistes Français, 1892, *15890*
line illustration, *12996*
mannerism in pen drawing, *6651*
notes, 1892, *15921*
painting on view, New York, 1893, *16316*
whereabouts, 1893, visit to New York, *22280*
Foraker, Joseph Benson, 1846-1917
notes, 1896, *22964*
Forberg, Ernst Carl, 1844-1915
illustrations
Head of a child (after Greuze), *112*
Prayer in the forest (after H. Salentin), *54*, *9258*
Wine tasters (after E. Kurzbauer), *9307*
Wisdom of Solomon (after L. Knaus), *22051*
Forbes, Charles Stuart, 1856-1926
exhibitions
Salon, 1883, *24521*
Salon, 1887, *2449*
FORBES, Edmund, *24083*
Forbes, Edward Waldo, b.1873
collection, gift to Fogg Museum of Italian paintings, 1900, *13145*
Forbes, Edwin, 1839-1895
etchings, *13616*
notes, 1894, *16557*
obituary, *16705*
Forbes, Elizabeth Adela Stanhope Armstrong, 1859-1912
exhibitions
New York Etching Club, 1891, *3533*
Royal Society of Painters in Water Colours, 1907, *14333*
Salon, 1885, *2035*
whereabouts, 1887, St. Ives, *25495*
FORBES, George, *10842*
Forbes, James Staats, 1823-1904
collection, *17600*
Forbes, John Colin, 1846-1925
portrait of Harrison, *17016*
Forbes Library, Northampton See: **Northampton (Massachusetts). Forbes Library**
Forbes, P. J.
opens Athenaeum, New York, 1855, *19312*
FORBES ROBERTSON, John, *9918*, *10009*, *10079*, *21752*, *21764*, *21802*, *21814*, *21827*, *21870*, *21902*, *21915*, *21917*, *21923*, *21927*, *21931*, *21932*, *21934*, *21946*, *21952*, *21969*, *21971*, *21984*, *22017*, *22029*, *22038*, *22055*
Forbes, Stanhope Alexander, 1857-1943
exhibitions
London, 1890, *25937*
Royal Academy, 1884, *10007*
Royal Academy, 1890, *25924*
illustrations, *After the boats come in*, *13322*
Forbes, Stanhope Alexander, Mrs. See: **Forbes, Elizabeth Adela Stanhope Armstrong**
FORBES, Urquhart Atwell, b.1850, *10457*
Forchhammer, Peter Wilhelm, 1801-1894
obituary, *16452*
Ford, B., Mrs., fl.1893
exhibitions, New York, 1892, landscapes, *4094*
Ford, Edward Onslow, 1852-1901
commission for equestrian statue of Field Marshall Strathnairn, 1891, *26476*
elected academician, Royal Academy, 1895, *22787*
exhibitions
Carnegie Galleries, 1902, bronze portrait of E. A. Abbey, *7803*
Chicago World's Fair, 1893, *4437*
Royal Academy, 1885, *10172*
Marlowe memorial, *26035*, *26193*
memorial to Major-General Charles G. Gordon, 1892, *26722*
monument to Shelley, *26310*, *26397*, *26548*, *26591*, *26640*
Peace and Marlowe Memorial, *26425*
sculpture, 1886, *10357*

statue of Henry Irving as Hamlet, *26135, 26227*
Ford, Gordon Lester, 1823-1891
 obituary, *15772*
Ford, Henry Chapman, 1828-1894
 Etchings of the Franciscan Missions of California, review, *24727*
 exhibitions
 Chicago Academy of Design, 1871, *10712*
 New England Manufacturers' and Mechanics' Institute, 1883, *24768*
 illustrations, etchings of California missions, *24738*
 landscapes, 1870, *10567*
 paintings and etchings of old California missions, *2701*
 whereabouts, 1883, Boston and Santa Barbara, *24755*
Ford, John, 1586-ca.1640
 dramas, *18359*
Ford, John T., 1829-1894
 collection, *16019*
FORD, Mary Bacon, *17517*
FORD, Mary Hanford, *12428, 14169*
Ford, Paul Leicester, 1865-1902
 bibliographies, *14999*
 portraits, photograph, *23223*
Ford, R. H., fl.1898
 illustrations, group from Greek Harvest Festival, *12433*
Ford, Sheridan, d.1922
 Art of Folly, review, *13222*
 article on need for reform in art education, *16056*
Ford, Simeon, 1855-1933
 portraits, photograph, *8281*
Foreign Art Exhibition, Boston See: **Boston (Massachusetts). Foreign Art Exhibition, 1883**
Foreign Photograph Company, Chicago
 notes, 1899, *12861*
FOREIS, Ole, *5118, 5701, 6505*
forests and forestry
 description of tramp through woods in February, *22927*
 New Forest, England, *9757*
 Pennsylvania forest scenery, *18660*
 wood scenery, *21064*
forgeries
 1890, *15386*
 1895, *16792*
 1898, *17401, 17421*
 1899, *17498, 17512, 17535*
 advice to investors, *13613*
 ancient art, *2765*
 anecdote, *16705*
 antiques, *15728, 15787*
 furniture, *1759*
 spurious antiques, *665*
 warning about forged antiques in Holland, 1893, *4626*
 antiquities
 counterfeiting in Europe and America, *7181*
 Russian antiquities, 1894, *16531*
 tomb belonging to British Museum, *676*
 arms and armor, *1846*
 art, *1859*
 difficulties in mounting exhibitions of Old Masters, *3152*
 Eudel prepares book, 1883, *1671*
 Eudel's articles, *1830*
 Eudel's articles on "truquage." 1884, *1714*
 forgeries blamed on fraudulent art dealers, misattributions, and misuse of artists' copies, 1894, *4702*
 forgeries in United States, 1892, *3952*
 forgers "Thompson" and Waring, 1892, *3924*
 frauds on collectors, *16015*
 frauds on colllectors, *16023*
 in collection taken as collateral at Harlem River Bank, 1894, *5033*
 notes, 1887, *2542*
 precautions in France, *25008*
 spurious works, *828*
 United States, *2800*

art market
 1884, *25099*
 1890, *15302*
autographs, *16335*
bonsai trees, 1900, *7260*
bookbindings, *15506*
books, *15339*
 and manuscripts, *1846*
china
 1889, *2959*
 old faïence, *1776*
 spurious "Sèvres", *2030*
coins, *665*
 1890, *15332*
 1894, *16462*
 1895, *16800*
collectors and collecting, *15098*
 private collections, *14314*
copies made in museums, *20333*
counterfeits and cutting up old works, 1883, *1517*
decorative arts, 1890, *15204*
early English paintings and Napoleon relics, 1894, *5115*
etchings
 1883, *1486*
 Rembrandt, 1894, *16585*
falsification of old objects, 1998, *16154*
forger of Burns documents sentenced, 1893, *16304*
forgers arrested in Pittsburgh, 1894, *16567*
forgers in Paris, 1893, *16402*
French counterfeiters arrested, 1890, *3310*
French dealers sell forgeries to Americans, *10942*
furniture, *2764*
gems, *17542*
jewelry, underlaid gems, *1846*
mummies, 1890, *15314*
need to prosecute forgers and dealers, *24953*
notes, *18542*
 1891, *3571*
painting, *1751*
 1895, *16726*
 1899, *17676*
 American paintings, *13421*
 anecdote, *20162*
 art dealers, *14102*
 Constable, *16515*
 Constable and Neuville, 1894, *16466*
 Constable and Turner, *17335*
 Corot, *15322*
 Corot, Detaille, De Neuville and Tissot, *25877*
 counterfeiting pictures, 1900, *7261*
 Courbet counterfeiters in France, 1890, *3359*
 Daubigny and others, *1732*
 Degroux, Robbe, Boulanger, *16939*
 DeHaas, *1328*
 del Sarto and da Vinci, *18952*
 discoveries of "Old Master" paintings usually cannot be verified, *4100*
 Dumas-Corot-Trouillebert affair, *10961, 10968*
 European painting on American art market, 1883, *1549*
 factory in Hoboken, N.J., *788*
 fake Corots, Millets and Harpignies sold in Paris, *13712*
 forged paintings frequently on art market, *17591*
 forged paintings substituted for originals, 1894, *16535*
 forgeries of Millet and Bastien-Lepage, *3281*
 France, *11062*
 frauds in Scott collection, *16678*
 fraudulent pictures in American collections, *11101*
 French frauds, *10943*
 French picture counterfeiters, 1883, *1616*
 French picture counterfeiters, 1888, *2746*
 French picture frauds, *10941*
 Herring's pictures copied, *14579*
 in American collections, 1907, *14302*
 LaTour portrait of Madame de Pompadour, *15054, 15076*
 manufactory of forged paintings found, 1899, *17474*

O'er Western land, the loved of Fortune's child, 14004
Peaceful night, Normandie, 14060
Petite Vénise, Crécy en Brie, 13865
Sunset after rain, 13507
notes, 1906, *14070*
whereabouts, 1895, Paris, *11515*
Fournier, Anatole, 1878-1926
illustrations, Sèvres porcelain, *13653*
Fournier, Edouard, b.1857
statue of Balzac, *25698*
Fourteenth of July See: **Bastille Day**
Fowler, Evangeline, d.1934
exhibitions, Chicago, 1894, *11375*
FOWLER, Frank, 1852-1910, *2094, 3542, 3580, 3651, 3726,*
3756, 3796, 3842, 3877, 3901, 3929, 3961, 3995, 4018, 4044,
4079, 4147, 4148, 4191, 4242, 4321, 4366, 4414, 4480, 5909,
6559, 6659, 22487
Fowler, Frank, 1852-1910
advice on proportions of the human body, *5499, 7623*
book on drawing in charcoal and crayon, *2076*
book on oil painting with instructions for still life, *2121*
ceiling painting for Waldorf Hotel, New York, *6386*
comments on mural painting, *13281*
decorative artist, *22515*
decorative work, *1907*
elected to council, National Academy of Design, 1901, *13228*
exhibitions
Artists' Fund Society, 1884, *24967*
Artists' Fund Society, 1885, *1916*
Carnegie Galleries, 1900, *13130*
Carnegie Galleries, 1903, *13675*
Essex Art Association, 1884, *25102*
Metropolitan Museum of Art, 1881, *1165*
National Academy of Design, 1880, *889*
National Academy of Design, 1883, *24480*
National Academy of Design, 1900, *12997*
National Academy of Design, 1903, *13547*
New York, 1895, portraits, *5300*
Paris Exposition, 1889, *At the piano, 25695*
Salmagundi Club, 1882, *1265*
Society of American Artists, 1881, *367*
Society of American Artists, 1884, *1802*
Society of American Artists, 1897, *10538*
Union league Club of New York, 1884, *Dawn, 25193*
Hints on Practical Drawing and Painting, excerpt, *4196*
illustrations
Head, 22610
Spring, 1330
Music and dancing, 22495
notes
1883, *24568*
1895, *5403*
Oil Painting, review, *25331*
plans class in portraiture, 1897, *6421*
Portrait and Figure Painting, review, *4898*
portrait of Archbishop Corrigan, *5653*
portrait of Charles A. Dana shown in New York, 1894, *27005*
portrait of Gov. Flower, *22765*
commissioned, 1895, *22738*
portrait of Governor Greenhalge, *6487*
portrait of Mme. Modjeska, *25096*
portrait of Rev. H. N. Powers, 1883, *24742*
Song, 24513
whereabouts
1883, *24609*
1883, Bridgeport,Conn, *24657*
1883, painting portrait at Bridgeport, Ct, *24703*
1896, summer plans, *23056*
work, 1883, *24492*
Fowler, Frank, Mrs. See: **Odenheimer Fowler, Mary Berrian**
Fowler, Harriet Webster, fl.1892-1900
exhibitions, New York, 1891, watercolors, *15797*
Fowler, John, 1817-1898
collection, sale, 1899, *17629*

Fowler, Mary Berrian Odenheimer See: **Odenheimer Fowler, Mary Berrian**
fowling
See also: **falconry**
Fox, Anna, fl.1893
illustrations, floral spray, *4517*
Fox, Charles Lewis, 1854-1927
art classes at Portland, Maine studio, 1890, *3450*
exhibitions, Prize Fund Exhibition, 1887, *562, 2456*
Fox, Helen A., fl.1890-1893
illustrations
Blackberry blossom design, *4453*
Plant analysis, 3467
Fox, Henry Charles, b.1860
exhibitions, London, 1886, *10302*
Fox, Stanley, 1845?-1875
obituary, *8590*
Fox Talbot, William Henry See: **Talbot, William Henry Fox**
Frackelton, Susan Stuart See: **Frackleton, Susan Stuart Goodrich**
Frackleton, Susan Stuart Goodrich, 1848-1932
advice on Christmas china painting gifts, 1894, *5142*
American china painter, *6030*
exhibitions
New York, 1894, stoneware experiments, *4845*
Paris, 1901, decorative pottery, *7515*
Philadelphia pottery and porcelain exhibition, 1888, *2826*
illustrations, china painted objects, *4299*
Fradelle, Albert Eugene, fl.1880's
illustrations
portrait of Briton Rivière (photograph), *21732*
portrait of Erskine Nicol (photograph), *21713*
portrait of George Dunlop Leslie (photograph), *21818*
portrait of Joseph Edgar Boehm, *21846*
portrait of Keeley Halswelle, *22024*
portrait of Lawrence Alma Tadema (photograph), *21717*
portrait of P. H. Calderon (photograph), *21629*
portrait of Peter Graham (photograph), *21703*
Fraenkel, Theodore Oscar, 1857-1924
biographical sketch, *11417*
illustrations, *Home for the friendless, 11774*
Fragiacomo, Pietro, 1856-1922
exhibitions, Carnegie Galleries, 1900, *13130*
Fragonard, Jean Honoré, 1732-1806
exhibitions, London, 1899, decorative paintings, *17474*
illustrations, *Oath of love, 4591*
Love and *Youth* panel, *6841*
panels found to be fakes, 1906, *14195*
Fragonard, Théophile Evariste Hippolyte Etienne, 1806-1876
illustrations, vases in hard Sèvres porcelain, *13653, 13816*
Fraikin, Charles Auguste, 1817-1893
Belgian sculptor, *21098*
Fraipont, Gustave, b.1849
illustrations
carnation design, *7811*
Carnations, natural and conventional, 8000
Easter lilies, 5311
Fleur de lis, 5310
floral decorative motives, *6162*
tulip designs, *4957*
Frampton, Edward Reginald, 1873-1923
exhibitions, Royal Academy, 1907, *14312*
Frampton, George James, 1860-1928
exhibitions, Chicago World's Fair, 1893, *4437*
Français, François Louis, 1814-1897
exhibitions
New York, 1893, *Sun breaking through the mist, 26921*
Salon, 1890, awarded Medal of Honor, *3281*
Salon, 1890, *Foggy morning* wins Medal of Honor, *25986*
Société d'Aquarellistes Français, 1880, *21817*
Société d'Aquarellistes Français, 1882, *1353*
Société d'Aquarellistes Français, 1884, *1756*
illustrations
landscape studies, *2705*
pen sketch, *4916*

obituary, *6311*
picture at Kohn Gallery, 1890, *15428*
France
antiquities
cave paintings explored, 1902, *13366*
Gallo-Roman town excavated, 1895, *16767*
art sold due to lack of national funds, 1894, *16553*
artists' life
art student's trip, 1892, *4046*
restricted opportunities for women, *5263*
commerce, *19672*
description
account of art student's trip to Normandy and Paris, 1891, *3605*
art student's account of trip, 1891, *3577*
Haute-Loire, *20944*
landscape in spring, *20385*
description and views, *10242, 10249, 10266, 10279, 10288, 10301*
government buildings filled with art, *23646*
government buys paintings from Galerie Durand Ruel, 1890, *3335*
history
February Revolution, 1848, *21238*
February Revolution, 1848, injuries to works of arts, *14499*
Revolution, 1789-1799, *21150*
Revolution, 1789-1799, Blood list, *16589*
Revolution, 1789-1799, La Vendée, *20756*
independent Ministry of Fine Arts proposed, 1906, *14090*
kings, rights to coat of arms, *17262*
manufactures, Paris Exposition, 1878, *21639*
Meissonier paintings bequeathed to French government, 1898, *6709*
nobility, as amateur artists, *21154*
political parties, Jeunesse Royaliste, 1898, *24068*
Russian fleet at Toulon, 1893, *4661*
state acquires collection of Meissonier's wax maquettes, 1895, *5307*
student life, *26376*
tax on outdoor billboards, *13446*
women in arts and letters, 1897, *17254*
FRANCE, A. L., *1664, 1892*
FRANCE, Anatole, 1844-1924, *25874*
France. Assemblée nationale. Chambre des députés See: **Paris (France). Chambre des députés**
France. Commission permanente des beaux-arts
founding, 1848, *18631*
France. Conseil des musées nationaux
notes, 1903, *8238*
France, Eurilda Loomis, 1865-1931
exhibitions, New York, 1895, *5258*
woman in art, *22525*
France, J. L., *Mrs*. See: **France, Eurilda Loomis**
France, Jesse Leach, b.1862
comments on own work, *22546*
Life boat, *22731*
summer home and studio, *22571*
France, L. A. See: **France, A. L.**
France. Manufacture nationale de tapisseries des Gobelins See: **Paris (France). Manufacture nationale de tapisseries des Gobelins**
France. Mobilier national See: **Paris (France). Mobilier national**
Francesca, Piero della See: **Piero della Francesca**
Franchetti, Alberto, barone, 1860-1942
opera *Asrael*, *26178*
Francia, Il, 1450-1518
Virgin, acquired by Louvre, 1902, *7803*
Francis, David G., booksellers See: **New York. David G. Francis, booksellers**
Francis, David Rowland, 1850-1927
portraits, photograph, *8199*
Francis, Florence A., fl.1879-1888
exhibitions
American Watercolor Society, 1884, *25012*

National Academy of Design, 1887, *2606*
Prize Fund Exhibition, 1886, *25304*
illustrations, portrait study, *2852*
painting portraits, 1883, *24480*
Francis I, *king of France*, 1494-1547
architecture at Blois, *20520*
Francis, John F., 1808-1886
exhibitions, Art Union of Philadelphia, 1851, *23471*
Francis, Lydia Maria See: **Child, Lydia Maria Francis**
Franck, César Auguste, 1822-1890
Beatitudes, first performance, *8322*
Franck, G. A., *Mrs*. See: **Frank, Ellen A.**
Francke, Kuno, 1855-1930
solicits gifts in Germany for Harvard's Germanic museum, 1905, *13976*
François, Alphonse, 1814-1888
illustrations, *Michelangelo Buonarroti*, *8601*
François, Félix Léon, fl.1890
exhibitions, New York, 1890, *3458*
Frank, Ellen A., fl.1883-1912
exhibitions, New York, 1891, drawings of birds, *26418*
Frank, Eugene C., 1845-1914
whereabouts, 1883, Munich, *24535*
Frank, G. A., *Mrs*. See: **Frank, Ellen A.**
Frank, Julius O.
collection, sale, 1907, *14336*
Frankenstein, Eliza, fl.1870-1880
notes, 1871, *10731*
Frankenstein family
establish gallery, New York, 1871, *10731*
Frankenstein, George L., fl.1879-1890
notes, 1871, *10731*
Frankenstein, Godfrey N., 1820-1873
notes, 1871, *10677, 10731*
Frankenstein, Gustavus, fl.1850-1900
notes, 1871, *10731*
Frankenstein, John Peter, ca.1816-1881
family group, 1860, *24322*
family group portrait, *20209*
notes, 1871, *10731*
obituary, *358*
Frankenstein, Marie M. C., fl.1850-1880
notes, 1871, *10731*
Frankfort (Kentucky)
description, 1855, *18667*
Frankfurt am Main (Germany)
ghetto, *19591*
Franklin, Benjamin, 1706-1790
anecdote, 1894, *16502*
autograph letter for sale, 1892, *15910*
biography, *20890*
books and pamphlets donated to Metropolitan Museum, 1885, *11261*
founder of American Philosophical Society, *16269*
house at Passy, *17011*
imprints in Polock collection sale, 1895, *16868*
letter to C.W. Peale, *18613*
letter to Patience Wright, 1779, *19030*
Letters to Benjamin Franklin from His Family and Friends, excerpts, *18270*
monuments
sculpture by R. S. Greenough, *19033*
statue at University of Pennsylvania in poor condition, 1895, *16702*
statue by John J. Boyle, *12849*
statue given to Paris by John H. Harjes, 1905, *13974*
Poor Richard's Almanac, French edition, *15078*
portraits, *14619, 15855, 19931*
Grolier Club publication, 1898, *17394*
portrait by Grandmann, *1902*
portrait in British National Portrait Gallery, *6528*
relics, *16428*
prayer book, *17193*
Franklin, Charles, 1717-1768
biographical sketch, *18130*

 Guinevere, 11220
 Mowing, 182
 watercolor, *11214*
 illustrations, 1883, *24541, 24609*
 newspaper illustrations, *16557*
 studio reception, 1884, *25079*
Frederickson, Charles W., 1823-1897
 library, sale, 1897, *17353, 17375*
FREDERIK VII, king of Denmark, 1808-1863, *24324, 24337, 24346*
Free Academy, New York See: **New York. Free Academy**
Freeborne, Zara Malcolm, 1861-1906
 studio reception, 1884, *25079*
Freedlander, Joseph Henry, 1870?-1943
 model for Maine monument, second prize, *13213*
Freeman
 illustrations
 Home treasures, 18504
 September evening (after J. Constable), *18463*
FREEMAN, Anna Mary (Mrs. Goldbeck), fl.1846-1859, *19588, 19618, 19846*
Freeman, Anna Mary (*Mrs.*Goldbeck), fl.1846-1859
 exhibitions, New York artists' reception, 1858, *19784, 19800, 19817*
 Lines on a Picture, inspired by painting of G. Freeman, *19610*
 miniatures, *19767*
Freeman, Augusta Latilla, b.1826
 studio
 Rome, 1871, *10730*
 Rome, 1875, *8514*
Freeman, Charles H., 1859-1918
 exhibitions, National Academy of Design, 1891, *Lauretta, 3832*
Freeman, Edith See: **Sherman, Edith Freeman**
Freeman, Edward Augustus, 1823-1892
 as architectural historian, *10743*
 obituary, *26580*
 quote, on American architecture, 1883, *24569*
FREEMAN, Etta, *22891*
Freeman, Florence, 1836-ca.1876
 medallion portrait of Commodore Perry, *18880*
Freeman, George, 1789-1868
 painting inspires poem by A. M. Freeman, *19610*
FREEMAN, George L., *19727*
Freeman, James Edward, 1808-1884
 collection, *20284*
 exhibitions
 Albany, 1858, *19818*
 National Academy of Design, 1851, study of an angel, *14748*
 obituary, *10115*
 painting of Roman peasant girl, *19850*
 Rome studio, 1871, *10730*
 work in studio in Rome, 1876, *8626*
Freeman, James Edward, *Mrs.* See: **Freeman, Augusta Latilla**
Freeman, Julia Deane
 Women of the South Distinguished in Literature, review, *18507, 20305*
Freeman, Lucy Jane, b.1872
 Italian Sculpture of the Renaissance, review, *13416*
Freeman, William Henry, fl.1839-1875
 illustrations
 Aqueduct at Rio Janeiro, 21163
 Botafogo Bay, Rio Janeiro, 21163
 Bride of the village (after Greuze), *20930*
 Cart of a husbandman, Khosrovah, in Persia, 21042
 Cavern wells of Yucatan, 21229
 chapel of San Goncalo at Bahia, *21147*
 Chimpanzee (troglodytes niger), 21218
 cobra di capello, *20832*
 Falls of Itamarity (after W. G. Ouseley), *21191*
 Farmer's return (after P. Benazech), *20826*
 Flemish inn (after I. van Ostade), *20926*
 Gate of Konieh, 21159
 Haja, 20832
 harbour at Bahia, *21147*

 Javanese and the shark, 21043
 portrait of Adrian van Ostade, *21095*
 Religious music of the Kalmucks, 21286
 Returning from the fair (after F. Palizzi), *20753*
 Road to Yedo, Japan, 21200
 Roadside inn (after Ostade), *21018*
 Russian carriages, 20803
 Street in the city of Meissen, on the Elbe, 20794
 Tiger attacked by a boa constrictor (after J. Quartley), *21127*
 Tiger hunt, 21127
 Tomb of Cyrus, 20815
 View of Venice, 20787
freemasonry
 Francis Bacon's plays, *17027*
 Museum of Masonic Curiosities, *17165*
Freer, Charles Lang, 1856-1919
 collection, *15518*
 gift to Smithsonian Institution, 1905, *13875*
 Gravesend prints given to Detroit Museum of Art, *13875*
 Detroit collector, *3497*
Freer, Cora Fredericka, fl.1891-1910
 exhibitions
 Chicago Art Institute, 1903, *13673*
 National Academy of Design, 1896, *11909*
Freer, Frederick Warren, 1849-1908
 biographical sketch, *11417*
 career and works, *13272*
 Chicago member of Society of Western Artists, *12122*
 exhibitions
 American Watercolor Society, 1882, *1300*
 American Watercolor Society, 1883, *Annie Laurie, 1510*
 American Watercolor Society, 1884, *25012*
 American Watercolor Society, 1888, *2641*
 Boston Art Club, 1888, *2620*
 Chicago Art Institute, 1895, *11673*
 Chicago Art Institute, 1896, *11894*
 Chicago Art Institute, 1897, *12042*
 Chicago Art Institute, 1897, *Nursery rhymes, 6463*
 Chicago Art Institute, 1903, *13673*
 Chicago Art Institute, 1903, *Artists' prize, 13561*
 Chicago Artists' Exhibition, 1899, *12310*
 Chicago Inter-State Industrial Exposition, 1880, *199*
 Cincinnati Art Museum, 1898, *12754*
 Cincinnati Art Museum, 1900, *13067*
 National Academy of Design, 1884, *Adagio, 10982*
 National Academy of Design, 1887, *2431, 10786*
 National Academy of Design, 1889, *14970*
 National Academy of Design, 1896, *11909*
 National Academy of Design, 1897, *10540*
 New York Etching Club, 1888, *2641*
 Pennsylvania Academy of the Fine Arts, 1882, *1450*
 Philadelphia Society of Artists, 1882, *1270*
 Society of Western Artists, 1903, *13698*
 Society of Western Artists, 1906, *14038*
 Trans-Mississippi and International Exposition, Omaha, 1898, *12775*
 Her conquests, 22495
 illustrations
 Connoisseurs, 10934
 Fair, lovely woman, 23067
 Head (etching), *17767*
 Love's token, 10800
 Passing glance (after C. Beckwith), *10838*
 Repose of the model, 13985
 Summer girl, 22519
 watercolor, *11214*
 Young mother, 13985
 illustrator, *22609*
 member, Society of American Artists, *11241*
 obituary, *27009*
 paintings, 1883, *24553*
 paintings, 1887, *20426*
 portrait of Adele Lewing shown in Boston, 1892, *26851*
 portraits, photograph, *22539*
 reception, Studio Building, Chicago, 1895, *11493*

teaching, conducts summer school in Illinois, 1898, *12181*
whereabouts
 1871, Munich, *10680*
 1883, returns from abroad, *24728*
 1883, summer in Europe, *24656*
Freer, Mary Ellen Edwards See: **Edwards, Mary Ellen**
FREILIGRATH, Ferdinand, 1810-1876, *10546, 19397*
Frelinghuysen, Frederick Theodore, 1817-1885
 monuments, monument by Gerhardt in Newark, *27016*
Frémiet, Emmanuel, 1824-1910
 equestrian statue of General John Eager Howard for Baltimore, 1904, *13752*
 exhibitions
 Chicago Art Institute, 1896, *5701*
 London, 1887, *10452*
 Salon, 1885, *2000*
 Salon, 1887, medal of honor, *2476*
 Salon, 1894, *27007*
 French sculptor, *5934, 23114*
 illustrations, *Joan of Arc*, *5938*
 monument to Raffet, *16391*
 sculpture of prehistoric men, *13384*
 statue of Joan of Arc, *17670*
 Washington monument, proposed for Philadelphia, 1880, *149*
Frémine, Charles, b.1841
 Monet criticism, *22346*
French
 French disdain for America and Americans, 1893, *4599*
 Frenchmen abroad, *23893*
 love the color red, *7372*
 reaction to Dreyfus affair, *24029*
French, Alice, 1850-1934
 notes, 1897, *23251*
French and Smithwick See: **Smithwick and French**
French architecture See: **architecture, French**
French art See: **art, French**
French artists See: **artists, French**
French, Bessie Foster, fl.1897-1900
 describes art department of Oshua College, 1897, *12048*
French bookbinding See: **bookbinding, French**
French bronzes See: **bronzes, French**
French chairs See: **chairs, French**
French costume See: **costume, French**
French, D.
 illustrations, ceramic panel, *13515*
French, Daniel Chester, 1850-1931, *11556, 12983, 22983*
 Alma Mater, for Columbia University, *13161*
 Angel of death and the young sculptor, *11557*
 appointed to pass on statuary for New York City, 1893, *22249*
 assistants, H. Augustus Lukeman, *23038*
 bas-relief portrait of Mrs. Brown, *11570*
 bust of A. Bronson Alcott, *26220*
 bust of Emerson, donated to Exeter, N.H. library, 1896, *16996*
 bust of Gen. W. F. Bartlett, 1883, *24707*
 bust of Postmaster Pierson, *4977*
 bust of Ralph Waldo Emerson, *813*
 Columbus quadriga, *12985*
 commissions, 1886, *516*
 decoration for Boston Public Library, *22131*
 bronze doors, *13332*
 Dewey medal, *6873, 17538*
 donates sculpture to Exeter Public Library, *11794*
 elected academician, National Academy of Design, 1901, *13228*
 elected associate, National Academy of Design, 1901, *13265*
 exhibitions
 Boston Art Club, 1880, *158*
 Chicago World's Fair, 1893, *4565*
 Chicago World's Fair, 1893, *Republic* and *Gallaudet*, *4468*
 Louisiana Purchase Exposition, 1904, *13806*
 National Academy of Design, 1902, *13359*
 National Sculpture Society, 1898, *12721*
 National Sculpture Society, 1898, *Erin*, *12733*
 Paris Exposition, 1900, *13065*
 Pennsylvania Academy of the Fine Arts, 1899, *12836, 17526*
 Pennsylvania Academy of the Fine Arts, 1901, *13163*

Pennsylvania Academy of the Fine Arts, 1903, *13548*
Pennsylvania Academy of the Fine Arts, 1905, *13853*
Fighting Joe, unveiled at Boston State House, 1903, *8175*
General Cass, plaster model, *11471*
honored by Accademia San Luca, 1899, *12903*
illustrations
 angel for Chapman Memorial, Milwaukee, *23213*
 Death and the sculptor, *12820*
 Gallaudet teaching a deaf-mute, *5373*
 Truth, *14026*
Jefferson, at St. Louis Exposition, 1904, *13618*
Labor supporting the home and promoting the Fine Arts, near completion, 1883, *24707*
Manila medal for Tiffany and Company, *12879*
member of sculpture committee for Louisiana Purchase Exposition, 1902, *8081*
memorial to Richard Morris Hunt, *23240*
 collaboration with Bruce Price, 1897, *6187, 23190*
 for Central Park, *23008*
Minuteman, *17433*
monument to Henry G. Pearson, *25782, 25887*
monument to John Boyle O'Reilly planned, 1893, *26923*
monument to Lewis Cass, commissioned, 1886, *25323*
monument to Millmore, *26567*
notes
 1886, *10744*
 1890, *25733*
Paul Revere statue prize, 1883, *24569*
Peace on Dewey arch, *7096*
quadriga for capitol in St. Paul, *14246*
Republic, *12984, 22980*
sculptural decorations of World's Fair buildings, 1893, *4433*
sculptural group for Boston Post Office, *24722*
sculpture, *13203, 13556*
sculpture at Chicago World's Fair, 1893, *26981*
sculpture, Boston, *13604*
sculpture for Louisiana Purchase Exposition, 1904, *13685*
sculpture for St. Bartholomew's, New York, *13637*
statue of General Bartlett, commissioned, 1902, *13421*
statue of General James Anderson, *22108*
statue of George Washington
 commissioned for Paris, 1896, *17068, 23030*
 copy for Chicago Art Institute, 1902, *13366*
 replica of equestrian statue for Chicago's Washington Park, 1902, *13503*
 unveiled in Paris, 1900, *7291*
statue of John Harvard, *1883, 10892, 10900*
 model, 1883, *24905*
statue of Ralph Waldo Emerson
 completed, 1883, *14880*
 for Concord, Mass., 1883, *24492*
statue of Rufus Choate unveiled in Boston, *12808*
statue of Starr King unveiled in San Francisco, 1892, *26816*
statue of The Republic at Chicago World's Fair, 1892, *26821*
statue of Thomas Starr, *25813*
statue of William Lloyd Garrison
 for Newburyport, 1893, *26975*
 model, 1893, *26923*
statue of William the Silent commissioned by Holland Sociey of New York, 1896, *23008*
whereabouts
 1891, arrival in Paris, *26440*
 1896, summer in Paris, *23056*
French, David M., 1827-1910
 statue of Louisa May Alcott for New Orleans, 1890, *25798*
French decorative arts See: **decorative arts, French**
French drawing See: **drawing, French**
French, Edwin Davis, 1851-1906
 bookplate designs, *17550*
 obituary, *14271*
French embroidery See: **embroidery, French**
French enamels See: **enamel, French**
French engraving See: **engraving, French**
French etching See: **etching, French**

French, Frank, 1850-1933
See also: Smithwick and French
drawings, engravings, *22498*
exhibitions, Boston Museum of Fine Arts, 1881, *1254*
illustrations, *Woodland road, 22645*
illustrations for *Scribner's Magazine*, 1893, *22490*
wood engravings, *182, 22546*
French, Frederick William, 1842-1900
collection, sale, 1901, *13254*
French furniture See: **furniture, French**
French Gallery, London See: **London (England). French Gallery**
French, George, fl.1903
illustrations, *Still-life, 13618*
French, Gilbert James, 1804-1866
on symbolism of nimbus in Christian art, 1894, *4788*
French glass See: **glassware, French**
French goldsmithing See: **goldsmithing, French**
French illustration See: **illustration, French**
French interior decoration See: **interior decoration, French**
French jewelry See: **jewelry, French**
FRENCH, John McLean, 1863-1940, *23176*
French landscape painting See: **landscape painting, French**
French language
Barrès' project to reform spelling, *24155*
FRENCH, Lillie Hamilton, b.1854, *22516*
French literature
18th century, *24042*
publications, 1858, *18206*
French lithography See: **lithography, French**
French metal work See: **metal work, French**
French national characteristics See: **national characteristics, French**
French national songs See: **national songs, French**
French painting See: **painting, French**
French poetry
Parnassiens, *10522*
poets of Paris, 1893, *8334*
symbolism, *22352*
Symbolism, *22363*
verse of P. Verlaine, *21478*
French porcelain See: **porcelain and pottery, French**
French portrait painting See: **portrait painting, French**
French portraits See: **portraits, French**
French posters See: **posters, French**
French satire See: **satire, French**
French sculptors See: **sculptors, French**
French sculpture See: **sculpture, French**
French silver See: **silverwork, French**
French Society of Original Engravings in Color See: **Société de la gravure originale en couleurs**
French stained glass See: **glass painting, French**
French tapestry See: **tapestry, French**
French tombs See: **sepulchral monuments, French**
French travellers See: **travellers, French**
French vases See: **vases, French**
French water colors See: **watercolor painting, French**
French, Wilfred Augustus, 1855-1928
exhibitions, Boston Society of Amateur Photographers, 1884, *10899*
French, William, 1815-1898
illustrations, *Cromwell at Marston Moor* (after E. Crofts), *9584*
FRENCH, William Edward Pattison, b.1855, *17748, 17764*
FRENCH, William Merchant Richardson, 1843-1914, *5948, 11299, 11559, 12633, 12651, 13249, 13445*
French, William Merchant Richardson, 1843-1914
candidate to head World's Fair art department, 1891, *3565*
director of Chicago Art Institute, 1891, *3608*
lectures
1894, *11344*
address to Art Congress at Chicago on American and French art, 1893, *4599*
for the Central Art Association, 1895-96, *11606*
lecture, 1878, *9014*
lecture, 1880, *191*

paper at Art Congress, World's Columbian Exposition, Chicago, 1893, *22264*
tour, 1897, *12067*
whereabouts, 1894, lecture tour in West, *11430*
French wood carving See: **wood carving, French**
Freneau, Philip Morin, 1752-1832
music, *20380*
Frenzeny, Paul, ca.1840-1902
illustrations, *Treasurer of Club drives out in search of funds, 22199*
Frère, Charles Edouard, 1837-1894
obituary, *16616*
Frère, Edouard, 1819-1886
art colony at Ecouen, *8743*
biography, *16460, 20219*
exhibitions
London, 1858, *19851*
Paris, 1887, palettes of artists, *2490*
Salon, 1859, *20060*
forgeries of work, *20259, 20284*
illustrations, *Cooper's family, 8372*
painter of Ecouen, *10354*
paintings in studio, 1880, *21889*
Potage, in collection of S. Fales, *19718*
representations of peaceful villagers, *713*
Ruskin's criticism, *19702, 19872*
studio, 1860, *20270*
Frere, John Tudor, b.1843
exhibitions, Chicago World's Fair, 1893, *4463*
library, sale, 1896, *16996*
Frère, Théodore, 1814-1888
view of island of Philae, exhibited in San Francisco, 1875, *8462*
Frerichs, William C. A., 1829-1905
heads school of Essex Art Association, 1884, *25109*
obituary, *13878*
Fresch, J. F. J., 1863?-1890?
obituary, *25825*
fretwork
grilles for interiors, *11439*
Moorish fretwork, *3941*
technique, *3044*
Freudenberger, Sigmund, 1745-1801
Contes de la Reine de Navarre, discovered, 1877, *8901*
Frey, Robert A., fl.1896-1901
exhibitions, American Art Association of Paris, 1899, *12890*
Freytag, Gustav, 1816-1895
library, acquired by Frankfurt public library, 1897, *17273*
on publication of correspondence, 1895, *16845*
Friant, Emile, 1863-1932
exhibitions, Salon, 1889, *2966*
Frick, Charles E., fl.1900's
exhibitions, Philadelphia Photographic Salon, 1900, *13120*
Frick, Henry Clay, 1849-1919
presents Chartran painting to government, 1903, *13676*
purchases Lenox Library site to build fine arts building, 1907, *14271*
Friday Club, Chicago See: **Chicago (Illinois). Friday Club**
Friederich, Woldemar, 1846-1910
illustrations
Wild hunstman - The monk's story of wrong, 22742
Wild hunstman - Volrat meets the count, 22750
Wild hunstman - Waldtraut's misfortune, 22732
Wild huntsman - Burial of Count Hackelberend, 22775
Wild huntsman - Death of Count Hackelberend, 22771
Wild huntsman - Hunting until doomsday, 22781
Wild huntsman - Storming Castle Treseburg, 22779
Wild huntsman - The bishop's letter, 22723
Wild huntsman - The count's daughters, 22745
Wild huntsman - The sacrilegious hunt, 22725
Wild huntsman - The wounded count, 22760
Wild huntsman - Wodan and his spectral train, 22730
Friedrich II, der Grosse, *king of Prussia*, 1712-1786, *21167*
collection, *16491*
mausoleum at Potsdam consecrated, 1890, *26052*
monuments, monument by C. Rauch, *14591*

Friedrichs, Ernest H., d.1894
 obituary, *27009*
FRIEND, Ethelyn, *23661, 23683, 24011, 24035, 24059*
friendship
 humorous description, *23986*
Friese, Richard, 1854-1918
 animal painter, *10295*
Frieseke, Frederick Carl, 1874-1939
 elected chairman of art committee, American Art Association of
 Paris, 1903, *13687*
 elected to board of governors, American Art Association of
 Paris, 1903, *13701*
 exhibitions
 Paris, 1904, *13819*
 Salon, 1902, *13414*
 Salon, 1906, *14116*
 illustrations, *Hélene, 13670*
Frieze, Henry Simmons, 1817-1889
 biography of Giovanni Dupré, review, *2377*
friezes
 designs, *9385, 9401*
Frink, I. P.
 lighting of Munkacsy's *Christ before Pilate*, 1887, *2364*
Fripp, George Arthur, 1813-1896
 exhibitions, Royal Society of Painters in Water Colours, 1861,
 20385
Fritel, Pierre, b.1853
 exhibitions
 St. Louis Exposition, 1897, *Conquerors, 12015*
 Salon, 1892, *15914*
Frith, Cyril, fl.1896
 illustrations, *Surf breaking over the rocks* (photograph), *5902*
 Surf breaking over the rocks, history of the photograph, *5900*
Frith, Gilbert, fl.1892
 equestrian statue of Queen Victoria shown in Toronto, 1892,
 26816
Frith, William Powell, 1819-1909, *21684*
 anecdote, *17353*
 Autobiography and Reminiscences, review, *2979*
 Bed time, engraving published by Williams, Stevens, Williams
 & Co., 1855, *18639*
 daughters are London business women, *26185*
 Derby day, 6397
 exhibitions
 Paris Exposition, 1878, *9024, 21610*
 Royal Academy, 1850, *14644*
 Royal Academy, 1854, sketch of Goodwin Sands, *18633*
 Royal Academy, 1860, *20257*
 Royal Academy, 1878, *9023, 21602*
 Royal Academy, 1883, *1603*
 Royal Academy, 1884, *1813, 10007*
 finding Old Masters for Royal Academy exhibition, 1892, *3931*
 Life at the sea-side, 21248
 portraits, photograph, *22558*
 quote
 on art and photography, 1893, *4660*
 on business men's lack of knowledge in art matters, 1894,
 5033
 Race for wealth, 9364, 21831
 at Chicago World's Fair, 1893, *22274*
 Reminiscenses
 excerpt on Turner, *16814*
 published, 1888, *2619*
 Roll call, engraved by Fine Art Society, *21655*
 sales and prices
 1861, *Life at a railway station* sells for $45,000, *20341*
 1896, *5862*
 1898, *Road to ruin* series, *6614*
 Sweetest beggar, reproduced by Gertrude Dale, *26412*
 tells anecdote of Queen Victoria, 1894, *4837*
Fritsche, W., b.1853
 glass ewer, *25395*
 shown in New York, 1886, *25378*
Fritz, Anton, fl.1880's
 Fortune-teller, 10460

Fröbel, Julius, 1805-1893
 *From America: Experiences, Travels and Studies. German
 Emigration and its Significance in the History of Culture*,
 review, *18206*
Froebel, Julius See: **Fröbel, Julius**
Froelich, Maren Margrettie, 1870-1921
 exhibitions, California School of Design, 1891, *3483*
 illustrations, *Autumn, 22186*
 notes, 1902, *22142*
Frohman, Charles, 1860-1915
 anecdote, *24237*
 produces *Lash of a Whip*, 1901, *7570*
Frohman, Daniel, 1851-1940
 notes, 1897, *23197*
Frohock, Jean T.
 Mary and Jesus photographs, excerpts, *20689*
Frølich, Lorenz, 1820-1908
 exhibitions, St. Louis Exposition, 1895, *11622*
Froment, Eugène, 1844-1900
 illustrations
 decoration of putti, *2465*
 design for album cover, *1796*
 Ligeia (after W. C. T. Dobson), *21625*
 November (after A. Rapin), *5137*
Froment Meurice, François Désiré, 1802-1855
 obituary, *18726*
Fromentin, Eugène, 1820-1876, *1885*
 Arab encampment, in collection of Madame de Cassin, *2528*
 art importations to U.S., 1879, *734*
 artist and writer, *25119*
 Audience chez un calife, on view in New York, 1892, *15882*
 Barbizon School, *17487*
 Eugène Fromentin by L. Gonse, *24802*
 review, *321*
 exhibitions
 Chicago World's Fair, 1893, *4839*
 École des beaux-arts, 1877, *8846*
 Fantasia, in Probasco collection, *25420*
 Gorge de la chiffa, location unknown, 1897, *6370*
 illustrations
 Arab falconer, 2655
 Centaurs and centauresses, 7524
 dog study, *6230*
 Falconer, 13274, 13807
 Head of an Arab, 7023
 Head of an old woman, 7023
 Oriental scene, 14213
 Maítres d'Autrefois: Belgique-Hollande
 excerpt, *10895*
 review, *8837*
 monuments, plans for monument at La Rochelle, 1903, *13701*
 notes, 1898, *17447*
 obituary, *8752*
 paintings in Astor collection, *1368*
 paintings in Probasco collection, *2429*
 paintings in Robinson collection, *25357*
 paintings in Secrétan collection, Paris, *10823*
 paintings in Seney collection, *2458*
 portfolio of etchings after his paintings published, 1878, *8981*
 realism in France, *23020*
 Romantic painting in France, *22994*
Fromkes, Maurice, 1872-1931
 portrait of Cardinal Merry del Val, *14071*
Fromuth, Charles Henry, 1861-1937
 exhibitions
 Cincinnati Art Museum, 1898, *12754*
 Pennsylvania Academy of the Fine Arts, 1900, *13007*
 Pennsylvania Academy of the Fine Arts, 1903, *13548*
 Society of American Artists, 1899, *17552*
 illustrations, *Dismantled boats, 13101*
Fröschl, Carl, 1848-1934
 exhibitions, New York, 1895, *Domestic infelicity, 16726*
 frontispeice, *The Chautauquan*, 1894, *27008*
FROSSARD, Edouard, 1837-1899, *15729, 16012, 16769, 16857,
 17028, 17054, 17128, 17544*

G

excerpt from letter on paint texture, *19496*
exhibitions
 Carnegie Galleries, 1902, *13520*
 Grosvenor Gallery, 1885, *10127*
 London, 1896, *5653*
 London, 1899, portrait of Anne, Duchess of Cumberland, *7177*
 New York, 1892, *3957*
 New York, 1892, drawings and sketches, *26572*
 New York, 1895, *5564, 16738*
 New York, 1896, *17154*
 New York, 1896, *Pastoral, 17191*
 New York, 1898, *Watering place* study, *6495*
 Royal Academy, 1880, *21807*
 Royal Academy, 1882, *9603*
 Royal Academy, 1890, *25781, 25823*
forgeries, 1900, *7261*
Great Artists: Gainsborough and Constable, by M. Brock-Arnold, excerpt, *9491*
Housemaid, photogravure published by Colnaghi, 1890, *26017*
illustrations
 Baillie family, 5613
 Lady Mulgrave, 5429
 Mrs. Isabella Kinloch, 13696
 Mrs. Siddons, 4941
 portrait of Miss LeNain, *7483*
 portrait of Mrs. Fischer, his daughter, *6095*
 portrait of the Duchess of Devonshire, *7588*
musical ability, *6187*
painting destroyed by fire, 1890, *25867*
paintings acquired by National Gallery, 1897, *17320*
paintings in American collections, *6008*
paintings in Lenox Library collection, *771*
paintings in National Gallery, London, *5043, 5088*
paintings praised, 1865, *23339*
pictures in Fuller collection, *3917, 15828*
portrait of Duchess of Devonshire, *4521, 13265*
 found after theft, 1898, *6786*
 story of its theft, 1901, *7589*
 theft of so-called Gainsborough, 1893, *22505*
Portrait of Fanny Kemble, 3695
portrait of James Wolfe, attribution questioned, 1897, *6278*
portrait of Lady Day and Baroness de Noailles, *26006*
portrait of Lady Mulgrave, *5732, 16845*
 miniature, *5611*
portrait of Mrs. Siddons, *17729*
portrait of Signora Baccelli, *17231*
portrait of Viscount Mountmorres, *5482*
portrait painting, *21659*
portraits in J. P. Morgan and James Price collections, 1895, *5399*
sales and prices
 1885, *Sophia, daughter of John Boldero, Esq., and wife to Thomas Hibbert, Esq, 10161*
 1888, *16038*
 1890, *15312*
 1895, *Lady Mulgrave, 16781, 22346*
 1895, portraits in Price sale, *5429*
 1896, *5900*
 1898, *Halcyon days in England, 12133*
 1900, *7230*
sayings, *9547*
Gaisford, Thomas, b.1817
library, sale, 1890, *15224*
Gale, William, 1823-1909
Wounded knight, 21248
Galena (Illinois)
monuments, monument to Gen. Grant unveiled, 1891, *26356*
Galerne, Prosper, b.1836
illustrations, *At Chateaudun, 1365*
Galet, Denis
collection, purchases paintings while insane, 1895, *16650*
Galilei, Galileo, 1564-1642
tomb in Santa Croce, *18219*

Galimard, Auguste, 1813-1880
obituary, *83*
GALLAGHER, Caroline Harris, *23219*
Gallagher, Sears, 1869-1955
exhibitions, American Watercolor Society, 1897, *Foggy weather, 23213*
GALLAGHER, William Davis, *24330*
Gallagher, William Davis, 1808-1894, *18435*
Gallait, Louis, 1810-1887
Bohemian wayfarers, 9386
Last honors paid to the bodies of Count Egmont and Count Horn, 26353
 at Brussels Exhibition, 1851, *14809*
notes, 1891, *26441*
paintings, *19898*
paintings in Stewart collection, *753, 2393*
paintings in Walters collection, *1003, 1045*
Prière après la vendange, 19993
Galland, Pierre Victor, 1822-1892, *2661*
architect and painter of Paris, *977*
collection, to be sold, 1895, *16726*
decorative paintings, *1415, 2683*
exhibitions, Architectural League of New York, 1898, *6571*
illustrations
 decorative initial, *6304*
 Music, 2829
Gallard Lepinay, Emmanuel, 1842-1885
illustrations, *Rouen, 3697*
GALLATIN, Albert Eugene, *13544*
Gallatin, Grace See: **Seton, Grace Gallatin**
Gallaudet, Thomas Hopkins, 1787-1851
monuments, statue by D. C. French, *12983*
Gallé, Emile, 1846-1904, *22442*
exhibitions, Paris Exposition, 1889, *3033*
Hartmann's assessment, *10548*
Gallegos y Arnosa, José, 1859-1917
Grand procession on All Saints' Day, in Mannheimer collection, *16989*
paintings at Kohn Gallery, 1890, *15390*
Gallen Kallela, Akseli, 1865-1931
exhibitions, Berliner Secession, 1902, *13372*
Gallerey, Mathieu, fl.1905-1909
illustrations, panels of beaten copper, *13862*
GALLETTI, Margaret, *24132*
Galliac, Louis, 1849-1931
illustrations, *Proof of the etching, 7714*
Galliéra, Maria Brignole-Sale, *duchessa* di, d.1889
See also: Paris. Musée Galliéra
collection, gift to Paris announced, 1878, *21651*
funds museum in Paris, 1891, *15755*
museum donated to Paris, 1890, *25832*
Galliéra Museum
See also: **Paris (France). Musée Galliéra**
building for museums, *15755*
Gallison, Henry Hammond, 1850-1910
exhibitions
 Boston Art Club, 1904, *13717*
 Boston Art Club, 1907, *14252*
 Cincinnati Art Museum, 1900, *13067*
 Munich, 1901, *13316*
 Turin Esposizione, 1903, *Departings Mists, 13618*
 Worcester Art Museum, 1902, *13483*
Gallori, Emilio, 1846-1924
monument to Garibaldi, *10161*
GALLOWAY, George D., *13283*
Galloway, Margaret See: **Fogg, Margaret Galloway**
Galloway, Walter, fl.1895
illustrations, headpiece, *22327*
Galt, Alexander, 1827-1863
bust of Psyche, *14821*
bust of Virginia acquired by American Art Union, 1851, *14753*
sculpture of Jefferson, *18509, 18913*
Virginia, 14731
whereabouts, 1851, Florence, *14779*
work, 1860, *20284*

collection
 autographs, *16473*
GAYLORD, Laura Cleveland, *12577*
Gaylord, Thomas, fl.1871
 Dying Clown, *10720*
 notes, 1871, *10676*
Gazzaniga Malastina, Marieta, 1824-1884
 singer praised, *20078*
Gebhardt, Eduard von, 1838-1925
 Call to follow, *21526*
 Disciples at Emmaeus, *8792*
Gebhardt, Karl, 1860-1917
 Eve over the body of Abel, in progress, 1883, *14904*
Gebhart, Emile, 1839-1908
 Histoire du Sentiment Poétique de la Nature dans l'Antiquité Grecque et Moderne, review, *20308*
Gébleux, Léonard, 1883-1928
 illustrations, Sèvres porcelain, *13653*
Geddes, Andrew, 1783-1844
 notes, 1895, *16803*
Gedon, Lorenz, 1843-1883
 illustrations, chandelier design, *1808*
Gee, George Edward, fl.1881-1930
 Hallmarking of Jewelry, review, *9752*
Gee, Hiram, d.1896
 fellowship for female art students at Syracuse University, *12148*
Geefs, 19th century
 marble monument for America, 1860's, *20367*
Geefs, Fanny Corr, 1807-1883
 obituary, *14879*
Geeraerts, Marcus, 1561-1635
 illustrations, portrait, *5481*
Geertz, Julius, 1837-1902, *15655*
 portrait of Wilhelm II commissioned by Deutscher Verein of New York City, 1891, *15728*
Geffroy, Gustave, 1855-1926
 excerpts from article on Impressionism, 1894, *4799*
Geflowski, E. Edward, fl.1867-1894
 portrait of Duke of Clarence and Avondale in process, 1892, *26527*
Gegenbaur, Anton von, 1800-1876
 obituary, *8641*
GEIBEL, Emanuel von, *19137*
Geiger, Harry, fl.1906-1910
 exhibitions, Philadelphia Sketch Club, 1906, *14237*
Geiger, Peter Johann Nepomuk, 1805-1880
 obituary, *264*
GELASMA, *10709*
Geldmeister, Karl See: **Gildemeister, Karl**
Gélée, Claude See: **Claude Lorrain**
Gelert, Johannes Sophus, 1852-1923, *11388*
 Beethoven bust, unveiled in Chicago, 1897, *6343*
 exhibitions
 Chicago Art Institute, 1895, *11680*
 Chicago Art Institute, 1896, *11894*
 Chicago World's Fair, 1893, *4565*
 Cosmopolitan Club, Chicago, 1895, *11465*
 Cosmopolitan Club, Chicago, 1896, *11777*
 National Academy of Design, 1898, *American soldier*, *6815*
 National Sculpture Society, 1898, *Little architects*, *12721*
 Paris Exposition, 1900, *Little architects*, *13074*
 Philadelphia Art Club, 1899, sculpture gold medal, *12977*
 Tennessee Centennial Exposition, 1897, medal, *11971*
 Grant monument, Galena, Ill
 designer, 1891, *26356*
 panel, 1890, *26100*
 illustrations
 Gothic art, *13682*
 Hans Christian Andersen, *13556*
 Struggle for work, *11997*
 marries Georgine Sundbert, 1896, *11898*
 notes, 1896, *11883*
 sculpture for Louisiana Purchase Exposition, 1904, *13685*
 statue of Hans Christian Andersen
 cast by American Bronze Company, 1896, *11793*

 for Chicago, 1892, *26721*, *26779*
 poem by Fiske, *12950*
 statue of Sheridan, *25888*
 whereabouts, 1898, moves to New York City, *12711*
 work, 1891, *3565*
Gélibert, Jules Bertrand, 1834-1916
 illustrations, *Ready to start*, *1807*
Gellatly, John, 1853-1931
 collection, American paintings, *10537*
Gélon, Marie See: **Cameron, Marie Gélon**
Gemäldegalerie, Kaiser Friedrich Museum See: **Berlin (Germany). Kaiser Friedrich Museum. Gemäldegalerie**
gems, *17723*, *19275*
 Antique Gems by C. W. King, *20341*
 artistic use, *1195*, *1212*
 bogus gems on the market, 1890, *26072*
 collection shown at Charity Organization Society, New York, 1893, *26936*
 collectors and collecting, *16612*, *16841*, *17542*
 Carlisle collection bought by British Museum, 1890, *25976*
 Harvard University collection, *17115*
 Johnston collection shown at Metropolitan Museum, 1879, *9159*
 Maxwell Sommerville collection given to University of Pennsylvania, 1892, *15837*
 Marlborough gems to be sold, 1899, *17608*
 Reed collection, *16556*
 Sultan of Turkey collection, *17383*
 Tiffany & Co. collection, 1892, *15797*
 Tiffany collection of jades and crystals, *17020*
 Tiffany collection acquired by DeYoung, 1894, *16616*
 colors, *8105*, *21579*
 crown jewels of Persia, *16058*
 engraving techniques, *16208*
 gem-encrusted copy of Alkoran, *16811*
 gems of quartz origin, *17046*
 glass pastes used by ancients to imitate gems, *20609*
 green garnets, *17187*
 history, *9497*
 paper read before Central Art Association, 1898, *12240*
 Peacock throne described, 1890, *3326*
 qualities and characteristics, *2765*
 rare stones for artistic dress, *1479*
 sales and prices
 1896, Chinese carved stones, *16969*
 1896, French crown collection, *17169*
Gendron, Auguste, 1817-1881
 obituary, *476*
Genealogical and Biographical Society See: **New York. Genealogical and Biographical Society**
genealogy
 lineal descent, *5727*
 Long Island Historical Society collection, *17305*
 notes, 1860, *18429*
 United States, *20394*, *20407*, *20414*, *20418*, *20425*, *20433*, *20442*, *20450*, *20452*, *20468*, *20470*
General Federation of Women's Clubs
 Art Committee, suggestions to member organizations, 1899, *12861*
 biennial convention, 1900, *13090*
 meeting, 1898, *12152*
 suggestions for support of art, 1899, *12289*
General Society of Mechanics and Tradesmen See: **New York. General Society of Mechanics and Tradesmen of the City of New York**
general stores
 England, *21170*
General Theological Seminary, New York See: **New York. General Theological Seminary of the Protestant Episcopal Church in the United States**
Geneva (Switzerland)
 exhibitions
 1854, *21373*
 1859, *20113*
 monuments

German drawing See: drawing, German
German illustration See: illustration, German
German industrial arts See: industrial design, German
German Institute for Archaeology at Rome See: Rome.
 Archäologisches Institut des Deutschen Reichs
German literature
 importance for American morality, *19613*
 model for American art, *19571*
 publications, 1858, *18206*
 translating, Goethe's *Faust*, *19603*
German lithography See: lithography, German
German metal work See: metal work, German
German mural painting See: mural painting and decoration,
 German
German national characteristics See: national characteris-
 tics, German
German painting See: painting, German
German pottery See: porcelain and pottery, German
German wood carving See: wood carving, German
German wood engraving See: wood engraving, German
Germans
 United States, 1858, *19921*
Germantown (Pennsylvania)
 monuments, monument to battle of Germantown designed by
 Frank Miles Day, *13819*
Germany
 antiquities
 mosaic discovered at Treves, 1895, *16894*
 Roman ruins discovered by Dr. Kofler, 1891, *26236*
 drawing in German public schools, 1895, *5405*
 F. S. Lamb's impressions of German cities, 1903, *8264*
 German Government Building at World's Fair, Chicago, 1893,
 4524
 heads world production of artificial coloring materials, 1893,
 4490
Gernie, H. May, fl.1895
 illustrations, "B.O.S.S." alphabet, *22329*
Gérôme, Jean Léon, 1824-1904, *716, 8775, 9044, 21878, 22909*
 After the masquerade, *10072*
 Aigle expirant, *13845*
 annual banquet given by students, 1896, *23625*
 Arnauts playing draughts, *9243*
 autobiography, *16631*
 biography, *16442, 20219*
 bust of Sarah Bernhardt, *17309*
 Call to prayer, acquired by Mark Hopkins Institute, 1898, *6545*
 Chariot race, *8691*
 classical painting, *22969*
 Cleopatra and Caesar, *8774*
 Cleopatra before Caesar, *960*
 Collaboration, *8376*
 commission for Waterloo battle monument, 1903, *13613*
 Consulting the oracle, *10498*
 decline in popularity among collectors, *2542*
 Deep thought, *15377*
 detail in paintings, *17657*
 Diogenes, in Hart-Sherwood collection, *792*
 drawings, *1288*
 Duel after the masquerade, in Walters collection, *1003*
 Duret's criticism, *11668*
 Eastern woman, shown in London, 1878, *9092*
 Egyptian conscripts, in Roberts collection, *979*
 exhibitions
 Carnegie Galleries, 1896, *Tanagra image shop*, *6061*
 Cercle de l'Union Artistique, 1880, *9309*
 Cercle des Mirlitons, 1877, *8828*
 Cercle des Mirlitons, 1878, *8992*
 Chicago World's Fair, 1893, *4467*
 Metropolitan Museum of Art, 1884, *Myezzin's call to prayer*,
 1803
 National Academy of Design, 1859, *20128*
 National Academy of Design, 1898, *17443*
 New York, 1865, *23327*
 New York, 1887, *10814*
 Paris, 1857, *19714*

Paris, 1883, *14869*
Paris, 1884, *1756*
Paris Exposition, 1878, *9034, 21662*
Salon, 1859, *18315, 20060*
Salon, 1874, *11667*
Salon, 1881, *22029*
Salon, 1892, *3991*
Salon, 1895, *5401*
Salon, 1896, *11825*
fraudulent picture at Detroit Art Loan Exhibition, 1883, *24826*
Greeks at prayer, *9431*
Guard-house in Cairo, *9107*
Guardian, in collection of H. C. Gibson, 1891, *3500*
health, 1894, *16628*
home, *2023*
illustrations
 Bath, *7617*
 Conspiracy for the restoration, *7671*
 drapery studies, *4814*
 Eminence grise (studies), *2862*
 Golgotha, *13733*
 Greek and Egyptian playing a game of draughts, *7669*
 Greyhound, *5465*
 Joueuse de boules, *13516, 13985*
 Oedipus, *5402*
 pencil study of the nude, *7615*
 Prayer in a mosque, *13865, 14039*
 sketches, *3728*
 studies of lions and tigers, *4197*
Keeper of the hounds, *2485*
lectures on importance of studying antiquity, *26109*
letter to Schaus on American duties on foreign art, 1884, *25212*
Life and Works of Jean Leon Gerome, published 1892, *26873*
monuments, memorial in Paris planned, 1905, *13900*
notes, 1879, *9122*
nudes, *7611*
O P'ti cien street sign, *8102*
obituary, *13740, 22201*
Oedipus
 on view, New York, 1892, *16022*
 shown in New York, 1893, *16171*
Old clothes dealer, Cairo, *108*
Old mosque at Cairo, in Wolfe collection, *25436*
opinion on mixed-sex life classes, 1890, *3422*
Oriental carpet merchant, in Thorne collection, *22483*
paintings in American collections, *15292*
paintings in Astor collection, *1286, 1368*
paintings in Hilton collection, *793*
paintings in Probasco collection, *2429*
paintings in Stebbins collection, *1171, 2839*
paintings in Stewart collection, *753, 2368, 2408, 10768, 10823,*
 25406
paintings in Walters collection, *1045, 1931*
paintings in Wolfe collection, *832*
paintings of Italian colonization of Abyssinia, *7179*
pictures on view in New York, 1891, *15769*
Pifferari, acquired by H. T. Chapman, jr., 1883, *14865*
polychrome sculpture, *3959, 6278*
 tinted sculpture, *3751*
Quintus Curtius, *25585*
Reception at Versailles of the Prince de Condé by Louis XIV,
 9014
Rembrandt in his studio, *9162*
Republic, on view in Louvre, 1880, *9262*
response to Chanler proposal, 1891, *26348*
sales and prices
 1879, *Keeper of the hounds* in Spencer collection, *678*
 1891, *15676*
 1893, *4317*
 1893, pictures in Knoedler collection, *26928*
 1897, *Egyptian conscripts crossing the desert* in Roberts col-
 lection to be sold, *6092*
 1903, *Eminence grise*, *8124*
 W. J. Loftie's projections on market value, 1890, *3359*
salon pictures at Haseltine's, 1892, *11310*

sculpture, 1892, *26753*
sculptures, *13504*
Serpent charmer
 on exhibit, New York, 1880, *282*
 on view in New York, 1881, *1059*
studio in Paris, *8400*
Sword-dance, on exhibit, New York, 1877, *8834*
Tanagra, *25713*
 polychrome statue, *3310*
tells anecdote of artists' model, 1902, *7992*
whereabouts, 1891, Paris to St. Petersburg, *26315*
Geronimo, *Apache chief*, 1829-1909
portraits, portrait by Elbridge Ayer Burbank, *12774, 12825*
Gerry, Elbridge Thomas, 1837-1927
collection, *15616*
Gerry, Samuel Lancaster, 1813-1891
elected president, Boston Art Club, 1858, *19785*
exhibitions
 Boston Athenaeum, 1861, *20355*
 National Academy of Design, 1858, *19835*
notes
 1857, *19581*
 1871, *10616, 10674*
obituary, *26336*
Over the River, *10708*
Pasture gate, *10646*
pictures, 1861, *20330*
sales and prices, 1858, Boston, *19942*
sketches of North Conway, 1858, *19785*
studio, Boston, 1858, *19955*
whereabouts
 1858, summer quarters, *19891*
 1859, European trip, *20033*
work, 1861, *20343*
Gerspach, Edouard, 1833-1906
Tapisseries Coptes, publication announced, 1890, *15289*
Gerster, Etelka, 1855-1920
ability as songstress, 1884, *1716*
Gervais, Paul Jean Louis, b.1859
exhibitions
 Salon, 1891, *3624*
 Salon, 1895, *5401*
 Salon, 1897, *23809*
illustrations, portrait sketch of Frank Myers Boggs, *1828*
Gervex, Henri, 1852-1929
exhibitions
 Salon, 1879, *9188*
 Salon, 1887, *2432, 10463*
 Société des Pastellistes Français, 1892, *15890*
illustrations, *Portrait of a little girl*, *6294*
painting of coronation of Czar commissioned by French government, 1898, *24047*
receives Cross of St. Anne of the Second Class, 1897, *17312*
teacher of Prince Eugene of Sweden, *25849*
GERVINUS, Georg Gottfried, *19807, 19824, 19885, 19895, 20083, 20097*
Gervinus, Georg Gottfried, 1805-1871
History of German Poetry, excerpt on Jean Paul Richter, *20002, 20020*
Gescheidt, Ludovicus Antonius, 1808-1876
collection, sale, 1891, *15529*
Gesellschaft für vervielfältigende Kunst See: **Vienna (Austria). Gesellschaft für vervielfältigende Kunst**
Geselschap, Friedrich, 1835-1898
decoration of dome of Berlin Zeughas, *9770*
Gesne, Albert de, 1834-1903
illustrations, *Stag at bay*, *1348*
gesso
English gesso work, 1895, *5447*
technique
 for decoration, *3881*
 painting, *10490*
Gest, A. P., *Mrs.*, fl.1894
Angelus (photograph), *22561*
GEST, Joseph Henry, *12754*

Getchell, Edith Loring Peirce, b.1855
exhibitions
 Pennsylvania Academy of the Fine Arts, 1885, *11280*
 Philadelphia, 1883, water colors, *24607*
 Worcester Art Museum, 1902, *13483*
illustrations, *Bit of sunshine* (etching), *22531*
Gettysburg (Pennsylvania)
monuments
 battlefield, 1895, *22765*
 equestrian statue to General Slocum, design competition, 1897, *23240*
 equestrian statues, *17639*
 High Water Mark Monument dedicated, 1892, *26677*
 state monuments dedicated, 1892, *26779*
 statue by E. C. Potter of General Slocum dedicated, 1902, *13503*
 Vermont Veteran Regiment monument, *26617*
Getz, John, 1854?-1928
offers drawings from Duke de Durcal's collection, *15828*
opens art rooms and studio, 1896, *17027*
proposed theater and gallery, *15800*
Gevers, Hélène, fl.1883-1895
female portraits, *22592*
portraits, photograph, *22559*
Geyger, Ernst Moritz, 1861-1941
Spring (after Botticelli), *16556*
Geyling, Rudolf, 1839-1904
Fruitless labor, *21931*
Ghent (Belgium)
exhibitions, 1859, *20103*
Ghent (Belgium). Exposition triennale See: **Ghent (Belgium). Salon**
Ghent (Belgium). Hotel de Ville
history, *21239*
Ghent (Belgium). Musée des beaux-arts
building, new museum building, 1905, *13955*
exhibitions, 1902, inaugural exhibition, *13533*
Ghent (Belgium). Salon
1883, *14870*
 French contributions, *14911*
Ghiberti, Lorenzo, 1378-1455
sculpture, *23298*
Ghil, René, 1862-1925
poem, *8334*
Ghirlandaio, Ridolfo, 1483-1561
exhibitions, Royal Academy, 1882, *9603*
eyeglasses in portraits, *25960*
illustrations, *Ludovica Tornabuoni* (mezzotint by S. Arlent Edwards), *13998*
works in Louvre, *5969*
ghosts
genuineness of ghosts, *23868*
Giacomelli, Hector, 1822-1904
illustrations
 etching, *17890*
 Larks, *5739*
 studies, *5841*
 Titmice, *3305, 4575*
illustrations for Michelet's *The Insect*, *8566*
illustrations for *Song Birds and Seasons*, 1888, *628*
"Raphael of birds", *5544*
Giallina, Angelos, b.1857
exhibitions, London, 1891, *3648*
Giambologna See: **Bologne, Jean de**
Gianinni, Joseph, fl.1856-1860
model for statue of Henry Clay completed, 1860, *24335*
Giannini, O.
illustrations, jardinières, *20508*
Gianoli, Giovanni, 1834-1896
portrait of Napoléon I (after Delaroche), *15380*
Gibb, Benaiah, d.1877
founder of Montreal Art Association, *11171*
Gibb, Robert, 1845-1932
exhibitions
 Royal Academy, 1881, *21997*

gifts
art as Christmas gifts, *24930*
hints for Christmas gifts, 1892, *3863*
Gignoux, Régis François, 1816-1882
Canadian travels, *19564*
exhibitions
Century Club, 1859, *19973*
National Academy of Design, 1857, *19668*
National Academy of Design, 1858, *19857*
New York, 1859, *19978*
New York, 1883, *24905*
forest scene for Lord Ellesmere, *19334*
Fulton fish market in summer and *First snow storm*, *18473*
New Hampshire mountains, in Layton Art Gallery, Milwaukee, *12813*
Niagara by moonlight, *19930, 19979*
Niagara Falls, *13265, 18209, 19875*
shown in St. Louis, 1860, *20302*
notes, 1849, *21381*
pictures in progress, 1855, *18762*
sales and prices
1857, *19752*
1858, Romney collection sale, *19957*
Spring, in the American Art Union Gallery, 1848, *14376, 14400, 14435, 14443, 14452, 14458*
View in the dismal swamp, *19801*
view of Trenton Falls, *19767*
whereabouts
1850, coast of Maine, *14696*
1856, returns to city from country, *19545*
Winter scene, at Century Club festival, 1858, *19783*
Winter view of Niagara Falls, *18380*
work, 1860, *20248*
Gigoux, Jean François, 1806-1894
collection, left to city of Besançon, France, 1895, *16726*
exhibitions, Chicago World's Fair, 1893, *4567*
obituary, *16639*
Gihon, Albert Dakin, b.1866
illustrations
illustration, *6357*
Vanne de Montigny, *13549, 13673*
whereabouts, 1896, bicycle tour abroad, *23056*
Gil, fl.1884
exhibitions, Madrid, 1884, *10067*
Gilardi, Giuseppe, 1846-1924
illustrations, portrait of Louis Kossuth, *4972*
Gilbert
collection, sale, 1880, *788*
Gilbert, A., fl.1853-1888
illustrations
Interior of St. Paul's cathedral during the interment of the Duke of Wellington, November 18, 1852, *20762*
portrait of Antoine-Louis Barye, *3102*
portrait of Philippe Rousseau (after E. Dubufe), *2654*
view of the interior of the Great Industrial Exhibition, Dublin (after J. Mahony), *20897*
Gilbert, Achille Isidore, 1828-1899
La Sortie (after C. Jacque), *10744*
Gilbert, Alfred, 1854-1934
monument to Frank Holl, *26349*
monument to Lord Shaftesbury unveiled, 1893, *26962*
sarcophagus for Duke of Clarence, *26722*
sculpture, 1886, *10357*
statue of John Bright erected in London, 1896, *23008*
statue of Queen Victoria, *26052*
shown at Royal Academy, 1888, *25513*
Victorian sculptor, *10436*
Gilbert, Anne Hartley, 1821-1904
portraits, portrait by C. de Grimm, *20473*
Gilbert, Cass, 1859-1934
designs Art Palaces for Louisiana Purchase Exposition, 1902, *7968*
exhibitions, Chicago Architectural Club, 1899, *12887*
selection in competition for Customs House design, 1899, *7153*

Gilbert, Charles Allan, 1873-1929
illustrator of *Little Minister* by J. M. Barrie, *12808*
Gilbert, Charles Camille, b.1838
illustrations, *Headsman* (after G. Moreau), *2052*
Gilbert, Ellen L., fl.1886
instructor in landscape painting, Boston, 1886, *493*
Gilbert, Emily S. See: **Gibson, Emily Gilbert**
Gilbert, Helen, fl.1906
illustrations, decorative design, *14171*
Gilbert, John, 1817-1897, *21612*
book illustrations, *106*
compared with G. Doré and E. A. Abbey, 1897, *6426*
exhibitions
London, 1897, *6342*
Royal Academy, 1877, *8859*
Royal Academy, 1879, *9189*
illustrations
Bartolomeo, the charlatan, *20936*
Bianca, Giulo, and Jacques, in the boudoir, *20958*
Discovery of the Pacific Ocean, *20939*
Don Juan, *22598*
Dr. Johnson reading the "Vicar of Wakefield", *20734*
Duke of Wellington at Windsor Castle, *20743*
Entrance of Queen Elizabeth into Kenilworth Castle, *20905*
Evening, *21841*
Fruit piece (after G. Lance), *20935*
Henry VIII dismissing Cardinal Wolsey, *21152*
Interior of St. Paul's Cathedral during the interment of the Duke of Wellington, November 18, 1852, *20762*
Interior of the House of Commons, *20729*
King John refusing to sign the Magna Charta at Oxford, in 1215, *20744*
Lorenzo de Medici receiving the exiled Greek philosophers, *20950*
Mrs. Bunyan before the justices, *20831*
My Uncle Toby and Corporal Trim, *21706*
Oliver Goldsmith, *20734*
Queen Elizabeth knighting Drake, *20905*
Scene in the "Dead Bridal", *20787*
William III entering Exeter, *20768*
Wycliffe, attended by the Duke of Lancaster, *20876*
notes, 1893, *16227*
paintings given to Birmingham by artist, 1893, *26933*
paintings given to British nation, 1893, *16223*
pictures given to various English museums, 1893, *26924*
portraits, photograph, *22706*
resigns office of president of Old Water Colour Society, 1886, *10341*
sketches given to Royal Academy, 1891, *26466*
wood-engravings to illustrate Longfellow, 1855, *19303*
Gilbert Martin, Charles, 1839-1905
Don Quichotte, publisher and illustrator, *15703*
Gilbert, Sarah Bascomb, d.1887?
obituary, *611*
Gilbert, Victor Gabriel, 1847-1933
illustrations
Blowing bubbles, *3012*
Waltz, *5236*
Gilbert, William Schwenck, 1836-1911
Broken Hearts, performances, 1886, *2191*
Mikado, mistakes of local color, *2085*
notes, 1896, *22988*
Pirates of Penzance, performances, New York, 1880, *817*
visit to New York with *H.M.S. Pinafore*, 1879, *781*
Gilchrist, Adelaide, fl.1895-1901
teacher of charcoal drawing, Shinnecock Summer School of Art, 1895, *11696*
Gilchrist, Herbert H., fl.1876-1914
picture shown in New York, 1893, *26921*
Gilchrist, William Wallace, 1879-1926
exhibitions
National Academy of Design, 1907, *14311*
Pennsylvania Academy of the Fine Arts, 1906, *14244*
Gildemeister, Charles See: **Gildemeister, Karl**

Man of snow, 20820
Monkey, 20820
Return of the herds, 20837
Sketch of the Sierra Nevada (after E. Giraud), 21213
View of the Mosque el Moyed, 20965
Woman of Cairo smoking, 21183
Village doctor, 20909
Girardet, Paul, 1821-1893
illustrations, *Bulgarians, inhabitants of Turkey in Europe*, 20979
Girardin, Frank J., 1856-1945
exhibitions, Cincinnati Art Club, 1903, purchase prize, 13594
Girardot, Louis Auguste, 1856-1933
Femme du riff, 20488
Giraud, Charles Sebastien, 1819-1892
obituary, 26803
Giraud, Eugène, 1806-1881
illustrations, *Sketch of the Sierra Nevada*, 21213
Giraudat, Edgar, fl.1887-1889
illustration, design for fireplace screen, 2977
girls
description of tomboys, 23596
Girodet Troison, Anne Louis, 1767-1824
portrait of Mlle. Lange, 1312
Giron, Charles, 1850-1914
Deux soeurs, 2559, 20426
shown in New York, 1887, 10814
exhibitions
Salon, 1881, 22038
Salon, 1883, 1568
illustrations
Deux soeurs, 1594
Portrait of a Parisian lady, 20441
Summer, 4480
Two sisters, 20430
Girou de Buzareingues, Louis Adolphe Edouard François, 1805-1891
collection, catalogue, 15434
Giroux, Alphonse
illustrations, Japanese cabinet, 1275
Girsch, Frederick, 1821-1895
obituary, 16912
Girtin, Thomas, 1775-1802
drawings, 9437
drawings bought by South Kensington Museum, 1885, 10161
watercolor painter, 10496
Giuliano, Carlo, d.1895
obituary, 16845
Giulio Romano See: **Romano, Giulio**
Giza (Egypt). Museum See: **Cairo (Egypt). al Mathaf al Misri**
Glackens, Louis M., 1866-1933
illustrations
Ox-tail soup, 22501
Resting, 22508
sketch, 3432
Glackens, William James, 1870-1938
elected to board, Society of Illustrators, 1903, 13604
exhibitions
Carnegie Galleries, 1905, honorable mention, 14016
Pennsylvania Academy of the Fine Arts, 1906, 14244
illustrations
Floral fancy, 22560
On Logan Square, 22508
illustrations in Christmas magazines, 1899, 7182
mural decoration for Pennsylvania Academy of the Fine Arts, 11964
Gladston Lingham
Science of Taste, review, 228
GLADSTONE, William Ewart, 1809-1898, 26077
Gladstone, William Ewart, 1809-1898
lecture, 9219
library, 16911
monuments, statue for Westminster Abbey, 1903, 13605
notes, 1895, 22860

portraits
last drawings from life by A. S. Forrest, 24085
photograph, 22558
Wedgwood, excerpts from an address delivered in 1863, 23340
Glaenzer, Georges A.
exhibitions, Architectural League of New York, 1893, 4304
treasure house collection, 1899, 17516
Glaenzer, Georges A., & Co., New York
furniture reproductions, 1891, 15748
Glaister, Elizabeth
book on needlework, 1880, 922
Needlework, 1028
Glaman, Eugenia Fish, 1873-1956
exhibitions
Chicago Art Students' League, 1898, 12819
Society of Western Artists, 1903, 13698
Society of Western Artists, 1906, 14038
illustrations, *Interior of a stable with swine*, 14263
Glasgow, Daniel, jr., 1834-1858
obituary, 19819
Vermont scenes, 1856, 19545
Glasgow, David See: **Glasgow, Daniel, jr.**
Glasgow (Scotland)
art
Glasgow artists in St. Louis Exposition, 1896, 6011
Glasgow school of painters, 5736, 14152, 22377
Glasgow School of painters, 22394
nude paintings censored, 1894, 4904
promotion of art and music, 1891, 26425
descriptions and views, 9769
exhibitions, 1883, Italian art, 9765
Glasgow (Scotland). Art Gallery and Museum
buildings
fund, 1890, 25772
gallery finished, 1901, 13270
plans for Kelingrove Park, 1892, 26640
collection, 25975
Kelvingrove galleries, 26476
lecture by Patterson on landscape, 1892, 26558
lectures, 1892, 26817
Glasgow (Scotland). Art Union of Glasgow
annual meeting, 1850, 14635
exhibitions, 1856, 19542
system of selecting pictures, 1857, 19714
Glasgow (Scotland). Corporation Galleries of Art See: **Glasgow (Scotland). Art Gallery and Museum**
Glasgow (Scotland). Glasgow Art Club
history, 10346
Glasgow (Scotland). Glasgow Institute of the Fine Arts
annual exhibitions
1879, 21714, 21736
1880, 21848, 21973
1881, 9478
1882, 9622
1883, 14875
1884, 9984
1887, 10431
1891, 26212
1892, 26518
1895, 16799
1901, 13361
1905, 13886
exhibitions
1876, 8630
1880, black-and-white and loan exhibition, 21912
1885, 10139
1892, 26596
Glasgow (Scotland). Glasgow School of Art
exhibitions, 1879, needlework, 760
Glasgow (Scotland). Glasgow Society of Artists
exhibitions, 1903, 13588
founded, 1902, 13436
Glasgow (Scotland). International Exhibition, 1888, 17833
catalogue, review, 25671

Glasgow (Scotland). International Exhibition, 1901
 American photography, *13238*
 buildings, *13128*
 works exhibited used as illustrations for MacColl's *Nineteenth Century Art*, *13539*
Glasgow (Scotland). Royal Infirmary
 exhibitions, 1878, *21651, 21653*
Glasgow (Scotland). Royal Scottish Society of Painters in Water Colours
 annual exhibitions
 1891, *26236, 26441*
 1893, *26976*
 annual luncheon, 1892, *26863*
 formation, 1878, *21651*
 meeting, 1892, *26496*
Glasgow (Scotland). Society of Artists See: Glasgow (Scotland). Glasgow Society of Artists
glass
 annealed, *8485*
 color changes when exposed to light, *6116*
 exhibitions, London, 1889, *25669*
 glass bedstead for Indian nabob, *17848*
 glass pastes used by ancients to imitate gems, *20609*
 kiln for firing, *6244*
 notes, 1888, *17848*
 sales and prices, 1899, Arabic glass, *17505*
 technique for etching, *7737*
glass craft
 antique modelling process with glass paste, *5187*
 glass carving as an art, *10232*
 smoke pictures, technique, *3040*
 technique
 firing, *5011, 6126, 8298*
 staining table glass, *6125*
 works by Union Glass Co., Somerville, Mass., *12998*
Glass, James William, 1825-1855
 Don Quixote, in progress, 1850, *14606*
 Gov. Winthrop, Charles II and the pine-tree shilling, in the American Art Union Gallery, 1848, *14345, 14352, 14360, 14368, 14376, 14384, 14392, 14400, 14407, 14413, 14419, 14427, 14435, 14443, 14452, 14458*
 illustrations
 Standard bearer, *14601*
 Standard in danger, *14601*
 notes, 1850, *14680*
 obituary, *19310, 19357*
 paintings, 1849, *14524, 14590*
 paintings in American Art Union Gallery, 1848, *14445*
 whereabouts, 1850, England, *14696*
glass manufacture
 decorative glassware, *778*
 Gaffield library, *16915*
 use of lead, *25669*
glass, ornamental
 Blaschka glass flowers, *16387*
 exhibitions, New York, 1890, *3227*
 glass for architectural decoration, *13025*
 illustrations, transom in white leaded glass by Redding, Baird and co., *12998*
 technique, etching and embossing an ornamental window, *8224*
glass painting, *11484*
 13th century stained glass, *1303*
 canons for stained glass workers by C. Coleman., *22342*
 colored glass for the home, *1157*
 decorative use, *1907*
 exhibitions
 Architectural League of New York, 1894, stained glass designs, *4787*
 Architecural League of New York, 1897, stained glass, *6237*
 Chicago World's Fair, 1893, *4827*
 New York, 1893, women's stained glass, *4379*
 Pedestal Fund Loan Exhibition, 1883-4, *1705*
 F. S. Lamb on stained glass in Europe, 1903, *8264*
 floral designs and figures, *503*
 glass shapes available in shops, 1895, *5605*

Heinigke and Bowen's stained glass, 1900, *7204*
history, *20496*
 and technique of stained glass, *6594*
 stained glass, *7679*
inexpensive stained glass for domestic architecture, 1892, *3911*
influence of stained glass on poster design, *5448*
modern stained glass inferior to old, *26970*
modern stained glass windows, *14202*
mosaic glass, *22383*
notes
 1887, *17777*
 1892, *4222*
 1894, *4829, 4967*
 1895, *5294*
 1898, *6581*
poster art glass, *12304*
roles of designers and mechanics who execute stained glass designs, *3196*
Ruskin's ideas, *18910*
stained glass in Architectural League exhibition, 1898, *6571*
stained glass suggestions for private houses, 1896, *5717*
substitute for fire-screens, *667*
tariff on imports to United States, *3055*
technique, *795, 4253, 4372, 4408, 4442, 4506, 4861, 5012, 5553, 5874, 5992, 6169, 6235, 6446, 6627, 9458, 11536, 11757, 11784, 21619*
 advice to amateurs, *11701*
 decorating table glass, *4331*
 excerpts from H. P. Sancré's *Designing and Painting with Vitrifiable Colors on Glass*, *5283*
 firing, *6512*
 firing and raised paste, *6480*
 firing decorated glass, 1890, *3449*
 flexible lead for stained glass windows, *8169*
 for amateurs, *4618*
 for windows, *25995*
 gilding, *8295*
 heraldic decoration for beer stein, *5846*
 mixing colors and choosing brushes, *8025*
 painting glass holding flowers, *8188*
 painting with enamels, *6578*
 Sancré's *Designing and Painting with Vitrifiable Colors on Glass*, *5238*
 sketching the design, *6605*
 stained glass for the home, *6296*
 transparencies for home decoration, *4724*
 use of color, *6539*
 vitrifiable colors, *5190, 5237*
 yellow stain and flash glass, *6748*
use in private houses and public buildings, *1971*
window designs, *1133*
windows without bars, *1260*
women's work in stained glass exhibited at Chicago World's Fair, 1893, *4631*
glass painting, American, *339, 365*
 American stained glass, *3299*
 Chicago artists, *11762*
 design for window of St. Paul's Methodist Episcopal church, New York, 1892, *26507*
 designs by John LaFarge, *1579*
 exhibitions
 Boston Society of Arts and Crafts, 1907, *14267*
 Chicago, World's Columbian Exposition, 1893, *16316*
 Paris, Exposition universelle, 1900, *13066*
 Philadelphia Exhibition of American Art Industry, 1889, *3093*
 Tiffany Glass Company, 1890, *3217*
 Tiffany's, 1893, stained glass windows, *4593*
 Francis Lathrop's window wins medal, 1889, *25694*
 Grand Pacific Hotel's breakfast window, decorations for Wayne Hotel, *20503*
 mosaic glass, *486*
 mosaic technique, *11865*
 notes, 1886, *502*
 stained glass to be used in Louvre cupolas, 1890, *3393*

1870, *10567*
1871, *10620*
whereabouts, 1871, Munich, *10680*
Gordigiani, Eduardo, 1866-1961
exhibitions, National Academy of Design, 1900, *12997*
portrait of Duse, *23008*
Gordon, Archibald D., 1835-1895
obituary, *16650*
GORDON CUMMING, Constance Frederica, *9566*
Gordon Cumming, Roualeyn George, 1820-1866
Lion-slayer at Home, review, *19090*
GORDON, Forrester, *20666, 20680, 20721*
Gordon, Frederick Charles, 1856-1924
exhibitions, Cincinnati Art Museum, 1898, *12754*
illustrations
Italian type, *22486*
Saturday morning's work, *22576*
View from my window, *22805*
Watching the game, *22513*
Gordon, Henry C., b.1835
medium, manifestations of spirits, *20705*
Gordon, John Sloan, 1868-1940
illustrations
advertisement for Brentano's, *23649, 23667, 23690, 23712,*
23731, 23772, 23794, 23813, 23834, 23855, 23876, 23894,
24000, 24051, 24071, 24098, 24118, 24158
After the service, *24232*
decorative initial, *24165, 24190, 24214, 24220*
decorative landscape, *23682*
illustrations of Bal des Quatre Arts, *23620*
illustrations to story *Told at the Club*, *23661*
Return of Tannhauser, *23624*
whereabouts, 1897, returns to Hamilton, Canada, from France,
23728
Gordon, John Watson See: **Watson Gordon, John**
Gordon, Robert James, fl.1871-1893
whereabouts, 1884, New York, *25132*
Gore, Christopher, 1758-1827
portraits, commemorative bust planned, 1858, *18243*
Gorgas, Lewis H.
collection, family relics, *16119*
Gorges Society See: **Portland (Maine). Gorges Society**
Gorham Manufacturing Company
Bryant vase, *8436*
casting jobs, 1891, *26375*
exhibitions
1891, sculpture, *26396*
Chicago World's Fair, 1893, *4390, 4510, 26985*
Turin Esposizione, 1902, gold medal, *13618*
illustrations, silverware, *13376*
issuing of Columbian medal delayed, 1892, *26862*
memorial tablet for Bishop Loughlin, 1892, *26685*
memorial tablet for Henry Ward Beecher, 1892, *26721*
showroom wares, 1892, *4135*
silver art-work, *8564*
souvenir ring for World's Fair, Chicago, 1893, *26946*
statue of Roman sentinel for the Belgravia, New York, 1892,
26686
success at the Paris Centennial Exhibition, 1889, *3055*
Gormley, Anna, fl.1894-1907
illustrations
Down the ravine, *22537*
M. E. Dignam's home, *22571*
Gorski, Belle Silveira, b.1877
exhibitions, Chicago Art Students' League, 1897, *12643*
illustrations, pencil sketch, *12720*
Gorsuch, Marie T. See: **Hart, Marie Theresa Gorsuch**
Gorton, Elmer E.
Teco pottery, *13360*
GOSHORN, Laura K., *17834*
Goslar (Germany). Kaiserhaus, *9668*
Goss, Nathaniel Stickney, 1826-1891
collection, birds of North America, *15612*
Gossaert, Jan See: **Mabuse (Jan Gossaert)**
GOSSE, Edmund William, *21992, 22004*

Gosse, Edmund William, 1849-1928
Critical Kit Kats, review, *23200*
library, *16556*
quote
comments on Boston architecture, 1885, *1935*
remarks on American architecture, 1885, *25240*
Gosset de Guines, Louis Alexandre See: **Gill, André**
Gotch, Thomas Cooper, 1854-1931
Awakening, at Royal Academy, 1898, *24090*
exhibitions, Carnegie Galleries, 1905, *14016*
GOTHAM, *2505*
Gotham Art Students See: **New York. Gotham Art Students**
Gothenburg (Sweden)
art, *22419*
Gothic revival
American interiors, *3819*
England, *23272*
principles of Gothic revival, *23315*
Gottschalk, Louis Gaston, b.1849
director of Gottschalk Lyric School, *11651*
Gottschalk Lyric School See: **Chicago (Illinois). Gottschalk
Lyric School**
Gottwald, Frederick Carl, 1860-1941
exhibitions
Cleveland Art Association, 1895, *11470*
Cleveland Brush and Palette Club, 1899, *17607*
National Academy of Design, 1898, *Life in Dordrecht*, *6616*
Götzenberger, Jakob, 1800-1866
allegorical frescoes, *18712*
change in English works, *19381*
gouache painting
technique, *3367, 4056, 4149*
Goubie, Jean Richard, 1842-1899
painting at Reichard's, New York, 1884, *25195*
Postillion, *9001*
Goucher, John Franklin, 1845-1922
collection, Chinese coins, *16114*
Goudy, Frederic William, 1865-1947
teacher at School of Illustration, Chicago, *12964*
Gouffier, Hélène de Hangest, d.1537
pottery and Faience d'Orion, *6411*
Gough, John Bartholomew, 1817-1886
early life, *21011*
Goujon, Jean, d.1567?
illustrations
figure designs for furniture panels, *1762*
Huntress Diana, *1175*
wood-carving, *17831*
Gould, George Jay, 1864-1923
collection, *15616*
acquisitions, 1900, *7427*
English paintings acquired at Paris Exposition, 1900, *13128*
residence and collection destroyed by fire, 1903, *8124*
Gould, Helen Miller, b.1868
refuses to help American artists in Paris, 1907, *14275*
Gould, Jay, 1836-1892
collection, *16061, 16786*
acquires Bonheur cattle piece, 1883, *14882*
orchids, *15616*
paintings in Carnegie Institute annual exhibition, 1902,
13520
History of Delaware County, New York, *15897*
library, catalogue, *15475*
Gould, Joseph J., jr., ca.1880-ca.1935
exhibitions, New York, 1902, *13334*
posters, *12612*
Lippincott Magazine, *12867*
Gould, S. Baring See: **Baring Gould, Sabine**
Gould, Theodore A., fl.1846-1857
whereabouts, 1851, Florence, *14779*
Gould, Thomas Ridgeway, 1818-1881
Cleopatra, *10640*
notes, 1860, *20284*
obituary, *9601*
portrait-busts, 1871, *10708*

whereabouts
 1851, *14808*
 1851, England, *14779*
 1857, *19682*
 1858, summer quarters, *19891*
GRAY, J. M., *9462, 9711, 10040*
Gray, J. M.
 on Smibert and Brydells' *Art in Scotland*, *25726*
GRAY, Philip, *23790*
Gray, R. D., fl.1895-1910
 exhibitions, 1895, screen pictures in colors from photos of
 Yosemite, *5262*
Gray, Thomas, 1716-1771
 Elegy Written in a Country Churchyard
 illustrated by Mr. Murphy, *9938*
 original version of 19th stanza, *18235*
 plagiarism alleged, *17949*
 portraits, bust by Thornycroft unveiled at Cambridge, 1885,
 10188
GRAY, Walter Ellsworth, *13344, 13360, 13373, 13391*
GRAYSON, Clifford Prevost, 1857-1951, *25026, 25082*
Grayson, Clifford Prevost, 1857-1951
 Bereft, purchased by Philadelphia Art Club, 1891, *3454*
 Calling the ferryman, *24829*
 exhibitions
 Boston Art Club, 1890, *25730*
 Chicago Inter-State Industrial Exposition, 1889, *3056*
 National Academy of Design, 1888, *2843*
 National Academy of Design, 1889, *3101*
 Pennsylvania Academy of the Fine Arts, 1882, *1450*
 Prize Fund Exhibition, 1886, *2226, 25304*
 Prize Fund Exhibition, 1886, prize, *25304*
 Salon, 1884, *25132*
 Salon, 1889, *2985*
 illustrations, *Fishing boats coming in - Pt. Kabellon in distance*,
 24932
 Market day, Brittany, *25007*
 shown in New York, 1884, *24995*
 member of art jury, Tennessee Centennial, 1896, *11843*
 Rainy day - Pont Aven
 selected for Chicago Exposition, 1883, *24725*
 sold at Chicago Exposition, 1883, *24829*
 studio at Concarneau, 1883, *24702*
 whereabouts
 1883, Concarneau, *24703, 24736*
 1883, summer at Concarneau, *24819*
 1895, summer in Corsica, *22738*
 writes letter on art tariff, 1884, *25021*
GRAYSON, F. W., *24782, 24921, 25068, 25114, 25127, 25202*
Grayson Smith, Millicent, fl.1894
 illustrations, Shaftesbury sketches, *22537*
Gréard, Octave, 1818-1904
 Meissonier: His Life and His Art, publication notice, 1896,
 17154
Great Britain
 history
 17th century, Covenanters, *21133*
 civil war, 1642-1649, Battle of Edge Hill, *20999*
 house of Warwick, *21235*
 princes and princesses, murder of the princes in the tower,
 21275
Great Britain. Navy
 trophies exhibited, 1891, *15644*
Great Britain. Parliament
 House of Lords inquiry into use of Chantry trust, 1904, *13810*
 oratory, *21287, 21309, 21325*
Great Britain. Royal Commission on Technical Instruction
 report, 1884, *10054*
Great Exhibition, London, 1851 See: **London (England).**
 Great Exhibition of the Works of Industry of All Nations,
 1851
Greatbach, Daniel, fl.1839-1866
 pottery, *11828*
Greatbach, George, fl.1846-1870
 illustrations

Feeding-time (after A. Paoletti), *9353*
 Gold (after A. H. Tourrier), *8484*
Greatbach, Joseph, fl.1877-1882
 illustrations
 Guests (after Baron Leys), *9454*
 Reverie (after Delobbe), *9323*
 Student in disgrace (after J. Burgess), *9629*
 Volumnia reproaching Brutus and Sicinius (after J. D.
 Linton), *8827*
Greatbach, William, b.1802
 illustrations
 Between school hours (after C. E. Perugini), *8757*
 Experimental gunnery (after H. S. Marks), *9485*
 Intercepted dispatches (after J. S. Lucas), *9696*
 Judgment of Wouter van Twiller (after G. Boughton), *8947*
 Last voyage of Henry Hudson (after J. Collier), *10470*
 Rabbit on the wall (after D. Wilkie), *8959*
 Riven shield (after P. R. Morris), *8523*
 Samson (after E. Armitage), *9134*
 Turkish school (after J. F. Lewis), *9057*
 Visitation (after E. S. T. Butler), *9676*
 Wooing of Henry V (after W. F. Yeames), *8745*
Greater America Exposition, 1899 See: **Omaha (Nebraska).**
 Greater America Exposition, 1899
Greatorex, Eleanor, 1854-1897, *2038*
 American woman painter, *11230*
 December roses, in Clarke collection, *24943*
 exhibitions
 Brooklyn Art Association, 1884, watercolor, *25092*
 National Academy of Design, 1885, *1970, 25271*
 New York Etching Club, 1888, *10843*
 Paris, 1902, *13372*
 Society of American Artists, 1882, *1349*
 Society of American Artists, 1884, *1802, 11003*
 illustrations, *New book*, *22501*
 illustrations for *Godey's Magazine*, 1892-1893, *22473, 22490*
 magazine illustrations, 1893, *22482*
 studio reception, 1884, *25079*
 work, 1884, *24995*
GREATOREX, Eliza Pratt, *24358*
Greatorex, Eliza Pratt, 1820-1897
 etchings, *340*
 Old New York, 1883, *24551*
 exhibitions
 Artists' Fund Society, 1884, *24967*
 New York, 1859, *19978*
 lady artist of New York, 1880, *915*
 obituary, *6243, 17241*
 Souvenirs of 1876, folio of etchings, *8777*
 whereabouts, 1883, *24817*
Greatorex, Elizabeth Eleanor See: **Greatorex, Eleanor**
Greatorex, Henry M., *Mrs.* See: **Greatorex, Eliza Pratt**
Greatorex, Kate See: **Greatorex, Kathleen Honora**
Greatorex, Kathleen Honora, 1851-1913, *2038*
 American woman painter, *11230*
 exhibitions
 American Art Association, 1885, *2085*
 American Watercolor Society, 1883, *1510*
 American Watercolor Society, 1884, *1736*
 American Watercolor Society, 1885, *1933*
 American Watercolor Society, 1887, *2384*
 American Watercolor Society, 1888, *2641, 10843*
 London, 1883, American Water-Color Exhibition, *24713*
 Paris, 1902, *13372*
 Society of Painters in Pastel, 1884, *25089*
 Woman's Art Club of New York, 1895, *5260*
 illustrations
 Group of models, *22473*
 Incense, *1731*
 studio reception, 1884, *25079*
 summer sketch class, 1883, *24551*
 work, 1883-4, *24995*
Grébaut, Eugène, 1846-1915
 Musée Egyptien, review, *26098*
 work on Egypt reprinted, 1890, *26177*

National Academy of Design, 1855, *18705, 18754*
National Academy of Design, 1857, *19668*
National Academy of Design, 1858, *19857*
National Academy of Design, 1859, *20030*
New York, 1859, *19978*
New York artists' reception, 1858, *19800, 19817*
Pennsylvania Academy of the Fine Arts, 1858, *19858*
obituary, *18*
painting, 1855, *18596*
Greene, Gertrude, fl.1894
woman illustrator, *22525*
GREENE, Lilian, 1856-1940, *10909*
Greene, Lilian, 1856-1940
exhibitions, Boston Art Students' Association, 1884, *10898*
illustrations
Achilles and Penthesilea, *10849*
Richmond architecture, *10863*
Washerwomen of Brittany, *7075*
Greene, Mary Shepard See: **Blumenschein, Mary Shepard Greene**
Greene, N. B., fl.1891
illustrations, figure drawing, *3706*
GREENE, T. Whitcombe, *21682, 21748, 21801*
Greener, Richard Theodore, 1844-1922
lectures for benefit of Grant Monument Fund, 1891, *26226*
GREENFIELD, Dora, *8542*
GREENLEAF, Edward H., *10839, 25460*
Greenleaf, Edward H.
acting director of the Museum of Fine Arts, Boston, 1890, *26071*
Greenleaf, Grace, fl.1905
bookplate designs, *13946*
Greenleaf, James Leal, 1857-1933
landscape architect, *12887*
Greenleaf, Janet, fl.1898
illustrations, figure done in modeling class, 1898, *12736*
Greenleaf, May, fl.1905
bookplate designs, *13946*
GREENLEE, Lennie, *22631, 22679, 22696*
Greenough, Gordon, d.1880
obituary, *238*
GREENOUGH, Horatio, 1805-1852, *18621, 18697, 18747, 18778, 18829, 19047, 19095*
Greenough, Horatio, 1805-1852, *17994*
biography, *20159*
excerpt from Emerson's *English Traits*, *23342*
bronze bas reliefs, *19819*
excerpt from Emerson, *19520*
exhibitions, Boston Athenaeum, 1857, *19767*
group for the Capitol, *14487, 14731, 14834, 23443*
letter from Italy on Greenough, 1851, *14794*
library, sale, 1895, *16738*
Pioneer, *14779*
sculptures left to Boston Museum by wife, 1892, *26703*
statue of America, *18282*
statue of George Washington
and Capitol group, *19263*
criticized by W. Stillman, *18395*
for Washington, D.C., Rotunda, *4560*
suggestion that a protective temple be placed over, 1893, *4640*
tribute, 1856, *19333*
whereabouts
1851, arrives in Boston, *23468*
1851, on tour in Switzerland, *14821*
work in Washington, D.C., *18319*
works in progress, Florence, 1849, *14590*
works in progress, Florence, 1850, *14606*
Greenough, Richard Saltonstall, 1819-1904
Benjamin Franklin, *18680, 18692, 18705, 19033, 19931*
casting, *18560*
inaugurated in Boston, 1856, *19520*
praised by W. Stillman, *18395*
exhibitions, Salon, 1859, *18315*
notes

1860, *20237*
1871, *10674*
obituary, *13752*
sculpture, Paris, 1858, *19912*
statue of Governor Winthrop
in progress, Paris, 1856, *19407*
to be duplicated for Boston, 1879, *33*
will soon leave Florence for U.S., 1858, *19801*
work begun, 1855, *18880*
statuette of old Indian, *20080*
whereabouts
1851, Rome, *14763*
1860, Paris, *20270*
Greenough, Walter Conant, 1855-1898
exhibitions, New York, 1890, opalescent glass, sketches and cartoons, *25940*
Greenway, Kate See: **Greenaway, Kate**
Greenwich (Connecticut)
Cos Cob Summer School of Art, 1895, *5556*
Greenwich Village See: **New York. Greenwich Village**
Greenwood Cemetery, Brooklyn See: **New York. Greenwood Cemetery**
Greenwood, Grace, *pseud*. See: **Lippincott, Sara Clarke**
Greenwood, Joseph H., 1857-1927
Bit of nature, *22945*
exhibitions, Worcester Art Museum, 1902, *13483*
notes, 1899, *12348*
summer home and studio, *22571*
Greer, Blanche, b.1883
prizes, 1907, *Woman's Home Companion* competition, fourth prize, *14300*
Greer, Charles H., d.1916
elected permanent salesman of National Academy of Design, 1893, *16222*
GREER, H. H., *13386, 13728*
greeting cards
methods of display, *837*
Prang's holiday cards, 1883-4, *1694*
Prang's holiday cards, 1884, *1751*
season of salutation cards, *1469*
Greey, Edward, 1835-1888
collection
sale, 1889, *631*
sale, 1890, *15100*
GREG, Thomas Tylston, *9545, 10209, 10320*
GREGAN, John Edgar, 1813-1865, *649*
Gregg, J. H., fl.1871
Log-cabin, reproduced by Prang in chromo, 1871, *23606*
GREGO, Joseph, 1843-1908, *16718*
Grego, Joseph, 1843-1908
publishes reproductions of early English prints, 1895, *16678*
Rowlandson the Caricaturist, review, *9342*
Gregory, Anna M., fl.1871-1878
New-England school-house, reproduced by Prang in chromo, 1871, *23606*
Gregory, Anne See: **Ritter, Anne Louise Gregory**
Gregory, Charles, 1849-1920
illustrations
Dole, *21704*
Folklore, *21613*
Weal and woe, *9607*
Gregory, Edward John, 1850-1909
exhibitions
Grosvenor Gallery, 1878, *21604*
Grosvenor Gallery, 1879, *21708*
Grosvenor Gallery, 1881, *22013*
Grosvenor Gallery, 1883, *9828*
Royal Academy, 1879, *21708*
Royal Institute of Painters in Water Colours, *9820*
illustrations, *Dawn*, *21610*
Gregory, Eliot, 1854-1915
exhibitions, National Academy of Design, 1887, *10831*
Model, *22945*
Page, *9256*

views of C. Haag's studio, *9756*
views of Glasgow (after C. J. Lauder), *9769*
views of Richmond Park, London, *9799*
views of Warkworth, *9862*
Griffiths, John, *Rev.*
 collection
 sale, 1883, *14894*
 sale of old prints, 1883, *14886*
Griggs, Samuel W., 1827-1898
 exhibitions, Boston Athenaeum, 1861, *20355*
 Nahant scenery, 1861, *20330*
 notes, 1871, *10616*
 Off the rocks at Neponset, in Boston, 1858, *19785*
 sales and prices, 1858, Boston, *19819*
 visit to Lake George, 1858, *19859*
 work, 1861, *20343*
Grillon, Albert Fulgence, b.1851
 illustrations, *Walnut trees in winter, 5227*
GRILLPARZER, Franz, *24283*
Grimm, Constantin de, 1845-1898
 illustrations
 After-dinner talker, 20484
 Debutante, 20428
 Illustrated, 20462
 illustrations of Daly and his theater, *20473*
 Prince, 20410
 World famed, 20445
 newspaper illustration, *22504*
 portraits, photograph, *22580*
 Prayer, 22741
Grimm, Herman Friedrich, 1828-1901
 Life of Michael Angelo, review, *11947*
 Life of Raphael, review, *2927*
Grimm, Jacob, 1785-1863
 Household Stories, pictures by Walter Crane, *9730*
Grimmer, Abel, ca.1570-1619
 decorative designs found in paintings, *10367*
Grimou, Alexis, 1678-1733
 exhibitions, Lotos Club, 1895, *16713*
Grimthorpe, Edmund Beckett, *1st baron,* 1816-1905
 lectures on church building, *19828*
 speech on architects, *1469*
Grindle, Elsie
 seance at house, *20713*
Grinnell, Arthur G., fl.1886-1907
 class in wood-carving, Boston, 1886, *493*
Grinnell, William Milne, d.1920?
 design of bridge and tower for Milford, Conn, *25651*
Griset, Ernest Henry, 1844-1907
 illustrations, *Sleeping lion, 1504*
 illustrations for *Aesop's Fables, 8656*
Grison, Adolphe François, 1845-1914
 biographical note, *16510*
 illustrations, *Market day at Vitr&ea, 1807*
Griswold, Casimir Clayton, 1834-1918
 exhibitions
 National Academy of Design, 1864, *23313*
 National Academy of Design, 1865, *23331*
 notes
 1860, *18417*
 1871, *10731*
Griswold, Julia Widgery, fl.1878-1886
 exhibitions, Artists' Fund Society, 1884, *24967*
Griswold, Mariana See: **Van Rensselaer, Mariana Griswold**
Griswold, Rufus Wilmot, 1815-1857
 amending of *Red hunters* by M. V. Fuller, *18235*
Grivaz, Eugène, 1852-1915
 exhibitions
 Grolier Club, 1892, illustrations for *Life of Peg Woffington,*
 26480
 New York, 1892, illustrations, *15800*
 illustrations and watercolors, *15495*
 illustrations to *Peg Woffington, 15828*
 whereabouts, 1895, returns to New York, *16726*
Grivaz, Eugène, *Mme* See: **Grivaz, Marie**

Grivaz, Marie, fl.1892
 notes, 1892, *15828*
Grivolas, Antoine, 1843-1902
 illustrations, *Chrysanthemums, 4535*
Grob, Konrad, 1828-1904
 Bird-trap, 9229
Groiseilliez, Marcelin de, 1837-1880
 obituary, *83*
Grolier Club See: **New York. Grolier Club**
Grolier, Jean, *vicomte* d'Aguisy, 1479-1565, *20402*
 bookbindings, *10797, 12989*
 collector of bookbindings, *3170*
 Du Bois' *Jean Grolier, Some Account of his Life and Famous*
 Library, published, 1892, *15910*
 library, Beatus Rhenanus' *Rerum Germanicarum* offered, 1891,
 15501
GROLIERITE, The, *20402, 20453*
Groll, Albert Lorey, 1866-1952, *14165*
 exhibitions
 American Watercolor Society, 1902, *13424*
 Corcoran Art Gallery, 1907, *14282*
 National Academy of Design, 1907, *14266, 14311*
 Pennsylvania Academy of the Fine Arts, 1906, award, *14077*
 Salmagundi Club, 1904, Shaw prize, *13739*
 illustrations
 Evening hour, 13842
 Harmony in gold, 14099
 landscape painter, *13500*
 notes, 1906, *14071*
 Salmagundi mug painting, 1907, *14319*
 work, 1901, *13218*
Groll, George C., fl.1894-1896
 Boatman's daughter, 22916
 illustrations, *Along the docks, 22567*
 member, Cleveland Water Color Society, *22591*
Grolleron, Paul Louis Narcisse, 1848-1901
 exhibitions, New York, 1891, *15760*
 illustrations, *Soldier's meal, 20441*
Groom, Emily Parker, 1876-1975
 exhibitions, Chicago Art Students' League, 1897, *12643*
Gropius, Martin Philipp, 1824-1880
 obituary, *314*
Gros, Antoine Jean, *baron,* 1771-1835, *10511*
 classical painting, *22969*
Gross, Alice Martha Murphy See: **Murphy, Alice Martha**
Gross, August, *colonel,* fl.1891-1893
 dealer visits editor of *Art Amateur,* 1891, *3623*
 dealer's libel suit against *Art Amateur,* 1892, *3952*
 dishonest associates dealing art in Milwaukee, 1892, *3895*
 importer of pictures, *15790*
 imports paintings then seized by customs, 1891, *26465*
 notes, 1893, *4387*
 U.S. Treasury inquiry into dealer's evasion of tariffs on works
 of art, 1892, *3831*
Gross, Emilie M., fl.1898
 illustrations, student sketch, *11782*
Gross, Herman W., *Mrs.* See: **Murphy, Alice Martha**
Gross, Richard, 1848-1912
 American Art Club, Munich, 1884, *1834*
 exhibitions
 Internationale Kunstausstellung, Munich, 1883, *1835*
 Society of American Artists, 1879, *9150*
 whereabouts, 1883, Munich, *24650*
Grosse, Theodor Franz, 1829-1891
 obituary, *26427*
Grossmith, Walter Weedon, 1854-1919
 exhibitions, American Art Association, 1886, *2344*
Grosso, Giacomo, 1860-1938
 Last rendezvous, criticized for nudity, 1895, *16767*
Grosvenor Gallery, London See: **London (England).**
 Grosvenor Gallery
grotesque
 in art, *10110, 21945*
 rural architecture, *19254*

H

notes, 1896, *16984*
Hague, William, 1808-1887
 Home Life, review, *18582*
Hahnemann, Samuel, 1755-1843
 monuments
 competition models exhibited, 1895, *5262*
 memorial by C. H. Niehaus and J. F. Harder, *6487*
 role of National Sculpture Society in competition, 1896, *6058*
Hahs, Philip B., 1853-1882
 exhibitions, Philadelphia Society of Artists, 1882, *1270*
 illustrations, *Teaching the mocking bird a tume*, *1300*
Haig, Axel Herman, 1835-1921
 biographical note, *16570*
 etchings, *15620*, *17176*
 Amiens Cathedral, *16480*
 Cefalu Cathedral, *7740*
 exhibitions
 Boston, 1888, *2801*
 Chicago, 1902, *13379*
 New York, 1885, etchings, *11278*
 New York, 1888, *2823*
 New York, 1888, etchings, *25547*
 New York, 1894, cathedrals, *16451*
 illustrations, *Round tower, Windsor Castle* (etching), *10435*
 Old German mill, *9454*
 Old Hanse town (etching), *9788*
 print published, 1892, *15998*
 Return from the festival, Pampeluna (etching), *25474*
 Round tower at Windsor (etching), *10433*
Haigh, Eliza Voorhies, b.1865
 exhibitions, Paris, 1902, *13372*
Haight, Charles Coolidge, 1841-1917
 exhibitions, Architectural League of New York, 1894, *4787*
Haight, R. K.
 collection, gives Crawford's *Flora* to Central Park, 1860, *20248*
HAINES, Elizabeth Halsey, *3904*, *3935*, *3965*, *3998*, *4019*, *4053*, *4084*, *4119*, *4121*, *4155*, *4156*, *4157*, *4205*, *4250*, *4251*, *4299*, *4329*, *4371*
hair
 locks of hair as relics, *16679*
 technique for painting, *5867*, *5915*, *6741*
hairdressing
 art of dressing and being dressed, *8900*
 women's hairstyles affected by increasing art sensitivity, *13004*
Haité, George Charles, 1855-1924
 illustrations
 Cupids and the star, *3119*
 decorative panel, *3802*
 design for tiles, *1278*
 mural panel designs, *13934*
 mural peacock design (wallpaper), *13934*
 Musical cupids, *3202*
 mural decoration, *13449*
HAKE, Alfred Egmont, fl.1878-1897, *21956*
Hake, Otto Eugene, b.1876
 illustrations, design, *14303*
Hakluyt Society See: **London (England). Hakluyt Society**
Hal (Belgium). Notre Dame
 high altar, *20808*
Hald, Frithjof Smith See: **Smith Hald, Frithjof**
Halderman, John A., b.1838
 collection, given to Y.M.C.A. of Leavenworth, Kan., 1892, *26627*
 correspondence loaned to Lotos Club, 1894, *16491*
HALE, Anne Gardner, *18431*
HALE, Edward Everett, *10608*, *10694*
Hale, Edward Everett, 1822-1909, *10660*
 article on the Club of Ten, *10628*
Hale, Edward, *of Haverhill*
 library, sale, 1891, *15494*
Hale, Ellen Day, 1855-1940
 exhibitions
 Bostom Museum of Fine Arts, 1880, *225*
 Boston, 1887, *2346*

Salon, 1883, *1602*
Hale, Frank Gardner, 1876-1945
 exhibitions, Minneapolis Arts and Crafts Society, 1901, *13184*
Hale, John Parker, 1806-1873
 monuments, statue for Concord, N.H., 1892, *26627*, *26686*
 speech on art, 1860, *20195*
Hale, Lillian Westcott, 1881-1963
 exhibitions, Rhode Island School of Design, 1905, *13935*
Hale, Nathan, 1755-1776
 monuments, statue designed by Karl Gebhardt, 1887, *583*
 portraits, bust in East Haddam, Connecticut, *13059*
HALE, Philip Leslie, *22336*, *22403*
Hale, Philip Leslie, 1865-1931
 exhibitions
 American Art Galleries, 1887, *2607*
 Chicago Art Institute, 1907, *14333*
 Copley Society, 1905, *13924*
 New York, 1900, *7204*
 Pennsylvania Academy of the Fine Arts, 1890, *25768*
 Pennsylvania Academy of the Fine Arts, 1906, *14244*
 Salon, 1885, *2000*
 Society of American Artists, 1897, *6250*
 follower of Tarbell, *10521*
 illustrations, autolithograph, *22417*
 letter on study abroad, 1897, *6135*
 mural for Episcopal Church, Portland, Maine, *14161*
Hale, Philip Leslie, *Mrs*. See: **Hale, Lillian Westcott**
Hale, Sarah Josepha Buell, 1788-1879, *17931*
Hale, Susan, 1833-1910
 exhibitions, Boston Art Club, 1881, *1046*
 publishes landscapes for self-instruction in water-color, 1880, *917*
Hale, Walter Stearns, 1869-1917
 exhibitions, Chicago, 1895, *11637*
Halévy, Ludovic, 1834-1908
 Abbé Constantin, illustrations by Madeleine Lemaire, *25538*
Halfnight, Richard William, fl.1878-1907
 Summer time, presented to Sunderland Art Gallery, 1892, *26763*
Halhed, Harriet, d.1933
 illustrations, *In dreamland*, *5677*
Haliburton, Thomas Chandler, 1796-1865
 anniversary celebrated by Haliburton Society, 1896, *17193*
Halifax (Nova Scotia)
 exhibitions, 1887, Art Loan exhibition, *583*
HALKETT, George Roland, *10035*, *21714*, *21736*, *21744*, *21848*, *21872*, *21912*, *21916*, *21936*, *21973*, *21987*, *22059*
HALL, Adelaide Susan, *12040*, *13004*
Hall, Adelaide Susan, b.1857
 leader of Woman's Club, 1895, *11686*
Hall, Alberta, fl.1899-1900
 exhibitions, Chicago Architectural Club, 1899, *12887*
Hall, Anna Maria Fielding, 1800-1881
 obituary, *9467*
HALL, C. E., *13715*
HALL, C. H., *14104*
Hall, C. Winslar, *Mrs*., fl.1885
 exhibitions, Salon, 1885, *2035*
Hall, Chambers, 1786-1855
 obituary, *19133*
Hall, Cyrenius, fl.1873-1884
 whereabouts, 1883, sketching in Manitoba, *24820*
HALL, Daisy Patterson, *12886*, *13118*
HALL, E. E., *2942*
Hall, Edna A., fl.1877-1880
 exhibitions, Boston Art Club, 1880, *878*
HALL, F. A., *3321*, *3347*, *3847*, *4052*
HALL, F. B., *6480*, *6512*
HALL, Fanny E., fl.1888-1897, *3062*, *3106*, *3238*, *3374*, *3406*, *5011*, *6446*, *6539*, *6578*, *6605*, *6630*, *6667*, *6717*, *6832*, *7104*, *7135*
Hall, Fanny E., fl.1888-1897
 advice on china firing, *2994*
 china painter, *5879*
Hall, George Henry, 1825-1913
 April shower, *18771*

Carnegie Galleries, 1902, *13520*
London, 1903, *13602*
New York, 1897, portrait, *6457*
Union League Club of New York, 1891, *3454*
Fool, *21641*
Herrings for sale, *26252*
illustrations
Archers of St. George, *15750*
Bohemian woman, *12184*
Fool, *21567*
Hille Bobbe, *4520*
portrait, *7821*
portrait in Chicago Art Institute, *12651*
Portrait of a gentleman, *13696*
portrait of his son, *6729*
René Descartes, *12205*
notes, 1893, *4560*
painting acquired by Metropolitan Museum, 1893, *22521*
paintings in Art Institute of Chicago, 1894, *5086*
paintings in Marquand collection, 1899, *17662*
paintings in Mniszech collection offered to Metropolitan
Museum, 1905, *14028*
Portrait of a woman, acquired by Boston Museum of Fine Arts,
1902, *13379*
portrait of William van Heythuysen, etched, 1893, *16316*
portrait offered at Durand Ruel Galleries, New York, 1890,
15449
portraits of Beresteyn family
acquired by Louvre, 1885, *10139, 10151*
hung in Louvre, 1885, *10161*
Psalm singer, in Smith collection, *26209*
sales and prices
1883, *Meisje*, to Baroness Rothschild of Frankfort, *14910*
1889, *Man with a cane*, *25618*
1892, *Cavalier*, *26599*
1897, portrait, *17340*
1899, *17600*
work in Hutchinson collection, 1899, *17667*
work in National Gallery, London, 1894, *4941*
Halsall, William Formsby, 1841-1919
exhibitions
Boston Paint and Clay Club, 1884, *25083*
Boston Paint and Clay Club, 1887, *543*
painting of battle between the Monitor and the Merrimac, *2090*
painting of Puritans arriving, *980*
pictures of yachts in demand, 1886, *2304*
studio near Boston, 1883, *24619*
HALSE, George, *10217*
Halsey, Calista See: **Patchin, Calista Halsey**
Halstead, Murat, 1829-1908
notes, 1896, *22964*
Halstead, Richard H. See: **Halsted, Richard Haines**
Halsted, Richard Haines, 1854?-1925
collection
sale, 1886, *10467, 10754, 10763*
sale, 1887, *531, 2364, 25403*
sale, 1895, *5220*
sale of Inness paintings, 1895, *16656, 16678*
sale, with prices, 1887, *2406*
to be sold, 1887, *518*
Van Marcke forgery, *2477*
Van Marcke painting possibly a forgery, *2448, 2504, 2522*
works by Inness contributed to loan exhibition, New York,
1893, *16277*
Halswelle, Keeley, 1832-1891, *9128, 22024*
exhibitions
London, 1884, *9934*
Royal Academy, 1880, *21841*
Royal Academy, 1881, *22013*
Royal Academy, 1884, *10007*
Royal Institute of Painters in Water Colours, *9820*
obituary, *26343*
sales and prices, 1891, *26376*
views of Venice, *8356*
Ham, Alice See: **Brewer, Alice Ham**

Hamann, Carl F., d.1927
illustrations, *Wyoming*, *13684*
Hambidge, Jay, 1867-1924
magazine illustration, 1894, *22517*
magazine illustrations, 1900, *7252*
Hamburg (Germany)
description, *21071*
Hamburg (Germany). Museum für Kunst und Gewerbe
exhibitions, 1902, bogus antiques, *13545*
Hamel, Maurice, b.1856
criticism of American artists in Paris Exposition, 1889, *25660*
Hamerton, Eugénie Gindriez, 1858-1894
Memoirs of Philip Gilbert Hamerton, excerpt and review,
12595
HAMERTON, Philip Gilbert, *1557, 1703*
Hamerton, Philip Gilbert, 1834-1894
advice on management of color, *2807*
Art Essays, review, *346*
as writer-artist, *10806*
biography, *8733*
comments on Stang's etching in *Portfolio*, 1884, *25153*
Contemporary French Painters, review, *13307*
Etcher's Handbook, review, *440*
Etching and Etchers, review, *8095, 8640, 10795, 13505*
etching revival in England, *21634*
Graphic Arts
excerpts on chalk drawing, *1577*
excerpts on charcoal drawing, *1557*
excerpts on pen drawing, *1591*
ideas on art, *8721*
Imagination in Landscape Painting, review, *11835*
Landscape
excerpt on trees, *599*
review, *1975*
Life of Turner, review, *9167*
Man in Art
published, 1892, *26754, 26837*
review, *4307*
Memoirs of Philip Gilbert Hamerton, excerpts and review,
12582, 12595
Mr. Seymour Haden's etchings, excerpts, *939*
obituary, *5115, 16612*
Painting in France after the Decline of Classicism, *13326*
Portfolio Papers, review, *2927*
quote
on absence of line in landscape, 1890, *3435*
on government patronage, *545*
on painting, 1892, *4022*
on rapid oil sketching, *959*
on red chalk drawing, *1638*
on right and wrong in art, 1891, *3678*
on tapestry painting, 1893, *4355*
on tapestry painting aesthetics, 1896, *5881*
on tapestry painting as decoration, 1892, *4161*
on writing as a form of drawing, 1896, *5625*
Hamilton, Alexander, 1757-1804
monuments
statue commissioned by Hamilton Club, Brooklyn, *26932*
statue commissioned by Hamilton Club of Brooklyn, 1892,
26656
relics, watch, *16313*
will, *16915*
Hamilton, Annette Heald, fl.1890's
opens studio in Fresno, 1900, *22099*
HAMILTON, Charles E., *20471*
Hamilton Club, Brooklyn See: **New York. Hamilton Club,
Brooklyn**
Hamilton, E. Lee See: **Lee Hamilton, Eugene**
Hamilton, Edgar Scudder, 1869-1903
illustrations, *Vanity and virtue*, *12787*
Hamilton, Edward Wilbur Dean, 1864-1943
exhibitions
Cincinnati Art Museum, 1898, *12754*
Detroit, 1899, *12314, 12842*
National Academy of Design, 1897, *10540*

New Orleans, 1899, *12842*
illustrations, *Where the tide comes in*, *534*
notes, 1899, *12823*
Hamilton, Emma, *lady,* 1761-1815
model to George Romney, *5571*
notes, 1894, *16577*
Hamilton, Gail, *pseud.* See: **Dodge, Mary Abigail**
HAMILTON, George, *4992*
Hamilton Gordon, George, *4th earl of Aberdeen* See:
Aberdeen, George Hamilton-Gordon, *4th earl of*
Hamilton, Hamilton, 1847-1928
Communiantes (after Breton), *514*, *516*
etching published by Klackner, 1886, *504*
exhibitions
American Art Galleries, 1882, *1297*, *9624*
American Art Union, 1883, *Apple blossoms*, *10913*
American Watercolor Society, 1881, *296*
American Watercolor Society, 1884, *1736*, *25023*
American Watercolor Society, 1885, *25239*
London, 1883, American Water-Color Exhibition, *24713*
National Academy of Design, 1883, *24480*
National Academy of Design, 1884, *Dreamer*, *10982*
National Academy of Design, 1887, *552*, *2431*
New York Etching Club, 1885, *1934*
New York Etching Club, 1887, *2385*
Pennsylvania Academy of the Fine Arts, 1885, *2091*
Philadelphia Society of Artists, 1882, *1270*
Prize Fund Exhibition, 1885, *End of September*, *25278*
Prize Fund Exhibition, 1886, *2226*, *25304*
Prize Fund Exhibition, 1887, *562*
illustrations
study, *17813*
study of a head, *24552*
portrait of Mrs. Nimmo Moran, 1883, *24586*
studio, *22686*
in the Sherwood, N.Y., 1883, *24804*
reception, 1884, *25079*
whereabouts
1883, New Windsor, N.Y, *24728*
1894, summer in Estes Park, *27014*
Hamilton, James, 1819-1878
exhibitions
Chicago Academy of Design, 1871, *10712*
Pennsylvania Academy of the Fine Arts, 1858, *19858*
illustrations, illustration for Willis' *Birth-day Verses*, *18357*
Magic Lake, *10723*
marine paintings in Philadelphia Art-Union, 1849, *21404*
notes
1870, *10596*
1871, *10619*, *10649*
student at Pennsylvania Academy of the Fine Arts, *22508*
studio, 1871, *10717*
whereabouts, 1875, preparing for trip around the world, *8480*
HAMILTON, James, *22458*
Hamilton, James Whitelaw, 1860-1932
exhibitions, St. Louis Exposition, 1895, *11622*
Glasgow School painter, *14152*, *22394*
illustrations
Clyde shipyard, *6011*
Venice, *22377*
Hamilton, Jessie, fl.1902-1925
exhibitions, Society of Western Artists, 1902, *13542*
Hamilton, John McLure, 1853-1936
exhibitions
London, 1884, *1720*
Paris Exposition, 1878, *9072*
Pennsylvania Academy of the Fine Arts, 1877, *8847*
Pennsylvania Academy of the Fine Arts, 1885, *11280*
Pennsylvania Academy of the Fine Arts, 1891, *3535*
Pennsylvania Academy of the Fine Arts, 1894, *4754*
Pennsylvania Academy of the Fine Arts, 1899, *12836*
Pennsylvania Academy of the Fine Arts, 1901, *13163*
Salon, 1892, *3991*
notes, 1897, *6312*
portrait of Gladstone, *26753*

portrait of Mr. Gladstone in Downing Street, *4832*
Hamilton, John R., fl.1860-1870
design of Dusseldorf Gallery, New York, *20330*
HAMILTON, Marion Ethel, b.1881, *22827*, *23042*
Hamilton, *Mr,* fl.1892
statue of Red Jacket for Buffalo unveiled, 1892, *26696*
Hamilton, Norah, b.1873
directs art school, Fort Wayne, 1895-96, *11659*
Hamilton Palace collection See: **Hamilton, William Alexander Louis Stephen Douglas Hamilton,** *12th duke of*
Hamilton, Whitelaw See: **Hamilton, James Whitelaw**
Hamilton, Wilbur Dean, 1864-1943
exhibitions
New York, 1894, competition designs for New York Criminal Court, *4907*
Worcester Art Museum, 1902, *13483*
Hamilton, William Alexander Louis Stephen Douglas Hamilton, *12th duke of,* 1845-1895
collection
sale, London, 1882, *1382*, *1398*, *1416*, *1421*, *1428*, *1439*, *9667*, *9670*, *9677*
vases, *723*, *742*
wine cellar sold, 1897, *17340*
Hamlin, Augustus Choate, 1829-1905
collection, tourmalines, *16905*
Hamman, Edouard, *fils,* b.1880
illustrations
head of a cow, *7431*
Pastureland in Normandy, *4051*
Hamman, Edouard Jean Conrad, 1819-1888
Haydn's inspiration for the Seasons and Creation, in Walker collection, Minneapolis, *12924*
Hammell, A. H., fl.1896
illustrations, *Game after school*, *23152*
Hammer, John J., 1842-1906
exhibitions
Prize Fund Exhibition, 1885, *25278*
Salmagundi Club, 1885, *1916*
hammers
hammer to drive last nail in Women's Building, Chicago World's Fair, 1892, *26745*
HAMMERSMITH, Paul, *22761*
Hammond, Clara See: **Lanza, Clara Hammond**
Hammond, Elizabeth See: **Stickney, Elizabeth Hammond**
Hammond, Henry B., b.1840
library, sale, 1895, *16670*
Hammond, Jane Nye, 1857-1901
exhibitions, American Girls' Club of Paris, 1896-7, *23717*
Hope, *12823*
HAMMOND, Josephine, *23084*, *23141*
Hammond, William Alexander, 1828-1900
collection, bric-a-brac, 1879, *665*
Hamon, Jean Louis, 1821-1874, *436*, *8552*
Aurora, engraved by J. Levasseur, *9010*
classical painting, *22969*
exhibitions, Metropolitan Museum of Art, 1884, *1803*
fan designs, *815*
Feeding the chickens, *9162*
paintings in Wolfe collection, *832*
Hampden, John, 1594-1643
biography, *21056*
Hampton Court
collection
vandalism, 1903, *8124*
vandalism of Holbein's portrait of Henry VIII, 1903, *8161*
destroyed by fire, 1883, *9751*
Hampton (Virginia). Hampton Institute
exhibitions, 1895, students' drawings, *22738*
Hancke, Marie See: **Wiegmann, Marie Elisabeth Hancke**
Hancock, Dorothy Quincy, 1750-1828
model for twelve paintings by R. Pyle, *13036*
Hancock, E. Campbell
Amateur Pottery andd Glass Painter, excerpts, *1009*
Hancock, Ernest LaTouche See: **Hancock, La Touche**

Hancock, John, 1737-1793
 monuments
 portrait statue model by C. E. Dallin for Society of the Sons
 of the Revolution, *12949*
 tomb in Granary to have monument designed by
 Schweinfurth, 1895, *22765*
 tomb, *16792*
Hancock, Joseph Lane, 1864-1925
 exhibitions, Chicago Art Institute, 1900, *13137*
HANCOCK, La Touche, b.1860, *12478*
Hancock, Winfield Scott, 1824-1886
 monuments
 monument unveiled in New York, 1893, *26886*
 statue by H. J. Ellicott unveiled in Washington, 1896, *23008*
 statue for New York, *26923*
hand
 depiction of hands in art, *488*
 drawing technique, *6960, 13009*
 importance of ambidexterity, *8020*
 in painting and photography, *14187*
 painting technique, *7429*
 taking a plaster cast, *3402, 7025*
hand-to-hand fighting
 See also: boxing; lasso
Handel, George Frederic, 1685-1759
 birthplace at Halle, *26844*
 monuments
 statue by H. Heidel, *18282*
 statue, Halle, *18345, 19941*
 oratorios to be performed in London, 1859, *18074*
 rivalries, *648*
handicraft
 artist and artisan, *12163*
 as business, *17848*
 Chicago Arts and Crafts Society organized, 1897, *12638*
 decline due to industrialization, *22289*
 India, *1178*
 societies, goals, *12998*
handkerchiefs
 collectors and collecting
 anecdote, *15331*
 Confederate bandana, *16567, 16599, 16605, 16622, 16629*
Handley, John Montague
 sued for libel by sculptor, 1902, *13828*
HANDY, Frank W., *12171*
Handy, Moses Purnell, 1847-1898
 special commissioner from U.S. to Paris Exposition, 1900,
 12021
Haney, Ella, fl.1895-1909
 exhibitions, Corcoran Art Gallery, 1895, bronze medal, *11591*
Hanford, Emma C. Marshall
 collection
 paintings at Chicago Art Institute recalled, 1901, *13316*
 sale, 1902, *13354*
Hanford, P. C., *Mrs.* See: **Hanford, Emma C. Marshall**
Hanford, Philander C.
 collection, *15811*
 recent acquisitions exhibited at Chicago Art Institute, 1891,
 15656
 sale, 1902, *7822*
Hanfstaengl Fine Art Publishing House See: **New York.**
 Hanfstaengl, Franz, Fine Art Publishing House
Hangest, Hélène de See: **Gouffier, Hélène de Hangest**
Hanks, Henry Garber, 1826-1907
 collection, minerals, *16193*
Hanna, Henry Bathurst, 1839-1914
 collection, Persian and Indian art shown at Dowdeswell's, 1890,
 25951
HANNAY, David, 1853-1934, *10380, 10395, 10414, 10447*
Hanoteau, Hector, 1823-1890
 exhibitions, Salon, 1881, *22038*
 obituary, *25901*
Hanover Club, Brooklyn See: **New York. Hanover Club,**
 Brooklyn
Hanover Gallery, London See: **London (England). Hanover**

Gallery
Hanover (Germany)
 F. S. Lamb's impressions, 1903, *8264*
Hanover (New Hampshire). Dartmouth College
 acquisitions, 1883, portraits, *24716*
Hansbrough, Mary Berri Chapman, fl.1893-1898
 illustrations
 Autumn foliage, *22588*
 Autumn leaves, *22560*
 Lucille, *22501*
 Man of private opinions, *22590*
 models, Negro, *22519*
 portraits, photograph, *22539*
 Washington, D.C., artist, *22587*
 woman painter, *22525*
Hanseatic League
 history, *21108*
Hansen, Carl Frederik, 1841-1907
 illustrations, *Sentenced to death*, *22986*
Hansen, Constantin, 1804-1880
 obituary, *118*
Hansen, Frederick, b.1865, *11950*
 exhibitions
 Chicago Art Institute, 1895, *11673*
 Cosmopolitan Club, Chicago, 1896, *11776*
 National Academy of Design, 1896, *11909*
 illustrations, decorative charcoal sketch, *12252*
Hansen, Herman Wendelborg, 1854-1924
 frontier pictures, 1901, *22134*
Hansen, Theophilus Edvard, *Freiherr* von, 1813-1891
 obituary, *26274, 26282, 26289*
Hansson, Laura Mohr, b.1854
 Six Modern Women, review, *12525*
Hansteen, Christopher, 1784-1873
 Souvenirs of a Journey in Siberia, excerpts, *19060*
Hapgood, Edward T., d.1915
 illustrations, country house design, *4677*
 inexpensive country house, 1895, *5248*
Hapgood, M. P., fl.1879
 Washington monument, project, *23*
Hapgood, Melvin H., 1860-1899
 exhibitions, Architectural League of New York, 1890, *3166*
Hapgood, Theodore Brown, 1871-1938
 illustrations
 cover for *Engraver and Printer*, *12527*
 design and initial for prospectus for Boston Arts and Crafts
 exhibition, *22438*
 initials for *Modern Art*, *22434, 22436, 22442, 22443*
Happersburger, Frank, 1859-1932
 McKinley monument, San Francisco, *22141*
 statue of California for San Francisco City Hall, 1890, *25968*
 whereabouts, 1883, Munich, *24535*
Haquette, Georges Jean Marie, 1854-1906
 exhibitions, Milwaukee Industrial Exposition, 1898, *Pilots*,
 12800
 Fisherman's boat near Dieppe, figure used by G. W. Edwards,
 1987
 illustrations
 Fisherman's return, *7691*
 Heavy haul, *4777*
 His first catch, *4841*
Harang, Guillaume Alphonse See: **Cabasson, Guillaume**
 Alphonse Harang
Harby, Clifton See: **Levy, Clifton Harby**
HARCOLM, Alice M., *13155*
HARCOURT, C. E., *13792*
Harcourt, George, 1868-1948
 exhibitions, Salon, 1897, *23809*
Hardenberg, Friedrich, *Freiherr* von, 1772-1801, *19613*
Hardenbergh, Gerard Rutgers, 1855-1915
 notes, 1883, *24777*
 work, 1883, *24871*
Hardenbergh, Herbert Janeway, 1847-1918
 arch for centennial of Washington's inauguration, *12841*
 building for American Fine Arts Society, *26198, 26206, 26408*

Harder, Julius F., 1866?-1930
 exhibitions, Architectural League of New York, 1889, gold
 medal, *15019*
 illustrations, entrance for a World's Fair, *3514*
 memorial to Hahnemann, *6487*
Hardie, Robert Gordon, 1854-1904
 exhibitions
 National Academy of Design, 1885, *25271*
 National Academy of Design, 1892, *26583*
 National Academy of Design, 1894, *4873*
 portrait of President Eliot of Harvard College, *25950*
 portrait of Proctor commissioned by War Department, 1892,
 26713
 portrait of Washington planned, 1899, *17591*
 whereabouts, 1893, summer, *22491*
Harding, Charlotte See: **Brown, Charlotte Harding**
Harding, Chester, 1792-1866
 autobiography published and edited by daughter Margaret L.
 White, 1890, *26167*
 biography, *20159*
Harding, Duncan, fl.1892
 pictures on view in Brooklyn, 1892, *15934*
Harding, James Duffield, 1798-1863
 re-elected to Old Water-Color Society, 1856, *19512*
HARDING, James S., *2480*
Hardouin Mansart, Jules, 1646-1708
 Saint Louis des Invalides, *20974*
Hardware Club of New York See: **New York. Hardware
 Club of New York**
Hardwick, Melbourne Havelock, 1857-1916
 exhibitions
 Boston, 1899, *12892*
 Philadelphia, 1894, water colors, *26998*
 Philadelphia Water Color Club, 1901, *13215*
 illustrations
 Awaiting the fleet, *12902*
 Cloudy afternoon - North Sea, *14333*
 sales and prices, 1893, watercolors, *26923*
Hardy, Dudley, 1867-1922
 exhibitions, Venice Bienniale d'Arte, 1903, *Moors in Spain* pur-
 chased by Venice Municipal Gallery, *13613*
Hardy, Frederick Daniel, 1826-1911, *8388*
Hardy, Heywood, 1842-1930
 Ulysses ploughing the sea shore, *8727*
Hardy, Leopold Amédée, 1829-1894
 iron and glass building for Paris Exposition, 1878, *21570*
Hardy, Thomas, 1840-1928
 notes, 1896, *22912*
 Tess of the D'Urbervilles, Lorimer Stoddard's production, 1897,
 23222
Hardy, William John, 1857-1919
 Book Plates, excerpts, *5768*
HARE, Augustus John Cuthbert, *10242, 10249, 10266, 10279,
 10288, 10301*
Hare, Thomas Leman, b.1872
 discussion of process of reproduction for illustration, 1895,
 5489
Hargrave, D. Ronald, fl.1902-1915
 illustrations, pen-and-ink sketch, *13445*
Harjes, John Henry, 1830-1914
 gives statue of Franklin to Paris, 1905, *13974*
Harker, George A., fl.1898
 illustrations, student sketch, *11782*
Harland, Marion See: **Terhune, Mary Virginia Hawes**
Harlanoff, fl.1884
 exhibitions, Boston Art Club, 1884, *24992*
Harlem River Bank
 collection, sale, 1895, *16865*
Harley, Charles Richard, b.1864
 illustrations, *Study*, *22508*
HARLEY, Christian, *23178*
Harley, James Kimball, 1828-1889
 portrait paintings, *19875*
 studio in Baltimore, 1858, *19819*

Harley, John, fl.1894
 newspaper illustrations, *16557*
Harley, Joseph S., fl.1857-1882
 illustrations
 from *The Riverside Magazine* (after F. O. C. Darley), *123*
 Last of the harvest (after G. Inness, Jr.), *9317*
 main hall of the Metropolitan Museum (after G. Gibson),
 9337
 May Day in Fifth Avenue (after A. W. Thompson), *9399*
 objects in Metropolitan Museum (after G. Gibson), *9397*
 wallpaper (after G. Gibson), *9251*
 wood engravings, *137*
Harlow, Alfred B., 1857-1927
 See also: **Longfellow, Alden and Harlow, architects**
Harlow, George Henry, 1787-1819
 exhibitions, New York, 1895, portrait of Sir J. Yeo, *16738*
 notes, 1893, *16304*
Harlow, Louis Kinney, 1860-1913
 Glimpse of Schiedam (drawing), *504*
 illustrates *Flotsam and Jetsam* and *The Home of Shakespeare*,
 628
 illustrations for Longfellow's *Daybreak*, 1886, *518*
 illustrations for *The Picuresque Coast of New England*, *592*
 paintings reproduced in chromo by Prang & Co., 1889, *3068*
Harmer, Alexander F., 1856-1925
 studio, Los Angeles, *2701*
Harmon, Anna Lyle, 1855-1930
 work, 1899, *22077*
Harmon, Charles Henry, 1859-1936
 exhibitions, Denver Artists' Club, 1905, *13907*
 whereabouts, 1903, Colorado, *22176*
Harmon, Dorothy, fl.1898
 illustrations, oil from still life, *12756*
HARMON, M. F., *4962, 5016, 5593*
HARMON, N. H., *12310*
Harmonie Club of the City of New York See: **New York.
 Harmonie Club of the City of New York**
harmony, *762*
 lessons, *797, 839, 884, 988*
Harmsworth, J., fl.1861-1879
 illustrations, *Greenwich* (after J. Aumonier), *21997*
Harnett, William Michael, 1848-1892
 exhibitions
 Internationale Kunstausstellung, Munich, 1883, *24693*
 National Academy of Design, 1884, *25187*
 National Academy of Design, 1887, *25437*
 obituary, *16022, 26827*
 sales and prices
 1890, pictures offered, *15373*
 1891, *Emblems of peace*, *15646*
 1893, highest price paid for painting by Bement, *16329*
 still life given to San Francisco Art Association, 1900, *22091*
 still lifes, *16316*
 Trophies of the chase, comment by W. T. Evans, *17573*
Harney, Paul E., b.1850
 illustrations, *Barnyard*, *13958*
 notes, 1871, *10678*
Harnisch, Albert E., b.1843
 statue of John C. Calhoun for Charleston, *82, 540, 566*
Haro, Etienne François, 1827-1897
 collection, sale, 1892, *15921*
Harper & Brothers, publishers, New York
 awards witheld in drawing competition, 1883, *24772*
 competition for Christmas drawing, 1884, *25047*
 notes, 1893, *22476*
Harper, Charles G., 1863-1943
 Drawing for Reproduction, review, *5065*
 *Practical Handbook of Drawing for Modern Method of
 Reproduction*, review, *11440*
Harper, Francis Perego, 1856?-1932
 books offered, 1893, *16127*
 letter to Dingley regarding tariff, 1897, *17319*
 library, Civil War material, *15050*
Harper, J. Abner
 collection

European painting exhibited, 1880, *9310*
exhibited preceding its sale, 1892, *3925*
sale, 1880, *82, 102, 846*
sale, 1892, *15800, 15840, 26516, 26522, 26536*
to be sold, 1892, *3895*

Harper, William A., 1873-1910
exhibitions
Chicago Art Institute, 1902, *13370*
Society of Western Artists, 1906, *14038*
illustrations
Half leafless and dry, 14263
painting, *13190*
painting of female head, 1883, *24502*

Harper, William St. John, 1851-1910
copies after Rembrandt made for Metropolitan Museum's Loan
Exhibition, 1883, *24538*
design for Christmas card competition, 1884, *25206*
exhibitions, National Academy of Design, 1892, *Autumn*
awarded Clarke prize, *3988, 26617*
illustrations, *Suffer little children, 628*
illustrations for editions of the poets, 1883, *24568*
illustrations for *Lay of the Last Minstrel* and for *Fair Ines* 1886,
509
influences, *22520*
models, favorite model, 1894, *22519*

Harpignies, Henri Joseph, 1819-1916
advice to Alexis J. Fournier, *12926*
biographical information, *16442*
exhibitions
Carnegie Galleries, 1902, *13520*
New York, 1887, *10792*
Paris, 1887, palettes of artists, *2490*
Paris Exposition Nationale, 1883, *1680*
Royal Academy, 1897, rejected, *6311, 17371*
Salon, 1896, *23618*
Société d'Aquarellistes Français, 1884, *1756*
illustrations
Brook, 2749
Castle, 3314
From the balustrade, 3103
Landscape, 3707
Matinee dans le Dauphine, 14328
Moonlight, 23020
street view in Paris, *3012*
Matin aux loups, pres Bonny-sur-Loire, acquired by Carnegie
Institute, 1903, *13604*
notes, 1896, *17042*
Solitude, wins Paris Salon medal of honor, 1897, *6396*

harpsichord
oldest known in Rhode Island collection, *16031*
virginals become a rarity, 1897, *17228*

Harral, Horace, fl.1862-1876
illustrations, *Zelic and Hector* (after W. J. Henessey), *9730*

Harrell, F. W., fl.1897
illustrations, cup and saucer decoration for copying on china,
6450

Harring, William, fl.1869-1871
Kitchen bouquet, reproduced by Prang in chromo, *23529,
23560, 23568, 23604*
notes, 1870, *23601*

Harrington, G. D.
library, sale, 1891, *15732*

Harrington, John A., fl.1872-1882
contributor to *The Lantern*, *16568*

Harrington, Joseph A., 1841-1900
obituary, *22118*

HARRIS, A., *9850, 10054, 10385*

HARRIS, C. A., *13206*

Harris, Caleb Fiske, 1818-1881
library, history, *15690*

Harris, Charles N., fl.1905
illustrations, Salmagundi mug, *13879*

Harris, Charles Xavier, b.1856
biography in brief, *11246*
exhibitions

American Art Galleries, 1887, *10832*
National Academy of Design, 1884, *1879, 25187*
National Academy of Design, 1885, *25271*
National Academy of Design, 1887, *552, 10786, 10831,
25437*
National Academy of Design, 1896, *22996*
Prize Fund Exhibition, 1885, *1985, 25278*
Prize Fund Exhibition, 1887, *562*
Trans-Mississippi and International Exposition, Omaha,
1898, *12775*
illustrations, cat, *11178*
notes, 1883, *24551*

Harris, Clayton Stone, fl.1890's
Wreaths for May (photograph), *22561*

HARRIS, Edna, *12853, 12884, 12940, 12958, 12975*

Harris, Edward M.
collection
pictures shown at American Art Galleries, 1899, *17563*
sale, 1899, *6927, 6954, 17547, 17597*

Harris, Francis Xavier, fl.1884
exhibitions, Union League Club of New York, 1884, *25193*

Harris, Frank X. See: **Harris, Francis Xavier**

HARRIS, J. O., *22951*

Harris, Joel Chandler, 1848-1908
Sister Jane, review, *23200*

HARRIS, M. A., *3402*

Harris, M. S., fl.1886
exhibitions, National Academy of Design, 1886, *2352*

Harris, Robert, 1849-1919
exhibitions, Pan-American Exhibition, Buffalo, 1901, *13276*

HARRIS, Wesley, *11930, 11950*

Harris, William Laurel, 1870-1924
exhibitions
Architectural League of New York, 1898, *6571*

Harrisburg (Pennsylvania)
collectors, *16054*
monuments, statue of William Denning, *26143*
municipal parks and planning, *13635*
State House
busts of Quay, Penrose and Durham, *14334*
illustration of *Time, 14131*
murals by Oakley, *14238*
plans for decoration, 1903, *13549*
plans for Oakley's decoration of Pennsylvania State House
raises protests by Catholics, *14097*

Harrisburg (Pennsylvania). Harrisburg Arts and Crafts Club
annual exhibitions, 1906, *14108*

Harrison, A. B. See: **Harrison, Apollo Butler**

Harrison, Agnes, fl.1901
exhibitions, Minneapolis Arts and Crafts Society, 1901, *13184*

Harrison, Alexander, 1853-1930, *12899*
Amateurs
criticism of horizon line, *24839*
in Chicago Art Institute, *12763*
purchased by Chicago Art Institute, 1883, *24829*
bachelor of science degree conferred by University of
Pennsylvania, 1898, *12796*
biographical sketch, *24989*
Crépuscule, 26184
prize awarded St. Louis Museum, 1885, *11294*
shown in Boston, 1885, *25259*
criticized by M. Hamel, 1889, *25660*
declines Officier d'Academie, 1889, *14955*
elected academician, National Academy of Design, 1901, *13228*
elected to art committee of American Art Association, Paris,
1903, *13701*
exhibitions
American Art Association, 1884, *Graves of the shipwrecked,
25191*
American Art Association, 1884, *Twilight, 25201*
American Art Association, 1885, *2085*
American Art Galleries, 1884, *1732, 24979, 25018, 25024*
American Art Galleries, 1887, *2607, 10832*
American Art Galleries, 1890, *15426, 26196*
American Art Galleries, 1891, *3457*

Jewish festival, 14644
Henry Clay, 18509, 20179
 statue completed, 1859, 18380
 statue to be inaugurated in New Orleans, 1860, 24339
invention of sculptural measuring device, 18623
obituary, 8818
Purity, sculpture group, 1875, 8591
sculpture in Florence, 1851, 14731
Senator John J. Crittenden, 9062
whereabouts
 1851, Florence, 14779, 14821
 1858, Italy, 18154
 1859, Rome, 20045
Woman triumphant, 21650
 at Southern Exposition, Louisville, 1884, 11051
Hart, Joseph Coleman
paper on unity in architecture read before American Institute of
 Architects, 1859, 19992
Hart, Letitia Bonnet, b.1867
exhibitions
 National Academy of Design, 1892, 4182
 National Academy of Design, 1898, Dodge prize, 12710
 National Academy of Design, 1900, Dodge prize, 13173
 Trans-Mississippi and International Exposition at Omaha,
 Nebraska, 1898, 12775
illustrations, study painted with Mary Theresa Hart, 7527
Hart, Marie Theresa Gorsuch, 1829-1921
Easter morning, reproduced by Prang in chromo, 23523, 23529,
 23560, 23568, 23604
notes, 1870, 23601
Hart, Mary E., d.1899
flower painter, 22525
HART, Mary Theresa, 1872-1921, 22577
Hart, Mary Theresa, 1872-1921
exhibitions
 National Academy of Design, 1900, Dodge prize, 13173
 National Academy of Design, 1901, 13202
illustrations, study painted with Letitia B. Hart, 7527
Portrait study, wins Norman W. Dodge prize, 1901, 13213
Yard of violets, 22816
Hart, Robert, fl.1860
bust of Theodore Parker, 20284
HART, Solomon Alexander, 18736
Hart, Solomon Alexander, 1806-1881
lecture on physiological make-up of artists, 19439
lectures on painting, 18725
 excerpts, 18712
obituary, 430, 21897
Hart, Thomas, d.1886
illustrations, views of Dublin, 21799
Hart, William Howard, 1863-1934
exhibitions, National Academy of Design, 1891, 26313
Hart, William M., 1823-1894, 8492, 18185
Berkshire landscapes, 1871, 10720
biography, 20159
coastal studies, 20302
elected to National Academy of Design, 1858, 19859
exhibitions
 Albany, 1858, 19818
 American Watercolor Society, 1871, 10647
 Brooklyn Art Association, 1875, 8460
 Chicago, 1870, 10598
 Chicago Academy of Design, 1871, 10652
 Detroit Art Loan Exhibition, 1883, 24826
 Milwaukee Exposition, 1883, 24799
 National Academy of Design, 1857, 19668
 National Academy of Design, 1858, 19835
 National Academy of Design, 1859, 20048
 National Academy of Design, 1860, 20208
 National Academy of Design, 1870, 10631
 National Academy of Design, 1885, 1970
 New York artists' reception, 1858, 19800, 19817
 Southern Exposition, Louisville, 1884, *Near Kingston, Ulster
 County, N.Y*, 11051
Hudson River villa, 18283

interview, 1884, 10922
landscape, 1875, 8517
landscape and cattle pictures, 1883, 24380
landscape in Clarke collectionn, 24943
Marine, 19955
notes
 1857, 19752
 1870, 23601
 1871, 10617
 1887, 611
obituary, 4973
paintings in Evans collection, 11185
paintings in Stewart collection, 10768
paintings of landscapes, 813
quote, on painting landscape and cattle, 2487
sales and prices
 1857, 19645
 1858, Romney collection sale, 19957
 1895, 16734
studies from nature, 1859, 20104
studies of Maine, 19596
study from nature, 19169
Sunday morning, completed, 1859, 18380
views on influence and individualtiy in art, 11008
whereabouts
 1850, living and working in Scotland, 14696
 1858, trip to Maine, 18209
 1859, summer travel, 20080
 1879, summer travels, 703
 1883, Keene Valley, 24762
work, 1883, 24871
HARTE, Bret, 1836-1902, 10638
Harte, Bret, 1836-1902
poetry on nature, 9225
portraits, Colby's bust, 10679
Harte, Jessamy, fl.1896
illustrator for the press, 11870
HARTE, Walter Blackburn, 1867-1898, 21475
Hartford (Connecticut)
architecture, Vanderbilt residence, 3219
art, public art collection, 26411
exhibitions, 1893, items made from Charter Oak, 16387
free public library and art gallery, 25822
monuments
 Frederick Fox bequest for monument, 1892, 26617
 statue of Dr. Wells falls from pedestal, 1886, 25333
 Warner's statue of Gov. Buckingham for the Capitol, 25137
Hartford (Connecticut). Connecticut Historical Society
acquisitions, 1897, John Cotton Smith correspondence, 17363
Hartford (Connecticut). Hartford Theological Seminary
collection of S. Merrill will form archaeological museum, 327
Hartford (Connecticut). Hartford Veterans of the City Guard
exhibitions
 1884, Art Loan Exhibition, 25093
 1884, art loan exhibition, 25104
Hartford (Connecticut). Wadsworth Athenaeum
acquisitions
 1892, statue of Nathan Hale by E. S. Woods, 26696
 1900, Hosmer sculpture, 13161
 1900, West's *The raising of Lazarus*, 7427, 13106
 1901, *Zenobia* by H. Hosmer, 22125
 1902, 13366
collection, 12416, 17646
description of building and collection, 1855, 18803
library, opens, 1892, 26740
Spencer bequest, 13265
Hartford (Connecticut). Watkinson Library of Reference
opens in Wadsworth Athenaeum, 1892, 26740
Hartkamp, A. Th.
compiler of Vondel collection, 7643
Hartland, Albert See: **Hartland, Henry Albert**
Hartland, F. Dixon See: **Dixon Hartland, Frederick D.**
Hartland, Henry Albert, 1840-1893
exhibitions, Dudley Gallery, 1878, 21572
HARTLEY, Jonathan Scott, 1845-1912, 1888, 1904, 1924, 1937

HARVEY, James L., *13321*
HARVEY, Margaret Boyle, d.1912, *17739*, *17743*
Harvey, Paul, 1878-1948
 exhibitions, Chicago Opera House Gallery, 1871, *10653*
Harvey, William, 1578-1657
 discoverer of circulation of blood, *20783*
HARVEY, William Hamilton, *23653*, *23700*, *23723*, *23747*, *23763*
Harwood, Burt, fl.1894-1895
 teacher, St. Paul art school, 1895, *11444*
Harwood, James Taylor, 1860-1940
 art instructor, University of Utah, 1894, *27016*
 exhibitions, Denver, 1898, *12794*
Hasbrook, Charles E., 1847?-1920
 publisher, *Evening Traveler*, 1896, *23015*
Hasbrouck, DuBois Fenelon, 1860-1917
 exhibitions
 National Academy of Design, 1884, *1879*
 Prize Fund Exhibition, 1886, *25304*
 illustrations
 Autumn evening, *5474*
 Catskill forest in winter, *22663*
 Old home by the roadside, *5108*
 Old sugar house in the woods, *5210*
 Streamlet by the wayside, *4639*
 sales and prices, 1892, *26495*, *26517*
 summer home and studio, *22571*
Hasbrouck, Henry
 committed to mental hospital, 1901, *13327*
HASBURG, John W., *12220*
Haseltine, Charles Field, 1840-1915
 collection, *20482*
 pictures shown at Detroit Art Loan Exhibition, *24826*
 pictures shown in Detroit questioned by Kurtz, 1883, *24872*
 plans for Detroit Art Loan Exhibition, 1883, *24721*
 sale, 1887, *2428*, *10467*
 shown in New York, 1887, *557*
 pictures shown, 1892, *11310*
 receives Philadelphia real estate from John Wannamaker, 1887, *592*
 replicas of antique reliefs, *16329*
Haseltine Galleries, Philadelphia See: **Philadelphia (Pennsylvania). Haseltine Art Galleries**
Haseltine, William Stanley, 1835-1900
 exhibitions
 Boston Athenaeum, 1859, *20104*
 Chicago Exposition, 1883, *24748*
 National Academy of Design, 1860, *20208*
 National Academy of Design, 1861, *20354*
 National Academy of Design, 1896, *22996*
 Pennsylvania Academy of the Fine Arts, 1857, *19658*
 Pennsylvania Academy of the Fine Arts, 1859, *20049*
 landscapes, *19850*
 paintings, 1859, *20013*
 paintings of Gloucester, *23361*
 studies, *20302*
 studies from nature, 1859, *20129*
 whereabouts
 1856, Düsseldorf, *19581*
 1857, *19752*
 1859, summer travel, *20080*
Hasenclever, Johann Peter, 1810-1853
 Examination of the student, shown in New York, 1849, *14508*
 self-portrait engraved by T. Janssen, *18933*
Hasenpflug, Carl Georg Adolph, 1802-1858
 exhibitions, Pennsylvania Academy of the Fine Arts, 1855, *18793*
Haskell, Ernest, 1876-1925
 illustrations
 Boul' Mich' belle, *24153*
 cover design for *The Quartier Latin*, *23835*, *24139*
 design for table of contents for *The Quartier Latin*, 1897, *23837*, *23858*
 Elisabeth, *24115*
 In a Paris café, *24228*
 studio in Paris, 1898, *24134*

Haskell, Ida C., 1861-1932
 exhibitions, Woman's Art Club of New York, 1892, *26542*
 teaches at New Orleans, 1885, *11296*
 woman painter, *22525*
Haskell Oriental Museum See: **Chicago (Illinois). University of Chicago. Haskell Oriental Museum**
Haskins, George W., fl.1899
 classes in house furnishing and decorating, Chicago, 1899, *12339*
HASKINS, Roswell Willson, 1796-1870, *23424*, *23433*, *23439*
Haslehurst, Minette Tucker, fl.1899-1910
 exhibitions, Chicago, 1899, miniatures, *12434*
Hassall, John, 1868-1948
 exhibitions, London, 1898, *24114*
Hassam, Childe, 1859-1935
 April lady, shown at Union League Club, New York, 1892, *26552*
 exhibitions
 American Art Association, 1883, *24398*
 American Art Association, 1885, *2085*
 American Art Galleries, 1887, *10832*
 American Watercolor Society, 1887, *2384*
 American Watercolor Society, 1891, *3532*
 American Watercolor Society, 1892, *3893*
 American Watercolor Society, 1893, *22483*, *26893*
 American Watercolor Society, 1894, *4800*
 American Watercolor Society, 1898, *Alice in Wonderland*, *6556*
 American Watercolor Society, 1902, *13424*
 American Watercolor Society, 1904, *13746*
 American Watercolor Society, 1906, *14118*
 American Watercolor Society, 1907, *14333*
 Berlin Akademie der Künste, 1903, *13605*
 Boston, 1884, *25046*
 Boston, 1887, *549*
 Boston, 1898, *12823*
 Boston Art Club, 1885, *1935*
 Boston Art Club, 1890, *25730*
 Boston Society of Water Color Painters, 1887, *549*
 Boston Society of Water Color Painters, 1888, *2841*
 Brooklyn Art Club, 1892, *26501*
 Carnegie Galleries, 1898, *Sea* awarded silver medal, *6817*
 Carnegie Galleries, 1898, second class medal, *12270*
 Carnegie Galleries, 1898, silver medal for *Sea*, *12804*
 Carnegie Galleries, 1900, *13130*
 Carnegie Galleries, 1903, *13675*
 Carnegie Galleries, 1905, third prize, *14016*
 Carnegie Galleries, 1907, *14328*
 Chicago Art Institute, 1895, *5342*, *11547*
 Chicago Art Institute, 1900, *13137*
 Chicago Art Institute, 1902, *13536*
 Chicago Inter-State Industrial Exposition, 1889, *3056*
 Cincinnati Art Museum, 1898, *12754*
 Cincinnati Art Museum, 1900, *13067*
 Corcoran Art Gallery, 1907, *14282*
 Denver Artists' Club, 1905, *13907*
 Kansas City Art Club, 1902, *13337*
 Munich Exposition, 1892, awarded medal, *4100*
 National Academy of Design, 1890, *3455*
 National Academy of Design, 1892, *3953*
 National Academy of Design, 1893, *4236*
 National Academy of Design, 1896, *22996*
 National Academy of Design, 1897, *10540*
 National Academy of Design, 1899, *By the sea*, *6955*
 National Academy of Design, 1902, *13359*
 National Academy of Design, 1905, Clark prize, *13827*
 New York, 1889, *25674*
 New York, 1891, *15783*
 New York, 1893, *22492*
 New York, 1893, watercolors, *4234*
 New York, 1894, *4942*
 New York, 1895, *5258*
 New York, 1900, *7204*, *13000*
 New York, 1905, *13843*, *13886*
 New York Athletic Club, 1898, *6643*

Havemeyer, Emelie de Loesy, d.1914
 donates seventeenth-century vestments to St. Stephen's Church, 1892, *3952*
Havemeyer, Henry Osborne, 1847-1907
 collection, *15811*
 acquisitions, 1889, *3073*
 buys Schrader portrait of Alexander von Humboldt, 1889, *2934*
 French paintings may be exhibited at World's Fair, 1893, *4179*
 portrait of Rosa Bonheur by Corot, *15486*
 purchases at Vever sale, 1897, *6187*
 Rembrandt, *3393*
 Rembrandt paintings, *6458*
 Rembrandt portraits on loan to Metropolitan Museum, 1889, *25574*
 Rembrandt portraits photographed by Kurtz, 1889, *3099*
 terracottas, *25742*
 collector, *3561*
 library, sale, 1889, *3144*
Havemeyer, Theodore Augustus, 1834-1897
 collection, *15616*
Havemeyer, Theodore Augustus, Mrs. See: **Havemeyer, Emelie de Loesy**
Havemeyer, William Frederick, 1850-1913
 collection
 sale, 1899, *6927, 17527, 17533*
 to be sold, 1899, *6902, 17516*
 portraits, portrait by Perry, *26200*
Havens, Belle See: **Walcott, Belle Havens**
HAVERFORDE, H. H., *16093, 16118, 16151, 16219, 16238*
Havermaet, Pieter van See: **Van Havermaet, Pieter**
Haviland, David, 1814-1879
 establishment of pottery works, *666*
 obituary, *46, 814*
Haviland porcelain See: **porcelain and pottery, French**
Hawaii
 description and views, *23116*
Hawaiian Islands See: **Hawaii**
Haweis, Hugh Reginald, Mrs. See: **Haweis, Mary Eliza Joy**
HAWEIS, Mary Eliza Joy, *9314, 9382, 9402*
Haweis, Mary Eliza Joy, 1852-1898
 Beautiful Houses: Being a Description of Certain Well-known Artistic Houses, 1422
Hawes, Josiah Johnson, 1808-1901
 inventor of process to magnify daguerreotypes, *14680*
 obituary, *7708*
HAWES, Martha, *12058*
Hawes, Mary Jane See: **Holmes, Mary Jane Hawes**
Hawes, Mary Virginia See: **Terhune, Mary Virginia Hawes**
Hawgone, Kiowa artist, fl.1897-1898
 working method, *12774*
HAWKE, Maulger, *22010, 22023*
HAWKES, Clarence, 1869-1954, *12576, 22941*
Hawkes, Clarence, 1869-1954
 Pebbles and Shells, excerpt and review, *12541*
Hawkins, Louis, fl.1895
 exhibitions, Chicago Art Institute, 1895, *11673*
HAWKINS, Rush Christopher, *619, 14100, 15945, 16000*
Hawkins, Rush Christopher, 1831-1920
 American Art Commissioner to Paris Exposition of 1889, *633, 2823, 25551*
 attempts to improve installation of American works, *3009*
 candidate for World's Fair art director, 1890, *3425*
 collection, sale, with prices, 1887, *2442*
 letter criticizing New York library consolidation, 1897, *17265*
 letter on National Academy of Design site, 1897, *17283*
 letter opposing New York library consolidation, 1895, *16727, 16742, 16771*
 quote, on Metropolitan Museum's purchases, 1907, *14253*
 report as U.S. art commissioner to the Paris International Exposition, 1893, *4282*
 report on American art at Paris Exhibition, 1891, *26214*
 report on fine arts at Paris Exposition Universelle, 1889, *16041*
 report on the state of American art, *16089*

hawks
 American sparrow hawk, *21337*
HAWLEY, Caroline A., *18182*
HAWLEY, Elizabeth Walworth, *22869*
Hawley, Hughson, 1850-1936
 exhibitions
 American Art Galleries, 1882, *1297*
 American Art Galleries, 1882, watercolors rejected by Watercolor Society, *9624*
 American Watercolor Society, 1881, *296*
 American Watercolor Society, 1884, *1736*
 Chicago Architectural Club, 1899, *12887*
 illustrations
 decorative designs, *1292*
 World's Fair administration building, *22490*
 portraits, photograph, *22518*
 St. Thomas's Church, 1181
Hawley, Royal De Forest
 collection, *15616*
 sale of violins, 1896, *17090*
Hawley, Wilhelmina Douglas De Koning, 1860-1958
 exhibitions
 American Girls' Club of Paris, 1896-7, *23717*
 American Woman's Art Association of Paris, 1897-8, *23992*
Hawthorne, Charles Webster, 1872-1930, *12928, 13877*
 exhibitions
 National Academy of Design, 1901, *13202*
 National Academy of Design, 1902, *13359*
 National Academy of Design, 1903, *13702*
 National Academy of Design, 1905, Hallgarten prize, *14062*
 National Arts Club, 1905, *13993*
 New York, 1899, *17620*
 Worcester Art Museum, 1904, *13803*
 illustrations, *Portrait of my mother, 14002*
 summer school, *13059*
HAWTHORNE, Julian, *10804, 22545*
Hawthorne, Julian, 1846-1934
 notes, 1896, *22912*
Hawthorne, Nathaniel, 1804-1864
 anecdote, *23094, 26425*
 house at Rock Park, England, *16828*
 Marble Faun
 references to statues by Paul Akers and William Story, *24325*
 review, *18447, 20199*
 tribute to P. Akers' *Dead pearl diver, 18418*
 on art, *20273*
 portraits, bust by L. Lander, *18437*
 reminiscence by E. DeLeon, *26159*
 Scarlet Letter, subject of painting by Hugues Merle, *20367*
Hawthorne, Rose See: **Lathrop, Rose Hawthorne**
Hay, Alice See: **Clay, Alice Hay**
Hay, David Ramsay, 1798-1866
 Harmonic Law of Nature Applied to Architectural Design, review, *18742*
 Scheme of Beauty, review, *19420*
Hay, John, 1838-1905
 Castillian Days, excerpts, *8721*
HAY, Mary Cecil, *9354, 9356, 9370*
Hayashi, Tadamasa, 1853-1906
 quote, on oriental ceramics, *2783*
Hayden, Charles Henry, 1856-1901
 companion of Edward H. Barnard, *12883*
 exhibitions, Boston Art Club, 1891, *3491*
 illustrations, *Connecticut hillside, 13251*
 landscapes, *20625*
 obituary, *13269*
Hayden, Edward Parker, d.1922
 exhibitions, Society of American Artists, 1890, *Calm day in December, 15205*
 illustrations for *Idyls and Pastorals*, 1886, *509*
Hayden, Harriet Clark Winslow, 1840-1906
 exhibitions
 Denver Artists' Club, 1898, *12180, 12706*
 Denver Artists' Club, 1899, *12327, 12886*
 whereabouts, 1894, summer at Montclair, *27014*

Hayden, Sara Shewell, fl.1893-1931
appointed art instructor at University, Lincoln, Neb., 1899, *12407*
exhibitions
Chicago, 1898, *12269*
Chicago, 1899, *12876*
Chicago, 1899, miniatures, *12333*
Chicago Art Institute, 1899, *12902*
Denver Artists' Club, 1899, *12886*
Palette Club of Chicago, 1892, *11307*
Palette Club of Chicago, 1895, *11467*
illustrations, *Girl in black*, *11704*
paper on pictorial composition read at meeting of Western Drawing Teachers' Association, 1899, *12914*
Hayden, Sophia G., ca.1868-1953
architect of Woman's Building, Chicago World's Fair, 1892, *4435, 26815*
Haydn, Franz Josef, 1732-1809
portraits, bust stolen, 1895, *16828*
Haydock, Atha See: **Caldwell, Atha Haydock**
Haydock, May S., b.1878
exhibitions, Philadelphia Plastic Club, 1902, *13537*
Haydon Art Club See: **Lincoln (Nebraska). Haydon Art Club**
HAYDON, Benjamin Robert, *645*
Haydon, Benjamin Robert, 1786-1846, *19394, 21983, 22052*
Ariel and Satan, in Chapman collection, New York, *15859*
Autobiography, character resembles DuMaurier's Trilby, *17278*
drawings acquired by British Museum, *21898*
early career, *19323*
exhibitions, New York, 1896, drawings, *17176*
Life of Benjamin Robert Haydon, review, *18554*
marriage and financial troubles, *19412*
recollected by C. Leslie, *18471*
sees Elgin marbles, *19372*
Haydon, Parker See: **Hayden, Edward Parker**
HAYES, Edith M., *12143*
Hayes, Edmund, 1849?-1923
elected vice-president, Buffalo Fine Arts Academy, 1902, *13440*
Hayes, Edwin, 1819-1904
exhibitions, Royal Institute of Painters in Water Colours, 1861, *20374*
Lively Polly entering harbour, *21575*
Hayes, George H., fl.1853-1860
wood engravings, *106*
Hayes, H. E.
collection, *17567*
Hayes, Rutherford Birchard, *pres. U.S.*, 1822-1893
Ohio home, *9215*
Hayman, Francis, 1708-1776
portrait of Garrick, *19634*
Hayn, Hugo, 1843-1923
Bibliotheca Erotica et Curiosa Monacensis, publication announced, 1890, *15263*
Hayne, Paul Hamilton, 1830-1886
poetry on nature, *9199, 9225*
Haynes, C. Younglove, fl.1850
bas-relief of Henry Clay, *23377*
Haynes, Caroline Coventry, fl.1889-1939
exhibitions
Boston Art Club, 1894, *8340*
National Academy of Design, 1891, *26307*
Woman's Art Club of New York, 1891, *26292*
Woman's Art Club of New York, 1892, *26542*
HAYNES, D. F., *25906*
HAYNES, Henry Williamson, 1831-1912, *175*
Haynes Williams, John, 1836-1908, *22048*
Congratulations, *21646*
illustrations, scenes in Salamanca, Spain, *21911*
prints after pictures published, 1892, *15847*
Hays, Austin, 1869-1915
model for Maine monument, third prize, *13213*
Hays, Barton S., 1826-1914
notes
1871, *10677*

1887, *611*
portrait paintings, 1871, *10710*
Hays, Frank Allison, d.1930
exhibitions, Chicago Architectural Club, 1899, *12887*
illustrations
Clean street?, *22560*
Coombs Alley, *22531*
Entrance to Philadelphia Sketch Club, *22576*
Grandma's home, *22590*
Philadelphia Sketch Club quarters, *22560*
summer home and studio, *22571*
Hays, M. P., fl.1896
illustrations
Dorothy, *23152*
sketch of child, *23132*
Hays, William Jacob, 1830-1875
animal pictures, 1856, *19363*
biography, *20205*
elected to National Academy of Design, 1858, *19859*
exhibitions
Century Club, 1859, *19973*
National Academy of Design, 1858, *19857*
National Academy of Design, 1859, *20030, 20048*
New Bedford, 1858, *19891*
New York, 1859, *19978*
New York artists' reception, 1858, *19800, 19817*
Flushing the covey, *19801*
game pieces, 1857, *19767*
illustrations of old New York City, *7505*
obituary, *8426*
sales and prices, 1858, Romney collection sale, *19957*
Hayter, George, 1792-1871
Martyrdom of Riley and Latimer, *19381*
Trial of Lord William Russell, *9204*
HAYWOOD, Emma, *2509, 2530, 2531, 2550, 2572, 2591, 2610, 2645, 2828, 2829, 2845, 2846, 2866, 2915, 2976, 3013, 3023, 3062, 3083, 3109, 3162, 3187, 3329, 3337, 3342, 3351, 3352, 3370, 3382, 3444, 3516, 3586, 3607, 3609, 3611, 3635, 3685, 3687, 3709, 3760, 3802, 3845, 3876, 3878, 4163, 4204, 4216, 4217, 4269, 4291, 4333, 6172, 6204, 6235*
Haywood, Emma, fl.1885-1897
fires china in Wilke and Jay's studio kiln, 1891, *3618*
illustrations
designs for fish plates, *3084*
fish plate design, *3162*
Maple leaf decoration, *3119*
Orchid plate, *3193*
Haywood, Maude, fl.1889
illustrations, designs for chair back and seat, *3084*
Haywood, Mordan, *Mrs.* See: **Haywood, Emma**
Hazard, Arthur Merton, 1872-1930
exhibitions
National Academy of Design, 1903, *13702*
Worcester Art Museum, 1902, *13483*
HAZARD, Thomas Robinson, *20705*
Hazell, Ada Kate, fl.1895
illustrations
"Hazel Nut" alphabet, *22329*
Hazel nut, initials, *22334*
Hazeltine, William Stanley See: **Haseltine, William Stanley**
Hazelton, Mary Brewster, 1868-1953
awarded Paige scholarship, 1899, *12920*
exhibitions
National Academy of Design, 1896, award, *17016*
National Academy of Design, 1897, *10540*
receives award from Yale University, 1899, *7014*
wins Hallgarten prize, 1896, *23008*
Hazenplug, Frank, b.1873
decoration of William Bulger's pottery, *12801*
illustrations, *Madonna*, *12996*
posters, *12867*
Hazlett, William Convers, fl.1878-1900
exhibitions, Architectural League of New York, 1890, *3166*
Hazlitt, William, 1778-1830
conversations with James Northcote, *9555*

Hinton, Alfred Horsley, 1863-1908
 illustrations
 Rain from the sea (photograph), *12973, 13274*
Hinton, Charles Louis, 1869-1950
 exhibitions, National Academy of Design, 1892, awarded prize,
 3985
 statue of Hendrik Hudson for Chicago World's Fair, 1892,
 26750
Hiolle, Ernest Eugène, 1834-1886
 obituary, *504*
Hipkins, J., fl.1885
 illustrations
 Bible Regal, *10222*
 Powerscourt harpsichord, *10196*
 well-head from Palazzo Molin, Venice, *10230*
hippopotamus, *20750*
Hiram Abiff
 appointed deputy grandmaster of Freemasonry by Solomon,
 20654
Hiroshige, 1797-1858
 53 stations of Tokaido, *8348*
 illustrations
 Bridge over the Soumida, at Tokyo, *22661*
 figure composition, *22152*
 wood-block print, *12653*
 notes, 1899, *17461*
Hirsch, Clara Bischoffsheim, *Baronin* von, 1833-1899
 collection, sale, 1897, *17337*
 furniture, sale, 1897, *17273*
Hirsch, William
 Genius and Degeneration, review, *23178*
Hirschberg, Alice Kerr-Nelson, b.1856
 exhibitions
 American Watercolor Society, 1885, *25239*
 Boston Art Club, 1887, *568*
 illustrations
 Lilian, *4639*
 Maggie Tulliver, *566*
 portrait study, *3849, 3862*
Hirschberg, Carl, 1854-1923
 whereabouts, 1883, Paris, *24457*
Hirschberg, Carl, *Mrs.* See: **Hirschberg, Alice Kerr-Nelson**
Hirst, Claude Raguet, 1855-1942
 exhibitions, National Academy of Design, 1897, *10540*
 flower studies, 1883, *24525*
 illustrations
 Corner of Grandpa's study, *22684*
 Study in still life, *23152*
 still life painter, *22525*
Hirth, Georg, 1841-1916
 Meister Holzschnitte aus Vier Jahrhunderten, review, *25554*
historic buildings
 United States, Beverley Robinson house, *16071*
Historical Printing Club of Brooklyn See: **New York.**
 Historical Printing Club of Brooklyn
Historical Society of Delaware See: **Wilmington (Delaware).**
 Historical Society of Delaware
Historical Society of New Mexico See: **Santa Fe (New**
 Mexico). Historical Society of New Mexico
Historical Society of Pennsylvania See: **Philadelphia**
 (Pennsylvania). Historical Society of Pennsylvania
history
 cultural history, *20120*
 Furlong collection of statistics and data, *17151*
history in art
 artists as historians, *22597*
 criticism, *18626*
 historical accuracy in wall decoration, *17887*
 historical pictures can encourage patriotism, *12770*
 history painting, 1897, *17353*
 history painting as genre, *24718*
 painters West and Reynolds, *25494*
Hitch, Nathaniel, fl.1884
 statues for Westminster Abbey, *26310*

Hitchcock, DeWitt C., fl.1845-1879
 guest on Baltimore and Ohio Railroad excursion, 1858, *19876*
 illustrations, *To my mother, from the Apennines*, *18329*
Hitchcock, George, 1850-1913, *3155*
 Conception of the Christ, commission, 1906, *14098*
 Dunes at Egmond, *17447*
 exhibitions
 1890, *3310*
 American Watercolor Society, 1881, *1065*
 American Watercolor Society, 1884, *25038*
 Berlin Akademie der Künste, 1903, *13605*
 Chicago, 1890, *Annunciation*, *3364*
 Internationale Kunstausstellung, Munich, 1901, second class
 medal, *13270, 13379*
 London, 1890, pastels, *25942*
 National Academy of Design, 1888, *25516*
 New York, 1890, pastels, *3427, 26140*
 New York, 1892, *16041, 26814*
 New York, 1892, pastel studies of Spain, *4184*
 New York, 1892, Spanish views, *26841*
 New York, 1893, *4355, 16193*
 New York, 1894, *26998*
 Pennsylvania Academy of the Fine Arts, 1902, *13363*
 Prize Fund Exhibition, 1888, *2700*
 Royal Academy, 1892, *Scarecrow*, *4012*
 Royal Academy, 1899, *6983*
 Salon, 1887, *571*
 Salon, 1887, honorable mention, *2476*
 Salon, 1887, *Tulip growing*, *2449*
 Salon, 1888, *2694*
 Salon, 1889, *2985*
 Salon, 1890, *3283*
 Society of American Artists, 1887, *10789*
 Society of American Artists, 1888, *2678, 10846*
 Society of American Artists, 1890, *Dunes in autumn*, *15205*
 Vienna, 1902, *13421*
 Vienna, 1903, *13572*
 Flower girl in Holland, in Chicago Art Institute, *12763*
 illustrations
 Crocus beds in early spring, *3172*
 Dutch tulip garden, *2702*
 Madonna and child, *4353*
 illustrations for *Scribner's Magazine*, 1891, *26413*
 notes, 1888, *2782*
 St. George, *6311*
 whereabouts, 1895, Holland, *22765*
Hitchcock, James Ripley Wellman See: **Hitchcock, Ripley**
Hitchcock, Lucius Wolcott, 1868-1942
 exhibitions
 Buffalo, 1896, *11806*
 Buffalo Society of Artists, 1898, *6669*
 Royal Academy, 1898, *Promise of March*, *6644*
Hitchcock, M. L., fl.1897
 illustrations, embroidery design for copying, *6305*
HITCHCOCK, Ripley, *1922, 2142, 2168, 10741, 10748, 10762,*
 10768, 10776, 10786, 25804
Hitchcock, Ripley, 1857-1918
 art critic, *17796*
 article on art schools and museums of the West, 1886, *25337*
 employment at Appletons, *25968*
 Representative Etchings, review, *10814*
Hitchcock, Sophia Candace See: **Page, Sophia Candace**
 Stevens Hitchcock
Hite, George Harrison, d.ca.1880
 notes, 1849, *21381*
Hittell, Charles Joseph, 1861-1938
 illustrations, *Sheep on a dusty road*, *22167*
Hittites, *192*
Hittorff, Jacob Ignaz, 1792-1867
 commissioned architect of Paris Opera House, *19872*
Hlasko, Annie, fl.1879-1881
 exhibitions, Salon, 1880, *913*
HOADLEY, Frances A., *24084*
Hoag, Daniel T., *Mrs.* See: **Hoag, Susan Howland**

Hollyer, Fred, 1837-1933
 photographs of his studio, 1896, *5927*
 swindled in Boston, 1886, *2323*
Hollyer, Samuel, 1826-1919
 bookplate designed for Pruyn library, 1896, *17140*
 engraved portraits of literary and theatrical people, 1896, *17016*
 etched portraits of famous literary personalities, *16193*
 etching offered, 1897, *17241*
 etchings issued, 1895, *16894*
 exhibitions, New York, 1895, reproductions of English Pre-
 Raphaelite paintings, *5603*
 illustrations, bookplate for W. W. Chevalier, *5209*
 notes, 1892, *15859*
 portrait of Daniel Webster (after J. A. Ames), *25146*
 series of theatrical portraits, 1894, *16535*
HOLMAN, F. Ernest, *24203*
Holman, Frank, 1865-1930
 exhibitions, Tennessee Centennial Exposition, 1897, honorable
 mention, *11971*
 Rose of the Alhambra, *26143*
Holman, Jane S., fl.1887-1900
 studio reception, 1894, *27005*
Holman, Louis Arthur, 1866-1939
 illustrations, *Canterbury Cathedral from the back walk*, *22473*
 portraits, photograph, *22518*
Holman, S. Francis See: **Holman, Frank**
Holmberg, August Johann, 1851-1911
 illustrations, *Mandolin player*, *1615*
 Latest acquisition, in Layton Art Gallery, Milwaukee, *12813*
Holme, Charles, 1848-1943
 recognition of lithography, *12952*
 Representative Art of Our Time
 review of part I, *13564*
 review of parts IV and V, *13619*
 Royal Academy from Reynolds to Millais, review, *13838*
Holme, Frank See: **Holme, John Francis**
Holme, John, d.1701
 American poet, *20371*
HOLME, John Francis, 1868-1904, *12191*, *12699*, *13152*
Holme, John Francis, 1868-1904
 cover illustration for *Brush and Pencil*, *12844*
 drawings, *11934*
 exhibitions
 Chicago Art Institute, 1897, *6145*, *12642*
 Denver Artists' Club, 1899, *12327*, *12886*
 illustrations
 Miss B. Ostertag, *12641*
 Portrait of Bessie Potter, *12698*
 Portrait of William Schmedtgen, *12667*
 red chalk sketch, *12219*
 scenes of Salon de refuse, *12685*
 sketches made at Art Students' League ball, *12861*
 sketches of sculpture students working on temporary fountain
 at Chicago Art Institute, *12927*
 Study, *13146*
 study of the nude, *13985*
 newspaper artist, *12718*
 School of Illustration, Chicago
 founder and teacher, *12964*
 manager, *12826*
 studies at Chicago Art Academy, *12671*
Holme, Lucy D., fl.1881-1915
 exhibitions, Pennyslvania Academy of the Fine Arts, 1884,
 1884
 illustrations, *Field laborer*, *22525*
Holmes, Burton, 1870-1958
 lectures, 1898, *12201*
Holmes, Charles John, 1868-1936
 Hokusai, review, *13222*
HOLMES, Ellen A., fl.1883-1917, *11672*
Holmes, Ellen A., fl.1883-1917
 art reception, Chicago, 1895, *11682*
Holmes, Fanny Bowditch Dixwell, d.1929
 exhibitions
 Boston Museum of Fine Arts, 1880, embroidery, *9343*

Boston Museum of Fine Arts, 1880, silk pictures, *878*
 landscapes in embroidery, *9505*
Holmes, Harold R., fl.1895
 illustrations, *Dreamer*, *11420*
Holmes, Mary Jane Hawes, 1825-1907
 Cousin Maud and Rosamond, review, *20229*
HOLMES, Oliver Wendell, 1809-1894, *10901*
Holmes, Oliver Wendell, 1809-1894
 library, *16710*
 obituary, *11404*
 ode for opening of World's Fair, 1893, *26878*
 poem, *16698*
 portraits
 bust proposed for Boston Public Library, 1894, *27027*
 painting by Mrs. Anna Lea Merritt, *25473*
Holmes, Oliver Wendell, *Mrs.* See: **Holmes, Fanny Bowditch
Dixwell**
Holmes, Philip H., fl.1871-1877
 painting in Centennial Exhibition, 1876, found in Philadelphia
 hotel, 1890, *26192*
Holmes, Rhoda See: **Nicholls, Rhoda Holmes**
HOLMES, Thomas, *4411*, *4445*, *5409*, *5441*, *7409*, *7432*
HOLMES, William Henry, *13263*
Holmes, William Henry, 1846-1933
 discovers Mexican objects at Smithsonian to be fakes, *14143*
 exhibitions
 Louisville's Southern Exposition, 1883, *24760*
 Washington Water Color Club, 1902, Parsons prize, *13537*
HOLMES, Wilson, *14166*
Holmesdale, William Pitt Amherst, *viscount* See: **Amherst,
William Pitt**, *earl of*
Holroyd, Charles, 1861-1917
 Michael Angelo Buonarroti, review, *13606*
Holsman, Elizabeth Tuttle, b.1873
 exhibitions
 Chicago Art Students' League, 1895, *11469*
 Chicago Art Students' League, 1898, *12819*
Holst, Herman Eduard von, 1841-1904
 monuments, statue presented to University of Chicago, *13676*
Holst, Lauritz Bernhard, 1848-1934
 exhibitions, Chicago Opera House Gallery, 1871, *10653*
 Golden Gate, *10567*
Holt, Rosa Belle
 Rugs, Oriental and Occidental, Antique and Modern, review,
 13290
Holy Land See: **Palestine**
Holy Week
 celebration, *22965*
Holzer, J. A., b.1858
 designs Tiffany glass window for Princeton College, 1896,
 23030
Holzschuher, Hieronymus, 1469-1529
 portraits, portrait by Dürer, *25218*
Homan, Emma See: **Thayer, Emma Homan**
Homans, Nannie, b.1861
 exhibitions, Woman's Art Club of New York, 1892, *26542*
Home Art School
 notes, 1903, *8195*
Home Arts and Industries Association See: **London
(England). Home Arts and Industries Association**
home economics
 advice, 1897, *23181*, *23254*
 hints, 1897, *23204*
home ownership
 beautify the home, *19101*
homeopathy
 manuel published, *18212*
HOMER, 8th century B.C., *20299*
Homer, 8th century B.C.
 Iliad, excerpt, *21109*
 tale of Troy presented as tableaux, London, 1883, *9843*
 view of women, *18422*
Homer, Winslow, 1836-1910, *3486*, *6788*, *9027*, *10770*
 anecdote, *17692*
 art, *13393*

Below zero, 16494
crayon studies, *13534*
elected to Carnegie Institute jury of awards, 1897, *12020*
etchings, *10792*
exhibitions
 American Art Galleries, 1886, watercolor sketches, *2131*
 American Watercolor Society, 1876, *8624*
 American Watercolor Society, 1877, *8805*
 American Watercolor Society, 1879, *9123*
 American Watercolor Society, 1881, *296, 1065*
 American Watercolor Society, 1882, *1300*
 American Watercolor Society, 1883, *1510, 24425*
 American Watercolor Society, 1884, *1736, 25002, 25012,
 25038*
 American Watercolor Society, 1887, *534*
 American Watercolor Society, 1888, *2641, 10843*
 American Watercolor Society, 1891, *3532*
 Artists' Fund Society, 1863, *23289*
 Artists' Fund Society, 1885, *1916, 25225*
 Boston, 1880, *258*
 Boston, 1881, *1046*
 Boston, 1883, *24905, 24946*
 Boston, 1899, *12892*
 Boston, 1901, *13293*
 Carnegie Galleries, 1896, *11906*
 Carnegie Galleries, 1896, *Wreck, 6061*
 Carnegie Galleries, 1897, *12117*
 Carnegie Galleries, 1897, gold medal, *12809*
 Carnegie Galleries, 1900, *13130*
 Carnegie Galleries, 1901, *13322*
 Carnegie Galleries, 1903, *13675*
 Carnegie Galleries, 1907, *14328*
 Century Club, 1875, *8383*
 Century Club, 1880, *235*
 Charleston Inter-State and West Indian Exposition, 1901-
 1902, gold medal, *13436*
 Chicago, 1880, *46*
 Chicago, 1902, *13399*
 Chicago World's Fair, 1893, *4340*
 Corcoran Art Gallery, 1907, *14282*
 Eden Musée, 1890, watercolors, *3284*
 Louisiana Purchase Exposition, 1904, *13785*
 National Academy of Design, 1875, *8441*
 National Academy of Design, 1876, *8673*
 National Academy of Design, 1877, *8830*
 National Academy of Design, 1878, *9002*
 National Academy of Design, 1879, *657, 9151*
 National Academy of Design, 1880, *111, 867, 9324*
 National Academy of Design, 1884, *1772, 25125*
 National Academy of Design, 1884, *Life line, 10982*
 National Academy of Design, 1886, *508, 2112, 2352, 10754*
 National Academy of Design, 1887, *552, 2431, 10786, 25437*
 National Academy of Design, 1888, *10846*
 National Academy of Design, 1892, *4143*
 National Academy of Design, 1892, Columbian Celebration
 Loan Exhibition, *26798*
 National Academy of Design, 1907, *14266*
 New York, 1880, *9310*
 New York, 1890, *15084*
 New York, 1890, watercolors, *3208*
 New York, 1891, *15488, 26233*
 New York, 1892, *15800*
 New York, 1892, watercolors, *26869*
 New York, 1893, *26900*
 New York, 1893, pictures in Clarke collection, *16171*
 New York, 1898, *Light on the sea, 6527*
 New York, 1898, watercolors of Quebec scenes, *12723*
 New York Etching Club, 1889, *2887*
 Pan American Exposition, 1901, *13209*
 Paris Exposition, 1878, *9072*
 Pennsylvania Academy of the Fine Arts, 1888, *2659, 17804*
 Pennsylvania Academy of the Fine Arts, 1897, *Saco Bay,
 6179*
 Pennsylvania Academy of the Fine Arts, 1900, *13007*
 Pennsylvania Academy of the Fine Arts, 1901, *13163*

 Pennsylvania Academy of the Fine Arts, 1902, *13363*
 Pennsylvania Academy of the Fine Arts, 1902, Semple gold
 medal, *13379*
 Pennsylvania Academy of the Fine Arts, 1903, *13548*
 Pennsylvania Academy of the Fine Arts, 1904, *13716*
 Pennsylvania Academy of the Fine Arts, 1905, *13851*
 Pittsburgh, 1899, *12976*
 Society of American Artists, 1897, *6250*
 Society of American Artists, 1900, *7292*
 Union League Club of New York, 1890, *3177, 25779*
 Union League Club of New York, 1891, *Eight bells, 3498*
 Union League Club of New York, 1893, *4237, 4380*
 Union League Club of New York, 1898, *6590*
 Union League Club of New York, 1901, *7524*
Fox hunt, shown in New York, 1893, *16193*
illustrations
 Eight bells, 6784
 figure study, *13815*
 Fog horn, 14200
 Fog warning, 13064
 Summer squall, 13792
 Undertow, 13807
 Voice from the cliff, 1504
 watercolor, *11214*
Life line, shown at Century Club preview, 1884, *25064*
Lookout "All's well" and *Fog warning* in Boston Museum of
 Fine Arts, *13073*
marine painting shown in New York, 1892, *26638*
member, Tile Club, *11267*
newspaper illustrations, *16557*
notes, 1898, *17403*
paintings for Chicago Columbian Exposition shown in New
 York, 1893, *22483*
paintings in Frederick Gibbs collections, *13250*
paintings in the Clarke collection, 1896, *17191*
picture in Evans collection, *15079*
position in American art, *70*
praise, *15783*
Prang prints after watercolors, *22401*
Return from the hunt, criticized, *15790*
sales and prices
 1880, 72 watercolors, *102*
 1880, charcoal drawings and watercolors, *9326*
 1883, water colors, *24925*
 1899, paintings in Clarke collection, *12871*
 1900, picture in Evans collection, *13008*
Shepherdess, 9412
Silent night, purchased by Musée du Luxembourg, 1901, *13208*
sketches and studies, *9301*
Summer morning in Virginia, in Evans collection, *11185*
Uncle Ned's happy family, in Clarke collection, *24943*
Undertow, dispute over subject matter, *556*
Weaning the calf, in Hart-Sherwood collection, *792*
whereabouts
 1879, summer travels, *703*
 1880, *980*
 1883, moves to Maine, *24843*
 1883, moves to Scarborough, Me, *24728*
 1883, retires to Maine, *24678*
 1883, to settle in Maine, *24609*
Homes, Elizabeth See: **Brainard, Elizabeth Homes
Washburn**
Hone, Horace, 1756-1825
 illustrations, miniatures, *1711*
 miniatures, *1575*
Hone, Philip, 1780-1851
 obituary, *14755*
Honiss, Lucie, fl.1896-1897
 pastels, *11934*
Honiton lace See: **lace and lace making**
Honolulu (Hawaii)
 art, *12048*
 Honolulu Museum buys back Hawaiian idols, 1896, *17027*
Honolulu (Hawaii). Kilohana Art League
 exhibitions, 1901, *22127*

Horsley, Walter Charles, 1855-1934
 exhibitions
 Royal Academy, 1879, *21730*
 Royal Academy, 1887, *10461*
 French in Cairo, 10229
 illustrations, *Exhibition of the Royal Academy at Somerset House*, 9617
Horter, Frederick Formes, b.1869
 illustrations, sculpture for Louisiana Purchase Exposition, 1903, *13687*
Horti, Pol, 1865-1907
 illustrations, silver jewel-case with enamel decorations, *13973*
horticulture
 expeditions, 1896, *17119*
Horticulture Society of New York See: **New York. New York State Horticultural Society (founded 1818)**
Horton, Carrie See: **Blackman, Carrie Horton**
Horton, William Samuel, 1865-1936
 illustrations, *Village green, Oxford, England*, 13345
Hoschedé Monet, Blanche, 1865-1947
 sales and prices, 1901, *7611*
HOSFORD, Arthur P., *14094*
Hoskin, Robert, b.1842
 exhibitions
 Boston Museum of Fine Arts, 1881, *1254*
 Salon, 1883, medal, *24678*
 Salon, 1885, *2035*
 wood engravings, *155, 182*
Hoskins, Emily J., fl.1898
 illustrations, *Mending day*, 12724
Hoskins, John, d.1664
 English miniaturist, *16606*
 miniatures, *17700*
HOSKINS, Mary Aurelia, *11786, 11809, 11826, 11868, 11892, 11908, 11920, 11933, 11945, 11952*
Hosmer, Harriet Goodhue, 1830-1908, *18368*
 Aeone, bought by St. Louis collector, 1857, *19645*
 Beatrice Cenci, *17962, 19753, 19942*
 biography, *20205*
 clasped hands of Brownings
 acquired by Chicago Art Institute, 1894, *5002*
 given to Chicago Art Institute, 1894, *27006*
 shown at Tennessee Exposition, 1897, *11965*
 commission for statue of Thomas H. Benton, 1860, *20259*
 commission from Prince of Wales, *20077*
 exhibitions, Boston, 1857, *19609*
 libretto with Miss Pendleton, *25831*
 notes
 1857, *18082, 19682, 19767*
 1860, *18509, 20237*
 1871, *10611*
 1893, *16379*
 1895, *16745*
 1899, *17625*
 Pompeian sentinel, *9077, 21654*
 Puck, 8534
 reception at Indianapolis Art Association. 1890, *26200*
 reception in her honor, Chicago, 1895, *11476*
 sales and prices, 1859, *Puck on a mushroom*, *18315*
 sculpture in Stewart collection, *753, 10773*
 Sleeping faun, *9070*
 statue of Lincoln, *25959*
 statue of Queen Isabella, *26835*
 commission from Queen Isabella Association for Chicago World's Fair, 1891, *26382*
 commissioned for World's Fair, 1890, *26043*
 model, 1891, *26386*
 subject of letter from Rome, 1857, *19609*
 whereabouts
 1855, working in Rome, *18705*
 1871, Rome, *10730*
 1890, leaving Chicago for Europe, *26063*
 1894, Chicago, *11374*
 1899, Watertown, *12920*
 work, 1857, *17991, 19596*

 work in Italy, 1858, *18154*
 Zenobia, *20033, 23321*
 gift to Wadsworth Athenaeum, 1901, *13161, 22125*
Hosmer, Wells R.
 music for *Beauty and the Beast*, *12545*
Hosmer, William Howe Cuyler, 1814-1877
 poetry on nature, *9199*
hospitals
 England, Haslar Hospital, Portsmouth, *21348*
 in art, *2429*
 pictures for patients, *21652*
Hotchkiss, Thomas Hiram, ca.1834-1869
 Catskill Mountain view, *19995*
 exhibitions
 National Academy of Design, 1858, *19835*
 National Academy of Design, 1859, *20030, 20048*
 New York, 1859, *19978*
 notes
 1856, *19564*
 1860, *20237, 20284*
 1871, *10671*
 studies from nature, 1859, *20129*
 whereabouts
 1857, *19682*
 1858, summer quarters, *19891*
 1859, summer travel, *20080*
Hôtel de Ville, Paris See: **Paris (France). Hôtel de Ville**
Hotel Drouot, Paris See: **Paris (France). Hôtel Drouot**
Hotel Paiva, Paris See: **Paris (France). Hôtel Païva**
Hotelin, Laurent, fl.1836-1884
 See also: **Best, Hotelin et cie.; Best, Hotelin et Regnier; Hotelin, Best et cie.**
Hotelin, Best et cie.
 illustrations
 Brimham rocks (after F. W.), *20841*
 Brother Alfus listening to the song of the bird of paradise (after K. Girardet), *20738*
 Cart of a husbandman, Khosrovah, in Persia (after Freeman), *21042*
 Church of Notre Dame de l'êapine, *20864*
 Nicholas, Emperor of Russia (after T. H. Nicholson), *21136*
 Renaissance (after C. Landelle), *21016*
 view of the Hotel de Ville at Ghent (after F. Stroobant), *21239*
 views of tomb of Napoleon (after A. Mathieu), *20974*
hotels, taverns, etc.
 bar-room art, *515*
 decoration of bar-rooms by paintings deplored, 1887, *17747*
 London, entertainment, *20772*
 United States, New York, decorations of Broadway hotel, 1884, *1859*
Houard, Georges, fl.1895
 illustrations
 American beauty roses, *5388, 5395*
 flower painting, *5381*
Houdain, André, d', 1860-1904
 obituary, *13747*
Houdard, Charles Louis Marie, fl.1888-1911
 illustrations, etching, *13305*
Houdon, Jean Antoine, 1741-1828
 bust of Washington, account of life-cast bust, *17694*
 George Washington, copied by Alfred Jones for postage stamp, 1883, *24843*
 mask of Washington, *10773*
 model for C. Mill's *Washington*, *18416*
 portrait of Benjamin Franklin, *19931*
 portrait of Washington, *18063, 19894*
 sculptures rediscovered at Versailles, *13504*
 statue of George Washington, *2559*
 in Richmond capitol, *25471*
 replicas, *3888*
 Thomas Jefferson, *18319*
Hough, Elliott P., fl.1895
 Washington, D.C., artist, *22587*

Hough, Emerson, 1857-1923
Singing Mouse Stories, review, *12520*
Hough, John Stockton, 1845-1900
medical library, *16544*
Houghton, Arthur Boyd, 1836-1875
obituary, *8607*
HOUGHTON, George Washington Wright, *17753, 17769, 17784*
Houghton, Georgiana, b.1814
Chronicles of the Photographs of Spiritual Beings, review,
20662
Houghton Hall
and the Walpoles, *10404*
Hours, Books of
exhibitions, New York, 1899, *6986*
printed Books of Hours, *10797*
house buying
City and Suburban Homes Company of New York City, 1897,
23179
House, James, fl.1857-59
exhibitions, Troy, New York, 1858, *19818*
House of Tudor See: **Tudor, House of**
house painting
technique, *8036*
household linens
embroidery on bed linen and coverlets, *2774*
etching on linen, *921*
Housman, Laurence, 1867-1959
illustrations
House of joy, *12527*
Song of Three Kings, *12568*
Houssaye, Arsène, 1815-1896
collection, sale, 1896, *17085*
Houssaye, Arsène, *Mme*, 1826?-1854?
obituary, *18605*
Houssaye, Henry, 1848-1911
Cleopatra
edition published by Duprat and Co., 1890, *15487*
English edition published, 1890, *15399*
collection, *16639*
Houston (Texas)
exhibitions
1893, loan exhibition, *16227*
Houston, Frances C. Lyons, 1867-1906
exhibitions
American Art Association, 1883, *24398*
Boston Art Club, 1880, *72, 807*
Boston Museum of Fine Arts, 1880, *225*
Detroit Art Loan Exhibition, 1883, *24826*
illustrations
charcoal drawing, *10876*
sketch, *10903*
Houston, Mary G., fl.1896-1904
exhibitions, National Arts Competition, 1899, awarded gold
medal, *7127*
Houten, Barbara Elisabeth van, 1862-1950
exhibitions, New York, 1891, *15608*
Houten, Sientze Mesdag van See: **Mesdag van Houten,
Sientze**
Houve, Paul de la See: **LaHouve, Paul de**
Hovenden, Helen Corson, 1846-1935
American woman painter, *11230*
exhibitions, American Watercolor Society, 1884, *25012*
illustrations
Of high degree, *22508*
Thomas Hovenden's studio, *22571*
Hovenden, Thomas, 1840-1895
American subject commissioned by Battell, 1883, *24376*
Breaking home ties, *11597*
photogravure published by Klackner, 1893, *4761, 16330,
22252*
Brittany image seller, in Evans collection, *11185*
exhibitions
American Art Galleries, 1885, *1916*
American Watercolor Society, 1881, *296, 1065*
American Watercolor Society, 1882, *Dem was good ole*

times, *1300*
Cotton States International Exposition, 1895, *Breaking of
home ties*, *5568*
National Academy of Design, 1879, *657*
National Academy of Design, 1881, *1129*
National Academy of Design, 1882, *1330, 9646*
National Academy of Design, 1886, *2112*
National Academy of Design, 1887, *2431*
National Academy of Design, 1888, *2680*
National Academy of Design, 1889, *2936*
National Academy of Design, 1891, *Breaking home ties*,
3603
National Academy of Design, 1895, *5340*
National Academy of Design, 1896, *11791*
National Academy of Design, 1896, *The founders of a state*,
22996
Paris Exposition, 1878, *9072*
Pennsylvania Academy of the Fine Arts, 1885, *Harbor bar is
moaning*, *11280*
Pennsylvania Academy of the Fine Arts, 1891, *3535*
Pennsylvania Academy of the Fine Arts, 1895, memorial
exhibition, *11638*
Salmagundi Club, 1884, drawings, *25211*
Society of American Artists, 1890, *25929*
Union League Club of New York, 1884, *Last moments of
John Brown*, *25193*
Faint heart never won fair lady, *1253*
frontispiece for *Lippincott's*, 1883, *24459*
Grandmother's second sight, on view, New York, 1892, *16006*
illustrations
Old shaver, *10807*
Orchard, *22508*
Vendean peasants preparing for insurrection, *2489*
watercolor, *11214*
In the hands of the enemy, *25866*
Jerusalem the golden, *11570, 21554*
John Brown, *11155*
John Brown being led to execution, presented to Metropolitan
Museum, 1897, *17315*
Last moments of John Brown
acquired by Metropolitan Museum of Art, 1897, *6280*
on exhibition at Knoedler's, 1884, *11011*
member, Society of American Artists, *11241*
Negro studies in Clarke collection, *24943*
notes, 1894, *16446*
obituary, *5458, 16792*
picture in Evans collection, *15079*
summer home and studio, *22571*
Vendean volunteer, *9211*
whereabouts, 1883, Plymouth Meeting, Pa., working on John
Brown picture, *24728*
Hovenden, Thomas, *Mrs*. See: **Hovenden, Helen Corson**
HOVEY, Richard, *21495*
Hovey, Richard, 1864-1900
Marriage of Guinevere, review of book design, *22373*
HOW, Louis, *23706, 23804*
HOWARD, A. A., *13806*
HOWARD, Bertha M., *12321*
HOWARD, Blanche M., *12056, 12083, 12107, 12122*
Howard, Bronson, 1842-1908
notes, 1896, *22912*
Old Love Letters, performances, 1886, *2191*
HOWARD, E. M., *11562*
HOWARD, Ellsworth E., *13187*
Howard, Francis, 1874-1954
exhibitions, International Society of Sculptors, Painters,
Gravers, 1907, *14248*
illustrations
Along the Arno, Florence, *22704*
Piazza della Signoria, Firenze, *23152*
HOWARD, George, *11357, 11384*
HOWARD, Harrison N., *13359, 13547, 13702*
Howard, J. H. fl.1857-1864
illustrations, illustration for Willis' *Unseen Spirits*, *18357*
HOWARD, Mary R. Bradbury, *3577, 3605, 3650, 3697, 4026,*

National Academy of Design, 1885, *25271*
New Bedford, 1858, *19891*
New York, 1859, *19978*
monuments, memorial statue, *25876*
notes
 1859, *18283*
 1860, *20237*
 1883, *24480*
picture of Mt. Pleasant, 1883, *24568*
sales and prices, 1889, *2911*
studies, 1856, *19564*
view of Lake Pleasant, 1883, *24502*
whereabouts
 1858, summer quarters, *19891*
 1859, summer travel, *20080*
works in studio, 1875, *8573*
Hubbard, Wilmer, fl.1904-1929
illustrations, pencil study, *22202*
Hubbell, Charles E., fl.1896-1915
exhibitions, National Academy of Design, 1907, *14311*
illustrations, *New neighbor*, *23067*
Hubbell, Henry Salem, 1870-1949
biographical sketch, *11446*
exhibitions
 American Art Association of Paris, 1906-7, *14252*
 Chicago Art Institute, 1903, *13673*
 Chicago Art Students' League, 1895, *11469*
 Chicago Society of Artists, 1895, *11483*
 Pennsylvania Academy of the Fine Arts, 1906, *14244*
 Salon, 1904, medal, *13780*
 Society of Western Artists, 1906, *14038*
illustrations, *Caress*, *13851*
HUBBELL, Horatio, *19927, 19947, 20036, 20137, 20324, 20357*
Hubbell, Medora, fl.1882-1885
exhibitions
 American Art Galleries, 1885, *1921*
 National Academy of Design, 1884, *25187*
Huber, Conrad, fl.1855-1857
exhibitions, National Academy of Design, 1857, *19668*
portrait engraving of Winfield Scott, *19942*
HUBERT, Philip Gengembre, *22592, 22705, 22733*
Huberti, Edouard Jules Joseph, 1818-1880
obituary, *165*
Hubley, Grace, fl.1903
illustrations, *Cliff* (photograph), *22183*
Hübner, Carl Wilhelm, 1814-1879
Düsseldorf school, *14602*
Emigrants bidding farewell to the graves of their household, *18347*
Emigrants' farewell, *18999*
exhibitions
 Chicago Academy of Design, 1871, *10712*
 New York, 1849, *14508*
 Pennsylvania Academy of the Fine Arts, 1855, *18793*
Matrimonial quarrel, in Philadelphia Art-Union, 1849, *21404*
obituary, *64*
Poor weavers, *19298*
Hübner, Julius, 1806-1882
catalog of Royal Gallery of Dresden, *19692*
Pastor's blessing, *18542*
Hudson, Charles William, 1871-1943
illustrations
 Ahead of the style, *22490*
 Chicago chariot, *22590*
 Sailing the boat, *22645*
portraits, photograph, *22539*
Hudson Falls (New York). Halm Art Pottery Company See: **Halm Art Pottery Company, Hudson Falls, New York**
Hudson, Grace Carpenter, 1865-1937
exhibitions
 Denver Artists' Club, 1899, *12886*
 San Francisco, 1897, *Let's make up*, *6453*
illustrations
 Leggin' girl (from *Overland*), *22517*
 Mistiza, *22501*

Mountain lioness, *22945*
notes, 1903, *22176*
portraits, photograph, *22559*
woman in art, *22525*
Hudson, Hannah See: **Moore, Hannah Hudson**
Hudson, Henry, d.1611
monuments
 monument proposed for Atlantic Highlands, N.J., 1891, *26375*
 statue for Chicago World's Fair, 1892, *26750*
Hudson, John W., *Mrs.* See: **Hudson, Grace Carpenter**
Hudson River
description, 1855, *19088*
description and views, *8352, 8373, 8391, 8413, 8430, 8449, 8468, 8490, 10305*
description by Irving, *18914*
Hudson, William Lincoln, fl.1890-1905
Old fisherman, *22495*
Huet, Jean Baptiste, 1745-1811
illustrations
 design for painted tapestry decoration, *1822*
 Dog and geese, *23022*
Huet, Paul, 1803-1869
pen drawings, *1591*
Huffington, J. W.
dealer in spurious etchings, *1486*
Hugenholtz, Arina, 1851-1934
exhibitions, New York, 1892, *15800*
whereabouts, 1892, studio in New York, *26495*
Huger, Katherine Middleton, fl.1894-1902
illustrations, sketch, *22564*
woman in art, *22525*
Hugh of Avranches, d.1101
monuments, equestrian statue by G. F. Watts, *21792*
Hughes, Arthur, 1832-1915
pre-Raphaelite follower, *19723*
Ruskin's criticism, *19872*
Hughes, Ball See: **Hughes, Robert Ball**
Hughes, Edna, fl.1897
illustrations, charcoal head, *12630*
HUGHES, Elbert, *13767*
HUGHES, John Henry, *13484*
Hughes, Robert Ball, 1806-1868
biography, *20205*
exhibitions, Troy, New York, 1858, *19818*
lecture on sculpture, *19819*
notes, 1857, *19682*
obituary, *26520*
statue of Oliver Twist, *14834, 23467*
statue of Washington, *19942*
statues, *19801*
Washington Irving, *18441*
Hughes, Thomas, 1822-1896
obituary, *22988*
Peter Cooper biography, *17053*
School Days at Rugby, review, *19709*
Hughes, William, 1793-1825
illustrations, wood engraving by G. T. Devereux, *106*
HUGO, Victor Marie, *22634, 22656, 22677, 22697, 22719, 22746, 22780, 22806, 22807, 22835, 22864*
Hugo, Victor Marie, 1802-1885
as artist, *2025*
as writer-artist, *10806*
drawing of Ben Franklin's house at Passy, *13503*
drawings offered, 1891, *15720*
earliest publication of works, *15506*
exhibitions, New York Public Library, 1902, portraits of Hugo with drawings by him, *7968*
home, Paris house becomes museum, 1903, *8279*
illustrated books, *628*
letters
 published, 1897, *23750*
 to be published, 1896, *17074*
monuments
 monument planned for Paris, *25899*

Hunt, Alfred W., *Mrs.* See: **Hunt, Margaret Raine**
Hunt, Alfred William, 1830-1896
 excerpts on 19th century English landscape painting, *952*
 exhibitions
 Royal Academy, 1885, *2019*
 Royal Society of Painters in Water Colours, 1878, *21595*
 illustrations, *Barnard Castle from the Manor Fields,* *10487*
 loses election to Royal Academy associates, 1884, *9969*
 obituary, *17042*
 Tynemouth, *10013*
 visits Turner sites in Yorkshire, *1063*
Hunt, Annie M., fl.1895
 exhibitions, Corcoran Art Gallery, 1895, gold medal, *11591*
Hunt, Aubrey See: **Hunt, E. Aubrey**
Hunt, Catharine Howland, fl.1894
 on hand versus machine-made embroidery, 1894, *4852*
Hunt, Charles Day, 1840-1914
 exhibitions, Brooklyn, 1893, at artist's studio, *26906*
Hunt, E. Aubrey, 1855-1922
 exhibitions
 Boston, 1888, etchings, *2801*
 London, 1887, *2602*
 Royal Academy, 1887, *576*
 Society of American Artists, 1889, *2986*
 whereabouts, 1884, London, *25046*
Hunt, Henry P., d.1861?
 obituary, *20343*
Hunt, Holman See: **Hunt, William Holman**
Hunt, Jane, 1822-1903
 whereabouts, 1888, California, *2701*
Hunt, Leavitt, 1830-1907
 book in preparation, 1879, *17*
HUNT, Leigh, 1784-1859, *18677*
HUNT, Leigh Harrison, *11194, 17388, 17402, 17422, 17435, 17442, 17456, 17476, 17483, 17495, 17499, 17509, 17519, 17525, 17528, 17541, 17549, 17551, 17555*
Hunt, Leigh Harrison, 1858-1937
 whereabouts
 1899, *17571*
 1899, departs for France, *17626*
HUNT, Margaret Raine, *9618, 9640, 9663, 9708, 9725, 9862, 9940, 10015, 10107, 10451, 10487, 10506*
Hunt, Margaret Raine, 1831-1912
 Our Grandmothers' Gowns, review and excerpt, *3385*
Hunt, Mortimer
 library, sale, 1899, *17672*
Hunt, Myron, 1868-1952
 illustrations, architectural details, *13005*
HUNT, Richard Morris, *19639, 19655, 19666, 19766, 19780, 19794, 19910, 19953, 19970, 20091, 20112, 20161*
Hunt, Richard Morris, 1827-1895
 appointed to French Academy of Fine Arts, 1894, *22540*
 architectural plans for Metropolitan Museum of Art carried out after death, *14039*
 bronze doors for Trinity Church, *5064, 26331, 26341*
 collection
 fragment of ancient Greek sculpture of Pallas illustrated, *3126*
 sculpture casts gift to Metropolitan Museum, *1463*
 consulting architect for Columbian Exposition, *26051*
 design of house of T. P. Rossiter, *20031*
 designer, pedestal, Statue of Liberty, *2343*
 designs for Chicago World's Fair building, 1891, *26459*
 designs for Plymouth Church, Brooklyn, *20126*
 exhibitions
 Architectural League of New York, 1896, memorial statue, *5699*
 National Academy of Design, 1865, *23334*
 gates for Vanderbilt house, Newport, *15882*
 monuments
 B. Price and D. C. French collaboration, 1897, *23190*
 Central Park memorial unveiled, 1898, *17396*
 memorial designed by Bruce Price, executed by French, 1897, *6187*
 memorial for Central Park to be designed by French, *23008*

 model of memorial to be erected, 1897, *23240*
 to be erected, 1896, *17053*
 notes, 1858, *19953*
 officer, American Institute of Architects, 1859, *19970*
 opinion on J. Coleman Hart's paper on unity in architecture, *19992*
 portraits
 bust by D. C. French, *12983*
 portrait by J. S. Sargent commissioned by G. Vanderbilt, *22738*
 president of Municipal Art Society, New York, *22787*
 reception at Architectural League exhibition, 1887, *2621*
 Whitney house on Fifth Avenue, *2524*
 Yorktown monument, *450, 9561*
 commission, *178*
Hunt, Richard Morris, *Mrs.* See: **Hunt, Catharine Howland**
HUNT, Robert, *14819*
Hunt, Samuel Valentine, 1803-1893
 illustrations, *West Rock, New Haven* (after F. E. Church), *14801*
 Morning in the tropics (after F. Church), *20302*
HUNT, Sumner P., *12380*
Hunt, T. W., fl.1840-1884
 illustrations
 Ione (after T. N. MacLean), *9338*
 Richard Baxter (after T. Brock), *8871*
 Souvenir of St. Mark's (after Brunin), *10060*
 Susannah (after G. B. Lombardi), *8475*
Hunt, W., fl.1847-1858
 illustrations
 Astonishment, *18151*
 Neglected genius, *18106*
Hunt, William Henry, 1790-1864
 exhibitions
 Fine Art Society, 1879, *21796*
 New York, 1887, *10792*
 Royal Society of Painters in Water Colours, 1858, *19898*
HUNT, William Holman, *25461*
Hunt, William Holman, 1827-1910, *19551, 21860*
 Bride of Bethlehem, *2035*
 Christ in the temple, *18542*
 concern with purity of pigments, *8517*
 criticizes quality of artists' pigments in London, *9373*
 defense of English art, *26373*
 English Pre-Raphaelite, *17793, 17811*
 exhibitions
 Birmingham, 1891, *26422*
 Century Club, 1893, *26894*
 Chicago Art Institute, 1890, *Triumph of the innocents,* *3230*
 Glasgow Institute, 1880, *21973*
 Grosvenor Gallery, 1879, *9178*
 Grosvenor Gallery, 1887, *25455*
 London, 1886, *10302*
 London, 1890, *26059*
 London, 1906, *14222*
 New York, 1878, *9084*
 Paris, 1855, *19119, 19211*
 Paris Exposition, 1855, *18800*
 Royal Society of Painter in Water Colours, 1864, *23339*
 experiments with moonbeams, 1902, *7913*
 Finding of Christ in the temple, *17093, 18449, 20235*
 saved from fire, 1861, *20341*
 Flight into Egypt, *25008*
 completed, *21648*
 illustration for edition of *Pearl,* 1891, *26366*
 illustrations
 Isabella and the pot of basil, *21854*
 Light of the world, *13484*
 lectures
 on canvas in London National Gallery, 1881, *1068*
 on color, 1880, *9396*
 on pigments used by mediaeval artists, 1880, *982, 1007*
 on pigments used by modern artists, 1881, *1047*
 Light of the world, *19789*
 as Christian art, *19963*
 damage repaired, 1886, *10375*

Hurley, Vena, d.1898?
 obituary, *12701*
HURLL, Estelle May, 1863-1924, *5531*, *7056*
Hurll, Estelle May, 1863-1924
 Correggio, review, *13397*
 Greek Sculpture, review, *13239*
 Landseer, review, *13347*
 Murillo, review, *13178*
 Raphael, review, *12965*
 Rembrandt, review, *12468*
 Sir Joshua Reynolds, review, *13140*
 Titian, review, *13252*
 Tuscan Sculpture, review, *13450*
 Van Dyck, review, *13450*
HURLL, Margaret M., *13153*
Hurst, Mary E., fl.1882-1901
 exhibitions, National Academy of Design, 1886, *2352*
Hurst, S. E., Mrs.
 medium, *20697*
Hüser, A. C., fl.1895
 illustrations, *Sunset in Connecticut*, *5251*
Huss and Buck, architects
 competition design for St. John the Divine, 1891, *3600*
Huss, George Martin, b.1853
 See also: **Huss and Buck, architects**
 illustrations
 design for country house, *2849*
 Gothic bands for a wood-carving design, *2849*
Huston, C. Aubrey, b.1857
 illustrations, *On the hillside*, *22531*
Huston, William, fl.1875-1901
 exhibitions
 American Art Association, 1884, study of grapes, *25209*
 Prize Fund Exhibition, 1885, *25278*
HUTCHENS, Frank Townsend, *7518*, *7532*, *7552*
Hutchens, Frank Townsend, 1869-1937, *7269*
 illustrations, *Dutch peasant girl*, *7517*
 My guitar, *22503*
 notes, 1899, *17686*
 summer lake cottage, 1893, *22491*
Hutchings, C. A., fl.1895
 English dining room design, *5513*
Hutchins, Frank M., d.1896
 illustrations, *Revery*, *22490*
 obituary, *23030*
Hutchins, Frank T. See: **Hutchens, Frank Townsend**
Hutchins, Will, b.1878
 exhibitions, Deerfield, 1905, *13952*
Hutchinson, Allen, b.1855
 bust of Walter Scott, *17383*
 whereabouts, 1891, in Honolulu, *26227*
Hutchinson, Charles Lawrence, 1854-1924
 collection, *4073*, *15797*, *15811*, *17667*, *17682*, *22222*
 Pre-Raphaelite paintings exhibited, 1893, *4286*
 president of Chicago Art Institute, *3608*, *10792*, *13440*
 purchases Demidoff collection for Art Institute of Chicago, 1890, *3335*
 whereabouts, 1892, abroad, *3887*
Hutchison, Robert Gemmell, 1855-1936
 illustrations, *Bairnies cuddle doon*, *14016*
Huth, Charles Frederick
 collection, sale, 1895, *16786*
Huth, Julius, 1838-1892, *26716*
HUTT, Frank Wolcott, *4669*
Hutt, Henry, b.1875, *12696*
 exhibitions, Chicago Art Students' League, 1897, *12643*
 illustrations
 Dog show, *12724*
 sketch, *12724*
Hutten, Ulrich von, 1488-1523
 life and poetry, *19885*, *19895*
Hutton, Laurence, 1843-1904
 Artists of the Nineteenth Century and their Works, review, *9152*
 death mask collection, *15232*, *16401*
 attempt to acquire Eugene Field's death mask, 1896, *16915*

presented to Princeton University, 1897, *17276*
 Portraits in Plaster, *16610*
Huxley, Thomas Henry, 1825-1895
 lecture on science and religion, 1859, *20015*
Huy (Belgium)
 description, *21360*
Huyot, Jules Jean Marie, b.1841
 illustrations
 American cemetery (after T. Taylor), *21908*
 birds, *17860*
 Declaration in the olden time (after Maurice Leloir), *5861*
 farm scene, *17859*
 tailpiece, *17873*, *17874*
HUYSMANN, Karl, *23696*, *23735*, *23761*
Huysmans, Cornelius, 1648-1727
 landscape painting, *21370*
Huysmans, Jacobus Carolus, 1776-1859
 notes, 1899, *17679*
Huysmans, Joris Karl, 1848-1907
 Certains
 excerpt, *17633*
 excerpts from chapter on Millet, *17648*
 excerpts on Puvis de Chavannes and Degas, *17664*
Huysum, Jan van, 1682-1749, *21081*
 anecdote, *21055*
 flower painting, *2027*
 flower painting technique, *3636*
 flower-piece in Boston museum, 1881, *1108*
Huyvetter, Albert d'
 collection, sale, 1887, *574*
Hyatt, Anna Vaughn See: **Huntington, Anna Vaughn Hyatt**
Hyatt, Harriet Randolph See: **Mayor, Harriet Randolph Hyatt**
HYDE, Harlow, *13286*
Hyde, Helen, 1868-1919
 color etchings, *13530*
 exhibitions, Detroit, 1898, *12826*
 illustrations
 Baby San, *13985*
 On the bund, *22103*
 Japanese madonna, *13095*
 notes
 1900, *22114*
 1901, *22134*
Hyde, James Hazen, 1876-1959
 elected to board of governors, American Art Association of Paris, 1903, *13687*, *13701*
Hyde, John, 1846-1927
 illustrations, *At the academy*, *22598*
Hyde, Josephine Maria, 1862-1929
 travel and study in Japan with Helen Hyde, *13530*
Hyde, Mary M., fl.1893-1898
 illustrations, *Still life*, *6500*, *6524*
Hyde, Nathaniel Alden
 resigns presidency of Indianapolis Art Association, 1894, *26999*
Hyde Park, London See: **London (England). Hyde Park**
Hyde, Raymond Newton, b.1863
 exhibitions, New York, 1902, *7850*
Hyde, William Henry, 1858-1943
 exhibitions
 Chicago Society of Artists, 1895, *11483*
 National Academy of Design, 1900, *12997*
 New York, 1893, *22521*
 Society of American Artists, 1897, *10538*
 illustrations, *At our boarding house*, *22473*
 illustrations for *Harper's Weekly*, 1893, *22482*
hyenas, *21274*
hygiene, public
 town air and water supplies, *21330*
Hyland, F., fl.1894-1897
 illustrations, illustrations to *The White Walrus*, *23911*
hymns
 Evangelical Hymnal edited by Rev. Charles Cuthbert Hall and Mr. Sigismond Lasar, *1075*
 I. Watts and C. Wesley, *18235*

Roujoux, P., *Histoire Pittoresque de l'Angleterre*, 21444
Sutherland Clarendon, acquired by British Musum, 1891,
 15540
Tennyson, A., *Princess* illustrated by American artists, 1883,
 1667
Thackeray, W., *Chronicle of the Drum*, 1268
Three Cities, illustrated by Childe Hassam, 12879
Updike, D., *Altar Book*, 22425
Wonders of Italian Art, 10602
illustrated books, children's, 22808
 1883, *9730*
 Boutet de Monvel, *12323*
 colored illustrations, *12422*
 Denslow's illustrations, *13633*
 holiday books
 1881, *1251*
 1882, *1272*
 1885, *2049*
 1886, *Christmas Wide Awake*, 518
 1898, Christmas books published by J. M. Dent & Co, *24235*
 lecture by Chas. Welsh, 1899, *12372*
illustrated periodicals, 10804
 advice on getting illustrations accepted by magazines, 1897,
 6199
 advice on magazine illustration, 1891, *3538*
 art features, 1898, *12661, 12673*
 Century, illustrations, 1884, *24994*
 Christmas issues, 1899, *7182*
 cost of engravers' work to magazines, 1894, *4716*
 drawings for magazine publishers, 1891, *3468*
 DuMaurier lecture on comic periodicals, 1894, *5082*
 English Illustrated Magazine, illustrations praised, 1890, *3127*
 Harper's Magazine
 1892, *26688*
 1892-1893, *22476*
 illustrations, 1894, *4995*
 illustrations in magazines, *3173, 4793, 11445*
 1882, *1382*
 1890, *3148*
 1893, *4685*
 1894, *4897, 4928*
 1900, *7208, 7252*
 size, *4811*
 Lewis Frazer lecture on magazine illustration, 1894, *4716*
 Lewis Frazer on techniques and materials for magazine illustra-
 tion, 1893, *4666*
 Life, illustrations exhibited, 1894, *16616*
 pen drawing for photo-engraving, *2892*
 Scribner's, April issue, 1895, *5345*
 types of drawings required by illustrated periodicals, 1892,
 4199
 United States, monthly magazines, 1857, *17981*
illustration
 advice on book illustration, 1890, *3436*
 as parody, *22716*
 book and magazine illustration, *3250*
 designing for lithographers, *5183*
 drawing for illustration, *4549*
 drawing for publication, *5069*
 drawing technique, *4534, 5164, 6214, 6818*
 DuMaurier lecture on comic illustration, 1894, *5082*
 DuMaurier's influence, *23240*
 effect of excessive illustration on literature, *11113*
 engraved portraits in books, *919*
 exhibitions
 Buffalo Society of Artists, 1897, *12085*
 London, 1890, *Daily Graphic* annual exhibition, *3335*
 New York, 1893, women's work, *4379*
 San Francisco, 1897, work of students of J. H. E. Partington,
 6421
 grangerizing, or extra-illustrating books, *3869*
 half-tone illustrations, *11607*
 Harper's *Drawing for Reproduction*, 1894, *5065*
 history
 book illustration, *18329*

modern illustration, *12191*
illustrated books
 1851, *23481*
 1888, *628*
illustrated poetry, *24828*
lecture by Tredwell on Grangerism, 1891, *15653*
line drawings, *12996*
manufacturers' catalogues influenced by poster craze, *11660*
mistakes city-raised artists make in depicting farm life, 1894,
 4775
newspapers, *11198, 12142*
 1894, *4832*
 careers, *5808*
 finding a market, *3237*
 history, *16536, 16548, 16557*
 portrait illustration, 1891, *3578*
notes
 1889, *3122*
 1892, *3949, 4065, 4154, 4222*
 1893, wash drawings, *4640*
 1894, *4829*
 1895, *5363*
observation and accuracy, 1895, *22609*
Pennell's criticism of art of the illustrator, 1890, *3359*
photographic reproduction processes, *1899*
photomechanical relief-plates, *598*
prayerbooks, *1476*
preparing designs for publication, 1894, *5028*
processes for reproduction, *5077*
requirements compared to painting, *22596*
study and teaching
 class at Art Institute of Chicago, 1898, *12720*
 Reinhart's illustration class, 1895, *5539*
 School of Illustration, Chicago, *12964*
technique, *6003*
 advice on pen drawing, *4323*
 composition, *6221*
 depicting characters in a crowd, *7742*
 draped figure, *5124*
 drawing, *6848, 7773*
 drawing for reproduction, *5268*
 drawing over photographs, *5986*
 DuMaurier's drawing technique, *5175*
 E. J. Meeker on pen illustration, 1893, *4292*
 for book illustration, *5833*
 landscape drawing, *3799*
 London Society of Arts' discussion of process reproduction,
 1895, *5489*
 making chalk plates for newspaper illustration, *7594*
 pen and ink, *5079*
 pen and ink drawing, *7719*
 pen drawing, *3203, 3761*
 pen drawing for book illustration, *3504*
 pen drawings and drawings done from photographs, *8214*
 pen work for reproduction, *5177*
 pencil drawing, *5835*
 Raffaelli's technique in pen and crayon, *5305*
 rendering values in pen and ink, *5227*
 silver prints and stipple paper, *4249*
 suggestions to illustrators, 1890, *3436*
 use of solid black, *7885*
travel books, *17983*
types of illustrations wanted by publishers, 1901, *7650*
war news, 1898, *12740*
William Morris on woodcuts of Gothic books, 1892, *26624*
wood engraving, *1249*
illustration, American
art in book illustration, *509*
artists' favorite subjects, *22741*
biographies of artists, *11446*
book engravings, *19717*
book illustration, *17772*
Building of the Mohammedan Empire illustrated by Eric Pape,
 12879
Century Company to return to wood engraving, *12826*

Inglis, Thomas, Gallery See: **Boston (Massachusetts). Inglis, Thomas, Gallery**
Ingram, William Ayerst, 1855-1913
 exhibitions
 Brooklyn Art Association, 1884, watercolor, *25092*
 London, 1885, marine pictures, *10151*
 Sabrina fair, 10357
Ingres, Jean Auguste Dominique, 1780-1867
 Cardinal Bibbiena presenting Raphael to his niece Maria Bibbiena, in New York, 1891, *26438*
 classical painting, *22969*
 exhibitions
 Chicago World's Fair, 1893, *4467*
 London, 1855, *18852*
 Paris, 1861, *20367*
 Paris, 1884, drawings, *1773*
 Paris Exposition, 1855, *18841, 19226*
 home, commemorative inscription placed at former home, 1890, *25806*
 illustrations, drawing after portrait, *2728*
 Odalisque couchée, 17554
 Oedipus and the sphynx, 25642
 portrait of M. Bertin, acquired by Louvre, 1897, *6278*
 portrait of Mme. Moitessier, ownership of sketches disputed, *9017*
 sales and prices
 1882, drawing of Mlle. Boinnard, *14865*
 1883, drawings, *14884*
initials
 history, early printers, *9591*
Injalbert, Antoine Jean, 1845-1933
 statue criticized for nudity, 1896, *16935*
ink
 drawing in India ink, *2309*
 India inks, *5069, 5084*
 Indian and Chinese inks, *6470*
 printing ink for etching, *7648*
 recipes, *8283*
 sales of printing ink by William Johnston, 1894, *27026*
 sepia ink, *3996*
 vitrifiable ink for china painting, *2238, 5990*
INKERSLEY, Arthur, *23074, 23150*
inkstands
 Italian Majolica inkstand dated 1492, *25932*
Inman, Henry, 1801-1846, *14652*
 and T. S. Cummings, *22784*
 biography, *20205*
 with catalog of works, *21384*
 letter describing visit to Wordsworth, *14693*
 notes, 1901, *7641*
 Portrait of Martin Van Buren, given to Metropolitan Museum of Art, 1893, *26930*
 sales and prices, 1832, portraits, *14652*
 Van Buren and Seward portraits, *19183*
 works of the 1840's, especially portrait of Wordsworth, *644*
Inman, John O'Brien, 1828-1896
 illustrations
 Asher B. Durand, 2428
 decorative designs, *798*
 Maiden defending herself against love (after Bouguereau), *929*
Inness, George, 1825-1894, *8621, 11728*
 After a shower, 10782
 art philosophy, *9242*
 Autumn oaks, shown at Metropolitan Museum loan exhibition, 1886, *25359*
 biography by R. R. Rockwell planned, 1896, *23008*
 Clouded sun, at Paris Exposition, 1900, *13101*
 essay by Trumble, 1894, *16583*
 exhibitions
 American Art Galleries, 1879, *767*
 American Art Galleries, 1884, *25025, 25096, 25115*
 Boston, 1880, *9326*
 Boston Art Club, 1880, *102, 855*
 Brooklyn Crescent Athletic Club, 1891, *3524*

Carnegie Galleries, 1902, *13520*
Chicago Art Institute, 1895, *11485*
Chicago Art Institute, 1895, list of paintings exhibited, *5329*
Chicago Art Institute, 1901, *13345*
Chicago Inter-State Industrial Exposition, 1889, *3056*
Chicago Opera House, 1871, *10712*
Chicago World's Fair, 1893, *4380, 22258*
Detroit Art Loan Exhibition, 1883, works to be exhibited, *24721*
Kohn Gallery, 1890, *15428*
Ladies' Art Association of New York, 1880, *9445*
Lotos Club, 1895, *16694*
Lotos Club, 1899, *17548*
National Academy of Design, 1849, *21429*
National Academy of Design, 1858, *19835*
National Academy of Design, 1859, *20030, 20048*
National Academy of Design, 1860, *20208*
National Academy of Design, 1877, *8830*
National Academy of Design, 1878, *9002*
National Academy of Design, 1879, *9151*
National Academy of Design, 1882, *1330*
National Academy of Design, 1883, *24509*
National Academy of Design, 1885, *1970, 25271*
National Academy of Design, 1886, *2188*
National Academy of Design, 1888, *2680, 2695, 10846*
National Academy of Design, 1889, *2936*
National Academy of Design, 1892, *4143*
National Academy of Design, 1894, *4706*
New York, 1863, *23290*
New York, 1882, *9588*
New York, 1884, *1767, 1793, 10990, 10998*
New York, 1890, *15306*
New York, 1891, *End of a summer shower, 3793*
New York, 1893, *16122, 16277, 16316*
New York, 1893, Clarke's pictures, *16260*
New York, 1893, pictures in Clarke collection, *16171*
New York, 1894, *4975, 27005*
New York, 1895, estate paintings and Halsted collection, *5220*
New York, 1897, *6101*
New York, 1898, *6495*
New York, 1904, *13808*
New York, 1905, view of Perugia, *13843*
New York Athletic Club, 1888, *2638*
New York Fine Arts Society, 1894, memorial exhibition, *16628*
Paris, 1898, comment by A. Alexandre, *17412*
Prize Fund Exhibition, 1885, *1985, 25278*
San Francisco, 1891, *26341*
Seventh Regiment Fair, N.Y., 1879, *766*
Southern Exposition, Louisville, 1884, *11051*
Union League Club of New York, 1887, *10833*
Union League Club of New York, 1893, *4380*
Union League Club of New York, 1898, *6590*
Georgia pines, in Barrie collection, *15647*
Golden autumn, in Wadsworth Atheneum, *17646*
Harvest time in the Delaware Valley, in Walker collection, Minneapolis, *12924*
home
 acquired by William T. Evans, 1899, *17686*
 Montclair, N.J., open house, 1902, *8052*
illustrations
 Approaching storm, 13324, 13726
 Clouded sun, 14333
 Evening on the Hudson, 13510
 Harvest time, 14200
 Harvest time in the Delaware Valley, 13300
 In the gloaming, 3479
 Landscape, 13084
 Landscape - sunset, 13441
 Storm, 11625
 Summer morning, 11185
 Sunset, 11873
 Viaduct at Laricha, Italy, 13337
 Woodland scene, 10783

J

illustrations
 Daniel Boone's first view of Kentucky (after W. Ranney),
 14612
 Guiding the thread, *22546*
 Mexican news (after R. C. Woodville), *14720, 14732*
 distributed by American Art Union, 1851, *14823*
 Murray's defense of Toleration (after Rothermel), *14787*
JONES, Alfred Garth, *24090*
Jones, Alfred Garth, 1872-ca.1930
 illustrations
 advertisement for Goyvaerts Fils, *23897, 23921, 23949*
 advertisement for Spaulding & Co, *24184, 24216, 24244,*
 24277, 24308
 advertisement for *The Quartier Latin*, *23751, 23834*
 And the rain, it raineth every day, *23811*
 Beerbohm Tree as Falstaff, *24062*
 cover design for *The Quartier Latin*, *23773, 23856, 24217,*
 24245
 design for table of contents, *The Quartier Latin*, 1897,
 23731, 23797
 design for *The Quartier Latin*, *23772, 23794, 23813, 23855,*
 23876, 23894, 23919
 Don Quixote, *23867*
 Evening, *23742*
 ex libris G. Oliver Onions, *24258*
 Fairy musician, *23820*
 Farewell, *23929*
 headpiece, *24055*
 Icarus, *24012*
 illustration to poem, *24291*
 King Lear, *23962*
 Love starved out, *23845*
 Olden lore, *24057*
 Sir Henry Irving and Cardinal Wolsey, *24027*
 Student, *23759*
 Summer night, *24121*
 tailpiece, *24068*
 Wandering minstrel, *23886*
 Why so pale and wan, fond love?, *24229*
 Zephyrus and Flora, *23691*
 illustrations for *The Minor Poems of John Milton*, 1898, *24236*
Jones, Aneurin, 1824-1904
 criticized, 1890, *26076*
 removed as superintendent of Brooklyn parks, 1892, *26547*
 superintendent of parks, New York City, 1890, *26015, 26049*
 restricts sketching in Central Park, *25964*
Jones, Annie Weaver, fl.1871-1911
 exhibitions
 Chicago Art Institute, 1903, *13561*
 Denver Artists' Club, 1899, *12886*
 Palette Club of Chicago, 1892, *11307*
 Palette Club of Chicago, 1895, *11467*
 illustrations, *Chrysanthemums*, *11482*
Jones, Bolton See: **Jones, Hugh Bolton**
Jones, Caroline See: **Chisholm, Caroline Jones**
Jones, Charles, 1836-1892
 sheep painter, *4490*
Jones, David, d.ca.1880
 collection, sale, 1881, *1125*
Jones, Edward Burne See: **Burne Jones, Edward**
JONES, Florence A., *22887, 23175*
Jones, Florence Edmond, fl.1895-1897
 illustrations
 Romance, *23898*
 Wild flowers, *23746*
Jones, Francis Coates, 1857-1932
 elected to council, National Academy of Design, 1901, *13228*
 exhibitions
 American Watercolor Society, 1897, *Torch-bearer*, *23213*
 Fellowcraft Club, 1890, *26181*
 National Academy of Design, 1885, *1970*
 National Academy of Design, 1885, Clarke prize, *25279*
 National Academy of Design, 1886, *2112*
 National Academy of Design, 1887, *552*
 National Academy of Design, 1890, *3228*

Society of American Artists, 1884, *Hazy afternoon*, *11003*
Society of Painters in Pastel, 1884, *9998*
Union League Club of New York, 1884, *Exchanging confi-
 dence*, *25193*
illustrations
 Holiday gifts, *4275, 5943*
 Little visitor, *11971*
 Marsh grasses, *567*
 Running for home, *13250*
 Sappho, *6011*
 Torch bearer, *6186*
 Won't play!, *10745*
In the woods, shown in Brooklyn, 1893, *26916*
member of Sketch-Box Club, Paris, 1883, *24640*
paintings in Clarke collection, *11207*
 exhibited in New York, 1893, *16171*
pictures in Montross collection, *25418*
statement regarding movement to create school of fine arts
 under government control, *14193a*
Stepping stones (originally entitled *Helping hand*), *11252*
whereabouts
 1883, Paris, *24871*
 1883, sales for Paris, *24367*
 1883, travels to Paris, *24689*
Jones, Frank C. See: **Jones, Francis Coates**
Jones, Frank Eastman, fl.1887-1891
 whereabouts, 1887, summer travel, *2543*
Jones, George, 1812?-1890?
 obituary, *25879*
JONES, Grahame, *20552, 20559*
JONES, H., *10202*
Jones, H. Bolton See: **Jones, Hugh Bolton**
Jones, Haydon, fl.1894-1924
 illustrations, character sketch, *11445*
Jones, Henrietta Ord, b.1860
 illustrations, pottery, *13958*
Jones, Horatio Gates, 1822-1893
 obituary, *16193*
Jones, Hugh Bolton, 1848-1927, *9273*
 exhibitions
 American Watercolor Society, 1885, *1933*
 Artists' Fund Society, 1884, *24967*
 Baltimore, 1871, *10709*
 Chicago, 1902, *13399*
 London, 1883, American Water-Color Exhibition, *24713*
 Minnesota State Art Society, 1905, *13905*
 National Academy of Design, 1883, *Near Annisquam*, *9936*
 National Academy of Design, 1884, *1879, 10982, 25125*
 National Academy of Design, 1887, *25437*
 National Academy of Design, 1903, *13547*
 National Academy of Design, 1905, *14062*
 National Academy of Design, 1907, *14311*
 New York, 1877, *10782*
 New York, 1889, *14946*
 New York, 1890, *15306*
 Pennsylvania Academy of the Fine Arts, 1882, *1450*
 Pennsylvania Academy of the Fine Arts, 1883, *1677*
 Philadelphia Society of Artists, 1880, *246, 1025*
 Society of American Artists, 1881, *367*
 Society of American Artists, 1884, *Spring morning*, *11003*
 Society of American Artists, 1886, *2227*
 Society of American Artists, 1890, *3255*
 Society of American Artists, 1902, Webb prize, *13403*
 Society of Painters in Pastel, 1884, *25089*
 Worcester Art Museum, 1902, *13483*
 illustrations
 Early morning, *24434*
 Early snow, *13202*
 Early spring, *10772*
 Gray day, *13359*
 Late November, *13387*
 Near Sheffield, Massachusetts, *12015*
 November, *12787*
 illustrations for Buchanan's *Closing Scene*, 1886, *509*
 landscape of New Jersey scene, 1883, *24618*

landscape shown at Century Club preview, 1884, *25064*
landscape shown at Reichard's, New York, 1884, *25195*
landscape sketch, *3259*
landscapes, 1884, *25074*
member of art jury, Tennessee Centennial, 1896, *11843*
notes
 1883, *24492, 24551*
 1887, *546*
painting out-of-doors, 1882, *24367*
paintings in Clarke collection, *11207, 24955*
sales and prices
 1883, *24480*
 1885, Seney collection sale, *1963*
 1891, *September* in Seney collection sale, *15473*
Wayside pool, *1129*
whereabouts
 1883, *24804*
 1883, Coffin's Beach, *24755*
 1887, summer travel, *2543*
Winter twilight, *24379*
work, 1883, *24817*
Jones, Isabelle, fl.1898-1919
 illustrations, pen-and-ink from still life, *12756*
JONES, Jenkin Lloyd, *13192, 13374*
JONES, Jessie Barrows, *5974, 22367*
Jones, John, 1800?-1882
 collection, bequest to South Kensington Museum, *9779, 9810,*
 9826, 9887, 9903, 14882
Jones, John Edward, 1806-1862
 illustrations, *William Dargan, Esq.*, *20937*
 meeting with Wordsworth, *17193*
JONES, John Tracy, *23182*
Jones, Lucy See: **Hooper, Lucy Hamilton (Jones)**
Jones, Maud Raphael, fl.1889-1907
 female name, *3335*
Jones, *Mr*, of Philadelphia
 collection, sale, Philadelphia, 1858, *19875*
Jones, Owen, 1809-1874
 Crystal Palace, Hyde Park, *14765*
 decoration of Alfred Morrison house, *21702*
 decoration of Crystal Palace, London, *14742*
 English designer, *10438*
 Grammar of Ornament, *22393*
 publication, *19357*
 plan for painting interior of Crystal Palace, 1851, *14738*
Jones, Philip Burne See: **Burne Jones, Philip**
Jones, Rebecca, fl.1902-1903
 exhibitions, Paris, 1902, *13372*
Jones, Reginald, 1857-1904
 exhibitions, London, 1892, *26678*
Jones, Theodore, fl.1856-1860
 illustrations, masthead design for *The Sketch Club* (after
 Noble), *24309, 24327, 24342*
 picture of a flying Indian shown in Cincinnati, 1860, *24335*
 sketch for Cincinnati Sketch Club meeting, 1860, *24347*
Jones, Thomas Alfred, 1823-1893
 obituary, *26955*
Jones, Thomas Dow, 1811-1881
 bust of Hon. Thomas Ewing, *24339*
 bust of Salmon P. Chase, *18349*
 obituary, *333*
 whereabouts, 1850, move to New York, *14696*
Jones, William Foster, ca.1815-ca.1869
 exhibitions, Art Union of Philadelphia, 1851, *23471*
JONES, William Henry Rich, *9895*
JONES, Wyeth, *13089*
Jongers, Alphonse, 1872-1945
 exhibitions, New York, 1899, portraits, *6903*
 notes, 1899, *17516*
Jonghe, Gustave Leonhard de, 1829-1893
 stricken with apoplexy, 1884, *25097*
Jongkind, Johan Barthold, 1819-1891, *15099*
 exhibitions
 Boston, 1899, *12855*
 New York, 1892, *3834*

 New York, 1895, *16650*
 New York, 1896, *16984, 22980*
 Paris, 1887, palettes of artists, *2490*
obituary, *26274*
sales and prices
 1891, *15538, 15772, 15790*
 1903, *8126*
sketch shown in New York, 1887, *25399*
Jonnard Pacel, Paul, d.1902
 illustrations
 Artemis (after H. Thornycroft), *22004*
 Cinderella, *123*
 Intercepted dispatches (after A. Neuville), *22011*
 Last day of a condemned prisoner (after M. Munkácsy),
 22035
 Vintage Festival (after Alma Tadema), *9738*
Jonson, Ben, 1573?-1637
 biography, *20801*
Jopling, Joseph Middleton, 1831-1884
 obituary, *10115*
Jopling, Joseph Middleton, *Mrs*. See: **Jopling, Louise Goode**
JOPLING, Louise Goode, *3800, 6260, 21729*
Jopling, Louise Goode, 1843-1933, *21839*
 advice to artists on drawings and palette, 1897, *6315*
 article on artist's models, *25814*
 exhibitions
 Dudley Gallery, 1878, *21572*
 Royal Academy, 1878, *21590*
 hints to amateurs in watercolors, 1892, *3852*
 illustrations, *Five o'clock tea*, *21832*
 paintings in studio, 1878, *21575*
 portrait of Nathaniel de Rothschild acquired by Lord
 Beaconsfield, 1878, *21649*
Jordaens, Jacob, 1593-1678
 biography and works, *20885*
 Jupiter and the goat, *20887*
 sales and prices, 1890, *Portrait of a syndic*, *15248*
Jordan Art Gallery, Boston See: **Boston (Massachusetts).**
 Jordan Art Gallery
Jordan, David Wilson, b.1859
 illustrations
 Studio muse, *22560*
 Warrior bold, *22531*
 summer home and studio, *22571*
 whereabouts, 1895, Liverpool, 1895, *22738*
Jordan, Fedor Ivanaovich See: **Iordan, Fedor Ivanovich**
Jordan, Max, 1837-1906
 resigns from Berlin's National-Galerie, 1895, *16862*
 Stammbuch der National-Galerie, review, *271*
Jordan, Rudolf, 1810-1887
 exhibitions, Amsterdam, 1859, genre painting, *19993*
Jordan, Thomas Brown, 1808?-1890, *26066*
Jorgensen, Christian, 1860-1935
 exhibitions, San Francisco, 1899, *22069*
 landscapes, 1901, *22134*
 whereabouts
 1895, Santa Cruz mountains, *22765*
 1900, California, *22114*
 1903, *22176*
Joseffy, Rafael, 1852-1915
 pianist, *23154*
Joseph Bonaparte, *king of Spain*, 1768-1844
 collection, sale, 1890, *3177*
Joseph, Edward
 collection
 English miniatures sold, 1890, *3310*
 miniatures, *1575*
 miniatures shown at Pedestal Fund Loan Exhibition, 1883,
 1705
 sale, 1890, *3231, 15176*
 to be sold, 1890, *3207*
Joseph, Felix A., 1840-1892
 collection
 drawings donated to Nottingham, 1892, *26486*
 English drawings donated to Castle Museum at Nottingham,

1890, *15199*
obituary, *26755*
Joseph, *Nez Percé chief*, ca.1840-1904
portraits, portrait by Elbridge Ayer Burbank, *12774, 12807*
Josephi, Isaac A., 1860?-1954
exhibitions
American Society of Miniature Painters, 1900, *13022*
American Society of Miniature Painters, 1905, *13866*
American Watercolor Society, 1902, *13424*
whereabouts, 1896, summer in town, *23056*
Josephson, *Mr*
collection, purchases in Rome, 1861, *20330*
JOSEPHUS, 11231
Josey, Richard, 1841?-1906
engravings after Barber and Ouless, published, 1884, *10022*
Josselyn, Charles, 1847-1925
My Favorite Book-Shelf, book cover competition, 1902, *22158*
Jossot, Abdul Karim See: **Jossot, Henri Gustave**
Jossot, Henri Gustave, b.1866
illustrations, comic vignettes, *22540*
Jouaust, Damase, 1834-1893
obituary, *16211*
publications, *15748*
Joubert, Ferdinand, 1810-1884
illustrations
Faithful unto death (after E. J. Poynter), *10323*
Infant Jesus and St. John the Baptist (after Rubens), *8431*
Messenger of good tidings (after F. W. W. Topham), *9947*
obituary, *10127*
quote, *20339*
Jouett, Matthew Harris, 1787?-1827
biography by C. H. Hart, *17205*
exhibitions, Southern Exposition, Louisville, 1884, *11051*
Kentucky portrait painter, *576*
notes, 1896, *17191*
Jouffroy, François, 1806-1882
work, 1859, *18380*
Joullin, Amédée, 1862-1917
assistant director, San Francisco School of Design, 1888, *2701*
awards, 1900, *22099*
exhibitions
San Francisco, 1897, *Presidio marsh*, *6453*
Trans-Mississippi and International Exposition, Omaha, 1898, *12775*
notes, 1903, *22190*
painting for the Northern Pacific Railroad, *22176*
whereabouts, 1895, Alameda County, *22765*
Jourdain, Charles, 1817-1886
Philosophie de Saint Thomas d'Aquin, review, *19916*
Jourdain, Roger Joseph, 1845-1918
exhibitions
Cercle Artistique, 1877, *8817*
Société d'Aquarellistes Français, 1880, *9278*
illustrations
drawing, *7075*
figure study, *3734*
Low tide, 3287
Sandy beach, 5038
sketch, *6347*
Venice, 6214
Jourdan, Theodore, b.1833
illustrations, *Sheep drinking, 1143*
journalism
theories, *20262*
Joy, Albert Bruce See: **Bruce Joy, Albert**
Joy Didier, Ida See: **Didier, Ida Joy**
Joy, George William, 1844-1925
notes, 1896, *17090*
Thirty years before Trafalgar, reproduced on photogravure, 1886, *10270*
Joy, Ida See: **Didier, Ida Joy**
Joy, Mary Eliza See: **Haweis, Mary Eliza Joy**
JOYCE, Cecile, *22857*
J.-S., C., *24086*

Judd, Sylvester, 1813-1853
Margaret: a Tale of the Actual and the Ideal, Blight and Bloom, illustrated by F. O. C. Darley, *12996*
Judge, William Quan, 1851-1896
obituary, *22988*
Judson, Charles Chapel, 1864-1946
assistant professor at California School of Design, 1899, *22077*
exhibitions, San Francisco, 1897, *6453*
illustrations, *Chilly morning, 22125*
notes, 1904, *22203*
Judson, Maria See: **Strean, Maria Judson**
JUDSON, William Lees, *12384*
Judson, William Lees, 1842-1928
picture of Holy Family, *11308*
third prize for stained glass, 1900, *12452*
Juengling, Frederick, 1846-1889
collection, sale, 1890, *3208*
engraving for *Scribner's Magazine*, 1893, *22490*
engravings after Shirlaw's illustrations, *11274*
engravings for Goldsmith's *The Hermit*, 1885, *10281*
exhibitions
American Watercolor Society, 1884, *25038*
Dudley Gallery, 1881, *22025*
Internationale Kunstausstellung, Munich, 1883, prize for wood-engraving, *24791*
Prize Fund Exhibition, 1885, *1985*
Salmagundi Club, 1890, *25805*
Salon, 1885, *2035*
illustrations
Impudence (after W. M. Chase), *9301*
In the desert (after R. Swain Gifford), *17705*
Old peasant and his daughter (after W. Leibl), *170*
Portrait of a lady (after W. M. Chase), *242*
portrait study (after F. R. Strobridge), *221*
Professor (after Duveneck), *195*
sketch (after J. C. Beckwith), *9287*
study (after W. M. Chase), *9301*
Very old (after W. Shirlaw), *385*
In the land of promise (after C. F. Ulrich), *514*
Lesson (after C. N. Flagg), *11209*
obituary, *3171*
sales and prices, 1890, *25771, 25847*
teaches Gotham Art Students, 1885, *11219*
wood engravings, *168, 15141*
Juerdens, A. See: **Joerdens, A.**
Juergens, Alfred, 1866-ca.1934
exhibitions
Chicago, 1900, *13141*
Kansas City Art Club, 1902, *13337*
illustrations, *Wind-tossed, 14153*
notes, 1899, *17702*
painter, *13187*
jugglers
Madras, *18992*
Juglaris, Tommaso, 1844-1925
exhibitions
Boston, 1902, murals for Ray Memorial in Franklin, Mass., *13537*
Boston Museum of Fine Arts, 1880, *225*
Pennsylvania Academy of the Fine Arts, 1881, *1128*
illustrations
Couture on his deathbed, 460
headpiece and initial, *338*
Pupils of love (after S. P. B. Dodson), *246*
War episode (after M. Muncácsy), *341*
name should make fame, *25047*
portrait of a young woman selected by Boston Art Club jury, 1884, *25001*
Julian, Rodolphe Louis, 1839-1907
art teacher, Paris, *26383*
notes, 1895, *5186*
obituary, *14305*
Julian, Rodolphe Louis, *Mme* See: **Beaury Saurel, Amélie**
JULIEN, Jules, *1292*

canvas moved to Albany capitol, 1895, *16842*
designs for hangings, *10071*
exhibitions
 American Watercolor Society, 1888, *10843*
 Denver Artists' Club, 1905, *13907*
 National Academy of Design, 1887, *2606, 10831*
 National Academy of Design, 1888, *10846*
 New York, 1888, tapestries, *10843*
 Society of American Artists, 1880, *844*
 Society of American Artists, 1882, *1349*
 Society of American Artists, 1886, *25309*
 Society of Independents, 1894, *22540*
 Woman's Art Club of New York, 1890, pastels, *15128*
illustrations
 chrysanthemum screen, *1711*
 initial, *434*
 initial and tailpiece, *459*
 mermaid design, *1913*
 portrait plaque, *1976*
Painting Book, children's competition to color book, 1883, *24774*
portieres for Mrs. Langtry, 1884, *25018*
portraits of authors, *26051*
 undertaken, 1887, *549*
reception at Central Art Association, 1898, *12248*
second prize, Prang's Christmas card competition, 1881, *1268, 9572*
silk tapestry shown at Cincinnati Exposition, 1883, *24827*
work for Associated Artists, *1907*
KEITH, Mercia Abbott, *23236*
Keith, William, 1839-1911
 artists in San Francisco, *811*
 California paintings, *13095*
 exhibitions
 Buffalo Pan-American Exposition, 1901, awarded medal, *22124*
 New York, 1892, *16022*
 New York, 1893, *16157*
 San Francisco, 1893, *16206*
 San Francisco, 1897, *6453*
 San Francisco, 1897, *High Sierras near Yosemite, 6421*
 illustrations
 Collis P. Huntington, 22105
 Morning near San Raphael, 12956
 Morning star, 22134
 notes
 1899, *17639*
 1903, *22176*
 painting of Mt. Shasta, *738*
 panels for St. Francis Hotel, *22190*
 portrait of Jane K. Sather, *22142*
 Summit of the Sierras, given to San Francisco Art Association, 1900, *22091*
 whereabouts, 1895, Sierra Nevada, *22765*
 work in Benjamin Avery collection, 1898, *6545*
Kekulé von Stradonitz, Reinhard, 1839-1911
 Griechische Thonfiguren aus Tanagra, review, *15*
Kelekian, Dikran, inc. See: **New York. Dikran Kelekian G., inc.**
Kélékian, Dikran Khan, 1868-1951
 appointed Persian Consul to New York, 1902, *8035*
 New York gallery exhibition, 1899, *17591*
 notes, 1899, *17607*
 opens New York gallery, 1894, *16505*
 title of Khan conferred by Shah of Persia, 1900, *7427*
 wares, 1899, *17554*
Keller, Albert von, 1844-1920
 exhibitions, St. Louis Exposition, 1896, *6011, 11873*
 Secession, *22315*
Keller, Arthur Ignatius, 1866-1924
 elected president, Society of Illustrators, 1903, *13604*
 exhibitions
 American Watercolor Society, 1900, *13021*
 American Watercolor Society, 1902, Evans prize, *13424*
 American Watercolor Society, 1903, *13592*

American Watercolor Society, 1904, *13746*
American Watercolor Society, 1906, *14118*
National Academy of Design, 1887, *552*
New York Water Color Club, 1893, *4284*
illustrations
 About finished, 22513
 Golden wedding, 14333
illustrator, *13409*
What shall I say?, 22638
Keller, F. W., fl.1892
 exhibitions, Union League Club of New York, 1891, *Street scene, 3831*
Keller, Ferdinand, 1842-1922
 exhibitions, Chicago World's Fair, 1893, *4651*
 illustrations
 Landscape - decorative oil painting, 14081
 Landscape - decorative oil-painting, 13522
 Waldküre, 13526
Keller, George, 1842-1935
 design for Buffalo's Soldiers' and Sailors' monument, 1881, *472*
Keller, Henry George, 1870-1949
 exhibitions
 Chicago Art Institute, 1902, *13536*
 Munich, 1901, first prize, *13244*
Keller, Joseph von, 1811-1873
 sales and prices, 1858, *Dispute of Raphael, 18243*
Keller Leuzinger, Franz, 1835-1890
 Amazon and Madeira Rivers, review, *8421*
Keller Reutlingen, Paul Wilhelm, 1854-1920
 exhibitions, St. Louis Exposition, 1896, *11873*
Kellerman, Mrs., fl.1886
 plaques of cowboys, *503*
Kelley, Emily See: **Moran, Emily Kelley**
Kelley, Gwendolyn Dunlevy See: **Hack, Gwendolyn Dunlevy Kelley**
Kelley, Horace, 1819-1890
 bequest to Cleveland Museum and School of Art, *12859*
 bequest to found art gallery in Cleveland, 1890, *26220*
Kellogg, Alice DeWolf See: **Tyler, Alice Kellogg**
KELLOGG, Alice Maude, 1862-1911, *7277, 7512, 7529*
Kellogg, Amy L., fl.1887-1895
 exhibitions
 Berkeley Athletic Club of New York, 1892, *26576*
 Salmagundi Club, 1887, *534*
 illustrations, *Holiday clothes, 22513*
 portraits, photograph, *22518*
Kellogg, Harrietta, fl.1889-1905
 exhibitions, National Academy of Design, 1891, *26307*
Kellogg, Jane Elizabeth Crosby, d.1892
 obituary, *26846*
KELLOGG, Lavinia Steele, fl.1882-1888, *1776, 1855, 1872, 1890, 1909, 1940, 2587, 2590, 2610, 2611, 2629, 2645, 2647, 2665, 2685, 2701, 2709, 2710, 2732, 2750, 2771, 2772, 2789, 2810, 2829, 2846, 2867, 2890, 2893, 2916, 2945, 2970, 2994, 3015, 3036, 3037, 3081*
Kellogg, Lavinia Steele, fl.1882-1888
 exhibitions
 American Watercolor Society, 1885, *1933*
 Berkeley Athletic Club of New York, 1892, *26576*
 illustrations, *Nasturtiums, 4485*
 notes, 1888, *2726*
Kellogg, Lizzie, fl.1870
 notes, 1870, *10569*
Kellogg, Martin, 1828-1903
 portraits, portrait by Orrin Peck, *22140*
Kellogg, Miner Kilbourne, 1814-1889
 collection
 authenticity of Raphael's *Belle jardinière* questioned, *18313*
 controversy over *Herodias* attributed to Leonardo, 1880, *888, 908, 931*
 portraits of Gen. Scott and Taylor, *23416*
 whereabouts, 1851, returns to Italy after 4 years in U.S, *14821*
KELLOGG, Warren Franklin, b.1860, *598*
KELLY, George Forbes, *10843, 10846*
KELLY, J. Henderson, fl.1881-1894, *22564*

Klein, Catharina, 1861-1929
German flower painter, *6319*
illustrations, flower study for copying, *6352*
Klein, Charles, 1867-1915
Heartsease, performed, 1897, *23197*
Klein Chevalier, Friedrich, b.1862
exhibitions, New York, 1899, *17538*
Klein, Johann Adam, 1792-1875
obituary, *8535*
Klein, Johann Evangelist, 1826-1883
obituary, *14895*
Klein, Lillie V. O'Ryan, fl.1900-1924
Mrs. Edward Newell jr., *22190*
portraits completed, 1904, *22203*
KLEIN, Margaret A., *11508*
Klein, Margaret A.
appointed associate editor, *The Arts*, 1895, *11567*
Kleinhans, Lucia See: **Mathews, Lucia Kleinhans**
Kleist, Heinrich von, 1777-1811
Zerbrochene Krug, illustrations by A. von Menzel, *9650*
Klemm, Matilda, fl.1897-1898
exhibitions
Chicago, 1897, decorated china, *11967*
Chicago, 1898, *12251*
Chicago, 1898, china, *12195*
Klepper, Max Francis, 1861-1907
At liberty, *22945*
illustrations
Inspection of officers, *22473*
Shielding him by her shadow, *13290*
models, horses, *22519*
Klever, Julius Sergius, 1850-1924
exhibitions, Internationale Kunstausstellung, Munich, 1883, *14916*
Russian landscape painter, *25623*
Klimt, Gustav, 1862-1918
murals for Beethoven room, Vienna Secession, 1902, *13465*
Kline, William Fair, 1870-1931
awarded Lazarus Scholarship, 1894, *27027*
elected associate of National Academy, 1902, *13351*
exhibitions
American Art Association of Paris, 1896, *23709*
Architectural League of New York, 1900, *7231*
National Academy of Design, 1900, Clark prize, *13173*
National Academy of Design, 1901, Clarke prize, *13202*
National Academy of Design, 1903, second Hallgarten prize, *13547*
Flight into Egypt, Thomas B. Clarke prize, 1901, *13213*
illustrations
headpiece, *23626, 23686, 23753, 23774, 23796, 23815, 23836, 23857, 23878, 23896*
Poésie, *23630*
Thanksgiving Day menu, *23703*
whereabouts
1896, summer travel in Italy, *23626*
1897, returns to New York from Paris, *23998*
Klinger, Max, 1857-1920
illustrations
bust of Nietzsche, *13563*
statue of Beethoven, *13985*
notes, 1898, *17393*
Penelope, *22408*
Secession, *22315*
statue of Beethoven, at Vienna Secession, 1902, *13465*
Klinkicht, Moritz, b.1845
illustrations
Applicants for a sou (after J. Sant), *21783*
Awake (after J. E. Millais), *21669*
Christ asleep on the lap of the Virgin (after M. Basaiti), *21849*
Col. the honourable Charles Hugh Lindsay (after L. Jopling), *21839*
Dancing group (after G. Romney), *21932*
Delphic sibyl (after Michelangelo), *21836*
First Prince of Wales (after J. Gilbert), *21612*

Forbidden book (after K. Ooms), *21982*
Four children (after Rubens), *21857*
Geiz und Liebe (after L. Löfftz), *21752*
Great St. Bernard, Mont Velan (after E. Walton), *21937*
illustrations for Longfellow's *Evangeline* (after F. Dicksee), *9657*
Lady Blessington (after T. Lawrence), *21699*
Lizard (after F. Bouré), *21988*
Memories (after J. D. Linton), *21691*
Oh! wha wad buy a silken gown (after T. Faed), *21599*
painting of shepherd (after C. Green), *21782*
painting of woman in forest (after F. Dicksee), *21782*
Paolo and Francesca (after G. F. Watts), *21642*
portrait of Briton Rivière (after photograph), *21732*
portrait of Elizabeth Butler (after photograph), *21733*
portrait of Erskine Nicol (after photograph), *21713*
portrait of Francis Seymour Haden (after photograph), *21724*
portrait of G. F. Watts (after Watts), *21642*
portrait of George Dunlop Leslie (after photograph by A. E. Fradelle), *21818*
portrait of H. Herkomer (after photograph by Elliott and Fry), *21826*
portrait of H. S. Marks (after photograph), *21689*
portrait of H. W. B. Davis (after photograph by R. Faulkner), *21943*
portrait of J. C. Hook (after photograph), *21661*
portrait of J. L. E. Meissonier, *21947*
portrait of J. L. Gérôme (after photograph by F. Mulnier), *21878*
portrait of John Haynes Williams, *22048*
portrait of Joseph Noel Paton, *21744*
portrait of Louise Jopling (after photograph by A. Boucher), *21839*
portrait of Marcus Stone (after photograph), *21769*
portrait of P. H. Calderon (after photograph), *21629*
portrait of Peter Graham (after photograph), *21703*
portrait of Robert Allan (after H. Raeburn), *21737*
Portrait of the artist's mother (after J. Ward), *21807*
Portrait of the first Marquess of Stafford (after G. Romney), *21969*
portrait of Thomas Lawrence (after T. Lawrence), *21699*
portrait of Vicat Cole (after photograph), *21616*
portrait of W. P. Frith (after photograph), *21684*
portrait of William Holman Hunt (after photograph by T. G. Hemery), *21860*
Reverend Mr. Score (after J. Jackson), *21807*
Scene in Hal o' the wynd's smithy (after J. Pettie), *21905*
Sibyl (after W. W. Story), *21739*
Symbol (after F. Dicksee), *21997*
view of Fowey, England (after J. E. R.), *21866*
view of Morlaix, France (after B. F. B.), *21834*
Widowed (after F. Holl), *21797*
Klio Association, Chicago See: **Chicago (Illinois). Klio Association**
Klippart, Josephine, 1848-1936
exhibitions, Columbus Ceramic Club, 1894, *11432*
Klischowski, Emanuel
illustrations, interiors, *20537*
Klopstock, Friedrich Gottlieb, 1724-1803, *19571*
Klopstock, Margareta Moller, 1728-1758
letter to Samuel Richardson, *19571*
Klösz, György, fl.1860-1880
M. Munkácsy (photograph), *318*
Klots, Alfred Partridge, fl.1900-1925
exhibitions, American Society of Miniature Painters, 1900, *13022*
Klotz, Gustave François, 1810-1880
obituary, *83*
Klügmann, Adolf, d.1880
obituary, *288*
Klumpke, Anna Elizabeth, 1856-1942
exhibitions
Chicago Art Institute, 1897, *6463*
Paris Exposition, 1889, *Portrait of a woman*, *25695*
Pennsylvania Academy of the Fine Arts, 1902, *13363*

Philadelphia Art Club, 1892, *26859*
Prize Fund Exhibition, 1886, *2226, 25304*
Salon, 1882, *1397*
Salon, 1883, *1602*
Salon, 1884, *1814*
Salon, 1889, *2985*
Salon, 1899, *12915*
Woman's Art Club of New York, 1892, *26531, 26542*
lecture on art life in Chicago before Unity Art Club, Boston, 1894, *27027*
notes, 1899, *17639*
Kluth, Robert, 1854-1921
exhibitions, National Academy of Design, 1903, *13547*
Klyn, Charles F. de See: **DeKlyn, Charles F.**
Knackfuss, Hermann Joseph Wilhelm, 1848-1915
Deutche Kunstgeschichte, review, *25891*
painting of entry of German Emperor into Jerusalem, *8124*
completed, 1903, *13545*
Knaffl Brothers, Knoxville, Tennessee
exhibitions, Photographers' Association of America Convention, 1899, *12937*
illustrations, *Jovial son of the South* (photograph), *23141*
Knapp, Arthur N.
lecture, Baltimore, 1880, *9326*
KNAPP, Arthur Taylor, *21493*
KNAUFFT, Ernest, 1864-1942, *2892, 2913, 2939, 2968, 3012, 3035, 3077, 3103, 3129, 3181, 3182, 3209, 3237, 3259, 3286, 3287, 3314, 3336, 3366, 3401, 3432, 3436, 3467, 3503, 3504, 3540, 3544, 3578, 3579, 3608, 3630, 3640, 3653, 3676, 3679, 3705, 3725, 3761, 3799, 3890, 3898, 4032, 4151, 4195, 4199, 4249, 4534, 5079, 5124, 5126, 5175, 5176, 5177, 5227, 5268, 5305, 5344, 5377, 5407, 5439, 5463, 5498, 5536, 5835, 5908, 5949, 5972, 6386, 6405, 6416, 6436, 6448, 6483, 6518, 6543, 6579, 6607, 66247186, 7304*
Knaufft, Ernest, 1864-1942
Drawing for Printers, review, *12943*
editor and publisher of *The Art Student*, *4134*
illustrations, naval decoration for china, *7121*
students, exhibit in Chautauqua, 1892, *26728*
summer classes, 1898, *6669*
Knaus, Ludwig, 1829-1910
biographical sketch, with paintings sold in New York, 1863-88, *2989*
Bohemian festival, shown at Knoedler's, 1890, *26147*
Children at play, *9833*
Children's party, in Stewart collection, *25406*
Death of the Count of Hilfenstein, in Schaus collection, *15840*
exhibitions
Chicago World's Fair, 1893, *4709*
National Academy of Design, 1893, *4491*
New York, 1889, *2884*
New York, 1890, *Campement des Bohémiens*, *26150*
Paris Exposition, 1855, *18999*
Paris Exposition, 1878, *9109*
Pennsylvania Academy of the Fine Arts, 1877, *8847*
Holy family, *2584*
in Catherine Wolfe collection, *2428*
honorary member of Royal Academy, 1883, *24475*
illustrations
domestic scenes, *3757*
drawing, *6556*
Forrester's home, *23078*
Funeral of a child, in Seney collection, 1891, *3502*
studies of German village children, *6119*
Madonnas, *12461*
paintings in Stewart collection, *719, 2368, 10768*
paintings in Wolfe collection, *832*
sales and prices
1890, pictures offered, New York, *15390*
1891, *26270*
1891, *Funeral of a child*, *3528*
Virgin and Child, in Wolfe collection, *25436*
Wisdom of Solomon, *22051*
Kneeland, Horace, 1808?-1860?
bronze busts of Washington for American Art Union, 1850,

14663
information wanted on Kneeland, 1896, *17082*
Kneeland, Stillman Foster, 1845-1926
collection, *15647*
Kneller, Godfrey, 1646-1723
documents, *10145*
manuscripts, payment entries, *16624*
notes, 1896, *17050*
portrait of Bloody Judge Jeffreys, *6528*
portrait of James II as Duke of York, *17140*
portrait of Lady Townley in Annapolis, Md, *26175*
portrait of Newton, *26236*
portrait of Roger Coke, *17191*
resident of Covent Garden, *24082*
Knickerbocker, J. H., b.1860?
newspaper illustration, *22504*
newspaper illustrator, *22498*
November day, *22684*
Knight, Charles Robert, 1874-1953
illustrations
decorative border, *22576*
Tiger and tigress at play, *22576*
Tiger patience, *22590*
Knight, Daniel Ridgway, 1839-1924, *1951*
Bergère, *3990*
exhibitions
Brooklyn Art Association, 1884, *1740*
Liege Exposition, 1905, *13965*
London, 1883, *1572*
Louisville's Southern Exposition, 1883, *24760*
Milwaukee Industrial Exposition, 1898, *Gardener's daughter*, *12800*
National Academy of Design, 1876, *8660*
New York, 1897, *23190*
New York, 1897, *Shepherdess at Rolleboise*, *6096*
Philadelphia, 1871, *10649*
Royal Academy, 1902, *13431*
Salon, 1880, *21870*
Salon, 1881, *22038*
Salon, 1882, *1352, 1381*
Salon, 1883, *24521*
Salon, 1884, preparation, *1738*
Salon, 1884, prepares, *25029*
Salon, 1885, *1967, 2000*
Salon, 1886, *2193*
Salon, 1887, *571, 2432, 2449*
Salon, 1889, *2985*
Salon, 1896, *11825*
Salon, 1898, *Sur la terrasse*, *6646*
Salon, 1899, *12915*
Salon, 1904, *13747*
San Francisco, 1893, *16206*
Utica, 1899, *17591*
Gossip, shown in New York, 1884, *25090*
Gossips, *1494*
Harvest scene, *8603*
illustrations
After lunch on the banks of the Seine, *1143*
Hailing the ferryman, *4465*
In October (charcoal study), *6963*
In October (drawing after painting), *2463*
Mourner, *1348*
pencil sketch in the harvest field, *2039*
study from Salon picture, *593*
Without dowry, *1594*
painting for Detroit Museum, 1892, *26740*
painting in Layton Art Gallery, Milwaukee, *12813*
paintings, *13147*
Reaper's rest, on exhibit, New York, 1883, *1586*
Rural gossip, print published, 1892, *15984*
sales and prices
1885, Seney collection sale, *1963*
1891, *Day dreams* in Seney collection sale, *15473*
Sans dot, reproduced in *Figaro*, 1883, *24631*
Shepherdess, shown in Chicago, 1892, *11310*

appointed curator, Gray collection of engravings, Boston Museum of Fine Arts, 1887, *25427*
appointed head, Print Department, Boston Museum of Fine Arts, 1887, *546, 566, 2386*
art critic, *17796*
book in preparation, 1879, *17*
catalogue of Dürer exhibition, Boston Museum of Fine Arts, 1888, *25552*
Catalogue of the Engraved and Lithographed Work of John Cheney and Seth Wells Cheney, *15592*
curator, exhibition of Rembrandt etchings, Boston, 1887, *25444, 25465*
essay in Philadelphia Society of Etchers exhibition, 1882-3, excerpt, *24712*
Exhibition of Albert Dürer's Engravings, Etchings and Dry Points, Boston Museum, 1888, publication announcement, *14964*
forms print collection at National Museum, Washington, 1887, *10814*
Illustrations of the History of Art, review, *43*
introduction to volume of etchings by American artists, 1883, *24872*
lectures
　　in Boston on photo-mechanics, 1892, *26475*
　　lecture at Essex Institute, 1880, *257*
　　on engraving at Boston Museum of Fine Arts, 1893, *16412*
　　paper on Blake and Meryon at Long Island Historical Society, 1887, *25400*
memoir of Juengling, 1890, *25847*
obituary, *7451, 13125*
opposes purchase of Regnault painting for Boston Museum, 1884, *25047*
organizes exhibition of American prints, Boston Museum of Fine Arts, 1893, *16280*
promotion of American etching, Boston exhibition, 1881, *13616*
report on graphic arts in U.S. National Museum, 1892, *26557, 26917*
teaches Gotham Art Students, 1885, *11219*
translation of Lalanne's *Treatise on Etching*, *21891*
United States Art Directory and Yearbook
　　1883, *24740*
　　1883-4 edition, *25047*
　　review, *10999*

Koekkoek, Barend Cornelis, 1803-1862
landscape painting in Munger collection at Chicago Art Institute, *12785*

Koepping, Karl, 1848-1914
Archers of St. George (after Hals), *3831, 15772*
　　published, 1891, *15750*
etchings after Rembrandt, *20482*

Koerle, Pancraz, 1823-1875
Tiff, *9187*

Koerner, Mr., fl.1851
professor of drawing, Free Academy, 1851, *14834*

Köhler, Christian, 1809-1861
David as shepherd boy, *19887*
pictures of Melbourne engraved for sale, 1891, *26357*

Kohler, W. H.
art dealer, Rotterdam, *15183, 15319, 15800*

Kohlfeld, Mr., b.1883?
exhibitions, Salon, 1904, medal, *13780*

Kohn's Art Rooms, New York　See: **New York. Kohn Gallery**

Kolberg, Andreas Johnsen, 1817-1869
whereabouts, 1859, Rome, *19993*

Koller, Guillaume, 1829-1884
Emperor Maximilian and Albert Dürer, *10445*
pictures in Schwabe collection, *10238*

Koller, Wilhelm　See: **Koller, Guillaume**

Kollock, Mary, 1840-1911
American woman painter, *11230*
illustrations
　　Summer on Rondout creek, *10957*
　　Uncle Primus, *10957*
lady artist of New York, 1880, *915*

negro studies, 1882, *24424*
Köln　See: **Cologne (Germany)**
Komori, N., fl.1893
exhibitions, New York, 1893, *16079*
Konewka, Paul, 1841-1871
silhouettes with children, *9847*
Konieh (Turkey)　See: **Konya (Turkey)**
König, Friedrich, 1857-1941
decorative panel for Beethoven room, Vienna Secession, 1902, *13465*
illustrations, mural panel, *14087*
König, Gustav Ferdinand Leopold, 1808-1869
engravings for *Life of Luther*, *19303*
illustrations for *Luther*, *19261*
Königswarter, Baron von
collection, sale, 1907, *14276*
Koning, Victor, 1842-1904
collection, sale, 1893, *16220*
Konoike, F., fl.1904
illustrations
　　punch-set in repoussé silver work, *13741*
　　silver repoussé punch set, *13655*
Konrad von Kilchberg, Graf, 13th cent.
May, illustrated by N. Orr & Co, *18410*
Konti, Isadore, 1862-1938
exhibitions, National Academy of Design, 1907, *14311*
illustrations
　　Fishery, *13684*
　　Gay music and children, *13263, 13556*
　　sculpture for Louisiana Purchase Exposition, *13682, 13683, 13688*
　　West Indies, *7094*
sculpture for Louisiana Purchase Exposition, 1904, *13685*
West Indies on Dewey arch, *7096*
Konya (Turkey), *21159*
Koopman, Augustus B., 1869-1914
exhibitions
　　American Art Association of Paris, 1898, *24043*
　　American Art Association of Paris, 1898, drawings, *24010*
　　American Art Association of Paris, 1899, *12890*
whereabouts, 1895, Paris, *22738*
Kopeli, ca.1874-1899?
portraits, snake chief at Walpi, by Elbridge Ayer Burbank, *12905*
Koran, *21319*
printed copies allowed by Sultan of Turkey, 1892, *26518*
Korean art　See: **art, Korean**
Korean pottery　See: **porcelain and pottery, Korean**
Korff, Alexander Hugo Bakker　See: **Bakker Korff, Alexander Hugo**
Korin Ogata　See: **Ogata, Korin**
Körner, Alexander, 1815-ca.1850
railway pictures, *19872*
Korovin, Konstantin Alekseevich, 1861-1939
Russian painter, *13759*
Korsak, Albert de, fl.1893
illustrations, drawings (after Boucher), *4574*
Korvin Pogosky, A., fl.1893
burnt wood engravings at Chicago World's Fair, 1893, *26984*
Kos (Greece)
antiquities, excavation of temple of Aesculapius on Island of Kos, 1903, *8146*
Kosciusko, Tadeusz, 1746-1814
burial, 1895, *16861*
relics, set of pistols presented by Washington, *16272*
Kose Kanaoka　See: **Kanaoka Kose**
Kossuth, Lajos, 1802-1894
monuments, monument planned for New York, 1893, *26969*
reception in New York City, 1851, *14834*
Kost, Frederick Weller, 1865-1923
exhibitions
　　American Art Association, 1884, *Old orchard, South Beach, Staten Island*, *25209*
　　American Art Association, 1885, *2085*
　　Chicago, 1899, *12893*

Kuznetsov, Pavel Vargolomeevich, b.1878
 illustrations, *Portrait of Tschaïkowsky*, *13759*
Kyle, Joseph, 1815-1863
 panorama illustrating Bunyan's *Pilgrim's Progress*, *14657*,
 14753
Kyrle Society See: **London (England). Kyrle Society**
Kytko, Theodore, fl.1893
 newspaper illustration, *22504*

L

L., *11072*, *11075*, *11105*, *11114*, *11115*, *11117*, *14314*
L., A., *9483*
L., A. R., *19052*
L., A. T. v(monogram A.T.v L.) See: **Van Laer, Alexander Theobald**
L., E. T., *24835*, *24903*, *24981*
L., G. B. (monogram G.B.L.)
 illustrations, Beaconsfield Club, London, *21749*
L., G. C., *11018*
L., H., *4939*, *4940*
L., J. H., *18491*, *18538*
L., J. M. (monogram J.M.L.)
 illustrations, *Lover on the sea*, *18023*
L., J. (monogram J.L.)
 illustrations, mirror in Paris Exposition, 1878, *21626*
L., J. R., *18409*
L., L., *18555*, *19723*, *19742*, *20383*, *20384*
L., W., *6179*
L., W. (monogram WL.f)
 illustrations
 masthead design, *11315*, *11334*, *11355*, *11413*, *11442*
 masthead for *The Arts*, *11381*
La Gandara, Antonio de See: **Gandara, Antonio de la**
LaBarre, Anatole, d.1906
 illustrations, *Awakening of the cupids* (decoration on vase),
 17773
LaBarte, Jules, 1797-1880
 Handbook of the Arts of the Middle Ages and Renaissance,
 excerpt, *19471*
 obituary, *219*
Labatut, Jules Jacques, b.1851
 Last moments of Cato of Utica, *26259*
Laborde, Alexandre Louis Joseph, *comte* de, 1773-1842
 research on the Parthenon, *14511*
Labouchère
 illustrations, porcelain mosaic (with Thooft), *13502*
LaBoulaye, Paul A. de, fl.1883
 exhibitions, Ghent Salon, 1883, *14870*
Labrouste, Henri, 1801-1875
 obituary, *8516*
Labrunie, Gerard See: **Nerval, Gérard de**
lace and lace making, *12249*, *21624*, *21731*
 amateur lacework, *780*
 antique lace, *17752*
 collectors and collecting, *15427*, *16939*
 Hearst collection, *16825*
 lace patterns, *16181*
 cut lace, *1598*
 decorative work, *940*
 designs for borders, *9304*
 English designs, *9272*, *9322*, *9350*
 English Honiton lace, *9368*
 exhibitions
 London, 1889, *25669*
 Metropolitan Museum of Art, 1906, *14151*
 New York, 1893, *4303*
 New York, 1893, women's work, *4379*
 Pennsylvania Museum, 1894, *16453*
 female American Indian pillow-lace makers, 1893, *4233*

 illustrations of designs in lace, *13794*
 illustrations of examples of modern lace work, *7826*
 Irish lace, *10426*
 Italian Renaissance, *17744*
 Japan, *26387*
 lace albums, *725*
 machine and hand-made lace, *1242*
 Mrs. Wheeler on darned lace, *3115*
 notes, 1879, *688*
 open lace, *1608*
 origins, *963*
 point lace, *12038*
 school at Bruges, *10405*
 Spanish and French point work, *816*
 technique
 Renaissance lace, *7133*
 use of linen, *2375*
 weaving pillow lace, *6715*
 technique for painting, *3900*, *5355*
Lacey, Henry
 publishes group of portraits commemorating Robert Burns' cen-
 tenary birthday, *18280*
Lacey, Jessie Pixley, b.1865
 exhibitions, Chicago Art Institute, 1902, *13370*
Lachenal, Edmond, 1855-1900
 illustrations, ceramics, *13766*
Lachmann, Teresa See: **Paiva, Thérèse Pauline Blanche Lachmann**, *marquesa* de
Lachmund, Carl Valentine, 1853-1928
 collection of musical autographs, *16419*
Lacoste, Henri Emile Brunner See: **Brunner Lacoste, Henri Emile**
Lacour, Octave L., fl.1887-1891
 illustrations
 Approach of night (after H. W. B. Davis), *21943*
 Charge of witchcraft (after H. Glindoni), *21929*
 decorative panel (after E. Brewtnall), *22001*
 English birds (after A. Barraud), *21990*, *22019*, *22028*
 Huntsmen and hounds (after R. Caldecott), *21961*
 illustrations for Longfellow's *Evangeline* (after F. Dicksee),
 9657
 Jacobites, 1745 (after J. Pettie), *21905*
 Lost and found (after J. R. Reid), *21958*
 On the road to German prisons (after A. Neuville), *22011*
 Queen of swords (after W. Q. Orchardson), *21991*
 Social eddy - left by the tide (after W. Q. Orchardson), *21991*
 Trout fishing at Arran (after J. Pettie), *21997*
 views of Oxford (after G. L. S.), *22010*, *22023*
 Wellington monument (detail, after A. G. Stevens), *21974*
lacquer and lacquering
 technique
 how to make celluloid lacquer, *7874*
 lacquering metal, *7412*
lacquer and lacquering, Japanese, *8852*
 collection of Brayton Ives, *3559*
 craftsmanship, *3623*
 lacquer objects, *985*
 lacquer screen, *964*
 notes, 1901, *7785*
 technique, *8591*
 works in Walters collection, *1956*
Lacroix, Paul, 1806-1884
 Arts of the Middle Ages and the Renaissance, review, *10265*
 *Military and Religious Life in the Middle Ages, and at the
 Period of the Renaissance*, review, *8368*
 *Sciences et Lettres au Moyen Âge et à l'É.poque de la
 Renaissance*, review, *9020*
Ladd, F. B., 1815-1898
 painter's model, *26790*
Ladd, Herbert Warren, 1843-1913
 collection, *15765*, *17580*
Ladd, John B., fl.1893-1910
 collection, *16359*
 shown at Brooklyn Art Association, 1892, *15934*

1880, *46*
1891, *Autumn landscape* in Seney collection sale, *15473*
stained glass, *3217, 9917, 10778, 13897*
 commissioned abroad, 1894, *22540*
 Harvard memorial window for Trinity Church, Boston, *339*
 interviewed on working in glass, 1896, *6038*
 memorial to Edwin Booth, *6698*
 window called *Wisdom*, *7740*
 window, Church of the Ascension, New York, *2871, 10527*
 window for church in Stockbridge, Mass., *10744*
 window for First Congregational, Methuen, Massachusetts, *5173*
 window for Judson Memorial Church unveiled, 1893, *26932*
 window for Presbyterian Church, Chicago, *4555*
 window for Trinity Church, Newark, *24654*
 window in Public Library, Quincy, Mass, *1971*
 window shown in London, 1890, *25806*
 windows, *365, 2550, 13132*
 windows for Channing Memorial Church, Newport, and for Harvard, *9550*
 windows for Emmanuel Church, Baltimore, *6487, 8173*
 windows for Judson Memorial Church, 1892, *26666, 26824*
 windows for Trinity Church, Boston, 1883, *1682*
 windows made for residence of Mr. F. Ames, Boston, *1496*
 windows, mansions of W. H. Vanderbilt and C. Vanderbilt II, *9601*
teaching, teacher and lecturer, Metropolitan Museum of Art Schools, 1893, *26961*
technique for winter scenes in watercolor, *7553*
Waern essay in *Portfolio*, 1896, *5865*
whereabouts
 1879, summer travels, *703*
 1887, returned from Japan to New York, *529*
LaFarge, Louis Bancel See: **LaFarge, Bancel**
Lafayette, Marie Joseph Paul Yves Roch Gilbert du Motier, *marquis* **de,** 1757-1834
 letters, publication, *16266*
 manuscripts, *17273*
 monuments
 American sculptors create monument for Paris, 1900, *12340*
 designs for statue at Washington submitted, 1887, *574*
 equestrian statue given by American people to France, *13012*
 memorial proposed for Paris, 1898, *6785*
 monument by P. W. Bartlett, *7294*
 monument in Washington by French artists, *26116*
 selection of sculptor for Paris statue, 1899, *17607*
 statue by Paul W. Bartlett, *13065*
 statue for Washington, D.C. commission by U.S. government, 1887, *2559*
 statue shipped from France, 1890, *26026*
 statues by Mercié and Falguière, *25798*
 relics, *16264*
 Bible, *16691*
 tomb, American colony's Decoration Day celebration in Paris, *24068*
LAFFAN, William Mackay, 1848-1909, *10*
Laffan, William Mackay, 1848-1909
 exhibitions, New York Etching Club, 1882, *1296*
 member, Tile Club, *1851, 11267*
 Oriental Ceramic Art, review, *22431*
 summer home and studio, *22571*
 whereabouts, 1886, visiting Walters collection, Baltimore, *529*
Lafitte, Alphonse, b.1863
 illustrations, etching, *13305*
LaFollette (Tennessee)
 architecture, Mrs. Eugene Davis residence, 1895, *5511*
LaFontaine, Jean de, 1621-1695
 Fables, illustrated by French artists, 1881, *21897*
 memorial celebration, 1890, *26052*
LaFrance, Jules Isidore, 1841-1881
 obituary, *314*
LaGarde, Paul Anton de, 1827-1891
 library, bought by City University of New York, 1893, *16291, 16428*
Lagourdaine, Louis Pierre Martin Norblin de See: **Norblin**

de Lagourdaine, Louis Pierre Martin
LaGrange, E., fl.1896
 illustrations, illustrations for *His Masterpiece*, *22940*
Lagrange, Léon, 1828-1868
 proposes support for women artists, *20323*
Laguillermie, Frédéric Auguste, 1841-1934
 Bella (after Titian), published, 1892, *15998*
 Children of Charles I (after Van Dyck)
 published, 1891, *15750*
 published, 1893, *16146*
 portrait after Van Dyck, *16329*
 Young duke (after Orchardson), *15656*
Lahaye, Alexis Marie, 1850-1914
 illustrations, *Indolence*, *2252*
Lahey, Marguerite Dupuz, 1890-1958
 exhibitions, Richmond Art Association, 1903, *13714*
 illustrations, bookbindings, *13950*
LaHouve, Paul de, 17th century
 illustrations, *Maximilien de Béthune, duc de Sully* (after du Boys), *17752*
Laighton, Celia See: **Thaxter, Celia Laighton**
Laing, Alexander
 gives art gallery to Newcastle-on-Tyne, 1905, *13837*
Laing, F. W.
 discovers heiroglyphics in Vancouver, 1897, *17257*
Laing, Frank, b.1862
 exhibitions, Chicago, 1901, etchings, *13173*
 illustrations, *Auvers* (etching), *13185*
Lairesse, Gérard de, 1640-1711
 painting acquired by The Hague, 1903, *13701*
Lake George (New York)
 description, for artists, 1892, *4050*
Lake Michigan See: **Michigan, Lake**
Lake Nemi See: **Nemi, Lago di**
Lake View Art Club See: **Chicago (Illinois). Lake View Art Club**
Lakey, Emily Jane Jackson, 1837-1896
 cattle painter, *1820*
 notes, 1871, *10620*
 Right of way, on exhibition in New York, 1888, *2697*
Lakin, Mary Elizabeth See: **Steele, Mary Elizabeth Lakin**
Lalaing, Jacques de, 1858-1917
 LaSalle statue in Chicago, *4911*
 monument to heroes of Waterloo, *26176*
Lalanne, Maxime, 1827-1886
 etchings, *17495, 26352*
 exhibitions
 New York, 1890, *14937, 15100, 25804*
 New York, 1890, etchings and drawings, *3208*
 illustrations
 etchings, *13259*
 Friday market at Rouen, *1997*
 Holland sketches, *3314*
 obituary, *10352*
 pen sketch, *3259*
 sales and prices, 1890, auction of studio contents, *25889*
Lalauze, Adolphe, 1838-1905
 etchings for Musset's *La Mouche*, *15882*
 exhibitions, New York Public Library, 1906, *14237*
 Halte (after Meissonier), *1027*
 illustrates *Memoires de Mme. de Staal Delaunay*, *15506*
 illustrations
 Algerian woman (after P. M. Beyle), *2137*
 Indolence (after Lahaye), *2252*
 Last sheaf (after M. Leloir), *9807*
 Postillion (after R. Goubie), *9001*
 Trio (after E. Nicol), *21900*
 obituary, *14224*
Lalique, René, 1860-1945
 illustrations
 bracelet, *13504, 14046, 14267*
 vase, *13503*
L'Allemand, Conrad, 1809-1880
 obituary, *264*
L'Allemand, Thierry See: **L'Allemand, Conrad**

Laly, Charles, fl.1852-1887
illustrations, sculpture from tomb of Napoleon, *20974*
Lam qua, fl.1835-1850
studio in Canton, *14681*
Lamaism See: **Buddha and Buddhism**
Lamartine, Alphonse Marie de, 1790-1869
Life of Mary Stuart, Queen of Scots, review, *20169*
Lamb & Rich, architects
Harlem Club, New York, *25545*
illustrations, living room, *20600*
Lamb, Charles, 1775-1834
Confessions of a Drunkard, manuscripts found, 1894, *16586*
Elia vase, *7179*
letter to Barron Field, *16939*
letters found, 1895, *16678*
Martin's *In the Footprints of Charles Lamb*, publication
announcement, *15422*
Masque of Days, illustrated by Walter Crane, review, *13377*
portraits
etching by Pulham, *15348*
mezzotint by Sartain after portrait by Wageman, *17053*
works
prices, 1894, *16573*
sale, 1891, *15555*
Lamb, Charles Rollinson, 1860?-1942
designer, mosaic in Cornell University Sage Memorial Chapel,
13059
Dewey arch, *7096*
exhibitions
Architectural League of New York, 1893-4, *22540*
Architectural League of New York, 1894, mosaic altarpiece,
4711
Architectural League of New York, 1900, studies for mosaics
for Cornell University, *7231*
lectern, *14974*
Mission Building chapel interior at Pan-American Exposition,
Buffalo, 1901, *7725*
New York City apartment, 1900, *7328*
officer, Society of Mural Painters, *22787*
party for Walter Crane, 1892, *26577*
Lamb, Charles Rollinson, Mrs. See: **Lamb, Ella Condie**
Lamb, Elizabeth Shepherd See: **Thompson, Elizabeth
Shepherd Lamb**
Lamb, Ella Condie, 1862?-1936
exhibitions
Architectural League of New York, 1888, *2873*
Architectural League of New York, 1890, *Advent angel*,
15019
Architectural League of New York, 1893-4, *22540*
Architectural League of New York, 1894, mosaic altarpiece,
4711
Atlanta Exposition, 1895, *11698*
Salmagundi Club, 1887, *2364*
Woman's Art Club of New York, 1890, *Advent angel*, *15128*
Woman's Art Club of New York, 1896, *22958*
Woman's Art Club of New York, 1903, *13703*
illustrations
cartoon for stained glass window for Christ Church,
Springfield, Ill, *3166*
Church militant, *3166*
decorative panel, *2849*
Praying angel, *22486*
Ressurection angel, *4304*
Russell Memorial window for Wells College, 1902, *7944*
summer studio on the Palisades, 1893, *22491*
Lamb, Frederick Stymetz, 1863-1928
Conception of the Christ, commission, 1906, *14098*
Good Shepherd, mural for Bethany Presbyterian Church, *14951*
illustrations, study for mosaic altar in All Angels' Church, New
York, *3514*
impressions of progress in European cities and of stained glass,
1903, *8264*
Mission Building murals and stained glass at Pan-American
Exposition, Buffalo, 1901, *7725*
New York City apartment, 1900, *7328*

stained glass design for New Church, Washington, D.C., *6267*
suggests public schools hang photos of examples of city plan-
ning, 1902, *7944*
Lamb, Hugo, 1848-1903
See also: **Lamb & Rich, architects**
Lamb, J. and R., Art Workers, firm, *15146*
decorations, Bethany Presbyterian Church, Philadelphia, *14951*
dome mosaic for Cornell University chapel, 1899, *7125*
exhibitions
Paris Exposition, 1900, *Religion supported by the church*,
7264
Turin Esposizione, 1902, silver medal, *13618*
loan to Indianapolis Citizens' Education Society exhibition,
1899, *12918*
mosaic for Holy Trinity church, 1892, *26526*
Russell Memorial window for Wells College, 1902, *7944*
window, designed by Walter Crane, for St. Paul's church, New
York, 1892, *26507*
Lamb, Joseph, 1833-1898
See also: **Lamb, J. and R,. Art Workers**
obituary, *6876*
windows for Stanford library, *22072*
LAMB, Louis Albert, *13264, 13285*
LAMB, Martha J., *8945*
Lamb, Mary, fl.1887
illustrations, pansies, *2577*
Lamb, Richard, 1835?-1909
See also: **Lamb, J. and R,. Art Workers**
LAMBDIN, George Cochran, 1830-1896, *10925, 11039, 11089,
11129*
Lambdin, George Cochran, 1830-1896
exhibitions
American Watercolor Society, 1880, *827*
Artists' Fund Society, 1863, *23289*
National Academy of Design, 1858, *19857*
National Academy of Design, 1859, *20030, 20048*
National Academy of Design, 1860, *20224*
National Academy of Design, 1886, *2112, 2352*
New York, 1859, *19978*
New York, 1860, *20166*
New York artists' reception, 1858, *19817*
Pennsylvania Academy of the Fine Arts, 1855, *18793*
Pennsylvania Academy of the Fine Arts, 1856, *19437*
Pennsylvania Academy of the Fine Arts, 1857, *19658*
Pennsylvania Academy of the Fine Arts, 1858, *19858*
Pennsylvania Academy of the Fine Arts, 1859, *20049*
Pennsylvania Academy of the Fine Arts, 1885, *11280*
Prize Fund Exhibition, 1886, *25304*
figure-piece bought by Walters, 1859, *20114*
illustrations, *Waiting* (drawing), *11050*
notes, 1871, *23607*
painting of invalid, *19785*
Wild fruit, reproduced by Prang in chromo, *23568, 23604*
work, 1856, *19564*
work, 1883, *24608*
LAMBDIN, James Reid, 1807-1889, *10937*
Lambdin, James Reid, 1807-1889
appointment to Art Commission, Washington, D.C., 1859,
18319, 20051
qualification, *20064*
report of commissioners, *20191*
Baron Von Humboldt, *19581*
exhibitions
American Watercolor Society, 1885, *1933*
Pennsylvania Academy of the Fine Arts, 1858, *19858*
George Peabody, *19626*
Girl at study, in Philadelphia Art-Union, 1849, *21404*
opens school for the practical study of art, Philadelphia, *19801*
organizes first exhibition in Pittsburgh, 1860, *20146*
Lambdin, Victor R., fl.1898-1901
exhibitions, Denver Artists' Club, 1898, *12251*
Lambert, Alphonse, 1823-1883
obituary, *14879*
Lambert, Catholina, 1834-1923
collection, *15811, 17584*

English and Dutch paintings exhibited at Lotos Club, 1899, *17588*
Puvis de Chavannes, *3598*
LAMBERT, Charles, *11671*
Lambert, Eugène See: **Lambert, Louis Eugène**
Lambert, Henri Lucien, 1836-1909
illustrations, Potiche vase, *3637*
Lambert, John, 1861-1907
exhibitions
Chicago Art Institute, 1896, *Mirror, 6010*
Pennsylvania Academy of the Fine Arts, 1901, *13163*
Pennsylvania Academy of the Fine Arts, 1906, *14244*
Worcester Art Museum, 1904, *13803*
illustrations
Actor, 13851
Tragic actor, 14077
Lambert, Louis Eugène, 1825-1900
art in Paris, 1876, *8623*
dog sketches, *2625*
exhibitions
Salon, 1878, *9036*
Société d'Aquarellistes Français, 1880, *873, 9341, 21817*
fan painting, *17884*
illustrations
fan design, *3771*
Invasion of the domicile, 7371
Kittens, 3694, 5465
sketches of cats, *1204*
Unwelcome guest, 2751
obituary, *7341*
paintings of cats, *2562*
"Raphael of cats", *3873*
Lambert, N., fl.1853-1856
illustrations, *Press room* (after C. Jacque), *20834*
Lambeth (England)
faience, *21670*
Lambeth Palace See: **London (England). Lambeth Palace**
Lambeth Palace Library See: **London (England). Lambeth Palace. Library**
Lambinet, Emile Charles, 1815-1877, *14973*
biography, *20219*
exhibitions
London, 1858, *19851*
Salon, 1859, *20060*
New York dealer resells sketches after filling them in, *714*
obituary, *8964*
pictures in New York, 1889, *15007*
studio in Montmartre, *20367*
Lamborn, Robert Henry, fl.1882-1891
collection, *15772*
Lambron des Piltières, Albert, b.1836
Jester, 8411
Lameire, Charles Joseph, 1832-1910
illustrations, decorative panels, *1520*
Lamerie, Paul de, 1688-1751
silversmith, *3549*
Lami, Eugène Louis, 1800-1890
obituary, *15483*
Lami, Stanislas, 1858-1944
wax sculptures, *13533*
Lamier, A. P.
illustrations, poster, *20537*
Lamotte, Alphonse, 1844-1914
illustrations, *Young bride* (after J. Lefebvre), *9790*
Lampert, Emma See: **Cooper, Emma Lampert**
lamps
aesthetic electric lamps, 1892, *3858*
American-made glass lamps, *11893*
decoration of lamp globes, *6576*
design, *558*
instructions for making wrought iron lamps, *5155*
Stanford White lamp made by Martiny, *3647*
technique for painting lamp shades, *8093*
technique for painting lamp vase, *6862*
use of glass chimneys, *17833*

lamps, American
gas fixtures, *8911*
lamps, English
dining rooms, *8669*
Lamy, Pierre Franc, 1855-1919
exhibitions, Chicago World's Fair, 1893, *Spring, 4805*
Lance, George, 1802-1864
Fruit piece, 20935
Pantry, 21307
Lancelot, Dieudonné Auguste, 1822-1894
illustrations, *Church at Mouzon, 21190*
Lanciani, Rodolfo Amedeo, 1847-1929
plans of ancient Rome published, 1893, *16246, 26940*
Lançon, Auguste André, 1836-1887
dog portrait, *2625*
exhibitions, Union League Club of New York, 1890, watercolors, *3227*
French delineator of animals, *17821*
illustrations
Age of iron, 5934
drawings after sculptures, *1623*
pen sketches of dogs, *2751*
Trappistes, 9906
Lancret, Nicolas, 1690-1743
Earth, 20882
Happy marriage (painted fan), *1451*
sales and prices, 1896, parlor decorations, *17085*
LANDEAU, Sandor Leopold, b.1864, *23641*
Landeau, Sandor Leopold, b.1864
exhibitions
American Art Association of Paris, 1896, *23709*
Salon, 1896, *11825, 23618*
whereabouts, 1895, Paris, *11515*
Landelle, Charles, 1821-1908
exhibitions, Salon, 1879, *9176*
illustrations
Messenger of the tempest, 1622
Naiad, 1365
Renaissance, 21016
Venetian woman, 2342
Judith, posed by Teresa Vaughan, *22522*
Salmacis, 8944
inspires poem by St. George Best, *23964*
scenes of the Orient, *22665*
LANDER, Benjamin, *22564*
Lander, Benjamin, b.1842
exhibitions, New York Etching Club, 1884, *25013*
illustrations, *Afterglow, 22546*
influence of Corot, *22520*
New moon, 22503
portraits, photograph, *22518*
prints in Library of Congress, 1898, *12806*
Robin's Vesper, 22861
summer home and studio, *22571*
summer studio, 1893, *22491*
Under the moonbeams, published, 1892, *15998*
LANDER, E. T., *8840, 8879, 9046, 9339*
Lander, Louisa, 1826-1923
Boston studies, 1858, *19875*
bust of Nathaniel Hawthorne, *18437*
Evangeline, 18082, 20033
Evangeline asleep, 18509
exhibitions, New York, 1860, *18412*
Nathaniel Hawthorne, 18509
notes, 1857, *19682, 19767*
sculptor, *18536*
sculpture to be shown in Boston, 1858, *19859*
stauette of Virginia Dare and marble bust of Gov. Gore, *18243*
Virginia Dare, 19913
Landerkin, Charles E., fl.1891
designs for furniture shown at annual exhibition of Architectural League of New York, 1890-1, *26206*
Landers
illustrations, tailpiece for *Arts, 11646*

Landers, Margaret, fl.1884-1887
 illustrations, pen drawing of Mrs. C. B. Coman's studio, *2399*
LANDERS, W. T., *13827*
Landis, Perry, 1850-1905
 obituary, *14047*
Landor, Arnold Henry Savage, 1865-1924
 whereabouts, 1892, traveling around the world, *26839*
Landor, Henry Savage See: **Landor, Arnold Henry Savage**
Landor, Louisa See: **Lander, Louisa**
Landor, Walter Savage, 1775-1864
 portraits, portrait by C. C. Coleman for Kate Field, *12274*
 Writings, excerpts, *19365*
landscape
 absence of line, *3435*
 color, *24735*
 Egypt, Nile River, *21255*
 England
 Cornwall, *21571, 21614*
 East Anglia, landscape of the braods, *9672*
 Jersey, *22056*
 Lynton and Lynmouth, *21637*
 rural scenery, *21181*
 views from railroad trains, *21776*
 views of Rye, *9469, 9490*
 excerpt from Goethe, *18552*
 Finland, *21284*
 Ireland, *21354*
 nature described by landscape painter, *10924*
 poetry of Bryant, *18553*
 poetry of Lowell, *18698*
 poetry of Street, *18580*
 rainbows, *20157*
 Scotland, *23098*
 Perth County, *21632*
 Switzerland
 Geneva, *21373*
 Lake of Saarnen, *21295*
 Valley of Lauterbrunnen, *21086*
 United States, *19683, 19700, 19718, 19734, 21198*
 Adirondacks, *10842*
 camping trip to isolated lake by landscape painter, *11053*
 Catkill Mountains, *19696*
 description of Lake George area for artists, 1892, *4050*
 description of Louisiana Bayou, *24585*
 description of New England mountains and coast, 1850, *14691*
 Illinois, *12738*
 Kansas City parks by Kessler, *13700*
 list of scenic spots in America, 1901, *7543*
 national character in scenery, *18218*
 Pennsylvania views, *22589*
 scenery, *21176*
 Southern coast scenery, *19732*
 West Campton, New Hampshire, *19548*
 use in fiction, *21842*
 wood scenery, *21064*
landscape architecture
 city parks, *18896*
 country houses, *19457*
 excerpts from the *North American Review*, *19623*
 French style compared to natural styles, *19056*
 gardening, *19495*
 landscape art at Louisiana Purchase Expositionn, 1904, *13754*
 Llewellen Park, New Jersey, *19677*
 mansion grounds, *19507, 19557*
 Olmsted's views, *10810*
 practical gardening, *19779*
 principles, *19592*
 principles for rural homes, *19713*
 United States, Central Park, *19469*
 villa, *19765*
landscape drawing
 anecdote of day spent sketching outdoors, *18617*
 sketching, *18845*
 sketching from nature, *2212, 2231, 2249, 2268, 2286*

 sketching out of doors "off-season", *4720*
 technique, *3761, 4048*
 trees, *4478*
landscape drawing, English, *9437*
 views of Home Counties, *9546*
LANDSCAPE PAINTER, A, *488, 513, 525*
landscape painting
 accessory in pictures of old masters, *21849*
 autumn glories, *10216*
 Durand on landscape painting, *18551, 18600, 18627, 18674,*
 18720, 18766, 18819, 18577, 18870
 exhibitions, Paris, 1891, plein air painting, *3537*
 geology and landscape painting, *20079*
 history, *5941, 14317, 22378*
 Humboldt on landscape painting, *19387*
 nature in modern art and landscapes of Insley, *22744*
 notes, 1899, *6934, 17535*
 open-air painting, *6656*
 out-door painting increases in Europe, 1885, *11271*
 painting in oil, *1152, 1188, 1206, 1593, 1606*
 pastel painting, *1385*
 rocks, ground and trees, *2705*
 scarcity of mountains in landscape painting, 1898, *17401*
 scenes by Both, *21245*
 scientific observation in landscape painting, *2353*
 students study at Richmond, Mass., 1882, *10863*
 suggestions of Arcadia in the work of Thomas B. Craig, *22758*
 taste, *18863*
 technique, *3184, 3545, 4077, 4569, 4901, 6962, 7745, 7827,*
 8217, 18589
 autumn oak leaves, *7351*
 Bruce Crane's suggestions, *5007*
 brushes, *8190*
 brushstroke, *7658*
 buildings as subjects, *2862*
 clear blue sky, *7647*
 clouds, *7908*
 composition, *4608*
 covered bridge in perspective, *5052*
 drawing for landscape painting, *5743*
 excerpts from M. B. Smith's *Landscape Painting in Oil*, *4665*
 finding the motif, *4093*
 foliage, *7510*
 foliage in watercolor, *4412*
 for beginners, *4152, 7324, 7349, 7997*
 for china painting, *3213*
 hints on landscape painting, *2461, 2488, 2551*
 how to win acclaim at exhibitions, *7618*
 inserting buildings, *7674*
 light and shadow, *2769*
 maple trees, *4497*
 materials, *6822*
 materials for sketching from nature, *4532*
 measuring distances, *6159*
 moonlight scenes, *7699*
 notes from H. Mosler's class, 1892, *4049*
 oil painting, *2354, 2748, 2768, 2808, 14677*
 painting, *5348, 5464*
 painting an autumn subject, *5981*
 painting autumn landscapes, *5541*
 painting distances, *4115*
 painting in monochrome, *5309*
 painting mist and fog, *5233*
 painting snow, *4719*
 painting snow and ice, *6112, 6158*
 painting the farmyard, *5136*
 perspective, *6262*
 rainbow, *6304*
 reflections in water, *3886*
 rocks, ground and trees, *2729*
 selection of gray days, *7797*
 setting the palette, *6850*
 sketching, *4074, 4498*
 sketching from nature, *2413, 2437, 2731, 7624, 13894*
 skies, *4192*

Lane, Harriet C., 1832-1908
 work, 1883, *24855*
Lane, John, 1854-1925
 establishment of the Bodley Head in America and forthcoming
 books, 1896, *12568*
 Modern Cottage Architecture, publisher, *13811*
 Representative Work of Our Time, review of parts II and III,
 13581
LANE POOLE, Stanley, 1854-1931, *9837, 9851, 10036, 10065,
 10149*
Lane Poole, Stanley, 1854-1931
 Cairo: Sketches of its History, Monuments, and Social Life,
 publication, 1892, *26772*
Lane, Richard James, 1800-1872
 obituary, *22030*
Lane, Walter Paye, 1817-1892
 monuments, monument planned for Marshall, Texas, 1893,
 26938
Lanfranconi, Grazioso Enea, fl.1895-1896
 collection, sale, 1896, *16962*
LANG, Andrew, *17088*
Lang, Andrew, 1844-1912
 Ballads and Lyrics of Old France, review, *12582*
 excerpt on Millais's *Christ in the house of his parents*, *9764*
 opinion on decoration of St. Paul's Cathedral, London, 1899,
 7014
Lang, Andrew, *Mrs.* See: **Lang, Leonora Blanche**
Lang, Annie Traquair, 1885-1919
 exhibitions
 American Watercolor Society, 1907, *14333*
Lang, Charles Michael Angelo, 1860-1934
 portrait of David B. Hill, *25887*
 portrait of Gov. Flower, *21521*
LANG, Leonora Blanche, *10357*
LANG, Louis, *14803*
Lang, Louis, 1814-1893
 biography, *20281*
 Carnival at Rome, description by artist, *14563, 14581*
 Dorcas Society, *19767*
 at Century Club festival, 1858, *19783*
 drawings of artist life in Rome, *14801*
 exhibitions
 Century Club, 1859, *19973*
 National Academy of Design, 1858, *19857*
 National Academy of Design, 1859, *20030, 20048*
 National Academy of Design, 1860, *20224*
 New Bedford, 1858, *19891*
 figure painting, *19955*
 Fourth of July, offends firemen, *14711*
 guest on Baltimore and Ohio Railroad excursion, 1858, *19876*
 James Guthrie, *18680*
 Last supper of Mary Queen of Scots, *20166*
 Mary Queen of Scots, *20302*
 notes
 1871, *10678*
 1894, *16536*
 paintings, *19819*
 paintings in American Art Union, 1849, *14560*
 Procession in the Middle Ages and other transparencies at
 Twelfth-night festival, Century Club, 1858, *19783*
 sales and prices, 1857, *Lazy lesson*, *19645*
 Souvenirs of summer, *19609*
 studio in Rome, *8514*
 whereabouts, 1849, New York, *14537*
 will, *26961*
 works, 1855, *18771*
Lang, O. N., fl.1894
 illustrations, *In the winter of life*, *22576*
Langdon, Katherine See: **Corson, Katherine Langdon**
Lange, Ludwig, 1808-1868
 exhibitions, Munich, 1858, views of Corinth for benefit of
 earthquake victims, *19912*
Langen, Albert
 collection, sale, 1899, *17658*
Langenburg, *Prinz* von Hohenlohe See: **Hohenlohe**

**Langenburg, Viktor Ferdinand Franz Eugen Gustav Adolf
Constantin Friedrich**, *Prinz* von
Langer, Theodor Karl Hermann, 1819-1895
 illustrations
 Children at play (after L. Knaus), *9833*
 Weaving the May coronet (after L. Pohle), *9083*
Langerfeldt, Theodore Otto, 1841-1906
 exhibitions, St. Botolph Club, 1900, *13112*
Langley, Charles Elmer, fl.1894-1897
 exhibitions, National Academy of Design, 1897, *10540*
 illustrations, *Wash-day*, *22528*
Langley, Walter, 1852-1922
 exhibitions
 Royal Institute of Painters in Water Colours, 1883, *9820*
 Royal Institute of Painters in Water Colours, 1884, *1813*
 Royal Institute of Painters in Water Colours, 1885, *10183*
Langton, Mary Beach
 How to Know Oriental Rugs, review, *13742*
Langtry, Lillie, 1853-1929
 collection, fans, *15795*
 retirement from stage, 1895, *22837*
language and languages
 See also: **English; French; Turkish (languages)**
Lanier, Charles, 1867-1926
 collection, *15616*
Lanier, Sidney, 1842-1881
 portraits, bust presented to Macon, Ga., by Charles Farrell,
 1890, *25997*
Lankester, E. G.
 Warranted, New York performances, 1884, *1752*
LANMAN, Charles, *11055, 11128, 18667*
Lanman, Charles, 1819-1895
 *Adventures in the Wilds of the United States and British
 American Provinces*, publication announcement, 1856, *19549*
 American landscapes, *22574*
 collection, *18667*
 exhibitions, National Academy of Design, 1880, *126*
 Fusujama, *22495*
 interview with Asher B. Durand and son, John, 1883, *24720*
 obituary, *16705*
 pictures of American scenery, *24390*
 portraits, photograph, *22539*
 sales and prices, 1883, *24925*
 Washington artist, *24387*
 whereabouts, 1883, *24656*
 work, 1883, *24855*
Lansdale, William Moyland, fl.1879-1895
 illustrations, *At Grand Manan*, *22531*
Lansdowne, Henry Petty FitzMaurice, *3d marquis of*, 1780-
 1863, *21293*
Lansil, Walter Franklin, 1846-1896
 exhibitions
 Boston Art Club, 1880, *72*
 Boston Art Club, 1881, *297*
 Boston Art Club, 1887, *534*
 Boston Paint and Clay Club, 1887, *543*
 marine pictures, *24619*
 sales and prices, 1901, *Venice, noonday on the riva*, *13210*
 whereabouts, 1883, *24657*
Lansing, A. L., fl.1880
 Washington monument, Philadelphia, proposed, 1880, *149*
Lansing, Garret, fl.1804-1840
 wood engravings, *87*
Lansyer, Emmanuel, 1835-1893
 illustrations
 Cumulous clouds before a storm, *2749*
 Death of the oak, *2705*
 End of the tempest, *2786*
 English Channel, *2786*
 Storm clouds, *2749*
 painted fan, *1451*
lanterns
 China, *16091*
Lanthier, Louis A., 1840-1910
 collection, buys Beaumont's *Holding the skein* from Schaus col-

Lauters, Paul, 1806-1875
 obituary, *8607*
Lauth, Charles, 1836-1913
 resigns as director, French National Porcelain Manufactory, 1887, *17777*
Lautner, Max
 Who Is Rembrandt?, review, *3670*
Lautrec, Henri Toulouse de See: **Toulouse Lautrec, Henri Marie Raymond de**
Lauzet, A. M., 1865-1898
 etchings for Lecomte book on Durand-Ruel's private collection, *15902, 26708*
LaValiere, Louise de, 1644-1710
 portraits, Le Brun portrait in Kip collection, *10643*
Lavaron, Leonide C., 1866-1931
 illustrations
 Day's afterglow, *13093*
 decorative metal work, *13537, 14267*
 landscape (monotype), *13515*
 pyrographs, *13155*
Lavarron, Leonide See: **Lavaron, Leonide C.**
Lavée, Jules Marie, fl.1879-1888
 illustrations
 Homage to Ceres (after Rubens), *21771*
 Roman emperor (after Alma-Tadema), *9738*
Lavergne, Claudius, 1814-1887
 French glass stainer, *10101*
Lavery, John, 1856-1941
 exhibitions
 Carnegie Galleries, 1896, *11906*
 Carnegie Galleries, 1903, *13675*
 Carnegie Galleries, 1905, *14016*
 International Society of Sculptors, Painters, Gravers, 1907, *14248*
 Pennsylvania Academy of the Fine Arts, 1900, *13007*
 Pennsylvania Academy of the Fine Arts, 1902, *13363*
 Royal Academy, 1890, *3311*
 Royal Academy, 1895, *22359*
 St. Louis Exposition, 1896, *6011, 11873*
 Glasgow School painter, *22394*
 illustrations, *Woman in rose*, *13792*
 member, jury of Carnegie exhibition, 1898, *12808*
 notes, 1898, *17386*
Lavieille, Jacques Adrien, 1818-1862
 illustrations
 Forest scene (after P. Brill), *20980*
 Painter in his studio (after Adrian van Ostade), *21095*
 paintings after J. Vernet, *20796*
LaVillette, Élodie Jacquier, b.1843
 illustrations
 drawing, *7075*
 Full tide near Lorient, *2807*
law
 ancient law, *20348*
law and art
 Benzinger vs. Gaus, *13701*
 France
 Bibliotheque Nationale involved in court case on retaining objects acquired illegally, 1894, *4973*
 conviction of forger in Paris, 1904, *13712*
 Moitessier's suit against Ingres' heirs, *8981, 9017*
 international agreement on recovery of stolen objects, 1905, *13900*
 paintings not returned to artists after exhibitions, 1896, *6008*
 photographic reproduction upheld, 1855, *19234*
 plea for stamping and registration of works of art, *2504*
 United States
 art as taxable property, *11085*
 dealers attempt to defeat Treloar bill, 1896, *17027*
 libel and art criticism, *13828*
 Macbeth Gallery's difficulty retrieving painting from Customs, 1894, *5170*
 New York Court rules ceiling paintings part of real estate, 1894, *5037*

Law, David, 1831-1901
 etcher, *16122*
 exhibitions, New York Etching Club, 1884, *25013*
 Fishing boats off Whitby, *9538*
 illustrations, *Night scene in East London* (after G. Doré), *9881*
 Westminster, *10004*
Lawman, Jasper Holman, 1825-1906
 anecdote, 1887, *592*
 notes
 1856, *17910*
 1884, *25109*
 1887, *583, 611*
 obituary, *14111*
LAWRENCE, Alfred E., *13616*
Lawrence Archer, James Henry See: **Archer, James Henry Lawrence**
Lawrence, Cyrus J.
 collection
 buys Barye tiger, 1888, *2676*
 contributions to Barye exhibition, 1889, *3102*
 Greek art exhibited at Union League Club, New York, 1890, *3157*
 gift of Barye sculpture to Metropolitan Museum, 1890, *3127*
LAWRENCE, Edward, *20644, 20695*
Lawrence, Edward, *20726*
Lawrence, Edwin Henry
 library, provenance of first edition of *Paradise Lost*, *16551*
Lawrence, Frederick K., fl.1899-1903
 illustrations
 End of a November day (photograph), *13182, 13894*
 photographs, *12832*
 Wet road - evening (photograph), *13532, 13894*
 installation of Chicago Photographic Salon, 1900, *13035*
LAWRENCE, Harold T., *13147, 13443, 13493*
Lawrence (Kansas). Kansas State University
 annual exhibitions, 1904-1905, *13816*
 exhibitions, 1903, *13688*
Lawrence Park (Pennsylvania)
 artists' homes, 1898, *17447*
Lawrence, Samuel See: **Laurence, Samuel**
Lawrence, Sydney See: **Laurence, Sydney Mortimer**
Lawrence, T. E., 1828-1893
 obituary, *16168*
Lawrence, Thomas, 1769-1830
 anecdote, *20362*
 Angerstein portrait, acquired by Louvre, 1896, *16968*
 Angerstein's patronage, *16616*
 Countess of Blessington, *14526*
 exhibitions
 Boston, 1899, *12855*
 Carnegie Galleries, 1902, *13520*
 Lotos Club, 1899, *Duke of Wellington*, *17588*
 New York, 1895, portrait of Mrs. W. C. Lambert, *16738*
 New York, 1898, *6558*
 Union League Club of New York, 1889, *25684*
 illustrations
 Countess of Blessington, *6053*
 Duchess of Sutherland and child, *6097*
 Elizabeth, Countess of Grosvenor, *6091*
 Lady Peel, *6024*
 Lady Waldscourt, *5537*
 Master Lambton, *3951*
 Miss Baring, *6007*
 Mrs. Charles James Fox, *6095*
 Nature (Children of Mrs. Calmady), *5531*
 master of painting hands, *5525*
 notes, 1895, *5399*
 painting exhibited at Boussod, Valadon, 1895, *5224*
 paintings in vogue in England, 1904, *13712*
 portrait of a lady, in Brandus gallery, 1898, *17405*
 portrait of Angerstein children, *16749*
 portrait of Benjamin West, in Wadsworth Atheneum, *17646, 18803*
 portrait of John J. Angerstein, *17140*
 portrait of John P. Curran, *7660*

portrait of Kemble as Hamlet, *15287*
 shown in New York, 1893, *16157*
portrait of Lady Peel, *6587*
portrait of Mr. and Mrs. Angerstein acquired by Louvre, 1896, *5693*
portrait of Mrs. Gibbin as Miranda in the Tempest, *17498*
portrait of Mrs. Gibbon, *7483*
portrait of Sir John Soane, *7202*
portrait of woman owned by J. W. Bouton, *14953*
portrait paintings, *21699, 21726*
 idealize sitters, *6092*
sales and prices
 1831, portraits, *14652*
 1890, *John Kemble as Nero* offered, *15417*
Two brothers and *Portrait of a child*, in Walker collection, Minneapolis, *12924*
Lawrence, William Hurd, 1866-1938
 elected member of Society of Illustrators, 1903, *13604*
Lawrie & Co., London See: **London (England). Lawrie & Co.**
Lawrie, Alexander, 1828-1917
 exhibitions
 National Academy of Design, 1858, *19857*
 Pennsylvania Academy of the Fine Arts, 1857, *19658*
 Pennsylvania Academy of the Fine Arts, 1859, *20049*
 studio in Philadelphia, 1858, *19785*
 whereabouts, 1856, Düsseldorf, *19581*
Lawrie, Lee, 1877-1963
 sculpture for Louisiana Purchase Exposition, 1904, *13685*
Lawson, Cecil Gordon, 1851-1882
 exhibitions
 Grosvenor Gallery, 1879, *21708*
 Grosvenor Gallery, 1880, *21885*
 Royal Academy, 1881, *22013*
 illustrations
 In the valley, *3702*
 Sunrise, *4883*
 Sunrise in autumn, *2749*
 Kentish hop-gardens, *9258*
 paintings in studio, 1878, *21575*
Lawson, Ernest, 1873-1939
 exhibitions, Pennsylvania Academy of the Fine Arts, 1906, Jennie Sesnan medal, *14244*
 illustrations, *Winter*, *13803*
Lawson, Francis Wilfred, 1842-1935
 exhibitions, Royal Academy, 1881, *21999*
 paintings of poor children, *21650*
Lawson, Louise, d.1900
 notes, 1887, *592*
 sales and prices, 1892, *Mermaid*, *26713*
 sculptor from Ohio, *16332*
 statue of S. S. Cox, *26116, 26286, 26332, 26395*
 condemned by artists, *26333*
 ridiculed, 1893, *26917*
Lawson, Thomas William, 1857-1925
 presents Tiffany silver cup to Yacht Club of Hull, Massachusetts, 1901, *7777*
Lawson, Wilfrid See: **Lawson, Francis Wilfred**
LAWTON, C. E., *13775*
Lawton, Henry Ware, 1843-1899
 monuments, *8262*
Lay, Oliver Ingraham, 1845-1890
 exhibitions
 Artists' Fund Society, 1885, *Victor*, *25225*
 Brooklyn Art Association, 1884, *1696*
 National Academy of Design, 1884, *25187*
 Last Days of Aaron Burr, *15772*
 notes, 1883, *24883*
 obituary, *25980*
 portrait paintings, 1883, *24925*
 sketch of H. K. Brown given to Century Club, 1892, *26607*
 whereabouts
 1883, summer at Stratford, Ct, *24703*
 1883, summer in Connecticut, *24728*

Layard, Austen Henry, 1817-1894
 excavations in Near East, *20799*
 Handbook of Painting, review, *10431*
 speech at Arundel Society, 1858, *19837*
 tracings from Italian frescoes published by Arundel Society, *19912*
LAYMAN, The, *17402*
Layton, Frederick, 1827-1919
 funds art gallery in Milwaukee, 1886, *25337*
 Layton Art Gallery, Milwaukee, *12813, 13627*
 offers museum building to Milwaukee, 1883, *24678*
LAYTON, Julia H., *18484*
Lazarus, Amelia B., d.1906
 bequest to Metropolian Museum of Art, *14312*
 scholarship for students at Metropolitan Museum, 1893, *26884*
LAZARUS, Emma, 1849-1887, *1705*
Lazarus, Jacob Hart, 1822-1891
 dinner party described, 1887, *566*
 exhibitions, New York artists' reception, 1858, *19817*
 illustrations, *Henry Inman*, *21384*
 obituary, *26228*
 portrait of John Jacob Astor, *25959*
 sales and prices, 1857, *Toilet*, *19645*
 scholarship at Metropolitan Museum Art School created in his name, 1892, *26661*
 scholarship for study of mural painting, *13869*
 award, 1906, *14089*
 third triennial competition, 1902, *8035*
 whereabouts, 1883, returns to New York, *24762*
Lazarus, Jacob Hart, *Mrs* See: **Lazarus, Amelia B.**
Lazarus, Moses, d.1885
 collection, miniatures and enamels in Metropolitan Museum of Art, *3074*
Le Brun Art Club See: **Denver (Colorado). LeBrun Art Club**
Le Faouët (France) See: **Faouët, Le (France)**
Le Febvre, Jules See: **Lefebvre, Jules Joseph**
Le Mans (France)
 description, art student's trip, 1892, *4046*
Le Puy (France)
 monuments, *20143*
Lea, Anna See: **Merritt, Anna Lea**
Lea, Bertha See: **Low, Bertha Lea**
Lea, Marion, d.1944
 married, 1891, *26440*
 notes, 1890, *25998*
LEA, Vernon, *9874*
lead work
 technique, casting wrought lead objects, *6449*
Leader, Benjamin Williams, 1831-1923
 Evening hour, *10192*
 exhibitions
 Royal Academy, 1884, *10039*
 Royal Academy, 1890, *25924*
 On the Llugy, north Wales, *9057*
 Sheep-pastures, north Wales, *9290*
 Tintern abbey - moonlight on the Wye, *8354*
League of American Artists, Paris See: **Paris (France). League of American Artists**
Leaming, Edward, 1861-1916
 advice to amateur photographers, *3064*
Lean, Florence Marryat Church See: **Marryat, Florence**
Lear, Edward, 1812-1888
 exhibitions, Royal Society of British Artists, 1855, *18800*
 pre-Raphaelite follower, *19723*
Learmont, William
 collection, Montreal, *5003*
leather work
 cuir-boulli, or stamped leather-work, *10262*
 English leather embossing, 1895, *5447*
 exhibitions, New York, 1888, *621*
 gilded and stamped leather, *7074*
 history of gilded leather, *12998*
 ornamental and embroidered leather work, *530*
 Spitzer collection, *3857*
 stamped leather

New York, 1897, *6370*
St. Louis Exposition, 1894, *5036*
St. Louis Exposition, 1894, *Communion, 11402*
Salon, 1880, first class medal, *9371*
Salon, 1883, *14906*
illustrations
 Nativity of Christ, 22849
 Organ recital (detail), *5830*
 Shepherdess, 11942
landscape painting acquired by Boston Museum of Fine Arts, *1832*
Organ, given to Metropolitan Museum, 1887, *10792*
Organ loft, shown at Metropolitan Museum loan exhibition, 1886, *25359*
painting on view in New York, 1891, *15748*
paintings in Seney collection, *2458*
Peasant-girl knitting, shown at Reichard's, New York, 1884, *25195*
realism in France, *23020*
works in New York, 1890, *15083*
LeRoux, Charles, 1814-1895
obituary, *16713*
Leroux, Hector, 1829-1900
art importations to U.S., 1879, *734*
Athenian maidens praying to Minerva, on exhibit in New York, 1889, *25585*
exhibitions
 Salon, 1878, prepares, *8961*
 Salon, 1880, *9355*
 Union League Club of New York, 1882, *9612*
illustrations
 Fishers, 1355
 group from *Vestals, 7289*
 sketch, *6347*
paintings in Astor collection, *1286, 1368*
LeRoux, Hugues, 1860-1925
Fleurs à Paris, illustrated by E. H. Avril, *15241*
Jeux du Cirque, et la Vie Foraine, illustrated by J. Garnier, *15072*
quote, on circus collection, *15219*
Leroux, Joseph
Medaillier du Canada, review, *16012*
LeRoux, Louis Hector See: **Leroux, Hector**
LEROY, Amèlie Claire, b.1851, *25663, 25670, 25704, 25778, 25789, 25924, 25936, 25937, 25972, 25983, 25994, 26003, 26010, 26059*
Leroy, Auguste, fl.1887-1892
illustrations
 collection of Mrs. Hicks Lord, *20431*
 Haunted guitar, 20449
 Louis XV. bed, in *Vernis Martin* by Martin brothers, *20448*
 Paris taverns, *20457*
 pictures at exhibition of New York Society for the Promotion of Art, 1887, *20441*
 Tsimshian Indians, *20471*
 views of Norwich Connecticut, *20476*
 window drapery, *3045*
whereabouts, 1892, opens studio in Chicago, *11308*
LEROY, Leslie, *18241*
Leroy, Louis, 1812-1885
Pensionnaires de Louvre: Dessins de Paul Renouard, review, *417*
LeRoy (New York). Ingham University
College of Fine Arts, *8462*
 exhibition, 1887, *583*
 exhibition of works by students, 1881, *400*
 notes, 1879, *757*
 notes, 1880, *211*
 opens, 1879, *9124*
Leroy Saint Aubert, Charles, b.1856
exhibitions, Salon, 1884, *1789*
Lescher, T. A., fl.1897-1898
elected vice-president, American Art Association of Paris, 1898, *24114*

LeSidaner, Henri Eugène Augustin, 1862-1939
exhibitions
 Carnegie Galleries, 1901, *13322*
 International Society of Sculptors, Painters, Gravers, 1907, *14248*
Lesigne, Léopold, fl.1889-1904
illustrations, *Shepherd and flock* (etching), *13259*
Lesley, Edith S., fl.1894
illustrations, *Making a call, 22576*
subjects, favorite subject, 1894, *22519*
summer home and studio, *22571*
woman illustrator, *22525*
Lesley, Ellen, 1875-1920
woman illustrator, *22525*
Lesley, Margaret See: **Bush Brown, Margaret Lesley**
LESLIE, Amy, *22428*
Leslie and Travers, firm
tinted wood engraving after F. O. C. Darley, *14510*
LESLIE, Charles Robert, *14631, 14643*
Leslie, Charles Robert, 1794-1859, *21705*
American nationality, *4702*
Anne Page, slender and shallow, engraved for American Art Union, 1850, *14601, 14663*
Autobiographical Recollections, 18462
 excerpts, *18471*
 review, *20250*
exhibitions
 Pennsylvania Academy of the Fine Arts, 1858, *19858*
 Royal Academy, 1849, *14526*
 Royal Academy, 1850, *14644*
 Royal Academy of Arts, 1851, *14751*
Handbook for Young Painters
 excerpts, *18861, 18883, 18894, 18900, 18928, 18970*
 review, *18633, 18822*
lectures on painting, *14603, 14616*
Life and Letters of John Constable, R.A., excerpts, *18978, 19585*
Manuscript, 10723
Memoirs of the Life of John Constable, R.A., excerpts, *18917, 19016, 19056*
notes
 1850, *14617, 14632*
 1859, *20060*
 1899, *7145*
obituary, *18315, 20045*
Offer of the crown to Lady Jane Grey, 8883
painting in Boston Athenaeum, 1850, *14676*
paintings in Lenox Library collection, *771*
posthumous exhibition planned, 1861, *20352*
Queen receiving the sacrament at her coronation, originally attributed to Winterhalter, *25456*
quote, *25109*
Sancho Panza and Dr. Pedro Rezio, 18960
Sancho Panza at dinner while governor of Barataria, 20959
subjects of paintings, *14678*
Victorian artist, 10434
Washington Irving, 18441
works in America, *20260*
Leslie Cotton, Mariette See: **Cotton, Mariette Leslie**
Leslie, Fanny, 1857?-1935
portraits, photograph, *23250*
Leslie, Frank, 1821-1880
See also: **Leslie and Travers, firm**
illustrations, landscape composition (after Kensett), *14664*
obituary, *63*
wood engraving after Harlow's group portrait of Kemble's acting company, *16304*
Leslie, Frank, *Mrs.* See: **Leslie, Miriam Florence Folline**
LESLIE, George Dunlop, *9604*
Leslie, George Dunlop, 1835-1921, *21818*
exhibitions
 Paris Exposition, 1878, *9024*
 Royal Academy, 1877, *8859*
 Royal Academy, 1877, prepares, *8829*
 Royal Academy, 1878, *9023, 21590*

illustrations, *23656*
 Arms of Paris, *23974*
 Norman knight, *24074*
 Tempest, *24239*
 Mermaid, *23656*
Lewis and Clark Centennial Exposition, Portalnd, 1905 See: **Portland (Oregon). Lewis and Clark Centennial Exposition, 1905**
Lewis and Clark Expedition (1804-1806)
 Charles Floyd memorial celebration in Sioux City, 1895, *16792*
 medal, *16911*
Lewis, Arthur Allen See: **Lewis, Allen**
Lewis, Charles George, 1808-1880
 illustrations
 Chevy chace (after E. Landseer), *8634*
 Comical dogs (after E. Landseer), *8930*
 Entrance to the Grand Canal, Venice (after J. Holland), *9669*
 Harvest time in the Scottish Highlands (after E. Landseer), *8588*
 Head of a deerhound (after E. Landseer), *9057*
 In the Glen (after E. Landseer), *8686*
 Odin (after E. Landseer), *9187*
 Offer of the crown to Lady Jane Grey (after C. R. Leslie), *8883*
 Pet of the duchess (after E. Landseer), *8760*
 Prince of Spain's visit to Catalina (after G. S. Newton), *9134*
 Resting-place of the deer (after R. Bonheur), *9243*
 Safe! (after E. Landseer), *8664*
 Sancho Panza (after E. Landseer), *8898*
 Stable (after E. Landseer), *8619*
 There's no place like home (after E. Landseer), *8977*
 Trial of Lord William Russell (after G. Hayter), *9204*
 Under the old fir-tree (after E. Landseer), *8871*
 Waiting for the countess (after E. Landseer), *8991*
 obituary, *165*
Lewis, Charles James, 1830-1892
 exhibitions, Royal Society of Painters in Water Colours, 1850, *14632*
 obituary, *26529*
Lewis, Edmonia, b.1845
 Henry Wadsworth Longfellow, *10640*
 notes, 1871, *10730*
 sculptures, 1871, *10721*
 statue for Centennial, 1876, *8642*
Lewis, Edmund Darch, 1835-1910
 exhibitions
 Pennsylvania Academy of the Fine Arts, 1855, *18793*
 Pennsylvania Academy of the Fine Arts, 1877, *8847*
 sketches, 1883, *24607*
 whereabouts
 1859, summer travel, *20080*
 1883, Narragansett, *24742*
LEWIS, Elizabeth W., *22818*
LEWIS, Estelle Anna Robinson, *18494*, *18534*
Lewis, Eugene Castner, b.1846
 portraits, portrait by F. Thompson, *11862*
Lewis, Eugene Howard, b.1852, *25927*
Lewis, Florence
 China Painting, excerpts, *2238*
LEWIS, Frank, *17736*
Lewis, Frederick Christian, 1813-1875
 obituary, *8516*
Lewis, George Lennard See: **Lewis, Lennard**
Lewis, H. W., fl.1894-1895
 illustrations
 Newly cut field, *22567*
 Under the hill, *22591*
Lewis, Henry Clay, 1820-1894
 collection
 acquires pictures from Thompson collection sale, 1870, *10572*
 bequeathed to University of Michigan, *11638*, *16764*, *22738*
 controversy over disposition, 1895, *11571*
Lewis, Ida, fl.1903
 illustrations, decorative design, *13618*

Lewis, James, 1837-1896
 portraits, portrait by C. de Grimm, *20473*
Lewis, John Frederick, 1805-1876
 elected president of Old Water-color Society, *19328*
 Kibab shop, Scutari, Ruskin's comments, *19872*
 obituary, *8735*
 paintings in Matthews collection, *21989*, *22005*
 sales and prices, 1855, sketches of Spain and Greece, *18949*
 Spanish peasants, *14678*
 Turkish school, *9057*
Lewis, John Hardwicke, 1840-1927
 drawings of the Thames, *9825*, *9831*, *9855*, *9872*, *9901*
Lewis, John Smith, fl.1888-1910
 exhibitions
 Prize Fund Exhibition, 1888, honorable mention, *2700*
 Salon, 1893, *4426*
Lewis, Lennard, 1826-1913
 paintings in studio, 1878, *21575*
Lewis, Lily See: **Rood, Lily Lewis**
Lewisohn, Adolph, 1849-1938
 home, E. H. Blashfield mural for New York residence, *8081*
Lewiston (Maine). Art Students' League
 formed, 1894, *26999*
lexicology
 notes, 1860, *18489*
Lexington (Kentucky)
 exhibitions, 1891, benefit loan exhibition, *26266*
 monuments
 Henry Clay monument proposed, 1855, *18771*
 Henry Clay monument proposed, 1857, *19626*
 museum planned, 1904, *13739*
Lexington (Massachusetts)
 monuments, monument to the Minute Man proposed, 1859, *18316*
 portraits of Paul Revere and Amos Muzzey given to city, 1883, *24569*
Lexington (Virginia). Washington and Lee University
 acquisitions, 1897, C. W. Peale portraits, *6396*
Leyden, Lucas van See: **Lucas van Leyden**
Leyendecker, Frank Xavier, 1877-1924
 exhibitions, Denver Artists' Club, 1899, *12327*, *12886*
 illustrations
 Bal Bullier, Luxembourg gardens, *13201*
 cover for *Brush and Pencil*, 1897, *12635*
 Portrait of Ralph Clarkson, *12654*
 studies of drapery, *13230*
Leyendecker, Joseph Christian, 1874-1951
 exhibitions
 Chicago Art Institute, 1899, *12902*
 Chicago Art Students' League, 1895, *11469*
 Denver Artists' Club, 1899, *12886*
 New York Life Building, 1898, *12657*
 illustrations
 Bal Bullier, Luxembourg Gardens, *12847*
 color plate, *12948*
 Francis McComas, *13042*
 illustrtations from *Kiss of Glory*, *13527*
 Model, *12652*
 November, *12608*, *13615*
 Parisienne, *12777*
 portrait of Henry Hutt, *12696*
 poster for *Century Magazine*, *12507*
 self-portrait, *12507*
 illustrator, *12614*
 posters, *12612*
 Century Magazine, *12867*
 first prize in *Century* poster competition, 1896, *22413*
 prize, 1896, *11831*
 teacher at School of Illustration, Chicago, *12964*
 whereabouts, 1896, student in Paris, *23684*
Leykauf, George, fl.1895-1896
 American china painter, *5920*
 whereabouts, 1895, New York to teach china painting, *5329*
Leyland, Frederick Richards, 1831-1892
 bequests, *26548*

collection, sale, 1892, *3895, 26667, 26697*
obituary, *15837*
Peacock dining room decorated by Whistler, *3779*
Leys, Hendrik, *baron*, 1815-1869
and L. Alma Tadema, *22937*
collection, sale, 1894, *16456*
dining room paintings, *16861*
exhibitions
Chicago World's Fair, 1893, *4467*
Paris Exposition, 1855, *18841*
Guests, 9454
In the sunshine (etching), *26787*
painting in Hutchinson cllection, 1899, *17682*
Rembrandt's studio, in Hutchinson collection, *22222*
Young Luther singing hymns in the streets of Eisenach, 25607
Lhermitte, Léon Augustin, 1844-1925, *10332, 15083*
Ami des humbles, given to Boston Museum of Fine Arts, 1892, *26786*
Baignade, shown in New York, 1889, *25674*
biographical information, *16442*
compared to Millet, *14929*
exhibitions
Chicago, 1894, *26998*
Chicago, 1899, *12314*
Chicago World's Fair, 1893, *4766*
Chicago World's Fair, 1893, *Friend of the lowly, 4605*
Dudley Gallery, 1878, *21663*
Dudley Gallery, 1881, *22025*
London, 1875, *8488*
New York, 1892, *15820*
New York, 1897, *6370*
Paris Exposition Nationale, 1883, *1680*
Paris Exposition,1889, *25670*
St. Louis Exposition, 1894, *5036*
Salon, 1880, *187*
Salon, 1892, *26673*
Salon, 1892, *Friend of the humble, 4013*
Salon, 1895, Paris Hôtel de Ville decorations, *5375*
Société des Pastellistes Français, 1887, *2453*
Société des Pastellistes Français, 1892, *15890*
Glaneuses, at Knoedler's, 1890, *15067*
Haymakers' repose (etching), *25474*
illustrations
Glaneuses près des meules, 13613
Washerwomen on the banks of the Marne (engraved by C. Baude), *4727*
pastels, *7290*
realism in France, *23020*
sketching technique, *5838*
Washing the sheep, 7719
Lhuillier, Victor Gustave, fl.1877-1888
His legal adviser (after E. Nicol), *9767*
illustrations, *Surprise* (after J. D. Linton), *9527*
Tale of Edgehill (etched after S. Lucas), *9955*
Libbey Glass Company, Toledo, Ohio
display of cut-glass at Chicago World's Fair planned, 1892, *26545*
exhibitions, Chicago World's Fair, 1893, *4619*
Libbie, C. F., & Co., Boston See: **Boston (Massachusetts). Libbie, C. F., & Co.**
Libbie, Frederick James, 1866-1927
collection, bookplates, *16329*
Liberal Art League See: **New York. Liberal Art Society**
Liberty Bell
vandalism prevented, 1895, *16803*
liberty of the press
Crayon and "naked art", *20145*
Libonis, Léon Charles, 1846-1901
illustrations, ebony chest of drawers by A. C. Boulle, *20448*
LIBRA, 20553, 20561
libraries
art and art books in public libraries, *23053*
criticized for censoring books by infamous authors, 1895, *5336*
ideal library, *1854*
influence of public libraries on morality, *23027*

national libraries compared, 1892, *26619*
proposal that libraries add restaurants, 1896, *17191*
thefts of rare books from public libraries, *16171*
United States
donations, 1896, *17111*
Hedeler compiles list of American libraries, 1894, *16499*
list of art books, Y.M.C.A, New York, 1893, *4694*
libraries, private
advice on building a library, 1890, *3303*
Brooklyn book collectors, *16264*
list of books for an art student's library, 1893, *4455, 4638*
Sir Walter Scott's library at Abbotsford, *5284*
libraries, university and college
United States, *10585*
Library Company of Philadelphia See: **Philadelphia (Pennsylvania). Library Company of Philadelphia**
Library of Congress See: **Washington (D.C.) Library of Congress**
Libri, Guillaume, 1803-1869
library, books stolen?, *14896*
Lichtenauer, Joseph Mortimer, b.1876
prizes, Architectural League of New York's bronze prize, 1907, *14270*
LICHTENSTEIN, Richard C., *20397, 20415, 20434, 20478*
Lick, James, Trust See: **James Lick Trust, San Francisco**
Liddell, J. fl.1875-1876
illustrations, furniture at Bethnal Green Museum, 1878, *21643*
Lie, Jonas, 1880-1940
exhibitions
National Academy of Design, 1907, *14311*
Pennsylvania Academy of the Fine Arts, 1906, *14244*
Pratt Institute, 1906, *14088*
LIEBER, Francis, *20156*
Liebermann, Max, 1847-1935
exhibitions
Internationale Kunstausstellung, Munich, 1883, *1658, 14916*
Petit Gallery, 1887, *2482*
illustrations, *Dutch interior, 5831*
notes, 1894, *16544*
quote, on program of Berlin Secession, *13588*
Secession, *22315*
Liebscher, Gustave, 1870-1953
illustrations, *On Long Island, 22610*
Lieck, Joseph, b.1849
Lydia, posed by Caroline Miskel, *22522*
Liège (Belgium). Exposition universelle et internationale, 1905
announcement, *13735*
French and American art, *13965*
Lienau, Detlef, 1818-1887
member, American Institute of Architects, 1859, *19992*
objections to adoption of Gothic style for public buildings, *19871*
paper on Romantic and classic architecture read at American Institute of Architects, 1858, *19847*
Lier, Adolf Heinrich, 1826-1882
illustrations, *Return of the flock* (engraved by Lepère), *3984*
Lièvre, Edouard, 1829-1886
engravings after Holbein in Mantz's book, *16*
life
See also: **country life; outdoor life; quality of life; river life; spiritual life**
light
artificial white light, *18189*
as locomotive power, *22454*
Lightfoot, Peter, 1805-1885
illustrations
Found at Naxos (after H. Wallis), *9045*
Mary, Queen of Scots, led to execution (after L. J. Pott), *8435*
Nine worthies (after R. Hillingford), *8712*
Professor's lecture (after Rossi), *9419*
Spanish flower girl (after Murillo), *8789*
Tiff (after P. Koerle), *9187*
lighthouses
France, Cordouan, *21000*
history, *9270*

1864, *23326*
1887, *25442*
1889, *25606, 25612*
1893, *16151*
French atelier system to be adopted, 1891, *3524*
Garnier paintings seized as indecent, 1891, *3454*
Gassiot collection given to London, 1902, *13533*
sculpture, *21992*
art schools, *13504*
Bank of England, curiosities, *16612*
Bedford Park aesthetic suburb, *24737*
bridges
 Blackfriars Bridge, *10352*
 Old Battersea Bridge, *26052*
Burnham Beeches Park, artists' huts prohibited, 1903, *8238*
churches
 clergy and artists association plan reform of church decora-
 tion, 1901, *13213*
 Fairford Church, *26135*
 Holy Trinity Church, *16387*
 London church towers threatened by "Union of Benefices
 Bill", *20270*
 northern suburbs, *9991*
club of women artists who have exhibited in Paris formed,
 1899, *6902*
Columbus banquet, 1892, *26817*
Corporation gift of medals and books to Corporation of Ottawa,
 1904, *13712*
Covent Garden, home to many English painters, *24082*
decoration of spandrels, *26052*
description
 Billingsgate, *20789*
 Chelsea, *9447*
 Cheyne Walk, Chelsea, *9701*
 Hammersmith and Chiswick, *10157*
 Hyde Park and Kensington Gardens, *9980*
 Inns of Court and Temple, *10050*
 People's Palace for East London, *25625*
 Regent's Park, *10016*
 St. James Park, Chelsea Hospital, Battersea Park, *9996*
 St. James Street and clubs, *10129*
 tavern entertainment, *20772*
 Thames, *10005*
Devonshire House, history and description, 1897, *6342*
Epping Forest, praised as sketching ground, 1896, *5942*
exhibitions
 1760-1880, catalogue of portraits exhibited, *9882*
 1850, *14635*
 1851, *14729, 14751, 14766*
 1854, French painting, *21281*
 1854, German painting, *21317*
 1855, English architecture, *19328*
 1856, *19542*
 1858, French paintings, *19851*
 1859, *20143*
 1881, *240, 21894, 21896*
 1881, amateur pottery, *1184*
 1881, Salon, *21897*
 1881, Swiss art, *9391, 21894*
 1882, smoke abatement exhibition, *9616*
 1883, *9734, 24637, 24684*
 1883, American water colors, *24562, 24615, 24713*
 1883, mediumistic drawings, *20710*
 1884, *9985, 10983, 25008*
 1884, "Anno Domini" at Mr. Long's, *9934*
 1885, autumn, *10247*
 1887, *10419, 10431, 10452*
 1889, *25615, 25637*
 1889, English humorous sketches, *25636*
 1890, *26135*
 1890, French art, *26035, 26044*
 1890, studies of wild animals at Dunthorne's gallery, *26166*
 1890, Tudor exhibition, *25778, 25799*
 1891, *26334, 26342*
 1891, Women's Handicraft Exhibition, *26236*

 1892, cyclorama of ancient Egypt, *26763*
 1892, French impressionists, *26482*
 1894, *27007*
 1896, *17179*
 1897, *17206, 17321, 17378*
 1897, royal anniversary exhibition of manuscripts and relics,
 17276
 1898, Hare & Co.'s annual exhibition of posters, designs and
 show cards, *24114*
 1899, *17608*
 1899, international art exhibition, *17554*
 1900, women's exhibition, *7250*
 1902, *13361*
 1903, *8281*
 1903, Dutch art, *13602*
 1905, New York Water-Color Club, *13892*
 1906, Austrian art associations at Earl's Court, *14174*
galleries, dealers charge admission, 1896, *5933*
history
 exhibitions, *10394, 10406*
 London bridge, *21149*
 picture exhibitions, *10450*
Hotel Cecil, interior decoration, *6298*
international exhibition of Christian art proposed, 1893, *26918*
Jubilee ball, 1887, *25455*
King's-Cross terminus, *20830*
mayors, Lord Mayor's show, 1889, *25705*
Metropolitan Drawing Classes, 1890, *25832*
monuments
 buildings and sculpture, *21784*
 criticized, 1879, *21745*
 equestrian monarchs on Blackfriars bridge planned, 1902,
 13399
 Iddesleigh Memorial Fund, 1890, *25806*
 Nelson Monument, *19912*
 statue of George Washington proposed, 1897, *6187*
 Steell's disgusting statue of Burns, *25152*
 Wellington monument commission, 1856, *19564*
 Wellington monument controversy, 1856, *19484*
 Wellington monument prize money, *19561*
museums
 attendance on first Sunday open, 1896, *17074*
 criticized, 1878, *9014*
notes, 1893, *16238*
Railway Art Distribution Society proposal, 1890, *25799*
restaurants, Copper Kettle, *16391*
Richmond Park, *9799*
St. John's Wood, haven for artists, *26376*
school of design for women to be founded, 1894, *5073*
signs, Parliament restricts size, 1891, *26246*
social life and customs
 1857, *19631*
 garden parties, 1889, *25625*
 silly season, 1891, *3722*
theaters, *12861*
 Drury Lane, *20576, 20587*
views, Society for Photographing Views of Old London, *9893*
London (England). Agnew, Thomas and Sons
collection, British paintings, *26052*
exhibitions
 1881, paintings, *21890*
 1883, watercolours, *1572*
 1890, *Legend of the Briar Rose* by Burne-Jones, *26003*
 1896, *Twenty masterpieces of the English School*, *5653*
 1899, *17641*
 1899, *Twenty masterpieces* of early English art, *7177*
 1902, *13372*
sales and prices, 1890, paintings from Manchester collectors,
 26006
London (England). Albert Memorial
designed by G. Gilbert Scott, *8755*
renovation to be paid for by British government, 1902, *13516*
London (England). American Exhibition, 1887, *25455*
art, *25464*
art exhibition announcement, *502*

London (England). Howell and James
annual exhibitions
1878, china painting, *21623*
1879, china painting, *21738*
1880, china painting, *21862*
1882, china painting, *1366*
1883, Cincinnati Pottery Club exhibit, *1589*
exhibitions
1880, tapestry painting, *21879*
1881, English amateur china painters, *1184*
1882, pottery and porcelain exhibit, *1438*
1890, antique embroideries, *26176*
London (England). Hunterian Museum See: **London (England). Royal College of Surgeons of England. Museum**
London (England). Hyde Park
description, 1856, *19565*
London (England). India Museum
move to South Kensington, 1875, *8506*
reopens, 1880, *9285*
London (England). International Exhibition, 1862
American and English reviews, *23335*
planned, 1860, *24334*
Zenobia by Harriet Hosmer, *23321*
London (England). International Exhibition Society See: **London (England). United Arts Gallery**
London (England). International Health Exhibition, 1884
aims to show that cleanliness and healthiness are compatible with beauty, *10048*
description, *10002*
description of exhibits, *9983*
London (England). International Inventions Exhibition, 1885
music and musical instruments, *10153, 10196, 10206, 10222*
London (England). International Society of Sculptors, Painters.. See: **International Society of Sculptors, Painters and Gravers**
London (England). Kanooser Club
collectors' club formed by illiterate art dealer, 1891, *3576*
London (England). King's College
ladies' art classes, 1878, *21647*
London (England). Kit Cat Club
history, *15478*
origin of portrait size, *16786*
London (England). Kyrle Society
charitable activities, *21810*
London (England). Ladies' Work Society
needlework, 1880, *21803*
London (England). Lambeth Palace
collection, *21757*
history, *21754*
portraits, *9213*
London (England). Lambeth Palace. Library
notes, 1896, *17200*
London (England). Law Courts See: **London (England). Royal Courts of Justice**
London (England). Lawrie & Co.
exhibitions, 1895, *16705*
London (England). Leighton House
exhibitions, 1903, G. F. Watts, *8222*
London (England). London Stereoscopic and Photographic Co., ltd.
album of prize photographs , 1886, *10375*
illustrations
portrait of H. H. Armstead, *21869*
portrait of Marcus Stone, *21769*
portrait of Tom Taylor, *21924*
London (England). Maclean Gallery
exhibitions, 1887, *10452*
London (England). Madame Tussaud and Sons' Exhibition
notes, 1894, *16498*
London (England). Marlborough House
catalogue of art works, *18927*
collection, British pictures belonging to the nation, *14694*
exhibition rooms for Vernon collection, 1850, *14635*
London (England). Museum of Practical Geology
collection of English ceramics, *1612*

London (England). National Art Collections Fund See: **National Art Collections Fund**
London (England). National Art Schools' Competition
1886, *10352, 10361*
1899, *7163, 17688*
works from exhibition illustrated, *7161, 7162*
London (England). National Art Training School, South Kensington
Poynter's revolutionary teaching, *3260*
students' successes, 1892, *26714*
London (England). National Gallery
acquisitions
1856, *19512, 19542*
1857, *19749*
1876, Ellis bequest, *8691*
1878-92, pictures purchased from Chantrey bequest, *26568*
1882, *9723, 9740, 9801*
1883, *9889*
1883, Antonello da Messina portrait, *14899*
1883, new Velasquez painting, *14909*
1883, Tintoretto, Velasquez and Raeburns, *14917*
1884, *9999*
1884, Blenheim Raphael, *11084*
1884, Botticelli, Poussin and Hogarth paintings, *10095*
1885, *10174*
1889, drawings of the Arundel Society, *25662*
1890, *26006, 26035*
1890, conditional donation of English paintings, *25823*
1890, Holbein's *Ambassadors*, *26095*
1890, Italian paintings, *26052*
1890, Lawrence's portrait of Kemble as Hamlet, *15287*
1890, paintings by Holbein, Velasquez, and Moroni, *26072*
1890, *Portrait of Admiral Adrian Puldio Pareja* by Velasquez, *26129*
1891, *26357, 26392, 26397*
1891, Janssens portraits, *26365*
1891, three Veronese paintings, *26387*
1891, Whitmore bequest, *26280*
1892, *26753*
1892, bequests, *26714*
1892, Dutch paintings, *26496*
1892, Habich collection, *26508*
1892, Lady Hamilton's bequest, *26704*
1893, *26976*
1893, Van der Meer painting, *26888*
1896, Bellini's *Circumcision*, *17169*
1896, Corot paintings, *17107*
1896, Gilbert Stuart self portrait, *6092*
1899, *17595*
1901, *13177, 13257*
1905, *13837*
1905, Fithian portrait, *13875*
1906, Lucy Cohen bequest of Italian masters, *14255*
principles used in selection, *14665*
annual report
1887, *25455*
1890, *25960, 26035*
attendance, 1877, *21648*
bequests
1892, *26558*
Rogers' pictures, 1856, *19328*
Samuel Rogers bequest, 1856, *19381*
Turner bequest, 1856, *19404*
building
additions and alterations, 1885-87, *10474*
alterations and additions completed, 1887, *25464*
changes, 1876, *8750*
new building plan, 1851, *14766*
reopens, 1855, *19215*
scheduled reopening, 1856, *19561*
cleaning controversy, 1855, *18793*
collection, *3410*
1897, *6397*
condition of Holdbein painting, 1892, *26640*
description, 1894, *5005, 5043*

illustratiions by Mary Hallock, *8777*
letter discussing poem, 1857, *19641*
Song of Hiawatha, *18984*
 review, *19354*
Wayside Inn, Howe's Tavern sold, 1893, *26917*
LONGFELLOW, Samuel, *19829*
Longhi, Giuseppe, 1766-1831
 catalogue of engravings, *983, 1008*
Longhi, Pietro, 1702-1785
 Venetian painter, *10347*
Longman, Evelyn Beatrice, 1874-1954
 exhibitions
 National Sculpture Society, 1905, honorable mention, *14009*
 Society of Western Artists, 1900, *12986*
 sculpture for Louisiana Purchase Exposition, 1904, *13685*
 winner of bronze doors competition, U.S. Naval Academy, 1906, *14161*
LONGMAN, John B., *13148*
Longman, John B., b.1860
 In the valley of the shadow, *11845*
 member of art jury, Tennessee Centennial, 1896, *11843*
Longman, Mary Evelyn Beatrice See: **Longman, Evelyn Beatrice**
Longpré, Paul de, 1855-1911, *10544*
 exhibitions
 Chicago, 1896, flower paintings, *11793*
 Chicago, 1899, *12861*
 Chicago, 1899, flower paintings, *12290*
 New York, 1896, *5855*
 New York, 1898, watercolors, *6545*
 New York, 1899, flowers, *6841*
 New York, 1901, *7505*
 holiday calendars, 1897, *12069*
 home, Hollywood, California, 1902, *7803*
 ill health, 1901, *22127*
 illustrations
 American Beauties, *5859*
 American beauty rose and white lilacs, *4591*
 Apple blossoms, *4517*
 Bunch of roses, *4930*
 Carnations, *5025*
 Damask roses and lilacs, *5722, 5760*
 Fragrant and fair, *22546*
 Fragrant decoration, suggestions for copying, *4168*
 Geraniums, *5327*
 Golden rod, *5419, 5426*
 Honey-bee, *23067*
 La France roses, *4453*
 Lilacs, *4824*
 Peonies, *4639, 5068*
 Poppies, *5289*
 Roses and lilacs, *4548*
 illustrations for William Cullen Bryant's *Poems of Nature*, 1893, *16211*
 notes
 1892, *4179*
 1893, *16098, 16343*
 1902, *8081*
 portraits, photograph, *22539*
 whereabouts, 1892, New York, *15859*
Longus
 Daphnis and Chloe illustrated by R. Collin, *15225*
LONGWELL, C. P., *23027, 23053*
Longworth, Maria See: **Storer, Maria Longworth Nichols**
Lonsdale, Horatio Walter, 1844-1919
 English Victorian designer, *10438*
Loo, Leon van See: **Van Loo, Leon**
Loomis, Charles Russell, fl.1883-1891
 exhibitions, Prize Fund Exhibition, 1886, *25304*
Loomis, Chester, 1852-1924
 exhibitions
 Boston, 1883, *24380*
 Royal Academy, 1879, *21741*
 Salon, 1879, *9188*
 Society of American Artists, 1889, *2986*

West Museum, 1891, *26382*
Phoebe, shown in Brooklyn, 1893, *26916*
summer art school, Round Lake, N.Y
 director, 1893, *26969*
 manages, 1894, *4900*
 opens, 1893, *26952*
Loomis, Eurilda See: **France, Eurilda Loomis**
Loomis, Osbert Burr, 1813-1886
 panorama of Cuba, *14696*
Loop, Henry Augustus, 1831-1895
 copies after old masters made for Metropolitan Museum's Loan Exhibition, 1883, *24538*
 exhibitions
 American Art Union, 1883, *Love's crown*, *10913*
 Brooklyn Art Association, 1884, *1696*
 National Academy of Design, 1880, *111*
 National Academy of Design, 1881, *342, 1129*
 National Academy of Design, 1884, *1772*
 National Academy of Design, 1884, *Summer moon*, *10982*
 New York, 1859, *19978*
 Southern Exposition, Louisville, 1884, *Awakening*, *11051*
 landscapes done in Rome, *19850*
 Love's crown, *22638*
 obituary, *16861*
 summer home and studio, *22571*
 whereabouts
 1860, moves studio, *20237*
 1883, Lake George, *24728*
Loop, Henry Augustus, Mrs. See: **Loop, Jennette Shepherd Harrison**
Loop, Jennette Shepherd Harrison, 1840-1909
 exhibitions, National Academy of Design, 1885, *25271*
 lady artist of New York, 1880, *915*
Loperfido, Luigi, fl.1897-1899
 Italian artist, *6375*
 whereabouts, 1899, Rome, *7042*
Lopez, Charles Albert, 1869-1906
 commission for McKinley memorial, 1903, *13618*
 East Indies on Dewey arch, *7096*
 exhibitions
 National Sculpture Society, 1906, memorial exhibition, *14222*
 Pennsylvania Academy of the Fine Arts, 1905, *13853*
 illustrations
 Arts, *13263, 13556, 14124*
 Quadriga, *13682*
 obituary, *14125*
 sculpture for Louisiana Purchase Exposition, 1904, *13685*
LORCH, Emil, *13262*
Lorch, Emil, b.1870
 appointed to Chicago School of Architecture, 1900, *13128*
LORD, Agnes Wright, *12248*
Lord, Annette Hicks See: **Hicks Lord, Annette Wilhelmina Wilkins**
LORD, Caroline A., *5440*
Lord, Caroline A., 1860-1928
 exhibitions
 Cincinnati Art Museum, 1898, *12754*
 Cincinnati Art Museum, 1900, *13067*
Lord, Hicks, Mrs. See: **Hicks Lord, Annette Wilhelmina Wilkins**
Lord's Day See: **Sunday**
Lord's Day Alliance of the U.S. See: **American Sabbath Union**
Lord's Prayer
 versions from Middle ages to the Renaissance, *18298*
Lorenz, Richard, 1858-1915
 exhibitions
 Chicago Art Institute, 1895, *11673*
 Cosmopolitan Club, Chicago, 1897, *12064*
 Milwaukee Industrial Exposition, 1898, *Texas ranger*, *12800*
 Society of Western Artists, 1896, *11919*
 Society of Western Artists, 1906, *14038*
 illustrations, *Wordless farewell*, *13017*

established, 1883, *10912*
opened, 1884, *11017*
Louisville (Kentucky). Southern Exposition
1883
 American Art Union exhibition, *10912, 10927, 24913*
 art building and pictures, *24760*
 art department a success, *24804*
 art exhibit, *1661, 24673*
 art sales, *24786*
 buildings and art department, *24657*
 Catalogue of Works of Art, 24761
 poem spoofing art exhibition, *24770*
1884
 Art Department, *11016*
 pictures, *11051*
1885, American pictures, *11218*
1886, catalogue of paintings, *25347*
Lourie, Alexander See: **Lawrie, Alexander**
Loustaunau, Louis Auguste Georges, 1846-1898
 obituary, *12201*
Loutherbourg, Philippe Jacques de, 1740-1812
 exhibitions, Royal Academy, 1891, *26259*
 notes, 1893, *16391*
 scene paintings, *17510*
Louvain (Belgium). Saint Pierre (church), *20790*
Louveau Rouveyre, Marie, fl.1873-1877
 etching published by MacMillan, 1893, *26923*
Louvre See: **Paris (France). Musée national du Louvre**
love
 husband and lover, *19989*
 influence in the fine arts, *18838*
Love, John T., d.1903?
 suicide, 1903, *13676*
Love, William H.
 collection, Indian relics, *16313*
Lovell, Patience See: **Wright, Patience Lovell**
Lover, Samuel, 1797-1868
 contributor to *The Lantern*, *16568*
 illustrations, *Renvyle Castle, Connemara, 21066*
Lovett, George Hampden, 1824-1894
 obituary, *16535*
Low, Bertha Lea, b.1848
 exhibitions, Philadelphia, 1894, water colors, *26998*
Low, J. and J. G., Chelsea, Mass.
 center for ceramics, *4818*
 Gold medal from London, Liverpool, and Manchester
 Agricultural Society, *191*
 guest cards, *987*
 illustrations, *Hayfield, 546*
 office, *593*
 Plastic Sketches, publication of tiles, 1886, *2360*
 Plastic Sketches of J. G. and J. F. Low, publication announced,
 1886, *493*
 tiles, catalogue, 1884, *25146*
Low, John F.
 See also: **Low, J. and J. G., Chelsea, Mass., firm**
Low, John Gardener, 1835-1907
 founder of Low Art Tile Works, *4818*
 tiles
 1886, *493*
 1890, *3425*
Low Library See: **New York. Columbia University. Low
Library**
Low, Mary Fairchild, 1858-1946
 decoration, Woman's Building, Chicago World's Fair, *4435*
 commission, 1892, *26694*
 tympana, 1893, *26922, 26815*
 exhibitions
 American Art Galleries, 1887, *10832*
 Chicago Art Institute, 1891, *Between neighbors, 3812*
 Chicago Art Institute, 1896, *6010, 11894*
 Chicago Art Institute, 1898, *12251*
 Chicago Art Institute, 1901, *13345*
 Paris, 1902, *13372*
 Pennsylvania Academy of the Fine Arts, 1896, *5656*

Salon, 1889, *2985*
Salon, 1899, *12915*
Salon, 1902, *13414*
Salon, 1906, *14116*
Society of American Artists, 1896, *22996*
Society of American Artists, 1897, *6250*
Society of American Artists, 1902, Shaw prize, *13403*
illustrations
 Blossom time in Normandy, 13536
 Breeze, 6011
Low, Seth, 1850-1916
 address at opening of Metropolitan Museum of Art's new wing,
 1903, excerpt, *8113*
 contribution to Columbia College, New York, *22738*
LOW, Will Hicok, *13519, 22522, 24466*
Low, Will Hicok, 1853-1932, *4015*
 article on French paintings, 1892, *26855*
 Conception of the Christ, commission, 1906, *14098*
 cover design for *Book Buyer*, 1892, *26592*
 cover for *Scribner's* Fiction Number, *22413*
 currency design, *11661*
 Descent of the rapids, 17705
 design for $1 certificate, 1894, *27006, 27027*
 designer of medals and coins for Chicago World's Fair, 1892,
 26815
 designs new United States paper money, 1896, *5815*
 drawings for *The Manhattan*, 1883, *24856*
 elected Academician, National Academy, 1890, *3254*
 elected to Carnegie Institute jury of awards, 1897, *12020*
 exhibitions
 American Watercolor Society, 1882, *Ninon, A.D.1812, 1300*
 Architectural League of New York, 1888, *10843*
 Architectural League of New York, 1893, *4304*
 Chicago Art Institute, 1902, *13536*
 Chicago Inter-State Industrial Exposition, 1889, *3056*
 Fellowcraft Club, 1891, *3464*
 National Academy of Design, 1884, *1790*
 National Academy of Design, 1891, *26313*
 National Academy of Design, 1894, *4873*
 National Academy of Design, 1895, painting purchased by
 Lotos Club, *5341*
 National Academy of Design, 1897, *10540*
 National Academy of Design, 1902, *13359*
 New York, 1894, competition designs for New York Criminal
 Court, *4907*
 Paris Exposition Universelle, 1889, illustrations of poems by
 Keats, *25675*
 Society of American Artists, 1881, *367*
 Society of American Artists, 1882, *1327*
 Society of American Artists, 1884, *1802*
 Society of American Artists, 1888, *2678, 10846*
 Society of American Artists, 1889, *2986*
 Society of American Artists, 1890, *25895*
 Society of American Artists, 1890, *Diana in the woods,
 15205*
 Society of American Artists, 1899, *Seasons, 6957*
 Tiffany Glass Company, 1890, *Pilgrim's progress* window,
 3217
 Union League Club of New York, 1882, *24392*
 Union League Club of New York, 1887, *10833*
 illustrates George Elliot's works, 1883-4, *24959*
 illustrations
 Aurora, 14039
 By the fountain, 10824
 decorative figure, *4035, 4068*
 design for Harvard memorial window (after J. LaFarge), *339*
 Elysian lawn, 13841
 Interlude, 13543, 13852
 kneeling woman, *24454*
 leaded glass, *20577*
 stained glass window, *13897*
 illustrations for *Scribner's Magazine*, *22482*
 illustrator of *Odes and Sonnets of Keats*, 1887, *592, 10814*
 illustrator of Read's *The Closing Scene*, *2360*
 member, Municipal Art Society of New York, 1893, *26932*

American Watercolor Society, 1899, *Sleep*, *6905*
Carnegie Galleries, 1903, *13675*
Carnegie Galleries, 1905, *14016*
National Academy of Design, 1893, *4316*, *4388*
National Academy of Design, 1900, 2d Hallgarten prize, *13173*
National Academy of Design, 1901, *13202*
New York, 1892, water colors, *26869*
New York, 1895, *5258*
New York, 1895, studio exhibition, *5329*
New York, 1897, *6370*
New York Water Color Club, 1890, *Cabbage field by moonlight*, *3426*
New York Water Color Club, 1900, *13141*
Paris Exposition, 1899, *22072*
St. Louis Exposition, 1894, *11402*
Woman's Art Club of New York, 1893, *4363*
Good story, second Hallgarten prize, 1901, *13213*
illustrations
 Good story, *14221*
 Life's peaceful evening, *23067*
influence of Dutch painters, *10548*
notes
 1892, *15847*
 1895, *16705*
 1898, *17403*
sales and prices, 1894, *Retrospection* bought by Boston Art Club, *26999*
studies of Dutch life, *22550*
whereabouts, 1896, summer in Holland, *23056*
woman painter of Dutch scenes, *22525*
Macchetta, Blanche Roosevelt Tucker, 1853-1898
Life of Gustave Doré, review, *10233*
McClain, F. M., fl.1903-1910
illustrations, painting, *8289*
McClellan, Elizabeth, 1851-1920
Historic Dress in America, review, *13838*
McClellan, George Brinton, 1826-1885
monuments
 all designs rejected for Washington, D.C. monument, 1903, *8262*
 model for equestrian statue by Elliot, *26696*
 statue for Philadelphia planned, 1892, *26808*
 statue proposed for Philadelphia, 1888, *621*
McClintock, John, 1814-1870
Cyclopedia of Biblical, Theological and Ecclesiastical Literature, review, *18476*
McCloskey, Alberta Binford, 1863-1911
exhibitions, National Academy of Design, 1886, *2352*
McCloskey, William John, fl.1888-1904
exhibitions, Prize Fund Exhibition, 1888, *2700*
McClure, Grace M;, fl.1898
illustrations, oil from still life, *12756*
McClurg, A. C., and Company See: **Chicago (Illinois). McClurg, A. C., and Company**
McClurg, Trevor, 1816-1893
exhibitions, National Academy of Design, 1858, *19857*
notes, 1856, *17910*
whereabouts, 1860, New York, *20179*
MacColl, Dugald Sutherland, 1859-1948
bookbindings, *7014*
keeper of National Gallery critical of Royal Academy, 1906, *14185*
Nineteenth Century Art, review, *13539*
writings on Impressionism, *13535*
McColloch, Alice See: **McCullough, Alice**
McComas, Francis John, 1874-1938
exhibitions
 Chicago, 1902, *13399*
 San Francisco, 1902, *22161*
 San Francisco, 1903, *22190*
sales and prices, 1904, *22203*
watercolors, *13042*
whereabouts, 1900, Australia, *22114*

McComas, Frank See: **McComas, Francis John**
McComas, William R., fl.1860
picture of death of a Pioneer shown in Cincinnati, 1860, *24335*
sketch for Cincinnati Sketch Club meeting, 1860, *24347*
McConkey, Benjamin M., ca.1821-1852
landscapes, *14634*
whereabouts, 1850, Dusseldorf, *14696*
McConkey, William, fl.1849-1850
whereabouts, 1849, Switzerland, *14537*
McConnell, Mary Cary, fl.1890-1900
illustrations, *Seeing double*, *22537*
McCord, George Herbert, 1848-1909
Day's work is done, reproduced by Prang in chromo, 1871, *23606*
exhibitions
 American Art Galleries, 1882, watercolor rejected by American Water Color Society, *9624*
 American Watercolor Society, 1884, *25023*
 American Watercolor Society, 1887, *25409*
 Artists' Fund Society, 1884, *24967*
 Brooklyn Art Association, 1884, watercolors, *25092*
 Cincinnati Exposition, 1879, *Under the Palisades*, *756*
 Milwaukee Exposition, 1883, *24799*
 National Academy of Design, 1884, *Ice harvest*, *10982*
 National Academy of Design, 1888, *2695*
 New York, 1891, *15636*, *15643*
 New York, 1892, *15882*, *26622*
 New York, 1893, *4429*
 New York, 1899, *17607*
 New York, 190l, *13202*
 Pennsylvania Academy of the Fine Arts, 1877, *8847*
 Salmagundi Club, 1893, *22483*
 Salmagundi Club, 1901, Shaw prize, *13208*
Haven under the hills, *17554*
illustrations
 paintings in Detroit Museum of Art, *13875*
 Sunset near Moret, France, *13218*
Near Biddeford, Maine, in Clarke collection, *24955*
notes
 1871, *23607*
 1890, *15162*
 1899, *17670*
painter of sunsets, *22533*
pastel sketch, 1899, *17701*
Rounding the buoy, *22495*
sales and prices, 1889, *14961*
studio on the Harlem, 1882, *24367*
Summer evening on the Harlem, *24424*
whereabouts
 1883, Morriwtown, N.J, *24728*
 1891, return from Europe, *26333*
 1893, returns to New York, *16379*
 1896, summer class at Magnolia, Mass, *23056*
 1899, sketching trip, *17639*
MCCORD, J. C., *13628*
McCord, William A., d.1918
exhibitions
 Cincinnati Art Club, 1900, *13037*
 Kansas City Art Club, 1902, *13337*
McCormick, Arthur David, 1860-1943
Artist in the Himalayas, review, *22388*
McCormick, Cyrus Hall, 1859-1936
gift of $75,000 to Chicago Art Institute for Stickney memorial room, 1899, *12330*
McCormick, Evelyn, 1869-1948
notes
 1899, *22077*
 1904, *22203*
McCormick, Leander Hamilton, 1859-1934
collection, loans to Royal Academy exhibition, 1902, *13545*
studio, Chicago, 1895, *11637*
whereabouts, 1895, returns from England, *16781*
McCormick, M. Evelyn See: **McCormick, Evelyn**
McCormick, Robert Hall, 1847-1917
appointed art commissioner for the Tennessee Centennial, 1896,

11913
 collection, *15759, 16432, 16616*
 at Chicago Art Institute, 1895, *11457*
 book of English pictures issued, 1898, *12151*
 English masters, *12826, 16140*
 on exhibit, Chicago Art Institute, 1894, *11430*
McCosker, David
 collection, sale, 1899, *17558*
McCreery, M., *Mrs.,* fl.1899-1900
 illustrations, decorated ceramics, *12873*
McCulloch, Alice See: **McCullough, Alice**
McCulloch, George, 1848-1907
 collection, oft-loaned paintings by Luke Fildes, *4798*
Macculloch, Horatio, 1805-1867
 exhibitions, Royal Scottish Academy, 1880, *21936*
MCCULLOCH, Hugh, *21478*
McCullough, Alice, fl.1904-1905
 exhibitions, Richmond Art Association, 1903, *13714*
 illustrations, bookbinding, *13950*
McCullough, John, 1832-1885
 acting career, *1860*
McCullough, William A., fl.1893-1906
 illustrations
 Caller, 22482
 On the alert, 22501
 sketchbook studies, *22734*
MCCUTCHEON, John Tinney, *13555*
McCutcheon, John Tinney, 1870-1949
 Cartoons, review, *13606*
 drawings, *11934*
 exhibitions
 Chicago Art Institute, 1897, *6145, 12642*
 Chicago Art Institute, 1899, *12838*
 Chicago Society of Artists, 1895, *11483*
 illustrations, *Mr. Bryan making speeches on time, 13865*
 whereabouts, 1897, trip round the world, *12646*
McCutcheon, Samuel G., 1844?-1884
 exhibitions
 American Watercolor Society, 1882, *1300*
 New York Etching Club, 1882, *1296*
 illustrations, Salmagundi Club invitation sketch, *1041*
 notes, 1884, *25099*
 obituary, *25140*
MacDermot, Mary W., fl.1894
 photographs, *22561*
MacDonald, Alexander, 1837-1884
 collection, bequest to city of Aberdeen, *10127*
MacDonald, Charles Harold L. See: **MacDonald, Harold L.**
MacDonald, Donald, fl.1880-1921
 stained glass, *12338*
Macdonald, Frances See: **MacNair, Frances Macdonald**
MACDONALD, George, *14186*
MacDonald, Harold L., 1861-1923
 illustrations, *Night, 23078*
McDonald, James See: **MacDonald, James Wilson Alexander**
MACDONALD, James Wilson Alexander, *17694*
MacDonald, James Wilson Alexander, 1824-1908
 amateur sculptor, St. Louis, *20209*
 bust of Lucas, 1870, *10599*
 colossal bust of Gen. W. S. Hancock cast by Ames Co., 1892, *26779*
 design for Grant memorial proposed, 1885, *11206*
 exhibitions
 St. Louis, 1871, *10654*
 Salmagundi Club, 1886, *2131*
 illustrations, statue of Fitz-Greene Halleck in Central Park, New York, *8360*
 monument to General Custer, criticized by Mrs. Custer, *9343*
 monument to Washington Irving, proposed, 1875, *8498*
 notes
 1871, *10731*
 1896, *23008*
 paid to withdraw from competition for Peter Cooper statue, *583*
 statue of General Hancock, *26800*
 statue of *Italia, 20330*

 whereabouts, 1883, St. Joachim, Canada, *24762*
MacDonald, John See: **Kinneir, John MacDonald**
McDonald, Pirie, 1867-1942
 exhibitions, Photographers' Association of America Convention, 1899, *12937*
McDonald, William Purcell, 1865-1931
 exhibitions, Cincinnati Art Club, 1900, *13037*
 partner with J. Dee Wareham on prize winning design for 1900 calendar for Armour & Co, *12941*
MacDonall, Angus, 1876-1927
 illustrations
 Goldsmith's blacksmith, 14227
 untitled, *14301*
 Seekers after knowledge, in permanent exhibition of Chicago's Palette and Chisel Club, Chicago, 1905, *14036*
MACDONOUGH, Glen, *22768*
MCDOUGALL, Isabel, *5569, 5734, 5783, 5826, 6010, 6012, 6061, 6103, 6145, 6312, 6463, 6503, 6637, 6763, 11909, 12718, 12753, 12799, 12841*
MacDougall, John A., b.1843
 exhibitions, Copley Society, 1902, *13442*
 whereabouts, 1896, Nantucket, *23056*
McDougall, John Alexander, 1810-1894
 obituary, *5002*
McDougall, Walter H., b.1858
 newspaper illustration, *22504*
McDowel, Mary E., fl.1893
 illustrations, *Music room, 4681*
McDowell, Edward, fl.1883-1901
 exhibitions, Society of American Artists, 1894, *4834*
 whereabouts, 1883, Pont Aven, *24702*
MacDowell, Elizabeth, 1858-1953
 exhibitions, Pennsylvania Academy of the Fine Arts, 1882, *1450*
MCDOWELL, Malcolm, *12667*
McDowell, Mary E. See: **McDowel, Mary E.**
MacDowell, Susan Hannah See: **Eakins, Susan Hannah MacDowell**
McElroy, Jane Roma, 1867-1923
 exhibitions, California School of Design, 1891, *3483*
MCENTEE, Jervis, *19362*
McEntee, Jervis, 1828-1891, *8668*
 autumn landscape, 1883, *24541*
 exhibitions
 American Art Union, 1883, *Over the hills, 10913*
 Chicago Academy of Design, 1871, *10712*
 Chicago Inter-State Industrial Exposition, 1880, *199*
 National Academy of Design, 1858, *19835*
 National Academy of Design, 1859, *20030*
 National Academy of Design, 1860, *20208*
 National Academy of Design, 1876, *8673*
 National Academy of Design, 1877, *8830*
 National Academy of Design, 1879, *657, 9151*
 National Academy of Design, 1880, *867, 9324*
 National Academy of Design, 1884, *1790*
 National Academy of Design, 1884, *Yellow autumn woods, 10982*
 National Academy of Design, 1887, *10786*
 New York, 1892, *26576*
 New York artists' reception, 1858, *19800, 19817*
 Union League Club of New York, 1884, *25090*
 illustrations, *Over the hills, 10934*
 landscape shown at Century Club preview, 1884, *25064*
 landscapes, 1860-1, *20330*
 notes
 1860, *20237*
 1871, *10676*
 painting in Layton Art Gallery, Milwaukee, *12813*
 painting of autumn scene, 1883, *24502*
 portrait series of Edwin Booth, *9326*
 sales and prices
 1888, paintings, *2655*
 1891, *15745*
 1892, *26590*
 1892, New York auction, *26356*

MacLean, Thomas Nelson, 1845-1894
exhibitions, Royal Academy, 1879, *21730*
Io, *21655*
Ione, *9338*
Sister's birthday, *9479*
McLellan, H. W., fl.1884
illustrations, *Lady of the day*, *1722*
McLenan, John, 1827-1866
American caricaturist, *11289*
caricaturist from Ohio, *16332*
contributor to *The Lantern*, *16568*
exhibitions, National Academy of Design, 1858, *19857*
newspaper illustrations, *16557*
MCLENNAN HINMAN, Teana, *12364, 13912*
McLennan Hinman, Teana, fl.1896-1909
art reception, Chicago, 1895, *11682*
exhibitions
Chicago, 1898, *12132*
Cosmopolitan Club, Chicago, 1897, *12064*
New York, 1897, *6289, 11957*
flower paintings win medal in Holland, 1896, *11913*
illustrations
At the end of summer, *6387*
decorative design for vase, *12228*
La France roses, suggestions for copying, *6288*
notes, 1897, *12616*
pastels, *11934*
MacLeod Art School See: **Los Angeles (California). Los
Angeles School of Art and Design**
MACLEOD, William, 6, *9047*
MacLeod, William, 1811-1892
obituary, *26716*
Maclise, Daniel, 1806-1870
Banquet-scene in Macbeth, *9107*
exhibitions
Paris, 1855, *19211*
Paris Exposition, 1855, *19037*
Royal Academy, 1850, *14644*
Royal Academy, 1851, *14763*
Royal Academy, 1855, *18800*
frescoes for Parliament, *20092*
Interview between Charles I and Cromwell, *9025*
literary portraits for *Fraser's Magazine*, *22736*
notes, 1897, *17335*
painter of portrait of wife of Alexander Hamilton?, *10763*
Sacrifice of Noah, *18752*
sales and prices, 1861, *Halt of the Bohemian gipsies*, *20352*
Wrestling, in As You Like It, *18960*
McLoughlin, Brothers, publishers
unauthorized publication of Walter Crane's *Noah's Ark
Alphabet*, *25514, 25515*
McM., B. (monogram BMcM) See: **McManus, Blanche**
McMahon, P. H.
collection, sale, 1893, *26921*
McManus, Blanche, b.1869
illustrations
decorative initial, *11318, 11324, 11325, 11340, 11341, 11357,
11362, 11364, 11384, 11401, 11419, 11420, 11488*
headpiece, *11321, 11324, 11338, 11341*
notes, 1896, *17106*
McMicken School of Design See: **Cincinnati (Ohio).
Cincinnati Museum Association. Art Academy of Cincinnati**
Macmillan, Alexander, 1818-1896
obituary, *16948*
Macmillan Company
limited editions of art reproductions, *26873*
McMillan, Emily D., fl.1905-1917
exhibitions, Minnesota State Art Society, 1905, *13905*
MACMILLAN, Hugh, *9913, 9931, 9944, 9963, 9990, 10020,
10062, 10077, 10441*
McMillan, James, 1838-1902
collection, *15518*
McMillin, Emerson, 1844-1922
collection, paintings in Carnegie Institute annual exhibition,
1902, *13520*

gift of land and money for Columbus museum, *13253*
MACMONNIES, Frederick William, *13394*
MacMonnies, Frederick William, 1863-1937, *13386*
as painter, *22108*
awarded Cross of Legion of Honor, 1894, *26997*
Bacchante, *22440*
acquired and exhibited by Metropolitan Museum of Art,
1897, *6461*
Boston Public Library reconsiders refusal, 1896, *6054*
rejected by Boston Public Library, 1896, *17140*
replica for Boston Public Library, *16678*
bronze chariot for Prospect Park Arch, *6841*
Columbian fountain, *War* and *Peace* reliefs, *4973*
commission for Indianapolis Soldiers' And Sailors' Monument,
1894, *27004*
Detroit monument, *13112*
doors for Congressional Library, *11934*
elected associate, National Academy of Design, 1901, *13228*
exhibitions
Buffalo Society of Artists, 1896, *11806*
Carnegie Institute, 1907, *14328*
Cincinnati Art Museum, 1898, *12754*
Cincinnati Art Museum, 1900, *13067*
National Sculpture Society, 1898, *12721, 12733*
New York, 1902, *8059*
Paris, 1890, *25899*
Paris Exposition, 1900, *13065, 13074*
Paris Exposition Universelle, 1889, *Diana*, *25675*
Salon, 1891, *26382*
Society of American Artists, 1889, *2986*
Society of American Artists, 1891, *26329*
Society of American Artists, 1893, *4235*
Society of American Artists, 1896, *5780*
first prize in sculpture, Ecole des beaux-arts, 1887, *611*
fountain at Jackson Park, *12927*
Fuchs claims design was stolen, 1896, *17058*
fountain for Chicago World's Fair, 1892, *26453, 26615, 26761*
fountain in Lincoln Park, Chicago, *4911*
illustrations
Army, Brooklyn triumphal arch, *14026*
Bacchante, *5373, 13985*
bust of Ruckstuhl, *22578*
fountain at Chicago World's Fair, *4563*
Horse tamer, *13263*
sculpture, *3626*
list of works completed 1890 to 1900, *13081*
McClellan monument commission, *13637*
monument to prison-ship martyrs proposed, 1899, *17591*
notes
1896, *5862*
1899, *6954*
portraits, pen portrait of MacMonnies illustrated, *4430*
quadriga for Prospect Park Memorial Arch, *17408, 17431*
sculpture for Brooklyn soldiers and sailors memorial, *12769*
sculptures, *13556*
soldiers' and sailors' monument for Indianapolis, *5393, 11616,
22787*
groups commissioned, 1894, *22280, 22307*
statue of Benjamin West
commissioned by Swarthmore, *13604*
for Swarthmore, *13213*
statue of J. S. T. Stranahan, *26341*
statue of Joseph Jefferson as Rip Van Winkle
commissioned for Central Park, 1906, *14223*
plans for Central Park, *14175*
statue of Sir Henry Vane, *11561, 16556*
for Boston Public Library, 1894, *27016*
studies of horses in action, *24047*
studio in Paris, 1895, *11598*
study in Paris, *12792*
teaching
art school established in Paris with Whistler, 1898, *24180*
instructor at Académie Whistler in Paris, 1898, *12796*
Victory, *7074*
rejected for Battle Monument, West Point, 1896, *23030*

Maeder, Gaspard, d.1892
 obituary, *26488*
Maes, Dirk, 1659-1717
 Gypsies and cavaliers, in Walker collection, Minneapolis, *12924*
Maes, E. R.
 illustrations, *King of the flock, 12192*
Maes, Godfried, 1649-1700
 Fish auction, 16705
Maes, Nicolaes, 1632-1693
 painting offered to Boston Museum, 1881, *1108*
Magdalen College See: **Oxford (England). Oxford University. Magdalen College**
MAGEE, Harriet Cecil, *11415, 11929*
Magee, Harriet Cecil, fl.1895-1932
 art educator, *12056*
Magel, Christen Daae. See: **Magelssen**
Magelssen, Christen Daae, 1841-1940
 experiments with clay, *14329*
Magill, Beatrice, b.1858
 illustrations, *Nasturtiums, 3664*
 sales and prices, 1896, *Mending nets, Venice, 11824*
Maginn, William, 1793-1842
 contributions to *Fraser's Magazine, 22736*
Maglin, Firmin Edouard, 1867-1946
 illustrations, poster, *13305*
Magna carta
 history, *20744*
Magne, Lucien, 1849-1916
 restores Renaissance fountain at Autun, 1892, *26608*
Magniac, Hollingworth
 collection, sale, 1892, *4094, 15958*
Magnus, Camille, fl.1875
 pictures in an American collection, *25585*
Magnussen, Harro, 1861-1908
 statue of Prof. Haeckel, 1904, *13747*
Magnùsson, Sigridr E.
 collection of Icelandic objects, *17276*
Magonigle, Harold Van Buren, 1867-1935
 model for Maine monument, first prize, *13213*
Magoon, Elias Lyman, 1810-1886
 collection
 described, 1856, *19563*
 exhibited at Albany, 1858, *19818*
 purchases Turner drawings, 1856, *19465*
 works by Turner, *19646*
 Course of Empire, chapter on art, *19518*
 eulogy of John Britton, *19607*
 obituary, *2508*
 report on drawing and painting at Albany Female Academy, *19980*
Magrath, William, 1838-1918, *1400*
 Bacchic dance, etching by James King published, 1889, *2979*
 exhibitions
 American Watercolor Society, 1878, *8979*
 American Watercolor Society, 1884, *25038*
 American Watercolor Society, 1887, *534, 2384*
 American Watercolor Society, 1888, *2641, 10843*
 American Watercolor Society, 1889, *2883, 25576*
 Brooklyn Art Association, 1884, watercolor, *25092*
 Dudley Gallery, 1880, *21780*
 London, 1883, *1572*
 National Academy of Design, 1879, *679, 9151*
 National Academy of Design, 1884, *Sop for Neddy, 10982*
 National Academy of Design, 1887, *10786*
 Royal Academy, 1880, *9354, 21863*
 illustrations, *On the old sod, 182*
 picture in Clarke collection, *24955*
Maguire, Bertha, fl.1881-1904
 illustrations
 Arum lilies and amaryllises, 3331
 Azaleas, 3553
 Basket of daffodils, 3249
 Convolvuli, 3276
 Cottage garden, 3222

 Easter lilies, 3222
 Field daisies, 3719
 flower paintings, *5943*
 Pansies, 3387
 painting purchased by Queen of Italy, 1890, *3368*
Maguire, Helena J., 1860-1909
 illustrations
 Amateur yachtsmen, 5011
 Butterflies, 4064, 5388, 5396, 5943
 drawing of horse, *3850*
 Duck and ducklings, 3553
 Geese, 4517
 Good morning, 3821
 Head of a fox terrier, 5428
 Head of a horse, 3862
 Head of a red deer, 5398
 Hens and chickens, 3617
 Kittens, 3354, 3522
 Kittens meeting, suggestions for copying, *3786*
 Mischievous kittens, 4896
 Mischievous puppies, 4308
 Pony's head, 3947
 Puppies, 3387
 Rabbits, 4346
 Setter, 4419, 5474
 Swallows, 5943
 Swallows and reeds, 4966
 Swallows in flight, 3969, 3981
 Three little kittens, 4684
MAHAN, E. L., *12350*
Mahaut, *countess of Artois and of Burgundy*, d.1329
 charity and crime, *20994*
Maher, Elizabeth Brooks, fl.1894-1920
 illustrations, *Morning duty, 11416*
Maher, George Washington, 1864-1926
 illustrations, interiors, *20525*
MAHLSTICK, 1662
MAHLSTICK, Eazel P., *17909*
mahogany, *20611*
 notes, 1889, *2949*
Mahoney, Felix See: **Mahony, Felix**
Mahoney, James, 1816-1879
 illustrations
 Blarney Castle from the peephole on the bridge, 21066
 view of the interior of the Great Industrial Exhibition, Dublin, *20897*
 views of Ireland, *21354*
Mahoney, John H., fl.1881-1925
 Morton McMichael statue, Philadelphia, *450*
Mahony, Felix, d.1939
 Washington, D.C., artist, *22587*
Mahony, James See: **Mahoney, James**
Maiano, Benedetto da See: **Benedetto da Maiano**
Maignan, Albert Pierre René, 1845-1908
 Attentat d'Agnani, given to Metropolitan Museum by London dealer, 1883, *14882*
 Carpeaux, earns salon medaille d'honneur, 1892, *15943*
 exhibitions
 Cercle Artistique, 1877, *8817*
 Cercle Artistique, 1880, *9325*
 Cercle de l'Union Artistique, 1880, *9309*
 Cercle des Mirlitons, 1878, *8992*
 Cercle Volney, 1897, *23745*
 Chicago World's Fair, 1893, *4805*
 Salon, 1879, *9188*
 Salon, 1887, *10463*
 Salon, 1892, *15914*
 Société d'Aquarellistes Français, 1885, *1952*
 Sleep of Fra Angelico, 9675
Maigrot, Henri See: **Henriot**
Maillart, Diogène Ulysse Napoléon, 1840-1926
 illustrations, *Penelope*(tapestry), *963*
Maine
 views in paintings of Frank De Haven, *22529*
MAINE, Henry James Sumner, *Sir, 20348*

Maine Historical Society See: **Portland (Maine). Maine Historical Society**

Maintenon, Françoise d'Aubigné, *marquise* de, 1635-1719
anecdote, *21273*

Mainz (Germany). Cathedral, *9695*

Mainz (Germany). Römisch-germanisches Zentralmuseum
finds Roman column, with reliefs, 1906, *14209*

Maisse, André Hurault, *sieur* de, 1539-1607
French ambassador to Queen Elizabeth of England, *21145*

Maist, Elizabeth, fl.1904-1905
illustrations, bookbinding, *13950*

Maistre, Xavier, *comte* de, 1763-1852
anecdote, *21067*

Maizeroy, René, *pseud.* See: **Toussaint, René Jules Jean,** *baron*

majolica
design for panel, *9286, 9336*
Kaiser Wilhelm II interested in reviving manufacture, *13533*

majolica, Italian
collectors and collecting, 1893, *16211*
history, *8870*
inkstand from 1492, *25932*
modern Roman majolica manufactory, *21980*
tints used, *20534*

Major, Ernest L., b.1864
drawings shown in New York, 1887, *25399*
exhibitions
Boston Art Club, 1890, *25730*
National Academy of Design, 1888, *25516*
Society of American Artists, 1890, *25895*
West Museum, 1891, *26382*
Worcester Art Museum, 1902, *13483*
St. Geneviève, shown at Chicago World's Fair, 1893, *26914*
teacher at Cowles Art-School, 1890, *25950*
winner of Hallgarten art scholarship, 1885, *1916, 25222, 25224*

Major, Henry B., fl.1844-1854
See also: **Sarony and Major, firm**

Majorelle, Louis, 1859-1926
art furniture, *13449*

Makart, Hans, 1840-1884, *1849*
Abundatia, 8571
anecdotes, Munich visit, *731*
as colorist, *14886*
criticism of works retracted by *The Studio, 25152*
Diana hunting, 10814
Diana's hunting party, in American Art Galleries, 1887, *10832*
exhibitions
American Art Galleries, 1887, *2607, 20460*
New York, 1887, *20443*
Paris Exposition, 1878, *9109*
Salon, 1883, *14898*
Union League Club of New York, 1882, *9612*
Vienna Annual Exhibition, 1883, *14894*
fire destroys paintings, 1884, *25032*
Five senses, prints by heliogravure process, *1486*
Jagdzug der Diana, bought by James A. Banker, 1883, *14909*
obituary, *10088*
paintings in Munger collection at Chicago Art Institute, *12785*
student of C. T. von Piloty, *22946*
studio, *9512*
visited, 1883, *10884*
work criticized by *The Studio,* 1884, *25145*

Makoffsky, Constantin See: **Makovskii, Konstantin Egorovich**

Makovskii, Konstantin Egorovich, 1839-1915
exhibitions
Milwaukee Industrial Exposition, 1898, *Russian wedding feast, 12800*
Paris Exposition, 1878, *9096*
Judgment of Paris, shown in New York, 1889, *25711*
paintings in Schumann collection, *16211*
reception, New York, 1893, *26923*
Russian painter, *13759, 25623*
Russian wedding feast, 2132, 20460
on display, New York, 1887, *2559*

studio, opening in New York, 1893, *22249*
whereabouts
1893, New York, *26961*
1893, on way to U.S, *22483*
work, 1888, *2823*

Makovskii, Vladimir Egorovich, 1846-1920
Duet, 26170

Makovsky, Constantin See: **Makovskii, Konstantin Egorovich**

Makovsky, Vladimir Egorovitch See: **Makovskii, Vladimir Egorovich**

Makowsky, Constantin See: **Makovskii, Konstantin Egorovich**

Makowsky, Elena See: **Luksch Makowsky, Elena**

Malan, Solomon Caesar, 1812-1894
Aphorisms on Drawing, review, *19583*
obituary, *16664*
quote, *19708*

Malassis, Auguste Poulet See: **Poulet Malassis, Auguste**

Malastina, Marieta Gazzaniga See: **Gazzaniga Malastina, Marieta**

Malbone, Edward Greene, 1777-1807, *21316*
exhibitions
Copley Society, 1902, *13442*
Pennsylvania Academy of the Fine Arts, 1849, *14533*
Hours, in sister's collection, Newport, *14806*
illustrations, miniature portrait, *6721*
miniature portraits to be shown at Atlanta Exposition, 1895, *22765*
miniatures of William and Eliza Dana, *17591*
paintings in Newport, *19899*

MALCOLM, David, *5121, 5613*

Malczewski, Jacek, 1855-1929
illustrations, *Spring song, 13759*
Polish painter, *13597*

Maldarelli, Federico, 1826-1893
studio in Naples, *8551*

Malempré, Louis Auguste, fl.1848-1879
Guiding angel, 9290
Reaper and the flower, 9369

Maliavin, Filipp Andreevich, 1869-1940
exhibitions, Moscow, 1905, *13943*
Russian painter, *13759*

Maliutin, Sergei Vasilevich, 1859-1937
exhibitions, Moscow, 1905, *13943*

Mallarmé, Stéphane, 1842-1898
as Symbolist, *22363*
French poet, Verlaine's successor, *23750*
inscriptions published, 1895, *16664*
Tuesday evening reception, *8315*

Mallett, Mark
Amateur Work, excerpts, *1759*

Mallory, Richard P., fl.1840's-1860's
illustrations, *Russian conveyance, 22598*

Maloney, J. A., fl.1895
illustrations, *Jerseys, 22590*

Malta
antiquities, Roman villa discovered, *383*
description and history, grotto of St. Paul, *20776*

Malyutin, Sergei See: **Maliutin, Sergei Vasilevich**

Man, Isle of
description and views, *21920*
monuments, tower edifice being erected, 1890, *26176*

man, prehistoric
origins, *20786*

Man, William
collection, porcelain at American Art Association, 1883, *24467*

Manatt, James Irving, 1845-1915
Mycenaean Age, review, *23251*

Manatt, William Whitney, b.1875
exhibitions, Pennsylvania Academy of the Fine Arts, 1905, *13853*
illustrations, sculpture for Louisiana Purchase Exposition, 1904, *13685*

Royal Academy, 1882, *9654*
Royal Society of Painters in Water Colours, 1878, *21595*
Royal Society of Painters in Water Colours, 1885, *10183*
Experimental gunnery, *9485*
illustrations
 Apothecary, *21610*
 Flamingoes, *1117*
 studies, *5841*
 studies for paintings, *21930*
Memories, *16603*
paintings in progress, 1887, *566*
Select committee, *26425*
MARKS, Montague Laurence, *655, 676, 697, 714, 731, 749, 767,*
788, 804, 825, 846, 871, 890, 911, 932, 954, 977, 1001, 1043,
1063, 1086, 1105, 1125, 1147, 1167, 1184, 1201, 1218, 1234,
1251, 1268, 1283, 1298, 1312, 1328, 1350, 1366, 1382, 1398,
1412, 1428, 1446, 1464, 1486, 1508, 1530, 1549, 1569, 1589,
1603, 1618, 1635, 1651, 1671, 1694, 1714, 1732, 1751, 1767,
1786, 1801, 1813, 1830, 1846, 1859, 1877, 1899, 1916, 1931,
1946, 1963, 1981, 1998, 2019, 2035, 2049, 2069, 2085,
21082542, 2559, 2579, 2600, 2619, 2638, 2655, 2676, 2697,
2723, 2746, 2764, 2782, 2800, 2823, 2839, 2858, 2881, 2908,
2934, 2959, 2984, 3009, 3031, 3055,
Marks, Montague Laurence, b.1847
 asked to speak to Cleveland Art Association, 1895, *5217*
 claims paintings in Mendonça collection forgeries, 1892, *3952*
 criticizes D'Ascenzo's house painting course, 1893, *4314*
 Cyclopaedia of Home Arts, review, *12369*
 death falsely reported, 1890, *3393*
 founder of *Art Amateur*, *6982*
 mistake in *Art Amateur*, *22280*
Marlatt, Hector Irving, d.1929
 Bend of the river, *22879*
 illustrations, *At the well*, *22645*
 Pennsylvania views, *22589*
Marlatt, Wilson, 1838-1911
 Pennsylvania views, *22589*
Marlborough (England). Marlborough College
 art instruction and art collection, *10213*
Marlborough, George Charles Spencer Churchill, *8th duke of*,
1844-1892
 collection, *15383*
 praises French art at expense of English art, *26373*
Marlborough House, London See: **London (England).**
Marlborough House
Marlowe, Julia, 1866-1950
 actress, *7551*
 performances, Mary in *For Bonnie Prince Charlie*, 1897, *23222*
Marmontel, Antoine François
 collection, sale, 1898, *6613*
Marnock, Robert, 1809?-1889
 obituary, *25679*
Marochetti, Charles, *baron*, 1805-1867
 Coeur de Lion, shown at London Exposition, 1851, *14791*
 colored sculpture, *19328, 19357*
 monument to Coldstream Guards, *19542*
 monuments in London, *19484*
 position in England, *19458*
 Scutari monument, *19420*
 statue of Richard Coeur de Lion, *20317*
 war monument and Peace Trophy, *19431*
 Wellington monument competition, *19125, 19141, 19150*
Marold, Ludek, 1865-1898
 exhibitions, American Art Association of Paris, 1898, drawings,
 24010
Marot, Daniel, ca.1663-1752
 illustrations, tall pendulum clock, *17872*
Marot, Elizabeth Griscom, fl.1903-1904
 exhibitions, Richmond Art Association, 1903, *13714*
Marple, Charles F., fl.1902-1913
 exhibitions, Philadelphia T-Square Club, 1902, *13334*
Marquand, Allan, 1853-1924
 appointed professor of Fine Arts at Princeton College, 1884,
 10962
 examines antique Venus, 1897, *6425*

lecture at Archaeological Club of America, 1890, *25898*
raises funds for Princeton Art Museum, *633*
Marquand, Allan, Mrs. See: **Marquand, Eleanor Cross**
Marquand, Eleanor Cross, 1873-1950
 exhibitions, Woman's Art Club of New York, 1891, *15550*
Marquand, Frederick Alexander, 1799-1882
 funds establishment of art school at Princeton University, 1883,
 14913, 24587, 24959
Marquand, Henry Gurdon, 1819-1902
 addresses ceremony for cornerstone laying of Washington
 Memorial Arch, 1890, *25933*
 collection, *8124*
 acquired Van der Helst portrait, 1900, *13081*
 acquires Rembrandt, 1883, *24704*
 antique bronze sculpture acquired and exhibited by
 Metropolitan Museum of Art, 1897, *6461*
 catalogue, 1902, *8081*
 catalogue, 1903, *8102*
 donations to Metropolitan Museum of Art, *15800*
 duty charged on Gainsborough landscape, *15016*
 duty on statue of Eros, 1892, *26617*
 gift of terra cotta of Della Robbia school to Metropolitan
 Museum of Art, *1454*
 gift to Metropolitan Museum of Art, 1889, *2908*
 gift to Metropolitan Museum of Art, 1892, *15811*
 in Metropolitan Museum of Art, *17662*
 old masters, *10763*
 paintings given to Metropolitan Museum, 1891, *15521,*
 26279
 paintings lent to Metropolitan Museum, 1887, *25389*
 paintings on loan to Metropolitan Museum, summer, 1884,
 11027
 Persian bottle, *25779*
 requests tax free admission of European tapestry and
 Limoges, 1890, *25954*
 sale, 1902, *8059*
 sale, 1903, *13562*
 sale, 1903, prices and buyers listed, *8154*
 statue of Eros imported, 1890, *26411*
 tariffs paid on imported works of art, *16291*
 terracottas, *25742*
 Van Dyck acquired, 1887, *540*
 gift of $50,000 to Metropolitan Museum, 1892, *26485*
 home
 commissions Alma Tadema to design furniture for music-
 room, *10464*
 decoration of music room in mansion, *2144*
 decorations and furniture in New York and London houses,
 2579
 painted ceiling by Sir Frederic Leighton, *2245, 2486*
 influence to revise tariff laws, 1886, *2343*
 notes, 1893, *16211*
 opposes tariff on art in the *Princeton Review*, 1883, *25078*
 quote, on Sunday openings at Metropolitan Museum, *25586*
 views on art tariffs, *2746, 10987*
Marquet, Aimé Benoit, 1797-1865
 engraving after Perugino, *18670*
marquetry
 English marquetry in New York, 1888, *2683*
 notes, 1897, *6452*
 tarsia work, or wood mosaic, *7053*
Marquette Club, Chicago See: **Chicago (Illinois). Marquette**
Club
Marquis, L.
 library, sale, 1890, *15084, 15127*
MARQUIS, W. G., *13273*
Marr, Carl von, 1858-1936, *23165*
 American Art Club, Munich, 1884, *1834*
 exhibitions
 Chicago World's Fair, 1893, *4494*
 Internationale Kunstausstellung, Munich, 1883, *1835, 24774*
 Internationale Kunstausstellung, Munich, 1892, *4037*
 Metropolitan Museum of Art, 1886, *25359*
 National Academy of Design, 1881, *1129*
 Prize Fund Exhibition, 1886, *2226, 25304*

Dance at the inn (after Adrian van Ostade), *21095*
landscape (after Constable), *18463*
Strolling musicians (after Adrian van Ostade), *21095*
Marwood, Lucy See: **Kennedy, Lucy Marwood**
Mary Stuart, *queen of the Scots*, 1542-1587
monuments, monument in Antwerp church, *17582*
portraits, miniature portrait, *5120*
Skelton's *Mary Stuart*, *16274*
Mary, Virgin
Florentine votive Madonna, *10066*
Madonna collection, *16063*
Madonna in art studied by West Aurora High School, 1896-7, *12717*
Madonna in modern art, *12461*
portraits
photograph of materialized form appearing at seance in Terre Haute, *20672*
the Virgin by St. Luke, *16639*
psychometric reading by Anna Kimball, *20667*
Virgin and Child in art, *23136*
Maryland Academy of Science and Literature See: **Baltimore (Maryland). Maryland Academy of Science and Literature**
Maryland Historical Society See: **Baltimore (Maryland). Maryland Historical Society**
MARYON, M., *22944*
Marziale, Marco, fl.1492-1493
paintings' influence on decorative arts, *10299*
Masaccio, 1401-1428?
frescoes in Santa Maria Novella discovered, 1859, *19993*
Last Supper, *9740*
Mascagni, Pietro, 1863-1945
anecdote, *16694*
Mase, Carolyn Campbell, d.1948
exhibitions, American Watercolor Society, 1902, *13424*
MASEN, Julius, *19228*
Maskell, Alfred
Ivories, excerpts, *13947*
Maskell, William, 1841-1890
obituary, *25892*
masks
death masks, *6849*
criticised, 1894, *5002*
Hutton collection, *15232, 16401*
Hutton collection presented to Princeton, 1897, *17276*
of Carlyle, *16586*
method of taking casts of faces, *3184*
primitive portrait masks, *22671*
Masoch, Leopold Sacher, *Ritter* von See: **Sacher Masoch, Leopold, *Ritter* von**
Masolino da Panicale (Tommaso Fini), 1383-1440?
frescoes in Castiglione di Olona, *10181*
Mason, Abraham John, b.1794
illustrations, *Funeral procession of the late Duke of Wellington* (after T. Nicholson), *20743*
wood engravings, *106*
Mason, Elizabeth, fl.1899-1903
exhibitions, New York Society of Keramic Arts, 1899, *7189*
illustrations
bowl design for copying, *7732*
cup, *7165*
Mason, George Champlin, 1820-1894
Life and Works of Gilbert Stuart
book in preparation, 1879, *31*
review, *78*
obituary, *16482*
Mason, George Champlin, jr., 1849-1924
monuments for Greenwood Cemetery and St. Stephen's Church, *26089*
Mason, George Hemming, 1818-1872
biographical sketch, *9741, 9773, 9805*
Victorian artist, *10434*
Mason, John W.
collection, *15647*

Mason, Louis Gage, fl.1886-1889
exhibitions, Boston Paint and Clay Club, 1887, *543*
illustrations
decorative initial, *514*
Fire beacon, ancient Siena, *538*
House of the tanners, Siena, *538*
Sunny uplands - Millis, *588*
views of Oak Grove farm, Millis, Mass, *589*
Wolf of Rome in Siena, *526*
Mason, M. M., fl.1900-1903
china painting classes, 1901, *7735*
exhibitions, New York Society of Keramic Art, 1901, *7516*
illustrations, vase of roses, *7166*
MASON, Otis Tufton, *59, 77, 249, 306, 322, 370*
Mason, Otis Tufton, 1838-1908
quote, on art of American Indians, *13829*
Mason, Walter George, fl.1842-1857
illustrations, sugar refining, *21212*
Mason, William, fl.1808-1844
wood engravings, *87*
Mason, William Albert, 1855-1923
elected vice-president, Eastern Art Teachers' Association, 1905, *13914*
paper on drawing instruction in public schools, *11953*
Mason, William Sanford, 1824-1864
Parting signal, at Philadelphia Art-Union, 1849, *21404*
Maspero, Gaston Camille Charles, 1846-1916
account of Egyptian excavations, 1883, *14918*
Masqueray, Emmanuel Louis, 1861-1917
chief of design, Louisiana Purchase Exposition, 1904, *13753*
Massachusetts
description, coast, *10868*
history, court records, 1673-1675, *18200*
Massachusetts artists want Massachusetts jury for Paris Exposition, 1899, *6873*
Massachusetts State Building at World's Fair, 1893, *4432*
North Shore popular with artists, 1890's, *25992*
Massachusetts Academy of Fine Arts See: **Boston (Massachusetts). Massachusetts Academy of Fine Arts**
Massachusetts Charitable Mechanic Association See: **Boston (Massachusetts). Massachusetts Charitable Mechanic Association**
Massachusetts Historical Society See: **Boston (Massachusetts). Massachusetts Historical Society**
Massachusetts Institute of Technology See: **Boston (Massachusetts). Massachusetts Institute of Technology**
Massachusetts Normal Art School See: **Boston (Massachusetts). Massachusetts Normal Art School**
Massachusetts Society of the Colonial Dames See: **National Society of the Colonial Dames of America. Massachusetts**
Massachusetts State House See: **Boston (Massachusetts). State House**
Massaranti, Marcello, b.1813?
collection, purchased by Henry Walters, 1903, *13668*
Massarini, Tullo, 1826-1905
illustrations, *Childhood in ancient Greece*, *3547*
Masseau, Fix See: **Fix Masseau, Pierre Félix**
Massena, André, 1758-1817
portraits, statue by L. Megret, *18380*
Massenet, Jules Emile Frédéric, 1842-1912
Cid, review, *23225*
Massey, Gerald, 1828-1907
Poetical Works, review, *19684*
Massie, Julia M., 1869-1949
member of art jury, Tennessee Centennial, 1896, *11843*
Massier, Clément, ca.1845-1917
exhibitions, Newcomb College, 1899, pottery, *7179*
Massin
jewelry designs, *1195*
Massinger, Philip, 1583-1640, *609*
Masson, Antoine, 1636-1700
Portrait of Brisacier (after Mignard), *13523*
Masson, Benedict, 1819-1893
illustrations, *Spring*, *913*

Masson, Noël, 1854-1889
last etching, *25725*
MASSON, R. Douglas, *24221*
Massoulle, André Paul Arthur, 1851-1901
illustrations, *One of our ancestors*, *12669*
Massys, Quentin See: **Metsys, Quentin**
Master E. S., 15th cent.
playing cards, facsimiles issued by International
Chalcographical Society, 1891, *15645*
mastodon
bones discovered, New Jersey, 1894, *16552*
bones found, 1894, *16636*
collectors and collecting, *17350*
living mastodons in Alaska, 1896, *17173*
remains found in Cooper River, *19185*
skull found in Michigan, 1896, *17018*
tooth found, 1896, *17075*
tusks discovered, 1894, *16531*
Masure, Jules, b.1819
illustrations, *Sunset*, *13613*
Matejko, Jan, 1838-1893
exhibitions, Salon, 1880, *187*
illustrations
crayon portrait study, *2706*
Sobieski before Vienna, *13759*
Polish painter, *13597*
Mather, Cotton, 1663-1728
poems republished, 1896, *16981*
Mather, Margaret, 1862-1898
in role of Imogen, 1897, *23197*
notes, 1896, *22896*
Mathew, *Father* See: **Mathew, Theobald**
Mathew, Theobald, 1790-1856
temperance apostle arrives in New York, 1849, *21445*
Mathews, Arthur Frank, 1860-1945
design for Washington monument project, 1879, *23*
Discovery of the Bay of San Francisco by Portala, awarded
Phelan prize, 1896, *17027*
exhibitions, San Francisco Art Association, 1905, *13886*
illustrations, mural painting in vestibule of Mechanics' Library,
22198
mural decoration for Taussig residence, 1903, *22176*
mural painting in library of Mechanics Institute, San Francisco,
22189
notes, 1902, *22161*
San Francisco house decorations, *22123*
whereabouts, 1899, returns from Europe, *22072*
Mathews, Arthur Frank, *Mrs.* See: **Mathews, Lucia
Kleinhans**
Mathews, Ferdinand Schuyler, 1854-1938
illustrations
1896 poster calendar, *22372*
decorative border, *22324*
illustrations for *Cosmopolitan*, 1893, *22490*
MATHEWS, Grace Elisabeth, *12174*
Mathews, Joseph F., fl.1889-1891
exhibitions, National Academy of Design, 1889, *3101*
Mathews, Lucia Kleinhans, 1870?-1955
illustrations
Figure, *22086*
poster, *22095*
MATHEWS, Mara, *11906*
Mathews, Robert N., fl.1898
studies at Chicago Art Academy, *12671*
Mathews, Sarah See: **Benjamin, Sarah Mathews**
Mathews, Schuyler See: **Mathews, Ferdinand Schuyler**
Mathews, W. L., *Mrs.*, fl.1894-1900
exhibitions, Boston, 1894, *26998*
Mathews, William Thomas, 1821-1905
Daniel Webster, *18283*
obituary, *13910*
portrait paintings, 1855, *18771*
whereabouts, 1860, moves studio, *20237*
Mathey Doret, Emile Armand, b.1854
Country cousins (after J. L. Moran), *16803*

etchings published, 1892, *15998*
Mystic marriage of St. Catherine (after Van Dyck), *16329*
portrait of Giovanni Tornabuoni (after Ghirlandaio), *6613*
Mathey, Paul, 1844-1929
illustrations
Engraver, *4499*
Portrait of Paul Renouard (engraved by Genty), *5010*
Mathiesen, Marie Lokke, b.1877
exhibitions, Chicago Art Institute, 1903, *13561*
Mathieu, Auguste, 1810-1864
illustrations, views of tomb of Napoleon, *20974*
Mathieu Meusnier, Roland, 1824-1876
statue of Napoleon, Place Ventimille, *14681*
Mathieu, Oscar Pierre, 1845-1881
Idyll, *21673*
Mathilde Bonaparte, *princesse*, 1820-1904
collection, *17702*
Matignon, Albert, b.1869
exhibitions, National Academy of Design, 1885, *25271*
Matsuki, Bunkio
collection, sale of Japanese carvings, 1902, *7822*
Matsys, Quentin See: **Metsys, Quentin**
Matteson, Tompkins Harrison, 1813-1884
book illustrations, *14537*
Examination of a witch, in the American Art Union Gallery,
1848, *14345*, *14352*
exhibitions
Albany, 1858, *19818*
National Academy of Design, 1849, *21429*, *21430*
Justice's court in the backwoods, *14731*
notes
1849, *21381*
1856, *19315*, *19545*
1857, *19698*
Planting the church in America, *19913*
Trial scene in the back woods, *14696*
whereabouts, 1850, moves to Sherburne, *14606*
MATTHEWS, Brander, 1852-1929, *1540*, *9196*, *21468*
Matthews, Brander, 1852-1929
Bookbindings Old and New, review, *16882*
bookplate, designed by Abbey, *16349*
Matthews, Charles P.
collection, *21989*, *22005*
English 19th century painting, *15693*
sale, 1891, *26376*
Matthews, Edward
collection
estate sale, 1888, *621*
sale, 1888, *2638*
Matthews, Elizabeth St. John, 1875-1911
Martyr presidents, *7850*
Matthews, F. O.
medium, manifestations of spirits, *20705*
Matthews, Ferdinand Schuyler See: **Mathews, Ferdinand
Schuyler**
Matthews, George Bagby, 1857-1944
portrait of John Paul Jones, *623*
Matthews, James Brander See: **Matthews, Brander**
Matthews, Marmaduke M., 1837-1913
description of man and work, 1892, *26824*
sales and prices, 1892, auction in Toronto, *26806*
Matthews, William, 1822-1896
library
sale, 1897, *17236*, *17242*
to be sold, 1897, *17219*
obituary, *17027*
Matthiessen, Francis Otto, 1833-1901
collection
bequeathed to Metropolitan Museum, *13752*
sale, 1902, *7915*, *13418*
sale, 1904, *13713*
to be sold, 1902, *7877*
Mattioli, Ercole Antonio, *conte*, 1640-1703
man in the iron mask, *20972*

American Watercolor Society, 1902, *13424*
Architectural League of New York, 1888, *25564*
Boston Art Club, 1880, *72*
Boston Museum of Fine Arts, 1880, *225, 1026*
National Academy of Design, 1879, *657*
National Academy of Design, 1880, *111, 889*
National Academy of Design, 1884, *1772, 25187*
National Academy of Design, 1885, *1970, 25271*
National Academy of Design, 1890, *3228*
Pennsylvania Academy of the Fine Arts, 1880, *142*
Pennsylvania Academy of the Fine Arts, 1881, *1128*
Philadelphia Society of Artists, 1880, *1025*
Philadelphia Society of Artists, 1882, *1270*
Prize Fund Exhibition, 1887, *2456*
Salmagundi Club, 1880, *247, 804*
Salmagundi Club, 1882, *1265*
Salmagundi Club, 1887, *2364*
Society of American Artists, 1881, *1130*
Society of American Artists, 1884, *1802*
Society of American Artists, 1887, *10789*
Society of American Artists, 1888, *10846*
Society of American Artists, 1888, *Genius of civilization,*
 2678
Society of American Artists, 1897, *10538*
frieze panels for Appellate Division of Supreme Court building,
 New York, *12997*
illustrations, *Old and rare, 552*
illustrations for *Scribner's Magazine, 22482*
member, Salmagundi Club, *11166*
murals on marble using Endolithic process, *510*
officer, Society of Mural Painters, *22787*
painting, 1883, *24502, 24513*
Student, 24553
War correspondent, 1129
Maynard, Guy Ferris, 1856-1936
exhibitions
 Chicago Art Institute, 1895, *11673*
 Salon, 1889, *2985*
Maynard, Harrison E.
collection, sale, 1880, *258, 1039*
MAYNARD, William H., *12260*
Mayor, Harriet Randolph Hyatt, 1868-1960
Head of laughing child, 11386
Mayr, Christian, 1805?-1851
exhibitions, National Academy of Design, 1849, *21429, 21430*
Mazade Percin, Charles, 1820-1893
obituary, *26941*
Mazerolle, Alexis Joseph, 1826-1889
ceiling of the Comédie française, *9217*
illustrations, study, *3631*
Mazzanovich, John, fl.1884-1885
exhibitions, American Watercolor Society, 1885, *25239*
Mazzanovich, Lawrence, 1872-1959
illustrations, *Portrait of Frank Holme, 12718*
Mazzolino, Ludovico, 1480-ca.1528
decorative elements in his pictures, *10289*
Mazzonovich, John, fl.1884
illustrations, *On the Bronx River, 1722*
illustrations for magazine article, 1883, *24657*

Mc names beginning **Mc** are interfiled with **Mac**

Mead, Edward Spencer, 1847-1894
obituary, *16451*
Mead, Larkin Goldsmith, 1835-1910
composition of river god, 1887, *531*
Ethan Allen, 20195
Holyoke soldiers' monument, *8573*
Lincoln monument, *10731*
Lincoln monument, Springfield, Ill., *18, 33, 191, 380, 404*
monument to Columbus criticized, *10611*
Recording angel, 19767
sculpture, 1860, *18509*
sculptures at Chicago World's Fair, 1892, *26821*
Stanford family, 22111

statue of Ethan Allen, *8661, 18208, 19899*
 for Vermont, *24361*
statue of river god, *8281*
statue of Vermont, *19974*
statuettes, 1861, *20330*
MEAD, Leon, *23087*
MEAD, Lucia True Ames, 1856-1936, *13075*

Mead, Samuel W., 19th cent.
exhibitions, Architectural League of New York, 1887, *2380*
Meade, Edwin, Jr., d.1894?
library, sale, 1895, *16731*
Meade, George Gordon, 1815-1872
collection, *1990*
monuments, statue for Fairmount Park by Calder, *592*
Meade, William, 1789-1862
portraits, portrait by J. Neagle, *19626*
Meade, William Rutherford, 1846-1928
See also: **McKim, Meade and White, architects**
MEAKIN, Lewis Henry, *12267*
Meakin, Lewis Henry, 1850-1917
exhibitions
 Boston, 1899, *12874*
 Cincinnati, 1898, *12806, 12817*
 Cincinnati, 1900, *13141*
 Cincinnati Art Club, 1900, *13037*
 Cincinnati Art Museum, 1898, *12754*
 Cincinnati Art Museum, 1900, *13067*
 Denver Artists' Club, 1905, *13907*
 St. Louis Art Museum, 1899, *12267*
 Society of Western Artists, 1896, *11919*
 Society of Western Artists, 1898, *12679*
 Society of Western Artists, 1898, *Three brothers* and
 Moonlight, 12802
 Society of Western Artists, 1900, *12986*
 Society of Western Artists, 1902, *13388, 13542*
 Society of Western Artists, 1903, *13698*
 Society of Western Artists, 1906, *14038*
illustrations
 landscape, *13019*
 Olive trees, 13785
 Rainy weather, 12833
 Silence, 14282
lecture on *Development of art in the Middle east*, 1903, *8102*
member of art jury, Tennessee Centennial, 1896, *11843*
member of Society of Western Artists, 1898, *12083*
Moonrise on Cape Ann, purchased by Exposition Company at
 Omaha, 1898, *12824*
Measom, Wil, fl.1850's
illustrations
 Group of humming birds (after H. Weir), *20889*
 Leucoryx antelope (after H. Weir), *20924*
 Omar Pasha (after T. H. Nicholson), *21092*
Méaulle, Fortuné Louis, b.1844
illustrations
 Cedars of Mount Lebanon, 9274
 illustrations for Hugo's *Jean Valjean* (after various artists),
 22634
 Milton dictating "Paradise Lost" to his daughters (after M.
 Munkácsy), *21789*
 statue of Francis Arago (after M. J. A. Mercié), *21934*
Mechanics and Tradesmen See: **New York. General Society
of Mechanics and Tradesmen of the City of New York**
Mechanics' Institute, San Francisco See: **San Francisco.
Mechanics' Institute**
Mecina, Jozef Krzesz See: **Krzesz Mêcina, Józef**
Meckenem, Israhel van, *the elder*, d.1503
illustrations, *Beheading of John the Baptist, 26011*
prints in Claghorn collection, *9149*
Mecklenburg, Heinrich von
collection, sale, Paris, 1854, *18668*
MECRACKEN, Sara L., *20691, 20696*
medals
Amis des Medailles numismatic society established, Paris,
 1898, *17432*

celebration, 1895, *16891*
Children's album, acquired by German National Museum, 1890, *25966*
eightieth birthday, 1896, *22980*
exhibitions
 Berlin, 1895, commemorative exhibition, *5521*
 Boston Museum of Fine Arts, 1894, *27015*
 Chicago World's Fair, 1893, *4464, 4651, 22258*
 Internationale Kunstausstellung, Munich, 1883, *14916*
 Lenox Library, 1905, *13976*
 London, 1903, *8264*
Flute concert at Sans Souci, *22787*
German artist, *14234*
illustration technique, *5710*
illustrations
 decorations for sconces from Royal Porcelain Manufactory of Berlin, *17813*
 sketch, *6347*
 studies, *5712*
illustrator, *12191*
lithographs, *12952*
manual dexterity, *2035*
notes
 1890, *26016*
 1891, *26425*
 1903, *8238*
obituary, *13878*
paintings in Stewart collection, Paris, *10823*
pencil drawings, *6436*
portraits, bust by R. Begas illustrated, *4460*
Promenade des Fontaines, completed, 1890, *25806*
quote
 on art schools, *13712*
 on Klopstock, *19571*
scholarship established by Royal Academy of Fine Arts, Berlin, 1903, *8281*
wood cuts, *9628*
 Kubler's *Geschichte Friedrichs des Grossen*, *9704*
Menzler Peyton, Bertha Sophia, 1874?-1947
exhibitions
 Chicago, 1898, *12269*
 Chicago, 1899, *12876*
 Chicago Art Institute, 1900, *13137*
 Chicago Art Institute, 1902, *13536*
 Chicago Art Institute, 1903, *13561*
 Chicago Art Institute, 1903, special prize, *13673*
 Chicago Art Students' League, 1892, prize, *11308*
 Chicago Artists' Exhibition, 1899, *12310*
illustrations
 Fisherman's hut, *11307*
 study, *3630*
notes, 1896, *11913*
Menzler, Wilhelm, b.1846
illustrations, *Bianca*, *1474*
Mercantile Library Association, New York See: **New York. Mercantile Library Association**
Mercantile Library Association, San Francisco See: **San Francisco. Mercantile Library Association**
Mercator, Gerhard, 1512-1594
monuments, monument in Duisberg, *9074*
Mercedes, Maria de las See: **Maria de las Mercedes,** *consort of Alfonso XII, king of Spain*
MERCEY, Frédéric Bourgeois de, 1805-1860, *19416, 19474*
Mercié, Antonin See: **Mercié, Marius Jean Antonin**
Mercié, Marius Jean Antonin, 1845-1916
exhibitions
 Chicago Art Institute, 1896, *5701*
 Chicago World's Fair, 1893, *4463*
 Salon, 1885, *2000*
 Salon, 1886, *2206*
French sculptor, *23114*
illustrations
 David victor, *12669*
 Gloria victis, *4399*
 In spite of all, *11820*

Moses (after Michelangelo), *16639*
notes, 1890, *26064*
statue of Francis Arago, *21934*
statue of Lafayette, *25798*
statue of Meissonier, design, 1891, *26304*
statue of Robert E. Lee, *25831, 25848*
equestrian statue commissioned for Richmond, 1887, *592*
Mercier, Louise, fl.1879-1907
etchings, 1889, *3094*
illustrations, *Haydee*, *1622*
Meredith, George, 1828-1909
poems, 1851 volume, *20482*
Meredith, Owen See: **Lytton, Edward Robert Bulwer-Lytton,** *1st earl of*
Meriden (Connecticut)
art
 galleries of C. F. Munroe closed, 1883, *24586*
 Mr. Monroe's art rooms, 1883, *24749*
exhibitions, 1883, American oil paintings, *24569*
MERIGHI, Caroline A., *23072*
Mérimée, Prosper, 1803-1870
Colomba, review, *19444*
Merle, Hugues, 1823-1881
Beatrice and Benedick, in Layton Art Gallery, Milwaukee, *12813*
exhibitions
 New York, 1875, *8573*
 New York artists' reception, 1860, *20195*
 Salon, 1878, *9036*
 Seventh Regiment Fair, N.Y., 1879, *766*
Fairy tales, *8444*
Ferdinand and Miranda, *9086*
Golden locks, owned by D. Deck, 1892, *4100*
Grandmother's story, *8554*
illustrations, *Golden locks*, *4126*
Lisette de Béranger, fakes, *20333*
obituary, *335, 21896*
paintings, *19819*
paintings, 1861, *20367*
paintings in Stewart collection, *659*
paintings in Wolfe collection, *832*
sales and prices, 1879, *Once upon a time* in Spencer collection, *678*
Merley, Louis, 1815-1883
obituary, *14912*
mermaids
in art, *9305, 9334, 9363*
Mérode, Cléo de, b.1873?
reception in Berlin, 1898, *24302*
Merriam, Augustus Chapman, 1843-1895
lecture on Mycenaean art, 1892, *26495*
Merrill, Alice See: **Horne, Alice Merrill**
Merrill, Frank Thayer, b.1858
illustrates Thackeray's *The Mahogany Tree*, *493*
illustrations for *Lay of the Last Minstrel* and for *Sights Worth Seeing by Those Who Saw Them*, 1886, *509*
illustrator, *12464*
MERRILL, James McKinney, *23025*
Merrill, Selah, 1837-1909
collection, to form nucleus of archaeological museum at Hartford, 1881, *327*
lecture, 1880, *178*
MERRILL, Stuart, 1863-1915, *20457, 20482*
Merrill, Susan See: **Farnham, Susan Merrill**
MERRIMAN, Ann, *23991, 24005*
Merriman, Ralph, fl.1895
exhibitions, Chicago, 1895, posters, *11501*
Merritt, Anna Lea, 1844-1930
American woman artist, *8385*
American woman painter, *11230*
etchings, *85*
exhibitions
 Boston Art Club, 1880, *158*
 Chicago Art Institute, 1890, portraits, *25810*
 Chicago Inter-State Industrial Exposition, 1889, *3056*

excavations, at Niffer and Ur by Americans, 1890, *25823*
Mesplès, Paul Eugène, b.1849
 illustrations for Molière's plays on market, 1890, *15253*
MESSER, Edmund Clarence, *14157*
Messer, Edmund Clarence, 1842-1919
 Summer afternoon in Virginia, *22587*
 summer home and studio, *22571*
Messys, Quentin See: **Metsys, Quentin**
metal work
 See also: **architectural metal work; brass work; bronzes; ironwork**
 cabinets, *2923*
 collection of the Chicago Art Institute, 1898, *12752*
 decorative cut metal work, *1191*
 Eibar work, description, *7350*
 exhibitions
 Architectural League of New York, 1894, *4787*
 New York, 1893, women's work, *4379*
 galvano-plastic reproductions, *2464*
 history and techniques of ornamentation, *9585, 9597, 9620, 9632, 9643, 9655, 9666, 9679, 9691, 9698, 9714*
 keys, *21748, 21801*
 notes, 1900, *7474*
 offer from manufacturer to hire anyone who can raise a bowl from *Art Amateur*'s directions, 1900, *7180*
 ornamental brass work, *1759*
 ornamental iron work, *1611*
 ornamentation, *21171*
 plant forms in iron, *21762*
 repoussé
 history, *3298*
 materials and tools, *3328*
 technique, *3380, 10300*
 tools and appliances, *3345*
 silvering metal, *7907*
 Spitzer collection, *3857*
 stylo-chiselry, *12013*
 technique, *5587, 7737, 26050*
 alms basin, *4218*
 bellows mount in repoussé, *4272*
 book cover and portfolio corner, *7490*
 burnishing and spinning repoussé, *6032*
 colors produced by alloys, *2738*
 cutting, bending, transferring designs, *7219*
 decoration of alms dish or salver, *7433*
 embossing sheet lead, *7441*
 enlarging designs for metalwork, *4210*
 etching metal objects for personal adornment, *7514*
 finishing repoussé, *5938, 6043*
 flat chasing, *3442*
 frustum from a cone into an iris bowl, *7462*
 hinges, blind stamps, and rounded forms, *5197*
 hints for amateurs, *6266*
 lacquering, *7412*
 raising a bowl out of sheet metal, *7159*
 raising a vase, *7278*
 repoussé, *4213, 7355*
 repoussé, design transfer, bowl raising, *7187*
 repoussé for decorated bell, *4226*
 repoussé methods for raising a design from the back, *4336*
 soldering, *7253, 7500*
 tools, materials, and workshop, *7143*
 tracing, *7329*
 use of coloring solutions, *7386*
 Turkish pipes, *21183*
 women's work in metal exhibited at Chicago World's Fair, 1893, *4631*
 works by Loren H. Martin, *12998*
metal work, American, *26573*
 Colonial hardware, *11939*
 metal casting, *1157*
 ornamental, *13992*
metal work, ancient, *21585*
metal work, English
 designs for frame, jug, and bells, *9417*

designs for presentation casket and candelabrum, *9286*
designs for race cup and gas bracket, *9272*
exhibitions, 1892, Armourers' and Braziers' Company, *26600*
gold and silver manufacture, 1883, *9731*
Paris Exposition, 1878, *21626*
Sussex, *10360*
metal work, French
 gold and silver manufacture, 1883, *9746*
metal work, German
 Hildesheim, ecclesiastical ornament, *21914*
metal work, Gothic
 discoveries at Petrossa, Rumania, *21951*
metal work, Hindu, *8371, 8433, 8501*
metal work, Indic, *21819, 21840, 21884*
metal work, Irish
 designs for watch cases, *9322*
 interlaced metal-work, *8838, 8891*
metal work, Japanese, *8797*
 exhibitions, New York, 1894, *16432*
 Shakudo and Shibuitchi, *3593*
metal work, Russian
 orfèvrerie at Russian National exhibition, 1882, *9817*
metals
 Japanese metal mixtures Shakudo and Shibuitchi, *3593*
 physical properties affecting metal work, *26050*
Metcalf, Jesse Houghton, 1860-1942
 fund, income used for purchase of painting in exhibition of Rhode Island School of Design, *13525*
Metcalf, Julia, fl.1895
 teacher, St. Paul art school, 1895, *11444*
Metcalf, Willard Leroy, 1858-1925
 collaborative design for New York Appellate Court, 1898, *6613*
 exhibitions
 American Art Association, 1883, *24398*
 Boston Art Club, 1880, *72*
 Carnegie Institute, 1907, *14328*
 Corcoran Art Gallery, 1907, gold metal, *14282*
 New York, 1900, *13038*
 New York, 1905, *13886*
 Pennsylvania Academy of the Fine Arts, 1906, Temple gold medal, *14244*
 Prize Fund Exhibition, 1886, *25304*
 Salon, 1888, *2694*
 Society of American Artists, 1887, *25451*
 Society of American Artists, 1889, *2986*
 Society of American Artists, 1896, Webb prize for *Gloucester Harbor*, *22996*
 Ten American Painters, 1906, *14095*
 illustrations
 Family of a Pueblo tenement, *22627*
 Lily pond, *22610*
 Young hornbeam, *22645*
 Young oak, *14082*
 illustrator, *22596*
 mural for Appellate Division of Supreme Court building, New York, *12997*
 plans to donate $50,000 for Milwaukee museum, 1883, *24553*
 sketches of Brittany and of the Southwest, *22662*
 whereabouts
 1883, travels to Europe, *24755*
 1884, Paris, *25046*
meteorology
 photographic apparatus, *20840*
Methfossel, Herman, 1873-1912
 illustrations, *Portrait of Harry M. Walcott*, *4933*
Methven, Harry Wallace, b.1875
 art director, Beloit College, 1895, *11660*
 conducts summer school in Michigan, 1898, *12181*
 exhibitions
 Chicago Art Institute, 1895, *11673*
 Chicago Art Institute, 1900, *13137*
 Chicago Society of Artists, 1895, *11483*
 Cosmopolitan Club, Chicago, 1895, *11465*
 Cosmopolitan Club, Chicago, 1896, *11776*
 member of art jury, Tennessee Centennial, 1896, *11843*

Military Service Institution of the United States
 collection, arms and armor neglected, *16342*
MILL, John Stuart, 1806-1873, *20188, 20201*
Mill, John Stuart, 1806-1873
 Political Economy, excerpt, *19655*
 quote, *19746*
 on destruction of nature by man, *19759*
Millais, John Everett, 1829-1896, *21669, 22961*
 anecdote, *5967, 7639, 17176*
 as sign painter, *17011*
 Autumn leaves, anecdote, *23130*
 Bride of Lammermoor, *9037, 21648*
 Bubbles
 artist's proofs, *25908*
 Millais's grandson is model, *3964*
 Christ in the house of his parents, *9764*
 collection, sale, 1897, *17379*
 commission to paint pictures of children, 1884, *25033*
 completes painting of Nell Gwynne begun by Landseer, *17053*
 criticism, *24563*
 criticized as not up to the American standard, 1896, *17093*
 Ducklings, *16726*
 Effie Deans, on exhibit, London, 1877, *8864*
 elected president of Royal Academy, 1896, *16968*
 English Pre-Raphaelite, *17793*
 exhibitions
 Century Club, 1893, *26894*
 Chicago World's Fair, 1893, *4604, 4763*
 Fine Art Society, 1881, *21893*
 Grosvenor Gallery, 1878, *21584*
 Grosvenor Gallery, 1879, *21667*
 Grosvenor Gallery, 1880, *9356, 21885, 21961*
 Grosvenor Gallery, 1887, *25442*
 London, 1886, *10269*
 London, 1890, *25937, 25994, 26059*
 National Academy of Design, 1894, *5174*
 Paris, 1855, *19211*
 Paris Exposition, 1855, *18800, 19119*
 Paris Exposition, 1878, *9024, 21610*
 Royal Academy, 1855, *18800, 18852*
 Royal Academy, 1856, *19420*
 Royal Academy, 1859, *20045*
 Royal Academy, 1860, *20257*
 Royal Academy, 1875, *8458*
 Royal Academy, 1877, *8859*
 Royal Academy, 1877, prepares, *8829*
 Royal Academy, 1878, *9023, 21581*
 Royal Academy, 1879, *9177, 21704*
 Royal Academy, 1880, *9370, 21841*
 Royal Academy, 1881, *21997, 21999*
 Royal Academy, 1882, *9642, 9664*
 Royal Academy, 1883, *1603, 9827, 14892, 24675*
 Royal Academy, 1884, *10021*
 Royal Academy, 1885, *2019, 10172*
 Royal Academy, 1887, *2480, 25455*
 Royal Academy, 1889, *2984*
 Royal Academy, 1890, *25924*
 Royal Academy, 1891, *26347*
 Royal Scottish Academy, 1881, *21987*
 eyesight, *25951*
 Ferdinand and Ariel, *26015*
 Forerunner, given to Kelvingrove Gallery, 1903, *13613*
 health
 failing, 1896, *17042*
 ill, 1896, *23030*
 home, house and studio, 1881, *21994*
 Huguenot, as Christian art, *19963*
 Huguenot lover, *19176, 23280*
 illustrations
 Christ in the house of his parents, *13484*
 Ducklings, *5399*
 Huguenot, *11901*
 Listening to the cuckoo, *8123*
 study, *4414*
 Watching and waiting, *8530*

interview with M. H. Spielman on black and white art, *4282*
invited to Chicago World's Fair, 1892, *26761*
Isabella, *9645*
Lingering autumn, bought by Australian collector, 1891, *26334*
models, *26064*
Moorish chief, *9243*
Northwest passage, *21675*
notes
 1895, *16705*
 1896, *17137*
 1899, *17525*
officer of Belgian Order of Leopold, 1895, *16745*
Order of Release, engraving by S. Cousins on exhibit, 1856, *19443*
paintings, *1109, 19789*
paintings in collection of David Price, Esq., *8816*
paintings in Matthews collection, *21989, 22005*
paintings in Seney collection, *2458*
paintings in studio, 1878, *21575, 21654*
panels for house in Leeds, *11924*
Parables of our Lord and Saviour Jesus Christ, review, *23304*
personality, *16589*
Pomona, *1494*
portrait of Cardinal Newman, sitting, 1890, *26027*
portrait of Lord Beaconsfield, exhibited, 1881, *21895*
portrait of Lord James of Hereford, *17151*
portrait of Marquis of Lorne, given to Canadian National Gallery, 1884, *25074*
portrait of Mrs. Joseph Chamberlain, *26080, 26304*
portrait of Ruskin, admired by Eastlake, *18670*
portrait of the Poet Laureate, 1881, *21896*
portrait painting, *21638*
portraits, photograph, *22558*
portraits of Mrs. Chamberlain and Miss Lawson, *25867*
pre-Raphaelite, *21180*
Pre-Raphaelitism, *19528*
president of Royal Academy, 1896, *5737*
presides at Academy banquet, 1895, *22765*
Princes in the tower, *9911*
Proscribed royalist, *20973*
quote, on art and photography, 1893, *4660*
relationship with Thackeray, *16981*
Rescue, *18960*
Return of the dove to the ark, *20055*
sales and prices
 1890, *3376*
 1896, *5967*
 1901, *13271*
Spring, *20067, 20143*
 satirized, *18384*
studio and personality compared with Leighton, *17148*
Two fair maidens, *21583*
Vale of rest, *26016*
Victorian artist, *10434*
work, 1857, *19642*
work, 1883, *9937*
works in National Art Collection, London, 1897, *6397*
Youth (drawing), *9570*
Millar, Addison Thomas, 1860-1913
 exhibitions, National Academy of Design, 1903, *13547*
 illustrations, *Cabbage patch*, *22528*
 portraits, photograph, *22603*
 summer home and studio, *22571*
 summer studio, 1893, *22491*
MILLAR, Alexander Hastie, 1847-1927, *9458*
MILLER, Allen, *23027*
MILLER, Antoinnette Ward, *13570*
MILLER, Bianca Adams, *23217*
Miller, C. C., fl.1897-1898
 illustrations
 bonbonnières for copying on china, *6547*
 plate design for copying, *6336*
Miller, Carrie
 biographical sketch, *20687*
 bouquet from Mrs. F. E. Rogers, *20727*

National Academy of Design, 1884, *1790*
National Academy of Design, 1886, *2188*
National Academy of Design, 1891, *15561*
National Academy of Design, 1893, *4316*
National Academy of Design, 1894, *4706*
National Academy of Design, 1896, *22996*
New York, 1893, *16122*
New York, 1896, *17154*
New York, 1897, *6217, 10519, 17233, 17276*
New York, 1897, landscapes, *23240*
New York, 1899, *17551*
Prize Fund Exhibition, 1885, *1985, 25278*
Prize Fund Exhibition, 1886, *25304*
Royal Academy, 1880, *9354*
Society of American Artists, 1887, *2452, 10789*
Society of American Artists, 1889, *2986*
illustrations, *Evening, 10791, 13348*
landscape studies, 1883, *24553*
landscapes, 1882, *24400*
landscapes in England, 1883, *24541*
letter on Theodore Robinson, 1899, *17514*
Looking seaward, 22495
notes, 1898, *17389*
paintings in Hilton collection, *793*
paintings in Stewart collection, *10768*
pictures in Evans collection, *11775, 15079*
quote, on importance of W. Evans sale, *13016*
sales and prices
 1892-1900, *13736*
 1899, landscapes, *17571*
 1900, pictures in Evans collection, *13008*
studio, *22686*
 New York, 1901, *13218*
whereabouts
 1879, summer travels, *703*
 1883, Adirondacks, *24697*
 1896, summer in Waterford, *23056*
Minott, Joseph Otis, d.1909
 exhibitions, Copley Society, 1902, *13442*
Minotta, Agnes Sorma, *countess* See: **Sorma, Agnes**
Minton, Sophie E.
 collection, sale, 1902, *8059*
Minton ware See: **porcelain and pottery, English**
Mintrop, Theodor, 1814-1870
 children's bacchanals at Dusseldorf Gallery, 1850, *14657*
Minturn, Anna Mary Wendell, d.1886?
 collection, bequest to Metropolitan Museum of Art, 1890, *15125*
Minturn, Robert Bowne, 1805-1866
 collection, purchases drawing by Overbeck, 1850, *14668*
Minturn, Robert Bowne, *Mrs.* See: **Minturn, Anna Mary Wendell**
Miola, Camilla, 1840-1919
 exhibitions, Esposizione Internazionale di Belle Arti, Rome, 1883, *9795*
Miranda, Fernando, b.1842
 Columbus monument, *4012*
 fountain monument to Columbus and the Pinzons, *26696*
 sculptural group of Columbus and the Pinzons, *26879*
mirrors
 black mirror for artists' studios, *7385*
 Etrusco-Hellenic carved mirror, *759*
 frames, *21827*
 history, *7724*
misericords
 art under the seats, *8379, 8394, 8432*
missals
 Sistine Missal offered, 1896, *16968*
missions
 California, *12418*
 adobe, *12380*
 Lemuel Wiles, mission painter, *16383*
 movement to preserve missions, 1896, *16912*
 paintings by Edwin Deakin, *13801*
 Spanish Missions of Alta California published, 1893, *16344*

Missouri Historical Society See: **Saint Louis (Missouri). Missouri Historical Society**
Missouri River
 description of steamboat trip, *18059*
Missouri. University See: **Columbia (Missouri). University of Missouri**
Misti Mifliez, Ferdinand, fl.1898-1907
 exhibitions, London, 1898, *24114*
Mitchel and Halbach, architects
 Auditorium Annex cafe, *20526*
 decoration of Lexington Hotel, Chicago, *20530*
 Kuppenheimer residence, Chicago, *20492*
MITCHELL, Anne, *19290, 19299*
Mitchell, Arthur, b.1864
 illustrations, *Autumn, 13958*
Mitchell, Beulah See: **Clute, Beulah Mitchell**
Mitchell, Charles LeMoyne, 1844-1890
 collection, etchings, *24821*
Mitchell, Charles William, fl.1876-1893
 exhibitions, Grosvenor Gallery, 1885, *2035*
MITCHELL, Donald Grant, *22680, 22699*
Mitchell, Edith See: **Prellwitz, Edith Mitchill**
MITCHELL, Edward P., *23488*
MITCHELL, Elmer C., *13883*
Mitchell, Guernsey, 1854-1921
 exhibitions, Salon, 1893, *4426*
 statue of Dr. Anderson, *26779*
 successful sculptor, *631*
Mitchell, Helen Elizabeth See: **Gruppe, Helen Elizabeth Mitchell**
Mitchell, Henry, ca.1854-1914
 designer of bas-relief for Pilgrim Hall, Plymouth, Mass., *215*
 member of jury of coin competition, 1891, *26356*
Mitchell, Henry R.
 library, sale, 1891, *15673*
Mitchell, Ida, fl.1894-1895
 illustrations, *Old friends, 22537*
 Shady corner, 22704
Mitchell, Irving, fl.1901
 illustrations, design for *The Integral, 13236*
Mitchell, James Tyndale, 1834-1915
 collection, sale of engraved portraits of Washington, 1906, *14091*
Mitchell, Jessie, fl.1895-1896
 illustrations
 Chomin, initials, *22334*
 end piece, *22398*
Mitchell, John Ames, 1845-1918
 etchings, *363*
 exhibitions
 Paris Exposition, 1878, *9072*
 Philadelphia Society of Artists, 1880, *1025*
Mitchell, John Lendrum, 1842-1904
 collection, *15797*
Mitchell, Lucy Myers Wright, 1845-1888
 History of Ancient Sculpture, review, *10027, 11663*
 History of Sculpture, publication, 1883, *24884*
Mitchell, Maria, 1818-1889
 earth's orbit, *18150*
Mitchell, Neil Reid, 1858-1934
 exhibitions, National Academy of Design, 1884, *1879*
MITCHELL, Violet Etynge, *22859, 22963, 23014, 23135*
Mitchill, Bleecker N., fl.1882-1893
 exhibitions, American Watercolor Society, 1884, *25012*
Mitchill, Edith See: **Prellwitz, Edith Mitchill**
MITOTO, *24146*
Mitra, Rajendralala, *raja*, 1824-1891
 obituary, *26436*
Mitrecey, Maurice, 1869-1894
 Samson brought to Gaza, Prix de Rome winner, 1893, *22294*
MITSCHKA, *17503, 17526*
Mitterwurzer, Friedrich, 1844-1897
 obituary, *10527*
Mittineague Paper Company
 exhibitions, Louisiana Purchase Exposition, St. Louis, 1904,

Molière, Jean Baptiste Poquelin, 1622-1673
 plays illustrated by Mesplès, *15253*
 works illustrated by Leloir, *15344*
Molijn, Pieter de, 1595-1661
 Travellers before an inn, 91
Moline (Illinois)
 gallery, 1895, *11588*
Molitor, John, 1872-1928
 wins Stewardson Architectural Scholarship, 1902, *7873*
Moller, Margareta See: **Klopstock, Margareta Moller**
MOLLETT, John William, *9532, 21938, 21998, 22015*
Mollett, John William
 books on Barbizon painters, 1890, *3386*
Molt, William
 illustrations, *Symbolic conceit*, *13405*
Moluccas
 antiquities, prehistoric village found, 1896, *17116*
Momberger, William, 1829-1895
 obituary, *16726*
MONA, L., *11701*
MONACHESI, Hannah Davis, *4861, 5797, 6326*
Monachesi, Hannah Davis, fl.1897-1907
 American china painter, *6030*
 lectures at American Association of Allied Arts on Japanese
 ceramic art, 1899, *17554*
 Manual for China Painters, review, *12069*
Monachesi, Nicola di Rienzi, *Mrs.* See: **Monachesi, Hannah Davis**
Monaco
 landscape, *21048*
Monaco, Lorenzo See: **Lorenzo Monaco**
MONAGHAN, James Charles, *12111*
Monahan, F. W., fl.1897
 illustrations, cover illustration for *Home and Country*, 1897, *23162*
monasteries *See also:* abbeys; Athos
Monchablon, Ferdinand Jean, 1855-1904
 biographical note, *16510*
 illustrations
 anatomical drawings, *5230*
 Landscape, *13303*
 landscape on view, New York, 1892, *16006*
 letter to *Collector*, 1890, *15103*
 master of realism, *15015*
 painting in Connor collection, *15035*
 Prairie, *15162*
 Saône à Lorincourt, Vosges, exhibited in Chicago, 1902, *13353*
Monchablon, Jan See: **Monchablon, Ferdinand Jean**
Monet, Blanche Hoschedé See: **Hoschedé Monet, Blanche**
Monet, Claude, 1840-1926, *15515, 17513, 25663*
 American followers, 1896, *5780*
 as Impressionist, *11846*
 biographical information, *16442*
 comments by W. T. Evans, *17573*
 criticism, *15783, 15790*
 criticism by Muther, *22436*
 decorations for apartment of Georges Durand-Ruel, *7372*
 dissolution of form, *12751*
 Duret's comments, *25294*
 exhibitions
 American Art Galleries, 1886, *2189, 25290*
 American Art Galleries, 1893, *4427, 16243*
 Boston, 1892, *15869*
 Boston, 1905, *13860*
 Buffalo, 1896, *11806*
 Carnegie Galleries, 1902, *13520*
 Chicago World's Fair, 1893, *4839*
 London, 1892, *26482*
 New York, 1891, *26438*
 New York, 1892, *3895*
 New York, 1893, *4356*
 New York, 1894, *16451*
 New York, 1895, *5218, 16650*
 New York, 1896, Rouen cathedral series, *5782*
 New York, 1899, *6903, 12861*

 New York, 1905, *13843*
 Paris, 1889, *3032*
 Paris, 1895, *16767, 22765*
 Paris, 1901, *13174*
 Paris Exposition Universelle, 1889, *2987*
 Petit Gallery, 1887, *2482*
 Pittsburgh, 1899, *12976*
 St. Botolph Club, 1892, *26604*
 St. Botolph Club, 1899, *12855*
 Union League Club of New York, 1891, *3530*
 illustrations
 Church at Varangeville, *4146*
 On the Seine, *4146*
 Windmills, *6259*
 Impressionism, *13535*
 Impressionist vision, *14060*
 influence on English artists, *4914*
 influence on Theodore Butler, *13021*
 influence on Theodore Robinson, *12935, 12936*
 interview by A. Seaton Schmidt at Giverny, *22443*
 landscape in Mallarmé's collection, *8315*
 late development in style, *20622*
 notes, 1894, *4799*
 Olympia, *25812*
 paintings at Chicago Art Institute, 1895, *11497*
 paintings of Waterloo bridge, *13309*
 Pollard willows, shown in New York, 1887, *574*
 portraits, portrait shown in New York, 1896, *23008*
 praise, *25496*
 Rouen Cathedral series, criticism by C. Frémine., *22346*
 sales and prices
 1897, *20625*
 1901, *7611*
 technique
 snow scene technique, *7554*
 working methods, *22403*
money
 See also: coins; paper currency
 United States, Confederate States, *16115*
Mongin, Augustin, 1843-1911
 illustrations
 Pansies (after Albert Moore), *9496*
 Sculptor and his model (after Hirschman), *1623*
Monginot, Charles, 1825-1900
 First prize, *4599*
 illustrations, *Little marquis*, *5630*
Mongols *See also:* Kalmucks
monkeys, *20884*
 anecdote, *16705*
 notes, 1896, *16964*
Monkhouse, Cosmo See: **Monkhouse, William Cosmo**
MONKHOUSE, William Cosmo, *9477, 9509, 9667, 9677, 9788, 9807, 9916, 9924, 9955, 9997*
Monkhouse, William Cosmo, 1840-1901
 In the National Gallery, recommended to art students, 1899, *17632*
 study of Henry Dawson, *15180*
monks in art, *9923*
 pictures by Grützner, *22585*
Monks, John Austin Sands, 1850-1917, *17768*
 exhibitions
 American Watercolor Society, 1883, *Sheep going home*, *1510*
 American Watercolor Society, 1884, *25023*
 American Watercolor Society, 1885, *1933*
 Boston, 1899, *12903*
 Boston Art Club, 1887, *534*
 Boston Art Club, 1907, *14252*
 National Academy of Design, 1884, *1790*
 National Academy of Design, 1884, *Cloudy day*, *10982*
 New York Etching Club, 1884, *25013*
 New York Etching Club, 1885, *1934*
 illustrations
 Cloudy day, *1772*
 Crossing Hill Pasture, *1736*
 Morning call (etching), *22549*

Rocky nest (etching), *17807*
views of Oak Grove farm, Millis, Mass, *589*
member, Salmagundi Club, *11166*
notes, 1895, *16862*
whereabouts, 1892, summer and fall at Jackson, N.H, *26839*
Monks, Robert Hatton, 1856-1923
collection, bronzes by Frémiet and Barye lent to Museum, 1894, *27025*
exhibitions
American Art Association, 1884, *Old willows at Potigny*, *25191*
Pennsylvania Academy of the Fine Arts, 1883, *1677*
Salon, 1883, *24521*
whereabouts
1883, France, *24413*
1884, working at Potigny, *10893*
Monnoyer, Jean Baptiste, 1636-1699
biography and works, *21017*
monograms
embroidery on table linen, *6751*
for china painting, *7241*
history and how to make a monogram, *8953*
lettering styles, *3113*
name devices and monograms illustrated, *3443*
notes
1881, *1228*
1890, *3344*
monotypes
compared with etchings, *1486*
description, *25440*
difference between monotypes and Herkomer's spongotypes, *6147*
Horsfall's monotypes, *6738*
notes
1898, *6590*
1900, *7396*
popularity among Paris students, 1898, *24047*
technique, *1268, 6092, 12624, 13560, 17429, 17495, 23073*
process developed by C. A. Walker, *9572*
Monroe, Alice See: **Pape, Alice Monroe**
Monroe Doctrine
notes, 1895, *22872*
MONROE, H. H., 3056, 3364
MONROE, Harriet, 3230, 12493, 12532
Monroe, James, *pres. U.S.*, 1758-1831
inauguration, *23193*
monuments
monument proposed for Fredericksburg, 1896, *23008*
proposal, 1859, *19974*
MONROE, Lucy, 12698
Monrovia (Liberia)
president's house, *20927*
monsters
grotesque in art, *10110*
Mont Blanc
mountaineering, *20918*
Mont Saint Michel (France)
history and tour, *2003*
threatened by causeway, 1885, *10210*
Montagni, Pierre Antoine See: **Montagny, Pierre Antoine**
Montagny, Pierre Antoine, fl.1790-1816
illustrations, medallions of Louis XVI and Marie Antoinette, *3021*
Montagu Douglas Scott, Walter Francis, *duke* **Buccleuch** See: **Buccleuch, Walter Francis Montagu-Douglas-Scott**, *5th duke*
Montagu, Hyman, d.1895
collection
coins and medals, *16857*
sale, 1896, *17065*
sale of coins, 1896, *17090*
sale of Greek coins, 1896, *17050*
Montague, fl.1883
whereabouts, 1882, Washington, *24387*
Montague, Martin, fl.1894
hasty paintings, *27007*

MONTAIGU, Annie, *countess*, *22661, 22689*
Montalant, Julius O., fl.1851-1861
notes, 1858, *19850*
whereabouts
1857, *19752*
1859, Rome, *20045*
Montalba, Clara, 1842-1929
Browning's palace at Venice, to be shown at Chicago World's Fair, 1893, *26917*
exhibitions
Dudley Gallery, 1878, *21663*
French Gallery, 1879, *21767*
French Gallery, 1880, *9275*
Grosvenor Gallery, 1880, *21798*
London, 1875, *8488*
Royal Academy, 1878, *21581*
Royal Academy, 1879, *21708*
Royal Academy, 1880, *21841*
Royal Academy, 1881, *22013*
Royal Society of Painters in Water Colours, 1878, *21595*
illustrations, *Venice*, *5491*
Venice views, *9786*
Montalba, Ellen, fl.1868-1902
exhibitions, London, 1879-80, *9275*
Regatta, to be shown at Chicago World's Fair, 1893, *26917*
Montalba, Henrietta Skerret, 1856-1893
exhibitions, Chicago World's Fair, 1893, *4437*
illustrations, *Tito Milema*, *3035*
sculpture, 1886, *10357*
Montalba, Hilda, d.1919
exhibitions, Royal Academy, 1880, *21841*
portrait study to be shown at Chicago World's Fair, 1893, *26917*
Montauk Club, Brooklyn See: **New York. Montauk Club, Brooklyn**
Montbard, Georges, 1841-1905
illustrations
In the forest, *5185*
In the woods in winter, *4824*
Solitude, *5543*
Montclair (New Jersey)
architecture
Harry Fenn house, *6040*
Inness house, *5091*
artists' colony, 1894, *16505*
Monte Cassino (Benedictine abbey)
excavation, restoration and decoration, *388, 411*
Monte Oliveto See: **Monteoliveto Maggiore (Benedictine abbey)**
MONTEFIORE, Edward Levy, *9818*
MONTEFIORE, Leonard A., *21598, 21633, 21722, 21785*
Montefiore, Leonard A., 1853-1879
obituary, *21786*
Montégut, Emile, 1826-1895
article on Hawthorne and sculpture, 1860, *20273*
Montenard, Frédéric, 1849-1926
illustrations, *Enterrement de jeune fille en Provence*, *13605*
Montenegro
war with Turkey, *21092*
Monteoliveto Maggiore (Benedictine abbey)
frescoes by Sodoma, *9956, 9973*
Monterey (California)
artists colony, *22142*
Montes, Lola See: **Montez, Lola**
Monteverde, F. E., fl.1901-1906
illustrations, *March* (photograph), *13285, 14107*
Monteverde, Florencio
collection, minerals, *16164*
Monteverde, Giulio, 1837-1917
Dr. Jenner inoculating his son, *21628*
exhibitions, Paris Exposition, 1878, *9096*
sculpture, *13611*
studio in Rome, 1877, *8788*
Montevideo (Uruguay)
capitol, prizes offered for design, 1904, *13735*

Montez, Lola, 1818-1861, *17365*
 portraits, portrait by Jacquand of her and her husband, *14681*
Montezuma See: **Marks, Montague Laurence**
Montford, Horace, fl.1880-1911
 exhibitions, Chicago World's Fair, 1893, *4437*
MONTFORT, M. Helen E., *5842*
Montfort, M. Helen E., fl.1896
 American china painter, *5844*
 exhibitions
 National League of Mineral Painters, 1896, *6080*
 New York Society of Keramic Arts, 1896, *5648*
 Helpful Hints for Ceramic Artists, excerpt, *5921*
Montgolfier, Jacques Etienne, 1745-1799
 early balloon ascensions, *21112*
MONTGOMERY, C. S., *22556*
Montgomery, Edmund, *Mrs.* See: **Ney, Elizabet**
Montgomery, Elizabet Ney See: **Ney, Elizabet**
Montgomery family
 Eglinton peerage, *20395*
 pedigrees, *20394, 20414*
Montgomery, Robert, 1807-1855
 portraits
 caricature by D. Maclise, *22736*
 medallion by A. Bruce-Joy, *22765*
Montgomery, Robert, 1839-1893
 exhibitions, Ghent Salon, 1883, *14870*
MONTGOMERY, Thomas Harrison, *20425*
MONTGOMERY, Whittier, *14115*
months
 homily on September, *18040*
months in art
 medieval, *8798, 8865*
Monti, Raffaello, 1818-1881
 lectures
 on Early Christian art, 1855, *18933*
 on Greek and Roman sculpture, 1855, *18900*
 on Italian Renaissance, 1855, *18964*
 Veiled lady, given to Metropolitan Museum, 1887, *25472*
Monticelli, Adolphe Joseph Thomas, 1824-1886
 date of birth, *16884*
 early paintings, *2676*
 exhibitions
 Edinburgh International Exhibition, 1886, *25519*
 London, 1892, *26482*
 New York, 1888, *2724*
 New York, 1899, *6926*
 Pedestal Fund Loan Exhibition, 1883-4, *24968*
 forgeries, *16023*
 Fountain of youth, acquired by Carnegie Institute, 1903, *13604*
 illustrations, *Summer day's idyl*, *13982*
 notes
 1887, *2723*
 1895, *16860*
 painting in Walker collection, Minneapolis, *12924*
 paintings in Learmont collection, 1894, *5003*
 sales and prices, 1902, paintings sold to John Pratt, *13545*
Monticello (Virginia)
 description, *19693*
Montigneul, Emile, fl.1840-1850
 illustrations
 Joseph Vernet, *20796*
 Karavellas and other Turkish vessels (after C. et B.), *21010*
Montigny, Jules Léon, 1847-1899
 exhibitions, Ghent Salon, 1883, *14870*
MONTMARTEL, P. W., *14182*
Montmorency (France). Saint Martin (church)
 stained glass, *22383*
Montreal (Quebec)
 architecture, Château de Ramhay, converted into museum, 1893, *16342*
 art
 collections, 1894, *4974*
 picture collections, 1894, *5003*
 art dealers, 1895, *5298*
 exhibitions, 1887, *10453*

 monuments, statue of Maisonneuve by Hébert, *17475*
 National Fine Arts Institute closes school, 1883, *24569*
Montreal (Quebec). Art Association of Montreal
 annual exhibitions, 1896, loan exhibition, *5611*
 annual report, 1893, *16519*
 bequest from W. J. Tempest, *15877*
 building, enlarged, 1893, *16428*
 collection, criticized, 1885, *11171*
 exhibitions
 1887, *2406*
 1892, *15824*
 1894, *4712, 16556*
 1895, *16882*
 1905, *13866*
Montreal (Quebec). McGill University
 notes, 1890, *25856*
Montreal (Quebec). Montreal Museum of Fine Arts See: **Montreal (Quebec). Art Association of Montreal**
Montreal (Quebec). Musée des beaux arts See: **Montreal (Quebec). Art Association of Montreal**
Montreal (Quebec). Royal Canadian Academy of Arts
 annual exhibitions, 1907, *14336*
 exhibitions, 1890, *25865, 25898*
 gambling, 1896, *16964*
Montreal (Quebec). Scott, W., and Sons, paintings
 letter defending quality of paintings sent to Lotos Club exhibition, 1895, *5217*
Montrose, Caroline Beresford, *duchess* of, 1836-1894
 collection, sale, 1894, *16600*
 exhibitions, Newport, 1890, *26033*
Montrose, James Graham, *1st marquis* of, 1612-1650
 relics, *17262*
Montrose (Scotland)
 monuments, Joseph Hume, *18315*
Montross, N. E., Gallery See: **New York. Montross Gallery**
Montross, Newman Emerson, 1849-1932
 collection
 sale, 1887, *2406, 10782, 25418, 25429*
 sale, American paintings, 1887, *557*
 dealer in American artists, *10545*
monuments
 England
 commemorative statues commissioned, 1851, *14742*
 criticism, 1879, *21745*
 criticism, 1880, *21784*
 notes, 1880, *21888*
 notes, 1881, *21892*
 Europe
 1860, *20282*
 notes, 1881, *314*
 Germany
 colossal statue of Germania unveiled, 1883, *14922*
 competition for a Liebig memorial, *9079*
 Hermann monument, *8423*
 Greece, Niobe of Mount Sipylos, *288*
 international monuments needed, *20063*
 Italy
 free admission for artists, teachers and students, 1902, *13487*
 notes, 1881, *21893*
 memorial sculpture, *12782*
 monumental sculpture, *11401*
 notes
 1878, *21653, 21654, 21655*
 1880, *150, 165, 179, 192, 219, 240*
 1881, *360*
 Portugal, Diego Cano's pillar removed to Kiel, 1895, *16662*
 public monuments to great men, *19915*
 sculpture as municipal embellishment, *17989*
 sculpture is preferred medium, *17547*
 Spain, monuments commemorating the discovery of America, *26126*
 United States
 aesthetics, *10739*
 appeal for monuments to women patriots, 1891, *26375*
 Civil War monuments, *12106*

committee on monument art formed by Central Art
Association, 1898, *12091*
competition design for battle monument for Shiloh,
Tennessee National Military Park to be presented by the
state of Illinois, *12944*
Congressional aid for Revolutionary War monuments, 1880,
261
epidemic of monuments in West, 1890's, *26386*
inventory completed, 1907, *14271*
monument to Revolution planned for Rhode Island, 1891,
26382
notes, 1879, *18, 33*
notes, 1880, *46, 63, 82, 102, 117, 133, 149, 164, 178, 191,
237*
notes, 1881, *427*
sculpture by J. Bracken and St. Gaudens, *12105*
sculptures by C. Dallin, *12949*
sculptures by D. C. French, *12983*
Monvel, Louis Maurice Boutet de See: **Boutet de Monvel,
Louis Maurice**
Monza (Italy). Duomo
collection of relics, *16710*
Moody, Francis Wollaston Thomas, 1824-1886
lecture on even distribution in design, 1895, *5466*
moon
technique for painting moonlight for beginners, *7997*
technique for painting moonlight scenes, *7699*
telescopic description, *19117*
Mooney, Edward Ludlow, 1813-1887
exhibitions
National Academy of Design, 1849, *21429*
National Academy of Design, 1858, *19857*
Mooney. Ella F., fl.1883
whereabouts, 1883, working from nature at Red Hook, N.Y,
24728
Moor, Carel de, 1656-1738
illustrations, *Burgomaster of Leyden and his wife, 5830*
MOORE, Aimee Osborne, *6500, 6623*
Moore, Albert Joseph, 1841-1893, *9495*
Dreamers, presented to Corporation Art Gallery, 1883, *9919*
exhibitions
Architectural League of New York, 1888, *2873*
Chicago World's Fair, 1893, *4653*
Glasgow Institute, 1879, *21736*
Grosvenor Gallery, 1878, *21594*
London, 1881, *21894*
Royal Academy, 1878, *21602*
Royal Academy, 1879, *21708*
Royal Academy, 1882, *1366*
illustrations
Musicians, 7822
Pearls, 4599
Portrait, 5692
Sea gulls, 5114
Shells, 5114
mural on canvas in Victoria and Albert Museum, *13504*
notes
1881, *9516*
1893, *16379*
obituary, *4599, 5121*
paintings, *1109*
Pansies, 9496
study of a head, *10047*
Moore, Augustus M.
attacked by J. M. Whistler, 1890, *3359*
Moore, Bloomfield H.
collection, sale, 1900, *7315*
Moore, Bloomfield, *Mrs.* See: **Bloomfield Moore, Clara
Sophia Jessup**
Moore, Charles Herbert, 1840-1930
exhibitions
American Art Galleries, 1882, watercolor, *9624*
American Watercolor Society, 1885, *25239*
Artists' Fund Society, 1865, *23366*
National Academy of Design, 1859, *20030*

National Academy of Design, 1860, *20208*
lectures to Boston Arts Students' Association, 1893, *26886*
response to critics, *23341*
series of plates completed, 1881, *442*
sketches, *23318*
MOORE, Charles M., *24665*
Moore, Charles M., fl.1883
whereabouts, 1883, returns to America from Munich, *24905*
MOORE, Clement Clarke, *18361*
Moore, Edward Charles, 1827-1891
collection, *15715*
bequest to Metropolitan Museum of Art, *3924, 15783, 15885,
26448*
Japanese baskets, *26057*
on exhibit at Metropolitan Museum, 1894, *16612*
received by Metropolitan Museum, 1892, *26517*
Tanagra figurines, *15727*
collector, *3561*
exhibitions, Paris Exposition, 1889, *3033*
notes, 1892, *15882*
obituary, *15709*
MOORE, Edward Howard, *13584, 13649*
Moore, Edwin Augustus, 1859-1926
exhibitions, National Academy of Design, 1885, *25271*
notes, 1883, *24883*
whereabouts, 1883, near Hartford, Conn, *24656*
Moore, Esther See: **Moore, Ethel M.**
Moore, Ethel M., fl.1890-1893
exhibitions, Chicago World's Fair, 1893, *4437*
Moore, Frances See: **Brooke, Frances Moore**
Moore, George, 1852-1933
calls for cuts in public funding to art schools in England, 1893,
4560
Confessions of a Young Man
excerpt, *25560*
excerpts, *25571*
review, with excerpt, *25543*
unauthorized American edition, 1888, *25553*
Evelyn Innes
desription of characters, *24154*
review, *24176*
feud with Whistler, 1895, *16746*
Impressions and Opinions, Julian's studio, *26335*
letter to Whistler regarding the Eden commission, *16713*
Meissonier and the Salon Julian, excerpt, *6372*
Modern Painting
excerpt on Puvis de Chavannes, *22273*
excerpt on Whistler, *22275*
review, *22302*
quote, on art collecting, 1899, *17617*
Moore, George A., fl. 1890's
See also: **Little, Brown and Moore, architects**
MOORE, George Belton, *22470*
Moore, George Belton, 1805-1870
obituary, *8607*
Moore, George Henry, 1823-1892
bibliophile, *15945*
library
sale, 1893, *16227*
sale, 1894, *16487*
obituary, *15897*
Moore, Guernsey, 1874-1925
illustrations in Christmas magazines, 1899, *7182*
Moore, Hannah Hudson, 1857-1927
Old China Book, review, *13644*
Moore, Harry Humphrey, 1844-1926
exhibitions
Ladies' Art Association of New York, 1880, *9445*
Lotos Club, 1880, *804*
Union League Club of New York, 1887, *10833*
illustrations
Japanese musicians, 7341
Temptation of Martin Luther, 22199
Japanese scene on view in New York, 1891, *15748*
pictures of Japanese life, *1963*

collection
fund to purchase for Boston, *26382*
Japanese pottery, *2655, 15847, 25476, 25782*
Japanese pottery acquired by Boston Museum of Fine Arts, 1892, *26557, 26617*
Japanese pottery in the Museum of Fine Arts, Boston, *25828*
Japanese pottery sale to Boston woman denied, 1888, *2823*
sale of Japanese pottery, 1888, *2782*
disagreement with James L. Bowes, 1890, *26210*
Japanese Homes and Their Surroundings
excerpts, *2872*
review, *10352*
lectures
at Essex Institute, 1880, *257*
for Beacon Society, 1890, *25848*
on building of Museum of Fine Arts, 1892, *26526*
on Japanese art at Detroit Museum of Fine Art, 1890, *25782*
letter corrected by *errata*, 1891, *26239*
Memoirs of the Science Department, University of Tokyo, review, *322*
on Japanese pottery, *17763*
plea for public museums, *16329*
MORSE, Frances Clary, *16899*
Morse, Frances Clary, d.1912?
collection, old china, *16304*
Morse, Joseph W., fl.1840-1860
wood engravings, *137*
Morse, Samuel Finley Breese, 1791-1872, *11544*
artists' reception, New York, 1858, *19784*
development of the telegraph, *19369*
House of Representatives, *19698*
illustrator, *22598*
lead secession of National Academy of Design, *7044*
letter on color photography, 1851, *23427*
picture for steamboat *Albany*, *19654, 19665*
president, National Academy of Design, 1861, *20376*
reward for invention of telegraph, 1858, *19860*
submarine telegraph, *19899*
Morse, Sidney H., fl.1877-1894
bust of Emerson, *25866*
bust of Walt Whitman, *583*
busts of Channing and Jefferson, *8860*
whereabouts, 1894, Detroit, *27025*
MORSE, T. Vernette, *11316, 11399, 11518, 11599, 11624, 11645, 11698, 11844, 11931, 12150, 12197, 12199, 12284, 12307, 12334, 12385, 12465, 12609*
Morse, T. Vernette, b.1852
lectures, 1894, *11344*
Morse, W. H., fl.1851-1881
illustrations
Bridge (after F. B. Schell), *9302*
illustrations for *Picturesque Europe* (after H. Fenn), *8770*
Morstatt, H., fl.1893
paintings of South African flora shown at Chicago World's Fair, 1893, *16112*
Morston Ream's Art Rooms, New York See: **New York. Morston Ream's Art Rooms**
Mortimer, Charles, fl.1893
newspaper illustration, *22504*
Morton, C. A., fl.1889-1890
illustrations
blackberry border, *3222*
plate borders, *3331*
tulip tree blossom, *3202*
yellow oxalis sprays, *3195*
MORTON, Frederick William, *13096, 13137, 13166, 13201, 13234, 13272, 13299, 13356, 13393, 13423, 13477, 13520, 13541, 13622, 13694, 13710, 14069*
Morton, Laura B., fl.1883
decorative painting, 1883, *24817*
vase decoration, *1581*
vase painted in Bennet underglaze, *24586*
Morton, Thomas, 1764-1838
character of Mrs. Grundy, *16935*

Morton, Thomas Corsan, 1869-1928
illustrations, *Evening*, *11873*
mortuary customs
collectors and collecting, O'Sullivan collection of mortuary curiosities, *16661*
Morvan (France)
forest, *21250*
Morviller, Joseph, fl.1855-1870
artists' reception, New York, 1858, *19784*
notes, 1871, *23607*
Sunlight in winter, reproduced by Prang in chromo, *23529, 23560, 23568, 23604*
mosaics, *20593*
advantages of mosaic over painting in cities, *25170*
ancient mosaic-work found in California, 1895, *16710*
exhibitions, Chicago World's Fair, 1893, *4827*
history, *11811*
and method of glass mosaic, *6655*
and technique, *20142, 20176, 21847*
in interior decoration, *3218*
in decoration, *20530*
in interior decoration, *6972*
map of Palestine found, *17263*
mosaic discovered at Treves, 1895, *16894*
mosaic-powder work, *10428*
notes, 1901, *7563*
technique, *6237, 10350, 18466*
mosaics, American
technique, *11865*
mosaics, English
in Chester cathedral, *8751*
mosaic decoration of St. Paul's Cathedral, 1896, *5936*
mosaics, Indic
decorative stone inlay, *21921*
mosaics, Italian
St. Marks, Venice, *19560*
Venice and Murano Company Venetian palace mosaics, *17016*
mosaics, Roman
history, *942*
mosaic depicting Virgil, *17205*
mosaic found in Tunisia, 1896, *17191*
notes, 1890, *3218*
Roman mosaic found in Patras, Greece, 1896, *17173*
technique, Roman mosaic working, *20594*
Moscheles, Felix Stone, 1833-1917
exhibitions, London, 1892, *26722*
flatters American artists, 1884, *25025*
notes, 1884, *1859*
Pictures with a Purpose series, *6614*
portrait of Grover Cleveland, *26879*
portrait of Robert Browning on exhibit in Chicago, 1892, *26547*
sales and prices, 1885, New York, *1931*
Moschowitz, Paul, 1876-1942
elected to Society of American Artists, 1901, *13240*
exhibitions
Society of Washington Artists, 1905, *13886*
Worcester Art Museum, 1902, *13483*
illustrations, illustrations for *The Choquard Farm*, *22913, 22942, 22967, 22990, 23018*
Moscow (Russia)
architecture, *21320*
art, 1858, *19925*
description, Easter week, *23216*
exhibitions
1891, French Exhibition, *26310*
1891, French Exhibition planned, *26193*
1898, *17432*
1905, Soyouz society, *13943*
Imperial throne, *21228*
libraries
lost library of Ivan the Terrible, *16562*
Rumanzieff Museum Library destroyed by fire, 1896, *17116*
Moscow (Russia). Tret'iakovskaia Galleria
bequest to city of gallery, with funds, 1892, *26801*

1895, *27025*
1896, returns to Cincinnati, *23008*
1896, summer class at East Hampton, *23056*
Mosman, Melzar Hunt, 1845-1926
commissioned to cast bronze doors of Capitol (from models by W. Rinehart after designs by T. Crawford), 1903, *13618*
Moss, Charles Eugene, 1860-1901
exhibitions
Boston Mechanic Association, 1881, *Prodigal son*, *1236*
National Academy of Design, 1884, prepares, *25061*
Salon, 1882, *1381*
whereabouts, 1883, Paris, *24413*, *24457*
Moss Engraving Company, New York
illustrations
Comédie humaine (after J. L. Hamon), *436*
cover for *The Art Journal*, 1882, *9574*, *9589*, *9602*, *9613*, *9625*, *9636*, *9647*, *9659*, *9671*, *9681*, *9694*, *9707*
cover for *The Art Journal*, 1883, *9722*, *9737*, *9753*, *9768*, *9782*, *9798*, *9814*, *9830*, *9861*, *9894*
Escamoteur (after J. L. Hamon), *436*
objects from the Green Vaults, Dresden, *461*
Moss, Frank, b.1838
Christ among the doctors, *1253*
exhibitions
American Art Galleries, 1884, *24988*
Boston Mechanic Society, 1881, *Christ among the doctors*, *1236*
Chicago Exposition, 1883, *24748*
National Academy of Design, 1881, *1129*
Pennsylvania Academy of the Fine Arts, 1881, *1128*
Philadelphia Society of Artists, 1880, *246*
Prize Fund Exhibition, 1886, *25304*
Prize Fund Exhibition, 1887, *562*, *2456*
Salmagundi Club, 1892, *26493*, *26506*
Salon, 1883, *24521*
religious works, *2024*
sales and prices, 1884, *25007*
mosses
collection of sea ferns and mosses, *15790*
Europe, description, *20838*, *21025*
Mosses, W. J., fl.1876-1879
illustrations
Among the old masters (after E. Nicol), *21713*
Belgian chimneypiece, *21939*
interior of Leighton house, London, *21960*
interior of Millais house (after W. Hatherell), *21994*
scenes in Salamanca, Spain (after J. Haynes-Williams), *21911*
view of Trentham Hall, *21932*
Mossman, John, 1817-1890
obituary, *26145*
Mostaert, Jan, ca.1475-1555
Ecce Homo - Mater Dolorosa, acquired by Metropolitan Museum, 1905, *13951*
Mostyn, John, 17th century
Spaine & Portugall, description of 1683 book, *535*
Mote, Marcus, 1817-1898
Indiana's Quaker artist, *11591*
Mote, W. H., fl.1842-64
illustrations, *Mlle. Rosa Bonheur* (after R. Buckner), *18195*
Motherwell, William, 1797-1835
poetry, *18107*
moths, *21236*
hunting, *944*
Lunar May moth, *16911*
motion pictures
anecdote, *24018*
Lumière's Cinematographe, *23092*
Motley, Eleanor Warren, 1847-1942
exhibitions, Boston Water Color Club, 1888, *2841*
Motley, John Lothrop, 1814-1877
portraits, etching by Zilcken, *15844*, *15847*
Motley, Thomas, Mrs. See: **Motley, Eleanor Warren**
motor ability
importance of ambidexterity, *8020*

Mott, Charles T., fl.1889-1898
exhibitions, Architectural League, 1891, hall design, *3512*
illustrations, design for drawing-room mantel, *2849*
Mott, J. L., Iron Works
objects at Philadelphia Exhibition, 1876, *8677*
Mott, Jordan Lawrence, 1829-1915
collection, sale, 1888, *2638*
Mott Smith, Harold M., fl.1896-1906
exhibitions, American Art Association of Paris, 1896, *23709*
illustrations
illustrations to story *Vernissage*, *23683*
Paris-bound, *23770*
whereabouts, 1898, leaves Paris for America, *24114*
MOTT SMITH, May Bird, 1879-1952, *23910*
Mott, W. F., fl.1886-1889
exhibitions, Prize Fund Exhibition, 1886, *25304*
Motte, Henri Paul, 1846-1922
Circe changing Ulysses' companions into swine, *9122*
Richelieu at the siege of Rochelle, *9710*
Mottl, Felix, 1856-1911
conductor of Colonne orchestra, Paris, *23750*
Mottram, Charles, 1807-1876
illustrations, *Three dogs* (after Landseer), *8720*
Mouilleron, Adolphe, 1820-1881
obituary, *335*
Mould, Jacob Wrey, 1825-1886
Church of All Souls, *19766*
decorative painting in home of J. A. C. Gray, *19976*
designs for Plymouth Church, Brooklyn, *20126*
home of Albert Bierstadt, *8596*
obituary, *25325*
plans for Metropolitan Museum, *11216*
Moulin, Charles Lucien, fl.1895-1914
wins Grand Prix de Rome, 1896, *23646*
Moulton, Alston M., Mrs. See: **Moulton, Sue Buckingham**
Moulton, Sue Buckingham, b.1873
exhibitions, Washington Ceramic Club, 1899, *12370*
mounds *See also:* **earthworks**
Mount Athos See: **Athos (monasteries)**
Mount Auburn cemetery, *19928*
monument, *19942*
statuary commissioned, 1855, *18596*
Mount McGregor Art Association See: **Saratoga Springs (New York). Mount McGregor Art Association**
Mount, Shepard Alonzo, 1804-1868
Rose of Sharon, *14680*
Mount Vernon
description and history, *19894*
notes, 1903, *8262*
poem by J. Searson, *19961*
purchase by public, *19899*
Mount Vernon (Illinois)
Art League meeting, 1898, *12152*
Mount Vernon (Iowa). Cornell College
description, 1871, *10706*
Mount Vernon (New York)
monuments
soldiers and sailors monument dedicated, 1891, *26356*
Soldiers' Monument Association, 1890, *25959*
Mount, William Sidney, 1807-1868
Axe to grind, in Clarke collection exhibition, 1883-4, *24955*
Bargaining for a horse, engraved for American Art Union, 1851, *14720*, *14732*, *14823*
criticism in French revue, 1851, *14834*
exhibitions
National Academy of Design, 1849, *21429*
National Academy of Design, 1849, *Turning of the leaf*, *14497*
National Academy of Design, 1850, *14615*
National Academy of Design, 1851, *14735*, *14748*
National Academy of Design, 1855, *18705*
National Academy of Design, 1858, *19857*
National Academy of Design, 1859, *20030*, *20048*
Girl returning from orchard, *20330*
Mischievous drop, *19733*

Music is contagious!!, *21458*
notes, 1849, *21381*
paintings, *19819*
paintings in American Art Union Gallery, 1848, *14445*
Power of Music, purchased by Century Club, 1880, *214*
Right and left, *14680*
Turning the leaf, purchased by J. Lennow, 1849, *21405*
mountain sheep
Rocky Mountain sheep painted by Bierstadt, *10981*
mountaineering
South America, *20894*
Switzerland, Mont Blanc, *20918*
mountains in art
mountains as art, *17568*
scarcity of mountains in landscape painting, *17401*
MOURET, Etienne, *13426*
mouth
drawing technique, *12907*, *12919*, *12930*
Mouzon (France)
description of town and environs, *21190*
Mouzon (France). Notre Dame (church), *21190*
Mowatt, Anna Cora Ogden See: **Ritchie, Anna Cora Ogden Mowatt**
Mowbray, Henry Siddons, 1858-1928
Clarke prize, 1888, *25507*
collection, Bastien Lepage's *Study for an angel*, *25744*
exhibitions
National Academy of Design, 1883, *9936*
National Academy of Design, 1886, *508*, *2352*, *10754*, *25370*
National Academy of Design, 1887, *2431*, *10786*
National Academy of Design, 1888, *10846*
National Academy of Design, 1889, *2936*
National Academy of Design, 1891, *3603*
National Academy of Design, 1898, *17443*
New York, 1887, *10763*
New York, 1893, *Evening breeze*, from Clarke collection, *16171*
New York, 1897, *17241*
New York, 1900, *7230*, *13021*
Salon, 1883, *24521*
Society of American Artists, 1898, *12710*
Union League Club of New York, 1887, *10833*
Union League Club of New York, 1890, *26155*
Union League Club of New York, 1893, *4380*
illustrations, untitled sketch, *22486*
illustrations for magazines, 1893, *22482*
interview on future of women artists, 1890, *3389*
member of art jury, Tennessee Centennial, 1896, *11843*
member, Society of Mural Painters, *22787*
mural for Appellate Division of Supreme Court building, New York, *12997*
collaborative design, 1898, *6613*
notes, 1887, *546*
picture in Evans collection, *15079*
sales and prices, 1900, picture in Evans collection, *13008*
Scheherezade, shown at Union League Club, 1889, *25565*
students
F. E. Kepp's work, *21524*
M. Nichols' work, *21513*
teacher at Art Students' League, *12474*
whereabouts, 1883, visits America, *24551*
Moyland, Nicolaas Adriaan, *baron* Steengracht van See: **Steengracht van Moyland, Nicolaas Adriaan, *baron***
Moynihan, Frederick, 1843-1910
bust of Robert E. Lee for Southern Society, *23008*
Moyse, Edouard, b.1827
illustrations, *Rabbis*, *1622*
Moza, Ruth
letter praising Prang's chromos, 1868, *23556*
Mozart, Wolfgang Amadeus, 1756-1791, *21349*
aria found, 1895, *16809*
Festspielhaus in Salzburg, *25799*
Mozier, Joseph, 1812-1870
Esther, *20272*
exhibitions, National Academy of Design, 1849, *21429*

letter from Rome, 1851, *14753*
letter on American artists in Florence, 1850, *14606*
marble bust for American Art Union, 1850, *14663*
Prodigal son, *17991*
sales and prices, 1857, *19626*
Silence, *17962*
bought by Mr. Josephson, 1861, *20330*
statue, *19930*
statues in Roman studio, *19887*
Truth and *Silence* presented to Mercantile Library Association, 1855, *19088*
whereabouts
1858, Rome, *19814*
1859, Rome, *20045*
work in Italy, 1858, *18154*
works, 1857, *19609*
works in progess, Rome, 1851, *14763*
M'pongo See: **Fan (African people)**
Mucha, Alphonse Marie, 1860-1939
illustrations, poster, *13825*, *13849*
issue of *La Plume* dedicated to his work, 1897, *12644*
posters, *12430*, *12612*, *20488*, *24134*
design, *13319*
Salon des Cent, 1896, *12515*
Sarah Bernhardt, *12867*
teaching
course at New York School of Applied Design for Women, 1905-6, *13994*
establishes Atelier Mucha, 1898, *24114*
Mücke, Heinrich Karl Anton, 1806-1891
St. Catherine carried to Mt. Sinai by angels, *26330*
MUCKERJI, G., *13948*
Muckley, William J.
collection, Japanese and Chinese enamels presented to Manchester, 1886, *10352*
Mueden, Mathilde See: **Leisenring, Mathilde Mueden**
Mueller, Charles See: **Müller, Charles**
Mueller Ury See: **Müller Ury, Adolf Felix**
Muenier, Jules Alexis, 1863-1942
Abbreuvoir, *4234*
illustrations
Basking in the sun, *7400*
colored etching, *13570*
etching, *13305*
muffs
history, *22926*
in art, *17729*
mugs
Salmagundi mug sale, *13879*
Mühlbacher, Gustave
collection, sale, 1899, *7016*, *17643*
Mühlig, Hugo, 1854-1929
German farm scenes, *22614*
Muhr, Philip, 1860-1916
exhibitions, Prize Fund Exhibition, 1886, *25304*
Muhrman, Henry, 1854-1916
biography, *221*
exhibitions
American Watercolor Society, 1879, *9123*
American Watercolor Society, 1880, *74*, *9292*
American Watercolor Society, 1882, *1300*
American Watercolor Society, 1883, *1510*
American Watercolor Society, 1885, *1933*
London, 1890, *25937*, *26151*
National Academy of Design, 1881, *1061*
Milking time in a Bavarian stable, in Clarke collectionn exhibition, 1883-4, *24955*
notes, 1898, *17429*
whereabouts, 1883, Cincinnati, *24553*
Muijden, Evert van See: **Muyden, Evert van**
Muirhead, James Patrick, 1813-1898
library, sale, 1899, *17672*
muleteers
Spain, *21213*

cost of frescoing and painting walls, 1893, *4581*
decoration, *1609*
distemper painting, *2123*
embossed wall decoration, *1292*
Endolithic process, *510*
flatness should be retained, *20574*
frescoes
 fresco painting, *20556*
 two systems, *1476*
historical reconstruction, *17887*
home use, *1422, 23348*
Jacob H. Lazarus scholarship
 1899, *17538*
 competition, 1902, *13503*
mosaic-powder work, *10428*
mural decoration in the home, *20599*
mural hanging material patented by J. H. Beale, *502*
New York court decision deeming wall paintings an inseparable
 part of the real estate, 1894, *16556*
notes, 1894, *4805*
printed wall decorations, *2550*
revival of interest, *2756*
stencilling and gilding, *861*
technique, *646, 1558, 1579, 13076*
 and aesthatic concerns, *13509*
 Fowler's Waldorf ceiling, *6386*
 fresco, *3555, 6737*
 fresco painting, from *Painting Popularly Explained*, *20316,*
 20327
 painting in wax, *4894*
 wax suggested over oil, *3780*
wall stencilling, *8148*
mural painting and decoration, American
 Boston Public Library, 1899, *12903*
 decorated lecture room at Pennsylvania Academy of the Fine
 Arts, 1897, *11964*
 decorations in Library of Congress, Boston Public Library,
 Boston State House, Baltimore Court House and Minnesota
 state capitol, *13953*
 development since Chicago World's Fair, 1893, *14087*
 growth of mural painting in America, 1890's, *5075*
 John La Farge urges American mural painters for American
 buildings, *14175*
 murals for Appellate Court building, New York, *12997*
 murals for Waldorf-Astoria Hotel by Will Low, *13519*
 notes, 1894, *4798*
 work of H. J. and W. B. Allen, Boston, *493*
mural painting and decoration, Chinese
 painted scrolls for wall decoration, *16070*
mural painting and decoration, English
 frescoes for Houses of Parliament, 1850, *14617*
 panels and stained glass, 1881, *22001*
mural painting and decoration, German
 Berlin, *9770*
 frescoes at Beuron Abbey, *10150*
mural painting and decoration, Italian
 destruction of mural paintings in Italy, 1857, *19714*
 fifteenth-century fresco painted over one of thirteenth century,
 16814
 frescoes discovered in Florence, ca.1881, *21896*
 frescoes found in Umbria, 1897, *17377*
 Monte Cassino, restoration and decoration, *388, 411*
 sixteenth century illusionistic ceiling decoration, *2044*
mural painting and decoration, Norman
 fresco discovered at Patcham Church, *9280*
mural painting and decoration, Pompeiian, *20572*
mural painting and decoration, Roman, *141*
 Bosco Reale frescoes, *8279*
 sales and prices, 1903, Roman Empire wall painting, *8252*
Murat, *prince*
 collection, sale, 1902, *13437*
Muraton, Alphone, *Mme* See: **Muraton, Euphémie Duhanot**
Muraton, Euphémie Duhanot, b.1840?
 illustrations
 Perlette, *4536*

Two friends, *2751*
Murdoch, Clara Racylia, d.1881
 exhibitions, Boston Mechanic Association, 1881, *1236*
Murdoch, John Gormley, 1861-1917
 collection, sale, 1903, *8199*
Murger, Henri, 1822-1861
 Vie de Bohème, revival in Paris, 1897, *23915*
Murillo, Bartolomé Esteban, 1617-1682, *12396*
 Adoration of the shepherds, shown at Schaus', 1890, *25917,*
 25956
 Apotheosis of the Virgin, *8470*
 in Chapman collection, 1896, *17068*
 awarded medal by Santa Barbara District Agricultural
 Association, 1894, *5002*
 catalogue of works of works by C. B. Curtis, *9884*
 Conception, *19798*
 in Aspinwall collection, *19785*
 Coronation of the Virgin, authorship questioned, *1703*
 Death of St. Clara, *16586*
 depictions of children, *9644*
 exhibitions
 New York, 1895, *Andalusian flower girl*, *16726*
 New York, 1895, D'Aulby collection, *5336*
 San Francisco, 1895, *16891*
 Flagellation (attributed), involved in litigation, *852*
 illustrations
 Divine shepherd, *5777*
 ImmaculateConception, *5969, 12717, 13570, 14231*
 St. John the Baptist, *5072*
 Spanish flower girl, *5376*
 Immaculate Conception, in Santo Domingo, *10715*
 Jesus and John, *5563*
 Madonna, reproduced by Prang in chromo, 1871, *23606*
 Madonnas, *23136*
 Magdalen
 copy sold as original in Mendonça sale, 1899, *17637*
 posed by Teresa Vaughan and Estelle Clayton, *22522*
 Mother and Child, copy by Rogers, *17992*
 notes, 1871, *23607*
 painting found, 1895, *16786*
 paintings in Dulwich College Gallery, London, *21975*
 portrait of a gentleman, attribution, *21499*
 St. Thomas de Villanueva distributing alms, *14533*
 sales and prices
 1858, Paris, *19852*
 1891, *15764*
 1899, attributed painting in Mendonça sale, *17632*
 San Diego Alcalá, shown in N. Y., 1881, *376*
 Self portrait, *11*
 Spanish flower girl, *5369, 8789*
 works, *20983*
Murphey, Virginia A., fl.1891-1898
 exhibitions, Palette Club of Chicago, 1892, *11307*
 illustrations, *June*, *11417*
 summer school, Winnetka, 1895, *11637*
Murphy, Ada Clifford, fl.1891-1905
 exhibitions
 New York, 1905, *13889*
 Philadelphia Water Color Club, 1901, *13215*
 Woman's Art Club of New York, 1891, *15550*
 illustrations, *Pleasant occupation*, *4346*
 marries J. Francis Murphy, 1883, *24762*
Murphy, Alice Martha, 1871-1909
 exhibitions, Kansas City Art Club, 1902, *13337*
Murphy, Anna Brownell See: **Jameson, Anna Brownell**
 Murphy
Murphy, Francis See: **Murphy, John Francis**
Murphy, Hermann Dudley, 1867-1945, *12957*
 exhibitions
 Boston, 1898, *12805, 12823*
 Chicago Art Institute, 1895, *11673*
 Chicago Art Institute, 1897, *6463*
 Chicago Art Institute, 1899, *12902*
 Chicago Art Institute, 1907, *14333*
 Copley Society, 1905, *13924*

Royal Academy, 1886, *10337*
Royal Academy, 1887, *10473*
illustrations, *Avon na Ghilean*, *9478*
In the Constable country, *8242*
Murray, Draper, Fairman & Co.
bank notes, *18644*
Murray, Elizabeth Heaphy, 1815-1882
Italian studio, *1298*
notes, 1871, *23607*
paintings reproduced in chromo by Prang, 1870, *23595*
sales and prices, 1883, *1486*
Murray, Richard, fl.1896-1897
illustrations
advertisement for Mutual-Reserve Fund Life Association,
*23610, 23629, 23649, 23667, 23690, 23712, 23731, 23754,
23775, 23797, 23816, 23837, 23858, 24098, 24118*
advertisement for Spaulding & Co, *23894, 23919, 23947*
advertisement for The Cheviot House, *23797, 23816*
whereabouts, 1896, plans to travel in Spain, *23626*
Murray, Samuel, 1870-1941
exhibitions, Pennsylvania Academy of the Fine Arts, 1904,
13716
illustrations, portrait bust, *13074, 13556*
Murtland, Morrow See: **Scully, Morrow Murtland**
Musatov, Borisov See: **Borisov Musatov, Viktor El
Pidiforovich**
Musée Carnavalet See: **Paris (France). Musée Carnavalet**
Musée ceramique, Sèvres See: **Sèvres (France). Manufacture
nationale de porcelaine. Musée céramique**
Musée des arts décoratifs, Paris See: **Paris (France). Musée
des arts décoratifs**
Musée du costume, Paris See: **Paris (France). Musée du cos-
tume**
Musée du Luxembourg See: **Paris (France). Musée national
du Luxembourg**
Musée Galliéra See: **Paris (France). Musée Galliéra**
Musée Gustave Moreau See: **Paris (France). Musée Gustave
Moreau**
Musée Victor Hugo See: **Paris (France). Musée Victor Hugo**
Musée Wiertz See: **Brussels (Belgium). Musée Wiertz**
Musées royaux des beaux-arts de Belgique See: **Brussels
(Belgium). Musées royaux des beaux-arts de Belgique**
Museo civico, Turin See: **Turin (Italy). Museo civico**
Museo nacional de bellas artes, Santiago See: **Santiago
(Chile). Museo nacional de bellas artes**
Museo Ostiense, Rome See: **Ostia (Italy). Museo Ostiense**
Museum Boijmans See: **Rotterdam (Netherlands). Museum
Boijmans**
Museum Council of France See: **France. Conseil des musées
nationaux**
Museum for the Arts of Decoration See: **New York. Cooper
Union for the Advancement of Science and Art. Museum for
the Arts of Decoration**
Museum für Kunst und Gewerbe, Hamburg See: **Hamburg
(Germany). Museum für Kunst und Gewerbe**
Museum of Comparative Zoology, Harvard University See:
**Cambridge (Massachusetts). Harvard University. Museum of
Comparative Zoölogy**
Museum of Fine Arts, Syracuse See: **Syracuse (New York).
Museum of Fine Arts**
museum techniques
background colors for statuary and division of space with cur-
tains, 1893, *4233*
Fine Arts Society exhibition of American paintings hung in
groups by artist, 1894, *4906*
labels on works of art, *676*
lighting techniques in galleries, *5939*
management of picture exhibitions, *3897*
picture hanging, *3743, 10801*
less crowded style and wall color important, *17676*
policy at Royal Academy, 1879, *21700*
structure and lighting, *2572*
museums
acquisition funds for American and European museums, 1899,
17535

alleged old masters in national collections listed, 1896, *6054*
electric light use in galleries, *9693*
England
gallery of British art proposed, 1883, *9780*
government support, *9450*
history of art institutions, *7613*
national gallery of British art urged, 1883, *9858*
Sunday openings, *11091*
entrance fees, *14214*
Europe, review of Thompson's *Handbook to the Public Picture
Galleries of Europe*, *145*
France
acquisitions, 1899, *17671*
departmental museums, *383*
plan to open museums to working men fails, *14028*
receive funds from Exposition Universelle, 1883, *14913*
function and formation, *9352, 9387*
fund raising idea, *13515*
Germany, museum of comparative sculpture planned for Berlin,
1902, *13516*
ideal picture gallery emphasizes aesthetics over history, *14219*
Italy
Florence, reorganization, *8655*
free admission to artists, teachers and students, 1902, *13487*
logistics and plans for ideal art gallery, *17421*
museum architecture criticised as extravagant, 1898, *17421*
museum of copies recommended by Dupuy, *14775*
notes, 1881, *314*
practical benefits, *13968*
provincial art galleries, *2397*
Studio's advice on starting public art collection, *25241*
Sunday openings discussed at Social Science Congress at
Hudderfield, England, 1884, *1700*
survey taken by Metropolitan Museum of Art on museum copy-
ing policies, 1906, *14217*
typological museums, *26471*
United States
1871, *10586*
attendance in New York, Boston, Philadelphia, and Detroit,
1904, *13739*
collections, 1899, *17617*
collections of classical sculptures, 1904, *13739*
collections of plaster casts after the antique, 1880, *954*
criticism of purchases, 1906, *14100*
gifts and donations, 1900, *13213*
history, *15469*
national art gallery recommended, 1903, *13650*
national art gallery urged by Thomas Moran, *13598*
national gallery recommended, 1884, *25015*
need for clearing house, *13923*
need for more support, *565*
new museums in Midwest, 1886, *25337*
opening hours controversy, 1893, *11306*
plea for greater expenditure on art from director, Syracuse
Museum, 1902, *13461*
recipients of prize-winning works from American Art
Association Prize Exhibition, 1885, *25142*
South, *10993*
Sunday openings controversy, 1887, *582, 10763*
Sunday openings controversy, 1891, *26375*
Musgrave, Sylvester, fl.1883-1893
exhibitions
Salmagundi Club, 1893, *22483*
Society of Independents, 1894, *22540*
On the Normandy coast, finishes, 1883, *24959*
pastels, 1884, *25032*
Waiting, *17705*
whereabouts, 1883, New York, *24630*
Musgrave, T. B.
collection, sale, 1891, *15581*
music
See also: **choirs; church music; opera; songs**
aesthetics, *648, 21475*
criticism, *18616*
effects, *19604, 20997*

German composers, *18701*
Germany, *23778*
hints to amateur composers, *988*
history, and musical instruments at International Inventions
 Exhibition, 1885, *10153*
in the home, *10685*
Irish ballads, *16480*
Kinder-symphonie by J. Strauss, *669*
lessons in harmony, *1031*
notes
 1880, *817, 839, 862, 884, 988, 1013, 1031*
 1881, *1052, 1075, 1097, 1118*
prehistoric, Thomas Wilson's paper, 1897, *17262*
publications from Witmark and Sons, 1897, *23183, 23205*
subject for painting, *14664*
United States
 1895, *11592*
 1896, *11766*
 appreciation questioned, *787*
 Chicago, 1870-71, *10627*
 Chicago, 1871, *10589, 10658, 10683*
 Chicago, 1895, *11527, 11550, 11572, 11639, 11662, 11689, 11713*
 Chicago, 1896, *11739, 11870, 11913*
 Chicago, 1897, *12043*
 Chicago, 1897, program for art congress, *11967*
 Chicago, 1898, *12179*
 in the home, *10557*
 New York, 1879, *744, 762, 781*
 New York, 1884, *1900*
 New York, 1885, *2036*
 New York music festival, 1881, *1118*
 New York Music Festival, 1881, *1161*
music and architecture, *20566*
 proportion, *20575*
music and art, *14664*
 comparison of trends, *14296*
 introduction, *138*
 musicians in art, *22613*
 painting and music, *14642, 20362*
 paintings which can be interpreted by music, *5531*
 sisterhood of painting and music, *23636*
music and color
 DuMond's use of green, *10550*
music clubs and societies, *648*
music criticism, *648*
 Sarcey and American critics, *10548*
music libraries
 American collections, *17101*
 Emerick music library, acquired by Philadelphia Library
 Company, 1896, *17027*
music publishing
 sales and prices, 1896, musical copyrights, *16996*
 sheet music, collectors and collecting, *15269*
musical instruments
 collectors and collecting, *15944, 17101*
 Donaldson Museum collection, *16612*
 Steinert collection, *15808*
 exhibitions
 Inventions Exhibition, London, 1885, *10196, 10206, 10222*
 Pedestal Fund Loan Exhibition, 1883-4, *1705*
 sales and prices, 1893, *16273*
 Windsor Castle collection, *17050*
musical instruments, Oriental, *2013*
 collectors and collecting, Coale collection, *15699*
musicals
 New York, 1896, *23124*
musicians
 compensation, *651*
MUSICK, John Roy, *23116*
Muslimism See: Islam
Muslims in the Philippines
 art of the Moro, *13481*
Muss Arnolt, Gustav, 1858-1927
 illustrations, *Tired out*, *24630*

Musset, Alfred de, 1810-1857
 governess' reminiscences published, 1897, *23915*
 Mouche, etchings by Lalauze, *15882*
Mussini, Luigi, 1813-1888
 studio in Florence, *8569*
MUTHER, Richard, *22439*
Muther, Richard, 1860-1909
 History of Modern Painting, review, *11901, 22436*
 Meister Holzschnitte aus Vier Jahrhunderten, review, *25554*
Mutual Art Association See: New York. Mutual Art
 Association
Muybridge, Eadweard, 1830-1904
 Animal Locomotion, *10754*
 Animals in Motion, influence on Meissonier, *10782*
 lecture on animal locomotion at Century Club, 1892, *26557*
 lecture on photographs of animals in motion, New York, 1883,
 1485
 lectures on animal locomotion in Berlin, 1891, *26303*
 locomotion photography, *9763*
 photographs of animals in motion, *2643, 9729*
 studied by Meissonier, *17763*
 theories on animal motion, *10888*
Muyden, Alfred van, 1818-1898
 Refectory of the Capucins at Albano, *18999*
Muyden, Evert van, 1853-1922
 biographical and critical sketch published by F. Keppel, 1893,
 16171
 bronze group, *16329*
 etcher, *15759*
 etchings, *11317*
 at Knoedler's, New York, 1891, *15754*
 of animals, *6219*
 exhibitions, New York, 1893, *4359, 22483, 26900, 26906*
 illustrations, *Lioness and cubs* (etching), *13259*
MUYDEN, Gustav van, *17827*
Muzaffar al-Din, *shah of Persia*, 1853-1907
 confers title of Khan on Dikran Kelekian, 1900, *7427*
Muzzey, Alice B., fl.1892
 exhibitions, Palette Club of Chicago, 1892, *11307*
Muzzioli, Giovanni, 1854-1894
 obituary, *16639*
Mycenae
 antiquities, *192*
 excavations, 1896, *16950*
 excavations by Dr. Schliemann, 1888, *17848*
 Mycenaean necropolis excavated, 1896, *16996*
 origin of tombs, *454*
 vase discovery, 1894, *16456*
MYDDLETON, Hope, *1892, 2078, 2100, 2144, 2163, 2217, 2236,
 2247, 2550*
Myers & Hedian, Baltimore See: Baltimore (Maryland).
 Myers & Hedian, art dealers
Myers, Mary, fl.1894-1900
 opens studio in Chicago with other lady artists, 1894, *11405*
Mygatt, Robertson K., d.1919
 exhibitions
 New York Etching Club, 1893, *22483*
 New York Etching Club, 1894, *4800*
Myrbach, Felician de, 1853-1909
 illustrations
 fabric pattern, *13341*
 views of Canterbury, *10402*
 views of Chester, *10491*
 views of Dover, *10390*
 views of Wales, *10423, 10444, 10458*
Myrick, Frank W., fl.1883-1901
 illustrations for *Lay of the Last Minstrel*, 1886, *509*
Myslbek, Josef Vaclav, 1848-1922
 Music, placed in Bohemian National Theatre, Prague, 1892,
 26844
Mystic (Connecticut)
 monuments, soldiers' monument to Sons of Mystic unveiled,
 1883, *14913*
 Spicer Memorial Library, opens, 1894, *16466*

National Free Art League
 annual meeting, 1890, *25770*
 artists before Congressional committee, 1890, *25710*
 executive board elected, 1889, *2934*
 supports free art clause, 1894, *16462*
 work opposing art tariff, *22738*
National Gallery, London See: **London (England). National Gallery**
National Gallery of Art, Washington, D.C. See: **Washington (D.C.) Smithsonian Institution. National Gallery of Art**
National Gallery of Ireland See: **Dublin (Ireland). National Gallery of Ireland**
National Gallery of Scotland See: **Edinburgh (Scotland). National Gallery of Scotland**
National League of Mineral Painters
 annual exhibitions
 1894, *5213*
 1898, *6669, 12152*
 1899, *12326, 17591*
 annual meeting
 1896, *5927*
 1899, *12351*
 convention, Buffalo, 1901, *7628*
 course of study, 1892, *4007*
 course of study, 1896, *5959*
 exhibitions
 Chicago, 1899, *12352, 12877*
 Chicago Ceramic Association, 1899, *7030*
 Cincinnati, 1896, prize list, *11870*
 Cincinnati Art Museum, 1896, *6080*
 mimickery and fads, 1895, *5504*
national parks and reserves
 United States
 1887, *10814*
 importance of national park systems, *14188*
National Philatelic Society
 foundation, 1892, *15825*
 petition, 1892, *15847*
National Photographic Association See: **Photographers' Association of America**
National Portrait Gallery, London See: **London (England). National Portrait Gallery**
National Sculpture Society See: **New York. National Sculpture Society**
National Society of Art Masters
 of Great Britain and Ireland, *8281*
National Society of Arts
 committee on organization, 1885, *1946*
 New York branch established, 1885, *1963, 2049, 25265*
National Society of Craftsmen
 exhibitions, 1906, first public exhibition, *14237*
 organization and officers, 1906, *14126*
 organized, 1906, *14109*
National Society of Mural Painters See: **New York. National Society of Mural Painters**
National Society of the Colonial Dames of America. Massachusetts
 competition for painting of spirit of colonial period, 1899, *6978*
 prizes for pictures of colonial themes, 1898, *12429*
National Society of the Fine Arts
 membership drive, 1907, *14271*
 organization, 1905, *13899*
national songs, French
 Marseillaise, 18750
 celebration of anniversary, 1892, *15904*
 centenary, *15755*
nationalism and art
 art as an indication of national position in history, *18532*
 art as international commodity, *13308*
 art as national expression, *18395*
 art as the spirit of a nationality, *18327*
 national character in scenery, *18218*
 nationality in art, *17947*
 spirit of a nationality, *17988*

Natorp, Gustav, b.1836
 exhibitions, Society of American Artists, 1886, *2227*
Natt, Phebe Davis, fl.1878-1901
 exhibitions, American Art Galleries, 1885, *1921*
Nattier, Jean Marc, 1685-1766
 illustrations
 portrait, *7524*
 Portrait of Mlle. Victorre, daughter of Louis XV, 7480
Natural Bridge (Virginia)
 summer art school planned, 1891, *26266*
 university of art and design planned, 1890, *26192*
natural history
 Joseph Banks, *20827*
 private collections, *15656*
 Smith collection, *17053*
naturalists
 enthusiasm for Japanese art, *22755*
nature
 English flower gardens, *9579*
nature (aesthetics)
 affinities of natural forms with thought and feeling, *13591*
 animated nature, *18968*
 anthill as microcosm of universe, *18333*
 antidote to business life, *19713*
 appreciation of nature and art, *18019*
 art and nature, *18017*
 art as subservient to nature, *18312*
 art as translation of nature, *21683, 21709*
 artists should prefer nature to history, *18626*
 beauty and deformity, *18049*
 beauty in nature, *22754*
 excerpt from Diderot, *25217*
 color, *24735*
 correspondence of natural sounds and aspects, *18905*
 description by landscape painter, *10924*
 diverse nature, *19100*
 fidelity to nature in landscape painting, *22020*
 flowers, *19051*
 forest's effect on mind of man, *9757*
 God in nature, *18172, 18220*
 Goethe's ideas of nature and art, *18618*
 idealized nature, *18135*
 imperfection in nature, *19057, 19141*
 individuality of response to nature, *18958*
 influences of nature, *19175*
 limitations of language in describing nature, *24581*
 lures of nature, *18904*
 major and minor truth, *19272*
 natural in art, *24877*
 naturalism and ornament, *20542*
 nature and art, *14794, 22744, 23433*
 nature and beauty, *18848*
 nature and the divine, *17905*
 nature as true source of artists' inspiration, *17897*
 nature in art, *987*
 nature vs. conventionalism, *22594*
 observations of Mace Sloper, *20304*
 observations of nature, *19018*
 perception, *18921*
 poetry, *19130*
 poetry of ocean and flowers, *19397*
 relationship of art to nature, *17481*
 role of art to interpret and reproduce, *18016*
 science of landscape, *2705*
 search for the picturesque, *19017*
 selectivity with nature, *19026*
 sketching from nature, *3018, 11128, 13894, 14760, 14773, 14788*
 sky and clouds, *18938*
 spirit and reverence of nature, *18888*
 sports as a means of appreciating the picturesque, *9672*
 suggestion to study nature and others' interpretations, 1894, *4721*
 three types of sunsets, *19065*
 truth to nature in landscape painting, *18870*

classes
 1890, *25918*
 1892, *26808*
 life drawing classes planned, 1898, *6805*
 taught by Candace Wheeler, 1891, *26402*
 William H. Gibson teaching illustration class, 1890, *26184*
exhibitions, 1897, student work, *6306*
notes
 1890, *3422*
 1891, *3774*
 1892, *4172*
 1897, *6487*
presents scholarships to New York Times, 1893, *4276*
reorganized, 1898, *6522*
second year gathering, 1890, *25941*
students
 circular issued, 1892, *26656*
 class work exhibited, 1893, *26906*
superintendant T. W. Stimson, 1894, *4794*
New York. Artists' Aid Society, *15611*
elections, 1892, *26721*
plans, 1859, *19995*
New York. Artists' Fund Society
annual exhibitions
 1863, *23289*
 1865, *23366*
 1871, *10647*
 1881, *235, 258, 309, 9455*
 1883, *1512, 24382, 24393*
 1884, *10933, 24967*
 1885, *1916, 25225*
 1886, *2151*
annual meeting
 1860, *20179*
 1861, *20355*
 1881, *311*
 1883, *24426, 24441*
 1893, *26932*
exhibitions
 1860, *20302*
 1860-1, *20320*
 1882, *9601*
 1883, *24371, 24402, 24416*
 1886, *10763*
 1886-7, *531*
finances, *11186*
history, *8404, 11281*
notes
 1880, *236*
 1883, *24415*
 1885, *11248*
officers elected, 1880, *9310*
sales and prices
 1861, *20330*
 1879, annual auction, *9124*
 1881, *1086*
 1883, *24433*
 1884, *10944, 24983*
trip to Niagara Falls,1880, *164*
New York. Artists' Reception Association
meeting, 1860, *20146*
receptions, 1860, *20320*
New York. Associated Artists
decoration of Church of the Divine Paternity, 1881, *9550*
designs by Mrs. Candace Wheeler, *4273*
drawing room decoration, *2356*
exhibitions
 1886, Kell's embroideries, *517*
 1886-7, *529*
 1887, *10763*
 1887, embroideries, *2592*
 1887, needlework, *2550*
 1887, tapesries and embroideries, *603*
 1891, industrial arts, *3483*
 1894, Frackleton's artistic stoneware, *4845*

firm of women designers, *4233*
ivory silk hanging, 1887, *530*
needle-woven tapestries, 1890, *3197*
notes
 1885, *1907*
 1895, *11498*
sales, 1884, *25018*
textiles and tapestries, *503*
work, 1882, *1362*
New York. Astor Library
annual report, 1890, *26303*
building, *14680*
competition for design, 1849, *14510*
celebrates fortieth anniversary, 1894, *16451*
collection, treasures, *15969*
consolidation with Tilden Trust Fund, 1895, *21531*
fine arts department, *14510*
marble bust stolen, 1881, *1234*
music library, *17101*
notes
 1893, *16154*
 1897, *17350*
New York. Athenaeum Association
description, 1850, *14696*
exhibitions, 1860, *20179*
New York. Athletic Club of the City of New York
annual exhibitions
 1889, loan exhibition, *2884*
 1890, American art, *3208*
 1892, loan collection of American paintings, *26577*
 1893, art loan exhibition, *22492*
 1894, loan exhibition, *26998*
exhibitions
 1887, *574*
 1888, American paintings, *2638*
 1891, American painting, *3627, 26314*
 1892, *15859, 26566*
 1896, *22980*
 1898, American paintings, *6643*
 1899, *12879*
notes, 1891, *26211*
New York. Authors Club
funding offer from Andrew Carnegie, 1890, *25848*
Liber Scriptorum: the Book of the Authors' Club, *16489, 16905*
notes, 1892, *26862*
publications, 1892, *15859, 26592*
New York. Avery Art Gallery
building, connected by staircase to Ortgies, *5115*
exhibitions
 1875, *8573*
 1878, *8994*
 1879, European pictures, *9263*
 1880, *846*
 1880, Barbizon paintings, *9422*
 1881, French pictures shown, *1217*
 1889, Knaus, *2884*
 1889, W. L. Picknell, *2911, 14992, 25822*
 1890, *15070, 15123, 15431*
 1890, Colman, *15081*
 1890, French and American artists, *26125*
 1890, Picknell, Coleman, and C. H. Davis, *3208*
 1890, Swain Gifford, *3229, 25822*
 1891, *15783*
 1891, F. Hopkinson Smith watercolors, *3495, 26245*
 1892, *3834, 26869*
 1892, Mrs. Whitman's work, *26867*
 1892, W. L. Picknell and Leonard Ochtman, *3894*
 1893, F. Hopkinson Smith watercolors, *4287*
 1893, L. Ochtman and C. W. Eaton, *4359*
 1893, Mrs. Whitman, *4237*
 1893, W. A. Coffin, *4317*
 1894, Dutch art, *16505*
 1894, English and Dutch portraits, *4835*
 1894, European painting, *16494*
 1894, F. H. Smith Venetian studies, *4874*

1894, F. H. Smith's watercolors, *4756, 5221*
1894, G. H. Smillie, *4801*
1895, DuMaurier's drawings, *5175*
1895, loan exhibition of decorative arts, *5374*
1895, Marcius Simons, *5300*
1895, Ochtman paintings, *5337*
1895, Percy Moran watercolors, *5224*
1895, Turner and Constable, *5400*
1896, DuMaurier studies for *Trilby*, *17000*
1896, E. A. Abbey pastels, *5735*
1897, Diaz, Rousseau, and F. H. Smith, *23190*
1898, E. A. Abbey scene from *Hamlet*, *6557*
1899, Monticelli, *6926*
1900, Elihu Vedder, *13021*
Noé joins firm, 1893, *26895*
pictures offered, 1890, *15422*
pictures on view, 1891, *15752*
shows bust of Robert Burns by Charles Calverly, 1890, *26184*

New York. Bangs & co.
book thefts, 1897, *17262*
books offered, 1893-4, *16334*
building, move to Fifth Avenue, 1896, *16920*
sales and prices
 1856, *19568*
 1892, *15992*
 1895, *16898*
sales catalogues, *15759*

New York. Barnard College
students' examination for admission to School of Arts, Columbia College, 1891, *26356*

New York. Battery Park
projected monument to Washington, 1855, *19279*

New York. Baumgarten, William, & Co. See: **Baumgarten, William, & Co., inc.**

New York. Belcher Mosaic Glass Co. See: **Belcher Mosaic Glass Co., New York**

New York. Berlin Photographic Company See: **Berlin Photographic Company, New York**

New York. Black and White Club
annual exhibitions
 1899, *12859, 17516*
 1900, *7248, 13158*
exhibitions, 1899, *17527, 17554*
organized, 1898, *17447*

New York. Black, Starr & Frost, inc. See: **Black, Starr & Frost, inc.**

New York. Blakeslee Galleries
acquires LeBrun painting, 1896, *22980*
building, rebuilt after fire, 1900, *7452*
catalogues
 1898, excerpt on early English painting, *17409*
 1899, *6845*
established, 1886, *504*
exhibitions
 1887, foreign paintings, *10814*
 1889, French painting, *2962*
 1891, J. A. Weir, *3487*
 1895, *16749, 16845*
 1895, early English painting, *16738*
 1896, *17140*
 1897, H. W. Ranger, *6191*
failure, 1889, *14978*
sales and prices
 1893, *4391, 16213*
 1895, *5564*
 1899, *6927, 6954*
wares, 1900, *7481*

New York. Blue Pencil Club
notes, 1900, *7206*

New York. Bonaventure, E. F., firm, bookseller, *20480*
appointed American agent for Georges Petit publications, 1896, *17165*
art catalog, 1892, *15791*
books offered
 1887, *603*

1890, *3171*
1891, *15786*
1892, *15800*
1892, and relics, *16044*
bookseller, *527*
catalogue issued, 1896, *16997*
collection, 1899, *7125*
exhibitions
 1893, summer, *16260*
 1897, Marie Antoinette relics, *6427*
 1899, bookbindings, *7153*
 1899, books of hours, *6986*
 1899, modern bookbindings, *6845*
 1900, bookbindings, *7263*
 1900, rare books, *7481*
 1902, bookbindings, *7816*
notes, 1885, *11295*
prints published, 1887, *2422*

New York. Bonnard Bronze Company See: **Henry Bonnard Bronze Company, New York**

New York. Botanical Garden See: **New York. New York Botanical Garden**

New York. Boussod, Valadon and Co.
acquisitions, 1892, Otlet collection, *3924*
Bouguereau, lent to Omaha, vandalized, 1891, *3571*
building, decorations, *6811*
exhibitions
 1890, Madeline Lemaire and John Fraser, *25822*
 1892, Dutch watercolors, *26822*
 1892, Turrell collection of miniatures, *3834*
 1893, George Hitchcock, *4355*
 1894, G. H. Bogert, *4874*
 1895, early English painting, *16713*
 1895, Society of Painters in Water-colors of Holland, *5300*
 1895, wares and T. Lawrence painting, *5224*
 1896, Society of Painters in Water-colors of Holland, *16916*
 1897, J. A. Weir, *23240*
 1897, Zawiejski sculpture, *6282*
 1899, A. Harrison, *6955*
 1899, F. Bridgman, *6873*
 1900, E. Shinn pastels, *7524, 7260*
 1900, H. G. Herkomer, *7179*
galleries open in New York, 1888, *25547, 25582*
governmental ruling regarding status, 1890, *25909*
imports paintings free of duty, 1890, *25927*
law suit brought by Knoedler, 1891, *15740*
lawsuit with Chauchard for selling repainted Millet, 1891, *3571*
Millet's *Woman spinning* returned to Paris, 1890, *25918*
prints published, 1892, *15796, 15998*
Rembrandt's *Portrait of Joris de Coulery* offered, 1891, *15491*
sues Omaha Art Exhibition Association for damage to Bouguereau painting, 1895, *16738*
system of pricing pictures, *15790*

New York. Bouton, J. W., booksellers, *15169*
Archaic Library, review of No. II, *15836*
books offered
 1883, *24526*
 1888, *2800*
 1889, *14957*
 1890, *15305, 15392*
 1890, art books, *15087*
 1891, *15635, 15648, 15727, 15745*
 1892, *15800*
 1893, *16157*
 1894, *16535, 16645*
 1895, *16678, 16897*
 1896, *16984, 17165*
English sketch club drawings for sale, 1861, *20365*
exhibitions, 1893, miniatures and enamels, *16374*
holiday publications, 1891, *15780*
moves store, 1890, *15213*
moves to new location, 1891, *15525*

New York. Brentano's
exhibitions, 1895, bookplates, *5331*

1893, Pre-Raphaelite painting, *4286, 26894*
1900, *13158*
festivities, 1892, *15800*
letter on Wiles as mission painter, 1893, *16383*
notes
1879, *673*
1893, *4254*
Shakespeare's birthday celebration, 1860, *20226, 20286*
Strawberry Festival, 1856, *19438*
Twelfth Night at the Century by G. C. Verplanck, review and excerpts, *19861*
Twelfth Night festival, 1858, *19783*
Twelfth Night festival, 1859, *19973*
verses by Peter A. Porter read at meeting, 1860, *20279*
New York. Century Club See: **New York. Century Association**
New York. Cercle artistique français
founding, 1880, *133, 895*
New York. Chadwick, John, and Co.
Spanish and Moorish curios shown, 1893, *4593*
New York. Chamber of Commerce of the State of New York
collection
portraits, *15780*
portraits catalogued by George Wilson, 1890, *15196*
New York. Chapman, Frederick A. (firm)
gallery collection, *17233*
New York. Charity Organization Society of the City of New York
exhibitions, 1893, gem collection, *26936*
New York. Chase School of Art
exhibitions, 1897, *6136*
founded by Chase, 1896, *5976*
notes, 1896, *11896*
student work, 1897, *6306*
New York. Chickering Hall
sales and prices
1878, paintings, *9014*
1880, European and American paintings, *9279*
1891, Aaron Healy collection, *3568*
New York. Church of the Divine Paternity
interior, 1881, *1245*
New York. City Hall, *18560*
Audsley design brings lawsuit, 1894, *5073*
Mayor's office, bronze tablet, 1893, *26975*
plans, 1854, *19334*
portrait paintings, *15978*
portraits in governor's room, *19183*
project for new building, 1855, *19247*
project for restoration, 1877, *10782*
rear wall painted as faux marble, 1891, *3460*
sandstone image of George Washington, *20320*
New York. City University of New York
acquisitions
1893, LaGarde library, *16428*
1894, geology library, *16462*
New York. Clausen Galleries
catalogue issued of Arlent Edwards mezzotints, 1893, *16420*
exhibitions
1894, C. P. Gruppe, *4874*
1896, *17165*
1896, Netherlandish panels, *17000*
1899, *17505*
1899, American art, *6903*
1902, R. N. Hyde, *7850*
1905, Bicknell, *13843*
fire in art store, 1892, *26879*
New York. Club Bindery, *22409*
New York. Collectors Club
founded, 1896, *17140*
New York. College of Archaeology and Aesthetics
incorporated, 1880, *278*
New York. Colonial Club of New York
annual exhibitions, 1893, *26930*
exhibitions, 1895, *16713*

New York. Columbia University
Alma Mater of D. C. French, *13161*
annual board meeting, 1890, *26108*
art school to be built by National Academy of Design for Columbia College, 1905, *13899*
attempts to acquire Vondel collection, 1901, *7643*
central gate by Lienan and Nash exhibited, 1898, *6545*
College grounds, 1855, *18771*
Columbia College ex-libris, *4864*
exhibitions, 1901, objects relating to Alfred the Great, *7740*
Fine Arts Department
established, 1902, *13510*
established, 1903, *13618*
joint department established with National Academy of Design, 1906, *14083*
lecture courses on fine arts offered, 1904, *13729*
proposed, 1902, *13436, 13478*
Hall of Fame to be erected, 1900, *7313*
lectures, lectures on art and music, 1892, *26485*
library
collections, *17350*
holdings in German history, *17371*
music library, *17101*
Schermerhorn library acquired, 1895, *16749*
New York. Columbia University. Avery Memorial Architectural Library
collection, shown, 1892, *15921*
founded, 1890, *15265*
gift from Samuel P. Avery, 1891, *26258*
notes
1891, *15759*
1893, *16412*
New York. Columbia University. Low Library
acquisitions, 1893, *16240*
building
murals by Robert Sewell refused, 1901, *7524*
nears completion, 1897, *17371*
stained glass windows, *26703*
donated by Seth Low, 1895, *22738*
New York. Columbia University. School of Architecture
anniversary dinner at American Academy of Fine Arts, 1902, *8081*
annual exhibitions, 1890, student drawings, *25946*
competition, 1892, *26590*
exhibitions
1892, student work, *26676*
1893, student work, *4487*
1902, student work, *8069*
fellowships, 1902, *13475*
students, drawings and studies shown, 1893, *26967*
New York. Columbia University. Teachers College
art classes, 1898, *6669*
art department, *6805*
art education, 1895, *5556*
conference on manual training, 1896, *5857*
establishes art history course, 1894, *4999*
exhibitions, 1897, *6389*
lectures, John LaFarge lectures on art education, 1896, *5771*
students, required to pass drawing exams, 1894, *5115*
New York. Cooper Union for the Advancement of Science and Art, *8366*
acquisitions, 1897, St. Gaudens' statue of Peter Cooper, *6313*
annual exhibitions, 1879, *675*
annual report
1860, *20169*
1890, *26235*
1892, *26495*
1893, *26961*
art department, technical instruction criticized, 1896, *5862*
association of women art students, 1895, *21504*
Bryan collection, *18281*
building, repairs, 1891, *26402*
classes
1883, *24800*
1894, *27027*

1900, *7198*
art classes, 1884, *1889*
night school classes, 1892, *26808*
wood engraving classes discontinued, 1890, *3254*
commencement
1875, *8480*
1891, *26322*
1892, *26663*
drawing from nude model desired, 1879, *655*
exhibitions, 1896, student work, *5892*
founding, *18092*
free night school, *26220*
gift from Andrew Carnegie for mechanical arts day school, 1900, *13016*
library offered by A. J. Davis, 1880, *102*
notes
1859, *20131*
1880, *9357*
1882, *9658*
prizes
1890, *3278*
awarded to art students, 1890, *25911*
Second Annual Report of the Trustees of the Cooper Union for the Advancement of Science and Art, review, *20389*
New York. Cooper Union for the Advancement of Science and Art. Museum for the Arts of Decoration
collection, *Catalogue of Etchings and Lithographs presented by Samuel P. Avery to the Cooper-Union Museum for the Arts of Decoration*, review, *6662*
museum of decoraive art added to Cooper Union, 1897, *6313*
notes, 1898, *6643*
opens, 1897, *17371*
New York. Cooper Union for the Advancement of Science and Art. School of Design for Women
annual reception
1878, *9025*
1883, *24607*
building, moves, 1858, *19859*
casts given by William Weill, 1858, *19873*
classes
1856, *19490*
1860, *20152*
1883, *24716*
1892, *26808, 26816*
women's designing class, 1878, *8950*
wood engraving taught, 1855, *19265*
lecture series planned, 1856, *19564*
notes
1856, *19384*
1879, *735*
1881, *400*
1890, *3306*
opened to public, 1893, *26960*
prizes
1871, *10731*
1881, *377*
reception, 1860, *20209*
students
exhibit at Chicago World's Fair, 1893, *4585*
receive medal for work at Paris Exposition of 1889, *26286*
teachers
instructors listed, 1890, *3389*
teaching criticized, 1865, *23340*
New York. Cosmopolitan Art Association See: **Cosmopolitan Art Association**
New York. Cottier & co.
exhibitions
1878, contemporary European paintings, *8981*
1888, Rembrandt portraits, *25544*
sales and prices, 1878, auction of French and Dutch paintings, *9014*
New York. Country Sketch Club
exhibitions, 1901, *13206*
New York. Crescent Athletic Club of Brooklyn
exhibitions, 1891, *3524*

New York. David G. Francis, booksellers
catalogue, 1890, *15331*
New York. Decorative Designers See: **Decorative Designers, New York**
New York. Delmonico, L. Christ, gallery
exhibitions
1892, *26493*
1893, pictures collected by Miss Hallowell for Chicago exhibition, *26921*
New York. Democratic Club of the City of New York
decorations, dome painting by Arthur Thomas, *17391*
exhibitions
1900, *13008*
1901, American art, *7568*
New York. Department of Parks
appointments of D. C. French, A. Saint Gaudens and J. Q. A. Ward to pass on statuary, 1893, *22249*
Miranda's Columbus monument under consideration, 1892, *4012*
New York. Department of Public Parks See: **New York. Department of Parks**
New York. Derby Gallery See: **New York. Institute of Fine Arts**
New York. Dikran Kelekian G., inc.
collection, *16591, 16681*
1899, *6954*
consignments, 1897, *17315*
exhibitions
1900, antique Greek ecclesiastical embroideries, *7481*
1900, Persian manuscripts, *7263*
1901, Persian textiles, *7526*
notes, 1900, *7179*
wares
1895, *16803*
1896, *17165*
1898, *17447*
1899, *7125*
1903, *8174*
New York. Dodd, Mead & Co. See: **Dodd, Mead & Co., New York**
New York. Dowdeswell and Dowdeswell
collection, sale, 1904, *13782*
New York Drawing Association See: **New York. National Academy of Design**
New York. Dunlap Society
plan for reorganization, 1896, *16915*
publications, *15944*
New York. Duprat and Co.
Book Lover's Almanac, *16398*
published, 1892, *15973*
catalogues, *14940*
firm closes, 1896, *16984*
Shakespeare's *Antony and Cleopatra* to be published, 1890, *26177*
New York. Durand Ruel Galleries
building, gallery moves, 1894, *16519, 16577*
collection, Rubens and Miereveld paintings, *3425*
Corots offered, 1891, *15486*
description, 1894, *16617*
exhibitions
1887, French paintings, *2448, 2483*
1889, *2911, 14963*
1889, Impressionist paintings, *2962*
1889, paintings, *2934*
1890, *3312*
1890, Dutch paintings, *15432*
1891, *3602*
1891, paintings by Monet and Ingres, *26438*
1892, European paintings, *3834*
1892, Monet and Puvis de Chavannes, *3895*
1893, *4234*
1893, European paintings, *4390*
1893, old masters, *16122*
1894, Barbizon School, *16432*
1894, French art, *4759*

1894, French school pictures, *27026*
1894, Pissaro and Boudin, *4840*
1895, *16865*
1895, Cassatt, *5339*
1895, exhibition of Christian art planned, *16694*
1895, *Exhibition of Madonnas*, *5298*
1895, LaFarge and Coffin, *5300*
1895, Manet, *5299*
1895, Monet, *5218*
1895, Puvis de Chavannes, *5173*
1896, *17016, 17191*
1896, J. L. Brown, *5615*
1896, M. Maufra, *5663*
1896, Vonnoh, *22421*
1897, portraits, *6457*
1898, Boudin and Puvis de Chavannes, *12273*
1898, Ten American Painters, *6619*
1899, Sisley, *6926*
1899, Ten American Painters, *6954*
1900, Philip Hale, *7204*
1900, second generation Impressionists, *7230*
1900, T. E. Butler, *7265*
1900, Ten American Painters, *7286*
1901, religious painting, *7505*
1902, F. MacMonnies, *8059*
1903, Ten American Painters, *8222*
1905, Boudin, *13889*
1905, Monet, *13843*
invitations to American artists to exhibit in Paris, 1891, *26303*
lends paintings to Union League Club exhibition, 1891, *3454*
paintings offered, 1891, *15470*
policies, 1893, *16342*
wares
 1890, *15327*
 1893, *4287*

New York. Düsseldorf Gallery
acquisitions
 1850, *14657*
 1850, paintings, *14619*
 1858, *18213*
agency of Dusseldorf Art Union, *14566*
collection, *18027, 18281, 19298*
 formation, *18086*
description, 1861, *20330*
exhibitions
 1849, *14498, 14508, 14524*
 1857, Powers' *Greek slave*, *18084*
founding, *18094*
influence on American art and taste, *14602, 18347*
influence on American artists, *18383*
intention to sell works of art, *18474*
notes, 1851, *23468*
permanent headquarters of the Cosmopolitan Art Association, *18281*
popularity of Düsseldorf School in America, 1893, *4355*
praise by press, 1857, *18039*
probable removal to Europe, 1857, *18008*
purchased by Cosmopolitan Art Association, 1857, *18022, 18040*
spirit of nationality, *17988*

New York. Duveen Brothers
discovery of a Boucher-designed Gobelins tapestry, 1890, *3152*
Italian furniture shown, 1893, *4349*
purchases at H. G. Marquand sale, 1903, *8154*

New York. Eastern Art Teachers' Association See: **Eastern Art Teachers' Association**

New York. Eden Musée
annual exhibitions, 1890, Autumn exhibition, *26184*
exhibitions
 1887, *2600*
 1890, watercolors, *3284*
 1892, *26806*
new wax-works, 1884, *1767*

New York. Ehrich Galleries
catalogue issued, 1895, *16650*

exhibitions, 1905, *13868*
sales and prices, 1905, *13888*

New York. Etching Club See: **New York. New York Etching Club**

New York. Euterpean Society
history, *648*

New York. Exchange for Woman's Work See: **New York. New York Exchange for Woman's Work**

New York. Exhibition of the Industry of all Nations, 1853-1854, *20976*

New York. Fellowcraft Club
acquisitions, 1891, Benoni Irwin portrait of Alexander, *3623*
elections, 1891, *26279*
exhibitions
 1890, artists' scraps and sketches, *26181*
 1891, *Artists' scraps and portfolio exhibition*, *3464*

New York. Fifth Avenue Art Galleries
annual exhibitions, 1894, summer, *27005*
building
 new gallery, 1892, *15923*
 renovated, 1892, *15995*
 site of T. B. Clarke's annual summer exhibitions, *16260*
exhibitions
 1889, American pictures, *14927*
 1890, F. A. Bridgman, *3229, 25853*
 1891, amateur photography, *26341*
 1891, paintings by De Haas, *26243*
 1892, contributions to the Grant Monument Fund, *26665*
 1892, J. A. Harper collection, *3925*
 1892, Schaus collection, *26532*
 1893, *22492*
 1893, J. LaFarge, *4462*
 1894, *4975*
 1894, *Twelve times twelve*, *16462*
 1895, *5603*
 1898, *6527*
 1899, Tisdall collection, *17501*
honest auctioneers at auction rooms, *3895*
notes, 1898, *17408*
sales and prices
 1889, *14961*
 1890, porcelain, *3207*
 1891, Healy collection sale, *3531*
 1891, W. M. Chase collection sale, *3572*
 1891, works of C. V. Turner and William H. Lippincott, *26314*
 1892, *26536, 26851*
 1892, Harper collection, *26522*
 1892, modern pictures, *26871*
 1894, American paintings and E. Runge collection, *4798*
 1899, *17577*
 1904, Inness paintings and sketches, *13726*

New York. Fifth Avenue Hotel
decoration
 1882, *1428*
 reception room, 1894, *5095*

New York. Fine Arts Federation of New York
building
 gallery plans, 1903, *13627*
 gallery proposal, *13637*
 movement to establish United Fine Arts Building, 1902, *7816*
 plans for fine arts building, 1906, *14126*
criticized, 1897, *23190*
description and work, 1896, *6108*
exhibitions
 1892, Fine Art Loan Exhibition planned, *3985*
 1893, loan exhibition, *4356*
 1894, American painting, *16556*
 1895, Inness estate paintings, *5220*
 1896, *22933*
meetings
 1900, requests bill for creation of U.S. art commission, *7292*
 1903, annual, *13618*
notes, 1901, *13327*
organization completed, 1895, *11546*

Donne poetry, 1895, *16842*
Milton's *Aeropagitica*, *15503*
monograph on Washington Irving, 1892, *26454*

New York. Hamilton Club, Brooklyn
project to place statue of Alexander Hamilton at clubhouse, 1891, *26411*
statue of Alexander Hamilton by W. O. Partridge unveiled, 1893, *26932*
statue of Alexander Hamilton commissioned, 1892, *26656*
statue unveiled, 1893, *26975*
subscription to fund statue of Hamilton, 1891, *26433*
vacancy caused by death of Seccomb, 1892, *26816*
winter reception, 1892, *26862*

New York. Hanfstaengl, Franz, Fine Art Publishing House
copyright violated, 1893, *16309*
notes, 1892, *16041*
photographic reproductions of old masters, *15980*
prints published, 1892, *15998*
publications
 1893, *16322*
 1893, reproductions of Dresden masterpieces, *16310*

New York. Hanover Club, Brooklyn
acquistions, 1892, *26835*
collection of John McKee deposited, 1891, *26341*
exhibitions
 1892, *26822*
 1892, loan exhibition, *26798, 26806*
 1892, loan exhibition of American artists, *26814*
 1893, art loan exhibition, *26900*

New York. Hardware Club of New York
exhibitions, 1899, fakes, *17632*

New York. Harlem River Bank See: **Harlem River Bank**

New York. Harmonie Club of the City of New York
annual exhibitions, 1893, *16412*
exhibitions
 1886, *2108*
 1894, loan exhibition, *4742*

New York. Harvard Club of New York City
commissions portrait of Joseph H. Choate from John Singer Sargent, *12909*

New York. Hebrew Institute
exhibitions, 1896, art loaned by dealers, *5855*

New York. Heights Club
exhibitions, 1899, loan exhibition, *17516*

New York. Heinemann, T. L., firm
opens, 1903, *8162*

New York. Herman Wunderlich Gallery
exhibitions
 1878, engravings, *9037*
 1883, *24905*
 1883, Whistler, *24837*
 1889, C. A. Platt etchings, *3120*
 1889, J. M. Whistler, *2911*
 1890, pastels by George Hitchcock, *3427, 26140*
 1890, Seymour Haden's collection of drawings,etchings,*3208*
 1890, Society of Painters in Pastel, *3256*
 1890, Whistler's etchings, *15126, 25827*
 1891, *15759*
 1891, eighteenth-century engravings, *3625*
 1891, etchings by William Strang, *26266, 26277*
 1891, J. H. Twachtman sketches, *3573*
 1891, paintings and pastels by Twachtman, *26320*
 1891, prints by Mary Cassatt, *26418*
 1891, tinted engravings, *26402*
 1891, William Strang etchings, *3561*
 1892, *26768*
 1892, exhibition illustrating history of engraving, *3925*
 1892, George Hitchcock pastels, *4184*
 1893, drawings for Scribner's Magazine, *22492*
 1893, J. T. Nettleship animal studies, *4655*
 1894, Napoleon I relics, *4910*
 1894, R. Turner, *4801*
 1894, Whistler lithographs, *5120*
 1895, Dutch painting and Maria Brooks, *5173*
 1895, J. A. Weir, *5300*
 1896, color engravings, *17191*
 1896, contemporary lithographs, *5732*
 1896, DuMaurier drawings of London society, *5615*
 1896, lithography, *16984*
 1896, Whistler lithographs, *5782*
 1897, eighteenth-century color engravings, *6098*
 1897, engraved portraits, *6459*
 1898, Baroness von Cramm water colors, *6555*
 1898, Rhead brothers' *Pilgrims' Progress* illustrations, *6545*
 1898, Whistler, *6785*
 1899, drawings by J. C. Beckwith, *6845*
 1900, Beckwith, *13021*
 1902, etchings and engravings, *8059*
notes, 1893, *16316*
offers subscriptions to international chalcographic society, 1884, *25219*
prints after Morland offered, 1893, *16329*
prints published
 1888, *2792*
 1892, *15998*
prints related to American history available, 1892, *15977*

New York. Herter Brothers See: **Herter Brothers, New York**

New York. Historical Printing Club of Brooklyn
books offered, 1890, *15377*
publications, 1890, *15257*
 books on American Revolution, *15140*

New York. Historical Society See: **New York. New York Historical Society**

New York. Holbein Galleries
annual exhibitions, 1893, summer, *26930*
exhibitions
 1893, American paintings, *26960*
 1893, Lydia F. Emmet, *4461*
 1893, sketches and illustrations, *22521*
 1893, summer, *22492*
opened, 1892, *26639*

New York. Holland Art Galleries
Aaron A. Healy named special partner, 1895, *16705*
collection, sale, 1897, *17241, 17269*
exhibitions
 1895, *5603, 16738, 16845*
 1895, Italian painting, *16713*
notes, 1895, *16650*

New York. Holland Society of New York
commissions statue of William the Silent, 1899, *17505*
library, catalogue of R. B. Roosevelt donation, *15504*
proposes monument to Dutch for Holland, 1890, *26175*
tablets to mark historic sites in Manhattan, *25887*
Year Book, 1888-1889, *15553*

New York. Industrial Art Exhibition Company
organized, 1893, *26967*

New York. Industrial Arts Schools See: **New York. Metropolitan Museum of Art. Industrial Arts Schools**

New York. Industrial Education Association
exhibitions, 1886, children's handiwork, *2151*
notes, 1887, *574*

New York. Institute of Fine Arts
collection, *18542*
 description and collection, 1860, *18510*
 J. Jarves collection, *18503*

New York. International Art Gallery, *15291*
exhibitions, 1890, *15246*

New York. International Art Union, *21377*
catalogue of engravings, 1849, *21448, 21453*
exhibitions, 1849, catalog, *21387, 21399, 21413, 21422, 21435, 21441, 21450*
free gallery, *21440*
honorary secretaries
 1848, *21389*
 1849, *21391, 21400, 21414, 21423, 21436*
members, 1849, *21388, 21390, 21400, 21414*
notes, 1849, *14567, 14572, 21443, 21451, 21455, 21456*
notices of the press, 1849, *21406, 21437*
pictures exhibited in Providence, 1849, *21427*
plan, 1849, *21386, 21398, 21412, 21421, 21435*

Huntington collection destroyed in San Francisco fire, 1906, *14143*
lack of a print collection lamented, 1893, *16316*
lack of Early Italian art, 1899, *17661*
Marquand collection, *17662*
Marquand collection acquires Van der Helst portrait, 1900, *13081*
method used by Roger Fry for conserving paintings, *14166*
Moses Lazarus collection of miniatures and enamels, *3074*
musical instruments, *16612*
notes, 1880, *874*
Parthenon model by Jouy described, 1890, *3427*
pictures requested for Chicago World's Fair, 1893, *26637*
Piero di Cosimo panels restored and exhibited, 1903, *13637*
plaster casts, *15554*
prints, *15966*
Raphael's *Madonna dei Candelabri*, *24706*
recommendation that museum lend undesireable objects to provincial museums, 1890, *3393*
refuses Theodore Robinson painting, 1898, *6872*
Rembrandt's portrait of Mynheer Domer, called *The Gilder*, *15321*
Sculptures of the Cesnola Collection of Cypriote Antiquities reviewed, *345*
Seney collection, *26923*
Vanderbilt collection of drawings authenticity questioned, *1146*
Vanderbilt collection of drawings shown, 1881, *327*
copying restrictions removed, 1906, *14217*
criticized by *The Studio*, 1884, *25215*
 correspondence, *25227, 25228*
description
 1880, *9397*
 1880, building and collections, *117, 9347*
 building and collections, *9337*
Di Cesnola controversy
 director's bad manners, 1887, *25391*
 museum should get rid of director and trustees, 1885, *25243*
 re-elected secretary despite opposition, 1895, *5298*
director criticized, 1886, *2323*
director criticized, 1887, *2364*
director's bad manners, 1889, *25678*
directorship, 1895, *16705*
establishment, *8363*
exhibitions
 1875, loan exhibition of paintings and statues, *8384*
 1878, laces and embroideries, *8950*
 1879, King collection of engraved gems, *9159*
 1880, loan exhibition, *210, 9422*
 1881, American pictures and Old Master drawings, *9516*
 1881, foreign pictures, *9528*
 1881, loan exhibition, *376, 1165, 1251*
 1882, loan exhibit criticized, *1428*
 1882, paintings, tapestries, *9718*
 1883, *Madonna dei candelabri* attributed to Raphael, *1488*
 1883, loan exhibition, *1586, 24493, 24503, 24514, 24538, 24553*
 1883, Old Master copies by American artists, *24817, 24862, 24867*
 1883, Pedestal Fund loan exhibition, *1671*
 1883, summer loan exhibition, *14886*
 1884, loan exhibition, *1803*
 1884, private New York collections, *11027*
 1884, Watts, *11100*
 1884, Watts loan collection, *25186*
 1885, fall and winter exhibition, *11261*
 1886, loan exhibition, *2323, 25359*
 1886, old masters, *518*
 1886, Society of American Artists, *25309*
 1887, *10814, 10830*
 1887, Dutch and Flemish paintings, *2343*
 1887, loan collection, *2448*
 1887, Sedelmeyer's Dutch and Flemish paintings, *25389*
 1890, *3313, 25888*
 1890, Willard Architectural Commission, *25968*
 1891, acquisitions, *3625, 3793*
 1892, Chateau d'Aulby collection, *26711*
 1892, pictures on loan from Château d'Aulby, *15948*
 1892, spring exhibition, *26616, 26626*
 1892, spring opening, *26648*
 1893, loan exhibition, *16227, 26906*
 1893, semi-annual, *26930*
 1894, *16556*
 1894, E. C. Moore collection, *16612*
 1894, J. Garland collection of Chinese porcelains, *4905*
 1895, Cullum collection of classical statuary, *16865*
 1895, early American art, *22738*
 1895, early American painting, *5565*
 1895, early American painting planned, *16678*
 1895, early American portraits planned, *5257*
 1895, gifts, loans and acquisitions, *16749*
 1897, acquisitions, *6280*
 1897, Magnussen collection of Icelandic objects, *17276*
 1899, gifts and loans, *17605*
 1900, Frederic E. Church, *13071*
 1902, Menke collection, *13473*
 1902, Vanderbilt collection, *13403*
 1902, Marfels and Durkee collections, *7816*
 1903, Bashford collection of Japanese armor, *13604*
 1906, lace, *14151*
exhibitions and list of gifts, 1897, *17335*
expels improperly-dressed patron, 1897, *17264*
fall opening, 1881, *9572*
Feuardent's charges against Di Cesnola, *178, 277, 305, 326, 350, 374, 934, 950, 954, 972, 996, 1125, 1127, 1145, 1167, 1311, 1326, 1350, 1363, 1428, 1446, 1464, 1486, 1530, 1569, 1674, 1689, 1694, 1709, 1714, 1732, 1745, 2113, 9391, 9407, 9445, 9467, 9635*
 committee for investigation, *1037*
 cost of trial, *1767*
 Di Cesnola exonerated by Museum, 1881, *1084*
 investigating committee, 1882, *1281*
 investigation, *1060*
 litigation, 1884, *25036*
 museum director arraigned, 1880, *930*
 new developments, 1881, *1102*
 value of investigating committee questioned, *1103*
finances
 1880, *910*
 1886, *10741*
 1887, *25400*
 1892, *26696*
 1901, *13265*
 expenses to be paid by Park Department, 1892, *26517*
 fund for purchasing Di Cesnola collection of Cypriote antiquities, *1813*
 funding by Board of Estimate, 1892, *26816*
 funds appeal, 1880, *869*
 Jacob S. Rogers bequest improves financial condition, 1904, *13739*
 proposal to Board of Estimate, 1892, *26462*
 support for the purchase of casts, 1891, *26286*
gift of Theodore Robinson painting refused, 1898, *12842, 12935, 17481*
gold room security, *13145*
history, Avery's speech, 1894, *16632*
inheritance taxes discussed, 1901, *13244*
Jacob S. Rogers bequest, *7740, 13281, 13309, 13384, 13594, 13688*
 settled, 1902, *13436*
lack of support to American artists, 1896, *5823*
lectures
 1898, LaFarge criticizes museums, *6643*
 by Louis Fagan on etching and engraving, 1890, *26150*
library
 etchings given by Loring M.Andrews, 1883, *24587*
 solicits gifts, 1883, *24678*
lighting
 description of art seen by electric light, 1890, *3300*
 electric, *25898*

1856, *19564*
1875, *8366*
1879, *735*
1883, *24424*
1884, *1889, 10945*
1894, *27027*
admission of women to life classes, *11230*
annual awards, 1893, *26946*
annual distribution of prizes, 1892, *26656*
art school to be built at Columbia University, 1905, *13899*
awards, 1896, *5857*
classes, 1855, *19200*
classes, 1881, *9550*
classes, 1892, *26752, 26816*
classes, 1901, *13270*
classes and prizes, 1903, *8279*
classes, curriculum and teachers, 1883, *24716*
classes offered, 1883, *24800*
description, 1884, *11063*
exhibitions, 1875, *8461*
free schools, 1903, *13658*
history, *11035*
instructors and classes, 1883, *24678*
life class described by instructor Wilmarth, 1887, *2350*
notice, 1893, *4586*
notice of life classes, 1903, *8207*
opening, 1891, *26391, 26396*
prizes, 1895, *21554*
student awards, 1883, *24599*
student baseball, 1883, *24586*
student work exhibited, 1897, *6306*
students must be under 30 years old, 1904, *13793*
Students' Society, *280*
summer classes, 1900, *13059*
travel scholarship, 1891, *26411*
tuition abolished, 1902, *13503*
Sunday openings
 1883, *24948*
 free, 1898, *6551*
 to public, 1883, *24946*
support of John Armstrong Chanler's plan, 1891, *26253*
New York. National Arts Club
building
 club house opening planned, 1899, *12909*
 clubhouse opens, 1899, *17607*
competition with L. Windmuller for right to exhibit American paintings from Paris Exposition, 1900, *7451*
congress, 1892, *3985*
exhibitions
 1899, *Art Amateur* educational exhibit, *7158*
 1899, Woman's Art Club, *7153*
 1900, J. L. Breck, *7265*
 1900, John Leslie Breck, *13021*
 1901, glass, *7589*
 1901, planned, *7740, 7772*
 1902, Municipal Art Society, *7877*
 1903, *13594*
 1903, American ideal art, *8199*
 1903, early American painting, *8242*
 1903, F. W. Stokes polar paintings, *8157*
 1903, Loie Fuller art collection, *8222*
 1905, *13993*
 1906, E. S. Curtis photography of American Indians, *14088*
goal to establish artistic standards for manufacturers, 1899, *7124*
incorporated, 1898, *6811, 12783*
lectures
 D. C. Beard talk, 1903, *8146*
 John W. Alexander lecture on American artists, 1901, *7776*
 L. H. Meakin on *Development of art in the Middle East*, 1903, *8102*
library for artists planned, 1900, *7426*
members, 1883, *24525*
movement to establish club, 1898, *12688*
starts subscription for rebuilding Venice Campanile, 1902, *7993*

New York. National Conservatory of Music of America
concert, 1892, *26808*
New York. National Philatelic Society See: **National Philatelic Society**
New York. National Sculpture Society
aims, exhibition, works, 1896, *6058*
annual banquet, 1901, *7611*
annual exhibitions
 1894-5, *27026*
 1895, announcement, *11522*
 1898, *6647*
collects photographs of sculpture, *12071*
competitions
 design for U.S. silver dollar, 1894, *5002*
 prize for silver-dollar design, 1894, *27006*
 sundial design, 1897, *6389*
Curran painting commemorating exhibition, 1896, *5778*
Dewey arch project, 1899, *7098*
election of officers
 1893, *26969*
 1906, *14071*
exhibitions
 1893, *4560, 4647*
 1895, *5373, 11549, 16749, 21564*
 1895, coins and medals, *16767*
 1898, *6545, 12721, 12733*
 1898, Photographic Competition, *6583*
 1902, *13379, 13525*
 1902, held jointly with New York Florists' Club, *8059*
 1902, planned for Madison Square Garden, *7877*
 1902, sculpture and horticulture, *13515*
 1902, two exhibitions planned, *7873*
 1905, portraits, *13993, 14009*
founding, 1893, *22492*
fund for artists' home, *14161*
issues circular, 1893, *26983*
meeting, 1894, *16462*
movement to build home for superannuated artists, *14193a*
notes, 1894, *4938, 22521, 22540*
offers services of sculptors for Dewey reception, 1899, *12931*
opposes Grand Army Memorial, New York, 1898, *6551*
pamphlet encouraging public art as good business, 1905, *13936*
planned, 1893, *26961*
rejects E. Herter's monument to Heine, 1896, *5611*
seceding sculptors establish new Society of American Sculptors, 1904, *13760*
New York. National Society of Mural Painters
annual banquet
 1896, *17053*
 1901, *7611*
annual meeting, 1898, *6669*
description, 1895, *22787*
Dewey arch project, 1899, *7098*
elections, 1897, *6109*
incorporated, 1895, *11571, 16768*
notes, 1895, *5336*
preparations for reception of Admiral Dewey, 1899, *7072*
New York. New York Academy of Sciences
History of the New York Academy of Sciences, 1817-1886, publication announced, 1886, *504*
New York. New York Academy of the Fine Arts See: **New York. American Academy of the Fine Arts**
New York. New York Aquarium
acquisitions, 1897, presented with Castle Garden platter, *17218*
New York. New York Art Guild
incorporated, 1891, *15797, 26303*
New York. New York Botanical Garden
establishment in Bronx proposed, 1889, *2915*
New York. New York Etching Club, *9339, 15100*
anecdote, 1883, *24382*
annual exhibitions
 1882, *24391*
 1883, *24393, 24416, 24428*
 1884, *10932, 25013*
 1884, sales, *10978, 25074*

miniatures, *1575*
NIXON, Mary E., *12749*
Nixon, Netta, fl.1896-1903
exhibitions, Chicago, 1896, *11813*
NIXON, Richard, *17814*
Noack, Christian Karl August, 1822-1905
class in drawing and painting at Ladies' Art Association of New York, 1891, *26279*
Noak, Carl See: Noack, Christian Karl August
Noble, Edith A., fl.1896
notes, 1896, *22958*
Noble, John Sargeant, 1848-1896
exhibitions, Royal Academy, 1879, *21730*
NOBLE, Louis Legrand, 1813-1882, *14576*
Noble, Matthew, 1818-1876
Earl of Derby, K.G., *8494*
Her Majesty the Queen, *8977*
obituary, *8722*
statue of Oliver Cromwell erected in Manchester, 1876, *8639*
Noble, Thomas Satterwhite, 1835-1907
Auld lang syne, *9326*
exhibitions
Chicago Academy of Design, 1871, *10712*
Society of Western Artists, 1898, *Old fort at Ambletinse*, *12802*
head, McMicken School of Design, 1870, *10597*
notes, 1871, *10677, 10678*
obituary, *14320*
portrait, 1871, *10710*
river scene, *813*
Slave market, 1871, *10651*
Unprotected, *27015*
whereabouts, 1883, returns to Cincinnati from Europe, *24820*
Noble, William Clark, 1858-1938
exhibitions, Boston Art Club, 1893, *26923*
lawsuit against Burns Monument Association, *26770, 26779, 26923*
model for Burns monument, 1891, *26333*
statue of Robert Burns, *26116, 26907*
to be set up in Providence, R.I, *15797*
statue of William Ellery Channing, *26730*
Twelve stations of the Crucifixion, *23008*
whereabouts, 1892, Cambridge, *26703*
Noble, William P., fl.1860-1871
illustrations, masthead design for *The Sketch Club*, *24309, 24327, 24342*
notes, 1871, *10677*
picture of Dutch pioneer shown in Cincinnati, 1860, *24335*
sketch for Cincinnati Sketch Club meeting, 1860, *24347*
Nocquet, Paul Ange, 1877-1906
illustrations, *Dancing girl*, *14244*
sales and prices, 1906, money from sale to benefit mother and sister, *14126*
sculpture, *14094*
Noé, Amédée de, 1819-1879
illustrations, *Berlioz and Wagner*, *10397*
obituary, *9231*
Noël, Alphonse Léon, 1807-1884
illustrations, *Violent storm* (after J. Vernet), *20796*
Music is contagious!! (after W. S. Mount), *21458*
Noël, Charles
collection, sale, 1891, *15577*
Noël, Edme Antony Paul, 1845-1909
statue of Jean Houdon, *25890*
Noël, Gustave Joseph, b.1823
exhibitions, Paris, 1882, faïence panel of *Roquebrune*, *1438*
Noël, Jules Achille, 1815-1881
exhibitions, Pennsylvania Academy of the Fine Arts, 1858, *19858*
illustrations, *Conversation on a journey* (after Berghem), *21368*
obituary, *360, 21895*
Nogent, Joseph, *comte* de, b.1813
General de Lourmel, *18380*
Nolan, Caroline See: Nolen, Caroline

Nolau, François Joseph, 1804-1883
obituary, *14902*
Nolen, Caroline, fl.1877-1886
designer of stained glass, *503*
Noll, Charles See: Noël, Charles
Nollekens, Joseph, 1737-1823
bust of Garrick, *19634*
NOMAD, *23870*
Nomura Ninsei See: Ninsei
Nono, Luigi, 1850-1918
exhibitions
Esposizione Internazionale di Belle Arti, Rome, 1883, *9795, 14884*
Internationale Kunstausstellung, Munich, 1883, *14916*
Refugium Peccatorum, *9853*
Noonan, Edith, b.1881
illustrations, painting, *8289*
Norblin de Lagourdaine, Louis Pierre Martin
collection, sale, 1855, *18726*
Norcross, Eleanor, 1854-1923
exhibitions
American Woman's Art Association of Paris, 1897-8, *23992*
National Academy of Design, 1886, *25370*
Salon, 1902, *13414*
Salon, 1906, *14116*
Woman's Art Club of New York, 1891, *26292*
study abroad, 1886, *25312*
Norcross, Emily Danforth, 1848-1909
exhibitions, Boston, 1885, *1964*
illustrations, sketch from model, *572*
Nordau, Max Simon, 1849-1923
criticism of Puvis de Chavannes, *22359*
Degeneration, criticism by G. B. Shaw, *22355*
notes, 1896, *23161*
Nordenberg, Bengt, 1822-1902
Communion in a village church, *22986*
Nordfeldt, Bror Julius Olsson, 1878-1955
exhibitions
Chicago Art Institute, 1902, *13536*
Chicago Art Institute, 1903, *13561*
Chicago Art Institute, 1905, *14017*
Nordhoff, Evelyn Hunter, d.1898?
exhibitions
Architectural League of New York, 1897, *10535*
Minneapolis Arts and Crafts Society, 1901, *13184*
monuments, memorial tablet erected, 1900, *7201*
obituary, *6877*
studio, sets up New York atelier, 1897, *17318*
Nordica, Lillian, 1859-1914
difficulties with Jean de Reszke, *23853*
Nordiska Museet See: Stockholm (Sweden). Nordiska Museet
Nordström, Karl Fredrik, 1855-1923
exhibitions
Chicago, 1896, *11758*
Chicago Art Institute, 1896, *5734*
Norfolk (county, England)
Broads, *10304*
Norfolk, Thomas Howard, *2nd duke of*, 1443-1524
biography, *20893*
Norfolk (Virginia). Art League
exhibitions, 1895, *22738*
Norfolk (Virginia). College of William and Mary
students organize Portfolio Society, 1891, *3524*
NORIMEAD, H. E., *5981, 6017, 6159*
Norman country See: Normandy
NORMAN, Henry, *9758*
Norman, John, ca.1748-1817
engravings of George and Martha Washington sold, 1888, *631*
Norman, William B., 1846?-1906
notes, 1892, *15995*
praise, *2406, 15847*
Normand, Adelsteen See: Normann, Eilert Adelsteen
Normand, Ernest, *Mrs.* See: Normand, Henrietta Rae

painting defended by George A. Hearn, *5217*
Roadside inn, 21018
sales and prices, 1893, *4387*
Ostend (Belgium)
description, *20991*
Österman, Carl Emil, 1870-1927
exhibitions, Louisiana Purchase Exposition, 1904, *13831*
Osterreichesches Handels-Museum See: **Vienna (Austria).
Osterreichesches Handels-Museum**
OSTERTAG, Blanche, *12624, 12748, 12834*
Ostertag, Blanche, fl.1897-1913, *12799*
art, *12641*
awarded Revell prize, 1898, *12248*
Chicago member of Society of Western Artists, *12122*
exhibitions
 Chicago, 1898, *12113*
 Society of Western Artists, 1898, *Rug weavers* and
 Dreamers, 12802
illustrations
 calendar poster, *12867*
 monotypes, *12075*
 portrait drawing of William Wendt, *13085*
 poster, *13148*
 *Reading of the Declaration of Independence before the Army
 in New York July 9th 1776, 9004*
illustrator of *Memories* by Max Müller, *13466*
pastels, *11934*
prints for schoolroom decoration, *12815, 12879*
Teco pottery, *13360*
Osthaus, Edmund Henry, 1858-1928
illustrations
 Leaders, 12986
 Siesta, 13388
 Slow music, 13542
painter of animals, *14180*
Ostia (Italy)
antiquities, statues found, 1881, *383*
Ostia (Italy). Museo Ostiense
founded, 1878, *9028*
Ostner, Charles Hinkley, fl.1856-1859
equestrian statue of George Washington for Idaho capitol,
 14028
Ostrander, William Cheesbrough, b.1858
Fairy's hammock, 22741
Ostroumova Lebedeva, Anna Petrovna, 1871-1955
exhibitions, Moscow, 1905, *13943*
Ostu, Elie, fl.1891
whereabouts, 1891, New York, *26411*
O'SULLIVAN, John Louis, *20688, 20723*
O'Sullivan, John Louis, 1813-1895, *20727*
O'Sullivan, William J.
collection of mortuary curiosities, *16661*
Osuna, Mariano Téllez Girón y Beaufort, *12e duque* de, 1814-
1882
collection
 exhibited in Madrid, 1896, *17042*
 sale, 1896, *17068*
library, acquired by German government, 1883, *14886*
Osvaldo, Pietro Paoletti di See: **Paoletti, Pietro**
Oswald, Frederick Charles, b.1875
exhibitions
 Chicago Art Students' League, 1897, *12643*
 Chicago Art Students' League, 1898, *12819*
Otero, Carolina, 1868-1965
notes, 1897, *23170*
Otero, La Belle See: **Otero, Carolina**
Otis, Bass, 1784-1861
portrait of Gilbert Stuart, *17040*
Otis, Elita Proctor, 1851?-1927
interview, 1897, *23170*
Otis, Fessenden Nott, 1825-1900
collection, to be sold, 1890, *15377*
Otis, Harrison Gray, 1765-1848
library, sale, 1889, *14977, 15023*

Otis, James, 1725-1783
monuments, statue by Thomas Crawford arrives in Boston,
 1858, *18243*
Otis, William Augustus, 1855-1929
illustrations, Episcopal Church, La Crosse, Wis., *12887*
lecturer, Art Institute of Chicago, 1898, *12701*
Otlet
collection
 acquired by Boussod, Valadon, and Co., 1892, *3924*
 sale, 1903, *13551*
Ott & Brewer, Trenton
Belleek pottery, *13344*
Ott, Ralph Chesley, b.1875
exhibitions, Salon, 1896, *11825*
Ottawa (Ontario). Art Association of Ottawa
notes, 1884, *25061*
Ottawa (Ontario). Royal Canadian Academy of Arts
annual exhibitions, 1906, *14124*
founded, 1880, *9310*
Ottenfeld, Rudolf Otto, *Ritter von*, 1856-1913
Guardian of the Harem, at Avery Art Gallery, 1890, *15070*
Ottenheim, fl.1890's
photograph of horse trotting, 1890, *26185*
Ottenheimer, Henry A., 1868-1919
illustrations
 hall, dining room, *20565*
 residence of J. Straus, *20555*
Otter & Williams, firm See: **Williams & Otter, firm**
Ottin, Auguste Louis Marie, 1811-1890
obituary, *26213*
Ottinger, George Martin, 1833-1917
elected president, Utah Art Institute, 1903, *13637*
Otto, Bodo, 1711-1787
portraits, portrait by Henry M. Otto, *22765*
Otto, Henry M.
portrait of Bodo Otto, 1895, *22765*
Otto, Karl, 1830-1902
obituary, *13533*
Otto, Martin Paul, 1846-1893
obituary, *26941*
Ottoni, C., fl.1878
Christ dying on the cross, 9049, 21648
Oudh (India)
kings, *20910*
Oudheidkundige musea See: **Antwerp (Belgium).
Oudheidkundige musea**
Oudinot, Achille François, 1820-1891
collection, *17787*
 sale, 1886, *2177*
exhibitions, Boston, 1877, *8934*
pupil of Corot, *22787*
whereabouts, 1883, Concarneau, *24736*
Oudinot, Eugène Stanislas, 1827-1889
obituary, *25716*
Oudry, Jean Baptiste, 1686-1755, *21178*
animal painter, *23022*
OUINA, *20652*
Ouless, Walter William, 1848-1933
exhibitions
 Royal Academy, 1878, *21590*
 Royal Academy, 1879, *21698*
 Royal Academy, 1880, *21850*
 Royal Academy, 1881, *21999*
 Royal Academy, 1885, *2019*
portrait of Darwin, etched by Rajon, *8994*
portrait of Sir Frederick Mappin, *26844*
prepares portraits, 1878, *21655*
studio, *22604*
Ouseley, William Gore, 1797-1866
illustrations, *Falls of Itamarity, 21191*
outdoor life
Norway, *22715*
popularity of countryside, *18019*
Outrim, John, fl.1840-1874
illustrations, *Napoleon in the prison of Nice, 1794* (after E. M.

London, 1859, *18343*
London, 1860, *20235*
National Academy of Design, 1850, *14615*
National Academy of Design, 1861, *20354*
National Academy of Design, 1885, *25271*
Flight into Egypt, *17991*
Governor Marcy, *19183*
Holy Family, in Boston Athenaeum, 1850, *14676*
lecture at Athenaeum Club, 1860, *20302*
letter from Florence, 1851, *14763*
letter from Rome on Titian, 1855, *18982*
Madonna and Child, *18680*
Moses on Mount Horeb, *19850*
obituary, *2069, 11238, 11275, 11287*
paintings in Boston Athenaeum, *20129*
portrait of Browning, not hung at Royal Academy exhibition, 1856, *19431*
portrait of Hiram Powers, Seymour Guy's comments, *10991*
portrait of Wright, *14537*
praise by press, 1861, *18542*
praised for fine colors, 1851, *14821*
president, National Academy of Design, 1871, *10721*
quote, on Titian's *Danaë*, *19038*
studio
New York, 1870, *10595*
Rome, 1856, *19430*
subject of anonymous epigram, *18543*
teaching, first life class for women, National Academy, *11230*
theory of color, *2271*
Venetian qualities of paintings, *18647*
Venus, *18379, 18417, 20093, 20114, 20127*
Venus on a dolphin, *17962*
whereabouts
1850, Europe, *14606*
1850, Florence, *14696*
1850, Paris, *14657*
1851, England, *14779*
1854, Rome, *18633*
1857, *19682, 19752*
1859, trip to London, *20064*
1860, returns from Rome, *20272*
work, 1857, *19667*
works sent to Boston, 1857, *19609*
Page, William, *Mrs.* See: **Page, Sophia Candace Stevens Hitchcock**
Pages, Jules, 1867-1946
Corner of the studio, *22072, 22092*
exhibitions, Chicago Art Institute, 1900, *13137*
notes, 1902, *22161*
sales and prices, 1900, *Corner of the studio*, *22114*
whereabouts, 1890, return to San Francisco from Paris, *26026*
Paget, Henry Marriott, 1856-1936
exhibitions, Royal Academy, 1881, *21999*
PAGET, Violet, *9890, 9945*
Paget, Violet, 1856-1935
Euphrion, review, *10090*
Paget, Walter Stanley, 1863-1935
illustrations for *Robinson Crusoe*, 1891, *26214*
Paillet, Eugène, 1829-1901
library, sale, 1887, *2516*
PAINE, Albert Bigelow, *12735*
Paine, Birdsall D., b.1858
illustrations
Misery loves company, *22590*
Sudden squall, *22531*
summer home and studio, *22571*
Paine, Cornelius
library, sale, 1891, *15620*
PAINE, Robert Treat, *13683*
Paine, Robert Treat, 1835-1910
monuments, statue to be erected in Taunton, Massachusetts, 1903, *8180*
Paine, Thomas, 1737-1809
portraits, portrait by Romney, *16905*
whereabouts of remains, *16787*

paint
See also: **colors; pigments**
artist's palette, *10109*
colors and hints for figure painting, *1780*
compressible tubes, *19545*
development of paint tubes, *19369*
Devoe & Co. pigments recommended by artists, 1883, *24728*
Dresden moist watercolors brands, 1891, *3610*
history of application, *10845*
Hunt on artists' colors, *9396*
materials
aureolin compared with cadmium, *7938*
bitumen an unsafe pigment, *7695*
brown oil paints, *4887*
brown paint and bitumen, *6706*
color chart, *6639*
creosote stains develped by S. Cabot, *518*
discoloration of green paint, *17386*
durability of oil colors, *4479*
for coloring photographs, *1331*
for landscape painting, *1152*
for landscape painting in oils, *1188, 1206*
for landscape painting in water colors, *1170*
for scene painting, *1316, 1969, 1986, 2004, 2041, 2054*
for stencil decoration, *1743*
for watercolor painting, *1223*
mediums for oil painting, *4259, 6315*
moist watercolors for china painters, *5365*
oil painting mediums problems, *3841*
painting photographs in oil, *1387*
paraffin as medium, *4105*
perishability of artists' pigments, *1372*
permanency of certain colors, *2492*
poisonous colors, *5020*
quick-drying paint, *16702*
recipe for paint, *6433*
solid oil colors, *13463*
solvents, *953*
tempera and encaustic in ancient art, *20059, 20075*
tests for purity of colors, 1895, *5272*
use of bronze powders, *2865*
oil, *1593, 1867, 4033*
how to modify white oil paint, *6658*
preparation for painting, *22458*
sketching from nature, *1573*
pigments at Paris Exposition, 1849, *14545*
pigments dangerous to health, *2645*
pigments used by mediaeval artists, *982, 1007*
pigments used by modern artists, *1047*
preparing panels for painting, *1621*
qualities and uses of each color listed, *7945*
testing artists' colors, *1981*
watercolors, lack of permanency, *10339*
Paint and Clay Club, Boston See: **Boston (Massachusetts). Paint and Clay Club**
Paint and Clay Club, Columbus See: **Columbus (Ohio). Paint and Clay Club**
Paint and Clay Club, New Haven See: **New Haven (Connecticut). Paint and Clay Club**
Paint Club, Kansas City See: **Kansas City (Missouri). Paint Club**
PAINTER, *11127*
Painter, Landscape See: **Landscape Painter, A**
painters
American china painters, 1896, *5844*
American painters as etchers, *24712*
cognomens, *9808*
color blindness, *17464*
crowded profession, *24561*
dates of famous painters, *18112*
necessary qualitites, *20307*
painting
See also: categories of painting, including **bark; china; encaustic; figure; flower; fruit; genre; glass; gouache; house; landscape; miniature; mural; portrait; pyrography;**

Paris (France). Sorbonne See: Paris (France). Université
Paris (France). Théatre français
 collection, *22084*
Paris (France). Tour Eiffel
 description, 1889, *17863*
 notes, 1890, *25799*
 proposed, 1887, *10431*
 receipts, 1890, *26176*
Paris (France). Triennial Salon See: Paris (France).
 Exposition nationale, 1883
Paris (France). Tuileries
 facade decorations planned, 1890, *25713*
Paris (France). Union centrale des arts décoratifs
 campaign for extension of industrial art education, 1883, *1635*
 exhibitions
 1883, furniture, *1520*
 1884, ceramics, *1890*
 1887, *557*
 1890, *26064*
 1891, *3515*
Paris (France). Union centrale des beaux-arts appliqués à l'in-
 dustrie
 exhibitions, 1880, *1178, 9405*
 exhibitions and other activities, *9000*
Paris (France). Union des femmes peintres et sculpteurs
 annual exhibitions, 1907, *14270*
 exhibitions
 1883, *14867*
 1884, *25110*
 1885, Americans represented, *1981*
 wins right for women to attend Ecole Nationale des Beaux-
 Arts, 1896, *23709*
Paris (France). Université
 amphitheater decorations, *573*
Paris (France). University Dinner Club
 banquet, 1897, *23994*
 banquet, 1898, *24037*
Paris (Frances). Exposition internationale See: Paris
 (France). Galerie Georges Petit
Paris, Walter, 1842-1906
 exhibitions, American Watercolor Society, 1884, *25038*
 founder of Tile Club, *11267*
Paris(France). Musée des moulages See: Paris (France).
 Musée de sculpture comparée
Park, Patrick, 1811-1855
 obituary, *19069*
Park, Richard Henry, b.1832, *11581*
 bust of Vice-President Hendricks rejected, 1887, *611*
 commission for Chicago sculpture, 1901, *13270*
 commission for Lincoln Monument under consideration, 1883,
 24685
 illustrations, *Bacchante, 11578*
 model for Religion, A. T. Stewart Memorial Church, *804*
 monument to Poe, 1885, *1981, 25283*
 monument to Thomas A. Hendricks, *25959*
 notes, 1896, *5862*
 Poe memorial, *24553*
 sales and prices, 1883, *Early sorrow, 24868*
 sculpture in Stewart collection, *10773*
 statue of Justice, Ada Rehan to pose, 1892, *26778*
 statue of Thomas A. Hendricks for Indianapolis, 1890, *25929*
 statue of W. A. Gresham, *22765*
 Venus triumphant, in Louisville's Southern Exposition, 1883,
 24760
Park, Stuart James, 1862-1933
 exhibitions
 St. Louis Exposition, 1896, *Gypsy maid, 6011*
 St. Louis Exposition, 1897, *12015*
 Glasgow School painter, *14152*
 illustrations, *Gypsy maid, 11873*
Parker, Anna Fenn See: Pruyn, Anna Fenn Parker
Parker, Charles S., 1860-1930
 exhibitions, American Art Association, 1886, *2344*
 notes, 1894, *16480*

Parker, Cordelia Newell, fl.1900
 first prize for stained glass, 1900, *12452*
Parker, Edward Griffin, 1826-1868
 Reminiscences of Rufus Choate, review, *20169*
Parker, Edythe Stoddard, fl.1903-1910
 illustrations, fountain of the Great Lakes, *13612*
Parker, Elizabeth F., fl.1883-1891
 exhibitions
 American Watercolor Society, 1885, *25239*
 Woman's Art Club of New York, 1891, *26292*
Parker, Emily See: Groom, Emily Parker
Parker, Francis Wayland, 1837-1902
 on teaching art in public schools, *11743*
Parker, Gilbert, 1862-1932
 Seats of the Mighty, review, *12541*
Parker, Harvey D.
 collection, Dutch and Flemish etchings exhibited at Boston
 Museum of Fine Arts, 1902, *13525*
 gift to the Boston Museum of Fine Arts, 1884, *1832*
Parker, Henry Taylor, 1867-1924
 excerpt on Rodin's Balzac, *12769*
Parker, John Henry, 1806-1884
 Introduction to the Study of Gothic Architecture, review, *20389*
PARKER, Lawton S., *13494*
Parker, Lawton S., 1868-1954
 exhibitions
 American Art Association of Paris, 1897, *24010*
 American Art Association of Paris, 1899, *12890*
 Carnegie Institute, 1907, honorable mention, *14328*
 Chicago Art Institute, 1902, *13536*
 instructor, Beloit College, 1893, *11319*
 prize for portraiture, Paris, 1898, *12146*
 wins Chanler Paris Art Scholarship, 1896, *17154*
Parker, Louis Napoleon, 1852-1944
 Mayflower, story outlined, 1897, *23250*
Parker, Minerva See: Nichols, Minerva Parker
Parker, Neilson T., *Mrs.* See: Steele, Zulma
Parker, Stephen Hills, 1852-1925
 exhibitions, Prize Fund Exhibition, 1885, *Sibyl, 25278*
 illustrations, *Norman peasant, 2443*
Parker, William Gordon, b.1875
 illustrations
 Argument, 22752
 sketch, *21519*
Parker, Zulma Steele See: Steele, Zulma
PARKES, Dacre, *9553*
Parkes, Henry, 1815-1896
 autograph collection, sale, 1897, *17245*
PARKHURST, Daniel Burleigh, *3545*
Parkhurst, Daniel Burleigh, fl.1883-1898
 exhibitions, National Academy of Design, 1885, *25271*
 illustrations, *November - beechwood, 12184*
 Painter in Oil, review, *12184*
 Sketching from Nature, excerpt, *3293, 3319*
Parkhurst, Harry L. See: Parkhurst, Henry Landon
Parkhurst, Henry Landon, 1867-1921
 biographical sketch, *11446*
 illustrations
 fifteen minute sketches, *11329*
 In Lincoln Park, Chicago, 22663
 Study, 22519
Parkinson, Ella P., 1861?-1893?
 obituary, *22521*
PARKINSON, T. Dwight, *22617, 22753*
Parkman, Francis, 1823-1893
 autobiography, read at Massachusetts Historical Society, 1893,
 16428
 examines authenticity of Sharples' portraits of Washington,
 10763
 manuscript collection, *16394*
 Vassell Morton, review, *19444*
parks
 See also: **national parks and reserves**
 excerpt from *Garden and Forest*, 1892, *26547*
 United States

city parks, *13095, 13635, 18896*
Kansas City, *13700*
New Jersey, Llewellen Park, *19677*
Parlaghy, Vilma Elisabeth, *princess Lwow*, 1863-1924
criticism, 1896, *17140*
exhibitions, Chicago World's Fair, 1893, *4651*
portrait of Admiral Dewey, *13128*
portrait of Empress commissioned, 1891, *26323*
portrait of Kuno Fischer, *13309*
Parliament See: **Great Britain. Parliament**
Parliament buildings See: **London (England). Parliament buildings**
Parlon, Albert M., fl.1896
decorations on glass lamps, *11893*
Parma (Italy)
description, *14749*
Parmelee, Elmer Eugene, 1839-1861
exhibitions, National Academy of Design, 1858, *19857*
Parmelee, Irene E., d.1939
exhibitions, Prize Fund Exhibition, 1886, *25304*
Parmelee, Lorin G.
collection
coins sold, 1890, *15216, 15256*
sale, 1890, *15235*
PARMENTER, F. A., 18377
Parmentier, Annette See: **Moran, Annette Parmentier**
Parnassiens See: **French poetry**
Parnassos, Athens See: **Athens (Greece). Philologikos Syllogos Parnassos**
Parnell, John Howard, 1843-1923
whereabouts, 1896, United States, *23038*
parody in art
in illustration, *22716*
parquet floors
increased use, *20526*
Parris, Edmund Thomas, 1793-1873
Bridesmaid, shown in New York, 1900, *7452*
Parrish, Clara Weaver, 1861-1925
exhibitions
American Watercolor Society, 1892, *3893*
Architectural League of New York, 1897, *10535*
Woman's Art Club of New York, 1892, *26542*
Woman's Art Club of New York, 1896, *22958*
illustrations
decorative panel, *22525*
Going to market, 22486
models, favorite model, *22519*
Parrish, Maxfield, 1870-1966, *12565*
appointed associate member of National Academy, 1905, *13953*
Century poster competition, 1896, 2d prize, *22413*
exhibitions
Pennsylvania Academy of the Fine Arts, 1905, *13851*
Society of American Artists, 1897, *10538*
illustrates Irving's *Knickerbocker History of New York*, *13140*
illustrations, cover design, *12691*
illustrator of *Mother Goose in Prose*, *12660*
line illustration, *12996*
mural decoration for Pennsylvania Academy of the Fine Arts, *11964*
posters, *12612*
Century Magazine, 12867
poster for Columbia bicycles, *22388*
Parrish, Samuel Longstreth, 1849-1932
collection, exhibited at American Fine Arts Society, 1893, *4315*
Parrish, Stephen, 1846-1938
etchings, *196, 11335*
1883, *24820, 24897*
1886, *514*
exhibitions
American Art Union, 1883, *November twilight, 10913*
Boston, 1881, etchings, *1108*
Boston Museum of Fine Arts, 1880, *225*
London, 1883, etchings, *24713*
National Academy of Design, 1880, *9324*
National Academy of Design, 1884, *1790, 25125*

New York, 1886, etchings, *516, 2343, 10744, 10748*
New York Etching Club, 1882, *1296, 24391*
New York Etching Club, 1884, *1734, 25013*
New York Etching Club, 1888, *10843*
New York Etching Club, 1889, *2887*
Pennsylvania Academy of the Fine Arts, 1881, *1128*
Philadelphia Society of Artists, 1883, *1490*
Prize Fund Exhibition, 1886, *2226, 25304*
Salon, 1885, *2035*
Salon, 1886, *2193*
illustrations, *On the Rance - Brittany, 2211*
quote, responds to review in *Art Amateur*, 1887, *2364*
sales and prices, 1883, etchings in London, *24829*
whereabouts, 1887, summer travel, *2543*
Parrish, Thomas, 1837-1899
exhibitions, New York Etching Club, 1889, *2887*
Parrish, William P., *Mrs.* See: **Parrish, Clara Weaver**
parrots
extinct parrot mounted by Smithsonian, 1896, *17188*
Parry, Charles Christopher, 1823-1890
herbarium and library, *16531*
Parsees, *13948*
PARSEY, Leo, *4164, 4214, 4262, 4679*
Parsis See: **Parsees**
Parsons, Alfred, 1847-1920
exhibitions
American Watercolor Society, 1882, *1300*
American Watercolor Society, 1885, *25239*
London, 1883, *24615*
London, 1884, *10983*
London, 1885, watercolor drawings, *10151*
New York, 1890, drawings, *25805*
New York, 1890, monochrome paintings, *3208*
New York, 1893, flower paintings done in Japan, *22483*
New York, 1893, Japanese pictures and objects, *26916*
New York, 1893, watercolors of Japan, *4359, 16171*
Royal Institute of Painters in Water Colours, 1883, *24684*
Vienna Salon, 1894, *16544*
illustrations
drawings of English countryside, *10117*
Evening, 4843
Fallen, 21613
Pompeii cemetery, *21908*
views along Avon River, *10130*
Vilkoff, 22476
Japanese watercolors purchased by Royal Uyeno Park Museum, Tokyo, 1893, *22249*
member, Tile Club, *1851*
picture in Layton Art Gallery, Milwaukee, *12813*
Parsons, Antoinette de Forest See: **Merwin, Antoinette de Forest**
Parsons, Charles, 1821-1910
Abandoned, 22495
artists' reception, New York, 1858, *19784*
Catskill Falls (after B. G. Stone), *19518*
exhibitions
American Watercolor Society, 1881, *1065*
American Watercolor Society, 1883, *Magnolia beach, 1510*
American Watercolor Society, 1884, *25023*
National Academy of Design, 1858, *19857*
illustrations
Absalom, 18329
illustrations for N. Willis' *An extract from a poem delivered at the departure of the senior class of Yale College in 1827, 18357*
Sandy Hook, 534
illustrations for *Harper's*, *22476*
member, Tile Club, *11267*
newspaper illustrations, *16557*
watercolor sketches of sunsets, *19829*
Parsons, Frances Theodora Smith Dana, 1861-1952
Plants and Their Children, review, *23251*
PARSONS, Frank Alvah, *4683*
Parsons, Frederick, fl.1892-1895
whereabouts, 1894, Boston, *27014*

portraits, *977*
process of photographic enlargement, *549*
renaissance, 1890's, *22557*
revival in 1880's, *10352*
societies of artists, 1885, *1963*
technique, *1370, 1385, 1419, 2313, 2530, 3763, 3811, 3864, 3980, 4203, 4866, 5461, 6065, 7050, 7407, 7651, 7702, 7778, 25091*
 and artists' materials, *4879*
 and materials, *8176*
 for beginners, *5707*
 how to make pastels, *8268*
 J. Wells Champney on materials, technique, and copying, 1895, *5491*
 landscape and portraits, *3843*
 materials, *7022*
 paper, *7598*
 paper for pastel painting, *5975*
 use of the stomp, *5047*
pastel drawing, American
 exhibitions
 1883, autumn exhibition planned, *1530*
 Society of Painters in Pastel, 1884, *9998*
 Pastellists Club organized in Chicago, 1897, *11934*
 pastellists organize, 1884, *24991*
 Society of Painters in Pastel's first exhibition, 1884, *25089*
 work of J. Wells Champney and others, *22557*
Pastel Society, London See: **London (England). Pastel Society**
Pastellists Club, Chicago See: **Chicago (Illinois). Pastelists**
Pasternak, Leonid Osipovich, 1862-1945
 exhibitions, Moscow, 1905, *13943*
 illustrations, portrait, *13759*
Pasteur, Louis, 1822-1895
 as artist, *11688*
 portrait of M. Chappuis (lithograph), in Marcou collection, *17787*
 portraits, engraving by Flameng, after Edelfeldt, *15998*
PATCHIN, Calista Halsey, fl.1879-1914, *664, 667, 701, 757, 772, 816, 1260, 1558, 1579, 1596, 1609*
Pater, Walter, 1839-1894
 quote, *22955*
 Story of Cupid and Psyche, review of translation fromm Apuleius, *13434*
Paterson, Helen See: **Allingham, Helen Paterson**
Paterson, James, 1854-1932
 exhibitions, St. Louis Exposition, 1895, *11622*
 Glasgow School painter, *22394*
 illustrations
 Castlefairn, *11625*
 views of Manor House, South Wraxall, *9895*
 notes, 1895, *16814*
Paterson, Robert, fl.1870-1889
 illustrations
 Angel (after A. Pollaiuolo), *9614*
 Caesar's Tower, Warwick (after Alfred Parsons), *10117*
 Durham (after W. E. Lockhart), *21999*
 etching and paintings after Colin Hunter, *10136*
 figure paintings (after H. Reid), *9711*
 illustrations of poetry (after J. McWhirter), *21690*
 La Mortola, *10062*
 New University Club (after W. Hatherell), *10129*
 Newcastle-upon-Tyne (after J. O'Connor), *9682*
 Reform and Carlton Clubs (after W. Hatherell), *10142*
 Rochester castle (after W. H. J. Boot), *21680*
 Totnes, from the river (after W. H. J. Boot), *21674*
 view of Lumley Castle, *21901*
 views along Avon River (after Alfred Parsons), *10130*
 views of Derbyshire, England (after W. H. J. Boot), *21740*
 views of Dovedale, England (after W. H. J. Boot), *21711*
 views of Holloway College, *10102*
 views of Hull (after W. L. Wyllie), *9592*
 views of Isle of Arran (after F. Noel-Paton), *10166*
 views of Portsmouth (after C. N. Hemy), *9605*
 views of Shere (after J. McWhirter and others), *9626*

Waterloo Place, with the United Service Club, *10176*
Patmore, Bertha G., fl.1876-1903
 exhibitions, Royal Academy, 1878, *21650*
Patmore, Coventry Kersey Dighton, 1823-1896
 Angel in the House: the Espousals, excerpts, *19526*
Paton, Jacqueline See: **Comerre Paton, Jacqueline**
Paton, Joseph Noel, 1821-1901, *9462, 21744*
 Beati Mundo Corde, *26227*
 Bond and free, *23295*
 exhibitions
 London, 1890, *26059*
 Royal Scottish Academy, 1880, *21872*
 illustrations
 Adversary, *21736*
 views of Isle of Arran, *10166*
 Muck-rake, *9127*
 notes, 1896, *23038*
 obituary, *7822, 13353*
 Vigilate et orate, *26044*
Paton, Noel See: **Paton, Joseph Noel**
Paton, Waller Hugh, 1828-1895
 exhibitions, Royal Scottish Academy, 1879, *21736*
 obituary, *16705*
Patras (Greece)
 antiquities, excavations, 1896, *17191*
Patrick, John Douglas, 1863-1937
 exhibitions, St. Louis Artists' Guild, 1891, *3483*
Patrois, Isidore, 1815-1884
 exhibitions, Pennsylvania Academy of the Fine Arts, 1858, *19858*
PATTEE, Elmer Ellsworth, d.1925, *23618*
Pattee, Elmer Ellsworth, d.1925
 account of art supplies in U.S., 1897, *23936*
 exhibitions, American Art Association of Paris, 1898, drawings, *24010*
 organizer of Art Talk Club, American Art Association of Paris, *24019*
Pattee, Fred Lewis, 1863-1950
 illustrations, illustration from "Mary Garvin", *8109*
Pattein, César, fl.1882-1914
 illustrations, *Oracle*, *7375*
Patten, Alfred Fowler, 1829-1888
 exhibitions, Royal Academy, 1850, *14644*
PATTEN, Benjamin Adam, *10714*
Patten, Julia M., fl.1892
 teacher of drawing at Chautauqua summer school, 1892, *26752*
PATTEN, William, *7182, 7208, 7232, 7252, 7266*
Patterson, Angelica Schuyler, 1864-1952
 exhibitions, National Academy of Design, 1903, *13547*
Patterson, Catherine Norris, d.1943
 elected vice-president, Philadelphia Plastic Club, 1905, *13914*
Patterson, Frank Thorne, *Mrs*. See: **Patterson, Catherine Norris**
PATTERSON, Henry S., *23373, 23479*
PATTERSON, John William, *13302*
PATTERSON, Wilfred, *17714, 17804, 17823*
Patti, Adelina, 1843-1919
 ability as songstress, 1884, *1716*
 McHenry-Patti album of photographs, *16589*
Pattison, Dorothy Wyndlow, 1832-1878
 English nurse, *10383*
Pattison, Helen Searle See: **Searle, Helen**
PATTISON, James William, *7188, 7342, 11403, 11563, 11703, 12687, 12707, 12752, 12800, 12813, 12902, 17623, 17667, 17682, 25004*
Pattison, James William, 1844-1915
 article on "sensuous art," 1884, *25047*
 Colorado scenes, *10570*
 exhibitions
 American Watercolor Society, 1884, *25012*
 Central Art Association, 1895, *11564*
 Central Art Association, 1897, *11955*
 Chicago Art Institute, 1896, *11894*
 Chicago Art Institute, 1899, *12423*
 Chicago Art Institute, 1903, *13673*

manufacture, *20735*
pens for drawing, *5080*
Prince's protean fountain pen, *19249*
PENTZ, P. C., *21509*
Peoli, John J. See: **Peoli, Juan Jorge**
Peoli, Juan Jorge, 1825-1893
collection, sale, 1894, *16562*
library, sale, 1896, *16996*
studio contents, 1883, *24424*
whereabouts, 1883, summer at Sandy Hill, N.Y, *24703*
Peoria (Illinois). Peoria Art League
exhibitions, 1905, *14088*
notes, 1895, *11670*
Peoria (Illinois). Peoria Public Library
building, *11671*
and mural decorations, 1897, *11947*
decoration by Peyraud and Maratta, *11793*
murals by H. G. Maratta and F. C. Peyraud, *5901*
Peploe, Fitzgerald Cornwall, 1861-1906
obituary, *14194*
Pepper, Charles Hovey, 1864-1950
exhibitions
American Watercolor Society, 1902, *13424*
New York Water Color Club, 1898, *Studies in Holland*, *6816*
Paris, 1897, *23998*
illustrations
Cherry dance, *13971*
Dutch youngster, *24148*
Girl in white, *24133*
In the Burgomaster's pew, *24182*
Kirmess, *23999*
Lady and the book, *24198*
White cottage, *24069*
Pepper, George Seckel, 1808-1890
obituary, *25892*
president, Pennsylvania Academy, 1890, *25898*
PEPPER, William, *25609*
Pepper, William, 1843-1898
monuments, statue by Karl Bitter, *12974*
Peppercorn, Arthur Douglas, 1847-1926
exhibitions
International Society of Sculptors, Painters, Gravers, 1907, *14248*
Royal Academy, 1907, *14312*
Pepys, Samuel, 1633-1703
Diary, new edition, *12557*
Peraire, fl.1884
exhibitions, Essex Art Association, 1884, *25102*
Peralta, Sophie Bendelari de See: **DePeralta, Sophie Bendelari**
Perard, Victor Semon, 1870-1957, *22554*
illustrations
design, *6881*
illustrations to article on Art Students' League, *22486*
scene in St. Augustine, Fla, *22576*
Stroller, *22513*
Taking a prospective view, *22546*
Tree's life-struggle, *22560*
Where can he be?, *22590*
illustrations for magazines, 1893, *22482*
portraits, photograph, *22502*
Printing House Square, *22503*
Perbandt, Lina von, 1836-ca.1884
exhibitions, San Francisco, 1897, *6453*
PERCE, Elbert, *22468*
Perce, Elbert, 1831-1869
editor, *Gulliver Joi*, *22471*
perception
selection in art, *19632*
sight, *18921*
Percier, Charles, 1764-1838
creator of Empire style furniture, *7887*
decorative arts designs, *1157*
Percy, Florence, *pseud.* See: **Allen, Elizabeth Ann Chase Akers**

Percy, Herbert Sydney, fl.1880-1903
exhibitions, Toronto, 1892, *26795*
illustrations
central figure in decorative design for a public building, *17775*
decorative design for public building, *10417*
Guy's Cliffe (after Alfred Parsons), *10117*
landscapes (after photographs by Berens), *10163*
North Easterly gale: Granston (after J. Brett), *10039*
Stall-work, Chester Cathedral, *10148*
views of Leith, *10040*
views of Whitby (after photographs by Sutcliffe), *10107*
Percy, Isabelle Clark, 1882-1976
illustrations, design for a bench, *22170*
Peregrine Pickle See: **Upton, George Putnam**
Perelli, Achille, 1822-1891
bust of Paul Morphy, *26322*
illustrations, *Child of the sea*, *17926*
monument of General Jackson, New Orleans, *237*
Pereyra, Vasco, b.1535
St. Peter enthroned as a pope, published as print, 1893, *4239*
Pérez, Alonso, fl.1893-1914
exhibitions, Chicago, 1902, *13399*
perfume bottles
collectors and collecting, Princess Marie of Rumania collection, *16419*
Pergamum
antiquities, *64, 268, 294*
sculptures from altar base, *9866*
Périgord, Maurice de Talleyrand, *duc de* Dino See: **Dino, Charles Maurice Camille de Talleyrand Périgord, *duc de***
Perino del Vaga, 1500-1547, *18338*
periodicals
See also: **illustrated periodicals**
Acorn, *20052*
Aesthetic Journal, founded, 1855, *19150*
American and English magazines of the 1850's, *18091*
American Architect
competition, 1880, *283*
praised, 1891, *15783*
American Art, description, *17763*
American Art Annual
1898 volume announced, *12808*
review of 1900-1901 edition, *13171*
review of 1904, *13730*
American Art Illustrated
declaration of purpose, 1886, *491*
French critic's comments, 1887, *586*
American Art Journal, 1892 issue, *15892*
American Art Review
article in the *Academy*, *178*
begins publication, 1879, *767, 9280*
ceases publication, 1881, *1216*
etchings, *1001*
statement of principles, *477*
statement of purpose, 1879, *3*
American Athenaeum, 1893, *16123*
American Etcher, first number, 1890, *25969*
American Journal of Fine Arts, plan and scope, *636*
American Journal of Numismatics, history, *15727*
anecdote, *16749*
Année Artistique
review of 1878, *30*
review of 1879, *189*
Applied Arts Book, founded by Applied Arts Guild, 1901, *13316*
Art Age, *11223*
stops publication, 1889, *14971*
Art Amateur
1883 issue praised by *The Studio*, *24380*
1889 prospectus, *2803*
1892, establishes bureau of art criticism and information, 1892, *4094*
1892 to feature drawing studies, *3794*
1897 prospectus, *6057*

Pettenkofen, August Xaver Carl, *Ritter* von, 1822-1889
 exhibitions
 Union League Club of New York, 1887, *2406*
 Vienna, 1889, *25679*
 painting shown in New York, 1892, *26638*
Pettie, John, 1839-1893, *21905*
 Death warrant, in Schwabe collection, *10238*
 exhibitions
 Glasgow Institute, 1880, *21848*
 London, 1884, *Crusader keeping watch over his armor*, *10983*
 Paris Exposition, 1878, *21610*
 Royal Academy, 1877, *8859*
 Royal Academy, 1878, *21581, 21590*
 Royal Academy, 1879, *9177*
 Royal Academy, 1880, *21863*
 Royal Academy, 1881, *21997*
 Royal Academy, 1882, *9642*
 Royal Academy, 1885, *2019*
 Royal Academy, 1887, *10473*
 Royal Scottish Academy, 1879, *21714*
 illustrations, *Mrs. Dominick Gregg and children*, *21831*
 obituary, *16157, 26919*
 sales and prices, 1893, *26976*
 studio, *22621*
Pettrich, Ferdinand Friedrich August, 1798-1872
 Dying Tecumseh, acquired by the Corcoran Gallery, 1878, *9047*
Pettus, James T.
 collection, description, 1897, *23190*
Petty FitzMaurice, Henry See: **Lansdowne, Henry Petty FitzMaurice, *3d marquis of***
Petzoldt, fl.1871
 sketch of Great Bear Canon, *10600*
Peyraud, Frank Charles, 1858-1948
 Chicago landscape painter, *11416*
 exhibitions
 Chicago, 1899, *12876*
 Chicago Art Institute, 1895, *11673*
 Chicago Art Institute, 1901, *13191*
 Chicago Artists' Exhibition, 1899, Young Fortnightly Club prize, *12310*
 Chicago Society of Artists, 1894, *11456*
 Cosmopolitan Club, Chicago, 1895, *11465*
 Cosmopolitan Club, Chicago, 1896, *11776*
 Minneapolis Society of Fine Arts, 1895, *11512*
 illustrations, *Last glow*, *13274*
 member of art jury, Tennessee Centennial, 1896, *11843*
 murals for Peoria Public Library, *5901, 11793, 11947*
 notes, 1896, *11736*
 whereabouts
 1895, Burlington, Wis, *22765*
 1898, New York, *12688*
 1898, will move from Chicago to New York, *12662*
Peyre, Emile, d.1904
 collection, woodcarvings left to Paris Museum of Decorative Arts, 1904, *13795*
Peyrol, Hippolyte, *Mme* See: **Bonheur, Juliette Peyrol**
Peyrol, Juliette Bonheur See: **Bonheur, Juliette Peyrol**
Peyton, Alfred Conway, *Mrs.* See: **Menzler Peyton, Bertha Sophia**
Peyton, Bertha Sophia Menzler See: **Menzler Peyton, Bertha Sophia**
Pezant, Aymar, b.1846
 cattle painting at Chicago World's Fair, 1893, *22532*
PFAU, Ludwig, *22326*
Pfeifer, Herman, 1879-1931
 prizes, 1907, *Woman's Home Companion* competition, fifth prize, *14300*
Pfitzer, Matthew, fl.1860-1861
 letter on recent work, from Oyster Point, L.I., 1861, *20332*
 oyster painter, *20167*
Phelan, James Duval, 1861-1930
 addresses California School of Design, 1891, *3483*
Phelps, Elizabeth Stuart, 1815-1852
 Madonna of the Tubs, illustrated by Turner and Clements, 1886,

509
Phelps, Elizabeth Stuart See: **Ward, Elizabeth Stuart Phelps**
Phelps, Helen Watson, 1859-1944
 exhibitions, Woman's Art Club of New York, 1903, *13703*
Phelps, William Preston, 1848-1923
 exhibitions, National Academy of Design, 1880, *889*
 sales and prices, 1899, *12837*
Phidias, ca.500-ca.430 B.C., *19788, 19805, 19822, 19841*
 sculpture for Temple of Zeus, Olympia, *88*
Philadelphia (Pennsylvania)
 architecture
 actor Joseph Jefferson's birthplace, *16814*
 Art Building, design competition, 1895, *16726*
 Betsy Ross house, *16905*
 homes illustrated, *17727*
 houses, *17711*
 Independence Square, *16738*
 National Bank of the Republic, *17715*
 Senate Chamber in Court of Common Pleas, *16925*
 art, *19733*
 1859, *20051, 20064, 20114, 20129*
 1860, *20146*
 1870, *10596*
 1871, *10619*
 1875, *8480*
 1883, *24608*
 1884, *10905*
 1887, private picture-galleries, *17787*
 1890, *3415*
 as art center, 1896, *11738*
 birthplace of American art, *27006*
 collection of Mr. Henry C. Gibson, 1891, *3500*
 donations by Daniel Baugh and Henry M. Bentley to buy art, 1890, *25918*
 mural paintings for John Sartain Public School, 1905, *13936*
 offer of Moorhead collection, 1902, *13403*
 presents pictures to Lexington, Ky., 1892, *26677*
 private collections, 1871, *10716*
 private collections, 1899, *17617*
 private collections acquire works by Frère, Achenbach, Leu, Weber, Wittkamp and Ten Kate, *19581*
 puritanical in terms of nudity, *3598*
 Widener to donate collection if city erects museum, 1903, *8199*
 art clubs meet, 1895, *21521*
 art schools compared with those in France and England, 1895, *5253*
 artist life, *11538*
 artists
 birthplace of many artists, *17315*
 exhibition of Philadelphia painters proposed, 1892, *26877*
 expatriates, *17527*
 lack of patronage, *25288*
 plan costume festival, 1901, *13208*
 plan to locate studios in one neighborhood, 1892, *26713*
 working, 1855, *18623*
 churches
 campanile begun for St. Elizabeth's Protestant Episcopal Church, 1902, *13473*
 new churches and synagogs, 1877, *8909*
 collectors, 1893, *16136*
 description, 1855, *18592*
 description by an English traveller, 1859, *20074*
 exhibitions
 1858, British exhibition, *19785*
 1858, watercolors for benefit of Hospital of Philadelphia, *19818*
 1898, photography, *6785*
 galleries, Wanamaker's Napoleon museum, *16553*
 history
 manuscripts sold, 1897, *17353*
 relics on display at World's Columbian Exposition, 1893, *16257*
 monuments
 Calder's statue of Gen. Meade for Fairmount Park, *592*

Newman's dry-colored photographs, *19328*
night photography, *703*
notes
 1881, *1050*
 1886, *2215*
 1887, *2462*
 1890, *26108*
 1892, *3949*
Orthochromatic method, *25319*
out-door photography, *10163*
P. M. C. Grenier portraits photographed on fabric, 1901, *7550*
paper negatives, *2098*
patents, 1890, *26116*
Philadelphia firsts, *16763*
photographic souvenirs, *3690*
photographs for wall decoration, *6132*
pictorial photography in America, *14107*
pictures of American Navy cruisers, 1890, *26080*
portraits, *2040, 12033, 12298, 19644*
 actresses, 1895, *22757, 22777*
 American artists, 1895, *22603*
 artists, 1894, *22559*
 Clark and Wade, *13052*
 collection of plates by Washington photographer A.
 Gardener, *16337*
 I. Benjamin, *12818*
 illustrations of artists, 1894, *22539*
 impressionist, *11654*
 in landscapes, *2417*
 indoors, *2832*
 notable men and women, 1896, *22943*
 painted and photographed, *2764*
 painting over photograph portraits, 1890, *3420*
 Photographers' Association of America Convention, 1899,
 12937
 photographs of American artists, 1893, *22502*
 photographs of American artists, 1894, *22518*
 portrait photography and painted portraits, *18280*
 posing, *2098*
 posing and illuminating, *11339*
 prominent people, 1896, *22988, 23015, 23038*
 prominent public figures, 1896, *22964*
 R. Peale on daguerreotypes, *19590*
 right to exhibit tried in court, 1859, *20045*
 studio of B. Tonnesen Chicago, *11864*
 work of Bushby & Macurdy, Boston, *493*
printing papers, *2971, 3024, 3042*
 Blanquart Everard's preparation, *14697*
 photo-cloride paper, *2944*
 plain paper, *3064*
printing processes, *2532*
 Gurney and Fredericks print on paper, *18560*
 how to avoid excessively high contrast, *3214*
 on opal glass, *2848*
prize offered by E. Anthony, 1851, *14753*
prizes offered by the League of American Wheelman, *26266*
proliferation, *18473*
Quarterly Illustrator prize competition, 1894, *22541*
Queen Victoria establishes photography department at Windsor
 Castle, 1895, *16792*
reproduction of art
 by F. Hanfstaengel, *15980*
 copying engravings, *18691*
 Hegger's carbon prints of masterpieces, *16953*
 photographic processes supplant wood engraving, *22307*
 trial, 1855, *19234*
rise of popularity of photography in Philippines, 1902, *7833*
Ruskin's view of role in teaching drawing, *18406*
Stillman's photographs of Athens, *15031*
subject of letter from London, 1857, *19607*
technique, *3027*
 advice on taking good photographs, *6344*
 and aesthetic advice, *6508*
 backgrounds, *11364*
 blue prints, *2868*

coloring photographs with aniline colors, *3189*
composite photographs, *2462*
development, *3139*
early use of electric lighting, *16260*
figures in landscapes, *2997*
for painting photographs with watercolor, *8158*
gum-bichromate technique, *12951*
hints for amateurs, *2668*
hints on photographing flowers, *8066*
how to duplicate negatives in the camera, 1902, *8098*
how to make photographs transparent, *4065, 6135*
improvements, 1851, *22464*
lantern slides, *3110*
making emulsion, *3165*
photo-galvanographic process, *19466*
photographic postcards, 1902, *8022*
photographing snow crystals, *7238*
photo-zinc and photo-engraving processes, *2868, 2944*
portrait photography, *1513*
posing and illuminating, *11339*
remedy for halation in negatives, *3215*
silver prints, *4249*
technique for amateurs, *1336, 1356, 1417, 1968, 1988, 2005,*
 2026, 2040, 2098, 2122, 2143, 2161, 2179, 2195, 2215,
 2241, 2254, 2273, 2333, 2355, 2372, 2396, 2417, 2438,
 2494, 2511, 2532, 2571, 2589, 2612, 2630, 2651, 2687,
 2812, 2832, 2868, 2894, 2917, 2944, 2971
tinting, *7465*
toning and fixing, *2549*
transparencies, *3085*
use of additional lenses to reduce foreshortening, *16243*
United States
 Chicago Society of Amateur Photographers, *12832*
 Newark Camera Club, *12790*
use for architectural students, *14822*
use for artists, *12826*
use in detection of restorations, *288*
use in meteorological instruments, *20840*
use in wood engraving, *18191*
use of glass plates, 1849, *14591*
value as art, *1271, 21838*
Vernon Heath's autotypes, *8502*
views of White Mountains published, 1860, *20320*
war news, 1898, *12740*
photography, aerial
 experiements in France, *25341*
photography, architectural
 architectural photographical association organized, 1857, *19795*
photography, artistic, *10880*
 artistic side of photography, *22561*
photography, flash light, *2668*
 Dr. Piffard's flash light, *2589*
photography, stereoscopic
 American Stereoscopic Company views, *19997*
photogravure, *10744*
 combination with etching, *10814*
 development, *527*
 European Architecture, monthly periodical, *12659*
 Hendy Scott & Co. publish photogravures after Percy Moran
 and K. Van Elten, 1887, *583*
 holiday book illustrations, 1885, *1911*
 notes, 1895, *16803*
 process, *540*
 Rajon's drawing of Whistler, *515*
 technique, *603*
Photogravure Co., New York
 notes, 1885, *11190*
 publishes Muybridge's *Animal Locomotion*, *10754*
 Yellowstone National Park, *10814*
photomechanical processes
 Osborne photolithographic process, *15833*
 replaces wood-engraving in illustration, *1899*
 technique for making photographic copies of plates in library
 books, 1901, *7611*

Victor, O.
 Great Miracle, 18460
 Monk's Dream, 17917
 Phantom Field, 18493
W.
 All Twisted, 24023
 At Julian's, 24261
 Ballade, 24294
 Chaumont, 19687
 Coster Love Song, 24050
 Decadent Painters, 23945
 Farewell, 24106
 Improbable, 23917
 Invocation, 24183
 Love Ditty, 23741
 Love in Death, 23765
W., E. A., *Thorwaldsen's Christ*, 14603
W., G., *Sketcher*, 19988
W., T., *In the Place Carrousel*, 24102
Ward, J., *Mental Photographs*, 18438
Waterman, N., *Garden of Genius*, 12491
Watts, T., *Poet*, 19536
Wells, S., *Utopia*, 11558
Wheeler, K., *Light*, 22947
Wheeler, P., *Sunset at the Weir*, 23104
White, E., *Song of High Summer*, 12546
Whiting, C., *Old Love*, 12553
Williams, C., *Ideal Collection*, 20398
Williamson, S., *To the Incarnate Bride*, 20648
Willis, N.
 Birth-day Verses, 18357
 Hagar in the Wilderness, Sacrifice of Abraham, 18294
 Infant Beauty, 19260
Winny, *Dreams*, 19103
Winsor, J.
 Art and Heart, 19414
 Art-Portraiture, 18876
 Art-Seer, 18844
 Beauty, 19531
 Castle of Art, 19292
 Cupid of the Field, 19121
 Delaroche, 19572
 Great Thoughts, 18813
 Homage of Science to Art, 19601
 Kind of Dream, 19287
 Lowly Worth, 19306
 Noblest of his Kind, 19455
 Orison of Night, 18741
 Perfect Artist, 19485
 Ranger, 19374
 Reverence for Age, 19353
 Shrine of the Beautiful, 18636
 Sibyls of Nature, 18981
 Ways to Art, 19120
 Within Doors, 19587
Witte, B.
 Last Year's Nest, 21497
 Proxy, 21480
Wood, E., *Reading of Hamlet*, 23883
Wordsworth, W.
 Sonnet, Upon the Sight of a Beautiful Picture Painted by Sir George Beaumont, 14548
 Tintern Abbey, excerpt, 23277
Wright, J.
 Love's Suicide, 12578
 Narcissus, 12600
Young, E., *Night Thoughts*, 18402
Yriarte, C., *Country Squire*, 20877
poetry, 18620
 aesthetics, 640
 elevating influence, 20158
 on winter, 10970
 origins of the Edda, 21353
 poetical contests of Toulouse, France, 20087
 popularity, 18113

thoughts by John Stuart Mill, 20188, 20201
poetry and art, 9046, 14664
 differences in expression between painting and poetry, 17897
 landscape elements in Street's poetry, 18580
 landscape images in Bryant, 18553
 landscape images in Lowell, 18698
 landscapes inspired by American poetry, 9089, 9117, 9130, 9139, 9171, 9184, 9199, 9225
 poetry and painters, 20742
 superiority of painting or poetry, 19553
 superiority of poetry over art, 17952
 Virgil and landscape painting, 19621
poets
 insensibility to architecture, 9726
Poetzsch, Paul Rudolf Heinrich, 1858-1936
 Dresden painter, 22881
Poggenbeck, Geo See: **Poggenbeek, George Jan Henrik**
Poggenbeck, Thomas Gustaaf W., 1872-1942
 notes, 1899, 7074
Poggenbeek, George Jan Henrik, 1853-1903, *14934*
 exhibitions
 American Watercolor Society, 1885, *1933*
 American Watercolor Society, 1888, *2641*
 American Watercolor Society, 1890, *25777*
 Brooklyn Art Association, 1884, watercolors, *25092*
 illustrations, pen drawing, *11940*
Pogliaghi, Lodovico, 1857-1950
 Columbus medal, 1893, *16111*
Pogosky, A. Korvin See: **Korvin Pogosky, A.**
Pohle, Leon Friedrich, 1841-1908
 illustrations, *Ludwig Richter*, *10156*
 Weaving the May coronet, *9083*
Poillon, William, 1844-1918
 coin collection, sale, 1893, *16356*
 library, sale, 1895, *16873*
Poilpot, Théophile, 1848-1915
 Passeur, *8905*
Poincy, Paul, 1833-1909
 member of art jury, Tennessee Centennial, 1896, *11843*
Point, Armand, 1861-1932
 painting, *6845*
Pointelin, Auguste Emmanuel, 1839-1922
 illustrations, *In the Côte-d'Or*, *2268*
Poiré, Emmanuel, 1859-1909
 caricatures that are anti-Zola and anti-Semitic, *24155*
 caricatures vilifying Zola, *24068*
 check-book covered with sketches at Bouton's, 1893, *16122*
 notes, 1891, *26386*
Poirson, Maurice, 1850-1882
 obituary, *9766*
Poisat, Alfred Bellet du See: **Bellet du Poisat, Alfred**
poisons
 collectors and collecting, *15334*
Poisson, Jeanne Antoinette See: **Pompadour, Jeanne Antoinette Poisson**, *marquise* de
Poitiers, Diane de, *duchesse* de Valentinois, 1499-1566
 patroness of the arts, *1175*
Pokitonov, Ivan, 1851-ca.1924
 biographical information, *16461*
Poland
 antiquities, gold ornaments discovered, 1878, *9062*
 salt city in Kelburg, *8260*
 social life and customs, raising children, *22841*, *22870*
Poland Spring Art Gallery See: **South Poland (Maine). Poland Spring Art Gallery**
Poldi Pezzoli Museum See: **Milan (Italy). Museo Poldi-Pezzoli**
Polenov, Vasilii Dimitrievich, 1844-1927
 illustrations, *Christ and the law breakers*, *13759*
Polglase, Grace, fl.1902
 exhibitions, Chicago Ceramic Association, 1902, *13511*
Polidori, John William, 1795-1821
 picture given to British National Portrait Gallery, *16879*
Polignac, Armand Jules Marie de, 1771-1847
 scenes of Reign of Terror presented to Musée Carnavalet, 1892,

26825

Polish art See: **art, Polish**

political caricature and cartoons
 dogs by Thomas Landseer, *21203*
 illustrations, W. A. Rogers drawings, *7116*

political science
 teaching, *20156*

politics and war
 necessity of separating commercial interests from politics, 1897, *23202*

Polk, Charles Peale, 1757-1822
 portrait of Washington discovered, 1893, *16228*

Polk, Willis Jefferson, 1867-1924
 exhibitions, Chicago Architectural Club, 1901, *13221*

Pollaiuolo, Antonio del, d.1498
 depiction of children, *9614*
 Hercules slaying the centaur Nessus, in the Yale collection, *25592*
 paintings in London National Gallery, *4360*
 Virgin and infant Jesus, *1760*

Pollard, Edward Alfred, 1831-1872
 Virginia Tourist, views of Virginia scenery, *10723*

POLLARD, Percival, *12513*

POLLEN, George, *13462*

POLLEN, John Hungerford, *9608, 9614, 9644, 9715, 9731, 21585, 21643, 21659, 21681, 21695, 21726, 21750, 21993*

Pollet, Victor Florence, 1811-1882
 obituary, *9766*

Polock, Moses, 1817-1903
 collection, sale, 1895, *16868*

POLONIUS, *1652*

polychromy
 did Greeks paint sculpture?, *26636*
 did our forefathers paint their sculptures?, *26682*
 exhibitions
 Boston Museum of Fine Arts, 1891, *3601*
 Boston Museum of Fine Arts, 1892, *26604*
 Chicago Art Institute, 1892, polychrome sculpture, *3887*
 lecture by Westmacott, 1859, *20015*
 painted sculpture in Middle Ages and Renaissance, *25363*
 painting statues during Middle Ages, *2282*
 polychrome sculpture, 1899, *17702*
 revival of polychrome sculpture, 1892, *3959*

Polyclitos, 5th cent. B.C.
 attribution of statue found at Ephidauros, *454*

Polytechnic Institute of Brooklyn See: **New York. Polytechnic Institute of Brooklyn**

Polytechnic Society of Kentucky See: **Louisville (Kentucky). Polytechnic Society of Kentucky**

Polytechnikum See: **Zurich (Switzerland). Polytechnikum**

Pomeroy, Frederick William, 1856?-1924
 exhibitions, Chicago World's Fair, 1893, *4437*

Pommayrac, Paul, 1807-1880
 obituary, *165, 9389*

Pompadour, Jeanne Antoinette Poisson, *marquise* de, 1721-1764
 library, *14969*
 portraits
 portrait by LaTour, *15030*
 portrait by LaTour in Twombly collection exposed as copy, *15054*

Pompeii
 description of city and state of excavations, 1897, *17249*
 destruction, *21034*
 excavations
 1855, *18670*
 1875, *8536*
 1885, wall paintings uncovered, *10198*
 1890, *26035*
 1890, discovery of murals, *26144*
 1890, murals discovered, *25998*
 1891, suspended, *26397*
 1894, bathhouse, *16612*
 1894, house, *16636*
 1895, *11661*

1896, funds needed, *16933*
 1901, bronze statue, *13208*
 monuments opened to public, 1891, *26425*
 Pompeian house described and illustrated, 1890, *3348*
 visit by Empress of Austria, 1890, *26201*

Ponchielli, Amilcare, 1834-1886
 Gioconda, New York performances, 1884, *1716*

Pond & Pond, architects
 illustrations
 drawings for David Swing settlement buildings, Chicago, *13028*
 house at La Salle, Ill, *13221*
 member of Eagle's Nest colony, *12765*

Pond, Allen Bartlit, *12888*
 See also: **Pond & Pond, architects**

Pond, Irving Kane, 1857-1939
 See also: **Pond & Pond, architects**
 illustrations, auditorium and coffee house at Hull House, *12887*
 lecture, Central Art Association, 1894, *11408*

POND, Nathan Gillet, b.1832, *25651*

Ponsan, Edouard Bernard Debat See: **Debat Ponsan, Edouard Bernard**

Pont Aven (France)
 artists' colony, *22662*
 description and views, 1879, *21660*

Pont, Léon Bopp du See: **Bopp du Pont, Léon**

Ponte, Francesco da See: **Bassano, Francesco da Ponte**

Pontenier, Auguste, b.1860
 illustrations
 Above balloon at a greater elevation, *21112*
 Angels appearing to Joan of Arc (after A. Watts), *20962*
 Ascent of a balloon from Dijon, April 25, 1784 (after V. Foulquier), *21112*
 Botafogo Bay, Rio Janeiro (after Freeman), *21163*
 Celebrated experiment with the Magdeburg chambers (after J. Gagniet), *20785*
 drawings for Schiller's *Pegasus in Harness* (after M. Retzch), *21023*
 sword of Napoleon, *20974*
 views of tomb of Napoleon (after E. Thérond), *20974*

Ponton d'Amécourt, Gustave, *vicomte* de, 1825-1888
 collection, sale, 1887, *25426*

Pool, Maria Louise, 1841-1898
 In a Dike Shanty, excerpt and review, *12541*

Poole, Eugene Alonzo, 1841-1913
 elected vice president, Pittsburgh Artists' Association, 1902, *13436*
 portrait work, 1894, *27004*

Poole, F. J.
 collection, theatrical souvenirs, *16663*

Poole, Paul Falconer, 1807-1879
 exhibitions
 Royal Academy, 1850, *Job*, *14655*
 Royal Academy, 1883-4, *9949*
 Lorenzo and Jessica, *9570*
 obituary, *34*

Poole, Reginald Stuart, 1832-1895
 leaves British Museum for University College, 1893, *16208*
 Lectures on Art, delivered in support of the Society of the Protection of Ancient Buildings, review, *24459*
 retires from Department of Coins and Medals, British Museum, 1892, *26741*

Poole, Stanley Lane See: **Lane Poole, Stanley**

Poole, William Frederick, 1821-1894
 memorial planned, 1896, *17140*
 obituary, *16505*

Poor, Henry Warren, b.1863
 exhibitions, Boston Art Club, 1907, *14252*

Poore, Henry Rankin, 1859-1940
 Close of a city day, in American Exhibition, London, 1887, *25464*
 exhibitions
 American Art Association, 1884, *25201*
 National Academy of Design, 1884, *1879, 25125*
 National Academy of Design, 1891, *26307*

Mother and son, 22495
painters in Boston, 1879, *794*
Portrait of a lady, reproduced by Kurtz, *25341*
portrait of Mrs. Clews, in Boston Museum of Fine Arts, 1885, *1983*
portrait of Mrs. Cruger shown in New York, 1892, *26841*
portrait of Mrs. Van Rensselaer Cruger shown in New York, 1892, *26869*
portrait painter, *2304*
portrait paintings, *2504*
sales and prices, 1890, versus those of J. S. Sargent, *3425*
Porter, Bruce, 1865-1953
exhibitions, San Francisco, 1902, murals, *22161*
fountains, San Francisco, 1899, *22082*
notes, 1903, *22190*
studio and home near Mill Valley, 1901, *22134*
Porter, Charles E., 1847?-1923
flower paintings shown in Rockville, Conn., 1892, *26814*
Porter, Henry Kirke, 1840-1921
collection, *15388*
 paintings in Carnegie Institute annual exhibition, 1902, *13520*
Porter, Horace, 1837-1921
awarded by American Numismatic and Archaeological Society, 1897, *17335*
portraits, photograph, *23193*
PORTER, Peter A., *20279*
Porter, Robert Kerr, 1777-1842
Battle of Agincourt, exhibited in London, 1880, *21888*
Storming and capturing of Seringapatum, huge size makes it a curiosity, *21765*
Porter, William Arnold, 1844-1909
illustrations, *Tangled path, 22531*
summer home and studio, *22571*
Portes, Henriette des See: **Field, Henriette des Portes**
Portfolio Club, Indianapolis See: **Indianapolis (Indiana). Portfolio Club**
Portielje, Gérard, 1856-1929
designs commemorative stamp, 1899, *17554*
Portielje, Jan, 1829-1895
Morning mail, shown in Chicago, 1898, *12222*
Portland (Maine)
art, *26835*
 Fox Art School and artists' activities, 1895, *22738*
 Mr. C. L. Fox gives art classes at his studio, 1890, *3450*
 murals for Episcopal Church, *14161*
Portland (Maine). Gorges Society
publications, *15172*
Portland (Maine). Maine Historical Society
acquisitions, 1893, Fogg autograph collection, *16428*
Portland (Maine). Portland Society of Art
annual exhibitions
 1884, *11044*
 1887, *574*
building, club house completed, 1884, *10955*
exhibitions
 1883, *24896*
 1895, *22738*
notes, 1884, *25096*
officers, 1899, *12274*
Portland (Oregon)
art, collectors, *15825*
monuments
 soldiers monument put in position, 1891, *26382*
 soldiers monument unveiled, 1904, *13768*
 statue of Longfellow by F. M. Simmons, *25547*
Portland (Oregon). Lewis and Clark Centennial Exposition, 1905
art, *14002*
art of India, *13948*
competition for symbolic dseign, 1902, *8035*
emblem design competition, *13515*
fine arts exhibition, *13921*
Missouri State building burns, *13996*
St. Louis art, *13958*

Portland (Oregon). Oregon Art Students League
reorganized, 1906, *14109*
Portland (Oregon). Portland Art Association
bequest of H. W. Corbett, *22176*
exhibitions
 1900, *22111*
 1901, *22127*
Portland (Oregon). Sketch Club of Oregon See: **Portland (Oregon). Oregon Art Students League**
Porto Riche, de
collection, sale, 1890, *15257*
portrait drawing
crayon portraiture, *4486*
fraudulent advertisement for portrait drawings, 1893, *4355*
studio and materials for crayon portraiture, *4290*
technique
 crayon, *3929, 4502*
 crayon backgrounds, *4415*
 drawing face from memory, *5972*
 drawing free-hand from a photograph, *4481*
 drawing heads, *6768*
 mechanical methods of enlargement, *4367*
portrait painting, *10700, 21638*
advice of Hubert von Herkomer, *1449*
advice of Virgil Williams, *2436*
advice to student, *14774*
anecdote, *17639*
artist advertises ability to repaint portraits of deceased sitters, 1901, *7727*
color schemes, *4103*
complaints of an anonymous portrait painter, *18543*
criticism of modern portrait painting, *13696*
defence of portrait painting from article in French journal, *14789*
draperies in portrait paintings, *5490*
etiquette for sitters, *20309*
experiences of a portrait painter, *20037*
foreign portrait painters to work in America, 1896, *6054*
formal concerns new departure, 1898, *6645*
hints from J. C. Beckwith, 1890, *3433*
notes
 1891, *3828*
 1898, *6659*
 1902, *7818*
painter to paint first lady not yet chosen, 1887, *531*
portrait as art, *7483*
posing, *2728*
role of sentiment in portraits of children, *7751*
selection of costume in painting men's portraits, 1901, *7741*
should painter idealize sitter?, *5784*
studies in watercolor, *2250*
technique, *2114, 2996, 3079, 3263, 3400, 3756, 4838, 5607, 5905, 7624, 7702, 7748, 19400*
 accessories and drapery, *4044*
 advice from J. Carroll Beckwith, 1895, *5535*
 and aesthetics, *3842*
 and method of criticism, *3122*
 arms and hands, *5746*
 backgrounds, *3796*
 colors, *3877, 3901*
 composition, *4018*
 crayon, *3916*
 depicting expression, *3961*
 drawing facial features, *5832*
 drawing from life and from photographs, *4324*
 features, *3369*
 head, *3726*
 hints for securing likeness and expression, *7620*
 Ideal head by E. Welby, *3135*
 idealization of sitter and lighting techniques, *5134*
 lighting and backgrounds, *3236*
 miniature painting, *3370*
 oils, *2354, 2369, 2395*
 painting head in oil, *5234*
 palette, *3260, 3995*

technique
 how to make chalk plates, *5519*
 printer's procedure described, *3403*
three-color process, *13201*
type spacing and design, *12584*
United States
 Altar Book, *22425*
 Chap Book criticized, 1894, *22307*
 photo-engraving of pictures in America, *13865*
 prizes for printing specimens, 1896, *12505*
 Sketches of Printers and Printing in Colonial New York by
 Hildeburn reviewed, 1895, *16882*
 style of *Modern Art*, *22426*

prints
 American print copyright laws, 1895, *16678*
 artists' proofs, *25908*
 black and white work, *24596*
 caricatures of American Civil War offered, 1896, *17119*
 collectors and collecting, *16612*
 1891, *3473*
 advice, *879*
 bad taste, *12415*
 caution against buying old prints, 1895, *5422*
 Chicago, *16168*
 collection of Charles E. West, New York, *1607*
 Crimmins collection of prints of New York, *17554*
 print collectors cautioned, 1881, *1240*
 prints available, 1900, *7341*
 prohibition of importation through the U.S. mail, 1891,
 15723
 review of J. Maberly's *Print Collector*, *130*
 color schemes for translating black and white prints into color,
 8112
 conservation and restoration, *16207*
 cleaning and restoring, *4222*
 how to remove a print from its mount, *6771*
 technique, *661*
 destroying the plate, *527*
 Estampe Française publications, *15275*
 exhibitions, Pedestal Fund Loan Exhibition, 1883-4, *1705*
 frauds on art market, 1882, *1418*
 German Art Publishers Association, *15182*
 Hoeschotype process, *1416*, *1436*
 how to split a print and remove text from reverse, 1890, *3420*
 international chalcographic society proposed, 1884, *25219*
 Keppel's views on European market, 1880, *961*
 lectures, New York, 1891, *15492*
 notes, 1889, *3120*
 publications
 1888, *2792*
 1892, *15998*
 sales and prices
 1883, *1618*
 1886, Morgan collection, *2171*
 1894, *16600*
 1895, *16759*
 1896, *16939*, *16954*
 1896, London, *17005*
 1896, Paris, *17225*
 1897, *17290*, *17312*, *17368*
 1897, London, *6487*
 value, *939*
prints, American
 collectors and collecting, *1189*
 development, *70*
 exhibitions
 Boston Museum of Fine Arts, 1893, *16280*
 Dresden Royal Gallery, 1886, etchers and wood engravers,
 2323
 historical prints at Wunderlich's, 1892, *15977*
prints, Japanese
 collectors and collecting, *16589*
 exhibitions
 Grolier Club, 1889, *2952*
 New York, 1894, A. Herter collection, *4703*

New York, 1896, *5661*
Printsellers Association See: **London (England). Printsellers
 Association**
Prinz, A. Emil, fl.1896
 exhibitions, National Academy of Design, 1896, *22996*
Prior, W. H., fl.1854-1855
 illustrations
 Cutting machine, *21158*
 Second cutting room, *21158*
 sugar refining, *21212*
Priou, Louis, b.1845
 illustrations, *Feeding birds*, *17809*
prisons
 hanging cages, *16786*
Pritchard, J. Ambrose, 1858-1905
 exhibitions, Boston Art Club, 1894, *8340*
 obituary, *13878*
PRITCHETT, Robert Taylor, *8782*, *8794*, *8808*, *8820*, *8839*, *8854*,
 8866, *8877*, *8892*, *8903*, *8921*, *8938*, *8956*, *8968*, *8988*, *8998*,
 9007, *9016*, *9029*, *9040*, *9052*, *9066*, *9078*
Pritchett, Robert Taylor, 1828-1907
 Iceberg lake, *9095*
Prix de Rome
 1858, *19887*
 1881, *383*
 1894, winners, *22294*
 Bastien Lepage failed to receive, *23833*
 description, *14907*
 exhibitions, Paris, 1896, *23646*
 first women finalists in history, 1903, *13585*
 Mauclaire's criticism, *14041*
 new regulations, 1879, *9233*
Probasco, Henry, 1820-1902
 collection, *10792*, *15797*, *25420*
 Cincinnati, *12274*
 Durand Ruel claims right to profits from sale, 1890, *3127*
 exhibited, 1887, *10782*
 exhibition and sale, 1887, *10773*
 improprieties at sale, 1891, *3490*
 sale, 1887, *566*, *2429*, *2448*, *2471*, *25438*, *25448*
 sale, 1899, *17488*, *17516*
 library
 sale, 1890, *15422*
 sale, 1899, *6873*, *17507*
Procter, Bryan Waller, 1787-1874
 Dramatic Scene, review, *19659*
 quote, *20269*
Proctor, Adam Edwin, 1864-1913
 exhibitions, Royal Society of British Artists, 1892, *26848*
Proctor, Alexander Phimister, 1862-1950
 animal sculptor, *12761*
 exhibitions
 National Academy of Design, 1902, *13359*
 Paris Exposition, 1900, *13065*
 Pennsylvania Academy of the Fine Arts, 1904, *13716*
 illustrations
 Indian warrior, *13556*, *13806*
 Panther, *14026*
 Quadriga, *13263*
 Rocky mountain sheep, *13218*
 quadriga for portico of United States Pavilion at Exposition
 Universelle, 1900, *12999*
 sculpture for Louisiana Purchase Exposition, 1904, *13685*
 whereabouts
 1898, opens New York studio, *17450*
 1898, returns to America, *12796*
 1901, visiting Seattle, *22127*
Proctor, Charles Edward, fl.1890-1900, *6821*
 art class for young women, 1892, *26835*
 fame, *7230*
 illustrations, *Reflections*, *7176*
 whereabouts, 1896, summer in Sullivan County, New York,
 23056
 wins Rinehart bequest award from Peabody Institute,
 Baltimore, 1896, *5648*

Purdie, Evelyn, 1858-1943
 study in Paris, 1884, *10893*
Purdy, James
 illustrations, frieze, *13862*
PURDY, Lillian E., *22820*
PURDY, Theodore, *22748*
PURMAN, D. Gray, *23023*
Pursell, Edward W., fl.1898
 artist photographer, *6681*
Put, Albert van de See: **Van de Put, Albert**
Putnam, Arthur, 1873-1930
 illustrations, *Tiger and snake*, *22140*
 studies of animals, 1903, *22176*
 whereabouts, 1904, moves to Sausalito, *22203*
PUTNAM, Frank, *23183*
PUTNAM, Frederic Ward, *90*, *269*, *272*
Putnam, Frederic Ward, 1839-1915
 article on Egyptian antiquities, *278*
 excavations at Madisonville, Ohio, *398*
 lectures, 1881, *401*
Putnam, G. P., publishers, New York
 Art Handbooks, review, *24606*
 exhibitions, 1902, bookbinding, *8059*
Putnam, Israel, 1718-1790
 portraits
 sketch by Trumbull, *25422*
 sketch by Trumbull and painting by H. J. Thompson, *25364*
 role in Revolutionary War, *16805*
Putnam, John Pickering, 1847-1917
 Open Fireplace in All Ages, *1050*
 Outlook for the Artisan and his Art, review, *12868*
Putnam, Mary See: **Jacobi, Mary Putnam**
Putnam, Sarah Gould, fl.1880-1908
 exhibitions, Boston Museum of Fine Arts, 1880, *1026*
Putnam, William Clement, 1862-1906
 bequest to Davenport Academy of Science, 1905, *14071*
Putney (England)
 bridge, *9436*
Putzki, Paul A., 1858-1936
 American china painter, *5920*
PUVIS DE CHAVANNES, Pierre, *24283*
Puvis de Chavannes, Pierre, 1824-1898, *3430*, *3461*, *8329*,
 22353
 anecdote, *3924*
 attempts to obtain Legion of Honor decoration for Willette,
 1896, *16996*
 cartoons for Gobelin tapestries, 1891, *26280*
 conversation with Arsène Alexandre, 1898, *17427*
 criticism by Nordau, *22359*
 death means end of "New Salon", *20628*
 designs for Gobelin tapestries, 1892, *26763*
 drawings offered to Dijon Museum, 1899, *17641*
 excerpt from Huysmans's *Certains*, *17664*
 exhibitions
 Carnegie Galleries, 1898, *Inter artis et naturum*, *6817*
 Chicago Art Institute, 1890, *Sacred wood*, *3230*
 Chicago World's Fair, 1893, *4653*
 chronological list, 1895, *16644*
 National Academy of Design, 1887, *2483*, *25459*
 New York, 1887, *574*
 New York, 1892, *3895*, *15828*
 New York, 1895, *5173*, *16865*
 New York, 1898, *12273*
 Paris, 1894, *16589*
 Paris, 1899, *17669*
 Paris Exposition Universelle, 1889, *2987*
 Salon, 1879, *9188*
 Salon, 1882, *9675*
 Salon, 1883, *9838*, *14898*
 Salon, 1884, *1806*
 Salon, 1887, *17774*
 Salon, 1892, *Winter*, *4013*, *26673*
 Salon, 1894, *Apotheosis of Victor Hugo*, *4939*
 Salon, 1895, Boston Public Library decorations, *5375*
 Salon, 1896, *23618*
 Salon, 1896, Boston Public Library panels, *22413*
 Salon d'Automne, 1904, *13795*, *13817*
 Société des Pastellistes Français, 1892, *15890*
 Union League Club of New York, 1892, *26612*
 French painter, *23045*
 illustrations
 cartoon, *6710*
 cartoons for mural decoration, *5870*
 Morning, *3740*
 Night, *3740*
 studies, *5872*
 Vision of antiquity: symbol of form, *14333*
 marriage, 1897, *6342*
 monuments, square in Lyons to be named after him, 1899, *6872*
 motifs used in teaching by Arthur W. Dow, *12929*
 murals
 decoration for Sorbonne amphitheater, *573*
 decorations for Boston Public Library, *4492*, *5640*, *6106*,
 6811, *13351*, *17140*, *17562*, *22876*
 decorative art, *23833*
 excerpt from George Moore, *22273*
 fresco left unfinished in Panthéon, 1902, *7803*
 murals in Panthéon should be removed to museum, 1898,
 17449
 notes
 1891, *26365*, *26387*
 1895, *16667*
 1897, *17231*
 1898, *6812*
 obituary, *12224*, *12808*
 paintings for Lyons Museum, *2205*, *2206*
 paintings in Warren collection, 1895, *16672*
 paintings on billboards by Union Pour Action Morale, 1896,
 17116
 Pierre Puvis de Chavannes: a Sketch, by L. L. Rood, review,
 22373
 Poor fisherman, *25499*
 Mallarmé's comments, *8315*
 portraits, Bonnat's portrait illustrated, *4481*
 Pro Patria Ludus, wins Medal of Honour, 1882, *9656*
 quote
 on drawing from live models, 1900, *7266*
 on mural painting, *13519*
 response to Chanler proposal, 1891, *26348*
 room in Luxembourg, Paris, opens, 1899, *22084*
 sales and prices
 1897, *Ludus pro patria*, *6187*
 1902, *13470*
 technique, *6398*
 work at Amiens, *22366*
 works in Johnston and Lambert collections, 1891, *3598*
Puy, Le See: **Le Puy (France)**
Puyo, Constant, 1857-1933
 illustrations, *Torso*, *13120*, *14222*
Puyplat, Jules Jacques, fl.1877-1890
 illustrations, furniture designs, *1439*
Pye, John, 1782-1874
 illustrations, *Wycliffe, near Rokeby* (after Turner), *8507*
Pyle, Howard, 1853-1911
 appointed associate member of National Academy, 1905, *13953*
 artist-author, *17803*
 Christmas illustrations, *13081*
 director of Drexel School of Illustration, 1897, *6421*
 drawings for *Harper's Magazine*, 1893, *22490*
 exhibitions
 Buffalo Society of Artists, 1897, *12085*
 New York, 1897, grisaille drawings, *6099*
 illustrations
 illustration for *The Closing Scene*, 1886, *509*
 illustration from *The Closing Year*, *10392*
 Pastoral without words, *4254*
 illustrations for *Harper's Magazine*, 1893, *22501*
 illustrations for magazines, 1893, *22482*
 illustrations in Christmas magazines, 1899, *7182*
 illustrator of Read's *The Closing Scene*, *2360*

interest in American history, *17191*
line illustration, *12996*
Merry Adventures of Robin Hood, review, *1686*
Otto of the Silver Hand, *628*
posters, *12495*
retiring from Drexel Institute, 1900, *13046*
PYLE, Katharine, *6199, 6221, 6290*
Pyle, Robert, fl.1761-1766
 illustrations
 Autumn, *13036*
 portrait of woman, *14019*
Pym, John, 1584-1643
 biography, *20819*
Pynchon, William, 1590-1662
 Meritorious of Price of Our Redemption, rare book of 1650, *26917*
Pyne, James Baker, 1800-1870
 exhibitions, Royal Society of British Artists, 1858, *19851*
Pyne, John, d.1895
 obituary, *16667*
Pyne, R. L., b.1815
 work, 1883, *24883*
pyramids
 Egypt, *20570*
 Giza, *22850*
 Sakkara, *383*
Pyrenees
 views, *Bridge of Cauterets*, *20732*
pyrography, *12885*
 aesthetic advice, *6195*
 artists' materials
 pyropen, *7521*
 tools, *3802*
 exhibitions, Architectural League of New York, 1897, *6237*
 furniture designed by W. R. Clarke, *13433*
 history, *15742*
 and technique, *3760, 13155*
 Smith, leading English practitioner, *16288*
 interview with J. W. Fosdick, 1894, *5093*
 "leatherboard" material, *6138*
 notes
 1892, *16074, 26547*
 1893, *4377*
 "poker-work", *4725*
 poker-picture maker Smith, of Craven, Yorkshire, *16288*
 progress of the craft, 1902, *7929*
 technique, *3845, 3886, 3916, 5519, 5883, 6134, 6170, 6357, 6542, 6571, 6601, 7338*
 and aesthetic advice, *5849*
 bellows decoration, *7796*
 bellows lift, *7916*
 box decoration, *7891*
 cat tail panel, *7830*
 chair backs, *7865*
 choice of designs, *6626*
 clock front decoration, *7498*
 decorating a tabouret, *7144*
 decoration for a stool, *8184*
 decorative box, *7829*
 electric appliance, *6000*
 fish panels for chair backs, *7923*
 for wood and fabric in interior decoration, *7435*
 Indian head design on leather, *7533*
 leather, *6044*
 leather jewel box, *7519*
 lustra colors, *3876*
 nasturtium mirror frame, *7886*
 Norse designs for a box, *7981*
 photograph frame, *7922*
 rococo tray, *7838*
 stool top decoration, *7909*
 take down seat, *7903*
 use of stains and colors, *7676*
 Viking-style panel design, *7213*
 used to decorate dining room, *11321*

women's work exhibited at Chicago World's Fair, 1893, *4631*

Q., *19743*
Quadlino, John, fl.1903
 illustrations, *Portrait*, *13616*
Quadrone, Giovanni Battista, 1844-1898
 exhibitions, Paris, 1879, *9165*
quality of life
 art in life, *12622*
 art of living, *11990*
 experiencing art, *11989*
 importance of devoting time to art, *11672*
 plea for simpler living, *12171*
Qualley, Lena, fl.1898-1910
 exhibitions, Paris, 1902, *13372*
 illustrations
 bust done in modeling class, 1898, *12736*
 charcoal head, *12670*
 studies, *13249*
QUARITCH, Bernard, *15817*
Quaritch, Bernard, 1819-1899
 bookseller of London, *20406*
 Boston premises robbed, 1890, *15232*
 catalogue of books on games and sports, *25726*
 king of booksellers, *15682*
 letter on G. W. Smalley, 1892, *15968*
 letter to *Collector*, 1890, *15064*
 letter to Gov. McKinley, 1892, *26503*
 New York business, *14991, 15025*
 notes, 1890, *26136*
 questions authenticity of Columbus letter in Ives collection, 1891, *15552*
 sells Blake drawings in Boston, 1890, *15198*
 stolen books returned, 1890, *15285*
Quaritch, booksellers See: **London (England). Quaritch, firm, booksellers**
Quartley, Arthur, 1839-1886, *9064*
 After the rain, *1130*
 April day, New York, *1129*
 exhibitions
 American Art Association, 1884, *1739*
 American Art Galleries, 1883, *24663*
 American Art Galleries, 1884, *24988*
 American Watercolor Society, 1880, *827*
 American Watercolor Society, 1881, *1065*
 American Watercolor Society, 1883, *1510*
 American Watercolor Society, 1884, *25023, 25038*
 American Watercolor Society, 1885, *1933, 25239*
 Art Students' League, 1880, *234*
 Artists' Fund Society, 1884, *24967*
 Detroit Art Loan Exhibition, 1883, *24826*
 Internationale Kunstausstellung, Munich, 1883, *1637*
 Milwaukee Exposition, 1883, *24799*
 National Academy of Design, 1877, *8830*
 National Academy of Design, 1879, *657, 9151*
 National Academy of Design, 1880, *126, 867, 9324*
 National Academy of Design, 1883, *Queen's birthday*, *24509*
 National Academy of Design, 1884, *1790, 25125*
 National Academy of Design, 1884, prepares, *25074*
 New York, 1884, *1767*
 New York Tile Club, 1886, *10744*
 Philadelphia Society of Artists, 1880, *1025*
 Philadelphia Society of Artists, 1882, *1270*
 Prize Fund Exhibition, 1886, *25304*

Salmagundi Club, 1882, *1265*
Society of American Artists, 1881, *367*
Glow of sunset upon the coast of Long Island, *24513*
illustrations
 Afternoon in August, *155*
 Dignity and impudence, *1857*
 Riverside antique, *1300*
Low water, Long Island shore, in Clarke collection exhibition, 1883-4, *24955*
marine painting, 1883, *24551*
member, Society of American Artists, *11241*
member, Tile Club, *1851*, *11267*
notes, 1883, *24492*
On the Thames, *24366*
painted panel for table, 1880, *892*
painting in Layton Art Gallery, Milwaukee, *12813*
paintings in Evans collection, *11185*, *15079*
picture in Union League collection, *15783*
quote, on Tile Club, *24990*
sales and prices
 1884, *25120*
 1890, *15064*, *25782*
sketches and studies, *9287*, *9412*
studio
 in Sherwood, 1883, *24607*
 reception in Sherwood, 1884, *25079*
Summer afternoon off Orient, Long Island, shown in Baltimore, 1883, *24948*
whereabouts
 1883, *24569*
 1883, Huntington, L.I, *24728*
 1883, returns from Huntington, *24762*
work, 1883, *24609*, *24820*
Quartley, Frederick William, 1808-1874
wood engravings, *137*
Quartley, John, fl.1835-1867
illustrations
 Church of St. Pantaléon, at Troyes, *21347*
 Death of Socrates - from a painting by David (after A. H. Cabasson), *21150*
 Flemish inn (after I. van Ostade), *20926*
 Fontenay Vendee, department of La Vendee (after J. Champin), *20756*
 illustrations after J. B. Burgess, *9415*
 Roadside inn (after Ostade), *21018*
 Street in the city of Meissen, on the Elbe (after W. H. Freeman), *20794*
 Tempest (after J. Vernet), *20796*
 Tiger attacked by a boa constrictor, *21127*
 View of Pausilippo (after J. Vernet), *20796*
quartz
art objects, *7524*
exhibitions, Tiffany and Co., 1896, *5853*
gems of quartz origin, *17046*
rock crystal cutting process and Tiffany exhibit, 1900, *7591*
rock crystal vessels, *1628*
Quatorze Juillet See: **Bastille Day**
Quatremère Disjonval, Denis Bernard, 1754-1830
imprisonment, *20880*
Queen Anne style
criticism by W. A. Potter, *10753*
QUELIN, René T., *5595*
Quentin, J., fl.1890's
illustrations, *Labor* (photograph), *12254*
Quercia, Jacopo della, ca.1367-1438
tomb of Ilaria del Carretto, *21773*
Querol, Agustín, 1863-1909
illustrations, *St. Francis*, *13609*, *14026*
Questel, Charles Auguste, 1807-1888
fountain for Nismes, France, *14779*
Quick, Israel, ca.1830-1901
photograph painting and studies of skies, 1860, *20209*
portrait paintings, 1870, *10597*
portrait paintings, 1871, *10710*
studies skies, 1860, *24322*

Quick, William Michael Roberts, 1813-1927
illustrations, *On the Yare, at Bramerton*, *10304*
quicksand
notes, 1893, *16243*
Quidor, John, 1801-1881
notes, 1895, *16786*
Peter Stuyvesant watching the festivities on the Battery, *8089*
QUILTER, Harry, 1851-1907, *9536*, *9784*
Quilter, Harry, 1851-1907
advice to art collectors, *13473*
English art critic criticized, 1883, *1589*
Quimperlé (France)
artists' life, Henry Mosler class sketching trip, 1892, *4047*
Quincy, Josiah, b.1859
address delivered in Chicago on city art commissions, 1898, *12701*
Quincy, Josiah Phillips, 1829-1910
Charicles. A Dramatic Poem, review, *19598*
Quinn, James Peter, 1871-1951
exhibitions, American Art Association of Paris, 1899, *12890*
illustrations, *Mendiante de St. Sulpice*, *23660*

R

R., *540*, *14751*, *19159*, *19378*, *19556*, *19593*
R., *14118*, *23783*
R., C. B. (monogram C.B.R.)
illustrations, title page emblem, *21566*
R., C. G., *19427*
R., C. (monogram C.R.)
illustrations
 advertisements, *12560*
 Retaliation (after C. B. Birch), *21613*
R., C. S., *19620*, *19635*
R., E. B., *20007*
R., G. R. See: **Redgrave, Gilbert Richard**
R., H. P., *18292*
R., H. W., *4912*
R., J. E., *21821*, *21866*
R., J. E. (monogram J.E.R.)
illustrations, views of southern coast of England, *21821*, *21866*
R., J. T., *11891*
R., L. B., *10715*
R., M., *18141*
R., N., *14078*, *19718*
R., P. C., *14246*
R., P. (monogram P.R.)
illustrations, *Penolver, from Honsel Cove* (after R. E. Wilkinson), *21614*
R., P. O. (monogram P.O.R.)
illustrations, decorative initial, *21593*
R., W. C., Jr., *21550*
Raab, Doris, b.1851
illustrations, *Death-warrant - Mary, Queen of Scots* (after K. Piloty), *9083*
Rabelais, François, ca.1490-1533
Garnier's paintings after Rabelais seized as indecent, 1891, *3454*
illustrations by Garnier censored in London, 1891, *3598*
works illustrated by Garnier, 1891, *15776*
race
characteristics, *21105*
Rachel See: **Félix, Elisa Rachel**
Rachmiel, Jean, b.1871
paintings of the Champagne, *13462*
Rachou, Henri, 1856-1944
exhibitions, St. Louis Exposition, 1897, *How the Dauphin of France entered Paris in 1358*, *12015*
Racinet, Albert Charles Auguste, 1825-1893
Costume Historique, new publication, 1877, *8860*, *9014*

1902, gold medal, *13436*
Chicago Art Institute, 1902, *13536*
Denver Artists' Club, 1905, *13907*
London, 1895, *27025*
London, 1901, *7611*
National Academy of Design, 1888, *10846*
National Academy of Design, 1891, *3603*
New York, 1889, *14925, 14946, 14985*
New York, 1890, *15306, 15350, 15390*
New York, 1890, paintings of Holland, *3425*
New York, 1891, *15350*
New York, 1892, *3895, 15813, 15828, 26516, 26524*
New York, 1892, water colors, *16028, 26869*
New York, 1893, *16122*
New York, 1894, *4801, 16480, 22540*
New York, 1897, *6191, 17241*
New York, 1898, *6588*
New York, 1899, *17488*
New York, 1900, *13000*
New York, 1906, *14071*
Pennsylvania Academy of the Fine Arts, 1901, *13163*
Pennsylvania Academy of the Fine Arts, 1902, *13363*
St. Louis Exposition, 1894, landscapes, *11402*
Salmagundi Club, 1887, *534, 2364*
Society of American Artists, 1890, *15205*
Worcester Art Museum, 1902, *13483*
illustrations
 Brooklyn Bridge, New York, 13982
 coastal scene, *2598*
 Corn-field - Lyme, Conn, 13792
 Early morning, 11673
 Landscape, 13505
 Noank shipyard, 13873
 Rocks and oaks, 12787
 Willows, 14282
illustrations for *The Century*, 1893, *22490*
interview on Holland and his technique, 1893, *4365*
notes
 1890, *15162, 15199, 15309*
 1891, *15759*
 1895, *16667, 16862*
 1896, *17154*
 1898, *17389*
painting in Fop Smit Jr. collection, *15455*
painting on view in New York, 1892, *15887*
pictures, *17515*
sales and prices, 1899, landscapes, *17571*
Sheep pasture, acquired by Pennsylvania Academy of the Fine
 Arts, 1901, *13209*
summer home and studio, *22571*
watercolors, *10826, 15014*
 views of Crane Island exhibited, 1885, *11282*
whereabouts, 1895, Canada and London, *22765*
works recommended to collectors, 1889, *14941*
RANGER, Robert, *22633*
Rankin, Helen Houser See: **Copp, Ellen Rankin**
Rankin, Hugh, fl.1898
illustrations, poster, *12720*
RANKIN, Leland, *11862*
Ranney, William Tylee, 1813-1857
Artists' Fund Society contribution to Ranney family, *11281*
*Boone's first sight of Kentucky from the Cumberland
 mountains*, in the American Art Union Gallery, 1849, *14573*
Encampment of Boone, 14537
exhibitions
 National Academy of Design, 1850, *On the wing, 14615*
 National Academy of Design, 1851, *14748*
 National Academy of Design, 1858, *19942*
illustrations
 Daniel Boone's first view of Kentucky, 14612
 On the wing, 14680
Marion and his men crossing the Pedee
 completed, 1850, *14696*
 engraved for American Art Union, 1851, *14720, 14732,
 14823*

obituary, *19767*
paintings, 1850, *14606, 14657*
sales and prices
 1857, *Crossing, 19645*
 1858, *19836, 19957, 19974*
Scouting party, purchased by American Art Union, 1851, *14787*
Veterans of 1776 revolution returning from the war, in the
 American Art Union Gallery, 1848, *14445*
Ransom, Caroline L. Ormes, 1838-1910
portrait of General Thomas
 government purchase possible, 1885, *1946*
 purchase protested by Pennsylvania Academy, 1885, *25242*
Ranvier, Joseph Victor, 1832-1896
illustrations, decorative panel, *2315*
Raoul Rochette, Désiré, 1789-1854
Lectures on Ancient Art, review, *18648*
Raphael, 1483-1520, *12412, 12427, 14664, 14676, 14689, 23391,
23403*
analytical criticism, *17441*
Ananias cartoon of female head, *16786*
anecdote, *5525*
Ansidei Madonna, 10161
 bought by British government, 1884, *25167*
 purchased by National Gallery, 1884, *11084*
Apollo and Marsyas
 acquired by Louvre, 1883, *1603, 14889*
 sold to Louvre, 1883, *24684*
Archangel Michael, inspires poem by E. Lee Hamilton, *9865*
as artist-writer, *10806*
Belle jardinière, 21119
 authenticity questioned, *18313*
cast of skull in Fabris' studio, Rome, *19076*
Colonna Madonna
 acquired by Marlborough Gallery, London, 1896, *17102*
 provenance, *17374*
compared to Holman Hunt, *24752*
Crucifixion, in Ward collection, *18974*
Dance of the muses, china plate after Raphael's painting, *7895*
depiction of children, *9614*
differences between pictures and studies, *23318*
discovery of work, 1857, *18083*
Donna velata, attributed, *9575*
drawings in British Museum, 1883, *9892*
drawings in Taylorian Galleries, Oxford, *21633*
excerpt from Allston's *Monaldi, 19503*
excerpt from *Bartol's Pictures of Europe, 19423*
exhibitions
 Liverpool, 1887, *10480*
 New York, 1900, Loukmanoff cartoons, *13558*
frescoes in the Farnesina, *10889*
Holy Family, purchased by J. P. Morgan, *22133*
illustrations
 Alba Madonna, 21993
 Fourth hour of the night, 12184
 Madonna di San Sisto, 21569
 portrait of Cesare Borgia (attributed), *6277*
 Sistine Madonna, 12717, 13570, 14231
 Virgin and Child, 9457
Last Supper at St. Onofre, Florence, attributed to Raphael,
 21372
Madonna and Child found, 1896, *17042*
Madonna and Child study, Braun reproduction, *22392*
Madonna dei candelabri, 2265
Madonna dei candelabri (attributed), shown at Metropolitan
 Museum of Art, 1883, *1446, 1488*
Madonna del popolo, 10701
Madonna dell Staffa, 14896
Madonna della sedia, 8513
Madonna di San Sisto, original unlocated, 1900, *7179*
Madonna of St. Anthony of Padua, provenance, *7822*
Madonnas, *10098, 10113, 10133, 10212, 10228, 23136*
monuments
 monument by Belli unveiled in Urbino, 1897, *6396*
 Urbino monument competition, 1882, *9706*
Oath of Leo X, 14643

painting found, 1899, *17527*
painting recovered, 1883, *24925*
paintings in Borghese Palace collection, *19925*
paintings in Prado, *9848, 11028*
papal commissions, *18257*
pen drawings, *1591*
portrait of Cesare Borgia, *26403*
 smuggled out of Rome, 1892, *4027*
Raphael, a Study of his Life and Work by J. Cartwright, review, *11714*
Raphael by J. A. Crowe and G. B. Cavalcaselle, review, *10198*
Raphael, His Life, Works and Times by Müntz, excerpt, *9600*
religious art, *24759*
religious subjects, *19935*
St. Cecilia, *11150, 21903*
St. Michael, *5531*
sales and prices
 1878, *Madonna dei candelabri*, *21650*
 1896, *5967*
 1897, *6187*
School of Athens, copy for University of Virginia, 1856, *19512*
Self-portrait, rescued from oblivion, *17958*
tapestry cartoons, *18400, 18970*
 Gobelins tapestries after his cartoons, *14176*
 imitations, *3695*
 in Louvre, *26323*
 in South Kensington, *26376*
 interpreted for manufacture, *17233*
 to remain in South Kensington Museum, *26568*
 Vatican cartoon in England, 1891, *26349*
Tebaldo portrait, authenticity contested, 1896, *17016*
Virgin and Child (drawing), *20931*
works, *23297*
works in National Gallery, London, 1894, *4913*
youth, *9874, 9890*
Raphael des chats See: **Mind, Gottfried**
Raphael, Joseph M., 1872-1950
 illustrations, *Evening*, *22105*
Rapin, Aimée, 1868-1956
 armless portrait painter in London, 1895, *11688*
 notes, 1893, *16304*
Rapin, Alexandre, 1839-1889
 illustrations
 November, *5137*
 Winter in the woods, *2838*
 obituary, *15067*
Rapp, Ada M., fl.1902
 exhibitions, Kansas City Art Club, 1902, *13337*
Raquette River
 description, *19166, 19197, 19212*
Raschen, Henry, ca.1854-ca.1937
 exhibitions, San Francisco, 1897, *6453*
Rascovich, Roberto Benjamine, 1857-1905
 exhibitions
 Cosmopolitan Club, Chicago, 1895, *11465*
 Cosmopolitan Club, Chicago, 1896, *11776*
 memorial tribute, Art Institute of Chicago, 1906, *14070*
 notes, 1896, *11883*
 obituary, *14013*
 sketches of Cape Breton, 1895, *11660*
Ratisbon (Germany). St. Peter
 architecture and history, *21141*
RATISBONNE, Louis, b.1827, *19905*
Rattray, Alexander William Wellwood See: **Rattray, Wellwood**
Rattray, Wellwood, 1849-1902
 illustrations, *Gate of the Highlands*, *9478, 21973*
RAU, Charles, 1826-1887, *204*
Rau, Charles, 1826-1887
 Palenque Tablet in the United States National Museum, Washington, D.C., review, *77*
Rau, Leopold, 1847-1880
 obituary, *103*
Raubitschek, Frank, fl.1892-95
 exhibitions, New York, 1892, *26493*

sues Snedicor's auction house, 1893, *26932*
whereabouts, 1892, alive in New York, *26517*
Rauch, Christian Daniel, 1777-1857
 Hero and the Lion., commissioned by King Frederick William, 1851, *14835*
 marbles, 1855, *19134*
 Mendiant, shown at Art-Union Gallery, New York, 1850, *14711*
 monument to Frederick the Great, *14591, 14620*
 colossal equestrian statue, *14712*
 plaster model, 1851, *14809*
 unveiling, 1851, *14766*
 monument to king of Hanover, *19090*
 monuments of York and Gneisenau, *18971*
 obituary, *18160, 19795*
 portrait statues of Goethe and Schiller, *14697*
 sculpture in progress, 1855, *18771*
 statue of Kant, *19041*
 statue of York of Wartenberg, *14780*
Raught, John Willard, 1857-1931
 pictures in Lassell Seminary collection, *630*
RAULSTON, J. J., *22614*
Raulston, John B., *Mrs.*, fl.1897
 china decorator, *12016*
Raven Hill, Leonard, 1867-1942
 illustrations, comic vignettes, *22540*
Ravensburg, Goeler von See: **Goeler von Ravensburg, Friedrich, *Freiherr***
Rawlinson, Henry Creswicke, 1810-1895
 honored, 1891, *26246*
 obituary, *16705*
 publication of cuneiform inscriptions, 1855, *19021*
RAWLINSON, William George, *9470*
Rawlinson, William George, 1840-1928
 Turner's Liber Studiorum, a Description and a Catalogue, review, *146, 9137*
Rawson, Albert Leighton, 1829-1902
 illustrates Wilder's *Eleusinian and Bacchic Mysteries*, *15441*
Rawstorne, Edward, fl.1859-1860
 exhibitions, National Academy of Design, 1859, *20030*
Ray, Clary, b.1865
 Cincinnati, *22587*
RAY, Edward Arthur, *13601*
RAYET, Olivier, *343*
Raymond, E. Launitz See: **Launitz Raymond, Eugenia**
Raymond, Henry Jarvis, 1820-1869
 elected to Committee of Management, American Art Union, 1851, *14823*
Raymond, Katharine T., fl.1884-1901
 exhibitions, Chicago Art Institute, 1899, *12902*
Raymond, Pierre See: **Reymond, Pierre**
razors
 collectors and collecting, *17331*
Read, Buchanan See: **Read, Thomas Buchanan**
Read, Elmer Joseph, 1862-1925
 fishing as subject, *22704*
 illustrations, *Bachelor's home*, *22663*
READ, Harriette Fanning, fl.1847-1865, *19493, 19529, 19967*
Read, Henry, 1851-1935
 exhibitions
 Denver Artists' Club, 1898, *12180, 12706, 12822*
 Denver Artists' Club, 1898, sketches of Indians, *12251*
 Denver Artists' Club, 1899, *12327, 12886*
 Denver Artists' Club, 1905, *13907*
 Trans-Mississippi and International Exposition, Omaha, 1898, *12775*
 illustrations, *And the sun went down*, *13337*
 teaching
 head of art department of Colorado Springs summer school, 1895, *11610*
 summer school in drawing, Colorado Springs, 1894, *27014*
Read, Thomas Buchanan, 1822-1872
 Closing Scene
 illustrated edition, 1886, *2360*
 illustrated poem, 1886, *509*
 Closing Year, illustrated by American artists, *10392*

commissioned by city of Baltimore to paint George M. Dallas
 in London, 1860, *24334*
exhibitions, Philadelphia, 1858, *18243*
General Sheridan, *10730*
Murder of the innocents, *19850*
notes
 1859, *18283*
 1860, *18417*
painting from Cooper's *Wept of Wish-ton-Wish*, *18380*
paintings in Florence, *18872*
paintings in Florence, 1851, *14731*
poet-artist, *17898*
portrait of Longfellow, *20080*, *20104*
Sherman's Ride, *10596*
Spirit of the waterfall, *19995*
whereabouts
 1851, Florence, *14779*
 1851, Florence and Paris, *14821*
 1856, Florence, *19581*
 1857, *19752*
 1861, Paris, *20330*
Reade, Charles, 1814-1884
 Clouds and Sunshine and Art, review, *19107*
 Good Fight and Other Tales, review, *20153*
 It Is Never Too Late to Mend, review, with excerpts, *19549*
 quote, *25120*
 on reform of bare classroom walls, *16968*
READE, Christia M., 1868-1939, *11867*, *11876*, *11889*
Reade, Christia M., 1868-1939
 book plates and cover design, 1899, *12325*
 china painting course, Chicago, 1896, *11866*
 exhibitions
 Chiaco Palette Club, 1895, lithographs, *11704*
 Chicago Society of Artists, 1895, *11483*
 illustrations, book plate for Caroline Dupee Wade, *12640*
 interior decoration studio, Chicago, 1897, *11982*
 silver at Chicago Arts and Crafts Society, 1898, *12150*
Reade, John Chandos, 7th bart., 1785-1858
 collection, sale, 1895, *16788*
Reading (Pennsylvania)
 exhibitions, 1850-1, *14731*
Réal, Anthony
 Story of the Stick, published 1891, *15783*
Réal del Sarte, Marie Madeleine, d.1928
 illustrations, *After the ball*, *4489*
realism
 anecdote, *3335*
 in art, *9933*, *12925*, *22718*, *23317*
 quote from Veron, *17747*
 in French painting, *23020*
 in painting, *9388*, *23312*, *23361*, *23362*, *23369*
 in Scandinavian painting, 1893, *4496*
 inconsistency between theory and practice, *22403*
 Inness on realism, *5090*
 painting of Carl von Piloty, *22946*
 real vs. ideal in art, *25114*
 realism in painting, *16695*
Ream, Caducius Plantagenet, 1837-1917
 dessert pictures reproduced by Prang in chromo, 1871, *23606*
 exhibitions
 Brooklyn Art Association, 1884, *1696*
 Chicago, 1884, *25130*
 Chicago Art Students League, 1895, *11705*
 Cincinnati, 1871, still life, Indian portraits, *10710*
 Detroit, 1899, *12826*
 picture for Kansas City exposition, 1887, *603*
 studio, Chicago, 1896, *11737*
Ream, Morston, Art Rooms See: **New York. Morston Ream's Art Rooms**
Ream, Morston Constantine, 1840-1898
 exhibitions, Prize Fund Exhibition, 1885, *25278*
 whereabouts, 1883, returns from Europe, *24829*
Ream, Vinnie See: **Hoxie, Vinnie Ream**
Reaser, Wilbur Aaron, 1860-1942
 exhibitions

Chicago, 1899, *12861*, *17571*
New York, 1899, *12314*, *17488*
REASONER, Elsie, *12145*, *12177*
Reaugh, Frank, 1860-1945
 animal paintings, *11488*
 exhibitions, Chicago Art Institute, 1895, *5342*
 notes, 1895, *16705*
 organizes art school, Texas, 1898, *12292*
Reay, Martine R., b.1871
 illustrations, *Tramp's nemesis*, *12474*
Reber, Franz von, 1834-1919
 History of Ancient Art, review, *24435*
 History of Mediaeval Art, review, *25413*
Rebisso, Louis Thomas, 1837-1899
 equestrian statue of Gen. McPherson, *356*, *8763*
 Grant monument for Chicago
 commissioned, 1886, *504*
 equestrian statue, *26396*
 Lincoln monument, *10651*
 notes, 1871, *10677*
 Odd Fellows monument, Cincinnati, *149*
 statue of Gen. Grant for Chicopee, Mass, *26382*
 statue of Wm. Henry Harrison
 for Cincinnati, 1892, *26703*, *26730*
 for Ohio building, Chicago Fair, 1892, *26761*
Récamier, Jeanne Françoise Julie Adélaïde Bernard, 1777-1849
 correspondence, sold, 1895, *16781*
Red Bank (New Jersey)
 monuments, New Era monument dedicated, 1892, *26853*
Red, Indian See: **Indian Red**
Red Jacket, *Seneca chief*, 1751?-1830
 monuments
 monument at Canogo unveiled, 1891, *26396*
 monument for Buffalo to be erected, 1890, *26175*
 statue for Buffalo unveiled, 1892, *26696*
 relics, medal presented by George Washington, *26226*
Redden, Laura Catherine See: **Searing, Laura Catherine Redden**
Redding, Baird and co., Boston
 illustrations
 leaded glass, *20577*
 transom in leaded white glass, *12998*
Redfield, Edward Willis, 1869-1965
 elected to Society of American Artists, 1903, *13618*
 exhibitions
 Carnegie Galleries, 1903, *13675*
 Carnegie Galleries, 1905, second prize, *14016*
 Carnegie Galleries, 1907, *14328*
 Chicago, 1899, *12356*
 Chicago Art Institute, 1900, *13137*
 Cincinnati Art Museum, 1900, *13067*
 Copley Society, 1905, *13924*
 Corcoran Art Gallery, 1907, bronze metal, *14282*
 Minneapolis Society of Fine Arts, 1904, *13789*
 National Academy of Design, 1907, *14266*, *14311*
 Pennsylvania Academy of the Fine Arts, 1901, *13163*
 Pennsylvania Academy of the Fine Arts, 1902, *13363*
 Pennsylvania Academy of the Fine Arts, 1903, Temple gold
 medal, *13563*
 Pennsylvania Academy of the Fine Arts, 1905, *13851*
 Pennsylvania Academy of the Fine Arts, 1906, *14244*
 Society of American Artists, 1897, *10538*
 illustrations
 Delaware River, *14077*
 Pennsylvania hills, *13792*
 Surf, *13716*
 Three boats, *14002*
 Near Boothbay Harbor, Maine, receives Julius Hallgarten prize,
 National Academy of Design, 1904, *13717*
 Seine at Paris, acquired by Pennsylvania Academy of the Fine
 Arts, 1901, *13209*
Redfield, M. L., fl.1898
 illustrations, photograph frame for copying, *6608*

charcoal studies of a greyhound, *3730*
dog study, *6230*
studies of dogs, *2751*
influence on students, *24683*
praised by Fortuny, *22259*
sales and prices, 1882, *Automedon with the horses of Achilles*, *1312*, *9624*
Salomé, in collection of Madame De Cassin, *2528*
studies in Robinson collection, *25357*
Regnault, Thomas Casimir, 1823-1875
exhibitions, Paris, 1884, drawings, *1773*
illustrations, *Paul Bril*, *20980*
Regnier, Antony, 1835-1909
illustrations, monochrome plate decoration, *2030*
Regnier, Isidore Désiré, fl.1854-1864 See also: **Best, Hotelin and Régnier**
Regnier, Joseph Ferdinand, 1802-1870
illustrations, vases in hard Sèvres porcelain, *13653*, *13816*
Rehan, Ada, 1860-1916
notes, 1897, *23170*
performances
in *Magistrate*, 1897, *23222*
in *Rosalind*, 1896, *23157*
portraits
as Katherine, engraved by S. Arlent Edwards, *15893*
portrait by C. de Grimm, *20473*
portrait by J. S. Sargent, *5002*
solid silver statue, *4707*
Rehberg, Frederick, 1758-1835
technique for figure drawing, *6960*
Rehn, Frank Knox Morton, 1848-1914
elected to Society of American Artists, 1903, *13618*
exhibitions
American Art Association, 1885, *2085*
American Art Galleries, 1884, *24988*
American Art Galleries, 1886, watercolors, *2131*
American Art Galleries, 1887, *10832*
American Art Union, 1883, *10913*
American Watercolor Society, 1884, *25038*
American Watercolor Society, 1903, *13592*
Carnegie Galleries, 1900, *13130*
Chicago Art Institute, 1899, *12902*
Chicago Art Institute, 1902, *13536*
Cincinnati Art Museum, 1900, *13067*
Fellowcraft Club, 1890, *26181*
Milwaukee Exposition, 1883, *24799*
National Academy of Design, 1883, prepares, *24400*
National Academy of Design, 1887, *10831*
National Academy of Design, 1907, *14311*
New York, 1890, *25733*
New York, 1891, *15350*
New York, 1892, *26493*
New York, 1901, *13202*
Philadelphia Water Color Club, 1901, *13215*
Prize Fund Exhibition, 1885, *1985*, *25278*
Prize Fund Exhibition, 1886, *2226*, *25304*
Salmagundi Club, 1887, *2364*
Union League Club of New York, 1890, *26155*
illustrations
Afterglow, *3331*
Gloucester harbor, *24509*
Golden bar of evening, *13218*
In Gloucester Harbor (drawing), *24565*
New England harbor, *13424*
Wind-swept main, *13803*
June evening, acquired by Watertown Municipal Art Gallery, *14319*
notes, 1899, *17607*
painting, 1883, *24609*
receives letter suggesting a subject for a painting, *17571*
sales and prices, 1892, *15790*, *15811*, *26507*
Sun-shower on the Atlantic coast, in Clarke collection exhibition, 1883-4, *24955*
Venetian paintings, 1902, *8081*
watercolor wins prize, 1885, *11285*

whereabouts
1883, Gloucester, *24728*
1883, returns to New York in fall, *24791*
1883, summer plans, *24666*
1896, summer studio, Magnolia, Mass, *23056*
Reiber, Emile August, 1826-1893
armorial windows, *1415*
illustrations
painted and stained glass window for W. K. Vanderbilt, *5207*
stained glass window, *6594*
stained glass window for W. K. Vanderbilt mansion, *5318*
Reich, Jacques, 1852-1923
etching of Whittier, *26100*
illustrations
Alfred Tennyson (drawing), *2363*
Lord Russell of Killowen (etching), *6757*
portrait etcher, *6761*
Reichard, Gustav, & Co. See: **New York. Reichard and Co.**
Reichenberg, Suzanne, 1853?-1924
retirement, 1898, *24068*
Reichman, R., fl.1883
portrait paintings, 1883, *24817*
Reichmann, Josephine Lemos, 1864-1938
exhibitions, Chicago Ceramic Association, 1902, *13511*
illustrations, vase-landscape, *13912*
Reid Brothers, architects
illustrations, driveway gate, *20565*
Spreckels Pavilion, San Francisco, 1900, *22104*
Reid, Estelle Ray, fl.1902-1903
illustrations, portrait sketch, *13370*
Reid, George, 1841-1913, *9711*
exhibitions
Royal Academy, 1907, *14312*
Royal Scottish Academy, 1881, *21987*
Royal Scottish Academy, 1891-2, *26514*
Toronto, 1890, *26184*
knighthood, 1892, *26466*
notes, 1891, *26387*
picture of christening of son of Prince and Princess Henry of Battenberg, *26918*
resigns as president of Royal Scottish Academy, 1902, *13545*
Reid, George Agnew, 1860-1947
boys and girls in his paintings, *22651*
exhibitions, Ontario Society of Artists, 1891, *26364*
illustrations
Field flowers, *22560*
Garden walk, *22513*
portraits, photograph, *22559*
summer home and studio, *22571*
summer studio, 1893, *22491*
Reid, George Oglivy, 1851-1928
commission from Queen Victoria, 1891, *26441*
exhibitions, Royal Scottish Academy, 1887, *10430*
Reid, James William, 1851-1943,
See also: **Reid Brothers, architects**
Reid, John Robertson, 1851-1926, *10035*
exhibitions
Royal Academy, 1879, *21708*, *21723*
Royal Academy, 1880, *21874*
Royal Academy, 1881, *22022*
Royal Society of British Artists, 1880, *21958*
Reid, Marie Christine Westfeldt, fl.1882-1915
exhibitions
American Watercolor Society, 1885, *25239*
Brooklyn Art Association, 1884, watercolors, *25092*
Woman's Art Club of New York, 1891, *26292*
Reid, Marion, fl.1890-1925
illustrations
Mermaid fish service, *3387*, *3417*
roundels, *3172*
Reid, Mayne, 1818-1883
Plant Hunters, or, Adventures among the Himalaya Mountains, review, *19803*
Young Yagers, review, *19583*

whereabouts, 1883, *24762*
Richards, William Trost, 1833-1905, *8869*
Clearing off, in Seney collection, *24977*
exhibitions
 American Watercolor Society, 1877, *8805*
 American Watercolor Society, 1878, *8979*
 American Watercolor Society, 1880, *9292*
 American Watercolor Society, 1881, *296*
 American Watercolor Society, 1884, *25038*
 American Watercolor Society, 1885, *1933*
 American Watercolor Society, 1902, *13424*
 Boston Art Club, 1884, *24992*
 Brooklyn Art Association, 1884, watercolor, *25092*
 Chicago, 1896, *11813*
 Chicago Art Institute, 1897, *6463*
 Chicago Art Institute, 1899, *12902*
 Chicago Exposition, 1883, *24748*
 Denver Artists' Club, 1898, *12706*
 London, 1860, *20235*
 Lotos Club, 1883, *1464*
 Louisville's Southern Exposition, 1883, *24760*
 Metropolitan Museum of Art, 1880, *210*
 Metropolitan Museum of Art, 1880, watercolors, *9422*
 Milwaukee Industrial Exposition, 1898, *12800*
 National Academy of Design, 1861, *20354*
 National Academy of Design, 1877, *8830*
 National Academy of Design, 1881, *1129*
 National Academy of Design, 1884, *1790*
 National Academy of Design, 1884, *Wild New England shore*, *10982*
 National Academy of Design, 1885, *25271*
 New York, 1891, *15350*
 New York, 1896, *17154, 22958*
 New York, 1898, *6586*
 Pennsylvania Academy of the Fine Arts, 1855, *18793*
 Pennsylvania Academy of the Fine Arts, 1859, *20049*
 Pennsylvania Academy of the Fine Arts, 1881, *391, 1128*
 Pennsylvania Academy of the Fine Arts, 1884, *1884*
 Pennsylvania Academy of the Fine Arts, 1885, *2091*
 Prize Fund Exhibition, 1885, *1985, 25278*
 Prize Fund Exhibition, 1886, *25304*
 Royal Academy, 1879, *699*
 Royal Academy, 1880, *9354*
 Trans-Mississippi and International Exposition, Omaha, 1898, *12775*
 Worcester Art Museum, 1902, *13483*
illustrations
 Gray crag, Newport, *13851*
 Marine, *13702*
 watercolor, *11214*
Land's End, Cornwall, in Evans collection, *11185*
landscape, 1859, *20013*
landscape bought by Walters, 1859, *20114*
Lord Tyntagel's hill, shown in Boston, 1884, *24981*
marine painting on view in New York, 1891, *15752*
marine paintings at Goupil, 1889, *25674*
obituary, *14013*
paintings in Whitney collection, *2108*
picture in Evans collection, *15079*
sales and prices, 1885, Seney collection sale, *1963*
student at Pennsylvania Academy of the Fine Arts, *22508*
summer home and studio, *22571*
teacher of Arthur Parton, *22993*
whereabouts
 1857, *19682*
 1859, summer travel, *20080*
 1883, Conanicut, *24608*
 1887, summers in Cambridge, Mass, *574*
work, 1857, *19752*
Richardson
illustrations, F. D. Carley mansion, Louisville, *9416*
Richardson, Cora, fl.1875-1881
 American woman painter, *11230*
 lady artist of New York, 1880, *915*
RICHARDSON, Edward, *19855*

Richardson, Emma See: **Cherry, Emma Richardson**
Richardson, Francis Henry, 1859-1934
exhibitions
 Boston Art Club, 1907, *14252*
 Worcester Art Museum, 1902, *13483*
summer studio, 1893, *22491*
Richardson, Frederick, 1862-1937
Book of Drawings by Frederick Richardson, review, *12965*
exhibitions
 Chicago Art Students' League, 1898, *12819*
 Chicago Society of Artists, 1895, *11483*
illustrations
 All-nighters' clock, *14277*
 Snowman and the south wind, *12690*
illustrator, landscapist, stained glass artist, *12686*
teaching
 improves composition at Art School of Art Institute of Chicago, *12939*
 teacher of illustration, Art School of Art Institute of Chicago, 1898, *12720*
Richardson, Henry Hobson, 1838-1886
as interior designer, *2514*
Boston architecture, *1861*
design for monument to Oliver and Oakes Ames, Sherman, Wyo., 1881, *9561*
obituary, *2207, 10744, 25300*
portraits, portrait by Hubert Herkomer, *2177*
praise by E. W. Gosse, *25240*
Richardson, James H., fl.1848-1880
illustrations
 drawings of idols found at Granada, *14814*
 Scouting party (after W. T. Ranney), *14787*
RICHARDSON, Margaret F., *14060*
RICHARDSON, Mary, *18113*
Richardson, Mary Curtis, 1848-1931
exhibitions
 National Academy of Design, 1887, *552, 10786*
 National Academy of Design, 1887, Dodge prize, *25437*
graduate of San Francisco School of Design, *2701*
sales and prices, 1902, *Mother and child*, *22142*
still lifes, 1883, *24513*
Richardson, Samuel, 1689-1761
correspondence from Margareta Klopstock, *19571*
Richardson, Thomas Miles, 1812-1890
exhibitions, Royal Society of Painters in Water Colours, 1858, *19898*
Richardt, Ferdinand, 1819-1895
exhibitions
 National Academy of Design, 1859, *19979*
 New York, 1857, Niagara views, *19582*
 San Francisco, 1875, *Niagara Falls*, *8480*
opens Niagara Gallery and Scandinavian paintings, 1856, *19568*
Richebourg, Emile, 1833-1898
obituary, *24038*
Richelieu, Armand Jean du Plessis, *cardinal, duc de*, 1585-1642
body exhumed and head stolen, 1895, *16669*
collection, *14896*
skull returned to tomb, 1895, *16789*
Richemont, Louis, fl.1900
illustrations, *Roses*, *7369*
Richert, C. F., *Mrs.*, fl.1893
exhibitions, Elmira Inter-States Exhibition, 1893, china painting, *4576*
RICHERT, Marie, *6576, 6744*
Richet, Léon, 1847-1907
sales and prices, 1903, *Washerwoman*, *13704*
Richeton, Léon, fl.1878
illustrations, *Connoisseur* (after G. Boldini), *9022*
Richier, Ligier, ca.1500-1567
Ligier Richier by C. Cournault, review, *10503*
Richir, Herman Jean Joseph, b.1866
illustrations, *Elysian fields*, *13533, 13545, 13985, 14212*
RICHMOND, Eugene M., *23093*
Richmond, George, 1809-1896

Edward Matthew Ward, R.A., *9175*
illustrations
 portrait of E. M. Ward, *21573*
 Portrait of Sir Gilbert Scott, *85*
obituary, *17024*, *23008*
sales and prices, 1897, *17379*
studio, *22604*
Richmond (Indiana). Art Association
annual exhibitions
 1903, American bookbinders, *13714*
 1903, exhibitors, *13618*
 1904, *13781*
 1905, *13935*
exhibitions, 1906, spring, *14142*
Richmond (Indiana). Wilke Art School
notes, 1892, *4224*
students, china decoration shown at Chicago World's Fair, 1893, *4620*
studio kiln described, 1891, *3618*
Richmond (Massachusetts)
description, *10865*
summer school, 1882, *10863*
summer school, 1883, *10877*
tombstones in burying ground, *10870*
RICHMOND, Maude, *2391*, *4770*, *4810*
Richmond, Maude, fl.1894-1903
exhibitions, Architectural League of New York, 1898, *6571*
Richmond (Virginia)
monuments
 competition for pedestal of Lee statue, 1890, *26048*
 Confederate Soldiers' and Sailors' monument, *26999*
 Jefferson Davis Monument Association, *22980*
 Jefferson Davis monument planned, 1892, *26639*, *26790*
 Jefferson Davis monument site selected, 1891, *26433*
 monument to Gen. Ambrose Powell Hill unveiled, 1892, *26677*
 sculptor of Lee monument not yet chosen, 1887, *565*
 Washington monument inauguration, 1858, *19816*
Richmond (Virginia). Confederate Museum
Jefferson Davis house opens as Confederate museum, 1896, *16905*
Richmond (Virginia). Richmond Art Association
notes, 1881, *423*
Richmond (Virginia). Southern Historical Society See: **Southern Historical Society**
Richmond (Virginia). Valentine Museum
established by gifts of Valentine family, 1892, *16029*
opened, 1899, *17465*
Richmond (Virginia). Virginia Historical Society
list of publications, 1894, *16549*
prospectus, 1895, *16831*
Richmond (Virginia). Virginia State Library
books lost through poor management, *16845*
Richmond, Walter
collection, *15585*, *15765*, *22483*
 postponement of sale criticized, 1893, *16157*
 sale, 1893, *16061*
 sale, 1893, misattributions, *4355*
 sale, 1899, *12292*, *12861*, *17500*, *17521*
RICHMOND, William Blake, *9488*, *9500*
Richmond, William Blake, 1842-1921
advice to art students, *1301*
Audience in Athens during the representation of the Agamemnon, *2035*
decoration of St. Paul's cathedral, London, *7014*, *26365*
 choir, *26476*
elected academician, Royal Academy, 1895, *16800*, *22787*
exhibitions
 Grosvenor Gallery, 1879, *9178*
 Grosvenor Gallery, 1880, *9356*
 Grosvenor Gallery, 1881, *22013*
 Royal Academy, 1899, Portrait of Miss Muriel Wilson, *6983*
Lectures on Art, delivered in support of the Society of the Protection of Ancient Buildings, review, *24459*
Leighton monument, *17258*

mosaics for St. Paul's cathedral, *5816*
 designs, *26466*
 plans, *5936*
quote, on art and photography, 1893, *4660*
Richon Brunet, Richard Louis Georges, fl.1888-1900
exhibitions, Salon, 1888, *2694*
Richter, Gustav Karl Ludwig, 1823-1884
Christ raising the daughter of Jairus, *22858*
exhibitions, Internationale Kunstausstellung, Munich, 1883, *9879*
obituary, *476*
Portrait of Queen Louise, *5531*
Veil-dance, in Hilton collection, *793*
Richter, Jean Paul See: **Richter, Johann Paul Friedrich**
Richter, Johann Paul Friedrich, 1763-1825
commemoration, *20276*
German poet, *20002*, *20020*
writings, *19552*
Richter, Ludwig, 1803-1884
children in art, *9847*
exhibitions
 Berlin, 1903, *13687*
 Dresden, 1903, *13558*
obituary, *10156*, *25140*
Richter, Max Hermann Ohnefalsch See: **Ohnefalsch Richter, Max Hermann**
RICHTES, G. F. W., *20703*
Ricker, Nathan Clifford, 1843-1924
head of School of Architecture, University of Illinois, *11460*
Ricketson, Walton, b.1839
bust of Louisa M. Alcott presented to Old Concord Public Library, 1892, *26703*
Ricketts, Charles S., 1866-1931
founder of Vale Press, *12567*
illustration to Wilde's *Sphinx*, *22306*
Ricketts, Ella, fl.1895
designs for *Child's Garden of Song*, *11743*
Rico Ortega, Martín, 1833-1908
biographical information, *16461*
exhibitions
 New York, 1894, *16451*
 Paris Exposition, 1878, *9060*
 Union League Club of Philadelphia, 1899, *Seine near the Island of Billancourt*, *17618*
frienship with Fortuny and paintings of Venice, *1004*
Golden palace, in Seney collection, *24977*
illustrations
 Banks of the Adige, *23078*
 Corner of St. Mark's, *5077*
 Dario Palace, Venice, *2968*
 On the Seine, *5227*
 Venetian canal with view of Veronese's tomb, *6561*
 View of Paris from the Seine, *999*
paintings in Hart-Sherwood collection, *792*
paintings in Prado, *9136*
paintings in Stewart collection, Paris, *10823*
sales and prices
 1879, *Near Chartres* in Spencer collection, *678*
 1892, *On the river Seine* to be sold, *3924*
Scene near Venice, in Louisville's Southern Exposition, 1883, *24760*
Venice, in Walters collection, *1003*
Ricord, Frederick William, 1819-1897
library, *16313*
Riddle, George, 1851-1910
readings, Chicago, 1898, *12255*
RIDEING, William Henry, *811*, *8766*, *8780*, *8796*, *8809*, *8824*, *8835*, *8853*
Rideing, William Henry, 1853-1918
Captured Cunarder: an Episode of the Atlantic, review of design, *22388*
rebuttal of article "Artists in San Francisco" by M. B. Wright, *852*
Ridel, Louis Marie Joseph, b.1866
exhibitions, Carnegie Galleries, 1905, *14016*

Rixford, Geneve See: **Sargeant, Geneve Rixford**
roads
 England, old coach road from London to Dover, *10171, 10182*
 exhibit at Chicago World's Fair, 1893, *26709*
Robaudi, Alcide Théophile, 1850-1928
 illustrations
 Echo, 1812
 Fencing-lesson, 17822
 On the threshold, 1585
Robaut, Alfred, 1830-1909
 Descriptive Catalogue of the Work of Corot, 5336
Robb, James, 1814-1881
 collection
 exhibited at Pennsylvania Academy, 1851, *23406*
 sale, 1859, *18380*
Robbia, Giovanni della, 1469-1529
 relief, acquired by Brooklyn Museum, 1898, *6954*
Robbia, Luca della, 1400?-1481, *12397*
 Assumption of the Virgin
 acquired by Metropolitan Museum of Art, 1882, *9718*
 gift to Metropolitan Museum of Art, *1454*
 enamel ware, *897*
 illustrations
 Dancing, 3665
 Dancing children (drawn by C. E. Wilson), *5415*
 Song, 3665
 lunette given to Brooklyn Institute by A. Augustus Healy, 1898,
 12808, 17386
 review of monograph by the Marchesa Burlamacchi, *13172*
 Ruskin on sculptures of Campanile, Florence, *9595*
Robbins, Ellen, 1828-1905
 commission for book, 1860, *20259*
 flower paintings, 1860, *20227*
 paintings reproduced by Prang in chromo, *23560, 23568*
 water color flower pictures, *2580*
 water colors reproduced by Prang in chromo, *23529, 23576,
 23604*
 whereabouts, 1887, summer travel, *2543*
Robbins, Horace Wolcott, Jr., 1842-1904, *9118*
 elected Academician, National Academy, 1878, *9025*
 exhibitions
 American Watercolor Society, 1880, *9292*
 National Academy of Design, 1888, *2695*
 Prize Fund Exhibition, 1886, *25304*
 Union League Club of New York, 1884, *25090*
 Farmington River, 22495
 whereabouts
 1883, Adirondacks, *24697*
 1883, Keene Valley, *24657*
Robbins, Lucy Lee See: **Lee Robbins, Lucy**
Robbins, Richard Smith, b.1862
 Chicago landscape painter, *11416*
 exhibitions
 Chicago Art Institute, 1895, *11673*
 Cosmopolitan Club, Chicago, 1895, *11465*
 Cosmopolitan Club, Chicago, 1896, *11776*
 Minneapolis Society of Fine Arts, 1895, *11513*
 pastels, *11934*
 sales and prices, 1898, Chicago, *12701*
Röber, Fritz See: **Roeber, Fritz**
Robert, Alexandre Nestor Nicolas, 1817-1890
 exhibitions, Pennsylvania Academy of the Fine Arts, 1882,
 1354
Robert, Eugène, d.1912
 illustrations
 iron works, *13341*
 wrought-iron work, *13992*
Robert Fleury, Joseph Nicolas, 1797-1890
 classical painting, *22969*
 exhibitions, Paris, 1857, *19714*
 illustrations, *Benvenuto Cellini, 20412*
 obituary, *25892*
Robert Fleury, Tony, 1837-1911
 and Académie Julian, *6372*
 elected president of Société des Artistes Français, 1904, *13712,*

13817
 exhibitions
 Paris Exposition Internationale, 1883, *14919*
 Salon, 1876, *8718*
 poems in paint, *22653*
 quote, on Marie Bashkirtseff, *24282*
Robert, Hubert, 1733-1808
 illustrations, *Old temple, 13291*
 paintings acquired by Chicago Art Institute, 1901, *7524, 13301*
 panels acquired by Chicago Art Institute, 1900, *7372*
Robert, Karl, *pseud.* See: **Meusnier, Georges**
Robert, Léopold, 1794-1835
 painter of brigands, *14664*
Roberts, Alice Mumford See: **Mumford, Alice Turner**
ROBERTS, Charles, *22041*
Roberts, Charles, fl.1868-1874
 illustrations
 Age of innocence (after J. Reynolds), *21993*
 Claude Duval (after W. P. Frith), *21684*
 Constance (after P. H. Calderon), *21629*
 Cottage bedside at Osborne (after G. Steell), *21936*
 Emma Harte as a Bacchante (after G. Romney), *21681*
 Hen and chickens (after G. D. Leslie), *21999*
 Lady Warwick and her children (after G. Romney), *21681*
 Lord Gough (after F. Grant), *21582*
 Mrs. Siddons (after T. Gainsborough), *21659*
 Painter's ideal (after C. E. Perugini), *21885*
 Statue of the Olympian Jupiter (after C. B. B.), *21695*
 Trial of Queen Katherine (after L. Pott), *21910*
 view of Lynton, England, *21637*
 view of Pornic, France (after W. Wyllie), *22000*
ROBERTS, Charles George Douglas, *22856*
Roberts, Charles George Douglas, 1860-1943
 Forge in the Forest, review, *23223*
Roberts, David, 1796-1864
 exhibitions
 Royal Academy, 1850, *14644*
 Royal Academy, 1858, *19851*
 illustrations, grand staircase of Burgos Cathedral, *20822*
 notes, 1893, *16391*
 scene paintings, *17510*
 sketches of Spain, *20177*
ROBERTS, Edwards, *10382*
Roberts, Howard, 1843-1900
 Hypatia, on exhibit in Philadelphia, 1877, *8818*
 illustrations, *Premiere pose, 22531*
 Napoleon's first battle, 9025
 statue of Robert Fulton for Capitol, Washington, *427, 14896,
 24492*
ROBERTS, J. M., *20669*
Roberts, J. W.
 Looking Within, review, *23200*
Roberts, Joseph Jenkins, 1809-1876
 residence, Monrovia, Liberia, *20927*
Roberts, Marshall Owen, 1814-1880
 collection, *979, 3985*
 attitudes toward lending, *15759*
 denounced, 1897, *17233*
 description, 1856, *19463*
 description, 1897, *23190*
 Leutze's *Washington crossing the Delaware, 18281*
 sale, 1897, *17218*
 sale of books and prints, 1897, *6143*
 to be sold, 1897, *6092*
 Washington crossing the Delaware acquired by Metropolitan
 Museum of Art, 1897, *17233*
Roberts, Percy, fl.1866-1883
 illustrations
 view in Umbria, *21728*
 view of Bolton Abbey, *21694*
Roberts, R. A., 1870-1932
 portraits, photograph, *23250*
Roberts, Thomas Edward, 1820-1891
 exhibitions, Royal Society of British Artists, 1879, *21790*
 illustrations, *Recruiting sergeants* (after J. LeBlant), *21596*

Chicago World's Fair, 1893, *4463*
International Society of Sculptors, Painters, Gravers, 1907, *14248*
Louisiana Purchase Exposition, 1904, *13806*
New York, 1895, *16865*
Paris, 1889, *3032*
Pennsylvania Academy of the Fine Arts, 1899, *Brass age*, *17526*
Pennsylvania Academy of the Fine Arts, 1905, *13853*
Saint Louis Exposition, 1904, negotiations for space, *13658*
Union League Club of New York, 1899, *12861*
facsimile of 1886 Royal Academy rejection notice, *4490*
five works loaned to Boston Museum of Fine Arts, 1903, *8281*
French sculptor, *5934*
gallery in Paris planned by artist, 1899, *17655*
Gate of Hell, *7402*
illustrations
 bust of Falguiere, *14026*
 Waves, *14212*
marble figure given to Pennsylvania Academy of the the Fine Arts, 1903, *13549*
notes
 1892, *15934*
 1898, *6730*
Orpheus and Euridice, acquired by Yerkes, 1893, *4233*
Paris studios, *12515*
Penseur
 installed in front of Pantheon, 1904, *13795*
 speech delivered at inauguration, 1906, *14159*
Puvis de Chavannes, *22366*
 model for monument completed, 1903, *13558*
sculpture for Boston Museum 1894, *27006*
sculptures sold in America often forgeries, *26961*
statue of Balzac, *12265, 12758, 12764, 16639, 17450, 17641*
 controversy, 1898, *6674, 7074*
 criticized, 1903, *13672*
 refused by society that commissioned it, 1898, *12757, 12769*
works in Loie Fuller collection, 1903, *8222*
Rodman, Ella See: **Church, Ella Rodman MacIlvaine**
Rodrigues, Georges, d.1885
illustrations, *Brook of St. James*, *1365*
Rodriguez, Gaston, b.1856
etchings after Millet, Daubigny, *15167*
illustrations, *Tangled skein* (etching), *13259*
Rodriques de Rivera, Marie, fl.1894-1895
portraits, photograph, *22580*
still lifes, *22617*
Roeber, Fritz, 1851-1924
illustrations, studies of heads, *13230*
Roecker, Henry Leon, b.1860
Chicago landscape painter, *11416*
exhibitions
 Chicago Art Institute, 1895, *11673*
 Cosmopolitan Club, Chicago, 1896, *11776*
member of art jury, Tennessee Centennial, 1896, *11843*
sales and prices, 1898, Chicago, *12701*
Roederer, Jules, d.1888
collection, sale, 1891, *3670, 15693*
Roelofs, Willem, 1822-1897
modern painter of Holland, *6314*
Roentgen rays See: **X-rays**
Roerich, Nikolai Konstantinovich, 1874-1947
illustrations, *Maison de Dieu*, *13759*
Roestraten, Pieter Gerritz. van, ca.1630-1700
decoration and ornament in his painting, *10358*
detail from painting of silver vase, *17741*
Roffe, Edwin, fl.1852-1878
illustrations
 Thomas Carlyle (after J. E. Böhm), *9022*
 Widow's cruse (after J. Adams-Acton, *8844*
 Woodland spring (after R. W. Martin), *8420*
Roffe, W., 1820-1890
illustrations
 Albert (after J. H. Foley), *8814*
 Angel of the resurrection (after J. Adams-Acton), *9001*

Earl of Beaconsfield, K.G. (after R. Gower), *9639*
Earl of Derby, K.G. (after M. Noble), *8494*
First flight (after A. Bruce Joy), *9120*
Hagar and Ishmael (after C. Bauerlé), *9538*
Lady in "Comus" (after J. D. Crittenden), *9095*
Last voyage (after F. Miller), *9216*
Lieut-Gen Sir James Outram (after J. H. Foley), *8362*
Mouse (after J. Reynolds), *9778*
Panthea and Abradatus (after W. C. May), *9856*
Princess Alice of Hesse (after J. E. Böhm), *9676*
Reaper and the flower (after L. Malempré), *9369*
Right hon. William E. Gladstone, M.P. (after J. Adams-Acton), *8702*
Sister's birthday (after T. N. MacLean), *9479*
William H. Seward (after R. Rogers), *8883*
ROGÉ, Adolphe, d.1896, *22841*
Roger, Adolphe, 1800-1880
obituary, *103*
Roger Ballu See: **Ballu, Roger**
Roger Milés, Léon, 1859-1928
Art et Nature, *17364*
Rogers, Bruce, 1870-1957
cover for L. Bell's *Little Sister to the Wilderness*, *22334*
designs for Shelley's *Banquet of Plato*, *22388*
Ecclesiastes, preparation announced, 1894, *22297*
illustrations
 book designs, *22248*
 card for T. C. Steele's 1893 studio exhibition, *22281*
 cover for *Modern Art*, *12527, 22374, 22386, 22400, 22415*
 decorative border, *22338*
 decorative initial, *22236, 22240, 22293, 22300, 22323, 22325, 22328, 22332, 22352, 22353, 22355, 22362, 22363, 22366, 22367, 22368, 22369, 22434, 22436, 22437, 22440, 22442, 22443*
 gargoyles, *22255*
 page design, *22245, 22291*
 tailpiece, *22302*
 title decoration, *22238*
 title page, *Modern Art, Autumn Number, 1893* (after I. R. Henri), *22254*
 title page, *Modern Art, Spring Number, 1893*, *22221*
 title page, *Modern Art, Summer Number, 1896*, *22402*
 title page, *Modern Art, Winter Number, 1895*, *22322*
M. E. Steele's *Impressions*, *22249*
ROGERS, C. S., *20368*
Rogers, Charles A., ca.1840-1913
notes, 1899, *22077*
Rogers, Charles H., d.1898?
collection, sale, 1899, *17505, 17516*
Rogers, Edmund Law
collection
 prints, sale, 1896, *17032*
 sale, 1896, *17016*
ROGERS, Edward Thomas, *9103, 9114, 9126, 9142, 9156, 9169, 9182, 9193, 9208, 9224, 9236, 9254, 9269, 9300, 9348, 9367, 9378, 9394, 9414, 9426*
Rogers, Edward Thomas, 1830?-1884
obituary, *10043*
ROGERS, Emma Ferdon Winner, *11487*
ROGERS, F. E., Mrs., *20716*
Rogers, Franklin Whiting, b.1854
exhibitions
 American Art Association, 1883, *24398*
 Boston Paint and Clay Club, 1884, *25083*
sales and prices, 1901, *Quail country*, *13210*
ROGERS, George Alfred, *21942, 21976*
Rogers, Harry See: **Rogers, William Harry**
Rogers, Henry W., 1806-1881
president, Buffalo Fine Arts Academy, *10661*
Rogers, Henry Wade, Mrs. See: **Rogers, Emma Ferdon Winner**
Rogers, J. Henry,
collection, autograph sale, 1895, *16760*
Rogers, Jacob S., 1822?-1901
bequest to Metropolitan Museum, *8173, 13281, 13309, 13594,*

Rolshoven, Julius, 1858-1930
exhibitions
Royal Academy, 1898, *6644, 12734*
St. Botolph Club, 1889, *2859*
Salon, 1899, *12915*
Society of American Artists, 1882, *1349*
Society of Western Artists, 1906, *14038*
opinions on art criticism, *16326*
ROMA, 11150
Roman antiquities See: **classical antiquities**
Roman architecture See: **architecture, Roman**
Roman art See: **art, Roman**
Roman bronzes See: **bronzes, Roman**
Roman Catholic Church See: **Catholic Church**
Roman costume See: **costume, Roman**
Roman decoration See: **decoration and ornament, Roman**
Roman emperors
architecture, *20582*
Roman mosaics See: **mosaics, Roman**
Roman murals See: **mural painting and decoration, Roman**
Roman sculpture See: **sculpture, Roman**
Romanesque ornament See: **decoration and ornament, Romanesque**
Romanino, Girolamo, ca.1484-ca.1562
frescoes from Castle of Malpaca to be published by Arundel Society, 1892, *3946*
Romano, Giulio, 1499-1546
Dance of the muses, 5531
paintings in Borghese Palace collection, *19925*
panels for Raphael acquired by Metropolitan Museum, 1905, *13976*
Romanticism
decorated lodgings of the Romantic artists, *17068*
Romanticism in art
French painting, *22994*
paintings at Chicago World's Fair, 1893, *4766*
Rome
American writers in Rome, 1850's, *18194*
antiquities, *39, 134, 8589, 8605, 8734, 9062, 14883, 14900, 20077, 20581*
Ara Pacis excavations, *13724*
bust of Minerva discovered near Piazza del Popolo, *19594*
columns found, 1855, *19077*
discovery in the Vigna Nuova, 1891, *26323*
excavation of catacombs, 1891, *26334*
excavation of the Tiber, 1891, *26425*
excavations, 1855, *19171*
excavations, 1858, *19872*
excavations, 1883, *14918*
excavations, 1890, *26035*
excavations, 1891, *26315*
excavations, 1895, *16878*
excavations by French occupation army, 1849, *14591*
excavations forbidden, 1897, *17262*
excavations in forum, 1879, *9116*
Greek sculpture found, 1849, *14607*
Meta Sudans and fountain of Egeria, *20766*
milestone of Carausius excavated, 1895, *16662*
murals and stuccos near the Farnesina, *141*
Palatine excavations, *9049*
Pincian Hill obelisk inscription, *17140*
Roman sculpture excavated, *8427*
sculpture excavated, *14526*
statues uncovered, 1880, *9295*
the Tiber, *9086*
tomb of family of Pope Damasius excavated, 1903, *8238*
art, *14689*
1850, *14620*
1855-1856, *19459*
1856, *19419, 19430*
1858, *19872*
1859, *20077, 20092*
1859, American artists, *20045*
1877, *8788*
Michelangelo and Raphael, *14664, 14676*

Raphael portrait smuggled out of Rome, 1892, *4027*
art students, *26836*
1885, *2006*
artists
American artists, 1861, *20330*
congregate on the Via Margutta, *25045*
Ponte Molle Association of German artists, 1851, *14803*
catacombs, *19483*
Columbus celebration, 1892, *26825*
description
1854, *21344*
1855-56, *19403, 19511*
exhibitions, 1875, private collections, *8658*
Girls' Professional School, acquires American paintings, 1890, *3368*
gunpowder explosion, 1894, *26363*
map of ancient city published, 1893, *16246*
monuments
Pio Nono column and monument to Garibaldi, *10161*
progress on monument to Victor Emmanuel I, 1902, *13516*
social life and customs, Easter week, *23216*
Rome. Académie de France à Rome
art classes, *851*
Rome. Accademia di San Luca
art classes, *851*
collection, description, 1878, *8970*
reopens, 1850, *14712*
Rome. American Academy in Rome
building
Monte Baldrino donated by Albert Jones, 1883, *24930*
property donated by A. J. Jones, 1884, *25007*
endowment to be raised, 1905, *13899*
foundation legislation, 1902, *13440*
incorporation, 1905, *13944*
notes, 1897, *23174*
Rinehart Scholarship for Sculpture, notes, 1900, *13016*
Rome. Archäologisches Institut des Deutschen Reichs, *39*
Rome. British School at Rome
art classes, *851*
Rome. Chigi collection See: **Chigi collection**
Rome. Ecole français de Rome
Goya's name on the wall, *5904*
Mauclaire's criticism, *14041*
student works sent to Paris, 1881, *430*
Rome. Esposizione internazionale di belle arti
1883, *9795, 14868, 24588*
drawings and sculptures, *9853*
Italian pictures, *14884*
statistics, *14911*
1905, seventy-fifth exhibition, *13966*
Rome. Galleria Corsini See: **Rome. Galleria nazionale d'arte antica**
Rome. Galleria e museo Borghese
collection, *26518*
sold to Italian government, 1897, *17241*
restorations, 1891, *26441*
Rome. Galleria nazionale d'arte antica
instituted, 1895, *16828*
Rome. Museo Ostiense See: **Ostia (Italy). Museo Ostiense**
Rome. Museo Torlonia
sculpture collection, *718*
Rome. Palazzo Borghese
building and art collection, *19925*
gardens, proposed site for International Institute of Agriculture, *14302*
library, *15944*
Rome. Palazzo Corsini
description, 1856, *19403*
Rome. Palazzo Farnese
bought by French government, 1904, *13747*
purchased by France, 1904, *13724*
Rome. Santa Cecilia in Trastevere (church)
description, *19403*
Rome. Vatican
acquisitions, 1892, Borghese archives, *26486*

Assyrian sculptures and cuneiform inscriptions discovered, 1882, *14866*
Borgia Galleries
 open to the public, 1890, *26072*
 opening, 1890, *26236*
Borgia rooms open, 1897, *17315*
building, restoration of Apartamento Borgia, *25735*
collection, masterpieces or copies, 1899, *17527*
library, *26246*
 manuscript thefts solved, 1895, *16713*
 miniatures stolen, 1895, *16650*
mosaic factory, *26201*
photographs of works of art by Germans, 1905, *13900*
restoration of the papal chancery, 1891, *26280*
Vatican Exposition proposed by Pope, 1890, *26176*
view by torchlight, *14559*
Rome. Vatican. Capella Sistina
 ceiling, *18693*
 Holy Families by Michelangelo, *8601*
Romer, Louise Goode See: **Jopling, Louise Goode**
Romeyn & Stevens, architects
 plans for American Institute, 1893, *26952*
Romeyn, Charles W., 1854-1946
 See also: **Romeyn & Stevens, architects**
Römisch-germanisches Zentralmuseum, Mainz See: **Mainz (Germany). Römisch-germanisches Zentralmuseum**
Romney, George, 1734-1802
 depiction of children, *9715*
 essay by Schönberg, 1899, *17604, 17621*
 exhibitions
 Carnegie Galleries, 1902, *13520*
 New York, 1898, *6558*
 Royal Academy, 1886, *10280*
 Royal Academy, 1890, *25781, 25823*
 forgeries, 1900, *7261*
 house, *6759*
 illustrations
 Honorable Mrs. Wright, *13982*
 Lady Hamilton (mezzotint by S. Arlent-Edwards), *13998*
 Lady Scott, *6395*
 Patience (mezzotint by S. Arlent-Edwards), *13998*
 Portrait of the first Marquess of Stafford, *21969*
 portraits, *6024*
 Lady Hamilton
 in Alfred de Rothschild collection, *10169*
 prints popular, 1896, *5732*
 Milton and his daughters and *Titania, Puck and the changeling*, *26585*
 model Lady Hamilton, *5571*
 notes
 1890, *25978*
 1892, *15934*
 paintings in American collections, 1896, *6008*
 paintings in National Gallery, London, *5043*
 paintings in Trentham Hall, Staffordshire, *21932*
 portrait painting, *21681*
 in Hatfield House, *26452*
 relationship with Lady Hamilton, *16968*
 relics, sale, 1894, *27007*
 sales and prices
 1890, *15177*
 1890, portrait of Mrs. Stables and two daughters, *25772*
 1890, portraits, *25772*
 1894, *16577*
 1895, *5336, 16713*
 1896, portrait of Viscountess Clifden and Lady Elizabeth Spencer, *17068*
 1897, *6217*
 1898, *6730*
 1905, *13937*
 sketch shown at Union League Club of New York, 1890, *26189*
 works in H. G. Marquand collection, 1903, *8124*
Ronai, Josef Rippl See: **Rippl Ronai, Josef**
Roncière, Georges See: **Sainte Croix de la Roncière, Georges,** *comte* de

Rondel, Frederick, 1826-1892
 artists' reception, New York, 1858, *19784*
 exhibitions
 National Academy of Design, 1858, *19857*
 National Academy of Design, 1884, *1790*
 New York artists' reception, 1858, *19800*
 illustrations, *Picking beans in New Jersey*, *3626*
 whereabouts
 1860, New York, *20179*
 1883, Newport, *24841*
Roney, Cusack Patrick, 1810-1868
 organization of railroads, *21270*
Ronner, Henriette, 1821-1909
 exhibitions
 Fine Art Society, 1890, *25960*
 New York, 1889, *2884*
 illustrations
 Fine art school, *2018*
 Little gourmet, *2933*
 M. H. Spielmann's *Henrietta Ronner*, *4825*
Röntgen, Wilhelm Conrad, 1845-1923
 discovery of x-rays, *22954*
ROOD, Lily Lewis, *22366*
Rood, Lily Lewis
 Pierre Puvis de Chavannes: a Sketch, review, *22373*
Rood, Ogden Nicholas, 1831-1902
 lecture on methods of engraving gems used by the ancients, 1893, *16208*
 Modern Chromatics, with Applications to Art and Industry, review, *14, 9340*
ROOF, Katharine Metcalf, *13610*
roofing, slate
 colored roof slates from Vermont, *19377*
rook (bird)
 description, *23862*
Rook, Edward Francis, 1870-1960
 exhibitions
 Chicago Art Institute, 1897, *6463*
 Cincinnati Art Museum, 1898, *12754*
 Cincinnati Art Museum, 1900, *13067*
 Pennsylvania Academy of the Fine Arts, 1900, *13007*
 Society of American Artists, 1898, *12710*
 illustrations
 Flume in snow, *14244*
 Landscape, *14016*
 Santa Maria de Los Angeles de Cherubusco, *13716*
Rooke, Thomas Matthews, 1842-1942
 Elijah, Ahab, and Jezebel in Naboth's vineyard, *9369*
Rookwood pottery See: **porcelain and pottery, American**
Rookwood Pottery Company, Cincinnati
 imports Japanese potters, 1885, *2102*
 notes, 1896, *23008*
 school for keramic decoration opened, 1881, *400*
rooms
 proportion, *20578*
Roos, Christian Philip, 1853-1914
 library, sale, 1897, *17343*
Roos, Johann Heinrich, 1631-1685
 illustrations, *Study of sheep*, *3654*
Roos, L. F.
 collection, Diaz's *Isle des amours*, *15203*
 offerings, 1898, *17429*
Roos, Philipp Peter, 1657-1706
 wall paintings on lives of Abraham and Isaac, *6002*
Roosenboom, Margarete, 1813-1896
 exhibitions, London, 1890, watercolors, *26101*
Roosevelt, Blanche See: **Macchetta, Blanche Roosevelt Tucker**
Roosevelt, Robert Barnwell, 1829-1906
 criticizes sculptors, 1899, *7124*
Roosevelt, Samuel Montgomery, 1863-1920
 exhibitions
 New York, 1892, *26788*
 New York, 1902, portraits, *7913*

tual & physical types of beauty, 14735
National Academy of Design, 1851, *Types of beauty, 14748*
National Academy of Design, 1858, *19857*
National Academy of Design, 1859, *20030, 20048*
National Academy of Design, 1861, *20354*
New York, 1859, *19978*
New York, 1860, *20132*
New York artists' reception, 1858, *19817*
Washington, 1849, *21405*
figure painting, *19955*
guest on Baltimore and Ohio Railroad excursion, 1858, *19876*
home, house built by R. M. Hunt, *20031*
illustrations, *Type of beauty, 14746*
married to Miss Parmley, 1851, *23468*
Merchants of the country, 19767
Milton Gallery, 1854, *23327*
Mount Vernon, 19995
notes
 1849, *21381*
 1860, *20237*
painting of Preacher Davenport, 1850, *14657*
receives commission from W. Wright, *19626*
reception, 1860, *20179*
sales and prices
 1858, Romney collection sale, *19957*
 1859, *20146*
scriptural subjects, *20185*
teaching, offers instruction, 1857, *19733*
Types of beauty, in American Art Union Gallery, 1851, *14836*
Washington at home after the war, 20132
Washington at Mount Vernon, 20104
Rossler, fl.1900
illustrations, *Springtime, 7445*
Rost, Ernest C., fl.1883-1894
landcapes, 1883, *24607*
lawsuit against etching publisher, 1894, *16589*
whereabouts, 1883, summer in Keane Valley, *24703*
Rost, Reinhold, 1822-1896
library, to be sold, 1896, *17140*
ROSWELL, Clarence, *12473*
ROTCH, Arthur, *250, 273, 299, 369*
Rotch, Arthur, 1850-1894
exhibitions, Architectural League of New York, 1887, *2380*
Roth, Ernest David, 1879-1964
etchings, *13616*
exhibitions, New York, 1899, *17620*
Roth, Frederick George Richard, 1872-1944
exhibitions, Pennsylvania Academy of the Fine Arts, 1905, *13853*
illustrations
 Polar bears, 14244
 Quadriga, 13682
sculpture for Pan-American Exposition, 1901, *13263*
sculpture for Louisiana Purchase Exposition, 1904, *13685*
Rothan, Gustave, 1822-1890
collection, sale, 1890, *15183, 15248, 25998*
Rothenstein, Willaim, *Sir*, 1872-1945
drawings for *English Portraits*, 1899, *17565*
exhibitions, New English Art Club, 1903, *13588*
Goya, review, *13222*
Rothermel, A. W.
medium, *20682*
Rothermel, Peter Frederick, 1817-1895
Battle of Gettysburg, at American Exhibition, London, 1887, *25464*
exhibitions
 National Academy of Design, 1851, *14735*
 National Academy of Design, 1855, *18705, 18742*
 Paris, 1859, *18343*
 Pennsylvania Academy of the Fine Arts, 1849, *Judgement scene in the Merchant of Venice, 14533*
 Pennsylvania Academy of the Fine Arts, 1855, *18793*
 Pennsylvania Academy of the Fine Arts, 1857, *19658*
 Pennsylvania Academy of the Fine Arts, 1881, *1128*
 Pennsylvania Academy of the Fine Arts, 1895, memorial

exhibition, *11638*
Philadelphia, 1860, *20146*
Salon, 1859, *18315, 20060, 20077*
Salon, 1859, honorable mention, *20093*
illustrations, *Thought angel, 18329*
Judgement scene in the Merchant of Venice, 14537
King Lear, 19930
Laborer's vision of human progress, 23375
Murray's defense of Toleration, 14787
 in American Art Union Gallery, 1851, *14836*
notes, 1871, *10619*
obituary, *16786*
painting of King Lear, *19899*
paintings done in Rome, *19850*
Patrick Henry addressing the Virginia House of Burgesses, 23491
pictures on view in Philadelphia studio, 1859, *20114*
reception at the Art Club of Philadelphia, 1890, *25831*
sales and prices, 1858, *19814*
scene in House of Delegates, Virginia, to be engraved for Philadelphia Art Union, 1851, *14765*
student at Pennsylvania Academy of the Fine Arts, *22508*
studio, 1870, *10596*
Virtuoso, 18623
whereabouts
 1856, Rome, *19581*
 1857, *19752*
 1859, Paris, *19971*
 1883, lives on Pennsylvania farm, *24803*
work, 1857, *19667*
work, 1875, *8480*
Rothery, Mary Catherine Hume See: **Hume Rothery, Mary Catherine**
Rothschild, Adolphe de, *baron*, 1823-1900
bequests to the Louvre and Cluny museum, *13724*
collection
 bequest to Louvre, *13426*
 bequests to the Louvre and Musée de Cluny, *13701*
 purchases Onghena collection, 1878, *21655*
Rothschild, Alfred Charles de, 1842-1918
collection, *10169, 10179*
Rothschild, Charlotte Nataniel de, *baroness*, 1825-1899
exhibitions, Société d'Aquarellistes Français, 1883, *14871*
Rothschild, Ferdinand James de Rothschild, *baron*, 1839-1898
collection
 acquired by British Museum, 1899, *17516*
 bequest to British Museum, 1899, *6903*
 Louis XVI clock, *17231*
Rothschild, I. Russell, fl.1892
Saint Anthony of Padua, shown at Custom House, New York, 1892, *26760*
Rothschild, James, *baroness* de See: **Rothschild, Thérèse, *baronne de***
Rothschild, Leopold de, *baron*, 1845-1917
wood carving for library, *21889*
Rothschild, Lionel Walter, *baron*, 1868-1937
Zoological Museum opens, 1893, *16422*
Rothschild, Mayer Anselm, 1743-1812
coin collection, *16600*
Rothschild, Thérèse, *baronne de*, 1847-1931
anecdote, *3791*
Rothschild, Walter See: **Rothschild, Lionel Walter, *baron***
Rothwell, Richard, 1800-1868
notes, 1894, *16443*
Rothwell, Selim, 1815-1881
illustrations, *Honfleur, 606*
obituary, *476*
Roton, Gabriel de, *vicomte*, b.1865
illustrations for French edition of *Lysistrata, 24155*
Rotta, Silvio Giulio, 1853-1913
exhibitions
 Pittsburgh, 1899, *12976*
 Royal Academy, 1881, *22022*
Rotterdam (Netherlands). Museum Arti, *15319*

pen drawings, *1591*
pictures in W. H. Vanderbilt collection, *25469*
pictures in Wickenden collection, *22483*
Romantic painting in France, *22994*
sales and prices
 1889, *Ferme sous bois* purchased by Corcoran Gallery, *3031*
 1892, *Forest of Compiène*, *3952*
 1893, *4314*, *16243*
 1896, alleged Rousseau sold in Brandus sale, *5778*
Sketch at Barbizon, *2286*
Vallée de la Tiffauge, provenance, *4490*
View on the Ridge of Apremont, *7260*
Winter solitude, in Walters collection, *22213*
work in W. H. Fuller collection, 1892, *3917*
works in Robert Graves collection, *2388*
Rousseaux, Emil Alfred, 1831-1874
Christ and St. John (after Ary Scheffer), reproduced in chromo by Prang, 1870, *23595*
Roussel, Charles J., 1841?-1902?
obituary, *13533*
Roussel, Roubaix Valentin See: **Valentin Roussel, Roubaix**
Rousselet, Louis, 1845-1929
India and its Native Princes, review, *8652*
Roussin, Georges, b.1854
illustrations, *Coquette*, *6953*
ROUSSIN, L. G., *23677*
Roussoff, A. N. See: **Volkov, Aleksandr Nikolaevich**
Rouveyre, Marie Louveau See: **Louveau Rouveyre, Marie**
Rouvier Paillard
invention of ivoire coulé, 1849, *14545*
Roux et Feret, Paris
illustrations, *Imperial throne of Russia in the Kremlin at Moscow*, *21228*
Roux, Paul Louis Joseph, d.1918
Porspoder Point, Brittany, *2286*
Rouzée, William M., fl.1873-1890
Washington artist, *24387*
ROVER, Ralph, *16455*
Rover, Ralph
letter on Tussaud's waxworks, 1894, *16498*
Rovere, Giuliano della See: **Julius II,** *pope*
Rowan, Marian Ellis, 1847-1922
exhibitions, New York Museum of Natural History, 1897, *17331*
Rowbotham, Thomas Charles Leeson, 1823-1875
Art of Landscape Painting in Water Colors, *1170*
exhibitions, Royal Institute of Painters in Water Colours, 1858, *19898*
illustrations, drawings for *Art of Sketching from Nature*, *14760*
obituary, *8516*
ROWBOTHAM, Thomas Leeson, 1783-1853, *14788*
Rowbotham, Thomas Leeson, 1783-1853
Art of Sketching from Nature, excerpt, *14760*
Rowe, Clarence Herbert, 1878-1930
illustrations, headpiece, *24122*
Rowe, George Fawcett, 1834-1889
collection, *16589*
 Ribera's *Lo spagnoletto* given to Lotos Club, *25426*
sale, 1887, *566*
Rowe, John, 1715-1787
E. L. Pierce paper on Rowe, *16935*
Rowe, Louise Goode See: **Jopling, Louise Goode**
ROWE, Thomas Trythall, b.1856, *22668*, *23048*
Rowe, Thomas Trythall, b.1856
portraits, photograph, *22580*
Rowe, Walter, fl.1901
illustrations, study in oil from life, *13249*
ROWELL, Fanny Taylor, *6235, 6685, 6775, 6866, 6913, 6935, 6936, 6939, 6965, 7028, 7051, 7058, 7078, 7080, 7085, 7105, 7137, 7138, 7281, 7307, 7390, 7530, 7842, 7869, 8093*
Rowell, Fanny Taylor, 1865-1928
exhibitions, New York Society of Keramic Art, 1901, *7516*
illustrations
 bouillon cups and saucers for copying, *7540*
 china decoration, *7273*

Communion service, instructions for copying, *7496*
confiture box top and edges, *7359*
decoration for a rose jar (for copying), *7334*
decoration for a smoker's set for copying, *7216*
decorations for plate and bowl, *7306*
design, *7442*
designs for copying, *7242*
Hawthorn tea set for copying on china, *7391*
Honeysuckle decoration for a vase, *7414*
maple leaves design for a pitcher, *7470*
motives for china decoration, *7226*
pansy design for copying on china, *6235*
plate, *7581*
tea set, *7192*
tray, *7165*
tray design for copying, *6273*
vase with poppies and ferns for copying, *7495*
Violets, *7544*
whortleberries plate design for copying on china, *6450*
teaches art in Jersey City, 1894, *26999*
technique for drawing for reproduction praised, 1900, *7271*
Rowland, Orlando See: **Rouland, Orlando**
Rowlands, Alice See: **Hart, Alice Marion Rowlands**
ROWLANDS, Walter, *10467*
Rowlands, Walter, Gallery See: **Boston (Massachusetts). Walter Rowlands Galleries**
Rowlandson, Thomas, 1756-1827
caricatures, review of J. Grego's book, *9342*
England's great artist-humorist, *13774*
exhibitions, New York, 1893, watercolors, *16374*
illustrations, *Vicar's family on the way to church*, *13865*
sales and prices, 1895, prints, *16759*
watercolors on view in New York, 1892, *16003*
Rowner, Henriette See: **Ronner, Henriette**
Rowse, Samuel Worcester, 1822-1901
crayon head of Mrs. Longfellow, *20080*
crayon head of Ralph Waldo Emerson, *19875*
crayon heads, *19767*
crayon portrait of Emerson, *19942*
elected to National Academy of Design, 1858, *19859*
exhibitions
 National Academy of Design, 1857, *19668*
 National Academy of Design, 1859, *20048*
 National Academy of Design, 1860, *20208*
notes
 1860, *20237*
 1871, *10674*
obituary, *13257*
portrait of Longfellow, *19819*
teaches at New York University, 1856, *19581*
whereabouts, 1860, returns from Europe, *20259*
working at Newport, 1858, *19899*
Roxbury Crayon Club See: **Boston (Massachusetts). Roxbury Crayon Club**
Roy, Marius, b.1833
illustrations, *French drummer boys playing tops*, *5225*
Royal Academy of Arts See: **London (England). Royal Academy of Arts**
Royal Academy of Music See: **London (England). Royal Academy of Music (1720-1728)**
Royal Academy of San Fernando See: **Madrid (Spain). Academia de bellas artes de San Fernando**
Royal Albert Hall See: **London (England). Royal Albert Hall**
Royal Amateur Society See: **London (England). Royal Amateur Society**
Royal Archaeological Institute of Great Britain and Ireland See: **London (England). Royal Archaeological Institute of Great Britain and Ireland**
Royal Birmingham Society of Artists See: **Birmingham (England). Royal Birmingham Society of Artists**
Royal Botanic Society of London See: **London (England). Royal Botanic Society of London**
Royal Cambrian Academy of Art See: **Conway (Wales). Royal Cambrian Academy of Art**

working methods and home described, *25421*
works in Hamilton collection, *1421*
Rubinstein, Anton, 1829-1894
 Pensées, published in German periodical, 1897, *23728*
RÜCKERT, Friedrich, 1788-1860, *19343, 19397, 19481, 19614*
Ruckstuhl, Frederick Wellington See: **Ruckstull, Frederick Wellington**
RUCKSTULL, Frederick Wellington, 1853-1942, *13501, 22566*
Ruckstull, Frederick Wellington, 1853-1942
 Army on Dewey arch, *7096*
 director of sculpture, Louisiana Purchase Exposition
 appointed, 1901, *13270*
 organizes sculpture, 1901, *7589*
 plans, 1902, *13515*
 resigns, 1903, *13543*
 exhibitions
 National Sculpture Society, 1895, *5373*
 National Sculpture Society, 1898, *12733*
 National Sculpture Society, 1898, *Solon, 12721*
 illustrations
 Soldiers' Monument in Jamaica, Queens, New York, 1897, *23174*
 Victory, 22987
 Victory for soldiers' monument, *12106*
 lecture at Art Association of Orange, N.J, 1893, *26917*
 portraits, photograph, *22580*
 sculpture, *22578*
 sculpture for Louisiana Purchase Exposition, 1904, *13685*
 statue of John F. Hartranft, *17396, 23008*
 study in Paris, *12792*
 Victory, 22988
 whereabouts
 1896, summer in New Rochelle, *23056*
 1900, Paris, *7426*
Rudall, Henry Alexander
 Beethoven, review, *3386*
Rudaux, Edmond Adolphe, b.1840
 illustrations, figure study, *3734*
Rudder, Hélène de, b.1870
 embroideries, *13669*
 illustrations
 Eté, 13516
 Printemps, 13533
Rude, François, 1784-1855
 obituary, *19359*
 sculptures, *9975*
Rudell, Peter Edward, 1854-1899
 exhibitions
 American Watercolor Society, 1883, *Riverside, 1510*
 National Academy of Design, 1883, prepares landscape, *24367*
 Prize Fund Exhibition, 1886, *25304*
 illustrations
 Evening glow, 22546
 Glimpse of Long Island Sound, 22645
 In a Devonshire forest, 22503
 landscape, *22684*
 notes, 1899, *17639*
 portraits, photograph, *22539*
 summer home and studio, *22571*
 summer studio, 1893, *22491*
 whereabouts, 1883, Michigan, *24569*
Rudkin, William H.
 library, sale, 1895, *16773*
Rudolph, Franklin, *Mrs.* See: **Rudolph, Pauline Dohn**
Rudolph, Pauline Dohn, fl.1891-1933
 biographical sketch, *11417*
 Chicago member of Society of Western Artists, *12122*
 exhibitions
 Central Art Association, 1897, *11955*
 Chicago, 1899, *12876*
 Chicago Arché Salon, 1896, first aquarelle prize, *11750*
 Chicago Art Institute, 1895, *11673*
 Chicago Art Institute, 1901, prize winner, *13191*
 Chicago Artists' Exhibition, 1899, honorable mention, *12310*

Cincinnati Art Museum, 1898, *12754*
 Cosmopolitan Club, Chicago, 1897, *12064*
 Palette Club of Chicago, 1892, *11307*
 Society of Western Artists, 1896, *11919*
 Society of Western Artists, 1898, *Pear time, 12802*
 Society of Western Artists, 1900, *12986*
 Society of Western Artists, 1902, *13542*
 illustrations
 Caught, 12051
 Portrait (awarded the Yerkes prize for 1895), *11704*
 Preparing for the fête, 13827, 13985
 Ste. Jeanne de Chantal, 12678
 Village belle, 12982
 notes, 1896, *11883*
 poster, for Maternity Hospital benefit, 1895, *11686*
 reception, Studio Building, Chicago, 1895, *11493*
 Ste. Jeanne de Chantal, wins prize in Chicago, 1898, *12110*
Ruel, Charles Durand See: **Durand Ruel, Charles**
Ruel, Paul Durand See: **Durand Ruel, Paul**
Ruel, Pierre Léon Horace, fl.1868-1903
 exhibitions, Salon, 1881, *22017*
Ruelens, Edmond
 collection, sale, 1883, *14878*
Ruess, Jacob See: **Russ, Jacob**
Ruet, Louis, b.1861
 illustrations, *Partie perdue* (etching), *13259*
 News from Versailles (after Delort), published, 1892, *15998*
Ruetenik, Otto, fl.1894-1895
 illustrations
 Autumn leaves, 22567
 On a summer evening, 22591
 On the shore of Lake Erie, 22741
Rufer, Jacob See: **Russ, Jacob**
Rugby School
 art teaching, *10111*
 School Days at Rugby by T. Hughes, review, *19709*
Ruge, Clara, fl.1893
 portraits, photograph, *22559*
 summer studio, 1893, *22491*
Ruger, Thomas Howard, 1833-1907
 notes, 1895, *22860*
Ruggles, E. A., fl.1902
 illustrations, *Suburban railroad station, 13445*
Ruggles, Edward, fl.1851-1870
 American scenery paintings reproduced in chromo by Prang, 1870, *23595*
Ruggles, Theo Alice See: **Kitson, Theodora Alice Ruggles**
Rughind Kanta Nag See: **Nag, Rughind Kanta**
rugs and carpets, *23338*
 available, 1890, *3219*
 choosing carpets and rugs, *6895*
 designing, *1318, 3975, 6299, 6515, 7678*
 principles, *743, 923*
 dyes, *964*
 Indian preferred for club, *1020*
 merits, *1175*
 notes, 1879, *778*
 role in interior decoration, *8038*
 rug making and patrons, *13004*
 sales and prices
 1893, many forgeries, *4647*
 1894, forgeries, *4904*
 technique
 Body Brussels design, *6541*
 Tapestry Brussels design, *6600*
 treating floors for rugs and carpets, *7488*
rugs and carpets, American
 designs, *1157*
 Massachusetts carpets, *517*
 Wilton rugs, *12225*
rugs and carpets, Irish
 Irish rugs for interiors, *8277*
 notes, 1903, *8238*
rugs and carpets, Oriental, *9631, 14021, 20494, 20502, 20510*
 history and manufacture, *13273*

publisher of "Maude Adams Edition" of *Little Minister* by J. M. Barrie, *12808*
publisher of *Three Cities* with illustrations by Childe Hassam, *12879*
Russell, Sol Smith, 1848-1902
collection, comedians collection, *16351*
Russell, Walter, b.1871
portraits, photograph in studio, *22602*
Russell, William Howard, 1820-1907
Hesperothen, excerpt on Runkle collection, *14872*
Russell, William, lord, 1639-1683
biography, trial, *20752*
Russia
antiquities, southern provinces excavated, 1896, *16932*
description, *21168*
ethnology, *23103*
history
plot against Czar Alexander II, *23017*
Russian Campaign journal, *16946*
theater, *17172, 17229*
imperialism, *21223*
Navy, French enthusiastically receive Russian fleet, 1893, *4661*
nobility
life, *21168*
relations to peasants, *21131*
permanent exhibition of American industries planned, 1899, *7014*
royal collection, *15543*
war impending between Greece and Turkey, 1897, *23252*
Russian art See: **art, Russian**
Russian china See: **porcelain and pottery, Russian**
Russian costume See: **costume, Russian**
Russian decorative arts See: **decorative arts, Russian**
Russian embroidery See: **embroidery, Russian**
Russian enamels See: **enamel, Russian**
Russian industrial design See: **industrial design, Russian**
Russian literature
19th century, *21024*
Russian metal work See: **metal work, Russian**
Russian ornament See: **decoration and ornament, Russian**
Russian painting See: **painting, Russian**
Russo, Gaetano, fl.1880-1892
banquet proposed, 1892, *26816*
nominated Chevalier by King Humbert, 1892, *26808*
sales and prices, 1893, *22483*
statue of Columbus for New York, *26333, 26375, 26686, 26879, 26885*
description, 1892, *4172*
monument to be designed, 1890, *26002*
on its way, 1892, *26721*
Russov, Aleksandr N. See: **Volkov, Aleksandr Nikolaevich**
Ruszczyc, Ferdynand, 1870-1936
illustrations, *Millrace, 13597*
Rutan, Charles Hercules, 1851-1914
See also: **Shepley, Rutan and Coolidge, architects**
Rutherford, Alexander W., 1826-1851
illustrations, *Jack, the giant killer, 14474*
obituary, *14765, 14779*
receives Goupil, Vibert prize, 1850, *14619*
Ruthrauff, Charles C.
collection, *16905*
Velázquez painting, *17078*
Velázquez painting restored, 1896, *17093*
Rutten, August L, d.1896?
collection, sale, 1896, *16971*
RUUTZ REES, Janet Emily Meugens, *1258*
Ruysdael, Jacob van See: **Ruisdaal, Jacob van**
Ruysdael, Solomon van, d.1670
exhibitions, Lotos Club, 1899, *17588*
Ryall, Henry Thomas, 1811-1867
chalk engraver, *17679*
RYCKMAN, Byrtha Louise, *11726*
Rydén, Henning, 1869-1938, *13673*
exhibitions
Chicago Art Institute, 1903, *13561*

Denver Artists' Club, 1899, *12886*
illustrations, ivory carving, *12699*
Ryder, Albert Pinkham, 1847-1916, *10545, 17424*
elected associate, National Academy of Design, 1902, *13436*
exhibitions
American Art Galleries, 1887, *10832*
Architectural League of New York, 1891, *26459*
National Academy of Design, 1884, *1790, 25125*
National Academy of Design, 1887, *10786*
National Academy of Design, 1888, *2680, 10846, 25516*
National Academy of Design, 1892, *4143*
New York, 1890, *Jonah, 3208*
New York, 1904, *13808*
New York Athletic Club, 1888, *2638*
Prize Fund Exhibition, 1885, *25278*
Prize Fund Exhibition, 1887, *562, 2456*
Society of American Artists, 1880, *844*
Society of American Artists, 1884, *1802*
Society of American Artists, 1887, *10789*
Union League Club of New York, 1890, *25779*
landscape in Clarke collection exhibition, 1883-4, *24955*
landscapes shown at Metropolitan Museum of Art, 1881, *9516*
painting in American Art Galleries, 1884, *1899*
sales and prices, 1899, paintings in Clarke collection, *12871*
stamped leather designs, *25589*
visit to New York studio by S. Hartmann, 1897, *10520*
works, 1883, *24525*
Ryder, Henry Orne, b.1860
Anxious moments, in Lassell Seminary collection, *630*
exhibitions
American Institute Fair, 1897, *Sunset at Kernier, Brittany, 6432*
Boston Art Club, 1890, *25730*
Ryder, Platt Powell, 1821-1896
exhibitions
American Art Galleries, 1884, *24988*
American Art Union, 1883, *Warming up, 10913*
Art Students' League, 1887, *529*
National Academy of Design, *2606*
Prize Fund Exhibition, 1886, *25304*
Faithful servant, 22495
illustrations, *Draw game, 552*
notes, 1883, *24813*
picture in Evans collection, *15079*
Rydingsvard, Karl von See: **Von Rydingsvärd, Karl**
Rye (England)
views, *9469, 9490*
Ryerson, Martin Antoine, 1856-1932
elected vice-president, Chicago Art Institute, 1902, *13440*
Ryland, Robert Knight, 1873-1951
wins Lazarus scholarship, 1902, *8081*
Rylands, Enriqueta Augustina Tennant, d.1908
buys Althorp library for Manchester, 1892, *26763*
Rylands, John, Mrs. See: **Rylands, Enriqueta Augustina Tennant**
Ryley, Madeleine Lucette, 1865-1934
portraits, photograph, *23197*
Ryn, Broes van See: **Van Ryn, Broes**
Ryn, Jan van See: **Van Ryn, Jan**

S

S., *9335, 9346, 9362, 9380, 10057, 13641, 13727, 13985, 19350*
S., A. C., *14294*
S., A. E. (monogram A.E.S.)
 illustrations, decorative initial, *9808, 9819, 9825, 9832, 9833,*
 9836, 9841, 9848, 9849, 9850, 9852, 9854, 9862, 9866, 9896
S., A. (monogram A.S.)
 illustrations
 Farm on the Ohio, 21227
 views of Dorsetshire, England, *21811*
S., B. M., *4570*
S., D. G., *17624*
S., E. V., *19690, 19713, 19779, 20173*
S., F. A., *1013*
S., F. G., *19789, 20055*
S., F. M., *14282*
S., F. P. (monogram F.P.S.)
 illustrations, Chippendale furniture, *22050*
S., G. A., *4789*
S., G. L. (monogram G.L.S.)
 illustrations, views of Oxford, *22010, 22023*
S., G. W., *9376*
S., H. C., *8283*
S., I. A., *4017, 4080, 4115*
S., J., *9471, 23271, 23280*
S., J. A.
 medium, *20708*
S., J. D. B., *18811, 18850, 18871, 18890, 18906, 18923, 19046,*
 19067, 19289, 19321, 19346, 19371
S., J. H., *643*
S., J. M., *3864*
S., L., *14185*
S., L. F., *10856*
S., L. H., *18916*
S., M. E. W., *2006, 8724, 8737, 8906, 8949, 8974, 9053*
S. (monogram)
 illustrations, *Camberwell beauty (vanessa antiopa), 21193*
S., R., *22312*
S., S. J. (monogram SJS)
 illustrations, illustration to poem, *17713*
S., T. A., *25054*
S., T. H., *18114*
Saal, Georg Eduard Ott, 1818-1870
 Düsseldorf school, *14602*
 Moonlight scene, in American Art Union Gallery, 1849, *14573*
Sabin, J. F., fl.1882-1884
 exhibitions, New York Etching Club, 1884, *25013*
Sabin, William Warren, fl.1894-1896
 Afternoon sketch, 22916
 illustrations
 After a snowfall, 22567
 Nurse shop in abandoned Shaker village, 22567
 member, Cleveland Water Color Society, *22591*
Sabina von Strasbourg See: **Steinbach, Sabina von**
SABLE, 24520
Sacco, G., fl.1833-1865
 paintings exhibited, 1855, *18964*
Sacher Masoch, Leopold, *Ritter* **von**, 1835-1895
 obituary, *16556*
Sachs, Hans, 1494-1576, *19807, 19824*
Sachse, Emma F., fl.1905-1925
 elected vice-president, Philadelphia Plastic Club, 1905, *13914*
Sackett, Clara Elizabeth, fl.1897-1915
 exhibitions, Buffalo Society of Artists, 1898, miniatures, *6669*
Sackett, E. S., fl.1882-1884
 exhibitions, American Watercolor Society, 1884, *25012*
Sackett, Edith S., fl.1883-1900
 exhibitions
 Society of Painters in Pastel, 1890, *25904*
 Woman's Art Club of New York, 1890, *25803*

Sacramento (California)
 Bric-a-Brac Club, annual meeting, 1880, *937*
Sacramento (California). California State Fair
 1897, art exhibition, *6453*
 1900, art section, *22093*
 1902, annual art exhibition, *22161*
Sacramento (California). Crocker Art Gallery
 acquisitions, 1890, copy of Rubens' *Descent from the cross*
 donated by Mrs. E. B. Crocker, *15480*
Sacré Coeur See: **Paris (France). Sacré Coeur**
Sacred Music Society See: **New York. Sacred Music Society**
saddlery
 exhibitions
 London, 1892, *15944*
Saddler, John, 1813-1892
 illustrations
 Alms-giving (after G. Doré), *8930*
 Homeless (after G. Doré), *8540*
 Kentish hop-gardens (after C. G. Lawson), *9258*
 Sunset-Sussex (after G. Cole), *8802*
 Waning of the year (after E. Parton), *9900*
Sadée, Philip Lodewijk Jacob Frederik, 1837-1904
 exhibitions, Amsterdam Exhibition, 1883, *9841*
Sadler, Dendy See: **Sadler, Walter Dendy**
Sadler, Walter Dendy, 1854-1923
 exhibitions
 Chicago, 1897, *12613*
 Milwaukee Industrial Exposition, 1898, *12800*
 Royal Academy, 1881, *22022*
 Royal Academy, 1882, *9664*
 Friday, 10119
 picture at Union League Club of New York, 1893, *22483*
Saeltzer, Alexander, fl.1844-1879
 architect of Duncan & Sherman's bank, New York, 1856, *19433*
Saemundr Sigfusson Frodi, 1056-1133
 Edda Saemundar, *21353*
Sagan, *duchesse de* See: **Talleyrand Périgord, Dorothée von**
 Biron, *duchesse de*
sailing barges
 England, *22058*
Sain, Edouard Alexandre, 1830-1910
 illustrations, drawing of children, *4615*
Sain, Paul Jean Marie, 1853-1906
 exhibitions, Salon, 1892, *15914*
Saint Aubert, Charles Leroy See: **Leroy Saint Aubert,**
 Charles
Saint Aubin, Augustin de, 1736-1807
 illustrations
 Boulevards of Paris in 1789, 21326
 Jean-Jacques Rousseau (after La Tour), *10472*
Saint Augustine (Florida)
 architecture, oldest house in United States, *16953*
 description, 1860, *20211*
Saint Botolph Club, Boston See: **Boston (Massachusetts). St.**
 Botolph Club
Saint Gaudens, Annetta Johnson, 1869-1943
 reception, Women's Art Club, Columbus, 1899, *12273*
Saint Gaudens, Augustus, 1848-1907, *4433*
 appointed to pass on statuary for New York City, 1893, *22249*
 Bacchus, 9917
 bronze relief head for the Church of the Divine Paternity, *9550*
 bust of Dr. McCosh commissioned for Princeton, 1888, *621*
 bust of General Sherman, *26295*
 caryatid for mantel, *10071*
 ceiling panels in the Cornelius Vanderbilt house, *1558*
 commissions, 1883, *24707*
 competition for Buffalo's Soldiers' and Sailors' monument, *449,*
 472
 decoration for Boston Public Library, *4283, 22131*
 controversy, 1894, *16501*
 sculpture for facade, *13332*
 seal declared immodest, 1894, *16480*
 Detroit monument, *13112*
 Diana
 at Madison Square Garden, *3792, 15872, 26396*

at Madison Square Garden criticized, *15759, 15780*
at Madison Square Garden replaced, 1892, *15966*
at Madison Square Garden to be replaced by smaller copy, *15865*
cast at Chicago World's Fair, 1892, *26861*
Madison Square Garden statue to be shown at Chicago World's Fair, 1892, *15790*
model, *12133*
Philadelphia Times comments, *26433*
rejected by Chicago, *15800*
removed from Madison Square Garden for Chicago Fair, 1892, *26770*
replacement at Madison Square Garden, 1892, *26567*
exhibitions
Architectural League of New York, 1887-88, *2621*
Architectural League of New York, 1891, *26459*
Art Club of Philadelphia, 1890, *3428*
Boston, 1899, statuettes, *17516*
Boston Museum of Fine Arts, 1880, *225*
Louisiana Purchase Exposition, 1904, *13806*
National Academy of Design, 1888, *2680, 25516*
National Academy of Design, 1889, *2936*
Paris Exposition, 1900, *13065*
Pennsylvania Academy of the Fine Arts, 1885, *11280*
Pennsylvania Academy of the Fine Arts, 1904, *13716*
Pennsylvania Academy of the Fine Arts, 1905, *13853*
Salon, 1880, honorable mention, *9371*
Salon, 1899, *12915*
Society of American Artists, 1880, *94, 844, 9324*
Society of American Artists, 1881, *1130*
Society of American Artists, 1886, *2227, 25309*
Governor Flower Memorial in Watertown, New York, *13059*
honoured at Pan-American Exposition, 1901, *13281*
illustrations
Abraham Lincoln, 12854, 12904, 14026
Portrait, 10822
portrait of Miss Violet Sargent, *3626*
Robert G. Shaw memorial, *22129*
life, *9372*
Lincoln Monument, Washington
and Shaw memorial, *10744*
commission, 1883, *24685*
list of honors received and list of principal works, 1906, *14175*
medal design for Chicago World's Fair, 1893, *16767, 27006*
design rejected for indecency, 1894, *16466*
revised, 1894, *26997*
Senate ruling of indecency, 1894, *4798*
member of jury of coin competition, 1891, *26356*
member of sculpture committee for Louisiana Purchase Exposition, 1902, *8081*
member, Tile Club, *1851*
monument to Captain Randall unveiled, 1883, *24857*
monumental sculpture, *12105*
non-participation in National Sculpture Society exhibition, 1898, *12721*
notes
1888, *623*
1899, *17686*
nude boys on medal and seal protested, 1894, *22540*
opinion on mixed-sex life classes, 1890, *3422*
Phillips Brooks, completed for Trinity Church, Boston, 1903, *13604*
plaques of children, *1786*
portraits, portrait by Kenyon Cox, *25505*
praised by English artist, 1883, *24453*
proposal for an American Salon, 1891, *26232*
Puritan
for Philadelphia City Hall, *13936*
statue donated by New England Society to Fairmount Park, 1904, *13739*
quote
on art in America, 1898, *6586*
on C. E. Dallin's Paul Revere model, *12949*
relief of Violet Sargent, *25898*
response to survey on world's greatest masterpieces, 1898,

12750
Robert G. Shaw memorial, *11977, 26475*
and mausoleum for Gov. Edwin D. Morgan, *24722*
at Paris Exposition, 1900, *13074*
commissioned, 1883, *24553*
sculpture should be supported by public or by a millionaire, *538*
sculptures, *13556*
Stanford memorial arch, *22111*
statue of Admiral Farragut, New York, *164, 215, 380, 9407, 9422, 9528, 17361*
statue of Columbus for Chicago World's Fair, 1892, *26565*
statue of General Logan, *6370*
and copy of *The Puritan* for Chicago, 1897, *12618*
monument on lake front, Chicago, *11991*
unveiled in Chicago, 1897, *6343*
statue of General Sherman, *13614, 23008, 26308*
designs, *26382*
unveiled, 1903, *8242*
statue of Lincoln, Chicago, *4911, 10814, 12044*
for Lincoln Park, 1887, *592*
inauguration, 1887, *611*
statue of Peter Cooper, *17176*
for Cooper Union, *23008*
monument commissioned, 1888, *2676*
unveiled, 1897, *6313*
statue of Randall for Sailors Snug Harbor, *25137*
statue of Rip Van Winkle, *22521*
teaching
at Art Students' League, *12474*
dispute with Art Students' League over use of nude models, 1890, *25918*
withdrawal from Art Students' League, 1890, *25898*
whereabouts
1897, American Art Association of Paris, *23998*
1898, departure for Europe deplored, *12691*
1898, to live in Paris and Florence, *12133*
1900, Paris, *7426*
work, 1886, *516*
work in Chicago, *26981*
works purchased by French government, 1899, *22070*
Saint Gaudens, Louis, 1854-1913
bas reliefs, *10744*
bas-relief for Henry Villard, 1883, *24707*
Faun, 22483
work, 1886, *516*
Saint Gaudens, Louis, *Mrs.* See: **Saint Gaudens, Annetta Johnson**
Saint Giles' Cathedral, Edinburgh See: **Edinburgh (Scotland). St. Giles' Cathedral**
Saint Ives (England)
artists' life, *25482, 25495*
description, 1889, *25638*
Saint John, Elizabeth See: **Matthews, Elizabeth St. John**
Saint John, Everitte, 1844-1908
coin collection, sale, 1893, *16294*
Saint John, James Allen, 1872-1957
illustrations, *"Thomas", 12474*
New York studio, 1901, *13218*
Saint John (New Brunswick). Owens Art Gallery
plans, 1884, *11046*
SAINT JOHN, Percy Bolingbroke, *20737*
Saint John, Susan Hely, 1833-1913
studio reception, 1884, *25079*
Saint John's (Newfoundland)
St. John's School of Art requests aid after fire, 1892, *4094*
Saint Joseph (Missouri)
art, Schultheis collection to be sold, 1899, *17592*
Saint Lanne, Georges, fl.1878
Deceived, 957
SAINT LO, Mont., *24268*
Saint Louis Fair See: **Saint Louis (Missouri). Saint Louis Agricultural and Mechanical Association**
Saint Louis (Missouri)
academy of fine arts planned, 1859, *19974*
art

Summer (panel), *14026*
sculptor of Dumas tomb, *17271*
terra-cottas forged, *2619*
Saint Mark's, Venice See: **Venice (Italy). San Marco**
Saint Mémin, Charles Balthazar Julien Fevret de, 1770-1852
 engraved portraits
 collection in library of Corcoran Gallery, *468*
 discovery of engravings, 1860, *20225*
 engraved in U.S., 1795-1810, *20252*
 exhibitions, Grolier Club, 1899, *17538*
 illustrations, Aaron Burr, *20447*
 notes, 1899, *17591*
Saint Nicholas Society of the City of New York See: **New York. Saint Nicholas Society of the City of New York**
Saint Patrick's Cathedral See: **New York. Saint Patrick's Cathedral**
Saint Paul (Minnesota)
 art
 1895, *11444*
 Ladies' Art Class, *22738*
 art association planned, 1901, *13265*
 capitol
 building by Gilbert, murals by La Farge, Blashfield and Simmons, *13781*
 competition announced for building design, 1895, *22738*
 permanent art exhibition planned for new capitol, 1905, *13936*
 permanent exhibition planned, 1905, *13976*
 quadriga by French and Potter, *14246*
 wall painting commission to Millet and Volk, 1904, *13768*
Saint Paul (Minnesota). Minnesota State Fair
 1887, competition for artists, *574*
Saint Paul (Minnesota). Saint Paul School of Fine Arts
 meeting of directors, *13228*
 notes
 1895, *11688*
 1898, *12794*
 1899, *12909*
 1902, *13403*
Saint Paul (Minnesota). State Art Association See: **Minnesota State Art Society**
Saint Paul's cathedral See: **London (England). Saint Paul's cathedral**
Saint Petersburg (Russia)
 annual fair, 1890, *26101*
 architecture
 tax exemption for exceptional buildings, 1903, *13613*
 tax exemption for new ornamental buildings, *13712*
 exhibitions
 1884, of Russian furniture planned, *9969*
 1889, Russian art, *25679*
 monuments
 Alexander Column, *7992*
 pedestal erected for Peter the Great statue, 1897, *17276*
Saint Petersburg (Russia). Imperatorskii Ermitazh
 collection, *26334*
 pictures reproduced by M. Braun, *24981*
 reproduced by Berlin Photographic Company, 1896, *17124*
Saint Petersburg (Russia). Imperial Public Library See: **Saint Petersburg (Russia). Publichnaia Biblioteka**
Saint Petersburg (Russia). Publichnaia Biblioteka
 history, *17154*
 notes, 1890, *26177*
Saint Petersburg (Russia). Russkii Muzei Imperatora Aleksandra III
 acquisitions, 1901, controversial paintings by Repin, *7639*
 exhibitions, 1901, Repin paintings, *13270*
Saint Petersburg (Russia). Universitet
 description, 1895, *16878*
Saint Pierre, Gaston Casimir, 1833-1916
 Nedjma odalisque, *23077*
Saint Saens, Camille, 1835-1921
 programmes of French music at Chicago World's Fair, 1892, *26712*

Saint Thomas Island See: **São Thomé (island) West Africa**
Saint Valentine's Day
 Valentine decorations illustrated, 1903, *8133*
Saint Vidal, Francis de, 1840-1900
 Nuit, *9967*
Saint Wulstan Society, Worcester See: **Worcester (Massachusetts). St. Wulstan Society**
Sainte Croix de la Roncière, Georges, *comte* de, b.1872
 account of Peruvian exploration, 1895, *16754*
Saintin, Jules Emile, 1829-1894
 Action, *4151*
 Apple-seller, *10147*
 elected to National Academy of Design, 1858, *19859*
 exhibitions
 National Academy of Design, 1857, *19668*
 National Academy of Design, 1858, *19857*
 National Academy of Design, 1859, *20030, 20048*
 National Academy of Design, 1860, *20208*
 Salon, 1859, *18315*
 illustrations
 Apple dealer, *1601*
 Apple-seller, *10092*
 At the seashore, *1355*
 drawing after portrait, *2728*
 Reverie, *4579*
Sainton, Charles P., 1861-1914
 exhibitions
 London, 1891, drawings, *26254*
 London, 1892, *16053*
 illustrations, *Siren's cave*, *13583*
saints
 patron saint of tailors, *19029*
 symbols in art, *9690*
Saisett, Ernest Pierre de See: **DeSaisett, Ernest Pierre**
SAKING, H. S., *2354, 2369, 2395, 2547*
SALA, George Augustus, *9484*
Sala, George Augustus, 1828-1895
 anecdote, *16948*
 art criticism, *25832*
 library, sale, 1895, *16786*
 notes, 1895, *16678*
 obituary, *16894*
 on curios, 1895, *16896*
Salamanca (Spain)
 architecture, window grating from the Casa de las Conchas, *2044*
Salem (Massachusetts)
 monuments, statue of Father Mathew, *611*
Salem (Massachusetts). Essex Institute
 annual exhibitions, 1883, *24677*
 exhibitions
 1881, *378*
 1883, *24514*
 monthly meeting, 1883, *24656*
 notes, 1883, *24503*
 ship paintings for Chicago World's Fair, 1892, *26739*
Salentin, Hubert, 1822-1910
 exhibitions, Pennsylvania Academy of the Fine Arts, 1858, *19858*
 illustrations, *Prayer in the forest*, *54*
 Prayer in the forest, *9258*
SALIS SCHWABE, M. J., *9626*
Salisbury (England). Cathedral
 quote by R. W. Emerson, *19532*
Salisbury, Rebecca, d.1891
 collection, coins given to Boston Museum, 1892, *15811*
Salisbury, Stephen, 1835-1905
 bequest to Worcester Art Museum, *14300*
 founder, Worcester Art Museum, *11954, 22388*
 gift of portraits to Worcester Art Museum, 1899, *12416*
 gives land and funds for Worcester Art Museum, *12348*
 gives site and funds for art museum, Worcester, 1896, *11794, 11863*
SALLET, Friedrich von, *19397*
Salmagundi Club See: **New York. Salmagundi Club**

Sandier, Alexandre, b.1843
 illustrations, interior decoration illustrations, *4086*
 interior decorator, *25333*
 use of nails in interior decoration, 1893, *4580*
Sandona, Matteo, 1882-1964
 illustrations, *Portrait of children*, *22196*
 notes, 1901, *22134*
 painting portraits in Honolulu, 1903, *22190*
 portrait accepted at St. Louis Exposition, 1904, *22201*
Sandoz, Adolf Karol, b.1845?
 illustrations
 French furniture at Paris Exposition, 1878, *21635*
 view of Indian court at Paris Exposition, 1878, *21606*
Sandoz, Gustave
 jewelry designs, Renaissance breloquet, *1306*
Sandreczki, Otto, fl.1903-1917
 etchings, *13616*
Sandreuter, Hans, 1850-1901
 exhibitions, Basel, 1902, *13455*
sandstone
 use of Caen stone in New York, *19198*
SANDVOSS, C., *22881*
Sandys, Frederick, 1832-1904
 drawings and illustrations, *9942*
 obituary, *13910*
Sanesi, Nicola, 1818-1889
 illustrations, *Jason and Medea*, *718*
Sanford & Davis, photographers See: **Davis & Sanford, photographers**
SANFORD, Clara Goodall, *11890*
Sanford, Cordelia R.
 bequests, *27016*
Sanford, Milton A., *Mrs* See: **Sanford, Cordelia R.**
Sanford, Rollin
 collection, sale, 1859, *20129*
Sanford, Walter, fl.1883-1887
 Franklin Pierce statue, competed with K. Gerhardt for commission, *17042*
Sangiorgio, Abbondio, 1798-1879
 obituary, *47*
Sangster, Amos W., fl.1894
 whereabouts, 1894, studio in Buffalo, *27004*
Sanguinetti, Edward Phineas, fl.1878-1883
 exhibitions, Philadelphia Society of Artists, 1882, *1270*
 whereabouts, 1883, returns from Algeria, *1530*
Sano di Pietro, 1404-1481
 works in Louvre, *5969*
Sans y Cabot, Francisco, 1828-1881
 obituary, *407*
Sansovino, Andrea, ca.1460-1529
 illustrations, frieze, *2922*
Sansovino, Jacopo, 1486-1570
 Campanile of St. Mark's, Venice, *13497*
 sculpture in Birmingham museum, *10230*
Sant, James, 1820-1916, *21783*
 exhibitions
 Royal Academy, 1884, *10039*
 Royal Academy, 1887, *10473*
 Fortune-teller, *18979*
 Pinch of poverty, photo-reproduction published, 1893, *16322*
 studio, *22621*
Santa Barbara (California)
 description and views, *10382*
 Santa Barbara District Agricultural Association awards medal to artist Murillo, 1894, *5002*
Santa Cecilia in Trastevere See: **Rome. Santa Cecilia in Trastevere (church)**
Santa Engracia (convent) See: **Saragossa (Spain). Santa Engracia (convent)**
Santa Fe (New Mexico)
 history, Spanish documents, *16141*
Santa Fe (New Mexico). Historical Society of New Mexico
 library, acquisitions,1893, *16304*
Santa Maria Novella See: **Florence (Italy). Santa Maria Novella**

Santarelli, Emilio, 1801-1886
 sculpture in Florence, 1855, *18872*
 visit to studio, 1850, *14712*
Santerre, Jean Baptiste, 1651-1717
 Adam and Eve in Paradise
 discovered in New York, 1894, *27005*
 shown in New York City, 1895, *21521*
Santiago (Chile). Museo nacional de bellas artes
 thefts, 1901, *13225*
Santo Domingo (Dominican Republic)
 history and description, *10715*
Santuree, *marquesa* di
 illustrations
 dressing room, *20600*
 elevator, Carlton House terrace, *20600*
Sanz, Ulpiano Checa y See: **Checa y Sanz, Ulpiano**
Sanzio, Giovanni, 1435-1494
 alter-piece repaired, *430*
São Thomé (island) West Africa
 description, *20806*
sapphires
 Ceylon sapphire on market, 1897, *17300*
Sappho
 Greek poetess, *19965*
Saragossa (Spain). Santa Engracia (convent), *21294*
Saranac Lake (New York)
 description, *19140, 19151, 19230*
Saratoga (New York)
 art gallery to be built, 1883, *24569*
 monuments, Saratoga Monument Association annual meeting, 1892, *26730*
 permanent art exhibition set up by S. R. Coale, Jr., 1883, *24704*
Saratoga Springs (New York). Mount McGregor Art Association
 catalogue of exhibition, 1883, *24727*
 exhibitions
 1883, *24514, 24666*
 1883, summer exhibition prices, *24739*
 notes, 1883, *24677*
 sales and prices, 1883, *24792*
Sarcey, Francisque, 1827-1899, *20553*
 criticism, *8318, 10548*
sarcophagi
 sarcophagi of Vulci in Boston Museum of Fine Arts, *25259, 25478*
Sardou, Victorien, 1831-1908
 Fedora, New York performances, 1883, *1652*
 Nos Intimes, adapted for Mrs. Langtry, 1884, *1715*
 notes, 1896, *22912*
 Pamela, success in Paris, 1898, *24048*
 plays produced in America, *10544*
 Spiritisme, description, *23771*
Sargant Florence, Mary See: **Florence, Mary Sargant**
Sargant, Mary See: **Florence, Mary Sargant**
Sargant, Geneve Rixford, 1868-1957
 exhibitions
 Chicago Art Institute, 1902, *13370*
 Chicago Art Institute, 1903, Cahn prize, *13673*
Sargeant, John, fl.1824-1839
 portraits of British House of Commons, *4387*
Sargeant, Winthrop, *Mrs.* See: **Sargeant, Geneve Rixford**
Sargent, Charles Sprague, 1841-1927
 collection of water colors illustrating North American woods, *26220*
Sargent, Dudley Allen, 1849-1924
 composite figures of American young woman and American young man, *12805*
Sargent, G. F., fl.1840's-1850's
 illustrations
 chapel of San Goncalo at Bahia (after Freeman), *21147*
 Cobra di capello (after W. H. Freeman), *20832*
 Dunluce Castle, *20906*
 gold mining in Australia, *20913*
 Haja (after W. H. Freeman), *20832*
 harbour at Bahia (after Freeman), *21147*

Lesson interrupted (after R. Barter), *20937*
Rocks of Castle Follit (after P. Blanchard), *21076*
Russian carriages (after W. H. Freeman), *20803*
Vender of specimens, *20906*
view of the great central hall (after G. Dalziel), *20937*
Sargent, Henry, 1770-1845, *21316*
Sargent, John Singer, 1856-1925, *877*
award from French government, 1889, *25678*
Capri girl, *1130*
Carmencita, bought for Luxembourg, 1893, *26917*
Carnation, lily, rose, problems with oil paint, *3841, 8149*
chairman of Royal Academy hanging committee, 1898, *6614*
criticism
1883, *1618*
London critics, 1890, *3281*
reviewed by Baignères, 1883, *14880*
reviewed by Lady Colin Campbell, 1900, *13071*
Royal Academy paintings criticized by *Atheneum*, 1890, *3310*
death rumors boost fame and market value, 1899, *7042*
decorations for Boston Public Library, *4283, 5640, 6106, 13332, 17639, 22131, 26211, 26762*
1892, *26627*
mural, *13128*
mural, 1902, *26517*
mural unveiled, 1903, *13563*
murals, *11561, 22738*
murals contain mistakes in Hebrew quotations, *5732*
progress on murals, 1903, *13627*
defended by Humphrey Ward, 1890, *25929*
elected associate of Royal Academy, 1894, *4753, 16452, 22540*
elected Royal Academician, 1897, *6143, 11947*
Ellen Terry as Lady Macbeth, newspaper criticism, 1894, *4781*
exhibitions
Art Club of Philadelphia, 1890, awarded gold medal, *3428*
Berlin Akademie der Künste, 1903, *13605*
Berlin Akademie der Künste, 1903, gold medal, *13629*
Boston, 1888, *2699*
Boston, 1899, *12824, 12859, 12874, 17527*
Boston, 1899, portraits, *12314*
Boston and London, 1903, *8244*
Boston Art Club, 1888, *2620*
Boston Art Students' Association, 1899, *6926*
Carnegie Galleries, 1900, *13130*
Carnegie Galleries, 1903, *13675*
Chicago, 1890, *Carmencita*, *25977*
Chicago Art Institute, 1903, N. W. Harris prize, *13673*
Chicago World's Fair, 1893, *4602*
Chicago World's Fair, 1893, portraits, *22258*
Grosvenor Gallery, 1884, *10012*
Grosvenor Gallery, 1885, *2035*
Institute of Oil Paintings, London, 1906, *14222*
Liege Exposition, 1905, *13965*
London, 1890, *25994*
London, 1891, *26376*
London, 1897, portrait of Julian Gordon, *6278*
London, 1901, *13240*
London, 1903, studies, *8242*
Louisiana Purchase Exposition, 1904, *13787*
National Academy of Design, 1879, *657, 9151*
National Academy of Design, 1882, *9706*
National Academy of Design, 1888, *2680, 25503, 25516*
National Academy of Design, 1890, *3455*
National Academy of Design, 1891, *3603*
National Academy of Design, 1892, *4143*
National Academy of Design, 1894, *5174*
National Academy of Design, 1895, *5567*
National Academy of Design, 1897, portrait of Monet, *6460*
National Academy of Design, 1899, *6846, 17485*
National Academy of Design, 1907, *14311*
New English Art Club, 1887, *10452, 25442*
New York, 1888, *2724, 10846*
New York, 1900, *13021*
New York, 1900, portraits, *7265*
Paris, 1883, *24413*

Paris, 1884, *1756*
Paris, 1889, *3009*
Paris Exposition, 1889, *25660*
Paris Exposition, 1889, medal of honor, *25628*
Pennsylvania Academy of the Fine Arts, 1891, *3535*
Pennsylvania Academy of the Fine Arts, 1894, *4754*
Pennsylvania Academy of the Fine Arts, 1899, *12836, 17503*
Pennsylvania Academy of the Fine Arts, 1900, *13007*
Pennsylvania Academy of the Fine Arts, 1901, *13163*
Pennsylvania Academy of the Fine Arts, 1902, *13363*
Pennsylvania Academy of the Fine Arts, 1903, *13548*
Pennsylvania Academy of the Fine Arts, 1904, *13716*
Pennsylvania Academy of the Fine Arts, 1905, *13851*
Philadelphia Society of Artists, 1880, *1001*
Pittsburgh, 1899, *12976*
Royal Academy, 1884, *10039, 10983*
Royal Academy, 1885, *2019*
Royal Academy, 1886, *10310*
Royal Academy, 1886, portraits, *2225*
Royal Academy, 1887, *576, 2480*
Royal Academy, 1889, *2984*
Royal Academy, 1890, *25924, 25960*
Royal Academy, 1891, *26347*
Royal Academy, 1891, *Carmencita*, *3648*
Royal Academy, 1894, *16556*
Royal Academy, 1895, *22359*
Royal Academy, 1896, *Mr. Chamberlain*, *5825*
Royal Academy, 1897, *6311*
Royal Academy, 1898, *12711, 12734*
Royal Academy, 1898, portraits, *6644*
Royal Academy, 1899, *Mrs. Charles Hunter*, *6983*
Royal Academy, 1902, *13431*
Royal Academy, 1903, *8243, 13605*
Royal Academy, 1906, *14116*
Royal Academy, 1907, *14312*
Royal Society of Painters in Water Colours, 1907, *14333*
St. Botolph Club, 1888, *621*
St. Botolph Club, 1888, portraits, *2662*
Salon, 1879, *9188*
Salon, 1880, *187, 913, 9355*
Salon, 1882, *1352, 1381, 9675*
Salon, 1882, *Jaleo*, *9656*
Salon, 1883, *1588, 1603, 24521*
Salon, 1884, *1806, 10008*
Salon, 1885, *2000*
Salon, 1886, *Mrs. and Miss Burckhardt*, *2206*
Salon, 1888, *2694*
Salon, 1890, *3283*
Salon, 1892, *4013*
Salon, 1896, portraits, *23618*
Salon, 1902, *13414*
Society of American Artists, 1878, *8993*
Society of American Artists, 1880, *94, 9324*
Society of American Artists, 1883, *1551, 9824*
Society of American Artists, 1886, *2227, 25309*
Society of American Artists, 1888, *25505*
Society of American Artists, 1890, *3255, 25895*
Society of American Artists, 1890, *Carmencita*, *15205*
Society of American Artists, 1890, portraits, *25915*
Society of American Artists, 1891, *15643, 26329*
Society of American Artists, 1891, portrait of Beatrice Goelet, *3626*
Society of American Artists, 1892, *3986, 26634*
Society of American Artists, 1893, *4235*
Society of American Artists, 1897, *Portrait of a lady*, *6250*
Society of American Artists, 1898, *6618, 12710*
Society of American Artists, 1899, *17552*
Society of American Artists, 1899, portraits, *6957*
Society of Washington Artists, 1898, portrait of Ada Rehan, *6669*
Union League Club of New York, 1890, *3177*
Venice, 1901, *13257*
Walker Art Gallery, Liverpool, 1906, *14222*
expatriate American artist, *11197*
friendship with Carolus Duran, *5217*

exhibitions
 American Watercolor Society, 1884, *25038*
 Boston, 1884, *25032, 25072*
 Boston Art Club, 1880, *807*
 Kansas City Art Club, 1902, *13337*
 National Academy of Design, 1880, *111, 889, 9324*
 National Academy of Design, 1881, *1129*
 New York, 1905, *13843, 13868*
 New York Etching Club, 1888, *2641*
 Pennsylvania Academy of the Fine Arts, 1880, *142*
 Pennsylvania Academy of the Fine Arts, 1882, *1450*
 Prize Fund Exhibition, 1885, *On the marsh, 25278*
 Prize Fund Exhibition, 1886, *25304*
 St. Botolph Club, 1880, *159*
 Seventh Regiment Fair, N.Y., 1879, *766*
 Society of American Artists, 1880, *844*
 Society of American Artists, 1884, *1802*
 Society of American Artists, 1887, *10789*
illustrations
 Chapter from Koran, 1330
 head, *17831*
 Quiet moment (etching), *22531*
 Study, 22508
landscapes, 1883, *24541, 24568*
mezzotint after Wageman's portrait of Charles Lamb issued, 1896, *17053*
notes, 1883, *24631*
Nubian Sheik, exhibited at Metropolitan Museum of Art, 1881, *9516*
painted panel for table, 1880, *892*
painting of Kasba, Algiers, 1883, *24513*
president, Art Club of New York, 1884, *24956*
prints in Library of Congress, 1898, *12806*
Quiet moment (etching), *896*
Rialto, finished, 1883, *24959*
Sandy land near the sea, in Clarke collection exhibition, 1883-4, *24955*
sketches and studies, *9380*
teaching
 Art Students' League, 1883, *24716*
 Art Students' League, 1885, *11219*
 Free Art School for Women of Cooper Union, 1883, *24716*
Venetian scenes, 1883, *24607*
whereabouts, 1883, summer place near New Bedford, *24728*
Sarte, Marie Madeleine Réal See: **Réal del Sarte, Marie Madeleine**
Sarti, Diego, b.1860
 memorial to King Humbert, Rome, *13281*
Sarto, Andrea del, 1486-1530
 illustrations, *Portrait of a lady, 9457*
 notes, 1899, *12398*
 paintings in London National Gallery, *4360*
Sass, George, fl.1897
 exhibitions, Kansas City, 1897, *6487*
Sassoferrato, Il See: **Salvi, Giovanni Battista**
Satan See: **Devil**
satellites. *See also:* **moon**
satire
 DuMaurier address on social pictorial satire, 1892, *4029*
satire, French
 court ladies as Greek fates, *21205*
SATTERLEE, Walter, *2767*
Satterlee, Walter, 1844-1908
 advice on costume classes for artists, *2485*
 Coming from the vintage (etching), *25047*
 conversation on costumes and models, 1891, *3660, 3675*
 etchings, *24391*
 exhibitions
 American Art Association, 1884, *Holland tulips, 25209*
 American Art Galleries, 1884, *24988*
 American Art Union, 1883, *10913*
 American Watercolor Society, 1880, *74, 9292*
 American Watercolor Society, 1881, *1065*
 American Watercolor Society, 1882, *1300*
 American Watercolor Society, 1884, *25012*

 American Watercolor Society, 1888, *2641*
 Brooklyn Art Association, 1884, watercolors, *25092*
 National Academy of Design, 1883, *1552, 24480*
 National Academy of Design, 1884, prepares, *25061*
 National Academy of Design, 1885, *1970*
 National Academy of Design, 1886, Clarke prize, *25293*
 New York Etching Club, 1885, *1934*
 Prize Fund Exhibition, 1885, *1985*
 Prize Fund Exhibition, 1885, *Good bye, summer, 25278*
 illustrations
 Autumn, 24509
 Coming from the vintage (etching), *25035*
 Cup of water, 6908
 Grandmother, 6435
 Industry and idleness, 546
 Midday meal, 3532
 Monk in prayer, 22513
 Old salt, 7438
 Passion flower, 22546
 Prayer and praise, 7041
 Silver question, 6424
 sketches at Etretat, *2767*
 Souvenir of Morocco, 6435
 Turkey girl, 6434
 illustrations for Pallard's *Co-education*, 1883, *24655*
 Lightened load, 22503
 New altarpiece, 22495
 notes
 1887, *611*
 1898, *17389*
 Old salt, 7471
 Out of reach, in Clarke collection exhibition, 1883-4, *24955*
 paintings of young women, *813*
 pen sketches, *6430*
 Psyche, 24551
 sales and prices, 1883, etchings in London, *24829*
 students, reception and exhibition, 1884, *25074*
 studio, *22721*
 art school and pupils, *6428*
 exhibition of W. C. Hill's collection, 1899, *7125*
 Study of a French peasant, 24379
 teaching
 art classes, 1899, *7090*
 school at Bellport, L.I., 1895, *11549*
 summer class, Long Island, 1895, *22738*
 summer classes, 1898, *6669*
 Valkyrie, print after painting issued, 1901, *7714*
 views on women's dress, *1277*
 Votive offering, at American Art Union, 1884, *10989*
 water-colors, 1883, *24829*
 whereabouts
 1883, Adirondack trip, *24755, 24791*
 1883, summer at Conanicut, R.I, *24703*
 1883, summer in Narragansett, *24586*
 1896, costume class in Bellport, L.I, *23056*
Sattler, Hubert, 1817-1904
 exhibitions, National Academy of Design, 1851, *14748*
Sattler, Joseph, 1867-1931
 book plates, *22398*
 notes, 1895, *16639*
Saturday Art Club See: **Chicago (Illinois). Saturday Art Club**
Saturday Club, Boston See: **Boston (Massachusetts). Saturday Club**
SAUCRÉ, H. P., *11757, 11784*
Saucré, H. P., fl.1894-1896
 Designing and Painting with Vitrifiable Colors on Glass, excerpt, *5238, 5283*
Sauerwen, Frank Paul, 1871-1910
 exhibitions
 Denver Artists' Club, 1898, *12251, 12706, 12822*
 Denver Artists' Club, 1899, *12327, 12886*
Saulcy, Louis Félicien Joseph Caignart de, 1807-1880
 obituary, *264*

Schmitz, Bruno, 1858-1916
 Soldiers' monument, Indianapolis, *22280*
 prize for design, 1888, *621*
Schmolze, Karl H., 1823-1861
 decoration for Philadelphia Opera House, *19581*
Schmucker, Samuel L., fl.1900-1902
 exhibitions, Philadelphia T-Square Club, 1902, *13334*
SCHMUCKER, Samuel Mosheim, 1823-1863, *18257, 18399, 23391, 23403, 23415, 23426, 23441, 23456, 23478*
Schneider, Frederick, 1811-1893
 library, manuscripts and illustrated books, *15735*
Schneider, Hermann, 1847-1918
 Van Dyck painting the children of Charles I, *21944*
Schneider, Otto J., 1875-1946
 drawings of women, *13392*
 etchings, *13113*
 exhibitions, Chicago, 1900, *13141*
 illustrations
 Good point of view, *13385*
 Portrait, *13806*
 Portrait in red crayon, *13567*
 Spanish beauty, *13467*
 Voices, *13060*
 Waiting (dry point), *13703*
Schneider, William G., 1863-1915
 exhibitions, Society of Western Artists, 1898, *Girl with violin*, *12802*
 illustrations, *Jessamine*, *13746*
Schnorr von Carolsfeld, Julius, 1794-1872
 Bible illustrations, *19210*
 exhibitions, Berlin, 1878, *21647*
Schoelcher, Victor, 1804-1893
 obituary, *16473*
Schoenborn, Annie M., fl.1898-1908
 exhibitions, Washington Ceramic Club, 1899, *12370*
Schoenbrun, Lily, fl.1903
 illustrations, fountain of the Great Lakes, *13612*
Schoenbrun, Rose, fl.1899
 illustrations, illustration for *The Invisible Man*, *12964*
Schoenfeld, Flora See: **Schofield, Flora Itwin**
SCHOENHOF, R. F., *26354*
Schoff, Stephen Alonso, 1818-1905
 Bathers (after W. M. Hunt), *1569*
 engraved, 1883, *24620*
 plate published, 1881, *442*
 engraving of W. C. Bryant, *19942*
 exhibitions, Boston Museum of Fine Arts, 1893, prints, *16280*
 illustrations
 Portrait of Mrs. Adams (after W. M. Hunt), *36*
 Sea serpent (after E. Vedder), *120*
Schofield, Emma See: **Wright, Emma Schofield**
Schofield, Flora Itwin, 1873-1960
 exhibitions
 Chicago Art Students' League, 1898, *12819*
 Society of Western Artists, 1906, *14038*
Schofield, John McAllister, 1831-1906
 retires from Army, 1893, *22791*
Schofield, Levi T. See: **Scofield, Levi T.**
Schofield, Walter Elmer, 1867-1944
 exhibitions
 Carnegie Galleries, 1900, honorable mention, *13130*
 Carnegie Galleries, 1904, first class medal, *13792*
 Cincinnati Art Museum, 1900, *13067*
 National Academy of Design, 1900, 1st Hallgarten prize, *13173*
 National Academy of Design, 1903, *13702*
 Pennsylvania Academy of the Fine Arts, 1899, *January evening*, *12836*
 Pennsylvania Academy of the Fine Arts, 1902, *13363*
 Pennsylvania Academy of the Fine Arts, 1903, Sesnan gold medal, *13563*
 Society of American Artists, 1900, *13038*
 illustrations
 Across the river, *14328*
 Cornish village, *14016*

 Midwinter thaw, *14244*
 Sand dunes near Lelant, *14078*
 painting purchased by Pennsylvania Academy of the Fine Arts, 1899, *12877*
 Winter evening, first Hallgarten prize, 1901, *13213*
Scholander, Anna See: **Boberg, Anna Katarina Scholander**
Scholander, Fredrik Vilhelm, 1816-1881
 obituary, *407*
Scholl, Edward, 1884-1946
 illustrations
 Octogenarian (etching), *13608*
 Reflections, *13616*
Schommer, François, 1850-1935
 illustrations, posing for portrait, *2728*
SCHÖNBERG, James, *17358, 17434, 17437, 17453, 17477, 17510, 17542, 17604, 17611, 17621, 17649, 17663, 17679, 17697, 25732, 25743, 25794*
Schongauer, Martin, ca.1450-1491
 Arab scouts, in Nickerson collection, Chicago Art Institute, *13104*
 biography and works, *21005*
 prints in Claghorn collection, *9149*
Schönlank, Alexis
 collection, sale, 1896, *17016, 17068*
Schönn, Alois, 1826-1897
 Goose-market, Cracow, *9386*
Schook, Fred DeForest, 1872-1942
 illustrations
 drawing, *13190*
 sketch, *12819*
school buildings
 art in the schoolroom, *12174*
 England, art applied to town schools, *9487, 9498*
school decoration, *12203*
 art in public schools, *6864*
 art in schoolrooms, *10705, 11424, 12174, 12815, 12866, 12877, 12884, 13570, 26362*
 1899, *17465*
 anecdote, *13004*
 chromo-lithographs in the classroom, *23514*
 decoration of classrooms in West Aurora High School, *12717*
 municipal art society decoration of school rooms, *22320*
 pictures in schoolroom, *11535*
 pictures suitable for schoolrooms at Chicago Art Institute, 1897, *12022*
 prints by Blanche Ostertag for schoolroom decoration, *12879*
 reform of bare classroom walls, 1896, *16968*
 catalogue of suitable pictures compiled by C.A.A., 1897, *12021*
 decoration instills values, *6663*
 England
 art applied to English town schools, *9487, 9498*
 Art for Schools Association established, 1883, *9875*
 London's Art for Schools Association, 1887, *25462*
 F. S. Lamb suggests schools hang photos of examples of city planning, 1902, *7944*
 photographs, *13384*
 reproductions of masterpieces encouraged, *6724*
 simplicity, *11861*
 Sunday schools, *12340*
 United States
 1896, *11847*
 art reproductions suitable for schools and hospitals, Boston, 1897, *17205*
 Baltimore's Municipal Art Society beautifies school rooms, 1899, *17554*
 C. C. Perkins proposes society to provide art for Boston schools, 1884, *25047*
 Chicago Public School Art Society, *12854*
 Denver public schools, *12462*
 loan collection for Chicago tenement school, 1899, *12328*
 Los Angeles, 1898, *12381*
 Public Education Association decorates New York public schools with pictures, 1905, *13976*
 Public School Art League of Boston raises funds for school decorations, 1892, *4128*

school room in Waukegan, Illinois, *12282*

School of Applied Design for Women See: **New York. New York School of Applied Design for Women**

School of Design for Women See: **New York. Cooper Union for the Advancement of Science and Art. School of Design for Women**

School of Design for Women, Philadelphia See: **Philadelphia (Pennsylvania). Philadelphia School of Design for Women**

School of Design for Women, Pittsburgh See: **Pittsburgh (Pennsylvania). Pittsburgh School of Design for Women**

School of Fine Arts of the New England Conservatory of Music See: **Boston (Massachusetts). New England Conservatory of Music. School of Fine Arts**

School of Illustration, Chicago See: **Chicago (Illinois). School of Illustration**

School of Medieval Embroidery See: **London (England). School of Mediaeval Embroidery**

schools

A. V. Churchill on teaching drawing in public schools, 1900, *7314*

applications of honesty in art, *7685*

art schools, exclusion of male students from women's schools protested, 1894, *5110*

drawing instruction, textbooks for teaching drawing, *5702*

England, *9487, 9498*

exhibition of art from schools affiliated with South Kensington, 1877, *8940*

Germany, drawing in German public schools, 1895, *5405*

Japan, drawing system, 1898, *6776*

Paris public school and American Catholic school students' work exhibited at Chicago World's Fair, 1893, *4636*

Switzerland, Zurich public schools reject slates for paper, 1899, *17492*

United States

art in American schools and colleges, 1893, *4648*

art instruction, 1907, *14297*

Chicago public school drawing method, 1896, *6012*

Chicago public schools use *Art Amateur* color studies, 1894, *4872*

drawing instruction criticized, 1898, *6693*

teaching drawing in public schools, 1898, *6496*

Schoonmaker, J. M.

collection, *15388*

Schoonmaker, Marius, 1811-1894

Keeper of Senate House, Kingston, N.Y, *26567*

Schopenhauer, Arthur, 1788-1860

monuments, bronze bust at Frankfort-on-the-Main dedicated, 1895, *22765*

Schöpf, Peter, 1804-1875

obituary, *8572*

Schopin, Henri Frederic, 1804-1880

Divorce of Josephine, *9688*

obituary, *240*

Schrader, Julius Friedrich Anton, 1815-1900

Jephthah's daughter, *8789*

sales and prices, 1889, portrait of Alexander Von Humboldt sold to H. O. Havemeyer, *2934*

Schraudolph, Claudius, 1843-1902

tapestry paintings, acquired for Telfair Academy, Savannah, 1884, *10993*

Schregel, Bernard, 1870-1956

exhibitions, Louisiana Purchase Exposition, 1904, *13836*

Schreiber, fl.1899

exhibitions, Photographers' Association of America Convention, 1899, *12937*

Schreiber, Charlotte Elizabeth Bertie Guest, *lady*, 1812-1895

collection

ceramics given to South Kensington Museum, 1885, *10115*

fan collection catalogued, 1888, *15154*

playing cards, *16065*

playing cards sale, 1896, *17068*

obituary, *16678*

SCHREIBER, George L., *11465*

Schreiber, George L., fl.1895-1925

exhibitions, Cosmopolitan Club, Chicago, 1896, *11776*

illustrations, *Landscape*, *12057*

lectures, 1899, *12844*

Schreyer, Adolf, 1828-1899

Ambush, *24478*

etching by S. Ferris published, 1884, *25028*

Arab sheik crossing a stream, shown in Chicago, 1902, *13334*

biographical note, *16510*

exhibitions

Buffalo, 1896, *11779*

London, 1879-80, *9275*

Milwaukee, 1901, *13303*

Milwaukee Industrial Exposition, 1898, *12800*

New York, 1877, *8917*

New York, 1878, *8962*

New York, 1895, *16781*

illustrations, *Gypsy Encampment*, *2388*

landscape in Corcoran Gallery cleaned and retouched, 1890, *3393*

obituary, *17661*

death misreported, 1895, *16694*

painting of horse in Munger collection at Chicago Art Institute, *12785*

paintings in Whitney collection, *2108*

sales and prices

1879, *Winter travel in Russia* in Spencer collection, *678*

1886, picture in Morgan collection sale, *2132*

1892, *Wallachian posting house*, *3952*

1899, *17516*

1902, paintings in Reed collection, *13538*

Wallachian team, *140*

Winter scene, in Walker collection, Minneapolis, *12924*

Schreyer, Christian Adolf See: **Schreyer, Adolf**

Schreyvogel, Charles, 1861-1912

elected associate of National Academy, 1902, *13351*

exhibitions, National Academy of Design, 1900, Clark prize, *12997*

illustrations, *Attack at dawn*, *13827*

Schröder, Lina See: **Burger, Lina Schröder**

Schrödter, Adolf, 1805-1875

Düsseldorf school, *14602*

Falstaff, *19298*

Falstaff mustering his recruits, *18451, 18512*

obituary, *8641*

Schroeder, Seaton, 1849-1922

notes, 1897, *23246*

Schryver, Louis Marie de, 1863-1942

illustrations

First day of Spring, engraved by Reed, *17740*

Roses, *4646*

Schubert, Orlando V., fl.1894-1895

illustrations

Fishing village, *22567*

Gathering the seaweed, *22567*

member, Cleveland Water Color Society, *22591*

On the lake, *22879*

Schubin, Ossip See: **Kirschner, Lula**

Schuch, Werner Wilhelm Gustav, 1843-1918

exhibitions, New York, 1889, *2884*

Schuchard, F., Jr. See: **Schuchardt, Ferdinand, Jr.**

Schuchardt, Ferdinand, Jr., 1855-ca.1887

exhibitions

American Art Union, 1883, *10913*

Brooklyn Art Association, 1884, *1696*

Metropolitan Museum of Art, 1881, *1165*

notes, 1885, *11273*

paintings, 1883, *24502*

picture of little girl, 1883, *24541*

Song without words

in Clarke collection exhibition, 1883-4, *24955*

in Louisville's Southern Exposition, 1883, *24760*

still life, 1883, *24513*

whereabouts, 1883, New Hamburg, N.Y, *24762*

work, 1883, *24609*

SCHÜCKING, Levin, *19181*

Schuler, Charles
 illustrations
 Galatea (after Domenichino), *8531*
 Madonna della sedia (after Raphael), *8513*
Schuler, Hans, 1874-1951
 elected to art committee of American Art Association, Paris, 1903, *13701*
 Rinehart scholarship, 1900, *13046*
Schuller, Charles, fl.1880-1910
 illustrations
 bird and foliage design, *2421*
 decorative bird and floral designs, *2181, 2216, 2235, 2274*
 decorative bird design, *2513*
 flower and bird design, *3906*
 Magpies and fly-catchers, *2852*
 Night-hawk and nightingales, *2793*
Schulte, Eduard, firm, Berlin See: **Berlin (Germany). Schulte, Eduard, firm**
Schultheis, Henry
 collection, sale, 1899, *17592*
Schulthies, Henry See: **Schultheis, Henry**
Schultz, George F., b.1869
 exhibitions
 Chicago, 1896, watercolors, *11764*
 Chicago, 1898, *12701*
 illustrations
 Fishing house, *13370*
 Reflections, *12678*
 picture in permanent exhibition of Chicago's Palette and Chisel Club, 1905, *14036*
Schultz, Hermann, 1861-1924
 whereabouts, 1892, studio in Chicago, *11308*
Schultz, Ralph T., fl.1900-1921
 illustrations, book design, *7238*
Schultzberg, Anshelm Leonard, 1862-1945
 exhibitions, Louisiana Purchase Exposition, 1904, *13831*
Schultze, Louis, fl.1867-1871
 exhibitions
 American Art Union, 1883, *10913*
 St. Louis, 1871, *Prince Frederick of Germany*, *10713*
 notes, 1871, *10621*
 obituary, *13199*
 watercolors, St. Louis, *10570*
Schulz, Louis, 1843?-1901?
 illustrations, *Quiet life* (after G. C. Max), *21814*
Schulz, Oscar, fl.1878-1896
 illustrations, views of Iceland, *10471*
Schulze, Paul, 1827-1897
 Washington monument, project, *23*
Schulzenheim, Ida Eleonora Davida von, 1859-1940
 exhibitions
 Chicago World's Fair, 1893, *4568*
 National Academy of Design, 1892, *4182*
Schumann, Clara Josephine Wieck, 1819-1896, *18793*
Schumann, Robert Alexander, 1810-1856
 letters published, 1897, *23771*
Schumann, W. G.
 collection, Makoffsky paintings, *16211*
Schussele, Christian, 1824-1879
 director, Philadelphia Academy of Fine Arts, 1870, *10588*
 exhibitions
 American Exhibition, London, 1887, *25464*
 Boston Athenaeum, 1859, *20104*
 Pennsylvania Academy of the Fine Arts, 1855, *18793*
 newspaper illustrations, *16557*
 notes, 1860, *20146*
 obituary, *18*
 memorial sermon by Rev. G. H. Johnston, *99*
 Ocean life, *20186*
 student at Pennsylvania Academy of the Fine Arts, *22508*
 Washington Irving and his friends, in Stewart collection, *25406*
Schütze, Eva Lawrence Watson See: **Watson Schütze, Eva Lawrence**
Schützenberger, Louis Frédéric, 1825-1903
 illustrations, *Alsatian peasant*, *2180*

Souvenir d'Alsace, *9656*
SCHUYLER, F. Dix, *17795*
Schuyler, Mary Hamilton
 monuments, statue for World's Fair prohibited by lawsuit of descendants, *26886*
Schuyler, Sophie V. See: **Dey, Sophie V. Schuyler**
Schwab, Charles Michael, 1862-1939
 collection, paintings in Carnegie Institute annual exhibition, 1902, *13520*
 gift of portraits by Chartran to Admiral and Mrs. Dewey angers American artists, 1900, *13046*
 offer to buy painting retracted, 1906, *14161*
Schwabe, Carlos, 1866-1926
 frontispiece to *L'Art et l'Idée*, *26690*
 member of Rose Croix, *26645*
 work illustrated in *L'Art et l'Idée*, 1892, *16038*
Schwabe, Gustav Christian
 collection
 English art presented to city of Hamburg, 1885, *10127*
 English pictures, *10238*
 to go to Hamburg, *9937*
Schwabe, Henry August, 1842-1916
 exhibitions, Prize Fund Exhibition, 1886, *25304*
Schwabe, M. J. Salis See: **Salis Schwabe, M. J.**
Schwanthaler, Ludwig Michael, 1802-1848
 bronze statue of Mozart at Salzburg, *21349*
 statue of Bavaria, *14669*
 colossus of Munich, *18126*
 inauguration, 1850, *14697*
 unveiled, 1850, *14708*
 studio in Munich, *19811*
Schwartz, Samuel
 collection, sale, 1893, *26895*
Schwartze, Johann Georg, 1814-1874
 First religious service of Puritans in North America, exhibited, Amsterdam, 1858, *19941*
 Pilgrim fathers, *20195, 20212*
Schwartze, Thérèse, 1852-1918
 exhibitions
 Chicago World's Fair, 1893, *4526*
 Tennessee Centennial Exposition, 1897, pastel honorable mention, *11971*
Schwarz, Franz J., 1845-1930
 exhibitions, Chicago Ceramic Association, 1902, *13357, 13511*
Schwarzenbach, Peter A., b.1872
 illustrations
 carved wall-pocket for copying, *5926*
 woodcarving designs, *5994*
Schwarzott, Maximilian M., fl.1885-1917
 exhibitions, Architectural League of New York, 1897, *10535*
 illustrations, panel in high relief, *23213*
 paintings, *10533*
 teaches Gotham Art Students, 1885, *11219*
Schweinfurth, Charles Frederick, 1858-1919
 illustrations, hall, *20508*
Schweinfurth, Julius Adolph, 1858-1931
 commission to do monument to John Hancock, Boston, 1895, *22765*
 exhibitions, Architectural League of New York, 1887, *2380*
 illustrations, headpiece and initial, *36, 85*
Schweninger, Karl, 1818-1887
 illustrations, *Old love letters*, *1642*
Schweninger, Rosa, b.1849
 exhibitions, Southern Exposition, Louisville, 1884, *11051*
Schwenker, Karl, fl.1895
 Storm-tossed surf, *22861*
Schwerdgeburth, Carl August, 1785-1878
 engravings of life of Luther, *19971*
Schwerdt, Christian F., b.1836
 exhibitions, Chicago Academy of Design, 1877, *8818*
 portrait in Chicago gallery, 1870, *10567*
Schwessinger, Georg, 1874-1914
 illustrations, *Maiden sitting*, *13526*
Schwill, William V. See: **Schevill, William Valentine**

portraits, bust by Hutchinson, *17383*
recollected by C. Leslie, *18471*
relationship with publishing house of Constable, *17050*
relics
 Abbotsford by M.M. Maxwell, *16471*
 chair offered for sale, 1890, *15366*
Sir Walter Scott Club, Edinburgh, *16705*
Tantallon Castle, *26044*
SCOTT, William Bell, *19028, 19036, 19048, 19049, 19053,
19054, 19102*
Scott, William Bell, 1811-1890
 Autobiographical Notes, excerpt on Holman Hunt's *Scapegoat*,
 4233
 bequest to British Museum, *9099*
 collection, sale, London, 1892, *26722*
 commission given by Sir Walter Trevelan, 1857, *19642*
 commission to paint murals in mansion, 1856, *19484*
 designs for Pilgrims Progress commissioned, 1856, *19542*
 Eve of the deluge, given to National Gallery, 1891, *26310*
 exhibitions
 Century Club, 1893, *26894*
 London, 1891, drawings, *26304*
 South Kensington Museum, 1891, *26280*
 obituary, *26187*
Scott, William Earl Dodge, 1852-1910
 bird collection, acquired by Harvard University, 1895, *16800*
Scott, William Edouard, b.1884
 illustrations, mural decoration for dining-room, *14167*
Scott, William Wallace, 1819-1905
 exhibitions, Brooklyn Art Association, 1884, watercolors,
 25092
 studio, re-opens, 1891, *15693, 26382*
Scott, Winfield, 1786-1866, *21302*
 portraits
 engraving by Konrad Huber, *19942*
 portrait by Kellogg, *23416*
Scotten, Daniel
 library, *15518*
Scottish art See: **art, Scottish**
Scottish National Portrait Gallery See: **Edinburgh
(Scotland). Scottish National Portrait Gallery**
Scottish painting See: **painting, Scottish**
Scottish portraits See: **portraits, Scottish**
Scovell, Florence See: **Shinn, Florence Scovell**
Scovill, Fred, fl.1895
 illustrations, sketch, *21543*
Scoville, Jonathan, 1830-1891
 bequest to Buffalo Fine Arts Academy revoked in codicil, 1891,
 26356
scrapbooks
 advice to compilers, 1893, *16288*
 collectors and collecting, *16304*
screens
 Boucher designs for hand screen, *3138*
 carved and painted screens, *3250*
 decoration in drawing-rooms, *2898*
 designs, *2976, 9312*
 different screens to use in houses, *632*
 embroidered, *2977*
 exhibitions, Chicago World's Fair, 1893, *4546*
 for interior decoration, 1892, *3939*
 history, *4507*
 Japanese screen painting, *7703*
 Louis XV screen, *5203*
 needlework screens, *1028*
 painting and embroidering, *2925*
 tapestry fire screen, *584*
 technique
 instructions for making screens for the home, *584*
 painting, *3217*
 painting on textiles, *4990*
 wood, glass, and fabric, *2924*

Scribner, firm, Publishers, New York
 exhibitions
 1894, modern bookbinding, *5162*
 1896, book illustrations, *22980*
 Turin Esposizione, 1902, gold medal, *13618*
Scribner's Sons See: **Scribner, firm, Publishers, New York**
Scripps, James Edmund, 1835-1906
 collection, *15518, 15811*
 catalogue, 1889, *14989*
 catalogue of paintings given to Detroit Museum, *15623*
 in Detroit Museum, *3851*
 pictures given to Detroit Museum of Art, 1889, *14984*
 Detroit collector, *3497*
 donation to Detroit art student for study abroad, *26022*
 medal from Detroit Museum
 received, 1892, *15934*
 to acknowledge gifts, 1891, *26433*
scrolls, Chinese
 painted scrolls for wall decoration, *16070*
scrolls, Japanese
 exhibitions, New York, 1887, *2343*
 kakemono and its usage, *22661*
 kakemonos, *2934*
Scudder, James Long, 1836-1881
 exhibitions, National Academy of Design, 1863, *23266*
Scudder, Janet, 1875-1940, *11395*
 exhibitions, Woman's Art Club of New York, 1903, *13703*
 illustrations, *Amour on snail*, *13263, 13556*
 sculpture at Paris Exposition Universelle, 1900, *13074*
 sculpture for Louisiana Purchase Exposition, 1904, *13685*
 statue for Chicago World's Fair, 1892, *26778*
Scudder, John A.
 collection, *15842*
 European paintings acquired, 1880, *9343*
Scudder, Marthe See: **Twachtman, Marthe Scudder**
Scull, Sarah Amelia, fl.1880-1890
 exhibitions, Philadelphia, 1890, photographs of Greece, *25917*
Scully, Henry R., *Mrs*. See: **Scully, Morrow Murtland**
Scully, Morrow Murtland, 1853-1932
 screen with painted flowers, 1887, *583*
sculptors
 anecdote of blind sculptor, *6278*
 assumption that sculptors do own stone cutting, *5380*
 newspaper account of a sculptor at work, 1896, *5977*
 R. B. Roosevelt criticizes sculptors, 1899, *7124*
 St. Ulrich sculptors' colony, 1902, *7877*
 scandal of Royal Academy sculptor who exhibited a work exe-
 cuted by assistants, 1892, *4094*
sculptors, American
 disputes over public commissions, 1896, *5862*
 Italy
 1855, *18691*
 1858, J. Mozier, J. T. Hart, H. Hosmer, *18154*
 Paris, 1900, *7426*
 portraits, Chicago World's Fair sculptors, 1893, *11532*
 Rome
 1851, *14808*
 1871, *10721*
 woman sculptors, *26465*
sculptors, French
 biography of unknown artist, *14762*
sculpture
 See also: **ceramic sculpture; polychromy;
 portrait sculpture; relief**
 19th century, *23303*
 and painting, *18055*
 architectural decoration, *21981*
 architectural sculpture, *22224*
 background colors for exhibition of statuary, 1893, *4233*
 commemorative statues in Europe, 1851, *14809*
 conservation and restoration, dispute over restoration of stat-
 uette in Cesnola collection, *9391*
 costume in statuary, *5189, 9259*
 difficulty of rendering modern clothing in sculpture, *528*
 criticism of statues placed atop buildings, *14171*

Gigantomachia at Pergamon, *294*
gold and ivory, *21695*
Heraion, Olympia, *109*
hidden statues, *26135*
history, *17553*
Laocoon, *14559*
　remarks by G. Lessing, *18258*
Niobe of Mount Sipylos, *360*, *407*
Phidias' statues, *19822*, *19841*
polychrome sculpture criticized, 1891, *3601*
sculpture found in excavations, 1895, *16789*
statue found in Rome, 1849, *14607*
statues discovered in Russia, 1895, *16734*
Tanagra and Myrina work, 1891, *3459*
Temple of Zeus at Olympia, *52*, *88*
Venus of Melos, *60*
Victory of Samothrace, *156*
vs. modern sculpture, *14001*

sculpture, Italian
exhibitions, Roman Esposizione, 1883, *9853*
garden sculpture imported to U.S, *13674*
Piazza della Signoria, Florence, *21859*, *21868*, *21882*
Prof. Rossi's response to critics, *9294*

sculpture, Japanese
bronze image of Daibutsu, near Hasemura, *26508*
bust of girl shown at American Art Association, 1888, *25511*
purchased for Detroit Museum of Art, 1893, *16098*

sculpture, medieval
Adoration of the Magi theme, *8758*
cathedral building and medieval sculptors, lecture by A. D. White, *19924*

sculpture, Oriental
collectors and collecting, joss figures, *15768*
soapstone, *15793*

sculpture, pre-Columbian
Guatamala, *59*
Mexico, Palenque, *77*
Nicaragua, discovery by E. G. Squier, *14653*

sculpture, Renaissance, *23298*

sculpture, Roman
bust of Tiberius at Boston Museum of Fine Arts, *25790*
casting in plaster, *75*, *92*
Hercules attributed to Diogenes, *430*
history, *17553*
in Webb collection, *14779*

Sculpture Society of New York　See: **New York. National Sculpture Society**

sculpture, Spanish
Central Park acquires copy of bronze statue, 1894, *4904*

sea power
United States, need for improvement, 1896, *23004*

SEABURY, Emma Playter, *23089*

Seaford, John Albert, 1858-1936
Indiana artist residing in Boston, *14061*

seals (animals), *21321*

seals (numismatics)
collectors and collecting, *16935*
　Henry C. McCook collection, *16600*
design competition for American Forestry Association, 1897, *6487*
exhibitions, 1895, Assyrian and Babylonian seals, *16702*
great seal of Queen Elizabeth, *5416*
great seal of the U.S, *16165*
seal of Shah of Persia, *7315*
seals of colonial governors of New York, *20399*

Seaman, Lazarus, d.1675
library, sale, 1676, *16265*

SEARING, Laura Catherine Redden, *10701*

Searle, H. R.
Washington monument, project, *5*, *23*

Searle, Helen, 1830-1884
work, 1883, *24959*

Searles, Edward Francis, 1841-1920
collection, acquired by Mark Hopkins Institute of Art, 1898, *6545*

funds new gallery for San Francisco Art Association, 1899, *22076*
gift to Mark Hopkins Institute, 1895, *21554*
offers statue of George Washington to Methuen, Mass., 1891, *26402*
Searles collection and Mark Hopkins' house donated to University of California in San Francisco, 1898, *12806*

Searles, Edward Francis, *Mrs.*　See: **Searles, Mary Frances Sherwood**

Searles, Mark Hopkins, *Mrs.*　See: **Searles, Mary Frances Sherwood**

Searles, Mary Frances Sherwood, d.1891
bequest disappoints San Francisco, *26391*
collection, umbrella stands ordered from Degolier and Barrows, 1883, *24424*
home, house to be Mark Hopkins Institute, 1893, *16304*

Searles, Victor A., fl.1892-1901
illustrations for *Life of Columbus in Pictures*, 1892, *16055*

Sears, Charles Payne, 1864-1908
whereabouts
　1883, sails for Europe, *24855*
　1883, to go to Paris to study, *24829*
　1884, studying in Paris, *25061*

Sears, George Edward
library, sale, 1893, *16337*

SEARS, Hamblen, *22667*

Sears, J. Montgomery, *Mrs.*　See: **Sears, Sarah Choate**

SEARS, John V., *22397*

Sears, Joshua Montgomery, 1855-1905
collection
　acquires paintings by Thayer and Brush, 1894, *4872*
　buys George de Forest Brush picture, 1894, *26999*
　purchases, 1892-3, *22483*

Sears, Kate B., 19th century
pottery, *11828*

Sears, Mary Crease, d.1938
design for fan, *559*
illustrations, design for a fan, *556*

Sears, Sarah Choate, 1858-1935
exhibitions
　American Watercolor Society, 1893, *22483*
　American Watercolor Society, 1893, Evans prize, *4316*, *26885*, *26893*, *26895*, *26917*
　New York Water Color Club, 1894, *4703*
　New York Water Color Club, 1898, *Lady and the butterfly*, *6816*
　Philadelphia Photographic Salon, 1899, portrait studies, *12973*
　St. Botolph Club, 1891, *3601*
Romola, *4382*

Sears, Willard T.
See also: **Cummings and Sears, architects**

Searson, John, b.1750
Mount Vernon, review and excerpts, *19961*

seashore
in art, *14808*

seasons
winter and summer, *19627*

seasons in art
end of the year, *10373*
Indian summer, *19199*
medieval, *8798*, *8865*
screens with seasons motif illustrated, *8266*

seating (furniture)
curtained settle, *3818*
history of French furniture, *2973*
technique for carving wood hall seat, *7531*

SEATON SCHMIDT, Anna, *22443*

SEATON, Thomas, *23728*, *23750*, *23771*, *23787*, *23793*, *23807*, *23812*, *23833*, *23850*, *23853*, *23875*

Seattle (Washington). Seattle Art League and School of Design
fourth anniversary, 1900, *22093*

Seavey, George W., d.1913
whereabouts
　1880, *960*

Serret, Charles Emmanuel, 1824-1900
 exhibitions, American Art Galleries, 1886, *25290*
Serrur, Henri Auguste César, 1794-1865
 copies of Venetian paintings, *14669*
Sessions, Annamay Orton, 1855-1947
 illustrations, decorated ceramics, *12873*
Sessions, Frank M., Mrs. See: **Sessions, Annamay Orton**
Sesto, Cesare da, 1477-1523
 Herodias, attribution, *888*
Seton, Charles C., fl.1881-1894
 exhibitions, Royal Academy, 1887, *10473*
SETON, Ernest Thompson, *23622, 23739, 23935*
Seton, Ernest Thompson, 1860-1946
 Art Anatomy of Animals, review, *23722*
 exhibitions, New York, 1899, *12896, 17571*
 Studies in the Anatomy of Animals, excerpts on drawing, with
 diagrams, *6194*
Seton family
 Eglinton peerage, *20395*
SETON, Grace Gallatin, *23758*
SETON, Robert, *20395, 20413*
Setoun, Gabriel, pseud. See: **Hepburn, Thomas Nicoll**
Settignano, Desiderio da See: **Desiderio da Settignano**
Seubert, Adolf, 1819-1880
 obituary, *118*
Seuil, Augustin du See: **DuSeuil, Augustin**
Seurat, Georges, 1859-1891
 exhibitions, American Art Galleries, 1886, *25290*
 notes, 1886, *25312*
 obituary, *26317*
Sevastopol (Ukraine)
 museum completed, 1897, *17311*
Seventh Regiment Armory Fair See: **New York. Seventh
 Regiment Armory Fair**
Severn, Arthur, 1842-1931
 exhibitions
 Dudley Gallery, 1878, *21572*
 Dudley Gallery, 1880, *21958*
 Grosvenor Gallery, 1880, *21961*
 illustrations
 drawings of Cheyne Walk, Chelsea, *9701*
 Putney bridge, *9436*
 sketches of Herne Hill, *10253*
Severn, Edmund, 1862-1942
 music for *Beauty and the Beast*, *12545*
Severn, Walter, 1830-1904
 lecture on sketching from nature, *1153*
 president of Dudley Gallery, *26027*
SEVERNE, Paul, *23818, 23844, 23863*
Seville (Spain)
 views, *9521, 9537*
Seville (Spain). Cathedral
 architecture, *25832*
Sèvres (France). Manufacture national de porcelaine
 factory reorganized, 1891, *3722*
 porcelain factory, *2522*
 state of factory, 1890, *25986*
**Sèvres (France). Manufacture nationale de porcelaine. Musée
 céramique**
 building and collection, *200*
 collection, *226*
Sevres porcelain See: **porcelain and pottery, French**
Sewagen, Heinrich See: **Seewagen, Heini**
Sewall, Alice Archer See: **James, Alice Archer Sewall**
Sewall, Henry F., 1816-1896
 collection
 print collection acquired by Boston Museum, 1898, *6492*
 prints in Cincinnati Exposition, 1879, *756*
 prints sold to United States National Museum, 1893, *16101*
 letter regarding market value of Shakespeare, 1894, *16537*
 library, *17176*
 sale, 1896, *17167, 17178, 17195*
 sale, 1897, *17210, 17237, 17246*
 to be sold, 1896, *17068, 17119*
 obituary, *17042*

SEWALL, Jotham Bradbury, *10583*
Sewall, May Wright, 1844-1920
 letter on art education to *Arts for America*, *11957*
Seward, William Henry, 1801-1872, *21128*
 monuments, statue by Walter G. Robinson, *557*
 portraits, portrait by Leutze, *20051*
Sewell, Amanda Brewster, 1859-1926
 Dodge prize, 1888, *25507*
 exhibitions
 American Art Galleries, 1887, *10832*
 Architectural League of America, 1899, *Hecatomb*, *6905*
 National Academy of Design, 1887, *2606, 10831*
 National Academy of Design, 1888, *2680, 10846, 25503*
 National Academy of Design, 1889, *25685*
 National Academy of Design, 1890, *3228*
 National Academy of Design, 1890, *Pleasures of the past*,
 25884
 National Academy of Design, 1903, Clark prize, *13547*
 National Academy of Design, 1903, wins Clarke prize, *8133*
 New York, 1892, *3834*
 Prize Fund Exhibition, 1887, *562, 2456*
 Society of American Artists, 1886, *25309*
 West Museum, 1891, *26382*
 Woman's Art Club of New York, 1891, *15550, 26292*
 illustrations
 Lavoir in the Gatanais, *2481*
 Portrait, *13202*
 Portrait of Mrs. Robert V. V. Sewell, *13702*
 pictures on view in New York, 1892, *15797*
Sewell, Lydia A. B. See: **Sewell, Amanda Brewster**
Sewell, Robert Van Vorst, 1860-1924
 elected associate of National Academy, 1902, *13351*
 exhibitions
 Architectural League of New York, 1897, *10535*
 Architectural League of New York, 1900, *7231*
 Chicago Art Institute, 1896, *6010*
 National Academy of Design, 1886, *25370*
 National Academy of Design, 1890, *3228*
 National Academy of Design, 1895, *5340*
 New York, 1892, *3834*
 Prize Fund Exhibition, 1885, *25278*
 Salon, 1885, *2035*
 Salon, 1887, *2449*
 Society of American Artists, 1889, *2986*
 Society of American Artists, 1896, *Groves of Persephone*,
 5780
 Union League Club of New York, 1890, *25779*
 Union League Club of New York, 1901, *7524*
 West Museum, 1891, *26382*
 Law and *Justice* murals refused by Columbia College, 1901,
 7524
 pictures on view in New York, 1892, *15797*
Sewell, Robert Van Vorst, Mrs. See: **Sewell, Amanda
 Brewster**
sewing
 technique, *5097*
sewing machines
 hand-made versus machine-made embroidery, *4852*
 history of Grover and Baker Sewing Machine Company, *18386*
 popularity of Grover and Baker sewing machine, *18518*
 sewing machine emvroidery, *4832*
Sexton, Mary Jane See: **Morgan, Mary Jane Sexton**
Seyboth, Adolphe, 1848-1907
 appointed director, Strasbourg Museum, 1893, *16343*
Seyffer, Otto
 coin collection, sale, 1891, *15745*
Seymour, George L., fl.1876-1888
 drawings
 Barcelona, *9460*
 Cadiz, *9515*
 Cairo, *9348, 9367, 9378*
 Cairo mosques, *9269, 9300*
 Chartres Cathedral, *9708*
 Cordova, *9489*
 Egypt, *9103, 9114, 9126, 9142, 9156, 9169, 9182, 9193,*

9208, 9224, 9236, 9254, 9394, 9426
Gibraltar, *9559*
Granada, *9440, 9451*
Marseilles, *9699*
Orléans, *9663*
Rouen, *9576, 9618*
Seville, *9521, 9537*
Suez canal, *9414*
Tours, *9640*

Seymour, Horatio, 1810-1886
portraits, portrait by C. L. Elliot, *19626*

Seymour, M., fl.1882-1884
exhibitions, American Art Galleries, 1882, *1297*

Shotei, Watanabe See: **Watanabe Sh&om.tei (Seitei)**

Shackleton, William, 1872-1933
illustrations
 Feeding pigeons in Venice, 23892
 Florentine idyll, 23946
 Gallery entrance, 24274
 Jessica and Lorenzo, 23705
 Laurent at la charmante Isabeau, 23873
 Lady of Shalott, 24093
 Rose bush, 24250
 Scarlet poppy, 24016
 sketch of Mrs. Patrick Campbell, *24307*
 Undine, 24049
 Venetian night, 23847

Shade, William Auguste, 1848-1890
obituary, *26103*

shades and shadows
painting of shadows, *3078, 8139*
Ruskin's views on perspective, shadows and teaching drawing, *18406*

Shadwell, Bertrand, fl.1903
illustrations, *Funeral procession - from life, 13624*

Shah Nasir al-Din See: **Nasir al-Din**, *shah of Persia*

Shakespeare Society of New York See: **New York.**
Shakespeare Society of New York

Shakespeare, William, 1564-1616
anecdote, *16723*
Anne Hathaway's cottage, *26731*
 acquired by Shakespeare Birthplace Trustees, 1892, *26741*
Antony and Cleopatra, illustrated by Avril, *15317, 15679*
autograph purchased by British Museum, 1858, *18206*
Baconian theory of Shakespeare, *17151*
bibliography, *16337*
birthday celebration at Century Club, 1860, *20226, 20286*
Boydell edition sold, 1891, *15797*
center proposed for Chicago, 1891, *26402*
characters, according to race, *20311*
Comedy of Errors, performed, 1896, *16935*
correspondence, *16814*
criticized, 1895, *16805*
DeQuincy on Shakespeare, *18050*
folio discovered in Italy, 1895, *16792*
folios and quartos, market value, 1894, *16537*
Hamlet, Edwin Booth as Hamlet, *20366*
Henry V, illustrations, *8745*
Jusserand's study of Shakespeare in France, 1897, *17306*
Macbeth
 Mrs. Patrick Campbell as Lady Macbeth, *24206*
 playing Lady Macbeth, *25158*
monuments
 group by Reginald Gower, *603*
 sculptures dedicated to Shakespeare, *9554*
 statue by Otto Lessing unveiled in Weimar, 1905, *13955*
 Ward's statue, *10672*
portraits, *16589, 16939*
 Davenant bust, *16770*
 etching after portrait in National Gallery, *15326*
 Flameng etches Chandos portrait, *15400*
 life mask, *14669*
 portrait by Faed, *18320, 19243*
relics, *17068*
 collectors and collecting, *16227*

sales and prices, 1896, *17165*
Romeo and Juliet, 18359
 illustrated edition, 1893, *16174*
stage sets from Shakespeare's time, *17529*
Taming of the Shrew, analysis of characters, *25517*
theory that he visited Denmark, *16948*
Timon of Athens, illustrations, *8667*

shamanism
description of Siberian shaman, *19052*

Shands, Anne T., fl.1895-1901
exhibitions, St. Louis, 1895, *11582*

Shannon, Charles Haselwood, 1863-1937
exhibitions, International Society of Sculptors, Painters,
 Gravers, 1907, *14248*
founder of Vale Press, *12567*
illustration to Marlowe's *Hero and Leander, 22306*
lithographs, *12952*

Shannon, Effie, 1867-1954
poses for living picture after C. von Baudenhausen and P.
 Wagner, *22563*

Shannon, James Jebusa, 1862-1923
exhibitions
 Berlin Akademie der Künste, 1903, *13605*
 Carnegie Galleries, 1897, *Miss Kitty* wins gold medal, *6462*
 Carnegie Galleries, 1900, *13130*
 Chicago World's Fair, 1893, *4763*
 Corcoran Art Gallery, 1907, *14282*
 International Society of Sculptors, Painters, Gravers, 1907,
 14248
 London, 1897, portraits, *6278*
 London, 1901, *13240*
 New York, 1905, *13889*
 Pennsylvania Academy of the Fine Arts, 1901, *13163*
 Royal Academy, 1895, *22359*
 Royal Academy, 1898, *12734*
 Royal Academy, 1902, *13431*
 Royal Academy, 1903, *8243, 13605*
 Royal Academy, 1906, *14116*
 Royal Academy, 1907, *14312*
 Venice International Art Exhibition, 1905, *13927*
Flower girl, acquired by Royal Academy, 1901, *7611*
illustrations, *Lady Marjorie Manners, 13792*
Motherhood, purchased by Royal Academy, 1901, *13244*
notes, 1897, *6311*

Shapleigh, Frank Henry, 1842-1906
California views, 1871, *10708*
notes, 1871, *10674*
White Mountain subjects, 1883-4, *24981*
Yosemite, 1871, *10616*

Shapley, Rufus Edmonds, 1840-1906
collection, sale, Philadelphia, 1906, *14145*

Share, Henry Pruett, 1853-1905
decorative initials for The Art Union, 1885, *11196*
etchings, *10808*
exhibitions, Salmagundi Club, 1882, *1265*
illustrations
 Afternoon mail, 11181
 Art for the poor, 22501
 Cobbler (after J. H. Niemeyer), *10934*
 Dreamers (after F. S. Church), *10736*
 Mother and child (after E. W. Perry), *11097*
 On the classic beargrass (after C. Brenner), *10934*
 Phyllis, 10769
 pictures in American Art Union exhibition, 1883, *10913*
 Salmagundi Club invitation sketch, *1041*
 sketches from water colors in the American Art Union, *10957*
notes, 1883, *24541*
portfolio of etchings, *10814*

sharks
Java, *21043*

Sharman, Florence M., b.1876
exhibitions, Society of Western Artists, 1902, *13542*

Sharp, Avery, b.1870
whereabouts, 1890, Munich studying with Karl Marr, *26192*

Shenton, Francis Kingston John, 1832?-1893
 obituary, *26941*
Shepard, Elliott Fitch, 1833-1893
 portraits, portrait to be commissioned by Republicans, 1893, *26917*
Shepherd, George H.
 Short History of the British School of Painting
 publication announcement, 1897, *17335*
 review, *21891*
Shepherd, Richard Herne, 1842-1895
 obituary, *16861*
Shepherd, W. T.
 collection, *17154*
Shepherd, William See: **Sheppard, William**
Shepley, Annie Barrows, fl.1888-1907
 exhibitions
 National Academy of Design, 1893, *4236*
 New York Water Color Club, 1895, *5566*
 Woman's Art Club of New York, 1896, *5697*
 Worcester Art Museum, 1902, *13483*
 landscape painter, *22525*
Shepley, George Foster, 1860-1903
 See also: **Shepley, Rutan & Coolidge, architects**
Shepley, Rutan & Coolidge, architects
 fireplaces, *20525*
 illustrations
 conservatory in residence of Franklin Macveagh, *20614*
 fountain for courthouse at South Bend, Indiana, *12887*
 interiors, *20508, 20547, 20555*
Sheppard, Moses, 1771-1857
 newspaper collection, *16800*
Sheppard, Warren, 1858-1937
 exhibitions
 Brooklyn, 1890, *15039*
 Essex Art Association, 1884, *25102*
 Prize Fund Exhibition, 1886, *25304*
 illustrations, *Boats-in-waiting*, *22590*
 portraits, photograph, *22580*
 Restless sea, accepted for Chicago World's Fair, 1893, *22483, 26907*
 sales and prices
 1887, *583*
 1891, *15646*
 summer home and studio, *22571*
 whereabouts, 1887, *611*
 world travel plans, 1901, *13309*
Sheppard, William, fl.1650-1660
 documentation, *10099*
Sheppard, William Ludwell, 1833-1912
 exhibitions, American Watercolor Society, 1885, *1933*
 statue for Confederate Monument of Richmond, *26999*
Sheraton, Thomas, 1751-1806
 chairs and table, *3588*
 furniture, *3141, 3268*
 illustrations, furniture, *3322*
 window decorations, *3297*
Sherborn, Charles William, 1831-1912
 bookplates, list, 1894, *4899*
 exhibitions, New York, 1893, bookplates, *16374*
 illustrations, *Vision of St. Helena* (after Veronese), *10034*
Sherbrooke (Quebec)
 art museum proposed, 1885, *25241*
Shere (England)
 description and views, *9626*
Sherer, A. L., Mrs., fl.1892
 studio reception, 1892, *26871*
Sheridan, Richard Brinsley, 1751-1816
 monody on Garrick, *19600*
 School for Scandal, *16562*
Sherk Brothers, Brooklyn See: **New York. Sherk Brothers**
Sherman, Edith Freeman, b.1876
 student of Taft, Chicago Art Institute school, 1899, *12371*
SHERMAN, Frank Dempster, *23183*
SHERMAN, Frederic Fairchild, *12556*

Sherman, John, 1823-1900
 collection, medals donated to Mansfield, Ohio, Memorial Museum, *13658*
 notes, 1895, *22860*
SHERMAN, Karl Morgan, *12554*
Sherman, L. Gordanier, Mrs., fl.1891-1892
 exhibitions, Palette Club of Chicago, 1892, *11307*
Sherman, Mary Read, b.1866
 Huckleberry lot, *22879*
 summer home and studio, *22571*
Sherman Rohlfing, Cora See: **Rohlfing, Cora Sherman**
Sherman, Samuel Stevens, Mrs., fl.1899
 exhibitions, Chicago, 1899, miniatures, *12333, 12434*
SHERMAN, Stephen Olin, *23180, 23192*
Sherman, W. H.
 collection, catalogue, 1899, *17473*
Sherman, William Tecumseh, 1820-1891
 monuments
 Army of the Tennessee sponsors monument for Washington, D.C., 1895, *22876*
 competition for equestrian portrait statue in Washington D.C., *12949*
 equestrian statue by St. Gaudens, *26308*
 equestrian statue for Washington, D.C. competition, 1896, *17042*
 monument kept in Westerly, R.I. by striking workers, 1892, *26853, 26862*
 monument proposed by Society of the Army of the Tennessee, 1891, *26396, 26433*
 monument proposed for Washington, D.C., 1892, *26526*
 role of National Sculpture Society in Washington, D.C., statue, *6058*
 Sherman Statue Committee meets in New York, 1891, *26303*
 Sherman statue fund, 1891, *26382*
 statue by Carl Rohl Smith, *13503*
 statue competition, 1896, *11829, 22958*
 statue planned for Lancaster, Ohio, 1896, *23008*
 portraits, bust by Simmons, *26424*
 recollections by H. King, *22973, 23000*
 relics, collection sold, 1897, *17248*
Sherratt, Thomas, fl.1860-1884
 illustrations
 Elijah, Ahab, and Jezebel in Naboth's vineyard (after T. M. Rooke), *9369*
 Henry III of France and the Dutch envoys (after Staniland), *9974*
 Lorenzo and Jessica (after P. F. Poole), *9570*
 Music hath charms (after G. A. Storey), *9010*
 Princess Elizabeth in the tower (after R. Hillingford), *8570*
Sherree, H. See: **Schervee, Herman**
Sherwood, John H.
 collection
 sale, 1879, *767*
 sale, 1880, *46, 792, 802*
 proprietor of studio buildings, *25109*
SHERWOOD, Mary Clare, *11696*
Sherwood, Mary Frances See: **Searles, Mary Frances Sherwood**
Sherwood, Rosina Emmet, 1854-1948
 American woman painter, *11230*
 exhibitions
 American Watercolor Society, 1884, *25012*
 Cincinnati Art Museum, 1898, *12754*
 Cincinnati Art Museum, 1900, *13067*
 National Academy of Design, 1881, *1129*
 National Academy of Design, 1882, *1330, 9646*
 National Academy of Design, 1883, *1678*
 National Academy of Design, 1887, *552*
 New York Water Color Club, 1890, pastels, *3426*
 Prize Fund Exhibition, 1886, *2226, 25304*
 Society of American Artists, 1881, *367, 1130*
 Society of American Artists, 1882, *1349*
 Society of American Artists, 1883, *1551*
 Society of American Artists, 1887, *10789, 25451*
 Society of Painters in Pastel, 1890, *25904*

United States, Belding Brothers & Co, *12028*

silk thread
 American embroidery silks, *2712*
 American silks should be used in American needlework, *539*
SILKE, Lucy S., fl.1895-1907, *11803, 13010*
Silke, Lucy S., fl.1895-1907
 instructor, art department of the Colorado summer school,
 1895, *11610*
Silliman, Benjamin, 1779-1864
 collection, Trumbull paintings to be sold, 1896, *17176*
 monuments, statue by J. F. Weir at Yale, *25137*
 proposes publishing Trumbull's memoranda, 1858, *19932*
SILVA, Francis Augustus, 1835-1886, *11031, 11214*
Silva, Francis Augustus, 1835-1886
 exhibitions
 American Art Galleries, 1884, *24988*
 American Watercolor Society, 1880, *827, 9292*
 American Watercolor Society, 1881, *296*
 American Watercolor Society, 1884, *25038*
 American Watercolor Society, 1885, *1933*
 National Academy of Design, 1883, *24480*
 marine painting, 1883, *24525*
 water colors, 1883, *24513, 24541, 24841*
 whereabouts
 1883, Long Island, *24843*
 1883, summer at Long Branch, *24656, 24728*
Silveira, Belle See: **Gorski, Belle Silveira**
SILVER, Arthur, *6299*
silver plating
 technique, *2813*
silverpoint drawing
 work of Carl J. Becker, *22720*
silverwork
 art of the silversmith, *1115*
 collectors and collecting, *15218*
 Huntington collection, *15410*
 United States, *15693*
 competition for silver service for cruiser *New York*, 1892,
 26557
 design for cup, salver, clock case, *9304*
 exhibitions
 Chicago World's Fair, 1893, *4691*
 New York, 1893, *4356*
 Pedestal Fund Loan Exhibition, 1883-4, *1705*
 Philadelphia Centennial Exhibition, 1876, *8729*
 filigree silver, *17151*
 forgeries
 1895, *16792*
 and alterations, *2738*
 counterfeit old silver, *3735*
 counterfeiters, 1891, *3550*
 history, *12166*
 modern silverware, 1887, *17788*
 sales and prices
 1895, *16789*
 1897, *17316*
 1899, London, *17627*
 1901, antique apostle spoons, *7740*
 silver-plated ware, *724*
 silverware designs, *1403*
 tax in Britain on manufactured silver, *9875*
 technique, how to oxidize silver, *8230*
silverwork, American
 art-work, *8564*
 exhibitions
 Boston Society of Arts and Crafts, 1907, *14267*
 Philadelphia, 1889, *17874*
 Gorham Manufacturing Company's showroom wares, 1892,
 4135
 ink stand praised in England, 1861, *20341*
 Japanese influence, *2336*
 martelé, *14232*
 Meridian Britannia Co.'s new warehouse in New York, *8934*
 Ocean challenge cup by Tiffany & Co, *8491*
 Tiffany designs, *663*

Tiffany objects made for Paris Exposition, 1889, *25593*
Tiffany punch bowl made for Society of Colonial Wars, *16424*
silverwork, ancient
 antique vases found in Italy, 1895, *16786*
 history, *9395*
 Pompeiian silver presented to Louvre, 1895, *16800*
silverwork, Australian
 casket, *9959*
 mace and chain of office, *9871*
silverwork, Chinese, *16002*
silverwork, classical
 Greek bowl found, 1894, *16612*
 history, *9395*
silverwork, Dutch
 modern Dutch silver disdained by collectors, 1891, *3571*
silverwork, English
 Cambridge University collection of old college plate, *9804*
 designs for cups and presentation casket, *9385*
 designs for inkstands, *9401*
 forgeries, *16786*
 1898, *6786*
 counterfeit silver made from portions of original, *5732*
 hall marks, *17017, 17757*
 Houblon tankard, *16391*
 notes, 1893, *16367*
 presentation tazza designed by M. Morel Ladeuil, *8578*
 Queen Anne, *17841*
 sales and prices
 1901, James I Apostle spoons, *7568*
 1903, *8140*
 scarcity of good English designs, *3528*
 trophies of American Rifle Team, *8525*
silverwork, French
 authentic Louis XIV silver is rare, 1893, *4267*
 Germain family of goldsmiths, *17843*
 toilet service, *2830*
silverwork, Indic
 Punjab gold and silver work, *26365*
silverwork, Islamic
 three Algerian objects, *20781*
silverwork, medieval, *9424*
Silvestre, Paul Armand, 1837-1901
 Nu au Salon, *15659*
Simart, Pierre Charles, 1806-1857
 illustrations, statue of Napoleon, *20974*
Simier, Alphonse, fl.1828
 binding of Chateaubriand edition, *15389*
SIMMONS, Edward Emerson, *25515*
Simmons, Edward Emerson, 1852-1931, *10545, 13003*
 decoration for New York Appellate Court
 collaborative design, 1898, *6613*
 commission to paint court room, 1894, *26996*
 murals, *12997*
 decoration for Waldorf Astoria Hotel, New York City, *6474*
 mural, *10550*
 decorations for Liberal Arts Building, Chicago World's Fair,
 1893, *4185*
 decorations for Library of Congress, *6106*
 decorations of New County Court House, New York City, *5639*
 drawings, *24933*
 exhibitions
 Architectural League of New York, 1896, Hotel Manhattan
 decorations, *5699*
 Boston, 1885, *1983*
 Chicago Inter-State Industrial Exposition, 1889, *3056*
 National Academy of Design, 1884, *25125*
 National Academy of Design, 1884, *Winnowers*, *10982*
 National Academy of Design, 1889, *2936*
 New York, 1894, competition designs for New York Criminal
 Court, *4907*
 New York, 1900, *13038*
 Paris Exposition, 1889, *25724*
 Pennsylvania Academy of the Fine Arts, 1890, *3181*
 Pennsylvania Academy of the Fine Arts, 1891, *3535*
 Prize Fund Exhibition, 1886, *2226*

Prize Fund Exhibition, 1886, prize, *25304*
Salon, 1883, *1588, 24521*
Salon, 1884, *1806*
Salon, 1885, *2000*
Salon, 1887, *2449*
Salon, 1888, *2694*
Salon, 1889, *2985*
Society of American Artists, 1888, *2678*
Society of American Artists, 1892, *3986, 26660*
Ten American Painters, 1899, *6954, 17564*
Union League Club of New York, 1892, *26552*
illustrations
 Concarneau types (drawings), *24939*
 decorative initial, *24932*
 Justice of the Law, *14087*
 Melpomene (mural), *14087*
illustrations for *Scribner's Magazine*, *22482*
Jeanne, in American Art Galleries, 1884, *1899*
John Anderson, my Joe, John, *25977*
mural for Criminal Court building, New York, 1895, *22787*
murals for Boston State House, *13351*
notes, 1883, *24948*
sales and prices, 1883, *Winnower, 24703*
secedes from Society of American Artists, 1898, *6527*
whereabouts
 1883, Concarneau, *24589, 24702, 24736, 24819*
 1884, Spain, *25132*
 1887, St. Ives, *25495*
 1887, summer travel, *2543*
window design for Harvard's Memorial Hall, *26693*
work, 1883, *10893*
Simmons, Franklin, 1839-1913
America, erected in Portland, Me., 1892, *26835*
bust of Gen. Sherman, *26424*
Paris and Helen, finished in studio in Rome, 1892, *26880*
soldiers and sailors monument for Portland, Me, *26375*
statue of General Grant for Washington Capitol, 1894, *27004*
statue of Longfellow for Portland, Me, *621, 25547*
statue of Roger Williams
 for Providence, 1878, *9008*
 model given to Colby College, 1883, *24896*
statue of Senator Morton, *191, 24798*
studio, Rome, 1885, *2006*
Washington monument, Philadelphia, proposed, 1880, *149*
whereabouts
 1891, to America from Rome, *26454*
 1892, Washington, D.C, *26507*
William King and the Naval Monument, Washington, *9073*
Simmons, Freeman Willis, 1859-1926
commissions, 1894, *27025*
exhibitions
 Cleveland Art Association, 1895, *11470*
 Minneapolis Society of Fine Arts, 1895, *11513*
whereabouts, 1894, opens studio in Cleveland, *27004*
Simmons, Haydn M., *Mrs.* See: **Beale, Nellie Church**
SIMMONS, J. Wright, *18312*
Simmons, Vesta, fl.1889
exhibitions, Salon, 1889, *2985*
SIMMS, William Gilmore, *18492, 19739*
Simms, William Gilmore, 1806-1870, *18367*
Egeria, or, Voices of Thought and Counsel for Woods and Wayside, excerpts, *18170*
quote, *19742*
Simon, George Gardner See: **Symons, George Gardner**
Simon, Hermann, b.1846?
illustrations
 Study, *6190*
 Sunny days, *22531*
magazine illustration, 1894, *22517*
picture, 1883, *24803*
Simon, Lucien, 1861-1945
exhibitions
 Carnegie Galleries, 1905, first prize, *14016*
 Pennsylvania Academy of the Fine Arts, 1907, *14333*
 Pittsburgh, 1899, *12976*

Salon, 1902, *13414*
illustrations, *Evening in a studio*, *14332*
Simonds, George, b.1843
bust of Ralph Waldo Emerson, *24737*
statue of Tollemache, *26591*
Simonet, Maurice, fl.1901
illustrations, etching, *13305*
Simonetti, Attilio, 1843-1925
exhibitions, Rome, 1876, *8675*
illustrations
 After the ball, *7594*
 figure drawing, *2939*
paintings in Stewart collection, *10768*
Simonis, Eugène, 1810-1882
Leopold I, *8887*
Simonnet, Lucien, 1849-1926
illustrations, *Winter landscape*, *12738, 13697*
Simons, Amory Coffin, 1869-1959
exhibitions
 American Art Association of Paris, 1899, *12890*
 Pennsylvania Academy of the Fine Arts, 1905, *13853*
SIMONS, Fred H., *11489, 11509, 11586, 11946, 11972*
Simons, Fred H., fl. 1894-1897
organizes course in graphic design in La Porte, Ind., 1894, *11349*
Simons, O. W., fl.1894
illustrations, illustrations to story by H. M. Eaton, *22575*
Simons, Pinky Marcius See: **Marcius Simons, Pinckney**
Simpson, Charles, *Mrs.* See: **Davidson, Clara D.**
Simpson, Clara Davidson D. See: **Davidson, Clara D.**
SIMPSON, Evelyn Blantyre, *10449*
SIMPSON, Joseph, *8781*
Simpson, Joseph
reply to his letter on early art, *8840*
Simpson, William H., d.1872
Resolute, *19836*
Sims, Richard, 1816-1896
obituary, *17053*
Sinclair Crewe, William See: **Crewe, William Sinclair**
Sindelar, Charles J., fl.1897-1925
illustrations
 design, *6881*
 portrait study in charcoal, *6871*
Sinding, Stephan Abel, 1846-1922, *13734*
exhibitions, Chicago World's Fair, 1893, *26959*
illustrations, *Mother in bondage*, *14212*
Rohl Smith's monument to Sherman, Washington
 completes, 1903, *8262, 13627*
 completes *War*, 1902, *13473*
Sinet, André, b.1867
notes, 1894, *16628*
Sing Sing (New York)
collectors and collecting, 1893, *16371*
prison, art classes introduced, 1897, *6487*
Singer, Hans Wolfgang, b.1867
Etchers of Our Time, review, *16984*
Singer, Herbert, fl.1880
design for clock case, *9304*
design for race cup, *9272*
Singer, J. H., fl.1875
monumental brasses, *8541*
SINGER, J. W., *9928, 10083*
SINGER, W. H., *9395, 9424*
Singer, Winaretta Eugenie, b.1865
exhibitions
 Salon, 1882, *1397*
 Salon, 1885, *2000*
singers
American singers, *23201*
hints, *817*
singing
American singers, 1897, *23201*
origin of song, *24094*
Singleton, Esther, 1865-1930
Social New York under the Georges, review, *13521*

1894, returns from Europe, *27025*
Smith, K. H., fl.1886-1887
exhibitions, National Academy of Design, 1886, *2352*
SMITH, Katharine A., *24107*
SMITH, Katherine Louise, *12962*
Smith, Letta Crapo, 1862-1921
exhibitions, New York Water Color Club, 1891, *3833*
sales and prices, 1896, *In St. Mark's*, *11824*
Smith Lewis, John See: **Lewis, John Smith**
SMITH, M. B., *4198*, *4293*, *4369*, *4530*
Smith, M. B.
Landscape Painting in Oil, excerpt, *4665*
Practical Hints for Beginners in Oil Painting, excerpt, *4200*,
4328, *5873*
SMITH, M. C., *23808*
Smith, Marshall D., fl.1896-1939
Lost Chicura, *22945*
Smith, Mary E.
collection, sale, 1893, *16122*, *26886*
SMITH, Mary Nelson, *11583*
Smith, May Mott See: **Mott Smith, May Bird**
Smith, Millicent Grayson See: **Grayson Smith, Millicent**
Smith, Murray Clinton, fl.1888-1890
exhibitions, National Academy of Design, 1890, *Plain of Enfer*,
3455
SMITH, N. L., *11720*, *11754*
SMITH, Niva H., *11644*
Smith (*of Craven, Yorkshire*), fl.1812-1818
English poker-painter, *16288*
Smith, Oliver Phelps, 1867-1953
exhibitions, New York, 1893, studio work, *4277*
Smith, Pamela Colman, ca.1877-ca.1950, *13054*
designs for *Trelawny of the Wells*, *17571*
illustrations to Yeats's *Land of Heart's Desire*, *6812*
Smith, Robert Catterson, b.1853
paintings of Burne-Jones's *Chaucer* illustrations, *6872*
SMITH, Robert Henry Soden, *21574*, *21593*, *21603*, *21693*,
21710, *21855*, *21951*
Smith, Robert Murdoch, *Sir*, 1835-1900
lecture on Persian calligraphy, *26464*
Smith, Roswell, 1829-1892
obituary, *26620*
publisher, *Scribner's Monthly*, *22480*
Smith, Russell, 1812-1896
decoration for Philadelphia Opera House, *19581*
exhibitions, Pennsylvania Academy of the Fine Arts, 1856,
19437
illness, 1892, *26617*
scene painting, 1870, *10596*
SMITH, S. L., *13802*
Smith, Samuel S., 1809-1879
illustrations
David playing before Saul (after D. W. Wynfield), *9404*
Jephthah's daughter (after J. Schrader), *8789*
Strawberry girl (after P. De Coninck), *8467*
Toilette of the young princess (after Léon y Escosura), *9022*
Smith, Sarah A., d.1905
collection, sale, 1895, *16889*
Smith, Sidney Lawton, 1845-1929
book plates, *22413*
enamel plaques, *538*
etcher and stained glass designer, *538*
etching of Fritsche ewer, *25395*
etchings for *The Studio*, *25393*
exhibitions, Society of American Artists, 1882, *1349*
For Easter Day (decorated poem), *25595*
illustrations
drawing of Japanese baskets from the Moore collection,
26057
John Quincy Adams at the age of 16 (after Schmidt), *25410*
Tiffany coffee pot (etching), *25369*
Japanese objects (etching), *25633*
Smith, Suzanne F., fl.1894-1898
summer home and studio, *22571*
Sunny afternoon, *22741*

Smith, Sydney, 1771-1845
recollected by C. Leslie, *18471*
Smith, T. Guilford, 1839-1912
elected president, Buffalo Fine Arts Academy, 1902, *13440*
Smith, Thomas Henry, fl.1843-1849
Columbus explaining his plans, *14537*
SMITH, Thomas Lochlan, *10970*
Smith, Thomas Lochlan, 1835-1884
exhibitions
American Art Union, 1883, *10913*
National Academy of Design, 1881, *342*
illustrations, winter scenes, *10970*
landscapes, 1883, *24841*
obituary, *11098*
whereabouts, 1883, summer in Albany, *24817*
Smith, Thomas Roger, d.1903
Classic Architecture, review, *11410*
Smith, Walter, 1836-1886
controversy, *1131*
obituary, *10744*
SMITH, Walter, *12315*
SMITH, Walter F., *23654*, *23697*, *23756*, *23786*, *23826*, *23842*,
23860, *23931*, *23961*, *23997*, *24105*, *24276*
Smith, Walter Granville, 1870-1938
exhibitions
Carnegie Institute, 1907, honorable mention, *14328*
National Academy of Design, 1900, third Hallgarten prize,
12997
illustrations, *Gotham girl*, *12484*
illustrations for *Godey's*, 1893, *22482*
illustrations for *Vogue*, 1893, *22490*
magazine illustrations, 1893, *22482*
notes, 1898, *17389*
Salmagundi mug painting, 1907, *14319*
whereabouts, 1896, summer plans, *23056*
Smith, Willard Adelbert, 1849-1923
awarded Tiffany vase, 1894, *4968*
Smith, William, 1808-1876
bequest to South Kensington Museum, *8829*
Smith, William C., fl.1896
planner of Tennessee Centennial, 1896, *11841*
Smith, William Henry, 1808-1872
Thorndale, or the Conflict of Opinions, excerpt, *18266*
review and excerpts, *19896*
Smith, William Henry, 1839-1935
custodian of library and art gallery, Columbian Exposition,
1892, *26799*
Smith, Xanthus Russell, 1839-1929
exhibitions
Pennsylvania Academy of the Fine Arts, 1856, *19437*
Pennsylvania Academy of the Fine Arts, 1857, *19658*
SMITHE, Theodore Marcellus, *20238*
Smithwick and French
illustrations
Autumn (after G. H. Boughton), *9427*
Page (after E. Gregory), *9256*
portrait study (after W. Sartain), *9380*
Summer's afternoon (after J. C. Beckwith), *9287*
Women drawing water from the Nile (after F. A. Bridgman),
362
Wrecking beach, L.I. (after A. Quartley), *9287*
wood engravings, *182*
Smithwick, John G., fl.1871-1882
See also: **Smithwick and French**
wood engravings, *182*
smoke
England
in manufacturing districts, *9578*
need of control, *9875*
smoke abatement exhibition, 1882, *9616*
smoke pictures on porcelain, *17089*
technique for painting smoke and fire, *4866*
smoking
Japan, *15944*
smoking customs of ancient Romans and American Indians,

17371

Smucker, Samuel Mosheim See: **Schmucker, Samuel Mosheim**

Smyth, Eugene Leslie, 1857-1932
 exhibitions, Boston Art Club, 1884, *1737*

snakes
 cobras, *20832*
 in art, *19154*

SNEAD, M. L., *6669*

Snedecor Gallery See: **New York. Snedecor's Gallery**

Snedecor, John, d.1897
 obituary, *17241*

Snell, Henry Bayley, 1858-1943
 Coming storm, *22968*
 elected associate, National Academy of Design, 1902, *13436*
 exhibitions
 American Watercolor Society, 1897, *Citadel of Quebec*, *23213*
 American Watercolor Society, 1902, *13424*
 Boston, 1899, *12892*
 Cincinnati Art Museum, 1898, *12754*
 National Academy of Design, 1898, *17402*
 New York Water Color Club, 1905, Beall prize, *14009*
 Pratt Institute, 1902, watercolors, *8081*
 Tennessee Centennial Exposition, 1897, water color first prize, *11971*
 Worcester Art Museum, 1902, *13483*
 illustrations
 English channel fisherman, *13803*
 Inner-harbor, September, *13875*
 With a favorable wind, *22486*
 sea paintings, *22687*

Snook, Florence, fl.1905
 illustrations, design for stained glass, *13905*

Snorra-Edda See: **Edda Snorra Sturlusonar**

Snorri Sturluson, 1178-1241
 Edda Snorra Sturlusonar, *21353*

snow
 in landscape, *10094*
 snow painters, 1890, *3419*
 technique for painting, *4719*, *4776*, *4808*, *6880*, *7780*
 for beginners, *7997*
 snow and ice, *6112*, *6158*
 snow scenes, *7554*, *8083*

Snow, A. D., fl.1890
 illustrations, fish plate doily designs, *3276*

SNOW, Bonnie, *11517*

snow crystals
 crystals as designs, *7238*

Snow, Edward Taylor, 1844-1913
 illustrations, *Low tide*, *12005*

snuff boxes
 collectors and collecting, *17084*
 jewelled snuff boxes at Tiffany and Co., 1902, *7969*
 Lenoir collection, *8532*
 Linnaeus's snuff box, *17080*
 notes, 1896, *5887*
 Oriental, *2581*
 sales and prices
 1895, *16789*
 1896, *17053*

Snyder
 illustrations, view of Prague, *21580*

Snyder, Henry M., fl. 1852-1871
 See also: **Van Ingen and Snyder**

Snyder, W. P., fl.1884-1893
 exhibitions, American Watercolor Society, 1884, *25012*
 illustrations, *Old Whimsey's girl*, *22473*

Snyder, William Henry, 1829-1910
 exhibitions, National Academy of Design, 1891, *26313*

Snyders, Frans, 1579-1657, *21750*

Soane, John, 1753-1837
 documents, *10194*
 museum in London, *9641*

Soane, John, Museum See: **London (England). Sir John Soane's Museum**

soapstone
 Chinese carvings, *15793*

Social Art Club, Baltimore See: **Baltimore (Maryland). Social Art Club**

social settlements
 church settlement houses, *13028*

socialism
 effect on architecture, *12868*

Société d'aquarellistes français See: **Paris (France). Société d'aquarellistes français**

Société d'archéologie lorraine See: **Nancy (France). Société d'archéologie lorraine et du Musée historique lorrain**

Société de la gravure originale en couleurs
 annual exhibitions, 1906, *14048*

Société de protrection de l'art français See: **Paris (France). Société de protection de l'art français**

Société des amis du Luxembourg See: **Paris (France). Société des amis du Luxembourg**

Société des artistes français
 Carolus Duran elected president, 1898, *12826*
 city of Paris acquisitions, 1903, *13629*
 elections, 1904, *13712*
 engraving and lithographic section, 1890, *26044*
 exhibitions
 1907, *14312*
 London, 1875, *8381*, *8488*
 London, 1875-1876, *8606*
 home for aged members
 plans, 1905, *13845*
 plans, 1906, *14176*
 meetings
 1890, *25751*
 1891, *26259*
 1904, annual, *13817*
 notes
 1890, *26135*
 1903, *13572*
 Salon, 1898, *6646*
 split from Société Nationale des Beaux-Arts, 1890, *25854*
 study of painting methods which resist decay, 1891, *3571*

Société des artistes indépendants
 annual exhibitions
 1884, *1801*
 1889, *25665*
 1894, *4801*
 arrival in United States, 1893, *16408*
 criticized, 1893, *16342*
 exhibitions
 1890, *25864*
 1892, *15874*
 1905, *13915*

Société des artistes, peintres, sculpteurs, et graveurs See: **Paris (France). Société nationale des beaux arts**

Société des bibliophiles contemporains See: **Paris (France). Société des bibliophiles contemporains**

Société des bibliophiles français
 notes, 1894, *16480*

Société des pastellistes français See: **Paris (France). Société des pastellistes français**

Société des peintres et sculpteurs, Paris See: **Paris (France). Société des peintres et sculpteurs**

Société des peintres graveurs français
 annual exhibitions, 1893, *16251*
 exhibitions, 1889, *25588*

Société des peintres lithographes
 quarterly periodical, 1892, *4220*

Société des sciences morales des lettres et des arts de Seine-et-Oise
 exhibitions, Versailles, 1877, *8915*

Société d'histoire et d'archéologia de Genève See: **Geneva (Switzerland). Société d'histoire et d'archéologie de Genève**

Société française de gravure
 transfers copper plates and proofs to Louvre, 1902, *13504*

circular opposing tariff legislation sent to European journals, 1883, *24507*

supports abolition, 1884, *25022*

prizes

1893, *16215*

annual prize for figure painting established, 1892, *26485*

award endowed by Andrew Carnegie, 1900, *13046*, *22089*

changes in conditions, 1901, *7543*

Shaw fund and prize established, 1902, *13351*

Webb prize for landscape painting established, 1887, *25446*

Webb prize to Bruce Crane and Shaw prize to George W. Maynard, 1897, *23240*

protests actions of Society for Suppression of Vice, 1887, *25480*

sales and prices

1883, *24553*

1892, *26649*

Theodore Robinson painting offered to Metropolitan Museum and refused, 1899, *12842*, *17458*

title of association confusing, *3571*

women members not on juries, *26932*

Society of American Embroiderers

exhibitions, 1883, for Liberty Pedestal Loan Exhibition, *24820*

Society of American Etchers

deplores issuing of unlimited proofs, *2800*

exhibitions, 1888, *2843*

prints published, 1889, *14942*

Society of American Fakirs See: **New York. Art Students' League**

Society of American Portrait Painters

exhibitions, 1902, announced, *13515*

notes, 1903, *13549*

officers, members, and purpose, 1902, *8059*

plans to form, 1902, *13455*

Society of American Sculptors

established, 1904, *13760*

Society of American Wood Engravers

annual meeting, 1884, *25007*

award from Berlin, 1891, *26411*

exhibitions

Berlin, 1895, *16749*

Boston Museum of Fine Arts, 1890, *15365*

Grolier Club, 1890, *3208*, *15106*

notes

1883, *24774*

1884, *25085*

1892, *26862*

portfolio published by Harper, 1887, *10814*

Society of Antiquaries See: **London (England). Society of Antiquaries**

Society of Architects, London See: **London (England). Society of Architects**

Society of Art Collectors See: **New York. Society of Art Collectors**

Society of Art Masters See: **National Society of Art Masters**

Society of Arts and Crafts, Boston See: **Boston (Massachusetts). Society of Arts and Crafts**

Society of Arts and Crafts, Duluth See: **Duluth (Minnesota). Society of Arts and Crafts**

Society of Associated Arts

annual exhibitions, 1903, *13578*

Society of Beaux Arts Architects See: **New York. Society of Beaux Arts Architects**

Society of British Artists See: **Royal Society of British Artists**

Society of British Sculptors See: **Royal Society of British Sculptors**

Society of Decorative Art, Boston See: **Boston (Massachusetts). Society of Decorative Art**

Society of Decorative Art, Chicago See: **Chicago (Illinois). Society of Decorative Art**

Society of Decorative Art, New York See: **New York. Society of Decorative Art**

Society of Decorative Art of California

founded, 1881, *353*, *1133*

Society of Female Artists, London See: **London (England).**

Society of Lady Artists

Society of French Artists See: **Société des artistes français**

Society of French Watercolor Painters See: **Paris (France). Société d'aquarellistes français**

Society of Illustrators, London See: **London (England). Society of Illustrators**

Society of Illustrators, New York See: **New York. Society of Illustrators**

Society of Independents See: **New York. Society of Independents**

Society of Keramic Arts, New York See: **New York. New York Society of Keramic Arts**

Society of Landscape Painters See: **New York. Society of Landscape Painters**

Society of Medallists, London See: **London (England). Society of Medallists**

Society of Mural Painters See: **New York. National Society of Mural Painters**

Society of Odd Brushes, Boston See: **Boston (Massachusetts). Society of Odd Brushes**

Society of Painter-Etchers and Engravers See: **Royal Society of Painter-Etchers and Engravers**

Society of Painters in Pastel See: **New York. Society of Painters in Pastel**

Society of Painters in Tempera See: **London (England). Society of Mural Decorators and Painters in Tempera**

Society of Painters in Water Colors

formation, 1851, *14731*

meeting, 1855, *18783*

Society of Painters on Stone

history, *12215*

Society of Scottish Artists

meeting, 1891, *26287*

Society of the Army of the Tennessee

General Sherman Statue Committee meets, 1891, *26433*

monument to Gen. Sherman proposed, 1891, *26396*

raises funds for Sherman monument, 1892, *26526*

sponsors competition for Sherman monument for Washington, D.C., 1895, *22876*

Society of Western Artists

annual exhibitions

1897, *6103*

1898, *6805*, *17412*

1898, purchases, *12273*

1898-1899, *12780*, *12802*, *12806*

1899-1900, *12986*

1899-1900, poor showing at Chicago Art Institute, *12921*

1900, *13158*

1901, *13206*

1902, *13388*, *13542*

1903, *13698*

1904, *13816*

1905, prizes, *13913*

1906, *14038*, *14227*

Chicago group, *12122*

convention, 1896, *11778*

description, 1898, *12680*

Duveneck elected president, 1896, *23008*

election of officers

1898, *12724*

1906, *14238*

exhibitions

1897, *17241*

1898, *12679*, *12701*

1899, *17686*

1899, Chicago, *12314*, *17623*

founded, 1896, *5787*, *11919*

history and members, *12083*

Indianapolis and Detroit groups, *12107*

meeting

1898, *12232*

1904, *13768*

notes

1896, *11913*, *17165*

1899, *12944*

Boston, 1890, animal paintings, *25911*
Salon, 1883, *1602*
Salon, 1884, *1814*
Salon, 1885, *2000*
Salon, 1886, *2193*
Five-o'clock tea in my studio, *22684*
illustrations
 Comrades (drawing), *2427*
 Orphans, *2694*
 Poachers, *2682*
woman dog painter, *22525*
Strong, Emilia Francis See: **Dilke, Emilia Francis Strong, lady**
STRONG, Henry, *12105*
Strong, James, 1822-1894
 Cyclopedia of Biblical, Theological and Ecclesiastical Literature, review, *18476*
Strong, Joseph Dwight, 1852-1899
 artists in San Francisco, *811*
 obituary, *22096*
Stroobant, François, 1819-1916
 illustrations
 high altar in the church of Notre Dame, Halle, Belgium, *20808*
 interior of St. Peter's church, Louvain, *20790*
 Mill at Kalkhaven, near Dordrecht, *3629*
 one of the windows at the Hotel de Ville at Ghent, *21239*
 Quai Rosaire, Bruges, *3650*
 view of Coblentz - taken from the height of Ehrenbreitstein, *21256*
 view of Ostend, *20991*
 view of the Hotel de Ville at Ghent, *21239*
Strother, David Hunter, 1816-1888
 artist-author, *17803*
 guest on Baltimore and Ohio Railroad excursion, 1858, *19876*
 illustrations for *Harper's*, *22476*
 newspaper illustrations, *16557*
 officer in Army during Civil War, *22787*
 paintings acquired by Pennsylvania Academy, 1877, *8917*
 sketches of Virginia scenery, *18639*
 whereabouts, 1859, summer travel, *20080*
Strozzi, Bernardo, 1581-1644
 notes, 1895, *16804*
Struck, Hermann, 1876-1944
 illustrations, *Portrait of an old man*, *13494*
Strudwick, John Melhuish, 1849-1935
 exhibitions, Grosvenor Gallery, 1880, *21885*
Struthers and Son, Philadelphia
 monument to Commodore Hull, Philadelphia, *647*
Struthers, John D. d.1951
 See also: **Struthers and Son, Philadelphia**
Struthers, William, 1812-1876
 See also: **Struthers and Son, Philadelphia**
Strutt, Edward C.
 Fra Filippo Lippi, review, *13434*
Struys, Alexander Théodore Honoré, 1852-1941
 exhibitions, Pennsylvania Academy of the Fine Arts, 1882, *1333*, *1354*
 Forgotten, gift to Pennsylvania Academy, 1882, *14865*
Stuart, Charles Edward See: **Charles Edward, *the Young Pretender***
Stuart, Charles Gilbert, 1787-1813
 Battle royal, *17154*
 notes, 1895, *16831*
 portrait of W. Woollett presented to English National collection, 1849, *14499*
Stuart Dodge, Elsie, fl.1896
 exhibitions, Salon, 1896, *23618*
Stuart, Dudley Coutts, *lord*, 1803-1854
 biography, *20771*
Stuart, Eliizabeth See: **Phelps, Elizabeth Stuart**
Stuart, Esmé, *pseud.* See: **Leroy, Amèlie Claire**
STUART, Gilbert, *20335*
Stuart, Gilbert, 1755-1828, *11422*, *21316*
 anecdotes, *10661*

birthplace, *5900*
Consul Barry, in Walters collection, *1003*
exhibitions
 Boston Museum of Fine Arts, 1880, *172*
 Boston Museum of Fine Arts, 1880, *894*
 Charleston Exposition, 1901-02, *13346*
 Cincinnati, 1896, portraits, *22958*
 Metropolitan Museum of Art, 1895, *5565*
 New York, 1893, *16277*
letter from R. Peale, *20146*
Mason's *Life and Works of Gilbert Stuart*
 book in preparation, 1879, *31*
 review, 1880, *78*
medal in series of distinguished American artists, American Art Union, 1848, *14367*, *14387*, *14395*, *14403*, *14459*
monuments
 body exhumed and monument planned, 1896, *16968*
 memorial proposed, 1897, *17335*
 proposed, 1896, *11765*
painting technique, *5115*
paintings in Boston Museum of Fine Arts, *720*, *2053*
paintings in Bowdoin's collection, *10583*
paintings in Lenox Library collection, *771*
portrait of Colonal Humphreys, in Wadsworth Atheneum, *17646*
portrait of Devere, *980*
portrait of Gen. John P. Van Ness, shown at Corcoran, 1881, *446*
portrait of John Parr on view in New York, 1893, *16227*
portraits
 life mask by Brouwere, *1147*
 portrait bust by J. Browere, *375*
 portrait by Bass Otis, *17040*
 self portrait acquired by London National Gallery, 1896, *6092*
portraits in T. J. Coolidge collection to be shown at Metropolitan Museum of Art, 1895, *22738*
portraits of Dr. and Mrs. Hartigan, *17218*
portraits of Martha and George Washington in Boston Athenaeum, *19995*
portraits of Martha Washington and John Jay reproduced by photogravure, 1893, *16329*
portraits of Washington, *18063*, *18148*, *19258*, *20404*
 copy by artist's daughter, *14680*
 copied by Hoit, 1856, *19388*
 copy commissioned of Robert Dunning, 1892, *26730*
 Indianapolis discovery, 1896, *11794*
 Indianapolis portrait reproduced by A. W. Elson, *22388*
 Isle of Man portrait, *3695*, *16894*, *17001*
 Lansdowne portrait, *17078*, *19369*
 Lansdowne portrait original sketch, *16883*
 Lansdowne portrait replica, *16818*, *16831*, *16846*, *17042*
 Lansdowne portrait studies, *16865*
 Lenox Library portrait copied by Vos, 1897, *17357*
 Marquis de Lacaze offers to lend to Chicago World's Fair, 1892, *26694*
 Pensylvania Academy portrait, *5933*
 portrait acquired by Lord Roseberry, *26006*
 portrait head copied by Kittrell, *27006*
 portrait in Durrett collection, *15598*
 portrait in Providence State House, *17068*
 portrait in Ruthrauff collection, *16905*
 portrait of *Washington* compared to Trumbull's, *19610*
 steel plate, *17429*
 studied by George W. Smalley, *14954*
sales and prices
 1850, *Portrait of Robert Morris*, *14619*
 1857, *19645*
studio, *17144*
style, *21121*
tomb
 Boston, *11616*
 grave found in Boston, 1896, *11759*
 yet unmarked, 1896, *16939*
STUART, Henry, *12015*

Stuart, James Everett, 1852-1941
 awarded medal, 1902, *22161*
 whereabouts, 1890, studio moved from Cincinnati to Portland, *26220*
Stuart, James Reeve, 1834-1915
 exhibitions
 National Academy of Design, 1886, *508, 2112*
 St. Louis, 1871, *10713*
 portraits, 1870, *10599*
 studio, St. Louis, 1871, *10654*
 work, 1870, *10570*
Stuart, Jane, 1812-1888
 portrait of Washington (after G. Stuart), *14680*
 sales and prices, 1859, copy after *Washington at Faneuil Hall*, *18283*
 whereabouts, 1857, visits Europe, *19682*
 work, 1857, *19596*
Stuart, John, *earl of Darnley* See: **Darnley, John Stuart Bligh**, *6th earl of*
Stuart, Mabel, fl.1891-1897
 exhibitions, Society of American Artists, 1897, *10538*
Stuart, Mary McCrea, d.1891
 collection, given to Lenox Library, 1892, *15800*
 repeals gifts to protest museums' Sunday openings, 1892, *3867*
 will's codicils exclude Metropolitan Museum and American Museum of Natural History for Sunday openings, *26475*
STUART, Muriel, *23940*
Stuart, Robert Leighton, 1806-1882
 collection
 coins sold, 1892, *15837*
 donated to Lenox Library, 1892, *15800*
 shown at Lenox Library, 1893, *4361, 26916*
Stuart, Robert Leighton, *Mrs.* See: **Stuart, Mary McCrea**
Stuck, Franz von, 1863-1928
 exhibitions
 Carnegie Galleries, 1900, *13130*
 Carnegie Galleries, 1903, *13675*
 Pittsburgh, 1899, *12976*
 St. Louis Exposition, 1896, *6011, 11873*
 illustrations
 Beethoven, *13322*
 border ornament, *2846*
 decorative panels, *8250*
 illustrator, *12191*
students
 art students
 advice on travel to Paris, 1900, *7266*
 advised on travel abroad, 1884, *11013*
 advised on where to study art, 1891, *3651*
 affectations, *12626*
 American females in Paris, 1900, *7372*
 Americans discouraged from studying abroad, 1896, *5709*
 Americans' reactions to Paris Salon, 1901, *7776*
 Americans studying art abroad, 1884, *11030*
 art centers for Americans, 1902, *7804*
 art student's excursion to Forest of Fontainebleau, *5231*
 books suggested for art student's library, 1893, *4455, 4638*
 Chicago students at Julian Academy, Paris, 1898, *12146*
 cost of life in Paris, 1891, *3716*
 Delaroche student dies in atelier hazing, 1891, *3528*
 freedom given in Paris art schools, 1894, *4849*
 illustration of work at Macleod Art School, *14041*
 in New York, 1905, *13994*
 life at Art Students' League, N.Y., 1882, *10855*
 life in Munich, 1890, *3450*
 living expenses in Paris, 1896, *5987*
 paper on life in Munich, 1894, *4947*
 Paris studios closed due to student hazings, 1891, *3541*
 should poor students marry?, *23902*
 summer life for students in Paris, 1900, *7321*
 summer sketches shown in Boston, 1882, *10866*
 work at Art Institute of Chicago, 1902, *13425, 13445*
 work at Los Angeles School of Art and Design, 1906, *14048*
 art student's travel abroad, 1891, *3629, 3650, 3697, 3724*
 art student's travel abroad, 1892, *4046*

art student's travel to Brittany, 1892, *4026*
art student's trip to Holland, Belgium, and France, 1891, *3577, 3605*
art student's year in Paris, 1895, *5263*
conduct of American college students, *24021*
Stumm, Maud, fl.1893-1910
 illustrations
 Countess Castellane roses, *5790*
 Oranges, instructions for copying, *3914*
 Pansies, *4419, 5132, 5159*
 Sweet revery, *22486*
 Violets, *6118*
 Wild roses, *3617, 5943*
 portraits and figures, *22498*
 woman in art, *22525*
Sturdevant, Austa Densmore, 1855-1936
 career, *12446*
 exhibitions, Salon, 1896, *23618*
Sturges, Jonathan, 1802-1874
 address at opening of exhibition of National Academy, 1851, *14741*
 collection, American landscapes, 1855, *19331*
Sturgis, Richard Clipston, 1860-1951
 paper on English country house, 1898, *12245*
STURGIS, Russell, *1818, 1838, 13478, 23260, 23265, 23269, 23272*
Sturgis, Russell, 1836-1909
 Appreciation of Sculpture, review, *13861*
 article on painted Greek sculpture, 1890, *25833*
 contradicts Di Cesnola, 1884, *1745*
 design for Knoedler Gallery, 1890, *26157*
 handbook reviewed, 1906, *14043*
 introduction to H. G. Marquand collection catalogue, *8102*
 lectures
 at Brooklyn Institute, 1891, *26333*
 at Chicago Art Institute, 1904, *13752*
 Columbia College, 1892, *26507*
 on art in Japan at Aldine Club, 1890, *25866*
 on bronzes, 1886, *25378*
STURLESON, Hjalmar, *737, 775, 810, 830, 854*
Sturluson, Snorri See: **Snorri Sturluson**
Sturtevant, G. V., fl.1892
 china painting shown at home in Brooklyn, 1892, *26869*
Sturtevant, Helena, 1872-1946
 exhibitions, Rhode Island School of Design, 1905, *13935*
Stuttgart (Germany)
 art, 1858, *19941*
Stuyvesant, Peter, 1592-1672
 seal, *20399*
Styka, Jan, 1858-1925
 exhibitions, Société des Artistes Français, 1907, *14312*
 Golgotha, to be cut into theater curtains, *14161*
style
 affectation in art, *9809*
 American architecture, *13049*
 defined by Leigh Hunt, 1899, *17483*
 definition, *15927*
 definition by Lambdin, *11129*
 Goethe's ideas of nature and art, *18618*
 imitation of "Old Masters", *17951*
 mannerisms in painting, *17951*
Suarez de Mendoza, Ferdinand, b.1852
 theories on color hearing, *8322*
SUB ROSA, *24387*
subject matter in art, *21503*
 advice from Raffaelli to sketch in theaters, *5349*
 advice on finding subjects, *3659*
 American artists should paint American subjects, *12217*
 American subjects, *12726*
 artists should prefer nature to history, *18626*
 beggars, *22822*
 choice of subject in pictures, drama and novels, *24980*
 choosing landscape subjects, *3677*
 choosing subject matter, *5440*
 daily life, *20023*

disappearance of subject from art, *4661*
ethnographical painters, *2265*
F. Harrison's article on decadence of art, 1893, *4459*
favorite subjects of American artists, *22684, 22704, 22731,*
 22741, 22770, 22805, 22861, 22879, 22916, 22945, 22968
Greeks' treatment of ordinary life, *9793*
information for artists on sketching in Holland and Normandy,
 1894, *4912*
Japan in American art, *22714*
notes, 1894, *5039*
press as subject, *20041*
selecting subject matter, *4954*
subjects for pictures, *14664*
subjects of American paintings, *10750*
sublime, the
 John Martin's sublime themes, *19564*
 landscape gardening, *19779*
 remarks by W. J. Stillman, *19630*
Suchetet, Auguste Edme, 1854-1932
 exhibitions, Salon, 1880, *187*
Suchorowski, Marceli, 1840-1908
 Nana, and other pictures shown, 1887, *10502*
Sudermann, Hermann, 1857-1928
 Magda, review, *12519*
Suermondt Museum, Aix-La-Chapelle See: **Aachen**
 (Germany). Suermondt Museum
Suez Canal
 description and views, *9414*
Suffolk County Historical Society See: **Riverhead (New**
 York). Suffolk County Historical Society
suffrage
 United States, *22842*
sugar
 history, *20940*
 manufacture and refining, *21212*
suicide
 facetious essay, *23951*
Suisse, Charles Alexandre, fl.1833-1850
 atelier in Paris, *14652*
Sullivan, Arthur Seymour, 1842-1900
 Mikado, mistakes of local color, *2085*
 notes, 1896, *22988*
 opera *Asrael*, *26178*
 Pirates of Penzance, performances, New York, 1880, *817*
 visit to New York with *H.M.S. Pinafore*, 1879, *781*
Sullivan, Edward, 1852-1928
 English bookbinder, *17029*
Sullivan, H. Wood
 collection, *15647*
 sale, 1903, *13589*
 sale, 1903, prices listed, *8203*
Sullivan, John Lawrence, 1858-1919
 monuments, statue by Donoghue, *591*
 portraits
 commissions statue, 1885, *11204*
 statue by Donoghue, *2580*
Sullivan, Louis Henry, 1856-1924
 address to Architectural League of America, 1899, excerpt,
 13005
 designs and photographs, *20499*
 illustrations
 Bayard Building, *20529*
 bronze door, *13992*
 elevator enclosures, Stock Exchange Building, Chicago,
 20565
 mantle, *20547*
 letter on American architecture in T Square Club, Philadelphia,
 exhibition catalogue, 1899, *12870*
 Objective and Subjective, excerpts, *20507*
 quote, *20511*
 on American architecture, *12979*
Sullivan, Mabel Ansley, fl.1894
 illustrations, *Whirl of color*, *22537*
Sullivant, Thomas Starling, b.1854
 illustrations, *Why grandpa, it's a Fifth Avenue stage horse!*,

22482
 portraits, photograph, *22559*
Sulloway, Cyrus Adams, 1839-1917
 notes, 1896, *22896*
Sully, Thomas, 1783-1872, *21316*
 Adieu, in Philadelphia Art-Union, 1849, *21404*
 advice to Genin, *19161*
 anecdotes, *10582*
 exhibition proposed, 1859, *20104*
 exhibitions
 Charleston Exposition, 1901-02, *13346*
 Pennsylvania Academy of the Fine Arts, 1849, *14533*
 illustrator of *Robinson Crusoe*, *20051*
 notes
 1871, *10619*
 1892, *15921*
 1898, *6708*
 picture for steamboat *Albany*, *19654, 19665*
 portrait of Charles Calvert, *24773*
 portrait of Commodore Decatur, *26266*
 portrait of Gilroy, *15535*
 portrait of Queen Victoria, *10937, 17596*
 history, *17622*
 reception in honor of Peale and Sully, 1859, *20033*
 sales and prices, 1861, *Peasant girl* bought in St. Louis, *20330*
summer resorts
 United States, *19904*
Sumner, Charles, 1811-1874
 article on *The best portraits in engraving*, *15803*
 collection, Washington, 1871, *10731*
 letter praising Prang's chromos, 1868, *23556*
 monuments, statue by Anne Whitney offered to Cambridge,
 Mass., 1903, *13537*
Sumner, George Heywood Maunoir, 1853-1940
 illustrations, embroidered wall hanging, *3440*
Sumner, Heywood See: **Sumner, George Heywood Maunoir**
sun
 midnight sun in Norway, *11888*
 sunsets in painting of G. H. McCord, *22533*
Sunday
 significance of Sunday in religous observances, *20326*
Sunday observance See: **Sunday**
Sunday schools
 school room decoration, *12340*
Sunday Sketch Club, Cincinnati See: **Cincinnati (Ohio).**
 Sunday Sketch Club
Sunderland, Charles Spencer, 3d earl, 1674-1722
 library, sale, 1883, *14886*
Sunderland, John E., 1885-1956
 illustrations
 Becalmed, *13527*
 Feline aristocracy, *13405*
 portrait study in crayon, *13517*
SUNFLOWER, *11325*
Suñol, Jeronimo, 1839-1902
 statue of Columbus commissioned for New York, 1892, *26843*
sunset phenomena
 technique for painting, *4664*
 types of sunsets, *19065*
Sunter, Harry J., fl.1883
 exhibitions, Milwaukee Exposition, 1883, *24799*
superstition
 19th century beliefs, *20865*
 England, *21361*
Surand, Gustave, b.1860
 Mercenaires de Carthage, *1815*
Surrey (England)
 description and views, *21759*
Susa (ancient city)
 antiquities, *17777*
 J. de Morgan's excavations, *7072*
 excavations, 1903, *8146*
Sutcliffe, Frank Meadow, 1853-1941
 photographs of Whitby, *10107*
SUTHERLAND, J., *5186, 5231, 5263, 5669*

T

Tempest, John William, d.1892
 collection, left to Montreal Art Assocation, *15877*
Tempest, Marie, 1866-1942
 quote, on portraits, *26952*
Tempio Malatestiano See: **Rimini (Italy). Tempio Malatestiano**
Temple Bar, London See: **London (England). Temple Bar**
Temple, Henry John, *viscount* Palmerston See: **Palmerston, Henry John Temple**, *3d viscount*
Temple, Joseph E., 1811-1886
 elected director, Pennsylvania Academy, 1884, *25032*
 endowment of Pennsylvania Academy, 1880, *102*
 endows Pennsylvania Academy with purchase prize, 1883, *1677*
 funded Sunday openings at Pennsylvania Academy, *25425*
 gifts to Pennsylvania Academy, 1882, *14865*
 gives Picknell painting to the Pennsylvania Academy, 1881, *307*
 notes, 1883, *24803*
 offers prizes to all American artists, *24803*
 prizes for historical paintings at Pennsylvania Academy, *10929*
Templeman, C. B., fl.1891
 pastel portraits of Governor Randolph of New Jersey, *26396*
temples
 Egypt, Rameses temple at Abu-Simbel, *16675*
 Ethiopia, temple of Soleb, *20595*
 Japanese temple to be constructed at Chicago World's Fair, 1893, *26878*
temples, Buddhist
 Egyptian character of altar decoration, *1520*
temples, Greek
 temple of Neptune at Paestum, *21264*
Ten American Painters See: **New York. Ten American Painters**
Ten Eyck, Cuyler, fl.1891-1895
 portrait of Gov. Flower, *21521*
 portrait of Roscoe Conkling, *26258*
Ten Kate, Herman Frederik Carel See: **Kate, Herman Frederik Carel ten**
Ten Kate, Mari See: **Kate, Mari ten**
Ten, The See: **New York. Ten American Painters**
Teniers, David, *the younger*, 1610-1690
 anecdote, *17697*
 Chatain's examination of alleged Teniers, 1899, *17696*
 compared with Wilkie, *18579*
 exhibitions
 Boston, 1896, *17165*
 Union League Club of New York, 1889, *Five senses*, *3099*
 painting in Boston museum, 1881, *1108*
 paintings in Art Institute of Chicago, 1894, *5086*
 pictures in Alfred de Rothschild collection, *10179*
 sales and prices, 1889, *Five senses* for sale, *14963*
TENISWOOD, George F., *8362*
Tennant, Dorothy See: **Stanley, Dorothy Tennant**
Tennant, Enriqueta Augustina See: **Rylands, Enriqueta Augustina Tennant**
Tennessee
 antiquities, *17009*
Tennessee Army Society See: **Society of the Army of the Tennessee**
Tennessee Centennial and International Exposition, 1897 See: **Nashville (Tennessee). Tennessee Centennial and International Exposition, 1897**
Tenniel, John, 1820-1914
 Bacchus and the Water Thieves, *8611*
 Book of Beauty, *5066*
 caricatures, *9581*
 illustrations for edition of Poe's poems, *18212*
tennis
 how to make a raquet stand of wood, *7397*
Tenny, Arnold, 1831?-1881
 obituary, *476*
Tennyson, Alfred, *baron*, 1809-1892
 anecdote, by Ruskin, *16777*
 autograph, *17056*

December, *18373*
Fairy Lillian, illustrations, *628*
first editions shown at Grolier Club, 1897, *6465*
Idylls of the King
 illustrated by Kappes, *11235*
 review, *20115*
manuscripts, *16915*
Maud, review, with excerpts, *19316*
Mungo, the American, unpublished manuscript, *16531*
November, *18240*
poems, early illustrated edition reprinted, 1893, *16316*
Poems of Two Brothers, *16810*
 manuscripts, *15145*
Poetical Works of Alfred Tennyson, Poet-Laureate, review, *19471*
portraits
 bust by T. Woolner, *19642*
 etching by Rajon, *15989*
 Jacque Reich's charcoal drawing, 1887, *2363*
Princess, illustrated by American artists, 1883, *1667*
relics, sales and prices, 1891, *15599*
work, *20184*
Tennyson, Emily Sellwood Tennyson, *baroness*, 1813-1896
 musical settings of Tennyson poems, *8322*
Ter Borch, Gerard See: **Terborch, Gerard**
Ter Meulen, Frans Pieter, 1843-1927, *11507*
Terborch, Gerard, 1617-1681
 exhibitions
 Carnegie Galleries, 1902, *13520*
 Union League Club of New York, 1891, *Glass of lemonade*, *3454*
 illustrations, *Guitar lesson*, *6840*
 paintings in Art Institute of Chicago, 1894, *5086*
 pictures in Alfred de Rothschild collection, *10179*
Terburg, Gerard See: **Terborch, Gerard**
Terhune, Mary Virginia Hawes, 1830-1922
 Nemesis, review, *20274*
Termohlen, Karl Emil, b.1863
 exhibitions
 Chicago, 1905, *13868*
 New York, 1896, *White cart horse*, *6093*
 paintings, *13671*
terra cotta
 art work manufacture, *1794*
 indoor and outdoor ornament, *2790*
 material in architecture, *504*
 use in architectural ornament, *23407*
 use in architecture, *5019*
 use in sculptural modeling, *1701*
terra cottas
 decorative reliefs, *13396*
 forgeries, 1900, *7313*
 statuettes from Asia Minor, *6845*
terra cottas, American
 art tiles and architectural tiles, 1879-1895, *11716*
 Rookwood Pottery terracottas at Chicago World's Fair, 1893, *4510*
terra cottas, classical
 exhibitions, New York, 1889, *2915*
 nymph on sea horse from Hoffman collection, *25338*
 Sappho, *25567*
terra cottas, Etruscan
 bust of priestess or divinity acquired by Boston Museum, 1888, *26174*
terra cottas, Greek
 Asia Minor, *25487*
 collectors and collecting
 1893, *16158*
 American collectors, 1891, *3497*
 United States, 1890, *15245*
 exhibitions, Union League Club, New York, 1890, *3157*
 forgeries, *25811*, *25841*, *25872*, *25873*, *25885*, *25926*, *25974*, *25984*
 market place group imported to United States, 1890, *25886*
 Myrina and Tanagra, *25499*

Paris Sketch-book by Mr. Titmarsh, review, *10247*
praise of Trumbull, *25665*
relationship with Millais, *16981*
Romance of a Portrait, based on portrait of Addison, *17358*
use of "acrography", *25743*
Vicar of Wakefield
 illustrated edition, 1890, *26177*
 prices, *16208*
views on French painting, *3055*
Thaclier, A. C. See: **Thacher, Amy C.**
Thai pottery See: **porcelain and pottery, Siamese**
Thames River
 description and views, *9789, 9825, 9831, 9855, 9872, 9901*
Thamugadi See: **Timgad (Algeria)**
Thanet, Octave, *pseud.* See: **French, Alice**
Tharp, Newton J., 1867-1909
 Navy monument, San Francisco, *22182*
 O'Connell memorial, *22156*
Thatcher, John Boyd See: **Thacher, John Boyd**
Thaulow, Frits, 1847-1906, *13649, 14218, 20630*
 essay by R. Faure, 1898, *17390*
 exhibitions
 Boston, 1899, *12855*
 Carnegie Galleries, 1896, *11906*
 Carnegie Galleries, 1897, *Arques at Ancourt - evening* wins
 silver medal, *6462*
 Carnegie Galleries, 1900, *13130*
 Chicago, 1900, *12455*
 London, 1899, *17595*
 New York, 1896, *17176*
 New York, 1897, *12071*
 New York, 1898, *6495*
 Pennsylvania Academy of the Fine Arts, 1900, *13007*
 Pittsburgh, 1899, *12976*
 St. Louis Exposition, 1897, *12015*
 illustrations
 Entrance to the Royal Palace, Copenhagen, *14016*
 Péniche, *13605*
 River in Normandy - winter, *11622*
 Smoky city, *13322*
 notes
 1895, *16814*
 1896, *16939*
 1897, *23240*
 Old bridge at Verona, *13112*
 pastels, *7290*
 views W. T. Evans collection, 1898, *17401*
Thaw, Mary Copley, 1842-1929
 collection, painting in Carnegie Institute annual exhibition,
 1902, *13520*
Thaxter, Celia Laighton, 1835-1894
 Idyls and Pastorals, illustrated publication, 1886, *509*
 poetess and artist, *25007*
 poetry on nature, *9199*
 whereabouts, 1880, *960*
Thaxter, Edward R., 1854-1881
 illustrations, *First dream of love*, *10749*
 obituary, *428*
 sculpture in Florence studio, 1881, *21893*
Thayer & Chandler, Chicago See: **Chicago (Illinois). Thayer
& Chandler**
Thayer, Abbott Handerson, 1849-1921
 Caritas
 in Boston Museum of Fine Arts, *13073*
 receives Elkins prize, 1896, *16939*
 subject matter opposed, 1897, *6396*
 elected academician, National Academy of Design, 1901, *13228*
 exhibitions
 Architectural League of New York, 1897, *10535*
 Artists' Fund Society, 1884, *24967*
 Artists' Fund Society, 1885, *25225*
 Chicago, 1890, *3364*
 Chicago, 1890, winner of Dole prize for *Head*, *26116*
 Chicago Art Institute, 1896, *11894*
 Chicago Inter-State Industrial Exposition, 1889, *3056*

National Academy of Design, 1880, *111, 889*
National Academy of Design, 1894, *4873*
National Academy of Design, 1898, Clarke prize, *12710*
New York, 1904, *13808*
Paris Exposition, 1889, *Corps ailé*, *25724*
Pennsylvania Academy of the Fine Arts, 1891, *3535*
Pennsylvania Academy of the Fine Arts, 1896, *Caritas*, *5656*
Pennsylvania Academy of the Fine Arts, 1904, *13716*
Pittsburgh, 1899, *12976*
St. Botolph Club, 1880, *159*
Society of American Artists, 1880, *94, 844, 9324*
Society of American Artists, 1881, *1130*
Society of American Artists, 1882, *1327, 1349, 9635*
Society of American Artists, 1883, *1551*
Society of American Artists, 1884, *1802, 11003*
Society of American Artists, 1886, *2227*
Society of American Artists, 1887, *562, 2452, 10789, 25451*
Society of American Artists, 1888, *10846*
Society of American Artists, 1888, *Angel*, *2678*
Society of American Artists, 1890, *3255*
Society of American Artists, 1890, *Portrait of a lady*, *25915*
Society of American Artists, 1891, *26329*
Society of American Artists, 1892, *3986*
Society of American Artists, 1892, *Virgin enthroned*, *26634*
Society of American Artists, 1896, *22996*
Society of American Artists, 1896, *Diana*, *5780*
illustration in Koehler's *American Art*, 1886, *509*
illustrations
 Caritas, *13807, 14282*
 Portrait of a lady, *13792*
Madonna, *3888*
Portrait, in Seney collection, *24977*
recommended by McKim, Meade & White to decorate Boston
 Public Library, *22738*
sales and prices, 1900, picture in Evans collection, *13008*
sketches and studies, *9301, 9335*
studio, Dublin, 1890, *26063*
Virgin enthroned, *4872*
whereabouts, 1883, Cornwall, *24728*
Thayer, Abbott Handerson, *Mrs.*. See: **Thayer, Emmeline
Buckingham Beach**
Thayer, Elmer, *Mrs.* See: **Thayer, Emma Homan**
Thayer, Emma Homan, 1842-1908
 uses Alice Stewart's flower illustrations in book, without per-
 mission, *2108*
Thayer, Emmeline Buckingham Beach, 1850-1924
 exhibitions
 Society of American Artists, 1886, *25309*
 Society of American Artists, 1889, *2986*
 Woman's Art Club of New York, 1891, *26292*
Thayer, Sanford, 1820-1880
 obituary, *286*
Thayer, Theodora W., 1868-1905
 exhibitions, American Society of Miniature Painters, 1900,
 13022
theater
 See also: **drama; opera; playbills; tableaux**
 anecdote, *16659*
 Booth as Hamlet, *20366*
 Campbell collection of theater souvenirs, *17098*
 England
 1895, *22837*
 William West's engravings, *10413*
 France, *20552*
 19th century, *9196*
 19th century restoration of Greek drama, *19073*
 Charley's Aunt in Paris, 1898, *24155*
 Comedie Francaise, *20559*
 Paris, 1889, *17875*
 Paris, new regulations, 1898, *24155*
 Paris Theater Salon, 1896, *17173*
 free admission to plays, *20563*
 India, jugglers of Madras, *18992*
 literature, *15362*
 morality, *19658*

Dr. Bellows and Dr. Donaldson on the stage, *19658*
notes
1897, *23170, 23197, 23222, 23250*
1898, *24206*
1901, *7525*
Poole collection of theatrical souvenirs, *16663*
relics
collectors and collecting, *16291*
memorabilia shown in London, 1893, *16130*
Russia
1855, *19077*
history, *17172, 17229*
stage as school of art, *9976*
stage craft, criticism, 1898, *17413*
United States
1880, *977*
actors and actresses, 1895, *22837*
criticism by R. Stodart, *23071*
J. L. Smith's outdoor productions, 1899, *20562*
New York, *650*
New York, 1883, *1652, 1672*
New York, 1883, *Queen's Lace Handkerchief* opening at
Casino Theater, *1486*
New York, 1884, *1695, 1715, 1733, 1752, 1770*
New York, 1885, *1917, 1948, 1982, 2036, 2051, 2071, 2086*
New York, 1886, *2109, 2172, 2191*
New York, 1886, *Acharnians, 25374*
New York, 1889-90, *17890*
New York, 1895, *22777, 22833, 22863, 22888*
New York, 1895, Abbey Theater's production of *Madame
sans Gêne, 5298*
New York, 1896, *22922, 22948, 22970, 22995, 23021,
23046, 23092, 23107, 23124, 23143*
New York, 1897, *23157*
New York, 1898, *17454*
New York, 1901, *7507, 7551*
New York, 1901, plays by Frohman and Boddington, *7570*
New York, Booth's Theater, *16948*
New York, disappearance of Christmas plays, 1900, *7482*
New York, fall season, 1884, *1847*
New York, *Hamlet* by Sothern and *Henry V* by Mansfield,
1900, *7456*
New York, playbills of early nineteenth century, *2246*
New York, plays, 1900, *7428*
New York season, 1884, *1860, 1878*
New York season, 1885, *1900, 1965*
New York summer season, 1884, *1831*
traveling companies, *22773*
theater programs
designs by artists, *24155*
theaters
See also: **toy theaters**
France
actresses' dressing rooms, *722*
new regulations, 1898, *24155*
Greece, Milne's evidence of Greek stages, *26387*
stage setting and scenery, *601, 1969, 9976, 17395, 17413,
20551, 20560*
England, *20573*
Faust, London, 1886, *10257, 10268*
for amateur theatricals, 1892, *4093*
hints for scene painters, *1316*
history, *17434*
history of scene painting, *17510*
horizon lines, *731*
mechanisms for Wagner's *Parcifal, 1435*
need for understanding of composition and color, *22320*
open-air performances at Coombe House in natural stage,
10204
painted scenery for *Wolfert's Roost*, 1879, *714*
painting temporary scenery, *7285*
pre-Charles II, *17453*
scene painting, *1986, 2004, 2041, 2054*
scene painting for amateurs, *759*
scene painting of John Rettig, *22701*

time of Charles II, *17477*
time of Shakespeare, *17529*
United States, *20561*
Theatre français See: **Paris (France). Théatre français**
Theatre of Arts and Letters, New York See: **New York.
Theatre of Arts and Letters**
theatrical posters
criticism, 1898, *17413*
Thebes (Egypt)
antiquities
mummies and papyri discovered, 1881, *21899*
Petrie's ecavations, 1896, *17078*
relics from royal tombs found, *454*
Theed, William, 1804-1891
illustrations, statue of the Prince Consort, *10433*
obituary, *26406*
statue of Sir Isaac Newton, *19925*
Theobald, Jean G., fl.1899-1905
illustrations
designs for iron work, *12918*
designs for silver work, *12963*
wrought-iron work, *13992*
Theosophical Society
notes, 1896, *22988*
Theotocopuli, Domenico See: **El Greco**
Thérond, Emile Théodore, b.1821
illustrations
cloister of the choir of the cathedral of Chartres, *20879*
external view of the dome - church of the Invalides, *20974*
Lighthouse of Cordouan, 21000
palace of the Emperor of China at Nankin, *20938*
sacristy of the cathedral of Notre Dame, Paris, *20800*
views of tomb of Napoleon, *20974*
Thesmar, Fernand André, 1843-1912
bowls of transparent enamel, *13973*
exhibitions, Salon, 1891, *3649*
illustrations
bowls of transparent enamel, *13525, 13545*
game plates, *7956*
THEURIET, André, *23744, 23767*
Theuriet, André, 1833-1907
criticizes American woman, *23793*
Reine des Bois illustrated by Laurent Desrousseaux, publication
announcement, *15422*
Thew, Robert, fl.1850-1860
illustrations, *Greek slave* (after H. Powers), *18084*
Thibault, Charles Eugène, b.1835
illustrations
At the fountain (after J. E. Aubert), *10051*
Broken thread (after J. E. Aubert), *9045*
Reverie (after J. Aubert), *9083*
Thiede, Henry A., b.1871
exhibitions, Palette and Chisel Club, Chicago, 1906, *14227*
Thiele, Arthur Julius, 1841-1919
Severe winter, 10507
Thiem, Adolph
collection, given to Berlin, 1904, *13795*
Thiers, Adolphe, 1797-1877
collection
bequest to Louvre, *21893*
bequest to the state, *8915*
home, house, Paris, *14072*
Thiersch, Ludwig, 1825-1909
Charon als Seelenfuhrer, 19853
Thiriat, Henri, fl.1874-1882
illustrations
engravings after G. Doré, *9898*
Pauline Bonaparte (after Canova), *907*
portrait of Cesare Borgia (after Raphael), *6277*
Return of the herd (after Vuillefroy), *5435*
THISELTON DYER, Thomas Firminger, *10204*
Thivier, Eugène Siméon, 1845-1920
exhibitions, Louisiana Purchase Exposition, 1904, *13806*
Thoinan, Ernest, 1827-1894
Relieurs Français, review, *16172*

Tholen, Willem Bastiaan, 1860-1931, *14934, 22208*
 exhibitions
 American Watercolor Society, 1891, *3532*
 New York, 1894, *16505*
Tholey, Charles P., d.1898
 obituary, *12674*
Thom, James, 1799-1850
 illustrations, *American eagle, 18291*
 obituary, *14619*
 statue of Washington, litigation of ownership rights, 1861, *20387*
Thom, James Crawford, 1835-1898
 exhibitions
 Brooklyn Art Association, 1875, *8460*
 New York, 1883, *24415*
 sales and prices, 1891, auction of oil paintings, *26279*
 studies with Frère, 1860, *20195*
 whereabouts
 1860, Paris, *24361*
 1861, Paris, *20330*
 1883, New Jersey, *24656*
Thoma, Hans, 1839-1924
 illustrations, untitled, *22315*
 lithographer, *12952*
 notes, 1898, *17393*
Thomas à Kempis, 1380-1471
 De Imitatione Christi, price, 1895, *16786*
 Imitation of Christ, 16685
Thomas, A., *Miss*, fl.1897
 illustrations, plate design for copying, *6235*
THOMAS, Abel C., *23379*
Thomas and sons, architects
 Presbyterian church, New York, 1858, *19766*
THOMAS, Ann E., *22890*
Thomas Aquinas, *Saint*, 1225?-1274
 philosophy, *19916*
Thomas, Arthur, 1858-1932
 Dear Christ mourned by the Holy Women, gift to Pennsylvania Academy, 1882, *14865*
 dome painting for Democratic Club, *17391*
Thomas, Augustus, 1857-1934
 Capitol, played in New York, 1895, *22833*
Thomas, Conrad Arthur See: **Thomas, Arthur**
Thomas, D. F., d.1924
 exhibitions, Society of American Artists, 1898, *Fete day at Sandia, Peru, 6618*
Thomas, Elizabeth Haynes, fl.1895-1910
 sales and prices, 1896, *Library corner, 11824*
Thomas, Ella, d.1947
 exhibitions, Paris, 1902, *13372*
Thomas, George Housman, 1824-1868
 illustrations, *Lord Dudley Stuart, 20771*
Thomas, Griffith, 1820-1878
 See also: **Thomas and Sons, architects**
Thomas, Grosvenor, 1860-1923
 Glasgow School painter, *14152*
Thomas, Havard See: **Thomas, James Havard**
Thomas, James Havard, 1854-1921
 exhibitions, Royal Academy, 1907, *14312*
Thomas, John Rochester, 1848-1901
 New York Hall of Records, plans changed by building firm, 1899, *7072*
Thomas, Jules, 1824-1905
 exhibitions, Salon, 1880, *187*
Thomas, Percy, 1846-1922
 Old White Hart Inn yard (etching), *9767*
Thomas, Philip Francis, 1810-1890
 library, sale, 1891, *15494*
Thomas, Stephen Seymour, 1868-1956
 exhibitions
 Internationale Kunstausstellung, Munich, 1901, second class medal, *13379*
 Salon, 1901, third class medal, *13253*
 Salon, 1904, medal, *13762, 13780*
 Société des Artistes Français, 1907, *14312*

illustrations, *Lesson, 12015*
THOMAS, W. Cave, *9444*
Thomas, W. Cave
 Pre-Raphaelitism Tested by the Principles of Christianity, excerpt, *20317*
Thomas, William Luson, 1830-1900
 rejoinder to Pennell's criticism of art of the illustrator, 1890, *3359*
Thomes, William Henry, 1824-1895
 obituary, *16705*
Thompson, Albert, b.1853
 exhibitions, Boston Art Club, 1880, *72*
 Ordination of the first minister, commissioned by Woburn Public Library, 1894, *27014*
 painting presented to Woburn Public Library, 1895, *22738*
 portrait of John Sullivan to be shown at American Institute Fair, 1892, *26798*
THOMPSON, Alfred, *20482*
Thompson, Alfred, 1831?-1895
 illustrations for Daly's *Woffington*, 1891, *15783*
 illustrations for *The Story of the Stick*, 1891, *15783*
 obituary, *16803*
Thompson, Alfred Wordsworth, 1840-1896, *9399*
 exhibitions
 American Art Galleries, 1884, *24988*
 American Art Union, 1883, *Fete at Menton on St. m John's Eve, 10913*
 Artists' Fund Society, 1884, *24967*
 Artists' Fund Society, 1885, *1916*
 Chicago Inter-State Industrial Exposition, 1880, *199*
 National Academy of Design, 1880, *9324*
 National Academy of Design, 1881, *1129*
 National Academy of Design, 1889, *3101*
 National Academy of Design, 1892, *11302*
 Pennsylvania Academy of the Fine Arts, 1881, *1128*
 Philadelphia Society of Artists, 1882, *1270*
 Prize Fund Exhibition, 1885, *25278*
 Union League Club of New York, 1887, *2406*
 illustrations, *Old Phillips church, 1750, 22560*
 In a weary land, 22495
 Noonday in the olden time, in Louisville's Southern Exposition, 1883, *24760*
 Old stone church in Sleepy Hollow, in Clarke collection exhibition, 1883-4, *24955*
 portraits, photograph, *22518*
 sketches of Colonial times and views of Brittany, *22673*
 studio, *22721*
 summer studio, 1893, *22491*
 summer home and studio, *22571*
 Traveling in Italy, in Evans collection, *11185*
 whereabouts
 1883, travel in Europe, *24817*
 1895, summer in Summit, N.J, *23056*
 work, 1884, *25061*
Thompson, Alice Christiana See: **Meynell, Alice Christiana Thompson**
Thompson, Benjamin See: **Tompson, Benjamin**
Thompson, Cephas Giovanni, 1809-1888
 portraits done in Rome, *19850*
 whereabouts
 1859, opens studio in New York City, *20093*
 1859, Rome, *20045*
Thompson, Edward G., fl.1858-1860
 houses in New York State, *8596*
Thompson, Elizabeth See: **Butler, Elizabeth Southerden Thompson**, *lady*
THOMPSON, Elizabeth Shepherd Lamb, *10711*
Thompson, Ellen Kendall Baker See: **Baker, Ellen Kendall**
Thompson, Ernest Seton See: **Seton, Ernest Thompson**
Thompson, F., fl. 1896
 illustrations, *E. C. Lewis, 11862*
Thompson, Frederic Louis, b.1868
 In the sunny South, 22968
Thompson, Harry, fl.1882-1910
 exhibitions, Fort Wayne, 1896, *11827*

Timbal, Louis Charles, 1821-1880
 obituary, *264*, *21891*
Timbs, John, 1801-1875
 Anecdote Biography, excerpts on Hogarth and Reynolds, *20298*
 Painting Popularly Explained
 excerpt, *19991*, *20043*, *20206*, *20220*, *20245*, *20256*, *20280*
 excerpt on mosaic painting, *20142*, *20176*
 excerpt on tempera and encaustic, *20059*, *20075*, *20089*, *20100*
time capsules
 notes, 1903, *8262*
Timgad (Algeria)
 antiquities, *13672*
Timmons, Edward J. Finley, 1882-1960
 illustrations, pen-and-ink sketch, *13445*
Timms, fl.1839-1865
 illustrations
 Ancient harbour of Genoa (after Berghem), *21368*
 Common lobster and the hermit crab, *21085*
 Little bridge (after J. Van Huysum), *21081*
 Morning (after R. Wilson), *20763*
 Skittle players (after J. Steen), *20947*
TINCOMBE FERNANDEZ, W. G., *13834*
Tingley, George E., 1864-1858
 illustrations, photograph of Dodge MacKnight, *12855*
Tinker, Franklin H., d.1890
 library, sale, 1890, *15258*, *25969*
Tinkham, Alice S., fl.1881-1896
 exhibitions, Boston Art Students' Association, 1884, *10898*
Tintoretto (Jacopo Robusti), 1512-1594
 Christ washing Peter's feet, bought at Hamilton sale for National Gallery, 1883, *14917*
 Madonna and Child, shown in New York, 1900, *7452*
 Miracle of the slave, *12750*
 notes
 1893, *26982*
 1896, *17086*
 1899, *12398*
 paintings in Appleton collection, *876*
 Paradise, taken down for re-lining, 1903, *13652*
 portrait of Henry III, in Marquand collection, 1903, *8124*
 Temptation of Christ, Satan, *9899*
Tinworth, George, 1843-1913
 English designer, *10438*
 exhibitions, London, 1883, *9802*
Tirard, Helen Mary Beloe
 lectures on Eygpt, British Museum, 1890, *25806*
Tirard, Nestor Isidore Charles, Mrs. See: **Tirard, Helen Mary Beloe**
Tiratelli, Aurelio, 1842-1900
 exhibitions, New York, 1894, *4758*
TIREBUCK, William Edwards, 1854-1900, *9732*, *10069*
Tirebuck, William Edwards, 1854-1900
 satire on W. Daniels, *98*
Tiryns
 Schliemann's excavations, *10258*
Tisdall, Edward W.
 collection
 exhibited at Fifth Avenue Galleries, 1899, *17501*
 sale, 1899, *6903*
Tisio, Benvenuto da Garofalo, 1481-1519
 altarpiece, *21627*
 Holy Family, at Windsor Castle, *10437*
Tissot, James Joseph Jacques, 1836-1902, *12279*
 art importations to U.S., 1879, *734*
 Bible illustrations, *23030*
 collection, bequest of four paintings to Louvre, *13533*
 etchings, at Knoedler's, 1889, *25582*
 exhibitions
 Chicago, 1899, *12844*, *12877*
 Chicago, 1899, *Life of Christ*, *17623*
 Chicago Art Institute, 1899, *Life of Christ*, *12850*
 Glasgow Institute, 1879, *21736*
 Grosvenor Gallery, 1878, *21594*
 Grosvenor Gallery, 1879, *9178*

New York, 1898, life of Jesus, *12255*
 Paris, 1901, *13269*
 Paris Exposition Nationale, 1883, *1680*
 Salon, 1894, illustrations of *Life of Christ*, *4939*
 Société d'Aquarellistes Français, 1884, *1756*
 forgeries, *25877*
 paintings, *25890*
 French painter, *23045*
 How we read the news of our marriage, *26420*
 illustrations
 Convalescent (etching), *13259*
 Faust and Marguerite, *13850*
 His first pair of breeches (dry point), *13703*
 Matin (etching), *13169*
 Pharisees and the Herodians take counsel against Jesus, *13843*
 Reverie (dry point), *14084*
 Visitors in the Louvre, *3565*
 Life of Christ, *6811*, *17403*, *17429*
 publication, 1895-6, *22876*
 watercolors at Brooklyn, 1901, *13253*
 Margaret and Faust in the garden, shown in New York, 1865, *23355*
 Marguerite, in Walters collection, *1003*
 notes, 1898, *17441*
 obituary, *7992*
 painting in Cutting collection, *26562*
 paintings in Hilton collection, *793*
 Pencil reporting from the Life of Christ, *16473*
 religious paintings, *13484*
 scriptural paintings acquired by Brooklyn Institute of Art and Sciences, *22090*
 whereabouts, 1890, in the Holy Land, *25832*
 work, 1877, *8792*
Titcomb, Caroline King, fl.1891-1895
 exhibitions, Palette Club of Chicago, 1892, *11307*
Titian, 1477-1576, *10267*, *10284*
 Ages of man, *14643*
 analytical criticism, *17441*
 art in Venice, *14705*
 Assumption, *5531*
 coloring, *19449*
 Danaë, *18922*, *18931*, *18982*, *19019*, *19034*, *19038*
 attribution, *18869*
 depiction of children, *9614*
 discovery of pictures, 1858, *18156*
 Entombment, *12750*
 excerpts from A. Des Essarts in translation, *19745*
 exhibitions
 New York, 1895, D'Aulby collection, *5336*
 New York, 1895, *Diana at the bath*, *16726*
 Flora, *18991*
 Holy Family and Magdalen, *16738*
 illustrations
 Adoring angels, *22849*
 Entombment, *13484*
 Isabella d'Este, rediscovered, 1903, *13652*
 Later Works of Titian, review, *14084*
 life and character, *20085*
 life, color, *19344*
 Madonnnas, *23136*
 memorial tablet placed in Pieve di Cadore, *8901*
 notes, 1893, *26982*
 painting of Mary Magdalene found, 1902, *8056*
 painting rediscovered in Paris, 1858, *19852*
 paintings discovered by J. R. Tilton, 1894, *4798*
 paintings in Borghese Palace collection, *19925*
 paintings in Prado, *9848*
 pen drawings, *1591*
 Peter Martyr, copy by Bartolomei for Baltimore, 1851, *14808*
 Portrait of a Knight of Malta, in Cook collection, *10143*
 Saint Sebastian, found at Gorizia, 1901, *13257*
Titmarsh, Michael Angelo See: **Thackeray, William Makepeace**

Titz, Louis, 1859-1932
 illustrates *Salammbô*, 1883, *15062*
Tixier, E. L. J.
 illustrations, lace collar, *13526, 14151*
Tiziano Vecelli See: **Titian**
TNEL, *24691, 24698*
toads, *21288*
Toaspern, Otto, 1863-1940, *22751*
 illustrator for *Harper's*, *22473*
 instructor, summer school of art at Round Lake, N.Y., 1892, *26666*
 lecture at West Art Museum, Round Lake, N.Y., 1892, *26713*
 magazine illustration, 1894, *22517*
 work, 1892, *26839*
tobacco jars and boxes
 ornamental tobacco box by Charles and Edouard Avisseau, *21308*
tobacco pipes
 collectors and collecting, *15844*
 Blucher's pipe in Sheffield collection, *17102*
 Daudet collection, *16936*
 Meerschaum pipes, *15045*
 Watteville's collection, *15323*
 first meerschaum pipe, *16337*
 flat-heeled pipes, *16860*
 Turkey, *21183*
Toché, Charles, 1851-1916
 fresco paintings at Chenonceaux, *2410*
 newcomer in French art, 1887, *2391*
 notes, 1887, *546*
Tocqueville, Alexis de, 1805-1859
 Oeuvres et Correspondance Inédites, edited by G. de Beaumont, *20340*
TOD, Wirtos, *23614, 23638, 23663, 23670, 23721, 23732, 23760, 23769, 23838, 23869, 23884, 23929*
Todd, Dolly Payne See: **Madison, Dolly Payne Todd**
TODD, Frederick Dundas, *12033*
TODD, Pleasant E., *22828*
Toefaert, Albert, fl.1883
 exhibitions, Ghent Salon, 1883, *14870*
TOEPFFER, Rodolphe, 1799-1946, *19373, 19922, 19969*
Tofano, Eduardo, 1838-1920
 exhibitions, Salon, 1878, *9036*
Tojetti, Virgilio, 1851-1901
 decorations for restaurant, 1883, *24817*
 Embarrassing question, living picture created by actress Eleanor Barry, *22563*
 exhibitions
 American Watercolor Society, 1884, *25012*
 American Watercolor Society, 1885, *1933*
 Prize Fund Exhibition, 1885, *25278*
 Southern Exposition, Louisville, 1884, *Richelieu and Julie, 11051*
 illustrations, *Little sweethearts*, *6471*
 Judith, *11220*
 Progress of America, finishes, 1875, *8573*
 studio reception, 1884, *25079*
Tokyo (Japan). Exhibition of National Arts and Industries
 See: **Tokyo (Japan). Naikoku Kangyo. Hokurankai**
Tokyo (Japan). Naikoku Kangyo. Hokurankai
 1890, announcement, *25635*
Toledo (Ohio)
 exhibitions, 1898, benefit for treasury of Newsboys' and Bootblacks' Union, *12824*
 fair, 1902, *6996*
 women's art club organized, 1905, *13819*
Toledo (Ohio). Libbey Glass Company See: **Libbey Glass Company, Toledo, Ohio**
Toledo (Ohio). Nasby Art Galleries
 opened, 1899, *12859*
Toledo (Ohio). Toledo Art League
 organized, 1895, *11683*
Toledo (Ohio). Toledo Museum of Art
 building, new galleries open, 1906, *14223*
 exhibitions

1901, European loans, *13312*
1902, *13384*
notes, 1901, *13253*
plans art school, 1904, *13739*
plans completed, *13270*
Toledo (Ohio). Toledo University of Arts and Trades
 description of art school to be established, 1875, *8403*
 notes, 1879, *735*
 School of Design opens, 1875, *8425*
Toledo (Spain)
 Alcazar destroyed by fire, *557*
TOLMAN, Leroy D., *14107*
Tolman, Stacy, 1860-1935, *13133*
 illustrations
 Corner of a studio, *10871*
 symbolic figure, *13934, 14282*
 In the Egyptian gallery, *10851*
 Kenmore from the East, *10863*
 sketch, *10849*
Tolstoi, Lev N. See: **Tolstoy, Leo**
TOLSTOY, Leo, 1828-1910, *26097*
Tolstoy, Leo, 1828-1910
 What Is Art?
 excerpts, *12880*
 review, *17517*
Toma, Gioacchino, 1836-1891
 exhibitions, Rome International Exhibition of Fine Arts, 1905, *13966*
Tomlins, William Lawrence, 1844-1930
 Child's Garden of Song, review, *11743*
 lectures, 1896, *11766*
TOMLINSON, H. W., *13907*
TOMLINSON, Walter, *1573, 1593, 1606*
Tompkins, Arnold, 1849-1905
 paper on expression presented to Northern Illinois Teachers' Association meeting, 1896, *11907*
Tompkins, Arthur G., d.1892?
 bequests, 1892, *26790*
Tompkins, Clementina, 1848-1931
 exhibitions, Corcoran Gallery of Art, 1887, *592*
Tompkins, Frank Hector, 1847-1922
 Boston artist, *10549*
 exhibitions
 Boston, 1888, *2662*
 Boston Art Club, 1887, *534*
 Boston Art Club, 1907, *14252*
 illustrations, *Memories*, *561*
 training and works, *8320*
Tompson, Benjamin, 1642-1714
 American poet, *20371*
Toms, Peter, d.1776
 drapery painter, *1801*
 English drapery painter, *5525*
tonalism
 definition, *5732*
 definition of tonality, *17469*
 dialogue defining tonalism, 1898, *17422*
 letter from the Critic, 1899, *17502*
 tonality, *17484*
Tonetti Dozzi, Louis See: **Tonetti, François Michel Louis**
Tonetti, François Michel Louis, 1863-1920
 illustrations
 Au bord du Loing, *14244*
 Birth of Athene, *13263, 13556*
 member of Rose Croix, *26645*
 sculpture for Louisiana Purchase Exposition, *13685*
Tonnesen, Beatrice, fl.1890's
 photographic portraits, *11864*
Tony Noël See: **Noël, Edme Antony Paul**
TOOKE, M. A., *8730*
tools
 recipe for rust-proofing compound, *7984*
Toorop, Jan Theodoor, 1858-1928
 exhibitions
 Amsterdam, 1892, *15979*

Berliner Secession, 1902, *13372*
Tooth, Arthur, & Sons, Ltd. See: **London (England). Tooth, Arthur, & Sons, ltd.**
Tooth, Arthur, & sons, New York See: **New York. Tooth, Arthur, & Sons**
Toovey, James, 1814-1893
obituary, *16329*
Topeka (Kansas)
artists, form league, 1906, *14109*
Topham, Francis William, 1808-1877, *9266*
Topham, Frank William Warwick, 1838-1924
exhibitions, Royal Academy, 1881, *21999, 22022*
Home after service, *9623*
Messenger of good tidings, *9947*
Toppan, Charles, 1796-1874
bank note engraving, *18644*
Topping, Helen M., fl.1896-1899
exhibitions
Chicago, 1896, *11881*
National League of Mineral Painters, 1899, *12352*
illustrations
decorated ceramics, *12873*
tobacco jar, *7188*
notes, 1896, *11913*
Torlonia Museum, Rome See: **Rome. Museo Torlonia**
Toro, Luigi, 1836-1900
paintings, 1876, *8722*
Toronto (Ontario)
art, *26816*
murals for parliament buildings, *13240*
civic improvements urged by Association of Architects, 1906, *14071*
exhibitions
1890, Art Students' League, *25928*
1892, industrial fine arts loan exhibition, *26795*
Toronto (Ontario). Central Ontario School of Art and Industrial Design
replaces Toronto Art School, 1890, *26175*
Toronto (Ontario). Ontario Society of Artists See: **Ontario Society of Artists**
Toronto (Ontario). Royal Canadian Academy of Arts
anecdote, 1883, *24553*
exhibitions, 1880, inaugural, *857*
sales and prices, 1883, *24678*
selection committee for Chicago World's Fair, 1893, *4342*
Toronto (Ontario). Woman's Art Association of Canada See: **Woman's Art Association of Canada**
Torremuzza, Gabriello Lancellotto Castelli e Valguarnera, *principe* di, 1809-1894
collection, *17196*
Torrent, Onofre Gari See: **Gari Torrent, Onofre**
TORREY, Charles, 1859-1921, *25017, 25046, 25072, 25083, 25106, 25129*
Torrey, George Burroughs, 1863-1942
notes, 1899, *17516*
Torrigiano, Pietro, 1472-1528, *21815*
anecdote, *5336*
bronze bust bought for British Museum, 1892, *26657*
manner of death, *21054*
notes, 1896, *5868*
Tortat
faïence ware decoration, *822*
torture
instruments
collection for sale, 1895, *16890*
collectors and collecting, *15027*
in Royal Castle of Nuremberg, *16405*
Toschi, Paolo, 1788-1854
Correggio copies, *9709*
engravings after Correggio and Parmigiano, *18669*
engravings after Correggio's frescoes, *1069*
membership in Académie des Beaux-Arts, *18569*
totems
Tsimshian Indians, *20471*
toucans, *20871*

Touche, Gaston de la See: **LaTouche, Gaston de**
Toudouze, Edouard, 1848-1907
exhibitions, Salon, 1877, *8884*
illustrations
figure study, *3734*
Flemish maiden of the Seventeenth Century, *2574*
Plage d'Yport (detail), *153*
obituary, *14305*
Toulmouche, Auguste, 1829-1890
Bouquet, *8898*
painting show in New York, 1865, *23355*
paintings in Stewart collection, *753*
Toulouse (France)
festival of poetry, *20087*
Toulouse Lautrec, Henri Marie Raymond de, 1864-1901
exhibitions, Salon d'Automne, 1904, *13817*
posters and paintings, *12515*
sales and prices, 1901, *7611, 7740*
Toulza, Jeanne Bole, *comtesse* See: **Bole, Jeanne, *comtesse* Toulza**
Tour Eiffel See: **Paris (France). Tour Eiffel**
Tourcoing (France)
international exposition of textile industries planned for 1906, *13952*
Tourgee, Aimée, fl.1891
awarded gold medal at Philadelphia School of Design for Women, 1891, *26375*
tourist trade
English tourist in France, *23893*
tourmaline
collectors and collecting, Hamlin collection, *16905*
Tournachon, Félix, 1820-1910
photograph of Zola, *15709*
photographs Chevreul, 1886, *25378*
portrait of Gautier, *15635*
Tourny, Joseph Gabriel, 1817-1880
obituary, *118*
Tourrier, Alfred Holst, 1836-1892
Gold, *8484*
Tours (France)
description and views, *9640*
Toussaint, Henri, 1849-1911
illustrations
Henry Havard's *L'Art dans la Maison*, *1706*
Japanese vases and furniture, *1208*
White House porcelain service, *1029*
Toussaint, René Jules Jean, *baron*, 1856-1918
Adorée, illustrated by Paul Jazet, *14958*
towers
Crimea, military watch towers, *21339*
France, tower of Augustus at Turbie, *21290*
Scotland, ancient towers in the North, *20987*
United States, New York, *8825*
Town and Planning Association See: **Garden City Association**
Town, Ithiel, 1784-1844
houses built on Fifth Avenue, New York, *19899*
TOWN TRAVELLER, The, *17430, 17444*
Towne, Ann Sophia See: **Darrah, Ann Sophia Towne**
TOWNE, Charles Hanson, *23215*
TOWNE, Charles M., *13246*
TOWNE, Francis E., *13603*
Towneley, John, 1731-1813
library, sale, 1883, *14911*
TOWNSEND, C. E., *14062*
Townsend, Ethel Hore, b.1876
exhibitions, American Watercolor Society, 1903, *13592*
Portrait sketch, *22916*
Townsend, Frances B., d.1916
illustrations, *In a New England orchard*, *11971*
painting of cows, *22805*
summer home and studio, *22571*
Townsend, Frederic
Glimpses of Nineveh, B.C. 690, review, *19757*

Townsend, Horace, 1859-1922
 discussion of process of reproduction for illustration, 1895, *5489*
TOWNSEND, James Bliss, *6314, 6345*
Townsend, James Bliss, 1855-1921
 art critic and poet, *493*
 director, art exhibition, Interstate and West Indian Exposition, 1901, *13312*
Townsend, John, *Mrs.* See: **Townsend, Ethel Hore**
TOWNSEND, M. E., *14016*
TOWNSEND, Patty, *10324*
toy theaters
 prints by William West, *10413, 10425*
toys
 collectors and collecting, New York collection, *16658*
Trachsel, Albert, 1863-1929, *8313*
Tracy, G. P. See: **Tracy, S. Prescott**
TRACY, John M., *24683, 24922*
Tracy, John M., 1844-1893
 Bergère Créole, *583*
 dog pictures shown in Brooklyn, 1893, *26916*
 exhibitions
 American Art Association, 1884, *Setter* and *Pointer*, *25209*
 American Art Gallery, 1883, *24586*
 National Academy of Design, 1885, *25271*
 Prize Fund Exhibition, 1885, *1985*
 Prize Fund Exhibition, 1885, *Close work*, *25278*
 obituary, *16193*
 paintings of horses and dogs, *22599*
 sales and prices, 1895, studio sale, *16667, 16697*
 studio contents to be sold, 1893, *16374*
TRACY, Marguerite, *22541, 22551, 22572, 22599, 22623, 22635, 22687, 22752, 22778, 23022, 23126*
Tracy, S. Prescott, fl.1858-1859
 exhibitions, New York, 1858, *18209*
TRAFTON, R. W., *Mrs.*, *10554*
translating and interpreting
 theories of translation with reference to Goethe's *Faust*, *19603*
Trans-Mississippi and International Exposition, Omaha, 1898
 See: **Omaha (Nebraska). Trans-Mississippi and International Exposition, 1898**
transparencies
 technique, *3085*
transportation
 schedule of express trains between New York and Chicago, 1902, *8031*
Trapier, Richard Shubrick, 1811-1895
 notes, 1896, *16953*
Trapnell, Alfred
 collection, sale of old Worcester ware, 1899, *7074*
Trask, G. G., *Mrs.* See: **Trask, Mary Chumar**
Trask, John E. C., 1871-1926
 secretary of Pennyslvania Academy of the Fine Arts, 1906, *14077*
Trask, Mary Chumar, fl.1899-1915
 miniature of Mrs. Wilbur, *17670*
travellers, English
 compared to French, *20249*
travellers, French
 compared to English, *20249*
Traver, Charles Warde, b.1880?
 designer of magazine covers, *6596*
 illustrations, pen drawing from life, *12238*
 My dog, *22770*
 whereabouts, 1895, returns to Chicago, *11570*
Traver, George A., 1864-1928
 illustrations
 figure sketches, *22610*
 Movement under difficulty, *22576*
 Old character, *22576*
 Professor, *22486*
 Rich can ride in their chaises, *22590*
 sketches of heads, *22546*
 Three to one, *22513*
 illustrations for magazines, 1893, *22482*

illustrations of beggars, *22822*
illustrator, *22498*
No choice, *22731*
portraits, photograph, *22502*
Traver, Warde See: **Traver, Charles Warde**
Travers, John A., fl. 1848-1850
 See also: **Leslie and Travers, firm**
Travis, Emily, fl.1900-1916
 illustrations, figure, *22086*
Travis, G. W., fl.1860's
 portrait of Lincoln bought by U. S. Congress, *2764*
Travis, J. F.
 chandeliers, *8600*
Treadway, William Henry
 collection, *15616*
Treadwell, Prentice, fl.1898-1903
 exhibitions
 Architectural League of New York, 1898, *6571*
Tredick, Benjamin T., d.1877
 collection, presented to Dover Public Library by sister, 1905, *13996*
Tredwell, Daniel M., 1826-1921
 lecture on extra-illusrated books, 1880, became book, *15653*
 Monograph on Privately Illustrated Books: A Plea for Bibliomania, *395*
 review, *15835*
Tree, Beerbohm See: **Tree, Herbert Draper Beerbohm**
Tree, Herbert Draper Beerbohm, 1853-1917
 actor, *24295*
 notes, 1897, *23170*
Tree, Lambert, 1832-1910
 builder, Studio Building, Chicago, *11493*
 purchases C. E. Dallin's *Signal of peace* as gift to Chicago, 1899, *12949*
 quote, on disappearing Indians soon to be known only from art works, *12949*
trees, *20854*
 characteristics of oak trees, *3290*
 description by Burnet, *14693*
 descriptions and techniques for drawing willows and cone-bearing trees, *4478*
 descriptions of species of maples, *4497*
 drawing American trees, *5579*
 elm and willow described and illustrated, *3317*
 fable, *24189*
 Hamerton on trees in landscapes, *599*
 in cities, *7670*
 in work of J. Francis Murphy and John L. Fitch, *17670*
 J. M. Shull on hawthorns, 1897, *6275*
 Lombardy poplar, birch, and beech are described and illustrated, *3341*
 spiritual value, *12562*
 technique for drawing and painting, *3999*
 technique for painting oaks, beeches, and nut trees, *4054*
 technique for painting trees, *4028*
TREGELLAS, Walter Hawken, *9757, 9864, 10216, 21571, 21614*
Treglown, Ernest G., d.1923
 illustrations, decorative initials, *12501*
Trego, William Brooke Thomas, 1859-1909
 Battery en route, acquired by Pennsylvania Academy, 1882, *14865*
 exhibitions
 American Art Galleries, 1884, *24988*
 National Academy of Design, 1886, *2352*
 National Academy of Design, 1887, *10831*
 National Academy of Design, 1891, *3603*
 Pennsylvania Academy of the Fine Arts, 1882, *1450*
 Pennsylvania Academy of the Fine Arts, 1883, *1677*
 Pennsylvania Academy of the Fine Arts, 1883, Temple award for *The march to Valley Forge, December 16, 1777*, *24894*
 Pennsylvania Academy of the Fine Arts, 1891, *3535*
 Prize Fund Exhibition, 1885, *1985*
 Prize Fund Exhibition, 1885, *Pursuit*, *25278*
 Prize Fund Exhibition, 1886, *25304*
 Society of American Artists, 1887, *10789*

law suit against Pennsylvania Academy, *10988, 11266, 25132*
for failure to award Temple prizes, 1884, *24987, 24993*
portraits, photograph, *22580*
student at Pennsylvania Academy of the Fine Arts, *22508*
summer home and studio, *22571*
United States cavalryman, in Clarke collection exhibition, 1883-4, *24955*
Treidler, Adolph, 1886-1981
illustrations, study, *22170*
Trelawny, Edward John, 1792-1881
Recollections of the Last Days of Shelley and Byron, excerpts, *18128*
TRENCH, Richard Chenevix, *19848*
Trench, Richard Chenevix, *Abp. of Dublin*, 1807-1886
On the Authorized Version of the New Testament, review, *19913*
Trentacoste, Domenico, 1859-1933
illustrations, plastic panel, *13533*
Trentanove, Gaetano, 1858-1937
Last of the Spartans, acquired by Layton Art Gallery, 1893, *16428*
statue of Austin Blair, *16921*
Trentanove, Raimondo, 1791-1832
bust of Napoleon, *16639*
Trenton (New Jersey)
monuments
Battle Monument modelled by O'Donovan and cast at National Fine Art Foundry, 1894, *26999*
legislation for Battle of Trenton monument, 1891, *26314*
Trenton Battle-Monument fund, *26108*
Tresch, John F. J., fl.1881-1884
portrait of Abbé de l'Epée, *24777, 24791*
Tretyakov Gallery, Moscow See: **Moscow (Russia). Tret'iakovskaia Galleria**
Trevor, Edward, d.1885
illustrations, *In the graveyard*, *24932*
Trichon, Auguste, b.1814
illustrations
Francesco and his family escaping from the flood, *21177*
Hawking party, *21146*
Hungarian boatmen, *21231*
Oath of the Horatii, from a painting by David (after A. H. Cabasson), *21150*
Peter the Great in the family of the Kalfs - the Marquis of Bernardini (after G. Janet), *21210*
Queen Elizabeth's reception of the French Ambassador, *21145*
Wreck of the Medusa (after Géricualt), *20982*
Triedler, Adolph See: **Treidler, Adolph**
Triggs, Floyd Wilding, 1872-1919
illustrations, *Leonard Ochtman*, *12844, 13299*
TRIGGS, Laura McAdoo, *12925*
TRIGGS, Oscar Lovell, *11961, 12035, 12638, 12868*
Triggs, Oscar Lovell, 1865-1930
Chapters in the History of the Arts and Crafts Movement, review, *13505*
Trimolet, Anthelme, 1798-1866
collection, left to Dijon museum, *21895*
Tring (England). Rothschild Museum See: **Tring (England). Zoological Museum**
Tring (England). Zoological Museum
opens, 1893, *16422*
Trinidad (Cuba)
description, *19993*
Trinity
nimbi, *4822, 5061*
Trinity Chapel, New York See: **New York. Trinity Chapel**
Trinity Church, Boston See: **Boston (Massachusetts). Trinity Church**
Trinity Church, New York See: **New York. Trinity Church**
Trinquesse, Louis Rolland, ca.1746-ca.1800
illustrations, *Mandolin player*, *1784*
Tripler, Charles Eastman, b.1849
exhibitions
National Academy of Design, 1884, *25187*
Prize Fund Exhibition, 1885, *25278*

Tripp, B. Wilson, fl.1899-1927
cover design for *Helpers*, *12975*
Triscott, Samuel Peter Rolt, 1846-1925
anecdote, *11765*
exhibitions
Boston Art Club, 1893, *26951*
Boston Society of Water Color Painters, 1887, *549*
Chicago Art Institute, 1899, *12902*
Eden Musée, 1890, watercolors, *3284*
TRISTAN, *1673*
Trobriand, Régis, *comte* de, 1816-1897
editor of *Revue du Nouveau Monde*, *21457*
exhibitions, National Academy of Design, 1861, *20354*
View of Niagara Falls, published for subscribers of International Art-Union, 1849, *21451*
Trocadero Palace See: **Paris (France). Palais du Trocadéro**
Trollope, Anthony, 1815-1882
Kellys and the O'Kellys, review, *18476*
TROLLOPE, Thomas Adolphus, *21957, 21980, 22018*
Trollope, Thomas Adolphus, 1810-1892
obituary, *16074*
trompe l'oeil painting
permits needed to own paintings of dollar bills, 1897, *6396*
Trood, William Henry Hamilton, 1860-1899
illustrations, *Sick puppy*, *3885*
trophies
English silver for American Rifle Team, *8525*
sales and prices, 1897, Earl of Rosslyn collection, *17312*
Troschel, Julius, 1806-1863
statuary for Tortonia palace, *19971*
Troth, Henry, 1860-1945
exhibitions, Philadelphia Photographic Salon, 1900, *13120*
illustrations
Break in the dunes (photograph), *13532*
Bridge in the wilderness (photograph), *13204*
By the seaside (photograph), *13939*
In the fold (photograph), *13238, 14107*
plant photography, *13264*
Trotter, Mary K., b.1857
exhibitions
Chicago, 1890, *Boy with a racket*, *3364*
Pennsylvania Academy of the Fine Arts, 1880, *142*
Pennsylvania Academy of the Fine Arts, 1882, *1450*
Philadelphia Society of Artists, 1883, *1490*
Society of American Artists, 1886, *2227*
Trotter, Newbold Hough, 1827-1898
exhibitions
Chicago Academy of Design, 1871, *10712*
Pennsylvania Academy of the Fine Arts, 1877, *8847*
Prize Fund Exhibition, 1885, *25278*
illustrations, *Travelling minstrels*, *5216*
notes, 1860, *20146*
pictures of transportation in Pennsylvania, *24569*
painted for H. H. Houston, 1883, *24608*
rebuttal of allegations of misconduct by Philadelphia Society of Artists, 1883, *24915*
whereabouts, 1883, Philadelphia, *24803*
works, 1877, *8950*
troubadours, *20970*
Troubetzkoy, Paul, *prince*, 1866-1938
exhibitions
New York, 1897, portraits, *6097*
Pennsylvania Academy of the Fine Arts, 1904, *13716*
Girl, purchased for Venice International Gallery of Modern Art, *13627*
illustrations, *Master M. William Wright*, *13552*
influence on American women potters, *13074*
notes
1893, *16387*
1896, *17191*
1902, *13379*
sculpture at Chicago World's Fair, 1893, *26981*
Troubetzkoy, Pierre, *prince*, 1864-1936
exhibitions, New English Art Club, 1892, *26678*
notes, 1893, *16387*

Tsimshian Indians
legends and customs, *20471*
Tsountas, Chrestos, 1857-1934
Mycenaean Age, review, *23251*
tsunamis
Japan, 1896, *23161*
Tübbecke, Paul Wilhelm, 1848-1924
illustrations, *Post-station in Thuringia*, *17773*
Tuck, Raphael & Sons, Ltd., publishers, London
sponsors competitive exhibition for art students and amateurs, 1889, *2882*
Tuck, Somerville Pinckney, 1848-1923
art commissioner, Paris Exhibition of 1889, *25551*
circular to American artists on Paris Exposition of 1889, *25546*
Tuck, William Henry, and Co., London
illustrations, portrait of W. C. T. Dobson (photograph), *21625*
Tucker, Blanche See: **Macchetta, Blanche Roosevelt Tucker**
Tucker, Edna, fl.1906
illustrations, decorative design, *14171*
Tucker, William H., *Mrs.* See: **Corinne**
Tuckerman, Arthur Lyman, 1861-1892
obituary, *26570*
TUCKERMAN, Henry Theodore, *14664, 14726, 18217, 18355, 18159, 18483, 19760, 19943*
Tuckerman, Henry Theodore, 1813-1871
artists' reception, New York, 1858, *19784*
Months in England, excerpt on Turner, *19913*
Tuckerman, Stephen Salisbury, 1830-1904
exhibitions
American Art Association, 1883, *24398*
Boston, 1881, *1150*
Boston Paint and Clay Club, 1884, *25083*
Boston Paint and Clay Club, 1887, *543*
Society of American Artists, 1887, *10789*
inventor of clipper sled for children, *493*
whereabouts, 1887, *531*
Tudor, House of
exhibitions
London, 1890, *25746, 25761*
london, 1890, *25778*
Tuileries See: **Paris (France). Tuileries**
Tuke, Henry Scott, 1858-1929
exhibitions
Royal Academy, 1890, *3311*
Royal Academy, 1899, *Diver*, *6983*
Tuley, Benjamin P., fl.1903
illustrations, *Painting from life*, *13637*
tulipmania
Duma's novel about tulip raising, *15890*
TULLOCH, Eliza C., *22901*
Tunis
beauty for artists, *1171*
Tunison, Luella, fl.1891
illustrations, drawing, *3540*
TUPPER, John Lionel, d.1879, *18946, 19026, 19145, 19192, 19207, 19239, 19273, 19322, 19347, 19370, 19452, 19615, 19636, 19662*
Tupper, John Lionel, d.1879
early life, *19192*
obituary, *34*
reminiscences, *19145*
studies Greek and Roman art, *19239, 19273*
thought and sculpture, *19207*
Tupper Lake
description, *19182*
Tura, Cosimo, 1430?-1495
Madonna and Child enthroned, decorative detail, *10289*
turbans
turbans in colonial America, *6355*
Turbie (France)
Tower of Augustus, inscriptions, *21290*
Turcas, Jules, 1854-1917
commission to paint portrait of Governor Minor of Connecticut, 1894, *26999*
exhibitions, Worcester Art Museum, 1902, *13483*

TURGENEV, Ivan Sergeevich, *24283*
Turgenev, Ivan Sergeevich, 1818-1883
obituary, *14912*
Turin (Italy)
description, *19031*
exhibitions, 1877, *8875*
Turin (Italy). Esposizione generale italiana, 1884
description, *10024*
notes, *25097*
Turin (Italy). Esposizione internazionale d'arte decorativa moderna, 1902
American award recipients, *8242, 13618*
American exhibits, *13781*
announcement, *13265*
notes, 1901, *13328*
prevalence of Art Nouveau designs, *13502*
U.S. committee, *13270*
Turin (Italy). Esposizione italiana d'architettura, 1890
first exhibition, *26004*
Turin (Italy). Esposizione nazionale italiana, 1880, *21873*
Turin (Italy). Museo civico, *8407*
Turini, Giovanni, 1841-1899
Columbus and Isabella, project, 1893, *16342*
dies while at work on Dewey arch, 1899, *7098*
lawsuit, 1891, *26303*
statue of Baralta, *25528*
statue of Garibaldi, *557*
not as designed and to be replaced, 1896, *5823*
Turkestan
ruins of Mingai explored, *26296*
Turkey
anecdotes about the life of a Frenchman in Turkey, *21266*
antiquities, Greek ruins in provice of Diarbekir, *14890*
army, organization, *21283*
barbers, *21221*
description, *21182*
history, *20979*
Turks in Europe, *21010*
impending war with Greece, 1897, *23252*
justice, *21182*
relationship with Greece, 1897, *23226*
social life and customs, *19090, 21189*
Sultan forms libraries, 1894, *16491*
Turkish architecture See: **architecture, Turkish**
Turkish embroidery See: **embroidery, Turkish**
Turkish jewelry See: **jewelry, Turkish**
Turkish language, *21242*
Turkish literature, *21242*
Turkish rugs See: **rugs and carpets, Turkish**
Turks
history, Turks in Europe, *21010*
Turner, Alfred M., 1851-1932
crayon heads shown in New York, 1896, *23008*
exhibitions
American Watercolor Society, 1884, *25012*
American Watercolor Society, 1887, *2384*
American Watercolor Society, 1889, *2883*
American Watercolor Society, 1903, *13592*
Philadelphia Water Color Club, 1901, *13215*
Prize Fund Exhibition, 1885, *25278*
Prize Fund Exhibition, 1886, medal, *25305*
illustrations, *Then arise - the lark is shaking sunlit wings*, *13218*
picture in Evans collection, *15079*
portrait of Ada Rehan as Katherine, *15893*
Turner, August Drexler, d.1919
illustrations
Held by the enemy, *4591*
June half-holiday, *4453*
Turner, Charles, 1773-1857
obituary, *18083, 19714*
TURNER, Charles, *22608, 22644, 22655, 22695, 23167*
Turner, Charles Louis, fl.1899-1918
illustrations, still life, *22086*

Turner, Charles Yardley, 1850-1918
 commission for Baltimore courthouse murals, 1901, *13208,*
 13228
 copies after old masters made for Metropolitan Museum's Loan
 Exhibition, 1883, *24538*
 Courtship of John Alden, etched by J. S. King, *514*
 director of color decoration at Pan American Exposition,
 Buffalo, 1900, *7331*
 color scheme of buildings and sculpture, *13235*
 external color scheme for buildings, *13034*
 Dordrecht milkmaid, shown at Art Students' League reception,
 1883, *24880*
 elected president, Art Students' League, 1901, *13240*
 etchings, *10808*
 exhibitions
 American Art Association, 1884, *1739*
 American Art Galleries, 1884, *Chrysanthemums, 24988*
 American Watercolor Society, 1882, *Dordrecht milkmaid,*
 1300
 American Watercolor Society, 1884, *1736, 25002, 25012,*
 25038
 American Watercolor Society, 1885, *1933*
 American Watercolor Society, 1889, *2883*
 American Watercolor Society, 1907, *14333*
 Architectural League of New York, 1896, Hotel Manhattan
 decorations, *5699*
 Boston Art Club, 1884, *24981, 24992*
 Brooklyn Art Association, 1884, *1696*
 Brooklyn Art Association, 1884, watercolor, *25092*
 Lotos Club, 1883, *1464*
 National Academy of Design, 1882, *1330, 9646*
 National Academy of Design, 1884, *1772, 1879, 25125,*
 25187
 National Academy of Design, 1884, Hallgarten prize for
 Courtship of Miles Standish, 1786, 10982
 National Academy of Design, 1885, *1970, 25271*
 National Academy of Design, 1886, *2112, 2188*
 National Academy of Design, 1887, *10786, 25437*
 National Academy of Design, 1891, *3832*
 National Academy of Design, 1896, *Enchanting secrets,*
 5657
 New York Etching Club, 1888, *2641*
 Philadelphia Society of Artists, 1883, *1490*
 Society of American Artists, 1884, *Autumn day, 11003*
 illustrations
 Autumn grasses, 10816
 In the barnyard, 13250
 portrait sketch, *14311*
 Sunny days, 1504
 watercolor, *11214*
 Manhattan Hotel decorations, *6085*
 member, Society of American Artists, *11241*
 Merry milkmaid, in Clarke collection exhiibtion, 1883-4, *24955*
 mural for Appellate Division of Supreme Court building, New
 York, *12997*
 notes, 1883, *24551*
 painting, 1883, *24525*
 picture in Crowell collection, *15184*
 restaurant decor for Waldorf Astoria Hotel, New York City,
 6474
 Return of Priscilla after the wedding, in process, 1883, *24728*
 sales and prices
 1891, *15582*
 1891, *Dreaming* in Seney collection, *15473*
 1891, New York auction, *26314*
 students, Walcott's young male nude, *21513*
 teaching, Art Students' League, 1883, *24716*
 whereabouts, 1883, East Hampton, *24689*
 whereabouts, 1896, summer in town, *23056*
Turner, E. S.
 promoter of good architecture for Newburgh, N.Y, *25149*
Turner, Edwin Page, fl.1880-1884
 Victorian designer, *10438*
TURNER, Geik, *12510*

Turner, George W., 1850-1932
 presents statues of sailor Riggin to President Harrison, 1893,
 26901
TURNER, Godfrey Wordsworth, *21701*
Turner, Henry, fl.1845-1859
 studies with Leutze in Dusseldorf, 1859, *18283*
Turner, Joseph Mallord William, 1775-1851, *14747*
 anecdote, *7614, 11138, 14791, 17016*
 Turner and Joseph Gillott, *5778*
 use of color, *21247*
 attitude toward color, *18543*
 bequest, *19579*
 book illustrations, *16219*
 Cascade of Terni, 20946
 collectors and collecting
 Edinburgh collector, *17641*
 in C. Vanderbilt collection, *4428*
 works recommended to collectors, 1890, *3441*
 comments by Leslie, *18633*
 comments on old masters, *21898*
 Conway Castle, 9110
 in American Art Galleries, 1880, *825*
 criticism, *18961*
 by H. T. Tuckerman and W. Ware, *19913*
 French opinion, *5033*
 Hamerton's and Ruskin's assessment, *1173*
 Ruskin and Thackeray on Turner, *18560*
 Ruskin's admiration for Turner's catholicity, *17499*
 Ruskin's comments, *14802*
 William Hart's views, *11008*
 Crossing the brook, in Walker collection, Minneapolis, *12924*
 Depositing of John Bellini's three pictures, 18912
 differences between pictures and studies, *23318*
 drawings
 in London private collection, 1864, *23339*
 in Magoon collection, *19646*
 of Richmondshire, *26159*
 of Yorkshire, *9448*
 sketches of Yorkshire, *1063*
 early watercolors and drawings, *15667*
 Egglestone abbey, near Barnard castle, 8389
 engravings in Sturges collection, *19331*
 excerpt from Frith's *Reminiscences, 16814*
 exhibitions
 American Fine Arts Society, 1893, *4315*
 Carnegie Galleries, 1902, *13520*
 Fine Art Society, 1878, *9061*
 Lenox Library, 1893, *4361*
 London, 1858, *19898*
 London, 1899, *7005, 17595*
 London, 1899, to be viewed by Ruskin, 1899, *17641*
 Metropolitan Museum of Art, 1893, *26930*
 National Academy of Design, 1857, *19716*
 New York, 1858, copies, *18208*
 New York, 1892, *3957*
 New York, 1892, drawings and sketches, *26572*
 New York, 1893, *16227*
 New York, 1894, *Nore, 16589*
 New York, 1895, *5400*
 New York, 1897, *17262*
 Royal Academy, 1849, *14526*
 Royal Academy, 1850, *14644*
 Royal Academy, 1886, watercolors, *10280*
 Royal Academy, 1887, *10408*
 Royal Academy, 1890, *25781*
 Royal Society of Painters in Water Colours, 1855, *18824*
 Tate Gallery, 1901, unfinished works, *14072*
 Union League Club of New York, 1892, *26612*
 Falls of Schaffhausen (drawing), acquired by Birmingham
 Museum, 1891, *26383*
 Fonthill Abbey (watercolor), *16616*
 forgeries, 1897, *17335*
 Grand Canal, Venice, 13006
 bought by C. Vanderbilt, 1890, *3177*
 Grand Coast at Venice, acquired by Metropolitan Museum,

1899, *7153*
Harbors of England, *19542*
 engravings, *19512*
 influence on Ruskin, *19537*
home
 house, London, *6759*
 house where Turner died, *16811*
Hornby castle, Yorkshire, *8558*
Hurrah for the good ship Erebus, *5370*
Hurrah for the whaler Erebus!, *16749*
Huysmans's chapter on Turner from *Certains,* excerpt, *17633*
illustrations
 Burial at sea of the body of Sir David Wilkie, *5941*
 Dido building Carthage, *5941*
 Sun rising in a mist, *5941*
illustrations of Richmondshire, *10506*
influence on Impressionism, *4187*
influence on Thomas Moran, *6187*
Liber Studiorum, *9470, 16831, 25900*
 pen drawing technique, *7101*
 review of Rawlinson's *Turner's Liber Studiorum,* *146, 9137*
 review of vol. three, *10027*
 sales and prices, *454*
 shown at Grolier Club, 1888, *2642*
monuments, statue in St. Paul's Cathedral mutilated, *10270*
notes
 1850, *14617*
 1851, *14806*
 1855, *18811*
 1859, *19971*
 1860, *20143*
 1894, *5087*
Old Termeraire going to her last berth, *19789*
painting on envelope, *16589*
painting to be purchased by Metropolitan Museum of Art, 1895, *16882*
paintings in American collections, *5429*
paintings in Lenox Library collection, *771*
paintings in National Gallery, London, 1894, *5088*
paintings in Sir John Soane's Museum, London, *9641*
physical description, 1851, *14835*
pictures in William Henry Hurlbert collection, *24625*
recollected by C. Leslie, *18471*
reminiscenses of Caen, *18639*
St. Mark's Place, Venice, *5611, 5823, 16803, 16831, 16894*
 on art market, 1895, *5564*
sales and prices
 1856, drawings purchased by E. L. Magoon, *19465*
 1857, *Windermere,* *17973, 18083*
 1861, *Burning of the Houses of Parliament,* *20352*
 1878, paintings in Novar collection, *21647*
 1879, etching, *1156*
 1889, *Grand Canal, Venice,* *25679, 25686*
 1890, *3376, 15262*
 1890, and list of work in American collections, *3335*
 1890, paintings in Fawkes collection, *25986*
 1890, *Sheerness Harbor,* *26016*
 1891, *3598*
 1894, *Ancient Italy,* *27007*
 1895, *5482, 5525*
 1895, *Trout stream,* *16842*
 1896, *5653, 5900, 16948*
 1897, *6311*
 1897, Pender sale at Christy's, London, *20620*
 1898, *Lake Thun, Switzerland,* *6613*
 1899, early work preferred, *7016*
 1901, *7776, 13329*
 1901, *Rockets and blue- lights,* *22133*
 1905, *13901*
shadows, *19075*
Slave ship
 Boston Museum acquisition denounced by many, *17571*
 purchased by Boston Museum of Fine Arts, 1899, *12896, 22070*
Victorian artist, *10434*

views of Rouen, *9618*
views of Yorkshire, *9439*
vignette drawings, published, 1884, *10075*
Vision of Venice, *16047*
 on view in New York, 1893, *16152*
watercolor drawings, *14677*
watercolor drawings and sketches at National Gallery, London, *2151*
Weathercote cave, Yorkshire, *8448*
work in South Kensington Museum and National Gallery, 1865, *23326*
works bequeathed to England, *20221*
works in London National Gallery, 1890, *3410*
Wycliffe, near Rokeby, *8507*
Turner, Page See: **Turner, Edwin Page**
TURNER, Ross Sterling, *26957*
Turner, Ross Sterling, 1847-1915
Art for the Eye, review, *12253*
book illuminations, *13281*
exhibitions
 American Art Association, 1885, *2085*
 American Watercolor Society, 1884, *1736*
 American Watercolor Society, 1897, *Golden galleon,* *23213*
 American Watercolor Society, 1902, *13424*
 Boston, 1884, *25085*
 Boston, 1898, *12805, 12823*
 Boston, 1899, *12892*
 Boston Paint and Clay Club, 1884, *25083*
 Boston Paint and Clay Club, 1885, *1949*
 Boston Society of Water Color Painters, 1887, *549*
 Chicago Water-color Club, 1896, *Sea rover,* *5826*
 New York, 1894, *16480, 22540*
 New York, 1894, watercolors, *4801*
 New York, 1897, *17353*
 New York Water Color Club, 1890, *26139*
 St. Botolph Club, 1891, *3601*
 Worcester, 1899, *12877*
illustrations, *In olden time,* *548*
illustrations for Phelps' *The Madonna of the Tub,* 1886, *509*
notes, 1896, *16939*
On the Use of Water Colors for Beginners
 excerpt, *2376*
 review, *2377*
sales and prices, 1884, *25106*
teaching
 class in water color, Boston, 1894, *27014*
 outdoor classes, 1891, *26286*
 studio classes, 1891, *26391*
water-colors reproduced by Prang, 1887, *531*
whereabouts
 1885, departure from Boston, *2090*
 1887, summer travel, *2543*
Turner, Shirley, fl.1892-1913
 study of head, *26790*
Turners Company, London See: **London (England). Turners Company**
Turney, Olive, 1847-ca.1939
 notes, 1887, *583, 611*
turning
 machinery and tools, *20934*
 technique, *21028*
TURNURE, Arthur B., *8958*
Turnverein, New York See: **New York. Turnverein**
Turrell, Charles James, 1845-1932
 exhibitions
 New York, 1891, portrait miniatures, *15772*
 New York, 1892, miniatures, *3834*
 New York, 1898, miniatures, *6586*
Tusayan Indians See: **Hopi Indians**
Tuscany
 description and views
 Stagno, *10231*
 the Maremma, *9926*
Tuson, G. E., d.1880
 obituary, *264*

Tussaud, Madame, and Sons' Exhibition See: **London (England). Madame Tussaud and Sons' Exhibition**
Tuthill, William Burnett, 1855-1929
 exhibitions, Architectural League of New York, 1892, *3872*
Tuttle, Franklin, fl.1882-1890
 portrait of Grover Cleveland, *25831, 25865*
Tuttle, Ruel Crompton, 1866-1940
 exhibitions, Deerfield, 1905, *13952*
Tuzo, Jennie, fl.1882-1883
 whereabouts, 1883, Fanwood, N.J, *24728*
Twachtman, J. Alden See: **Twachtman, John Alden**
Twachtman, John Alden, b.1882
 receives award from Yale University, 1899, *7014*
Twachtman, John Henry, 1853-1902
 biography, *221*
 comments on patronage in U.S, *13269*
 Dutch landscape, 1883, *24513*
 exhibitions
 American Art Galleries, 1893, *4427*
 American Art Galleries, 1903, retrospective, *13610*
 American Art Union, 1883, *10913*
 American Watercolor Society, 1882, *1300*
 American Watercolor Society, 1893, *26893*
 Carnegie Galleries, 1900, *13130*
 Chicago Art Institute, 1901, *13173*
 Chicago World's Fair, 1893, *4764*
 National Academy of Design, 1880, *867*
 National Academy of Design, 1892, *3953, 4143*
 National Academy of Design, 1892, *Brook in winter*, *26594*
 National Academy of Design, 1893, *4316*
 New York, 1889, *2882, 25580*
 New York, 1891, *15564, 26302, 26320*
 New York, 1891, sketches, *3573*
 New York, 1893, *16243*
 New York, 1894, *4942*
 New York, 1898, *Pool in the woods*, *6619*
 New York, 1900, *13038*
 New York, 1903, *8222*
 New York, 1905, *13843*
 New York Water Color Club, 1894, *4703*
 Pennsylvania Academy of the Fine Arts, 1906, *14244*
 Pittsburgh, 1899, *12976*
 Prize Fund Exhibition, 1885, *25278*
 Prize Fund Exhibition, 1886, *2226, 25304*
 Society of American Artists, 1879, *9150*
 Society of American Artists, 1880, *94, 844, 9324*
 Society of American Artists, 1883, *1551*
 Society of American Artists, 1887, *10789*
 Society of American Artists, 1888, *10846*
 Society of American Artists, 1888, Webb prize, *2695*
 Society of American Artists, 1892, *22483*
 Society of American Artists, 1893, *4235*
 Society of American Artists, 1894, *4834*
 Society of American Artsist, 1895, *5338*
 Society of Painters in Pastel, 1888, *2696*
 Society of Painters in Pastel, 1889, *2961*
 Society of Painters in Pastel, 1890, *3256, 25904*
 Ten American Painters, 1899, *6954*
 Meadow brook, in Clarke collection exhibition, 1883-4, *24955*
 painter from Ohio, *16332*
 sales and prices
 1889, *2881*
 1903, *13589*
 1903, studio sale, *8238*
 secedes from Society of American Artists, 1898, *6527*
 snow scene technique, *7554*
 teaching
 art instructor, Cincinnati, 1879, *9263*
 at Art Students' League, *12474*
 instructor at Brooklyn Art School, 1895, *21554*
 summer art school in Connecticut, *22572*
 whereabouts
 1883, Cincinnati, *24553*
 1883, New York, *24502*

Twachtman, John Henry, Mrs. See: **Twachtman, Marthe Scudder**
Twachtman, Marthe Scudder, fl.1882-1888
 exhibitions, Society of American Artists, 1882, *1349*
Twain, Mark, 1835-1910
 anedote, 1895, *22837*
Tweed, John, 1869-1933
 Duke of Wellington tomb, *8281*
TWELLS, Julia Helen Watts, *23026*
Twentieth Century Club, Boston See: **Boston (Massachusetts). Twentieth Century Association**
Twining, Henry
 Elements of Picturesque Scenery, review, *19420*
 On the Philosophy of Painting, review, *14546*
Twining, Louise, 1820-1912
 Symbols and Emblems of Early and Mediaeval Christian Art, review, *10270*
Twombly, Hamilton McKown, 1849-1910
 collection, *15616*
 LaTour copy, *15054, 15076*
 LaTour's portrait of Madame de Pompadour, *15030*
 purchases Marie Antoinette's furniture, 1887, *25426*
 home, Blashfield murals, *24820*
Twopeny, William, 1797-1873
 English Metal Works, review, *14084*
TWOSE, George M. R., *12709*
Tyler, Alice Kellogg, 1862-1900
 biographical sketch, *11417*
 Chicago member of Society of Western Artists, *12122*
 exhibitions
 Central Art Association, 1895, *11537*
 Chicago Art Institute, 1895, *11673*
 Chicago Art Institute, 1899, *12902*
 Cosmopolitan Club, Chicago, 1896, *11776*
 Cosmopolitan Club, Chicago, 1897, *12064*
 Palette Club of Chicago, 1895, *11467*
 Woman's Art Club of New York, 1892, *26531*
 illustrations, *Portrait*, *11414*
 illustrations for *Singing Verses for Children*, 1897, *12046*
 Instruction, decoration of Illinois State Building at World's Fair, 1893, *4466*
 notes, 1896, *11883*
 pastels, *11934*
Tyler, Bayard Henry, 1855-1931
 exhibitions, Prize Fund Exhibition, 1886, medal, *25305*
 work, 1892, *26839*
Tyler, Carolyn Dow, b.1879
 exhibitions
 Chicago, 1899, miniatures, *12434*
 Chicago, 1899, miniatures on porcelain, *12333*
 National League of Mineral Painters, 1899, *12352*
 opens studio in Chicago with other lady artists, 1894, *11405*
TYLER, James Gale, 1855-1931, *22564*
Tyler, James Gale, 1855-1931
 Columbus' caravels in sight of land, engraved, 1893, *16277*
 Dream of the new world, *22503*
 exhibitions
 Brooklyn Art Club, 1889, *2886*
 Detroit Art Loan Exhibition, 1883, *24826*
 National Academy of Design, 1897, *10540*
 Prize Fund Exhibition, 1886, *25304*
 illustrations
 Combination, *22560*
 Fishing steamer, *22645*
 Fortunes of war, *552*
 Waiting for wind, *22560*
 marine painter, *22510*
 Norman's woe, *22862*
 sales and prices
 1892, *26506, 26517, 26526*
 1905, Des Moines exhibition, *14009*
 Storm, *22805*
 Westward the Star of Empire takes its way!, *22638*
Tyler, William Henry, b.1839
 illustrations, *Hercules and Lichas*, *21602*

TYLOR, Edward Burnett, *26727*
TYNAF LOWER, *6966, 6968, 6997*
Tyner, George N., d.1904
 collection, sale, 1901, *13195*
type and type-founding, *12596*
 art and type-making, *12498*
 Caxton type, *22300*
 cuneiform type font, *17176*
 Kelmscott Press, *22390*
 letters and ornament, *12594*
 moveable type, *17456*
 primer of ornament and design, *12584*
 prizes for printers, *12505*
typogravures
 use in reproduction, *10302*
Tyree, Bessie, 1870-1952
 portraits, photograph, *23222*
Tyrol (Austria)
 painters of Tyrolian types, *14149*
TYRWHITT, Richard St. John, *22003, 22016*
Tyson, Carroll Sargent, Jr., 1877-1956
 exhibitions, Pennsylvania Academy of the Fine Arts, 1906, *14244*
 illustrations, portrait group, *14254*
Tyson, Job Roberts, 1803-1858
 lecture at opening exhibition of Washington Art Association, 1858, excerpts, *18152*
Tyszkiewicz, Michel, *comte*, 1828-1897
 collection, *7125*
 collector, *5814*
 Memoirs of an Old Collector, *17569*
 Notes et Souvenirs d'un Vieux Collectionneur, *6925, 6927*
Tytler, Sarah See: **Keddie, Henrietta**

U

Uccello, Paolo, 1396-1475
 anecdote, *17697*
Uffizi, Florence See: **Florence (Italy). Galleria degli Uffizi**
Uhde, Fritz Karl Hermann von, 1848-1911
 Come, Lord Jesus, and be our guest, *26633*
 exhibitions
 Chicago World's Fair, 1893, *4464, 4467*
 Internationale Kunstausstellung, Munich, 1883, *14916*
 New York, 1893, *Sewing bee in Holland*, *26921*
 St. Louis Exposition, 1896, *6011, 11873*
 Salon, 1887, *Last supper*, *2449*
 illustrations
 Couturières (drawing), *4470*
 Family concert, *7851*
 Good Friday morning, *12015*
 Peasant mother, *22315*
 Journey to Bethlehem, *25832*
 Last supper, *26691*
 on exhibit in St. Louis museum, 1892, *26566*
 shown in Chicago, 1892, *26638*
 picture shown in New York, 1892, *16006*
 pictures in Schaus collection, *15840*
 religious art, *4656*
 Sewing bee in Holland, *16694*
 Walk to Bethlehem, at Kohn Gallery, 1890, *15428*
UHLAND, Ludwig, *18571, 19395*
Uhland, Ludwig, 1787-1862, *21118*
Ukiyo-e
 exhibitions, San Francisco Art Association, 1902, *22152*
Ulenburgh, Saskia van See: **Uylenburgh, Saskia van**
Ulke, Henry, 1821-1910
 Washington portrait painter, *24387*

Ullman, Alice Woods, 1871-1959
 exhibitions, Society of Western Artists, 1898, *12802*
 illustrations, illustration for *Edges*, *8173*
Ullman, Eugene Paul, 1877-1953
 exhibitions
 National Academy of Design, 1902, *13359*
 Pennsylvania Academy of the Fine Arts, *14244*
 Pennsylvania Academy of the Fine Arts, 1906, gold medal, *14077*
 Salon, 1906, *14116*
Ullman, Eugene Paul, *Mrs.* See: **Ullman, Alice Woods**
Ulman, Raoul André, b.1867
 illustrations, studies of cattle, *4051*
Ulmann, Eugene Paul See: **Ullman, Eugene Paul**
Ulrich, Charles Frederick, 1858-1908, *15497*
 biographical note, *16570*
 Carpenter at work, in Louisville's Southern Exposition, 1883, *24760*
 Clarke prize, 1884, *1786*
 Engraver on glass at work, purchased by Ralph N. Plumb, 1883, *24569*
 exhibitions
 American Art Association, 1884, *25201*
 Brooklyn Art Association, 1884, *1740*
 Brooklyn Art Association, 1884, *Wood engraver*, *10951*
 National Academy of Design, 1882, *1330*
 National Academy of Design, 1884, *1772, 25125*
 National Academy of Design, 1884, Clarke prize for *In the land of promise*, *10982*
 National Academy of Design, 1885, *1970*
 National Academy of Design, 1887, *552, 2431, 10786, 25437*
 New York, 1884, pastels, *1769*
 New York, 1893, *Glassblowers*, from Clarke collection, *16171*
 Paris Exposition, 1889, *25724*
 Prize Fund Exhibition, 1886, *2226*
 Prize Fund Exhibition, 1886, prize, *25304*
 Prize Fund Exhibition, 1887, *2456*
 Society of American Artists, 1883, *1551*
 Society of Painters in Pastel, 1884, *25089*
 Glass engraver, *24513*
 Glassblowers, in Clarke collection, *11207, 25109*
 illustrations
 Glass blower, *24509*
 In the land of promise, *11185*
 In the land of promise, *15390*
 engraved by F. Juengling, *514*
 member, Society of American Artists, *11241*
 notes
 1883, *24551*
 1892, *15859*
 Old lady spinning, shown at Art Students' League, 1883, *24880*
 painting of courtroom scene, 1884, *25032*
 painting of interior, 1883, *24792*
 paintings in Clarke collection, *1719*
 exhibition, 1883-4, *24955*
 picture in Evans collection, *15079*
 sales and prices, 1900, picture in Evans collection, *13008*
 selection of American artists for Munich exhibition, 1892, *26595*
 summer studies, 1882, *24367*
 Village printing shop in Haarlem, in American Art Galleries, 1884, *1899*
 whereabouts, 1892, America and Venice, *26599*
 Wood engraver
 engraved by Henyneman, 1883, *24905*
 in Seney collection, *24977*
 in Seney collection sale, 1891, *15473*
Ulysse Besnard See: **Ulysse, Jean Jude**
Ulysse, Jean Jude, d.1884
 faience ware, *1193*
Umar Ibn al Khattab, ca.581-644
 biographical excerpt from Winchester's *Biographical and Descriptive Catalogue*, *20659*

Umar Pasha, *originally* **Lattas,** 1806-1871
 biography, *21092*
Umberto I, *king of Italy*, 1844-1900
 portraits, presents bust for Boston Exposition, 1883, *24722*
Umbria
 description and views, *21728*
Underhill, Elizabeth See: **Coles, Elizabeth Underhill**
Underhill, Georgia Edna, fl.1892-1901
 exhibitions
 National Academy of Design, 1899, *Intruders*, *6955*
 Woman's Art Club of New York, 1892, *26542*
Underwood, Abby E., fl.1894
 woman illustrator, *22525*
Underwood, Clarence Frederick, 1871-1929
 illustrations, *Girls*, *12484*
Unger, R. von
 illustrations, *Goose-market, Cracow* (after A. Schönn), *9386*
Unger, William, 1837-1932
 etchings, *8763*
 publication completed, 1877, *8934*
 illustrations
 Preparing for school (after M. Munkácsy), *318*
 St. Francis Xavier raising the dead (after Rubens), *25*
 Saskia van Ulenburgh (after Rembrandt), *389*
 Travellers before an inn (after P. Molijn), *91*
 Wallachian team (after A. Schreyer), *140*
UNGERN STERNBERG, Alexander, *20313*
Union centrale des arts décoratifs See: **Paris (France). Union centrale des arts décoratifs**
Union centrale des beaux-arts appliqués à l'industrie See: **Paris (France). Union centrale des beaux-arts appliqués à l'industrie**
Union Club of the City of New York See: **New York. Union Club of the City of New York**
Union des femmes peintres et sculpteurs See: **Paris (France). Union des femmes peintres et sculpteurs**
Union Glass Company, Somerville, Massachusetts
 glassware, *12998*
Union League Club, Chicago See: **Chicago (Illinois). Union League Club**
Union League Club, New York See: **New York. Union League Club**
Union League Club of Brooklyn See: **New York. Union League Club of Brooklyn**
Union League, Philadelphia See: **Philadelphia (Pennsylvania). Union League**
Union Pacific Railroad
 scenery along railway, *8766, 8780, 8796, 8809, 8824, 8835, 8853, 8863*
United Arts Club
 established, 1906, *14208*
United Arts Gallery See: **London (England). United Arts Gallery**
United Brotherhood of Carpenters and Joiners of America
 resolution against Sunday-closing of Chicago World's Fair, 1892, *26739*
United Crafts and Arts See: **San Francisco. United Crafts and Arts**
United States
 art, art world in summer, *17654*
 art centers, 1905, *13953*
 census, increase in population 1840-1860, *19921*
 civilization, *20006*
 commerce, popularity of cheap Italian and Oriental goods, 1886, *514*
 description by an English traveller, 1859, *20074*
 emblems, great seal, *16165*
 emigration and immigration, *19921*
 history
 Civil War, Allen photograph collection, *16162*
 Civil War, artists in military service, *20369*
 Civil War, artists in Seventh Regiment, *20376*
 Civil War, battle between *Monitor* and *Merrimac*, *23195*
 Civil War, battle of *Kearsage* and *Alabama*, *23023*
 Civil War, collection of Confederate financial documents,

15676
 Civil War, Confederate invasion of Missouri, 1864, *22824*
 Civil War, coverage by press, *20364*
 Civil War envelopes, *22828*
 Civil War, Gen. W. T. Sherman, *22973*
 Civil War, illustrated stationery, *15670*
 Civil War, illustrations in *The Century*, *501*
 Civil War, military correspondence, *20377*
 Civil War, military execution, *23001*
 Civil War, military illustrations by G. Gaul, *22494*
 Civil War, recollections of Gen. W. T. Sherman, *23000*
 collecting historical relics, *16227*
 collecting relics, *16224*
 collecting relics of Rovolutionary and Civil wars, *16279*
 collecting souvenirs of 'seventy-six, *16256*
 collections of relics, *16299*
 collectors of historical relics, *16218*
 Colonial relics shown at Brooklyn woman's Club, 1893, *16179*
 destruction of relics for Columbian Bell condemned, 1893, *16243*
 early exploration and settlement, *21332*
 forgeries and fabrications of historical relics, *16277*
 relic collections, *16266*
 Revolution, anecdotes, *18490*
 Revolution, role of Sarah Benjamin, *18137*
 Revolution, war relics in Washington Headquarters, Morristown, New Jersey, *16296*
 Scharf collection of books, manuscripts and pamphlets donated to Johns Hopkins University, *15676*
 War of 1898, war pictures at Chicago Art Institute, 1899, *12838*
 Immigration Bill revived, 1897, *23252*
 national art gallery desirable, *13650*
 national art gallery urged by Thomas Moran, *13598*
 national flower
 argument against goldenrod as national flower, 1890, *3393*
 columbine chosen, 1896, *6059*
 Indian corn suggested, 1892, *3886*
 politics and government
 1893-1897, *23129*
 1896, *23109*
 events, 1897, *23179, 23202, 23226*
 gold vs. silver, 1896, *23128*
 presidential inaugurations, *23193*
 social conditions, 1850's, *20014*
 social life and customs, *19012*
 colonial life, *13036*
 Dutch colonization in the New Netherlands, *13103*
 statesmen, lack of interest in art, *5033*
United States. Army
 artists in Civil War, *20369*
 commander-in-chief, 1895, *22791*
 Taylor water color for Headquarters, *453*
United States Art Commission
 abolishment of Capitol Art-Commission, 1860, *18468*
 appointments, 1859, *18319*
 appointments to regulate Capitol art, 1859, *20051*
 dissolved, 1860, *20272*
 meeting of artists, 1858, *19836, 19974*
 meetings, 1860, *20130, 20166*
 notes, 1859, *20013*
 qualifications of members, *20064*
 report, 1860, *20191, 20195*
 report on completion of Capitol, 1860, *24320*
United States. Bureau of American Ethnology
 Tusayan kivas and kisis, *22640*
 Zuñi kitchens, *22627*
United States. Congress
 appropriates monies for Revolutionary War monuments, 1880, *261*
 bills to establish national conservatory of music and art, 1902, *13436*
 bills to preserve American prehistoric monuments, 1900, *7315*
 commissions sculpture, 1875, *8478*

national gallery proposed, 1902, *13379*

need for legislation affecting business interests, 1896, *23053*

report on Art Commission, 1859, *20033*

United States. Department of Agriculture

plant collection, *16166*

United States. Department of State

collection of manuscripts and autographs, *16527*

historical papers, *16114*

United States. Department of the Treasury

manuscripts vandalized, 1895, *16882*

United States Encaustic Tile Company, Indianapolis

contributions to Indianapolis Citizens' Education Society exhibition, 1899, *12918*

United States. Library of Congress See: **Washington (D.C.) Library of Congress**

United States Military Academy See: **West Point (New York). United States Military Academy**

United States. Mint See: **Philadelphia (Pennsylvania). United States Mint**

United States. National Museum See: **Washington (D.C.) United States National Museum**

United States Naval Academy See: **Annapolis (Maryland). U. S. Naval Academy**

United States. Navy

new ships, 1897, *23246*

United States. Post Office Department

collection, postage stamps, *16691*

United States Potters' Association

competitive exhibition, 1889, *2934*

proposes technical school, 1890, *26100*

report of Committee on Design, 1890, *25906*

United States. Treasury See: **United States. Department of the Treasury**

Unity Art Club See: **Boston (Massachusetts). Unity Art Club**

Unity Club, Newport See: **Newport (Rhode Island). Unity Club**

Universal Peace Congress, 6th, Antwerp, 1894 See: **Antwerp (Belgium). Congrès international de la paix, 1894**

universities and colleges

United States, art departments, *13670*

University Art Club, Denver See: **Denver (Colorado). University Art Club**

University Club, Paris See: **Paris (France). University Dinner Club**

University of California at Berkeley See: **Berkeley (California). University of California**

University of Chicago See: **Chicago (Illinois). University of Chicago**

University of Cincinnati See: **Cincinnati (Ohio). University of Cincinnati**

University of Heidelberg See: **Heidelberg (Germany). Universität**

University of Illinois See: **Urbana (Illinois). University of Illinois**

University of Kansas See: **Lawrence (Kansas). Kansas State University**

University of London See: **London (England). University of London**

University of Michigan See: **Ann Arbor (Michigan). University of Michigan**

University of Minnesota See: **Minneapolis (Minnesota). University of Minnesota**

University of Missouri See: **Columbia (Missouri). University of Missouri**

University of Pennsylvania See: **Philadelphia (Pennsylvania). University of Pennsylvania**

University of Southern California See: **Los Angeles (California). University of Southern California**

University of St. Petersburg See: **Saint Petersburg (Russia). Universitet**

University Settlement Society of New York See: **New York. University Settlement Society of New York**

Unnever, John Gerhard, 1822-1893

obituary, *26911*

Untermyer, Samuel, 1858-1940

collection, paintings in Carnegie Institute annual exhibition, 1902, *13520*

Unwins, Thomas See: **Uwins, Thomas**

Updike, Daniel Berkeley, 1860-1941

Altar Book, *22425*

Merrymount Press publications, *12527*

review, 1896, *22431*

Upham, Thomas Cogswell, 1799-1872

quote, *19622*

upholstery

bad taste, *1404*

new upholstery notions, 1900, *7489*

notes, 1859, *19980*

Uphues, Joseph, 1850-1911

Frederick the Great, to be given to U.S., *13440*

Upjohn, Anna Milo, fl.1895-1940

paintings for cathedral, 1895, *22787*

UPJOHN, Edwin Parry, *12474*, *21509*

Upjohn, Edwin Parry, 1871?-1949

illustrations, drawing, *21561*

Upjohn, Richard, 1802-1878

address at first annual dinner of American Institute of Architects, 1858, *19813*

churches, *20093*

design of Bowdoin College chapel, *14765*

Episcopal church on Staten Island, *23355*

officer, American Institute of Architects, 1859, *19970*

opinion on J. Coleman Hart's paper on unity in architecture, *19992*

paper read to American Institute of Architects, 1857, *19655*

Pierrepont residence, Brooklyn, *19890*

remarks on Gothic architecture, *19871*

speech at American Institute of Architects, 1859, *19999*

Upjohn, Richard Michell, 1827-1903

whereabouts, 1850, Venice, *14696*

upper classes

United States, evil of the rich, *23144*

Uppingham School

art teaching, *10366*

Upson, Arthur Wheelock, 1877-1908

Octaves in an Oxford Garden, review, *13564*

Upton, Florence Kale, 1873-1922

illustrations

Her last new gown, *22525*

Japanese pose, *22663*

portraits, photograph, *22539*

UPTON, George Putnam, *10614*, *10632*

Upton, Louise See: **Brumback, Louise Upton**

Urbana (Illinois). University of Illinois

art gallery, *11468*

department of ceramics founded, 1906, *14193a*

exhibitions

1899, public school pupils' art, *17538*

1899, school art, *12340*

inauguration of president Draper and opening of engineering hall, 1894, *11429*

School of Architecture in new engineering building, 1895, *11460*

Urbana (Illinois). University of Illinois. Department of Art and Design

notes, 1879, *757*

Urbana (Illinois). University of Illinois. Library

murals by Newton A. Wells, *13076*

murals to be painted by Newton A. Wells, 1898, *6545*

URMY, Clarence Thomas, *23137*

Urner, Nathan Dane, 1839-1893

obituary, *16157*

Urquhart, Cora See: **Potter, Cora Urquhart**

Urrabieta y Vierge, Daniel See: **Vierge, Daniel**

Ury, Adolf Felix Müller See: **Müller Ury, Adolf Felix**

Ury, Lesser, 1861-1931

exhibitions, Berlin, 1902, *13361*

Utah

bill to create Utah Art Institute, 1899, *12901*

Utah Art Institute See: **Salt Lake City (Utah). Utah Art Institute**
Utah. University See: **Salt Lake City (Utah). University of Utah**
Utamaro, Kitagawa, 1753-1806
 illustrations
 Evening escapade, 22661
 print, 22152
 wood-block print, 12650
Utica (New York)
 exhibitions, 1899, loan exhibition, 17591
 monuments, soldiers' and sailors' monument dedicated, 1891, 26402
Utica (New York). New Century Club
 notes, 1895, 22738
Utica (New York). Utica Public Library
 acquisitions, 1894, Conkling library of public documents, 16531
Utica (Tunisia)
 antiquities, relics found, 454
Uwins, Thomas, 1782-1857
 Cabin in a vineyard, 21248
 Cottage toilette, 21248
 memoirs, review and excerpts, 19971
 obituary, 19714
Uxmal site (Mexico)
 description, 1896, 22971
Uylenburgh, Saskia van, 1612-1642
 portraits, *Jewish bride* and other portraits, 389
UZANNE, Louis Octave, 17729
Uzanne, Louis Octave, 1852-1931
 criticism of Hotel Drouot building, 2746
 editor of *L'Art et l'Idée*, 16038
 Miroir du Monde, 2644
 illustrated by E. H. Avril, 15055
 Nos Amis les Livres, review, 2317
 notes, 1893, 16211
 on history of screens, 1893, 4507
 Son Altesse la Femme, review, 10126
 Sunshade, Glove and Muff, review, 9876
Uzès, Anne de Rochechouart Mortemart, *duchesse* d', 1847-1933
 sculpture placed in Valence, 1897, 23916

vacation homes
 decorating a seaside cottage, 2439
 decorating schemes for house by the sea and mountain house, 1891, 3613
 decorating summer homes, 3589
 decorating summer house and veranda, 7052
 interiors for summer cabins, 7529
 summer cottage windows and window seats, 7032
 temporary decoration of seaside cottage, 2495
Vacher, Sydney
 Fifteenth-Century Italian Ornament, compared to G. T. Robinson's articles on decorative design, 1886, 10302
Vachon, Marius, 1850-1928
 report on art education in England, 1891, 3524
 report on European art schools, 1891, 3482
Vacquerie, Auguste, 1819-1895
 collection, sale, 1899, 17658
Vaditz, Carl, b.1850
 etching after Grützner, 10082
Vaga, Perino del See: **Perino del Vaga**
Vago, Ambrose Lewis
 Instructions in the Art of Modelling in Clay, 1623
 review, 205

Vail, Elizabeth D., d.1887?
 collection, sale, 1887, 2448
Vail, Eugene Lawrence, 1857-1934
 criticized by M. Hamel, 1889, 25660
 exhibitions
 American Art Galleries, 1887, 2607, 10832
 Chicago Art Institute, 1903, 13673
 Chicago Inter-State Industrial Exposition, 1889, 3056
 Paris, 1902, 13372
 Pennsylvania Academy of the Fine Arts, 1888, 17804
 Prize Fund Exhibition, 1885, *Port de Pêche, Concarneau*, 25278
 Salon, 1885, 2000
 Salon, 1887, 2449
 Salon, 1889, 2985
 Salon, 1902, 13414
 Salon, 1906, 14116
 Société Nouvelle, 1901, 13240
 Vienna, 1902, 13421
 illustrations
 On the river, 4559
 St. Mark's, 13805
 whereabouts
 1883, Concarneau, 24736
 1884, Grez, 24702
Vaillant, Marie Baubry See: **Baubry Vaillant, Marie Adélaide**
Vaini, Pietro, 1847-1875
 obituary, 8535
VALABRÈGUE, Anthony, 17884
VALCOURT VERMONT, Edgar de, 20394, 20414, 20433, 20441, 20443, 20450, 20460, 20470, 20482
Vale, Euphemia See: **Blake, Euphemia Vale**
Vale Press, 12567
Valentien, Albert R., 1862-1925
 illustrations, Rookwood vase, 13037
 member of Society of Western Artists, 1898, 12083
Valentien, Albert R., Mrs. See: **Valentien, Anna Marie Bookprinter**
Valentien, Anna Marie Bookprinter, 1862-1947
 exhibitions, Atlanta Exposition, 1895, 11698
Valentin, Henry, 1820-1855
 illustrations
 costumes of the Moldavians and Wallachians, 21052
 In the present day, 20852
Valentin, Henry Augustin, 1822-1886
 illustrations
 Arnauts playing draughts (after Gérôme), 9243
 Ophelia (after Aizelin), 1623
 Renaissance (after C. Landelle), 21016
Valentin Roussel, Roubaix
 collection, sale, 1899, 17658
Valentine, Albert R. See: **Valentien, Albert R.**
Valentine, Anna Marie See: **Valentien, Anna Marie Bookprinter**
Valentine, David Thomas, 1801-1869
 compiler of manuals on the history of New York City, 15968
Valentine, Edward Virginius, 1838-1930
 Andromache and Astyanax, 631
 bust of Matthew Fontaine Maury, 1890, 26192
 early career, 105
 praise, 565
 statue of Breckenridge for state of Kentucky, 1887, 592
 statue of Robert E. Lee, 8462
 to be unveiled at Lexington, Va., 1883, 14896
 unveiled, Lexington, Va., 1883, 24722
 Valentine family library and collection given to Richmond, 1892, 16029
Valentine, Mann Satterwhite, 1824-1892
 Valentine family library and collection bequeathed to Richmond, 16029, 17465
Valentine Museum See: **Richmond (Virginia). Valentine Museum**
valentines
 Prang's cards

1880, *804*
1884, *1732*
1885, *1931*
Vallance, William Fleming, 1827-1904
 exhibitions, Royal Scottish Academy, 1887, *10430*
Vallely, Henry E., 1881?-1950
 illustrations
 Cartoon, 12964
 News picture, 12964
Vallette, Louise Arc See: **Arc Vallette, Louise**
Vallette, Maurice, 1852-1880
 obituary, *165*
Vallette, R., fl.1890's?
 illustrations
 drawing of a deer, *7431*
 Ducks (drawings), *5136*
 Stags, 5102
Vallotton, Félix Edouard, 1865-1925
 illustrations, advertisement for Ed. Sagot (wood-cut), *23629,
 23649, 23667, 23690*
 woodcuts in *L'Art et l'Idée*, 1892, *16038*
Valnay Desrolles, Jacques, 19th century
 illustrations, illustrations for Hugo's *Jean Valjean, 22634,
 22656*
Valparaiso (Chile)
 description, *19097*
Valton, Edmond Eugène, 1835-1910
 illustrations, drawing after portrait, *2728*
Van Alen, James H., d.1885?
 collection, sale, 1888, *621*
Van Arsdale, Emma See: **Van Arsdele, Emma**
Van Arsdele, Emma, fl.1881-1886
 exhibitions, National Academy of Design, 1882, *1330*
Van Beers, Jan See: **Beers, Jan van**
Van Beest, Albert See: **Beest, Albert van**
VAN BERGEN, Robert, *12547*
Van Boskerck, Robert Ward, 1855-1932
 biography in brief, *11246*
 exhibitions
 Brooklyn Art Association, 1884, watercolors, *25092*
 Chicago Inter-State Industrial Exposition, 1880, *199*
 National Academy of Design, 1884, *1790*
 National Academy of Design, 1903, *13547*
 New York, 1891, *3529, 15488, 26235*
 New York, 1891, English scenery, *26256*
 New York, 1893, *16122*
 New York, 1894, *4801*
 Prize Fund Exhibition, 1885, *Indian summer, 25278*
 Society of American Artists, 1887, *10789*
 illustrations
 October landscape, 1772
 On the Seine, 14311
 landscapes, 1883, *24568*
 landscapes at Goupil, 1889, *25674*
 notes
 1887, *546*
 1894, *16480*
 1896, *16939*
 studio, *22686*
 reception, 1884, *25079*
 whereabouts, 1883, Hackensack, *24728, 24856*
 work, 1883, *24424, 24883*
 work, 1884, *25074*
Van Briggle, Artus, 1869-1904
 exhibitions
 Cincinnati Art Club, 1900, *13037*
 Cincinnati Art Museum, 1898, *12754*
 pottery, *13283, 13899*
 closed, 1905, *13869*
 protégé of Rookwood Pottery Co., 1896, *23008*
Van Briggle, Artus, Mrs. See: **Ritter, Anne Louise Gregory**
VAN BRUNT, Henry, *5, 23, 43, 129*
Van Brunt, Henry, 1832-1903
 See also: **Ware and Van Brunt, architects**
 design for Grant memorial proposed, 1885, *11206*

lectures
 paper on cast iron architecture at American Institute of
 Architects, 1858, *19953, 19970*
 speech at American Institute of Architects, 1859, *19999*
 opinion on J. Coleman Hart's paper on unity in architecture,
 19992
 Yorktown monument, *450, 9561*
 commission, 1880, *178*
Van Buren, Amelia C., fl.1880-1901
 illustrations
 Mother and child, 13167
 portrait of mother and infant, *14019*
Van Buren, Martin, *pres. U.S.*, 1782-1862
 inauguration, *23193*
Van Cleef, A. See: **Dodgshun, A. Van Cleef**
Van Cleef, Augustus D., 1851-1918
 exhibitions, New York Etching Club, 1884, *25013*
Van Dael, Jean François, 1764-1840
 Tomb of Julia, 21225
Van de Put, Albert
 Hispano-Moresque Ware of the Fifteenth Century, review,
 13838
Van de Velde, Henry See: **Velde, Henry van de**
Van Deman, E. R., fl.1903
 illustrations, *Landscape sketch, 13637*
Van Den Bos, Georges, 1853-1911
 exhibitions, Salon, 1889, *Armed for conquest, 25664*
 illustrations
 Fructidor, 23208
 Happy hours, 23047
Van Den Broeck, Clémence See: **Broeck, Clémence van den**
Van Depoele, Charles Joseph, 1846-1892
 portraits, bust by R. Kraus, *22738*
VAN DER DATER, *12557, 12568, 12582, 12595, 12605*
Van Der Hecht, Henri See: **Hecht, Henri van der**
Van Der Kemp, John Mayne, fl.1886-1890
 exhibitions
 Prize Fund Exhibition, 1888, *2700*
 Salon, 1887, *2449*
 Salon, 1887, honorable mention, *2476*
Van Der Maarel, Marinus See: **Maarel, Marinus van der**
Van Der Weyde, Henry, fl.1889-1897
 pioneers use of special lenses to reduce foreshortening in pho-
 tography, *16243*
 use of electric light in photography, *16260*
Van Der Weyden, Harry, b.1868
 exhibitions
 American Art Association of Paris, 1896, *23709*
 American Art Association of Paris, 1897, *24010*
 Internationale Kunstausstellung, Munich, 1901, second class
 medal, *13379*
 Pennsylvania Academy of the Fine Arts, 1901, *13163*
 Salon, 1899, *12915*
 Salon, 1902, *13414*
 illustrations, *Watering place, 13851*
 sales and prices, 1897, *20620*
Van Deusen, Alice B.
 collection
 crockery, *17247*
 pottery donated to Smithsonian, 1897, *17218*
Van Deusen, Allen W., d.1897
 illustrations, *Rezonville* (after A. Morot), *22520*
Van Deusen, Robert Thompson
 antiques offered, 1892, *16075*
 letter offering plate for sale, 1893, *16352*
 letter on colonial relics, 1894, *16571*
 publisher of *The China Collector, 16016*
Van Dongen, Kees See: **Dongen, Kees van**
Van Du Zee, Edith, fl.1884-1887
 illustrations
 head of a model, *555*
 portrait, *10907*
Van Duzee, Edith See: **Van Du Zee, Edith**
Van Dyck, Anthony See: **Dyck, Anthonie van**
VAN DYKE, Clara Brinton, *4166, 4209, 4271, 11419, 11447,*

vases, Chinese
 peach blow vase scandal, 1891, *3528, 3560*
 peach blow vase location unknown, 1894, *5170*
vases, English
 design for lamp vase, *9286*
 designs, *9350*
vases, Etruscan
 unguent jar, *414*
vases, French
 Haviland sculptured vase, decorated by E. Lindeneher, *1445*
vases, Greek
 appreciation and history, *2765*
 decoration, *1304*
 exhibitions, Union League Club, New York, 1890, *3157*
 Portland vase, *16017*
 red-figure vase with birth of Plutus, *17040*
vases, Japanese
 bronze vases, *1248*
 Satsuma vase in Chicago, 1897, *11975*
Vasnetsov, Apollinarii Mikhailovich, 1856-1933
 exhibitions, Moscow, 1905, *13943*
 illustrations, *Place d'Ivan Veliki au Kremlin*, *13759*
Vasnetsov, Viktor Mikhailovich, 1848-1926
 Russian painter, *13759*
Vassar College See: **Poughkeepsie (New York). Vassar College**
Vasselot, Anatole Marquet de See: **Vasselot, Jean Joseph Marie,** *comte* de
Vasselot, Jean Joseph Marie, *comte* de, 1840-1904
 exhibitions, Salon, 1896, sculpture, *23618*
Vatican See: **Rome. Vatican**
VAUGHAN, Henry, 1621-1695, *20472*
Vaughan, Henry, 1842-1917
 illustrations, bishop's chair, *12906*
Vauquelin, Louis Emile Félix, fl.1879-1883
 Kabyle beggar at the door of the mosque, destroyed, 1883, *24643*
Vauthier, Charles Moreau See: **Moreau Vauthier, Charles**
Vautier, Benjamin, 1829-1898
 exhibitions
 Metropolitan Museum of Art, 1884, *Mayor's dinner*, *1803*
 Milwaukee Industrial Exposition, 1898, *Examination in a village church*, *12800*
 Pennsylvania Academy of the Fine Arts, 1858, *19858*
 Little barefoot, *9479*
 paintings, 1858, *19887*
 paintings in Whitney collection, *2108*
VAUX, Calvert, *23347*
Vaux, Calvert, 1824-1895
 anecdote, *16894*
 Central Park plan, *19859*
 children's playground project, 1890, *26150*
 design for Grant monument
 criticized, 1887, *583*
 proposed, 1885, *11206*
 design of home of J. A. C. Gray, *19976*
 exhibitions, National Academy of Design, 1865, *23334*
 member, American Institute of Architects, 1859, *19992*
 New York house, *19899*
 opinion on iron as material for architecture, *19953*
 paper read to American Institute of Architects, 1857, *19666*
 plans for Metropolitan Museum, *11216*
 remarks on Gothic architecture, *19871*
 reply to criticism in *New Path*, *23347*
 Villas and Cottages, review, *19647*
Veaux, James de See: **Deveaux, James**
Veber, Jean, 1864-1928
 exhibitions, Salon, 1902, *13414*
VEBER, Pierre, *13593*
Vecelli, Tiziano See: **Titian**
Vecellio, Cesare, 1521-1601
 copy of Amman's *Ein fraw auss Peruuia*, *9484*
Vecellio, Geo. Francesco, 17th century
 Gesta Artificum, description of 1639 book, *544*
Vedder, Elihu, 1836-1923, *120, 136, 843*

commission for Baltimore courthouse murals, 1901, *13208, 13228*
cover design for *The Studio*, 1883, *24420*
cover illustration for *Century*, 1883, *24569*
decoration for Bowdoin College, *16586*
 murals for Walker Art Building, *27016*
decoration for Library of Congress
 commissioned, 1895, *22765*
 panels, 1896, *22980, 23015*
decorations for the World's Columbian Expositon, 1893, *26790*
dispute with *L'Art*, *9124*
exhibitions
 American Art Association, 1884, illustrations for *Rubáiyát* of Omar Khayyám, *25209*
 Architectural League of New York, 1891, *26459*
 Architectural League of New York, 1895, *5318*
 Architectural League of New York, 1896, Library of Congress decorations, *5699*
 Art Students' League, 1880, *102, 234*
 Boston, 1883, *24525*
 Boston, 1887, *559*
 Boston Art Club, 1880, *158*
 Boston Museum of Fine Arts, 1882, *9693*
 Carnegie Galleries, 1896, *11906*
 London, 1899, Omar Khayyam illustrations, *7005*
 National Academy of Design, 1864, *23313*
 National Academy of Design, 1865, *23331*
 National Academy of Design, 1882, *1330, 9646*
 New York, 1880, *82, 9310*
 New York, 1887, *10782*
 New York, 1887, illustrations to Omar Khayyam, *2487*
 New York, 1900, *13021*
 Paris Exposition, 1889, *Ever-present love*, *25695*
 Pennsylvania Academy of the Fine Arts, 1885, Omar Khayyam drawings, *11280*
 Union League Club of New York, 1890, *25779*
 Union League Club of New York, 1891, *26224*
Identity, inspired by poem, *9326*
illustrations
 cover design for *The Studio*, *25315, 25700, 25738, 25785, 25835, 25880*
 decorative panel, *20588*
 emblem for *The Studio*, *26168, 26866, 26994*
 Soul between doubt and faith, *13258*
illustrations for *Rubáiyát* of Omar Khayyám, *1786, 1883, 10115, 10896, 25132, 25200*
Keeper of the threshold, acquired by Carnegie Galleries, 1901, *7597*
Lair of the sea serpent, in Boston Museum of Fine Arts, *13073*
member, Society of Mural Painters, *22787*
member, Tile Club, *1851*
Mistral, in Clarke collection exhibition, 1883-4, *24955*
notes
 1860, *20284*
 1871, *10671*
 1886, *493*
 1887, *557*
 1892, *16038*
 1894, *27004*
paintings, *803*
paintings in San Francisco, 1880, *895*
portrait of Kate Field, presented to Boston Museum, 1895, *16814*
Prang's Christmas card competition
 prize, 1881, *1104, 9572*
reception before his return to Italy, 1883, *1549*
Sansone, criticism in England, 1883, *24453*
stained glass screen for Tiffany, 1882, *24367*
Twilight in Italy, shown in Boston, 1883, *24755*
views on women's dress, *1441*
whereabouts, 1892, returns to America from Rome, *26835*
Vedder, Simon Harmon, b.1866
 Indian horseback race, *26386*
 notes, 1893, *26960*
Veenfliet, Richard, fl.1895-1915

Vermont
 description, 1855, *19088*
Vermont, Edgar de Valcourt See: **Valcourt Vermont, Edgar de**
Vermorcken, Frédéric Marie, b.1860
 exhibitions
 National Academy of Design, 1889, *3101, 14970, 25685*
 Pennsylvania Academy of the Fine Arts, 1890, *25768*
Verne, Jules, 1828-1905
 notes, 1896, *22912*
Verner, Frederick Arthur, 1836-1928
 exhibitions, American Exhibition, London, 1887, *25464*
Vernet, Carle, 1758-1836
 honored, 1901, *7550*
 lithographs of soldiers and war, *12952*
Vernet, Horace, 1789-1863
 anecdote, *1312, 18351*
 Brethren of Joseph, shown in New York, 1855, *18666*
 Brigands surprised by Papal troops, in Walters collection, *1003*
 Capture of the Malakoff, 18207
 Choléra et socialisme, 17505
 commission to decorate saloon of Tuileries, 1855, *18780*
 death of wife, *18243*
 exhibitions
 Paris Exposition Universelle, 1889, *2987*
 Salon, 1849, portrait of Changarnier, *14544*
 honored, 1901, *7550*
 illustrations, *Mazeppa pursued by wolves, 7550*
 Lion, in Robinson collection, *25357*
 Lion-hunt, 9386
 Napoleon I, 18380
 painting, 1855, *18726*
 painting of siege of Rome, project, 1850, *14607*
 painting of St. Jerome, *7614*
 paintings for Capitol, *19626*
 paintings, Paris, 1855, *18670*
 teacher, Suisse's school, *24683*
 whereabouts, 1855, trip to Algiers, *18998*
Vernet, Joseph, 1714-1789
 biography and seascapes, *20796*
 technique, *14574*
VERNEUIL, Maurice Pillard, *13669*
Verneuil, Maurice Pillard, 1869-1942
 illustrations, frieze, *13362*
Vernier, Emile Louis, 1829-1887
 exhibitions, Salon, 1880, *187*
 On the beach, 7380
Vernon, J. R., fl.1855-1858
 exhibitions, Royal Academy, 1858, *19851*
Vernon, Robert, 1774-1849
 collection
 copies of drawings shown in U.S, *14678*
 to be placed in Marlborough House, *14635*
 obituary, *14526*
VERNON, W. W., *12236*
VERNON, William, *13499*
VÉRON, Eugene, *17712, 25253*
Véron, Eugene, 1825-1889
 criticism of government education, *2074*
 quote, on realism, *17747*
Verona (Italy)
 description and views, *10499*
Veronese, Paolo Cagliari, *known as*, 1528-1588
 Christ in the costume of a Pilgrim at the table of Gregory the Great, injured, 1850, *14647*
 differences between pictures and studies, *23318*
 Family of Darius, acquired by London National Gallery, 1857, *19749*
 Marriage at Cana, relined, 1893, *4633*
 notes, 1893, *26982*
 ornament and decoration in his painting, *10336*
 Vision of St. Helena, 10034
 work in National Gallery, London, 1894, *4941*
Verplanck, Gulian Crommelin, 1786-1870
 artists' reception, New York, 1858, *19784*

 letter on portraits of George Washington, *19676*
 letter to A. M. Cozzens on Pine's portrait of Garrick, *19600*
 portraits, portrait by Huntington, *19626*
 quote, *20327*
 on moral influence, *19948*
 Twelfth Night at the Century, review and excerpt, *19861*
Verplanck, Julia Campbell See: **Keightley, Julia Campbell Verplanck**
Verrio, Antonio, ca.1639-1707
 anecdote, *17697*
 documentation, *10220*
Verrocchio, Andrea del, 1435?-1488
 Colleoni, 9729
 equestrian statue of Colleoni, *10316*
 sculpture, *23298*
 Virgin and child, 9665
Versailles (France). Château
 acquisitions, 1896, bust of Louis XVII, *16948*
 museum opened, 1904, *13810*
 Orangerie in poor condition, 1895, *16819*
 Trianons' interior decoration, *3021*
Versailles (France). Musée national
 acquisitions, 1903, David's *Death of Marat, 13701*
 building
 galleries open, 1902, *13446*
 new galleries opened, 1899, *17671*
 statues, *14669*
Versailles (France). Société des sciences morales See: **Société des sciences morales des lettres et des arts de Seine-et-Oise**
Verschuur, Wouter, 1812-1874
 exhibitions, Pennsylvania Academy of the Fine Arts, 1855, *18793*
Vertunni, Achille, 1826-1897
 exhibitions, Esposizione Internazionale di Belle Arti, Rome, 1883, *14884*
 Italian landscape painter, *25045*
Verwee, Alfred Jacques, 1838-1895
 obituary, *16879*
VERY, Lydia Louisa Anna, *23584*
Vesaria, Lilian, fl.1895-1900
 whereabouts, 1900, travels, *22099*
vespers
 Italy, vesper bell, *20866*
Vespucci, Amerigo, 1451-1512
 portraits, copy found in Lancaster, Kentucky, 1904, *13781*
Vesuvius
 description, *23013*
 eruption, 1855, *18654, 18865*
Veterans of the City Guard, Hartford See: **Hartford (Connecticut). Hartford Veterans of the City Guard**
Veth, Jan Pieter, 1864-1925
 illustrations, Jozef Israels, *13710*
Vever, Henri, 1854-1943
 collection, sale, 1897, *6143, 6187, 17244*
Veyrassat, Jules Jacques, 1828-1893
 exhibitions
 Cercle Artistique, 1877, *8817*
 Cercle Central des Lettres et des Arts, 1880, *9389*
 illustrations
 Day's work done - midsummer, 3049
 Haytime: the last load, 5650
 Relay, 1812
 notes, 1894, *16525*
 obituary, *16291*
 sales and prices
 1884, *1827, 16451*
Vézelay (France). Basilique de la Madeleine, *20977*
Vezin, Frederick, b.1859
 notes, 1884, *25121*
Via Appia See: **Appian Way**
VIARDOT, Louis, *20269*
Viardot, Louis, 1800-1883
 Brief History of the Painters of All Schools, review, *9146*
Viau, Georges
 collection, sale, 1907, *14306*

Boston, 1884, *1751*
Boston Art Club, 1880, *72*
Boston Museum of Fine Arts, 1880, *225*, *1026*
Boston Paint and Clay Club, 1884, *25083*
Boston Paint and Clay Club, 1885, *1949*
Boston Paint and Clay Club, 1885, portrait of Prof. A. P.
 Peabody, *25259*
National Academy of Design, 1880, *111*, *889*, *9324*
National Academy of Design, 1887, *552*, *10786*
National Academy of Design, 1889, *2936*
National Academy of Design, 1891, *26313*
National Academy of Design, 1903, *13547*
French peasant woman, in Clarke collection exhibition, 1883-4,
 24955
illustration in Koehler's *American Art*, 1886, *509*
lectures
 on German art to Boston Art Club, 1879, *660*
 on John Singer Sargent, 1899, *12874*
marries Annie M. Pierce, 1883, *24722*
member of art jury, Tennessee Centennial, 1896, *11843*
on C. E. Dallin's Paul Revere model, *12949*
painters in Boston, 1879, *794*
paintings in Appleton collection, *876*
portrait in Boston Museum of Fine Arts, 1885, *1983*
portrait of Alanson W. Beard hung in Boston Customs House,
 1895, *22738*
portrait of Archbishop Williams, *22738*
portrait of C. F. Adams, *700*
portrait of Wendell Phillips in Boston, 1881, *1221*
portrait painting, *1131*
whereabouts, 1890, return to Boston from Paris, *26143*
Vintraut, Godefroy Frédéric, fl.1882-1900
illustrations, *When Spring unlocks the flowers to paint the
laughing soil*, *5742*
Viola, Tommaso, b.1810
exhibitions, Esposizione Internazionale di Belle Arti, Rome,
 1883, *14884*
violin
anecdote, *16535*, *16616*, *16767*
collectors and collecting, *15341*, *16134*, *16257*, *16781*, *17650*
 1893, *16157*, *16409*
 anecdote, *16664*
 Anton collection, *15999*
 gourd violin, *16257*
 Haddock collection, *16208*
 New York collectors, *17038*
Customs House tariff, 1895, *16845*
exhibitions, Vienna, 1892, *16032*
experiences of a dealer, 1894, *16473*
forgeries, *15233*
George Washington violin, *16643*
"Hercules" Stradivarius, *16851*
list of violinmakers, 1894, *16567*
measurements recorded for identification, *17053*
notes, 1894, *16624*
Ole Bull's fiddle, *16268*
sales and prices, *16291*
 1890, *15022*
 1890, Stradivarius *Messiah* sold, *15248*
 1892, *15944*
 1893, Pressender violins, *16387*
 1894, *16448*
 1896, *16911*, *17188*
 1896, Hawley collection, *17090*
 1897, *17212*, *17312*
Stradivarius, *16911*
violin maker H. W. Oakes, *17064*
Violin Times, established, 1894, *16476*
violins and mandolins made of porcelain, *7740*
violinists, violincellists, etc.
hints to amateur violinists, *884*
Viollet le Duc, Eugène Emmanuel, 1814-1879
as artist-writer, *10806*
baronial bedroom illustrated, *7411*
defense of artist's profession, *20062*

Dictionnaire Raisonné du Mobilier Français, excerpts, *23319*,
 23325
illustrations, *Church of the Madeleine, Vezelay, France*, *20977*
Learning to Draw, or the Story of a Young Designer, review,
 273
portraits, pen portrait by E. de Liphart, *5578*
restoration of Chateau de Pierrefonds, *22301*
violoncello
collectors and collecting, Stradivarius attribution upheld in
 court, 1891, *15671*
Viotti, Angelo, fl.1899
modeling classes, Detroit Art School, 1899, *12292*
Virgil
Aeneid
 interpretation, *19641*, *19665*, *19676*
 new interpretation, *19621*
mosaic depicting Virgil, *17205*
Virginia
description of Tinker Mountain, *18803*
history and description, *18527*
maps, *Virginia Cartography*, published 1897, *17348*
State of Virginia records returned to state, 1896, *17053*
Virginia State Building at World's Fair, 1893, *4432*
Virginia HIstorical Society See: **Richmond (Virginia).**
 Virginia Historical Society
Virginia State Library See: **Richmond (Virginia). Virginia
State Library**
Visaria, Lilian See: **Vesaria, Lilian**
Vischer, Peter, ca.1460-1529
illustrations, *King Arthur of England*, *12669*
Visconti, Pietro Ercole, 1780?-1880
obituary, *240*
Visini, fl.1856
illustrations
 statue of Psyche, *17941*
 Venus and apple (after Thorwaldsen), *17932*
visiting cards
collectors and collecting, *16710*
 list of items in unidentified collection, *16872*
lithographed cards replace pasteboard, *17271*
Vitti Academy, Paris See: **Paris (France). Académie Vitti**
Vittorio Emanuele III, *king of Italy*, 1869-1947
collection, buys pictures at Venice exhibition, 1905, *13974*
whereabouts, 1902, visits Russia, *7992*
VITZETELLY, Francis Horace, 1864-1938, *22659*
vivariums
London Zoological gardens, *21085*
VIVIAN, *12213*
Vizetelly, Frank, 1830-1883
illustrations, *Eugenie, empress of the French*, *20797*
Vizetelly, Frank H. See: **Vitzetelly, Francis Horace**
Vizetelly, Henry, 1820-1894
obituary, *16466*
Vlierboom van Hoboken, Marius
collection, sale, 1896, *16990*
Voelter, Frieda See: **Redmond, Frieda Voelter**
Vogel, Heinrich, 1818-1904
donates property for establishment of institution for artists,
 1904, *13735*
Vogel, Hermann, 1856-1918
illustrations
 illustrations for Hugo's *Jean Valjean*, *22807*
 illustrations for Hugo's *Les Misérables*, *22697*, *22719*,
 22746, *22780*, *22835*
Vogel, Lorenz, 1846-1902
Beethoven at the piano, *14904*
Vogler, Paul, 1852-1904
sales and prices, 1901, *7611*
Vogrich, Max Wilhelm Carl, 1852-1916
collection, *15727*
Vogt, Adolph, 1843-1871
obituary, *10731*
Vogt, Louis Charles, b.1864
exhibitions
 New York, 1892, *16061*

tile decorations, *5675*
tile design, *1070*
tiles in Old Delft style, *5501*
Virginia rail plate, *4958*
Vision of Venice (drawing after Turner), *16047*
Volkmar faience, *1475*
Washington's headquarters, Newburgh, N.Y., *5897*
White turkeys, *1363*
Whitefish plate for copying, *6938*
Wild geese plate, *5103*
Wild turkey plate, *5280*
Woodcock plate, *5055*
illustrations for *The Land of Rip Van Winkle*, 1885, *11223*
Limoges paintings shown in New York, 1887, *534*
mantle of painted tiles, *557*
Martha Washington tea set, 1895, *5482*
member, Salmagundi Club, *11166*
notes
 1892, *15948*
 1894, *4818*
 1896, *17093*
print restoration services offered, 1893, *16362*
quote, on Delft blue, 1896, *5726*
sales and prices, 1883, *Quiet spot*, *24684*
studio reception, 1884, *25079*
teaching
 class on blue underglaze china painting, 1896, *5633*
 Gotham Art Students, 1885, *11219*
 to open pottery school, 1900, *7286*
underglaze Limoges produced, 1885, *11276*
Washington's headquarters, instructions for copying, *6233*, *6272*

Volkmar, Charles, Sr., 1809-1892
restorer of paintings, *15948*
Volkov, Aleksandr Nikolaevich, 1844-1928
Venice views, *9786*
Vollmering, Joseph, 1810-1887
restorer of paintings, *24783*
Vollon, Alexis, b.1865
illustrations, *Declaration*, *7836*
Vollon, Antoine, 1833-1900
exhibitions
 Cercle des Mirlitons, 1877, *8828*
 New York, 1892, *26622*
 Paris, 1887, palettes of artists, *2490*
 Salon, 1878, *9036*
French painter, *23045*
illustrations, *After the storm*, *7550*
notes, 1897, *6396*
obituary, *7452*, *13128*
On the English channel, shown in New York, 1899, *17563*
paintings, *25107*
 1876, *8790*
paintings forged, *2448*
paintings in Cutting collection, *26562*
paintings in Stewart collection, Paris, *10823*
Port studies, in Hart-Sherwood collection, *792*
Pumpkin, bought by Ellsworth of Chicago, 1892, *26557*
sketch shown in New York, 1887, *25399*
Still life, shown in New York, 1885, *25266*
still-life in Schaus collection, *15840*
still-life shown in New York, 1886, *25346*
view of Mentiques, *2600*
Volpato, Giovanni, 1733-1803
notes, 1895, *16816*
Voltaire, François Marie Arouet de, 1694-1778
body exhumed and removed from Pantheon, *16669*
letter to Titon du Tillet, *26040*
portraits, *16890*
quote on fashion, *18009*
relics, *17068*
tomb, *24015*
Volz, Wilhelm, 1855-1901
exhibitions, Chicago World's Fair, 1893, *4464*
Von Cramm, Helga See: **Cramm, Helga von**

Von Glehn, Jane Emmet, 1873-1961
illustrations, *On summer sands*, *22528*
Von Glehn, Wilfred Gabriel, *Mrs.* See: **Von Glehn, Jane Emmet**
Von Hillern, Bertha, fl.1880-1885
exhibitions
 American Art Galleries, 1885, *1921*
 Boston, 1885, *1983*
 Boston Art Club, 1880, *807*
 Philadelphia, 1884, *25056*
 Washington, 1884, *25109*
whereabouts
 1883, leaves summer studio in Strasburg, Va. for Boston, *24959*
 1883, sketching trip on the railroad, *24607*
 1883, Straburg, Va, *24755*
work, 1883, *24871*
Von Hoesslin, George See: **Hoesslin, Georg von**
Von Hofsten, Hugo See: **Hofsten, Hugo Olof von**
Von Marr, Carl See: **Marr, Carl von**
VON RYDINGSVÄRD, Karl, *5509, 5552, 5588, 5634, 5678, 5719, 5761, 5800, 5848, 5882, 6031, 6086, 6332, 6356, 6385, 6475, 6824, 6856, 6893, 6920, 6941, 6973, 7141, 7168, 7213*
Von Rydingsvärd, Karl, fl.1895-1910
illustrations, picture frame, *6975*
Von Rydingsvard School of Art Wood-Carving See: **New York. Von Rydingsvard School of Art Wood-Carving**
Von Saltza, Charles Frederick, 1858-1905, *12803*
collecting art for Tennessee Centennial Exposition of 1897, *23056*
exhibitions
 Chicago, 1896, *11758*
 Chicago, 1898, *12202*
 Chicago Art Institute, 1898, *12222*
 St. Louis, 1895, *11582*
illustrations, *Mora*, *22431*
member of Society of Western Artists, 1898, *12083*
My fair lady, *22879*
obituary, *14047*
teaching
 appointed instructor, Art Institute of Chicago, 1898, *12227*
 improves color work at Art School of Art Institute of Chicago, *12939*
 portrait classes, St. Louis Museum art school, 1897, *12061*
Von Stosch, Wilhelmina, fl.1895
Book, *22587*
Von Wahl, B., fl.1897
illustrations, design for copying, *6305*
Vondel, Joost van den, 1587-1679
collection compiled by A. Th. Hartkamp sought by Columbia University, *7643*
Vondrous, John Charles, b.1884
illustrations, *Arab chief* (etching), *13626*
Vonnoh, Bessie Onahotema Potter, 1872-1955, *11387, 12698*
awarded Arché Club prize, 1895, *11548*
exhibitions
 Boston Art Club, 1899, *12837*
 Chicago Art Institute, 1895, *11680*
 Chicago Art Institute, 1896, *11894*
 National Sculpture Society, 1895, *11549*
 National Sculpture Society, 1898, *12721*
 Paris Exposition, 1900, sculptures, *13074*
 Pennsylvania Academy of the Fine Arts, 1899, *17526*
 Pennsylvania Academy of the Fine Arts, 1905, *13853*
 Woman's Art Club of New York, 1903, *13703*
gold statue of Maude Adams denied admission to Paris Exposition, 1900, *7292*
illustrations
 Modern Madonna, *14080*
 Mother and child, *12160*
 Nature's child, *11777*
 portrait bust of Prof. David Swing, *11382*
 Susan B. Anthony and Mrs. S. E. Gross, *11886*
 Twins, *11971*
 Young mother, *13806*

modeled portraits of Mrs. Clayton Marks' children, 1895, *11711*
notes, 1896, *11793*, *11913*, *16905*
statuettes at Tennessee Exposition, 1897, *11965*
whereabouts, 1895, returns to Chicago from abroad, *11660*
Young mother, presented to Peabody Normal School, 1898, *12224*

Vonnoh, Robert William, 1858-1933
collection, posters exhibited, Philadelphia, 1896, *22388*
exhibitions
 Boston, 1892, *15811*
 Boston Museum of Fine Arts, 1885, *1983*
 Boston Museum of Fine Arts, 1896, *11765*
 Boston Paint and Clay Club, 1885, *1949*, *25259*
 Carnegie Galleries, 1903, *13675*
 Charleston Inter-State and West Indian Exposition, 1901-1902, gold medal, *13436*
 Chicago Art Institute, 1896, *5662*, *11732*
 Chicago Art Institute, 1899, portraits, *12290*
 Chicago Inter-State Industrial Exposition, 1889, *3056*
 Cincinnati Art Museum, 1898, *12754*
 National Academy of Design, 1901, portrait of Mrs. M. E. Potter, *7524*
 National Academy of Design, 1903, *13702*
 National Academy of Design, 1905, *14062*
 New York, 1896, *11738*, *16953*, *22421*
 Pennsylvania Academy of the Fine Arts, 1883, *1677*
 Pennsylvania Academy of the Fine Arts, 1897, *6179*
 Pennsylvania Academy of the Fine Arts, 1899, *Little Louise*, *17503*
 Pennsylvania Academy of the Fine Arts, 1900, *13007*
 Pennsylvania Academy of the Fine Arts, 1901, *13163*
 Pennsylvania Academy of the Fine Arts, 1902, *13363*
 Salon, 1883, *1588*, *24521*
 Salon, 1888, *2694*
 Salon, 1889, *2985*
illustrations
 Hydrangeas, *13345*
 Little Louise, *13785*
 Portrait of Dr. S. Weir Mitchell, *12787*
 Portrait of Mrs. M. E. Porter, *13202*
 sketch on invitation, *22431*
night scenes, 1899, *17612*
notes, 1894, *16519*
portraits of Elkins family, *12094*
whereabouts
 1894, Chicago, *11430*
 1895, to Paris, June, *22738*

Vonnoh, Robert William, *Mrs.* See: **Vonnoh, Bessie Onahotema Potter**

Voorhees, Clark Greenwood, 1871-1933
exhibitions
 American Watercolor Society, 1900, *The pump: Dutch interior*, *7245*
 National Academy of Design, 1905, Hallgarten prize, *14062*

Voorhees, Verde van See: **Dundas, Verde Van Voorhees**

Vorce, A. D., fl.1894-1905
buyer at Brinkley sale of Chinese ceramics, 1897, *6425*
collection, 1899, *7125*
gallery, exhibition of porcelain, New York, 1899, *7097*
shows antique glass, 1900, *7263*

VORS, Frederic, *665*, *666*, *686*, *687*, *705*, *716*, *722*, *733*, *761*, *778*, *796*, *814*, *838*

Vos, Hubert, 1855-1935
copy of Stuart's Lenox Library portrait of Washington, 1897, *17357*
exhibitions
 Chicago World's Fair, 1893, *4526*
 New York, 1895, *5223*
 Union League Club, 1900, *Types of various races*, *7247*
Home rule, *26166*
notes
 1893, *4387*
 1895, *16639*
portrait of Edmund J. Moffat, *26771*
portrait of General Olney, *11570*

portrait of Senator Brice, *6095*
promotes society of portrait painters, 1902, *13455*
quote, on Society of American Portrait Painters, 1902, *8059*
whereabouts, 1896-7, to work in America, *6054*

Vos, Jacob de, b.1803
collection, sale, 1883, *14919*

Vos, Maarten de, 1532-1603
illustrations, *Children*, *4888*
Virgin Mary with the Child and attendant angels, in the Durcal collection, *25620*

Vose, Robert C., Gallery See: **Boston (Massachusetts). Robert C. Vose Gallery**

Vose, Robert Churchill, 1873-1964
collection, Reynolds painting acquired, 1899, *12837*

Vose, Seth Morton, 1831-1910
American expert, first to offer Barbizon painter, *15451*
art dealer, Providence, *15797*, *26319*
collection
 lends paintings to Providence Art Club, 1890, *26108*
 paintings, 1896, *17068*
 pictures lent to Providence Art Institute, 1891, *15765*
exhibits Corot, 1891, *15573*

Voss, E. Christine, fl.1889-1892
exhibitions, Brooklyn Art Club, 1889, *2886*
pictures on view in Brooklyn, 1892, *15934*

Voss, Karl Leopold, 1856-1921
Pilgrimage to Kevlaar, *10483*

Vought, Olin V., fl.1896
water-color sketch, *22916*

voyages and travels
artists' travel
 advice to art student on travel to Paris, *7266*
 art student's travel abroad, 1891, *3629*
 diary and illustrations by C. W. Allers, 1895-96, *22783*, *22790*, *22832*, *22850*, *22885*, *22910*, *22939*, *22962*, *22984*, *23013*, *23035*
 excursion on the Baltimore and Ohio, 1858, *19876*
 sketching grounds in Holland and Normandy, 1894, *4912*
discovery of Straits of Juan de Fuca, *18396*
Missouri River trip, *18059*
popularity of travel, 1896, *23106*
travel books
 illustrations, *17983*
 Julia L. Barber's scrapbook *Mediterranean Mosaics*, *16882*
travel study course, 1897, *12040*
travel to New Zealand suggested, 1897, *23210*

Voysey, Charles F. A., 1857-1941
illustrations, frieze, *13362*

Vreeland, Wallace N., fl.1902
illustrations, *But a month to spring* (photograph), *13342*

Vries, Jan Vredman de, b.1527
influence on English arts of design, *10254*

Vroubel, Mikhail A. See: **Vrubel, Mikhail Aleksandrovich**

Vrubel, Mikhail Aleksandrovich, 1856-1910
exhibitions, Moscow, 1905, *13943*

Vuillefroy, Félix Dominique de, b.1841
cattle paintings in Walker collection, Minneapolis, *12924*
illustrations, *Return of the herd*, *5435*
quote, on Chicago Worlds Fair art exhibit, 1892, *26842*
representative of France's Minister of Fine Arts, Chicago World's Fair, 1892, *26799*
study course, *12361*

Vuillier, Gaston Charles, 1847-1915
illustrations, *Valley of Pierre Fol*, *1348*

W

composition discovered, 1896, *17169*
excerpt from Huysmans's chapter on Wagner from *Certains*, *17633*
feted in Rome, 1877, *8792*
Flying Dutchman, performed in Paris, 1897, *23833*
life in Paris, *23963*
monuments, monument in Leipzig, *26166*
museum, *15119*
moves to Eisenach, 1896, *17116*
notes, 1890, *25867*
Parsifal
description of Bayreuth performance, 1883, *25328*
performance at Bayreuth, 1886, *10351*
stage mechanisms required, *1435*
Pictorial Wagner, published, 1895, *16854*
portraits
caricatures from Julien's book, *10397*
portrait by G. Gaul, *20441*
Tristan und Isolde, performance at Bayreuth, 1886, *10362*
Wagner, Richard, Museum See: **Vienna (Austria). Richard Wagner Museum**
Wagner, Theodor, 1800-1880
obituary, *192*
Wagrez, Jacques Clément, 1846-1908
exhibitions, Salon, 1880, *187*
illustrations
Cupid asleep, *13250*
Decorative berries, *5845*
Juliet, *5068*, *23164*
Love rules the world, *6272*
Old familiar melody, *4473*
illustrations for *Romeo and Juliet*, 1893, *16174*
Wagstaff, Charles Edward, 1808-1850
Christiana and her childen in the Valley of Death (after Huntington), engraved for Art Union of Philadelphia, 1851, *14834*
illustrations, *Saul and the witch of Endor* (after W. Allston), *14850*
Wahlberg, Alfred, 1834-1906
Moonlight, in Munger collection at Art Institute of Chicago, *12785*
Wain, Louis William, 1860-1939
exhibitions
Chicago, 1900, cats, *12467*
London, 1898, *24114*
Wainewright, Thomas F., 1809-1887
exhibitions, Boston, 1887, *2602*
Wainwright, Thomas F. See: **Wainewright, Thomas F.**
WAIT, Carrie Stow, *7170*, *7330*, *7556*
Wait, Erskine L., d.1898
exhibitions, Brooklyn Art Club, 1892, *26501*
Wait, Fanny Rowell See: **Rowell, Fanny Taylor**
Wait, Horace C., Mrs., 1865-1928 See: **Rowell, Fanny Taylor**
Wait, Horace C., Mrs., b.1851 See: **Wait, Carrie Stow**
WAIT, Marshall, *12832*
Wait, Marshall, fl.1899
illustrations
five photographs, *12832*
Pond (photograph), *13894*
Waite, Robert Thorne, 1842-1935
exhibitions, Royal Society of Painters in Water Colours, 1878, *21595*
Waite, Thorne See: **Waite, Robert Thorne**
Wakley, Archibald, d.1906
murdered, *14194*
Walcheren (Netherlands)
description of Dutch island, *10031*
Walcott, Anabel Havens See: **Walcott, Belle Havens**
Walcott, Belle Havens, b.1870
exhibitions, National Academy of Design, 1903, third Hallgarten prize, *13547*
illustrations, *Going home*, *13163*
Walcott, Benjamin S., 1829-1890
obituary, *15111*

Walcott, George
spirit portrait of Franklin Pierce's son, *20640*
Walcott, Harry Mills, 1870-1944
exhibitions
American Art Association of Paris, 1896, *23709*
American Art Association of Paris, 1898, drawings, *24010*
American Art Association of Paris, 1899, *12890*
Carnegie Galleries, 1904, honorable mention, *13792*
National Academy of Design, 1903, *13702*
National Academy of Design, 1903, Hallgarten prize, *8133*, *13547*
illustrations
Cotillion, *14266*
Hare and hounds, *14083*
young male nude, *21513*
Walcott, Harry Mills, *Mrs.* See: **Walcott, Belle Havens**
Walcutt, William, 1819-1882
design for *Commodore Perry*, *18509*
paintings, 1855, *18596*
Waldeck, Carl Gustave, 1866-1931
appointed officer of French Academy, 1905, *13885*
exhibitions, Society of Western Artists, 1902, *13388*, *13542*
illustrations, *My newsboy*, *12986*, *13886*
Waldeck, Jean Frédéric Maximilien, *comte* de, 1776-1875
illustrations
views of bell founding, *21091*
views of lumber production, *20758*
Waldeck, Nina V., 1868-1943
illustrations, *Stunted, but sturdy*, *22537*
Walden, Lionel, 1861-1933
elected member, Society of American Painters of Paris, 1901, *13228*
elected to art committee of American Art Association, Paris, 1903, *13701*
exhibitions
American Art Association of Paris, 1898, *24043*
American Art Association of Paris, 1899, *12890*
American Art Association of Paris, 1906-7, *14252*
Chicago Art Institute, 1897, *Steel works at night*, *6463*
Chicago Art Institute, 1902, *13536*
St. Louis Exposition, 1894, *5036*
St. Louis Exposition, 1894, painting of coal barges, *11402*
Salon, 1887, *2449*
Salon, 1896, award, *23626*
Salon, 1903, medal, *13618*
illustrations, *Toilers of the sea*, *4979*
Waldmüller, Ferdinand Georg, 1793-1865
Children leaving school, in collection of International Art Union, *21427*, *21437*
Waldo and Jewett
illustrations, *Portrait of Colonel John Trumbull*, *432*
Waldo, George Burrette, fl.1895-1898
competitor for Lazarus scholarship, 1897, *23174*
Waldo, Samuel Lovett, 1783-1861
exhibitions, National Academy of Design, 1861, *20354*
George Washington Parke Custis, acquired by the Corcoran Gallery, 1878, *9037*
obituary, *20358*
Waldorf Astoria Hotel See: **New York. Waldorf Astoria Hotel**
Waldorp, Antonie, 1803-1866
On the banks of the Meuse, *22044*
Waldstein, Charles See: **Walston, Charles**
Wales
description, southern coast, *10019*
description and views, *10423*, *10444*, *10458*
Wales, George Washington, d.1896?
bequest to Boston Museum of Fine Arts, *17090*
collection, pottery and porcelain bequest to Boston Museum of Fine Arts, *13604*
Wales, James A., 1850-1886
caricaturist from Ohio, *16332*
obituary, *529*
Wales, Susan Makepeace Larkin, 1839-1927
exhibitions

American Watercolor Society, 1879, *9123*
Boston Art Students' Association, 1884, *10898*
Walker Art Gallery, Liverpool See: **Liverpool (England).**
Walker Art Gallery
Walker Art Museum, Bowdoin College See: **Brunswick**
(Maine). Bowdoin College. Museum of Fine Arts
Walker, Charles Alvah, 1848-1920
developes monotype process, *9572*
drawings in printers' ink on copperplate, *475*
etchings, *1000, 1021*
exhibitions
New York, 1883, *24569*
New York, 1887, monotypes, *25440*
Prize Fund Exhibition, 1886, *25304*
Walker, Charles Howard, 1857-1936
commissioned to buy photographs of German architecture for
Boston Public Library, 1899, *12920*
instructor at Boston School of Drawing and Painting, 1892,
4055
Walker, Evelyn, fl.1892
exhibitions, Ladies Art Association of New York, 1892, *26806*
WALKER, F. E., 6852
WALKER, Frances Antill L., 1872-1916, 6883, 6911, 6964, 6994
Walker, Frances Antill L., 1872-1916
illustrations
Gladiola, 7972
Hollyhocks, 7077, 7080
Narcissus, 8001
Roses, 8028
White tulips, 6883
Walker, Frederick, 1840-1875, *3674, 8738*
artist in *Trilby*, *4973*
character in DuMaurier's *Trilby*?, *5073*
charcoal drawings, *14620*
design for a poster, *21996*
exhibitions
London, 1876, *8626*
London, 1876, life-work exhibition proposed, 1875, *8517*
London, 1885, drawings, *10151*
Fishmonger's shop, etched by R. Macbeth, *25380*
notes, 1893, *4282*
obituary, *8497*
painting of Jesus Hospital near Bray, England, *9725*
Vagrants, etched by Waltner, *9920*
wood cuts, *9628*
works in National Art Collection, London, 1897, *6397*
Walker, H. O. See: **Walker, Henry Oliver**
Walker, Harriet Sarah Thayer
collection, bequest to Boston Museum of Fine Arts, 1903,
13594
Walker, Henry Oliver, 1843-1929
decoration for New York Appellate Court
collaborative design, 1898, *6613*
mural, *12997*
elected to National Academy of Design, 1902, *13436*
exhibitions
Architectural League of New York, 1888, *2873*
Boston, 1892, *26576*
Charleston Inter-State and West Indian Exposition, 1901-
1902, gold medal, *13436*
Fellowcraft Club, 1890, *26181*
National Academy of Design, 1890, *3228*
National Academy of Design, 1891, *3603*
National Academy of Design, 1894, *4873*
National Academy of Design, 1895, *5340*
National Academy of Design, 1895, wins Clarke prize, *5341*
National Academy of Design, 1903, *13702*
New York Athletic Club, 1898, *6643*
Prize Fund Exhibition, 1889, *2960*
Society of American Artists, 1888, *2678*
Society of American Artists, 1889, *2986*
Society of American Artists, 1892, *3986*
Society of American Artists, 1892, *Pandora*, *26660*
Society of American Artists, 1894, *4834*
Society of American Artists, 1894, Shaw prize, *22540*

Society of American Artists, 1895, *5338*
Fortune and the child, 26279
illustrations, *Musa Regina, 13792*
painting, 1883, *24525*
pictures in Evans collection, *11775*
studio, Boston, 1886, *2304*
Walker, Horatio, 1858-1938, *6564*
exhibitions
American Art Galleries, 1887, *10832*
American Watercolor Society, 1887, *2384*
American Watercolor Society, 1888, *10843*
American Watercolor Society, 1889, *2883*
American Watercolor Society, 1894, *22540*
American Watercolor Society, 1896, *Potato pickers*, *5696*
American Watercolor Society, 1898, *Milking: a summer
morning*, *6556*
Charleston Inter-State and West Indian Exposition, 1901-
1902, gold medal, *13436*
National Academy of Design, 1888, *2695*
National Academy of Design, 1891, *26313*
National Academy of Design, 1892, *Morning*, *3953*
National Academy of Design, 1899, *17566*
National Academy of Design, 1899, *Oxen drinking*, *6955*
New York, 1893, *16316*
New York, 1897, *10539, 17293*
New York, 1900, *13038*
Oxford Club of Brooklyn, 1890, *15039*
Pennsylvania Academy of the Fine Arts, 1906, gold medal,
14077
Prize Fund Exhibition, 1887, *2456*
Prize Fund Exhibition, 1888, *2700*
Society of American Artists, 1887, *2452, 25451*
Society of American Artists, 1888, *10846*
Society of American Artists, 1889, *2986*
Society of American Artists, 1890, *25895*
Society of Washington Artists, 1905, *13886*
illustrations
Girl feeding turkeys, 13851
Pastoral, 591
portrait of Henry W. Ranger, *2605*
Rainy day, 5945
Return from the field, 6550
Sheep-shearing, 13716
Spring plowing, 13101, 13982
painting in the Ladd collection, 1893, *16359*
paintings, *20482*
picture in Crowell collection, *15184*
picture in Evans collection, *15079*
pictures, *14939*
sales and prices, 1905, *13868*
watercolor on view in New York, 1892, *15887*
watercolors, *10826*
works recommended to collectors, 1889, *14941*
Walker, Isaac
collection, sale, 1889, *2858*
Walker, James Alexander, d.1898
exhibitions, Salon, 1884, *25133*
Walker, John Brisben, 1847-1931
plan to found University, 1897, *23943*
Walker, Nellie Verne, 1874-1973
illustrations, *Funeral procession - from life, 13624*
Walker, Robert, 1607-1658
illustrations, *Children carrying flowers* (after Rubens), *2163*
WALKER, Robert, 10332
WALKER, Robert, fan collector, 9769
Walker, Robert, *fan collector*
collection, fans, sale, London, 1882, *1451*
Walker, Sophia Antoinette, 1855-1943
genre portraits, *22525*
Walker, Thomas Barlow, 1840-1928
collection, *15032, 15797*
acquisitions, 1891, *15709*
Minneapolis, Minnesota, *11444, 12912, 12924*
Walker, Wilhelmina, fl.1894-1898
exhibitions, Woman's Art Club of New York, 1895, *5260*

stamped paper a precursor, *7338*
stamped wall leather, *795*
styles, 1896, *5755*
technique for coloring designs, *4209*
technique for printing designs, *4166*
use of nature sketches, *5008*
wallpaper, American
Colman and Tiffany designs, *898*
manufacture, *13170, 13934*
wallpaper, English
Crane's peacock frieze, *25669*
designs, *9401, 9417*
walls
designs for dados, *9284*
dining room, *9511*
William Morris on wall color, *5149*
Walpole family
Houghton Hall, *10404*
Walpole, Horace, 1717-1797
anecdote, *6587*
collection, sale, 1883, *1635*
memoir by Dobson illustrated by Percy Moran, *15405*
Walsh, Blanche, 1873-1915
portraits, photograph, *23222*
Walsh, Richard M. L., fl.1896-1910
exhibitions, National Academy of Design, 1897, *10540*
Walsh, William Shepard, 1854-1919
notes, 1893, *16122*
Walston, Charles, 1856-1927
appointed Slade Professor at Cambridge, 1895, *21531*
director, American Archaeological Institute, Athens, 1892, *26495*
elected director of Fitzwilliam Museum, 1883, *9919*
lectures in New York, 1884, *25007*
lectures on Platea excavations, 1890, *3310*
offered post of director of American School at Athens, 1887, *10409*
permission to excavate at Sparta, 1892, *26577*
report on Argos excavations, 1893, *16261*
Walter, Edgar, 1877-1938, *22168*
Walter, James
claims for authenticity of Sharples' portraits, *537*
defends authenticity of Sharples' portraits of Washington, *10763*
Walter, Solly, 1846-1900
obituary, *22096*
Walter, Thomas Ustick, 1804-1887
officer, American Institute of Architects, 1859, *19970*
Walters, Curtis, fl.1904-1905
exhibitions, Indianapolis Sketching Club, 1903, *13714*
illustrations, bookbinding, *13950*
Walters, Frederick Arthur, fl.1890-1892
watercolor method described by Louise Jopling, 1891, *3800*
Walters, George Stanfield, 1838-1924
exhibitions, Boston, 1896, *17165*
Sheepfold, at American Art Galleries, 1889, *14972*
Walters, Henry, 1848-1931
collection
1900, *7452*
acquires Raphael's *Vierge et candelabres*, 1901, *13225*
acquisitions, 1899, *6902*
museum for collection in Baltimore planned, 1905, *13810*
opens galleries, 1899, *12859*
purchased Massaranti collection, 1903, *13668*
erects gallery for Massaranti collection, 1906, *14089*
Walters, William Thompson, 1820-1894
collection, *858, 1003, 1045, 1066, 1931, 11245, 15797, 15811, 17600*
acquires Richards and Lambdin paintings, 1859, *20114*
Baltimore, *7568*
Barye bronze room, *1877*
catalogue in preparation, 1891, *15560*
catalogue of oriental ceramics, *22431*
description, 1887, *17787*
Díaz and Dupré, *22240*
exhibited in Baltimore, 1881, *352*

Fortuny and Bonnat, *22259*
gallery of pictures open to public, 1880, *9310*
gift of Barye works to Baltimore, 1893, *22264*
Millet and Corot paintings, *22226*
offered to city of Baltimore, 1892, *26507*
open to public, 1884, *25120*
open to public, 1891, *15617*
open to public, 1895, *16691*
open to public, 1896, *16953*
opened to public for benefit of Poor Association, 1887, *565*
opens Baltimore gallery for benefit of City Poor Association, 1880, *9326*
opens Baltimore gallery for benefit of City Poor Association, 1887, *10773, 25400*
opens to public for benefit of Poor Association of Baltimore, 1884, *25054*
peach-blow vase scandal, 1891, *3528, 3560*
pictures, *22213*
Prang lithographs of collection, *17227*
purchases Corot's *St. Sebastien*, 1884, *1694*
Rousseau's *Givre*, *15056*
shown for benefit for Poor Association, 1892, *26506*
triumph for American art, *25063*
valued at $1,000,000, 1887, *17763*
weeding Oriental ceramics, 1887, *546*
collector, *3561*
donates casts to Maryland Institute, 1880, *211*
obituary, *5170, 16616*
poem by M. Nicholson, *22327*
offers funds for Sunday openings of Metropolitan Museum, 1889, *25586*
publication on French critics, *546*
will, 1894, *16628*
Waltham (Massachusetts). Waltham Pencil and Brush Club
exhibitions, 1884, sketches and oils, *25109*
Waltmann, Harry Franklin, 1871-1951
exhibitions, New York, 1901, *13202*
Waltner, Charles Albert, 1846-1925
Abreuvoir (after Troyon), *1069*
Angelus (after Millet), *10795, 14988*
Christ before Pilate (after Munkacsy), *9952*
etchings after Rembrandt and Marcus Stone, published, 1884, *10022*
illustrations
Angelus (after Millet), *25641*
Gilder (after Rembrandt), *1930*
Last Supper (after Dagnan Bouveret), *17154*
Night watch (after Rembrandt), *527*
portrait of Domer (after Rembrandt), *1931*
Sibyl (etching after Burne Jones), *9876*
sued by print dealer over Rembrandt etching, 1884, *1751*
Vagrants (after F. Walker), *9920*
WALTON, Clifford Stevens, *23187*
Walton, Edward Arthur, 1860-1922
elected to Royal Scottish Academy, 1905, *13900*
exhibitions
Carnegie Galleries, 1898, honorable mention, *12270, 12804*
Carnegie Galleries, 1900, *13130*
Glasgow Institute, 1892, *26596*
Glasgow School painter, *22394*
illustrations
Alice, *11625*
Shepherd, *14328*
Walton, Elijah, 1832-1880
obituary, *192, 9422, 21937*
Walton, Izaak, 1593-1683
Compleat Angler
new edition, *12568*
Nicolas edition, *17074*
inscription found, *16948*
memorial stained glass window, 1895, *16746*
Walton, Octavia See: **LeVert, Octavia Walton**
WALTON, William, *2606*
Walton, William, 1843-1915
exhibitions

Lhermitte's *Washerwomen on the banks of the Marne* illustrated, *4727*

Warren, Edmund George, 1834-1909
 exhibitions
 Royal Institute of Painters in Water Colours, 1858, *19898*
 Royal Institute of Painters in Water Colours, 1861, *20374*

Warren, Edward Perry, 1860-1928
 collection, Greek gems exhibited in London, 1903, *13652*

WARREN, Edward Royal, *14027*

Warren, Eleanor See: **Motley, Eleanor Warren**

Warren, Gouverneur Kemble, 1830-1882
 monuments
 monument proposed, 1891, *26433*
 statue by Henry Baerer, *26440*

WARREN, Harold Broadfield, *21470*

Warren, Harold Broadfield, 1859-1934
 drawings by Harvard art pupil, 1885, *1949*
 exhibitions, Prize Fund Exhibition, 1886, *2226*

Warren, Henry, 1794-1879
 illustrations, *Story-teller*, *20798*
 obituary, *64*

Warren, Joseph, 1741-1775
 monuments
 pedestal of Prospect Park statue criticized, 1896, *5933*
 proposed, 1850, *14696*
 statue by Dexter, 1857, *19596*

Warren, Knighton, fl.1878-1892
 illustrations, portrait, *6739*

Warren, Mabel
 spirit portrait, *20676*

Warren, Samuel Dennis, *Mrs*. See: **Warren, Susan Cornelia Clarke**

Warren, Susan Cornelia Clarke, 1825-1901
 collection
 acquires Puvis de Chavannes paintings, 1895, *16672*
 catalogue for sale, 1902, *8084*
 exhibited at American Art Galleries, 1903, *8102*
 sale, 1902, *8059*
 sale, 1903, *13503, 13551*
 sale, 1903, prices listed, *8124*

Warren, Wilmot L.
 collection, on exhibit, American Art Association, 1889, *25585*

warships
 United States, battle between *Monitor* and *Merrimac*, *23195*

Warwick (England). Warwick Castle
 history, *21235*

Warwick, Frances Evelyn Maynard Greville, *countess* of, 1861-1938
 exhibitions, London, 1878, china painting, *21623*

Warwick, George Guy, *4th earl of*, 1818-1893
 collection, sale, 1896, *17068, 17102*

Warwickshire (England)
 description, *19015*
 gardens, Arlescote, *6264*

Washburn, Cadwallader Lincoln, 1866-1965
 exhibitions, American Art Association of Paris, 1897, *24010*
 illustrations
 Casa Cecchino (etching), *14159*
 Flowers and trees, *22528*

Washburn, Elizabeth See: **Brainard, Elizabeth Homes Washburn**

WASHBURN, W. J., *Mrs.*, *12383*

Washington and Lee University See: **Lexington (Virginia). Washington and Lee University**

Washington Association of New Jersey See: **Morristown (New Jersey). Washington Association of New Jersey**

Washington, Booker Taliaferro, 1856?-1915
 notes, 1895, *22860*

Washington (D.C.)
 architecture
 Baltzel house in Georgetown, *16038*
 shipment of marble for government buildings, *18064*
 Treasury, Patent Office, Post Office, *19418*
 art
 1855, *18619, 18667*

1882, *24387*
1887, private picture-galleries, *17787*
cannot compare to New York as art center, *501*
lack of interest in art, 1899, *17626*
portrait series of Secretaries of the Treasury hung in Departments of War and Justice, 1880, *9326*
sculpture commissioned by Congress, 1875, *8478*
 artists, *22587*
 artists' convention, 1860, *20146*
 Capitol, *19402*
 appointment of Art Commission to regulate art, 1859, *18319, 20051*
 art, *19913*
 art commission proposed, 1901, *13309*
 art criticism, *18319*
 art projects, *19263*
 bronze doors commissioned, 1903, *13618*
 bronze doors designed by Crawford and Rinehart, *13953*
 Brumidi's successor for decoration selected, 1880, *102*
 building extension, *18881, 19154, 19232*
 building extension sculpture, *20064*
 congressional bill to form Art Commission, 1901, *13265*
 decoration, *14717*
 decoration and cost, *18079*
 decoration by Crawford, *19596*
 dissolution of Art Commission, 1860, *18468*
 dome, *18953*
 doors, *10672*
 doors by Rogers completed, 1860, *24340*
 extension, *19516*
 House of Representatives' ceiling, 1856, *19565*
 interior decoration, *18146*
 Ney statues installed, 1904, *13781*
 painting cleaned and restored, 1894, *27016*
 paintings by H. Vernet, *19626*
 plans to enlarge, 1851, *14731*
 Rotunda frescoes, *683, 9141*
 Rotunda frieze, *46*
 Rotunda frieze completed, 1906, *14051*
 Rotunda paintings ordered by Congress, 1855, *18667*
 Rotunda paintings restored, 1883, *14896*
 sculptures by Crawford and paintings by Brumidi, *19645*
 statue of General Baker by Horatio Stone, *8698*
 statue of Jefferson by David d'Angers, *25481*
 Thomas Crawford's sculptural decoration, *3867*
 U.S. Art Commission report, 1860, *20191, 20195*
 city improvements, 1851, *14808*
 exhibitions
 1898, *6669*
 bill to establish permanent international exposition in District of Columbia, *13563*
 National Fair, 1879, art department, *772*
 monuments, *14271*
 all designs rejected for McClellan monument, 1903, *8262*
 bill to erect statue of Grant, 1890, *25918*
 bills in congress for Washington and McClellan statues, 1901, *13213*
 bust of Hannibal Hamlin, *26143*
 competition for equestrian statue of General Sherman, *12949*
 cost of monuments and statues, *26816*
 designs for statue of Lafayette, 1887, *574*
 Grant Memorial Statue of Niehaus and Shrady, *8035*
 Hahnemann monument competition models, *5262*
 Jefferson Memorial planned, 1903, *8238*
 Lafayette monument placed, 1891, *26322*
 Lafayette statue ceremonies, 1892, *26607*
 McClellan commission rejects all models, 1903, *13627*
 McClellan models submitted, 1902, *13436*
 memorial to Grant proposed, 1890, *26089*
 models for statues of Hancock and Logan, 1892, *26871*
 monument to Charles Dickens, *26134*
 monumental arches, *24707*
 obelisk proposed, 1903, *8306*
 plans for monument to Columbus, 1902, *13455*
 Rochambeau statue paid for by Congress, *13421*

Young woman of the time of Louis Treize, 2647
Watkins, Susan See: **Serpell, Susan Watkins**
Watkinson Library See: **Hartford (Connecticut). Watkinson Library of Reference**
Watmough, Amos, fl.1879-1885
 illustrations
 Puerta del vino, Alhambra (after H.H.J.), *21911*
 view of Aston Hall, *21725*
Watrous, Harry Willson, 1857-1940
 exhibitions
 National Academy of Design, 1894, *4873*
 National Academy of Design, 1897, *10540*
 Union League Club of New York, 1884, *Drawn game*, *25193*
 Union League Club of New York, 1890, *25779*, *26189*
 Union League Club of New York, 1891, *26224*
 Union League Club of New York, 1893, *26905*
 sales and prices, 1889, *14961*
 studio, *22686*
 whereabouts, 1896, summer on Lake George, *23056*
Watson, A. Francis See: **Wattson, A. Francis**
Watson, Albert Mortimer, *Mrs.* See: **Taylor, Elizabeth Vila**
Watson, David Thompson, 1844-1916
 collection, paintings in Carnegie Institute annual exhibtion, 1902, *13520*
Watson, Dawson See: **Dawson Watson, Dawson**
Watson, Elizabeth Vila Taylor See: **Taylor, Elizabeth Vila**
Watson, Eva Lawrence See: **Watson Schütze, Eva Lawrence**
WATSON, George R., *22801*
Watson Gordon, John, 1788-1864
 knighthood, 1850, *14658*
Watson, Harry S. See: **Watson, Henry Summer**
Watson, Henry Summer, 1868-1933
 illustration for *Cosmopolitan*, 1893, *22490*
 illustrations
 Jib-boomer, *22560*
 Knowing one, *22610*
 On strictly correct lines, *22519*
 Taking it easy, *22576*
 Unmistakable type, *22590*
 illustrations in magazines, 1892-3, *22482*
 illustrator, *22498*
 Lawzy! Don't I reckollect!, *22638*
 notes, 1894, *22546*
 portraits, photograph, *22502*
 Wheeling, *22503*
Watson, John, 1685-1768, *21316*
 first American limner, *14646*
 first professional painter in America, *12705*
Watson, John, 1850-1907
 notes, 1897, *23178*
 stories translated into French, *23793*
Watson, John Dawson, 1832-1892
 exhibitions
 Manchester, 1878, *21647*
 Royal Academy, 1880, *21863*
 illustrations
 decorative panel, *22001*
 stained glass window, *22001*
 Taking home the bride, *9560*
 obituary, *26498*
 paintings destroyed by fire at Portland, 1905, *13996*
 Parting, *8613*
 When the kye come hame (with W. M. Fisher), *9717*
Watson, M. L. D., *Mrs.*, fl.1887
 exhibitions, Salmagundi Club, 1887, *534*
 illustrations, studies of children, *533*
Watson Schütze, Eva Lawrence, 1867-1935, *13086*
 exhibitions
 Chicago, 1900, *13106*
 Chicago Photographic Salon, 1900, *13035*
 Philadelphia Photographic Salon, 1900, *13120*
 illustrations
 In the woods (photograph), *13738*, *13894*
 Snow shadows (photograph), *13738*
 Study of the chubby hands of childhood (photograph), *14187*

Watson, William, d.1921
 Highland sheep, in Walker collection, Minneapolis, *12924*
Watt, James, 1736-1819
 inventions, *20953*
Watteau, Jean Antoine, 1684-1721, *21209*, *26010*
 drawing, *1898*
 illustrations
 Country dance, *4486*
 Cupids' conquest, *7970*
 decorative composition, *1913*
 Fete champetre, *4219*
 figure sketches, *3471*
 figure studies in red chalk, *1844*
 head of child, *3077*
 In the harvest field, *4591*
 Lesson in love, *3109*
 Minuet, *4541*
 Music lesson, *2828*
 pencil study of woman, *9586*
 studies of female heads, *13788*
 Troubador, *4219*
 Waiting, *4377*
 monuments
 monument in Gardens of Luxembourg unveiled, 1896, *17176*, *23684*
 notes, 1898, *17441*
 painting in Ruthrauff collection, 1896, *16905*
 portrait of Mme. Victorre, *7483*
 sales and prices
 1891, *26376*
 1892, *15811*
 1896, *17063*
 Staley's *Watteau and His School*, 1903, *8165*
 tapestry design, *2550*
 work in the Hertford House collection, 1900, *7401*
WATTERSON, Henry, *14293*
Watterson, R. C. See: **Waterston, Robert Cassie**
WATTS, Anna Mary Howitt, *19286*, *19342*, *19764*, *19811*, *19844*, *19869*, *20878*, *20933*, *20945*, *20962*, *20995*, *21013*, *21037*, *21074*, *21093*, *21114*
Watts, Anna Mary Howitt, 1824-1884
 illustrations, illustrations to *School of Life*, *20878*, *20933*, *20945*, *20962*, *21013*
WATTS, George Frederick, *11264*
Watts, George Frederick, 1817-1904, *1881*, *9909*, *21642*
 appointed trustee of National Portrait Gallery, London,1896, *17116*
 Ascension, reproduced in mosaic, 1886, *10281*
 Britomart and her nurse, *21678*
 builds church, 1896, *17187*
 collection, donated to London National Portrait Gallery, 1895, *16894*
 comment on women's fashion, 1892, *3912*
 criticizes realism of Verestchagin, *2858*
 Dawn, in progress, 1903, *13672*
 declines baronetcy, 1894, *4832*
 donation to London Home Arts and Industries Association, 1895, *22765*
 equestrian statue of Hugh Lupus, *21792*
 exhibitions
 Chicago World's Fair, 1893, *4604*, *4653*, *4766*
 Edinburgh, 1890, *Paolo and Francesca*, *25983*
 Grosvenor Gallery, 1878, *21584*
 Grosvenor Gallery, 1880, *21874*
 Grosvenor Gallery, 1881, *22013*
 Grosvenor Gallery, 1883, *9828*
 Grosvenor Gallery, 1887, *25455*
 Leighton House, 1903, *8222*
 London, 1886, *2245*
 London, 1890, *Ariadne*, *25994*
 London, 1901, *13240*
 London, 1904, *13747*
 London, 1905, memorial exhibition, *13974*
 Metropolitan Museum of Art, 1884, *11100*, *25186*
 Metropolitan Museum of Art, 1885, criticized, *11133*

magazine illustration, 1894, *22517*
Wechter, Georg, 1526-1586
design for a silver cup, *1403*
Weckesser, August, 1821-1899
historical painting, *19853*
weddings
floral decorations for home weddings, *5386*
Wedgwood, Josiah, 1730-1795
centenary of death celebrated by exhibitiion, 1895, *16865*
copies of Barberini Vase, *3643*
porcelain industry, *1373, 23340*
WEDMORE, Frederick, *9482, 9637, 9771, 9832, 10125, 10189, 13891*
Wedmore, Frederick, 1844-1921
article on Whistler as etcher, *729*
Etching in England, review, *16882*
lecture on living English painters, *1109*
response to Whistler's attack on critics, *9233*
Whistler's Etchings, review, *25402*
Wednesday Club of Baltimoree See: **Baltimore (Maryland).**
Wednesday Club of Baltimore
Weed, Raphael A., d.1931
pyrography, *7110*
Weed, W. Francis, fl.1895
illustrations, *Hopeful of a bite*, *22610*
Weeden, Howard, 1847-1905
Southern artist, *503*
Weeden, Maria Howard See: **Weeden, Howard**
Weedon, Augustus Walford, 1838-1908
illustrations, *Putney bridge*, *9436*
Weehawken (New Jersey)
architecture, F. Wallis's design for Karl Bitter's studio
Lueginsland, 23213
Weekes, Frederick, fl.1854-1908
drawings for Bakers' Hall decorations, *9888*
Weekes, Henry, 1807-1877
obituary, *8860*
Weekes, William, fl.1864-1909
Daring highway robbery, published in mezzotint, 1886, *10302*
WEEKS, Caleb S., *20658*
Weeks, Caleb S.
phrenological interpretation of Jesus, *20683*
WEEKS, Charlotte J., *21881, 22009*
Weeks, Charlotte J., fl.1876-1903
illustrations, views of Taufers, Austria, *21881*
Weeks, Edwin Lord, 1849-1903
anecdote, *1671*
article, with illustrations, on Indian life and art, 1894, *27018*
elected to Academy of Florence, 1884, *25018*
elected to Carnegie Institute jury of awards, 1897, *12020*
exhibitions
Boston, 1878, *8994*
Boston, 1883, *24925*
Carnegie Galleries, 1900, *13130*
Chicago Inter-State Industrial Exposition, 1889, *3056*
Louisiana Purchase Exposition, 1904, *13785*
National Academy of Design, 1903, *13702*
Paris, 1902, *13372*
Paris Exposition, 1889, *Raja de Jodhpore, 25724*
Pennsylvania Academy of the Fine Arts, 1882, *1450*
Pennsylvania Academy of the Fine Arts, 1883, *1677*
Prize Fund Exhibition, 1886, *25304*
St. Louis Exposition, 1897, *12015*
Salon, 1883, *24521*
Salon, 1885, *2000*
Salon, 1886, *2193, 2206*
Salon, 1887, *571, 2449*
Salon, 1889, *2938, 2985*
Salon, 1891, *3624*
Salon, 1904, *13747*
Venice, 1901, *13257*
Halt, 1494
illustrations
Beggars of Cordova, 4494
Mogul Emperor returning from prayer, 2197

Paris success, *980*
WEEKS, F. C., *13921*
WEEKS, Lyman Horace, *508, 531, 534, 549, 552, 568, 614, 621, 630*
Weeks, Robert E., fl.1903
illustrations, *Patience* (photograph), *13532*
Weerts, Jean Joseph, 1847-1927
exhibitions
Salon, 1880, *187*
Salon, 1883, *14906*
Salon, 1895, *Pour l'humanité pour la patrie, 5375*
illustrations
Cowl of resignation, 12485
decorative panels for the Sorbonne, *13605, 14131*
mural for Sorbonne reception hall, 1903, *8238*
Weertz, Jean Joseph See: **Weerts, Jean Joseph**
Wegelin, Adolf, 1810-1881
obituary, *335*
Wegerif, Christiaan, 1859-1920
illustrations, hall in Dutch section of Turin Exposition, 1902, *13502*
Wegman, Jules F., fl.1898-1913
illustrations, park entrance, *20547*
Wegner, Harry, 1850-1932
notes, 1887, *592*
Wehnert, Edward Henry, 1813-1868
exhibitions, Pennsylvania Academy of the Fine Arts, 1855, *18793*
First ragged school, 19963
German influence, *14678*
Wehrley, Edward J., fl.1890's
portraits and enlargements, *12790*
Weidenbusch, Hans
collection, sale, 1899, *17658*
Weidner, Carl A., 1865-1906
exhibitions, American Society of Miniature Painters, 1900, *13022*
Weigel, Theodor Oswald, 1812-1881
collection, sale of drawings and engravings, 1883, *14911*
Weil, Gertrude, d.ca.1900
exhibitions, American Girls' Club of Paris, 1896-7, *23717*
Weil, Leo D., fl.1896-1898
exhibitions
Chicago, 1896, photographs, *11898*
New York, 1897, non-studio photographs, *17233*
Weil, Mathilde, b.1871
exhibitions
Philadelphia Photographic Salon, 1899, *12973*
Philadelphia Photographic Salon, 1900, *13120*
Weil, Theodore G.
collection, sale, 1903, *8222*
Weiland, Johannes, 1856-1909
illustrations, *Dutch interior, 14183*
Weinert, Albert, 1863-1947
memorial monument of the Battle of Lake George unveiled, 1903, *13676*
Weinheimer, Jakob, b.1878
illustrations
decorative panel for pyrography, *7918*
landscape panel for pyrography, *7859, 7883*
Weinman, Adolph Alexander, 1870-1952
elected to Society of American Artists, 1903, *13618*
exhibitions, Pennsylvania Academy of the Fine Arts, 1905, *13853*
illustrations, sculpture for Louisiana Purchase Exposition, *13682, 13683*
sculpture for Louisiana Purchase Exposition, 1904, *13685*
Weir, Alden See: **Weir, Julian Alden**
Weir, Edith Dean See: **Perry, Edith Dean Weir**
Weir, Harrison William, 1824-1906
drawings for Bloomfield's *Farmer's Boy, 19769*
exhibitions, Royal Institute of Painters in Water Colours, 1861, *20374*
granted a pension, 1891, *26397*
illustrations

Battle Abbey, 21132
Group of humming birds, 20889
Hippopotamus as seen with his Nubian keeper, 20750
Leucoryx antelope, 20924
Malayan sun-bear, 21364
Mandrill, or ribbed-faced baboon, 20884
obituary, *14047*
Weir, Irene, 1862-1944
Pose - Drawing with Brush and Ink, review, *12226*
Weir, John Ferguson, 1841-1926
Artist as Painter, article in *Princeton Review*, 1883, *24754*
design for Bennington battle monument, 1883, *24741, 24821*
exhibitions
 Artists' Fund Society, 1885, *Roses, 25225*
 Boston Art Club, 1904, *13717*
 Boston Museum of Fine Arts, 1885, *1983*
 Carnegie Galleries, 1898, honorable mention, *12270*
 Carnegie Galleries, 1898, *Roses* receives honorable mention, *12804*
 Cincinnati Exposition, 1879, *Forging the shaft, 756*
 National Academy of Design, 1902, *13359*
Forging the shaft, 15783
lectures at Princeton, 1881, *281*
Memorial Catalogue of the Paintings of Sanford Robinson Gifford, N.A., review, *321*
response to survey on world's greatest masterpieces, 1898, *12750*
statue of Dr. Woolsey, *25805, 25977*
statue of Prof. Benjamin Silliman, at Yale, *25137*
studio, 1876, *8608*
whereabouts, 1883, vacation in Branchville, N.Y, *24829*
Weir, Julian Alden, 1852-1919
address to Art Students' League members on Bastien Lepage, 1885, *25231*
copies after old masters made for Metropolitan Museum's Loan Exhibition, 1883, *24538*
decorations for Liberal Arts Building, Chicago World's Fair, 1893, *4185, 4378, 4469*
dinner previous to departure, 1883, *24551*
executor of Gamage estate, *26952*
exhibitions
 American Art Galleries, 1887, *10832*
 American Art Galleries, 1893, *4427*
 American Watercolor Society, 1884, *1736, 25002, 25012, 25038*
 American Watercolor Society, 1884, *Sunday morning, 10932*
 American Watercolor Society, 1885, *1933*
 American Watercolor Society, 1887, *534, 2384*
 American Watercolor Society, 1888, *2641, 10843*
 American Watercolor Society, 1890, *3178, 25777*
 American Watercolor Society, 1894, *4800, 22540*
 Architectural League of New York, 1898, stained glass, *6571*
 Artists' Fund Society, 1883, *1512*
 Blakeslee Galleries, 1891, *15488*
 Boston Art Club, 1884, *24992*
 Boston Art Club, 1887, drawing, *568*
 Boston Art Club, 1899, *12837*
 Boston Museum of Fine Arts, 1880, *225, 1026*
 Boston Museum of Fine Arts, 1885, *1983*
 Brooklyn Art Club, 1892, *26501*
 Carnegie Galleries, 1897, *Face reflected in a mirror* wins bronze medal, *6462*
 Carnegie Galleries, 1903, *13675*
 Chicago Art Institute, 1902, *13536*
 Chicago Art Institute, 1903, *13673*
 Cincinnati Art Museum, 1898, *12754*
 Cincinnati Art Museum, 1900, *13067*
 Internationale Kunstausstellung, Munich, 1883, *24715*
 London, 1882, *1285*
 National Academy of Design, 1878, *9002*
 National Academy of Design, 1879, *679, 9151*
 National Academy of Design, 1880, *111*
 National Academy of Design, 1882, *9646*
 National Academy of Design, 1884, *1772, 25125*
 National Academy of Design, 1885, *1970, 25271*
 National Academy of Design, 1887, *2606, 10786, 10831, 25437*
 National Academy of Design, 1888, *2680, 25503*
 National Academy of Design, 1892, *26583*
 National Academy of Design, 1893, *4316*
 National Academy of Design, 1895, *5567*
 National Academy of Design, 1898, *17402*
 National Academy of Design, 1898, *Figure with head reflected in mirror, 6616*
 National Academy of Design, 1899, *Portrait of a young lady, 6846*
 National Academy of Design, 1903, *13547*
 National Academy of Design, 1905, Inness prize, *14062*
 National Academy of Design, 1907, *14311*
 New York, 1880, *9324*
 New York, 1883, *24905*
 New York, 1888, *2724, 10846*
 New York, 1889, *2882, 25580*
 New York, 1891, *3487, 26241*
 New York, 1893, *16243*
 New York, 1894, *Portrait of Captain Zabrinski, 4942*
 New York, 1895, *5300*
 New York, 1897, *10530, 23240*
 New York, 1898, *Noonday rest, 6619*
 New York, 1905, *13886*
 New York Etching Club, 1888, *2641, 10843*
 New York Etching Club, 1892, *3893*
 New York Etching Club, 1893, *22483*
 Pennsylvania Academy of the Fine Arts, 1903, *13548*
 Pennsylvania Academy of the Fine Arts, 1905, *13851*
 Prize Fund Exhibition, 1885, *1985, 25278*
 Prize Fund Exhibition, 1888, prize, *2700*
 Salon, 1883, *1568, 1588*
 Society of American Artists, 1878, *8993*
 Society of American Artists, 1879, *9150*
 Society of American Artists, 1880, *94, 844*
 Society of American Artists, 1881, *367, 1130*
 Society of American Artists, 1882, *1327*
 Society of American Artists, 1883, *1551*
 Society of American Artists, 1886, *2227*
 Society of American Artists, 1887, *562, 2452, 10789*
 Society of American Artists, 1889, *2986*
 Society of American Artists, 1891, *26329*
 Society of American Artists, 1892, *3986, 22483, 26634*
 Society of American Artists, 1893, *4235*
 Society of American Artists, 1894, *4834*
 Society of American Artists, 1895, *5338, 21531*
 Society of Painters in Pastel, 1888, *2696*
 Ten American Painters, 1898, *12710*
 Ten American Painters, 1899, *6954*
 Ten American Painters, 1900, *13038*
 Ten American Painters, 1906, *14095*
 Worcester Art Museum, 1902, *13483*
illustrations
 Birds of Paradise, 2776
 Gentlewoman, 14082
 Portrait, 10834
 Roses, 6817
 stained glass window, *13132*
 Summer evening, 14244
 Sunday morning, 1731
 window for church, *13897*
 window for Church of the Ascension, *12836*
illustrations for *Scribner's Magazine, 22482*
letter on American art gallery at Metropolitan Museum, 1899, *17484*
marries Kate Baker, 1893, *22521*
member, Society of American Artists, *11241*
member, Tile Club, *1851, 11267*
notes, 1883, *24631*
picture in Evans collection, *15079*
pictures shown at Century Club preview, 1884, *25064*
portrait of Dr. Hodge, 1883, *24502*
portrait of Peter Cooper commissioned by Union League Club, 1884, *25051*

New York artists' reception, 1858, *19800, 19817*
Scene in Berkshire Country, Mass, 19875
studies of New York and New Hampshire, *19930*
View of Great Barrington, 14484
description by artist, *14580*
Wenzler, Henry Antonio See: **Wenzler, Anthon Henry**
Wenzler, Wilhelmina, d.1871?
exhibitions, National Academy of Design, 1863, *23266*
Werenskiold, Erik Theodor, 1855-1938
exhibitions, Berliner Secession, 1902, *13372*
Werner, Anton Alexander von, 1843-1915
cartoon for mosaic, Column of Victory, Berlin, *8367*
exhibitions
Internationale Kunstausstellung, Munich, 1879, *21752*
Paris Exposition, 1878, *9109*
German military painter, *10381*
painting of Berlin Congress, *21895, 21897*
paintings, 1892, *26763*
picture of Emperor William commissioned, 1891, *26376*
Proclamation of the German emperor at Versailles on January 18, 1871, 8848
sketching Prince Bismarck, *10302*
Werner, Carl, 1875-1943
exhibitions, Paris Exposition, 1900, first prize, *22093*
Werner, Carl Fridrich Heinrich, 1808-1894
exhibition
Royal Institute of Painters in Water Colours, 1861, *20374*
WERTHEIMBER, Louis, 483, 497, 511
Wertheimber, Louis
Muramasa Blade, illustrated publication, 1886, *509*
Wertheimer, Asher
advice on collecting, 1898, *6701*
collection
acquires Hope collection, 1898, *6730*
buys Dutch paintings from Lord Francis Hope, 1898, *12769*
Wertheimer, Gustav, 1847-1902
sales and prices, 1887, *Kiss of the siren, 583*
Wertmüller, Adolph Ulric, 1751-1811
Danaë, 18542
provenance, *17055*
Rembrandt Peale's reminiscences, *19081*
subject of letter from Charles H. Hart, 1896, *17036*
Wertz, Hiram, fl.1891-1896
monotypes, *23073*
Wery, Petit See: **Petit Wéry, Georges**
Wesley, Charles, 1757-1834
manuscripts, found, 1896, *16996*
remarks on hymns, *18235*
Wesley College See: **Cincinnati (Ohio). Wesley College**
Wessel, Herman Henry, 1878-1969
illustrations
drawing, *8288*
study from life, *13637*
Wesson, Daniel Baird, 1825-1906
home, bequeaths residence to Springfield for art gallery, 1907, *14300*
West, Benjamin, 1738-1820, *21316, 21671, 24407*
and the Royal Academy, *5073*
anecdote, *17697*
bibliography, *25268*
career in England, *18775*
comments by J. R. Tyson, 1858, *18152*
Death of Caesar, destroyed by fire, 1894, *16505*
Death of Wolfe, 4523, 25494
early life and works, *18440*
etching, *961*
excerpt from Dr. Waagen, *18752*
exhibitions, New York, 1890, *Expulsion from Eden, 3208*
friendship with Matthew Pratt, *18995*
landscapes acquired by South Kensington Museum, 1899, *7016*
Lear discovered in the hut by Gloucester, in Walker collection, Minneapolis, *12924*
monuments
memorial planned for Swarthmore, 1901, *22125*
statue to be erected in Swarthmore, 1901, *13161*

notes, 1901, *7641*
Penn's treaty with the Indians, 14808
portraits
portrait in British National Portrait Gallery, *6528*
profile by a physiognotrace, *19712*
Raising of Lazarus
acquired by Wadsworth Atheneum, 1900, *7427, 13106*
sales and prices
1851, *Penn's treaty with the Indians, 14791, 14795*
1896, *Raising of Lazarus* offered for sale, *5693, 11765, 16953, 17140*
1898, *Raising of Lazarus* on art market, *17428*
1900, *Raising of Lazarus, 22084*
West, Charles Edwin, 1809-1900
collection, *15787*
prints, *1607*
West, George Parsons, Mrs. See: **Percy, Isabelle Clark**
West, George R., fl.1855-1857
whereabouts, 1855, Georgetown, *18667*
West Indian Exposition See: **Charleston (South Carolina). South Carolina Inter-State and West Indian Exposition, 1901-1902**
West, Isabelle Clark See: **Percy, Isabelle Clark**
West, Mabel, fl.1899-1900
art teacher in Indianapolis, *12918*
West, Margaret See: **Kinney, Margaret West**
West, Margaret W., fl.1895-1901
illustrations, *Landscape, 11416*
West, Mary, fl.1892
exhibitions, Palette Club of Chicago, 1892, *11307*
West Point (New York)
West Point chain, *16502*
West Point (New York). United States Military Academy
acquisitions, 1889, portraits of Generals Grant, Sherman and Sheridan, *25656*
Biographical Dictionary of the Officers and Graduates of the United States Military Academy at West Point by G. W. Cullum, recommended to collectors, *15651*
classes
art instruction by C. W. Larned, 1883, *24716*
status of art and language classes, 1856, *19520*
WEST, Richard W., 9992
West, William, fl.1812-1830
theatre prints, *10413, 10425*
West, William Edward, 1788-1857
paintings in American Art Union Gallery, 1849, *14496*
Westall, William, 1781-1850, *14607*
Westcott, Lillian See: **Hale, Lillian Westcott**
Western Academy of Art See: **Saint Louis (Missouri). Western Academy of Art**
Western Art Union See: **Cincinnati (Ohio). Western Art Union**
Western Association of Architects
annual convention, 1886, Chicago, *516*
Western China Decorating Works See: **Chicago (Illinois). Western China Decorating Works**
Western Drawing Teachers' Association
annual meeting
1896, *5857*
1897, St. Louis, *11947, 11966*
congress, 1896, *11762*
notes
1895, *11523*
1899, *12914*
Western, Lucille, 1843-1877
manifestation of spirit writing, *20713*
Western Reserve School of Design for Women See: **Cleveland (Ohio). Western Reserve School of Design for Women**
Western Reserve University See: **Cleveland (Ohio). Western Reserve University**
Western United States
artists, *23030*
description and views, *8766, 8780, 8796, 8809, 8824, 8835, 8853, 8863, 13118, 13180, 18108, 18871, 18890, 20066*

New York, 1898, *17394*
New York, 1898, etchings, *6785*
New York, 1900, *13141*
New York, 1902, *8035*
Paris, 1887, *574*
Paris, 1901, *13209*
Paris Exposition, 1878, *21606*
Paris Exposition Internationale, 1883, *14919*
Pennsylvania Academy of the Fine Arts, 1882, *1495*
Pennsylvania Academy of the Fine Arts, 1894, *4754*
Pennsylvania Academy of the Fine Arts, 1898, *Symphony in violet and blue, 6532*
Pennsylvania Academy of the Fine Arts, 1899, *12836, 17503*
Pennsylvania Academy of the Fine Arts, 1902, *13363*
Pennsylvania Academy of the Fine Arts, 1902, gold medal, *13379*
Pennsylvania Academy of the Fine Arts, 1903, *13548*
Pennsylvania Academy of the Fine Arts, 1904, *13716*
Pennsylvania Academy of the Fine Arts, 1906, *14244*
Petit Gallery, 1887, *2482*
Salon, 1859, *18315*
Salon, 1882, *M. Harry-Wen, 9656*
Salon, 1883, *24631*
Salon, 1883, medal, *14886*
Salon, 1884, *1806*
Salon, 1891, *3649*
Salon, 1892, *4013*
Salon, 1894, *4939, 27007*
Salon, 1902, *13414*
Society of American Artists, 1879, *9150*
Society of American Artists, 1882, *9635*
Society of American Artists, 1893, *4235*
Society of American Artists, 1898, *6618*
Society of American Artists, 1899, *Music room, 6957*
Society of American Artsist, 1899, *17552*
Society of British Artists, 1885, *10183*
Society of British Artists, 1887, *10452, 25442*
Society of Portrait Painters, 1902, *13361*
expatriate American artist, *11197*
feud with George Moore, 1895, *16746*
forgery of painting, *3009*
Gentle Art of Making Enemies
 republished, 1893, *16151*
 review, *3304*
George Moore's praise in *Modern Painting, 22275*
Harmony in blue and gold, on view in London, 1886, *10327*
head of International Society of Sculptors, Painters and Gravers, 1898, *12740*
honorary member, Royal Scottish Academy, 1902, *13421*
illustrations
 Battersea, 13084
 Joe, 13051, 14226
 Music room, 13807
 Old Battersea bridge (etching), *9447*
 Portrait of Sarasate, 13605
 Putney bridge, 9436
 Self portrait, 168
 Symphony in white, no. 3, 11901
 Unsafe tenement (etching), *13898, 14131*
influence on interior decoration, *1569*
influence on St. Ives painters, *25495*
Lady of the yellow shoe, 17386
Lady with the yellow buskin, purchased by Fairmount Park commissioners, 1895, *11591*
lectures
 American lecture tour, 1885, *11267*
 tour in America, 1886, *2303*
 United States, 1885-86, *11243*
lithographs, *12952*
Little Rose and *Head of a blacksmith* in Boston Museum of Fine Arts, *13073*
meeting with Dannat, 1892, *26697*
memorial exhibitions, 1903, *13658*
model Carmen sells sketches, *13761*
monuments, International Society of Painters, Sculptors and

Engravers plans memorial, 1905, *13995*
Mrs. B. Sickert, 5253
Muther's estimate, *22439*
My mother, acquired by Musée National du Luxembourg, 1891, *3831*
nocturnes, *17612*
notes
 1886, *501*
 1887, *529*
 1890, *26052*
 1892, *15840, 26486*
 1893, *4387, 22483*
 1895, *16789*
 1897, *6425*
 1899, *17654*
Notes, published, 1890, *3177*
obituary, *8264*
Old Chelsea, 9629
painting method, *4521*
paintings, *13623*
paintings acquired by Boston Museum, 1897, *17205*
pamphlet denouncing art critics, *9124*
Peacock room, 5016, 8829
 dining room for F. R. Leyland's home, *3779*
personality, *3310, 10737, 22242*
photographs of pictures to be published, 1893, *16190*
plans to become French citizen, 1894, *4702*
portrait of A. J. Eddy, *5178*
portrait of Carlyle, *21654, 26334*
portrait of Lady Colin Campbell, *2364*
portrait of Lady Eden
 lawsuit, *12094*
 quarrel over portrait, 1895, *16732*
portrait of Miss Florence Leyland bought by Brooklyn Museum, 1907, *14294*
portraits
 caricatures collected by Avery, *13145*
 Chase's painting, *25329*
 crayon sketch by P. Rajon, *3309*
praise, *23745, 24034*
praised in *Gazette des Beaux-Arts*, 1883, *14922*
prints in West collection, New York, *1607*
protests U.S. import duty on art, 1901, *13312*
publication of letters and other writings, 1890, *25822*
quote, *22239, 22440*
 on Alma Tadema, 1895, *16841*
 on portraiture, *13379*
reproduction of works in magazines, *26721*
 seldom gives permission, *4042*
room decorated in black and yellow described, 1890, *3379*
Rosa Corder, at Louisiana Purchase Exposition, 1904, *13785*
sales and prices
 1880, etchings, *879, 919*
 1891, portrait of Carlyle, *26315*
 1892, *15930*
 1892, painting bought for Luxembourg Museum, *26466*
 1893, *Falling rocket, 4344*
 1901, *13313*
 1902, *13470*
 1904, prints, *13724*
 1906, *Henry Irving as King Philip II of Spain, 14145*
 increase in value of paintings throughout career, *13270*
Seymour Haden confuses his work with F. Duveneck's, 1890, *3335*
studio, *22721*
symbol of American art, *13081*
teaching
 Académie Whistler in Paris, 1898, *12796*
 art school established in Paris with Macmonnies, 1898, *24180*
 Paris atelier, *13055*
Ten O'Clock
 pamphlet of lecture, *25520*
 review, *2759*
 theory compared with Reynolds', *13458*

Wilder, Ralph Everett, b.1875
 studies at Chicago Art Academy, *12671*
WILES, Irving Ramsey, *21505*
Wiles, Irving Ramsey, 1861-1948
 elected to council, National Academy of Design, 1901, *13228*
 exhibitions
 American Art Galleries, 1887, *10832*
 American Watercolor Society, 1888, *2641, 10843*
 American Watercolor Society, 1889, *2883, 25576*
 American Watercolor Society, 1890, *3178*
 American Watercolor Society, 1897, *Green cushion* wins
 Evans prize, *6190, 17233, 23213*
 Berlin Akademie der Künste, 1903, *13605*
 Chicago Art Institute, 1900, *13137*
 Denver Artists' Club, 1898, *12706*
 Louisiana Purchase Exposition, 1904, *13787*
 National Academy of Design, 1884, *1879*
 National Academy of Design, 1886, third Hallgarten prize,
 25293
 National Academy of Design, 1887, *552*
 National Academy of Design, 1888, *2843, 10846*
 National Academy of Design, 1890, *3455*
 National Academy of Design, 1891, *3603*
 National Academy of Design, 1900, *12997*
 National Academy of Design, 1902, *13359*
 National Academy of Design, 1903, *13547*
 National Academy of Design, 1907, *14311*
 New York, 1900, *13158*
 New York, 1901, *13202*
 Prize Fund Exhibition, 1885, *Courtyard in France, 25278*
 Prize Fund Exhibition, 1886, *25304*
 Society of American Artists, 1897, *10538*
 Society of American Artists, 1900, *13038*
 Society of Painters in Pastel, 1888, *2696*
 Society of Painters in Pastel, 1890, *25904*
 Society of Washington Artists, 1905, *13886*
 Tennessee Centennial Exposition, 1897, portrature medal,
 11971
 Trans-Mississippi and International Exposition at Omaha,
 1898, *12775*
 Union League Club of New York, 1891, *Arrangement in light
 tones, 3498*
 Grandmamma, 22495
 illustrations
 Danseuse, 11673
 Green cushion, 6186
 Lunch time, 22560
 Miss Gladys Wiles, 13702
 Portrait, 14002
 Portrait begun, 22752
 Russian tea, 12015
 illustrations for *Persia and the Persians*, 1886, *509*
 illustrations for *The Century*, 1893, *22490*
 member of Sketch-Box Club, Paris, 1883, *24640*
 notes
 1893, *26984*
 1894, *22513*
 portraits, photograph, *22539*
 sales and prices
 1900, picture in Evans collection, *13008*
 1901, *Interior, 13210*
 sketches of women, *22797*
 teaching, Art Students' League, 1895, *12474*
 whereabouts
 1883, Paris, studying with Carolus Duran, *24424*
 1896, summer in town, *23056*
Wiles, Lemuel Maynard, 1826-1905
 exhibitions
 Brooklyn, 1892, *26703*
 Trans-Mississippi and International Exposition, Omaha,
 1898, *12775*
 lecture on chromatics at National Academy of Design, 1882,
 1332
 obituary, *13878*
 paintings of the California missions, *16383*

 studies of Genesee, *10617*
 Western scenes, 1883, *24424*
 whereabouts
 1883, European trip, *24551*
 1883, Ingham University, *24855*
Wilhelm I, *German emperor*, 1797-1888
 monuments, monument to be erected in Westphalia, 1893,
 26962
WILHELM II, German emperor, *13340*
Wilhelm II, *German emperor*, 1859-1941
 book on art inspired by Kaiser, *13995*
 Emperor of Germany dominates Berlin Art Exhibition awards,
 1894, *16647*
 gift of plaster casts to Harvard University, 1902, *13503*
 interest in art, *25966*
 interest in reviving manufacture of pure majolica ware, *13533*
 notes, 1896, *22943*
 patronage, *13699*
 support for Bismark monument, *25877*
Wilhelmina, *queen of the Netherlands*, 1880-1962
 collection, dolls, *16342*
 presented with Tiffany loving cup, 1901, *7589*
Wilinson, Elia See: **Peattie, Elia Wilkinson**
Wilke Art School See: **Richmond (Indiana). Wilke Art
School**
Wilke, F. A., Mrs., fl.1892-1896
 American china painter, *5956*
 director of Wilke Art School, 1892, *4224*
Wilkes Barre (Pennsylvania)
 architecture
 courthouse built by Joseph C. Wells, *19899*
 W. H. Conyngham residence, *7383*
Wilkie, David, 1785-1841
 arrival in London, *19305*
 canvas grounds and improper pigments, *5040*
 childhood, *19117*
 Columbus before the Prior of the Covenant, 6845
 compared with Teniers, *18579*
 English genre painter, *5903*
 etchings, *10795*
 exhibitions
 British Institution, 1850, *Penny wedding, 14666*
 Royal Scottish Academy, 1880, *21936*
 Family sorrows, 16412
 friendship with Haydon, *19323*
 illustrations
 Gipsey mother, 18234
 peasants, *9532*
 life and work, *14726*
 life drawing, *19343*
 Life of Wilkie, excerpts, *19485*
 paintings, *14643*
 paintings in Lenox Library collection, *771*
 personality, *18987*
 prints in West collection, New York, *1607*
 quote
 on genius in art, *19126*
 on pure art, *19016*
 Rabbit on the wall, 8959
 Rent day, reception, *19225*
 sales and prices, 1895, portrait of the Abbotsford family, *16823*
 student in Edinburgh, *19234*
 Washington Irving, 18441
 works in National Art Collection, London, 1897, *6397*
Wilkie, Robert David, 1827-1903
 fruit pieces reproduced by Prang in chromo, 1871, *23606*
Wilkin, Charles, 1750-1814
 engraver of Hoppner's paintings, *10255*
Wilkins, Annette W. See: **Hicks Lord, Annette Wilhelmina
Wilkins**
Wilkinson, Gardner See: **Wilkinson, John Gardner**
Wilkinson, John Gardner, 1797-1875
 *On Color, and on the Necessity for a General Diffusion of Taste
 Among All Classes*
 excerpt, *20053, 20058, 20073*

Williams, Henry S., fl.1890-1901
 illustrations, *My sheep, hear my voice* (photograph), *13285*
Williams, Herbert Deland, fl.1897-1923
 illustrations, title-page for *Modern Art*, *22433*
Williams, Hugh William, 1773-1829
 watercolors, *19854*
Williams, Ichabod T.
 collection
 catalogue, 1898, *17448*
 French and Dutch paintings, *25876*
Williams, Inglis Sheldon See: **Sheldon Williams, Inglis**
Williams, Isaac L., 1817-1895
 exhibitions, Pennsylvania Academy of the Fine Arts, 1895,
 memorial exhibition, *11638*
 notes, 1857, *19581*
 obituary, *16738*
 picture in Philadelphia Art-Union, 1849, *21404*
 studio, 1870, *10596*
 whereabouts
 1850, trip to Maine, *14657*
 1883, Catskills studio, *24618*
WILLIAMS, J. B., *12304*
Williams, J. Fred, d.1879
 obituary, *46*
Williams, James, fl.1763-1786
 portrait of John Wesley purchased by Lincoln College, Oxford,
 1889, *25687*
Williams, L. Lunt, fl.1873-1886
 American woman painter, *11230*
 exhibitions
 Salon, 1882, *1397*
 Salon, 1883, *1602*
 Salon, 1884, *1814*
Williams, Mamie, fl.1891
 exhibitions, California School of Design, 1891, *3483*
Williams, Mary See: **Davison, Mary Williams**
Williams, Mary Anne, fl.1858-1908
 illustrations, *United States mail steam ship "Atlantic"* (after A.
 Williams), *20888*
Williams, Mary Elizabeth, 1825-1902
 exhibitions, St. Botolph Club, 1891, paintings of interiors of
 Italian churches, *26303*
 obituary, *13503*
Williams, Mary Ella See: **Dignam, Mary Ella Williams**
Williams, Mary Rogers, 1856-1907
 exhibitions
 New York Water Color Club, 1894, *4703*
 New York Water Color Club, 1895, *5172*
 New York Water Color Club, 1896, pastels, *6060*
 woman painter, *22525*
Williams, Max, 1874-1927
 establishes printseller firm, 1893, *16212*
Williams, Oliver H., Mrs. See: **Baldwin, Esther M.**
Williams, Roger, ca.1603-1683
 monuments, *10672*
 Monument Association organized, 1860, *20248*
Williams, T., fl.1849-1879
 illustrations
 Chittennango Falls, *20952*
 Dunluce Castle (after G. F. Sargent), *20906*
 Entrance of Queen Elizabeth into Kenilworth Castle (after J.
 Gilbert), *20905*
 Interior of the House of Commons (after J. Gilbert), *20729*
 *Residence of Joseph Roberts, president of the Republic of
 Liberia*, *20927*
 William III entering Exeter (after J. Gilbert), *20768*
Williams, Thomas J.
 library, *15656*
Williams, True W., fl.1869-1880
 illustrations
 Chicago statuary, *10613*
 Hawk's nest (etching), *10637*
 Under the daisies, *10626*
Williams, Virgil, 1830-1886
 advice on painting, *2436*

 artist in San Francisco, *811*
 exhibitions
 Boston Art Club, 1880, *878*
 National Academy of Design, 1858, *19857*
 monuments, memorial proposed, 1903, *22176*
 notes, 1871, *10674*
 obituary, *529*, *22201*
 sporting scenes, 1871, *10646*
 whereabouts, 1859, Rome, *20045*
Williams, W.
 Art of Landscape Painting in Oil Colours, *1152*
Williams, William R., 1804-1885
 library, to be sold, 1896, *17119*
Williamson, Charters, b.1856
 addresses Essex Art Society, 1883, *24656*
 exhibitions, American Art Union, 1883, *Green and gold*, *10913*
 painting of interior, 1883, *24551*
 paintings, 1883, *24607*
 whereabouts, 1882, New York studio, *24400*
Williamson, Francis John, 1833-1920
 Elaine, *8898*
 memorial to John Pearson, *26081*
 Queen's memorial to Princess Charlotte and Leopold, King of
 the Belgians, *9819*
 sculpture of "Sister Dora", *10383*
 Spring and autumn, *8439*
 statue of Dr. Priestley, *8789*
Williamson, George Charles, 1858-1942
 Bryan's Dictionary of Painters and Gravers, review, *13811*
 Richard Cosway R.A. and His Companions, *5482*
WILLIAMSON, Harry, *22208*, *22236*, *22313*
Williamson, Harry, fl.1893-1894
 exhibitions, Indianapolis Art Association, 1893, *22280*
 illustrations
 decorative drawing, *22277*
 drawing, *22313*
 Dutch landscape, *22208*
 headpiece, *22312*
 "Hirsau bei Calw," The Black Forest, *22235*
 title page for *Modern Art*, summer number, 1894, *22299*
 vignettes, *22280*
 illustrations to M. E. Steele's *Impressions*, *22249*
 impressions of the Chicago World's Fair, 1893, *22236*
Williamson, J. C., fl.1881-1883
 class in Elizabeth, New Jersey, 1883, *24871*
Williamson, John, 1826-1885
 exhibitions
 Chicago Academy of Design, 1871, *10652*
 National Academy of Design, 1858, *19857*
 National Academy of Design, 1859, *20030*
 New York, 1859, *19978*
 illustrations, decorative designs, *1213*
 Trip to the tropics and California, *18609*
WILLIAMSON, Sara, *20702*, *20706*, *20711*
Williamson, Sara
 medium, *20666*, *20680*
 poem *To the Incarnate Bride*, *20648*
 receives spirit address to Maud Lord written by Forrester
 Gordon, *20721*
Williamson, William, b.1829?
 notes, 1860, *18417*
Williamsport (Pennsylvania)
 bequest of J. V. Brown for public library and art gallery, 1904,
 13810
Williamstown (Massachusetts)
 architecture
 banquet hall of Delta Psi, *516*
 Van Rensselaer Mansion to be re-erected, 1894, *16515*
Williamstown (Massachusetts). Williams College
 interior decoration of fraternity lodge, *2334*
WILLIS, Annie Isabel, *22734*
Willis, Edmund Aylburton, 1808-1899
 obituary, *17516*
Willis, George William, fl.1845-1869
 illustrations

sketch of standing woman, *23126*
Wilson, May, fl.1907-1936
exhibitions, National Academy of Design, 1907, *14311*
Wilson, Patten, 1868-1928
illustrations, cover plate for *Arcady Library*, *12527*
Wilson, Richard, 1713-1782
English landscapist, *17679*
exhibitions
Lotos Club, 1894, *4904*
New York, 1895, *16726*
landscape painter, *20763*
paintings in Fuller collection, *15828*
portrait of Angelica Kauffmann, attribution questioned, 1896, *5611*
portrait of George III and his brother left to National Gallery by Lady Hamilton, 1892, *26704*
portrait paintings, *5482*
resident of Covent Garden, *24082*
Waterfall near Tivoli, *16738*
WILSON, Rufus Rockwell, *22829, 22858, 22886, 22909, 22937, 22961, 22983, 23011, 23034, 23091, 23114, 23136, 23169, 23191, 23216*
Wilson, Rufus Rockwell, 1865-1949
biography of Inness planned, 1896, *23008*
Wilson, Ruth See: **Tice, Ruth Wilson**
Wilson, S. M., fl.1894-1895
illustrations
illustrations for *Vista Through the Shadow*, *22762*
Music and refreshments, *22576*
Wilson, U. G., fl.1895
Can you say your A, B, C?, *22805*
Wilstach, Anna H., d.1892
bequests to Philadelphia institutions, 1892, *26547*
collection
bequeathed to Memorial Hall instead of the Pennsylvania Academy of the Fine Arts, *15856*
French paintings left to Memorial Hall, Philadelphia, *26557*
left to Memorial Hall, Philadelphia, 1892, *26599*
listed and appraised, 1892, *15917*
Wilstach collection See: **Philadelphia (Pennsylvania). Pennsylvania Museum and School of Industrial Art**
Wilstach, William P., d.1873
collection, Wilstach Art Gallery opened, 1893, *16291*
Wilstach, William P., *Mrs.* See: **Wilstach, Anna H.**
Wimar, Charles Ferdinand, 1828-1862, *290*
Indian objects and sketches, *19942*
studio, St. Louis, 1859, *20129*
work, 1860, *20209*
work, 1861, *20330*
Wimbledon (England)
camp, description, 1889, *25637*
Wimbridge, E. See: **Winbridge, Edward**
Wimmer & Co., New York See: **New York. Wimmer & Co.**
Wimperis, Edmund Morison, 1835-1900
exhibitions, London, 1887, illustrations of New Forest, *10452*
Winans, Ross, 1796-1877
home, house in Baltimore, by McKim, Mead & White, completed, 1882, *1496*
Winbridge, Edward, fl.1877-1878
founder of Tile Club, *11267*
member, Tile Club, *1851*
Winchester (England)
description, 1860, *20282*
Winchester (England). Cathedral
chantry of Cardinal Beaufort, *21008*
screen statues, *26064*
Winchester (Indiana)
monuments, soldiers' monument unveiled, 1892, *26713*
WINCHESTER, J., *20639*
Winchester, J., *20726*
and Ancient Band, *20641*
Biographical and Descriptive Catalogue, excerpts, *20643, 20650, 20654, 20659*
Winckelmann, Johann Joachim, 1717-1768
German Art Club of Rome tribute, *14176*

History of Ancient Art
on the Ideal in classical sculpture, *9548*
review, *229, 19664*
quote, *19561*
on the Greeks, *19590*
Windett, Villette, fl.1899-1903
exhibitions, Chicago, 1899, miniatures, *12333*
windmills in art
Dutch windmills in Bunner's work, *22743*
Windmüller, Louis, 1835?-1913
competition with National Arts Club for right to exhibit American paintings from Paris Exposition, 1900, *7451*
window gardening, *10656*
windows
See also: **show windows**
exhibitions
Tiffany Glass Company, 1890, *3217*
Tiffany's, 1893, stained glass windows, *4593*
French decorative window glass, *1133*
furnishings, *11627*
modern stained glass windows, *14202*
mosaic glass, *486*
New York, *8825*
painted windows, *6627*
paper window-glass developed, 1888, *17848*
poster art glass, *12304*
proportion and decoration, *20571*
Sheraton window decorations, *3297*
stained glass window design by Messrs. H. E. Sharp, Son & Colgate of New York, *8653*
stained glass window for Judson Memorial Church unveiled, 1893, *26932*
stained glass window for St. Paul's church, New York, 1892, *26507*
stained glass window for Troy, New York, Y.M.C.A., *5647*
stained glass window of Church of San Martino, Cimino, Italy found, 1901, *7714*
stained glass windows for New York institutions made by Mayer & Co., Munich, *26703*
stained glass windows in Church of Ascension, New York, *2550*
Tiffany rose window designed and made by women, *27006*
Tiffany window for Yale University Library, 1890, *3142*
window for Lafayette Avenue Presbyterian Church, Brooklyn, 1893, *26952*
window grating from Casa de las Conchas, Salamanca, *2044*
windows and window seats for summer cottage, *7032*
Windram, Annie K. T., fl.1895
illustrations, alphabet, *22329*
Windrim, James Hamilton, 1840-1919
design for Philadelphia memorial, 1895, *16749*
Windsor Castle
collection, *16992*
decorative art treasures, *838*
Holbein drawings, *17338*
musical instruments, *17050*
description of renovated interior, 1902, *7862*
library, *26297*
model for Chicago World's Fair, 1893, *26937*
Windus, Benjamin Godfrey
collection, sale, 1855, *18681*
Windus, William Lindsay, 1822-1907
Burd Helen, *19975*
Too late, *20067*
wine and winemaking
collectors and collecting, wines, *15944*
sales and prices, 1897, Duke of Hamilton wine cellar, *17340*
Wingate, Carl, b.1876
illustrations
Catskill cottage, *22610*
Study head, *13616*
Wingfield, Lewis Stange, 1842-1891
collection, sale, 1892, *15797*
wings
in art, *10154*

Winham, Edmund, fl.1894
 summer home and studio, *22571*
Winkler, Olof, 1843-1895
 Landscape in the moon, *21648*, *21655*
Winne, Liévin de, 1821-1880
 obituary, *150*
Winner, Emma Ferdon See: **Rogers, Emma Ferdon Winner**
Winner, William E., ca.1815-1883
 exhibitions, National Academy of Design, 1849, *21429*, *21430*
 picture on exhibit at Philadelphia Art Union gallery, 1851, *23385*
 portrait paintings, 1870, *10596*
WINNY, *19103*
Winslow Bros. Co., Chicago
 illustrations
 animal sculptures of Kemeys, *11336*
 column capital shown at Paris Exposition, 1900, *13099*
WINSLOW, F. A., *11860*
Winslow, Harriet See: **Hayden, Harriet Clark Winslow**
Winsor & Newton, firm
 royal appointment, *13265*
WINSOR, Justin, *18636*, *18741*, *18813*, *18838*, *18844*, *18876*, *18889*, *18905*, *18958*, *18968*, *18981*, *19120*, *19121*, *19130*, *19175*, *19287*, *19292*, *19293*, *19306*, *19353*, *19374*, *19414*, *19455*, *19485*, *19531*, *19572*, *19587*, *19601*, *19603*, *19634*
Winsor, Justin, 1831-1897
 lecturer on art, *19717*
Winston, Dudley, Mrs., fl.1898
 illustrations, *Virginia*, *12711*
Wint, Marvin A., fl.1891-1894
 illustrations, study, *22531*
Wint, Peter M. de, 1784-1849
 exhibitions, London, 1884, *9985*
winter
 description, *19597*
 in poetry and art, *10970*
 scenes in water-colors, *7553*
Winter, Alice Beach, 1877-1970
 illustrations, student sketch, *11782*
Winter, Charles Allan, 1869-1942
 exhibitions, National Academy of Design, 1902, *13359*
 illustrations, foreign scholarship drawing, 1894, *21534*
Winter, Charles Allan, Mrs. See: **Winter, Alice Beach**
Winter, Henry, fl.1896
 illustrations, advertisement for steamship company, *23690*, *23712*, *23731*
Winter, John Strange See: **Stannard, Henrietta Eliza Vaughan Palmer**
Winter, William, 1836-1917
 Joseph Jefferson biography, *16462*
 notes, 1871, *10677*
WINTERBOTHAM, Ruth W., *11511*
Winterbotham, Ruth W., fl.1893-1895
 paper read before Congress on Ceramic Art, 1893, *4540*
WINTERBURN, Florence Hull, *22808*, *22841*, *22870*, *22899*
Winterhalter, Franz Xaver, 1806-1873
 Florinde, exhibited at Boston, 1858, *19942*
Winterwerber, Mlle
 illustrations, fabric design, *13558*
Winthrop, John, 1588-1649
 manuscripts, family papers, *16409*
Winthrop, Robert Charles, 1809-1894
 collection, donates manuscript collection to Yale, 1897, *17335*
WINTHROP, Thomas L., *366*, *390*, *412*
Wirgman, Theodore Blake, 1845-1925
 exhibitions, Royal Institute of Painters in Water Colours, *9820*
WIRTH, B., *9533*
Wirts, Stephen M., fl.1897-1914
 appointed Vice-Chairman of Entertainment Committee, American Art Association of Paris, 1898, *24114*
 exhibitions, American Art Association of Paris, 1898, drawings, *24010*
 whereabouts, 1898, returns to Paris from America, *24134*
Wisconsin
 description of winter, *25581*

Wisconsin State Historical Society See: **Madison (Wisconsin). Wisconsin State Historical Society**
Wise, Charles S., fl.1895
 Study, *22816*
Wise, Henry Alexander, 1808-1876
 address at inauguration of Washington monument, Richmond, 1858, *19816*
WISEMAN, Edith Phillips, *13357*, *13511*
Wislicenus, Hermann, 1825-1899
 illustrations, Kaiserhaus, Goslar, Germany, *9668*
WISP, Will Peleg, *20246*
Wiswell Gallery, Cincinnati See: **Cincinnati (Ohio). Wiswell's Gallery**
Wiswell, William
 dealer in Cincinnati, 1860, *24335*
wit and humor
 anecdote concerning Dr. Johnson, *23094*
 jokes and puns, *18529*
 Parisian art wits, *1169*
wit and humor, pictorial
 exhibitions
 London, 1889, *25636*
 National Academy of Design, 1894, *22521*
 Japanese woodcuts, *21906*
witchcraft
 Boston State House witchcraft documents, *16662*
 bronze memorial tablet to John Proctor, last tried for witchcraft, *8035*
 relics in Salem Massachusetts, *16905*
Wither, George, 1588-1667, *21491*
Withers, Frederick Clarke, 1828-1901
 Astor reredos, Trinity church, New York, *8771*
 exhibitions
 Architectural League, 1889, *25693*
 National Academy of Design, 1865, *23334*
 Presbyterian church in Newburgh, New York, *19970*
Withers, George See: **Wither, George**
Withrow, Evelyn Almond, 1858-1928
 notes, 1900, *22099*
Withy, T.
 illustrations, tulip wreath flower vase mat, *21185*
Witkowski, Karl, 1860-1910
 sales and prices, 1905, Des Moines exhibition, *14009*
Witt, John Henry, 1840-1901
 exhibitions
 Chicago Inter-State Industrial Exposition, 1880, *199*
 National Academy of Design, 1884, *25187*
 National Academy of Design, 1890, *Good-bye*, *3455*
 National Academy of Design, 1892, *26858*
 National Academy of Design, 1897, *Nymphs' paradise*, *6248*
 Prize Fund Exhibition, 1885, *25278*
 Giving him half, in Seccomb collection, *15647*
 illustrations, *To the manner born*, *13202*
 whereabouts, 1883, Southport, Ct, *24777*
WITTE, Beatrice, *21480*, *21497*
Witte, Jean Joseph Antoine Marie, baron de, 1808-1889
 obituary, *25629*
Wittenberg (Germany)
 monuments, Melanchthon, *19714*
Wittig, Hermann Friedrich, 1819-1891
 busts of Tieck and von Radowitz, *18971*
Wittkamp, Johann Bernhard, 1820-1885
 Datheen preaching before the walls of Ghent, acquired by Pennsylvania Academy, 1857, *19626*
 Datheen preaching in the neighborhood of Ghent, *19658*
 Deliverance of Leyden, *18592*
 exhibitions, Pennsylvania Academy of the Fine Arts, 1855, *18793*
 Relief of Leyden, *16409*
Wittmer, Johann Michael, 1802-1880
 obituary, *150*
Wivell, Abraham, 1786-1849
 anecdote, *14549*
Wodin See: **Odin**

notes, 1899, *6927*
pupils of wood carving at Tokyo University, 1899, *6906*
wood carving, Philippine
notes, 1902, *7833*
wood carving, Scandinavian
role in typical Scandinavian household, *8062*
technique, and role in average family, *7513*
wood carving, Swedish
notes, 1901, *7660*
wood carving, Swiss
choir stalls of Berne Cathedral, *25647*
wood engraving
compared to engraving in copper, *21666*
competitions, *Scribner's Monthly*, 1881, *331*
craft replaced by new processes, 1890, *3254*
Europeans and Americans to exhibit at Vienna Special-
 Austellung der Graphischen Kunste, 1883, *24750*
exhibitions
 Boston Museum of Fine Arts, 1881, *1254*
 Grolier Club, 1890, *25758*
history
 and origin, *24328*
 and technique, *10827*, *17933*
 origins and development, *2142*, *21686*, *21692*, *21712*
illustrated books, *1249*
invention of graphotype, *18510*
lecture by H. von Herkomer, *9628*, *9638*
Lewis Frazer lecture on magaine illustration, 1894, *4716*
merits for illustration, *5077*
notes, 1898, *17410*, *17435*
photography versus engraving, *5130*
principles, *21772*, *21782*
renewed appreciation, 1896, *17093*
review of books, *42*
technique, *1865*, *1887*, *1905*, *1936*, *13727*, *15141*, *18208*
 embossing, *18178*
 use of photography, *18191*
 wood points, new technique, *13514*
wood cuts used by Arthur W. Dow in color and composition
 studies, *12929*
wood engraving versus process block, *4282*
woodcuts in Gothic book illustration, *26624*
wood engraving, American
early history, *87*, *106*, *123*, *137*, *155*, *168*, *182*
exhibition suggested, 1885, *1922*
exhibitions
 Boston, 1881, *378*
 Grolier Club, 1886, *2131*
 Vienna Graphic Arts Exhibition, 1883, *24750*
illustration of newspapers, *14779*
illustrations for Thackeray's *Chronicle of the Drum*, *1268*
Scribner's competition, 1880, *283*
tinted wood engravings, *14510*
wood blocks by Arthur W. Dow, *12929*, *22406*
work of Alexander Anderson, *66*
wood engraving, Dutch
early history, *21965*, *22053*
wood engraving, English
history, *9464*
Thomas Bewick, *21742*
works of Thomas and John Bewick, *9525*
wood engraving, German
Schäufelein's illustrations of *Theuerdank*, *15133*
wood engraving, Japanese
humor, *21906*
WOOD, Esther, *23819*, *23846*, *23872*, *23883*, *24123*
Wood, Fernando, 1812-1881
library, sale, 1895, *16900*
Wood, Francis Derwent, 1871-1926
exhibitions, Royal Academy, 1907, *14312*
Wood, George Bacon, jr., 1832-1910
Beyond repair, *22861*
exhbitions, Boston Society of Amateur Photographers, 1884,
 10899
illustrations

In Scrub Lane, *22531*
Scrub Lane, Germantown, Pa, *22560*
WOOD, Henry Rogers, *23053*, *23074*, *23128*
Wood, J. Ogden See: **Wood, Ogden**
Wood, James Rushmore, 1816-1882
Wood Museum of pathological specimens inaccessible, 1896,
 17119
Wood, John Warrington, 1839-1886
Sisters of Bethany, *8380*
Wood, John Z., 1846-1912
illustrations, *Dashing waves*, *590*
Wood, Katherine Bontecou, d.1913
Quotations for Occasions, review, *12582*
Wood, M. Louise See: **Wright, M. Louise Wood**
Wood, Marshall, d.1882
Song of the shirt, in Schaus collection, *15840*
Wood, Ogden, 1851-1912
exhibitions
 Salon, 1883, *24521*
 Salon, 1885, *2000*
 Salon, 1886, picture of cows and oxen, *2206*
Mailler Plain, in American Art Galleries, 1884, *1899*
sales and prices, 1889, *14961*
whereabouts, 1883, Paris, *24457*, *24589*
wood rats
description, *23622*
Wood, Robert William, b.1868
award for work on color photography, 1900, *13161*
Wood, Stanley L., 1866-1928
illustrates Burton's translation of *Arabian Nights*, *15241*
illustrator of *Sentimental Journey through France and Italy*,
 1891, *15783*
Wood, Starr, 1870-1944
illustrations, *Horse power*, from *Sketch*, 1893, *22492*
Wood, Thomas Waterman, 1823-1903, *8635*
Chiffonière, *20012*
copies after Bonheur and Titian, *18282*
Daughter of Eve, *24492*
Every man his own doctor (etching), *24541*
exhibitions
 American Art Union, 1883, *Taking toll*, *10913*
 American Watercolor Society, 1876, *8624*
 American Watercolor Society, 1879, *9123*
 American Watercolor Society, 1880, *74*, *9292*
 American Watercolor Society, 1881, *296*
 American Watercolor Society, 1882, *1300*
 American Watercolor Society, 1884, *25012*
 American Watercolor Society, 1885, *1933*
 American Watercolor Society, 1889, *2883*
 Milwaukee Exposition, 1883, *24799*
 National Academy of Design, 1858, *19857*
 National Academy of Design, 1859, *20030*, *20048*
 National Academy of Design, 1880, *111*
 National Academy of Design, 1881, *1061*
 National Academy of Design, 1884, *1790*
 National Academy of Design, 1884, *Good night*, *10982*
 National Academy of Design, 1885, *1970*
 New York Etching Club, 1882, *1296*, *24391*
 New York Water Color Club, 1890, *26139*
founds art gallery, 1895, *16734*
illustrations
 Cup that cheers, *22513*
 Curbstone politeness, *552*
 Darning day, *22546*
 Daughter of Eve (drawing), *11068*
 Difficult text, *10793*
 Good-night, *1772*
 His first business venture, *1731*
 It's only me, *1504*
 Nest, *13250*
 Stolen chance (etching), *11125*
 This world is all awry (etching), *22549*
 Uncle Ned and I, *1330*
notes
 1883, *24525*